# INTERNATIONAL GUIDE TO
# NINETEENTH-CENTURY PHOTOGRAPHERS
## AND THEIR WORKS

# INTERNATIONAL GUIDE TO
# NINETEENTH-CENTURY PHOTOGRAPHERS
## AND THEIR WORKS

*Based on Catalogues
of Auction Houses and Dealers*

GARY EDWARDS

G.K.HALL&CO.
70 LINCOLN STREET, BOSTON, MASS.

**Library of Congress Cataloging-in-Publication Data**

Edwards, Gary, 1934–
    International Guide to nineteenth-century
photographers and their works.

    1. Photography — History — 19th century — Sources.
2. Photographic art galleries — Catalogs — Bibliography.
3. Photographers — History — 19th century — Sources.
I. Title.
TR15.E48    1988      779'.09'034074      87-25120
ISBN 0-8161-8938-2

*This publication is printed on permanent/durable acid-free paper*
**MANUFACTURED IN THE UNITED STATES OF AMERICA**

# Contents

# Acknowledgments

The author gratefully acknowledges the assistance and encouragement of many collectors, dealers, curators, and photographic auction specialists who have been generous in offering useful suggestions as this work progressed, and in providing copies of catalogues that I did not already have available. Photography experts at the auction houses were without exception punctilious in seeing that I had, insofar as possible, a complete run of their photographic sales catalogues, sometimes by photocopying their own last reference copy. It would be impossible to single out those who helped me more than others because virtually everyone provided all the help it was in his power to give. I would be remiss, however, in not mentioning here two generous collectors and photography connoisseurs in Paris who allowed me access to their private libraries: Gérard Lévy and André Jammes. This was especially valuable since I lived in Paris when I was doing research on this project. André Jammes was also generous enough to contribute as a Foreword to the book a fascinating essay on the early period of what he calls "photology," an essay that not only gives the first published account of the "prehistory" of the collecting of nineteenth-century photographs, but also brings wonderfully to life those names that I for one knew only from their catalogues—Ernst Philip Goldschmidt, Ernst Weil, Georges Andrieux, and Nicholas Rauch.

I herewith give my heartfelt thanks to Michel and Michèle Auer, Chris Beady of Harris Auction Galleries, Terry Bennett of Old Japan, Denise Bethel of Swann Galleries, Gretchen Falk of California Book Auction Galleries, Philippe Garner of Sotheby's in London, Beth Gates-Warren of Sotheby's in New York, Claudia Gropper of Christie's in New York, Anne Horton of Sotheby's in California, Rodger Kingston, former owner of the Photographic Eye, Robert Koch, Hans P. Kraus, Jr., Harry Lunn, Hugo Marsh of Phillips in London, Alain Paviot of Galerie Octant, Howard Ricketts, Lindsey Stewart of Christie's in London, Addison Thompson of Phillips in New York, the Stephen White Gallery, Charles B. Wood III, and, for their spontaneous encouragement, William Johnson in Massachusetts, Stephen Joseph in Brussels, and Beaumont Newhall.

# Foreword by André Jammes

A living art can only thrive in a favorable environment created by the conjuncture of three forces—collectors, dealers, and curators. It is the collector—whether private or institutional—who discovers and values the raw material; he is the driving force behind any art that has life. His pioneering work is closely followed by the dealer—factors of economic survival and expansion come into play here. The dealer performs the essential role of bridging the gap between the material itself and the repository where it will finally be placed as an object of study and admiration. Then comes the curator, bringing his scientific outlook, and often devoting his whole life to the task. The curator puts a "seal of approval" on material that thenceforth becomes an accepted and respected work of art. But this three-way symbiosis in society is fragile. We know the sterility of artistic life in countries where there is an official impediment to the free circulation of art. We all know the difficulty that Germany has had in lifting itself out of the cultural eclipse that followed the Nazis' elimination of that country's best art dealers and its intellectual elite.

This book deals essentially with the marketing vehicles of art dealers, and in this respect it throws light on what is probably the least-known aspect of the nineteenth-century photography field. It offers us a global repertoire of the sale of nineteenth-century photographs beginning with the initial development of this market. Indeed, the market for nineteenth-century photographs is so new that this guide can claim to be practically complete. The book is, however, neither a price guide nor a market survey. The author has banished price indications from his statistics. Since the market for nineteenth-century photography is so new and still volatile, and since marketing practices are still in a state of flux, a price list would have had no real significance. But the author's register constitutes a reliable census of the photographic material that has passed through the hands of booksellers, galleries, and auction houses out into the world at large. This is a valuable contribution to the history of photography, which I dare say will be the envy of historians in those other artistic fields where market activity has, over a much longer timespan, been simply too vast to attempt to index it. Along with monographs, exhibition catalogues, and periodicals, photography has now been endowed with an additional indispensable tool.

The history of photographic sales should someday be written. But while memories are still alive it would be useful to recall the activities of the pioneering dealers in France and England who considered it their mission to develop a new clientele for a new art.

The first auction sale of nineteenth-century photographs for which there was a truly detailed catalogue took place in Geneva on Tuesday, 13 June 1961. The auctioneer was Nicholas Rauch, and he benefited from the collaboration of Marie-Thérèse Jammes in writing a catalogue whose aim was to bring to this new field the same rigorous standards of bibliographic scholarship as was the tradition in the rare book field.

Rauch was for a period of about forty years one of Europe's most important rare book dealers and one of the first to interest himself in photography, a field all but totally neglected in the period before World War II. He received his training from Marguerite Milhau, a very elegant lady who ran an antiques store near the Place Vendôme. Mme Milhau had a passion for old photographs, and she wanted to pass this passion on to her large clientele of connoisseurs. But in the crisis atmosphere that prevailed around 1935, her efforts to gain appreciation for old photographs met with little response, apart from Rauch's. At that time Rauch was the director of the Paris branch of the famous English rare book dealer Maggs Brothers, a firm that still has an important bookstore in London. In 1939 Rauch published a catalogue of rare books with a large section on photography that contained detailed information on calotypes, negative and positive processes, American photographers, Dagron's pigeon letters, Nadar's portraits, the incunabula of Hill and Adamson, and even prints by Charles Nègre. The commercial prospects for such an enterprise were limited, but Rauch wanted to support his friend Mme Milhau and the nascent field of "photology" with all the weight of his prestige and to bring to the field the traditions of classic bibliographic lore. It was naturally a total failure. When Mme Milhau died in the late 1950s Rauch acquired practically the whole of his friend's inventory and personal collection. But this courageous man wanted to win his battle before he too passed from the scene. The 1961 auction sale, even if its prices seem ridiculously low by today's standards, did achieve a certain degree of success and truly paved the way for today's era of frequent photographic auction sales.

We should not fail to mention another Parisian bookdealer, Pierre Lambert, a man who was so self-effacing that it is hard to discover his traces. He was actually a scientist, having first studied medicine. Being unable to practice because of his own bad health, he devoted himself entirely to books. He early on included daguerreotypes and other photographic incunabula among his offerings. In 1935 during the dispersal under shameful conditions of the collection of the Jussieu family with which Hippolyte Fizeau was connected, Lambert rescued from a pile of rubbish in the courtyard of the Chateau de la Ferté sous Jouarre, in the rain, all of Fizeau's photographic test engravings of 1841-43. His catalogues are rich in descriptions of books and documents illustrating the birth of photography. He was also the official source of material for an extraordinary English bookdealer of whom we will later have occasion to speak, and it was through that dealer that some of Lambert's very rare photographic material was acquired by William Ivins and passed into the collections of the Metropolitan Museum of Art in New York. Lambert died in July 1969.

The community of English rare book dealers can boast of having had among its members one of the most distinguished rare book dealers of all time—Ernst Philip Goldschmidt. He was born in Vienna in 1887 and, after a sound education at Cambridge, became a specialist in incunabula. He then became the director of an important bookstore in Vienna where he also organized auction sales. In 1923 he moved to London and published over one hundred catalogues and important works on the books of the Renaissance. He died in 1954. One of his principal catalogues contained a section entitled "a collection of early photographs and books commemorating the centenary of Fox Talbot and Daguerre, 1839-1939." The preface stated "For some years past we have been engaged in searching for these early specimens and documents of artistic photography, and found a gratifying response in the interest extended to these matters by some of the more far-seeing museums and collectors." But 1939 was not a good year to undertake such an initiative, and it met with almost no commercial success. Beginning in 1943 Goldschmidt's associate, Dr. Ernst Weil, opened his own bookstore and secured a large part of Goldschmidt's photographic inventory.

Weil was a rare book dealer in Vienna until 1933 when he was forced to leave Austria because of events there. A true scholar and author of a bibliography on Einstein, Weil specialized throughout his life in scientific literature. He published thirty-three fascinating catalogues containing numerous descriptions of rare photographs, important both for their historic and aesthetic qualities—material he searched for and found all over Europe. He was the inspiration and source for the earliest American collectors and curators. He died in 1965 but not before influencing many young book dealers in France as well as in the English-speaking countries. Among his disciples was Alain Brieux, who unfortunately died at a relatively early age just last year. He had a passion for photography and practiced photography himself enthusiastically albeit clandestinely, towards the end of World War II. He was given the opportunity to work in the bookstore of Georges Andrieux, an expert bookseller who also conducted well-known auction sales. Making use of his knowledge of photography and following the standards created by Weil, Brieux published two sales catalogues for Andrieux around 1951 and 1952. These catalogues had a certain amount of success with some of the American museums, especially the George Eastman House where Beaumont Newhall was then director. Brieux' legacy in this "prehistoric" period of the interest in photography was decisive in shaping a French "market" for nineteenth-century photography.

Photography will soon celebrate its one hundred fiftieth birthday. Historians of the more established fields of art may, looking down from their thousands of years of monumental art, regard this event with an amused and patronizing eye. Yet little by little photography is insinuating itself into this traditional sphere. This book is already a cornerstone of a "photological" edifice of serious publications that will surely pay tribute to these birthday celebrations.

André Jammes

Paris, 1987

# Preface

Photographic sales catalogues are often overlooked by researchers in the field of nineteenth-century photography, and their sales-oriented formats can make them difficult to use for research purposes. By reformatting the information alphabetically by photographer, I have with this guide made available to researchers the wealth of previous research conducted by outstanding dealers/scholars that went into the production of more than three hundred catalogues from international book and image dealers and auction houses.

The idea of writing this guide germinated with a project I recently undertook of making a complete checklist of photographers working in Greece in the nineteenth century. Several times I found I was looking for information that I vaguely remembered having seen in an auction or dealer catalogue but was unable to relocate with ease. For example, information on the early photographs of Greece by Henri Bevan and C. E. Fountaine came to me exclusively from auction catalogues. As another example of the arcane information contained in sales catalogues, the fact that the American photographic chronicler of the Acropolis of Athens, W. J. Stillman, had lived in Italy was known to me, and that he took photographs there I suspected. But the actual identification of such photographs probably appears nowhere else in published photographic literature than in Christie's New York catalogue of 16 May 1980, lot 188. It occurred to me that similarly valuable information on nineteenth-century photographers in fields of equally vital interest to other researchers was also contained in these seemingly banal listings. It was then simply a task of going through my extensive collection of catalogues and those made available to me by many generous collectors, dealers, and research archivists, to rearrange the listings alphabetically and to devise a shorthand system for registering basic information contained in the cataloguer's description of each lot.

A compromise between my desire to tell as much as was included in the original listing and the desirability of keeping the book to a manageable length has meant that this is only a guide, and that for many applications the researcher will have to consult the original catalogues. But this guide will tell the researcher when and where a photographer's name (or initials, in many cases) has appeared; if the photographer's work was illustrated; the number of items by the photographer included in the lot; if the work appeared in a book, album, or in the form of individual images; and, particularly important for the researcher, if the cataloguer added a note to supplement a standard description of the lot's contents and condition. These notes are sometimes no more than a reference to other published works concerning the particular image being offered, but on the other hand, the notes often contain obscure biographic data or other unusual and significant information about the material being offered.

Personally, I am more interested in uncovering basic information on obscure figures than obscure information on well-known figures, but different researchers will find different bits of information in the catalogues to be the very bit of "intelligence" they need to clarify a problem in nineteenth-century photography they are working on, which might be either what were the different countries that photographer $X$ photographed, or who were the different photographers who photographed country $X$. I have, accordingly, put into this guide every nineteenth-century listing, no matter how trivial or truncated, that the original cataloguers listed. In many cases small bits of information from different listings have added up to a useful composite picture of little-known photographers, providing fresh facts not previously recorded in photographic history books. I have followed the principle that anything I might have decided to leave out might be precisely what is most important to someone else. I understand it is axiomatic in the advertising world that everyone knows that half the money spent on advertising is wasted, but no one knows which half that is.

A word of caution about accepting all the data in this guide as absolutely true—I have merely repeated what other cataloguers, faced with the time pressures of handling volumes of the actual photographic material, have written. Cataloguers can make mistakes, and if they did, I have in most cases passed on those mistakes in this book (although I did detect and correct a fair number of typographical errors). Cataloguers can also be overoptimistic in attributing unfamiliar photographs to a well-known, hence higher priced, photographer. I have used the phrase "attributed" to cover all shadings used by cataloguers such as "possibly by," "probably by," "attributable on the basis of," etc. I have found, though, that examining attributed material can be among the valuable uses of this guide as it offers a professional opinion that has at least the strong potential of extending our knowledge of a photographer's oeuvre.

I consider this work to be still in progress. While this guide will undoubtedly offer to the field much new information on photography and individual photographers, there are many gaps that will be filled in only with time as new

material—material evidence as it were—comes into the market and is catalogued. I hope anyone, whether collector, researcher, or dealer, will write me (Box 458, Southampton, New York 11968) with corrections to or expansion of this data. I would hope, for instance, that the large number of American photographers listed, many of them obscure stereo photographers working in small communities in the 1860s and 1870s, would stimulate interest on the part of historical societies in pursuing research into the iconographic history of these communities. Geographic precisions on these American photographers—and indeed on topographical photographers everywhere in the world—should be added to the record to aid scholarly research into nineteenth-century society. This research will, I am convinced, undergo geometric growth over the next few years.

One basic problem in the study of photography is to decide when the nineteenth century ends and the twentieth begins. Auction houses usually begin the twentieth century with the Photo Secession, and I have followed their lead in eliminating this group of photographers even if some, Frederick Evans for example, did important work at the end of the nineteenth century. Photographers such as Edward Curtis and Karl Moon, though, are usually included in the nineteenth century section of sales catalogues. I have been more restrictive, partly out of dissatisfaction with the plethora of attention given to Curtis in auction catalogues at the expense of those whom I consider underrepresented in view of their documentary and aesthetic worth, for example Laurent or Naya. But of course this simply indicates market forces in action. It is due primarily to space limitations that I have eliminated from this guide Curtis and Atget, as well as the major publishers of stereo views who worked more in the twentieth century than in the nineteenth.

I have supplemented the information provided in the original catalogues with basic information on the photographers listed, taken from a variety of standard reference sources. I begin each photographer's listing with as much as is known on his nationality, dates of birth and death, inclusive dates for earliest and latest known photographs (not including reprints, unless they are known only or primarily in that form), processes used, formats, geographic range for topographic and documentary photographers, and studio location. I have arbitrarily assigned most photographic images of the nineteenth century to

fit into one of the following subject categories: portraits, topography, genre, or documentary work. My goal has been to initiate a system of limited indicators that can then provide computer-assisted guidance in the identification of photographs. One potential application would be, for example, to aid in identifying unsigned topographical prints of certain countries sorted by date and/or process and/or format. As another aid to data retrieval I have arbitrarily assigned surnumbers to photographers who are obviously different individuals but whose names are indistinguishable. There are five photographers simply named "Jones" in this guide, in addition to the eight Jonses with first names or initials.

This book is not a price guide. A photographer's name and a description of an image or lot is not a sufficient basis for pricing photographs. Each example of a photograph is different and must be examined personally. And the market dynamics on a particular day, in a particular sales room, vary. Readers of this guide will, however, have the opportunity to form an overall idea of the photographic market and its development: which photographers have appeared frequently and in what context, as a single, illustrated image or in an album with the work of other perhaps more significant photographers; which photographers are disappearing from auctions, perhaps because of scarcity or a loss of collector interest; and what new names have appeared in the market in recent years, because of either new discoveries or a reevaluation of a photographer's value.

The strongest conclusion I have drawn from my close contact with photographic sales catalogues in the preparation of this work is that one does not tire of nineteenth century photographs. Images by newly discovered photographers, and new images by established photographers, appear in the market regularly to renew its vitality. Nor does one lose interest in the known great images of the nineteenth century, even should the same image appear for sale a hundred times.

Gary Edwards

Paris and New York, 1987

# A Note on How to Use This Guide

The shorthand system I have used for describing lots is intended to be straightforward and easily decipherable. Below I will lead the reader through a hypothetical entry containing the formulations he will face in this guide, going from the simplest to the most complex:

**JONES, J.**
Sothebys NY 1/1/80: 10, 12 ill, 14 (2), 16 ill(4) (note), 18 (lot, J et al), 20 (album, J-1 et al), 22 ill(book, J-2 et al), 24 (2 ills)(lot, J et al), 26 (lot, J attributed et al), 28 (lot, J-1, J & Smith-2, et al);

Explanation:
lot 10 consists of a single image, not illustrated, by Jones.
lot 12 consists of a single image by Jones, illustrated.
lot 14 consists of two images by Jones, not illustrated.
lot 16 consists of four images by Jones, of which one is illustrated, and there is a supplementary note concerning the lot.
lot 18 consists of an unspecified number of images, not all by Jones, of which an unspecified number are by Jones.
lot 20 consists of an album with an unspecified number of images, of which only one is by Jones.
lot 22 consists of a book with an unspecified number of images, of which only two are by Jones, and one of Jones's is illustrated.
lot 24 consists of an unspecified number of images, not all by Jones, and two images by Jones are illustrated.
lot 26 consists of an unspecified numer of images, not all by Jones, of which an unspecified number are attributable to Jones.
lot 28 consists of an unspecified number of images, of which one is by Jones and two are by Jones collaborating with Smith.

These basic principles may be helpful to the reader:
1. A comma (unless it is within parentheses) terminates one lot and begins another.
2. The first number written is the lot number. If there is no other number the lot consists of a single image. If there is more than a single image in the lot, the number of images (if specified in the catalogue) will appear within parentheses.

# Catalogues Listed

Alexander Gallery, London

Alexander Lon 1976

Anderson & Hershkowitz, London

Anderson & Hershkowitz Lon 1976

John Anderson, Jr., New York (Gilsey Collection)

Anderson NY (Gilsey Coll.) 1/20/03
2/24/03
3/18/03

Georges Andrieux, Paris

Andrieux Paris 1951(?)
1952(?)

Bièvres, France

Bievres France 2/6/83

California Book Auction Galleries, San Francisco
and Los Angeles, California

California Galleries 9/26/75
9/27/75
4/2/76
4/3/76
4/4/76
1/22/77
1/23/77
1/21/78
1/22/78
1/22/79
3/30/80
12/13/80
6/28/81
5/23/82
6/19/83
7/1/84
6/8/85
3/29/86

Christie's, London

Christies Lon 7/13/72
6/14/73
10/4/73
4/25/74
7/25/74
6/10/76
10/28/76
3/10/77
6/30/77
10/27/77
3/16/78
6/27/78
10/26/78
3/15/79
6/28/79
10/25/79
3/20/80
6/26/80
10/30/80
3/26/81
6/18/81
10/29/81
3/11/82
6/24/82
10/28/82
3/24/83
6/23/83
10/27/83
3/29/84
6/28/84
10/25/84
3/28/85
6/27/85
10/31/85
4/24/86
6/26/86
10/30/86

Christie's, New York

Christies NY 5/4/79
9/28/79
10/31/79
5/14/80
5/16/80
11/11/80
5/14/81
11/10/81
5/26/82
11/8/82
2/8/83
5/9/83
10/4/83

11/8/83
2/22/84
5/7/84
9/11/84
11/6/84
2/13/85
5/6/85
11/11/85
5/13/86
11/11/86

## P. & D. Colnaghi & Co. Ltd., London

Colnaghi Lon 1976

## Daguerreian Era, Pawlet, Vermont

Vermont Cat 1, 1971
Cat 2, 1971
Cat 4, 1972
Cat 5, 1973
Cat 6, 1973
Cat 7, 1974
Cat 8, 1974
Cat 9, 1975
Cat 10, 1975
Cat 11/12, 1977

## Hotel Drouot, Paris

Drouot Paris 5/29/78
11/27/82
11/24/84
11/22/86

## Francis Edwards Ltd., London

Edwards Lon 1975

## Fraenkel Gallery, San Francisco, California

Fraenkel Cal 1984

## Frontier America Corporation, Bryan, Texas

Frontier AC, Texas 1978

## Allan Frumkin Gallery, Chicago, Illinois

Frumkin Chicago 1973

## E. P. Goldschmidt & Co., London

Goldschmidt Lon Cat 52, 1939

## Martin Gordon, Inc., New York

Gordon NY 5/3/76
11/13/76
5/10/77

## The Halsted 831 Gallery, Birmingham, Michigan

Halsted Michigan 1977

## Harris Auction Galleries, Inc., Baltimore, Maryland

Harris Baltimore 7/13/81
3/26/82
5/28/82
12/10/82
12/16/83
4/8/83
9/16/83
6/1/84
11/9/84
3/15/85
9/27/85
2/14/86
11/7/86

## International Museum of Photography at George Eastman House, Rochester, New York

IMP/GEH 10/20/77

## Robert Koch, Inc., Berkeley, California

Koch Cal 1981-82

## Hans P. Kraus, Jr., New York

Kraus NY Cat 1, 1984
Cat 2, 1986

## Janet Lehr, Inc., New York

Lehr NY Vol 1:2, 1978
Vol 1:3, 1979
Vol 1:4, 1979
Vol 2:2, 1979
Vol 6:4, 1984

## Stefan Lennert, Munich

Lennert Munich Cat 2, 1978
Cat 5, 1979
Cat 5II, 1979
Cat 6, 1981

**Loudmer-Poulain (and Auer), Paris**

Auer Paris 5/31/80

**Lunn/Graphics International, Washington, D.C.**

Lunn DC Cat 2, 1972
       Cat 3, 1973
       Cat 6, 1976
       Cat QP, 1978

**Maggs Brothers, London and Paris**

Maggs Paris 1939

**Mancini Gallery, Inc., Philadelphia, Pennsylvania**

Mancini Phila 1979

**Galerie Octant, Paris**

Octant Paris 11/1978
        3/1979
        3/1980
       10/1980
        1982
        9/1984

**Old Japan, Couldsen, Surrey, England**

Old Japan, England Cat 5, 1982
              Cat 8, 1985

**Petzold Photographica, Augsburg, Germany**

Petzold Germany 5/22/81
           11/7/81

**Phillips, Toronto, Canada**

Phillips Can 10/4/79
         10/9/80

**Phillips, London**

Phillips Lon 3/13/79
         3/12/80
         6/25/80
         3/18/81
         6/24/81
       10/28/81
         3/17/82
         6/23/82
       10/27/82
         3/23/83

         6/15/83
         11/4/83
         6/27/84
       10/24/84
         3/27/85
         6/26/85
       10/30/85
         4/23/86
       10/29/86

**Phillips, New York**

Phillips NY 11/4/78
        5/5/79
       11/3/79
      11/29/79
       5/21/80
      11/13/80
       1/29/81
       5/9/81
       2/9/82
       5/22/82
       9/30/82
       11/9/82
       7/2/86
      11/12/86

**The Photographic Eye, Inc., Cambridge, Massachusetts**

Kingston Boston 1976

**Nicolas Rauch S. A., Geneva:**

Rauch Geneva 12/24/58
           6/13/61

**Howard Ricketts, London**

Ricketts Lon 1974

**George R. Rinhart, New York**

Rinhart NY Cat 1, 1971
         Cat 2, 1971
         Cat 6, 1973
         Cat 7, 1973
         Cat 8, 1973

**Stephen T. Rose, Boston, Massachusetts**

Rose Boston Cat 1, 1976
         Cat 2, 1977
         Cat 3, 1978
         Cat 4, 1979
         Cat 5, 1980

**Stephen T. Rose, Coral Gables, Florida**

Rose Florida Cat 7, 1982

*Catalogues Listed*

## Sotheby's, Los Angeles, California

```
Sothebys LA 2/13/78
            2/7/79
            2/6/80
            2/4/81
            2/5/81
            2/16/82
            2/17/82
```

## Sotheby's, London

```
Sothebys Lon 12/21/71
             5/24/73
             12/4/73
             3/8/74
             6/21/74
             10/18/74
             3/21/75
             6/26/75
             10/24/75
             3/19/76
             6/11/76
             10/29/76
             3/9/77
             7/1/77
             11/18/77
             3/22/78
             6/28/78
             10/27/78
             3/14/79
             6/29/79
             10/24/79
             10/26/79
             3/21/80
             6/27/80
             10/29/80
             3/27/81
             6/17/81
             10/28/81
             3/12/82
             6/25/82
             10/29/82
             3/25/83
             6/24/83
             12/9/83
             6/29/84
             10/26/84
             3/29/85
             6/28/85
             11/1/85
             4/25/86
             10/31/86
```

## Sotheby's, New York

```
Sothebys NY (Weissberg Coll.) 5/16/67
Sothebys NY (Strober Coll.) 2/7/70
Sothebys NY (Greenway Coll.) 11/20/70
Sothebys NY 11/21/70
            2/25/75
            9/23/75
            5/4/76
            11/9/76
            2/9/77
            5/20/77
            10/4/77
```

```
            11/10/77
            5/2/78
            11/9/78
            5/8/79
            11/2/79
            12/19/79
            5/19/80
            5/20/80
            11/17/80
            5/15/81
            10/20/81
            10/21/81
            5/24/82
            5/25/82
            11/9/82
            11/10/82
            5/11/83
            11/9/83
            5/8/84
            11/5/84
            5/7/85
            5/8/85
            11/12/85
            5/12/86
            11/10/86
```

## Harry L. Stern Ltd., Chicago, Illinois

```
Stern Chicago 1975(?)
```

## Swann Galleries Inc., New York

```
Swann NY 2/14/52
         2/6/75
         9/18/75
         4/1/76
         11/11/76
         4/14/77
         12/8/77
         4/20/78
         12/14/78
         4/26/79
         10/18/79
         4/17/80
         11/6/80
         4/23/81
         7/9/81
         11/5/81
         4/1/82
         11/18/82
         5/5/83
         11/10/83
         5/10/84
         11/8/84
         5/9/85
         11/14/85
         5/15/86
         11/13/86
```

## E. Weil, London

```
Weil Lon Cat 1, 1943
         Cat 2, 1943(?)
         Cat 4, 1944(?)
         Cat 7, 1945
         1946
```

Cat 10, 1947(?)
Cat 14, 1949(?)
Cat 21, 1953
Cat 27, 1959
Cat 31, 1963
Cat 33, 1965

### The Weston Gallery, Carmel, California

Weston Cal 1978
1982

### Stephen White Gallery, Los Angeles, California

White LA 1977
1980-81

### Witkin Gallery Inc., New York

Witkin NY I 1973
II 1974
III 1975
IV 1976
V 1977
VI 1978
VII 1979
VIII 1979
IX 1979
Stereo 1979
X 1980

### Charles B. Wood III, Inc., South Woodstock, Connecticut

Wood Conn Cat 37, 1976
Cat 41, 1978
Cat 42, 1978
Cat 45, 1979
Cat 49, 1982

### Charles B. Wood III, Inc., Boston, Massachusetts

Wood Boston Cat 58, 1986

INTERNATIONAL GUIDE TO

# NINETEENTH-CENTURY PHOTOGRAPHERS

AND THEIR WORKS

**A & PV & P Co** [same] (American)
Photos dated: 1885
Processes:     Albumen
Formats:       Prints
Subjects:      Topography
Locations:     US - American West
Studio:        US - Arizona
    Entries:
Sothebys NY 22/25/75: 178 (lot, A et al);

**A., C.** [C.A.Co.] (British)
Photos dated: 1870s-1890
Processes:     Albumen
Formats:       Prints
Subjects:      Topography, ethnography
Locations:     Ceylon - Colombo & Kandy
Studio:
    Entries:
California Galleries 9/26/75: 250 (lot, A-1 et al);
California Galleries 1/22/77: 279 (13);
California Galleries 1/21/79: 411 (lot, A-1 et al);
Christies Lon 3/11/82: 178 (lot, A et al);
Christies Lon 3/29/84: 94 (lot, A et al);
Sothebys Lon 6/28/85: 214 (albums, C et al);

**A., J.** [J.A.](possibly J. ANDRIEU, q.v.)
Photos dated: 1871
Processes:     Albumen
Formats:       Stereos
Subjects:      Documentary (Paris Commune),
               topography
Locations:     France - Paris; Switzerland
Studio:        France
    Entries:
Rinhart NY Cat 7, 1973: 172;
Swann NY 11/10/83: 348 (lot, A et al);
Harris Baltimore 12/16/83: 128 (lot, A et al);
Swann NY 5/10/84: 311 (lot, A et al);

**A.W.B. & C.** [same]
Photos dated: c1880-1880s
Processes:     Albumen
Formats:       Prints
Subjects:      Topography
Locations:     Argentina - Buenos Aires
Studio:        Argentina
    Entries:
Swann NY 4/26/79: 429 (album, L et al);
Swann NY 5/9/85: 431 (lot, A et al)(note);

**ABBOTT & Co.** (American)
Photos dated: 1865
Processes:     Tintype
Formats:       Plates
Subjects:      Portraits
Locations:     Studio
Studio:        US - Waterbury, Connecticut; New York
               City
    Entries:
Vermont Cat 1, 1971: 195 (lot, A-5 et al);
Rinhart NY Cat 7, 1973: 605;

**ABBOTT, J.H.** (American)
Photos dated: 1860s-1870s
Processes:     Albumen
Formats:       Stereos
Subjects:      Topography, documentary (disasters)
Locations:     US - Chicago, Illinois
Studio:        US - Chicago, Illinois
    Entries:
Rinhart NY Cat 1, 1971: 163 (2);
California Galleries 9/27/75: 468 (lot, A et al);
California Galleries 1/23/77: 372 (lot, A et al);
Harris Baltimore 6/1/84: 23 (lot, A-2 et al), 25
    (lot, A et al);
Christies Lon 3/28/85: 46 (lot, A et al);

**ABDULLAH Frères** (Kevork and Wichen Biraderler,
               Armenian)
Photos dated: early 1850s-1890s
Processes:     Albumen
Formats:       Prints, cdvs, cabinet cards, stereos
Subjects:      Topography, portraits, ethnography
Locations:     Turkey; Syria; Bulgaria
Studio:        Turkey - Constantinople
    Entries:
Witkin NY II 1974: 921 (lot, A-4 et al);
California Galleries 9/26/75: 127 (album, A et al),
    166 (album, A et al);
Rose Boston Cat 1, 1976: 27 ill(note), 28 ill, 29
    ill;
Wood Conn Cat 37, 1976: 252 (album, A et al);
California Galleries 4/2/76: 144 (album, A et al);
Sothebys NY 5/4/76: 93 (album, 22);
Rose Boston Cat 2, 1977: 77 ill(note), 78 ill;
Sothebys NY 2/9/77: 42 (lot, A-2 et al), 43 ill
    (album, A et al);
Sothebys Lon 11/18/77: 105 (albums, A et al);
Swann NY 12/8/77: 320 (10), 380 (album, A et al),
    409 (lot, A et al);
Sothebys LA 2/13/78: 139 (album, A-27 et al);
Swann NY 4/20/78: 320 (album, A et al);
Phillips NY 11/4/78: 75 (30);
Rose Boston Cat 4, 1979: 89 ill(note);
California Galleries 1/21/79: 340 (album, A et al);
Swann NY 4/26/79: 463 (album, A-1 et al);
Christies Lon 6/28/79: 114 (albums, A et al);
Phillips NY 5/21/80: 230 (lot, A et al);
Christies Lon 6/26/80: 477 (album, A-9 et al);
Christies Lon 10/30/80: 441 (album, A-10 et al);
Swann NY 11/6/80: 278 (album, A et al), 314 (lot,
    A et al);
Swann NY 4/23/81: 456 (album, A et al);
California Galleries 6/28/81: 280 (lot, A et al),
    281 (lot, A et al);
Christies Lon 10/29/81: 142 (lot, A et al), 174
    (albums, A et al);
Swann NY 4/1/82: 263 (lot, A et al);
California Galleries 5/23/82: 189 (album, A et al);
Christies Lon 6/24/82: 366 (album, A et al);
Christies Lon 10/28/82: 60 (3);
Christies Lon 3/24/83: 94 (albums, A et al);
Swann NY 5/5/83: 334 (album, A et al)(note), 341
    (album, A-30 et al)(note);
California Galleries 6/19/83: 505 (lot, A-10 et al);
Christies Lon 6/23/83: 175 (albums, A et al);
Christies Lon 10/27/83: 87 (albums, A et al);
Swann NY 11/10/83: 185 (albums, A et al)(note);
Christies Lon 3/29/84: 62 (albums, A-20 et al);
Swann NY 5/10/84: 187 (lot, A et al);
Harris Baltimore 3/15/85: 62 (lot, A-3 et al);
Phillips Lon 10/30/85: 65 (lot, A et al);

ABDULLAH (continued)
Swann NY 11/14/85: 190 (lot, A et al)(note);
Harris Baltimore 2/14/86: 213 (album, A et al);
Christies Lon 6/26/86: 118 (albums, A et al);
Christies Lon 10/30/86: 153 (albums, A et al), 217
   (albums, A et al);
Phillips NY 11/12/86: 22;
Swann NY 11/13/86: 212 (lot, A et al), 330 (lot,
   A et al), 343 (lot, A et al);

ABEL, Mone
Photos dated: c1896
Processes:      Photogravure
Formats:       Prints
Subjects:      Genre
Locations:     France - Menton
Studio:        France - Menton
   Entries:
Christies Lon 10/25/79: 439;

ABELL & PRIEST (American)
Photos dated: 1889
Processes:      Albumen
Formats:       Prints
Subjects:      Documentary (military)
Locations:     US - San Francisco, California
Studio:        US
   Entries:
California Galleries 5/23/82: 381;

ABIEZES, Bacigalupi
Photos dated: 1880s-1890s
Processes:      Albumen
Formats:
Subjects:      Portraits
Locations:     Studio
Studio:        Europe
   Entries:
Swann NY 4/14/77: 203 (lot, A et al);

ABNEY, Sir William de Wiveleslie (British,
                     1843-1920)
Photos dated: 1874
Processes:      Woodburytype
Formats:       Prints
Subjects:      Topography
Locations:     Egypt - Thebes
Studio:        England
   Entries:
Wood Conn Cat 42, 1978: 2 (book, 22)(note);
Wood Conn Cat 45, 1979: 265 (book, 40)(note);
Christies Lon 3/15/79: 218 (book, 40)(note);
Sothebys Lon 6/17/81: 455 (book, 40);
Swann NY 5/10/84: 2 ill(book, 40)(note);
Drouot Paris 11/24/84: 116 (book, 40);
Christies Lon 3/28/85: 110 ill(book, 40);

ABRAHAM, G.P. (British)
Photos dated: 1885
Processes:      Albumen
Formats:       Prints
Subjects:      Portraits
Locations:     Great Britain
Studio:        Great Britain
   Entries:
California Galleries 9/26/75: 263 (lot, A-1 et al);

ABRAHAM, G.P. (continued)
Christies Lon 1/22/77: 295 (album, A-1 et al);
Christies Lon 6/30/77: 170 (lot, A-1 et al);

ADAMS & STILLIARD (British) [ADAMS 1]
Photos dated: c1885
Processes:      Albumen
Formats:       Prints
Subjects:      Portraits, architecture
Locations:     England
Studio:        England - London
   Entries:
Swann NY 10/18/79: 257 (album)(attributed);

ADAMS (British) [ADAMS 2]
Photos dated: 1858
Processes:
Formats:       Prints
Subjects:      Topography
Locations:     England - Stratford-upon-Avon
Studio:        Great Britain
   Entries:
Swann NY 11/13/86: 219 (lot, A-1 et al);

ADAMS, A. (British)
Photos dated: 1864
Processes:      Albumen
Formats:       Prints
Subjects:      Portraits
Locations:     Studio
Studio:        Scotland - Aberdeen
   Entries:
Edwards Lon 1975: 69 (book, A-1 et al);
Wood Conn Cat 37, 1976: 27 (book, A-1 et al);
Christies Lon 6/24/82: 71 (lot, A et al);

ADAMS, Ara W. (American)
Photos dated: 1873
Processes:      Albumen
Formats:       Stereos
Subjects:      Topography
Locations:     US - Iowa
Studio:        US
   Entries:
Harris Baltimore 12/16/83: 36 (lot, A-8 et al);

ADAMS, S.F. (American)
Photos dated: c1860-1880
Processes:      Albumen
Formats:       Stereos
Subjects:      Topography
Locations:     US - White Mountains, New Hampshire
Studio:        US - New Bedford, Massachusetts
   Entries:
Rinhart NY Cat 1, 1971: 138 (7);
Rinhart NY Cat 7, 1973: 211;
California Galleries 9/27/75: 438 (13);
Swann NY 11/11/76: 499 (lot, A et al);
California Galleries 1/23/77: 355 (13);
Swann NY 12/14/78: 295 (lot, A et al)(note), 296
   (lot, A et al), 297 (27), 298 (lot, A et al);
Swann NY 4/23/81: 542 (lot, A et al);
Harris Baltimore 7/31/81: 107 (lot, A et al);
Harris Baltimore 3/15/85: 58 (lot, A et al), 67
   (lot, A et al);

**ADAMS, W. Irving** (American)
Photos dated: 1885
Processes:      Albumen
Formats:        Prints
Subjects:       Documentary (public events)
Locations:      US - New Orleans, Louisiana
Studio:         US
    Entries:
California Galleries 6/8/85: 510 (lot, A et al);

**ADAM-SALOMON, Antoine Samuel** (French, 1811-1881)
Photos dated: 1858-1870s
Processes:      Daguerreotype, albumen, woodburytype
Format:         Plates, prints
Subjects:       Portraits incl. Galerie Contemporaine
Locations:      Studio
Studio:         France - Paris
    Entries:
Maggs Paris 1939: 520 ill, 521 ill(note);
Rauch Geneva 12/24/58: 197 (4), 238 ill, 254 ill;
Rauch Geneva 6/13/61: 139 (note);
Gordon NY 1/13/76: 56 (lot, A-1 et al);
California Galleries 1/22/77: 250 ill;
Sothebys NY 2/9/77: 51 ill(lot, A-2 et al);
Sothebys NY 5/20/77: 44 (lot, A-1 et al)(note);
Sothebys Lon 7/1/77: 260 (lot, A-1 et al);
Sothebys LA 2/13/78: 115 (books, A-4 et al)(note);
Swann NY 4/20/78: 187 ill(note), 188, 321 (lot,
    A-1 et al), 322 (lot, A-2 et al), 323 (lot, A-1
    et al);
Sothebys Lon 6/28/78: 150a (book, A et al);
Octant Paris 3/1979: 26 ill;
Rose Boston Cat 4, 1979: 33 ill(note);
California Galleries 1/21/79: 384;
Sothebys LA 2/7/79: 433 ill;
Sothebys Lon 3/14/79: 316 (lot, A et al);
Sothebys NY 5/8/79: 87 (books, A-4 et al);
Sothebys NY 11/2/79: 241 ill(attributed)(note);
Christies Lon 3/20/80: 227 (book, A et al);
Swann NY 4/17/80: 225 (note);
Sothebys NY 5/20/80: 381 ill(lot, A-2 et al);
Swann NY 4/23/81: 471 (lot, A et al);
Christies NY 5/26/82: 36 (books, A-8 et al);
Drouot Paris 11/27/82: 2 ill;
Christies NY 5/7/84: 19 (books, A-8 et al);
Sothebys Lon 6/28/85: 198 ill;
Wood Boston Cat 58, 1986: 136 (books, A-1 et al);
Christies Lon 4/24/86: 419 (lot, A et al);
Sothebys NY 11/10/86: 270 ill(note);

**ADAMSON, John** (British) [ADAMSON, John 1]
Photos dated: 1860s-1864
Processes:      Albumen
Formats:        Prints, cdvs
Subjects:       Topography, portraits
Locations:      Scotland
Studio:         Scotland
    Entries:
Sothebys NY (Weissberg Coll.) 5/16/67: 57 (2)(note);
Christies Lon 3/29/84: 321 (album, A-40 attributed
    et al)(note);

**ADAMSON, Dr. John** (British) [ADAMSON, John 2]
Photos dated: 1841-1843
Processes:      Calotype
Formats:        Prints
Subjects:       Portraits
Locations:      Scotland
Studio:         Scotland
    Entries:
Sothebys Lon 7/1/77: 91 ill(attributed);
Sothebys Lon 11/18/77: 251 (album, A attributed
    et al);

**ADAMSON, Robert** (British, 1821-1848)(see also HILL
                & ADAMSON)
Photos dated: 1842
Processes:      Calotype
Formats:        Prints
Subjects:       Architecture
Locations:      Scotland
Studio:         Scotland - Edinburgh
    Entries:
Sothebys NY 11/9/76: 18 ill(note);
Phillips NY 5/9/81: 2 ill(note);
Kraus NY Cat 1, 1984: 22 (2 ills)(2)(note);

**ADDIS & NOEL** (American)
Photos dated: Nineteenth century
Processes:      Albumen
Formats:        Cdvs
Subjects:       Portraits
Locations:      Studio
Studio:         US - Leavenworth, Kansas
    Entries:
Sothebys NY (Strober Coll.) 2/7/70: 290 (lot,
    A & N et al);

**ADDIS, R.W.** (American)
Photos dated: 1860s
Processes:      Albumen
Formats:        Cdvs, stereos
Subjects:       Portraits, topography
Locations:      US - California
Studio:         US - Washington, D.C.
    Entries:
Sothebys NY (Greenway Coll.) 11/20/70: 214 ill, 250
    (lot, A-1 et al);
Harris Baltimore 12/10/82: 17 (lot, A-1 et al);

**ADELE**
Photos dated: 1865-1893
Processes:      Albumen
Formats:        Cdvs, cabinet cards
Subjects:       Portraits
Locations:      Studio
Studio:         Austria - Vienna
    Entries:
Sothebys NY (Greenway Coll.) 11/20/70: 14 (lot,
    A-1 et al);
Christies Lon 10/30/80: 417 (album, A et al);

ADLER & Co. (British)
Photos dated: 1860s
Processes:      Ambrotype
Formats:        Plates
Subjects:       Portraits
Locations:      Studio
Studio:         England - Exeter
   Entries:
Christies Lon 6/26/80: 69 (lot, A-1 et al);

AFONG (see FONG, A.)

AGIUS, Horatio
Photos dated: 1880s
Processes:      Albumen
Formats:        Prints incl. panoramas
Subjects:       Topography
Locations:      Malta
Studio:         Malta
   Entries:
Vermont Cat 7, 1974: 742 ill(album, A-5 et al);
California Galleries 9/26/75: 167 (album, A et al);
California Galleries 4/2/76: 140 (album, A et al),
   153 (album, A et al);
California Galleries 1/22/77: 187 (album, A et al);
Swann NY 4/26/79: 282 (albums, A et al);
Christies Lon 6/28/79: 138 (albums, A-1 et al);
Christies Lon 10/25/79: 246 (albums, A et al);
Christies Lon 3/26/81: 276 (album, A et al);
Christies Lon 3/11/82: 197 (album, A-2 et al);
Swann NY 4/1/82: 327 (album, A-4 et al);
Christies Lon 6/24/82: 226 (album, A-3 et al);
Phillips NY 9/30/82: 985 (album, A-2 et al);
Christies Lon 3/24/83: 140 (album, A & Davison
   et al);
Christies Lon 6/23/83: 166 (albums, A et al);
Christies Lon 3/29/84: 56 (albums, A et al), 100
   (albums, A et al);
Harris Baltimore 6/1/84: 445 (lot, A et al);
Christies Lon 10/25/84: 104 (album, A et al), 106
   (album, A et al);
Christies Lon 3/28/85: 214;
Christies Lon 6/27/85: 82 (album, A-8 et al), 91
   (lot, A et al);
Christies Lon 10/31/85: 88, 134 (albums, A et al);
Christies Lon 6/26/86: 34 (albums, A et al), 105
   (albums, A et al), 154 (albums, A-3 et al);
Swann NY 11/13/86: 356 (lot, A et al);

AGOSTINI
Photos dated: Nineteenth century
Processes:      Albumen
Formats:        Cdvs
Subjects:       Topography
Locations:      Europe
Studio:         Europe
   Entries:
Christies Lon 3/20/80: 371 (lot, A et al);
Christies Lon 10/30/80: 456 (lot, A et al);

AGUADO, Comte Olympe (French, 1827-1894)
Photos dated: 1849-c1860
Processes:      Daguerreotype, albumen
Formats:        Plates, prints
Subjects:       Portraits, topography
Locations:      France
Studio:         France - Paris
   Entries:
Sothebys Lon 6/17/81: 199 ill(note), 200 ill,
   201 ill;
Sothebys Lon 3/25/83: 85 ill(3);
Sothebys Lon 12/9/83: 69 ill;

AHRENDTS, L. (German)
Photos dated: 1840s-1856
Processes:      Calotype, albumen
Formats:        Prints
Subjects:       Architecture
Locations:      Germany - Berlin
Studio:         Germany - Berlin
   Entries:
Sothebys Lon 10/29/76: 119 (lot, A-1 et al);
Petzold Germany 11/7/81: 265 ill(attributed), 266
   ill(2, attributed), 267 ill(attributed), 268 ill
   (attributed), 269 (1 plus 1 attributed);
Christies Lon 4/24/86: 470 ill;
Christies Lon 10/30/86: 89;

AITKEN, William (American)
Photos dated: 1884
Processes:      Heliogravure
Formats:        Prints
Subjects:       Portraits
Locations:      Studio
Studio:         US
   Entries:
Rinhart NY Cat 7, 1973: 1 (book, 1);

ALARY & GEISER
Photos dated: 1860s
Processes:      Albumen
Formats:        Cdvs, stereos
Subjects:       Ethnography, topography
Locations:      Algeria
Studio:         Algeria
   Entries:
Swann NY 12/8/77: 347 (lot, A & G et al);
Swann NY 11/14/85: 9 (lot, A & G et al);

ALBAREDA (see MOLINA & ALBAREDA)

ALBEE (see WEBSTER & ALBEE)

ALBEE, S.V. (American)
Photos dated: 1877-1880s
Processes:      Albumen
Formats:        Prints, stereos
Subjects:       Topography, documentary (public
                events)
Locations:      US - Pittsburgh, Pennsylvania
Studio:         US - Pittsburgh, Pennsylvania
   Entries:
Swann NY 5/9/85: 319;
California Galleries 6/8/85: 381 (2);
Swann NY 11/14/85: 157 (lot, A et al);

ALBER, A. (German)
Photos dated: Nineteenth century
Processes:      Albumen
Formats:
Subjects:       Portraits
Locations:      Studio
Studio:         Germany - Augsburg
    Entries:
Petzold Germany 5/22/81: 1977 (album, A et al);

ALBERT, Josef (German, 1825-1886)
Photos dated: 1850-1880s
Processes:      Albumen, albertype
Formats:        Prints
Subjects:       Architecture, portraits, documentary
                (medical)
Locations:      Germany
Studio:         Germany - Augsburg and Munich
    Entries:
Sothebys Lon 6/21/74: 69 (books, 100);
White LA 1977: 11 ill(note);
Swann NY 12/8/77: 183 (book, 1);
Wood Conn Cat 42, 1978: 13 (book, 6)(note), 14
    (book, 9);
Christies NY 5/16/80: 201 (lot, A-3 et al);
Petzold Germany 5/22/81: 1986 (album, A-1 et al);
Petzold Germany 11/7/81: 300 (album, A et al), 307
    (album, A et al);
Harris Baltimore 6/1/84: 388 (lot, A-1 et al);
Sothebys Lon 4/25/86: 208 (book, A-1 et al), 223;

ALBERT, Paul
Photos dated: 1880s-1890s
Processes:      Albumen
Formats:        Prints
Subjects:       Ethnography
Locations:
Studio:
    Entries:
Swann NY 11/14/85: 65 (lot, A et al);

ALDEN (see McKERNON & ALDEN)

ALDEN, A.E. (American)
Photos dated: 1860s-1870s
Processes:      Albumen
Formats:        Cdvs, stereos
Subjects:       Portraits, topography
Locations:      US - Rhode Island; Massachusetts
Studio:         US - Providence, Rhode Island
    Entries:
Vermont Cat 4, 1972: 468;
California Galleries 4/3/76: 395 (lot, A et al);
Swann NY 11/11/76: 499 (lot, A et al);
Harris Baltimore 12/16/83: 86 (lot, A et al);
Harris Baltimore 3/15/85: 11 (lot, A et al);

ALDHAM & ALDHAM
Photos dated: 1880s-1890s
Processes:      Albumen
Formats:        Prints
Subjects:       Documentary (industrial)
Locations:      South Africa - Grahamstown
Studio:         South Africa - Grahamstown
    Entries:
Swann NY 5/10/84: 302 (lot, A & A-1 et al);

ALDIS, Elijah (British)(photographer or author?)
Photos dated: 1873
Processes:      Albumen
Formats:        Prints
Subjects:       Documentary (art)
Locations:      England - Worcester
Studio:         Great Britain
    Entries:
Swann NY 2/14/52: 76 (book, 69);
Edwards Lon 1975: 49 (book, 68);

ALDRICH, G.H. (American)
Photos dated: 1870s-1880s
Processes:      Albumen
Formats:        Stereos
Subjects:       Genre
Locations:      US
Studio:         US - St. Johnsbury, Vermont;
                Littleton, New Hampshire
    Entries:
Harris Baltimore 7/31/81: 95 (lot, A et al);
Swann NY 11/18/82: 448 (lot, A et al);
Harris Baltimore 6/1/84: 99 (lot, A et al);

ALEXANDER Brothers (British)
Photos dated: c1895
Processes:      Albumen
Formats:        Cabinet cards
Subjects:       Portraits
Locations:      Studio
Studio:         Scotland - Glasgow
    Entries:
California Galleries 1/21/78: 140 (album, A et al);

ALEXANDER, Colonel John Henry (British, 1839-1899)
Photos dated: 1860-1873
Processes:      Salt, albumen
Formats:        Prints
Subjects:       Documentary (military), genre
                (domestic)
Locations:      Great Britain; India
Studio:         Great Britain
    Entries:
Christies Lon 10/29/81: 263 ill(albums, A et al)
    (note);
Christies Lon 6/24/82: 225 (album, A et al)(note);

ALEXANDER, Richard Dykes (British, 1788-1865)
Photos dated: 1850s-c1857
Processes:      Salt, albumen
Formats:        Prints, stereos
Subjects:       Portraits, genre
Locations:      England - Ipswich
Studio:         England
    Entries:
Sothebys Lon 6/28/78: 241 (2 ills)(album, A et al),
    242 (2 ills)(album, A et al), 244 (lot, A et al),
    260 (lot, A-1 et al);
Sothebys Lon 10/27/78: 195 (9);
Sothebys Lon 10/24/79: 308 (12);
Sothebys Lon 6/27/80: 258 (attributed);
Sothebys Lon 3/15/82: 316;
Christies Lon 6/24/82: 354;
Christies Lon 10/28/82: 165;
Christies Lon 3/24/83: 197 ill;
Swann NY 5/5/83: 266 (5)(note);
Harris Baltimore 3/15/85: 132;

**ALEXANDER, R.D.** (continued)
Christies Lon 3/28/85: 137;
Sothebys Lon 6/28/85: 117;
Sothebys Lon 4/25/86: 124 ill;

**ALEXANDER, Sam.**
Photos dated: 1880s
Processes:    Heliotype
Formats:     Prints
Subjects:    Topography
Locations:   South Africa
Studio:
   Entries:
Swann NY 11/14/85: 193 ill(book, 100)(note);

**ALEXANDRE**
Photos dated: 1870s-1893
Processes:    Albumen
Formats:     Prints
Subjects:    Topography
Locations:   France - Dieppe
Studio:      Europe
   Entries:
Wood Conn Cat 37, 1976: 249 (album, A et al);

**ALEXANDROVSKI** (Russian)(aka ALEXANDROVSKY)
Photos dated: 1850s-1860s
Processes:    Salt, albumen
Formats:     Prints
Subjects:    Topography
Locations:   Russia
Studio:      Russia
   Entries:
Sothebys Lon 3/25/83: 50 (3);

**ALGER, C.S.** (British)
Photos dated: c1860
Processes:    Albumen
Formats:     Stereos
Subjects:    Topography
Locations:   England
Studio:      England - Diss
   Entries:
Christies Lon 4/24/86: 335 ill(lot, A-30 et al);

**ALINARI, Fratelli** (Italian, Romualdo, 1830-1891,
                Leopoldo, 1832-1865, Giuseppe,
                1836-1890)
Photos dated: early 1850s-1890s
Processes:    Albumenized salt, albumen
Formats:     Prints incl. panoramas, cdvs, stereos
Subjects:    Topography, genre (still life)
Locations:   Italy; Greece
Studio:      Italy - Florence
   Entries:
Rinhart NY Cat 1, 1971: 409 (lot, A et al);
Witkin NY I 1973: 546 (album, 35), 547 (album, A et al), 548 (album, A et al);
Christies Lon 6/14/73: 214 (lot, A et al);
Sothebys Lon 12/4/73: 28 (album, A et al);
Witkin NY II 1974: 566 (album, 35), 567 (album, 27);
Witkin NY III 1975: 418 (album, 27);
Sothebys Lon 6/26/75: 120 (album, 40);
Swann NY 9/18/75: 144 (albums, A et al);
California Galleries 9/27/75: 389 (lot, A et al);
Sothebys Lon 10/24/75: 116 (note);

**ALINARI** (continued)
Kingston Boston 1976: 648 ill(note);
Wood Conn Cat 37, 1976: 6 (book)(note), 351 ill (note);
California Galleries: 4/2/76: 156 (album, A et al);
California Galleries 4/3/76: 384 (lot, A et al);
Gordon NY 5/3/76: 294 ill;
Sothebys NY 5/4/76: 74 (15);
Christies Lon 6/10/76: 56 (4), 58 (lot, A et al) (attributed), 64 (lot, A et al)(attributed);
Sothebys Lon 6/11/76: 50a (3);
Sothebys Lon 10/29/76: 148 (8);
Swann NY 11/9/76: 50;
Swann NY 11/11/76: 388 (album, A et al), 389 (albums, A et al), 395 (albums, A et al);
Rose Boston Cat 2, 1977: 51 ill(note), 52 ill;
California Galleries 1/22/77: 171 (album, A et al);
Sothebys Lon 3/9/77: 30;
Swann NY 4/14/77: 221 (albums, 200)(note), 242 (album, A et al);
Gordon NY 5/10/77: 814 ill(album, A attributed et al);
Sothebys NY 10/5/77: 216 (3), 217 (lot, A-1 et al);
Christies Lon 10/27/77: 95 (lot, A-1 et al), 97 (lot, A-4 et al), 157 (lot, A-1 et al);
Swann NY 12/8/77: 325 (albums, A et al), 371 (album, A et al), 384 (lot, A et al);
Rose Boston Cat 3, 1978: 41 ill(note), 42 ill;
Wood Conn Cat 42, 1978: 15 (album, 43);
Sothebys LA 2/13/78: 125 (4 plus 2 attributed);
Swann NY 4/20/78: 328 (lot, A et al);
Phillips NY 11/4/78: 71 ill, 72;
Lennert Munich Cat 5, 1979: 14;
Rose Boston Cat 4, 1979: 43 ill(note), 44 ill;
California Galleries 1/21/79: 388;
Phillips Lon 3/13/79: 59 (lot, A-4 et al), 62 (album, A et al);
Christies NY 5/4/79: 25 (2 ills)(album, A et al);
Phillips NY 5/5/79: 162;
Sothebys Lon 6/29/79: 151 ill(2), 152 ill, 153 ill, 154, 155 (9);
Sothebys Lon 10/24/79: 148 ill, 149 (2);
Christies Lon 10/25/79: 149 (lot, A-3 et al), 159 (albums, A et al), 164 (albums, A et al), 167 ill(note), 168 (2), 169 (2), 170, 171 (2), 172 (6), 395 (album, A-11 et al);
Christies NY 10/31/79: 38 (2);
Phillips NY 11/29/79: 256;
Sothebys NY 12/19/79: 24 ill, 25 ill, 26 ill, 27 ill, 28 ill, 29 ill, 30 ill;
White LA 1980-81: 28 ill(note), 29 ill;
Witkin NY X 1980: 98 (albums, A et al);
Christies Lon 3/20/80: 141 (4), 156 (albums, A et al);
Sothebys Lon 3/21/80: 149 ill;
California Galleries 3/30/80: 222;
Swann NY 4/17/80: 231;
Christies NY 5/16/80: 168 ill(note), 169, 170 (note), 171 ill, 172, 173, 174;
Phillips NY 5/21/80: 226 (attributed);
Christies Lon 6/26/80: 176, 177 (5), 196 (lot, A et al), 201 (lot, S et al), 204 (lot, A et al), 211 (albums, A et al), 278 (albums, A et al), 477 (album, A-3 et al), 485 (albums, A-1 et al);
Sothebys Lon 6/27/80: 92 (9);
Phillips Can 10/9/80: 8 ill (3), 9 (3);
Sothebys Lon 10/29/80: 88, 89, 90;
Christies Lon 10/30/80: 197 (lot, A-1 et al), 208 (3), 209 ill, 210, 211, 212, 213, 433 (albums, A et al);
Christies NY 11/11/80: 66 (2), 200 (lot, A et al);

## ALINARI (continued)

California Galleries 12/13/80: 181 (7);
Christies Lon 3/26/81: 182 (lot, A et al), 184
    (lot, A-8 et al), 217 (album, A-33 et al), 259
    (album, A et al), 261 (albums, A et al), 267
    ill(album, A-8 et al), 268 (lot, A et al);
Sothebys Lon 3/27/81: 22 (20), 132 (album, A et al);
Swann NY 4/23/81: 288 (lot, A-1 et al), 289, 456
    (albums, A et al);
Phillips NY 5/9/81: 28 (albums, A et al), 42 ill, 65
    (album, A attributed et al);
Sothebys Lon 6/17/81: 135, 137, 142 (attributed);
Christies Lon 10/29/81: 147 (lot, A et al), 185,
    186, 193 (album, A et al), 269 (albums, A et
    al), 271 (albums, A-8 et al), 370 (album, A-2
    et al);
Christies Lon 3/11/82: 137 (lot, A et al), 150
    (album, A-18 et al), 339 (lot, A-1 et al);
Harris Baltimore 3/26/82: 256;
Phillips NY 5/22/82: 640 (3), 641;
California Galleries 5/23/82: 197 (album, A et al);
Christies Lon 6/24/82: 127 ill(album, A-33 et al),
    133 (lot, A et al), 140 (album, A et al), 232
    (albums, A et al);
Sothebys Lon 6/25/82: 95 (lot, A-3 et al);
Phillips NY 9/30/82: 994 (lot, A et al);
Phillips Lon 10/27/82: 42 (lot, A-6 et al);
Christies Lon 10/28/82: 30 (lot, A et al), 54 (lot,
    A-8 et al), 99 (lot, A-2 et al), 213 (lot, A
    et al);
Bievres France 2/6/83: 137 (8);
Harris Baltimore 12/10/82: 191 (note), 391 (albums,
    A et al), 399 (lot, A-1 et al);
Christies NY 2/8/83: 34 (lot, A et al);
Phillips Lon 3/23/83: 32 (lot, A-6 et al);
Christies Lon 3/24/83: 69 (lot, A et al), 139
    (albums, A et al), 163 (books, A et al);
Swann NY 5/5/83: 381 (albums, A et al);
Christies Lon 6/23/83: 91 (lot, A-1 et al), 100
    (album, A et al), 106 (lot, A-4 et al), 112 (4),
    113 (2), 114 ill, 178 (albums, A et al);
Sothebys Lon 6/24/83: 51 (album, A et al);
Christies NY 10/4/83: 98 (album, 70), 99 (lot, A
    et al), 100 (lot, A et al), 110 (album, A et al);
Christies Lon 10/27/83: 69 (lot, A-1 et al), 71
    (lot, A et al), 73 (lot, A et al);
Phillips Lon 11/4/83: 126;
Christies NY 11/8/83: 15 ill (5);
Sothebys Lon 12/9/83: 22 (3), 23 (lot, A-7 et al),
    122 (6);
Harris Baltimore 12/16/83: 273;
Christies Lon 3/29/84: 55 (lot, A et al), 97 (album,
    A et al), 134 ill (7), 135;
Sothebys Lon 5/29/84: 59 (3);
Harris Baltimore 6/1/84: 214 (book, A et al), 307,
    389 (lot, A et al), 392 (2, attributed);
Christies Lon 6/28/84: 74 (lot, A et al), 140
    (album, A et al), 199 (7), 328 (lot, A et al);
California Galleries 7/1/84: 257 ill, 258, 259, 260,
    491 (5);
Phillips Lon 10/24/84: 161 ill(17);
Christies Lon 10/25/84: 103 (album, A et al), 179
    (lot, A-4 et al);
Sothebys Lon 10/26/84: 49 (27);
Christies NY 2/13/85: 142 (lot, A-1 et al), 143
    (lot, A-1 et al);
Harris Baltimore 3/15/85: 202 (albums, A attributed
    et al), 203 (attributed);
Christies Lon 3/28/85: 151 (albums, A-1 et al)
    (note);
Sothebys Lon 3/29/85: 122 ill, 123 (3);

## ALINARI (continued)

California Galleries 6/8/85: 268 (lot, A et al);
Phillips Lon 6/26/85: 225 (lot, A-1 et al);
Christies Lon 6/27/85: 64 (lot, A et al), 65 (lot,
    A et al);
Phillips Lon 10/30/85: 120 (lot, A-1 et al);
Christies Lon 10/31/85: 87 (albums, A et al), 193
    (lot, A-2 et al);
Swann NY 11/14/85: 193 ill(book, 100)(note);
Harris Baltimore 2/14/86: 210 (albums, A et al);
Christies Lon 4/24/86: 598 (lot, A-6 et al);
Swann NY 5/15/86: 264 (lot, A et al);
Christies Lon 6/26/86: 66 (lot, A et al);
Christies Lon 10/30/86: 93 (lot, A et al);
Sothebys NY 11/10/86: 386 ill(lot, A-4 et al);
Swann NY 11/13/86: 245 (lot, A et al), 357 (lot,
    A et al);

ALLAIN et Cie (French)
Photos dated: 1863-1864
Processes:      Albumen
Formats:        Prints
Subjects:
Locations:
Studio:         France
  Entries:
Christies Lon 3/11/82: 247 (books, 15);

ALLDERIGE, W. (American)
Photos dated: 1878
Processes:      Albumen
Formats:        Stereos
Subjects:       Documentary (disasters)
Locations:      US - Tariffville, Connecticut
Studio:         US
  Entries:
Rinhart NY Cat 7, 1973: 212 (3);

ALLEN & ROWELL (American) [ALLEN 1]
Photos dated: 1874
Processes:      Carbon
Formats:        Prints
Subjects:       Portraits
Locations:      Studio
Studio:         US - Boston, Massachusetts
  Entries:
Kingston Boston 1976: 331 (book, 1);
Harris Baltimore 6/1/84: 245;

ALLEN & Son (British) [ALLEN 2]
Photos dated: Nineteenth century
Processes:      Albumen
Formats:        Cdvs
Subjects:       Portraits
Locations:      Studio
Studio:         England - Alton, Hampshire
  Entries:
Rinhart NY Cat 6, 1973: 260;

ALLEN, A.M. (American)
Photos dated: c1845-1870s
Processes:      Daguerreotype, albumen
Formats:        Plates, stereos, cdvs
Subjects:       Portraits, topography
Locations:      US - Pennsylvania
Studio:         US - Pottsville, Pennsylvania
    Entries:
Witkin NY IX 1979: 12 ill;

ALLEN, C.E & E.L. (American)
Photos dated: 1860s-1870s
Processes:      Albumen
Formats:        Cdvs, stereos
Subjects:       Portraits, topography
Locations:      US
Studio:         US - Boston, Massachusetts
    Entries:
Sothebys NY (Strober Coll.) 2/7/70: 467 (lot,
    A et al);
Sothebys NY (Greenway Coll.) 11/20/70: 129 ill
    (lot, A & Horton-1 et al);
Vermont Cat 8, 1974: 545 ill(4);
Vermont Cat 11/12, 1977: 744 ill(4);
Harris Baltimore 12/10/82: 16 (8);
Harris Baltimore 3/15/85: 11 (lot, A et al);
Christies Lon 6/27/85: 276 (album, A et al);

ALLEN, C.V. (American)
Photos dated: c1855-1858
Processes:      Daguerreotype, ambrotype
Formats:        Plates
Subjects:       Portraits
Locations:      Studio
Studio:         US - Washington, D.C.
    Entries:
Vermont Cat 5, 1973: 371 ill;
California Galleries 9/26/75: 86 (lot, A-1 et al);

ALLEN, Charles Smith (British)
Photos dated: 1863-1890s
Processes:      Albumen, silver
Formats:        Prints, stereos
Subjects:       Topography, architecture
Locations:      Great Britain - South Wales and
                Monmouthshire
Studio:         Wales
    Entries:
Edwards Lon 1975: 12 (album, A et al);
Sothebys Lon 3/19/76: 41 (7);
Sothebys Lon 10/29/76: 136 (4);
Christies Lon 6/30/77: 236 (book, 31);
Sothebys Lon 7/1/77: 42 (book, 4), 43 (book, 130);
Christies Lon 10/27/77: 248 (book, 31);
Phillips NY 11/4/78: 117 ill(book, 30);
Christies Lon 3/20/80: 221 (book, 25);
Sothebys Lon 10/29/80: 6 (lot, A et al);
Christies Lon 10/30/80: 287 (book, 25);
Christies Lon 6/23/83: 72 (books, 31);
Swann NY 11/14/85: 194 ill(note);

ALLEN, E.H. (American) [ALLEN, E.H. 1]
Photos dated: 1880s-1890s
Processes:      Albumen
Formats:        Prints
Subjects:       Topography
Locations:      US - American west
Studio:         US
    Entries:
Sothebys LA 2/17/82: 230 (lot, A et al);
Swann NY 5/15/86: 131 (book, A et al);

ALLEN, E. Heron (British) [ALLEN, E.H. 2]
Photos dated: 1885
Processes:      Woodburytype
Formats:        Prints
Subjects:       Documentary (industrial)
Locations:      Great Britain
Studio:         Great Britain
    Entries:
Edwards Lon 1975: 50 (book, 3);

ALLEN, Frances Stebbins and Mary Electra
                (American)
Photos dated: 1890s-1900
Processes:      Platinum
Formats:        Prints
Subjects:       Genre, topography, portraits
Locations:      US - Deerfield, Massachusetts
Studio:         US - Deerfield, Massachusetts
    Entries:
Rose Boston Cat 3, 1978: 6 ill(note);
Sothebys NY 5/19/80: 48, 49, 50, 51 ill;
Phillips NY 5/21/80: 285 (4)(note), 286 (8);
Phillips Can 10/9/80: 61 ill(8);
Phillips NY 5/9/81: 79 (4), 80 (4);
California Galleries 6/28/81: 157, 158;
Harris Baltimore 7/31/81: 139 ill(album, 12)(note);
Sothebys LA 2/16/82: 20 ill(2);
Harris Baltimore 3/26/82: 171 (note), 172, 173,
    174, 175, 176, 177, 178;
Phillips NY 5/22/82: 642 (6);
California Galleries 5/23/82: 204, 205, 206 ill,
    207 (2);
Sothebys NY 5/24/82: 204 ill;
Harris Baltimore 12/16/83: 272;
California Galleries 7/1/84: 263 (3), 264 (3);

ALLEN, John Allen (British)
Photos dated: 1852
Processes:      Salt
Formats:        Prints
Subjects:       Topography, portraits
Locations:      England
Studio:         England
    Entries:
Sothebys Lon 6/27/80: 243 ill(album, 9);

ALLEN, M.
Photos dated: Nineteenth century
Processes:      Albumen
Formats:        Cdvs
Subjects:       Portraits
Locations:      Studio
Studio:         Ireland - Dublin
    Entries:
Christies Lon 6/24/82: 364 (album, A et al);

**ALLEN, Richard** (British)
Photos dated: 1874
Processes:      Albumen
Formats:        Prints
Subjects:       Topography
Locations:      Great Britain
Studio:         Great Britain
   Entries:
Swann NY 5/9/85: 164 (book, 30)(note);

**ALLEN, W.F.** (American)
Photos dated: 1860s-1870s
Processes:      Albumen
Formats:        Stereos
Subjects:       Topography
Locations:      US
Studio:         US - Jaffrey, New Hampshire
   Entries:
Rinhart NY Cat 6, 1973: 505 (4);
California Galleries 9/27/75: 512 (lot, A et al);
California Galleries 1/23/77: 410 (lot, A et al);
Swann NY 11/6/80: 390 (lot, A-1 et al)(note);

**ALLEN, W.P.** (American)
Photos dated: 1889
Processes:      Autoglyph
Formats:        Prints
Subjects:       Topography
Locations:      US - Cornell University, New York
Studio:         US - Gardner, Massachusetts
   Entries:
Swann NY 9/18/75: 354 (book, 26);

**ALLI, Darogha Ubbas** (Indian)(aka DAROGAH, Haji
              Abbas Ali)
Photos dated: 1874-1880
Processes:      Albumen
Formats:        Prints, cdvs
Subjects:       Topography, portraits
Locations:      India - Lucknow
Studio:         India
   Entries:
Christies Lon 10/28/76: 302 (book, 300);
Sothebys Lon 3/22/78: 26 (book, 50);
Sothebys Lon 3/14/79: 241 (book, 50);
Christies Lon 10/29/81: 234 (album, 50);
Phillips Lon 3/27/85: 165 (album, 50);
Christies Lon 6/26/86: 50 (album, 50);

**ALLON** (see BAILEY)

**ALLPORT, N.** (British)
Photos dated: 1860s
Processes:      Albumen
Formats:        Prints
Subjects:
Locations:
Studio:         Great Britain (Amateur Photographic
                Association)
   Entries:
Sothebys Lon 10/29/80: 310 (album, A et al);
Christies Lon 10/27/83: 218 (albums, A-3 et al);

**ALOPHE, Marie Alexandre** (French, 1811-1883)
Photos dated: 1870s-1878
Processes:      Albumen
Formats:        Prints, cdvs
Subjects:       Portraits
Locations:      France - Paris
Studio:         France - Paris
   Entries:
Rauch Geneva 6/13/61: 159 (lot, A et al);
Christies Lon 6/26/80: 471 (album, A-2 et al);
Drouot Paris 11/24/84: 113 (book, 66);
Harris Baltimore 11/7/86: 221;

**ALPERS, Ernst** (German)
Photos dated: 1867
Processes:      Albumen
Formats:        Prints
Subjects:       Documentary (art)
Locations:      Germany
Studio:         Germany - Hannover
   Entries:
Swann NY 4/1/76: 137 (book, 18);

**ALSTIN, Dr. Andrew Wemple Van** (American, died
              1857)
Photos dated: 1843-1857
Processes:      Daguerreotype
Formats:        Plates
Subjects:       Portraits
Locations:      Studio
Studio:         US - Worcester, Massachusetts
   Entries:
Swann NY 10/18/79: 327 (note);

**ALTOBELLI, Gioacchino** (Italian)(see also MOLINS)
Photos dated: 1859-c1878
Processes:      Albumen
Formats:        Prints, stereos, cdvs
Subjects:       Topography
Locations:      Italy - Rome
Studio:         Italy - Rome
   Entries:
Maggs Paris 1939: 498, 499, 500;
Phillips NY 11/3/78: 169 ill;
Lennert Munich Cat 5, 1979: 32;
Christies Lon 3/15/79: 184 (albums, A-1 et al)
   (note);
Sothebys Lon 6/29/79: 148 (A & Molins), 149 ill;
Sothebys Lon 10/24/79: 150 (A & Molins), 151 (A &
   Molins), 152 (A & Molins), 153 (A & Molins);
White LA 1980-81: 30 ill(note), 31 ill, 32 ill;
Christies NY 5/16/80: 167 (books, A et al);
Sothebys NY 5/20/80: 382 ill(2)(attributed)(note);
Phillips NY 5/21/80: 128 (albums, A attributed et
   al), 219 (note), 220 ill(attributed), 221 ill
   (attributed)(note);
Christies Lon 10/30/80: 207 (A & Molins);
Lennert Munich Cat 6, 1981: 16, 17 ill;
Sothebys Lon 3/27/81: 132 (album, A & Molins et al);
Phillips NY 5/9/81: 40 ill(note), 65 (album, A-1
   et al);
Sothebys Lon 10/28/81: 91 (A & Molins);
Christies Lon 10/29/81: 184 (A & Molins)(note), 190
   (lot, A et al);
Rose Florida Cat 7, 1982: 34 ill(album, A et al);
Phillips NY 5/22/82: 643 ill, 644, 645;
Christies Lon 10/28/82: 59;
Swann NY 11/18/82: 403 (lot, A et al);
Bievres France 2/6/83: 1 ill;

## ALTOBELLI (continued)

Christies Lon 6/23/83: 107 (lot, A & Molins et al),
110 ill(A & Molins, 21)(note);
Sothebys Lon 6/24/83: 42 ill(A & Molins)(note), 43
ill(A & Molins), 45 ill(A & Molins, 5), 46 ill
(A & Molins, 5);
Christies NY 10/4/83: 101 (albums, A et al);
Christies Lon 10/27/83: 98 ill(A & Molins, 3)
(attributed);
Christies Lon 3/29/84: 148 (lot, A & Molins et al),
149 (A & Molins)(note), 150 (A & Molins)(note),
151 ill(A & Molins)(note), 152 (A & Molins)
(note), 322 (album, A & Molins-1, et al);
Christies Lon 6/28/84: 75 (album, A-1 et al), 201
(A & Molins, 3)(attributed), 202 ill(A & Molins);
Sothebys Lon 10/26/84: 44 (album, A & Molins et al);
Phillips Lon 3/27/85: 219 (lot, A & Molins-1,
et al);
Christies Lon 3/28/85: 151 (albums, A-1 et al),
218 (2);
Sothebys NY 3/29/85: 119 ill(A & Molins, 23);
Sothebys Lon 6/28/85: 45 ill(album, A & Molins
et al);
Christies Lon 4/24/86: 382 ill(album, A-5 et al)
(note), 497 ill(lot, A & Molins-24, et al);
Sothebys Lon 10/31/86: 54 (lot, A & Molins-1,
et al);

## ALVORD, KELLOGG & CAMPBELL (American)
Photos dated: 1880s
Processes:      Albumen
Formats:        Stereos
Subjects:       Topography
Locations:      US - Jacksonville, Florida
Studio:         US - Jacksonville, Florida
    Entries:
Swann NY 11/14/85: 170 (lot, A et al);

## AMADIO, Joshua
Photos dated: 1855
Processes:      Daguerreotype
Formats:        Stereo plates
Subjects:       Documentary (public events)
Locations:      England - Sydenham
Studio:         England - London
    Entries:
Christies Lon 10/28/76: 188 ill(note);

## AMARANTE, Pascal
Photos dated: 1860s-1870s
Processes:      Albumen
Formats:        Prints
Subjects:       Topography
Locations:      Italy and/or France
Studio:         Europe
    Entries:
Swann NY 11/11/76: 450 (lot, A et al);
California Galleries 6/28/81: 220 (lot, A-1 et al);
California Galleries 5/23/82: 292 (lot, A-1 et al);

## AMBROSE, J.W. (British)
Photos dated: 1864-late 1860s
Processes:      Albumen
Formats:        Prints, stereos
Subjects:       Topography
Locations:      Wales - north
Studio:         Great Britain - Beaumaris
    Entries:
Weil Lon Cat 10, 1947(?): 299 (book, A et al);
Christies Lon 3/16/78: 206 (books, A et al);

## AMERICAN COLONY JERUSALEM
Photos dated: c1870s-1900s
Processes:      Albumen
Formats:        Prints
Subjects:       Topography
Locations:      Palestine
Studio:         Palestine - Jerusalem
    Entries:
Swann NY 2/6/75: 90 (album, A et al);
Swann NY 11/11/76: 486 (lot, A-2 et al);
Christies Lon 6/30/77: 120 (album, A et al);
Sothebys LA 2/13/78: 138 (lot, A-8 et al);
Christies Lon 3/20/80: 175 (albums, A et al);
Christies Lon 10/30/80: 222 (album, A et al);
Swann NY 4/23/81: 418 (album, A et al);
Swann NY 4/1/82: 330 (lot, A et al)(note);
Phillips Lon 6/15/83: 126 (lot, A-1 et al);
Phillips Lon 6/26/85: 181 (albums, A et al);
Phillips Lon 10/30/85: 15 (lot, A et al);
Christies Lon 10/30/86: 166 (11);

## AMERICAN PALESTINE EXPLORATION FUND
Photos dated: c1875
Processes:      Albumen
Formats:        Prints
Subjects:       Topography
Locations:      Palestine
Studio:         Lebanon - Beirut
    Entries:
Swann NY 4/1/82: 340 (25)(note);

## AMES, Henry St. Vincent (British)
Photos dated: 1860s
Processes:      Albumen
Formats:        Prints
Subjects:
Locations:
Studio:         Great Britain (Amateur Photographic
                Association)
    Entries:
Christies Lon 10/27/83: 218 (albums, A-2 et al);

## AMITIE (American)
Photos dated: 1850s
Processes:      Daguerreotype
Formats:        Plates
Subjects:       Portraits
Locations:      Studio
Studio:         US
    Entries:
Sothebys NY (Strober Coll.) 2/7/70: 142 (note);

**ALLEN, Richard** (British)
Photos dated: 1874
Processes:      Albumen
Formats:        Prints
Subjects:       Topography
Locations:      Great Britain
Studio:         Great Britain
    Entries:
Swann NY 5/9/85: 164 (book, 30)(note);

**ALLEN, W.F.** (American)
Photos dated: 1860s-1870s
Processes:      Albumen
Formats:        Stereos
Subjects:       Topography
Locations:      US
Studio:         US - Jaffrey, New Hampshire
    Entries:
Rinhart NY Cat 6, 1973: 505 (4);
California Galleries 9/27/75: 512 (lot, A et al);
California Galleries 1/23/77: 410 (lot, A et al);
Swann NY 11/6/80: 390 (lot, A-1 et al)(note);

**ALLEN, W.P.** (American)
Photos dated: 1889
Processes:      Autoglyph
Formats:        Prints
Subjects:       Topography
Locations:      US - Cornell University, New York
Studio:         US - Gardner, Massachusetts
    Entries:
Swann NY 9/18/75: 354 (book, 26);

**ALLI, Darogha Ubbas** (Indian)(aka DAROGAH, Haji
                Abbas Ali)
Photos dated: 1874-1880
Processes:      Albumen
Formats:        Prints, cdvs
Subjects:       Topography, portraits
Locations:      India - Lucknow
Studio:         India
    Entries:
Christies Lon 10/28/76: 302 (book, 300);
Sothebys Lon 3/22/78: 26 (book, 50);
Sothebys Lon 3/14/79: 241 (book, 50);
Christies Lon 10/29/81: 234 (album, 50);
Phillips Lon 3/27/85: 165 (album, 50);
Christies Lon 6/26/86: 50 (album, 50);

**ALLON** (see BAILEY)

**ALLPORT, N.** (British)
Photos dated: 1860s
Processes:      Albumen
Formats:        Prints
Subjects:
Locations:
Studio:         Great Britain (Amateur Photographic
                Association)
    Entries:
Sothebys Lon 10/29/80: 310 (album, A et al);
Christies Lon 10/27/83: 218 (albums, A-3 et al);

**ALOPHE, Marie Alexandre** (French, 1811-1883)
Photos dated: 1870s-1878
Processes:      Albumen
Formats:        Prints, cdvs
Subjects:       Portraits
Locations:      France - Paris
Studio:         France - Paris
    Entries:
Rauch Geneva 6/13/61: 159 (lot, A et al);
Christies Lon 6/26/80: 471 (album, A-2 et al);
Drouot Paris 11/24/84: 113 (book, 66);
Harris Baltimore 11/7/86: 221;

**ALPERS, Ernst** (German)
Photos dated: 1867
Processes:      Albumen
Formats:        Prints
Subjects:       Documentary (art)
Locations:      Germany
Studio:         Germany - Hannover
    Entries:
Swann NY 4/1/76: 137 (book, 18);

**ALSTIN, Dr. Andrew Wemple Van** (American, died
                1857)
Photos dated: 1843-1857
Processes:      Daguerreotype
Formats:        Plates
Subjects:       Portraits
Locations:      Studio
Studio:         US - Worcester, Massachusetts
    Entries:
Swann NY 10/18/79: 327 (note);

**ALTOBELLI, Gioacchino** (Italian)(see also MOLINS)
Photos dated: 1859-c1878
Processes:      Albumen
Formats:        Prints, stereos, cdvs
Subjects:       Topography
Locations:      Italy - Rome
Studio          Italy - Rome
    Entries:
Maggs Paris 1939: 498, 499, 500;
Phillips NY 11/3/78: 169 ill;
Lennert Munich Cat 5, 1979: 32;
Christies Lon 3/15/79: 184 (albums, A-1 et al)
    (note);
Sothebys Lon 6/29/79: 148 (A & Molins), 149 ill;
Sothebys Lon 10/24/79: 150 (A & Molins), 151 (A &
    Molins), 152 (A & Molins), 153 (A & Molins);
White LA 1980-81: 30 ill(note), 31 ill, 32 ill;
Christies NY 5/16/80: 167 (books, A et al);
Sothebys NY 5/20/80: 382 ill(2)(attributed)(note);
Phillips NY 5/21/80: 128 (albums, A attributed et
    al), 219 (note), 220 ill(attributed), 221 ill
    (attributed)(note);
Christies Lon 10/30/80: 207 (A & Molins);
Lennert Munich Cat 6, 1981: 16, 17 ill;
Sothebys Lon 3/27/81: 132 (album, A & Molins et al);
Phillips NY 5/9/81: 40 ill(note), 65 (album, A-1
    et al);
Sothebys Lon 10/28/81: 91 (A & Molins);
Christies Lon 10/29/81: 184 (A & Molins)(note), 190
    (lot, A et al);
Rose Florida Cat 7, 1982: 34 ill(album, A et al);
Phillips NY 5/22/82: 643 ill, 644, 645;
Christies Lon 10/28/82: 59;
Swann NY 11/18/82: 403 (lot, A et al);
Bievres France 2/6/83: 1 ill;

## ALTOBELLI (continued)

Christies Lon 6/23/83: 107 (lot, A & Molins et al),
    110 ill(A & Molins, 21)(note);
Sothebys Lon 6/24/83: 42 ill(A & Molins)(note), 43
    ill(A & Molins), 45 ill(A & Molins, 5), 46 ill
    (A & Molins, 5);
Christies NY 10/4/83: 101 (albums, A et al);
Christies Lon 10/27/83: 98 ill(A & Molins, 3)
    (attributed);
Christies Lon 3/29/84: 148 (lot, A & Molins et al),
    149 (A & Molins)(note), 150 (A & Molins)(note),
    151 ill(A & Molins)(note), 152 (A & Molins)
    (note), 322 (album, A & Molins-1, et al);
Christies Lon 6/28/84: 75 (album, A-1 et al), 201
    (A & Molins, 3)(attributed), 202 ill(A & Molins);
Sothebys Lon 10/26/84: 44 (album, A & Molins et al);
Phillips Lon 3/27/85: 219 (lot, A & Molins-1,
    et al);
Christies Lon 3/28/85: 151 (albums, A-1 et al),
    218 (2);
Sothebys NY 3/29/85: 119 ill(A & Molins, 23);
Sothebys Lon 6/28/85: 45 ill(album, A & Molins
    et al);
Christies Lon 4/24/86: 382 ill(album, A-5 et al)
    (note), 497 ill(lot, A & Molins-24, et al);
Sothebys Lon 10/31/86: 54 (lot, A & Molins-1,
    et al);

## ALVORD, KELLOGG & CAMPBELL (American)

Photos dated: 1880s
Processes:      Albumen
Formats:        Stereos
Subjects:       Topography
Locations:      US - Jacksonville, Florida
Studio:         US - Jacksonville, Florida
    Entries:
Swann NY 11/14/85: 170 (lot, A et al);

## AMADIO, Joshua

Photos dated: 1855
Processes:      Daguerreotype
Formats:        Stereo plates
Subjects:       Documentary (public events)
Locations:      England - Sydenham
Studio:         England - London
    Entries:
Christies Lon 10/28/76: 188 ill(note);

## AMARANTE, Pascal

Photos dated: 1860s-1870s
Processes:      Albumen
Formats:        Prints
Subjects:       Topography
Locations:      Italy and/or France
Studio:         Europe
    Entries:
Swann NY 11/11/76: 450 (lot, A et al);
California Galleries 6/28/81: 220 (lot, A-1 et al);
California Galleries 5/23/82: 292 (lot, A-1 et al);

## AMBROSE, J.W. (British)

Photos dated: 1864-late 1860s
Processes:      Albumen
Formats:        Prints, stereos
Subjects:       Topography
Locations:      Wales - north
Studio:         Great Britain - Beaumaris
    Entries:
Weil Lon Cat 10, 1947(?): 299 (book, A et al);
Christies Lon 3/16/78: 206 (books, A et al);

## AMERICAN COLONY JERUSALEM

Photos dated: c1870s-1900s
Processes:      Albumen
Formats:        Prints
Subjects:       Topography
Locations:      Palestine
Studio:         Palestine - Jerusalem
    Entries:
Swann NY 2/6/75: 90 (album, A et al);
Swann NY 11/11/76: 486 (lot, A-2 et al);
Christies Lon 6/30/77: 120 (album, A et al);
Sothebys LA 2/13/78: 138 (lot, A-8 et al);
Christies Lon 3/20/80: 175 (albums, A et al);
Christies Lon 10/30/80: 222 (album, A et al);
Swann NY 4/23/81: 418 (album, A et al);
Swann NY 4/1/82: 330 (lot, A et al)(note);
Phillips Lon 6/15/83: 126 (lot, A-1 et al);
Phillips Lon 6/26/85: 181 (albums, A et al);
Phillips Lon 10/30/85: 15 (lot, A et al);
Christies Lon 10/30/86: 166 (11);

## AMERICAN PALESTINE EXPLORATION FUND

Photos dated: c1875
Processes:      Albumen
Formats:        Prints
Subjects:       Topography
Locations:      Palestine
Studio:         Lebanon - Beirut
    Entries:
Swann NY 4/1/82: 340 (25)(note);

## AMES, Henry St. Vincent (British)

Photos dated: 1860s
Processes:      Albumen
Formats:        Prints
Subjects:
Locations:
Studio:         Great Britain (Amateur Photographic
                Association)
    Entries:
Christies Lon 10/27/83: 218 (albums, A-2 et al);

## AMITIE (American)

Photos dated: 1850s
Processes:      Daguerreotype
Formats:        Plates
Subjects:       Portraits
Locations:      Studio
Studio:         US
    Entries:
Sothebys NY (Strober Coll.) 2/7/70: 142 (note);

**AMODIO, Michele** (Italian)
Photos dated: 1850s-1880s
Processes:     Albumen
Formats:       Prints
Subjects:      Topography
Locations:     Italy - Naples; Pompeii
Studio:        Italy - Naples
   Entries:
Bievres France 2/6/83: 141 (lot, A-2 et al);
Sothebys NY 5/7/85: 13 ill(album, 50);
Christies Lon 10/31/85: 86 (albums, A-12 et al);

**ANDERSEN** (see STILLFRIED)

**ANDERSON** (American) [ANDERSON 1]
Photos dated: 1860s-1885
Processes:     Albumen
Formats:       Prints, cdvs, cabinet cards, stereos
Subjects:      Portraits, topography, ethnography
Locations:     US - Massachusetts et al
Studio:        US - Richmond, Virginia
   Entries:
Sothebys NY (Strober Coll.) 2/7/70: 282 (lot, A et
   al), 484 (17), 508 (lot, R et al);
Sothebys NY 11/21/70: 356 (lot, A et al);
Rinhart NY Cat 6, 1973: 556;
California Galleries 9/27/75: 571 (lot, A & Ennis
   et al);
California Galleries 1/23/77: 444 (lot, A & Ennis
   et al);
Christies NY 5/4/79: 125;
Sothebys LA 2/6/80: 70 ill;
Harris Baltimore 7/31/81: 102 (lot, A et al);
Harris Baltimore 5/28/82: 165 (lot, A et al), 166
   (lot, A-1 et al);
Harris Baltimore 9/16/83: 112 (lot, A-1 attributed
   et al);
Harris Baltimore 12/16/83: 141 (lot, A-9, A &
   Ennis-2, et al);
Harris Baltimore 2/14/86: 13 (lot, A et al);

**ANDERSON** (British) [ANDERSON 2]
Photos dated: 1880s
Processes:     Albumen
Formats:       Prints
Subjects:      Documentary (military)
Locations:     Scotland
Studio:        Great Britain
   Entries:
Christies Lon 3/29/84: 208 (lot, A-8 et al);

**ANDERSON, A.W.** (Canadian)
Photos dated: 1884
Processes:     Albumen
Formats:       Cabinet cards
Subjects:      Documentary (expeditions)
Locations:     Canada
Studio:        Canada
   Entries:
Phillips Can 10/4/79: 85 (lot, A-1 et al);

**ANDERSON, C.H.** (American)
Photos dated: 1860s
Processes:     Albumen
Formats:       Cdvs
Subjects:      Genre
Locations:     US
Studio:        US
   Entries:
Vermont Cat 4, 1972: 477 ill;

**ANDERSON, D.H.** (American)
Photos dated: 1880s-1892
Processes:     Albumen, heliogravure
Formats:       Prints
Subjects:      Portraits
Locations:     US - New York
Studio:        US - New York
   Entries:
Swann NY 2/6/75: 169 (lot, A et al);
California Galleries 1/23/77: 483 (book, 1);
Phillips NY 5/21/80: 287;
Swann NY 11/6/80: 257 ill;
Wood Boston Cat 58, 1986: 136 (books, A-1 et al);
Swann NY 5/15/86: 133 (book, A et al);

**ANDERSON, James** (British, born Isaac Atkinson,
             1813-1877) **and/or Domenico**
Photos dated: 1857-1875
Processes:     Albumen
Formats:       Prints, cdvs, stereos
Subjects:      Topography
Locations:     Italy - Rome et al; Gibraltar
Studio:        Italy - Rome
   Entries:
Rinhart NY Cat 1, 1971: 129 (7), 182 (10), 189 (4),
   203 (3), 255 (7), 289 (5);
Witkin NY I 1973: 547 (album, A et al), 548 (album,
   A et al);
Sothebys NY 2/25/75: 141 (lot, A et al);
Kingston Boston 1976: 184 ill(album, A-17 et al);
Rose Boston Cat 1, 1976: 10 ill(note);
Swann NY 4/1/76: 206 (lot, A et al);
Sothebys NY 5/4/76: 73 (4)(note);
Swann NY 11/11/76: 394 (albums, A et al);
Wood Conn Cat 42, 1978: 18 (book, 10)(note);
California Galleries 1/21/78: 208 (album, J &
   Domenico A, 36)(note);
Swann NY 4/20/78: 328 (album, A et al);
Rose Boston Cat 4, 1979: 45 ill(note);
Wood Conn Cat 45, 1979: 6 (album, 10);
California Galleries 1/21/79: 389;
Christies Lon 10/25/79: 235 (lot, A et al);
Christies NY 5/16/80: 165 ill, 188 (lot, A et al);
Phillips NY 5/21/80: 218 ill(note);
Christies Lon 10/30/80: 189 (albums, A et al);
Christies Lon 3/26/81: 262 (lot, A-35 et al);
Phillips NY 5/9/81: 28 (albums, A et al);
California Galleries 6/28/81: 177 ill(attributed);
Petzold Germany 11/7/81: 185 (lot, A-2 et al);
California Galleries 5/23/82: 182 (album, Domenico
   A, 84), 194 (album, A et al), 214 (3,
   attributed);
Christies Lon 6/24/82: 175 (lot, A et al);
Phillips NY 9/30/82: 994 (lot, A attributed et al);
Harris Baltimore 12/10/82: 192 (note), 391 (albums,
   A et al), 398 (6, attributed);
Swann NY 5/5/83: 377 (lot, A et al)(note), 380
   (albums, A et al)(note);

**ANDERSON, James** (continued)
Christies Lon 6/23/83: 92 (lot, A-1 et al), 111 (2)
   (attributed);
Christies NY 10/4/83: 101 (albums, A et al);
Christies Lon 10/27/83: 68 (5)(attributed);
Christies Lon 3/29/84: 144 ill(note);
Harris Baltimore 2/14/86: 210 (albums, A et al), 219
   (album, A et al), 238 (20);
Christies Lon 4/24/86: 484 ill(attributed);
Sothebys Lon 4/25/86: 58 (lot, A et al), 60 ill, 61
   (9), 62 (7, attributed);
Christies NY 5/13/86: 294 (lot, A-1 et al);
Swann NY 5/15/86: 264 (lot, A et al);
Sothebys Lon 10/31/86: 60 (lot, A et al);
Harris Baltimore 11/7/86: 279 (lot, A-1 et al);
Swann NY 11/13/86: 219 (lot, A et al);

**ANDREWS, J.** (British)
Photos dated: Nineteenth century
Processes:      Albumen
Formats:        Cdvs
Subjects:       Portraits
Locations:      Studio
Studio:         Great Britain
   Entries:
Christies Lon 3/20/80: 374 (albums, A et al);
Christies Lon 10/27/83: 224A (album, A et al);

**ANDREWS, J. Martin**
Photos dated: c1880
Processes:      Albumen
Formats:        Prints
Subjects:       Topography
Locations:      New Zealand
Studio:         New Zealand
   Entries:
California Galleries 1/21/78: 215 (album, A et al);

**ANDREWS, William**
Photos dated: 1850s
Processes:      Ambrotype
Formats:        Plates
Subjects:       Portraits
Locations:      Studio
Studio:         Ireland - Dublin
   Entries:
Vermont Cat 6, 1973: 590 ill;
Sothebys Lon 6/29/79: 15;

**ANDRIEU, J.** (French)(possibly J.A., q.v.)
Photos dated: 1860s-1870s
Processes:      Albumen
Formats:        Stereos, cdvs
Subjects:       Topography
Locations:      France - Paris and Pyrenees
Studio:         France - Paris
   Entries:
Sothebys Lon 10/18/74: 168 ill(lot, A-8 et al);
California Galleries 4/3/76: 337 (36), 471 (lot,
   A et al);
California Galleries 1/21/78: 153 (36), 171 (lot,
   A et al), 195 (lot, A et al);
Christies Lon 3/16/78: 166 (lot, A-36 et al);
California Galleries 1/21/79: 317 (lot, A et al);
Christies Lon 6/28/84: 30 (lot, A-3 et al);
Harris Baltimore 3/15/85: 2 (27), 3 (lot, A-25
   et al);

**ANDRIEU, J.** (continued)
Harris Baltimore 2/14/86: 28 (27);
Christies Lon 4/24/86: 344 (lot, A et al);

**ANDVORD, Rich.** (Norwegian)
Photos dated: 1892
Processes:
Formats:        Prints
Subjects:       Topography
Locations:      Norway
Studio:         Norway
   Entries:
Witkin NY II 1974: 915 (lot, A-1 et al);

**ANGEL, A.**
Photos dated: c1860
Processes:      Albumen
Formats:        Prints
Subjects:       Architecture
Locations:      France - Chartres
Studio:
   Entries:
Sothebys Lon 6/17/81: 136 (lot, A-2 et al);

**ANGEL, Owen** (British)
Photos dated: 1850s
Processes:      Daguerreotype, albumen
Formats:        Plates, stereos
Subjects:       Portraits, topography
Locations:      Great Britain
Studio:         England - Exeter
   Entries:
Christies Lon 3/28/85: 19 (lot, A et al);
Sothebys Lon 6/28/85: 1 (lot, A et al);
Christies Lon 4/24/86: 363 (lot, A-1 et al);

**ANGELL, C.L.** (American)
Photos dated: 1883
Processes:      Albumen
Formats:        Stereos
Subjects:       Documentary (railroads)
Locations:      US - Minnesota
Studio:         US - Minnesota
   Entries:
California Galleries 3/29/86: 775 ill;

**ANGERER, Victor** (1839-1894) **and/or Ludwig**
             (1827-1879)(Austrian)
Photos dated: 1856-1887
Processes:      Albumen, collotype
Formats:        Cdvs, stereos
Subjects:       Portraits, topography
Locations:      Roumania; Austria
Studio:         Austria - Vienna
   Entries:
Rauch Geneva 12/24/58: 219 ill(lot, A-1 et al);
Sothebys NY (Strober Coll.) 2/7/70: 278 (lot,
   A et al);
Christies Lon 10/30/80: 417 (album, A et al);
Petzold Germany 11/7/81: 328 (album, A et al);
Harris Baltimore 12/10/82: 39 (lot, A-17 et al), 351
   (lot, A et al);

**ANNAN, James Craig** (British, 1864-1946)
Photos dated: 1892-early 1900s
Processes:       Photogravure
Formats:         Prints
Subjects:        Portraits, topography
Locations:       Holland; Great Britain; Italy; Spain
Studio:          Great Britain
    Entries:
California Galleries 9/26/75: 218, 219, 220, 221;
Kingston Boston 1976: 2 ill(note), 3 ill;
Sothebys NY 5/20/77: 85 (album, 20)(note);
Christies Lon 3/15/79: 104;
Swann NY 10/18/79: 13 ill(book, JC & Thomas A et al)
    (note);
Phillips NY 11/3/79: 160 (note);
Christies Lon 3/11/82: 264 (book, 11);
Harris Baltimore 12/10/82: 193;
Christies NY 5/9/83: 12 ill(note), 13 (2 ills)
    (book, 11)(note);
Christies Lon 10/27/83: 262 (note), 263, 264 ill;
Christies Lon 3/29/84: 221 (11);
California Galleries 6/8/85: 150;

**ANNAN, Robert** (see ANNAN, Thomas)

**ANNAN, Thomas** (British, 1829-1887)
Photos dated: 1855-1878
Processes:       Photogravure, carbon, albumen
Formats:         Prints, stereos, cdvs
Subjects:        Portraits, architecture, documentary
                 (art)
Locations:       Scotland - Glasgow; England
Studio:          Scotland - Glasgow
    Entries:
Swann NY 2/14/52: 39 (book, 4), 135 (book, 16)
    (note), 301 (books, A-15 et al);
Rinhart NY Cat 6, 1973: 91 (book, 100);
Christies Lon 10/4/73: 100 (books, A-15 et al);
Ricketts Lon 1974: 52 ill(book, 50);
Sothebys Lon 3/8/74: 172 ill(book, 50);
Sothebys Lon 6/21/74: 157 ill(book, 41), 158 ill
    (book, 40), 159 ill(book);
Sothebys Lon 10/18/74: 247 ill(book, 13), 248 ill
    (book, 40), 249 ill(book), 250 ill(book);
Edwards Lon 1975: 51 (book, 50)(note), 85
    (book, 11);
Witkin NY III 1975: 680 ill(book);
Sothebys NY 2/25/75: 68 ill(book, 49);
Sothebys Lon 3/21/75: 122 (book, 8), 127 (3), 128
    ill(book, 41), 129 ill(book, 40), 130 (album,
    28), 131 ill(book, 50), 132 ill(book, 50), 133
    ill(book, 50), 307 (book, 15);
Sothebys Lon 6/26/75: 91, 92 ill(book, 50), 93 ill
    (book, 50), 94 ill(book, 50), 95 ill(book, 50);
Sothebys NY 9/23/75: 31 ill(note), 32 ill, 33
    (book, 49);
Sothebys Lon 10/24/75: 144 ill(book, 50), 144a ill
    (book, 50);
Colnaghi Lon 1976: 334 (6 ills)(book, 100)(note),
    335 ill(book, 40), 336 (2 ills)(book, 50);
Lunn DC Cat 6, 1976: 33.1 ill(note), 33.2 ill, 33.3
    ill, 33.4 ill, 34.1 ill(note);
Rose Boston Cat 1, 1976: 11 ill(note) 12 ill;
Witkin NY IV 1976: 15 ill, OP31 (book, 50);
Wood Conn Cat 37, 1976: 9 (book, 50)(note), 10
    (book, 13)(note), 11 (book, 15)(note), 13 ill
    (book, 53)(note);
Sothebys Lon 3/19/76: 37 ill(book, 50), 38 (book,
    100);

**ANNAN, T.** (continued)
Gordon NY 5/3/76: 292 ill, 293 ill;
Sothebys NY 5/4/76: 60 (note), 61, 62, 63 ill,
    64 ill;
Christies Lon 6/10/76: 49a (book, 15), 50 ill(book,
    100), 51 (book, 36), 52 (book, T & Robert A,
    14), 53 (book, T & Robert A, 76);
Sothebys Lon 6/11/76: 61 ill(book, 50), 62 ill
    (book, 40), 178;
Christies Lon 10/28/76: 95 (book), 96 (book, 28);
Sothebys Lon 10/29/76: 102, 139 (book, 28), 140 ill
    (book, 50), 141 ill(book, 50), 182 (book, 100);
Sothebys NY 11/9/76: 40 (3)(note), 41 (3), 42 (3);
Gordon NY 11/13/76: 26 ill, 27 ill, 28 ill(3)
    note), 29 (3)(note);
Vermont Cat 11/12, 1977: 512 ill(book, 100);
California Galleries 1/22/77: 213 (book, A et al);
Sothebys NY 2/9/77: 34 ill(3), 35 (3);
Sothebys Lon 3/9/77: 51 ill(18), 183 (attributed);
Christies Lon 3/10/77: 102, 103 (2);
Swann NY 4/14/77: 120 (book, 7);
Gordon NY 5/10/77: 827 ill, 828 ill;
Sothebys NY 5/20/77: 81 (note), 82 ill, 83 (3), 84
    ill(3);
Christies Lon 6/30/77: 208 (book, 12), 212 ill
    (book, 8), 217 (book, 15), 254 (book, T & Robert
    A, 49);
Sothebys Lon 7/1/77: 35 (book, 15), 38 (book, 8),
    157 (book, 28);
Sothebys NY 10/4/77: 191 (book, T & Robert A, 76),
    194 (book, 50), 195 (3), 196 (3);
Sothebys Lon 11/18/77: 69 (5), 70 ill(10);
Swann NY 12/8/77: 251 ill(note), 252, 253;
Witkin NY VI 1978: 6 ill, 7 (2 ills)(51);
Wood Conn Cat 41, 1978: 116 ill(book, 50)(note);
Wood Conn Cat 42, 1978: 23 (book, 13)(note), 24
    (book, 15)(note);
Sothebys LA 2/13/78: 130 ill(2)(note), 131 (3);
Christies Lon 3/16/78: 220 (book, 41), 231
    (book, 100);
Sothebys Lon 3/22/78: 76 ill(book, 50);
Sothebys NY 5/2/78: 64 ill(2)(note), 65, 66 ill;
Sothebys Lon 6/27/78: 110 ill(book, 40), 111 ill
    (book, 50);
Christies Lon 6/28/78: 69 ill(36)(note), 163 (book,
    15), 178 (book, T & Robert A, 49);
Sothebys Lon 10/27/78: 112 ill(book, 50);
Lehr NY Vol 1:4, 1979: 25 (book, 13);
Wood Conn Cat 45, 1979: 7 (book, 50)(note);
Sothebys LA 2/7/79: 445 ill(book, 50);
Phillips Lon 3/13/79: 152 (book, 8), 153 ill
    (book, 50);
Sothebys Lon 3/14/79: 148 (album, 20)(attributed);
Christies Lon 3/15/79: 300 (lot, T & Robert A-1,
    et al);
Christies NY 5/4/79: 34 (book);
Phillips NY 5/5/79: 143 (note), 144 (3);
Christies Lon 6/28/79: 164 (book, 28);
Sothebys Lon 10/24/79: 128 ill(book, 50), 129,
    130 ill;
Christies Lon 10/25/79: 116 ill, 282 ill(book, 40),
    283 (book, 100), 303 (book, 50);
Christies NY 10/31/79: 29 (book)(note);
Phillips NY 11/3/79: 153 (note), 154 ill(2)(note),
    155 ill(note);
White LA 1980-81: 5 ill(note);
Witkin NY X 1980: 5 (2 ills)(book, 50)(note), 90
    (book, 103), 91 (book, T & Robert A, 33)(note);
Sothebys LA 2/6/80: 133 (note), 134, 135 ill, 136
    ill(book, 100);
Sothebys Lon 3/21/80: 180 ill(book, 50);

ANNAN, T. (continued)
Christies NY 5/16/80: 303 ill (9);
Sothebys NY 5/20/80: 350 ill(note), 351;
Phillips NY 5/21/80: 165, 166, 167, 168, 169 ill(4), 170 (4), 171 (10);
Sothebys Lon 6/27/80: 112 ill(9), 114 (book, 12);
Phillips Can 10/9/80: 5 (5)(note);
Sothebys Lon 10/29/80: 312 (book, 100);
Christies Lon 10/30/80: 298 (book, 97), 318 (book, 50);
Christies NY 11/11/80: 46, 47 ill(2), 48;
Sothebys Lon 3/27/81: 112, 246 (book, 12), 248 ill (book, 50), 249 (book, T & Robert A, 65);
Swann NY 4/23/81: 11 (book, T & Robert A, 77)(note), 12 (book, 50);
Phillips NY 5/9/81: 13;
Sothebys Lon 6/17/81: 339 ill;
Christies Lon 6/18/81: 257 (book, 97), 267 (book, 50);
Sothebys Lon 10/28/81: 73, 230 (book, 50);
Christies Lon 10/29/81: 163;
Christies Lon 3/11/82: 110, 111, 258 (book, 97), 266 (book, 50);
Sothebys Lon 3/15/82: 202 (T & Robert A, 64), 361 ill, 362, 363;
Christies NY 5/26/82: 18 (2 ills)(book, 40);
Christies Lon 6/24/82: 118;
Phillips NY 9/30/82: 932;
Christies Lon 10/28/82: 52A (2), 130 (book, 50);
Sothebys Lon 10/29/82: 56 (book, 50);
Phillips NY 11/9/82: 17;
Swann NY 11/18/82: 10 ill(book, 50), 11 ill (book, 102);
Christies NY 2/8/83: 28 (2), 29;
Christies Lon 3/24/83: 243 (album, A et al);
Sothebys Lon 3/25/83: 44 ill(book, 22);
Swann NY 5/5/83: 11 (book, 15);
Christies Lon 6/23/83: 249 (lot, T & Robert A et al);
Christies Lon 10/27/83: 57 (book, 37), 65 (2);
Christies NY 11/8/83: 16 ill(book, 50)(note);
Swann NY 11/10/83: 9 ill(book, 100)(note), 10 (book, 17);
Christies Lon 3/29/84: 216;
Swann NY 5/10/84: 4 (book, 8);
Harris Baltimore 6/1/84: 308 (37)(note);
Christies Lon 6/28/84: 66 (34)(attributed), 67 ill (album, A-15 et al), 73 (T & Robert A), 74 (lot, T & Robert A et al);
Christies Lon 10/25/84: 63 (lot, T & Robert A-1, et al), 116 (books, A-13, et al);
Sothebys Lon 10/26/84: 157 (books, 67);
Christies NY 2/13/85: 168 (books, A-13 et al);
Harris Baltimore 3/15/85: 330 (37);
Christies Lon 3/28/85: 232 ill(4), 233 ill(A & Swan)(note);
Sothebys Lon 3/29/85: 179 (31);
Sothebys NY 5/6/85: 26 ill(5);
Swann NY 5/9/85: 166 (book, 40)(note), 167 (book, 100)(note), 168 ill(book, T & Robert A, 33) (note), 386 (albums, A et al);
Christies Lon 6/27/85: 103 ill(book, 100), 195 (A & Swan);
Sothebys Lon 6/28/85: 228 ill(book, 40);
Sothebys Lon 11/1/85: 104 ill(book, 50);
Christies NY 11/11/85: 295 (lot, A-1 et al);
Wood Boston Cat 58, 1986: 204 (album, 13) (attributed)(note);
Harris Baltimore 2/14/86: 104 ill(37);

ANNAN, T. (continued)
Sothebys Lon 4/25/86: 90 ill(album, A & Tunny-49, attributed), 116 ill(note), 117 ill(note), 118, 119, 120, 121 (31);
Swann NY 5/15/86: 234 (album, A et al);
Phillips Lon 10/29/86: 376 (lot, T & Robert A et al);
Christies Lon 10/30/86: 44 ill(31)(note), 45 ill (book, 100), 46 (2 ills)(book, 40), 46A (book, 40), 47 ill(book, 100);
Swann NY 11/13/86: 214 (album, A-4 et al);

ANRIOT
Photos dated: Nineteenth century
Processes:     Albumen
Formats:       Prints
Subjects:      Topography
Locations:     Italy
Studio:        Europe
   Entries:
Christies Lon 3/26/81: 183 (album, A-12 et al);
Christies Lon 3/11/82: 133 (album, A-12 et al);

ANSCHUTZ, Ottomar (German,1846-1907)
Photos dated: 1870s-1886
Processes:     Albumen
Formats:       Prints
Subjects:      Documentary (animal life)
Locations:     Germany; Austria; Asia
Studio:        Germany - Posen
   Entries:
Sothebys Lon 6/21/74: 177 (16)(note);
Rose Boston Cat 4, 1979: 55 ill(note);
Sothebys NY 5/20/80: 387 ill(lot, 22);
California Galleries 6/28/81: 184 (lot, A-2 et al);
Harris Baltimore 3/26/82: 257 (note);
Sothebys Lon 6/29/84: 85 (album, A-6 et al), 252 ill (2 plus 6 attributed);

ANSDELL, Gerrard (British)
Photos dated: 1882
Processes:     Albumen
Formats:       Prints
Subjects:      Topography, ethnography
Locations:     Fiji
Studio:
   Entries:
Lehr NY Vol 1:4, 1978: 35 (book, 43)(note);

ANSELME (see MORIN)

ANSIGLIONI, Giuliano
Photos dated: late 1850s-1860s
Processes:     Albumen
Formats:       Stereos
Subjects:      Topography
Locations:     Italy
Studio:        Italy - Rome
   Entries:
Christies Lon 3/11/82: 67 (lot, A et al);

**ANSON, Rufus** (American)
Photos dated: 1851-1867
Processes:      Daguerreotype, ambrotype, albumen
Formats:        Plates, cdvs
Subjects:       Portraits
Locations:      Studio
Studio:         US - New York City
  Entries:
Anderson NY (Gilsey Coll.) 3/18/03: 2951;
Sothebys NY (Weissberg Coll.) 5/16/67: 89 (lot,
  A-1 et al), 110 (lot, A-2 et al), 144 (lot,
  A-1 et al), 149 (lot, A-1 et al), 151 (lot,
  A-2 et al), 152 (lot, A-1 et al), 154 (lot,
  A-1 et al);
Sothebys NY (Strober Coll.) 2/7/70: 152 (lot,
  A-1 et al), 180 (lot, A-1 et al);
Rinhart NY Cat 1, 1971: 80;
Vermont Cat 4, 1972: 313 ill;
Vermont Cat 5, 1973: 372 ill;
Vermont Cat 6, 1973: 591 ill;
Vermont Cat 8, 1974: 463 ill;
Witkin NY III 1975: D66 ill;
Sothebys NY 2/25/75: 3;
Witkin NY IV 1976: D33 ill;
Gordon NY 5/3/76: 268 (lot, A et al);
Christies Lon 10/28/76: 6;
Sothebys NY 11/9/76: 7;
Swann NY 11/11/76: 314 (lot, A-1 et al);
Vermont Cat 11/12, 1977: 538 ill, 539 ill, 540 ill;
California Galleries 1/22/77: 72 (lot, A-1 et al);
Swann NY 4/14/77: 225 (note), 236;
Sothebys Lon 7/1/77: 217 (lot, A-1 et al);
Swann NY 12/8/77: 362 (lot, A-1 et al);
California Galleries 1/21/78: 132 (album, A et al);
Christies Lon 6/27/78: 18 (lot, A-2 et al);
California Galleries 1/21/79: 248 (lot, A-1 et al);
Christies Lon 3/15/79: 22;
Phillips NY 5/5/79: 86, 87 (3);
Phillips Can 10/4/79: 26;
Phillips NY 11/3/79: 114 (lot, A et al);
Rose Boston Cat 5, 1980: 166 ill;
Sothebys Lon 3/21/80: 11 (5);
California Galleries 3/30/80: 291 (lot, A-1 et al);
Swann NY 4/23/81: 218, 231 (lot, A-1 et al);
Sothebys Lon 6/17/81: 47 (lot, A-1 et al);
Sothebys Lon 10/28/81: 271;
Christies Lon 10/29/81: 9 (lot, A-1 et al);
Petzold Germany 11/7/81: 127;
Christies Lon 6/24/82: 5 (lot, A-1 et al);
Harris Baltimore 12/10/82: 380;
Christies NY 2/8/83: 75 (lot, A-3 et al);
Christies Lon 3/24/83: 3 (lot, A et al);
Phillips Lon 6/15/83: 110 (lot, A-2 et al);
California Galleries 6/19/83: 152;
Phillips Lon 11/4/83: 23 (lot, A-2 et al);
Sothebys Lon 10/26/84: 26 (lot, A-1 et al);
Harris Baltimore 3/15/85: 172;
Sothebys Lon 3/29/85: 24 (lot, A-1 et al);
Swann NY 11/14/85: 46 (lot, A et al);
Swann NY 11/13/86: 183 (lot, A-2 et al), 187 (lot,
  A-1 et al);

**ANTHONY, Edward** (American, 1818-1888)
Photos dated: 1840-1880s
Processes:      Daguerreotype, albumen
Formats:        Plates, cdvs, stereos, cabinet cards
Subjects:       Portraits, topography
Locations:      US - New York City; White Mountains,
                New Hampshire; Washington, D.C.;
                Yosemite, California
Studio:         US - New York City
  Entries:
Anderson NY (Gilsey Coll.) 2/24/03: 1582;
Sothebys NY (Weissberg Coll.) 5/16/67: 183 (lot,
  A-2 et al), 184 (lot, A-15 et al), 185 (lot, A-1
  et al), 188 (lot, A-2 et al), 193 (lot, A-2 et
  al), 194 (lot, A-9 et al), 197 (lot, A-10,
  EA-12, E & HTA-25, et al);
Sothebys NY (Strober Coll.) 2/7/70: 442 (36), 443
  (E &
  HTA, 46), 444 (lot, E & HTA et al), 445 (E &
  HTA, 30), 449 (lot, E & HTA et al), 451 (lot,
  E & HTA et al), 452 (lot, A-11 et al), 462 (lot,
  E & HTA-8 et al), 463 (lot, E & HTA et al), 465
  (lot, E & HTA et al), 481 (lot, A et al), 483
  (lot, E & HTA et al), 485 (lot, E & HTA et al),
  486 (lot, E & HTA et al), 511 (lot, E & HTA et
  al), 513 (lot, A-1 et al), 514 (lot, E & HTA et
  al), 521 (lot, E & HTA et al), 525 (lot, E & HTA
  et al), 538 (lot, A-8 et al), 544 (lot, E & HTA
  et al), 545 (lot, E & HTA et al), 546 (lot, E &
  HTA-20 et al), 547 (lot, E & HTA-12 et al), 549
  (lot, E & HTA-20 et al), 561 (lot, E & HTA-10
  et al)(note), 564 (lot, E & HTA-16 et al);
Sothebys NY (Greenway Coll.) 11/20/70: 1 (lot, A-1
  et al), 120 ill(lot, A-2, et al), 123 ill(lot,
  A-1 et al), 155 (lot, A-1 et al), 168 ill, 174
  (lot, A-1 et al), 176 (lot, A-1 et al), 219
  (lot, A-1 et al), 222 (lot, A-1 et al), 226
  ill(lot, A-1 et al), 230 ill, 243 ill(lot, A-1
  et al), 244 (lot, A-1 et al), 246 (lot, A-1 et
  al), 247 (lot, A-1 et al), 260 ill(lot, A-1 et
  al), 261 (lot, A-2 et al), 268 (lot, A-1 et al),
  276 (lot, A-1 et al), 279 (lot, A-1 et al), 283
  ill(lot, A-1 et al);
Sothebys NY 11/21/70: 326 (lot, A et al), 350 (lot,
  A-1 et al);
Rinhart NY Cat 1, 1971: 130 (3), 131 (3), 132 (3),
  133 (2), 159 (lot, A-1 et al), 160 (lot, A-4 et
  al), 169, 170, 171, 173, 237 (lot, A-1 et al),
  287 (lot, A-1 et al), 294 (lot, A et al), 308
  (lot, A-2 et al);
Rinhart NY Cat 2, 1971: 357 (lot, A-2 et al), 358
  (lot, A-1 et al), 359 (lot, A-3 et al), 438,
  439, 440 (2), 441, 442 (2), 443 (4), 525 (2),
  526, 541 (3), 553, 588 (lot, A-2 et al);
Vermont Cat 1, 1971: 227 (E & HTA, 19);
Vermont Cat 2, 1971: 216 (5), 217 (7), 218 (3);
Vermont Cat 4, 1972: 470 ill(E & HTA), 472 ill(E &
  HTA), 473 ill(E & HTA), 482 ill, 484 ill(lot, E
  & HTA-1 et al), 597 ill(E & HTA), 603 ill(lot,
  A-3 et al);
Rinhart NY Cat 6, 1973: 387 (E & HTA, 6), 411, 436,
  514, 517, 522, 528, 611 (E & HTA);

**ANTHONY, E.** (continued)

Rinhart NY Cat 7, 1973: 155 (album, A et al), 180
(E & HTA), 213 (E & HTA), 214 (E & HTA), 237,
238, 239 (E & HTA), 240 (E & HTA), 241 (E &
HTA), 242 (E & HTA), 243 (E & HTA), 244 (E &
HTA), 245 (E & HTA), 246 (E & HTA), 247 (E &
HTA), 248 (E & HTA), 249 (E & HTA), 250 (E &
HTA), 252 (lot, E & HTA-1, et al), 265, 266
(E & HTA), 274 (E & HTA), 315 (E & HTA), 316
(E & HTA), 317 (E & HTA), 318 (E & HTA), 319
(E & HTA), 320 (E & HTA), 321 (E & HTA), 322
(E & HTA), 323 (E & HTA), 324 (E & HTA),
536 (lot, E & HTA-1 et al), 543 (lot, E
& HTA-1 et al);
Rinhart NY Cat 8, 1973: 29 ill(E & HTA), 42 (E &
HTA), 54, 55 (E & HTA), 56 (E & HTA), 67 (E &
HTA), 74 (E & HTA);
Vermont Cat 5, 1973: 535 (lot, E & HTA-1 et al),
536 (7), 537 (5);
Vermont Cat 7, 1974: 605 ill(E & HTA), 606 ill
(E & HTA);
Vermont Cat 8, 1974: 546 ill(3), 547 ill(3), 548
ill, 549 ill, 550 ill, 551 ill, 552 ill, 553 ill;
Sothebys Lon 6/21/74: 18a (lot, E & HTA et al);
Sothebys Lon 10/18/74: 2 (lot, E & HTA-5 et al);
Sothebys NY 2/25/75: 44 (lot, E & HTA et al), 108
ill(album, A et al);
California Galleries 9/27/75: 457 (lot, E & HTA et
al), 480 (lot, E & HTA-1 et al), 531 (E & HTA,
20), 547 (lot, E & HTA et al), 548 (lot, A et
al), 562 (lot, E & HTA-6 et al), 574 (lot, E &
HTA et al), 584 (11 plus 1 attributed);
Witkin NY IV 1976: S6 ill(E & HTA);
Swann NY 4/1/76: 239 (lot, E & HTA et al);
California Galleries 4/2/76: 99 (lot, A-1 et al);
California Galleries 4/3/76: 338 (lot, E & HTA et
al), 343 (E & HTA, 8), 345 (lot, A-1 et al), 352
(lot, E & HTA et al), 374 (lot, E & HTA et al),
471 (lot, E & HTA et al), 486 (lot, E & HTA-1 et
al), 494 (lot, E & HTA et al), 496 (E & HTA, 17);
Christies Lon 10/28/76: 195 (lot, E & HTA-4 et al);
Swann NY 11/11/76: 346 (lot, A et al);
Vermont Cat 11/12, 1977: 745 ill, 746 ill(2), 747
ill, 748 ill(2), 749 ill(E & HTA, 4), 750 ill
(E & HTA), 751 ill(E & HTA, 3), 752 ill(E &
HTA), 753 ill(E & HTA, 4), 754 ill(E & HTA), 755
ill(E & HTA, 3), 756 ill(E & HTA, 6);
California Galleries 1/23/77: 364 (lot, E & HTA et
al), 368 (lot, E & HTA et al), 385 (lot, E & HTA
et al), 422 (E & HTA, 22), 430 (lot, E & HTA et
al), 432 (lot, A et al), 446 (lot, E & HTA et
al), 456 (E & HTA, 12);
Swann NY 4/14/77: 302 (lot, E & HTA et al), 322
(lot, E & HTA et al);
Frontier AC, Texas, 1978: 7 (E & HTA), 8 (E & HTA),
9 (E & HTA), 10 (E & HTA), 11 (E & HTA);
California Galleries 1/21/78: 194 (lot, A-1 et al),
195 (lot, A et al);
Christies Lon 3/16/78: 175 (lot, E & HTA-17 et al),
176 ill(lot, E & HTA-6 et al)(note), 179 (lot,
E & HTA-6 et al)(note), 180 (E & HTA, 14), 181
(lot, E & HTA et al);
Swann NY 4/20/78: 370 (lot, E & HTA et al), 371
(lot, E & HTA et al);
Swann NY 12/14/78: 299 (E & HTA, 28)(note);
California Galleries 1/21/79: 292 (lot, E & HTA et
al), 311 (lot, A et al), 315 (lot, E & HTA et
al), 317 (lot, E & HTA et al);
Christies Lon 3/15/79: 303 (album, E & HTA et al);
Swann NY 4/26/79: 431 ill(9)(note), 433 (6)(note);
Phillips NY 5/5/79: 109 (lot, E & HTA et al);

**ANTHONY, E.** (continued)

Christies Lon 6/28/79: 236 (lot, E & HTA et al);
Swann NY 10/18/79: 282 (note), 283, 290 ill, 296,
299 (note), 300, 398 (20)(note), 399 (E & HTA,
10), 421 (E & HTA, 6);
Christies Lon 3/20/80: 108 (lot, E & HTA-3 et al);
California Galleries 3/30/80: 413 (lot, E & HTA-1
et al);
Sothebys Lon 10/29/80: 261 (album, A et al);
Swann NY 11/6/80: 380 (lot, E & HTA-9 et al), 381
(E & HTA, 15), 386 (E & HTA, 6)(note), 391 (E
& HTA, 2)(note);
Christies Lon 3/26/81: 125 (lot, A et al);
Sothebys Lon 6/17/81: 21 (lot, A et al);
Christies Lon 6/18/81: 78 (lot, A et al), 107 (lot,
A et al);
California Galleries 6/28/81: 317 (lot, E & HTA-1
et al);
Harris Baltimore 7/31/81: 90 (E & HTA, 4), 103
(lot, A-2 et al), 112 (lot, E & HTA-7 et al),
122 (lot, A et al), 134 (album, A et al);
Christies Lon 10/29/81: 147 (lot, E & HTA et al);
Sothebys Lon 3/15/82: 18 (lot, A-1 et al);
Harris Baltimore 3/26/82: 1 (E & HTA, 23), 9 (E &
HTA, 16), 397 (lot, A et al), 399 (album, A
et al);
Swann NY 4/1/82: 357 (lot, E & HTA et al);
California Galleries 5/23/82: 190 (album, E & HTA
et al), 399 (lot, E & HTA et al), 431 (lot, E
& HTA-6 et al);
Harris Baltimore 5/28/82: 132, 134, 145 ill, 148
(lot, A-7 et al), 151 (lot, A-2 et al), 152 (3),
158 (lot, A-1 et al), 159 (lot, A-3 et al), 163
(lot, A-6 et al), 166 (lot, A-6 et al), 168
(lot, A-4 et al);
Harris Baltimore 12/10/82: 6 (E & HTA, 20), 7 (E &
HTA, 34), 8 (E & HTA, 43), 9 (E & HTA, 20), 10
(E & HTA, 36), 19 (lot, E & HTA-2 et al), 28
(E & HTA, 9), 35 ill(23), 36 (E & HTA), 41 (lot,
A et al), 62 (4 plus E & HTA, 16), 64 (lot, A et
al), 65 (lot, A et al), 68 (lot, A et al), 69
(lot, A et al), 84 (lot, A-1 et al), 95 ill
(lot, E & HTA attributed et al)(note), 117 (E
& HTA, 21);
Harris Baltimore 2/16/83: 122 (lot, E & HTA et al),
140 (lot, E & HTA et al), 296 (album, E & HTA et
al), 298 (album, A et al), 300 (album, E & HTA
et al);
Harris Baltimore 4/8/83: 3 (E & HTA, 60), 4 (E &
HTA, 29), 20 (lot, E & HTA-5 et al), 72 (lot,
E & HTA et al), 381 (lot, A et al);
Swann NY 5/5/83: 332 (lot, A et al);
California Galleries 6/19/83: 421 (E & HTA, 2);
Christies Lon 6/23/83: 47 (lot, A et al), 52 (lot,
A-1 et al), 252 (album, A et al);
Harris Baltimore 9/16/83: 121 (lot, A et al), 123
(lot, E & HTA et al), 186 (lot, E & HTA-1 et
al), 204 (lot, E & HTA-2 et al), 205 (lot, E
& HTA, 2);
Swann NY 11/10/83: 197, 239 (lot, E & HTA-6 et al)
(note), 242 (album, A et al), 243 (album, A et
al), 346 (lot, A et al), 353 (lot E & HTA et
al), 354 (lot, A et al);
Harris Baltimore 12/16/83: 5 (9), 6 (E & HTA, 145),
7 (E & HTA, 15), 10 (lot, A et al), 18 (lot, E
& HTA-2 et al), 20 (lot, E & HTA et al), 26
(lot, A et al);
Christies Lon 3/29/84: 23 (lot, A et al), 24 (lot,
A et al), 30 (lot, A-4, E & HTA-8, et al), 349
(album, E & HTA et al);

**ANTHONY, E.** (continued)
Swann NY 5/10/84: 195 (lot, A et al), 196 (albums,
    A et al), 321 (lot, A et al)(note);
Harris Baltimore 6/1/84: 6 (E & HTA, 60), 9 (lot,
    A-1 et al), 15 (lot, A et al), 29 (E & HTA, 11),
    32 (lot, E & HTA, 2), 79 (lot, E & HTA-1 et al),
    105 (lot, A et al), 107 (lot, A et al), 156
    (lot, A et al);
Christies Lon 6/28/84: 37a (lot, E & HTA et al);
California Galleries 7/1/84: 197 (lot, A-10 et al),
    213 (lot, E & HTA et al), 214 (lot, E & HTA-6
    et al);
Christies Lon 10/25/84: 44 (lot, A-4 et al);
Swann NY 11/8/84: 187 (album, A et al), 253 (lot,
    E & HTA et al), 264 (lot, E & HTA et al), 265
    (lot, E & HTA et al);
Harris Baltimore 11/9/84: 89 (E & HTA, 3), 90 (E &
    HTA, 7), 117 (E & HTA, attributed);
Harris Baltimore 3/15/85: 5 (E & HTA, 50), 7 (lot,
    A-1 et al), 21 (lot, A et al), 37 (lot, A-1 et
    al), 73 (lot, A et al), 76 (lot, A-5 et al), 81
    (lot, A et al), 106 (lot, A et al), 108 (lot,
    A-2 et al), 111 (lot, A-7 et al), 113 (lot, A et
    al), 161 (album, A-1 et al), 296 (lot, E & HTA-1
    et al);
Christies Lon 3/28/85: 46 (lot, A-3 et al), 49 (E &
    HTA, 23);
Swann NY 5/9/85: 372 (album, E & HTA et al)(note);
Phillips Lon 6/26/85: 136 (lot, A-6 et al), 212
    (lot, E & HTA-1 et al);
Harris Baltimore 9/27/85: 15 (lot, E & HTA-1 et
    al), 32 (E & HTA, 21);
Phillips Lon 10/30/85: 64 (lot, E & HTA-1 et al),
    130 (lot, E & HTA-1 et al);
Sothebys Lon 11/1/85: 3 (lot, E & HTA et al);
Swann NY 11/14/85: 122 (E & HTA)(note), 157 (lot,
    E & HTA et al), 165 (lot, A et al), 167 (lot,
    A et al), 168 (lot, A et al), 322 (lot, A-1 et
    al)(note);
Harris Baltimore 2/14/86: 1 (E & HTA, 12);
Phillips Lon 4/23/86: 186 (lot, A-2 et al);
Christies Lon 4/24/86: 340 (lot, A et al), 351
    (lot, A-13 et al);
Swann NY 5/15/86: 177 (lot, E & HTA et al), 304
    (lot, E & HTA et al), 306 (3 ills)(107)(note);
Christies Lon 6/26/86: 58 (lot, E & HTA et al), 155
    (lot, E & HTA-2 et al);
Phillips Lon 10/29/86: 246 (lot, A et al);
Christies Lon 10/30/86: 222 (album, A et al);
Swann NY 11/13/86: 170 (albums, A et al), 200 (lot,
    E & HTA et al), 324 (lot, E & HTA et al);

**ANTHONY, Henry T.** (American, 1813-1883)(see
    ANTHONY, Edward)

**ANTHONY, John** (British)
Photos dated: 1855-1857
Processes:      Albumen
Formats:        Prints
Subjects:       Topography
Locations:      Great Britain; Palestine - Jerusalem
Studio:         Great Britain (Photographic Club)
    Entries:
Sothebys Lon 3/21/75: 286 (album, A-1 et al);
Sothebys Lon 3/14/79: 324 (album, A-1 et al)(note);
Sothebys Lon 11/1/85: 59 (album, A-1 et al);

**ANTHONY, Mark** (British)
Photos dated: 1857
Processes:      Albumen
Formats:        Prints
Subjects:       Genre
Locations:      Great Britain
Studio:         Great Britain (Photographic Club)
    Entries:
Sothebys Lon 3/14/79: 324 ill(album, A-1 et al)
    (note);

**APOLLON**
Photos dated: between 1870s and 1890s
Processes:      Albumen
Formats:        Prints
Subjects:       Topography
Locations:      Middle East
Studio:         Europe
    Entries:
Swann NY 5/5/83: 408 (lot, A et al)(note);

**APOTHECARIES & Co.** (British)
Photos dated: Nineteenth century
Processes:      Albumen
Formats:        Prints
Subjects:       Topography
Locations:      Ceylon
Studio:         Ceylon - Colombo
    Entries:
Sothebys Lon 3/27/81: 99 (album, A et al);
Sothebys Lon 3/15/82: 106 (albums, A et al);
Harris Baltimore 12/10/82: 354 (album, A et al);
Christies Lon 3/29/84: 105 (albums, A et al);
Christies NY 9/11/84: 136 (album, A et al);
Christies Lon 10/25/84: 110 (album, A et al);
Swann NY 11/13/86: 191 (albums, A et al);

**APPELBY, W.W.**
Photos dated: c1890
Processes:      Albumen
Formats:        Cabinet cards
Subjects:       Portraits
Locations:
Studio:
    Entries:
California Galleries 7/1/84: 581 (2);

**APPERT, E.** (French)
Photos dated: c1860-1870s
Processes:      Albumen, woodburytype
Formats:        Prints, cdvs
Subjects:       Portraits incl. Galerie
                Contemporaine, documentary (Paris
                Commune)
Locations:      France - Paris
Studio:         France - Paris
    Entries:
Sothebys Lon 6/11/76: 180 (lot, A et al);
Sothebys Lon 7/1/77: 254 (lot, A-3 et al);
Swann NY 4/20/78: 323 (lot, A-2 et al);
Christies NY 5/14/81: 41 (books, A-2 et al);
Christies NY 5/26/82: 36 (book, A et al);
Christies NY 5/7/84: 19 (book, A et al);
Harris Baltimore 3/15/85: 272 (lot, A et al);

**APPLETON, D. & Co.** (American)
Photos dated: c1860-1863
Processes:      Albumen
Formats:        Cdvs, stereos
Subjects:       Portraits, topography
Locations:      US - New York
Studio:         US - New York City
  Entries:
Sothebys NY (Weissberg Coll.) 5/16/67: 172 (lot, A et al);
Sothebys NY (Greenway Coll.) 11/20/70: 83 ill;
Sothebys NY 11/21/70: 323 (lot, A et al);
Vermont Cat 2, 1971: 219;
Harris Baltimore 4/8/83: 385 (lot, A et al);
Harris Baltimore 9/16/83: 121 (lot, A et al), 163 (lot, A-1 et al);
Harris Baltimore 3/15/85: 73 (lot, A-1 attributed et al);
Swann NY 11/13/86: 200 (lot, A et al);

**APPS, E.** (British)
Photos dated: 1850s
Processes:      Daguerreotype
Formats:        Plates
Subjects:       Portraits
Locations:      Studio
Studio:         England - Leamington
  Entries:
Sothebys Lon 3/21/80: 80;

**ARCHER** (see ARGENT & ARCHER)

**ARCHER, Frederick Scott** (British, 1813-1857)
Photos dated: 1848-1857
Processes:      Albumen
Formats:        Prints
Subjects:       Topography, architecture, portraits
Locations:      England
Studio:         England
  Entries:
Swann NY 2/14/52: 27 (6)(note);
Sothebys Lon 3/19/76: 123;
Sothebys Lon 10/28/81: 197;
Sothebys Lon 6/25/82: 162 ill;
Phillips Lon 10/24/84: 160;
Christies Lon 4/24/86: 471 ill;
Phillips Lon 10/29/86: 383 ill(7), 384 (4), 385 (8);

**ARGENT & ARCHER** (British)
Photos dated: 1887
Processes:      Albumen
Formats:        Prints
Subjects:       Documentary (public events)
Locations:      Great Britain
Studio:         England - London
  Entries:
Christies Lon 3/16/78: 60 (lot, A & A-1 et al);

**ARMISTEAD, George** (American)
Photos dated: 1863
Processes:      Albumen
Formats:        Prints
Subjects:       Documentary (Civil War)
Locations:      US - Civil War area
Studio:         US
  Entries:
Harris Baltimore 6/1/84: 309;

**ARMSTEAD** (see ELLIOTT & ARMSTEAD)

**ARMSTRONG** (British)
Photos dated: 1860s
Processes:      Albumen
Formats:        Cdvs, stereos
Subjects:       Portraits, topography
Locations:      Great Britain
Studio:         Great Britain
  Entries:
Christies Lon 6/27/85: 39 (lot, A et al);
Christies Lon 10/31/85: 302 (album, A et al);
Christies Lon 10/30/86: 252 (album, A et al);

**ARMSTRONG, Lord C.B.** (British)(photographer or author?)
Photos dated: 1897
Processes:      Collotype
Formats:
Subjects:       Documentary (scientific)
Locations:
Studio:         Great Britain
  Entries:
Wood Conn Cat 49, 1982: 18 (book, 42)(note);

**ARMSTRONG, J.**
Photos dated: 1878-1891
Processes:      Albumen
Formats:        Prints
Subjects:       Topography
Locations:      South Africa
Studio:
  Entries:
Christies Lon 10/27/77: 14 (album, A-2 et al);
Christies Lon 3/16/78: 108 (lot, A-2 et al);
Christies Lon 3/24/83: 163 (books, A et al);

**ARMSTRONG, W.J.** (American)
Photos dated: 1860s and/or 1870s
Processes:      Albumen
Formats:        Stereos
Subjects:       Topography
Locations:      US
Studio:         US
  Entries:
Sothebys Lon 6/21/74: 18a (lot, A et al);

**ARNAUD** (see BERTSCH & ARNAUD)

**ARNAUDE, J.**
Photos dated: 1847
Processes:      Daguerreotype
Formats:        Plates
Subjects:       Portraits
Locations:
Studio:
   Entries:
Christies Lon 3/11/82: 1 (lot, A-1 et al);

**ARNOLD, C.D.** (American)
Photos dated: 1893
Processes:      Albumen, platinum, photogravure
Formats:        Prints
Subjects:       Documentary (public events)
Locations:      US - Chicago, Illinois
Studio:         US
   Entries:
Rinhart NY Cat 7, 1973: 407;
Wood Conn Cat 37, 1976: 257 ill;
California Galleries 4/2/76: 206 (3);
Swann NY 4/14/77: 216 (8), 54 (book, A &
   Higinbotham, 115);
California Galleries 1/21/78: 288 (23), 289 (28),
   290 (87);
Swann NY 12/14/78: 58 (book, A & Higinbotham, 115)
   (note);
California Galleries 1/21/79: 75 (book, A &
   Higinbotham, 50);
Swann NY 4/26/79: 54 (book, A & Higinbotham, 115)
   (note);
California Galleries 12/13/80: 186 (14);
Harris Baltimore 3/26/82: 357;
Swann NY 5/10/84: 169 (book, 17);
Harris Baltimore 6/1/84: 340 (5);
Harris Baltimore 2/14/86: 278 (attributed);
California Galleries 3/29/86: 633 (lot, A et al);

**ARNOLD, G.E.** (British)
Photos dated: Nineteenth century
Processes:      Albumen
Formats:        Stereos
Subjects:       Topography
Locations:      England
Studio:         Great Britain
   Entries:
California Galleries 9/27/75: 479 (lot, A et al);
California Galleries 1/23/77: 384 (lot, A et al);

**ARNOUX, Hte.**
Photos dated: 1860s-1888
Processes:      Albumen
Formats:        Prints
Subjects:       Topography, documentary (engineering)
Locations:      Egypt - Suez; Aden; Nubia
Studio:         Egypt - Port Said
   Entries:
Swann NY 2/14/52: 318 (book, 25);
Sothebys Lon 12/4/73: 18 (album, A-1 et al), 21
   (lot, A et al);
Sothebys Lon 3/8/74: 41 (album, A-8 et al);
Sothebys Lon 10/18/74: 108 (album, A et al), 109
   (lot, A et al), 110 (album, A et al);
Edwards Lon 1975: 37 (album, A et al);
Sothebys Lon 3/21/75: 74 (album, A et al), 109
   (album, A et al);
California Galleries 9/26/75: 127 (album, A et al);
Sothebys Lon 10/24/75: 102 (album, A et al);

**ARNOUX, H.** (continued)
Wood Conn Cat 37, 1976: 251 (album, A et al), 252
   (album, A et al);
Sothebys NY 5/4/76: 92 (album, A et al);
Sothebys Lon 6/11/76: 36a (album, A et al), 38
   (album, A et al);
Sothebys NY 2/9/77: 42 (lot, A-3 et al);
Christies Lon 3/15/79: 155 (albums, A et al);
Christies Lon 6/28/79: 114 (albums, A et al), 140
   (album, A et al), 148 (albums, A et al);
Christies Lon 10/25/79: 192 (album, A-4 et al), 236
   (lot, A-1 et al), 240 (lot, A-1 et al), 242
   (lot, A-1 et al), 254 (album, A-2 et al);
Sothebys NY 11/2/79: 259 (album, A et al);
Sothebys LA 2/6/80: 176 (lot, A-3 et al);
Christies Lon 3/20/80: 207 (album, A et al);
Christies NY 5/16/80: 204A (3), 221 (lot, A et al);
Christies Lon 6/26/80: 227 ill(lot, A-4 et al);
Christies Lon 10/30/80: 221 (album, A-1 et al), 267
   (lot, A-7 et al);
Christies Lon 3/26/81: 268 (lot, A et al);
Swann NY 4/23/81: 507 (lot, A-1 et al), 546 (album,
   A et al);
California Galleries 6/28/81: 280 (lot, A et al);
Christies Lon 10/29/81: 219 (albums, A et al), 221
   (album, A et al), 276 (albums, A-3 et al), 277
   (album, A et al);
Phillips Lon 3/17/82: 43 (albums, A-1 et al);
Phillips Lon 6/23/82: 38 (lot, A et al);
Christies Lon 6/24/82: 171 (album, A-6 et al), 172
   (album, A et al), 231 (lot, A et al);
Phillips NY 9/30/82: 968 (album, A-13 et al);
Phillips Lon 10/27/82: 39 (lot, A-7 et al);
Christies Lon 3/24/83: 136 (albums, A et al), 138
   (album, A et al);
California Galleries 6/19/83: 330 (lot, A et al);
Christies Lon 10/27/83: 154 (album, A-1 et al);
Swann NY 11/10/83: 305 (lot, A et al);
Sothebys Lon 12/9/83: 161 (lot, A-8 et al);
Christies Lon 3/29/84: 65 (album, A et al), 100
   (albums, A et al);
Swann NY 5/10/84: 277 (lot, A et al);
Christies Lon 6/28/84: 139 (album, A-17 et al), 327
   (album, A et al);
Christies Lon 10/25/84: 104 (album, A et al);
Swann NY 11/8/84: 195 (album, A et al)(note), 214
   (album, A et al), 283 (lot, A et al);
Sothebys Lon 3/29/85: 77 ill(albums, A et al);
Christies Lon 6/27/85: 70 (lot, A et al), 82
   (album, A et al), 92 (lot, A et al);
Christies Lon 10/31/85: 96 (albums, A-4 et al), 98
   (albums, A-8 et al), 124 (lot, A-1 et al), 129
   (albums, A et al), 131 (albums, A et al), 139
   (album, A-13 et al);
Swann NY 11/14/85: 131 (lot, A et al);
Harris Baltimore 2/14/86: 291, 292, 294, 295;
Christies Lon 4/24/86: 386 (album, A-3 et al), 409
   (albums, A-3 et al);
Christies Lon 6/26/86: 118 (albums, A et al), 154
   (album, A et al);
Christies Lon 10/30/86: 127 (album, A et al), 134
   (album, A-10 et al), 176 (album, A et al);
Sothebys Lon 10/31/86: 13 (albums, A et al);
Swann NY 11/13/86: 212 (lot, A et al), 239 (lot,
   A et al);

ARSENE
Photos dated: 1868
Processes:     Albumen
Formats:       Cdvs
Subjects:      Portraits
Locations:     England - Guernsey
Studio:        England - Guernsey
    Entries:
Sothebys NY (Greenway Coll.) 11/20/70: 37 ill;

ARTARIA, Fernandino (Italian)
Photos dated: 1850
Processes:     Daguerreotype
Formats:       Plates
Subjects:      Portraits, topography
Locations:     Italy
Studio:        Switzerland - Geneva; Italy - Milan
    Entries:
Christies Lon 3/24/83: 6;

ASH, Edwin
Photos dated: 1850s
Processes:     Daguerreotype
Formats:       Plates
Subjects:      Portraits
Locations:
Studio:
    Entries:
Christies Lon 6/28/84: 10 (lot, A-1 et al);

ASHE, Commander (photographer or author?)
Photos dated: 1869
Processes:     Albumen
Formats:       Prints
Subjects:      Documentary (expeditions)
Locations:     US
Studio:
    Entries:
Swann NY 2/14/52: 357 (book, 7)(note);

ASHFORD Brothers
Photos dated: c1864
Processes:     Albumen
Formats:       Cdvs
Subjects:      Portraits, genre
Locations:     Studio
Studio:        England - London
    Entries:
Sothebys NY (Strober Coll.) 2/7/70: 265 (lot,
    A-2 et al);
Christies Lon 6/10/76: 152 (album, A et al);

ASPLAND, T.L. (British)
Photos dated: 1868
Processes:     Albumen
Formats:       Prints
Subjects:      Topography
Locations:     England - Lake District
Studio:        Great Britain
    Entries:
Christies Lon 10/4/73: 96 (book, A et al);

ASPLET & GREEN (British)
Photos dated: c1870s
Processes:     Albumen
Formats:       Prints
Subjects:      Topography
Locations:     England - Jersey
Studio:        England - Jersey
    Entries:
Christies Lon 4/24/86: 374 (5);

ATHERTON, F.D. (American)
Photos dated: 1875
Processes:     Albumen
Formats:       Prints
Subjects:      Topography
Locations:     US - San Diego, California
Studio:        US
    Entries:
Rinhart NY Cat 7, 1973: 86 (book, A et al);

ATKINS, Anna (British)
Photos dated: 1843-1854
Processes:     Cyanotype
Formats:       Prints
Subjects:      Photogenic drawings
Locations:     Great Britain
Studio:        Great Britain
    Entries:
Sothebys NY 11/21/70: 87 ill (book, 12)(note);
Sothebys Lon 10/28/81: 220 ill(album, 160)(note);
Rose Florida Cat 7, 1982: 17 ill(note), 18 ill;
Swann NY 4/1/82: 254 ill(note);
Sothebys Lon 10/29/82: 60 ill, 61 ill(note);
Christies NY 2/8/83: 3 ill(2);
Christies Lon 3/24/83: 61;
Kraus NY Cat 1, 1984: 28 ill(note), 29 ill, 30 ill
    (note), 31 ill(note), 32 ill;
Christies Lon 3/29/84: 131 (3);
Christies Lon 6/28/84: 174 (6);
Drouot Paris 11/24/84: 96 ill;
Sothebys Lon 3/29/85: 125 (2 ills)(211)(note);
Christies NY 5/6/85: 36 ill(note);
Sothebys NY 5/7/85: 372 ill;
Sothebys Lon 6/28/85: 106 ill;
Christies NY 11/11/85: 83 ill(note), 84 ill;
Christies NY 5/13/86: 21 ill;

ATKINS, Ringrose
Photos dated: 1894-1896
Processes:     Glass diapositives
Formats:       Stereo plates
Subjects:      Topography
Locations:     Italy; Germany; Russia
Studio:
    Entries:
Christies Lon 6/27/85: 48 (lot, A-130 et al);
Christies Lon 6/26/86: 75 (lot, A et al);

ATTEBURY, Anna (British)
Photos dated: 1863
Processes:      Albumen
Formats:        Prints
Subjects:       Portraits
Locations:      Studio
Studio:         England - London
    Entries:
Christies Lon 6/10/76: 142;

ATTENHOFER
Photos dated: 1870s
Processes:      Albumen
Formats:        Cdvs
Subjects:       Ethnography
Locations:      Switzerland
Studio:         Europe
    Entries:
Harris Baltimore 6/1/84: 341 (lot, A et al);

AUBERT, François (French, 1839-1900)
Photos dated: 1865-1867
Processes:      Albumen
Formats:        Prints
Subjects:       Topography, documentary
Locations:      Mexico
Studio:
    Entries:
Christies NY 11/8/82: 21 ill(note);
Christies NY 5/9/83: 21 ill(note);
Sothebys Lon 6/24/83: 62 (2 ills)(12)(note);
Christies NY 11/8/83: 31 ill(note);
Christies NY 5/7/84: 15 ill(note);
Christies Lon 10/30/86: 130 (lot, A-1 et al);

AUBRY, Charles (French)
Photos dated: 1864-late 1860s
Processes:      Albumen
Formats:        Prints
Subjects:       Genre (still life)
Location:       Studio
Studio:         France - Paris
    Entries:
Rauch Geneva 6/13/61: 157 (lot, A-1 et al);
Lunn DC Cat QP, 1978: 27 ill;
Sothebys NY 5/2/78: 98 ill, 99, 100 ill;
Phillips NY 11/4/78: 59 ill;
Phillips Lon 3/13/79: 132 ill;
Christies NY 5/4/79: 48 ill(note);
Sothebys NY 5/8/79: 90 ill(attributed);
Sothebys Lon 10/29/80: 273 ill, 274 ill;
Sothebys NY 5/15/81: 100 ill;
Christies NY 11/10/81: 30 ill;
Sothebys Lon 3/15/82: 357 ill(6), 358 ill(5);
Phillips NY 5/22/82: 653 (2);
Swann NY 11/18/82: 327, 328 ill;
Swann NY 5/5/83: 274;
Christies NY 11/11/85: 85 ill;
Sothebys Lon 4/25/86: 194 ill;

AUCHINCLOSS, William S. (American)
Photos dated: 1874
Processes:      Albumen
Formats:        Prints
Subjects:       Topography
Locations:      Brazil
Studio:         US
    Entries:
Rinhart NY Cat 2, 1971: 63 (book, 9);
Witkin NY IV 1976: OP83 (book, 9);
California Galleries 4/2/76: 136 (book, 9);

AUDSLEY, George Ashdown (British)
Photos dated: 1872
Processes:      Albumen
Formats:        Prints
Subjects:       Documentary (art)
Locations:
Studio:
    Entries:
Witkin NY IX 1979: 2-6 (book, 41);

AUER, Alois (Austrian)
Photos dated: 1853
Processes:      Color electrotype
Formats:        Prints
Subjects:       Documentary (botany)
Locations:      Austria
Studio:         Austria
    Entries:
Swann NY 11/13/86: 137 (5)(note);

AUFIERE (see ROYER & AUFIERE)

AUSTIN (American) [AUSTIN 1]
Photos dated: 1880s
Processes:      Albumen
Formats:        Cabinet cards, cdvs
Subjects:       Portraits
Locations:      US - New Hampshire
Studio:         US - Nashua, New Hampshire
    Entries:
Swann NY 11/8/84: 225 (album, A et al)(note);

AUSTIN, Captain (British) [AUSTIN 2]
Photos dated: 1861
Processes:      Albumen
Formats:        Prints
Subjects:       Architecture
Locations:      England - Canterbury
Studio:         Great Britain
    Entries:
Christies Lon 3/29/84: 185;

AUSTIN, Elizabeth Alice (American, 1866-1952)
Photos dated: 1890s-1920s
Processes:      Photogravure
Formats:        Prints
Subjects:       Topography, genre
Locations:      US - New York City; England; France;
                Germany
Studio:         US - New York City
    Entries:
Phillips NY 5/21/80: 296 ill (12);

**AUTRY**
Photos dated: 1890s
Processes:     Albumen
Formats:       Prints
Subjects:      Topography
Locations:     Europe
Studio:        Europe
    Entries:
Harris Baltimore 12/10/82: 391 (albums, A et al);
Harris Baltimore 2/14/86: 210 (albums, A et al);

**AVANZO, B.**
Photos dated: 1870s
Processes:     Albumen
Formats:       Prints, cdvs
Subjects:      Genre
Locations:     Russia
Studio:        Russia - Moscow and St. Petersburg
    Entries:
Swann NY 11/5/81: 542 ill(5)(note), 543 (book, 18);

**AVERILL, H.K., Jr.** (American)
Photos dated: 1870s
Processes:     Albumen
Formats:       Stereos
Subjects:      Topography
Locations:     US - New York State
Studio:        US - Plattsburg, New York
    Entries:
California Galleries 4/3/76: 414 (lot, A et al);

**AYER, E.** (American)
Photos dated: Nineteenth century
Processes:     Albumen
Formats:       Stereos
Subjects:      Documentary (disasters)
Locations:     US
Studio:        US - Norwich, Connecticut
    Entries:
Vermont Cat 11/12, 1977: 757;

**AYERS, Thomas** (British)
Photos dated: 1860s-1880s
Processes:     Albumen
Formats:       Cdvs, prints
Subjects:      Portraits, topography
Locations:     England - Suffolk; Norfolk
Studio:        Great Britain
    Entries:
Rinhart NY Cat 6, 1973: 256;
Christies Lon 6/30/77: 81 (28);
Christies Lon 10/27/77: 66 (28);

**AYLING, Stephen** (British)
Photos dated: 1864-1866
Processes:     Albumen
Formats:       Prints
Subjects:      Portraits, genre (art)
Locations:     Studio
Studio:        England - London
    Entries:
Weil Lon Cat 7, 1945: 153 (book, A et al);
Christies Lon 10/4/73: 100 (books, A et al);
Edwards Lon 1975: 125 (book, A et al);
Sothebys Lon 3/19/76: 39 (lot, A-1 et al);

**AYLSWORTH, J.H.** (American)
Photos dated: 1870s
Processes:     Albumen
Formats:       Stereos
Subjects:      Topography
Locations:     US - Apponaug, Rhode Island
Studio:        US
    Entries:
Harris Baltimore 3/15/85: 86 (lot, A-9 et al);

**AYNTON, A.**
Photos dated: 1860s and/or 1870s
Processes:     Albumen
Formats:       Steros
Subjects:      Topography
Locations:     Ireland
Studio:        Europe
    Entries:
Christies Lon 6/28/80: 106 (lot, A-5 et al);

**AYOLA, José Garcia** (Spanish)
Photos dated: c1875-1900
Processes:     Albumen
Formats:       Prints
Subjects:      Topography
Locations:     Spain - Granada
Studio:        Spain - Granada
    Entries:
Fraenkel Cal 1984: 29 ill(note);

**B., A.** [A.B.] [B., A. 1]
Photos dated: 1860s
Processes:      Albumen
Formats:        Stereos (tissue)
Subjects:       Genre
Locations:      France
Studio:         France
    Entries:
Christies Lon 10/30/80: 108 (lot, B-1 et al);
Christies Lon 10/30/86: 28 (lot, B et al);

**B., A.** [A.B.] [B., A. 2]
Photos dated: Nineteenth century
Processes:      Albumen
Formats:        Prints
Subjects:       Topography
Locations:      Scotland
Studio:         Great Britain
    Entries:
California Galleries 9/26/75: 131 (album, B et al);
California Galleries 4/2/76: 151 (album, B et al);
California Galleries 1/22/77: 167 (album, B et al);

**B., A.W. & Co.** [A.W.B. & Co.]
Photos dated: 1880s
Processes:      Albumen
Formats:        Prints
Subjects:       Topography
Locations:      Argentina - Buenos Aires
Studio:         Argentina - Buenos Aires
    Entries:
Christies Lon 3/16/78: 151 (album, B et al);

**B., C.** [C.B.] (British)
Photos dated: 1860s
Processes:      Albumen
Formats:        Prints
Subjects:
Locations:
Studio:         Great Britain (Amateur Photographic
                Association)
    Entries:
Christies Lon 10/27/83: 218 (lot, B et al);

**B., D.** [D.B.] (French)
Photos dated: Nineteenth century
Processes:      Albumen
Formats:        Stereos (tissue)
Subjects:       Genre
Locations:      Studio
Studio:         France
    Entries:
California Galleries 9/27/75: 543 (lot, B et al);

**B., G.** [G.B.] (British)
Photos dated: 1860s
Processes:      Albumen
Formats:        Prints
Subjects:       Portraits, topography, genre
                (domestic)
Locations:      Great Britain
Studio:         Great Britain
    Entries:
Christies Lon 3/26/81: 378 ill(album, B-3 et al);
Christies Lon 6/24/82: 96 (lot, B-1 et al);

**B., J.** [J.B.]
Photos dated: 1880s
Processes:      Albumen
Formats:        Prints
Subjects:       Topography
Locations:
Studio:
    Entries:
Christies Lon 10/31/85: 132 (albums, B et al);

**B., L.** [L.B.] (French)
Photos dated: 1860s-1870s
Processes:      Albumen
Formats:        Stereos incl. tissues
Subjects:       Genre
Locations:      France
Studio:         France
    Entries:
Christies Lon 10/29/81: 158 (lot, B et al);
Harris Baltimore 4/8/83: 103 (lot, B et al);
Harris Baltimore 2/14/86: 50 (lot, B-2 et al);
Christies Lon 10/30/86: 28 (lot, B et al);

**B, N** [NB] (see BLANC)

**B., P.** [P.B.] (British)
Photos dated: Nineteenth century
Processes:      Albumen
Formats:        Stereos
Subjects:       Topography
Locations:      Great Britain
Studio:         Great Britain
    Entries:
Christies Lon 10/25/84: 47 (lot, B-12 et al);

**B., R.B.** [R.B.B.] (British)
Photos dated: 1863
Processes:      Albumen
Formats:        Prints
Subjects:       Genre (public events)
Locations:      England - Hereford
Studio:         England
    Entries:
Christies Lon 3/28/85: 165 (lot, B et al)(note);

**B., W.** [W.B.]
Photos dated: 1890s
Processes:      Albumen
Formats:        Prints
Subjects:       Topography
Locations:      Australia or New Zealand
Studio:
    Entries:
Christies Lon 3/28/85: 77 (lot, B et al);
Christies Lon 10/31/85: 116 (lot, B et al);

**BABAYEVA Studio** (Russian)
Photos dated: 1893
Processes:      Albumen with collage
Formats:        Prints
Subjects:       Documentary (art)
Locations:      Russia
Studio:         Russia - Foedosiya
    Entries:
Sothebys NY 5/2/78: 119 ill(note);

**BABBITT, Platt D.** (American)
Photos dated: 1853-c1870
Processes:  Daguerreotype, ambrotype, albumen
Formats:    Plates, prints
Subjects:   Documentary
Locations:  US - Niagara Falls, New York
Studio:     US - Niagara Falls, New York
  Entries:
Sothebys NY (Weissberg Coll.) 5/16/67: 198 (lot, B-5 et al);
Sothebys NY (Strober Coll.) 2/7/70: 438 (lot, B et al), 440 (lot, B, B & Tugby, et al);
Rinhart NY Cat 2, 1971: 483 (5)(note);
Vermont Cat 4, 1972: 585 ill;
Rinhart NY Cat 7, 1973: 346;
Vermont Cat 6, 1973: 605 ill(attributed), 606 ill (attributed);
Sothebys Lon 6/21/74: 26 ill (lot, B-5, B & Tugby-1, et al);
Anderson & Hershkowitz Lon 1976: 2 ill;
Sothebys Lon 10/29/76: 24 (lot, B et al);
Sothebys NY 11/9/76: 13 (lot, B-1 et al);
Sothebys Lon 11/18/77: 163 ill;
Sothebys Lon 3/22/78: 151 ill;
Sothebys Lon 10/27/78: 6 ill;
Christies NY 5/4/79: 72 (attributed)(note);
Sothebys Lon 3/21/80: 29 ill(note);
Christies NY 5/16/80: 229 ill(note);
Sothebys Lon 10/29/80: 139 ill(note);
Sothebys LA 2/4/81: 21 ill(attributed)(note);
Christies Lon 3/26/81: 79 ill, 138 (13);
Christies NY 5/14/81: 44 ill(note);
Christies Lon 6/18/81: 117 (lot, B-1 plus 11 attributed);
Christies NY 11/10/81: 42 ill(note);
Sothebys Lon 3/15/82: 39 (11);
Harris Baltimore 3/26/82: 179 ill;
Harris Baltimore 12/10/82: 70 (9), 71 (B & Tugby, 6);
Swann NY 5/5/83: 435 (B, B & Tugby, 9);
Sothebys Lon 6/24/83: 16 ill;
Harris Baltimore 9/16/83: 159;
Sothebys NY 5/8/84: 40 ill(note);
Swann NY 5/10/84: 308 (B, B & Tugby, 6)(note);
Sothebys Lon 6/29/84: 40 ill;
Sothebys Lon 3/25/85: 58 ill(note);
Phillips Lon 6/26/85: 35 (lot, B et al);
Swann NY 11/13/86: 328 (lot, B-5 et al);

**BACH** (Russian)
Photos dated: 1869
Processes:  Albumen
Formats:    Prints
Subjects:   Ethnography
Location:   Russia - Samara
Studio:     Russia - Samara
  Entries:
Sothebys NY 11/2/79: 211 ill(album, 23)(note);

**BACHELTER** (American)
Photos dated: 1846
Processes:  Daguerreotype
Formats:    Plates
Subjects:   Portraits
Locations:  Studio
Studio:     US - Salem, Massachusetts
  Entries:
Vermont Cat 7, 1974: 492 ill;

**BACHRACH, David, Jr.** (American, 1848-1921)
Photos dated: 1868-1880s
Processes:  Albumen
Formats:    Prints, stereos
Subjects:   Portraits
Locations:  US - Annapolis, Maryland
Studio:     US - Baltimore, Maryland; Washington, D.C.
  Entries:
Swann NY 11/10/83: 334;

**BACKHOUSE, Arthur** (British)
Photos dated: 1853-1857
Processes:  Salt, albumen
Formats:    Prints
Subjects:   Architecture
Locations:  Italy - Pisa, Venice; France - Nice
Studio:
  Entries:
Sothebys Lon 3/14/79: 162 (5);
Sothebys Lon 10/24/79: 330 (Thomas, Elizabeth & AB, 6);
Sothebys Lon 6/27/80: 90 ill;
Sothebys Lon 3/27/81: 367 ill(note), 368;
Christies Lon 10/31/85: 178 ill;

**BACKHOUSE, Thomas & Elizabeth** (see BACKHOUSE, Arthur)

**BACKOFEN**
Photos dated: 1860s
Processes:  Albumen
Formats:    Cdvs
Subjects:   Portraits
Locations:  Studio
Studio:     Europe
  Entries:
Harris Baltimore 3/15/85: 161 (album, B-1 et al);

**BACON** (see GILBERT & BACON) [BACON 1]

**BACON** (American) [BACON 2]
Photos dated: 1850s
Processes:  Ambrotype
Formats:    Plates
Subjects:   Portraits
Locations:  Studio
Studio:     US
  Entries:
Vermont Cat 6, 1973: 592 ill, 593 ill, 594 ill;

**BACON, W.P.** (American)
Photos dated: c1870s
Processes:  Albumen
Formats:    Stereos
Subjects:   Topography
Locations:  US - Utica, New York
Studio:     US
  Entries:
Rinhart NY Cat 1, 1971: 288 (2);
California Galleries 4/3/76: 430 (lot, B et al);
California Galleries 1/21/78: 184 (lot, B et al);

**BADEN-PRITCHARD, Henry**
Photos dated: 1886-1888
Processes:      Woodburytype
Formats:        Prints
Subjects:       Documentary (scientific)
Locations:
Studio:
    Entries:
Christies NY 5/14/80: 111 (4 ills)(book, B et al);

**BAER, Erwin** (American)
Photos dated: c1890
Processes:      Albumen
Formats:        Prints
Subjects:       Documentary (industrial)
Locations:      US - Arizona
Studio:         US
    Entries:
California Galleries 7/1/84: 266 (2);

**BAER, M.B.**
Photos dated: 1870s
Processes:      Albumen
Formats:        Cdvs
Subjects:
Locations:      Roumania
Studio:         Roumania - Bucharest
    Entries:
Swann NY 5/9/85: 425 (album, B et al)(note);

**BAERENDT**
Photos dated: Nineteenth century
Processes:      Albumen
Formats:        Prints
Subjects:       Topography
Locations:      Austria (?)
Studio:         Europe
    Entries:
Christies NY 5/16/80: 202 (albums, B et al);

**BAGG, E.N.** (American)
Photos dated: Nineteenth century
Processes:      Albumen
Formats:        Stereos
Subjects:       Topography
Locations:      US - Virginia
Studio:         US - Natural Bridge, Virginia
    Entries:
California Galleries 9/27/75: 571 (lot, B-1 et al);
California Galleries 1/23/77: 444 (lot, B et al);

**BAGLEY** (see PAYNE & BAGLEY)

**BAGLEY, J.M.** (American)
Photos dated: c1885-1890s
Processes:      Albumen
Formats:        Prints, boudoir card
Subjects:       Topography
Locations:      US - Pike's Peak, Colorado
Studio:         US
    Entries:
California Galleries 1/21/78: 279 (album, B et al);
Swann NY 12/14/78: 424 (lot, B-1 et al);

**BAILEY & ALLON**
Photos dated: 1860s
Processes:      Albumen
Formats:        Prints
Subjects:       Topography
Locations:      Australia
Studio:         Australia
    Entries:
Sothebys Lon 5/24/73: 5 (albums, B & A-20 et al);
Sothebys Lon 6/28/78: 125 (albums, B & A-20 et al);

**BAILEY, Captain N.** (British)
Photos dated: late 1850s-1860s
Processes:      Albumen
Formats:        Prints
Subjects:       Genre (still life)
Locations:
Studio:         England (Amateur Photographic
                Association)
    Entries:
Christies Lon 10/27/83: 218 (albums, B-1 et al);
Christies Lon 6/27/85: 156 ill;

**BAILEY Brothers** (S. and/or C.S.)(aka BAILY)
Photos dated: 1880s-1890s
Processes:      Albumen
Formats:        Prints
Subjects:       Topography
Locations:      Canada
Studio:         Canada - Vancouver
    Entries:
Swann NY 2/14/52: 75 (albums, SB et al);
Edwards Lon 1975: 35 (album, B et al);
Sothebys Lon 3/21/75: 84 (albums, CSB et al);
Christies Lon 6/30/77: 134 (album, B et al);
Swann NY 12/14/78: 343 (album, B et al);
Phillips Can 10/4/79: 56 (lot, B-2 et al);
Christies Lon 10/25/79: 225 (lot, B-6 et al);
Christies Lon 10/30/86: 150 (album, CSB-3 et al);

**BAILY & NEEDLANDS** (Canadian)
Photos dated: 1880s-1890s
Processes:      Albumen
Formats:        Prints
Subjects:       Topography
Locations:      Canada - Vancouver
Studio:         Canada
    Entries:
Christies Lon 10/26/78: 184 (album, B & N et al);
Phillips Can 10/4/79: 57 (lot, B & N-6 et al);
Christies Lon 3/11/82: 225 (lot, B & N et al);

**BAILY, H.H.**
Photos dated: c1880
Processes:      Albumen
Formats:        Prints
Subjects:       Topography
Locations:      Australia - Hobart
Studio:         Australia - Hobart
    Entries:
Christies Lon 3/16/78: 107 (album, B-3 et al);

BAINBRIDGE
Photos dated: c1875
Processes:    Albumen
Formats:     Cdvs
Subjects:    Portraits
Locations:
Studio:
    Entries:
California Galleries 1/22/77: 128 (lot, B et al);

BAIRD & GIBBON (American)
Photos dated: c1875
Processes:    Tintype
Formats:     Plates
Subjects:    Portraits
Locations:   US - Middletown, New York
Studio:      US - New York
    Entries:
California Galleries 6/8/85: 463;

BAKER (British) [BAKER 1]
Photos dated: 1850s-1857
Processes:    Daguerreotype
Formats:     Plates incl. stereo
Subjects:    Portraits
Locations:   Studio
Studio:      Great Britain
    Entries:
Sothebys Lon 10/29/80: 24, 24a ill;
Christies Lon 6/18/81: 15;

BAKER [BAKER 2]
Photos dated: Nineteenth century
Processes:    Albumen
Formats:     Cabinet cards
Subjects:    Portraits
Locations:
Studio:
    Entries:
Vermont Cat 2, 1971: 248 (lot, B-1 et al);
Harris Baltimore 4/8/83: 382 (lot, B et al);

BAKER & FARQUHAR [BAKER 3]
Photos dated: 1870s
Processes:    Silver
Formats:     Prints
Subjects:    Topography
Locations:   Australia - Melbourne
Studio:
    Entries:
Sothebys Lon 6/27/80: 123 ill(album, 12);

BAKER & RECORD (American) [BAKER 4]
Photos dated: Nineteenth century
Processes:    Albumen
Formats:     Stereos
Subjects:    Topography
Locations:   US - Saratoga Springs, New York
Studio:      US
    Entries:
Rinhart NY Cat 6, 1973: 567;
Harris Baltimore 4/8/83: 67 (lot, B & R et al);
Harris Baltimore 12/16/83: 117 (lot, B & R et al);
Harris Baltimore 3/15/85: 88 (lot, B & R-7 et al);

BAKER, A.E. (American)
Photos dated: 1850s
Processes:    Ambrotype
Formats:     Plates
Subjects:    Portraits
Locations:   Studio
Studio:      US - Haverhill, Massachusetts
    Entries:
Vermont Cat 6, 1973: 595 ill;

BAKER, G.A.
Photos dated: 1860s
Processes:    Albumen
Formats:     Cdvs
Subjects:    Genre
Locations:
Studio:
    Entries:
Sothebys Lon 3/21/80: 374 (7);

BAKER, Leander (American)
Photos dated: Nineteenth century
Processes:    Albumen
Formats:     Stereos
Subjects:    Topography
Locations:   US - Providence, Rhode Island
Studio:      US
    Entries:
Harris Baltimore 3/15/85: 11 (lot, B et al), 86
    (lot, B-15 et al);

BAKER, W. (British)(see also BURKE, J.)
Photos dated: c1870-late 1870s
Processes:    Daguerreotype, ambrotype, albumen
Formats:     Plates, prints, cdvs, cabinet cards
Subjects:    Topography, portraits
Locations:   India; Afghanistan
Studio:      India - Calcutta
    Entries:
Sothebys Lon 10/18/74: 79 (album, B et al);
Sothebys Lon 6/26/75: 130 (album, B-2, B & Burke-2,
    et al);
California Galleries 4/2/76: 153 (album, B et al);
Sothebys Lon 6/11/76: 36b (album, B-2, B & Burke-6,
    et al);
Sothebys NY 10/4/77: 145 (album, B-1 et al);
Christies Lon 10/27/77: 144 (album, B-3, B &
    Burke-2, et al);
Sothebys Lon 6/28/78: 116 (albums, B & Burke et al);
Sothebys Lon 10/24/79: 106 (album, B, B & Burke,
    et al);
Sothebys Lon 3/21/80: 108 (lot, B et al);
Christies Lon 6/26/80: 223 (lot, B-2 et al);
Christies Lon 10/30/80: 239 (lot, B-1 attributed et
    al), 243 (lot, B-1 et al), 265 (lot, B-6 et al);
Koch Cal 1981-82: 22 ill(note), 23 ill;
Christies Lon 3/26/81: 229 (album, B-2, B &
    Burke-7, et al), 279 (album, B & Burke-3, et
    al), 399 (albums, B-1, B & Burke-1, et al);
Sothebys Lon 3/27/81: 92 (album, B, B & Burke,
    et al);
Sothebys Lon 6/17/81: 234 (album, B et al);
Christies Lon 10/29/81: 238 (album, B-7 et al), 263
    (albums, B-5 et al);
Christies Lon 3/11/82: 179 (album, B et al);
Christies Lon 6/24/82: 197 (lot, B et al), 200
    (lot, B-1, B & Burke-2, et al), 225 (album, B-5,
    B & Burke-1, et al);

**BAKER, W.** (continued)
Swann NY 11/18/82: 401 (lot, B-1 et al);
Sothebys Lon 3/25/83: 57;
Christies Lon 6/23/83: 137 (lot, B attributed et
al), 138 (3, attributed), 173 (lot, B et al);
Sothebys Lon 12/9/83: 37 (album, B et al);
Christies Lon 3/29/84: 70 (B & Burke attributed,
3), 91 (lot, B et al);
Christies Lon 6/28/84: 93 (lot, B & Burke et al);
Christies NY 2/13/85: 120 (album, B & Burke et al);
Sothebys Lon 3/29/85: 43 ill;
Swann NY 5/9/85: 402 (lot, B-1 et al)(note);
Christies Lon 6/27/85: 83 (lot, B et al);
Christies Lon 10/31/85: 130 ill(lot, B attributed
et al);
Swann NY 11/14/85: 188 (album, B et al);
Phillips Lon 4/23/86: 209 (lot, B-1 et al), 224
(lot, B-1 et al) 264 (album, B et al);
Christies Lon 4/24/86: 404 (album, B-5 et al), 406
(album, B & Burke-2, et al);
Phillips Lon 10/29/86: 296 (album, B-1 et al);
Harris Baltimore 11/7/86: 272 (album, B-19, B &
Burke-9, et al);

**BAKER, W.H.** (American)
Photos dated: 1880s
Processes:      Albumen
Formats:
Subjects:       Portraits
Locations:      US - Mount McGregor, New York
Studio:         US - Saratoga, New York
  Entries:
Anderson NY (Gilsey Coll.) 2/24/03: 1152;

**BAKER, William J.** (American)
Photos dated: 1863-1881
Processes:      Albumen, heliogravure
Formats:        Cdvs, stereos, prints
Subjects:       Portraits
Locations:      Studio
Studio:         US - Utica and Buffalo, New York
  Entries:
Vermont Cat 4, 1972: 466 ill;
Rinhart NY Cat 6, 1973: 51 (book, 1);
Harris Baltimore 3/26/82: 8 (lot, B et al);
Harris Baltimore 11/9/84: 131 ill(note);

**BAKER, William Robert** (British, 1810-1896)
Photos dated: early 1850s
Processes:      Waxed paper negative
Formats:        Paper negatives
Subjects:       Topography
Locations:      England; Germany
Studio:         England
  Entries:
Christies Lon 10/31/85: 176 ill(10);

**BALCH, E.** (American)
Photos dated: 1840s-1850s
Processes:      Daguerreotype, ambrotype
Formats:        Plates
Subjects:       Portraits
Locations:      Studio
Studio:         US - New York City
  Entries:
Sothebys Lon 10/29/76: 186;
Swann NY 4/14/77: 230 (lot, B et al);
Swann NY 11/8/84: 180 (lot, B et al);

**BALCH, H.A.** (American)
Photos dated: 1860s-1870s
Processes:      Albumen
Formats:        Cdvs, stereos
Subjects:       Portraits
Locations:      Studio
Studio:         US - Memphis, Tennessee
  Entries:
Swann NY 10/18/79: 304 (lot, B et al);

**BALDI & WURTHLE** (Austrian)
Photos dated: 1860s
Processes:      Albumen
Formats:        Prints, stereos
Subjects:       Topography
Locations:      Austria - Salzburg
Studio:         Austria - Salzburg
  Entries:
Rose Boston Cat 4, 1979: 56 ill(note), 57 ill;
Christies NY 2/13/85: 133 (lot, B & W-1 et al);
Christies Lon 4/24/86: 344 (lot, B & W et al);

**BALDUS, Edouard-Denis** (French, 1815-1882)
Photos dated: 1849-1882
Processes:      Salt, albumen, heliogravure
Formats:        Prints incl. panoramas, stereos
Subjects:       Architecture, topography
Locations:      France - Paris et al
Studio:         France - Paris
  Entries:
Maggs Paris 1939: 437 ill(note), 438 (note), 439
(note), 440 (note);
Weil Lon Cat 4, 1944(?): 178 (35)(note), 179
(album, 30)(note);
Weil Lon Cat 7, 1945: 94 (note);
Andrieux Paris 1951(?): 3 (4), 7 (album, B
attributed, et al);
Andrieux Paris 1952(?): 691 (4);
Swann NY 2/14/52: 111 (book, 34), 115 (lot,
B et al);
Rauch Geneva 6/13/61: 74 (note), 75 (note), 76, 77
(6)(note), 78 (note), 79 (2), 80 (2)(note), 81
(2), 82 (2)(note), 83 ill(album, 69), 84 (33)
(note), 85 (46)(note), 86 (8)(note), 87 (4)
(note), 207 (10);
Witkin NY II 1974: 1222 (3 ills)(album, 32);
Sothebys NY 2/25/75: 142, 143;
Sothebys Lon 10/24/75: 137 ill(lot, B-21 et al), 260
ill(album, B-1 et al)(note);
Colnaghi Lon 1976: 93 ill(note), 94 ill, 95 (note),
96 (note);
Kingston Boston 1976: 5 (note), 6 ill, 7 ill, 8 ill,
9 ill, 10 ill, 11, 12, 13, 14;
Lunn DC Cat 6, 1976: 17.1 ill(note), 17.2 ill, 17.3,
17.4 ill, 17.5, 18 ill(note), 19, 20, 21 ill;
Wood Conn Cat 37, 1976: 250 (5 ills)(10);

## BALDUS (continued)

Christies Lon 10/28/76: 103 ill(note), 104;
Gordon NY 11/13/76: 41 ill;
White LA 1977: 12 ill(note), 13 ill, 14 ill, 15 ill, 16 ill, 17 ill;
Sothebys NY 2/9/77: 14, 15 ill, 16;
Gordon NY 5/10/77: 781 ill(attributed), 782 ill (note), 783 ill, 784 ill, 785 ill(note), 786 ill(attributed);
Sothebys NY 5/20/77: 92, 93 ill(note);
Christies Lon 6/30/77: 278 ill(note), 279 ill, 280 ill;
Sothebys Lon 7/1/77: 274 (2), 275 (4);
Sothebys NY 10/4/77: 198 ill, 199 ill;
Christies Lon 10/27/77: 83 ill;
Sothebys Lon 11/18/77: 240 ill;
Lehr NY Vol 1:2, 1978: 2 ill;
Lunn DC Cat QP, 1978: 14 ill(note);
Weston Cal 1978: 135 ill, 136 ill, 137 ill;
Wood Conn Cat 41, 1978: 3 ill(note), 4 ill, 5 ill, 6 ill, 7, 8 (book, 100);
Sothebys LA 2/13/78: 120 (2), 121 (books, B et al) (note);
Christies Lon 3/16/78: 69 ill, 70 (album, B-1 plus 1 attributed, et al);
Sothebys Lon 3/22/78: 63 (album, B-1 et al)(note);
Swann NY 4/20/78: 189 ill;
Sothebys NY 5/2/78: 125;
Christies Lon 6/27/78: 209, 210 ill, 211 ill, 212 ill, 213, 214, 215 (3), 216 (90), 217 (book, 33), 218 (17), 219 (33);
Sothebys Lon 6/28/78: 303, 304 ill;
Christies Lon 10/26/78: 302 ill, 303;
Sothebys Lon 10/27/78: 80 ill(album, B-4 et al), 138, 139 ill, 140 ill, 141;
Lennert Munich Cat 5, 1979: 27, 29;
Rose Boston Cat 4, 1979: 21 ill(note);
Wood Conn Cat 45, 1979: 14 (book, 100)(note), 15 (book, 100)(note), 266 ill(book, 100)(note);
California Galleries 1/21/79: 390 ill(10)(note);
Phillips Lon 3/13/79: 80, 81, 82, 83 ill;
Sothebys Lon 3/14/79: 273, 274, 275 ill, 276 ill;
Christies Lon 3/15/79: 250 ill, 251 (note);
Christies NY 5/4/79: 43 (note);
Phillips NY 5/5/79: 157;
Sothebys NY 5/8/79: 89 ill;
Christies Lon 6/28/79: 182, 183, 184;
Swann NY 10/18/79: 269;
Sothebys Lon 10/24/79: 124, 125;
Sothebys Lon 10/25/79: 343 ill, 344;
Christies NY 10/31/79: 33;
Sothebys NY 11/2/79: 236 ill(note), 277 (album, B et al);
Sothebys NY 12/19/79: 36 ill(book, 170), 19 ill (lot, B attributed, et al);
Rose Boston Cat 5, 1980: 48 ill(note);
White LA 1980-1981: 15 ill(note), 16 ill, 17 ill, 18 ill, 19 ill;
Sothebys LA 2/6/80: 127, 128 ill;
Christies Lon 3/20/80: 289, 290;
Sothebys Lon 3/21/80: 346 ill, 347 ill, 348 ill, 349 ill;
California Galleries 3/30/80: 236 ill(27)(note);
Christies NY 5/16/80: 134, 135 (4)(attributed);
Phillips NY 5/21/80: 196 ill;
Christies Lon 6/26/80: 178 ill(attributed), 179 (attributed), 180 (attributed), 181 (attributed), 182 ill(attributed), 183 (attributed), 184 (attributed), 185 ill(attributed), 320 ill(book, 100), 399 ill;

## BALDUS (continued)

Sothebys Lon 6/27/80: 147 ill, 148, 149, 150 ill, 151, 152 ill;
Christies Lon 10/30/80: 164 ill(attributed)(note), 165 ill(attributed)(note);
Christies NY 11/11/80: 59 ill;
Lennert Munich Cat 6, 1981: 8, 9 ill, 10 ill;
Christies Lon 3/26/81: 330, 331 ill, 332, 333, 334, 335, 336;
Sothebys Lon 3/27/81: 205 ill, 206 ill, 207 ill, 208 ill, 209 ill, 210;
Swann NY 4/23/81: 293;
Christies NY 5/14/81: 32 ill(album, 20), 33 ill;
Petzold Germany 5/22/81: 1778 ill;
Sothebys Lon 6/17/81: 209 ill, 210 ill, 211 ill, 212 ill, 213 ill;
Christies Lon 6/18/81: 174 (2);
California Galleries 6/28/81: 178 ill(8);
Sothebys Lon 10/28/81: 167 ill, 168 ill, 169 ill, 170, 171, 172 ill, 173;
Christies Lon 10/29/81: 177 ill;
Octant Paris 1982: 4 ill;
Rose Florida Cat 7, 1982: 11 ill(note);
Wood Conn Cat 49, 1982: 31 (book, 100)(note), 32 (book, 100);
Phillips NY 2/9/82: 24 ill;
Christies Lon 3/11/82: 124;
Sothebys Lon 3/15/82: 359 ill, 360 ill;
Christies Lon 6/24/82: 297, 298, 299, 300 (4), 301 ill;
Sothebys Lon 6/25/82: 211, 212 ill, 213 ill;
Christies Lon 10/28/82: 71, 72, 73, 74, 75 ill(4);
Drouot Paris 11/27/82: 16 (album, B-37 et al);
Sothebys NY 11/9/82: 121 ill(note);
Bievres France 2/6/83: 4 ill, 23 ill;
Christies Lon 3/24/83: 87;
Sothebys Lon 3/25/83: 83, 84;
Phillips Lon 6/15/83: 140 (4);
Christies Lon 6/23/83: 96 (lot, B-1 et al);
Christies Lon 10/27/83: 72A (lot, B-1 et al), 96, 97;
Phillips Lon 11/4/83: 142 ill, 143 ill, 144 ill;
Christies NY 11/8/83: 36 ill;
Swann NY 11/10/83: 19 (book, 100), 178;
Sothebys Lon 12/9/83: 60 ill, 61 ill, 62 ill, 63 ill, 64;
Christies Lon 3/29/84: 153, 154 ill, 155, 156 ill, 157 ill, 158 (2), 159, 160 ill, 161 (note);
Sothebys NY 5/8/84: 41 ill;
Sothebys Lon 6/29/84: 127 ill, 128 ill, 129 ill;
Christies NY 11/6/84: 19 ill(2);
Harris Baltimore 3/15/85: 138;
Christies Lon 3/28/85: 156 ill(note), 157, 158;
Sothebys Lon 3/29/85: 213 ill, 214 ill;
Christies NY 5/6/85: 39 ill(2);
Phillips Lon 6/26/85: 222 (2, attributed);
Christies Lon 6/27/85: 142 ill(4)(attributed);
Christies Lon 6/28/85: 196 ill(5), 197 (3);
Phillips Lon 10/30/85: 133 (2, attributed);
Sothebys Lon 11/1/85: 115 ill, 116 ill;
Sothebys NY 11/12/85: 29A ill(4);
Swann NY 11/14/85: 16, 17 (5);
Wood Boston Cat 58, 1986: 213 (book, 100)(note), 214 (book, 100);
Christies Lon 4/24/86: 488 ill(attributed), 489 ill, 490 ill;
Sothebys Lon 4/25/86: 195 ill, 196 ill, 197 ill, 198 ill, 199;
Sothebys NY 5/12/86: 39 ill;
Christies NY 5/13/86: 23 ill(album, 20);
Swann NY 5/15/86: 170 (5), 190 (lot, B-2 et al);

**BALDUS** (continued)
Christies Lon 6/26/86: 140;
Christies Lon 10/30/86: 76 ill;
Sothebys Lon 10/31/86: 160 (195);
Sothebys NY 11/10/86: 30 ill, 30A ill(2);
Swann NY 11/13/86: 141 (note), 142 ill(note), 143
    (lot, B-2 et al);

**BALDWIN** [BALDWIN 1]
Photos dated: 1850s
Processes:      Daguerreotype
Formats:        Plates
Subjects:       Portraits
Locations:
Studio:
    Entries:
Christies NY 2/8/83: 75 (lot, B-1 et al);

**BALDWIN** (American) [BALDWIN 2]
Photos dated: c1870s-1880
Processes:      Albumen
Formats:        Stereos
Subjects:       Topography
Locations:      US - Santa Cruz, California
Studio:         US
    Entries:
California Galleries 5/23/82: 423 (lot, B et al);

**BALDWIN, G.W.** (American)
Photos dated: 1870s-1880s
Processes:      Albumen
Formats:        Stereos
Subjects:       Topography
Locations:      US - Keeseville, New York
Studio:         US - Keeseville, New York
    Entries:
Rinhart NY Cat 6, 1973: 417;
California Galleries 4/3/76: 413 (lot, B et al);
California Galleries 1/21/78: 179 (lot, B et al);
Swann NY 11/8/84: 253 (lot, B et al);

**BALDWIN, Schuyler C.** (American)
Photos dated: 1870s
Processes:      Albumen
Formats:        Stereos
Subjects:       Topography
Locations:      US
Studio:         US - Kalamazoo, Michigan
    Entries:
Harris Baltimore 4/8/83: 57 (lot, B et al);

**BALFOUR, Charles** (British)
Photos dated: 1850s and/or 1860s
Processes:      Albumen
Formats:        Prints
Subjects:       Genre
Locations:      Great Britain
Studio:         Great Britain
    Entries:
Christies Lon 6/27/78: 229 (album, B et al)(note);

**BALL, William**
Photos dated: 1860s-1870s
Processes:      Albumen
Formats:        Stereos
Subjects:       Topography
Locations:      Great Britain
Studio:         Great Britain
    Entries:
California Galleries 9/27/75: 479 (lot, B et al);
California Galleries 1/23/77: 384 (lot, B et al);
Sothebys Lon 10/26/84: 3 (lot, B et al);
Swann NY 5/9/85: 177 (book, 32);

**BALLANTYNE, R.M.** (British)(photographer or
                author?)
Photos dated: 1867
Processes:      Albumen
Formats:        Prints
Subjects:       Topography
Locations:      Scotland - Edinburgh
Studio:         Scotland
    Entries:
Swann NY 4/20/78: 13 (book, 12);

**BALLARD, L.** (American)(photographer or
publisher?)
Photos dated: 1890s
Processes:      Albumen
Formats:        Prints
Subjects:       Topography
Locations:      US - Florida
Studio:         US
    Entries:
Sothebys NY 10/4/77: 96 ill(attributed)(note);

**BALLERSTAEDT, A.** (German)
Photos dated: c1870
Processes:      Albumen
Formats:        Prints
Subjects:       Topography
Locations:      Germany - Danzig
Studio:         Germany
    Entries:
Petzold Germany 188 ill(2), 189 (2), 190 (3), 191
    ill(2), 192 ill(2), 193 ill(2);

**BAMBRIDGE, W.** (British)(see also CAITHNESS)
Photos dated: 1856-1870s
Processes:      Salt, albumen
Formats:        Prints, cdvs
Subjects:       Portraits, genre (animal life)
Locations:      England - Windsor
Studio:         England
    Entries:
Swann NY 2/14/52: 34 (51);
Swann NY 4/14/76: 244 (album, B et al);
Sothebys Lon 10/29/80: 218;
Phillips Lon 11/4/83: 145 (album, B-14 et al)(note);
Sothebys Lon 6/28/85: 122 ill;

**BAME, John, Alva and Frank** (American)
Photos dated: late 1880s
Processes:        Albumen
Formats:          Prints
Subjects:         Portraits, topography, documentary
                  (disasters)
Locations:        US - Rensselaer County, New York
Studio:           US - Rensselaer County, New York
    Entries:
Swann NY 12/14/78: 354 ill(25)(note);
Swann NY 10/18/79: 270 (28)(note);

**BANCROFT, Milton Herbert** (American)
Photos dated: late 1890s
Processes:
Formats:          Prints
Subjects:         Genre
Locations:        US
Studio:           US
    Entries:
Swann NY 12/14/78: 355 ill(albums, B et al);

**BANKART, George** (British)
Photos dated: 1887-1888
Processes:        Photogravure
Formats:          Prints
Subjects:         Topography
Locations:        England - Derbyshire
Studio:           England
    Entries:
Witkin NY III 1975: 510 ill(book, B-27 et al);
Colnaghi Lon 1976: 364 (book, B-27 et al)(note);
Witkin NY IV 1976: OP140 (book, B-27 et al);
Wood Conn Cat 37, 1976: 60 (book, B-27 et al);
Swann NY 11/11/76: 294 (book, B et al);
White LA 1977: 277 (book, B-27 et al);
Christies Lon 3/10/77: 364 (book, B-25 et al);
Swann NY 4/14/77: 173 (book, B et al)(note);
Gordon NY 5/10/77: 894 (book, B-25 et al);
Sothebys NY 5/20/77: 89 (book, B-25 et al);
Sothebys NY 10/4/77: 188 (book, B-25 et al);
Swann NY 12/8/77: 184 (book, B et al)(note);
Weston Cal 1978: 148 (book, B-25 et al);
Wood Conn Cat 41, 1978: 111 (book, B-27 et al)
    (note), 112 (book, B-27 et al);
Swann NY 12/14/78: 246 (book, B et al)(note);
Wood Conn Cat 45, 1979: 97 (book, B-27 et al)(note),
    98 (book, B-27 et al);
Sothebys LA 2/7/79: 442 (book, B-25 et al);
Sothebys NY 5/8/79: 79 (book, B-25 et al);
Christies Lon 6/28/79: 172 (book, B-25 et al);
Christies Lon 10/25/79: 297 (book, B-25 et al);
Christies NY 10/31/79: 129 ill(book, B et al);
Sothebys LA 2/6/80: 127 (book, B-25 et al);
Christies NY 5/14/80: 117 ill(book, B et al);
Christies Lon 6/26/80: 335 (book, B-25 et al);
Swann NY 4/23/81: 206 ill(book, B et al)(note);
Wood Conn Cat 49, 1982: 151 (book, B-27 et al), 152
    (book, B-27 et al);
Swann NY 4/1/82: 78 (book, B et al)(note);
Christies Lon 6/28/84: 245 (book, B-25 et al);
Swann NY 11/8/84: 44 (book, B et al)(note);
Christies Lon 10/31/85: 151 (book, B-27 et al);
Sothebys NY 11/12/85: 111 (books, B-24 et al);
Swann NY 11/14/85: 222 (book, B-27 et al);
Christies Lon 4/24/86: 421 (book, B-25 et al);
Swann NY 5/15/86: 89 (book, B-27 et al)(note);
Swann NY 11/13/86: 47 (book, B et al)(note);

**BANKHART, Captain G.** (British)
Photos dated: 1860s
Processes:        Albumen
Formats:          Prints
Subjects:
Locations:        England - Leicestershire
Studio:           Great Britain (Amateur Photographic
                  Association)
    Entries:
Swann NY 2/14/52: 14 (lot, B et al);
Sothebys Lon 10/29/80: 310 (album, B et al);
Christies Lon 10/29/81: 359 (album, B-8 et al)
    (note);
Christies Lon 10/27/83: 218 (albums, B-15 et al);
Christies Lon 6/28/84: 230 (6)(note);

**BANKS, W.L.** (British)
Photos dated: early 1860s
Processes:        Albumen
Formats:          Prints
Subjects:
Locations:
Studio:           England (Amateur Photographic
                  Association)
    Entries:
Christies Lon 10/27/83: 218 (albums, B-1 et al);
Sothebys Lon 6/28/85: 134 (album, B et al);

**BAPERUKR, U.** (Russian)
Photos dated: Nineteenth century
Processes:        Albumen
Formats:          Cdvs
Subjects:         Topography, portraits
Locations:
Studio:
    Entries:
Phillips NY 11/3/79: 128 (album, B et al);

**BARBASHOV, P.N.** (Russian)
Photos dated: 1880s-1890s
Processes:        Albumen
Formats:          Prints
Subjects:         Topography
Locations:        Russia
Studio:           Russia - Moscow
    Entries:
Swann NY 11/18/82: 441 (lot, B-1 et al)(note);

**BARBER & MARKS** (British) [BARBER 1]
Photos dated: 1850s-1860s
Processes:        Albumen
Formats:          Stereos
Subjects:         Topography
Locations:        Great Britain
Studio:           Great Britain
    Entries:
Sothebys Lon 3/15/82: 299 (lot, B & M-1 et al);
Christies Lon 6/27/85: 37 (lot, B & M et al);

**BARBER** (British) [BARBER 2]
Photos dated: 1850s
Processes:      Ambrotype
Formats:        Plates
Subjects:       Portraits
Locations:      Studio
Studio:         Great Britain
    Entries:
Vermont Cat 8, 1974: 524 ill;

**BARBERON** (French)
Photos dated: 1850s
Processes:      Daguerreotype
Formats:        Plates
Subjects:       Portraits
Locations:      Studio
Studio:         France
    Entries:
Rauch Geneva 6/13/61: 40 (lot, B et al);

**BARBOU**
Photos dated: 1850s
Processes:      Salt
Formats:        Prints
Subjects:
Locations:
Studio:
    Entries:
Mancini Phila 1979: 5;

**BARCLAY, F.R.** (British)
Photos dated: c1860
Processes:      Albumen
Formats:        Prints
Subjects:       Topography
Locations:      Italy - Rome
Studio:         England (Amateur Photographic
                Association)
    Entries:
Christies Lon 10/27/83: 218 (albums, B-3 et al);
Sothebys Lon 3/29/85: 159 (lot, B et al);

**BARDI, Luigi** (Italian)
Photos dated: c1855-1870s
Processes:      Albumen
Formats:        Prints, stereos
Subjects:       Topography
Locations:      Italy
Studio:         Italy
    Entries:
Sothebys Lon 10/24/75: 117 (2);
Christies Lon 10/28/82: 54 (lot, B et al);

**BARDWELL** (American)
Photos dated: Nineteenth century
Processes:      Albumen
Formats:        Cdvs
Subjects:       Portraits
Locations:      Studio
Studio:         US - Detroit, Michigan
    Entries:
Sothebys NY (Strober Coll.) 2/7/70: 296 (lot,
    B et al);

**BARING & SMALL** (British)
Photos dated: Nineteenth century
Processes:      Albumen
Formats:
Subjects:       Portraits
Locations:      Great Britain
Studio:         Great Britain
    Entries:
Christies Lon 6/24/82: 364 (album, B & S et al);

**BARING, Sir Evelyn** (British)
Photos dated: 1859
Processes:      Albumen
Formats:        Prints
Subjects:       Topography, portraits
Locations:      Greece - Corfu
Studio:
    Entries:
Christies Lon 10/26/78: 115 (album, B et al);

**BARK, C.V.** (British)
Photos dated: Nineteenth century
Processes:      Albumen
Formats:        Stereos
Subjects:       Topography
Locations:      England
Studio:         Great Britain
    Entries:
California Galleries 9/27/75: 479 (lot, B et al);
California Galleries 1/23/77: 384 (lot, B et al);

**BARKALOW** (American)
Photos dated: 1880s
Processes:      Albumen
Formats:        Cabinet cards
Subjects:       Portraits
Locations:      Studio
Studio:         US - Colorado
    Entries:
Harris Baltimore 3/15/85: 165 (lot, B et al);

**BARKER, Dr. Alfred Charles** (British, New
                Zealander, 1819-1873)
Photos dated: 1859-1860s
Processes:      Salt, albumenized salt
Formats:        Prints
Subjects:       Topography, portraits
Locations:      New Zealand - Christchurch
Studio:         New Zealand - Christchurch
    Entries:
Christies Lon 10/27/77: 129 (2 ills)(album, 52);

**BARKER, F.E.**
Photos dated: Nineteenth century
Processes:      Silver
Formats:        Prints
Subjects:       Topography
Locations:      US - Colorado
Studio:
    Entries:
Swann NY 11/13/86: 132 (lot, B-1 et al);

**BARKER, George** (American)
Photos dated: c1860-1890
Processes: Albumen, collodion on glass, heliogravure
Formats: Prints, stereos (glass and card)
Subjects: Topography, genre
Locations: US - Niagara Falls, New York; Florida
Studio: US - Niagara Falls, New York
Entries:
Goldschmidt Lon Cat 52, 1939: 224 (lot, B et al);
Sothebys NY (Strober Coll.) 2/7/70: 465 (lot, B et al), 475 (lot, B et al);
Rinhart NY Cat 1, 1971: 241 (lot, B et al);
Rinhart NY Cat 2, 1971: 543 (lot, B-3 et al);
Vermont Cat 2, 1971: 230 ill(15), 232 (lot, B-2 et al);
Sothebys Lon 12/21/71: 163 (lot, B-8 et al);
Rinhart NY Cat 6, 1973: 468;
Rinhart NY Cat 7, 1973: 10 (book, 9);
Sothebys Lon 6/21/74: 26 (lot, B-1 et al);
Sothebys Lon 10/18/74: 1 (lot, B et al), 6 (lot, B-3 et al), 7 (lot, B-1 et al);
Witkin NY IV 1976: 337 ill, 338 ill(attributed), 340 ill, S5 ill;
Sothebys Lon 3/19/76: 4 (lot, B-3 et al);
Swann NY 4/1/76: 202 (lot, B-6 et al), 221 (lot, B et al);
California Galleries 4/3/76: 341 (lot, B et al), 368 (lot, B et al), 433 (lot, B et al), 435 (lot, B-7 et al);
Gordon NY 5/3/76: 307 ill;
Christies Lon 10/28/76: 197 (lot, B-35 et al), 198 (lot, B et al);
Swann NY 11/11/76: 285 (book, 9);
White LA 1977: 105 (attributed), 106 (attributed);
California Galleries 1/23/77: 431 (lot, B et al);
California Galleries 3/9/77: 26 ill, 28 (album, B-8 attributed et al), 29 (2, attributed);
Christies Lon 3/10/77: 206 (lot, B-8 et al);
Swann NY 4/14/77: 297 (lot, B et al), 323 (lot, B et al);
Gordon NY 5/10/77: 876 ill, 877 ill(2);
Christies Lon 10/27/77: 180 ill (album, B-2 attributed et al);
Swann NY 12/8/77: 404 (lot, B et al);
California Galleries 1/21/78: 143 (lot, B et al), 185 (lot, B-7 et al);
Sothebys LA 2/13/78: 46 ill(attributed);
Christies Lon 3/16/78: 148 (album, B-2 attributed, et al), 177 (lot, B-16 et al);
Sothebys Lon 3/22/78: 62 (album, B attributed et al);
Swann NY 4/20/78: 153 (book, 10)(note), 530 (lot, B et al);
Sothebys NY 5/2/78: 28 ill;
Christies Lon 6/27/78: 138 (3), 145 (album, B-3 et al);
Christies Lon 10/26/78: 183 (3);
Phillips NY 11/4/78: 95 ill, 96 ill(attributed);
Witkin NY VII 1979: 12 ill;
Witkin NY Stereo 1979: 1 ill(6)(note);
California Galleries 1/21/79: 391 (2)(note);
Christies Lon 3/15/79: 89 (lot, B et al);
Christies NY 5/4/79: 123 (attributed);
Phillips NY 5/5/79: 209 ill(attributed), 210;
Phillips Can 10/4/79: 48 (11), 49 ill, 50 ill, 51 ill, 52, 53;
Christies Lon 10/25/79: 96 (lot, B-1 et al), 97 (lot, B-25 et al);
Christies NY 10/31/79: 133 ill, 134 (attributed);
Phillips NY 11/3/79: 136 (lot, B et al);

Phillips NY 11/29/79: 284 (2)(attributed);
Christies Lon 3/20/80: 114 (lot, B-4 et al);
California Galleries 3/30/80: 238;
Christies NY 5/16/80: 324, 325 (10);
Sothebys NY 5/20/80: 325 ill(note);
Phillips NY 5/21/80: 283 (2), 284;
Phillips Can 10/9/80: 45 ill;
Sothebys Lon 10/29/80: 107 (attributed);
Christies Lon 10/30/80: 135 (lot, B-5 et al);
California Galleries 12/13/80: 189, 190 ill, 191 ill, 351 (lot, B-3 et al), 378 (lot, B-2 et al);
Christies Lon 3/26/81: 250 (2)(attributed);
Swann NY 4/23/81: 153 (book, 10)(note), 530 (lot, B et al);
California Galleries 6/28/81: 179 ill, 180 (attributed), 307 (lot, B-3 et al);
Harris Baltimore 7/31/81: 111 (lot, B et al);
Sothebys Lon 10/28/81: 103a (attributed);
Christies Lon 10/29/81: 147 (lot, B et al), 258 (2) (attributed);
Swann NY 11/5/81: 269 (note);
Christies NY 11/10/81: 78 ill(attributed);
Rose Florida Cat 7, 1982: 5 ill(note);
Christies Lon 3/11/82: 84 (lot, B-29 et al), 93 (lot, B-16 et al);
Harris Baltimore 3/26/82: 8 (lot, B et al), 10 (lot, B-5 et al);
Phillips NY 5/22/82: 657 ill, 658 ill;
California Galleries 5/23/82: 215 ill, 216, 357 (lot, B-2 attributed et al);
Sothebys NY 5/24/82: 214 ill, 215 ill;
Christies NY 5/26/82: 56;
Christies Lon 6/24/82: 73 (lot, B-5 et al);
Phillips NY 9/30/82: 934 ill;
Christies Lon 10/28/82: 28 (lot, B et al);
Swann NY 11/18/82: 331 (attributed);
Harris Baltimore 12/10/82: 69 (lot, B et al), 72 (6), 73 (13);
Christies NY 3/24/83: 45 (lot, B-1 et al), 125 (4) (attributed);
Harris Baltimore 4/8/83: 30 (lot, B et al), 46 (lot, B et al), 77 (52);
California Galleries 6/19/83: 430 (lot, B-3 et al);
Christies Lon 6/23/83: 55 (lot, B-3 et al), 164 (3) (attributed);
Christies NY 10/4/83: 103 ill, 104;
Christies Lon 10/27/83: 44 (lot, B et al), 144 ill (attributed), 152 (lot, B et al), 154 (album, B-1 et al);
Swann NY 11/10/83: 346 (lot, B et al);
Harris Baltimore 12/16/83: 36 (lot, B et al);
Christies NY 2/22/84: 32 (attributed);
Harris Baltimore 6/1/84: 77 (lot, B et al), 103 (lot, B et al), 109 (lot, B et al);
Sothebys Lon 6/29/84: 65 (album, B et al);
California Galleries 7/1/84: 195 (18);
Christies Lon 10/25/84: 48 (lot, B-1 et al), 231 (attributed)(note);
Sothebys Lon 10/26/84: 75 (5)(attributed);
Christies NY 2/13/85: 164 (2);
Harris Baltimore 3/15/85: 69 (lot, B et al), 75 (lot, B-12 et al), 76 (lot, B-8 et al);
Christies Lon 3/28/85: 44 (lot, B et al), 101 (album, B-1 et al);
Sothebys NY 5/7/85: 415 ill(lot, B-2 et al);
Christies Lon 6/27/85: 32 (lot, B-10 et al);
Swann NY 11/14/85: 168 (lot, B-13 et al);
Harris Baltimore 2/14/86: 41 (lot, B et al);
Christies Lon 4/24/86: 340 (lot, B et al);

BARKER, G. (continued)
Swann NY 5/15/86: 162 (lot, B-2 et al);
Swann NY 11/13/86: 323 (lot, B-20 et al);

BARKER, W.C. (British)
Photos dated: 1859
Processes:    Albumen
Formats:      Prints
Subjects:     Topography, portraits
Locations:
Studio:       Ireland - Dublin
   Entries:
Sothebys Lon 3/8/74: 170 (book, B et al);
Sothebys Lon 3/19/76: 142 (books, 2);

BARNABY
Photos dated: 1850s
Processes:    Daguerreotype
Formats:      Plates
Subjects:     Portraits
Locations:
Studio:
   Entries:
Christies NY 2/8/83: 78 (lot, B-1 et al);

BARNARD (British)
Photos dated: 1853-1860s
Processes:    Daguerreotype, ambrotype
Formats:      Plates
Subjects:     Portraits
Locations:    Studio
Studio:       England - London
   Entries:
Vermont Cat 9, 1975: 407 ill;
Petzold Germany 5/22/81: 1749;

BARNARD, C. (see BARNARD, H.)

BARNARD, George N. (American, 1819-1902)
Photos dated: 1848-1871
Processes:    Daguerreotype, albumen
Formats:      Plates, prints, stereos, cdvs
Subjects:     Documentary (Civil War, disasters)
Locations:    US - Oswego, New York; Civil War area;
              Chicago, Illinois;
Studio:       US - Oswego and Syracuse, New York
   Entries:
Goldschmidt Lon Cat 52, 1939: 177 (album, 48)(note);
Sothebys NY (Strober Coll.) 2/7/70: 14 (book, 61)
   (note), 381 (lot, B & Gibson-7, et al), 382
   (lot, B & Gibson-2, et al), 384 (lot, B & Gibson
   et al), 388 (lot, B et al), 389 (lot, B-1 et
   al), 410 (lot, B et al), 416 (lot, B et al), 422
   (lot, B-1 et al), 428 (lot, B-1 et al), 527
   (lot, B-5 et al), 540 (lot, B-10 et al), 541
   (lot, B-3 et al), 543 (lot, B-4 et al), 544
   (lot, B-4 et al), 550 (lot, B-6 et al), 563 (14);
Sothebys NY (Greenway Coll.) 11/20/70: 1 (B &
   Gibson), 3 (B & Gibson);
Vermont Cat 4, 1972: 314 ill(note), 465 (B &
   Gibson);
Frumkin Chicago 1973: 21, 22 ill, 23 ill;
Rinhart NY Cat 7, 1973: 325 (attributed), 326
   (attributed), 327 (attributed), 328 (attributed),
   408 ill;
Rinhart NY Cat 8, 1973: 47 ill(10)(note);

BARNARD, G. (cntinued)
Sothebys Lon 6/21/74: 162 (album, B & Gibson et al);
Christies Lon 7/25/74: 359 (2 ills)(book, 60);
Sothebys Lon 10/18/74: 137 (book, B & Gibson et
   al), 138 (3 ills)(61);
Sothebys NY 2/25/75: 46 (2 ills)(book, 61)(note),
   49 ill (attributed), 50 (attributed, 2);
Sothebys NY 9/23/75: 107 (lot, B-1 attributed et
   al), 111 ill(note), 112 ill, 113 ill, 114 ill,
   115 ill, 116 ill;
California Galleries 9/26/75: 228 (note), 229, 230,
   231, 232, 233, 234, 235, 236, 237, 238, 239,
   240, 241;
Colnaghi Lon 1976: 240 (4 ills)(album, 61)(note);
Lunn DC Cat 6, 1976: 49.15 ill(B & Gibson), 49.16
   (B & Gibson), 49.17 (B & Gibson), 50.1 ill
   (note), 50.2 ill, 50.3 ill;
Witkin NY IV 1976: 341 ill;
Wood Conn Cat 37, 1976: 17 (book, 61)(note), 129
   (book, B & Gibson-8, et al)(note), 130 ill
   (note), 131, 132, 133 ill, 134, 135, 136, 137,
   138 ill;
California Galleries 4/2/76: 188, 189, 190 ill,
   191 ill;
Gordon NY 5/3/76: 309 ill;
Sothebys NY 5/4/76: 110 (note), 111, 112, 113, 114,
   115 ill, 116;
Sothebys NY 11/9/76: 72 (lot, B-1 attributed et al)
   (note), 82 (B & Gibson), 85, 86 (note), 87, 88,
   89 (attributed);
Swann NY 11/11/76: 431 (lot, B-17 et al)(note), 478
   (lot, B & Gibson-4, et al)(note);
Gordon NY 11/13/76: 59 ill(61), 60 ill, 61 ill, 62
   ill, 63 ill, 64 ill, 65 ill, 66 ill, 67 ill, 68
   ill;
Halsted Michigan 1977: 72 ill(note), 577, 578, 579;
White LA 1977: 72 ill(note), 73 ill, 74 ill;
California Galleries 1/22/77: 255 ill, 256, 257,
   258, 259, 260, 261, 262, 263, 264, 265, 266;
Swann NY 4/14/77: 200A ill (61)(note), 250A (book,
   B et al);
Sothebys NY 5/20/77: 1 (B & Gibson), 3 (B & Gibson);
Sothebys NY 10/4/77: 1 ill, 2 (2), 3 (2);
Christies NY 10/27/77: 160 ill(note), 161 ill;
Frontier AC Texas, 1978: 18 ill(attributed);
California Galleries 1/21/78: 119 (lot, B &
   Gibson-4, et al), 291 ill;
Swann NY 12/14/78: 356;
Lehr NY Vol 2:2, 1979: 1 ill, 2 ill, 3 ill, 4 ill,
   5 ill(B & Gibson)(note);
Lennert Munich Cat 5, 1979: 25;
Witkin NY VII 1979: 13 ill;
Wood Conn Cat 45, 1979: 17 (book, 10)(note), 113
   (book, B & Gibson-8, et al)(note);
California Galleries 1/21/79: 392 (3);
Swann NY 4/26/79: 320 (lot, B & Gibson-5, et al)
   (note), 321 (attributed)(note);
Phillips NY 5/5/79: 190, 191, 192;
Christies NY 10/31/79: 60;
Sothebys NY 11/2/79: 282 (note);
Phillips NY 11/3/79: 189 ill;
Sothebys NY 12/19/79: 37 ill, 47 (2 ills)(albums,
   B & Gibson, et al);
California Galleries 3/30/80: 238A ill(book, 63);
Christies NY 5/16/80: 235 (B & Gibson, 2), 236 ill
   (10), 237, 238 ill, 239;
Sothebys NY 5/20/80: 278 (lot, B & Gibson-1, et al),
   285 ill, 286 ill;
Phillips NY 5/21/80: 259 ill(note), 260 (note), 261
   (note), 262 ill(note);
Christies Lon 6/26/80: 255 (B & Gibson), 257 ill;

BARNARD, G. (continued)
Swann NY 11/6/80: 87 (book, B et al);
Christies NY 11/11/80: 96 ill(note);
Sothebys NY 11/17/80: 98 ill(lot, B-1 et al), 99
    ill(2);
Christies Lon 3/26/81: 255;
Swann NY 4/23/81: 26 (book, 61)(note);
Phillips NY 5/9/81: 70 ill(note), 71 ill(note);
Harris Baltimore 7/31/81: 148;
Christies NY 11/10/81: 47 ill(3)(note), 48 (3)
    (note);
Weston Cal 1982: 12 ill(note);
Harris Baltimore 3/26/82: 180(note), 181, 182, 183,
    184, 185, 186, 187, 188, 189, 190 (note), 191,
    192, 193, 194, 195, 196, 197 (note), 198;
Phillips NY 5/22/82: 659 (note), 660 ill(note);
California Galleries 5/23/82: 217, 218 ill, 219 (5);
Sothebys NY 5/24/82: 216 ill;
Harris Baltimore 5/28/82: 1 (note), 2, 3, 4, 5, 6,
    7, 8, 9, 10, 11, 12, 13, 14, 15, 16, 17, 18, 19,
    20, 21, 22, 23, 24, 25, 26, 27, 28, 29 (B &
    Gibson)(note), 30 (B & Gibson), 31 (B & Gibson),
    62 (B & Gibson, attributed)(note), 63 (B &
    Gibson)(note), 64 (B & Gibson)(note), 65
    (B & Gibson), 66 (B & Gibson, attributed)(note),
    67 (B & Gibson), 68 (B & Gibson, attributed)
    (note), 69 (B & Gibson, attributed)(note), 88
    (lot, B-2 et al), 143 (3), 165 (lot, B-1 et al),
    169 (4, attributed)(note), 170 (4), 171 (3), 172
    (3, attributed), 173 ill, 182 (4, attributed),
    183 (4, attributed), 184 (5, attributed);
Phillips NY 9/30/82: 935 (note);
Harris Baltimore 12/10/82: 13 (lot, B-10 et al),
    14, 194 (note), 195, 196, 197, 198, 199, 245
    (B & Gibson), 246 (B & Gibson);
Christies NY 2/8/83: 18, 19 ill(4)(note);
Harris Baltimore 4/8/83: 298, 299, 360 (B &
    Gibson), 361 (B & Gibson), 362 (B & Gibson);
Swann NY 5/5/83: 107 (book, B & Gibson et al)(note);
Harris Baltimore 9/16/83: 4 (B & Gibson), 5 (B &
    Gibson), 6 (B & Gibson), 7 (B & Gibson), 8 (B &
    Gibson), 9 (B & Gibson), 10 (B & Gibson), 11
    (B & Gibson), 88, 89, 90, 91, 92, 93, 94, 95,
    96, 97, 98, 99, 100, 101, 102, 103, 104, 105,
    106, 107, 108, 109, 166 (B & Gibson, 2), 168
    (lot, B & Gibson-1, et al), 186 (lot, B-1
    attributed, et al);
Sothebys NY 11/9/83: 33 ill;
Sothebys Lon 12/9/83: 33 (2 ills)(book, 60);
Harris Baltimore 12/16/83: 26 (lot, B-1 et al);
Sothebys NY 5/8/84: 155 ill(book, B et al)(note);
Swann NY 5/10/84: 52 (book, B & Gibson et al)
    (note), 173, 174;
Harris Baltimore 6/1/84: 150 (lot, B-4 et al), 311,
    362 (B & Gibson);
California Galleries 7/1/84: 413 ill(B & Gibson);
Sothebys NY 11/5/84: 20A ill(album, 44)(note);
Harris Baltimore 11/9/84: 1 (B & Gibson), 2 (B &
    Gibson), 3 (B & Gibson), 33, 34, 35, 36, 37, 38,
    39, 40, 45 (B & Gibson), 47 (B & Gibson), 116
    ill(B & Gibson);
Christies NY 11/6/84: 36 (2 ills)(61)(note);
Harris Baltimore 3/15/85: 139 (3), 140 (3), 141
    (6), 192 (lot, B & Gibson-1, et al), 193 (lot,
    B & Gibson-1, et al);
Christies NY 5/6/85: 41 ill(album, 61)(note);
Swann NY 5/9/85: 372 (album, B & Gibson et al)
    (note);
California Galleries 6/8/85: 152 (B & Gibson,
    attributed);

BARNARD, G. (continued)
Harris Baltimore 9/27/85: 1 (note), 2 (note), 3
    ill(5), 4 (note), 5 (B & Gibson), 6 (B & Gibson);
Sothebys NY 11/12/85: 30;
Swann NY 11/14/85: 19 (note), 161 (lot, B et al),
    170 (lot, B et al), 304 (lot, B & Gibson-3,
    et al);
Harris Baltimore 2/14/86: 11 (lot, B-1 et al), 240
    (note);
California Galleries 3/29/86: 670 (2), 671, 672,
    673, 674 (2), 687 (B & Gibson);
Christies NY 5/13/86: 294 (lot, B-1 et al);
Harris Baltimore 11/7/86: 87 (note), 88 (note), 89
    (B & Gibson);
Phillips NY 11/12/86: 30 (6), 31 (note);

BARNARD, H. (British)
Photos dated:    1870
Processes:       Albumen
Formats:         Prints
Subjects:        Topography
Locations:       England - Thames River
Studio:          England - London
    Entries:
Goldschmidt Lon Cat 52, 1939: 238 (book, 18);
Swann NY 11/13/86: 144 (book, H & CB, 13);

BARNES & LHOSTE (American) [BARNES 1]
Photos dated:    1891
Processes:       Albumen
Formats:         Cabinet cards
Subjects:        Portraits
Locations:       Studio
Studio:          US - New Orleans, Louisiana
    Entries:
Harris Baltimore 11/9/84: 123;

BARNES & Son [BARNES 2]
Photos dated:    1887
Processes:       Albumen
Formats:         Prints
Subjects:        Documentary (railroads)
Locations:       India
Studio:
    Entries:
Christies Lon 3/28/85: 226 (lot, B-1 et al);
Christies Lon 10/31/85: 226 (lot, B-1 et al);

BARNES, George (American)
Photos dated:    c1863
Processes:       Albumen
Formats:         Cdvs
Subjects:        Portraits
Locations:       Studio
Studio:          US - Rockford, Illinois
    Entries:
Harris Baltimore 3/26/82: 400 (album, R et al);

**BARNES, Joseph K. & OTIS, George A.** (photographers
or authors?)
Photos dated: 1876
Processes:      Woodburytype
Formats:        Prints
Subjects:       Documentary (medical)
Locations:      US
Studio:         US
    Entries:
Swann NY 5/9/85: 178 (book, 14);

**BARNES, R.F.** (British)
Photos dated: 1857
Processes:      Photogalvanograph
Formats:        Prints
Subjects:       Topography
Locations:      England - Richmond
Studio:         England - London
    Entries:
Christies Lon 3/15/79: 92;
Phillips Lon 6/27/84: 206 (lot, B-1 et al);
Phillips Lon 3/27/85: 227 (lot, B-1 et al);

**BARNES, W.C.** (British)
Photos dated: 1868
Processes:      Albumen
Formats:        Prints
Subjects:       Topography
Locations:      Great Britain - Rosneath
Studio:         Great Britain
    Entries:
Christies Lon 4/24/86: 594 (album, 24);

**BARNHOUSE & WHEELER** (American)
Photos dated: 1870s
Processes:      Albumen
Formats:        Stereos
Locations:      US - American west
Studio:         US - Lake City, Colorado
    Entries:
Harris Baltimore 12/10/82: 109 (lot, B & W et al);

**BARNUM, Delis** (American)
Photos dated: c1861-1860s
Processes:      Albumen
Formats:        Stereos
Subjects:       Topography
Locations:      US - New York City; Boston,
                Massachusetts
Studio:         US
    Entries:
Sothebys NY (Strober Coll.) 2/7/70: 444 (lot, B et
    al), 449 (lot, B et al), 462 (lot, B et al), 463
    (lot, B et al), 465 (lot, B et al), 467 (lot, B
    et al), 469 (lot, B-5 et al), 525 (lot, B et al);
Rinhart NY Cat 6, 1973: 513;
Vermont Cat 7, 1974: 636 ill(lot, B-2 et al);
California Galleries 4/3/76: 351 (lot, B et al),
    420 (lot, B et al), 423 (lot, B-1 et al), 428
    (lot, B et al);
Vermont Cat 11/12, 1977: 758 ill;
California Galleries 1/21/78: 179 (lot, B et al);
California Galleries 1/21/79: 299 (lot, B et al);
California Galleries 3/30/80: 380 (lot, B et al);
Harris Baltimore 12/10/82: 27 (lot, B et al), 64
    (lot, B et al);
Harris Baltimore 4/8/83: 67 (lot, B et al);

**BARNUM, D.** (continued)
Harris Baltimore 12/16/83: 95 (lot, B et al), 117
    (lot, B et al);
Harris Baltimore 6/1/84: 107 (lot, B et al);
Harris Baltimore 3/15/85: 11 (lot, B et al), 76
    (lot, B-1 et al), 88 (lot, B-2 et al);

**BARR & YOUNG** (American)
Photos dated: c1865
Processes:      Albumen
Formats:        Cdvs
Subjects:       Portraits
Locations:      Studio
Studio:         US
    Entries:
California Galleries 1/21/78: 128 (lot, B & Y-1
    et al);

**BARR, D.P.** (American)
Photos dated: c1880
Processes:      Albumen
Formats:        Prints
Subjects:       Portraits
Locations:      US - Texas
Studio:         US
    Entries:
Frontier AC, Texas, 1978: 19 (note);

**BARRABLE, J.C.** (British)
Photos dated: 1850s and/or 1860s
Processes:      Albumen
Formats:        Prints
Subjects:       Portraits
Locations:      Great Britain
Studio:         Great Britain
    Entries:
Christies Lon 10/31/85: 211 (lot, B-2 et al);

**BARRATT** (British)
Photos dated: 1850s-1860s
Processes:      Daguerreotype, ambrotype
Formats:        Plates
Subjects:       Portraits
Locations:      Studio
Studio:         England - London
    Entries:
Christies Lon 6/28/79: 12 ill(B & Stanley);
Sothebys Lon 6/17/81: 46;
Christies Lon 6/18/81: 40 (lot, B & Stanley-1,
    et al);
Phillips Lon 10/29/86: 283 (B & Stanley, 2);

**BARRAUD, Herbert**
Photos dated: 1888-1891
Processes:      Carbon, albumen, woodburytype
Formats:        Prints, cdvs
Subjects:       Portraits
Locations:      Studio
Studio:         England - London and Liverpool
    Entries:
Sothebys NY (Strober Coll.) 2/7/70: 266 (lot, B-1
    et al)(note);
Rinhart NY Cat 6, 1973: 359 ill;
Rinhart NY Cat 7, 1973: 129 (books, B et al);
Sothebys Lon 12/4/73: 245 (book, 36);
Sothebys Lon 3/8/74: 158 (books);

BARRAUD, H. (continued)
Sothebys NY 2/25/75: 126 (lot, B-1 et al);
Sothebys Lon 3/21/75: 151 (books, B et al);
California Galleries 9/26/75: 108 (book, 36), 109
    (book, 35);
Sothebys Lon 10/24/75: 170 (book, 36);
Sothebys Lon 3/19/76: 159 (books, B et al);
California Galleries 4/2/76: 171 (books, B et al);
Sothebys Lon 10/29/76: 105 (album, B et al);
California Galleries 1/22/77: 119 (lot, B-1 et al),
    198 (book, 36);
Sothebys Lon 3/9/77: 190 (lot, B et al);
Christies Lon 3/10/77: 341 (book, B et al);
Christies Lon 6/30/77: 177 (lot, B-2 et al);
Sothebys Lon 7/1/77: 267 (books);
Sothebys Lon 11/18/77: 47 (8), 50 (book, 36);
California Galleries 1/22/78: 472 (book, B et al);
Sothebys LA 2/13/78: 141 (2)(note), 142 (2);
Sothebys Lon 10/27/78: 207 (16);
California Galleries 1/21/79: 31 ill(book, 35), 187
    (book, B et al);
Christies Lon 3/15/79: 303 (album, B et al);
Swann NY 4/26/79: 18 (book, 28)(note);
Christies Lon 6/28/79: 241, 250 (lot, B et al);
Christies NY 5/16/80: 321 (book, 144), 322
    (book, 36);
Christies Lon 10/30/80: 308 (book, 72);
Christies Lon 3/26/81: 167, 380 (lot, B-1 et al);
Sothebys Lon 6/17/81: 248 (lot, B-1 et al);
Christies Lon 6/18/81: 262 (book, 36);
Harris Baltimore 7/31/81: 149;
Christies Lon 10/29/81: 293 (book, B et al);
Sothebys Lon 3/15/82: 240 (lot, B-1 et al),
    241 (12);
Phillips Lon 3/17/82: 97 (7);
Christies Lon 10/28/82: 201 (album, B et al);
Harris Baltimore 12/10/82: 185 (books, B et al);
Harris Baltimore 4/8/83: 256 (book, B et al);
Swann NY 5/5/83: 455 (albums, B et al)(note);
Swann NY 11/10/83: 33 (books, B et al);
Harris Baltimore 3/15/85: 260, 308 (lot, B et al);
Phillips Lon 6/26/85: 219;
Phillips Lon 10/30/85: 131;
Sothebys Lon 4/25/86: 168 ill(books, B et al);
Swann NY 5/15/86: 313 (lot, B et al);

BARRAUD, William (British)
Photos dated: 1880s-1890s
Processes:      Woodburytype
Formats:        Prints
Subjects:       Portraits
Locations:      Studio
Studio:         England - London and Liverpool
    Entries:
Witkin NY VI 1978: 12 (2 ills)(2);
Phillips NY 5/5/79: 146 (B-2 plus 1 attributed);
Christies Lon 10/25/79: 298 (book, 72), 441 (lot,
    B et al);
Swann NY 11/18/82: 254 (books, B et al);

BARRETT (British)
Photos dated: c1865
Processes:      Albumen
Formats:        Cdvs
Subjects:       Portraits
Locations:      Studio
Studio:         Great Britain
    Entries:
California Galleries 1/21/78: 131 (album, B et al);

BARRETT, J.O. (American)
Photos dated: 1876
Processes:      Albumen
Formats:        Stereos
Subjects:       Topography
Locations:      US - Philadelphia, Pennsylvania
Studio:         US
    Entries:
Harris Baltimore 12/10/82: 22 (lot, B-1 et al);

BARRETT, W.W. (American)
Photos dated: 1876
Processes:      Albumen
Formats:        Stereo
Subjects:       Genre
Locations:      US - Philadelphia, Pennsylvania
Studio:         US
    Entries:
Rinhart NY Cat 6, 1973: 376;

BARRY, B.
Photos dated: 1887
Processes:      Albumen
Formats:        Prints
Subjects:       Documentary (railroads)
Locations:      India
Studio:
    Entries:
Christies Lon 3/28/85: 226 (lot, B-3 et al);
Christies Lon 10/31/85: 226 (lot, B-3 et al);

BARRY, D.F. (American, died 1934)
Photos dated: c1875-c1900
Processes:      Albumen, gelatin
Formats:        Prints, cabinet cards
Subjects:       Ethnography, documentary (military)
Locations:      US - American west
Studio:         US - Bismark, Dakota Territory
    Entries:
Frontier AC, Texas, 1978: 20 (note);
Sothebys LA 2/7/79: 482 ill, 483 (2), 484;
Sothebys LA 2/6/80: 74 ill(3), 75 ill(2), 76 (2);
Sothebys LA 2/4/81: 45 ill, 46, 47 (2);
California Galleries 3/29/86: 676, 677, 678 (3);

BARRY, P. (British)
Photos dated: 1863
Processes:      Albumen
Formats:        Prints
Subjects:       Documentary (maritime)
Locations:      England
Studio:         Great Britain
    Entries:
Sothebys Lon 6/21/74: 155 (2 ills)(book, 31);

BARTER, G.C. (British)
Photos dated: 1850s
Processes:      Daguerreotype
Formats:        Plates
Subjects:       Portraits
Locations:      Studio
Studio:         England - Southampton
    Entries:
Sothebys Lon 10/27/78: 15;

**BARTIER, W.**
Photos dated: 1895
Processes:      Gelatine
Formats:        Prints
Subjects:       Documentary
Locations:      England
Studio:         England - London
 Entries:
Sothebys Lon 6/28/78: 113;

**BARTLETT & CUTTINGS** [BARTLETT 1]
Photos dated: 1850s
Processes:      Ambrotype
Formats:        Plates
Subjects:       Portraits
Locations:
Studio:
 Entries:
Christies NY 2/8/83: 84 (lot, B & C et al);

**BARTLETT & FRENCH** (American) [BARTLETT 2]
Photos dated: 1860s-1870s
Processes:      Albumen
Formats:        Stereos
Subjects:       Topography
Locations:      US - Philadelphia, Pennsylvania
Studio:         US - Philadelphia, Pennsylvania
 Entries:
Swann NY 4/23/81: 530 (lot, B & F et al);
Christies Lon 3/28/85: 48 (25);

**BARTLETT, George O.** (American)
Photos dated: 1870s
Processes:      Albumen
Formats:        Prints
Subjects:       Documentary (industrial)
Locations:      US - Reading, Pennsylvania
Studio:         US - Reading, Pennsylvania
 Entries:
Sothebys NY 10/4/77: 94;

**BARTLETT, R.H.**
Photos dated: 1880s
Processes:      Albumen
Formats:        Prints
Subjects:       Topography
Locations:      New Zealand
Studio:         New Zealand
 Entries:
Sothebys Lon 5/24/73: 12 (album, 23);

**BARTLETT, R.L.** (British)
Photos dated: Nineteenth century
Processes:      Albumen
Formats:        Prints
Subjects:       Topography
Locations:      Great Britain
Studio:         England - Shrewsbury
 Entries:
Christies Lon 6/26/80: 157 (lot, B-2 et al);

**BARTON & ORR**
Photos dated: 1870s-1880s
Processes:      Albumen
Formats:        Prints
Subjects:       Topography
Locations:      India; Java
Studio:         India - Bangalore
 Entries:
Christies Lon 3/29/84: 68 (lot, B & O et al), 74 ill
 (album, B & O et al), 75 ill(album, 48);
Christies Lon 4/26/86: 48 ill(album, 48);

**BARTON, W. Harvey** (British)
Photos dated: 1860s-1870s
Processes:      Albumen
Formats:        Stereos
Subjects:       Topography
Locations:      England
Studio:         England - Bristol
 Entries:
Sothebys Lon 6/21/74: 65 (lot, B et al);
Christies Lon 10/28/82: 25 (lot, B et al);
Christies Lon 6/23/83: 43 (lot, B et al);
Christies Lon 6/27/85: 37 (lot, B et al);

**BARWELL, Richard** (British)(photographer?)
Photos dated: 1865
Processes:      Albumen
Formats:        Prints
Subjects:       Documentary (medical)
Locations:      England
Studio:         England
 Entries:
Wood Conn Cat 42, 1978: 38 (book, 28)(note);

**BASCHET** (French)
Photos dated: Nineteenth century
Processes:      Woodburytype
Formats:        Prints
Subjects:       Portraits
Locations:
Studio:
 Entries:
Swann NY 4/20/78: 321 (lot, B-1 et al), 322 (lot,
 B-1 et al), 323 (lot, B-4 et al);

**BASHLINE, W.M.** (American)
Photos dated: 1880s-1892
Processes:      Albumen
Formats:        Stereos
Subjects:       Topography
Locations:      US - Titusville, Pennsylvania
Studio:         US
 Entries:
Harris Baltimore 12/10/82: 80 (lot, B-4 et al);

**BASS, E.A.** (American)
Photos dated: 1870s
Processes:      Albumen
Formats:        Stereos
Subjects:       Topography
Locations:      US
Studio:         US - Rockland, Massachusetts
 Entries:
Christies NY 2/8/83: 36 (lot, B et al);

BASSANO, Alexander
Photos dated: 1860s-1887
Processes:      Woodburytype
Format:         Prints, cdvs, cabinet cards
Subjects:       Portraits
Locations:      Studio
Studio:         England - London
    Entries:
Christies Lon 6/14/73: 155 (book, B et al);
Christies Lon 10/4/73: 182 (book, B et al);
Sothebys Lon 12/4/73: 176 (book, B et al);
Christies Lon 4/25/74: 208 (book);
Christies Lon 7/25/74: 328 (book, B et al);
Sothebys Lon 10/24/75: 167 (book, B et al);
Christies Lon 6/10/76: 191 (book, B et al);
Christies Lon 10/28/76: 255, 311 (book, B et al);
Sothebys Lon 10/29/76: 104 (books, B et al), 105
    (album, B et al);
Swann NY 11/11/76: 256 (book, B et al);
Sothebys Lon 3/9/77: 192 (lot, B-1 et al), 197
    (album, B et al);
Christies Lon 3/10/77: 343 (book, B et al);
Christies Lon 10/27/77: 253 (book, B et al);
Sothebys Lon 6/28/78: 148 (book, B et al);
Christies Lon 10/26/78: 337 (album, B et al);
Swann NY 12/8/78: 458 (lot, B et al);
Christies Lon 3/15/79: 303 (album, B et al);
Christies Lon 10/25/79: 438 (album, B et al);
Phillips Lon 3/12/80: 169 (lot, B-1 et al);
Christies Lon 3/20/80: 366 (lot, B et al), 370
    (albums, B et al), 375 (album, B-1 et al), 381
    (album, B-1 et al);
Christies Lon 10/30/80: 317 (book, B et al), 427
    (album, B-1 et al), 438 (album, B et al), 444
    (lot, B-1 et al);
Christies NY 11/11/80: 83 (book, B et al);
Christies Lon 6/24/82: 364 (album, B et al);
Swann NY 11/10/83: 33 (books, B et al);
Harris Baltimore 3/15/85: 276 (lot, B et al), 277
    (lot, B et al), 287 (lot, B et al), 298 (lot,
    B et al), 302 (lot, B et al), 303 (lot, B et
    al), 319 (lot, B et al);
Christies Lon 6/27/85: 246 (albums, B et al)
    (note);
Sothebys Lon 6/28/85: 202 (album, B et al);
Christies Lon 10/31/85: 291 (lot, B et al);
Swann NY 11/14/85: 147 (album, B et al);
Harris Baltimore 2/14/86: 74 (lot, B et al);
Sothebys Lon 4/25/86: 168 (books, B et al), 206
    (album, B et al);
Swann NY 5/15/86: 313 (lot, B et al);
Christies Lon 10/30/86: 237 (lot, B et al);
Harris Baltimore 11/7/86: 225 (lot, B et al);

BASSET, C. (French)
Photos dated: 1860s-1870
Processes:      Albumen
Formats:        Prints
Subjects:       Architecture
Locations:      France - Rouen
Studio:         France - Rouen
    Entries:
California Galleries 3/9/77: 209 ill(lot, B-1
    et al);
Christies Lon 10/27/77: 91;
Christies NY 11/11/80: 60;

BASSO, Lieutenant Richard
Photos dated: 1882-1883
Processes:      Albumen
Formats:        Prints
Subjects:       Documentary (expeditions)
Locations:      Jan Mayen Island
Studio:
Sothebys Lon 7/1/77: 139 ill(20);
Christies Lon 3/16/78: 81 ill(album, 20);

BATELLE, W. (American)
Photos dated: 1866-1870s
Processes:      Albumen
Formats:        Stereos
Subjects:       Topography
Locations:      US - Taunton, Massachusetts
Studio:         US
Harris Baltimore 12/10/82: 87 (lot, B-1 et al);

BATEMAN (British)
Photos dated: c1865-c1875
Processes:      Albumen
Formats:        Prints, cdvs
Subjects:       Architecture, portraits
Locations:      England - Canterbury
Studio:         Great Britain
    Entries:
California Galleries 4/2/76: 219 (4);
California Galleries 1/22/77: 129 (lot, B et al);
California Galleries 1/21/78: 130 (album, B et al);

BATES, Charles Ellison (photographer or author?)
Photos dated: 1873
Processes:      Albumen
Formats:        Prints
Subjects:       Topography
Locations:      India - Kashmir
Studio:
    Entries:
Sothebys Lon 6/27/80: 153 (book, 39);
Sothebys Lon 3/27/81: 90 (book, 39);

BATES, J.L.
Photos dated: Nineteenth century
Processes:      Albumen
Formats:        Stereos
Subjects:       Topography, documentary (scientific)
Locations:      US - Niagara Falls, New York
Studio:
    Entries:
Harris Baltimore 7/31/81: 107 (lot, B et al), 111
    (lot, B et al);

BATES, Joseph (American)
Photos dated: late 1860s
Processes:      Albumen
Formats:        Stereos
Subjects:       Topography
Locations:      US; Canada
Studio:         US - Boston, Massachusetts
    Entries:
Rinhart NY Cat 6, 1973: 391;

**BATHE, W.** (British)
Photos dated: 1890s
Processes:     Albumen
Formats:       Stereos
Subjects:      Topography
Locations:     England - Torquay
Studio:        Great Britain
   Entries:
Sothebys Lon 3/15/82: 14 (20);

**BATSON, A.** (British)
Photos dated: 1855
Processes:
Formats:       Prints
Subjects:      Topography
Locations:     Great Britain
Studio:        Great Britain (Photographic Club)
   Entries:
Sothebys Lon 3/21/75: 286 (albums, B-1 et al);
Sothebys Lon 3/14/79: 324 (album, B-1 et al);
Sothebys Lon 11/1/85: 59 (album, B-1 et al);

**BATTERSBY, J.** (American)
Photos dated: 1860s-1870s
Processes:     Albumen
Formats:       Cdvs, stereos
Subjects:      Portraits, topography
Locations:     US - Chicago, Illinois
Studio:        US - Chicago, Illinois
   Entries:
Sothebys NY (Strober Coll.) 2/7/70: 264 (lot,
  B et al);

**BAUER & BAUERIN**
Photos dated: c1870s
Processes:     Albumen
Formats:       Cdvs
Subjects:      Ethnography
Locations:     Europe
Studio:        Europe
   Entries:
Rinhart NY Cat 7, 1973: 540 (lot, B & B-1 et al);

**BAUERIN** (see BAUER & BAUERIN)

**BAUGH & BENSLEY** (British)
Photos dated: 1860-1864
Processes:     Albumen
Formats:       Prints
Subjects:      Portraits
Locations:     Studio
Studio:        England - London
   Entries:
Christies Lon 10/30/86: 100 (3)(note);

**BAUM, J.** (British)
Photos dated: early 1850s
Processes:     Daguerreotype
Formats:       Plates
Subjects:      Portraits
Locations:     Studio
Studio:        Great Britain
   Entries:
Christies Lon 6/27/85: 22 (lot, B-1 et al);

**BAUTAIN** (French)
Photos dated: early 1850s
Processes:     Daguerreotype
Formats:       Stereo plates
Subjects:      Genre (nudes)
Locations:     Studio
Studio:        France - Paris
   Entries:
Christies Lon 6/27/78: 45 ill(note);

**BAYARD, Hippolyte** (French, 1801-1887)
Photos dated: 1839-1853
Processes:     Positive on paper, daguerreotype,
             salt, albumen
Formats:       Prints, plates, cdvs, stereos
Subjects:      Genre, topography, portraits
Locations:     France - Paris; Normandy
Studio:        France
   Entries:
Rauch Geneva 6/13/61: 65 (lot, B et al)(note);
Sothebys NY (Strober Coll.) 2/7/70: 278 (lot, B &
  Bertall et al);
Sothebys NY 11/21/70: 350 (lot, B-1 et al);
Vermont Cat 1, 1971: 254 ill(album, B attributed
  et al);
California Galleries 3/30/80: 288 ill(note);
Christies Lon 6/26/80: 400 (B & Renard)(note), 401
  (B & Renard), 402 (B & Renard);
Christies Lon 10/30/80: 101 (lot, B & Bertall-1,
  et al), 420 (album, B & Bertall-3, et al);
Sothebys NY 5/15/81: 95 ill;
Christies Lon 6/18/81: 426 (album, B & Bertall-3,
  et al);
Petzold Germany 11/7/81: 302 (album, B & Bertall
  et al);
Bievres France 2/6/83: 12 ill(note), 13 ill, 14;
Sothebys Lon 6/24/83: 65 (2)(note);
Sothebys Lon 10/26/84: 83 ill(note);
Christies NY 5/6/85: 50 (book, B et al)(note);
Sothebys Lon 11/1/85: 112 ill(note);
Sothebys Lon 4/25/86: 169 ill;
Sothebys Lon 10/31/86: 152 ill(note);

**BAYLEY, Lieutenant E.A.** (British)
Photos dated: 1860s
Processes:     Albumen
Formats:       Prints
Subjects:
Locations:
Studio:        Great Britain (Amateur Photographic
             Association)
   Entries:
Christies Lon 10/27/83: 218 (albums, B-1 et al);
Christies Lon 6/27/85: 155 (album, B et al)(note);

**BAYLEY, G. Herbert & Horace C.** (British)
Photos dated: 1887-1894
Processes:     Bromide
Formats:       Prints
Subjects:      Documentary (engineering)
Locations:     England - Manchester
Studio:        England
   Entries:
Swann NY 12/8/77: 393 (books)(note);
California Galleries 1/21/78: 134 (lot, B et al);
Sothebys Lon 3/21/80: 259 ill(books, 62);

**BAYLISS, Charles** (British, Australian, 1850-1897)
Photos dated: 1880s-1890s
Processes:      Albumen
Formats:        Prints
Subjects:       Topography
Locations:      Australia
Studio:         Australia - Sydney
    Entries:
Edwards Lon 1975: 37 (album, B-4 et al);
Swann NY 2/6/75: 20 (album, 25);
Sothebys Lon 3/21/75: 85 (albums, B et al);
Sothebys Lon 6/11/76: 36a (album, B et al);
Christies Lon 10/27/77: 151 (albums, B-12 et al);
Sothebys Lon 3/22/78: 94 (albums, B et al), 95 ill
    (album, B et al);
Sothebys Lon 10/27/78: 100 ill(album, B et al);
Christies Lon 6/26/80: 229 (album, 15);
Phillips NY 5/9/81: 69 (albums, B-56 et al);
Christies Lon 10/29/81: 272 (album, B et al);
Christies Lon 10/28/82: 120 (album, B et al);
Christies Lon 6/23/83: 180 (albums, B et al);
Christies Lon 6/28/84: 139 (album, B-15 et al);
Christies Lon 3/28/85: 106 (albums, B et al);
Christies Lon 6/26/86: 108 (album, B et al);

**BEAL** (American)
Photos dated: c1870s
Processes:      Albumen
Formats:        Stereos
Subjects:       Topography
Locations:      US - Minneapolis, Minnesota
Studio:         US
    Entries:
Rinhart NY Cat 6, 1973: 495;
Rinhart NY Cat 7, 1973: 198;
Harris Baltimore 6/1/84: 93 (lot, B et al);

**BEAL, Joshua H.** (American)
Photos dated: early 1860s-1876
Processes:      Albumen
Formats:        Prints incl. panoramas
Subjects:       Topography, documentary (Civil War,
                engineering)
Locations:      US - New York City
Studio:         US - New York City
    Entries:
Sothebys NY (Strober Coll.) 2/7/70: 411 (4)(note);
Rinhart NY Cat 6, 1973: 339;
Sothebys Lon 10/18/74: 136 ill;
Sothebys NY 2/25/75: 174;
California Galleries 9/26/75: 227;

**BEALES, Anthony** (British)
Photos dated: 1890s
Processes:      Albumen
Formats:        Prints
Subjects:       Portraits
Locations:      Studio
Studio:         England - Northampton
    Entries:
Sothebys Lon 6/17/81: 253;

**BEALS, A.J.** (American)
Photos dated: 1840s-c1860
Processes:      Daguerreotype
Formats:        Plates
Subjects:       Portraits
Locations:      Studio
Studio:         US - New York City
    Entries:
Vermont Cat 4, 1972: 315 ill;
Vermont Cat 10, 1975: 534 ill;
Witkin NY IV 1976: D23 ill;
Gordon NY 5/3/76: 268 (lot, B et al);
Sothebys Lon 7/1/77: 223 (lot, B-1 et al);
Swann NY 4/23/81: 248 (lot, B-1 et al);
Christies NY 2/8/83: 75 (lot, B-1 et al);

**BEAMAN, E.O.** (American)(see also HILLERS)
Photos dated: 1871-1872
Processes:      Albumen
Formats:        Stereos
Subjects:       Topography, ethnography
Locations:      US - Colorado, Arizona
Studio:         US
    Entries:
Rinhart NY Cat 1, 1971: 177 (3), 308 (lot,
    B-1 et al);
Rinhart NY Cat 2, 1971: 577 (B & Hillers, 5),
    578 (lot, B-1 et al);
California Galleries 4/3/76: 338 (lot, B et al);
Frontier AC, Texas, 1978: 88 (lot, B-1 et al)(note);
Wood Conn Cat 41, 1978: 204 (2 ills)(lot, B-7
    et al)(note);
Swann NY 12/14/78: 267 (4 ills)(note), 268 (4 ills)
    (note);
Swann NY 10/18/79: 425 (lot, B et al);
California Galleries 3/30/80: 409 (lot, B-4 et al);

**BEAMISH, Charles**
Photos dated: 1870s
Processes:      Albumen
Formats:        Prints
Subjects:       Topography
Locations:      England
Studio:         England
    Entries:
Sothebys Lon 3/15/82: 333 (32);

**BEARD & Co.** (British)
Photos dated: mid 1860s
Processes:      Albumen
Formats:        Prints
Subjects:       Architecture
Locations:      England - Berkshire County
Studio:         England - Twyford
    Entries:
Sothebys Lon 3/9/77: 163 ill(book, 72);

BEARD, Richard (British, c1801-1885)
Photos dated: 1841-1853
Processes:      Daguerreotype, ambrotype, albumen
Formats:        Plates incl. stereo, prints, cdvs
Subjects:       Portraits, architecture
Locations:      England
Studio:         England - London; Liverpool;
                Manchester; Brighton; Southampton
    Entries:
Vermont Cat 6, 1973: 511 ill;
Sothebys Lon 5/24/73: 142 (lot, B-1 et al);
Sothebys Lon 12/4/73: 188;
Vermont Cat 8, 1974: 465 ill;
Sothebys Lon 3/8/74: 133 (lot, B-1 et al), 135;
Sothebys Lon 6/21/74: 129 (lot, B-2 et al), 132;
Sothebys NY 2/25/75: 1 (lot, B-2 et al);
Sothebys Lon 3/21/75: 200, 201, 202, 203, 204;
Sothebys Lon 6/26/75: 162, 163, 164, 165, 166;
Sothebys Lon 10/24/75: 1 (lot, B-1 et al), 17, 18,
    19, 20 (2), 21 (lot, B-1 et al), 22, 24;
Colnaghi Lon 1976: 9 ill(note);
Rose Boston Cat 1, 1976: 79 ill;
Sothebys Lon 3/19/76: 94, 95 (2);
Christies Lon 6/10/76: 7;
Sothebys Lon 6/11/76: 121, 122, 123;
Christies Lon 10/28/76: 12, 13, 14, 15, 16, 17
    (note);
Sothebys Lon 10/29/76: 215 ill(note), 216 (3), 218
    (lot, B-1 et al);
Christies Lon 3/10/77: 3 ill(attributed)(note), 9,
    10, 11, 26 ill(note);
Christies Lon 6/30/77: 3 (lot, B-1 et al), 4, 5
    (lot, B-1, B & Sharp-2, et al), 10 ill
    (attributed)(note), 11 ill(attributed)(note),
    156 (lot, B-3 et al);
Sothebys Lon 7/1/77: 205 (lot, B & Foard-1, et al),
    227;
Christies Lon 10/27/77: 2 (lot, B-1 et al), 3 (2),
    4 (lot, B-1 et al), 28 ill(note);
Christies Lon 3/16/78: 1 (attributed), 2 (lot, B-3
    et al), 3;
Sothebys Lon 3/22/78: 147, 148;
Christies Lon 6/27/78: 2 (lot, B-1 et al), 6;
Sothebys Lon 6/28/78: 179 ill, 215 ill;
Sothebys Lon 3/14/79: 38, 39, 40 (B & Foard);
Christies Lon 3/15/79: 1, 2, 3 (note), 4 (note),
    5 ill, 6 ill(note), 7 (lot, B-1 et al);
Christies Lon 6/28/79: 1;
Sothebys Lon 6/29/79: 54, 55, 56, 59, 60 ill;
Christies Lon 10/25/79: 10, 11, 12 ill;
Christies NY 10/31/79: 5 ill;
Christies Lon 3/20/80: 1, 4, 5, 63;
Sothebys Lon 3/21/80: 38, 39 ill, 40 ill, 40a ill;
Christies Lon 6/26/80: 3;
Sothebys Lon 6/27/80: 35, 36 (B & Foard);
Sothebys Lon 10/29/80: 156 (lot, B-1, B & Foard-1,
    et al);
Christies Lon 10/30/80: 1, 16, 92, 444;
Christies Lon 3/26/81: 3, 17, 18 (lot, B-1 et al),
    46 (lot, B & Foard-1, et al), 403 (album, B
    et al);
Sothebys Lon 6/17/81: 59, 73 ill;
Christies Lon 6/18/81: 2 (lot, B-1 et al), 6 (lot,
    B-1 et al);
Sothebys Lon 10/28/81: 286, 287;
Christies Lon 10/29/81: 3, 4 (lot, B-1 et al), 60
    (lot, B-1 et al), 368 (lot, B-1 et al);
Christies Lon 3/11/82: 2 (lot, B-1 et al), 3, 4
    (lot, B-2 et al);
Swann NY 4/1/82: 282 (note);
Phillips Lon 6/23/82: 20 (lot, B-1 et al);

BEARD, R. (continued)
Christies Lon 6/24/82: 2 (lot, B-2 et al), 34;
Sothebys Lon 6/25/82: 35 (lot, B-2 et al);
Christies Lon 10/28/82: 1 (lot, B-1 et al);
Christies Lon 3/24/83: 19;
Phillips Lon 6/15/83: 107 (lot, B-2 et al);
Christies Lon 6/23/83: 15 (lot, B-1 et al), 16 (2),
    17, 18, 259 (lot, B et al);
Phillips Lon 11/4/83: 12 (lot, B-1 et al), 22 (lot,
    B-3 et al);
Christies Lon 10/25/84: 14, 14A;
Sothebys Lon 3/29/85: 54 (lot, B-2 et al), 55 ill,
    56 ill, 57 ill, 58, 59;
Christies Lon 6/27/85: 19, 20 (B & Foard), 21 (B &
    Clarkington);
Sothebys Lon 6/28/85: 26 (lot, B-1 et al), 27, 28
    ill(lot, B-1 et al)(note), 29 ill(note);
Christies Lon 10/31/85: 20 (lot, B-1 et al);
Christies Lon 4/24/86: 312;
Sothebys Lon 4/25/86: 3 ill, 4 ill;
Phillips Lon 10/29/86: 269 ill, 281 (lot,
    B-1 et al);
Christies Lon 10/30/86: 9 (lot, B-1 et al);

BEASLEY
Photos dated: Nineteenth century
Processes:      Albumen
Formats:        Prints
Subjects:       Topography
Locations:      Switzerland - Grindelwald
Studio:
    Entries:
Christies NY 2/13/85: 133 (lot, B-1 et al);

BEASLY, F., Jr. (British)
Photos dated: 1860s
Processes:      Albumen (Fothergill process)
Formats:        Prints
Subjects:       Topography
Locations:      England
Studio:         England (Amateur Photographic
                Association)
    Entries:
Sothebys Lon 10/29/80: 310 (album, B et al);
Christies Lon 10/27/83: 218 (albums, B-6 et al);
Christies Lon 3/29/84: 203 (5)(note);

BEATO, Antonio (died 1903)
Photos dated: 1862-1880s
Processes:      Albumen
Formats:        Prints, cdvs
Subjects:       Topography
Locations:      Egypt
Studio:         Egypt
    Entries:
Swann NY 2/14/52: 121 (album, B et al);
Sothebys Lon 5/24/73: 9 (lot, B-29 et al);
Witkin NY II 1974: 888 (lot, B-29 et al);
Sothebys Lon 6/21/74: 81 (albums, B et al), 83
    (album, B-2 et al);
Sothebys Lon 10/18/74: 111 (album, B et al), 112
    (album, B-20 et al);
Sothebys NY 2/25/75: 155 (lot, B-8 et al), 157 ill
    (lot, B-3 et al);
Sothebys Lon 3/21/75: 110 (album, B-21 et al), 112
    (album, B-13 et al)(note);
California Galleries 9/26/75: 128 (albums, B et al);
Sothebys Lon 10/24/75: 112 (album, B-9 et al);

## BEATO, A. (continued)

Kingston Boston 1976: 16 ill(1 plus 2 attributed),
175 (album, B-17 et al);
California Galleries 4/2/76: 209 (lot, B et al);
Christies Lon 6/10/76: 81 (album, B et al), 82
(album, B et al), 83 (album, B et al), 84
(album, B et al);
Sothebys NY 11/9/76: 126 (lot, B-1 et al);
Sothebys NY 2/9/77: 86 (lot, B-4 et al), 90
(lot, B-1 et al);
Christies Lon 3/10/77: 142 (album, B-11 et al);
Gordon NY 5/10/77: 803 ill(album, B et al);
Christies Lon 6/30/77: 122 (album, B-28 et al), 123
(album, B-23 et al), 135 (album, B-1 et al);
Christies Lon 10/27/77: 139 (lot, B-14 et al);
Sothebys Lon 11/18/77: 106 (album, B et al);
California Galleries 1/21/78: 223 (4);
Sothebys LA 2/13/78: 137 (lot, B-1 et al);
Christies Lon 3/16/78: 105 ill(album, B-20 et al),
147 (albums, B et al), 153 (lot, B et al);
Christies Lon 6/27/78: 120 (45), 124 (album, B-11
et al);
Christies Lon 10/26/78: 169 (16), 170 (lot, B-1
et al);
Christies Lon 3/15/79: 187 (albums, B-16 et al), 192
(album, B et al);
Sothebys NY 5/8/79: 106 (lot, B et al);
Christies Lon 6/28/79: 120 (albums, B-20 et al);
Christies Lon 10/25/79: 187 ill(album, B-29 plus 107
attributed), 236 (lot, B-1 et al);
Sothebys NY 11/2/79: 254 (lot, B-1 et al);
Sothebys LA 2/6/80: 166 ill(lot, B-40 et al), 167
(lot, B-3 et al);
Christies Lon 3/20/80: 163 (albums, B-8 et al), 205
(album, B-5 et al);
Sothebys Lon 3/21/80: 125 (album, B et al), 127 ill
(album, B et al);
California Galleries 3/30/80: 240 (4);
Sothebys NY 5/20/80: 394 ill;
Auer Paris 5/31/80: 66 ill, 69 (10), 71 (album, B-28
et al);
Sothebys Lon 6/27/80: 74 (album, B et al);
Sothebys Lon 10/29/80: 55 (album, B et al);
Christies Lon 10/30/80: 216 ill(album, B-15 plus 51
attributed)(note), 220 (lot, B et al), 248
(albums, B et al);
Swann NY 11/6/80: 277 (lot, B-2 et al);
Christies Lon 3/26/81: 223 (album, B-13 et al), 259
(album, B-3 et al);
Sothebys Lon 3/27/81: 53 (lot, B et al);
Swann NY 4/23/81: 454 (lot, B et al)(note);
Sothebys NY 5/15/81: 107;
Sothebys Lon 6/17/81: 158 (lot, B et al), 159 (lot,
B et al);
Christies Lon 6/18/81: 235 (lot, B et al);
Phillips Lon 10/28/81: 160 (albums, B et al);
Sothebys Lon 10/28/81: 105 (lot, B et al);
Christies Lon 10/29/81: 214 (album, B-13 et al), 219
(albums, B-6 et al), 222 (album, B-29 et al);
Swann NY 11/5/81: 270, 271 (7), 463 (album, B et al)
(note), 515 (lot, B-2 et al);
Rose Florida Cat 7, 1982: 42 ill;
Christies Lon 3/11/82: 161 (lot, B et al);
Swann NY 4/1/82: 255 ill(15)(note);
California Galleries 5/23/82: 283 (lot, B-2 et al);
Sothebys NY 5/25/82: 321 ill(album, B et al);
Phillips Lon 6/23/82: 43 (lot, B et al);
Christies Lon 6/24/82: 173 (album, B et al), 174
(lot, B-10 et al), 176 (17), 177 (album, B et
al), 178 (album, B-14 et al), 197 (lot, B et al);

## BEATO, A. (continued)

Swann NY 11/18/82: 367 (lot, B-18 et al), 368 (lot,
B-2 et al), 443 (album, B-1 et al);
Harris Baltimore 12/10/82: 200 (2), 385 (album, B-13
et al);
Christies Lon 3/24/83: 92 (album, B et al), 93
(albums, B et al), 138 (albums, B et al);
Swann NY 5/5/83: 406 (lot, B-19 et al);
Sothebys NY 5/11/83: 322 ill;
Christies Lon 10/27/83: 88 (lot, B et al), 91
(lot, B et al), 97 (album, B-13 et al);
Swann NY 11/10/83: 180 (album, 116)(note);
Swann NY 5/10/84: 210 (lot, B et al), 277 (lot,
B et al);
Christies Lon 6/28/84: 84 (album, B et al), 86
(album, B et al), 89 (lot, B et al), 142
(album, B et al);
Christies Lon 10/25/84: 73 (lot, B-5 et al), 99
(lot, B et al);
Sothebys Lon 10/26/84: 28 (albums, B et al), 51
ill(2);
Swann NY 11/8/84: 147 (lot, B et al)(note);
Phillips Lon 3/27/85: 213 (lot, B-2 et al);
Christies Lon 3/28/85: 68 (albums, B-8 et al), 98
(lot, B-39 et al), 216 (lot, B-1 et al);
Sothebys Lon 3/29/85: 76 ill(album, B et al);
Swann NY 5/9/85: 384 (lot, B et al);
Christies Lon 6/27/85: 83 (lot, B et al), 84 (lot,
B-2 et al), 92 (lot, B et al);
Phillips Lon 10/30/85: 83 (album, B et al), 146A
(album, B et al);
Christies Lon 10/31/85: 96 (album, B-32 et al), 97
(album, B-10 et al), 98 (albums, B-7 et al), 134
(albums, B et al), 192 (lot, B-1 et al);
Sothebys Lon 11/1/85: 35 (album, B et al);
Christies Lon 4/24/86: 385 (lot, B-3 et al), 386
(album, B-11 et al), 387 (album, B-2 et al), 402
(lot, B-3 et al), 407 (album, B-2 et al);
Sothebys Lon 4/25/86: 41 (albums, B et al);
Swann NY 5/15/86: 279 (lot, B-10 et al);
Christies Lon 6/26/86: 34 (albums, B et al), 72
(lot, B et al), 105 (albums, B et al), 118
(albums, B et al), 179 (album, B et al);
Phillips Lon 10/29/86: 322 (lot, B et al), 338 ill
(lot, B-19 et al);
Christies Lon 10/30/86: 134 (album, B-42 et al);
Sothebys Lon 10/31/86: 19 (album, B-4 et al);
Swann NY 11/13/86: 146 ill(album, 115), 212 (lot,
B et al);

## BEATO, Felice A. (British, c1830-c1903)(see also
ROBERTSON)

Photos dated: 1852-1885
Processes:    Salt, albumen
Formats:      Prints incl. panoramas, stereos, cdvs
Subjects:     Topography, ethnography
Locations:    Malta; Greece; Turkey; Palestine;
              India;
              China; Japan; Korea
Studio:
  Entries:
Goldschmidt Lon Cat 52, 1939: 175 ill(42)(note);
Weil Lon Cat 1, 1943: 142 (lot, B et al)(note);
Weil Lon Cat 4, 1944(?): 245 (B & Robertson, 6)
(note);
Weil Lon Cat 7, 1945: 86 ill(42)(note), 96 (4);
Weil Lon 1946: 117 (B & Robertson, 6);
Weil Lon Cat 14, 1949(?): 313 (B & Robertson, 6)
(note), 316 (42)(note), 317 (album, B-10 et al);
Lunn DC Cat 3, 1973: 13 ill(album, 186)(note);

**BEATO, F.** (continued)

Ricketts Lon 1973: 14 ill(album, 43);
Rinhart NY Cat 8, 1973: 32 (attributed);
Vermont Cat 5, 1973: 492 ill(B & Robertson)(note);
Sothebys Lon 12/4/73: 3 (album, B-1 et al), 214 (B & Robertson)(note), 215 (B & Robertson), 216 ill (B & Robertson), 217 ill(B & Robertson), 218 (2 ills)(album, B & Robertson-17, et al)(note);
Sothebys Lon 6/21/74: 198 (B & Robertson), 199 ill (B & Robertson), 200 (B & Robertson), 201 (B & Robertson), 202 (B & Robertson), 203 ill(B & Robertson), 204 (B & Robertson), 205 (B & Robertson), 206 (2 ills)(album, B & Robertson-58, et al)(note);
Sothebys Lon 10/18/74: 126 ill(album, B et al), 289 ill (B & Robertson)(note), 290 ill(B & Robertson), 291 (2 ills)(B & Robertson, 2), 292 (3 ills)(album, B & Robertson, 56)(note);
Edwards Lon 1975: 3 (album, B et al)(note);
Stern Chicago 1975(?): 5 ill(album, 24)(note);
Sothebys NY 2/25/75: 33 ill(B & Robertson)(note), 34 (B & Robertson), 35 ill(B & Robertson), 36 (B & Robertson, 2), 37 ill(note), 162 (2)(note), 163;
Sothebys Lon 3/21/75: 70 (B & Robertson)(note), 71 (B & Robertson, 2), 72 ill(album, B & Robertson-10, et al)(note), 116 (book, 24), 288 (album, B-1 et al);
Sothebys Lon 6/26/75: 132 (album, B-4, B & Robertson-5, et al), 133 (album, B & Robertson-3 attributed, et al), 139 ill(album, 25) (attributed);
Sothebys Lon 10/24/75: 123 ill(albums, B-70 attributed et al), 124 ill(album, 54) (attributed), 201 ill(B & Robertson), 201a (B & Robertson), 202 ill(B & Robertson), 203 ill(B & Robertson, 25), 204 (B & Robertson, 4);
Colnaghi Lon 1976: 59 ill(B & Robertson)(note), 60 ill(B & Robertson)(note), 61 (B & Robertson) (note), 62 (B & Robertson)(note), 63 (B & Robertson), 64 (B & Robertson), 65 (B & Robertson), 66 (B & Robertson), 67 (B & Robertson), 68 (B & Robertson), 69 (B & Robertson), 70 (B & Robertson), 71 (B & Robertson), 72 (B & Robertson)(note), 73 (B & Robertson), 74 ill(B & Robertson), 75 ill(B & Robertson), 76 ill(B & Robertson), 77 ill(B & Robertson), 78 (B & Robertson), 79 (B & Robertson), 80 (B & Robertson), 81 (B & Robertson)(note), 82 (B & Robertson), 83 (B & Robertson), 84 (B & Robertson), 85 (B & Robertson), 86 (B & Robertson), 87 (B & Robertson);
Kingston Boston 1976: 15 (4 ills)(9)(note);
Lunn DC Cat 6, 1976: 3 (album, B & Robertson, 58) (note), 4.1 ill(note), 4.2 (note), 4.3 ill (note), 6 ill(note), 7 ill(note), 8 ill, 9 ill;
Witkin NY IV 1976: 26 ill(note), 27 ill(note);
Sothebys Lon 3/19/76: 246 ill(album, B & Robertson, 12), 247 ill(album, B & Robertson-17, et al), 248 (B & Robertson), 249 ill(B & Robertson), 250 (B & Robertson, 4), 251 ill(B & Robertson), 252 (B & Robertson, 6), 253 (B & Robertson, 2), 254 (B & Robertson, 5);
Gordon NY 5/3/76: 295 ill(lot, B et al);
Sothebys Lon 6/11/76: 37 (lot, B-1 attributed, et al), 42 ill(album, B-39 attributed, et al), 231 (9, attributed), 232 (B & Robertson, 8), 233 (B & Robertson);
Sothebys Lon 10/29/76: 53 ill(album, B-14 attributed, et al);

**BEATO, F.** (continued)

Gordon NY 11/13/76: 44 ill(lot, B-10 et al);
Rose Boston Cat 2, 1977: 79 ill(note), 80 ill;
Sothebys Lon 3/9/77: 39 (album, B-65 attributed et al), 229 (B & Robertson, 3), 230 (B & Robertson, 6);
Christies Lon 3/10/77: 133 ill(B & Robertson-2 plus 1 attributed), 134 ill(lot, B-5, B & Robertson-7, et al)(note), 135;
Gordon NY 5/10/77: 804 ill, 805 ill(3), 806;
Christies Lon 6/30/77: 115 (album, B attributed et al), 117 (2 ills)(book, 25)(attributed)(note);
Sothebys Lon 7/1/77: 54 (book, 8)(attributed), 134 (lot, B & Robertson-1, et al);
Sothebys NY 10/4/77: 176 (lot, B & Robertson-2, et al), 177 (lot, B-1 et al), 178 (3), 179 (3);
Christies Lon 10/27/77: 127 (2 ills)(album, B-22 et al)(note);
Sothebys Lon 11/18/77: 118 ill(album, B & Robertson, 20)(note), 119 (2 ills)(album, B & Robertson, 58)(note), 120 ill(album, B & Robertson, 20);
Swann NY 12/8/77: 365 ill (lot, B-3 et al);
Lunn DC Cat QP, 1978: 35 ill;
Rose Boston Cat 3, 1978: 88 ill(note), 89 ill, 101 ill(B & Robertson);
Sothebys LA 2/13/78: 87 ill(B & Robertson), 88 ill (B & Robertson), 89 (B & Robertson), 90 ill(B & Robertson);
Christies Lon 3/16/78: 97 ill(album, B, B & Robertson, et al), 300 (album, B attributed, et al), 347 ill(B & Robertson)(note), 348 (B & Robertson)(note), 349 (B & Robertson, 3), 350 (B & Robertson), 351 ill(B & Robertson, 3), 352 (B & Robertson, 8);
Sothebys Lon 3/22/78: 50 ill(note), 51 ill(3), 52 ill, 53 ill(3), 54 ill, 55 ill(3), 56 ill, 57 (2), 58 ill(2), 191 (album, B & Robertson et al);
Christies Lon 6/27/78: 105 (B & Robertson), 106 (B & Robertson)(note), 107 (B & Robertson), 108 (B & Robertson), 109, 110, 113 ill(album, 14) (attributed);
Sothebys Lon 6/28/78: 70 ill(B & Robertson, 12), 71 ill (B & Robertson), 72 ill(B & Robertson), 73 ill(B & Robertson, 5), 74 ill(B & Robertson), 75 ill(B & Robertson), 76 ill(B & Robertson);
Christies Lon 10/26/78: 288 (B & Robertson, 3), 289 (B & Robertson), 290 (B & Robertson, 4), 291 ill (B & Robertson, 2), 292 (B & Robertson, 2), 293 (B & Robertson, 3), 294 (B & Robertson), 295 (B & Robertson), 296 (B & Robertson);
Sothebys Lon 10/27/78: 162 (lot, B & Robertson-15, et al);
Swann NY 12/14/78: 374 (albums, B et al);
Lennert Munich Cat 5, 1979: 19;
Witkin NY VIII 1979: 14 (4 ills)(4);
California Galleries 1/21/79: 394, 395 ill, 396 (12);
Phillips Lon 3/13/79: 60 (albums, B et al);
Christies Lon 3/15/79: 170 (B & Robertson)(note), 171 (B & Robertson)(3), 172 (B & Robertson), 173 (album, 14)(note);
Christies NY 5/4/79: 22 ill(note);
Sothebys NY 5/8/79: 61 (B & Robertson);
Sothebys Lon 6/29/79: 92 (2);
Christies Lon 6/28/79: 108 (B & Robertson);
Phillips Can 10/4/79: 14 ill, 15;
Christies Lon 10/25/79: 185 ill(album, B-2 attributed et al), 199 (lot, B-2 et al), 214 ill(B & Robertson)(note), 215 (B & Robertson), 216 (B & Robertson), 216A (B & Robertson, 2),

## BEATO, F. (continued)

217 ill(B & Robertson), 218 (B & Robertson), 219
(B & Robertson), 220 (B & Robertson), 378 ill
(album, B & Robertson-3, et al)(note);
Sothebys NY 11/2/79: 269 ill(5)(note), 270 (note),
271 ill, 272 ill, 273, 274 (2 ills)(album, B-23
et al)(note);
Phillips NY 11/3/79: 182a ill(album, B et al)
(note), 183 ill(3), 184 (album, B-5 et al);
Phillips NY 11/29/79: 261 (album, B-11 et al);
Sothebys NY 12/19/79: 38 ill, 39 ill, 40 ill, 95
(lot, B & Robertson et al);
Rose Boston Cat 5, 1980: 75 ill(note), 76 ill,
77 ill;
Sothebys LA 2/6/80: 169 ill(B & Robertson, 11), 182
ill, 183 ill, 184, 185;
Christies Lon 3/20/80: 180 (album, B-1 et al);
Sothebys Lon 3/21/80: 110 (B & Robertson, 2);
California Galleries 3/30/80: 241 (3);
Christies NY 5/16/80: 204 (lot, B et al), 213 (lot,
B et al), 217 ill(attributed), 218;
Sothebys NY 5/20/80: 409 ill(album, 23)(note), 410
ill(attributed)(note), 411 (2 ills)(album, B et
al)(note);
Phillips NY 5/21/80: 145 (album, B-1 et al),
233 (2);
Christies Lon 6/26/80: 216 (B & Robertson), 217 (B &
Robertson), 218 (B & Robertson)(2);
Sothebys Lon 10/29/80: 290 ill(B & Robertson);
Christies Lon 10/30/80: 369 ill(B & Robertson, 11)
(note), 370 ill(B & Robertson), 371 ill
(attributed), 372 (attributed), 373 (2)
(attributed), 374 ill(note), 375 ill(note),
376 ill(3);
Swann NY 11/6/80: 240 (4);
Christies NY 11/11/80: 78 (lot, B et al);
Sothebys NY 11/17/80: 90 ill(B & Robertson,
attributed)(note);
Sothebys LA 2/4/81: 51 (album, B et al)(note);
Christies Lon 3/26/81: 235 ill(lot, B-32 et al)
(note), 238 (lot, B-1 et al), 239 ill(album,
50), 240 ill(album, B et al), 270 (album, B et
al), 343 ill(album, B & Robertson-25, et al),
344 (lot, B & Robertson-2 et al);
Sothebys Lon 3/27/81: 77 ill(attributed), 78 ill
(attributed), 95, 413 ill(B & Robertson), 415 ill
(B & Robertson), 415a (B & Robertson);
Phillips NY 5/9/81: 56 ill(48), 64 ill(album, B et
al), 65 ill(album, B attributed, et al);
Sothebys Lon 6/17/81: 371 (B & Robertson), 375 (B &
Robertson), 376;
Christies Lon 6/18/81: 201 (B & Robertson), 202 (B &
Robertson), 203 (B & Robertson), 204 (B &
Robertson, attributed), 205 (B & Robertson,
attributed), 206 (B & Robertson, attributed),
223 (album, B attributed et al);
Harris Baltimore 7/31/81: 151 (note), 152;
Sothebys Lon 10/28/81: 122, 123, 329 (B &
Robertson), 330 (B & Robertson), 332 ill
(B & Robertson), 333 (B & Robertson, 5), 334
(B & Robertson);
Christies Lon 10/29/81: 205 (B & Robertson, 2), 213
ill(B & Robertson, attributed)(note), 243
(album, B-4 et al);
Swann NY 11/5/81: 539 (B & Robertson-1, plus B &
Robertson, attributed, 16)(note);
Old Japan, England, Cat 5, 1982: 4 (lot, B-1 et
al), 9 (lot, B et al), 10 (lot, B-1 et al), 17
ill(lot, B-28 et al), 18 ill(note), 19 (4 ills)
(30)(note);

## BEATO, F. (continued)

Christies Lon 3/11/82: 191 ill, 192 (2), 193 (2),
194 (3), 195 (4), 196 (8), 198 (lot, B et al),
200 (album, B et al), 201 (album, B et al);
Sothebys Lon 3/15/82: 108 ill(album, 50), 111 (lot,
B-32 et al), 349 (B & Robertson, 4), 350a (B &
Robertson, 3), 354 ill;
Harris Baltimore 3/26/82: 224 (2), 225 (2), 226
(note), 227 ill, 228, 229, 230, 231, 232, 233,
234, 235, 236, 237;
Sothebys NY 5/24/82: 217 ill(note);
Christies Lon 6/24/82: 186 (B & Robertson);
Sothebys Lon 6/25/82: 163 (B & Robertson, 5), 164
ill (album, B & Robertson, 34);
Christies Lon 10/28/82: 57 (lot, B & Robertson-3,
et al), 86 (B & Robertson, 10), 95 (lot, B-2 et
al), 96 ill(album, 25), 97 ill(album, 27);
Sothebys Lon 10/29/82: 41, 42 ill, 43;
Swann NY 11/18/82: 332 (4), 367 (lot, B &
Robertson-1, et al), 422 (lot, B & Robertson-1,
et al);
Bievres France 2/6/83: 17 (note), 18 ill;
Christies NY 2/8/83: 14 (2), 15 (lot, B attributed
et al);
Christies Lon 3/24/83: 107 (album, B et al)(note),
122 ill(album, B-10 et al)(note);
Swann NY 5/5/83: 276 (23), 426 (B & Robertson, 3)
(note);
California Galleries 6/19/83: 202, 203;
Christies Lon 6/23/83: 127 ill(B & Robertson, 6),
146 ill(album, B-10 et al)(note), 158 ill;
Sothebys Lon 6/24/83: 33 ill(18);
Christies Lon 10/27/83: 66 (album, B & Robertson-3,
et al), 111 ill(lot, B et al), 139 (4), 140
(attributed, 4), 141 (2 ills)(album, 48)(note);
Swann NY 11/10/83: 255 (albums, B et al)(note);
Sothebys Lon 12/9/83: 27 ill(album, 50);
Harris Baltimore 12/16/83: 278;
Christies NY 2/22/84: 11 (lot, B et al);
Christies Lon 3/22/84: 89 (3)(note);
Swann NY 5/10/84: 327 (album, B & Robertson-3,
et al)(note);
Harris Baltimore 6/1/84: 312 (note);
Sothebys Lon 6/29/84: 166 ill(lot, B & Robertson-43,
et al);
California Galleries 7/1/84: 278 ill, 279 (2), 280
(3), 281 ill(2), 282 (2);
Phillips Lon 10/24/84: 106 (album, B & Robertson
et al);
Christies Lon 10/25/84: 78 ill(album, B et al), 78A
(album, B-2 et al)(note), 79 (lot, B-2 et al);
Sothebys Lon 10/26/84: 55 ill(B & Robertson), 56
ill(B & Robertson) 57 ill(B & Robertson), 58 ill
(B & Robertson);
Christies NY 11/6/84: 4 ill(B & Robertson, 3);
Swann NY 11/8/84: 193 (album, B et al)(note), 195
(album, B et al)(note), 246 (B & Robertson, 5);
Old Japan, England, Cat 8, 1985: 8 (note), 9, 10
ill, 11 ill, 12 ill, 13, 14, 15, 16 (9), 17
(2 ills)(17);
Christies Lon 3/28/85: 90 (lot, B et al), 162 ill
(B & Robertson)(note), 163 (2)(note);
Sothebys Lon 3/29/85: 80 ill(B & Robertson), 81 ill
(B & Robertson), 97 ill, 98 ill(7), 99 ill(2),
100 ill(album, B et al), 152 (albums, B &
Robertson-1, et al);
Sothebys NY 5/7/85: 208A ill(album, B &
Robertson, 20);
California Galleries 6/8/85: 155 ill, 156;

## BEATO, F. (continued)

Sothebys Lon 6/28/85: 58 ill(B & Robertson), 59 ill
(B & Robertson), 60 ill(B & Robertson), 61 ill
(B & Robertson), 62 ill(B & Robertson), 63 ill,
64 ill;
Christies Lon 10/31/85: 109 (2 plus 1 attributed),
203 ill;
Sothebys Lon 11/1/85: 29 ill(B & Robertson);
Swann NY 11/14/85: 111 (album, B attributed et al)
(note);
Harris Baltimore 2/14/86: 338 (B & Robertson)(note);
Sothebys Lon 4/25/86: 28 ill(B & Robertson), 29
(lot, B & Robertson-1 attributed, et al); 30
(B & Robertson, 2), 31 ill(B & Robertson), 34
(lot, B-1 attributed, et al);
Swann NY 5/15/86: 226 (lot, B-8 et al);
Christies Lon 10/30/86: 37 (B et al), 111 (album, B
et al), 112 ill(album, B et al), 113 (album, B-3
et al), 167 (2 ills)(album, 39)(note);
Sothebys Lon 10/31/86: 9 (album, B & Robertson-6,
et al), 26 ill(B & Robertson), 27 ill(B &
Robertson), 28 ill(B & Robertson), 29 ill
(B & Robertson), 30 ill(B & Robertson), 31
ill(B & Robertson);
Sothebys NY 11/10/86: 325 ill;

## BEATTIE, J.W.

Photos dated: 1870s-1898
Processes:     Albumen
Formats:       Prints, stereos
Subjects:      Topography
Locations:     Tasmania - Hobart
Studio:        Tasmania
  Entries:
Edwards Lon 1975: 45 (album, B et al);
Christies Lon 10/28/76: 179 (album, B et al);
Sothebys Lon 7/1/77: 127 (album, 36);
Sothebys Lon 3/14/79: 167 (album, 36);
Christies Lon 6/28/79: 147 (albums, B-15 et al);
Christies Lon 3/20/80: 110 (lot, B-6 et al);
Christies Lon 10/28/82: 118 (album, B et al);
Christies Lon 3/28/85: 77 (lot, B et al);
Christies Lon 10/31/85: 116 (lot, B et al);
Christies Lon 4/24/86: 410 (lot, B-3 et al);

## BEATTIE, John (British)

Photos dated: c1850-1860s
Processes:     Daguerreotype, albumen
Formats:       Plates, stereos
Subjects:      Portraits, topography
Locations:     England
Studio:        England - Bristol
  Entries:
California Galleries 9/27/75: 479 (lot, B et al);
Sothebys Lon 3/19/76: 92;
California Galleries 1/23/77: 384 (lot, B et al);
Christies Lon 10/26/78: 45 (lot, B-1 et al);
Christies Lon 3/15/79: 17 (lot, B-3 et al);

## BEAU, Adolphe (French)

Photos dated: 1865-1870s
Processes:     Albumen
Formats:       Cdvs
Subjects:      Portraits
Locations:     Studio
Studio:        France
  Entries:
Christies Lon 6/27/78: 146 (album, B et al), 239
(album, B et al);
Sothebys Lon 6/27/80: 220 (lot, B et al);

## BEAUCHY, Jules & Cano (Jules, French; Cano, Spanish)(aka BEAUCHY, E.)

Photos dated: 1867-1908
Processes:     Albumen, gelatine bromide
Formats:       Prints
Subjects:      Topography
Locations:     Spain - Seville
Studio:        Spain - Seville
  Entries:
Christies Lon 6/27/78: 92 (album, B et al);
Rose Boston Cat 4, 1979: 66 ill(note);
Christies Lon 10/25/79: 162 (lot, B-3 et al), 242
(lot, B-5 et al);
Phillips NY 5/21/80: 128 (albums, B et al);
Auer Paris 5/31/80: 78 (album, B et al);
Christies Lon 6/26/80: 213 (lot, B-3 et al);
Christies Lon 3/26/81: 206 (lot, B-3 et al);
Christies Lon 6/23/83: 103 (albums, B et al);
Christies Lon 10/27/83: 87 (albums, B et al);
Fraenkel Cal 1984: 6 ill(note), 7 ill, 8, 9, 10, 11,
12 ill;

## BEAUCORPS, Gustave de (aka G.B.)

Photos dated: 1850s
Processes:     Albumen
Formats:       Prints
Subjects:      Architecture
Locations:     Spain
Studio:
  Entries:
Sothebys Lon 4/25/86: 193 ill;

## BEAUFORD (British)

Photos dated: 1850s
Processes:     Daguerreotype
Formats:       Plates
Subjects:      Portraits
Locations:     Studio
Studio:        England - Hereford
  Entries:
Christies Lon 6/27/85: 23 (2);

## BECHARD, H. (French)

Photos dated: c1870-1880s
Processes:     Albumen, phototype
Formats:       Prints
Subjects:      Topography, documentary (art)
Locations:     Egypt - Cairo et al
Studio:        Egypt - Cairo
  Entries:
Goldschmidt Lon Cat 52, 1939: 208;
Rinhart NY Cat 2, 1971: 45 ill(note);
Sothebys NY 2/25/75: 156 (lot, B-1 et al);
Sothebys Lon 3/21/75: 110 (album, B et al);
Wood Conn Cat 37, 1976: 240 (album, B et al);

BECHARD, H. (continued)
Christies Lon 6/10/76: 96 (album, B et al);
Christies Lon 6/30/77: 125 (2);
Christies Lon 3/16/78: 149 (albums, B-18 et al);
Christies Lon 6/27/78: 119 (2);
Lennert Munich Cat 5, 1979: 33;
Phillips Lon 3/13/79: 147 ill, 148;
Swann NY 10/18/79: 333 (album, B et al)(note);
Sothebys Lon 10/24/79: 164 (album, B et al);
Phillips NY 11/29/79: 275 (album, B et al);
Rose Boston Cat 5, 1980: 78 ill(note), 81 ill
   (attributed);
Phillips Lon 3/12/80: 166;
Sothebys NY 5/20/80: 395 ill(album, B & Delie,
   et al)(note);
Phillips NY 5/21/80: 141 ill(albums, B et al);
Phillips Lon 3/18/81: 116;
Christies Lon 3/26/81: 223 (album, B-26 et al),
   226 (4);
Sothebys Lon 3/27/81: 56 (album, 86), 57 (albums,
   B et al);
Petzold Germany 5/22/81: 1780 ill;
Sothebys Lon 6/17/81: 159 (lot, B et al);
Phillips Lon 10/28/81: 151 (album, 49);
Christies Lon 10/29/81: 214 (album, B-26 et al),
   220 (lot, B et al), 375;
Swann NY 11/5/81: 274;
Rose Florida Cat 7, 1982: 69 ill(B & Delie, 9)
   (note);
Christies Lon 6/24/82: 178 (album, B et al);
Phillips NY 9/30/82: 968 (album, B-2 et al);
Swann NY 11/18/82: 368 (lot, B-26 et al)(note);
Christies Lon 3/24/83: 138 (album, B et al);
Swann NY 5/5/83: 405 (lot, B-8 et al);
Christies NY 11/11/85: 295 (lot, B-1 et al);
Christies Lon 4/24/86: 402 (lot, B-2 et al);
Swann NY 5/15/86: 231 (lot, B-4 et al);
Christies Lon 6/26/86: 92 (albums, B-4 et al);
Sothebys NY 11/10/86: 326 ill(2);
Swann NY 11/13/86: 212 (lot, B et al);

BECHER, Henry C.R.
Photos dated: 1880
Processes:    Albumen
Formats:     Prints
Subjects:    Topography
Locations:   US; Canada; Mexico
Studio:
   Entries:
Witkin NY II 1974: 28 (book, 18);
Witkin NY III 1975: 449 (book, 18);
California Galleries 9/26/75: 163 (book, 13);
Witkin NY IV 1976: OP269 (book, 19);
Frontier AC, Texas, 1978: 21 (book, B-11 et al)
   (note);
Sothebys NY 5/8/79: 19 (books, B et al);
Swann NY 5/15/86: 69 (book, 20)(note);

BECK, J.
Photos dated: 1858-1863
Processes:    Albumen
Formats:     Stereos
Subjects:    Topography
Locations:   England - Leamington
Studio:      England - Leamington
   Entries:
Christies Lon 3/28/85: 41 (lot, B et al);

BECK, W.P.
Photos dated: 1850s
Processes:    Daguerreotype
Formats:     Plates
Subjects:    Portraits
Locations:
Studio:
   Entries:
Christies NY 10/4/83: 79 ill;

BECKEL Brothers (American)
Photos dated: late 1850s-1870s
Processes:    Albumen
Formats:     Stereos
Subjects:    Topography
Locations:   US - New York City
Studio:      US - Lockport, New York
   Entries:
California Galleries 9/27/75: 532 (lot, B-1 et al);
California Galleries 1/23/77: 420 (lot, B-1 et al);
California Galleries 1/21/79: 305 (lot, B-1 et al);
California Galleries 3/30/80: 405 (lot, B-1 et al);
Harris Baltimore 3/15/85: 8 (3);

BECKER (German)
Photos dated: 1854
Processes:    Salt, albumen
Formats:     Prints
Subjects:    Portraits
Locations:   Great Britain
Studio:
   Entries:
Phillips Lon 11/4/83: 145 (album, B-7 et al);

BECKERS, Alexander (American, 1843-1858)
Photos dated: 1843-early 1860s
Processes:    Daguerreotype
Formats:     Plates
Subjects:    Portraits
Locations:   Studio
Studio:      US - New York City
   Entries:
Sothebys NY (Strober Coll.) 2/7/70: 146 (B & Piard)
   (note);
Vermont Cat 10, 1975: 535 ill(B & Piard);
Witkin NY IV 1976: D10 ill(B & Piard);
Swann NY 4/14/77: 237 (lot, B & Piard-1, et al);
Phillips NY 11/3/79: 114 (lot, B et al);
Sothebys Lon 10/29/80: 151 (lot, B & Piard-1,
   et al);
Christies NY 2/8/83: 81 (lot, B & Piard-1, et al);

BECKET (British)
Photos dated: Nineteenth century
Processes:    Albumen
Formats:     Cdvs
Subjects:    Portraits
Locations:   Studio
Studio:      England - Scarborough
   Entries:
Sothebys NY (Strober Coll.) 2/7/70: 265 (lot,
   B et al);

BEDFORD, Francis (British, 1816-1894)
Photos dated: 1853-1880s
Processes:    Salt, albumen, autotype
Formats:      Prints, stereos, cabinet cards, cdvs
Subjects:     Topography
Locations:    England; Bavaria; Greece; Egypt
Studio:       England
   Entries:
Goldschmidt Lon Cat 52, 1939: 230 (book, B et al);
Weil Lon Cat 4, 1944(?): 198 (book, B et al)(note);
Weil Lon Cat 7, 1945: 97 (book, B et al);
Weil Lon 1946: 25 (book, 12);
Weil Lon Cat 10, 1947(?): 299 (book, B et al), 300
   (book, 12);
Andrieux Paris 1952(?): 719 (book, B et al);
Swann NY 2/14/52: 6 (lot, B-2 et al), 37 (book,
   48), 262 (album, B et al);
Rinhart NY Cat 1, 1971: 410 (2);
Rinhart NY Cat 2, 1971: 300 (10), 445 (2);
Vermont Cat 4, 1972: 497 ill(note), 498 ill, 499
   ill, 500 ill, 501 ill, 502 ill, 503 ill, 504
   ill, 505 ill, 506 ill, 507 ill, 508 ill, 509
   ill, 510 ill, 511 ill, 512 ill, 513 ill, 514
   ill, 515 ill, 516 ill, 517 ill, 518 ill, 519
   ill, 520 ill, 521 ill, 522 ill, 523 ill, 524
   ill, 525 ill, 526 ill, 527 ill, 528 ill, 529
   ill, 607 (2 ills)(book, 48)(note);
Ricketts Lon 1973: 8 ill(album, B-2 et al);
Rinhart NY Cat 6, 1973: 6 (album, B et al);
Rinhart NY Cat 7, 1973: 12 (album, 20), 533 (3);
Sothebys Lon 5/24/73: 36 (book, B-16 et al);
Christies Lon 10/4/73: 99 (books, B et al), 203
   (book, 48);
Sothebys Lon 12/4/73: 5 (albums, B-10 et al), 10
   (album, 30), 26 ill(album, B-12 et al), 33 (lot,
   B et al), 173 (book, B et al), 175 (books, B
   et al);
Vermont Cat 4, 1974: 607 ill(7), 752 (book, B
   et al);
Witkin NY II 1974: 206 (book, B et al), 734 ill;
Sothebys Lon 3/8/74: 38 (album, B et al), 163
   (book, B et al), 165 (book, B et al), 170
   (book, B et al);
Sothebys Lon 6/21/74: 17 (lot, B et al), 65 (lot,
   B et al), 68 (album, 10), 150 (books, B et al),
   151 (book, B et al);
Sothebys Lon 10/18/74: 7 (lot, B et al), 253
   (book, 48);
Edwards Lon 1975: 44 (album, B et al), 58 (book,
   10), 59 (book, 10), 110 (book, B et al), 111
   (book, B-4 et al), 139 (book, 12);
Vermont Cat 9, 1975: 554 ill, 555 ill, 556 ill;
Witkin NY III 1975: 19 ill;
Swann NY 2/6/75: 24 (book, 10), 162 (book, 1);
Sothebys NY 2/25/75: 147 (lot, B et al), 152 ill
   (3)(note);
Sothebys Lon 3/21/75: 75 (album, B et al), 135
   (albums, B et al), 136 (lot, B et al), 138
   (album, B et al), 146 (book, B-5 et al), 148
   (album, B et al), 222 (lot, B et al), 231 (lot,
   B et al), 286 (album, B-1 et al), 315 (book,
   B et al), 316 (books, B et al), 317 (book, 48);
Sothebys Lon 6/26/75: 6 (lot, B et al), 10 (62), 107
   (albums, B et al), 131 (albums, B-1 et al);
California Galleries 9/26/75: 179 (book, B et al);
California Galleries 9/27/75: 386 (lot, B et al),
   444 (11);
Sothebys Lon 10/24/75: 71 (lot, B et al), 83 (lot,
   B et al), 87 (lot, B-12 et al), 93 (lot, B et
   al), 142, 143 (lot, B-30 et al);

Colnaghi Lon 1976: 146 (2 ills)(book, 12)(note),
   147 (4);
Kingston Boston 1976: 17 ill(note), 18 ill, 19 ill
   (3), 649 (note), 650, 651, 652, 653, 654, 655
   ill, 656 ill, 657 ill, 658 ill, 659 ill;
Rose Boston Cat 1, 1976: 13 ill(note), 14 ill;
Sothebys Lon 3/19/76: 1 (lot, B et al), 39 (lot, B-2
   et al);
California Galleries 4/2/76: 217 (lot, B et al);
Sothebys NY 5/4/76: 87 (book, 48)(note);
Christies Lon 6/10/76: 45 (8), 99 (lot, B et al),
   101 (album, B et al), 102 (album, B et al);
Sothebys Lon 6/11/76: 91, 157 (book, B et al);
Christies Lon 10/28/76: 87 (album, B attributed, et
   al), 91 (albums, B et al), 93 (album, B et al),
   250 (albums, B et al), 275 (books, B et al), 280
   (book, 12);
Sothebys Lon 10/29/76: 30 (lot, B et al), 55 (book,
   B et al), 114 (albums, B et al), 125 (lot, B et
   al), 137 (albums, 20), 171 (book, B et al);
Sothebys NY 11/9/76: 56 (albums, B et al);
Swann NY 11/11/76: 247 (book, 10), 269 (book, B et
   al)(note);
Halsted Michigan 1977: 580 ill(note);
Rose Boston Cat 2, 1977: 12 ill(note), 13 ill;
Witkin NY V 1977: 60 (book, B et al)(note);
California Galleries 1/22/77: 212 (book, B et al);
Sothebys Lon 3/9/77: 44 (album, 30), 52 (album,
   10), 53 (album, B et al);
Christies Lon 3/10/77: 83 (album, B et al), 161
   (note), 162, 163 (book, 10), 189 (lot, B et al),
   202 (lot, B-4 et al);
Sothebys NY 5/20/77: 77 (lot, B et al);
Christies Lon 6/30/77: 90 (lot, B-2 et al), 112 ill
   (book, 48), 113 ill(note), 114, 156 (lot, B-2
   et al), 193 (book, B et al);
Sothebys Lon 7/1/77: 21 (book, B et al), 161 (lot,
   B et al), 164 (lot, B et al), 167 (album, 10);
Christies Lon 10/27/77: 56 (lot, B-1 et al), 209
   (book, B et al), 216 (book, 47), 218 (books,
   B et al);
Vermont Cat 11/12, 1977: 523 (book, B et al), 759
   ill(2), 760 ill, 762 ill, 763 ill, 764 ill, 765
   ill, 766 ill;
Sothebys Lon 11/18/77: 12 (lot, B et al), 13 (lot,
   B et al), 66 (lot, B-2 et al), 175 (book, B et
   al), 195 (books, B et al), 154 (album, B-4, B
   attributed et al);
Swann NY 12/8/77: 321 (album, B-25 et al), 431
   (album, B et al);
Lehr NY Vol 1:4, 1978: 38 (book, B et al);
Rose Boston Cat 3, 1978: 19 ill(note), 20 ill,
   21 ill;
Wood Conn Cat 41, 1978: 93 ill(note);
California Galleries 1/21/78: 215 (album, B et al),
   232 (lot, B et al);
Sothebys LA 2/13/78: 107 (book, 20);
Christies Lon 3/16/78: 55 (15), 56 (lot, B-1 et
   al), 112 (lot, B et al), 206 (books, B et al),
   214 (books, B-10 et al), 300 (album, B-2 et al);
Sothebys Lon 3/22/78: 23 (book, 12), 74 (2), 113
   (lot, B-5 et al), 116 (lot, B-1 et al);
Swann NY 4/20/78: 144 (book, 1);
Sothebys NY 5/2/78: 74, 75 ill:
Christies Lon 6/27/78: 59 (lot, B-10 et al), 68
   (album, B et al), 291 (book, 20)(note), 292 ill
   (book, 48);
Sothebys Lon 6/28/78: 21 (lot, B et al), 80 (album,
   B-5 et al);

## BEDFORD (continued)

Christies Lon 10/26/78: 89 (lot, B et al), 96 (7), 98, 104 (album, 20), 213 (book, 48), 339 (album, B et al);

Sothebys Lon 10/27/78: 104 (lot, B-5 et al), 115 (book, 10), 116 (lot, B et al), 118, 123 (2) (note);

Rose Boston Cat 4, 1979: 11 ill(note), 12 ill;

Witkin NY IX 1979: 2/8 ill(book, 10), 2/40 (book, B-6 et al);

Wood Conn Cat 45, 1979: 20 (book, 48)(note), 267 ill (book, 20)(note);

California Galleries 1/21/79: 114A (book, B et al), 259 (26), 328 ill(album, 46);

Phillips Lon 3/13/79: 135 ill(book, 72)(attributed);

Sothebys Lon 3/14/79: 13 (lot, B et al), 134 (2), 152 (album, B et al), 324 (album, B-1 et al);

Christies Lon 3/15/79: 80 (lot, B et al), 96, 99 (2), 144 ill(book, 20)(note), 145, 146;

Swann NY 4/26/79: 352 (lot, B et al);

Sothebys NY 5/8/79: 77 (6);

Christies Lon 6/28/79: 70 (lot, B-2 et al), 71 (lot, B et al), 88 (lot, B-1 et al), 139 (albums, B-2 et al), 156 (book, B et al), 157 (book, B et al);

Sothebys Lon 6/29/79: 126;

Phillips Can 10/4/79: 18 (albums, B et al);

Sothebys Lon 10/24/79: 32 (book, 12), 37 (lot, B et al), 43 (book, 12), 58 (lot, B et al), 113 (album, B et al), 131 (album, 16), 354 (lot, B et al);

Christies Lon 10/25/79: 84 (lot, B-17 et al), 120 (lot, B-3 et al), 123 (album, B et al), 183, 184, 233 (lot, B-1 et al), 245 (album, B et al), 249 (albums, B-2 et al), 407 (album, B-2 et al);

Christies NY 10/31/79: 25 (book, B et al);

Sothebys NY 11/2/79: 219 ill(lot, B-2 plus 3 attributed), 220 ill(25);

Phillips NY 11/29/79: 260;

Sothebys NY 12/19/79: 41 ill(note);

Rose Boston Cat 5, 1980: 25 ill(note), 26 ill;

Sothebys LA 2/6/80: 152;

Phillips Lon 3/12/80: 162 (lot, B-5 et al);

Christies Lon 3/20/80: 105 (lot, B-29 et al), 131 (albums, B et al), 135 (album, B et al), 218 (book, B et al), 352 (albums, B-2 et al), 371 (lot, B et al);

Sothebys Lon 3/21/80: 171 (9), 172 (3);

California Galleries 3/30/80: 299 (lot, B et al);

Phillips NY 5/21/80: 139 (albums, B et al);

Christies Lon 6/26/80: 97 (lot, B-1 et al), 101 (lot, B-13 et al), 107 (lot, B-9 et al), 111 (lot, B-9 et al), 119 (lot, B-9 et al), 151 (3), 157 (lot, B-3 et al), 162 (lot, B et al), 263 (lot, B-2 et al), 301 (book, 20), 302 (book, B et al), 484 (album, B-7 et al), 488 (album, B-1 et al);

Sothebys Lon 6/27/80: 3 (lot, B-39 et al);

Phillips Can 10/9/80: 13 (book, 48), 22, 23 (lot, B-1 et al);

Sothebys Lon 10/29/80: 12 (36), 53 (book, 48), 56 ill (book, 20);

Christies Lon 10/30/80: 117 (lot, B-34 et al), 121 (lot, B et al), 132 (lot, B-21 et al), 148 (albums, B et al), 284 (book, B et al), 400 (lot, B-1 et al), 435 (albums, B-2 et al), 456 (lot, B et al);

California Galleries 12/13/80: 156 (album, B-2 et al);

Phillips Lon 3/18/81: 88 (book, B et al), 107 (lot, B-3 et al);

## BEDFORD (continued)

Christies Lon 3/26/81: 126 (55), 128 (lot, B et al), 160 (albums, B et al), 161 (lot, B et al), 182 (lot, B et al), 259 (album, B et al), 280 (albums, B et al), 401 (album, B-1 et al), 413 (album, B et al);

Sothebys Lon 3/27/81: 6 (lot, B-3 et al), 9 (lot, B-19 et al), 11 (lot, B et al), 14 (lot, B-1 et al), 15 (lot, B et al), 19 (lot, B-39 et al), 31 (lot, B-2 et al), 383 (lot, B-1 plus B attributed);

Swann NY 4/23/81: 461 (lot, B et al);

Phillips NY 5/9/81: 24 (albums, B et al), 57 (74) (attributed)(note);

Sothebys Lon 6/17/81: 111 (albums, B et al), 114 (lot, B et al), 444 (book, B et al), 445 (book, B et al);

Christies Lon 6/18/81: 102 (lot, B-19 et al), 103 (lot, B et al), 155 (2)(attributed), 158 (lot, B-8 et al), 396 (album, B-1 et al)(note);

Phillips Lon 6/24/81: 83 (lot, B-3 et al);

California Galleries 6/28/81: 134 (album, B-2 et al), 188 (lot, B et al);

Harris Baltimore 7/31/81: 131 (lot, B-1 et al);

Phillips Lon 10/28/81: 133 (albums, B et al), 154 (lot, B-16 et al), 164 (lot, B-2 et al);

Sothebys Lon 10/28/81: 109, 197a;

Christies Lon 10/29/81: 119 (lot, B et al), 131 (lot, B et al), 137 (lot, B-13 et al), 138 (lot, B et al), 147 (lot, B et al), 167, 172 (4), 192 (lot, B-7 et al), 215 (album, B-3 et al);

Swann NY 11/5/81: 21 (book, 12)(note);

Petzold Germany 11/7/81: 82 (book, B et al);

Octant Paris 1982: 13 ill(note), 14 ill;

Christies Lon 3/11/82: 60 (lot, B-13 et al), 65 (lot, B et al), 80 (lot, B et al), 89 (lot, B et al), 114 (lot, B et al), 156 (38);

Sothebys Lon 3/15/82: 22 (170), 321, 436 (book, B et al);

Phillips Lon 3/17/82: 8 (lot, B-8 et al), 54 (lot, B-4 et al), 58 (lot, B-3 et al);

California Galleries 5/23/82: 20 ill(book, 48), 228 (lot, B et al), 446 (lot, B et al);

Phillips Lon 6/23/82: 23 (lot, B-4 et al), 44 (albums, B et al);

Christies Lon 6/24/82: 60 (lot, B et al), 63 (lot, B et al), 69 (lot, B et al), 74 (lot, B-11 et al), 80 (lot, B et al), 88 (2), 192, 193 (book, 48);

Harris Baltimore 3/26/82: 238;

Phillips Lon 10/27/82: 34 (lot, B et al), 35 (lot, B et al), 42 (lot, B-1 et al);

Christies Lon 10/28/82: 17 (lot, B et al), 26 (lot, B et al), 27 (lot, B-24 et al), 38 (lot, B-3 et al), 40, 44 (album, B et al), 54 (lot, B-3 et al), 62, 65 (lot, B et al), 79 (lot, B-13 et al), 80A, 84;

Swann NY 11/18/82: 446 (lot, B et al);

Harris Baltimore 12/10/82: 43 (lot, B-7 et al), 394 (album, B-2 et al);

Phillips Lon 3/23/83: 9 (lot, B-1 et al), 32 (lot, B-1 et al);

Christies Lon 3/24/83: 44 (lot, B et al), 51 (album, B-8 et al), 63 (3);

Harris Baltimore 4/8/83: 37 (lot, B-11 et al), 288 (album, B et al);

Swann NY 5/5/83: 282 (album, B et al), 283 (albums, B et al);

Phillips Lon 6/15/83: 95 (lot, B et al), 122 (lot, B-8 et al), 127 (albums, B et al), 128 (lot, B et al), 137 (lot, B-1 et al);

BEDFORD (continued)
Christies Lon 6/23/83: 43 (lot, B et al), 52 (lot,
   B-5 et al), 62 (lot, B-10 et al), 84 ill(album,
   30), 85 (14), 100 (album, B et al), 131 ill, 168
   (lot, B-1 et al);
Christies Lon 10/27/83: 21 (lot, B-10 et al), 28
   (lot, B-4 et al), 33 (lot, B et al), 53 (album,
   30)(note), 101 (lot, B-2 et al), 159 (album, B
   et al), 163 (book, B et al);
Phillips Lon 11/4/83: 65 (albums, B et al), 69
   (lot, B-8 et al), 78A (lot, B-6 et al);
Swann NY 11/10/83: 88 (book, B et al), 277 (album,
   B et al);
Sothebys Lon 12/9/83: 36 ill(2);
Harris Baltimore 12/16/83: 42 (lot, B-1 et al), 188
   (book, B et al);
Christies Lon 3/29/84: 27 (lot, B-12 et al), 29
   (lot, B-4 et al), 112 (book, B et al), 184 (lot,
   B-1 et al), 186 ill, 187 (book, 30);
Swann NY 5/10/84: 306 (lot, B et al);
Harris Baltimore 6/1/84: 64 (lot, B et al);
Christies Lon 6/28/84: 52 (lot, B-4 et al), 56
   (lot, B et al), 77 (album, B et al), 146 (books,
   B-12 et al), 218 (lot, B-11 et al), 221 (lot,
   B-1 et al), 244 (lot, B-3 et al), 328 (lot,
   B et al);
Sothebys Lon 6/29/84: 10 (lot, B-17 et al),
   16 (135);
Phillips Lon 10/24/84: 85 (lot, B-1 et al), 121
   (lot, B-1 et al), 131 (books, B et al);
Christies Lon 10/25/84: 41 (lot, B et al), 44 (lot,
   B-6 et al), 59 (album, 6)(attributed), 107
   (albums, B et al), 180 (books, 20);
Sothebys Lon 10/26/84: 7 (lot, B-31 et al), 54 (lot,
   B-2 et al);
Harris Baltimore 3/15/85: 184 (album, B-4 et al);
Phillips Lon 3/27/85: 144 (lot, B-1 et al), 212
   (lot, B et al);
Christies Lon 3/28/85: 40 (lot, B et al), 95
   (album, B et al), 151 (albums, B et al)(note),
   172 ill(20), 173 (10);
Sothebys Lon 3/29/85: 152 (albums, B-2 et al);
Sothebys NY 5/8/85: 631 (lot, B et al);
Phillips Lon 6/26/85: 126 (lot, B et al), 133 (lot,
   B et al);
Christies Lon 6/27/85: 37 (lot, B et al), 39 (lot, B
   et al), 43 (lot, B-17 et al), 57 (lot, B et al),
   94 (albums, B et al), 96 (album, B et al), 161
   (9), 162;
Sothebys Lon 6/28/85: 1 (lot, B et al), 128 ill,
   129 ill(3), 130 ill(4), 131 ill(2), 132 (16),
   133 (album, 30);
Christies Lon 10/31/85: 66 (lot, B-11 et al), 69
   (lot, B-5 et al), 70 (lot, B-11 et al), 132
   (albums, B et al), 149 (books, B-10 et al), 307
   (albums, B et al);
Sothebys Lon 11/1/85: 58 (book, B-7 et al), 59
   (album, B-1 et al), 103 (lot, B et al);
Swann NY 11/14/85: 27 (lot, B et al), 162 (lot,
   B et al);
Harris Baltimore 2/14/86: 215 (album, B-14 et al),
   241 (note), 308 (lot, B-2 et al);
Phillips Lon 4/23/86: 192 (lot, B-13 et al);
Christies Lon 4/24/86: 333 (lot, B-20 et al), 350
   (lot, B-33 et al), 363 (lot, B-3 et al), 369
   (lot, B-15 et al), 402 (lot, B-3 et al);
Sothebys Lon 4/25/86: 122 ill(7), 123;
Swann NY 5/15/86: 70 (book, 48)(note), 71 (book, 12)
   (note), 190 (lot, B-25 plus 4 attributed, et al),
   203 (lot, B et al);

BEDFORD (continued)
Christies Lon 6/26/86: 28 (lot, B-9 et al), 82
   (albums, 18), 137 (albums, B et al), 139
   (album, 11)(attributed), 150A (lot, B-15 et al),
   156 (lot, B et al), 175 (books, B et al),
   180 (3);
Phillips Lon 10/29/86: 223 (lot, B et al), 301
   (lot, B-1 et al), 358 (book, 48);
Christies Lon 10/30/86: 19A (lot, B et al), 30
   (lot, B et al), 32 (lot, B et al);
Sothebys Lon 10/31/86: 7 (lot, B et al), 74;
Sothebys NY 11/10/86: 389 (lot, B-3 et al);
Swann NY 11/13/86: 13 (book, 12)(note);

**BEDFORD LEMERE & Co.** (British)(photographer or
                              publisher?)
Photos dated:  c1870-1895
Processes:     Albumen, platinum
Formats:       Prints
Subjects:      Architecture
Locations:     England - London; France
Studio:        England - London
   Entries:
Kingston Boston 1976: 660 ill(4);
Sothebys Lon 10/29/76: 114 (albums, B et al);
Christies Lon 6/30/77: 84 (lot, B-26 et al);
Christies Lon 10/26/78: 129 (34);
Old Japan, England, Cat 8, 1985: 48 (3 ills)
   (book, 20);
Sothebys Lon 11/1/85: 110 ill(album);
Christies Lon 6/26/86: 100 (albums, B et al);

**BEEBY, John**
Photos dated:  1898
Processes:     Albumen, cyanotype
Formats:       Prints
Subjects:      Genre
Locations:     US - New York City
Studio:
   Entries:
Sothebys Lon 10/28/81: 214 (24);

**BEER Brothers** (American)
Photos dated:  1850s-1860s
Processes:     Albumen
Formats:       Cdvs, stereos
Subjects:      Topography
Locations:     US - Saratoga Springs and New York
               City, New York
Studio:        US - Saratoga Springs, New York
   Entries:
Harris Baltimore 3/26/82: 396 (lot, B-19 et al);

**BEER, Alois** (Austrian)
Photos dated:  1859-1879
Processes:     Albumen
Formats:       Prints, cdvs
Subjects:      Topography
Locations:     Austria; Greece
Studio:        Austria - Klagenfurt
   Entries:
Christies Lon 3/26/81: 202 (lot, B-4 et al);

**BEER, S.** (American)
Photos dated: 1860s
Processes:    Albumen
Formats:      Stereos
Subjects:     Documentary (industrial, scientific)
Locations:    US - New York City
Studio:       US - New York
   Entries:
Sothebys NY (Strober Coll.) 2/7/70: 462 (lot, B et al);
Rinhart NY Cat 6, 1973: 496;
Swann NY 11/6/80: 387 (22)(note);
Harris Baltimore 6/1/84: 105 (lot, B et al);

**BEERE, Daniel Manders** (1833-1909)
Photos dated: 1858-1860s
Processes:    Albumen
Formats:      Stereos
Subjects:     Topography, ethnography
Locations:    Canada; New Zealand; Australia
Studio:       Canada - Toronto
   Entries:
Christies Lon 6/27/85: 39 (lot, B & Hime et al);
Phillips Lon 4/23/86: 194 (lot, B-5 et al);

**BEERS, C.F.** (American)
Photos dated: 1850s-1860s
Processes:    Daguerreotype, albumen
Formats:      Plates, cdvs
Subjects:     Portraits
Locations:    Studio
Studio:       US - Boston, Massachusetts
   Entries:
Gordon NY 5/3/76: 267 (lot, B et al);
Gordon NY 11/13/76: 1 (lot, B et al);
Swann NY 5/15/86: 223 (album, B & Mansfield et al);

**BEHLES, Edmondo** (German, 1841-1921)(see also
                SOMMER, G.)
Photos dated: 1865-1890s
Processes:    Albumen
Formats:      Prints, stereos
Subjects:     Topography
Locations:    Italy - Rome
Studio:       Italy - Rome
   Entries:
Sothebys NY 11/9/76: 51 (album, B-5 et al)(note);
Harris Baltimore 7/31/81: 100 (lot, B et al);
Petzold Germany 11/7/81: 326 (lot, B et al), 328
  (album, B et al);
Phillips NY 9/30/82: 1042 (lot, B et al);
Swann NY 11/18/82: 454 (lot, B, B & Sommer, et al);
Harris Baltimore 4/8/83: 44 (lot, B et al);

**BEIBER, E.** (German)
Photos dated: Nineteenth century
Processes:
Formats:
Subjects:     Portraits
Locations:    Studio
Studio:       Germany - Hamburg
   Entries:
Edwards Lon 1975: 12 (album, B et al);

**BELL & CLAYTON** (American) [BELL 1]
Photos dated: 1850s
Processes:    Daguerreotype
Formats:      Plates
Subjects:     Portraits
Locations:    Studio
Studio:       US
   Entries:
Sothebys NY (Strober Coll.) 2/7/70: 144 (lot, B & C-1 et al);

**BELL & Co.** (American) [BELL 2]
Photos dated: c1880
Processes:    Albumen
Formats:      Prints
Subjects:     Portraits
Locations:    Studio
Studio:       US - St. Louis, Missouri
   Entries:
Swann NY 5/10/84: 273 (lot, B et al)(note);

**BELL, Charles K.** (American)
Photos dated: 1860
Processes:    Albumen
Formats:      Prints
Subjects:     Portraits
Locations:    Studio
Studio:       US - New York City
   Entries:
Sothebys NY 11/21/70: 17 (album, 53);

**BELL, Charles M. and/or F.A.** (American)
Photos dated: 1860s-1898
Processes:    Albumen
Formats:      Prints, cabinet cards, stereos
Subjects:     Portraits, ethnography, topography,
           documentary (medical, Civil War)
Locations:    US - Washington, D.C. et al
Studio:       US - Washington, D.C.
   Entries:
Sothebys NY (Weissberg Coll.) 5/16/67: 173 (lot, B et al);
Sothebys NY (Strober Coll.) 2/7/70: 480 (lot, B-7 et al), 481 (lot, B et al), 485 (lot, B et al), 550 (lot, B-2 et al);
Sothebys NY (Greenway Coll.) 11/20/70: 72 (lot, B-1 et al), 98 ill, 116, 232 (lot, B-1 et al), 252 (lot, B-1 et al), 253 (lot, B-1 et al), 258 (lot, B-1 et al);
Sothebys NY 11/21/70: 356 (lot, B et al);
Rinhart NY Cat 7, 1973: 275 (CM & FA B), 276 (CM & FA B, 3);
Witkin NY IV 1976: S9 ill(CM & FA B), S10 ill(CM & FA B);
California Galleries 4/3/76: 483 (FA B, 14);
Witkin NY VI 1978: 14 ill(note);
California Galleries 1/21/78: 202 ill(FA B, 14);
Witkin NY Stereo 1979: 2 (2 ills)(CM & FAB, 8) (note);
Phillips NY 5/5/79: 104 (lot, B et al);
Sothebys NY 5/8/79: 6 ill;
Swann NY 4/23/81: 128 (books, B et al);
Sothebys LA 2/16/82: 43 ill, 44 ill;
Christies Lon 6/23/83: 44 (lot, CM & FA B et al);
Harris Baltimore 9/16/83: 112 (lot, B-1 et al), 142 (lot, B-1 et al), 152 (lot, B et al), 154 (lot, B-1 et al);

**BELL, C. & F.** (continued)

Harris Baltimore 12/16/83: 143 (lot, B et al), 246, 268;

Christies Lon 3/29/84: 38 (lot, CM & FA B-2, et al);

Harris Baltimore 6/1/84: 156 (lot, B et al), 157 (lot, B et al), 260, 262, 291;

Christies Lon 3/28/85: 47 (lot, B et al);

Harris Baltimore 2/14/86: 13 (lot, B et al), 67 (lot, B-1 et al), 72 (lot, B-5 et al), 73, 75;

**BELL, H.** (British)

Photos dated: c1870s-1880s
Processes:     Albumen, carbon
Formats:       Prints
Subjects:      Topography
Locations:     England - Keswick
Studio:        Great Britain
  Entries:
Swann NY 4/14/77: 188 (album, B et al);
Harris Baltimore 2/14/86: 327 (lot, B-3 et al);

**BELL, J.R.** (American)

Photos dated: 1858-1859
Processes:     Daguerreotype
Formats:       Plates
Subjects:      Portraits
Locations:     Studio
Studio:        US - Boston, Massachusetts
  Entries:
Gordon NY 5/3/76: 267 (lot, B et al);

**BELL, John** (British)

Photos dated: c1860
Processes:     Ambrotype, salt
Formats:       Stereo plates, prints
Subjects:      Documentary (art, industrial)
Locations:     Great Britain
Studio:        Great Britain
  Entries:
Christies Lon 3/10/77: 200;
Swann NY 5/15/86: 190 (lot, B-4 et al);

**BELL, W.** (American)

Photos dated: 1850s
Processes:     Daguerreotype
Formats:       Plates
Subjects:      Portraits
Locations:     Studio
Studio:        US - Philadelphia, Pennsylvania
  Entries:
Rinhart NY Cat 2, 1971: 163;
Phillips NY 7/2/86: 323, 324;

**BELL, W.H.** (American)

Photos dated: 1870s-1880s
Processes:     Albumen
Formats:       Stereos
Subjects:
Locations:     US - Washington, D.C.
Studio:        US
  Entries:
Rinhart NY Cat 1, 1971: 134 (3), 294 (lot, B et al);
Rinhart NY Cat 6, 1973: 389, 413, 581 (lot, B-4 et al), 584, 585;
Swann NY 12/8/77: 424 (lot, B et al);

**BELL, W.H.** (continued)

Harris Baltimore 7/31/81: 128 (lot, B et al), 154 (note);

Harris Baltimore 11/9/84: 87 (lot, B-4 et al), 109 (lot, B et al), 111 (2), 113, 132 (lot, B-1 et al);

Harris Baltimore 3/15/85: 111 (lot, B-3 et al), 113 (lot, B et al);

Swann NY 5/9/85: 433 (lot, B-1 et al);

**BELL, William Abraham** (British, American, c1839-c1915)

Photos dated: 1860s-1872
Processes:     Albumen
Formats:       Prints, stereos
Subjects:      Topography
Locations:     US - American west
Studio:        US
  Entries:
Rinhart NY Cat 2, 1971: 583 (7), 584;
Rinhart NY Cat 6, 1973: 389, 584, 585;
Witkin I 1973: 277 ill, 278, 279, 280, 281, 282, 283, 284, 285, 286 (attributed), 287 (attributed);
Witkin II 1974: 733 ill;
Sothebys Lon 10/18/74: 13 (lot, B et al);
Sothebys Lon 6/26/75: 14 (lot, B-41 et al);
Sothebys NY 9/23/75: 126 ill, 127 ill;
Sothebys Lon 10/24/75: 139 (6)(note);
Lunn DC Cat 6, 1976: 52.1 ill(note), 52.2 ill, 52.3 ill;
Gordon NY 11/13/76: 85 ill;
IMP/GEH 10/20/77: 222 ill, 223 ill, 224 ill, 225 ill;
Lunn DC Cat QP, 1978: 29 (note);
Rose Boston Cat 3, 1978: 7 ill(note), 8 ill;
Wood Conn Cat 41, 1978: 172 ill(note), 173 ill, 174 ill, 175, 176, 177, 178 (lot, B et al)(note);
Christies Lon 3/16/78: 137 (note), 138, 139 ill;
Christies Lon 6/27/78: 135 (2);
Lehr NY Vol 2:2, 1979: 6 ill, 7 ill;
California Galleries 1/21/79: 509 ill(lot, B-1 et al);
Swann NY 4/26/79: 293 (note), 294, 295, 296 ill;
Christies NY 5/4/79: 104;
Christies NY 10/31/79: 72 ill(6), 73, 74;
Sothebys NY 11/2/79: 283 ill, 284, 285 ill;
Sothebys NY 12/19/79: 42 (2 ills)(2), 43 ill;
Christies NY 5/16/80: 253 ill(6), 254 ill, 255;
Swann NY 4/1/82: 256 ill;
California Galleries 5/23/82: 423 (lot, B et al);
Sothebys NY 5/24/82: 219 ill;
California Galleries 6/19/83: 454 (lot, B-3 et al);
Christies NY 10/4/83: 95;
Sothebys NY 11/9/83: 39 ill;
Christies NY 2/22/84: 25 (note);
California Galleries 7/1/84: 103 (book, 1);
Christies NY 2/13/85: 158 (2);
Christies Lon 3/28/85: 220 (album, B-2 et al)(note);
Sothebys NY 5/7/85: 66 ill(note);
Swann NY 5/9/85: 443 (lot, B-2 et al)(note);
Christies Lon 10/31/85: 216 (2 ills)(album, B-15 et al)(note);
Sothebys NY 11/12/85: 304 (album, B-2 et al)(note);
Swann NY 11/14/85: 256 ill(book, B et al)(note);
Harris Baltimore 2/14/86: 242 (note);
Swann NY 5/15/86: 132 (book, B et al);
Phillips NY 7/2/86: 323, 324;
Phillips NY 11/12/86: 34;
Swann NY 11/13/86: 331 (lot, B-4 et al);

BELLIS (American)
Photos dated: Nineteenth century
Processes:      Tintype
Formats:        Plates
Subjects:       Portraits
Locations:      US - Atlantic City, New Jersey
Studio:         US - Atlantic City, New Jersey
   Entries:
Swann NY 5/9/85: 335;

BELLOC, Auguste (French)
Photos dated: 1850s
Processes:      Albumen
Formats:        Prints
Subjects:       Genre (nudes)
Locations:      Studio
Studio:         France
   Entries:
Sothebys Lon 3/27/81: 212 ill;
Christies NY 5/13/86: 34 (lot, B-16 attributed
   et al)(note);
Drouot Paris 11/22/86: 18 ill;

BELLS (see PINE & BELLS)

BEMIS, Dr. Samuel (American, 1789-1881)
Photos dated: 1840-1841
Processes:      Daguerreotype
Formats:        Plates
Subjects:       Topography
Locations:      US - New England
Studio:         US - Boston, Massachusetts
   Entries:
Sothebys NY 11/9/82: 126A ill(note);

BENDANN, Daniel and/or Brothers (American)
Photos dated: 1860s-1870s
Processes:      Albumen
Formats:        Prints, cdvs, stereos
Subjects:       Portraits
Locations:      Studio
Studio:         US - Baltimore, Maryland
   Entries:
Sothebys NY (Strober Coll.) 2/7/70: 373 (50);
Swann NY 12/8/77: 23 (book, 62);
Harris Baltimore 3/26/82: 80 (book, 46);
Christies NY 2/13/85: 152 (lot, B-1 et al);
Harris Baltimore 3/15/85: 407 (book, 1);
Swann NY 11/14/85: 263 (books, B et al), 288 (note);

BENECKE, E. (French)
Photos dated: 1852-1853
Processes:      Calotype
Formats:        Prints
Subjects:       Architecture, topography
Locations:      Egypt; Lebanon; Syria
Studio:
   Entries:
Wood Conn Cat 37, 1976: 259 ill(note);
Christies Lon 10/27/77: 125 (note);
Christies Lon 6/18/81: 230;
Christies Lon 3/28/85: 153 (note);

BENECKE, R. (American)
Photos dated: 1860s-1870s
Processes:      Albumen
Formats:        Prints, stereos
Subjects:       Documentary (Civil War), topography
Locations:      US - St. Louis, Missouri
Studio:         US - St. Louis, Missouri
   Entries:
California Galleries 4/3/76: 404 (lot, B-1 et al);
Sothebys NY 10/4/77: 21 (lot, B-1 et al);
Christies Lon 10/30/80: 124 (lot, B-1 et al);

BENEDICT, P.H. (American)
Photos dated: 1850s
Processes:      Daguerreotype
Formats:        Plates
Subjects:       Portraits
Locations:      Studio
Studio:         US - Syracuse, New York
   Entries:
Swann NY 4/23/81: 247 (lot, B-1 et al)(note), 254
   (lot, B-1 et al);

BENNETT & BROWN (see BROWN, W.H.) [BENNETT 1]

BENNETT (British) [BENNETT 2]
Photos dated: c1870
Processes:      Albumen
Formats:        Cdvs
Subjects:       Topography
Locations:      England
Studio:         England
   Entries:
California Galleries 9/27/75: 386 (lot, B et al);

BENNETT, Charles (Canadian)
Photos dated: 1870s-1890s
Processes:      Albumen
Formats:        Prints
Subjects:       Ethnography
Locations:      Canada
Studio:         Canada - Montreal
   Entries:
Swann NY 11/11/76: 465 (lot, B-1 et al);
Phillips Can 10/9/80: 56 (2);

BENNETT, George Wheatly
Photos dated: 1866
Processes:      Albumen
Formats:        Prints
Subjects:       Topography, ethnography
Locations:      British Guiana
Studio:
   Entries:
Swann NY 2/14/52: 40 (book, 44);
Edwards Lon 1975: 61 (book, 42);
Frontier AC, Texas, 1978: 23 (book, 13)(note);
Swann NY 12/14/78: 18 (book, 15)(note);
Christies Lon 3/11/82: 251 (book, 44);

**BENNETT, Henry Hamilton** (American, 1843-1908)
Photos dated: 1868-c1900
Processes:      Albumen
Formats:        Prints incl. panoramas, stereos, cdvs
Subjects:       Topography, ethnography
Locations:      US - Wisconsin; Minnesota; Illinois
Studio:         US - Kilbourn City, Wisconsin
   Entries:
Rinhart NY Cat 2, 1971: 446;
Rinhart NY Cat 7, 1973: 199, 341;
Vermont Cat 5, 1973: 535 (lot, B et al);
California Galleries 4/3/76: 489 (lot, B-10 et al);
Vermont Cat 11/12, 1977: 767 ill(8);
White LA 1977: 75 ill(note);
California Galleries 1/21/78: 205 (lot, B-10 et al);
Witkin NY Stereo 1979: 3 (2 ills)(14)(note);
Swann NY 10/18/79: 401 (10)(note);
California Galleries 3/30/80: 384 (3);
Swann NY 11/6/80: 383 (lot, B-1 et al);
Rose Florida Cat 7, 1982: 90 (lot, B et al);
Christies NY 11/8/82: 25 ill;
Harris Baltimore 12/10/82: 57 (lot, B et al);
Harris Baltimore 4/8/83: 9 (21);
Christies Lon 6/23/83: 47 (lot, B et al);
Swann NY 11/10/83: 347 (165)(note);
Harris Baltimore 12/16/83: 13 (10);
Harris Baltimore 6/1/84: 10 (21);
Harris Baltimore 3/15/85: 9 (5);
Sothebys NY 5/8/85: 630 (lot, B et al);
Harris Baltimore 2/14/86: 3 (27);

**BENNOCH**
Photos dated: c1860
Processes:      Albumen
Formats:        Prints
Subjects:       Portraits
Locations:
Studio:
   Entries:
Sothebys NY 5/4/76: 105 ill(note);

**BENQUE, M.M.** (French)(see also KLARY)
Photos dated: 1895
Processes:      Albumen
Formats:        Cabinet cards
Subjects:       Portraits
Locations:      France - Paris; Italy - Milan
Studio:         France - Paris
   Entries:
Maggs Paris 1939: 539, 542;
Rauch Geneva 6/13/61: 159 (lot, B et al);
Sothebys NY (Greenway Coll.) 11/20/70: 42 ill(lot,
   B-1 et al);
Auer Paris 5/31/80: 62 (album, B et al);
Christies NY 5/14/81: 41 (books, B-3 et al);
Harris Baltimore 6/1/84: 304;

**BENSLEY** (see BAUGH & BENSLEY)

**BENTLEY, B.W.** (British)
Photos dated: c1870-c1876
Processes:      Albumen
Formats:        Prints
Subjects:       Architecture
Locations:      England - Chatsworth
Studio:         Great Britain
   Entries:
Christies Lon 10/26/78: 103 (album, B-43 et al);
Sothebys Lon 11/1/85: 79 ill(album, 46);

**BERG, Charles A.** (American)
Photos dated: 1895-1899
Processes:      Photogravure
Formats:        Prints
Subjects:       Portraits
Locations:      US
Studio:         US
   Entries:
California Galleries 1/21/79: 397 (2), 398;

**BERGAMANN**
Photos dated: c1870s
Processes:      Albumen
Formats:        Cabinet cards
Subjects:       Portraits
Locations:      Great Britain
Studio:         Great Britain
   Entries:
Harris Baltimore 12/16/83: 258;

**BERGAMSCO**
Photos dated: 1860s-1870
Processes:      Albumen
Formats:        Cdvs
Subjects:       Portraits
Locations:      Studio
Studio:         Russia - St. Petersburg
   Entries:
Sothebys NY 11/2/79: 227 (lot, B-1 et al);
Christies Lon 3/20/80: 353 (album, B et al), 370
   (albums, B et al);

**BERGER, Anthony** (American)
Photos dated: 1864-1865
Processes:      Albumen
Formats:        Prints, cabinet cards
Subjects:       Portraits
Locations:      Studio
Studio:         US - Washington, D.C.
   Entries:
Sothebys NY (Greenway Coll.) 11/20/70: 204 ill;
Sothebys NY 5/20/77: 6 ill(note);
Sothebys NY 5/2/78: 5 ill(note);
Swann NY 11/6/80: 334 ill(note);
Harris Baltimore 3/26/82: 346 (note), 348;
Swann NY 11/10/83: 298 (lot, B-1 et al);
Christies NY 11/11/85: 96 ill(note);
Swann NY 11/14/85: 119 ill
Christies NY 11/11/86: 61 ill(lot, B-3 et al)(note);
Swann NY 11/13/86: 264;

**BERGGREN, G.**
Photos dated: 1860s-1880s
Processes:     Albumen
Formats:       Prints
Subjects:      Topography
Locations:     Egypt; Turkey - Constantinople
Studio:        Egypt
  Entries:
California Galleries 4/2/76: 140 (album, B et al);
Swann NY 11/11/76: 409 (album, B et al)(note);
Swann NY 4/26/79: 463 (album, B et al);
Christies Lon 6/26/80: 264 (album, B-12 et al);
Christies Lon 10/30/80: 194 (album, B et al);
Swann NY 11/6/80: 314 (lot, B et al);
Christies Lon 3/26/81: 363 (album, B-12 et al);
Swann NY 4/23/81: 428 (lot, B et al);
California Galleries 6/28/81: 280 (lot, B et al),
  281 (lot, B et al);
Phillips NY 9/30/82: 985 (album, B-12 et al);
Christies Lon 10/28/82: 58 (lot, B et al);
Christies Lon 6/23/83: 102 (album, B et al);
Christies Lon 10/27/83: 88 (albums, B et al);
California Galleries 6/8/85: 468 (lot, B-4 et al);
Swann NY 11/14/85: 148 (albums, B et al);
Christies Lon 6/26/86: 101 ill(album, 38);

**BERGHEIM, Peter** (British)
Photos dated: 1860s-1880s
Processes:     Albumen
Formats:       Prints, stereos, cdvs
Subjects:      Topography
Locations:     Palestine - Jerusalem; Syria; Turkey;
               Greece
Studio:
  Entries:
Swann NY 2/14/52: 199 (album, 52);
Rinhart NY Cat 7, 1973: 409 (20, attributed);
Sothebys Lon 12/4/73: 20 (lot, B et al);
Edwards Lon 1975: 3 (album, B-2 et al);
Sothebys NY 2/25/75: 157 (lot, B et al);
California Galleries 4/2/76: 207 (13);
California Galleries 4/3/76: 298 (2), 301 (4),
  303 (21);
Sothebys NY 10/4/77: 134 ill(album, B-34 et al);
Christies Lon 6/27/78: 161 (book, B-3 et al);
Christies Lon 10/26/78: 170 (lot, B et al);
Phillips Lon 3/13/79: 56 ill(album, 43);
Sothebys Lon 3/14/79: 135 (album, B et al);
Phillips NY 5/21/80: 234 (2);
Christies Lon 3/11/82: 157 (lot, B-1 et al);
Harris Baltimore 3/26/82: 258 (15);
Christies Lon 3/24/83: 92 (album, B et al);
Swann NY 5/5/83: 405 (lot, B-2 et al);
California Galleries 7/1/84: 283;
Christies Lon 10/25/84: 97 (lot, B et al), 99 (lot,
  B et al);
Christies Lon 3/28/85: 93 (album, B et al);
Christies Lon 10/31/85: 122 (lot, B-2 et al);
Christies Lon 6/26/86: 185 ill(album, B et al);
Phillips Lon 10/29/86: 338 (lot, B-2 et al);
Christies Lon 10/30/86: 132 (album, B-8 et al);

**BERNARD** (see KINER, HIGBEE & BERNARD)

**BERNHEIMER, Charles L.**
Photos dated: 1892
Processes:     Albumen
Formats:       Prints
Subjects:      Topography
Locations:     Trinidad; Barbados
Studio:
  Entries:
Swann NY 9/18/75: 156 (28);

**BERNIER, A.** (French)
Photos dated: c1850
Processes:
Formats:       Prints
Subjects:      Topography
Locations:     France - Brittany
Studio:        France
  Entries:
Bievres France 2/6/83: 22 ill;

**BERNIERI** (Italian)
Photos dated: 1866
Processes:
Formats:       Prints
Subjects:      Documentary (public events)
Locations:     Italy - Turin
Studio:        Italy
  Entries:
Auer, Paris 5/31/80: 179 (album, B et al);

**BERNOUD, Alphonse** (French)
Photos dated: 1840s-1872
Processes:     Daguerreotype, albumen
Formats:       Plates, prints, stereos
Subjects:      Portraits, topography, genre (still
               life)
Locations:     Italy - Naples and Florence
Studio:        Italy - Naples; Florence; Genoa
  Entries:
Sothebys Lon 6/26/75: 124 (lot, B-2 et al);
California Galleries 4/3/76: 384 (lot, B et al);
Rose Boston Cat 2, 1977: 53 ill(note);
Swann NY 10/18/79: 271 ill(100)(note);
Christies NY 5/16/80: 85 (lot, B et al);
Swann NY 4/23/81: 526 (lot, B et al);
Christies Lon 3/11/82: 139 (lot, B et al);
Harris Baltimore 3/26/82: 14 (lot, B et al)(note);
Christies NY 5/26/82: 34 (album, 100);
Christies Lon 6/24/82: 138 (lot, B et al);
Harris Baltimore 12/10/82: 399 (lot, B-6 et al);
Bievres France 2/6/83: 142;
Christies Lon 10/27/83: 73 (lot, B et al);
Sothebys Lon 6/29/84: 48 (lot, B et al);
Harris Baltimore 3/15/85: 51 (lot, B-4 et al);

**BERTALL, Félicien** (French)(aka Vicomte
                d'Arnoux)(see also BAYARD)
Photos dated: 1860s-1877
Processes:     Woodburytype
Formats:       Prints, cdvs
Subjects:      Portraits incl. Galerie Contemporaine
Locations:     Studio
Studio:        France - Paris
  Entries:
Sothebys NY 2/9/77: 53 (lot, B-1 et al);
Sothebys NY 5/20/77: 43 (lot, B-2 et al);
Sothebys Lon 7/1/77: 259 (lot, B-1 et al);

BERTALL, F. (continued)
Swann NY 12/8/77: 347 (lot, B et al);
Witkin NY VI 1978: 62 ill(lot, B-1 et al);
Sothebys LA 2/13/78: 115 (books, B et al)(note);
Christies NY 5/14/81: 41 (books, B-3 et al);
Christies NY 5/26/82: 36 (book, B-4 et al);
Christies Lon 6/24/82: 366 (album, B et al);
Bievres France 2/6/83: 128 (lot, B-2 et al);
Christies NY 5/7/84: 19 (book, B-4 et al);
Christies NY 2/13/85: 135 (lot, B et al);

BERTHAUD, M. (French)
Photos dated: 1860s-1880s
Processes:      Woodburytype, albumen, collotype
Formats:        Prints
Subjects:       Portraits incl. Galerie
                Contemporaine, documentary
                (engineering)
Locations:      France
Studio:         France - Paris
   Entries:
Sothebys LA 2/13/78: 121 (books, B et al)(note);
Christies NY 5/26/82: 36 (book, B et al);
Christies NY 5/7/84: 19 (book, B et al);
Sothebys Lon 11/1/85: 117 ill(book, 23);

BERTHIER, Paul (French, 1822-1912)
Photos dated: 1857-1865
Processes:      Salt, photolithograph (Poitevin
                process),albumenized salt, albumen
Formats:        Prints
Subjects:       Topography, genre (nature),
                documentary (art)
Locations:      France; Italy; Switzerland
Studio:         France - Paris
   Entries:
Maggs Paris 1939: 441;
Lunn DC Cat QP, 1978: 38 (book, B et al)(note);
Octant Paris 3/1979: 13 ill, 19 ill;
Sothebys Lon 10/24/79: 337 (lot, B-1 et al);
Christies Lon 10/28/82: 54 (lot, B-2 et al);
Sothebys Lon 6/24/83: 79 ill(2);
Sothebys Lon 6/29/84: 107 ill(2);

BERTHOMIER
Photos dated: 1870s
Processes:      Albumen
Formats:
Subjects:       Topography
Locations:      Algeria
Studio:
   Entries:
Phillips NY 11/3/79: 179 (album, B et al);

BERTILLON, Alphonse (French)
Photos dated: 1880s-1890s
Processes:      Collotype
Formats:        Prints
Subjects:       Documentary (scientific)
Locations:      France - Paris
Studio:         France - Paris
   Entries:
Andrieux Paris 1951(?): 63 (book, 33)(note);
Weil Lon Cat 21, 1953: 44 (book, 81)(note);
Weil Lon Cat 31, 1963: 251 (book, 81)(note);

BERTILLON, A. (continued)
California Galleries 3/30/80: 32 ill(book, 30)
   (note);
Swann NY 11/14/85: 203 (book, 8)(note);

BERTIN (British)
Photos dated: Nineteenth century
Processes:      Albumen
Formats:        Cabinet cards
Subjects:       Portraits
Locations:      Studio
Studio:         England - Brighton
   Entries:
Sothebys NY 9/23/75: 65 (lot, B et al)(note);

BERTOJA, P.
Photos dated: 1870s
Processes:      Albumen
Formats:        Prints
Subjects:       Topography
Locations:      Italy
Studio:         Italy - Venice
   Entries:
Christies Lon 4/24/86: 377 (lot, B-6 et al);

BERTRAND, A. (French)
Photos dated: 1846-1878
Processes:      Daguerreotype, albumen
Formats:        Plates incl. stereo, prints
Subjects:       Portraits, topography, genre (still
                life)
Locations:      France; Italy - Rome
Studio:         France - Paris
   Entries:
Rauch Geneva 6/13/61: 37 (lot, B-1 et al)(note);
Vermont Cat 10, 1975: 536 ill;
Christies Lon 6/30/77: 91 ill(album, 12);
Sothebys Lon 4/25/86: 10 (lot, B-5 et al);

BERTSCH & ARNAUD
Photos dated: c1870
Processes:      Albumen
Formats:        Prints
Subjects:
Locations:      Mexico
Studio:
   Entries:
Christies Lon 10/30/86: 130 (album, B & A-1 et al);

BESSFORD (American)
Photos dated: 1890s
Processes:      Albumen
Formats:        Cabinet cards
Subjects:       Portraits
Locations:      US - New York
Studio:         US
   Entries:
Harris Baltimore 11/9/84: 110 (lot, B-1 et al),
   119 (2);

BETTESWORTH (see PILCHER & BETTESWORTH)

**BETTS** (American)(see also RICHARD & BETTS)
Photos dated: c1870
Processes: Albumen
Formats: Stereos
Subjects: Topography
Locations: US
Studio: US - Dansville, New York
   Entries:
Rinhart NY Cat 2, 1971: 545 (note);

**BEVAN, Henri** (French, born 1825)
Photos dated: 1864-1870s
Processes: Albumen
Formats: Prints
Subjects: Topography
Locations: France; Egypt; Greece; Reunion;
   Italy - Venice; Turkey -
   Constantinople
Studio: France - Louveciennes
   Entries:
Edwards Lon 1975: 62 (book, 52);
Swann NY 4/14/77: 19;

**BEVINGTON, G.** (British)
Photos dated: 1860s
Processes: Albumen
Formats: Prints
Subjects:
Locations:
Studio: Great Britain (Amateur Photographic
   Association)
   Entries:
Sothebys Lon 10/29/80: 310 (album, B et al);
Christies Lon 10/27/83: 218 (albums, B-6 et al);

**BEY, Saudic**
Photos dated: 1880s
Processes: Albumen
Formats: Prints incl. panoramas
Subjects: Topography
Locations: Middle East
Studio: Middle East
   Entries:
Sothebys Lon 3/21/75: 279 (lot, B et al);

**BEYER, F.** (Norwegian)
Photos dated: 1880s
Processes: Albumen
Formats: Prints
Subjects: Topography
Locations: Norway
Studio: Norway - Bergen
   Entries:
Christies Lon 10/29/81: 279 (album, B et al);

**BEYER, Karol** (Polish, 1818-1877)
Photos dated: 1848-c1870
Processes: Albumen
Formats: Prints
Subjects: Documentary (military)
Locations: Poland - Warsaw
Studio: Poland - Warsaw
   Entries:
Lennert Munich Cat 6, 1981: 14 ill;

**BIEGNER, E.B.** (German)
Photos dated: 1860s-1870s
Processes: Albumen
Formats: Stereos
Subjects: Portraits, genre (animal life)
Locations: Studio
Studio: Germany - Berlin
   Entries:
Rinhart NY Cat 6, 1973: 382;
Harris Baltimore 12/16/83: 110 (lot, B-3 attributed,
   et al);

**BIERSTADT Brothers** (Charles, died 1903, & Edward)
              (American)
Photos dated: c1860-1870s
Processes: Albumen, positive on glass
Formats: Prints, stereos, glass plates
Subjects: Topography
Locations: US - New Hampshire; New York;
   Massachusetts
Studio: US - New Bedford, Massachusetts
   Entries:
Sothebys NY (Weissberg Coll.) 5/16/67: 198 (lot, B-3
   et al);
Sothebys NY (Strober Coll.) 2/7/70: 311 (lot, B-1
   et al), 440, 467 (lot, B et al), 471 (lot, B-1
   et al), 501 (lot, B et al), 512 (lot, B-2 et
   al), 521 (lot, B et al), 525 (lot, B et al);
Rinhart NY Cat 7, 1973: 251, 347;
Wood Conn Cat 37, 1976: 20 (book, 12)(note);
Christies Lon 10/28/76: 198 (lot, B et al);
Sothebys NY 5/2/78: 27;
Swann NY 2/14/78: 295 (lot, B et al), 296 (lot,
   B et al), 298 (lot, B et al), 300 (3)(note), 301
   (3)(note), 302 (3), 303 ill, 308 (lot, B et al);
Swann NY 4/26/79: 204 (book, 24), 434 (48),
   435 (72);
Christies Lon 3/20/80: 108 (lot, B-5 et al);
Christies Lon 10/30/80: 135 (lot, B-4 et al);
Swann NY 4/23/81: 522 (lot, B-7 et al);
Harris Baltimore 5/28/82: 159 (lot, B-1 et al);
Swann NY 5/5/83: 434 (3);
Swann NY 5/9/85: 434 (lot, B et al);
Swann NY 11/14/85: 60 (album, B et al), 158 (lot,
   B et al), 161 (lot, B et al);
Harris Baltimore 2/14/86: 38 (lot, B et al);
Swann NY 5/15/86: 304 (lot, B et al);
Swann NY 11/13/86: 148;

**BIERSTADT, Charles** (American)
Photos dated: 1865-c1890
Processes: Albumen, positive on glass
Formats: Stereos, glass stereo plates, cdvs
Subjects: Topography
Locations: US - Niagara Falls, New York; White
   Mountains, New Hampshire; Yosemite
   Valley, California; Egypt; Palestine
Studio: US - New Bedford, Massachusetts;
   Niagara Falls, New York
   Entries:
Rinhart NY Cat 1, 1971: 241 (lot, B et al);
Rinhart NY Cat 2, 1971: 506 (8);
Vermont Cat 1, 1971: 241 (42)(note), 244 (8);
Vermont Cat 2, 1971: 232 (lot, B-2 et al);
Rinhart NY Cat 7, 1973: 195 (3), 277;
Vermont Cat 9, 1975: 557;
Swann NY 9/18/75: 298 (lot, B et al);
California Galleries 9/27/75: 530 (20), 580 (lot,
   B et al);

BIERSTADT, C. (continued)
Witkin NY IV 1976: S1 ill, S2 ill, S3 ill;
Swann NY 4/1/76: 221 (lot, B et al), 239 (lot,
   B et al);
California Galleries 1/23/77: 421 (20), 454 (lot,
   B et al);
Swann NY 4/14/77: 342 (lot, B et al);
California Galleries 1/21/78: 171 (lot, B et al);
Swann NY 12/14/78: 269 ill(12)(note), 279 (25);
California Galleries 1/21/79: 292 (lot, B et al);
Christies Lon 3/15/79: 77 (lot, B-3 et al);
Phillips Can 10/4/79: 43 (lot, B et al);
Swann NY 10/18/79: 435 (lot, B et al)(note);
California Galleries 3/30/80: 401 (lot, B-1 et al);
Swann NY 4/17/80: 367 (25)(note);
Sothebys NY 5/20/80: 322 (lot, B-24 attributed
   et al);
California Galleries 12/13/80: 358 (lot, B-1 et al),
   383 (lot, B-6 et al);
Swann NY 4/23/81: 522 (lot, B-6 et al), 531 (lot,
   B et al), 540 (lot, B et al);
California Galleries 6/28/81: 156 (album, B-2
   attributed et al), 181 (attributed);
Harris Baltimore 7/31/81: 107 (lot, B et al), 112
   (lot, B-15 et al), 113 (lot, B-10 et al), 129
   (lot, B et al);
Swann NY 11/5/81: 554 (lot, B et al);
Harris Baltimore 3/26/82: 10 (lot, B-3 et al);
Swann NY 4/1/82: 357 (lot, B et al);
California Galleries 5/23/82: 357 (lot, B-1
   attributed et al);
Harris Baltimore 12/10/82: 41 (lot, B et al), 64
   (lot, B et al), 69 (lot, B et al);
Harris Baltimore 4/8/83: 60 (lot, B et al), 75 (lot,
   B et al);
Christies Lon 6/23/83: 55 (lot, B-2 et al);
Christies Lon 10/27/83: 44 (lot, B et al);
Swann NY 11/10/83: 346 (lot, B et al), 352 (lot,
   B-13 et al);
Harris Baltimore 12/16/83: 18 (lot, B-1 et al), 20
   (lot, B-3 et al), 117 (lot, B et al);
Christies Lon 3/29/84: 38 (lot, B-2 et al);
Harris Baltimore 6/1/84: 15 (lot, B et al), 103
   (lot, B et al), 105 (lot, B et al), 109 (lot,
   B et al);
California Galleries 7/1/84: 196 (7);
Swann NY 11/8/84: 41 (book, 1)(note), 265 (lot,
   B et al);
Harris Baltimore 3/15/85: 67 (lot, B et al), 69
   (lot, B et al), 75 (lot, B-7 et al), 76 (lot,
   B-2 et al);
Christies Lon 3/28/85: 45 (lot, B et al);
Phillips Lon 6/26/85: 122 (lot, B-1 et al);
Christies Lon 4/24/86: 340 (lot, B et al);
Phillips Lon 10/29/86: 247A (lot, B et al);
Christies Lon 10/30/86: 34 (lot, B-2 et al);

BIERSTADT, Edward (American)
Photos dated: 1859-1887
Processes:   Autotype, artotype
Formats:     Prints, stereos
Subjects:    Portraits, topography
Locations:   US - St. Augustine, Forida; New York
             City
Studio:      US - New Bedford, Massachusetts
   Entries:
Rinhart NY Cat 1, 1971: 476 (book, 32);
Witkin II 1974: 85 ill(book, 31);
Stern Chicago 1975(?): 33 (book, B & Harroun, 32)
   (note), 38 (book, B & Harroun, 24);

BIERSTADT, E. (continued)
Kingston Boston 1976: 350 (book, B et al)(note);
Witkin III 1975: 530 (book, 31);
Witkin IV 1976: OP192 (book, 31);
Wood Conn Cat 37, 1976: 78 (book, B & Harroun, 52)
   (note), 84 (book, B & Harroun, 24)(note);
Swann NY 4/1/76: 125 (book, 1), 274 (book, B &
   Harroun, 32);
Swann NY 4/14/77: 178 ill(book, 24)(attributed)
   (note);
Swann NY 12/8/77: 25 (book, 51), 67 (book, B-1
   et al);
Wood Conn Cat 42, 1978: 210 (book, B & Harroun, 51)
   (note), 223 (book, B & Harroun, 24)(note);
Wood Conn Cat 45, 1979: 122 (book, B & Harroun, 51)
   (note), 128 (book, B & Harroun, 24)(note);
California Galleries 3/30/80: 242 (4);
Swann NY 4/17/80: 208 (book, 24)(note);
Christies NY 5/14/80: 356 (book, 1);
Swann NY 4/23/81: 101 (book, B & Harroun, 32);
Swann NY 7/9/81: 39 (book, 41), 40 (book);
Harris Baltimore 7/31/81: 156 (3);
Wood Conn Cat 49, 1982: 167 (books, B-48, B &
   Harroun-48), (note), 209 (book, 24)(attributed),
   499 (book, B-1 et al);
Swann NY 4/1/82: 20 (book, B & Harroun, 32);
Swann NY 11/18/82: 108 (book, B & Harroun, 32);
Swann NY 5/5/83: 118 (book, B & Harroun, 32);
Swann NY 11/10/83: 74 (book, B & Harroun, 32);
Swann NY 5/9/85: 180 (book, 24);
Swann NY 11/14/85: 164 (lot, B-6 et al), 168 (lot,
   B et al), 230 (book, B & Harroun, 51);
Swann NY 11/13/86: 126 (book, B-1 et al);

BIGELOW
Photos dated: c1860-1876
Processes:   Albumen
Formats:     Prints
Subjects:    Genre
Locations:
Studio:
   Entries:
Swann NY 2/14/52: 41 (book, 24);
California Galleries 7/1/84: 111 (book, 1);

BIGELOW, R.P. (American)
Photos dated: 1891
Processes:   Silver
Formats:     Prints
Subjects:    Topography
Locations:   Jamaica
Studio:      US - Baltimore, Maryland
   Entries:
Harris Baltimore 11/7/86: 274 (lot, B-14 et al);

BIGGS, Colonel R.A. (British)
Photos dated: 1855-1869
Processes:   Albumen, autotype
Formats:     Prints
Subjects:    Topography, architecture
Locations:   India - Ahmedabad et al
Studio:
   Entries:
Swann NY 2/14/52: 42 (books, 147);
Vermont Cat 7, 1974: 758 (3 ills)(book, 120)(note);
Christies Lon 4/25/74: 209 (books, B et al);
Vermont Cat 11/12, 1977: 514 ill(book, 120)(note);
California Galleries 3/30/80: 243 ill;

**BIGGS, R.A.** (continued)
Sothebys Lon 10/28/81: 137;
Christies Lon 6/23/83: 135 (lot, B et al);
Christies Lon 10/27/83: 218 (albums, B-2 et al);
Sothebys Lon 6/29/84: 99 ill(2);
Wood Boston Cat 58, 1986: 263 (book, B et al);

**BIGGS, Captain T.** (British)
Photos dated: 1856
Processes:      Albumen
Formats:        Prints
Subjects:       Architecture
Locations:      India - Beejapoor
Studio:
    Entries:
Sothebys Lon 6/27/80: 57 (2), 58 ill(2);

**BILBROUGH, J.E.** (American)
Photos dated: 1860s-1870s
Processes:      Albumen
Formats:        Cdvs, stereos
Subjects:       Portraits, topography
Locations:      US - Dubuque, Iowa
Studio:         US
    Entries:
Swann NY 11/6/80: 261 (lot, B-1 et al);

**BILL, Charles K.** (American)
Photos dated: 1860-1860s
Processes:      Albumen
Formats:        Prints, stereos
Subjects:       Portraits
Locations:      US - New York
Studio:         US - New York City
    Entries:
Rinhart NY Cat 1, 1971: 461 (album, 53);
Harris Baltimore 9/16/83: 137;
Harris Baltimore 11/9/84: 68 (lot, B-1 et al);

**BILLING, Archibald** (photographer or author?)
Photos dated: 1867
Processes:      Albumen
Formats:        Prints
Subjects:       Documentary (art)
Locations:
Studio:
    Entries:
California Galleries 9/26/75: 110 (book, 18);

**BILLINGTON, W.C.** (American)
Photos dated: c1885-c1890
Processes:      Albumen, silver
Formats:        Prints
Subjects:       Topography
Locations:      US - San Francisco, California
Studio:         US - California
    Entries:
California Galleries 1/21/78: 395 (4), 396 (3);
California Galleries 6/19/83: 371 (lot, B-1 et al);

**BINGHAM** (American) [BINGHAM 1]
Photos dated: 1870s
Processes:      Albumen
Formats:        Cdvs
Subjects:       Portraits
Locations:      Studio
Studio:         US - Memphis, Tennessee
    Entries:
Sothebys NY (Strober Coll.) 2/7/70: 296 (lot,
    B et al);
Christies Lon 6/26/80: 496 (albums, B-2 et al);

**BINGHAM** (British) [BINGHAM 2]
Photos dated: 1870s
Processes:      Albumen
Formats:        Cdvs
Subjects:       Portraits
Locations:      Studio
Studio:         England
    Entries:
Christies Lon 10/36/86: 227 (album, B et al);

**BINGHAM, H.V.** (Canadian)
Photos dated: c1870s
Processes:      Albumen
Formats:        Stereos
Subjects:       Topography
Locations:      Canada
Studio:         Canada - Winnipeg, Manitoba
    Entries:
Rinhart NY Cat 6, 1973: 390, 391;

**BINGHAM, Robert Jefferson** (British, died 1870)
Photos dated: mid 1840s-1860
Processes:      Salt
Formats:        Prints
Subjects:       Documentary (art)
Locations:      Studio
Studio:         France - Paris
    Entries:
Edwards Lon 1975: 79 (book, 86)(note), 159
    (book, 60);

**BINSSE, B.B. & Co.** (American)
Photos dated: 1850s
Processes:      Daguerreotype
Formats:        Plates
Subjects:       Portraits
Locations:      Studio
Studio:         US - New York City
    Entries:
Witkin NY III 1975: D83 ill, D91 ill;

**BIRD** (see SAWYER & BIRD)

**BIRD, Frederick C.** (British)
Photos dated: Nineteenth century
Processes:      Albumen
Formats:        Prints
Subjects:       Topography
Locations:      Great Britain
Studio:         Great Britain
    Entries:
Christies Lon 6/26/80: 157 (lot, B-1 et al), 480
    (albums, B et al)(note);

**BISCHOFF & SPENCER**
Photos dated: 1870s-1880s
Processes:      Albumen
Formats:        Prints, cdvs
Subjects:       Documentary (railroads)
Locations:      Chile
Studio:         Chile - Valparaiso; Santiago
    Entries:
Christies Lon 3/16/78: 131;
Christies Lon 10/30/80: 269A;

**BISHOP & NEEDLES** (American) [BISHOP 1]
Photos dated: 1860s
Processes:      Albumen
Formats:        Cdvs
Subjects:       Portraits
Locations:      Studio
Studio:         US
    Entries:
Sothebys NY (Greenway Coll.) 11/20/70: 261 (lot,
    B & N-1 et al);

**BISHOP** (British) [BISHOP 2]
Photos dated: Nineteenth century
Processes:      Albumen
Formats:        Stereos
Subjects:       Topography
Locations:      England - Poole
Studio:         England - Poole
    Entries:
Christies Lon 6/27/85: 281 (album, B et al);

**BISHOP Brothers** (American) [BISHOP 3]
Photos dated: c1870-1880s
Processes:      Albumen
Formats:        Stereos
Subjects:       Documentary (railroads)
Locations:      US - Maryland
Studio:         US - Cumberland, Maryland
    Entries:
Harris Baltimore 4/8/83: 8 (lot, B et al);

**BISSON Frères** (French, Louis-Auguste, 1814-1876,
                Auguste-Rosalie, 1826-1900)
Photos dated: 1841-1871
Processes:      Daguerreotype, salt, albumenized salt,
                albumen
Formats:        Plates, prints, cdvs, stereos
Subjects:       Architecture, topography, portraits,
                documentary (Paris Commune)
Locations:      France - Paris, Savoy et al; Italy -
                Pisa, Venice, Rome; Egypt; Syria
Studio:         France - Paris
    Entries:
Maggs Paris 1939: 442 (note), 443 (note), 501
    (note);
Goldschmidt Lon Cat 52, 1939: 223 (lot, B et al);
Weil Lon Cat 4, 1944(?): 181 (album, B et al);
Andrieux Paris 1951(?): 38 (7);
Rauch Geneva 6/13/61: 114 (27)(note), 115 ill
    (A-R B, 5)(note), 116 (A-R B, 2), 117 ill(25)
    (note);
Lunn DC Cat 3, 1973: 20 ill;
Sothebys Lon 12/4/73: 26 (album, B-16 attributed
    et al);
Sothebys NY 2/25/75: 144 (2);
Sothebys Lon 3/21/75: 102;
Sothebys Lon 6/26/75: 118 (albums, B-1 et al);
Sothebys Lon 10/24/75: 106 (lot, B-1 et al);
Colnaghi Lon 1976: 97 ill(note), 98 ill, 99, 100
    ill, 101;
Kingston Boston 1976: 183 (album, B attributed
    et al);
Lunn DC Cat 6, 1976: 14 ill(note), 15 (note),
    16 ill;
Wood Conn Cat 37, 1976: 21 (5 ills)(book, 12)
    (note), 262 ill(note);
Sothebys Lon 3/19/76: 23 (2);
Sothebys Lon 10/29/76: 298 ill(2);
Sothebys NY 11/9/76: 48 (L-A B, 2);
Sothebys NY 2/9/77: 17 ill;
Sothebys Lon 3/9/77: 208;
Gordon NY 5/10/77: 787 (book, 90)(note), 788 ill
    (attributed);
Christies Lon 6/30/77: 281 ill, 282 ill;
Sothebys NY 10/4/77: 201 (3);
Christies Lon 10/27/77: 8 ill(note);
Lunn DC Cat QP, 1978: 19 ill, 20, 21 ill(A-R B);
Rose Boston Cat 3, 1978: 65 ill(note);
Wood Conn Cat 41, 1978: 1 ill(note), 2 (book, 53)
    (note), 2a ill;
Sothebys LA 2/13/78: 118 ill;
Sothebys Lon 3/22/78: 183 (3);
Sothebys NY 5/2/78: 91 ill(book, 12);
Christies Lon 6/27/78: 201 ill(book, 12), 202 ill,
    203 ill, 204 ill, 205 ill, 206 ill, 207 ill
    (A-R B), 208;
Sothebys Lon 6/28/78: 301 ill;
Christies Lon 10/26/78: 300, 301 ill;
Sothebys Lon 10/27/78: 94;
Phillips NY 11/4/78: 53 ill, 54 (note), 55, 56;
Swann NY 12/14/78: 19 ill(book, 12), 358;
California Galleries 1/21/79: 399 ill;
Sothebys LA 2/7/79: 436 ill;
Phillips Lon 3/13/79: 84 (A-R B), 84A ill(A-R B), 85
    (A-R B), 86 (A-R B), 87 ill(A-R B),88 (A-R B),
    89 ill;
Sothebys Lon 3/14/79: 277 ill;
Christies Lon 3/15/79: 252 ill, 253 ill(L-A R);
Christies NY 5/4/79: 44;
Christies Lon 6/28/79: 96 (2)(attributed)(note),
    181, 199 (A-R B), 200 (A-R B);
Sothebys Lon 10/24/79: 339 ill, 340;

## BISSON (continued)

Christies Lon 10/25/79: 345, 346 ill, 347 ill, 348 ill, 349 (2), 350 ill;
Sothebys NY 11/2/79: 232 ill(2);
Phillips NY 11/3/79: 166 ill;
Sothebys NY 12/19/79: 44 ill, 45 ill;
White LA 1980-81: 20 ill(note), 21 ill, 44 ill;
Sothebys LA 2/6/80: 130 ill;
Christies Lon 3/20/80: 291 (A-R B), 292 (lot, L-A B-1 et al);
Sothebys Lon 3/21/80: 143 (12);
Christies NY 5/16/80: 164 ill(note);
Sothebys NY 5/20/80: 361 ill, 362 ill, 363 ill;
Phillips NY 5/21/80: 197 ill(lot, B-12 et al), 230 (lot, B et al);
Auer Paris 5/31/80: 77 (lot, A-R B et al);
Christies Lon 6/26/80: 403, 404, 405, 406;
Sothebys Lon 6/27/80: 214 (album, B et al);
Sothebys Lon 10/29/80: 287 ill, 288 ill;
Christies Lon 10/30/80: 362 (lot, B-4 et al), 363 (3), 364 (3), 365 (lot, L-A B-1 et al), 439 (lot, B-1 et al);
Swann NY 11/6/80: 241 ill;
Sothebys NY 11/17/80: 94 ill;
California Galleries 12/13/80: 192, 193 ill;
Koch Cal 1981-82: 27 ill(note);
Sothebys LA 2/4/81: 57 ill;
Christies Lon 3/26/81: 329 (3);
Swann NY 4/23/81: 32 (book, 12)(note), 294, 295, 296 ill;
Phillips NY 5/9/81: 26 ill;
Petzold Germany 5/22/81: 1781 ill, 1782 ill, 1783;
Sothebys Lon 6/17/81: 203 ill, 204 ill, 205, 206, 207, 208;
Christies Lon 6/18/81: 175 (6), 176 (6), 177 (lot, B-1, L-A B-1, et al);
California Galleries 6/28/81: 182 ill(attributed), 183 (attributed);
Sothebys Lon 10/28/81: 174 ill, 175 ill, 176 ill, 177 ill;
Christies Lon 10/29/81: 182, 370 (album, B-1 et al);
Swann NY 11/5/81: 25 (book, 12)(note);
Petzold Germany 11/7/81: 302 (album, B et al);
Rose Florida Cat 7, 1982: 12 ill(note);
Weston Cal 1982: 14 ill;
Christies Lon 3/11/82: 127 (4), 128 ill, 139 (lot, B et al);
California Galleries 5/23/82: 221 (attributed), 222 (attributed);
Christies Lon 6/24/82: 138 (lot, B et al), 302, 303, 304 (2), 374 (album, B-1 et al);
Sothebys Lon 6/25/82: 217 ill(5), 218 ill, 219 ill (3), 220 ill, 221 ill, 222 ill, 223 ill, 224 ill, 225 ill, 226 ill, 227 ill, 228 ill, 229 ill, 230 ill;
Christies Lon 10/28/82: 76;
Sothebys Lon 10/29/82: 96, 97 (4), 98 ill, 99 (6), 100, 101 ill(2), 103 ill, 104 ill, 105 ill, 106 ill, 107 (6), 108, 109 ill, 110 ill, 111 ill(3), 112 ill;
Drouot Paris 11/27/82: 21 ill, 22 (book, 12);
Bievres France 2/6/83: 24 ill, 25 ill, 26 ill, 27 ill, 28 ill, 29 ill, 30 ill, 31 ill, 132 (album, B-3 et al);
Christies Lon 3/24/83: 69 (lot, B-1 et al), 88 (A-R B), 89 (lot, B-2 et al), 90 (2);
Sothebys Lon 3/25/83: 92 (3), 93, 94, 95 (6), 96 (3), 97;
Christies Lon 6/23/83: 121 (4), 122 ill, 123 ill, 124 (A-R B), 256 (lot, B et al);
Christies Lon 10/27/83: 72 (album, B-4 et al);

## BISSON (continued)

Phillips Lon 11/4/83: 130, 131, 132 ill, 133, 134, 135, 136 ill, 137 ill, 138 ill, 139, 140, 141 ill;
Christies NY 11/8/83: 41 ill, 42 ill, 43 ill;
Sothebys Lon 12/9/83: 48 ill(B-5 plus 2 attributed);
Christies Lon 3/29/84: 162 (2), 163 ill, 164 ill (note), 165 ill(note), 166 ill(note);
Christies NY 5/7/84: 17 ill, 18 ill;
Sothebys NY 5/8/84: 47 ill;
Christies Lon 6/28/84: 198 ill;
Sothebys Lon 6/29/84: 124 ill, 125, 147 (2);
California Galleries 7/1/84: 287 ill;
Christies Lon 10/25/84: 171 ill;
Sothebys Lon 10/26/84: 94;
Christies NY 11/6/84: 24 ill, 25 ill;
Harris Baltimore 3/15/85: 143;
Christies Lon 3/28/85: 151 (albums, B-1 et al) (note), 159 (A-R B);
Sothebys Lon 3/29/85: 204 ill, 205, 206 ill, 207 ill, 208 ill, 209 ill;
Swann NY 5/9/85: 325 (4);
California Galleries 6/8/85: 158, 159 (2);
Phillips Lon 6/26/85: 231 ill(2);
Christies Lon 6/27/85: 150;
Christies Lon 10/31/85: 196 (A-R B), 198 (lot, B-1 et al);
Sothebys NY 11/12/85: 45;
Wood Boston Cat 58, 1986: 220 (book, 22)(note), 221 (book, 12)(note);
Christies Lon 4/24/86: 466, 467 ill, 468 ill;
Sothebys Lon 4/25/86: 200, 201 ill(album, 20);
Christies NY 5/13/86: 294 (lot, B-1 et al);
Swann NY 5/15/86: 171 (note), 172 (note), 173 (note), 174 (2)(note), 190 (lot, A-R B-1, B-1, et al);
Christies Lon 10/30/86: 90 ill, 91 ill, 92 (lot, B-1 et al);
Sothebys Lon 10/31/86: 165 (2), 166;
Christies NY 11/11/86: 51 ill;
Swann NY 11/13/86: 357 (lot, B et al);

**BIXBY, M.J.** (American)
Photos dated: 1870s
Processes:    Albumen
Formats:      Stereos
Subjects:     Topography
Locations:    US - Vermont
Studio:       US - Burlington, Vermont
   Entries:
Harris Baltimore 12/10/82: 106 (lot, B et al);

**BLACK, James Wallace** (American, 1825-1896)
Photos dated: 1856-1872
Processes:    Daguerreotype, albumen
Formats:      Plates, prints, cdvs, stereos
Subjects:     Documentary (Civil War, maritime, railroads)
Locations:    US - Boston, Massachusetts; New Hampshire
Studio:       US - Boston, Massachusetts
   Entries:
Sothebys NY (Strober Coll.) 31 (books, B et al), 427 (lot, B-1 et al);
Sothebys NY (Greenway Coll.) 11/20/70: 172 (lot, B & Case-1, et al), 182 (lot, B-1 et al), 235 (lot, B & Case-1, et al), 243 (lot, B-1 et al), 254 (lot, B & Case-1, et al), 261 (lot, B-1 et al);
Rinhart NY Cat 1, 1971: 320 ill;

**BLACK, J.W.** (continued)
Rinhart NY Cat 2, 1971: 288 (lot, B et al);
Rinhart NY Cat 7, 1973: 155 (album, B & Case et al);
Vermont Cat 5, 1973: 506 ill(note), 507 ill, 508
   ill, 509 ill, 510 ill, 511 ill, 512 ill;
Vermont Cat 7, 1974: 659 ill(note), 660 ill, 661
   ill, 662 ill, 663 ill, 664 ill;
Sothebys NY 2/25/75: 130;
Sothebys NY 9/23/75: 117;
Halsted Michigan 1977: 582;
Sothebys NY 5/20/77: 5 (note);
Sothebys NY 10/4/77: 23;
California Galleries 1/21/78: 129 (lot, B et al);
Witkin NY IX 1979: 2/47 (book, B-1 et al);
Swann NY 4/26/79: 297 (note);
Swann NY 10/18/79: 297;
Christies NY 11/11/80: 170;
Rose Florida Cat 7, 1982: 88 ill, 89 ill;
Sothebys LA 2/16/82: 52 (note);
Christies NY 2/8/83: 43 (lot, B & Case-1, et al);
Harris Baltimore 9/16/83: 195;
Harris Baltimore 6/1/84: 331;
Swann NY 11/8/84: 188 (album, B, B & Case, et al);
Swann NY 11/14/85: 11 (albums, B & Case et al)
   (note), 60 (album, B et al);
Sothebys NY 5/12/86: 49 ill(note), 50 ill, 51 ill;
Swann NY 5/15/86: 163 (lot, B & Case-1, et al), 175;
Harris Baltimore 11/7/86: 59 ill(lot, B & Case-1,
   et al);
Swann NY 11/13/86: 200 (lot, B et al);

**BLACKMAN, J.B.** (American)
Photos dated: 1864
Processes:      Albumen
Formats:        Cdvs
Subjects:       Portraits
Locations:      Studio
Studio:         US
   Entries:
Rinhart NY Cat 6, 1973: 247;

**BLACKMORE, William** (photographer or author?)
Photos dated: 1869
Processes:      Albumen
Formats:        Prints
Subjects:       Topography
Locations:      US - Denver, Colorado
Studio:
   Entries:
Frontier AC, Texas, 1978: 24a (book, 4)(note), 24b
   ill(book, 4);

**BLACKWOOD, W.**
Photos dated: 1859-c1870s
Processes:      Albumen
Formats:        Prints
Subjects:       Architecture, topography
Locations:      Australia - Sydney
Studio:         Australia
   Entries:
Sothebys Lon 10/28/81: 241a (book, 9);
Christies Lon 10/27/83: 136 (album, 13);

**BLAISE, Gabriel** (French)
Photos dated: 1865-c1870
Processes:      Albumen
Formats:        Prints, cdvs
Subjects:       Architecture, documentary
                (Franco-Prussian War)
Locations:      France - Tours; Chenonceau; Amboise;
                Orleans
Studio:         France
   Entries:
Rose Boston Cat 2, 1977: 37 ill(note), 38 ill;
Sothebys Lon 3/9/77: 209 (lot, B-2 et al);
Christies Lon 10/27/77: 92 ill(note);
Christies Lon 3/16/78: 304;
Mancini Phila 1979: 11 ill, 12, 13;
Christies Lon 3/15/79: 137 (3), 138 (note), 139;
Christies Lon 10/25/79: 150, 233 (lot, B-1 et al);
Christies Lon 6/26/80: 198, 261 (lot, B-2 et al),
   263 (lot, B-1 et al);
Swann NY 5/15/86: 190 (lot, B-1 et al);
Swann NY 11/13/86: 168 (album, B et al);

**BLAKEMORE, B.A.** (American)
Photos dated: c1880s
Processes:      Albumen
Formats:        Cabinet cards
Subjects:       Portraits
Locations:      Studio
Studio:         US - Staunton, Virginia
   Entries:
Harris Baltimore 2/14/86: 65 (lot, B-1 et al);

**BLANC** (see DEREPAR Frères & BLANC)

**BLANC, Numa et Fils** (French)(a.k.a. NB)
Photos dated: 1860s-c1890
Processes:      Albumen, woodburytype
Formats:        Prints, stereos, cabinet cards, cdvs
Subjects:       Portraits incl. Galerie Contemporaine,
                topography
Locations:      France - Paris
Studio:         France - Paris
   Entries:
Christies Lon 6/26/80: 210 (lot, B et al);
Christies NY 5/26/82: 36 (book, B, Numa-B, et al);
Christies NY 5/7/84: 19 (book, B, Numa-B, et al);
Harris Baltimore 3/15/85: 273 (lot, B et al);

**BLANCHARD** (see PIERCE & BLANCHARD)

**BLANCHARD, Fred** (American)
Photos dated: 1880s
Processes:      Albumen
Formats:        Prints
Subjects:       Topography
Locations:      US - Maine
Studio:         US - Bath, Maine
   Entries:
Rose Boston Cat 5, 1980: 1 ill(4)(note);

**BLANCHARD, J.B.** (American)
Photos dated: c1890
Processes:      Albumen
Formats:        Prints, cabinet cards
Subjects:       Topography
Locations:      US - Los Angeles, California
Studio:         US
   Entries:
White LA 1977: 79;
Harris Baltimore 12/16/83: 293 (lot, B et al);

**BLANCHARD, Valentine** (British, 1831-1901)
Photos dated: 1862-1870s
Processes:      Albumen
Formats:        Prints, stereos
Subjects:       Topography, documentary (art,
                maritime)
Locations:      England - London; Isle of Wight
Studio:         England
   Entries:
Sothebys Lon 10/18/74: 88 (albums, B et al);
Swann NY 2/6/75: 47 (book, 6);
California Galleries 9/26/75: 448 (lot, B et al);
Swann NY 4/1/76: 303 (book, 4)(note);
Sothebys Lon 6/11/76: 2 (lot, B et al);
Christies Lon 10/27/77: 60 (lot, B-4 et al);
Vermont Cat 11/12, 1977: 833 ill(10);
Christies Lon 3/16/78: 213 (books, B-6 et al);
Sothebys Lon 10/24/79: 58 (lot, B et al);
Christies Lon 3/20/80: 107 (lot, B et al);
Sothebys Lon 10/29/80: 6 (lot, B et al);
Christies Lon 10/30/80: 112 (lot, B-8 et al);
Christies Lon 3/26/81: 116 (lot, B et al);
Swann NY 4/23/81: 526 (lot, B et al);
Christies Lon 6/18/81: 99 (lot, B-6 et al);
Christies Lon 10/29/81: 119 (lot, B et al), 128
   (lot, B et al);
Christies Lon 3/11/82: 77 (lot, B-6 et al);
Sothebys Lon 3/15/82: 434 (book, 6);
Phillips Lon 3/17/82: 74 (album, B-1 et al);
Christies Lon 6/24/82: 63 (lot, B et al);
Sothebys Lon 6/25/82: 3 (lot, B et al), 4 (lot,
   B et al);
Harris Baltimore 4/8/83: 37 (lot, B-1 et al);
Phillips Lon 6/15/83: 96 (lot, B-20 et al);
Christies Lon 6/23/83: 50 (lot, B-4 et al);
Christies Lon 10/27/83: 33 (lot, B et al);
Harris Baltimore 12/16/83: 15 (45);
Christies Lon 3/29/84: 22 (lot, B et al);
Harris Baltimore 6/1/84: 64 (lot, B-4 et al);
Phillips Lon 10/24/84: 121 (lot, B-2 et al);
Christies Lon 10/25/84: 41 (lot, B et al);
California Galleries 6/8/85: 323 (lot, B-4 et al);
Christies Lon 6/27/85: 45 (lot, B et al);
Phillips Lon 10/30/85: 22 (lot, B-20 et al);
Christies Lon 10/31/85: 148 (book, 6);
Christies Lon 4/24/86: 338 (lot, B et al), 345 (lot,
   B et al);
Christies Lon 6/26/86: 2 (lot, B et al);
Phillips Lon 10/29/86: 223 (lot, B et al);
Christies Lon 10/30/86: 33 (lot, B et al), 34 (lot,
   B-7 et al);

**BLANCHE**
Photos dated: 1880s
Processes:      Albumen
Formats:        Prints
Subjects:       Genre (nudes)
Locations:
Studio:
   Entries:
Christies Lon 6/27/78: 255 ill(12);
Phillips NY 5/21/80: 133 (album, 12);

**BLANCHERE, Henri de la** (French)
Photos dated: 1859-1860
Processes:      Albumen
Formats:        Prints
Subjects:       Portraits
Locations:      Studio
Studio:         France
   Entries:
Swann NY 2/14/52: 281 (book, 10);
Drouot Paris 5/29/78: 69 (lot, B et al);
Swann NY 12/14/78: 205 (book, 10)(note);

**BLAND & LONG** (British)
Photos dated: 1850s
Processes:      Daguerreotype
Formats:        Stereo plates
Subjects:       Genre
Locations:      Great Britain
Studio:         England - London
   Entries:
Christies Lon 3/11/82: 61 (lot, B & L et al);
Phillips Lon 6/26/85: 129 ill;
Phillips Lon 10/30/85: 23;

**BLANQUART-EVRARD, Louis-Désiré** (French, 1802-1872)
Photos dated: 1847-1851
Processes:      Calotype (Blanquart-Evrard process)
Formats:        Prints
Subjects:       Topography, documentary (art)
Locations:      France
Studio:         France - Lille
   Entries:
Maggs Paris 1939: 444 (note);
Weil Lon 1946: 13 (album, 20)(note), 14 (album,
   20)(note), 15 (album, 20);
Andrieux Paris 1951(?): 7 (album, B-36 et al),
   8 (album, 12), 9;
Swann NY 2/14/52: 44 (book, 20)(note), 45 (book,
   20)(note);
Weil Lon Cat 31, 1963: 181 (book, 14)(note);
Vermont Cat 1, 1971: 254 ill(album, B et al)(note);
Witkin I 1973: 288 ill(attributed);
Witkin II 1974: 736 ill, 737 ill;
Witkin III 1975: 21 ill(note), 22 ill;
Lehr NY Vol 1:2, 1978: 3 ill;
Swann NY 4/20/78: 191 ill;
Bievres France 2/6/83: 32 (note);
Sothebys Lon 12/9/83: 46 (book, B-1 et al);
Christies NY 5/6/85: 50 ill(book, B et al)(note);

**BLAVETT** (see BROOKS & BLAVETT)

**BLESSING, S.T.** (American)
Photos dated: early 1870s-1878
Processes: Albumen
Formats: Stereos
Subjects: Topography
Locations: US - New Orleans, Louisiana
Studio: US - New Orleans, Louisiana
Entries:
Rinhart NY Cat 2, 1971: 499;
Rinhart NY Cat 6, 1973: 479, 512;
Rinhart NY Cat 8, 1973: 68;
Vermont Cat 5, 1973: 539 ill(3);
Vermont Cat 11/12, 1977: 769 ill(3);
Swann NY 11/14/85: 170 (lot, B et al);
Harris Baltimore 2/14/86: 37 (lot, B-2 et al);

**BLIGH, Frederick Arthur**
Photos dated: 1891
Processes: Gelatin silver, platinum
Formats: Prints
Subjects: Topography
Locations: Switzerland - St. Moritz
Studio:
Entries:
Christies Lon 10/31/85: 91 (album, 110);

**BLISS, H.L.** (American)
Photos dated: c1870s
Processes: Albumen
Formats: Prints
Subjects: Documentary (railroads)
Locations: US - Buffalo, New York
Studio: US - Buffalo, New York
Entries:
Rinhart NY Cat 7, 1973: 410;
California Galleries 9/26/75: 242;

**BLIVEN, R.H.** (American)
Photos dated: 1871
Processes: Albumen
Formats: Stereos
Subjects: Documentary (disasters)
Locations: US - Chicago, Illinois
Studio: US - Toledo, Ohio
Entries:
Frontier AC, Texas, 1978: 25;

**BLOCK, A.**
Photos dated: 1871
Processes: Albumen
Formats: Stereos
Subjects: Documentary (Paris Commune)
Locations: France - Paris
Studio:
Entries:
Christies Lon 6/24/82: 56 (lot, B et al);

**BLOMBERG**
Photos dated: Nineteenth century
Processes: Albumen
Formats: Cabinet cards
Subjects: Portraits
Locations:
Studio:
Entries:
Sothebys NY (Greenway Coll.) 11/20/70: 13 (lot, B-1 et al);

**BLOT, J.** (French)
Photos dated: 1851-1855
Processes: Salt (Blanquart-Evrard process)
Formats: Prints
Subjects:
Locations:
Studio: France
Entries:
Rauch Geneva 6/13/61: 65 (lot, B et al)(note);

**BLOT, Sabatier** (French)
Photos dated: 1846-1850s
Processes: Daguerreotype
Formats: Plates
Subjects: Portraits
Locations: Studio
Studio: France - Paris
Entries:
Auer Paris 5/31/80: 10 ill(note);
Sothebys Lon 6/25/82: 28 ill;
Sothebys Lon 3/29/85: 38 ill;

**BLOWERS, John** (British)
Photos dated: 1840s
Processes: Calotype
Formats: Prints
Subjects: Portraits
Locations: Great Britain
Studio: Great Britain
Entries:
Sothebys Lon 6/28/85: 123 (lot, B-1 et al);

**BOCK, Hermann** (German)
Photos dated: Nineteenth century
Processes: Albumen
Formats: Cabinet cards
Subjects: Portraits
Locations: Studio
Studio: Germany
Entries:
Petzold Germany 11/7/81: 324 (album, B et al);

**BODMAN, C.** (French?)
Photos dated: c1870
Processes: Albumen
Formats: Prints
Subjects: Genre (still life)
Locations:
Studio:
Entries:
Rose Boston Cat 1, 1976: 15 ill;

**BOEHRINGER, Carl B.** (German, died c1915)
Photos dated: c1890s-1915
Processes:      Albumen, silver
Formats:        Cabinet cards
Subjects:       Portraits
Locations:      Studio
Studio:         Greece - Athens
    Entries:
Harris Baltimore 3/15/85: 277 (lot, B et al);

**BOEKMANN & Co.** (Swedish)
Photos dated: 1860s
Processes:      Albumen
Formats:        Cdvs, stereos
Subjects:       Topography, ethnography
Locations:      Sweden
Studio:         Sweden - Stockholm
    Entries:
Christies Lon 10/27/83: 234 (album, B-4 et al);

**BOEL & KOENIG** (American)
Photos dated: 1860s-1870s
Processes:      Albumen
Formats:        Stereos
Subjects:       Topography
Locations:      US - St. Louis, Missouri
Studio:         US - St. Louis, Missouri
    Entries:
Rinhart NY Cat 1, 1971: 257 (2);
Vermont Cat 7, 1974: 608 ill(17), 609 ill(24);
Swann NY 11/6/80: 378 (lot, B & K-3 et al);
Christies Lon 3/28/85: 46 (lot, B & K et al);

**BOGARDUS, Abraham** (American, 1822-1908)
Photos dated: 1846-1887
Processes:      Daguerreotype, albumen
Formats:        Plates, cdvs, cabinet cards
Subjects:       Portraits
Locations:      Studio
Studio:         US - New York City
    Entries:
Sothebys NY (Weissberg Coll.) 5/16/67: 172 (lot,
    B et al);
Sothebys NY (Strober Coll.) 2/7/70: 259 (lot,
    B et al), 279 (lot, B-1 et al), 189 (lot,
    B et al), 302 (lot, B et al), 324 (lot, B
    et al), 367 (lot, B et al), 375 (lot, B et al);
Sothebys NY (Greenway Coll.) 11/20/70: 54a ill, 187
    (lot, B-1 et al), 237 ill(lot, B-1 et al);
Sothebys 11/21/70: 351 (lot, B et al);
Rinhart NY Cat 2, 1971: 366 (lot, B et al);
Vermont Cat 4, 1972: 316 ill;
Rinhart NY Cat 7, 1973: 534, 543 (lot, B-1 et al);
Gordon NY 11/13/76: 1 (lot, B et al);
California Galleries 1/21/78: 125 (lot, B et al);
Swann NY 12/14/78: 470 (lot, B et al);
Christies Lon 10/25/79: 25 (lot, B-1 et al);
Sothebys Lon 6/27/80: 30, 33;
Sothebys Lon 3/27/81: 285;
Harris Baltimore 3/26/82: 395 (lot, B et al);
Harris Baltimore 4/8/83: 382 (lot, B et al), 385
    (lot, B et al);
Swann NY 11/10/83: 361 (album, B et al)(note);
Swann NY 5/10/84: 196 (albums, B et al);
Swann NY 11/8/84: 226 (note);
Harris Baltimore 3/15/85: 314 (lot, B et al);
Christies Lon 10/31/85: 20 (lot, B-1 et al);
Swann NY 11/14/85: 263 (books, B et al);

**BOGARDUS, A.** (continued)
Wood Boston Cat 58, 1986: 136 (books, B-1 et al);
Harris Baltimore 2/14/86: 98 (lot, B et al);
Christies NY 11/11/86: 58 ill(note);
Swann NY 11/13/86: 186 (lot, B et al);

**BOHM** (see PERRY)

**BOISSONNAS, Frederick** (Swiss, 1858-1947)
Photos dated: 1886-1900s
Processes:      Photogravure, woodburytype, platinum
Formats:        Prints
Subjects:       Topography, genre, documentary
Locations:      Switzerland; Greece
Studio:         Switzerland
    Entries:
Christies NY 5/14/80: 111 (4 ills)(book, B et al),
    377 (book, B et al);
Harris Baltimore 3/26/82: 398 (lot, B-2 et al);
Christies Lon 3/24/83: 263;
Christies Lon 10/30/86: 93 (lot, B et al);

**BOLDING, William Johnson Jennis** (British)
Photos dated: c1850-1855
Processes:      Albumen
Formats:        Prints
Subjects:       Genre
Locations:      Great Britain
Studio:         Great Britain
    Entries:
Sothebys Lon 6/28/85: 126 ill;

**BOLETTI** (Italian)
Photos dated: Nineteenth century
Processes:
Formats:
Subjects:
Locations:      Italy - Perugia
Studio:         Italy
    Entries:
Christies Lon 3/15/79: 187 (albums, B et al);

**BOLLES, Charles E.** (American)
Photos dated: 1893-1894
Processes:      Albumen
Formats:        Prints
Subjects:       Genre
Locations:      US - Brooklyn, New York
Studio:         US - Brooklyn, New York
    Entries:
Rose Boston Cat 3, 1978: 9 ill(note);
Phillips NY 11/29/79: 296 (lot, B-1 et al);
Phillips NY 5/21/80: 288 (4);

**BOLLES, Jesse A.** (American)
Photos dated: c1870s
Processes:      Albumen
Formats:        Stereos
Subjects:       Genre
Locations:      US - Charleston, South Carolina
Studio:         US - Charleston, South Carolina
    Entries:
Rinhart NY Cat 6, 1973: 502;

**BOLTON, Gambier** (British)
Photos dated: 1860s-1870s
Processes:      Carbon (Swan's process)
Formats:        Prints
Subjects:       Genre (animal life)
Locations:      England
Studio:         England
    Entries:
Sothebys NY 5/8/79: 74 ill, 81 ill(albums, B et al);
Christies NY 5/16/80: 139 ill (album, 20), 140 ill;
California Galleries 6/28/81: 184 (lot, B-5 et al);
Harris Baltimore 3/26/82: 239, 240;
Harris Baltimore 12/10/82: 204, 205;
Christies Lon 10/27/83: 242 (4);
Harris Baltimore 12/16/83: 280;

**BOLTON, T.** (British)
Photos dated: 1859
Processes:      Albumen
Formats:        Prints
Subjects:       Topography
Locations:
Studio:         Great Britain
    Entries:
Sothebys Lon 3/8/74: 170 (book, B et al);

**BONAPARTE, Prince Roland Napoléon** (French,
                1858-1924)
Photos dated: 1880-1890
Processes:      Albumen, heliogravure
Formats:        Prints
Subjects:       Ethnography
Locations:      France; US; Canada; Mongolia
Studio:         France
    Entries:
Sothebys Lon 12/21/71: 182 (lot, B-34 et al)(note);
Wood Conn Cat 41, 1978: 11 ill(note);
Wood Conn Cat 45, 1979: 25 ill(book, 61)(note);
Wood Conn Cat 49, 1982: 46 (book, 61)(note), 47
    (book, 4)(note);
Phillips NY 11/9/82: 34 ill(5)(note), 35 ill(5);
Wood Boston Cat 58, 1986: 224 (book, 61)(note), 225
    (book, 4)(note);
Swann NY 5/15/86: 180 ill(book, 31);

**BOND, J.W.** (British)
Photos dated: 1850s
Processes:      Ambrotype
Formats:        Plate
Subjects:       Portraits
Locations:      Studio
Studio:         England - London
    Entries:
Christies Lon 10/25/84: 11 (lot, B-1 et al);

**BONDONNEAU, Emile** (French)
Photos dated: 1871
Processes:      Albumen, woodburytype
Formats:        Prints
Subjects:       Documentary (Paris Commune), portraits
Locations:      France - Paris
Studio:         France - Paris
    Entries:
Vermont Cat 8, 1974: 575 ill, 576 ill;
Swann NY 11/14/85: 142 (lot, B et al);
Christies Lon 6/26/86: 86 (lot, B et al);

**BONFILS, Adrien** (see BONFILS, Félix)

**BONFILS, Félix** (French, 1829-1885)
Photos dated: 1860s-1880s
Processes:      Albumen
Formats:        Prints, stereos, cdvs
Subjects:       Topography, ethnography
Locations:      France; Lebanon; Egypt; Syria;
                Palestine; Greece
Studio:         France - Alais; Lebanon - Beirut
    Entries:
Vermont Cat 2, 1972: 606 (2 ills)(album, 45)(note);
Rinhart NY Cat 7, 1973: 196 (2), 411, 412, 413,
    414, 415;
Witkin NY I 1973: 549 (album, B et al);
Christies Lon 10/4/73: 174 (6);
Sothebys Lon 12/4/73: 24 (lot, B et al);
Vermont Cat 7, 1974: 748 (6 ills)(albums, 147);
Christies Lon 7/25/74: 338 (albums, B et al);
Sothebys Lon 10/18/74: 110 (album, B et al);
Edwards Lon 1975: 3 (album, B-2 et al);
Sothebys NY 2/25/75: 157 (lot, B et al), 158 ill(3);
Sothebys Lon 3/21/75: 78 (album, B-3 et al), 109
    (album, B et al), 112 (album, B-17 et al), 114
    (album, B-8 et al);
Sothebys Lon 6/26/75: 134 (album, 50);
Sothebys NY 9/23/75: 70 ill(3);
California Galleries 9/26/75: 127 (album, B et al),
    128 (albums, B et al), 166 (album, B et al);
Sothebys Lon 10/24/75: 102 (album, B et al);
Kingston Boston 1976: 20 (4 ills)(20)(note);
Rose Boston Cat 1, 1976: 30 ill(note), 31 ill;
Wood Conn Cat 37, 1976: 247 (album, B et al), 252;
California Galleries 4/2/76: 210 (lot, B et al);
California Galleries 4/3/76: 299 (lot, B-6 et al),
    300 (34);
Swann NY 4/14/76: 240 (album, B et al);
Sothebys NY 5/4/76: 88 (2), 89 (2);
Christies Lon 6/10/76: 80 ill(album, 48), 81
    (album, B et al), 82 ill(album, B et al), 103
    (album, B et al);
Sothebys Lon 6/11/76: 38 (albums, B et al);
Christies Lon 10/28/76: 136 (album, B-14 et al), 143
    (albums, B et al);
Swann NY 11/11/76: 486 (lot, B-1 et al);
Gordon NY 11/13/76: 42 ill(10), 43 ill(10);
Rose Boston Cat 2, 1977: 81 (3 ills)(3)(note), 82
    ill, 83 ill, 84 ill;
California Galleries 1/22/77: 267;
Sothebys NY 2/9/77: 41 (albums, B et al), 42 (lot,
    B-6 et al);
Christies Lon 3/10/77: 142 (album, B et al), 143
    (album, B-14 et al), 148 (albums, B et al), 183
    (albums, B et al), 184 (album, B et al);
Gordon NY 5/10/77: 800 ill(15);
Sothebys NY 5/20/77: 104 (4);
Christies Lon 6/30/77: 123 (album, B-8 et al), 136
    (albums, B-20 et al);
Sothebys Lon 7/1/77: 147 (album, B-85 et al);
Christies Lon 10/27/77: 179 (album, B et al);
Swann NY 12/8/77: 366 (album, B et al), 398 (lot,
    B et al)(note), 399 (lot, B et al);
Rose Boston Cat 3, 1978: 90 ill(note), 91 ill,
    92 ill;
Wood Conn Cat 41, 1978: 18 ill(note), 19 ill,
    20 ill;
Sothebys LA 2/13/78: 136 (14), 137 (lot, B-1 et
    al), 139 (album, B-4 et al);
Christies Lon 3/16/78: 148 (album, B et al), 153
    (lot, B et al);

**BONFILS, F. (continued)**

Sothebys NY 5/2/78: 132 (album, B et al);
Christies Lon 6//27/78: 123 (albums, B-50 et al), 124 (album, B et al);
Sothebys Lon 6/28/78: 120 (albums, B et al);
Christies Lon 10/26/78: 173 (lot, B-40 et al);
Phillips NY 11/4/78: 63 (24)(note);
Rose Boston Cat 4, 1979: 87 ill(note), 88 ill, 89 ill;
California Galleries 1/21/79: 349 (album, B-9 et al), 424 ill(11);
Phillips Lon 3/13/79: 60 ill(albums, B et al);
Sothebys Lon 3/14/79: 132 (album, B et al), 136 (album, B et al);
Christies Lon 3/15/79: 155 (albums, B-18 et al);
Swann NY 4/26/79: 298 (album, 40);
Phillips NY 5/5/79: 169 (37), 170 (lot, B-10 et al), 171 ill(lot, B et al)(note);
Sothebys NY 5/8/79: 105 ill(29);
Christies Lon 6/28/79: 116 (albums, B et al), 120 (albums, B-7 et al), 148 (albums, B et al);
Sothebys Lon 6/29/79: 124 (albums, B et al);
Phillips Can 10/4/79: 13 ill(album, 37);
Christies Lon 10/25/79: 192 (album, B-2 et al), 197 (lot, B-1 et al), 238 (albums, B-3 et al), 242 (lot, B-2 et al), 244 (albums, B et al);
Phillips NY 11/29/79: 261 (album, B-20 et al);
Sothebys NY 12/19/79: 46 ill(lot, B-48 et al);
Rose Boston Cat 5, 1980: 79 ill(note), 80 ill;
Sothebys LA 2/6/80: 166 (lot, B-2 et al);
Christies Lon 3/20/80: 202 (album, B-17 et al), 205 (album, B-2 et al);
Sothebys Lon 3/21/80: 130 ill(lot, B et al), 131 (album, B et al);
California Galleries 3/30/80: 212A (album, B-27 et al), 244 (Adrien B), 245 (5);
Phillips NY 5/21/80: 142 (album, B-19 et al);
Auer Paris 5/31/80: 70 (lot, B et al), 71 (album, B-9 et al), 85 (2), 86 (8), 88 (album, B-94 et al), 89 (lot, B-17 et al), 90 ill(21);
Christies Lon 6/26/80: 222 ill(albums, 200), 228 (lot, B-20 et al), 272 (albums, B et al), 274 (album, B et al);
Phillips Can 10/9/80: 15 ill(album, B-42 et al) (note), 16 (16), 17 (22), 18 ill(21);
Christies Lon 10/30/80: 219 (album, B et al), 220 (lot, B-4 et al), 264 (album, B-15 et al), 268 (album, B-2 et al);
Swann NY 11/6/80: 242 (20), 243 (5), 244 (6), 245 (6), 246 (6), 247 (21), 278 (album, B et al), 316 (album, B et al);
Christies NY 11/11/80: 78 (lot, B et al);
California Galleries 12/13/80: 194 (8);
Christies Lon 3/26/81: 259 (album, B-8 et al);
Sothebys Lon 3/27/81: 57 (albums, B et al);
Swann NY 4/23/81: 417 (3)(note), 418 (album, B-35 et al), 454 (lot, B et al)(note), 455 ill (album, B et al);
Phillips NY 5/9/81: 58 ill(lot, B-1 et al), 59 ill (album, B-23 et al), 60 ill(attributed);
Sothebys NY 5/15/81: 106;
Petzold Germany 5/22/81: 1784 (lot, B-4 et al), 1785 (30);
Christies Lon 6/18/81: 235 (lot, B et al);
Phillips Lon 6/24/81: 79 (lot, B et al);
California Galleries 6/28/81: 185 (5), 216 (lot, B et al), 280 (lot, B et al), 281 (lot, B et al);
Sothebys NY 10/21/81: 211 (albums, B et al);
Phillips Lon 10/28/81: 156 (lot, B-11 et al);

**BONFILS, F. (continued)**

Christies Lon 10/29/81: 220 (lot, B et al), 221 (lot, B et al), 270 (albums, B-25 et al), 276 (albums, B-17 et al);
Swann NY 11/5/81: 275, 276 ill(2), 277 (2), 278 (6), 279 (10), 280 (11), 463 (album, B et al) (note), 481 (lot, B et al);
Rose Florida Cat 7, 1982: 45 ill(note), 46 ill, 47 ill, 48 ill;
Christies Lon 3/11/82: 160 (10);
Harris Baltimore 3/26/82: 259 (2), 260 (3);
Swann NY 4/1/82: 258 ill(6)(note), 259 (7)(note), 260 (23)(note), 327 (album, B et al);
California Galleries 5/23/82: 223 ill(34);
Phillips Lon 6/23/82: 34 (albums, B et al), 43 (lot, B et al);
Christies Lon 6/24/82: 171 (album, B-33 et al), 173 (album, B-14 et al), 197 (lot, B et al), 227 (album, B-22 et al), 229 (lot, B-1 et al), 231 (lot, B et al);
Phillips NY 9/30/82: 941 (4), 968 (album, B-31 et al);
Christies Lon 10/28/82: 79 (lot, B-7 et al), 81 (lot, B-24 et al), 218 (album, B et al);
Swann NY 11/18/82: 336 (album, B-35 et al), 337 ill (album, 154);
Harris Baltimore 12/10/82: 206 (album, 29), 385 (album, B-3 et al), 404 (lot, B-1 et al);
Bievres France 2/6/83: 33 ill;
Christies NY 2/8/83: 31 (2);
Christies Lon 3/24/83: 92 (albums, B et al), 93 (lot, B et al), 136 (albums, B et al), 140 (album, B et al);
Swann NY 5/5/83: 277, 278 (2), 279 (album, B-17 et al), 280 (24), 406 (lot, B-7 et al);
Phillips Lon 6/15/83: 126 (lot, B et al);
California Galleries 6/19/83: 328 (lot, B-1 et al), 329 (10), 358 (lot, B-11 et al);
Christies Lon 6/23/83: 173 (lot, B et al), 175 (albums, B et al);
Christies Lon 10/27/83: 87 (albums, B et al), 88 (albums, B et al), 102 ill(album, 100);
Swann NY 11/10/83: 184 (lot, B-17 et al)(note), 185 (album, B et al)(note);
Harris Baltimore 12/16/83: 103 (lot, B et al);
Christies NY 2/22/84: 7 (album, B et al), 10 (album, B t al);
Christies Lon 3/29/84: 61 (album, B-27 et al), 62 (albums, B-23 et al), 63 (album, B-33 et al), 64 (album, B-12 et al), 65 (album, B et al), 91 (lot, B et al), 97 (album, B et al);
Swann NY 5/10/84: 177 (42), 178 (lot, B et al), 276 (albums, B et al), 277 (lot, B et al);
Harris Baltimore 6/1/84: 317 (2);
Christies Lon 6/28/84: 87 (album, B-25 et al), 133 (lot, B-2 et al), 140 (album, B et al);
California Galleries 7/1/84: 291 ill(3), 293 ill, 294 (4);
Christies Lon 10/25/84: 97 (lot, B et al), 104 (album, B et al);
Sothebys Lon 10/26/84: 52 ill(6);
Christies NY 11/6/84: 29 ill(5);
Swann NY 11/8/84: 148 (14)(note), 193 (album, B et al)(note), 195 (album, B et al);
Christies NY 2/13/85: 147 (lot, B et al);
Harris Baltimore 3/15/85: 40 (lot, B-1 et al), 149 (album, 36)(note), 150;
Phillips Lon 3/27/85: 268 (lot, B-6 et al);
Christies Lon 3/28/85: 67 (lot, B et al), 68 (albums, B-82 et al), 70 (album, B et al);

## BONFILS, F. (continued)
Sothebys Lon 3/29/85: 77 (albums, B et al), 103 (album, B et al);
Swann NY 5/9/85: 326 (album, B et al);
California Galleries 6/8/85: 167 (13), 168 (12);
Christies Lon 6/27/85: 71 (album, B et al), 83 (lot, B et al), 84 (lot, B-6 et al);
Phillips Lon 10/30/85: 74A (album, B et al), 75 (album, B et al);
Christies Lon 10/31/85: 96 (album, B-23 et al), 97 (album, B-17 et al), 98 (albums, B-12 et al), 99 (album, B-41 et al), 108 (albums, B et al), 126 (albums, B et al), 134 (albums, B et al);
Sothebys Lon 11/1/85: 35 ill(album, B et al), 36 ill (album, 37);
Sothebys Lon 4/25/86: 41 (albums, B et al);
Swann NY 5/15/86: 231 (lot, B-6 et al), 235 (albums, B et al);
Christies Lon 6/26/86: 34 (albums, B et al), 72 (lot, B et al), 105 (albums, B et al), 115 (albums, B et al), 118 (albums, B-34 et al);
Christies Lon 10/30/86: 127 (album, B et al), 141 ill(albums, 1,084)(note);
Phillips NY 11/12/86: 38 (4), 39;
Swann NY 11/13/86: 150 (28), 212 (lot, B et al), 274 (lot, B-8 et al), 330 (lot, B et al);

## BONFILS, Maison (French)
Photos dated: 1895
Processes:  Photogravure
Formats:    Prints
Subjects:   Topography
Locations:  Palestine - Jerusalem
Studio:     Lebanon - Beirut
   Entries:
Swann NY 12/8/77: 27 (book, 30);

## BONIJOL, L. (Swiss)
Photos dated: 1847
Processes:  Daguerreotype
Formats:    Plates
Subjects:   Portraits
Locations:  Studio
Studio:     Switzerland - Geneva
   Entries:
Vermont Cat 11/12, 1977: 541 ill(note);
Auer Paris 5/31/80: 5 (2 ills);

## BONINE, E.A. (American)
Photos dated: 1870s-1880s
Processes:  Albumen
Formats:    Stereos, cdvs, boudoir cards
Subjects:   Ethnography
Locations:  US - California; Arizona; Florida
Studio:     US - Pasadena, California; Yuma, Arizona
   Entries:
Frontier AC, Texas, 1978: 26 ill(B & Joslin)(note), 88 (lot, B-7 et al);
Christies Lon 10/25/79: 445 (lot, B-2 et al);
Phillips NY 5/21/80: 120 (lot, B-4 et al);
Koch Cal 1981-82: 43 ill(album, B-32 et al);
Christies NY 2/8/83: 36 (lot, B et al);
California Galleries 6/19/83: 206 ill(attributed), 207 (attributed), 208 ill(attributed);

## BONINE, E.A. (continued)
Harris Baltimore 3/15/85: 38 (lot, B-8 et al);
California Galleries 3/29/86: 668;

## BONINE, R.K. (American)
Photos dated: 1889
Processes:  Albumen
Formats:    Stereos
Subjects:   Documentary (disasters)
Locations:  US - Johnstown, Pennsylvania
Studio:     US - Tyrone, Pennsylvania
   Entries:
Rinhart NY Cat 1, 1971: 212 (3);
Harris Baltimore 4/8/83: 47 (24)(note);
Harris Baltimore 12/16/83: 71 (11);
Harris Baltimore 6/1/84: 77 (lot, B-26 et al);
Harris Baltimore 2/14/86: 30 (21);

## BONING, R. (British)
Photos dated: 1862-c1870
Processes:  Albumen
Formats:    Stereos, cdvs
Subjects:   Genre, topography, portraits
Locations:  England - Isle of Wight
Studio:     England - London
   Entries:
Edwards Lon 1975: 12 (album, B et al);
Christies Lon 10/26/78: 339 (album, B-1 et al);
Christies Lon 10/25/84: 38 (lot, B-1 et al);
Christies Lon 3/28/85: 20, 43 (lot, B et al);
Christies Lon 6/27/85: 44 ill(lot, B-12 et al);

## BONNALLO (American)
Photos dated: c1880s
Processes:  Albumen
Formats:    Cabinet cards
Subjects:   Portraits
Locations:  Studio
Studio:     US - Philadelphia, Pennsylvania
   Entries:
Harris Baltimore 2/14/86: 63;

## BONNET, Jules (Swiss, 1840-1928)
Photos dated: 1860s
Processes:  Albumen
Formats:    Stereos
Subjects:   Topography
Locations:  Switzerland - Lucerne
Studio:     Switzerland
   Entries:
Christies NY 2/13/85: 133 (lot, B-1 et al);

## BONNEY
Photos dated: Nineteenth century
Processes:  Albumen
Formats:    Stereos
Subjects:   Topography
Locations:  US - Maine
Studio:
   Entries:
Harris Baltimore 12/10/82: 53 (lot, B et al);

**BONSAL, I.H.** (American)
Photos dated: 1860s
Processes:      Albumen
Formats:        Cdvs
Subjects:       Ethnography
Locations:      US - Chattanooga, Tennessee
Studio:         US - Arkansas City, Kansas
   Entries:
Christies Lon 10/26/78: 324 (album, B-8 et al);

**BONSALL** (see BUTLER, BONSALL & Co.)

**BOOL, Alfred & John** (see DIXON, Henry)(aka BOOLE)

**BOON, Constantin**
Photos dated: 1860s
Processes:      Albumen
Formats:        Cdvs
Subjects:       Portraits, ethnography
Locations:      Studio
Studio:         France
   Entries:
California Galleries 7/1/84: 171 (lot, B-1 et al);
Swann NY 5/15/86: 202 (album, B et al);

**BOORMAN, Hilann** (British)
Photos dated: 1850s
Processes:      Albumen
Formats:        Prints
Subjects:       Topography
Locations:      England
Studio:         England
   Entries:
Christies Lon 6/23/83: 59;

**BOORNE & MAY** (Canadian)
Photos dated: 1880s-1890s
Processes:      Albumen
Formats:        Prints
Subjects:       Topography, ethnography
Locations:      Canada - route of Canadian Pacific RR
Studio:         Canada - Calgary, North West
                Territories
   Entries:
Swann NY 2/14/52: 75 (albums, B & M et al), 194
   (album, B & M et al);
Christies Lon 6/30/77: 134 (album, B & M et al);
Phillips Can 10/4/79: 55 (album, B & M-5 et al);
Phillips Can 10/9/80: 55 (lot, B & M-1 et al);
Swann NY 4/23/81: 423 (note);
Christies Lon 3/26/81: 423 (11);

**BOOT, Edward** (British)
Photos dated: Nineteenth century
Processes:      Albumen
Formats:
Subjects:       Portraits
Locations:      Studio
Studio:         England - Leeds
   Entries:
Petzold Germany 5/22/81: 1980 (album, B et al);

**BOOTE, Arturo & Cia**
Photos dated: Nineteenth century
Processes:      Albumen
Formats:        Prints
Subjects:       Topography
Locations:      Argentina
Studio:         Argentina - Buenos Aires
   Entries:
Swann NY 11/13/86: 322 (lot, B-2 et al);

**BOOTE, Samuel**
Photos dated: 1880s
Processes:      Albumen
Formats:        Prints
Subjects:       Topography
Locations:      Argentina
Studio:         Argentina - Buenos Aires
   Entries:
Rinhart NY Cat 7, 1973: 16 (album, B & Niven, 29);
Swann NY 2/6/75: 34 (album, B & Niven, 20);
Wood Conn Cat 42, 1978: 559 (album, B-4 et al);
Christies Lon 3/10/77: 169 (album, B et al);
Christies NY 10/31/79: 56 (2);
Swann NY 4/23/81: 518 (album, B et al);
Christies Lon 6/23/83: 162 (album, B et al), 163
   (albums, B-25 et al);
Christies Lon 3/29/84: 100 (albums, B et al);
Swann NY 5/10/84: 303 ill(album, B-2 et al);
Christies Lon 3/28/85: 75 (album, B-6 et al);
Swann NY 5/15/86: 169 ill(album, B et al);
Swann NY 11/13/86: 322 (album, B-16 et al);

**BOOTH** (see HOLMES, BOOTH & HAYDEN) [BOOTH 1]

**BOOTH** (American) [BOOTH 2]
Photos dated: 1850s
Processes:      Ambrotype
Formats:        Plates
Subjects:       Portraits
Locations:      Studio
Studio:         US - Augusta, Maine
   Entries:
Vermont Cat 4, 1972: 493 ill(lot, B-1 et al);

**BOOTH** (British) [BOOTH 3]
Photos dated: 1881
Processes:      Albumen
Formats:        Prints
Subjects:
Locations:      Scotland
Studio:         Scotland
   Entries:
California Galleries 1/22/77: 213 (lot, B et al);

**BOOTH, Arthur W.**
Photos dated: 1890s
Processes:      Albumen, bromide
Formats:        Prints
Subjects:       Architecture, topography
Locations:      Argentina - Buenos Aires
Studio:         Argentina - Buenos Aires
   Entries:
Christies Lon 10/28/76: 159 (album, 25);
Christies NY 10/4/83: 112 (11);

**BOOTH, H.C.** (British)
Photos dated: 1847-1860s
Processes: Daguerreotype, albumen
Formats: Plates, stereos
Subjects: Portraits, topography
Locations: England
Studio: England - London, Harrogate
    Entries:
Rinhart NY Cat 7, 1973: 181 (2);
California Galleries 9/27/75: 479 (lot, B et al);
California Galleries 1/23/77: 384 (lot, B et al);
Christies Lon 3/16/78: 5;
Christies Lon 10/29/81: 72 (lot, B-2 et al);
Christies Lon 10/25/84: 44 (lot, B-14 et al);

**BOOTY, A.** (British)
Photos dated: 1860s
Processes: Albumen
Formats: Prints
Subjects:
Locations:
Studio: Great Britain (Amateur Photographic Association)
    Entries:
Christies Lon 10/27/83: 218 (albums, B-3 et al);

**BORAH** (American)
Photos dated: Nineteenth century
Processes: Albumen
Formats: Cdvs
Subjects: Portraits
Locations: Studio
Studio: US - Allegheny City, Pennsylvania
    Entries:
Sothebys NY (Strober Coll.) 2/7/70: 321 (lot, B et al);

**BORDA & FASSITT**
Photos dated: 1864
Processes: Albumen
Formats: Prints
Subjects:
Locations:
Studio:
    Entries:
Wood Boston Cat 58, 1986: 136 (book, B & F-2 et al);
Swann NY 5/15/86: 130 (book, B & F et al)(note);

**BORDEAUX, D.J.** (American)
Photos dated: c1890
Processes: Albumen
Formats: Prints
Subjects: Genre
Locations: Studio
Studio: US - Springfield, Massachusetts
    Entries:
Swann NY 4/20/78: 267 ill;

**BORG** (see MICALLEF & BORG)

**BORG, E.**
Photos dated: c1888
Processes: Albumen
Formats: Prints
Subjects: Topography
Locations: Malta
Studio: Malta
    Entries:
California Galleries 4/2/76: 277 (lot, B et al);
California Galleries 3/30/80: 342 (lot, B et al);
California Galleries 12/13/80: 309 (6);
California Galleries 5/23/82: 350 (6);

**BORRI, Vicenzo**
Photos dated: 1860s-1870s
Processes: Albumen
Formats: Prints, cdvs
Subjects: Topography, ethnography, portraits
Locations: Greece - Corfu
Studio: Greece - Corfu
    Entries:
Swann NY 4/23/81: 461 (lot, B et al);
Swann NY 11/14/85: 190 (lot, B et al);

**BORSOS, Josef** (Hungarian)
Photos dated: 1880s
Processes: Albumen
Formats: Prints
Subjects: Portraits
Locations: Studio
Studio: Hungary - Budapest
    Entries:
Sothebys Lon 6/27/80: 240;

**BOSETTI** (Italian)
Photos dated: 1870s-1880s
Processes: Albumen
Formats: Prints
Subjects: Topography
Locations: Italy
Studio: Italy
    Entries:
California Galleries 9/26/75: 151 (album, B et al);
Swann NY 4/26/79: 282 (albums, B et al);
Phillips NY 11/3/79: 172 ill(album, B et al);
Christies Lon 3/20/80: 208 (album, B-3 et al);
California Galleries 6/28/81: 261 (lot, B-1 et al);
Christies Lon 3/11/82: 150 (album, B et al);
Harris Baltimore 12/10/82: 391 (albums, B et al);
Christies Lon 6/28/84: 74 (lot, B et al);
Sothebys Lon 6/29/84: 53 (lot, B et al);
Christies Lon 3/28/85: 60 (lot, B et al);
Christies Lon 6/27/85: 93 (lot, B et al);
Harris Baltimore 2/14/86: 210 (albums, B et al);

**BOSS, D.W.** (American)
Photos dated: 1865-1870
Processes: Albumen
Formats: Cdvs
Subjects: Portraits
Locations: Studio
Studio: US
    Entries:
California Galleries 1/21/79: 231 (lot, B et al);

**BOSSI, Pasquale** (Italian)
Photos dated: 1870
Processes:    Albumen
Formats:      Prints
Subjects:     Topography
Locations:    Italy - Lake Maggiore
Studio:       Italy
   Entries:
Rinhart NY Cat 1, 1971: 456 (book, 22);

**BOSTON & ZIEGLER** (American)
Photos dated: Nineteenth century
Processes:    Albumen
Formats:      Stereos
Subjects:     Topography
Locations:    US - Colorado
Studio:       US
   Entries:
Sothebys NY (Strober Coll.) 2/7/70: 507 (lot,
   B & Z et al);

**BOSTON DAGUERREOTYPE CO.** (American)(a.k.a.
              TYLER & CO.)
Photos dated: late 1840s
Processes:    Daguerreotypes
Formats:      Plates
Subjects:     Portraits
Locations:    Studio
Studio:       US - Boston, Massachusetts
   Entries:
Swann NY 4/14/77: 229 (note);

**BOSTWICK Brothers** (American)
Photos dated: c1864
Processes:    Salt
Formats:      Print
Subjects:     Documentary (Civil War)
Locations:    US - Brandy Station, Virginia
Studio:       US
   Entries:
Swann NY 5/5/83: 328;

**BOSWELL, W. & Son** (British)
Photos dated: 1870s
Processes:    Albumen
Formats:      Prints
Subjects:     Topography
Locations:    England - Norwich
Studio:       Great Britain
   Entries:
Christies Lon 3/26/81: 154 (lot, B-1 et al);

**BOTTGER, Georg** (German)
Photos dated: 1860s-1870s
Processes:    Albumen
Formats:      Prints, stereos
Subjects:     Architecture
Locations:    Germany - Munich
Studio:       Germany - Munich
   Entries:
Christies NY 11/11/80: 200 (lot, B et al);
Christies Lon 6/24/82: 130 (lot, B-2 et al);

**BOUGHTONS** (British)
Photos dated: 1880s
Processes:    Carbon
Formats:      Prints
Subjects:     Genre
Locations:
Studio:       England - Lowestoft
   Entries:
Sothebys Lon 3/15/82: 336;

**BOULOGNE** (see DUCHENNE)

**BOURGOGNE, L.** (French)
Photos dated: c1860s
Processes:    Albumen
Formats:      Prints
Subjects:     Topography
Locations:    France - Dijon
Studio:       France
   Entries:
Harris Baltimore 12/16/83: 340 (2);

**BOURNE, Samuel** (British, 1834-1912)(see also
              SACHE)
Photos dated: 1853-1880s
Processes:    Albumen, autotype
Formats:      Prints incl. panoramas, cdvs, cabinet
              cards, stereos
Subjects:     Topography, ethnography, portraits
Locations:    India; Burma; Ceylon; England
Studio:       India - Simla and Calcutta
   Entries:
Sothebys Lon 12/21/71: 153 (album, 82)(note);
Rinhart NY Cat 6, 1973: 277 (3);
Rinhart NY Cat 7, 1973: 18 ill(book, B & Shepherd);
Sothebys Lon 12/4/73: 18 (album, B et al), 19 (lot,
   B-12, B & Shepherd-4, et al);
Sothebys Lon 6/21/74: 72 (album, B-9, B &
   Shepherd-2, et al);
Christies Lon 7/25/74: 337 (album);
Sothebys Lon 10/18/74: 74 ill(album, B-9 et al), 78
   (album, B-10 et al);
Edwards Lon 1975: 6 (album, B-68 et al)(note), 16
   (album, B-14 et al), 17 (album, B-11 et al), 20
   (album, 24)(note), 23 (albums, B & Shepherd
   et al);
Stern Chicago 1975(?): 55 (book, B & Shepherd, 25);
Sothebys NY 2/25/75: 164 (lot, B-15 et al);
Sothebys Lon 3/21/75: 74 (album, B-4 et al), 83
   (albums, B-21, B & Shepherd-3, et al), 84
   (albums, B-26, B & Shepherd-12, et al), 287
   (album, B-91 et al);
Sothebys Lon 6/26/75: 125 (album, B-6 et al), 126
   (album, B-1 et al), 127 (album, B-41 et al), 129
   (album, B-19 et al), 130 (album, B-16 et al),
   131 (album, B-14 et al), 132 (album, B-4 et al);
Swann NY 9/18/75: 157;
California Galleries 9/26/75: 113 (book, B &
   Shepherd, 24), 244 (8)(note);
Sothebys Lon 10/24/75: 102 (album, B & Shepherd et
   al), 110 (album, B-8 et al), 112 (album, B-9 et
   al), 125 (album, B, B & Shepherd, et al), 127
   (lot, B-20, B & Shepherd-4, et al), 128 ill
   (albums, B-43 et al), 129 (albums, B et al), 132
   (albums, B-14, B & Shepherd-18, et al), 269
   (album, B et al);
Anderson & Hershkowitz Lon 1976: 35 ill, 36 ill,
   37 ill;

<u>BOURNE</u> (continued)

Colnaghi Lon 1976: 271 ill(note), 272, 273, 274 ill, 275;
Lunn DC Cat 6, 1976: 10 ill(note), 11, 12;
Rose Boston Cat 1, 1976: 32 ill(note);
Wood Conn Cat 37, 1976: 256B (lot, B-15, B & Shepherd-10, et al);
Christies Lon 6/10/76: 79 (album, B et al);
Sothebys Lon 6/11/76: 44 (album, B-17, B & Shepherd-2, et al);
Christies Lon 10/28/76: 132 (album, B-10, B & Shepherd-1, et al), 134 (lot, B-17 et al), 172 (album, B-11 et al), 175 (album, B-20 attributed, et al), 180 (album, B & Shepherd-1, et al);
Sothebys Lon 10/29/76: 59 (albums, B et al), 110 (albums, B-3 et al), 114 (album, B & Shepherd et al), 159 (albums, B, B & Shepherd, et al), 163 (album, B-3), 164 (album, 40), 289 (lot, B & Shepherd-1, et al);
Sothebys NY 11/9/76: 56 ill(albums, B-1, B & Shepherd-1, B-1 attributed, et al);
Swann NY 11/11/76: 270 (book, B & Shepherd et al)(note);
Rose Boston Cat 2, 1977: 46 ill(note), 47 ill;
White LA 1977: 18 ill(note);
California Galleries 1/22/77: 268 (8);
Sothebys Lon 3/9/77: 42 (album, B-4 et al);
Christies Lon 3/10/77: 138 (album, B-12 et al);
Swann NY 4/14/77: 121 (book, B & Shepherd et al), 271 (album, B, B & Shepherd, et al);
Gordon NY 5/10/77: 810 ill(5);
Sothebys NY 5/20/77: 107 ill(album, B-72 et al);
Sothebys Lon 7/1/77: 117 (album, B & Shepherd et al), 119 (album, B-7 attributed, et al), 149 (albums, B, B & Shepherd, et al), 151 (albums, B et al);
Sothebys NY 10/4/77: 144 ill(album, B, B & Shepherd, et al), 145 (album, B et al);
Christies Lon 10/27/77: 144 (album, B-11, B & Shepherd-2, et al), 149 (albums, B & Shepherd-2, et al), 150 (album, B-7, B & Shepherd-3, et al);
Sothebys Lon 11/18/77: 98 (lot, B-30, B & Shepherd-14, et al), 100 (lot, B, B & Shepherd, et al), 101 (album, B-2 et al);
Witkin NY VI 1978: 21 ill(note);
Wood Conn Cat 42, 1978: 65 (book, B & Shepherd et al)(note), 66 (book, B & Shepherd et al), 67 (book, B & Shepherd, 26)(note);
Christies Lon 3/16/78: 102 (album, B-8 et al);
Sothebys Lon 3/22/78: 91 (albums, B, B & Shepherd, et al);
Christies Lon 6/27/78: 118 (album, B-6, B & Shepherd-1, et al), 148 (album, B et al);
Sothebys Lon 6/28/78: 116 (albums, B et al);
Christies Lon 10/26/78: 172 (lot, B & Shepherd-1, et al);
Sothebys Lon 10/27/78: 79 ill (album, B et al), 124 ill(B plus B attributed, et al), 126 ill(lot, B-1 et al), 128 ill(album, 69);
Swann NY 12/14/78: 363 (note);
Rose Boston Cat 4, 1979: 76 ill(note);
Wood Conn Cat 45, 1979: 28 ill(book, B & Shepherd, 26)(note);
California Galleries 1/21/79: 400 ill(lot, B-1, B & Shepherd, et al), 401 ill(lot, B-3, B & Shepherd-1, et al);
Sothebys Lon 3/14/79: 115 (8), 117 ill(album, B et al), 119 (album, B et al), 120 (album, B et al), 121 (album, B et al);

<u>BOURNE</u> (continued)

Christies Lon 3/15/79: 150 (album, B-13 et al), 184 (albums, B-7, B & Shepherd-2, et al);
Christies NY 5/4/79: 63 (lot, B et al);
Phillips NY 5/5/79: 172 (lot, B & Robertson, B & Shepherd, et al)(note), 173 (lot, B et al);
Sothebys NY 5/8/79: 111 ill(lot, B-1 et al);
Christies Lon 6/28/79: 111 ill (album, B-35 et al)(note);
Sothebys Lon 6/29/79: 89 ill(album, B et al), 95 (5);
Phillips Can 10/4/79: 11 ill, 12 ill;
Sothebys Lon 10/24/79: 94 (lot, B, B & Shepherd, et al), 102 (6), 103 (album, B et al), 104 (album, B et al), 106 (album, B et al);
Christies Lon 10/25/79: 186 ill(lot, B-7 et al), 195 (album, B-16 et al), 231 (album, B-2 et al);
Christies NY 10/31/79: 45 (lot, B et al), 46 (book, B & Shepherd et al);
Sothebys NY 11/2/79: 250 (album, B & Shepherd et al)(note), 253 ill(2), 254 ill(lot, B-3 et al), 255 (4), 256 (lot, B-3 et al), 257 ill(note);
Phillips NY 11/3/79: 176 ill(album, 19)(note), 177, 178;
Sothebys NY 12/19/79: 69 ill(lot, B & Shepherd-4, et al), 96 (2 ills)(lot, B et al);
Sothebys LA 2/6/80: 171 ill(16), 172 ill(10), 176 (lot, B et al);
Phillips Lon 3/12/80: 124 (lot, B & Shepherd et al), 137 (album, 26), 160 (B & Shepherd, 6);
Christies Lon 3/20/80: 164, 165 ill(B-10, B-17 attributed), 166 ill(B & Shepherd, 19), 203 (album, B-4, B & Shepherd-2, et al);
Sothebys Lon 3/21/80: 101 (lot, B-30 attributed et al), 108 (lot, B et al), 111 (5), 113 ill(46);
California Galleries 3/30/80: 247 (B & Shepherd, 11);
Swann NY 4/17/80: 116 (book, B & Shepherd, 26) (attributed)(note);
Christies NY 5/16/80: 206 (album, B et al), 222 (album, B & Shepherd et al);
Sothebys NY 5/20/80: 400 ill(album, 25)(note), 401 ill(book, B & Shepherd, 25);
Phillips NY 5/21/80: 242 (2), 243 (2);
Christies Lon 6/26/80: 222 ill(12), 264 (album, B-1, B & Shepherd-1, et al);
Sothebys Lon 6/27/80: 59 (B & Shepherd, 37), 62 (5), 64 (8);
Phillips Can 10/9/80: 19 (6), 20 (3);
Sothebys Lon 10/29/80: 26 (album, B et al), 29 (5), 31 (5);
Christies Lon 10/30/80: 95 ill(B attributed, B & Shepherd attributed, et al), 229 (lot, B-3 et al), 231 (lot, B-2 et al), 238 ill(album, B-45 plus 8 attributed), 239 (lot, B-6, B & Shepherd-1, et al), 240 (2 ills)(16), 241 ill (19), 265 (lot, B-1 et al), 302 (book, B & Shepherd et al), 433 (B & Shepherd-9, et al);
Swann NY 11/6/80: 321 (lot, B, B & Shepherd, et al)(note);
Christies NY 11/11/80: 81 ill(album, 69), 84 (lot, B & Shepherd et al);
California Galleries 12/13/80: 196 (B & Shepherd, 6);
Christies Lon 3/26/81: 222 (12), 224 (albums, B-2 et al), 263 (album, B-1, B & Shepherd-1, et al), 266 (albums, B attributed, et al), 269 (album, B & Shepherd-3, et al)(note), 270 (album, B-34 et al), 274 (album, B-1 et al), 280 (albums, B-1 attributed, et al), 399 (albums, B & Shepherd-1, et al);

## BOURNE (continued)

Sothebys Lon 3/27/81: 84 (album, B attributed et al), 88 (lot, B et al), 89 (8), 97 (album, B et al), 98 (4);

Swann NY 4/23/81: 299 (2), 472 (B-2 plus 1 attributed);

Phillips NY 5/9/81: 65 ill(album, B-53 et al);

Sothebys Lon 6/17/81: 173 (album, B et al), 178 (lot, B, B & Shepherd, et al), 179 (4), 234 (album, B & Shepherd et al);

Christies Lon 6/18/81: 118 (lot, B attributed et al), 208 ill(album, 58), 211 (album, B-3, B & Shepherd-1, et al), 212 (album, B attributed et al), 255 (book, B & Shepherd);

California Galleries 6/26/81: 186 ill(3);

Sothebys Lon 10/28/81: 58 (albums, B et al)), 141 (16), 142 (22), 143 (4), 149 ill (album, 30), 150 ill(album, B, B & Shepherd-1, et al), 151 (album, B et al);

Christies Lon 10/29/81: 224 ill, 225 (5), 226 (4), 227 ill(album, B-20 et al), 228 (12), 229 ill (lot, B-48, B & Shepherd-6, et al), 230 (lot, B-11 et al), 232 (lot, B, B & Shepherd attributed, et al), 235 (album, B-13 et al), 236 (album, B-6 et al), 239 ill(album, B-16, B & Shepherd-14, et al), 242 (album, B attributed et al), 276 (albums, B-6, B & Shepherd-9, et al);

Swann NY 11/5/81: 282, 283 (7), 284 ill(7), 285 (8), 540 (lot, B & Shepherd-1, et al)(note);

Octant Paris 1982: 32 ill(note);

Wood Conn Cat 49, 1982: 52 (book, B & Shepherd, 26) (note);

Christies Lon 3/11/82: 172 ill(14), 174 ill(6), 175 (5), 177 (lot, B-11 et al), 179 (album, B, B & Shepherd, et al), 180 ill(lot, B-9 et al), 181 (album, B-29, B & Shepherd-4), 183 (album, B-2, B attributed, et al), 187 (albums, B & Shepherd attributed, et al), 134 (album, B & Shepherd et al);

Sothebys Lon 3/15/82: 117 (21), 123 (album, B-5, B & Shepherd-5, et al), 415 (albums, B et al);

Phillips NY 5/22/82: 675 (3), 676 (3);

California Galleries 5/23/82: 224 ill(album, B-19 plus 1 attributed, B & Shepherd-4, et al), 225, 226 ill(6);

Christies Lon 6/24/82: 194 (12), 196 (lot, B-13 et al), 199 (album, B-8 et al), 200 (lot, B-4 et al), 226 ill(album, B & Shepherd et al), 231 (lot, B et al), 364 (album, B & Shepherd et al), 391 (B & Shepherd);

Sothebys Lon 6/25/82: 68 (29), 70 (album, B et al);

Phillips NY 9/30/82: 944 (2), 945 (2), 992 (album, B attributed et al);

Christies Lon 10/28/82: 93 ill(album, B-29, B & Shepherd-4, et al), 205 (album, B & Shepherd et al);

Sothebys Lon 10/29/82: 25 (album, B & Shepherd et al);

Swann NY 11/18/82: 339 (11)(note);

Harris Baltimore 12/10/82: 397 (album, B, B & Shepherd, et al);

Christies Lon 3/24/83: 104 ill(album, 83), 105 (lot, B-21 et al), 106 (album, B-32 et al), 130 (lot, B, B & Shepherd, et al), 163 (books, B & Shepherd et al);

Sothebys Lon 3/25/83: 29 ill(album, B et al), 38 ill(8);

California Galleries 6/19/83: 269 (lot, B-2 et al), 270 (lot, B-1 et al), 271 (lot, B-1 et al), 272 ill(lot, B-2 et al), 273 (lot, B-2 et al), 274 ill(lot, B-1 et al);

## BOURNE (continued)

Christies Lon 6/23/83: 135 (lot, B et al), 143 ill (album, B-57 et al), 144 (3), 173 (lot, B et al), 259 (lot, B & Shepherd et al);

Sothebys Lon 6/24/83: 24 (15);

Christies NY 10/4/83: 102 (lot, B & Shepherd et al);

Christies Lon 10/27/83: 103 ill(albums, B, B & Shepherd, et al), 106 ill(album, B-57 et al), 107 (12), 108 (12), 152 (lot, B et al);

Phillips Lon 11/4/83: 71 (lot, B et al);

Swann NY 11/10/83: 189 (album, B-7 et al), 284 (albums, B, B & Shepherd, B & Robertson, et al)(note);

Sothebys Lon 12/9/83: 37 (album, B et al), 38 (album, B & Shepherd et al);

Christies NY 2/22/84: 12;

Christies Lon 3/29/84: 66 (lot, B, B & Shepherd, et al), 68 (lot, B et al), 91 (lot, B et al), 99 (albums, B-13 et al), 332 (album, B & Shepherd et al);

Phillips Lon 6/27/84: 179 (albums, B et al);

Christies Lon 6/28/84: 93 (lot, B et al), 130 (albums, B-24 et al), 131 (album, B-28 et al), 133 (lot, B-8 et al), 135 (album, B & Shepherd et al), 210 (album, 99), 211 (18);

Sothebys Lon 6/29/84: 49 (5 ills)(album, B et al), 91 (album, B, B & Shepherd, 75), 96 (4);

California Galleries 7/1/84: 296 ill(3), 297 (lot, B-4, B & Shepherd-1, et al), 298 (lot, B-1 et al), 299 (lot, B-1 et al), 300 (lot, B-2 et al), 301 (3), 302 (lot, B-1 et al), 303 (3), 304 (4, attributed), 305 (B & Shepherd, 3), 306 ill(B & Shepherd-3 plus 1 attributed), 307 (lot, B-1, B & Shepherd-1, et al), 308 (lot, B & Shepherd-1, et al);

Christies NY 9/11/84: 126 (book, B & Shepherd et al), 136 (album, B & Shepherd et al);

Phillips Lon 10/24/84: 108 (lot, B-5 plus B attributed, et al), 111 (album, B-14 et al), 119 (album, B-21 et al), 121 (lot, B & Shepherd-1, et al), 125 (lot, B et al);

Christies Lon 10/25/84: 98 (album, B & Shepherd et al), 111 (album, B & Shepherd-1, et al), 175, 176 (15), 177 (12);

Sothebys Lon 10/26/84: 66 ill(album, B et al), 72 ill (album, B et al), 73 (2 ills)(album, B, B & Shepherd, et al), 74 ill(album, B attributed et al), 170 (album, B-7 et al), 172 (album, B & Shepherd et al);

Swann NY 11/8/84: 214 (album, B et al), 217 (album, B et al);

Phillips Lon 3/27/85: 205 (album, B-3, B & Shepherd-8, et al);

Christies Lon 3/28/85: 65 (lot, B & Shepherd attributed, et al), 91 (lot, B & Shepherd-1, et al), 212 ill(16), 213 (album, B & Shepherd-5, et al), 327 (album, B et al);

Sothebys Lon 3/29/85: 86 (album, B & Shepherd et al), 93 (albums, B & Shepherd et al), 101 (11), 102 ill(lot, B, B & Sache, et al);

Swann NY 5/9/85: 183 (book, B & Shepherd, 26) (note), 323 (album, B & Shepherd et al)(note);

California Galleries 6/8/85: 169 (3);

Phillips Lon 6/26/85: 199 (lot, B & Shepherd-3, et al);

Christies Lon 6/27/85: 82 (album, B-8, B & Shepherd, et al), 95 (album, B & Shepherd-5, et al), 164 (34), 165 (24), 166 (10), 167 (album, B-31 et al), 168 (album, B, B & Shepherd, et al);

**BOURNE** (continued)
Sothebys Lon 6/28/85: 74 (album, B et al), 76 ill
(album, B, B & Shepherd, 54), 77 (album, B-10 et
al), 80 (album, B-2 et al);
Phillips Lon 10/30/85: 74 (album, B-1 et al);
Christies Lon 10/31/85: 120 (album, B-20 et al), 123
(albums, B-3 et al), 125 (albums, B-16 et al),
130 (lot, B-3 et al);
Christies NY 11/11/85: 249;
Swann NY 11/14/85: 74 (lot, B-5 et al), 99 (album,
B et al), 188 (album, B et al);
Wood Boston Cat 58, 1986: 228 (book, B & Shepherd,
26)(note), 263 (book, B et al);
Harris Baltimore 2/14/86: 202 (album, B, B &
Shepherd, et al), 214 (album, B et al);
Phillips Lon 4/23/86: 264 (album, B-14 et al), 265
(lot, B & Shepherd et al);
Christies Lon 4/24/86: 403 (album, B-1 et al), 406
(album, B-6 et al), 507 ill(album, B-51 et al),
508 ill(lot, B-23 et al), 509 (lot, B-19, B &
Shepherd-1, et al), 510 (lot, B-30, B &
Shepherd-3, et al);
Sothebys Lon 4/25/86: 48 ill(album, 58);
Swann NY 5/15/86: 261 (lot, B et al);
Christies Lon 6/26/86: 46 (albums, B, B & Shepherd,
et al), 88 (album, 50), 92 (albums, B-32 et al),
114 (lot, B et al), 115 (albums, B et al), 116
(lot, B, B & Shepherd, et al), 179 (album, B
et al);
Phillips Lon 10/29/86: 324 (album, B & Shepherd
et al);
Christies Lon 10/30/86: 107 (26), 125 (album, B-1
et al), 146 (albums, B-48, B & Shepherd-10, et
al), 153 (albums, B, B & Shepherd, et al);
Sothebys Lon 10/31/86: 13 (albums, B-11 et al), 34
(album, B et al), 35 (album, B-3 et al), 36
(lot, B-1 et al), 38 (lot, B-1 et al), 40
(album, B et al), 106 ill(B & Robertson);
Sothebys NY 11/10/86: 327 ill(2);
Swann NY 11/13/86: 156 (lot, B & Shepherd et al),
239 (album, B, B & Shepherd, et al), 240 (album,
B, B & Shepherd, et al);

**BOWDOIN** (see CUTTING & BOWDOIN)

**BOWEN & CARPENTER** (British)
Photos dated: 1850s
Processes:      Ambrotype
Formats:        Plates
Subjects:       Portraits
Locations:      Studio
Studio:         Great Britain
  Entries:
Sothebys Lon 6/28/78: 153 (lot, B & C-1 et al);

**BOWERS** (see GARNETT, J.) [BOWERS 1]

**BOWERS** (see HILLS & BOWERS) [BOWERS 2]

**BOWERS** (American) [BOWERS 3]
Photos dated: 1860s
Processes:      Albumen
Formats:        Cdvs
Subjects:       Portraits
Locations:      Studio
Studio:         US
  Entries:
Sothebys NY (Greenway Coll.) 11/20/70: 267 (lot,
B-1 et al);
California Galleries 1/21/78: 137 (lot, B et al);

**BOWERS, H.T.** (British)
Photos dated: late 1860s
Processes:      Albumen
Formats:        Prints
Subjects:       Topography
Locations:      England
Studio:         England - Gloucester
  Entries:
Sothebys Lon 4/25/86: 149 ill;

**BOWMAN** (British)
Photos dated: c1860
Processes:      Ambrotype
Formats:        Plates
Subjects:       Portraits
Locations:      Studio
Studio:         Scotland - Glasgow
  Entries:
Christies Lon 10/26/78: 64 (lot, B-1 et al);

**BOWMAN, Henry** (see BRADY, G.S.)

**BOWMAN, W.E.** (American)
Photos dated: 1871-1880s
Processes:      Albumen
Formats:        Stereos, cdvs, cabinet cards
Subjects:       Documentary (disasters), portraits
Locations:      US - Chicago, Illinois
Studio:         US - Ottawa, Illinois
  Entries:
Swann NY 4/14/76: 322 (lot, B et al);
Harris Baltimore 4/8/83: 386 (lot, B et al);
Swann NY 5/5/83: 332 (lot, B et al);

**BOWNESS, M.** (British)
Photos dated: 1870s
Processes:      Albumen
Formats:        Cdvs, stereos
Subjects:       Topography
Locations:      England - Ambleside
Studio:         England - Ambleside
  Entries:
Swann NY 11/10/83: 277 (album, B et al)(note);

**BOWRIE**
Photos dated: 1870s
Processes:      Albumen
Formats:        Prints
Subjects:       Topography
Locations:
Studio:
  Entries:
Sothebys Lon 3/25/83: 30 (album, B et al);

BOYDELL (British)
Photos dated: 1883
Processes:      Woodburytype
Formats:        Prints
Subjects:       Genre
Locations:
Studio:         England - London
   Entries:
Wood Conn Cat 37, 1976 (book, 12);

BOYER, Paul
Photos dated: c1890
Processes:      Albumen
Formats:        Cabinet cards
Subjects:       Portraits
Locations:
Studio:
   Entries:
Maggs Paris 1939: 547;
Swann NY 5/10/84: 176 (lot, B et al);

BOYER, W.
Photos dated: 1850s
Processes:      Daguerreotype, ambrotype
Formats:        Plates
Subjects:       Portraits
Locations:      Studio
Studio:         England - Ramsgate
   Entries:
Sothebys Lon 6/26/75: 167;
Vermont Cat 11/12, 1977: 683 ill;
Sothebys Lon 6/29/84: 42 (2);

BRACHER (British)
Photos dated: 1850s and/or 1860s
Processes:      Albumen
Formats:        Prints
Subjects:       Portraits
Locations:      Studio
Studio:         England - Oxford
   Entries:
Sothebys Lon 3/27/81: 226 (lot, B et al);

BRADDOCK
Photos dated: 1870s
Processes:      Albumen
Formats:        Prints
Subjects:       Topography
Locations:      India and/or Ceylon
Studio:
   Entries:
Sothebys Lon 10/31/86: 40 (album, B et al);

BRADFORD, O.E. (American)
Photos dated: 1872
Processes:      Albumen
Formats:        Stereos
Subjects:       Topography
Locations:      US - Boston, Massachusetts
Studio:         US - Boston, Massachusetts
   Entries:
Rinhart NY Cat 6, 1973: 547;

BRADFORD, William (with J.L. Dunmore and
                          Critcherson)
Photos dated: 1873
Processes:      Albumen
Formats:        Prints
Subjects:       Documentary (expeditions)
Locations:      Arctic
Studio:
   Entries:
Swann NY 2/14/52: 50 (book, 140)(note);
Witkin III 1975: 427 (6 ills)(book, 129)(note);
California Galleries 9/26/75: 294 (lot, B-3 et al);
Gordon NY 5/3/76: 305 ill(7);
Sothebys NY 5/4/76: 154 ill(book, 129)(note);
Christies Lon 10/28/76: 292 ill(book, 128)(note);
Sothebys NY 10/4/77: 64 ill(attributed)(note);
Witkin VI 1978: 22 (4 ills)(4);
Sothebys Lon 3/22/78: 197 ill(book, 129);
Lehr NY Vol 2:2, 1979: 8 ill(note), 9 ill(note);
Wood Conn Cat 45, 1979: 29 (book, 129)(note);
Christies NY 5/4/79: 86, 87, 88;
Phillips NY 11/3/79: 198 ill(note);
Sothebys LA 2/6/80: 17 ill;
Christies NY 5/14/80: 38 ill(book);
Christies NY 5/16/80: 223;
California Galleries 12/13/80: 241 (note), 242 ill
   (note);
Christies Lon 3/26/81: 292 (2 ills)(book, 90)(note);
Sothebys Lon 6/17/81: 336 (4);
Christies NY 10/4/83: 96 (2);
Swann NY 11/14/85: 205 (2 ills)(book, 141)(note);

BRADING, James (British)
Photos dated: 1870s
Processes:      Albumen
Formats:        Cdvs
Subjects:       Portraits
Locations:      Studio
Studio:         England - Isle of Wight
   Entries:
Sothebys Lon 6/27/80: 324 (note);

BRADLEY (American) [BRADLEY 1]
Photos dated: c1870s
Processes:      Albumen
Formats:        Stereos
Subjects:       Topography
Locations:      US - Maine
Studio:         US
   Entries:
Rinhart NY Cat 1, 1971: 222 (3);
Harris Baltimore 12/10/82: 53 (lot, B et al);

BRADLEY [BRADLEY 2]
Photos dated: 1885
Processes:      Albumen
Formats:        Prints
Subjects:       Topography
Locations:      Argentina
Studio:         Argentina - Buenos Aires
   Entries:
Swann NY 4/23/81: 409 (2);
Swann NY 11/5/81: 422 (2);

BRADLEY, Henry W. & ROLUFSON, William Henry
          (1826-1878)(American)
Photos dated: 1863-c1880
Processes:    Albumen
Formats:      Cdvs, prints
Subjects:     Portraits
Locations:    Studio
Studio:      US - San Francisco, California
  Entries:
Rinhart NY Cat 2, 1971: 72 (book, 20);
Rinhart NY Cat 6, 1973: 626;
Rinhart NY Cat 7, 1973: 86 (book, B & R);
Swann NY 9/18/75: 229 (album, B & R et al);
Swann NY 11/11/76: 340 (lot, B & R et al), 353 (lot,
   B & R et al);
White LA 1977: 76 ill(note);
Swann NY 12/8/77: 163 (2), 260;
Frontier AC, Texas, 1978: 38 (book, B & R et al),
   250 (book, 1);
Swann NY 4/20/78: 268;
Lehr NY Vol 1:3, 1979: 35 ill;
California Galleries 1/21/79: 235 (lot, B & R
   et al), 332 (album, B & R et al);
Swann NY 4/26/79: 147 (book, 15)(note);
California Galleries 3/30/80: 248 (2), 322;
California Galleries 12/13/80: 112 (book, 1), 197
   (2), 198 (2), 199, 207 (lot, B & R et al);
California Galleries 6/28/81: 192 (lot, B & R
   et al), 194, 373 (10);
California Galleries 5/23/82: 191 (album, B & R
   et al), 249 (3), 255 (lot, B & R-9 et al), 296;
Harris Baltimore 3/15/85: 299;
Swann NY 11/14/85: 11 (albums, B & R et al)(note);
Wood Boston Cat 58, 1986: 136 (books, B & R-2,
   et al);
Swann NY 5/15/86: 133 (book, B & R et al);

BRADLEY, Milton (American)
Photos dated: Nineteenth century
Processes:    Albumen
Formats:      Stereos
Subjects:     Topography
Locations:    US - Springfield, Massachusetts
Studio:      US - Springfield, Massachusetts
  Entries:
Vermont Cat 2, 1971: 220 (16);

BRADLEY, N. (British)
Photos dated: 1858-1859
Processes:    Albumen
Formats:      Stereos
Subjects:     Documentary (industrial)
Locations:    England
Studio:      England
  Entries:
Christies Lon 10/25/84: 35 (lot, B-2 et al);

BRADY, George Stewardson (British, 1832-1892)
Photos dated: 1850s-1870s
Processes:    Albumen
Formats:      Prints
Subjects:     Topography
Locations:    US - New England
Studio:
  Entries:
Colnaghi Lon 1976: 144 ill;
Sothebys Lon 6/29/84: 165 ill(lot, B & Bowman et al)
   (note);

BRADY, Mathew B. (American, 1823-1896)
Photos dated: c1843-1869
Processes:    Daguerreotype, ambrotype, salt,
             albumen
Formats:      Plates, prints, cdvs, cabinet cards,
             stereos
Subjects:     Portraits, documentary (Civil War)
Locations:    US - New York City; Washington, D.C.;
             Civil War area
Studio:      US - New York City; Washington, D.C.
  Entries:
Anderson NY (Gilsey Coll.) 2/24/03: 1581 (2), 1872
   (note);
Anderson NY (Gilsey Coll.) 3/18/03: 2388, 2809;
Goldschmidt Lon Cat 52, 1939: 178 (note);
Swann NY 2/14/52: 51;
Sothebys NY (Weissberg Coll.) 5/16/67: 146 (lot,
   B-1 et al), 166 (lot, B-1 et al), 167 ill(lot,
   B-2 et al), 168 ill(lot, B-1 et al), 172 (lot,
   B-15 et al)(note);
Sothebys NY (Strober Coll.) 2/7/70: 13 (book, 10),
   131 (lot, B-1 et al)(note), 153 (3), 205, 210
   (3), 257 (lot, B-13 et al)(note), 259 (lot, B et
   al), 260 (lot, B et al), 262 (lot, B et al), 263
   (lot, B-5 et al), 264 (lot, B et al), 265 (lot,
   B-7 et al), 266 (lot, B et al), 267 (lot, B-1 et
   al), 270 (lot, B et al), 271 (lot, B et al), 272
   (lot, B et al), 273 (lot, B et al), 276 (lot,
   B-3 et al), 281 (lot, B-40 et al), 282 (lot, B
   et al), 283 (lot, B-5 et al)(note), 284 (lot, B
   et al), 285 (lot, B-26 et al), 286 (lot, B-17 et
   al), 287 (lot, B-1 et al), 288 (lot, B et al),
   289 (lot, B-26 et al), 290 (lot, B-35 et al),
   291 (lot, B-40 et al), 292 (lot, B-13 et al),
   293 (lot, B-17 et al), 295 (lot, B et al), 296
   (lot, B et al), 297 (lot, B et al), 298 (lot,
   B-33 et al), 300 (lot, B-14 et al), 302 (lot,
   B et al), 318 (lot, B et al), 320 (lot, B-1 et
   al), 321 (lot, B-24 et al), 322 (80), 323 (80),
   324 ill(12)(note), 329 (lot, B-2 et al)(note),
   331 (lot, B-5 et al), 333 (lot, B-6 et al), 339
   (lot, B-2 et al), 367 (lot, B et al), 375 (lot,
   B-3 et al), 376 (lot, B-1 et al), 380 (lot, B et
   al), 381 (lot, B-1 et al), 382 (lot, B-2 et al),
   383 (lot, B-8 et al), 384 (lot, B et al), 388
   (lot, B et al), 389 (lot, B-1 et al), 410 (lot,
   B et al), 416 (lot, B et al), 422 (lot, B-1 et
   al), 428 (lot, B-1 et al), 527 (lot, B-5 et al),
   540 (lot, B-10 et al), 541 (lot, B-3 et al), 543
   (lot, B-4 et al), 544 (lot, B-4 et al), 550
   (lot, B-6 et al), 563 (14);
Sothebys NY (Greenway Coll.) 11/20/70: 12 (lot, B-1
   et al), 88 (lot, B-1 et al), 94 ill, 109 (lot,
   B-1 et al), 166 ill, 175 (lot, B-2 et al), 176
   (lot, B-1 et al), 178 (lot, B-3 et al), 179
   (lot, B-2 et al), 180 (lot, B-1 et al), 181
   (lot, B-2 et al) 182 (lot, B-2 et al), 184 ill,
   185 ill(lot, B-4 et al), 186 (lot, B-4 et al),
   187 (lot, B-2 et al), 188 ill(lot, B-3 et al),
   189 (lot, B-3 et al), 190 ill(lot, B-3 et al),
   191 ill(lot, B-4 et al), 192 ill(lot, B-4 et
   al), 193 ill(lot, B-4 et al), 194 ill(lot, B-3
   et al), 195 ill(5), 196 ill(lot, B-4 et al), 197
   (lot, B-4 et al), 198 (lot, B-2 et al), 202
   (lot, B-1 et al), 203 ill(lot, B-1 et al), 206
   (lot, B-1 et al), 216 (lot, B-1 et al), 222
   (lot, B-2 et al), 225 ill, 231 ill, 234 (lot,
   B-2 et al), 236 (lot, B-1 et al), 238 (lot, B-1
   et al), 240 ill(lot, B-1 et al), 241 (lot, B-1
   et al), 242 ill(lot, B-2 et al), 243 (lot, B-1
   et al), 247 (lot, B-3 et al), 248 (lot, B-1 et

## BRADY (continued)

al), 249 (lot, B-1 et al), 250 (lot, B-1 et al),
251 (lot, B-1 et al), 253 (lot, B-4 et al), 254
(lot, B-3 et al), 255 (lot, B-1 et al), 257
(lot, B-1 et al), 261 (lot, B-1 et al), 267
(lot, B-1 et al), 268 (lot, B-1 et al), 269
(lot, B-1 et al), 271 (lot, B-3 et al), 272
(lot, B-1 et al), 274 (lot, B-1 et al), 279
(lot, B-2 et al), 280 (lot, B-3 et al), 282
(lot, B-2 et al), 283 (lot, B-1 et al), 285
(lot, B-1 et al);
Sothebys NY 11/21/70: 323 (lot, B et al), 326 (lot,
B et al), 331 ill(lot, B-2 et al), 343 (lot, B-1
et al), 349 (lot, B-1 et al), 351 (lot, B et al);
Rinhart NY Cat 1, 1971: 166, 454 (book, 8), 455
(book, B-1 et al);
Rinhart NY Cat 2, 1971: 150 (note), 387 (lot, B et
al), 409 (note);
Vermont Cat 1, 1971: 216 (3), 218 (2);
Vermont Cat 4, 1972: 317 ill, 452 ill(note), 453
ill, 454 ill, 455 ill, 469 ill(lot, B-1 et al),
481 ill(lot, B-1 et al), 485 (2 ills)(2);
Rinhart NY Cat 6, 1973: 252;
Rinhart NY Cat 7, 1973: 329, 330, 331, 416, 417;
Rinhart Cat 8, 1973: 30, 84, 103;
Vermont Cat 5, 1973: 377 ill, 494 ill(note);
Sothebys Lon 12/4/73: 210 ill(album, 137);
Vermont Cat 8, 1974: 464 ill;
Sothebys Lon 6/21/74: 163 (lot, B et al);
Sothebys NY 2/25/75: 39 ill(note), 44 (lot, B-6 et
al), 45 ill(lot, B-3 et al), 108 ill(album, B et
al), 209 (lot, B-1 et al);
Sothebys Lon 6/26/75: 267 (2, attributed), 268;
Swann NY 9/18/75: 158;
Sothebys NY 9/23/75: 91 (lot, B-1 et al), 104 ill(4)
(note), 105 ill(3)(note), 106 (7), 107 (lot, B-2
et al), 108 ill(4)(note), 109 ill(note), 110
(4 ills)(albums, B-240 et al)(note);
California Galleries 9/27/75: 380 (1 plus 1
attributed), 381 (2, attributed), 471 (lot,
B-1 et al);
Kingston Boston 1976: 420 (book, B et al);
Wood Conn Cat 37, 1976: 263 ill(note), 264 ill, 265
ill, 266 ill, 267 ill, 268 ill;
Swann NY 4/1/76: 160 (album, B et al);
California Galleries 4/2/76: 99 (lot, B-1
attributed, et al);
California Galleries 4/3/76: 352 (lot, B-8 et al);
Gordon NY 5/3/76: 307 ill;
Sothebys NY 5/4/76: 106 (album, B et al);
Christies Lon 6/10/76: 152 (album, B et al);
Sothebys NY 11/9/76: 72 (lot, B-13 et al), 73
(note), 74 (book, 8)(note), 75 ill(note), 76
ill(note);
Swann NY 11/11/76: 330, 346 (lot, B et al), 358
(lot, B et al), 373 (lot, B-18 et al), 383
(album, B et al)(note);
Gordon NY 11/13/76: 48 (albums, B et al), 58 ill,
69 ill (attributed)(note);
Halsted Michigan 1977: 587, 588, 589, 590;
California Galleries 1/22/77: 113 (lot, B-1 et al);
Christies Lon 3/10/77: 164, 165, 166, 249 (album,
B et al);
Swann NY 4/14/77: 195 ill(note), 198 (lot, B et
al), 204 ill(album), 224, 312 (note);
Christies Lon 6/30/77: 156 (lot, B-2 et al);
Sothebys NY 10/4/77: 12 ill(3)(note), 13 ill(note),
14 ill(note), 15 ill(attributed)(note), 16 ill
(lot, B-2 et al), 18 (lot, B-3 attributed, et
al)(note);
Christies Lon 10/27/77: 372 (album, B-1 et al);

## BRADY (continued)

Frontier AC, Texas, 1978: 27 (attributed), 91
(attributed)(note);
Lehr NY Vol 1:2, 1978: 4 ill, 5 ill, 6 ill;
Witkin NY VI 1978: 23 (2 ills)(2);
California Galleries 1/21/78: 121, 128 (lot, B et
al), 134 (lot, B-1 et al), 135 (15), 294;
Sothebys LA 2/13/78: 1 (2)(note), 2 (3), 3 (2), 4
(3), 5 ill, 6, 7 ill, 8 ill, 9 ill, 10, 11, 12
ill, 13 (2), 14, 15 (2), 16 ill, 17 (2), 18, 19
ill, 20 (2), 21 (2), 22 ill, 23, 24, 25, 26 ill,
27 ill, 28 (2), 29, 30 (2), 31, 32 (4), 33 ill,
34 (2), 35, 36 (attributed), 38 (note), 39 ill
(5), 40 (note), 42 (attributed)(note);
Christies Lon 3/16/78: 34 ill(note), 307 ill(note);
Swann NY 4/20/78: 294 ill(note);
Sothebys NY 5/2/78: 7 (3), 8 (note), 9;
Drouot Paris 5/29/78: 27 (album, B et al);
Swann NY 12/14/78: 275 (lot, B-5 et al);
Witkin NY VIII 1979: 23 (2 ills)(2), 24 ill;
California Galleries 1/21/79: 402, 403, 404 ill, 416
(attributed), 417 (attributed);
Sothebys LA 2/7/79: 402 ill;
Christies Lon 3/15/79: 302 (album, B et al)(note);
Swann NY 4/26/79: 285 (lot, B-1 et al), 299 (note),
320 (lot, B et al), 404 (1 plus 1 attributed)
(note);
Christies NY 5/4/79: 82 (note);
Phillips NY 5/5/79: 101 (lot, B-1 et al), 104 (lot,
B-4 et al), 186, 187 (2);
Sothebys NY 5/8/79: 2 ill(note), 3 ill, 4 ill(note);
Phillips Can 10/4/79: 25 ill(note);
Swann NY 10/18/79: 280 ill, 287 (3), 289, 291, 292,
293, 295 (note), 298 ill(note), 304 (lot, B-11
et al), 305 ill(lot, B et al)(note), 326 ill,
383 (lot, B-2 et al);
Sothebys Lon 10/24/79: 59 (lot, B-1 et al);
Christies NY 10/31/79: 59;
Phillips NY 11/3/79: 123 (24), 190 ill(note);
Phillips NY 11/29/79: 241 (lot, B-2 et al);
Sothebys NY 12/19/79: 47 (2 ills)(albums, B et al);
Rose Boston Cat 5, 1980: 14 ill(note);
Sothebys LA 2/6/80: 1 (lot, B et al), 2 (16), 3
ill, 4 (lot, B-12 et al), 5 ill, 6 ill(album,
B et al);
Phillips Lon 3/12/80: 123;
Christies Lon 3/20/80: 188 ill(note);
California Galleries 3/30/80: 252 ill(note), 253,
369 (lot, B-1 et al), 289 ill;
Swann NY 4/17/80: 252 (lot, B et al);
Christies NY 5/16/80: 231 ill(lot), 232, 232A,
232B;
Sothebys NY 5/20/80: 274 (lot, B et al);
Phillips NY 5/21/80: 138 (album, B et al), 263 ill
(attributed)(note), 264;
Phillips NY 6/25/80: 106;
Christies Lon 10/30/80: 430 (lot, B-1 et al);
Swann NY 11/6/80: 238 (lot, B-2 et al), 264 (lot,
B-5 et al), 265 (album, B et al), 335 (lot, B-2
et al), 400 (lot, B-1 et al)(note);
Christies NY 11/11/80: 98 ill(note), 102 ill(note),
103 ill(note), 104 ill(attributed), 105
(attributed)(note), 106 ill(attributed), 107 ill
(album, 99), 108 ill, 109 ill(note), 110 (note),
111 (note), 114 (3), 125 ill (note);
Sothebys NY 11/17/80: 96 ill(album, 100), 98 (lot,
B-1 attributed, et al);
California Galleries 12/13/80: 200;
Sothebys LA 2/4/81: 67 ill(note);
Swann NY 4/23/81: 300 (note), 301, 489, 490 (lot,
B-1 et al);

## BRADY (continued)

Christies Lon 6/18/81: 89 (lot, B-2 et al);
California Galleries 6/28/81: 187 ill;
Harris Baltimore 7/31/81: 133 (album, B-3 et al),
   134 (album, B et al), 168 (5), 169;
Sothebys NY 10/21/81: 22 ill(album, B et al)(note);
Swann NY 11/5/81: 286 (10)(note), 460 (lot, B-1 et
   al)(note), 510 (note);
Christies NY 11/10/81: 43 ill(note), 44 (lot, B et
   al), 45 (lot, B et al);
Rose Florida Cat 7, 1982: 84 ill;
Christies Lon 3/11/82: 340 ill(note);
Harris Baltimore 3/26/82: 156, 199, 200 (5), 201
   (note), 202, 203 ill(note), 204 (note), 205,
   206, 207, 208, 344, 345 ill, 399 (album, B
   et al);
Swann NY 4/1/82: 261 (note);
California Galleries 5/23/82: 190 (album, B-1 et
   al), 226A, 243 (lot, B et al);
Harris Baltimore 5/28/82: 70, 71 (note), 72, 73,
   74, 75, 76, 113, 123, 131, 134A (note), 137
   (attributed), 146 ill, 147 (3), 158 (lot,
   B-1 et al);
Christies Lon 6/24/82: 366 ill(album, B et al);
Swann NY 11/18/82: 300 (lot, B-1 et al), 302
   (lot, B-1 et al), 340 (2), 416 (2)(note);
Harris Baltimore 12/10/82: 51, 207, 356 (album,
   B-1 et al), 360 (lot, B-1 attributed et al),
   363 (lot, B-1 et al);
Christies NY 2/8/83: 4 ill(note);
Christies Lon 3/24/83: 247 (album, B et al);
Harris Baltimore 4/8/83: 301 (2), 302 (2);
Swann NY 5/5/83: 329 (lot, B-1 et al), 331
   (album, B-6 et al);
California Galleries 6/19/83: 209 (attributed);
Harris Baltimore 9/16/83: 117, 119, 120 ill
   (attributed), 123 (lot, B-1 et al), 124, 125,
   128, 129 (2), 132, 138, 139, 143 (2), 146 (4),
   153 (3), 160, 161 (2), 164 (2), 165 (2), 167
   (2), 180 (2), 205 (lot, B-3 et al);
Christies NY 11/8/83: 47 ill(note);
Sothebys NY 11/9/83: 48 ill(14);
Swann NY 11/10/83: 186 (lot, B-1 et al)(note), 190,
   191 (note), 200 (2)(note), 235 (2), 241 (lot,
   B-2 et al), 296;
Harris Baltimore 12/16/83: 26 (lot, B-6 et al), 254,
   267 ill, 297 (2), 298 (album, B et al);
Christies NY 5/7/84: 23 ill(B & Gardner, 3)(note);
Sothebys NY 5/8/84: 53 ill, 54 ill(attributed), 55
   ill(attributed);
Swann NY 5/10/84: 194 (lot, B-1 et al), 196 (albums,
   B et al);
Harris Baltimore 6/1/84: 32 (lot, B et al), 248
   (2), 249 ill, 251 (lot, B-2 et al), 258, 259,
   266, 272, 275 (attributed), 319 (13)(note), 320
   (5), 321 (note), 322, 336, 401;
Christies Lon 6/28/84: 314 (album, B et al);
California Galleries 7/1/84: 311 (3), 312;
Christies NY 9/11/84: 102, 104 (lot, B-1 et al)
   (note);
Christies NY 11/6/84: 33 ill(note);
Swann NY 11/8/84: 151 (attributed)(note), 187
   (album, B et al), 221 (album, B-2 et al);
Harris Baltimore 11/9/84: 42, 43 (attributed), 44
   (attributed), 46, 48, 62, 100 (lot, B-1 et al),
   101 (lot, B-1 et al), 103 (album, B et al), 112,
   117 (attributed), 118, 120, 122, 124, 128 ill,
   138 (attributed);
Harris Baltimore 3/15/85: 151 (note), 161 (album,
   B-2 et al), 287 (lot, B et al);
Sothebys Lon 3/29/85: 72 (2 ills)(26)(note);

## BRADY (continued)

Sothebys NY 5/7/85: 414 (lot, B-1 et al);
Swann NY 5/9/85: 369 (lot, B-1 et al), 371 (lot, B-1
   et al), 372 (album, B et al)(note);
California Galleries 6/8/85: 170 (attributed), 171;
Harris Baltimore 9/27/85: 35 (2, attributed), 37,
   38, 40, 42, 48 (2), 55 (2), 58, 59 ill, 61, 63,
   64, 65, 66, 67 (attributed), 73, 74, 75, 76, 81
   (note), 82, 83, 84 (attributed), 86 (lot, B et
   al), 89;
Sothebys Lon 11/1/85: 4 (lot, B et al);
Swann NY 11/14/85: 11 (albums, B et al)(note), 23,
   24 (8)(note), 120 (note), 121 (note), 285 ill
   (note), 286 ill(note), 289 ill(note), 290
   (note), 293 (6)(note), 294 (lot, B et al), 295
   (note), 296 ill(note), 297 ill(3)(note), 300 ill
   (note), 301 (note), 302 (2)(note), 303 (note),
   304 (12), 305 (21), 306 ill(lot, B et al), 307
   (41)(note), 308 (2), 309 (3)(note), 310 (note),
   311 (2)(note), 312 (note), 313 (note), 314
   (note), 315 (note), 316 (2)(note), 317 (2)(note), 318
   (3)(note), 319 (2)(note), 321 (lot, B-1 et al),
   322 (lot, B et al)(note), 324 (35)(note), 325
   (3)(note), 327 (25);
Harris Baltimore 2/14/86: 72 (lot, B-2 et al), 251,
   252, 253;
Sothebys NY 5/12/86: 57 ill(note), 405 ill(lot, B-1
   et al);
Swann NY 5/15/86: 163 (lot, B-1 et al), 222 (lot,
   B et al), 250, 305;
Phillips NY 7/2/86: 325, 326, 327;
Christies Lon 10/30/86: 222 (album, B et al), 224
   (album, B et al);
Harris Baltimore 11/7/86: 60 (lot, B-1 attributed
   et al), 64 (3), 65, 66 (lot, B-1 et al), 67 ill,
   72 ill(attributed), 76 (lot, B-2 et al), 78
   (attributed), 80 (lot, B et al), 81 (lot, B et
   al), 82 (6), 83 (lot, B et al), 84 (lot, B et
   al), 90 (attributed)(note), 107 (attributed)
   (note);
Sothebys NY 11/10/86: 39 ill(note), 153A (lot, B-1
   et al), 388 ill(lot, B-4 et al);
Christies NY 11/11/86: 61 ill(lot, B-3 et al)(note);
Swann NY 11/13/86: 145 (album, B-1 et al), 184
   (lot, B et al), 185 (lot, B-1 et al), 198 (lot,
   B-1 et al), 199 (lot, B-4 attributed et al);

## BRAND Frères (Belgian)
Photos dated: 1870s-1880s
Processes: Albumen
Formats: Stereos, cabinet cards, cdvs
Subjects: Topography, portraits
Locations: Belgium - Brussels
Studio: Belgium - Brussels
   Entries:
Swann NY 12/8/77: 369 (lot, B et al);
California Galleries 6/8/85: 247 (lot, B-1 et al);

## BRAND, Edwin L. (American)
Photos dated: 1858-1880
Processes: Daguerreotype, albumen
Formats: Plates, prints, cdvs
Subjects: Portraits
Locations: US - Chicago, Illinois
Studio: US - Chicago, Illinois
   Entries:
Sothebys NY (Strober Coll.) 2/7/70: 321 (lot,
   B et al);
Stern Chicago 1975(?): 10 (2);

**BRANDOUS, J.V.**
Photos dated: 1880s
Processes:      Bromide
Formats:        Cabinet cards
Subjects:       Topography
Locations:      US - Florida
Studio:
   Entries:
Christies Lon 3/11/82: 223 (11);

**BRANDSEPH, F.** (German, 1826-1915)
Photos dated: 1865-1880s
Processes:      Albumen
Formats:        Prints
Subjects:       Topography, genre
Locations:      Germany - Stuttgart
Studio:         Germany
   Entries:
Sothebys Lon 3/21/80: 142 (3);
Petzold Germany 5/22/81: 1786;

**BRANDT, Friedrich Christian** (German, 1823-1891)
Photos dated: 1864
Processes:      Albumen
Formats:        Prints, stereos
Subjects:       Documentary (military)
Locations:      Germany
Studio:         Germany
   Entries:
Lennert Munich Cat 5II, 1979: 23a ill, 24a;

**BRANFILL, J.**
Photos dated: 1860s
Processes:      Albumen
Formats:        Prints
Subjects:       Topography
Locations:      Germany; Switzerland
Studio
   Entries:
Sothebys Lon 3/29/85: 152 (albums, B et al);

**BRANSCOMBE, T.H.** (photographer or owner?)
Photos dated: 1860s
Processes:      Albumen
Formats:        Stereos
Subjects:       Topography
Locations:      China
Studio:
   Entries:
Sothebys Lon 10/28/81: 5 (7);

**BRANSGROVE, A.S.** (Australian)
Photos dated: 1898
Processes:
Formats:        Prints
Subjects:       Documentary (industrial)
Locations:      Australia - Queenstown
Studio:         Australia - Queenstown
   Entries:
Swann NY 11/5/81: 559 (album, 61)(note);

**BRANSON** (see McCRARY & BRANSON)

**BRAQUEHAIS, Bruno** (French)
Photos dated: 1850-1875
Processes:      Albumen
Formats:        Prints, stereos
Subjects:       Genre, documentary (Paris Commune,
              engineering)
Locations:      France - Paris
Studio:         France - Paris
   Entries:
Sothebys Lon 10/24/75: 1 (lot, B et al);
Lunn DC Cat QP, 1978: 9;
Sothebys NY 5/2/78: 93 ill(note);
Phillips Lon 3/13/79: 54 ill(attributed);
Octant Paris 1982: 16 ill;
Sothebys Lon 6/24/83: 66 (3);
Sothebys Lon 6/29/84: 104 (3);

**BRASCH, August** (German)
Photos dated: Nineteenth century
Processes:      Albumen
Formats:        Cdvs
Subjects:       Portraits
Locations:      Studio
Studio:         Germany - Leipzig
   Entries:
Sothebys NY (Strober Coll.) 2/7/70: 268 (lot,
   B et al);

**BRASSEY, Anna** (British)
Photos dated: 1872
Processes:      Albumen
Formats:        Prints
Subjects:       Topography
Locations:      US - New York City; Canada
Studio:
   Entries:
Swann NY 2/14/52: 53 (album, 37);

**BRAUN, Adolphe** (French, 1812-1877)
Photos dated: c1842-1880s
Processes:      Daguerreotype, albumen, carbon,
              woodburytype
Formats:        Plates, prints incl. panoramas, cdvs,
              stereos, cabinet cards
Subjects:       Topography, genre (still life),
              documentary (art)
Locations:      Switzerland; France - Paris; Greece -
              Athens; Egypt; Italy - Rome; Belgium;
              Holland; Germany
Studio:         France - Dornach (Alsace)
   Entries:
Goldschmidt Lon Cat 52, 1939: 205 (note), 206
   (note);
Weil Lon Cat 4, 1944(?): 185 (2)(note);
Rinhart NY Cat 6, 1973: 553;
Rinhart NY Cat 7, 1973: 164;
Vermont Cat 5, 1973: 540 ill(6);
Sothebys Lon 10/18/74: 13 (lot, B et al);
California Galleries 9/27/75: 451 (15);
Sothebys Lon 10/24/75: 87 (lot, B-17 et al), 92
   (lot, B et al);
Lunn DC Cat 6, 1976: 13.1 ill(note), 3.2 ill;
Rose Boston Cat 1, 1976: 16 ill(note), 17 ill;
Wood Conn Cat 37, 1976: 269 ill(6);
Gordon NY 11/13/76: 45 ill, 46 ill;
Vermont Cat 11/12, 1977: 770 ill, 771 ill(4);
White LA 1977: 19 ill(note);

**BRAUN** (continued)
California Galleries 1/22/77: 113 (lot, B-1 et al),
    298 (lot, B-3 et al), 300 (lot, B-1 attributed
    et al);
Sothebys NY 2/9/77: 18 ill(2), 19 (2);
Sothebys Lon 3/9/77: 6 (lot, B-3 et al), 206 (1
    plus 1 attributed), 207 ill(note), 215 (lot,
    B-13 et al);
Christies Lon 3/10/77: 206 (lot, B-4 et al);
Gordon NY 5/10/77: 790 ill, 791 ill, 792 ill
    (attributed);
Christies Lon 6/30/77: 181 (albums, B et al),
    304 ill;
Sothebys Lon 7/1/77: 282;
Sothebys NY 10/4/77: 185 (lot, B-1 attributed et
    al), 202 ill, 203, 204, 205, 206;
Christies Lon 10/27/77: 330 ill(note), 331, 332
    ill, 333;
Sothebys Lon 11/18/77: 5 (lot, B et al), 9 (lot, B-7
    et al);
Swann NY 12/8/77: 369 (lot, B et al);
Lehr NY Vol 1:2, 1978: 7 ill, 8 ill;
Rose Boston Cat 3, 1978: 66 ill(note), 67 ill, 68
    ill, 69 ill, 70 ill;
Witkin NY VI 1978: 26 (4 ills)(4);
Wood Conn Cat 41, 1978: 15 ill(note), 16 ill,
    17 ill;
California Galleries 1/21/78: 134 (lot, B et al),
    218;
Christies Lon 3/16/78: 168 ill(95);
Sothebys Lon 3/22/78: 3 (lot, B-4 et al), 72,
    181 (4);
Sothebys NY 5/2/78: 128;
Christies Lon 6/27/78: 246;
Sothebys Lon 6/28/78: 302 ill;
Swann NY 12/14/78: 366;
Rose Boston Cat 4, 1979: 61 ill(note), 62;
Wood Conn Cat 45, 1979: 31 (book, 49)(note);
California Galleries 1/21/79: 405, 406;
Phillips Lon 3/13/79: 140 (note);
Sothebys Lon 3/14/79: 236 ill(book, B et al),
    379 (3);
Christies Lon 3/15/79: 131 (note), 132, 133, 134,
    135, 136;
Christies NY 5/4/79: 47 ill;
Phillips NY 5/5/79: 95 (B, Clement & Cie);
Christies Lon 6/28/79: 75 (lot, B-10 et al), 242;
Sothebys Lon 6/29/79: 170 (2), 171 ill, 275 (book,
    B-1 et al);
Sothebys Lon 10/24/79: 54 (lot, B-11 et al), 122
    (attributed), 162 (lot, B-8 et al), 347 (14);
Christies Lon 10/25/79: 81 (43), 82 (34), 85 (lot,
    B-7 et al), 173 (note), 174, 175, 176 (lot, B-1
    et al);
Sothebys NY 11/2/79: 244 (lot, B-2 et al);
Phillips NY 11/3/79: 164, 165;
Phillips NY 11/29/79: 265 (lot, B-1 et al);
White LA 1980-81: 38 ill(note), 39 ill, 40 ill,
    41 ill;
Sothebys LA 2/6/80: 114;
Christies Lon 3/20/80: 94 (lot, B-6 et al), 98
    (lot, B-16 et al), 99 (lot, B-26 et al), 114
    (lot, B-5 et al), 371 (lot, B et al);
Sothebys Lon 3/21/80: 364 (lot, B-2 et al),
    371a (4);
California Galleries 3/30/80: 254;
Christies NY 5/16/80: 144 (2);
Phillips NY 5/21/80: 212;
Auer Paris 5/31/80: 114 (10);

**BRAUN** (continued)
Christies Lon 6/26/80: 102 (36), 112 (lot, B-13 et
    al), 114 (lot, B-5 et al), 212 (lot, B-1 et al),
    497 (album, B-2 et al);
Sothebys Lon 6/27/80: 84 (2, attributed), 86 ill,
    247 (attributed), 248 (3);
Sothebys Lon 10/29/80: 91, 92 ill, 93 ill;
Christies Lon 10/30/80: 116 (lot, B-19 et al), 196
    (lot, B-2 et al), 441 (album, B-1 et al), 456
    (lot, B et al);
Sothebys NY 11/17/80: 91 ill;
California Galleries 12/13/80: 201;
Christies Lon 3/26/81: 123 (lot, B-13 et al), 130
    (lot, B-19 et al), 176 (attributed), 203 (lot,
    B-30 et al);
Sothebys Lon 3/27/81: 5 (lot, B et al), 391 (3);
Christies NY 5/14/81: 41 (book, B-1 et al);
Petzold Germany 5/22/81: 1953 (lot, B-2 et al);
Sothebys Lon 6/17/81: 143 (lot, B-1 et al), 332 ill
    (attributed);
Christies Lon 6/18/81: 79 (lot, B et al), 103 (lot,
    B-4 et al), 107 (lot, B et al), 431 (album, B
    et al);
Sothebys Lon 10/28/81: 64 (album, B-26 et al);
Christies Lon 10/29/81: 139 (lot, B-19 et al), 142
    (lot, B et al), 143 (lot, B et al), 147 (lot, B
    et al), 158A (lot, B-13 et al);
Swann NY 11/5/81: 454 (2);
Petzold Germany 11/7/81: 293 (lot, B-3 et al), 327
    (lot, B et al);
Octant Paris 1982: 5 ill;
Rose Florida Cat 7, 1982: 40 ill(note), 70 ill(62)
    (note);
Wood Conn Cat 49, 1982: 67 (book, 49)(note), 499
    (book, B-4 et al);
Christies Lon 3/11/82: 66 (lot, B et al), 67 (lot,
    B et al), 83 (lot, B et al), 90 (lot, B et al),
    94 (lot, B-10 et al), 129 (5), 147 (album, 16),
    326 (album, B et al);
Sothebys Lon 3/15/82: 355, 356 ill;
Sothebys NY 5/24/82: 221 ill(note);
Christies NY 5/26/82: 36 (book, B-2 et al);
Christies Lon 6/24/82: 61 (lot, B et al), 164 ill
    (note), 165, 166 (37, attributed), 167 (lot, B-2
    plus 1 attributed, et al);
Sothebys Lon 6/25/82: 95 (lot, B et al);
Christies Lon 10/28/82: 30 (lot, B et al), 55A,
    77 (5);
Swann NY 11/18/82: 454 (lot, B et al);
Harris Baltimore 12/10/82: 39 (lot, B-28 et al);
Christies NY 2/8/83: 35;
Sothebys Lon 3/25/83: 89 (2 ills)(album, 34)(note);
Harris Baltimore 4/8/83: 100 (lot, B et al);
Christies Lon 6/23/83: 40 (lot, B-7 et al), 48
    (lot, B et al), 57 (lot, B et al), 100 (album,
    B et al);
Sothebys Lon 6/24/83: 17 (lot, B et al), 70 ill(2);
Christies Lon 10/27/83: 21 (lot, B et al), 43 (lot,
    B-4 et al);
Sothebys NY 11/9/83: 59 ill, 60 (2);
Swann NY 11/10/83: 192 (2), 193 (2), 348 (lot,
    B et al);
Harris Baltimore 12/16/83: 53 (lot, B et al), 132
    (lot, B et al);
Christies Lon 3/29/84: 24 (lot, B-16 et al), 58
    (album, B et al), 171;
Christies NY 5/7/84: 16 ill, 19 (book, B-2 et al);
Swann NY 5/10/84: 306 (lot, B et al);
Harris Baltimore 6/1/84: 341 (lot, B et al);
Christies Lon 6/28/84: 36 (lot, B-2 et al), 140
    (album, B et al), 212;

## BRAUN (continued)
Sothebys Lon 6/29/84: 8 (lot, B et al);
California Galleries 7/1/84: 313, 314 ill, 315,
    316, 317, 318, 319, 320, 321 (attributed);
Phillips Lon 10/24/84: 88 (lot, B-3 et al), 129
    (lot, B-9 et al), 164 (3 ills)(albums, 89);
Christies Lon 10/25/84: 103 (album, B et al), 224
    (note), 225 (note);
Christies NY 2/13/85: 129, 130 (attributed), 131
    (7 plus 2 attributed);
Harris Baltimore 3/15/85: 14 (lot, B-22 et al);
Phillips Lon 3/27/85: 143 (lot, B-1 et al), 148
    (lot, B et al);
Christies Lon 3/28/85: 51 (lot, B et al), 161;
Sothebys Lon 3/29/85: 215 ill;
Christies NY 5/6/85: 50 (book, B et al), 75 ill
    (note), 76 ill;
California Galleries 6/8/85: 453 (lot, B-2 et al);
Phillips Lon 6/26/85: 223 (93);
Christies Lon 6/27/85: 30 (lot, B et al);
Sothebys Lon 6/28/85: 3 (lot, B et al);
Phillips Lon 10/30/85: 15 (lot, B-9 et al), 134
    (lot, B-93 et al);
Christies Lon 10/31/85: 58 (lot, B et al), 69
    (lot, B et al), 123 (albums, B-6 et al);
Christies NY 11/11/85: 113 ill(attributed);
Sothebys NY 11/12/85: 60 ill, 61 ill;
Swann NY 11/14/85: 86 (lot, B et al);
Harris Baltimore 2/14/86: 254, 340 (lot,
    B attributed et al);
Phillips Lon 4/23/86: 300 (lot, B-93 et al);
Christies Lon 4/24/86: 344 (lot, B et al);
Sothebys NY 5/12/86: 77 ill;
Swann NY 5/15/86: 183 (9), 202 (album, B et al);
Christies Lon 6/26/86: 3 (lot, B et al), 34A (2),
    66 (lot, B et al), 156 (lot, B et al), 157
    (albums, B et al);
Phillips Lon 10/29/86: 326 (lot, B-1 et al);
Christies Lon 10/30/86: 35 (100), 88 (album, B et
    al), 93 (lot, B-5 et al);
Sothebys Lon 10/31/86: 2 (lot, B et al);
Harris Baltimore 11/7/86: 235 (2)(note);
Sothebys NY 11/10/86: 59 ill;
Drouot Paris 11/22/86: 26 ill, 27 ill;

## BRAUN, Max (German)
Photos dated: Nineteenth century
Processes:      Albumen
Formats:
Subjects:       Portraits
Locations:      Studio
Studio:         Germany - Dresden
    Entries:
Petzold Germany 11/7/81: 1980 (album, B et al);

## BRAY, James E. (British)
Photos dated: 1885
Processes:      Albumen
Formats:        Prints
Subjects:       Topography
Locations:      Great Britain - Beechworth
Studio:         Great Britain
    Entries:
Christies Lon 10/30/86: 171 (book, 17);

## BRAY, W. de
Photos dated: 1871-1880s
Processes:      Albumen, collotype
Formats:        Prints, stereos
Subjects:       Topography, documentary (scientific)
Locations:      France - Nice
Studio:         France - Nice
    Entries:
Sothebys LA 2/13/78: 121 (books, B et al)(note);
Christies Lon 10/30/80: 196 (lot, D-11 et al);
Christies Lon 3/26/81: 291 (book, 25);
Christies Lon 3/11/82: 83 (lot, B et al);
Bievres France 2/6/83: 145;
California Galleries 7/1/84: 403 (3);
Swann NY 11/13/86 (book, B et al);

## BRAYER (Belgian)
Photos dated: Nineteenth century
Processes:      Albumen
Formats:        Cdvs
Subjects:       Portraits
Locations:      Studio
Studio:         Belgium - Bruges
    Entries:
Phillips Lon 10/24/84: 123 (lot, B-1 et al);

## BRAYTON, J.G. (American)
Photos dated: c1870s-1886
Processes:      Albumen
Formats:        Prints, stereos
Subjects:       Topography
Locations:      US - Napa City, California
Studio:         US - Napa City, California
    Entries:
Rinhart NY Cat 1, 1971: 148;
California Galleries 3/30/80: 264 (lot, B-1 et al);

## BREBISSON, Louis-Alphonse de (French, 1798-1872)
Photos dated: 1839-1872
Processes:      Daguerreotype, salt
                (Blanquart-Evrard), albumen
Formats:        Plates, prints, stereos
Subjects:       Topography, portraits, genre (still
                life)
Locations:      France - Falaise
Studio:         France - Falaise
    Entries:
Rauch Geneva 6/13/61: 58 (note);
Sothebys Lon 10/27/78: 153 (album, B et al);
Sothebys Lon 4/25/86: 183 ill;

## BREEM, James L.
Photos dated: c1895
Processes:      Carbon
Formats:        Prints
Subjects:       Genre
Locations:
Studio:
    Entries:
California Galleries 3/30/80: 266 (lot, B-1 et al);

**BREESE, C.S.**
Photos dated: 1860s
Processes:    Diapositives on glass
Formats:     Stereo plates
Subjects:    Topography, documentary
Locations:   England
Studio:      England - Sydenham
   Entries:
Christies Lon 3/15/79: 69 (lot, B-1 et al);
Phillips Lon 6/15/83: 104 (lot, B-5 et al);
Phillips Lon 11/4/83: 21 (lot, B-5 et al);
Christies Lon 10/31/85: 71 (lot, B-2 et al);

**BREESE, G.** (British)
Photos dated: 1850s-1860s
Processes:    Albumen, glass diapositive
Formats:     Stereos
Subjects:    Topography
Locations:   Great Britain
Studio:      England - Birmingham
   Entries:
Christies Lon 6/24/82: 55 (lot, B-5 et al);
Sothebys Lon 6/29/84: 10 (lot, B-2 et al);
Christies Lon 3/28/85: 41 (lot, B et al);

**BREMNER, F.**
Photos dated: 1897
Processes:    Photogravure
Formats:     Prints
Subjects:    Documentary (military)
Locations:   India
Studio:      India
   Entries:
Christies Lon 4/25/74: 200 (album);

**BRENTANO, Emil**
Photos dated: 1889
Processes:    Albumen
Formats:     Cabinet cards
Subjects:
Locations:
Studio:
   Entries:
Petzold Germany 5/22/81: 1787 (17)(note);

**BRESCOTT, G.P.**
Photos dated: 1855
Processes:    Daguerreotype
Formats:     Plates
Subjects:    Portraits
Locations:
Studio:
   Entries:
Rinhart NY Cat 6, 1973: 186;

**BRESOLIN, D.**
Photos dated: early 1850s
Processes:    Salt, albumen
Formats:     Prints
Subjects:    Topography
Locations:   Italy - Venice
Studio:      Italy - Venice
   Entries:
Sothebys Lon 6/29/79: 137 (lot, B-1 et al);
Sothebys Lon 10/24/79: 336 (lot, B-1 et al);
Christies Lon 3/29/84: 132 (2);

**BRESOLIN, D.** (continued)
Christies Lon 6/28/84: 196 (1 plus 1 attributed);
Christies Lon 10/31/85: 195 (2);

**BRESSANINI, E.** (Italian)
Photos dated: 1860s-1880s
Processes:    Albumen
Formats:     Prints, stereos
Subjects:    Topography
Locations:   Italy - Verona; Spain - Barcelona
Studio:      Italy - Verona
   Entries:
California Galleries 9/27/75: 343 (lot, B-1 et al);
Christies Lon 6/18/81: 184;
Swann NY 11/18/82: 403 (lot, B et al);

**BREVETE, B.** (French)
Photos dated: 1840s
Processes:    Daguerreotype
Formats:     Plates
Subjects:    Portraits
Locations:
Studio:
   Entries:
Swann NY 11/8/84: 178 (2);

**BREWSTER** (British) [BREWSTER 1]
Photos dated: 1850s and/or 1860s
Processes:    Albumen
Formats:     Stereos
Subjects:    Genre
Locations:   Studio
Studio:      Great Britain
   Entries:
Sothebys Lon 10/29/76: 29 (lot, B et al);

**BREWSTER** (American) [BREWSTER 2]
Photos dated: c1870s-1880
Processes:    Albumen
Formats:     Stereos
Subjects:    Topography
Locations:   US - Santa Barbara, California
Studio:      US
   Entries:
California Galleries 5/23/82: 421 (lot, B et al);

**BREWSTER, Sir David** (British, 1781-1868)
Photos dated: 1845-1855
Processes:    Calotype
Formats:     Prints
Subjects:    Genre
Locations:   Scotland
Studio:      Scotland
   Entries:
Sothebys NY 2/25/75: 13 ill(album, B attributed
   et al);

BRICHARD (British)
Photos dated: Nineteenth century
Processes:      Albumen
Formats:        Stereos
Subjects:
Locations:      Great Britain
Studio:         Great Britain
    Entries:
Christies Lon 3/11/82: 65 (lot, B et al);

BRIDGEMAN, Lady Lucy Caroline (British,
                c1835-1858)
Photos dated: early 1850s
Processes:      Albumen
Formats:        Prints
Subjects:       Portraits
Locations:      England
Studio:         England
    Entries:
Mancini Phila 1979: 14 ill, 15 ill, 16 ill, 17 ill,
    18 ill, 19 ill;
Sothebys Lon 3/14/79: 328 (album, B et al);
Christies NY 11/11/80: 27 ill(note), 28, 29;

BRIDGES, Reverend George W. (British)
Photos dated: c1846-1852
Processes:      Calotype
Formats:        Prints
Subjects:       Topography
Locations:      Malta; Italy; Greece; Egypt; Palestine
Studio:
    Entries:
Sothebys Lon 10/18/74: 149 ill(3)(note);
Christies Lon 6/30/77: 73 (lot, B-1 attributed et
    al)(note);
Sothebys Lon 7/1/77: 89 ill(album, 30)(note), 90 ill
    (album, 36);
Christies NY 5/16/80: 145 ill(note);
Christies Lon 6/24/82: 356 (album, B-1 et al);
Sothebys Lon 3/25/83: 102 ill(attributed);
Christies Lon 10/27/83: 187 (album, B-1 et al)
    (note);
Christies Lon 6/27/85: 112 ill(album, B-1 et al)
    (note), 114;

BRIGGS & KNAPPS (American)
Photos dated: c1856
Processes:      Ambrotype
Formats:        Plates
Subjects:       Portraits
Locations:      Studio
Studio:         US - Washington, D.C.
    Entries:
California Galleries 9/26/75: 90;

BRIGGS, Archibald (British)
Photos dated: 1858-1870s
Processes:      Albumen
Formats:        Prints
Subjects:       Topography
Locations:      England - Liverpool; Wales
Studio:         England
    Entries:
Christies Lon 10/28/82: 43 ill(albums, 75);
Christies Lon 10/27/83: 51 (albums, 75);

BRIGGS, C.T. (American)
Photos dated: Nineteenth century
Processes:      Albumen
Formats:        Stereos
Subjects:       Topography
Locations:      US - Rhode Island
Studio:         US
    Entries:
Harris Baltimore 3/15/85: 86 (lot, B-3 et al);

BRIGHTMAN, G. (British)
Photos dated: 1860s
Processes:      Albumen
Formats:        Prints
Subjects:       Genre
Locations:      Great Britain
Studio:         England (West of England and Cornwall
                Photographic Society)
    Entries:
Sothebys Lon 3/9/77: 203;

BRINCKERHOFF, J. DeWitt (American)
Photos dated: 1840-1856
Processes:      Daguerreotype, calotype, albumenized
                salt, heliograph
Formats:        Plates, prints
Subjects:       Portraits
Locations:      Studio
Studio:         US - New York City
    Entries:
Sothebys NY (Strober Coll.) 2/7/70: 18 (23)(note);
Sothebys NY 2/25/75: 109 (album, 23);
Sothebys NY 10/4/77: 104 ill(note);
Lehr Vol 1:3, 1979: 12 ill;

BRIQUET, A. (French)
Photos dated: 1854-1896
Processes:      Salt, albumen
Formats:        Prints, stereos
Subjects:       Portraits, topography, documentary
                (military)
Locations:      France - Fontainebleau; Mexico;
                Central America
Studio:
    Entries:
Swann NY 2/14/52: 231 (albums, B et al);
Sothebys Lon 6/21/74: 73 ill(album, B-12 et al);
Sothebys Lon 6/26/75: 109 ill(31);
California Galleries 9/27/75: 314 (7);
Swann NY 4/14/77: 205 (lot, B-22 et al), 206 (14)
    (note);
Swann NY 12/8/77: 396 (album, B-12 et al);
California Galleries 1/21/79: 476 (lot, B-7 et al);
Swann NY 4/26/79: 406 (5);
Phillips NY 11/29/79: 301 ill(15), 302 (lot, B-9
    et al);
Rose Boston Cat 5, 1980: 85 ill(note), 86;
California Galleries 3/30/80: 345 (11);
Swann NY 4/23/81: 492 (12);
California Galleries 6/28/81: 153 ill(album,
    B-21 et al);
Octant Paris 1982: 19 ill;
Harris Baltimore 3/26/82: 421 (3);
Swann NY 11/18/82: 419 (10)(note);
Harris Baltimore 12/10/82: 403 (7);
Sothebys Lon 6/24/83: 74 ill;
Swann NY 5/10/84: 13 (album, B et al)(note);
Sothebys Lon 6/29/84: 108 ill;

**BRIQUET, A** (continued)
Christies Lon 10/25/84: 186 (3);
Christies NY 2/13/85: 155 (lot, B et al);
Swann NY 11/14/85: 165 (lot, B et al);
Christies Lon 10/30/86: 130 (lot, B-9 et al);

**BRITT, Peter** (Swiss, American, 1819-1905)
Photos dated: 1852-1905
Processes:      Daguerreotype, ambrotype, tintype,
                albumen
Formats:        Plates, prints, stereos, cdvs,
                cabinet cards
Subjects:       Portraits, topography, ethnography
Locations:      US - Oregon
Studio:         US - Jacksonville, Oregon
   Entries:
California Galleries 1/21/78: 370 (lot, B-1 et al);

**BRITTON, Dr.** (British) [BRITTON 1]
Photos dated: between 1851 and 1856
Processes:      Calotype
Formats:        Prints
Subjects:       Topography
Locations:      Great Britain
Studio:         Great Britain
   Entries:
Sothebys Lon 12/21/71: 138 (album, B attributed
   et al);

**BRITTON & Sons** (British) [BRITTON 2]
Photos dated: 1859-1860s
Processes:      Albumen
Formats:        Stereos
Subjects:       Topography
Locations:      England - Barnstable
Studio:         England
   Entries:
Sothebys Lon 10/18/74: 13 (lot, B et al);
Sothebys Lon 3/27/81: 9 (lot, B et al);
Christies Lon 6/18/81: 105 (lot, B-12 et al), 106
   (lot, B et al);
Christies Lon 6/24/82: 72 (lot, B-1 et al);
Christies Lon 6/23/83: 45 (lot, B et al);
Christies Lon 3/29/84: 29 (lot, B-1 et al);

**BROADBENT, Samuel** (American)
Photos dated: 1853-1870s
Processes:      Daguerreotype, ambrotype, albumen
Formats:        Plates incl. stereo, stereo cards,
                cdvs
Subjects:       Portraits, topography
Locations:      US
Studio:         US - Philadelphia, Pennsylvania
   Entries:
Sothebys NY (Strober Coll.) 2/7/70: 318 (lot,
   B et al);
Sothebys Lon 12/21/71: 206 (lot, B-2 et al);
Vermont Cat 6, 1973: 512 ill;
Vermont Cat 7, 1974: 493 ill;
Vermont Cat 9, 1975: 408 ill;
Sothebys NY 2/25/75: 1 (lot, B-1 et al);
Vermont Cat 11/12, 1977: 542 ill(note);
Christies Lon 10/29/81: 97 ill;
Harris Baltimore 2/14/86: 285;

**BROAKLEHURST** (British)
Photos dated: 1881
Processes:      Albumen
Formats:        Prints
Subjects:
Locations:      Scotland
Studio:         Scotland
   Entries:
California Galleries 1/22/77: 213 (lot, B et al);

**BROAS** (American)
Photos dated: 1860s
Processes:      Albumen
Formats:        Stereos
Subjects:       Documentary (educational institutions)
Locations:      US - Poughkeepsie, New York
Studio:         US - Poughkeepsie, New York
   Entries:
Harris Baltimore 6/1/84: 104 (Lot, B-3 attributed
   et al);

**BROCKMANN, F. & O.** (German)
Photos dated: 1860s-1870s
Processes:      Albumen
Formats:        Stereos
Subjects:       Topography
Locations:      Germany - Dresden
Studio:         Germany - Dresden
   Entries:
Harris Baltimore 12/10/82: 39 (lot, B-6 et al);

**BRODERICK, F.N., Jr.** (British)
Photos dated: 1870-1880s
Processes:      Albumen
Formats:        Prints
Subjects:       Topography, documentary (public
                events)
Locations:      England - Isle of Wight
Studio:         England - Ryde
   Entries:
California Galleries 4/2/76: 222 (lot, B-1 et al);
Sothebys Lon 10/28/81: 209 (3);
Sothebys Lon 6/29/84: 206;
Swann NY 5/15/86: 235 (albums, B et al);

**BRODIE, A.**
Photos dated: c1870
Processes:      Albumen
Formats:        Prints
Subjects:       Topography
Locations:      Australia
Studio:         Australia - Sydney
   Entries:
Christies Lon 10/30/86: 128;

**BRODIE, William**
Photos dated: 1840s-c1860
Processes:      Daguerreotype
Formats:        Plates incl. stereo
Subjects:       Documentary (art)
Locations:      England - London
Studio:         England
   Entries:
Swann NY 2/14/52: 4 (album, B et al);
Christies Lon 10/28/76: 190;

BROGI, Giacomo (Italian, 1822-1881)
Photos dated: 1860-1881
Processes:      Albumen
Formats:        Prints, cdvs, stereos, cabinet cards
Subjects:       Topography
Locations:      Italy - Florence et al; Egypt;
                Palestine
Studio:         Italy - Florence
  Entries:
Rinhart NY Cat 1, 1971: 409 (lot, B et al), 447
  (album, B et al);
Edwards Lon 1975: 13 (album, B-1 et al);
Sothebys Lon 6/26/75: 124 (lot, B-2 et al);
California Galleries 9/26/75: 151 (album, B et al);
Wood Conn Cat 37, 1976: 220 (album, B-1 et al), 250
  (album, B et al);
Swann NY 4/1/76: 206 (lot, B et al);
California Galleries 4/3/76: 384 (lot, B et al);
Christies Lon 6/10/76: 61 (album, B et al), 94
  (album, B et al);
Christies Lon 10/28/76: 115 (album, B et al);
Swann 11/11/76: 388 (albums, B et al), 389 (albums,
  B et al), 391 (album, B-11 et al), 394 (albums,
  B et al), 395 (albums, B et al), 449 (lot, B et
  al), 450 (lot, B et al);
Rose Boston Cat 2, 1977: 54 ill(note);
Sothebys NY 2/9/77: 36 (lot, B et al);
Swann NY 4/14/77: 245 (album, B et al), 300
  (album, 12);
Swann NY 12/8/77: 325 (albums, B et al), 367 (lot,
  B et al);
Rose Boston Cat 3, 1978: 43 ill(note), 44 ill,
  45 ill;
Christies Lon 3/16/78: 153 (lot, B et al);
Swann NY 4/20/78: 197 (8), 291 (album, B et al), 328
  (lot, B et al);
Christies Lon 10/26/78: 137 (album, 75);
Swann NY 4/26/79: 282 (albums, B et al);
Phillips NY 5/5/79: 165 (6);
Christies Lon 6/28/79: 103 (albums, B et al), 104
  (album, B et al);
Christies Lon 10/25/79: 147 (lot, B et al), 159
  (albums, B et al), 165 (album, B et al);
Phillips NY 11/29/79: 275 (album, B et al);
Christies Lon 3/20/80: 156 (album, B et al), 209
  (album, B et al), 371 (lot, B et al);
Christies NY 5/16/80: 183 (album, B et al), 185
  (lot, B et al), 189 (lot, B et al), 190 (3), 202
  (albums, B et al);
Phillips NY 5/21/80: 142 (album, B et al);
Christies Lon 6/26/80: 211 (albums, B et al), 278
  (albums, B et al), 284 (albums, B et al);
Christies Lon 10/30/80: 197 (lot, B-1 et al), 456
  (lot, B et al);
Swann NY 11/6/80: 283 (lot, B et al);
California Galleries 12/13/80: 284 ill;
Christies Lon 3/26/81: 268 (lot, B et al);
Swann NY 4/23/81: 461 (lot, B et al);
Phillips NY 5/9/81: 28 (albums, B et al), 50
  (albums, B et al), 65 (album, B attributed
  et al);
Sothebys Lon 6/17/81: 136 (lot, B-10 et al);
California Galleries 6/28/81: 220 (lot, B-2 et al);
Christies Lon 10/29/81: 147 (lot, B et al);
Swann NY 11/5/81: 80 (book, 16)(attributed)(note);
Petzold Germany 11/7/81: 185 (lot, B et al), 309
  (album, B et al);
Christies Lon 3/11/82: 83 (lot, B et al), 138 (lot,
  B et al);
California Galleries 5/23/82: 194 (album, B et al),
  292 (lot, B-2 et al);

BROGI (continued)
Phillips Lon 6/23/82: 23 (lot, B-10 et al), 36
  (albums, B et al), 40 (lot, B et al), 43 (lot,
  B et al);
Christies Lon 6/24/82: 55 (lot, B-6 et al), 231
  (lot, B-17 et al);
Phillips NY 9/30/82: 994 (lot, B et al);
Phillips Lon 10/27/82: 29 (lot, B et al), 33 (lot,
  B et al);
Swann NY 11/18/82: 367 (lot, B-3 et al), 403 (lot, B
  et al), 422 (lot, B-7 et al), 454 (lot, B et al);
Harris Baltimore 12/10/82: 391 (albums, B et al),
  399 (lot, B et al);
Bievres France 2/6/83: 143;
Swann NY 5/5/83: 381 (albums, B et al);
Christies Lon 6/23/83: 48 (lot, B et al), 100
  (album, B et al), 166 (albums, B et al), 178
  (album, B et al);
Christies NY 10/4/83: 101 (albums, B et al);
Christies NY 2/22/84: 10 (albums, B et al);
Christies Lon 3/29/84: 55 (lot, B et al);
Swann NY 5/10/84: 187 (lot, B et al), 306 (lot,
  B et al);
Harris Baltimore 6/1/84: 389 (lot, B et al), 445
  (lot, B et al);
Christies Lon 6/28/84: 73 (lot, B-2 et al), 75
  (lot, B-4 et al);
California Galleries 7/1/84: 494 (lot, B-1 et al);
Christies NY 9/11/84: 117 ill(album, B et al);
Christies Lon 10/25/84: 63 (lot, B-2 et al);
Swann NY 11/8/84: 200 (albums, B et al);
Harris Baltimore 3/15/85: 200 (lot, B et al);
Christies Lon 3/28/85: 62 (album, B et al), 92
  (albums, B et al);
California Galleries 6/8/85: 268 (lot, B et al);
Christies Lon 6/27/85: 147 (lot, B-1 et al);
Christies Lon 10/31/85: 69 (lot, B et al), 87
  (albums, B et al);
Harris Baltimore 2/14/86: 210 (albums, B et al), 218
  (album, B et al);
Christies Lon 4/24/86: 344 (lot, B et al), 386
  (album, B-4 et al);
Swann NY 5/15/86: 265 (lot, B et al);
Christies Lon 6/26/86: 117 (album, 62);
Christies Lon 10/30/86: 83 (lot, B et al);
Swann NY 11/14/85: 104 (albums, B et al), 162 (lot,
  B et al);
Harris Baltimore 11/7/86: 260 (lot, B et al);
Swann NY 11/13/86: 155 (23)(note), 218 (lot, B et
  al), 245 (lot, B et al);

BROMOCHARY, B.G. (Indian)
Photos dated: 1869
Processes:      Albumen
Formats:        Prints
Subjects:       Topography
Locations:      India - Benares
Studio:         India
  Entries:
Sothebys Lon 3/15/82: 127 ill(album, 24);

BRONSON, S.E.
Photos dated: Nineteenth century
Processes:      Albumen
Formats:        Prints
Subjects:
Locations:
Studio:
    Entries:
Harris Baltimore 2/14/86: 329 (lot, B-1 et al);

BROOK, R.J. (Canadian)
Photos dated: 1884
Processes:      Albumen
Formats:        Prints
Subjects:       Topography
Locations:      Canada
Studio:         Canada
    Entries:
Phillips Can 10/4/79: 54 (album, B et al);

BROOKE (British)
Photos dated: 1857
Processes:      Albumen
Formats:        Prints
Subjects:
Locations:      Great Britain
Studio:         Great Britain (Amateur Photographic
                Association)
    Entries:
Sothebys Lon 3/21/80: 255 (album, B-1 et al);

BROOKES (Australian) [BROOKES 1]
Photos dated: 1870s
Processes:      Albumen
Formats:        Prints
Subjects:       Topography
Locations:      Australia - Victoria
Studio:         Australia
    Entries:
Sothebys Lon 4/25/86: 18 (album, B et al);

BROOKES Brothers (British) [BROOKES 2]
Photos dated: 1860s
Processes:      Albumen
Formats:        Stereos
Subjects:       Topography
Locations:      Great Britain
Studio:         Great Britain
    Entries:
Christies Lon 10/28/82: 27 (lot, B et al);

BROOKS & BRAUVELT (American)
Photos dated: Nineteenth century
Processes:      Albumen
Formats:        Cdvs
Subjects:       Portraits
Locations:      Studio
Studio:         US - Port Hudson, Louisiana
    Entries:
Sothebys NY (Strober Coll.) 2/7/70: 297 (lot,
    B & B et al);

BROOKS, H. (British)
Photos dated: 1860s-1870s
Processes:      Albumen
Formats:        Prints, stereos
Subjects:       Topography, architecture
Locations:      England - Stonehenge
Studio:         England - Salisbury
    Entries:
Christies Lon 10/25/79: 125 (lot, B-1 et al);
Christies Lon 6/26/80: 166 (lot, B-1 et al);
Swann NY 5/5/83: 283 (albums, B et al);

BROOKS, Henry (American)
Photos dated: 1890
Processes:      Photogelatine
Formats:        Prints
Subjects:       Documentary (scientific)
Locations:      US - Massachusetts
Studio:         US
    Entries:
Swann NY 2/6/75: 56 (book, 58);
Wood Conn Cat 42, 1978: 565 (book, 58);
Swann NY 4/26/79: 55 (book, 58)(note);

BROOKS, W. (British)
Photos dated: 1860s
Processes:      Albumen
Formats:        Stereos
Subjects:       Topography
Locations:      Great Britain
Studio:         Great Britain
    Entries:
Sothebys Lon 6/11/76: 2 (lot, B et al);
Sothebys Lon 10/29/80: 14 (lot, B et al);
Christies Lon 6/24/82: 71 (lot, B et al);
Christies Lon 10/28/82: 17 (lot, B et al);
Sothebys Lon 3/25/83: 4 (lot, B et al);

BROTHERS, Alfred (British)
Photos dated: 1850s-1862
Processes:      Daguerreotype, ambrotype
Formats:        Plates incl. stereo
Subjects:       Portraits, documentary (scientific)
Locations:      Studio
Studio:         England - Manchester
    Entries:
Vermont Cat 11/12, 1977: 684 ill;
Christies Lon 6/30/77: 151 (2);
Christies Lon 3/15/79: 98 (lot, B-1 et al);
Christies Lon 6/28/79: 69 (lot, B-1 et al);
Sothebys Lon 3/21/80: 365 ill;
Christies Lon 3/26/81: 100 (lot, B-1 et al);
Sothebys Lon 6/29/84: 24 ill(3);

BROWN (see LINDSAY & BROWN) [BROWN 1]

BROWN (see WINTER & BROWN) [BROWN 2]

**BROWN** (American) [BROWN 3]
Photos dated: 1860s-1870s
Processes:      Albumen
Formats:        Cdvs
Subjects:       Portraits
Locations:      Studio
Studio:         US - Norwich, New York
   Entries:
Rinhart NY Cat 2, 1971: 366 (lot, B et al);
California Galleries 1/21/79: 232 (lot, B et al);

**BROWN** [BROWN 4]
Photos dated: Nineteenth century
Processes:      Albumen
Formats:        Stereos
Subjects:       Topography
Locations:      US - Maine
Studio:
   Entries:
Harris Baltimore 12/10/82: 53 (lot, B et al);

**BROWN, A.J.** (British?)
Photos dated: 1862
Processes:
Formats:        Prints
Subjects:       Documentary (scientific)
Locations:      Egypt - Sinai
Studio:         Halsted (England?)
   Entries:
Swann NY 2/14/52: 198 (book, 11)(note);
Swann NY 9/18/75: 363 (book, 19);

**BROWN, Arthur** (British)
Photos dated: 1860s-1873
Processes:      Albumen
Formats:        Prints
Subjects:       Genre (nature)
Locations:      England - Yorkshire
Studio:         England - Newcastle
   Entries:
Sothebys Lon 7/1/77: 280 (13);
Christies Lon 3/16/78: 226 (book, 13);
Christies Lon 6/27/78: 167 (book, 13);
Christies Lon 10/26/78: 220 (book, 13);
Sothebys Lon 3/14/79: 245 (book, 13);
Christies Lon 6/28/79: 167 (book, 13);
Christies Lon 10/30/80: 299 (book, 13);
Christies Lon 6/26/86: 175 (books, B-13 et al);

**BROWN, G.** (British)
Photos dated: c1850
Processes:      Daguerreotype
Formats:        Stereo plates
Subjects:       Genre
Locations:      Great Britain
Studio:         England - York
   Entries:
Christies Lon 6/30/77: 139;

**BROWN, H.S.** (photographer or author?)
Photos dated: 1872
Processes:      Albumen
Formats:        Prints
Subjects:       Topography
Locations:      India
Studio:
   Entries:
Sothebys Lon 3/15/82: 115 ill(book, 21);

**BROWN, Henry** (American)
Photos dated: Nineteenth century
Processes:      Albumen
Formats:        Stereos
Subjects:       Topography
Locations:      US - New Mexico
Studio:         US - New Mexico
   Entries:
Harris Baltimore 3/15/85: 50 (lot, B-4 et al);

**BROWN, J.M.** (British)
Photos dated: 1872
Processes:      Albumen
Formats:        Prints
Subjects:       Topography
Locations:      England - Isle of Wight
Studio:         Great Britain
   Entries:
Christies Lon 10/28/76: 83 (book, 50);
Christies Lon 6/26/80: 161 (album, B et al);
Christies Lon 3/26/81: 153 (album, 51)(attributed);
Christies Lon 3/24/83: 54 (album, B-1 et al);
Christies Lon 4/24/86: 338 (lot, B & Wheeler et al);

**BROWN, James A.** (American, born 1819)
Photos dated: 1843-1854
Processes:      Daguerreotype
Formats:        Plates
Subjects:       Portraits
Locations:      Studio
Studio:         US - New York City
   Entries:
Witkin NY 1976: D18 ill;

**BROWN, N.** (Nicholas?) (American)
Photos dated: 1862
Processes:      Salt
Formats:        Print
Subjects:       Documentary (Civil War)
Locations:      US - Corinth, Mississippi
Studio:         US
   Entries:
Sothebys NY 5/20/80: 284 ill(2);

**BROWN, W.** (British)
Photos dated: 1860s-1869
Processes:      Albumen
Formats:        Prints
Subjects:       Architecture, documentary (military)
Locations:      England - London
Studio:         England
   Entries:
Christies Lon 10/26/78: 99;
Auer Paris 5/31/80: 99 (2);
Christies Lon 6/26/80: 150 (lot, B-1 et al);
Swann NY 11/10/83: 279 (lot, B et al);

**BROWN, W. Cal** (American)
Photos dated: 1880s and/or 1890s
Processes: Albumen
Formats: Prints
Subjects: Ethnography
Locations: US
Studio: US
    Entries:
Christies Lon 6/27/78: 139 (lot, B-1 et al);

**BROWN, William Henry** (American)
Photos dated: 1870s-c1875
Processes: Albumen
Formats: Stereos, prints, cabinet cards
Subjects: Topography, ethnography, documentary
    (railroads)
Locations: US - Santa Fe, New Mexico; Colorado
Studio: US - Santa Fe, New Mexico
    Entries:
Rinhart NY Cat 2, 1971: 413, 414 ill, 433;
Swann NY 11/8/84: 258 (5)(note), 259 (5)(note);
Swann NY 5/9/85: 435 (lot, B, B & Bennet,
    et al)(note), 436 ill(8);

**BROWNE, John C.** (American)
Photos dated: 1864-1871
Processes: Albumen
Formats: Prints
Subjects: Topography, documentary (Civil War,
    maritime)
Locations: US - Civil War area
Studio: US - Philadelphia, Pennsylvania
    Entries:
Sothebys NY (Strober Coll.) 2/7/70: 414 (lot,
    B et al)(note);
Sothebys NY 10/4/77: 22 ill(lot, B-1 et al)(note);
Swann NY 10/18/79: 273 (2)(note);
California Galleries 7/1/84: 101 (book, 2);
Swann NY 11/14/85: 261 (book, B et al);
Wood Boston Cat 58, 1986: 136 (books, B-2 et al);
Swann NY 5/15/86: 131 (book, B et al)(note);

**BROWNE, T. Chapman** (British)
Photos dated: c1850-1850s
Processes: Daguerreotype
Formats: Plates
Subjects: Portraits
Locations: Studio
Studio: England - Leicester
    Entries:
Sothebys Lon 12/4/73: 182 (lot, B-1 et al);
Sothebys Lon 10/24/79: 229 (2)(note);
Sothebys Lon 3/29/85: 45;

**BROWNE, Thomas C.** (American)
Photos dated: Nineteenth century
Processes: Albumen
Formats: Stereos
Subjects: Topography
Locations: US - Pennsylvania
Studio: US
    Entries:
Harris Baltimore 3/26/82: 12 (lot, B et al);

**BROWNING, Benjamin** (British)
Photos dated: early 1850s-1880s
Processes: Calotype, albumenized salt, albumen
Formats: Prints
Subjects: Topography, genre (domestic)
Locations: England
Studio: England
    Entries:
Sothebys Lon 3/8/74: 161 (2 ills)(album, B et al);
Edwards Lon 1975: 2 (album, B et al)(note);
Sothebys NY 10/4/77: 160 ill;

**BROWNRIGG, T.M.**
Photos dated: 1859-1860s
Processes: Albumen
Formats: Prints, stereos
Subjects: Topography
Locations: Ireland - Dublin; Great Britain
Studio: Great Britain (Amateur Photographic
    Association)
    Entries:
Christies Lon 10/27/83: 19 (lot, B et al), 218
    (albums, B-1 et al);
Christies Lon 6/28/84: 39 (book, B et al)(note);

**BRUBAKER, C.B.** (American)
Photos dated: 1870s
Processes: Albumen
Formats: Cdvs, stereos
Subjects: Topography
Locations: US - Michigan
Studio: US - Houghton, Michigan
    Entries:
Swann NY 4/23/81: 497 (lot, B et al);
Harris Baltimore 6/1/84: 152 (lot, B-5 et al);

**BRUCE, George** (British)
Photos dated: 1878-1879
Processes: Carbon
Formats: Prints
Subjects: Genre
Locations: Scotland
Studio: Scotland
    Entries:
Christies Lon 6/28/79: 240;

**BRUCE, J.** (Canadian)
Photos dated: 1890s
Processes: Albumen
Formats: Prints
Subjects: Topography
Locations: Canada
Studio: Canada - Toronto
    Entries:
Christies Lon 6/27/78: 141 (album, 50);
Christies Lon 10/26/78: 187 (album, B-15 et al);

BRUCKMAN, Friedrich (German)
Photos dated: c1875-1889
Processes:    Albumen, woodburytype
Formats:      Prints
Subjects:     Topography, genre, ethnography,
portraits
Locations:    Germany - Munich
Studio:       Germany - Munich
   Entries:
Edwards Lon 1975: 67 (book, 15)(note), 95 (book,
   21);
Wood Conn Cat 37, 1976: 25 ill(book, 12)(note);
California Galleries 1/21/78: 276 (album, B &
   Zedler, 5);
Swann NY 4/20/78: 342 (book, 18);
California Galleries 3/30/80: 255 (6);

BRUGSCH, M.E.
Photos dated: 1881
Processes:    Albumen
Formats:      Prints
Subjects:     Documentary (scientific)
Locations:    Egypt
Studio:
   Entries:
Swann NY 2/14/52: 228 (books, 40);
Sothebys Lon 6/24/83: 63 ill(book, 20);

BRUNO
Photos dated: 1880s
Processes:    Albumen
Formats:      Prints
Subjects:     Topography
Locations:    Europe
Studio:       Europe
   Entries:
Christies Lon 3/29/84: 56 (albums, B et al);
Swann NY 11/13/86: 356 (lot, B et al);

BRUNSKILL
Photos dated: 1890s
Processes:    Albumen
Formats:      Prints
Subjects:     Topography
Locations:    Europe
Studio:       Europe
   Entries:
Swann NY 11/13/86: 214 (album, B et al);

BRUSA, Giovanni B.
Photos dated: 1860s
Processes:    Albumen
Formats:      Prints
Subjects:     Topography
Locations:    Italy
Studio:       Italy
   Entries:
Christies Lon 10/4/73: 163 (album, B et al);
Wood Conn Cat 37, 1976: 250 (album, B et al);
California Galleries 1/21/78: 211 (album, B et al);
Christies Lon 5/16/80: 188 (lot, B et al);
Auer Paris 5/31/80: 100 (6);

BRUTON, J.E.
Photos dated: Nineteenth century
Processes:    Albumen
Formats:      Cdvs
Subjects:     Ethnography
Locations:    South Africa
Studio:
   Entries:
Sothebys NY 5/8/79: 107 (lot, B et al);

BRYANT (American)
Photos dated: Nineteenth century
Processes:    Albumen
Formats:      Stereos
Subjects:     Topography
Locations:    US - Vermont
Studio:       US
   Entries:
Harris Baltimore 12/10/82: 106 (lot, B et al);

BRYCE, David (British)
Photos dated: 1863-1868
Processes:    Albumen
Formats:      Prints
Subjects:     Genre (domestic)
Locations:    England; Scotland
Studio:       England
   Entries:
Sothebys Lon 5/24/73: 6 (lot, B et al);
Sothebys Lon 3/9/77: 133 (album, 36);

BSCHERER, Jos (German)
Photos dated: 1860s
Processes:    Albumen
Formats:      Cdvs
Subjects:     Topography
Locations:    Germany - Bavaria
Studio:       Germany - Munich
   Entries:
Petzold Germany 11/7/81: 326 (lot, B et al);

BUCHFELD (German)
Photos dated: 1860
Processes:    Albumen
Formats:      Cdvs
Subjects:     Portraits
Locations:    Studio
Studio:       Germany - Dresden
   Entries:
Petzold Germany 11/7/81: 298 (album, B et al);

BUCHHOLZ, Herman (American)
Photos dated: c1880s
Processes:    Albumen
Formats:      Prints
Subjects:     Topography
Locations:    US - Holyoke, Massachusetts
Studio:       US
   Entries:
Harris Baltimore 3/16/82: 405;

**BUCHI** (Italian)
Photos dated: 1880s-1890s
Processes:      Albumen
Formats:        Prints
Subjects:       Topography
Locations:      Italy
Studio:         Italy
     Entries:
Phillips NY 5/9/81: 50 (album, B et al);

**BUCKLE, Samuel** (British)
Photos dated: 1851-1860s
Processes:      Calotype, albumen
Formats:        Prints
Subjects:       Topography
Locations:      England - Stratford-upon-Avon
Studio:         England - Peterborough
     Entries:
Weil Lon 1946: 37 (album, B et al);
Weil Lon Cat 10, 1947(?): 310 (album, B et al);
Sothebys Lon 7/1/77: 171 ill(book, 30)(note);
Christies Lon 10/25/79: 119 (lot, B-3 et al), 134
     (lot, B-2 et al);
Christies Lon 6/23/83: 64 (lot, B et al);
Sothebys Lon 11/1/85: 58 (book, B-1 et al);

**BUCKMAN, George Rex** (American)
Photos dated: 1893
Processes:      Photogravure
Formats:        Prints
Subjects:       Topography
Locations:      US - Colorado Springs, Colorado
Studio:         US
     Entries:
Sothebys NY 5/15/81: 51 (books, B-4 et al);

**BUCKMAN, H.**
Photos dated: c1880
Processes:      Albumen
Formats:        Prints
Subjects:       Topography
Locations:      Europe
Studio:
     Entries:
California Galleries 1/22/77: 171 (album, B et al):

**BUDE**
Photos dated: 1893
Processes:
Formats:        Cabinet cards
Subjects:       Portraits
Locations:
Studio:
     Entries:
Sothebys (Greenway Coll.) 11/20/70: 14 (lot,
     B-1 et al);

**BUDOGIONC**
Photos dated: c1898
Processes:      Albumen
Formats:        Prints
Subjects:       Documentary
Locations:      Russia - Sakhalin
Studio:
     Entries:
Harris Baltimore 12/10/82: 422 ill(176)(note);

**BUDTZ MULLER & Co.**
Photos dated: 1880s
Processes:      Albumen
Formats:        Prints
Subjects:       Topography
Locations:      Norway
Studio:         Norway; Denmark - Copenhagen
     Entries:
California Galleries 1/21/79: 499 (lot, B-1 et al);
Christies Lon 10/27/83: 84 (albums, B et al);
Christies Lon 6/26/86: 199 (lot, B-15 et al);

**BUEHMANN, H.** (American)
Photos dated: c1870-1880s
Processes:      Albumen
Formats:        Stereos
Subjects:       Topography, documentary (scientific)
Locations:      US - Arizona
Studio:         US - Tucson, Arizona
     Entries:
Frontier AC, Texas, 1978: 32 (note);
Christies Lon 3/16/78: 178 (7);
California Galleries 3/30/80: 382 (lot, B-4 et al);
Swann NY 4/17/80: 365 (lot, B-3 et al);

**BUELL, E.W.**
Photos dated: 1862
Processes:      Ambrotype
Formats:        Plates
Subjects:       Portraits
Locations:
Studio:
     Entries:
Vermont Cat 8, 1974: 525 ill;

**BUELL, O.B.** (Canadian)
Photos dated: 1870s
Processes:      Albumen
Formats:        Stereos
Subjects:       Topography
Locations:      Canada
Studio:         Canada - Montreal
     Entries:
Harris Baltimore 12/16/83: 21 (lot, B-1 et al);

**BUELL, W.A.** (American)
Photos dated: 1889
Processes:      Albumen
Formats:        Prints
Subjects:       Topography
Locations:      US - Kansas
Studio:         US
     Entries:
Rinhart NY Cat 6, 1973: 315;

**BUESCH, Fritz**
Photos dated: 1890s
Processes:      Albumen
Formats:        Prints
Subjects:       Topography
Locations:      Brazil
Studio:
     Entries:
Swann NY 5/10/84: 303 (album, B et al);

**BUFFORD, J.H.** (American)
Photos dated: 1860s
Processes:     Albumen
Formats:      Cdvs
Subjects:     Portraits
Locations:    Studio
Studio:       US - Boston, Massachusetts
   Entries:
Harris Baltimore 9/27/85: 39;

**BUGBEE, F.E.** (American)
Photos dated: 1870s
Processes:     Albumen
Formats:      Stereos
Subjects:     Topography
Locations:    US - New Hampshire
Studio:       US - Wilton, New Hampshire
   Entries:
Harris Baltimore 12/10/82: 60 (lot, B et al);
Harris Baltimore 4/8/83: 62 (lot, B et al);

**BULLOCK** (see DOLAMORE & BULLOCK) [BULLOCK 1]

**BULLOCK Brothers** (British) [BULLOCK 2]
Photos dated: 1860s
Processes:     Albumen
Formats:      Prints, cdvs
Subjects:     Portraits, topography
Locations:    England - Oxford
Studio:       England
   Entries:
Christies Lon 10/30/80: 182 (album, B-1 et al);
Christies Lon 3/26/81: 145 ill(album, B attributed
   et al);
Sothebys Lon 3/27/81: 8 (lot, B-1 et al);
Christies Lon 6/18/81: 189 (album, B-1 et al);
Christies Lon 3/11/82: 113 (album, B attributed
   et al);
Christies Lon 3/29/84: 334 (album, B et al);

**BULLOCK, Alexander** (British)
Photos dated: 1860s
Processes:     Albumen
Formats:      Prints
Subjects:     Topography
Locations:    England
Studio:       Great Britain
   Entries:
Gordon NY 5/10/77: 818 ill;

**BULLOCK, E.** (British)
Photos dated: Nineteenth century
Processes:     Albumen
Formats:      Prints
Subjects:     Topography
Locations:    England
Studio:       England - Salisbury
   Entries:
Christies Lon 6/26/80: 157 (lot, B-1 et al);

**BULLOCK, J.** (American)
Photos dated: 1870s-1880s
Processes:     Albumen
Formats:      Stereos
Subjects:     Topography, documentary (disasters)
Locations:    US - Chicago, Illinois
Studio:       US - Geneva Lake, Wisconsin
   Entries:
Sothebys NY (Strober Coll.) 2/7/70: 489 (lot,
   B-7 et al);
Sothebys NY 11/21/70: 366 ill(lot, B-7 et al);
Harris Baltimore 7/31/81: 87 (21);
Harris Baltimore 6/1/84: 163 (lot, B et al);

**BULLOCK, John J.** (American)
Photos dated: 1887
Processes:     Albumen
Formats:      Prints
Subjects:     Genre
Locations:    US - Virginia
Studio:       US - Philadelphia, Pennsylvania
   Entries:
Swann NY 12/14/78: 368 (note);

**BULLOCK, S.** (American)
Photos dated: Nineteenth century
Processes:     Albumen
Formats:      Stereos
Subjects:     Topography
Locations:    US - northeast
Studio:       US
   Entries:
Harris Baltimore 6/1/84: 148 (lot, B et al);

**BUNDY, J.K.** (American)
Photos dated: 1870s
Processes:     Albumen
Formats:
Subjects:     Portraits
Locations:    US - Middletown, Connecticut
Studio:       US - Hartford, Connecticut
   Entries:
Swann NY 11/6/80: 400 (lot, B-1 et al)(note);

**BUNKER, Reverend A.**
Photos dated: 1872-1876
Processes:     Albumen
Formats:      Stereos
Subjects:     Topography
Locations:    Burma
Studio:
   Entries:
Harris Baltimore 12/16/83: 47 (lot, B-3 et al);
Harris Baltimore 3/15/85: 17 (54)(note);

**BUNTINGTON, L. Shaw**
Photos dated: 1860s
Processes:     Ambrotype
Formats:      Plates
Subjects:     Portraits
Locations:
Studio:
   Entries:
Christies Lon 10/25/79: 47 (lot, B-1 et al);

**BURBACH, J.J.** (German)
Photos dated: c1850s
Processes:      Daguerreotype
Formats:        Plates
Subjects:       Portraits
Locations:      Studio
Studio:         Germany
    Entries:
Sothebys Lon 7/1/77: 228 (2);

**BURDICK, E.H.** (American)
Photos dated: 1870s
Processes:      Albumen
Formats:        Stereos
Subjects:       Topography
Locations:      US - Milton, Wisconsin
Studio:         US - Milton, Wisconsin
    Entries:
Rinhart NY Cat 6, 1973: 605;

**BUREAU, Ferdinand** (French)
Photos dated: c1865-c1875
Processes:      Albumen
Formats:        Prints
Subjects:       Topography
Locations:      Russia - Moscow
Studio:         Russia - Moscow
    Entries:
Auer Paris 5/31/80: 91 (album, B et al);
Sothebys Lon 10/28/81: 56 (4);

**BURGER, W.**
Photos dated: between 1860 and 1885
Processes:      Albumen
Formats:        Cdvs
Subjects:       Topography
Locations:      Austria
Studio:         Austria - Vienna
    Entries:
Petzold Germany 11/7/81: 328 (album, B et al);

**BURGESS, H.M.** (British)
Photos dated: late 1850s
Processes:
Formats:        Prints
Subjects:       Portraits
Locations:      Great Britain
Studio:         Great Britain
    Entries:
Christies Lon 3/11/82: 319 ill(album, B-1 et al);

**BURGESS, J.**
Photos dated: 1870s
Processes:      Albumen
Formats:        Prints
Subjects:       Genre
Locations:
Studio:
    Entries:
Sothebys Lon 10/24/79: 350 (5);

**BURGESS, William** (British)
Photos dated: c1894
Processes:      Albumen
Formats:        Cabinet cards
Subjects:       Topography
Locations:      England - Somerset
Studio:         England - Wiltshire; Devon
    Entries:
Edwards Lon 1975: 47 (5);
Phillips Lon 6/15/83: 112 (album, B et al);
Phillips Lon 11/4/83: 66 (album, B et al);
Phillips Lon 10/30/85: 39 (lot, B et al);

**BURGOYNE** (British)
Photos dated: 1870s-1875
Processes:
Formats:        Prints
Subjects:       Topography
Locations:      England - Birmingham
Studio:         England - Birmingham
    Entries:
Sothebys Lon 10/24/75: 145 ill(36)(note);

**BURGSTROM, Y.W.** (Swedish)
Photos dated: 1850s
Processes:      Daguerreotype
Formats:        Plates
Subjects:       Portraits
Locations:      Studio
Studio:         Sweden
    Entries:
Sothebys Lon 3/14/79: 66;

**BURKE** (British)
Photos dated: 1850s
Processes:      Daguerreotype
Formats:        Plates
Subjects:       Portraits
Locations:      Studio
Studio:         England - London
    Entries:
Christies Lon 6/28/79: 14;

**BURKE, John** (British)(see also BAKER, W.)
Photos dated: 1868-1879
Processes:      Albumen, carbon
Formats:        Prints, cdvs
Subjects:       Topography, documentary (military)
Locations:      Afghanistan; India - Kashmir
Studio:
    Entries:
Sothebys Lon 6/26/75: 130 (album, B-6, B & Baker-2,
    et al);
Sothebys Lon 6/11/76: 366 (album, B-5, B & Baker-6,
    et al);
Christies Lon 3/10/77: 141 (album)(attributed)
    (note);
Christies Lon 10/27/77: 144 (album, B-6, B &
    Baker-2, et al), 178 (album, B-4 et al);
Wood Conn Cat 42, 1978: 562 (album, B-7 et al)
    (note);
Sothebys Lon 6/28/78: 116 (albums, B & Baker et al);
Christies Lon 10/26/78: 172 (lot, B-1 et al);
Sothebys Lon 10/27/78: 127 ill(lot, B et al);
Christies Lon 6/28/79: 109 (lot, B et al), 110
    (lot, B-5 et al);

## BURKE, J. (continued)

Christies Lon 10/25/79: 194 ill(album, B et al), 243
    (albums, B-3 et al);
Sothebys NY 11/1/79: 251 ill(4)(note), 252 (5);
Christies Lon 3/20/80: 201 (lot, B-1 et al);
Christies NY 5/16/80: 123;
Phillips NY 5/21/80: 244 (8);
Sothebys Lon 10/29/80: 281 (19);
Christies Lon 10/30/80: 265 (lot, B et al);
Koch Cal 1981-82: 18 ill(note), 19 ill;
Sothebys LA 2/4/81: 100 Ill(4);
Christies Lon 3/26/81: 229 (album, B-5 et al), 242
    (album, B-3 et al);
Sothebys Lon 3/27/81: 92 (album, B, B & Baker,
    et al), 93 (album, 35)(attributed);
Sothebys Lon 6/17/81: 175 ill(album, 100);
Swann NY 7/9/81: 47 (book, 24)(note);
Christies Lon 10/29/81: 233 (album, 50)
    (attributed), 238 (album, B-33, B & Baker-6,
    et al), 263 (albums, B & Baker-1, et al), 166
    (album, B-6 attributed et al);
Sothebys Lon 3/15/82: 417 ill(album, 100);
Christies Lon 6/24/82: 200 (lot, B & Baker-2,
    et al), 225 (album, B & Baker-1, et al);
Sothebys Lon 10/29/82: 49 (album, B et al);
Harris Baltimore 12/10/82: 395 (album, B et al);
Christies NY 2/8/83: 30;
Christies Lon 6/23/83: 137 (lot, B attributed et
    al), 138 (3)(attributed);
Sothebys Lon 12/9/83: 37 (album, B et al);
Christies Lon 3/29/84: 70 (B & Baker, 3)
    (attributed);
Christies Lon 6/28/84: 92 ill(album, B-9 et al), 93
    (lot, B, B & Baker, et al);
Wood Boston Cat 58, 1986: 263 (book, B et al);
Christies Lon 4/24/86: 406 (album, B-7, B & Baker-2,
    et al), 410 (lot, B-2 et al);
Christies Lon 6/26/86: 115 (albums, B et al);
Harris Baltimore 11/7/86: 272 (album, B-10, B &
    Baker-9, et al);
Swann NY 11/13/86: 241 (6, attributed);

## BURMESTER, E.
Photos dated: 1860s
Processes:    Albumen
Formats:      Stereos
Subjects:     Topography
Locations:    South Africa
Studio:       South Africa
    Entries:
Christies Lon 6/28/84: 37a (lot, B et al);

## BURNHAM
Photos dated: c1848
Processes:    Daguerreotype
Formats:      Plates
Subjects:     Portraits
Locations:
Studio:
    Entries:
California Galleries 9/26/75: 27;

## BURNHAM, S.W. (American)
Photos dated: 1889
Processes:    Albumen
Formats:      Prints
Subjects:     Documentary (scientific)
Locations:    US - California
Studio:       US
    Entries:
Sothebys LA 2/7/79: 421 (book, B-1 et al)(note);

## BURNHAM, T.R. (American)
Photos dated: 1868-1870s
Processes:    Albumen
Formats:      Prints, stereos, cdvs
Subjects:     Portraits, topography
Locations:    US - Massachusetts; Vermont
Studio:       US - Boston, Massachusetts
    Entries:
Sothebys NY (Strober Coll.) 2/7/70: 263 (lot,
    B et al);
Phillips NY 11/3/79: 191 (note);
Harris Baltimore 12/10/82: 106 (lot, B et al);
Wood Boston Cat 58, 1986: 136 (books, B-1 et al);

## BURNS (see COUCH & BURNS) [BURNS 1]

## BURNS (American) [BURNS 2]
Photos dated: 1850s
Processes:    Daguerreotype
Formats:      Plates
Subjects:     Portraits
Locations:    Studio
Studio:       US - New York City
    Entries:
Rinhart NY Cat 2, 1971: 196 (lot, B-1 et al);

## BURNS, Archibald (British)
Photos dated: 1850s-1870s
Processes:    Salt, albumen
Formats:      Prints, stereos, cdvs
Subjects:     Topography
Locations:    Scotland - Edinburgh
Studio:       Scotland - Edinburgh
    Entries:
Christies Lon 10/4/73: 99 (books, B et al);
Sothebys Lon 3/21/75: 308 ill(book, 15);
Sothebys Lon 6/26/75: 89 ill(album, B et al)(note),
    90 (book, 15);
Sothebys Lon 10/24/75: 84 (lot, B-1 et al);
Sothebys Lon 10/29/76: 26 (lot, B et al);
Sothebys Lon 3/9/77: 47 (album, 12);
Christies Lon 6/30/77: 199 (book, 15);
Sothebys Lon 11/18/77: 12 (lot, B et al);
Swann NY 12/8/77: 364 (album, 12)(attributed);
Wood Conn Cat 42, 1978: 86 (book, 15)(note);
Christies Lon 10/30/80: 115 (lot, B-22 et al), 121
    (lot, B et al);
Christies Lon 3/26/81: 129 (lot, B-2 et al), 155
    (attributed);
Sothebys Lon 3/27/81: 239 (book, 15);
Sothebys NY 5/15/81: 82 ill(album, B-26 et al);
Sothebys Lon 6/17/81: 446 (book, 15);
Christies Lon 6/18/81: 120 (lot, B-22 et al);
Christies Lon 10/29/81: 192 (lot, B et al);
Christies Lon 3/11/82: 88 (lot, B et al);
Christies Lon 6/24/82: 71 (lot, B et al);
Christies Lon 3/29/84: 322 (album, B-1 et al);

BURNS, A. (continued)
Swann NY 5/10/84: 121 (book, 8);
Christies Lon 6/28/84: 37a (lot, B et al), 46 (lot,
    B-2 et al);
Phillips Lon 10/24/84: 120 (lot, B et al);
Christies Lon 10/25/84: 36 (lot, B-2 et al), 116
    (books, B-15 et al), 120 (books, B-14 et al);
Christies Lon 3/28/85: 169 ill(album, B et al);
Swann NY 5/9/85: 191 (book, 15);
California Galleries 6/8/85: 413 (lot, B-8 et al);
Christies Lon 6/27/85: 45 (lot, B et al);
Christies Lon 6/26/86: 2 (lot, B et al);
Phillips Lon 10/29/86: 236 (lot, B-10 et al);
Christies Lon 10/30/86: 33 (lot, B et al);

BURR, Michael (British)
Photos dated: 1850s-c1860
Processes:     Albumen
Formats:       Stereos
Subjects:      Genre
Locations:     Studio
Studio:        England
    Entries:
Sothebys Lon 6/29/84: 11 (lot, B et al), 17 (3);
Sothebys Lon 10/26/84: 6 (lot, B et al);
Christies Lon 4/24/86: 364 (38);

BURRITT, Elihu (photographer or author?)
Photos dated: 1864
Processes:     Albumen
Formats:       Prints
Subjects:      Topography
Locations:     England
Studio:        Great Britain
    Entries:
Christies Lon 3/16/78: 227 (book, B-5 et al);

BURRITT, J.C. (American)
Photos dated: 1869-1870s
Processes:     Albumen
Formats:       Stereos
Subjects:      Topography
Locations:     US - Ithaca, New York
Studio:        US - Ithaca, New York
    Entries:
Swann NY 2/14/52: 247 (book, 10);
Swann NY 11/6/80: 59 (book, 10)(note);
Harris Baltimore 5/28/82: 148 (lot, B-1 et al);

BURROUGH (American)
Photos dated: 1860s
Processes:     Tintypes
Formats:       Plates
Subjects:      Portraits
Locations:     Studio
Studio:        US - New York City
    Entries:
Rinhart NY Cat 2, 1971: 266 (lot, B et al);

BURROW, W. Thomas (British)
Photos dated: 1893
Processes:
Formats:       Prints
Subjects:      Documentary (industrial)
Locations:     Cornwall
Studio:        Great Britain
    Entries:
Edwards Lon 1975: 70 (book, 26)(note);

BURROWS, Frederic (British)
Photos dated: 1850s-c1860
Processes:     Ambrotype, salt, cyanotype, carbon
Formats:       Plates, prints
Subjects:      Portraits
Locations:     Great Britain
Studio:        Great Britain
Sothebys Lon 3/21/80: 269 (lot, B-1 et al);
Phillips Lon 4/23/86: 315 (lot);

BURROWS, Robert (British)
Photos dated: 1850s-1861
Processes:     Albumen
Formats:       Prints
Subjects:      Topography, genre (still life)
Locations:     England
Studio:        England - Ipswich
    Entries:
Sothebys Lon 10/29/80: 293 ill(note), 294 (6);
Sothebys Lon 3/27/81: 360 ill, 361, 362 ill, 363
    ill, 364, 364a, 365;
Sothebys Lon 6/17/81: 328 (2);
Sothebys Lon 10/28/81: 351, 352 ill, 353, 354 ill,
    355 ill, 355a, 356 (14);
Sothebys Lon 3/15/82: 352 ill, 353 ill;
Sothebys Lon 6/25/82: 182 ill, 183 ill(3);
Sothebys Lon 10/29/82: 147 (lot, B-3 et al);
Christies Lon 6/23/83: 81 ill, 82 (3);
Christies Lon 3/28/85: 138;
Sothebys Lon 11/1/85: 60 ill;

BURROWS, S.W. (American)
Photos dated: Nineteenth century
Processes:     Albumen
Formats:       Cdvs
Subjects:      Portraits
Locations:     Studio
Studio:        US - Brooklyn, New York
    Entries:
Sothebys NY (Strober Coll.) 2/7/70: 264 (lot,
    B et al);

BURTON Brothers (Alfred Henry, 1834-1914, Walter
                  John, 1836-1880)
Photos dated: 1868-1898
Processes:     Albumen
Formats:       Prints
Subjects:      Topography, ethnography, documentary
               (scientific)
Locations:     Australia; Tasmania; New Zealand;
               Samoa; Borneo; Java
Studio:        New Zealand - Dunedin
    Entries:
Sothebys Lon 6/21/74: 94 (album, B et al);
Sothebys Lon 3/21/75: 78 (album, B et al), 85
    (albums, B et al);

## BURTON Brothers (continued)
Sothebys Lon 10/24/75: 102 (album, B et al);
California Galleries 4/3/76: 285 (lot, B-1 et al);
Sothebys Lon 6/11/76: 36a (album, B et al), 50
   (album, B et al);
Christies Lon 10/28/76: 179 (album, B et al);
Swann NY 11/11/76: 366 (albums, B et al);
Christies Lon 3/10/77: 144 (album, B et al);
Sothebys Lon 11/18/77: 94 (album, B et al);
California Galleries 1/22/78: 430 (book);
Sothebys Lon 3/22/78: 94 (albums, B et al), 96
   (album, B et al);
Sothebys Lon 3/14/79: 104 (albums, B et al);
Christies Lon 3/15/79: 157 (albums, B et al), 193
   (album, B-20 et al);
Swann NY 10/18/79: 386 (album, B et al);
Christies Lon 10/30/80: 269 (albums, B et al);
Phillips NY 5/9/81: 69 (album, B, Muir & Moodie-26,
   et al);
Christies Lon 3/11/82: 236 ill(album, B-19 et al);
Sothebys Lon 3/15/82: 145 ill(album, B et al);
Christies Lon 10/28/82: 118 (album, B et al), 121
   (albums, B et al);
Christies Lon 3/24/83: 136 (album, B et al);
Sothebys Lon 3/25/83: 34 (album, B et al);
Christies Lon 6/23/83: 180 (albums, B et al);
Christies Lon 10/27/83: 158 (album, B et al);
Christies Lon 3/29/84: 100 (albums, B et al), 103
   (albums, B et al);
Swann NY 5/10/84: 295 (lot, B-4 et al);
Christies Lon 3/28/85: 78 (album, 13)(note), 95
   (album, B et al);
Christies Lon 6/26/86: 138 (album, B et al);
Swann NY 11/13/86: 140 (lot, B et al);

## BURTON, Charles
Photos dated: 1871
Processes: Artotype
Formats:
Subjects: Documentary (scientific)
Locations:
Studio:
  Entries:
Christies NY 11/8/82: 193 (lot, R-1 attributed
  et al);

## BURTON, J. Davis (British)
Photos dated: 1860s-1870s
Processes: Albumen
Formats: Prints, stereos
Subjects: Architecture, topography
Locations: England - London
Studio: England - London
  Entries:
Rinhart NY Cat 2, 1971: 465 (lot, B-1 et al);
Harris Baltimore 4/8/83: 52 (lot, B et al);
Harris Baltimore 6/1/84: 64 (lot, B-2 et al);
Christies Lon 10/25/84: 94 (lot, B-70 et al)(note);

## BURTON, John & Sons
Photos dated: 1860s
Processes: Albumen
Formats: Cdvs
Subjects: Portraits
Locations:
Studio:
  Entries:
Christies Lon 10/30/80: 422 (album, B et al);

## BURTON, W.K. (British)
Photos dated: 1886
Processes: Albumen
Formats: Prints
Subjects: Topography
Locations: England; Japan
Studio:
  Entries:
Swann NY 4/23/81: 111 ill(book, B et al);
Swann NY 4/1/82: 167 ill(book, B et al);
Swann NY 11/18/82: 186 (book, B et al);
Christies Lon 10/27/83: 62 (album, B et al);
Swann NY 5/10/84: 104 (book, B et al);

## BUSH, Miss (British)
Photos dated: 1850s
Processes: Salt
Formats: Prints
Subjects:
Locations: Great Britain
Studio: Great Britain
  Entries:
Sothebys Lon 7/1/77: 184 (album)(note);

## BUSH, W.L.
Photos dated: c1885
Processes: Albumen
Formats: Cabinet cards
Subjects: Portraits
Locations:
Studio:
  Entries:
California Galleries 12/13/80: 207 (lot, B et al);
California Galleries 6/28/81: 192 (lot, B et al);

## BUSHBY & HART (American)
Photos dated: 1870s
Processes: Albumen
Formats: Stereos
Subjects: Topography
Locations: US - Massachusetts
Studio: US - Lynn, Massachusetts
  Entries:
Harris Baltimore 12/10/82: 87 (lot, B & H-2, et al);

## BUSHEY, H.V. Lamenagen
Photos dated: 1871
Processes: Albumen
Formats: Prints
Subjects: Topography
Locations: Great Britain
Studio: Great Britain
  Entries:
Christies Lon 3/26/81: 289 (lot, B-7 et al);

BUSHNELL (see MURRAY & BUSHNELL)

**BUSTAMENTE, F.** (Mexican)
Photos dated: c1880
Processes:    Albumen
Formats:     Prints
Subjects:    Portraits
Locations:   Mexico - Puebla
Studio:      Mexico
   Entries:
Harris Baltimore 3/15/85: 262;

**BUTAEV, D.** (Russian)
Photos dated: 1880s-1890s
Processes:    Albumen
Formats:     Prints
Subjects:    Topography
Locations:   Russia
Studio:      Russia
   Entries:
Swann NY 11/18/82: 441 (lot, B-2 et al)(note);

**BUTLER** (see STANTON & BUTLER) [BUTLER 1]

**BUTLER, BONSALL & Co.** (American) [BUTLER 2]
Photos dated: early 1860s
Processes:    Albumen
Formats:     Prints
Subjects:    Documentary (Civil War)
Locations:   US - Civil War area
Studio:      US
   Entries:
Sothebys NY (Strober Coll.) 2/7/70: 418 (lot,
   BB et al);

**BUTLER, Preston** (American)
Photos dated: 1860
Processes:    Ambrotype
Formats:     Plates
Subjects:    Portraits
Locations:   US
Studio:      US
   Entries:
Sothebys NY 5/15/81: 111 ill(note);

**BUTLER, William H.** (American)
Photos dated: 1892
Processes:
Formats:     Prints
Subjects:    Documentary (industrial)
Locations:   US - Schenectady, New York
Studio:      US
   Entries:
Ricketts Lon 1974: 252 ill(24);
Sothebys NY 2/25/75: 70 (books, B-24 et al);
California Galleries 1/22/77: 166 (book, 125);

**BUTTER, H.** (British)
Photos dated: 1870s
Processes:    Albumen
Formats:     Prints
Subjects:    Documentary (military)
Locations:
Studio:      Great Britain
   Entries:
Christies Lon 6/28/84: 303 (lot, B-1 et al);

**BUTTERFIELD** (see McCULLUM & BUTTERFIELD)
   [BUTTERFIELD 1]

**BUTTERFIELD** (American) [BUTTERFIELD 2]
Photos dated: Nineteenth century
Processes:    Albumen
Formats:     Prints
Subjects:    Documentary (industrial)
Locations:   US
Studio:      US
   Entries:
Wood Conn Cat 49, 1982: 79 ill(book, 16);

**BUTTERWORTH**
Photos dated: 1880s
Processes:    Albumen
Formats:     Prints
Subjects:    Topography
Locations:   Egypt
Studio:
   Entries:
Sothebys Lon 10/28/81: 106 (album, 65);

**BUTTS, G.T.** (American)
Photos dated: 1863
Processes:    Albumen
Formats:     Prints
Subjects:    Portraits
Locations:   Studio
Studio:      US - Washington, D.C.
   Entries:
Vermont Cat 1, 1971: 223;

**BYERLY & Son** (American)
Photos dated: c1870s
Processes:    Albumen
Formats:     Cabinet cards
Subjects:    Portraits
Locations:   Studio
Studio:      US - Frederick, Maryland
   Entries:
Harris Baltimore 11/7/86: 68;

**BYRNES, Thomas** (American)
Photos dated: 1886
Processes:    Albumen
Formats:     Prints
Subjects:    Documentary
Locations:   US - New York City
Studio:      US - New York City
   Entries:
Rinhart NY Cat 7, 1973: 24 (book, 36);
Witkin NY II 1974: 190 ill(book, 204);
Witkin NY III 1975: 706 (book, 204);
California Galleries 9/26/75: 122 (book, 36);
Witkin NY IV 1976: OP88 (book, 204);
California Galleries 4/2/76: 141 (book, 36);
Halsted Michigan 1977: 130 (book);
Wood Conn Cat 42, 1978: 89 (book, 204)(note);
Wood Conn Cat 45, 1979: 275 (book, 204)(note);
California Galleries 1/21/79: 48 ill(book, 204);
Swann NY 4/23/81: 44 (book, 204)(note);
Wood Conn Cat 49, 1982: 80 (book, 34)(note);
Harris Baltimore 12/10/82: 141 (book, 204)(note);
Harris Baltimore 4/8/83: 150 (book, 204)(note);
Swann NY 5/9/85: 192 (book, 35)(note);

**BYRON, Joseph** (British, American, 1846-1922)
Photos dated: 1880s-1900s
Processes:      Albumen
Formats:        Prints
Subjects:       Architecture
Locations:      England; US
Studio:         US - New York City
    Entries:
Swann NY 4/17/80: 284 (8)(attributed)(note);

**BYRON, J.N.** (American)
Photos dated: Nineteenth century
Processes:      Albumen
Formats:        Cdvs
Subjects:       Portraits
Locations:      Studio
Studio:         US - Albany, New York
    Entries:
Rose Florida Cat 7, 1982: 80 ill;

C., A. [A.C.]
Photos dated: 1870s
Processes:      Albumen
Formats:        Stereos
Subjects:       Topography
Locations:      Switzerland
Studio:         Europe
    Entries:
Rinhart NY Cat 7, 1973: 163;
Harris Baltimore 12/10/82: 42 (lot, C-15 et al);
Harris Baltimore 12/16/83: 131 (lot, C-15 et al);

C., B. [B.C.] (British)
Photos dated: 1860s
Processes:      Albumen
Formats:        Prints
Subjects:
Locations:
Studio:         Great Britain (Amateur Photographic
                Association)
    Entries:
Christies Lon 10/27/83: 218 (lot, C et al);

C., F.A. [F.A.C.]
Photos dated: 1880s
Processes:      Albumen
Formats:        Prints
Subjects:       Topography
Locations:      New Zealand
Studio:         New Zealand
    Entries:
California Galleries 9/26/75: 167 (album, C et al);
California Galleries 1/22/77: 187 (album, C et al);
Sothebys Lon 10/31/86: 11 (albums, C et al);

C., H.C. [H.C.C.](possibly CAMMIDGE, H.C., q.v.)
Photos dated: 1867
Processes:      Albumen
Formats:        Prints
Subjects:       Topography
Locations:      China
Studio:
    Entries:
Christies Lon 6/10/76: 94 (album, C et al);
Christies Lon 3/26/81: 236 ill(lot, C-3
    et al)(note);
Sothebys Lon 3/15/82: 107 (lot, C-3 et al);

C., J.C. [J.C.C.]
Photos dated: 1850s
Processes:
Formats:        Prints
Subjects:
Locations:
Studio:
    Entries:
Sothebys Lon 6/21/74: 107 (album, C et al);

C., J.W. [J.W.C.] (British)
Photos dated: 1875
Processes:      Albumen
Formats:        Prints
Subjects:       Documentary (industrial)
Locations:      England
Studio:         England
    Entries:
Wood Boston Cat 58, 1986: 240 (book, 2)(note);

C., L. [L.C.] (possibly CRETTLY, L., q.v.)
Photos dated: c1860
Processes:      Albumen
Formats:
Subjects:       Topography
Locations:
Studio:
    Entries:
Christies Lon 3/15/79: 183 (album, C et al);

C., L. de [L. de C.] (British)
Photos dated: 1860-1865
Processes:      Albumen
Formats:        Prints
Subjects:       Topography, genre (domestic)
Locations:      England
Studio:         England
    Entries:
Christies Lon 3/28/85: 326 (album, C et al);

C., L.S. [L.S.C.] (British)
Photos dated: 1860s
Processes:      Albumen
Formats:        Stereos
Subjects:       Genre
Locations:      Great Britain
Studio:         Great Britain
    Entries:
Christies Lon 10/27/83: 37 (lot, C et al);
Christies Lon 3/28/85: 32 (lot, C-5 et al);

C., N. [C.N.] (French)
Photos dated: 1870s and/or 1880s
Processes:      Albumen
Formats:        Stereos
Subjects:       Topography
Locations:      France - Paris
Studio:         France
    Entries:
Vermont Cat 5, 1973: 548 ill(7);
California Galleries 4/3/76: 448 (lot, C et al);
California Galleries 1/21/78: 188 (lot, C et al);
Christies Lon 3/24/83: 44 (lot, C et al);
Harris Baltimore 4/8/83: 84 (18);
Harris Baltimore 12/16/83: 49 (lot, C-10 et al);
Harris Baltimore 2/14/86: 19 (lot, C et al);

C., R. & A. [R. & A.C.]
Photos dated: Nineteenth century
Processes:
Formats:        Prints
Subjects:       Topography and/or portraits
Locations:      England - Leeds
Studio:
    Entries:
Christies Lon 10/30/86: 245 (album, C-6 et al);

C., S.W. [S.W.C.]
Photos dated: 1867
Processes:    Albumen
Formats:      Prints
Subjects:     Topography
Locations:    Java
Studio:
   Entries:
Swann NY 5/10/84: 72 (book, 73)(note);

CABIBEL (French)
Photos dated: between 1850s and 1870s
Processes:    Collotype
Formats:      Prints
Subjects:     Documentary (engineering)
Locations:    France - Perpignan
Studio:       France - Perpignan
   Entries:
Sothebys LA 2/13/78: 121 (books, C et al)(note);

CADE, Robert (British)
Photos dated: c1855-c1860
Processes:    Ambrotype, albumen
Formats:      Plates, prints
Subjects:     Portraits, topography
Locations:    England - Ely and Cambridge
Studio:       England - Ipswich
   Entries:
Weil Lon Cat 1, 1943: 142 (lot, C-2 et al);
Goldschmidt Lon Cat 52, 1939: 194 (2);
Christies Lon 3/10/77: 28 (2);
Christies Lon 6/30/77: 64 (lot, C-1 et al);
Christies Lon 3/29/84: 174;

CAIRE, Nicholas John (British, 1837-1918)
Photos dated: 1870s and/or 1880s
Processes:    Albumen
Formats:      Prints
Subjects:     Topography, ethnography
Locations:    Australia - Melbourne and Victoria
Studio:       Australia - Victoria
   Entries:
Sothebys Lon 11/18/77: 95 ill(60);
Christies Lon 10/30/86: 175 (album, C et al), 177
   (album, C et al);

CAITHNESS, Earl of (and Mr. Bembridge of Windsor)
             (British)
Photos dated: 1864
Processes:    Albumen
Formats:      Prints
Subjects:     Topography
Locations:    England - Windsor
Studio:       Great Britain (Amateur Photographic
              Association)
   Entries:
Christies Lon 6/30/77: 195 (book, 20);
Christies Lon 3/16/78: 203 (book, 20)(note);
Wood Conn Cat 45, 1979: 172 (book, 20)(note);
Sothebys Lon 10/29/80: 310 (album, C et al);
Christies Lon 10/27/83: 218 (albums, C-1 et al);
Swann NY 11/10/83: 109 (book, 20)(note);
Sothebys Lon 6/29/84: 195 ill(book, 20);
Sothebys Lon 10/26/84: 107 ill(book, 20);
Sothebys Lon 3/29/85: 160 ill(book, 20);
Swann NY 11/14/85: 70 (9);
Swann NY 11/13/86: 157 (C & Bembridge, 3);

CALAVAS, A. (French)
Photos dated: 1860s
Processes:    Albumen
Formats:      Prints
Subjects:     Genre (nudes, still life)
Locations:    Studio
Studio:       France - Paris
   Entries:
Sothebys LA 2/13/78: 109 (2)(note), 110 (4);
Sothebys NY 5/2/78: 96 (3), 97 ill(album, 22);
Swann NY 12/14/78: 369 (23)(note);
California Galleries 1/21/79: 408 ill(3);
Phillips NY 5/5/79: 158;
Christies Lon 10/25/79: 410 ill(album, 22);
California Galleries 3/30/80: 258 ill(3), 259 (2),
   260 (2);
Swann NY 4/20/80: 271 (4)(note), 272 (8)(note), 273
   (album, 13)(note);
Phillips NY 5/21/80: 201 (2), 202 (3);
Auer Paris 5/31/80: 53 ill, 54, 55;
Christies NY 11/11/80: 61 ill(album, C et al);
California Galleries 12/13/80: 215 (3);
Harris Baltimore 3/26/82: 261;
California Galleries 5/23/82: 236 ill(3);
Christies Lon 6/24/82: 390 (lot, C-3 et al);
Swann NY 5/5/83: 381 (albums, C-32 et al)(note);
Sothebys NY 11/9/83: 263 (4)(note), 264 ill(2)
   (note);
California Galleries 7/1/84: 329 (2), 330 (2);
Swann NY 11/8/84: 235 (album, 22);
California Galleries 6/8/85: 185 (attributed);

CALDERONI & TARSA
Photos dated: 1880s-1890s
Processes:    Albumen, photochromes
Formats:      Prints
Subjects:     Topography
Locations:    Hungary - Budapest
Studio:       Hungary
   Entries:
Swann NY: 12/8/77: 411 (lot, C & T-8 et al);

CALDESI (Italian)
Photos dated: 1857-1890s
Processes:    Albumen
Format:       Prints, cdvs
Subjects:     Portraits, genre, documentary (art)
Locations:    England - Manchester
Studio:       Great Britain
   Entries:
Weil Lon Cat 7, 1945: 103 (book, 50)(note);
Weil Lon Cat 14, 1949(?): 339 (book, 50)(note);
Swann NY 2/14/52: 225 (books, C & Montecchi, 200),
   265 (book, 95)(note);
Weil Lon Cat 31, 1963: 183 (book, 50)(note);
Sothebys Lon 10/18/74: 257 (books, C-40 et al);
Edwards Lon 1975: 71 (book, C & Montecchi, 200), 131
   (book, C & Montecchi, 8);
Colnaghi Lon 1976: 198 (book, C & Montecchi, 100)
   (note);
Sothebys Lon 10/29/76: 48 (book, C & Montecchi
   et al);
Sothebys Lon 3/9/77: 181 (lot, C-1 et al);
Sothebys Lon 10/24/79: 319 (lot, C et al);
Christies Lon 10/25/79: 112 (book, C & Montecchi,
   100);
Sothebys Lon 10/29/80: 262 (album, C et al);
Christies Lon 10/30/80: 439 (album, C-1 et al);
Sothebys Lon 3/27/81: 387 (C & Montecchi, 43);

CALDELSI (continued)
Sothebys Lon 3/15/82: 199 (C & Montecchi);
Christies Lon 10/28/82: 54 (lot, C et al);
Christies Lon 3/24/83: 237 (lot, C et al)(note);
Phillips Lon 11/4/83: 145 (album, C-8 plus 2
    attributed, et al)(note);
Christies Lon 3/28/85: 170 (albums, C-1 et al);
Phillips Lon 6/26/85: 162 (album, C et al), 201
    (lot, C et al);
Phillips Lon 10/30/85: 32 (lot, C-4 et al), 57
    (lot, C et al);
Christies Lon 10/31/85: 302 (album, C et al), 303
    (lot, C-1 et al);
Phillips Lon 4/23/86: 226 (album, C-3 et al), 239
    (lot, C et al);
Christies Lon 6/26/86: 158 (lot, C-1 et al);
Phillips Lon 10/29/86: 310 (lot, C-1 et al);
Christies Lon 10/30/86: 252 (album, C et al);
Swann NY 11/13/86: 169 (albums, C, Blandford & Co.,
    et al);

CALFEE, H.B. (American)
Photos dated: 1883-mid 1880s
Processes:      Albumen
Formats:        Prints, stereos
Subjects:       Topography
Locations:      US - Yellowstone Park, Wyoming
Studio:         US - Bozeman, Montana
    Entries:
Sothebys Lon 10/18/74: 133 ill(album, C-5 et al);
Christies Lon 10/28/82: 34 (lot, C-10 et al);
Harris Baltimore 12/10/82: 109 (lot, C et al);

CALLENE
Photos dated: 1850s
Processes:      Ambrotype
Formats:        Plates
Subjects:       Portraits
Locations:
Studio:
    Entries:
Christies Lon 6/28/84: 4 (lot, C-2 et al);

CALLISTER (see KEIG & CALLISTER)

CALM, J.F.
Photos dated: 1880s
Processes:      Albumen
Formats:        Prints
Subject:        Topography
Locations:      Panama
Studio:         Panama - Colon
    Entries:
Christies Lon 6/23/83: 162 (album, C et al);
Swann NY 11/13/86: 294 (lot, C-1 et al);

CALZOLARI, Icilio (Italian)
Photos dated: 1867-1880s
Processes:      Albumen
Formats:        Prints
Subjects:       Topography
Locations:      Italy - Milan
Studio:         Italy - Milan
    Entries:
Petzold Germany 11/7/81: 309 (album, C et al);
Christies NY 5/16/84: 185 (lot, C et al);

CAM (French)(photographer or publisher?)
Photos dated: 1860s
Processes:      Glass diapositives
Formats:        Stereo plates
Subjects:       Topography
Locations:      France
Studio:         France - Paris
    Entries:
Christies Lon 10/26/78: 85 (lot, C et al);
Phillips Lon 10/29/86: 236 (lot, C-29 et al);

CAMBERLEY, G.R.
Photos dated: between 1870s and 1890s
Processes:      Albumen
Formats:        Prints
Subjects:       Topography
Locations:      Singapore
Studio:
    Entries:
Sothebys Lon 3/15/82: 106 (albums, C-22 et al);

CAMERON, Henry Herschel Hay (British)
Photos dated: 1870-1905
Processes:      Albumen, platinum, silver
Formats:        Prints
Subjects:       Portraits
Locations:      Great Britain
Studio:         Great Britain
    Entries:
Colnaghi Lon 1976: 196 ill(note);
Kingston Boston 1976: 39 ill(note);
Gordon NY 5/3/76: 338 ill(note);
Christies Lon 10/27/77: 389;
Christies Lon 6/27/78: 248 ill(note);
Phillips Lon 3/13/79: 122 (attributed)(note);
Christies Lon 3/20/80: 386 (lot, C-4 et al);
Christies NY 11/11/80: 36 ill(attributed);
Christies Lon 3/29/84: 215 ill(note);
Christies Lon 10/25/84: 129 (book, C et al), 217 ill
    (note);
Christies Lon 10/31/85: 291 (lot, C-3 et al);
Swann NY 11/13/86: 158;

CAMERON, Julia Margaret (British, 1815-1879)
Photos dated: 1863-c1875
Processes:      Albumen
Formats:        Prints, cdvs
Subjects:       Portraits, genre
Locations:      England; Ceylon
Studio:         England - Isle of Wight; Ceylon
    Entries:
Goldschmidt Lon Cat 52, 1939: 191 (20)(note);
Weil Lon Cat 4, 1944(?): 189 (12)(note), 190 ill;
Weil Lon 1946: 39 (13)(note), 40 (13);
Weil Lon Cat 10, 1947(?): 310 (13)(note);
Weil Lon Cat 14, 1949(?): 318 (6)(note), 320, 321
    (note), 322, 323 (13)(note);
Swann NY 2/14/52: 66 (4)(note), 67 (book, 12)(note);
Weil Lon Cat 21, 1953: 182 (note);
Weil Lon Cat 27, 1959: 248 ill(note), 249 (note);
Rauch Geneva 6/13/61: 150 ill(note);
Weil Lon Cat 31, 1963: 190 ill(note);
Sothebys NY (Weissberg Coll.) 5/16/67: 60 (book,
    13), 62 ill(note), 63, 64, 65, 66 (note), 67
    (note);
Sothebys NY 11/21/70: 88 ill, 89 ill(note), 90 ill
    (note), 91 ill, 92 ill(note);

<u>CAMERON</u> (continued)

Sothebys Lon 12/21/71: 274, 275, 276, 277, 278
(note), 279 (note), 280 (note), 281 (note), 282
ill, 283, 284, 285 ill 286, 287 ill, 288
(note), 289, 290, 291, 292 (note), 293, 294,
295, 296, 297, 298, 299 ill(note), 300 ill, 301,
302 ill, 303, 304 ill(book, 22)(note), 305
(book, 13);
Christies Lon 7/13/72: 55 (book, 50), 56, 57, 58
(4), 59, 60, 61, 62 (5), 63 (3), 64 (2), 65 ill,
66, 67 ill, 68, 69 ill;
Frumkin Chicago 1973: 31 ill, 32, 33 ill, 34 ill,
35 ill, 36, 37;
Lunn DC Cat 3, 1973: 32 ill(album, C et al);
Rinhart NY Cat 6, 1973: 286, 287 (3);
Witkin NY I 1973: 289 ill, 399 ill;
Sothebys Lon 5/24/73: 180, 181, 182, 183, 184 ill,
185 ill, 186 (note), 187 ill, 188 ill;
Christies Lon 6/14/73: 221 ill, 222, 223 (album,
12), 224, 225, 226, 227, 228 (3), 229 (3),
229A (5);
Christies Lon 10/4/73: 178, 179 ill;
Sothebys Lon 12/4/73: 37 ill, 38 ill, 39, 40, 41
(note), 42, 43 (2), 44 ill, 45 ill, 46 ill, 47
ill, 48 ill, 49 ill, 50 ill, 51 ill, 52 ill, 53
ill, 54 ill, 55 ill, 56 ill, 57 ill, 58 ill, 59
ill, 60 ill, 61 ill, 62 ill (note), 63 ill
(note), 64 ill, 65 ill, 66 ill, 67 ill, 68 ill
(book, 12), 69 ill(note), 70, 71 (2), 72 ill;
Ricketts Lon 1974: 29, 30, 31 ill, 32 ill, 33 ill,
34 ill, 35 ill, 36 ill, 37 ill, 38 ill, 39 ill,
40 ill, 41 ill, 42 ill, 43 ill, 44 ill, 45 ill,
46 ill, 47 ill;
Witkin NY II 1974: 781 ill;
Sothebys Lon 3/8/74: 88, 89, 90 ill, 91 ill, 92
ill, 93 ill, 94 ill, 95 ill, 96, 96a, 96b, 97
ill, 98 ill, 99 ill(note), 100 ill, 101 ill, 102
ill, 103 ill, 104 ill, 105 ill, 106 ill, 107
ill, 108 ill, 109 ill, 110 ill, 111 ill, 112
ill, 113 ill, 114 ill, 115 ill, 116 ill, 117
ill, 118 ill, 119 ill, 120 ill, 121 ill, 123
ill, 124 ill, 125 ill, 126 ill, 127 ill;
Sothebys Lon 6/21/74: 27 (22 ills)(album, C-58 et
al)(note), 28 ill(4), 29 ill, 30 ill, 31 ill, 32
ill, 33 ill, 34 ill, 35 ill, 36 ill, 37 ill, 38
ill(note), 39 ill, 40 ill, 41 ill, 42 ill, 43
ill, 44 ill, 45 ill, 46 ill, 47 ill, 48 ill, 49
ill, 50 ill, 51 ill, 52 ill, 53 ill, 54 ill, 55
ill, 56 ill, 57 ill, 58 ill;
Christies Lon 7/25/74: 394 ill, 395 ill, 396, 397,
398 ill, 399 ill, 400 ill(note), 401;
Sothebys Lon 10/18/74: 34 (94 ills)(album, 94)
(note), 35 (2), 36 ill, 37 ill, 38 ill, 39 ill,
40 ill, 41 ill, 42 ill, 43 ill, 44 ill, 45 ill,
46 ill, 47 ill, 48 ill, 49 ill, 50 ill(note), 51
ill, 52 ill, 53 ill, 54 ill, 55 ill, 56 ill, 57
ill, 58 ill, 59 ill, 60 ill(note), 61 ill, 62
ill, 63 ill, 296 (album, C-2 et al);
Witkin NY III 1975: 41 ill(note), 42 ill, 1180
(3 ills)(3), 1181 ill;
Sothebys NY 2/25/75: 78 ill(note), 79 ill, 80 ill,
81 ill(note), 82 ill, 83 ill, 84 ill, 85 ill
(note), 86 ill(note), 87 ill(note), 88 ill, 89
ill(note), 90 ill, 91 ill(note), 92 ill, 93 ill
(4), 95 ill(4), 96, 97 (2), 98, 128 (lot, C-1
et al);
Sothebys Lon 3/21/75: 287 ill(album, C-2 plus 1
attributed), 321 ill(book, 12), 322, 323 ill,
324, 325 ill, 326, 327 ill, 328 ill, 329 ill,
330 ill, 331 ill, 332 ill, 333 ill(note), 334
ill, 335 ill, 336 ill(note), 337 ill, 338 ill

<u>CAMERON</u> (continued)

(note), 339 ill, 340 ill, 341 ill, 342 ill, 343
ill, 344 ill, 345 ill, 346 ill, 347 ill;
Sothebys Lon 6/26/75: 45 (111 ills)(album, 111)
(note), 49 ill(book, 13), 50 (2 ills)(book, 13),
51 ill, 52 ill(album, C-8 et al), 53 ill, 54
ill, 55 ill, 56 (note), 57 ill, 58, 59 ill, 60
ill, 61 ill, 62 ill, 63 ill, 64 ill, 65 ill
(note), 66 ill, 67 ill, 68 ill, 69 ill, 70 ill,
71 ill, 72, 73 ill, 74 ill, 75, 76 ill(note), 77
ill, 78 (2), 79 (2), 80 (2), 81 (2), 82 (2), 83
(2), 84 (3), 85 (4), 86 (5), 87 (4), 88 (5);
Sothebys NY 9/23/75: 35 ill(note), 36 (lot, C-1 et
al)(note), 37, 38, 39 ill, 40 ill, 41 ill, 42,
43 (2), 44 ill, 45 ill, 46, 47 ill, 48 ill
(note), 49, 50 ill(note), 51 ill, 52, 53 ill
(note), 54 ill(note), 55 ill, 56, 57 (2);
Sothebys Lon 10/24/75: 207 (2), 208, 209 ill(note),
210 ill, 211 ill, 212 ill, 213 ill, 214 ill, 215
ill, 216 ill, 217 ill, 218 ill, 219 ill, 220
ill, 221 ill, 222, 223 ill, 224 ill, 225 ill,
226 ill, 227, 228, 229 ill, 230 ill, 231 ill,
232 ill, 233 ill;
Anderson & Hershkowitz Lon 1976: 38 ill, 39 ill, 40
ill, 41 ill;
Colnaghi Lon 1976: 163 (note), 164 (note), 165
(note), 166 ill, 167 (note), 168 ill(note), 169,
170, 171 ill, 172 ill, 173 (note), 174 ill, 175
(note), 176 ill(note), 177, 178 ill, 179, 180 ill
(note), 181, 182, 183, 184 ill, 185 ill(note),
186 (note), 187, 188, 189, 190 ill, 191 (note),
192 (note), 193, 194, 195 (6 ills)(books,
26)(note);
Lehr NY Vol 1:3, 1976: 22 ill;
Lunn DC Cat 6, 1976: 37.1 ill(note), 37.2 ill, 37.3,
37.4, 37.5, 37.6, 37.7 ill, 38 ill, 39 ill;
Witkin NY IV 1976: 58 ill, 59 ill, 60 ill, 61 ill,
62 ill, 63 ill, 64 ill, 65 ill;
Sothebys Lon 3/19/76: 227 ill, 228 ill(note), 229
ill, 230 (note), 231 ill(2), 232 ill(note), 233
ill, 234 ill, 235 ill, 236 ill, 237 ill, 238
ill, 239 ill(note), 240 ill(note), 241 ill, 242
ill, 243 ill(note), 244 ill(note), 245 ill(note);
Gordon NY 5/3/76: 281 ill, 282 ill, 283 ill, 284
ill, 285 ill, 286 ill, 287 ill, 288 ill;
Sothebys NY 5/4/76: 31 ill(note), 32, 33 ill, 34,
35, 36 (note), 37, 38, 39 ill, 40, 41 ill;
Christies Lon 6/10/76: 133 ill(note), 134 ill, 135
ill, 136, 137, 138;
Sothebys Lon 6/11/76: 186 (3), 186a (3), 187 ill,
188, 189 ill, 190 ill, 191 ill, 192 ill, 193
ill, 194 ill, 195 ill, 196 ill, 197 ill, 198
ill, 199 ill;
Christies Lon 10/28/76: 209 ill(note), 210 ill, 211;
Sothebys Lon 10/29/76: 268, 269, 270 ill, 271 ill,
272 ill, 273 ill(note), 274 ill, 275 ill;
Sothebys NY 11/9/76: 19 ill(note), 20, 21 (2 ills)
(book, 12)(note), 22 (note), 23 ill(note);
Swann NY 11/11/76: 429;
Gordon NY 11/13/76: 16 ill(note), 17 ill, 18 ill, 19
ill(2);
Halsted Michigan 1977: 603, 604 ill;
Rose Boston Cat 2, 1977: 14 ill(note);
White LA 1977: 20 ill(note), 21 ill, 22 ill;
Sothebys Lon 3/9/77: 231 ill, 232 ill, 233 ill, 234
ill, 235 ill, 236, 237 ill, 238 ill(note), 239
ill, 240 ill(book, 20);
Christies Lon 3/10/77: 222 ill(note), 223 ill
(note), 224 ill(note), 225 ill(note), 226 ill,
227 ill(note), 228 ill(note), 229 ill, 230 ill
(note), 231 ill(note), 232 ill, 233 ill, 234

**CAMERON** (continued)

ill, 235, 236, 237 ill, 238 ill(note), 239, 240 ill(book, 12)(note), 241 (2 ills)(book, 112) (note);

Gordon NY 5/10/77: 821 ill(note), 822 ill(note), 823 ill, 824 ill(2);

Sothebys NY 5/20/77: 39 (note), 40 ill(note), 41 (note);

Christies Lon 6/30/77: 311 ill(note), 312 ill (note), 313 ill(note), 314 ill(note), 315 ill, 316 ill(note), 317, 318 ill, 319 ill(note), 320 ill, 321 ill, 322 ill(note), 323 ill(note), 324 ill, 325 ill, 326 ill, 327 ill, 328 ill, 329 ill, 330, 331, 332;

Sothebys Lon 7/1/77: 303a, 304, 305, 306, 307, 308 ill, 309 ill, 310 ill, 311 ill, 312, 313, 314 ill, 315 ill;

Sothebys NY 10/4/77: 171 ill(note);

Christies Lon 10/27/77: 334 ill, 335 ill(note), 336 ill(note), 337 ill(note), 338 ill, 339 ill, 340 ill(note), 341 ill(note), 342 ill, 343 ill, 344 ill, 345, 346 (note), 347 (note), 348 ill, 349 ill, 350, 351, 352, 353;

Sothebys Lon 11/18/77: 261 (3), 274, 276 ill, 277 ill, 278 ill, 279 ill, 280 ill, 281 ill, 282 ill, 283 (2), 284 (2);

Swann NY 12/8/77: 265 ill(note), 266 (note);

Lehr NY Vol 1:2, 1978: 9 ill, 10 ill;

Lennert Munich Cat 2, 1978: 14, 15 ill;

Lunn DC Cat QP, 1978: 30 (note);

Weston Cal 1978: 140 ill(note), 141 ill, 142 ill, 143 ill;

Witkin NY VI 1978: 30 ill(note), 31 (4 ills)(4) (note);

Sothebys LA 2/13/78: 108 ill;

Christies Lon 3/16/78: 359 ill, 360 ill(note), 361 ill(note), 362, 363 ill(note), 364 ill(note), 365 ill(note), 366, 367 ill(note), 368 ill (note), 369 ill(note), 370 ill(note), 371 ill (note), 372 ill(note), 373 ill(note), 374 ill (album, 45)(note);

Sothebys Lon 3/22/78: 224 ill, 225 ill, 227;

Christies Lon 6/27/78: 297 ill(note), 298 ill (note), 299 (note), 300, 301 ill(note), 302 ill(note), 303 ill(note), 304 ill(note), 305 ill(note), 306 ill(note), 307 ill, 308 ill, 309 (note), 310 ill, 311 ill, 312 ill(note), 313 ill (note), 314 ill(note), 315, 316, 317 ill;

Sothebys Lon 6/28/78: 334 ill, 335, 336, 337, 338 ill, 339 ill, 341 ill, 342 ill, 343 ill(note), 344 ill, 345 ill, 346 ill, 347 ill(note), 348 ill(note), 349 ill, 350 ill, 351 ill, 351a;

Christies Lon 10/26/78: 309 (note), 310 (note), 311 ill, 312 ill(note), 313 ill(note), 314 ill (note), 315 ill(note), 316 ill, 317 ill;

Phillips NY 11/4/78: 39 ill(note), 40, 41 ill (note), 42 (note);

Swann NY 12/14/78: 370;

Lennert Munich Cat 5, 1979: 30 ill, 31;

Witkin NY VIII 1979: 27 ill;

Sothebys LA 2/7/79: 426 ill(note), 427 ill, 428 ill (note), 429 ill(2), 430 ill, 431 ill;

Phillips Lon 3/13/79: 111 ill(note), 112 ill, 113 ill, 114 ill, 115 (note), 116 ill(note), 117 ill (note), 118 ill, 119 ill, 120 (note), 121 ill (note);

Sothebys Lon 3/14/79: 353 ill, 354, 355, 356 ill, 357 ill, 358;

Christies Lon 3/15/79: 289 ill(note), 290 (note), 291, 292 ill(note), 293 ill(note), 294 ill (note), 295 ill;

**CAMERON** (continued)

Swann NY 4/26/79: 307 ill(note), 308 (note);

Christies NY 5/4/79: 29 ill, 30 ill, 31 (note);

Phillips NY 5/5/79: 136 ill, 137 ill, 138, 139, 140 ill, 141 ill;

Sothebys NY 5/8/79: 69 ill(note), 70 ill;

Christies Lon 6/28/79: 201 ill(note), 202 ill, 203 ill(note), 204 ill, 205 ill, 206 ill, 234 ill (album, C-2 et al)(note);

Sothebys Lon 6/29/79: 200 ill, 201 ill, 202 ill, 203 ill, 204 ill, 205 ill, 206 ill, 207 ill, 208, 209 ill;

Phillips Can 10/4/79: 3 ill, 4 ill(note), 5 ill (note), 6 ill(note);

Swann NY 10/18/79: 274 ill(note), 275;

Sothebys Lon 10/24/79: 283 ill, 285, 286, 287, 288 (5);

Christies Lon 10/25/79: 371 ill, 417 ill;

Christies NY 10/31/79: 17 ill, 18 ill, 19;

Sothebys NY 11/2/79: 223 ill, 224 ill, 225 ill, 226 ill, 227 (lot, C-2 et al);

Phillips NY 11/3/79: 149 ill(note);

Rose Boston Cat 5, 1980: 27 ill(note);

Sothebys LA 2/6/80: 145 ill, 146 ill(2), 147, 148;

Christies Lon 3/20/80: 307 ill, 308 ill, 310 ill (attributed)(note), 311 (attributed), 312 (attributed), 313 (attributed), 314 (attributed), 315 ill(attributed), 316 (attributed), 317 ill(attributed)(note), 318 ill (attributed), 319 (attributed), 320 ill (attributed), 321 (attributed), 322 (attributed), 323 ill(attributed)(note), 324 (attributed)(note), 325 (attributed), 326 (attributed), 327 (attributed), 328 ill(4) (attributed), 329 (5)(attributed);

Sothebys Lon 3/21/80: 307 ill, 308 ill, 309 ill, 310 ill, 311 ill, 312 ill, 313 ill, 314 ill, 315 ill, 316 ill, 317 ill, 318 ill, 319 ill, 320 ill, 321 ill, 322 ill, 323 ill, 324 ill, 325 ill, 326;

Christies NY 5/16/80: 109 ill, 109A ill, 110 (note);

Sothebys NY 5/20/80: 332 ill, 333 ill, 334 ill, 335 (note);

Phillips NY 5/21/80: 160 ill, 161 ill, 162;

Christies Lon 6/26/80: 454 ill(note), 455 ill (note), 456 ill, 457 ill, 458 ill;

Sothebys Lon 6/27/80: 290 (2), 291 ill, 292 ill, 293 ill, 294 ill, 295, 296, 297 ill, 298 (note), 299 ill, 300, 301 ill, 302 ill, 303, 304 ill, 305 ill, 306 ill, 307 ill, 308 ill, 309 ill, 310 ill, 311 ill, 312 ill, 313 ill, 314 ill, 315 ill, 316 ill, 317 ill, 318 ill, 319 ill (book, 11);

Phillips Can 10/9/80: 3 ill(note), 4 ill;

Sothebys Lon 10/29/80: 204 ill(note), 205 ill, 206 ill, 207 ill, 208 ill, 209 ill, 210 ill, 211 ill, 212 ill, 213 ill, 214 ill, 215 ill(album, C-31 et al)(note), 216 ill(album, 43)(note), 220 ill, 221 ill, 222 ill, 223 ill, 224 ill, 225 ill, 226 ill, 227 ill(note), 228 ill, 229 ill, 230 ill, 231 ill, 232 ill;

Christies Lon 10/30/80: 398 ill(note), 398A ill (note), 398B ill;

Christies NY 11/11/80: 30 ill(note), 31 ill, 32 ill, 33 ill, 34, 35 ill(note);

Sothebys NY 11/17/80: 82 ill(note);

Koch Cal 1981-82: 8 ill(note), 9 ill, 10 ill, 11 ill(note);

Sothebys LA 2/4/81: 116 ill(2);

Christies Lon 3/26/81: 368 (note), 369 ill, 370 ill (note), 371 ill(note), 396 ill(album, C-1 et al);

CAMERON (continued)

Sothebys Lon 3/27/81: 469 ill, 470 ill, 471 ill, 472 ill, 473 ill, 474 ill, 475 ill, 476 ill, 477 ill, 478 ill, 479 ill, 480 ill, 481 ill, 482 ill, 483 ill, 484, 485 ill, 486, 487 ill, 488 ill, 489 ill, 490 ill, 491 ill, 492 ill, 493;
Phillips NY 5/9/81: 9 ill(note), 10, 11;
Christies NY 5/14/81: 17 ill(note), 18 ill(note);
Sothebys NY 5/15/81: 89 ill;
Sothebys Lon 6/17/81: 400 ill, 401, 402 ill, 403 ill, 404, 405, 406 ill, 407 ill, 408 ill, 409 ill, 410 ill, 411 ill, 412 ill, 413 ill, 414, 415 ill, 416 ill, 417 ill, 418 ill, 419 ill, 420 ill, 421 ill, 422 ill, 423 ill, 424 ill, 425 ill, 426 ill, 427 ill, 428 ill, 429 ill, 430 ill, 431, 432, 433 ill, 434, 435 ill, 436 ill;
Christies Lon 6/18/81: 416 (note);
California Galleries 6/28/81: 200 ill;
Sothebys NY 10/20/81: 50 ill, 51 ill(note);
Sothebys NY 10/21/81: 53 ill(note), 54 (9 ills) (album, 111)(note), 55 ill, 56 ill, 57 ill, 58 ill, 59 ill;
Sothebys Lon 10/28/81: 382 ill, 383, 384, 385 ill, 386 ill, 387, 388;
Christies Lon 10/29/81: 337 ill(note), 338;
Christies NY 11/10/81: 20 ill, 21 ill, 22 ill, 23 ill;
Rose Florida Cat 7, 1982: 23 ill(note);
Weston Cal 1982: 23 ill;
Christies Lon 3/11/82: 304;
Sothebys Lon 3/15/82: 390 ill, 392 ill, 393 ill, 394 ill, 396, 397 ill, 398 ill, 399 ill, 400 ill, 401 ill, 402 ill, 403, 404 ill;
Phillips Lon 3/17/82: 94, 95;
California Galleries 5/23/82: 240;
Sothebys NY 5/24/82: 224 ill(note), 225 ill(note), 226 ill(note), 227 ill, 228 ill, 229 ill(note);
Christies NY 5/26/82: 13 ill(note), 14 ill, 15 ill (note), 16 ill(note);
Phillips Lon 6/23/82: 68 (album, C et al)(note), 87 ill;
Christies Lon 6/24/82: 336 ill(note), 337 ill (note), 338 ill, 339, 340 ill, 341, 342, 343 ill, 344;
Christies Lon 10/28/82: 167, 168 (note), 169 ill (note), 170 ill(note), 171 (note), 172 ill, 173 (note), 174 ill, 175 (note), 176 ill, 177, 178 ill, 179 ill, 180 (note), 181, 182 ill, 183 (note), 184 (note), 185, 186 ill, 187 ill(note), 188 (note), 189 ill, 190, 191 (2);
Sothebys Lon 10/29/82: 151 ill, 152 ill(attributed) (note), 153 ill(attributed), 154 ill(attributed);
Christies NY 11/8/82: 51 ill(note);
Phillips NY 11/9/82: 65 ill(note);
Drouot Paris 11/27/82: 35 ill;
Phillips Lon 3/23/83: 133 (lot, C-2 et al);
Christies Lon 3/24/83: 210 ill, 211, 212, 213 ill (13), 214, 215, 216, 217 ill, 218, 232 (2);
Sothebys Lon 3/25/83: 125 ill, 126, 127, 128 ill, 129, 130, 131 ill, 132 ill, 133 ill(album, C-31 et al)(note), 134 ill, 135 ill;
Swann NY 5/5/83: 288 ill, 289 (note), 290 (note);
Christies NY 5/9/83: 40 ill;
Sothebys NY 5/11/83: 353 ill;
Phillips Lon 6/15/83: 133 (lot, C-2 et al);
California Galleries 6/19/83: 214A ill;
Christies Lon 6/23/83: 230 ill, 231 ill, 232 ill, 233 (note), 234 ill, 235, 236, 237, 238, 239;
Sothebys Lon 6/24/83: 99 ill, 100 ill, 101 ill, 102 ill, 103 ill, 104, 105 ill, 106 ill, 107 ill (note), 108 ill, 109 ill, 110 ill;

CAMERON (continued)

Christies Lon 10/27/83: 208 (note), 209 ill(note), 210 ill(note), 211 ill, 212 (note), 213 ill, 214 ill;
Phillips Lon 11/4/83: 86 (lot, C-2 et al), 104 ill;
Christies NY 11/8/83: 63 ill(note), 64 ill, 65 ill (note);
Sothebys Lon 12/9/83: 98 ill, 99 ill, 100 ill, 101 ill, 102 ill(book, 13)(note), 103 ill, 104 ill;
Christies Lon 3/29/84: 209 ill(note), 210, 210A, 211, 212 (note), 213 ill(note), 213A, 214 ill, 214A (note);
Christies NY 5/7/84: 7 ill, 8 ill, 9 ill;
Sothebys NY 5/8/84: 84 ill(note);
Swann NY 5/10/84: 320 (album, C et al)(note);
Phillips Lon 6/27/84: 212;
Christies Lon 6/28/84: 223 ill, 224 ill, 225 ill, 226 ill, 227, 228;
Sothebys Lon 6/29/84: 196 ill, 197 ill, 198 ill, 199 ill, 200 ill, 201 ill, 202 ill, 203 ill, 204 ill, 205 ill;
Phillips Lon 10/24/84: 159;
Christies Lon 10/25/84: 196 ill(note), 197 (note), 198 (note), 199 ill(note), 200 ill, 201 ill (note), 202 ill, 203 ill(note), 204 (note), 205 ill(note), 206 ill(note), 207 ill(note), 208 (note), 209 ill(note), 210 ill(note), 211 ill (note), 212 ill(note), 213 ill(note), 214 ill (note), 215 ill(note), 216 ill(note);
Sothebys Lon 10/26/84: 136 ill, 137 ill, 138 ill, 139 ill, 140 ill, 141 ill, 142 ill, 143 ill, 144, 145 ill, 146 ill;
Sothebys NY 11/5/84: 57 ill, 58 ill(note);
Christies NY 11/6/84: 9 ill, 10 ill(note);
Christies NY 2/13/85: 122, 123;
Phillips Lon 3/27/85: 266 ill;
Christies Lon 3/28/85: 151 (albums, C et al)(note), 190 (note), 191 (lot, C-2 et al), 192, 193, 194, 195, 196, 197 ill(note), 198 (note), 199 (note), 200 ill, 201 ill, 202 ill(note), 203 ill(note), 204 ill(note), 205 (note), 206 ill(attributed), 207 ill(lot, C-3 et al);
Christies Lon 3/28/85: 191 ill(note), 192 ill, 193 ill, 194 ill(note), 195 ill(note), 379 ill;
Sothebys Lon 3/29/85: 164 ill(note), 165 ill, 166 ill, 167 ill, 168 ill, 169 ill, 170 ill(note), 171 ill, 172 ill;
Christies NY 5/6/85: 91 ill, 92 ill, 93 ill;
Sothebys NY 5/7/85: 191 ill(note), 192 ill, 193 ill, 194 ill(note), 195 ill(note), 379 ill;
Sothebys NY 5/8/85: 478 ill(note), 479 ill(note);
Christies Lon 6/27/85: 171 (note), 172 ill, 173, 174, 175 (note), 176, 177, 178 ill(note), 179 ill, 246 (albums, C-1 et al)(note);
Sothebys Lon 6/28/85: 146 ill, 147 ill, 148 (3), 149 ill, 150 ill, 151 ill;
Christies Lon 10/31/85: 209 ill, 210 (attributed);
Sothebys Lon 11/1/85: 69 (4), 70 ill(4), 71 ill, 72 ill(attributed)(note), 73 ill(note), 74 ill, 75 ill, 76 ill, 77 ill, 78 ill;
Christies NY 11/11/85: 124 ill(note);
Sothebys NY 11/12/85: 71 ill(note), 72 ill, 73 ill(2);
Swann NY 11/14/85: 29 (note), 99 (album, C-2 attributed et al)(note);
Phillips Lon 4/23/86: 318 (4 ills)(book, 13);
Christies Lon 4/24/86: 514, 515, 516, 517 (note);
Sothebys Lon 4/25/86: 130 ill, 131 ill, 132 ill, 133, 134 ill, 135 ill, 136 ill, 137 ill, 138 ill, 139 ill, 140 ill, 141 ill, 142 ill, 143 ill, 144 ill, 145 ill;

**CAMERON** (continued)
Sothebys NY 5/12/86: 97 ill(note), 199 ill(note),
    200 ill(note), 201 ill(note);
Christies NY 5/13/86: 64 ill(note);
Swann NY 5/15/86: 196;
Christies Lon 6/26/86: 150;
Christies Lon 10/30/86: 117, 118 (attributed), 119
    ill, 120, 121, 122 ill, 123 ill, 222 (album, C-1
    et al);
Sothebys Lon 10/31/86: 116 ill, 117 (lot, C-1 et
    al), 118 (3), 119 ill, 120 ill, 121 ill, 123 ill;
Sothebys NY 11/10/86: 69 ill, 70 ill, 275 ill
    (note), 276 ill(note), 277 ill(note);
Christies NY 11/11/86: 104 ill, 105 ill(note), 106
    ill(note);
Swann NY 11/13/86: 159, 160 (note), 161 (note), 162
    (note), 163 ill(note), 164 ill;
Drouot Paris 11/22/86: 28 ill;

**CAMIANOS**
Photos dated: 1860s-1870s
Processes:      Albumen
Formats:        Prints
Subjects:       Topography
Locations:
Studio:
    Entries:
Christies Lon 3/28/85: 324 (album, C et al);

**CAMINO, L.L.** (Portuguese)
Photos dated: 1880s-1890s
Processes:      Albumen
Formats:        Prints
Subjects:       Topography
Locations:      Portugal
Studio:         Portugal
    Entries:
Swann NY 5/5/83: 429 (albums, C et al);
Swann NY 11/10/83: 304 (albums, C et al);

**CAMM, J.W.** (British)
Photos dated: c1870
Processes:      Albumen
Formats:        Prints
Subjects:       Documentary (art)
Locations:      Studio
Studio:         England - Birmingham
    Entries:
Edwards Lon 1975: 21 (album, 92);

**CAMMAS, Henry & LEFEVRE, André** (French)
Photos dated: 1862
Processes:      Albumen
Formats:        Prints
Subjects:       Topography
Locations:      Egypt
Studio:
    Entries:
Sothebys NY 11/21/70: 15 ill (book, 86);

**CAMMIDGE, H.C.** (possibly H.C.H., q.v.)
Photos dated: 1868-1880s
Processes:      Albumen
Formats:        Prints
Subjects:       Topography
Locations:      China - Shanghai
Studio:         China - Shanghai
    Entries:
Swann NY 4/26/79: 50 (book, C et al)(note);
Sothebys NY 5/20/80: 404 ill(lot, C et al);
Harris Baltimore 11/7/86: 241 (album, C-4 et al);

**CAMPBELL** (see ALVORD, KELLOGG & CAMPBELL)
    [CAMPBELL 1]

**CAMPBELL** (see KLAUBER & CAMPBELL) [CAMPBELL 2]

**CAMPBELL** [CAMPBELL 3]
Photos dated: 1860s
Processes:      Ambrotype
Formats:        Plates
Subjects:       Portraits
Locations:
Studio:
    Entries:
Harris Baltimore 3/26/82: 160 (lot, C-1 et al);

**CAMPBELL, the Honorable A.** (British)
Photos dated: 1860s
Processes:      Albumen
Formats:        Prints
Subjects:
Locations:
Studio:         Great Britain (Amateur Photographic
                Association)
    Entries:
Christies Lon 10/27/83: 218 (albums, C-1 et al);

**CAMPBELL, Alfred S.** (American)
Photos dated: 1890-1904
Processes:      Albumen
Formats:        Stereos
Subjects:       Topography, genre (street life)
Locations:      US - New York City
Studio:         US - Elizabeth, New Jersey
    Entries:
Swann NY 12/14/78: 270 (14);
Harris Baltimore 4/8/83: 30 (lot, C et al), 52 (lot,
    C et al), 81 (lot, C et al);

**CAMPBELL, Lord, of Strachathro** (British)
Photos dated: c1855-c1857
Processes:      Calotype
Formats:        Prints
Subjects:       Topography
Locations:      England - Tullichewan Castle
Studio:         England
    Entries:
Colnaghi Lon 1976: 128 ill(attributed)(note), 129
    (attributed), 130 (attributed), 131 (attributed),
    132 (attributed);
Sothebys Lon 3/21/80: 229;
Christies NY 5/16/80: 90 ill, 91;
Sothebys NY 5/20/80: 349 ill(attributed)(note);
Sothebys Lon 10/29/80: 279 (2)(attributed)(note);

**CAMPBELL, Lord** (continued)
Sothebys Lon 10/28/81: 188 (attributed);
Sothebys Lon 3/15/82: 332 (attributed);
Christies Lon 10/28/82: 42 (2)(attributed);
Christies Lon 3/24/83: 48 (attributed);
Christies NY 5/7/84: 4 ill(note);
Christies Lon 10/25/84: 165;
Sothebys Lon 3/29/85: 153 ill;
Sothebys Lon 6/28/85: 119 ill(3).

**CAMPBELL, J.W.** (American)
Photos dated: c1863
Processes:     Albumen
Formats:      Cdvs
Subjects:     Portraits
Locations:    US - Civil War area
Studio:       US
    Entries:
Harris Baltimore 3/26/82: 400 (album, C et al);

**CAMPBELL, Mrs. M.** (British)
Photos dated: 1860s
Processes:     Albumen
Formats:      Prints
Subjects:     Portraits
Locations:    Great Britain
Studio:       Great Britain
    Entries:
Christies Lon 4/24/86: 501 (4);

**CAMPBELL, W.G.** (British)
Photos dated: 1855-1857
Processes:     Albumen
Formats:      Prints
Subjects:     Genre
Locations:    Great Britain
Studio:       Great Britain (Photographic Exchange
              Club; Photographic Club)
    Entries:
Weil Lon Cat 4, 1944(?): 237 (album, C et al)(note);
Sothebys Lon 3/14/79: 324 (album, C-1 et al);

**CANEVA, Giacomo** (Italian)
Photos dated: 1847-1864
Processes:     Daguerreotype, salt, albumenized salt
Formats:      Plates, prints
Subjects:     Topography
Locations:    Italy - Rome, Salerno
Studio:       Italy - Rome
    Entries:
Christies NY 5/16/80: 147 ill;
Christies NY 11/11/80: 63 (attributed), 69
    (attributed);
Sothebys NY 10/21/81: 60 ill(note);
Christies NY 11/6/84: 27 ill(note), 28 ill;
Christies Lon 10/30/86: 75 (lot, C-1 et al);
Sothebys Lon 10/31/86: 57 ill, 58 ill, 59
    (2, attributed), 61 ill(9, attributed), 62
    (lot, C-8 attributed, et al), 63
    (4, attributed), 64 ill(attributed), 65
    (4, attributed), 66 ill(40, attributed), 67
    (30, attributed), 68 (4, attributed), 69 ill
    (12, attributed);

**CANEY, W.L. and/or A.W.**
Photos dated: 1880s-c1895
Processes:     Albumen, photogravure, gelatin
Formats:      Prints
Subjects:     Topography, ethnography
Locations:    South Africa - Durban
Studio:       South Africa - Pietermaritzburg;
              Durban
    Entries:
Christies Lon 3/15/79: 193 (album, C-1 et al);
Swann NY 4/26/79: 5 (book, C at al);
Sothebys NY 5/20/80: 398 ill(album, C et al);
Christies Lon 6/26/80: 230 (album, C-2 et al);
Sothebys Lon 6/17/81: 342 ill(8);
Christies Lon 3/28/85: 70 (album, C-30 et al), 95
    (album, C et al);
Christies Lon 10/31/85: 108 ill(albums, C-30 et al);

**CANO** (Spanish)
Photos dated: 1860s-1870s
Processes:     Albumen
Formats:      Cdvs
Subjects:     Genre
Locations:    Spain
Studio:       Spain - Cadiz
    Entries:
Swann NY 12/14/78: 376 (lot, C et al);

**CANON**
Photos dated: c1870
Processes:     Albumen
Formats:      Cdvs
Subjects:     Portraits
Locations:    Studio
Studio:       West Indies
    Entries:
California Galleries 1/21/79: 237 (lot, C et al);

**CAPEL-CURE, Colonel Alfred** (British, 1826-1896)
Photos dated: 1852-c1859
Processes:     Albumen
Formats:      Print
Subjects:     Architecture
Locations:    England - Oxford; Gibraltar; France
Studio:       England
    Entries:
Christies Lon 10/27/77: 54 ill(album, 180)(note),
    55 ill(album, 154);
Weston Cal 1978: 138 (8 ills)(album, 180)(note);
Christies NY 5/4/79: 17 ill(note);
Phillips NY 5/5/79: 130, 131 ill;
Phillips NY 11/3/79: 148;
Christies NY 5/14/81: 9 (note);
Christies NY 5/26/82: 3 ill, 4;
Christies Lon 10/27/83: 64 (4 ills)(album, 234)
    (note);
Christies Lon 6/27/85: 246 (albums, C et al)(note);
Swann NY 11/14/85: 31, 32;
Sothebys Lon 4/25/86: 115;
Christies Lon 10/30/86: 251 (album, C-5 attributed
    et al);

CAPLAIN, J.W.
Photos dated: Nineteenth century
Processes:     Albumen
Formats:       Prints
Subjects:      Topography
Locations:     India
Studio:
    Entries:
Christies Lon 10/31/85: 125 (albums, C-7 et al);

CAPLE, N. & Co. (see also TRUEMAN & CAPLE)
Photos dated: 1870s
Processes:     Albumen
Formats:       Prints
Subjects:      Ethnography
Locations:     Canada
Studio:        Canada - Vancouver
    Entries:
Christies Lon 10/25/79: 225 (lot, C-7 et al);
Sothebys Lon 6/24/83: 19 ill;
Sothebys Lon 12/9/83: 18 (3);
Sothebys Lon 6/28/85: 40 (2 ills)(2);
Sothebys Lon 11/1/85: 22 ill(2);

CARBUTT, John (British, American, 1832-1905)
Photos dated: 1860-1887
Processes:     Albumen, woodburytype
Formats:       Prints, stereos, cdvs
Subjects:      Topography, documentary (railroads),
               portraits
Locations:     US - American west; Chicago, Illinois
Studio:        US - Chicago, Illinois; Philadelphia,
               Pennsylvania
    Entries:
Anderson NY (Gilsey Coll.) 1/20/03: 275;
Swann NY 2/14/52: 82 (book, 97)(note);
Sothebys NY (Strober Coll.) 2/7/70: 20 (book, 95),
    374 (95), 488 (23), 506 (lot, C et al), 521
    (lot, C et al), 522 (lot, C-13 et al);
Sothebys NY 11/21/70: 365 ill(13);
Rinhart NY Cat 1, 1971: 156 (2);
Rinhart NY Cat 2, 1971: 15 ill(book, 110);
Rinhart NY Cat 7, 1973: 200, 201;
Rinhart NY Cat 8, 1973: 4 (book, 110);
Vermont Cat 5, 1973: 535 (lot, C et al);
California Galleries 9/27/75: 504 (lot, C et al);
Swann NY 11/11/76: 266 (book, C-27 et al);
Vermont Cat 11/12, 1977: 772 ill, 773 ill;
Swann NY 4/14/77: 52 ill(book, 96)(note);
Frontier AC, Texas 1978: 50 (book, 50)(note);
California Galleries 1/21/78: 172 (7);
Swann NY 12/14/78: 117 (book, C-16 et al)(note);
Christies Lon 6/18/81: 78 (lot, C-10 et al);
Christies Lon 6/23/83: 44 (lot, C et al);
Christies Lon 10/27/83: 44 (lot, C et al);
Harris Baltimore 6/1/84: 148 (lot, C et al);
California Galleries 7/1/84: 102 ill(book, 1);
Christies Lon 3/28/85: 46 (lot, C et al);
Swann NY 11/14/85: 261 (book, C et al), 262 (book,
    C et al);
Christies Lon 4/24/86: 351 (lot, C-8 et al);
Swann NY 5/15/86: 132 (book, C et al);
Phillips Lon 10/29/86: 227 (lot, C et al);

CARDEN (American)
Photos dated: 1850s
Processes:     Daguerreotype
Formats:       Plates
Subjects:      Portraits
Locations:     Studio
Studio:        US - New York City
    Entries:
Harris Baltimore 2/14/86: 288;

CARET (French)
Photos dated: Nineteenth century
Processes:     Woodburytype
Formats:       Prints
Subjects:      Portraits incl. Galerie Contemporaine
Locations:     Studio
Studio:        France
    Entries:
Swann NY 4/20/78: 321 (lot, C-1 et al);
Swann NY 11/13/86: 53 (book, C et al);

CAREY
Photos dated: 1880s and/or 1890s
Processes:     Albumen
Formats:       Prints
Subjects:      Topography
Locations:     Australia
Studio:
    Entries:
Christies Lon 3/29/84: 103 (albums, C et al);
Christies Lon 10/25/84: 105 (album, C et al);

CARGO
Photos dated: c1852
Processes:     Daguerreotype
Formats:       Plates
Subjects:      Portraits
Locations:
Studio:
    Entries:
Sothebys NY 11/9/76: 2 ill;

CARJAT, Etienne (French, 1828-1906)
Photos dated: 1855-1875
Processes:     Salt, albumen, carbon, woodburytype
Formats:       Prints, cdvs, cabinet cards
Subjects:      Portraits incl. Galerie Contemporaine
Locations:     Studio
Studio:        France - Paris
    Entries:
Maggs Paris 1939: 559;
Andrieux Paris 1952(?): 714 (books, C et al);
Rauch Geneva 12/24/58: 203 ill, 215 ill(note), 250
    (2 ills)(lot, C-3 et al);
Rauch Geneva 6/13/61: 149 (note), 211 ill(book,
    C et al), 212 ill(book, C et al), 213 ill(note);
Sothebys NY (Weissberg Coll.) 5/16/67: 172 (lot,
    C et al);
Sothebys Lon 12/21/71: 182 (lot, C-2 et al)(note);
Rinhart NY Cat 6, 1973: 349;
Witkin NY I 1973: 251 ill(book, C et al), 419, 420,
    421, 422 ill, 423, 424, 425, 426;
Sothebys NY 2/25/75: 118 ill(note), 119 (note);
Sothebys Lon 3/21/75: 153 ill(book, C et al)(note);
Colnaghi Lon 1976: 111 (note), 112 ill, 114 ill;
Kingston Boston 1976: 41 ill(note), 686 ill(book,
    C et al)(note);

## CARJAT (continued)

Witkin NY IV 1976: 139 ill;
Gordon NY 5/3/76: 302 ill;
Sothebys NY 5/4/76: 102 (note);
Sothebys Lon 6/11/76: 180 (lot, C et al);
Christies Lon 10/28/76: 269 (3), 270, 271;
Swann NY 11/11/76: 349 (lot, C et al);
Gordon NY 11/13/76: 48 (albums, C et al), 49 ill,
  51 ill(lot, C-2 et al), 52 ill(2), 53 ill(2);
Halsted Michigan 1977: 606;
White LA 1977: 23 (note);
Sothebys NY 2/9/77: 52 (lot, C-1 et al);
Gordon NY 5/10/77: 797 ill(4);
Sothebys NY 5/20/77: 46 (lot, C et al);
Christies Lon 6/30/77: 302 ill(note);
Sothebys Lon 7/1/77: 257 ill, 258 (3);
Sothebys NY 10/4/77: 209 (lot, C-5 et al);
Christies Lon 10/27/77: 328 ill(note), 329 (2);
Wood Conn Cat 41, 1978: 25 ill(book, C-21 et al)
  (note);
Sothebys LA 2/13/78: 113, 114, 115 ill(books, C-16
  et al)(note), 116 (lot, C-1 et al);
Christies Lon 3/16/78: 311a (book, C-5 et al);
Sothebys Lon 3/22/78: 172;
Swann NY 4/20/78: 119 (book, C et al), 199 (note),
  321 (lot, C-2 et al)(note), 322 (lot, C-1 et al)
  (note), 323 (lot, C-3 et al)(note);
Sothebys NY 5/2/78: 123 (4);
Drouot Paris 5/29/78: 68, 69 (lot, C et al);
Christies Lon 6/27/78: 230 (note);
Sothebys Lon 6/28/78: 136 (lot, C et al);
Phillips NY 11/4/78: 64 ill;
Swann NY 12/14/78: 192 (book, C-1 et al);
Rose Boston Cat 4, 1979: 25 ill(note);
Witkin IX 1979: 2/17 (book, C et al);
Wood Conn Cat 45, 1979: 186 (book, C-21 et al)
  (note);
California Galleries 1/21/79: 410;
Sothebys LA 2/7/79: 434, 435 (lot, C-9 et al);
Swann NY 4/26/79: 309 (note), 310, 362 (lot,
  C et al);
Sothebys NY 5/8/79: 86 (album, C et al), 87 ill
  (books, C-18 et al);
Christies Lon 6/28/79: 227 (albums, C-4 et al);
Christies Lon 10/25/79: 392 (albums, C-1 et al),
  427 ill(note), 428;
Christies NY 10/31/79: 34 ill, 35 ill(book,
  C et al);
White LA 1980-81: 23 ill(note), 24 ill;
Sothebys LA 2/8/80: 123 ill(lot, C-5 et al);
Christies Lon 3/20/80: 224 (book, C et al), 227
  (book, C et al), 228 (book, C et al), 230
  (book, C et al);
Sothebys Lon 3/21/80: 238 (book, C et al);
California Galleries 3/30/80: 267 (3);
Phillips NY 5/21/80: 230 (lot, C et al);
Auer Paris 5/31/80: 126 (2);
Christies Lon 6/26/80: 329 (book, C et al), 477
  (album, C-1 et al);
California Galleries 12/13/80: 217 (2);
Koch Cal 1981-82: 33 (book, C et al);
Christies Lon 3/26/81: 293 (book, C et al);
Swann NY 4/23/81: 471 (lot, C et al), 472 (lot,
  C et al);
Christies NY 5/14/81: 41 ill(books, C-15 et al);
Christies Lon 10/29/81: 385 (album, C et al);
Petzold Germany 11/7/81: 296 ill(album, C et al),
  302 (album, C et al);
Octant Paris 1982: 13 ill;
Wood Conn Cat 49, 1982: 332 (book, C-21 et al)
  (note);

## CARJAT (continued)

Christies NY 5/26/82: 36 (book, C-36 et al);
Drouot Paris 11/27/82: 36 ill;
Bievres France 2/6/83: 132 (album, C-2 et al);
Christies Lon 3/24/83: 250 (album, C et al);
Christies Lon 6/23/83: 252 (album, C et al), 256
  (album, C et al);
Sothebys Lon 6/24/83: 81 ill, 82 (3);
Christies Lon 10/27/83: 232 (album, C et al);
Swann NY 11/10/83: 129 (book, C et al);
Christies Lon 5/7/84: 19 (book, C-36 et al);
Swann NY 5/10/84: 23 (book, C et al)(note), 51
  (book, C et al)(note), 223 (albums, C et al),
  321 (lot, C et al)(note);
Drouot Paris 11/24/84: 83 ill;
Christies NY 2/13/85: 134 (note), 135 (lot,
  C et al);
Swann NY 5/9/85: 331 (lot, C et al);
Christies Lon 6/27/85: 102 (books, C et al);
Sothebys Lon 6/28/85: 199 ill;
Wood Boston Cat 58, 1986: 326 (book, C-21 et al);
Christies Lon 4/24/86: 419 (books, C et al), 504
  (album, C-1 et al)(note);
Sothebys Lon 4/25/86: 191 ill, 192;
Christies NY 5/13/86: 93 (lot, C-1 et al);
Phillips Lon 10/29/86: 310 (lot, C-1 et al);
Sothebys Lon 10/31/86: 156 ill(119);
Phillips NY 11/12/86: 60;
Swann NY 11/13/86: 53 (book, C et al), 164 (4);
Drouot Paris 11/22/86: 70 (album, C et al);

## CARLETON

Photos dated: c1848-1850s
Processes:   Daguerreotype
Formats:     Plates
Subjects:    Portraits
Locations:   Studio
Studio:      Canada - Toronto
  Entries:
Christies Lon 6/28/79: 9;

## CARLETON, C.G. (American)

Photos dated: mid 1870s
Processes:   Albumen
Formats:     Cdvs, stereos
Subjects:    Portraits, topography
Locations:   Studio
Studio:      US - Waterville, Maine
  Entries:
Rinhart NY Cat 2, 1971: 291 (26), 292 (44);

## CARLETON, S.L. (American)

Photos dated: 1850s
Processes:   Daguerreotype
Formats:     Plates
Subjects:    Portraits
Locations:   Studio
Studio:      US - Portland, Maine
  Entries:
Vermont Cat 5, 1973: 373 ill;
Vermont Cat 8, 1974: 466 ill, 467 ill, 468 ill;

CARLIER, F. (French)
Photos dated: Nineteenth century
Processes: Albumen
Formats: Cdvs
Subjects: Topography
Locations: France
Studio: France - Vannes
    Entries:
Christies Lon 6/26/80: 261 (lot, C et al);

CARMONA Y VALLE, Dr. Manuel (Mexican)
              (photographer or author?)
Photos dated: 1885
Processes: Albumen
Formats: Prints
Subjects: Documentary (medical)
Locations: Mexico
Studio: Mexico
    Entries:
Wood Conn Cat 37, 1976: 33 (book, 6)(note);
Wood Conn Cat 42, 1978: 103 (book, 6)(note);

CARNEIRO & GASPAR
Photos dated: Nineteenth century
Processes:
Formats: Prints
Subjects: Topography
Locations: South America
Studio: South America
    Entries:
Christies Lon 10/30/86: 151 (lot, C & G-2 et al);

CARON (French)
Photos dated: 1857-1859
Processes: Collodion on canvas
Formats:
Subjects: Portraits
Locations:
Studio: France - Ham
    Entries:
Rauch Geneva 6/13/61: 118 (4)(note);

CARPENTER (see BOWEN & CARPENTER) [CARPENTER 1]

CARPENTER & MULLEN (American) [CARPENTER 2]
Photos dated: 1860s-1870s
Processes: Albumen
Formats: Stereos
Subjects: Topography
Locations: US
Studio: US - Lexington, Kentucky
    Entries:
Christies Lon 3/28/85: 46 (lot, C & M et al);

CARPENTER & WESTLY [CARPENTER 3]
Photos dated: c1853
Processes: Daguerreotype, albumen
Formats: Stereo plates, stereo cards
Subjects: Genre (still life), topography
Locations: Europe
Studio: England - London
    Entries:
Harris Baltimore 12/16/83: 43 (lot, C & W-1 et al);
Christies Lon 10/31/85: 44 (lot, C & W-1 et al);
Christies Lon 6/26/86: 195 (lot, C & W-1 et al);

CARPENTER [CARPENTER 4]
Photos dated: c1880
Processes: Albumen
Formats: Prints
Subjects: Topography
Locations: US - Colorado
Studio:
    Entries:
California Galleries 1/21/78: 215 (album,
    C-1 et al);

CARPENTER, A.C. (American)
Photos dated: 1894
Processes: Silver
Formats: Prints
Subjects: Topography
Locations: US - Washington
Studio: US - Washington
    Entries:
California Galleries 5/23/82: 242;

CARPENTER, James (see NASMYTH & CARPENTER)

CARPENTER, J.E. (British)
Photos dated: c1850
Processes: Daguerreotype
Formats: Plates
Subjects: Portraits
Locations: Studio
Studio: Great Britain
    Entries:
Christies Lon 3/16/78: 6;

CARPENTER, M. (American)
Photos dated: Nineteenth century
Processes: Albumen
Formats: Cdvs
Subjects: Portraits, documentary (military)
Locations: US
Studio: US - Cincinnati, Ohio
    Entries:
Sothebys NY (Strober Coll.) 2/7/70: 264 (lot,
    C et al);

CARRERA (see GOMEZ & CARRERA)

CARRICK, William (British, 1827-1878)
Photos dated: 1863-1870s
Processes: Albumen
Formats: Cabinet cards, cdvs
Subjects: Ethnography, portraits
Locations: Russia
Studio: Russia - St. Petersburg
    Entries:
Edwards Lon 1975: 125 (book, C et al);
California Galleries 1/22/77: 111;
Sothebys Lon 3/14/79: 289 ill(album, 65)(note);
Sothebys Lon 3/21/80: 372 (7)(note);
Christies Lon 6/26/80: 464 (2 ills)(album, 24)
    (note);
Sothebys Lon 6/27/80: 253 (7);
Sothebys Lon 3/27/81: 381 (5);
Sothebys Lon 3/15/82: 215 (19);
Christies Lon 3/24/83: 259 (album, 30);

**CARRICK, W.** (continued)
Christies Lon 6/27/85: 290 (albums, 43), 291 ill
   (lot, C et al);
Christies Lon 10/31/85: 290 (album, C-2 et al);
Sothebys Lon 4/25/86: 17 (album, C et al);
Christies Lon 10/30/86: 228 (2), 229 (album,
   C et al);

**CARRIGUES**
Photos dated:  1880s
Processes:     Albumen
Formats:       Prints
Subjects:      Topography
Locations:     Europe - south
Studio:
   Entries:
Christies Lon 10/27/83: 87 (albums, C et al);

**CARROLL, Lewis** (Reverend Charles Lutwidge Dodgson)
                (British, 1832-1898)
Photos dated:  1856-1875
Processes:     Albumen
Formats:       Prints, cdvs, cabinet cards
Subjects:      Portraits, genre, topography
Locations:     England
Studio:        England - Oxford
   Entries:
Sothebys NY (Weissberg Coll.) 5/16/67: 68 (book, 1)
   (note);
Frumkin Chicago 1973: 39 ill, 40 ill;
Lunn DC Cat 3, 1973: 34 ill;
Sothebys Lon 6/21/74: 27 (album, C et al)(note),
   212 ill(note), 213 ill;
Sothebys Lon 10/18/74: 295 ill(note), 296 (3 ills)
   (album, C et al)(note);
Sothebys NY 2/25/75: 75 ill(note), 76 ill(note), 77
   (2 ills)(2)(note);
Sothebys Lon 3/21/75: 288 ill(album, C-1 et al),
   355 ill, 356 ill, 357 ill, 358 ill;
Sothebys Lon 6/27/75: 265 (2 ills)(album, C-2
   et al);
Sothebys Lon 10/24/75: 206 ill;
Anderson & Hershkowitz Lon 1976: 27 ill, 28 ill;
Colnaghi Lon 1976: 151 (note), 152 ill(note), 153
   ill, 154 ill(note);
Sothebys Lon 3/19/76: 225 ill(note);
Gordon NY 5/3/76: 278 ill, 279 ill, 280 ill;
Christies Lon 10/28/76: 199 ill(note), 218 ill
   (album, C-1 et al)(note);
Sothebys Lon 10/29/76: 89 ill(attributed)(note), 90
   ill(attributed), 91 ill(attributed), 290
   (attributed), 291 ill(note);
Gordon NY 11/13/76: 13 ill(note), 14 ill(note), 15
   ill(note);
Christies Lon 6/10/76: 148 (album, C et al)(note);
Sothebys Lon 3/9/77: 252 ill;
Christies Lon 3/10/77: 219 ill(note), 220 ill
   (note), 221 ill(note), 248 (album, C et al)
   (note), 249 (album, C-2 attributed et al), 251
   (album, C-1 et al), 252 (album, C-1 et al), 253
   (attributed)(note), 254 (attributed)(note);
Christies Lon 6/30/77: 149a (lot, C-1 et al)(note);
Sothebys Lon 7/1/77: 316 ill, 317 ill, 318 ill;
Sothebys NY 10/4/77: 172 ill(note);
Christies Lon 10/27/77: 323 ill(note), 362 ill
   (attributed)(note);
Sothebys Lon 11/18/77: 271 ill(note), 272 ill, 273
   (3 ills)(album, C-10 et al)(note);

**CARROLL** (continued)
Christies Lon 3/16/78: 357a ill(attributed)(note),
   358 ill(note);
Swann NY 4/20/78: 200 ill(note);
Sothebys NY 5/2/78: 58 ill(note), 59 ill(note), 60
   ill(4)(attributed)(note);
Christies Lon 6/27/78: 229 (album, C-1 et al)(note);
Christies Lon 10/26/78: 304 ill(note);
Phillips NY 11/4/78: 38 ill(note);
Sothebys LA 2/7/79: 425 ill(note);
Phillips Lon 3/13/79: 75 (album, C-1 et al)(note),
   109 ill, 110 ill;
Sothebys NY 5/8/79: 67 ill(note), 68 ill(note);
Sothebys Lon 6/29/79: 210 (note), 211 ill, 212 ill,
   213 ill, 214 ill, 215 ill, 216 ill, 217 ill, 218
   ill, 219 (2 ills)(2);
Swann NY 10/18/79: 276 ill(note), 277 (3)(note);
Sothebys Lon 10/24/79: 277 (note), 278 ill, 279
   ill, 280 ill, 281 ill, 282;
Christies NY 10/31/79: 15 ill(note), 16 ill(note);
White LA 1980-81: 4 ill(note);
Sothebys Lon 3/21/80: 327 ill, 328 ill, 329 ill,
   330 ill, 331 ill, 332 ill, 333 ill(note), 334
   ill, 335 ill;
Sothebys Lon 6/27/80: 320 ill, 321 ill(note);
Sothebys Lon 10/29/80: 185 ill(note), 186 ill
   (note), 187 ill, 188 ill, 189 ill, 190 ill, 191
   ill, 192 ill, 193 ill, 194 ill, 195 ill, 196
   ill, 197 ill, 198 ill, 217 ill;
Koch Cal 1981-82: 3 ill(note), 4 ill;
Sothebys LA 2/4/81: 124 ill;
Phillips Lon 3/12/80: 125;
Sothebys Lon 3/27/81: 439 ill(note), 440 ill, 441,
   442, 443 ill, 444 ill, 445 ill, 446 ill, 447
   ill, 448 ill, 449 ill, 450 ill;
Phillips NY 5/9/81: 8 ill(note);
Sothebys NY 5/15/81: 87 ill(note);
Sothebys Lon 6/17/81: 377 ill, 378 ill, 379 ill,
   380 ill, 381 ill;
Harris Baltimore 7/31/81: 175 (attributed);
Sothebys Lon 10/28/81: 376, 377 ill, 378 ill, 379
   ill, 380 ill, 381;
Christies NY 11/10/81: 19 ill;
Sothebys Lon 3/15/82: 380 ill, 381 ill, 382 ill;
Sothebys Lon 6/25/82: 190 ill, 191 ill, 192 ill,
   193 ill, 194 ill, 195 ill, 196 ill, 197 ill, 198
   ill, 199 ill, 200 ill, 201 ill;
Sothebys Lon 10/29/82: 155 ill, 156 ill, 157 ill,
   158 ill;
Swann NY 11/18/82: 344 ill;
Christies Lon 3/24/83: 223, 224, 225 ill, 226 ill,
   227, 229 ill(19)(note), 230 ill(5), 231 ill;
Sothebys Lon 6/24/83: 111 (2);
Christies NY 10/4/83: 81 (note);
Christies Lon 10/27/83: 205, 206, 207 ill(2);
Christies NY 11/8/83: 68 ill;
Sothebys NY 11/9/83: 84 ill;
Swann NY 11/10/83: 196 (note);
Harris Baltimore 12/16/83: 294 ill(note);
Christies NY 5/7/84: 10 ill;
Swann NY 5/10/84: 320 (album, C attributed et al)
   (note);
Sothebys Lon 6/29/84: 207 ill;
Christies NY 9/11/84: 107 ill(attributed);
Sothebys Lon 10/26/84: 147 ill, 148 ill, 149 ill,
   150 ill, 151 ill, 152 ill, 153 ill;
Sothebys Lon 3/29/85: 175 ill, 176 ill;
Sothebys NY 5/7/85: 196 ill;
Sothebys Lon 6/28/85: 146 ill, 147 ill, 148 (3),
   149 ill, 150 ill, 151 ill;
Phillips Lon 10/30/85: 34;

CARROLL (continued)
Phillips Lon 4/23/86: 237;
Sothebys Lon 4/25/86: 129 ill;
Christies Lon 4/26/86: 472 ill, 473 ill(attributed)
    (note), 474 ill(attributed)(note);
Phillips Lon 10/29/86: 390 ill(note), 391 (2 ills),
    392 ill, 393 ill, 394 ill, 395 (2 ills)(2), 396
    (2 ills)(2), 397 (2 ills)(2);
Christies Lon 10/30/86: 226 (album, C et al);
Sothebys Lon 10/31/86: 124 ill, 125 ill, 126 ill(6);
Drouot 11/22/86: 29 ill;

CARTER, Charles William (American, 1832-1888)
Photos dated: c1863-1888
Processes:      Albumen
Formats:        Stereos, cdvs
Subjects:       Topography, portraits
Locations:      US - Salt Lake City, Utah
Studio:         US - Salt Lake City, Utah
    Entries:
Sothebys NY (Weissberg Coll.) 5/16/67: 185 (lot, C-5
    et al);
Sothebys NY (Strober Coll.) 2/7/70: 505 (lot, C et
    al), 511 (lot, C et al), 521 (lot, C et al), 531
    (lot, C et al);
Rinhart NY Cat 1, 1971: 258 (2);
Rinhart NY Cat 6, 1973: 564;
Rinhart NY Cat 7, 1973: 286;
Sothebys Lon 12/4/73: 213 (album, C et al);
Christies Lon 10/28/76: 196 (lot, C-2 et al);
California Galleries 1/23/77: 447 (lot, C et al);
Frontier AC, Texas 1978: 51, 52, 53, 54, 55, 56;
California Galleries 1/21/78: 125 (lot, C et al),
    198 (lot, C et al);
Swann NY 10/18/79: 431 (lot, C-1 et al);
California Galleries 12/13/80: 413;
Swann NY 4/23/81: 422 (lot, C-2 et al);
Rose Florida Cat 7, 1982: 82 ill, 83 ill;
Sothebys Lon 6/24/83: 1 (lot, C et al);
Harris Baltimore 12/16/83: 140 (lot, C-1 et al);
Harris Baltimore 6/1/84: 155 (lot, C-4 et al), 446
    (lot, C-3 et al);
California Galleries 6/8/85: 191, 192, 193, 194,
    442 (lot, C-4 et al), 517;

CARTLAND, G.P. (British)
Photos dated: 1890s
Processes:      Albumen
Formats:        Prints
Subjects:       Documentary (public events)
Locations:      England
Studio:         England - Windsor
    Entries:
Christies Lon 3/28/85: 337 (lot, C-2 et al);

CARTLAND, T.J.
Photos dated: 1892-1893
Processes:      Platinum
Formats:        Prints
Subjects:       Documentary (educational institutions)
Locations:      England - Eton; Windsor; the Thames
Studio:
    Entries:
Sothebys Lon 3/15/82: 339 (19);
Christies Lon 10/25/84: 233 (48);

CARTLIDGE, J.B. (British)
Photos dated: c1870
Processes:      Albumen
Formats:        Prints
Subjects:       Topography
Locations:      Scotland - Edinburgh
Studio:         Scotland - Edinburgh
    Entries:
Sothebys Lon 10/27/78: 105 (2);

CARUANA, A.A.
Photos dated: 1882
Processes:      Albumen
Formats:        Prints
Subjects:       Topography
Locations:      Malta
Studio:
    Entries:
Sothebys NY 2/25/75: 70 (books, C-38 et al);

CARVALHO, Solomon Nunes (American, 1815-1899)
Photos dated: c1850-1860s
Processes:      Daguerreotype, albumen
Formats:        Plates, cabinet cards
Subjects:       Portraits, topography
Locations:      US - Baltimore, Maryland; New York
                City; American west
Studio:         US
    Entries:
Phillips NY 5/5/79: 104 (lot, C et al);

CARY (American)
Photos dated: 1860s
Processes:      Ambrotype
Formats:        Plates
Subjects:       Portraits
Locations:      Studio
Studio:         US - New York City
    Entries:
Vermont Cat 8, 1974: 526 ill;

CASE & GETCHELL (American)
Photos dated: c1860-1860s
Processes:      Albumen
Formats:        Cdvs
Subjects:       Portraits
Locations:      Studio
Studio:         US - Boston, Massachusetts
    Entries:
Anderson NY (Gilsey Coll.) 1/20/03: 277;
Sothebys NY (Strober Coll.) 2/7/70: 284 (lot,
    C & G et al);
Sothebys NY (Greenway Coll.) 11/20/70: 210 ill;
Lehr NY Vol 1:3, 1979: 25 ill;
Swann NY 11/10/83: 361 (album, C & G-6 et al);

CASE, J.T. (British)
Photos dated: c1857
Processes:      Albumen
Formats:        Prints
Subjects:       Topography
Locations:      England - Lewes
Studio:         England - Lewes
    Entries:
Sothebys Lon 3/9/77: 45 (book, 12);

**CASEY, J.J.**
Photos dated: Nineteenth century
Processes:    Albumen
Formats:      Prints
Subjects:     Topography
Locations:    Australia
Studio:       Australia - Melbourne
   Entries:
Sothebys Lon 5/24/73: 21 (album, 60);

**CASKET PORTRAIT COMPANY** (British)
Photos dated: 1860s
Processes:    Collodion positive
Formats:      Self-contained stereo viewer
Subjects:     Portraits
Locations:    Studio
Studio:       England - London
   Entries:
Christies Lon 10/28/76: 231 ill(note);
Christies Lon 10/25/84: 34 ill(note);

**CASSEL & WILHELMSHOEHE**
Photos dated: 1860s and/or 1870s
Processes:    Albumen
Formats:      Stereos
Subjects:     Documentary (art)
Locations:
Studio:
   Entries:
Harris Baltimore 12/16/83: 128 (lot, C & W et al);

**CASWALL** (see SMITH, J. & C.)

**CASWELL, J.H.** (American)
Photos dated: c1880
Processes:    Albumen
Formats:      Stereos
Subjects:     Topography
Locations:    US
Studio:       US - Holyoke, Massachusetts
   Entries:
Rinhart NY Cat 2, 1971: 509 (4);
Christies Lon 10/30/80: 124 (lot, C & Davy-2,
   et al);
Harris Baltimore 7/31/81: 102 (lot, C et al);
Harris Baltimore 6/1/84: 93 (lot, C & Davy et al);

**CATALANOTTI**
Photos dated: 1880s
Processes:    Albumen
Formats:      Prints
Subjects:     Topography
Locations:    Tunis
Studio:
   Entries:
California Galleries 4/3/76: 292 (2);
Phillips NY 5/5/79: 175 (lot, C et al);

**CATFORD Brothers** (British)
Photos dated: 1860s and/or 1870s
Processes:    Albumen
Formats:      Prints, stereos
Subjects:     Topography
Locations:    Great Britain
Studio:       Great Britain
   Entries:
Christies Lon 10/25/79: 134 (lot, C-4 et al);
Christies Lon 6/18/81: 102 (lot, C-1 et al);

**CATHAN** (American)
Photos dated: 1843-1850
Processes:    Daguerreotype
Formats:      Plates
Subjects:     Portraits
Locations:    Studio
Studio:       US - Townshend, Vermont; Boston,
             Massachusetts
   Entries:
Vermont Cat 11/12, 1977: 543 ill(note);

**CAUDER Brothers**
Photos dated: 1860s
Processes:    Ambrotype
Formats:      Plates
Subjects:     Portraits
Locations:    Studio
Studio:       Ireland - Dublin
   Entries:
Christies Lon 10/30/80: 76 (lot, C-1 et al);

**CAULTHURST, Samuel** (British)
Photos dated: 1881
Processes:    Platinum
Subjects:     Genre (rural life)
Locations:    Wales
Studio:       Great Britain
   Entries:
Christies Lon 6/24/80: 1 ill;

**CAVE** (British)
Photos dated: 1850s
Processes:    Ambrotype, calotype
Formats:      Plates, prints
Subjects:     Portraits
Locations:    Studio
Studio:       England - London
   Entries:
Christies Lon 3/16/78: 31 (lot, C-1 et al);

**CAVE, Henry W.** (British)
Photos dated: 1894-1896
Processes:    Photogravure, collotype
Formats:      Prints
Subjects:     Topography
Locations:    Ceylon
Studio:
   Entries:
Wood Conn Cat 37, 1976: 35 ill(book, 47)(note);
Wood Conn Cat 42, 1978: 118 (books, 150)(note);
Phillips Lon 10/28/81: 124 (book);
Swann NY 11/5/81: 55 (book);
Christies Lon 10/25/84: 130 (book, 67);
Christies Lon 4/24/86: 425 (books, 67);
Swann NY 11/13/86: 34 (books);

**CAVILLA, A.**
Photos dated: 1880s
Processes:     Albumen
Formats:       Prints
Subjects:      Topography, ethnography
Locations:     Morocco - Tangier et al
Studio:
  Entries:
Phillips NY 5/5/79: 177 (lot, C & Molinari-7,
  et al);
Christies Lon 6/26/80: 274 (album, C et al);
Rose Florida Cat 7, 1982: 43 ill;

**CHACE & HAWES** (American)
Photos dated: 1860s
Processes:     Ambrotype
Formats:       Plates
Subjects:      Portraits
Locations:     Studio
Studio:        US
  Entries:
Vermont Cat 6, 1973: 597 ill;

**CHAFFERS, Louis** (British)(photographer or author?)
Photos dated: 1872
Processes:     Woodburytype
Formats:       Prints
Subjects:      Documentary (industrial)
Locations:     England
Studio:        England
  Entries:
Swann NY 2/14/52: 77 (book, 227)(note);
Witkin NY V 1977: 37 (book, 224)(note);
Christies Lon 3/10/77: 331 (book, 465);
Christies Lon 6/30/77: 205 (book, 465);
Christies Lon 10/27/77: 222 (lot, C et al);
Christies Lon 6/18/81: 252 (book, 227), 253
  (book, 430);
Swann NY 7/9/81: 76 (book, 224);
Swann NY 4/1/82: 50 (book, 224)(note);
Swann NY 5/5/83: 59 (book, 224)(note);

**CHALOT, I.** (French)
Photos dated: 1870s-1890s
Processes:     Albumen, photogravure
Formats:       Prints, cdvs, cabinet cards
Subjects:      Portraits
Locations:     Studio
Studio:        France
  Entries:
Maggs Paris 1939: 532;
Swann NY 11/11/76: 340 (lot, C et al);
California Galleries 3/30/80: 275 (4);
California Galleries 12/13/80: 225;
Bievres France 2/6/83: 162 (lot, C-1 et al);
Christies Lon 6/23/83: 256 (album, C et al);
Harris Baltimore 3/15/85: 319 (lot, C et al);

**CHAMBERLAIN, William G.** (American)
Photos dated: 1847-1882
Processes:     Daguerreotype, albumen, artotype
Formats:       Plates, prints, stereos
Subjects:      Portraits, topography, ethnography
Locations:     Peru - Lima; US - Colorado and
               Illinois
Studio:        US - Denver, Colorado
  Entries:
California Galleries 4/3/76: 354 (lot, C et al);
Wood Conn Cat 41, 1978: 139 ill(note), 140, 141, 142
  ill, 143, 144, 145 ill, 146;
Swann NY 4/20/78: 37 (book, 3);
Swann NY 4/17/80: 366 (lot, C et al);
Swann NY 11/6/80: 299 (lot, C-1 et al);
California Galleries 12/13/80: 361 (lot, C et al);
Harris Baltimore 12/10/82: 29 (lot, C et al);
Harris Baltimore 4/8/83: 21 (lot, C et al);
Christies Lon 6/23/83: 44 (lot, C et al);
Harris Baltimore 12/16/83: 29 (lot, C-18 et al), 86
  (lot, C et al);
Harris Baltimore 6/1/84: 153 (lot, C et al);
Swann NY 11/14/85: 158 (lot, C et al);
California Galleries 3/29/86: 685 (6), 686 (6);

**CHAMBEY** (French)
Photos dated: Nineteenth century
Processes:     Woodburytype
Formats:       Prints
Subjects:      Portraits incl. Galerie Contemporaine
Locations:     Studio
Studio:        France - Paris
  Entries:
Sothebys NY 2/9/77: 53 (lot, C-1 et al);
Sothebys NY 5/20/77: 43 (lot, C-1 et al);
Swann NY 4/20/78: 321 (lot, C-1 et al);
California Galleries 12/13/80: 57 (books, C et al);
Christies NY 5/14/81: 41 (books, C-1 et al);
Christies NY 5/26/82: 36 (book, C et al);
Christies NY 5/7/84: 19 (book, C et al);

**CHAMPAGNE, A.C.** (French)
Photos dated: 1890s
Processes:     Albumen
Formats:       Prints
Subjects:      Portraits, topography
Locations:     France - Paris
Studio:        France - Paris
  Entries:
Christies NY 5/16/80: 332C (11);
Swann NY 11/5/81: 475 (lot, C et al);
Swann NY 11/14/85: 104 (albums, C et al);

**CHANCELLOR**
Photos dated: 1880s
Processes:     Albumen, platinum
Formats:       Cdvs, prints
Subjects:      Portraits
Locations:     Studio
Studio:        Ireland - Dublin
  Entries:
Christies NY 5/16/80: 126 ill;
Christies Lon 6/24/82: 364 (album, C et al);

CHANDLER & SHEETZ
Photos dated: 1885
Processes:     Albumen
Formats:       Prints
Subjects:
Locations:
Studio:
    Entries:
Wood Boston Cat 58, 1986: 136 (books, C & S-1
    et al);

CHAPIN, Frederick H. (American)
Photos dated: c1875-1888
Processes:     Albumen, cyanotype
Formats:       Prints
Subjects:      Topography
Locations:     US - Colorado
Studio:        US
    Entries:
California Galleries 5/23/82: 259 (21);
California Galleries 6/19/83: 218, 219;

CHAPMAN (British) [CHAPMAN 1]
Photos dated: Nineteenth century
Processes:     Albumen
Formats:       Cdvs
Subjects:      Portraits
Locations:     Studio
Studio:        Wales - Swansea
    Entries:
Christies Lon 3/20/80: 374 (albums, C et al);

CHAPMAN (American) [CHAPMAN 2]
Photos dated: c1890
Processes:     Albumen
Formats:       Cabinet cards
Subjects:      Portraits
Locations:     Studio
Studio:        US
    Entries:
California Galleries 5/23/82: 183 (album, C et al);

CHAPMAN, Captain E.F.
Photos dated: 1873
Processes:     Albumen
Formats:       Prints
Subjects:      Topography
Locations:     Chaina - Yarkund
Studio:
    Entries:
Sothebys Lon 7/1/77: 59 ill(book, C et al);

CHAPMAN, G.T.
Photos dated: between 1870s and 1890s
Processes:     Albumen
Formats:       Prints
Subjects:      Topography
Locations:     New Zealand
Studio:        New Zealand - Aukland
    Entries:
Swann NY 11/13/86: 140 (lot, C et al);

CHAPMAN, James G. (British)
Photos dated: 1895
Processes:
Formats:       Prints
Subjects:      Topography
Locations:     Italy - Rome
Studio:
    Entries:
Christies Lon 3/16/78: 252 (lot, C et al);

CHAPPIUS, P.E.
Photos dated: Nineteenth century
Processes:     Albumen
Formats:       Stereos
Subjects:      Topography
Locations:     England - London
Studio:
    Entries:
Harris Baltimore 4/8/83: 52 (lot, C et al);

CHARCOT, Jean M. (French)
Photos dated: 1876-1880
Processes:     Albumen, photogravure
Formats:       Prints
Subjects:      Documentary (medical)
Locations:     France - Paris
Studio:        France - Paris
    Entries:
Wood Conn Cat 45, 1979: 55 ill(book, 113)(note);
Sothebys NY 5/20/80: 376 (2 ills)(book, 113)(note);
Swann NY 4/23/81: 129 (book, 21)(note);

CHARLES (French)
Photos dated: 1885
Processes:     Carbon
Formats:       Prints
Subjects:      Portraits
Locations:     Studio
Studio:        France
    Entries:
Christies Lon 6/27/78: 172 (book, C-1 et al);
Christies Lon 10/26/78: 229 (book, C-1 et al);
Christies Lon 10/25/79: 431 (book, C-1 et al);

CHARLES, M. (French)
Photos dated: 1857
Processes:     Albumen
Formats:       Prints
Subjects:      Documentary (engineering)
Locations:     France - Bordeaux
Studio:        France
    Entries:
Octant Paris 1982: 15 ill;

CHARLET & JACOTIN (French)
Photos dated: 1860s-1870s
Processes:     Albumen
Formats:       Cdvs
Subjects:      Portraits
Locations:     Studio
Studio:        France
    Entries:
Swann NY 4/14/77: 293 (lot, C & J et al);

CHARLETON, P. & Son
Photos dated: 1890s
Processes:      Bromide
Formats:        Prints
Subjects:       Documentary (military)
Locations:      Ireland - Newbridge
Studio:
   Entries:
Christies Lon 10/25/79: 446 (albums, C-3 et al)
   (note);

CHARLY (French)
Photos dated: 1850s
Processes:      Salt
Formats:        Prints
Subjects:       Topography
Locations:      France
Studio:         France
   Entries:
Sothebys Lon 12/9/83: 67 ill(2);
Christies NY 11/6/84: 14 ill;

CHARNAUX, F.
Photos dated: 1850s-1880s
Processes:      Albumen
Formats:        Prints, stereos, cdvs, cabinet cards
Subjects:       Topography
Locations:      Switzerland
Studio:         Switzerland - Geneva
   Entries:
Rauch Geneva 6/13/61: 223 (lot, C et al);
Rinhart NY Cat 7, 1973: 165;
Swann NY 12/8/77: 369 (lot, C et al);
Rose Boston Cat 3, 1978: 71 ill(note), 72 ill,
   73 ill;
Rose Boston Cat 5, 1980: 108 ill(note);
Christies Lon 3/20/80: 99 (lot, C-4 et al);
Christies Lon 6/26/80: 497 (album, C-6 et al);
Christies Lon 10/30/80: 125 (lot, C-2 et al);
Christies Lon 10/29/81: 144 (lot, C et al);
Christies Lon 6/23/83: 48 (lot, C et al);
Sothebys Lon 6/24/83: 17 (lot, C et al);
California Galleries 7/1/84: 337 (lot, C-2 et al);
Christies NY 2/13/85: 132 (lot, C-4 et al);
Harris Baltimore 2/14/86: 19 (lot, C et al);
Christies Lon 4/24/86: 344 (lot, C et al);

CHARNAY, Désiré (French, 1828-1915)
Photos dated: 1857-1897
Processes:      Albumen
Formats:        Prints, stereos
Subjects:       Topography, portraits
Locations:      Mexico; Argentina; Chile; Yemen; Java;
                Reunion; Madagascar
Studio:         France - Paris
   Entries:
Sothebys NY 5/8/79: 91 ill(note);
Sothebys NY 11/2/79: 235 ill;
Christies NY 5/16/80: 137 ill(note);
Christies Lon 10/30/80: 359 ill;
Koch Cal 1981-82: 32 ill(note);
Christies Lon 6/18/81: 199;
Christies NY 11/10/81: 28 ill(note);
Christies Lon 10/28/82: 85;
Sothebys NY 11/9/82: 172 ill(note);
Christies Lon 3/24/83: 128 ill(26)(attributed)
   (note);
Christies Lon 6/23/83: 126;

CHARNAY, D. (continued)
Christies Lon 10/27/83: 149 (lot, C-20 et al), 149A;
Sothebys Lon 10/26/84: 96 ill(6)(attributed)(note);
Christies NY 11/6/84: 26 ill(3)(note);
Sothebys Lon 3/29/85: 67 ill(5)(attributed)(note);
Sothebys NY 5/7/85: 101 ill(note);
Sothebys Lon 6/28/85: 36 ill(6)(note), 37 (lot, C-4
   attributed, et al);
Sothebys NY 11/12/85: 78A ill(5)(attributed)(note);
Sothebys NY 11/10/86: 83 ill(5)(note);

CHARTERIS, The Honorable Frank (British,
   1844-1870)
Photos dated: late 1860s
Processes:      Albumen
Formats:        Prints
Subjects:       Topography
Locations:      Spain - Seville
Studio:
   Entries:
Sothebys Lon 10/24/79: 126 ill, 127 ill;
Fraenkel Cal 1984: 13 ill(note), 14;

CHASE (American) [CHASE 1]
Photos dated: 1850s
Processes:      Daguerreotype
Formats:        Plates
Subjects:       Portraits
Locations:      Studio
Studio:         US - Washington, D.C.
   Entries:
Petzold Germany 11/7/81: 129;
Sothebys NY 11/10/86: 308 (lot, C-1 et al);

CHASE & GREW [CHASE 2]
Photos dated: c1880
Processes:      Albumen
Formats:        Prints
Subjects:       Topography
Locations:      US - Colorado
Studio:
   Entries:
California Galleries 349 (lot, C & G-4 et al);

CHASE & HATCH (American) [CHASE 3]
Photos dated: 1865
Processes:      Albumen
Formats:        Prints
Subjects:       Documentary (public events)
Locations:      US - Washington, D.C.
Studio:         US
   Entries:
Swann NY 4/1/82: 322;

CHASE, D.B. (American)
Photos dated: 1870s-c1890
Processes:      Albumen
Formats:        Prints, stereos
Subjects:       Ethnography, topography
Locations:      US - Santa Fe, New Mexico
Studio:         US - Santa Fe, New Mexico
   Entries:
Sothebys LA 2/6/80: 71 (lot, C-6 et al);
Phillips Can 10/9/80: 32 (lot, C et al);
Harris Baltimore 7/31/81: 95 (lot, C et al);

**CHASE, D.B.** (continued)
California Galleries 5/23/82: 379, 380;
Harris Baltimore 12/16/83: 305 (lot, C-1 et al);

**CHASE, H.L.** (American)
Photos dated: 1871-c1890
Processes:      Albumen
Formats:        Prints, cdvs, stereos, cabinet cards
Subjects:       Topography, ethnography, portraits,
                documentary (medical)
Locations:      Hawaii; Fiji; Bermuda
Studio:         Hawaii - Honolulu
    Entries:
Sothebys NY (Strober Coll.) 2/7/70: 279 (lot,
    C et al);
California Galleries 9/27/75: 375 (lot, C et al);
California Galleries 1/22/77: 112 (lot, C et al);
Swann NY 4/14/77: 268 (18)(attributed);
California Galleries 1/21/79: 235 (lot, C et al);
Swann NY 4/23/81: 467 ill(lot, C et al);
Swann NY 11/5/81: 474 (lot, C et al);
California Galleries 7/1/84: 543 (7);

**CHASE, Lorenzo G.** (American)
Photos dated: 1844-1855
Processes:      Daguerreotype
Formats:        Plates
Subjects:       Portraits
Locations:      Studio
Studio:         US - Boston, Massachusetts
    Entries:
Vermont Cat 7, 1974: 494 ill;
Vermont Cat 9, 1975: 409 ill;
Rose Boston Cat 4, 1979: 136 ill;
Christies NY 2/8/83: 76 (lot, C-2 et al), 77
    (lot, C-1 et al);
Swann NY 5/9/85: 360 (lot, C-1 et al);
Swann NY 11/14/85: 45 (lot, C-1 et al);

**CHASE, William M.** (American)
Photos dated: 1860s-1885
Processes:      Albumen
Formats:        Prints, stereos
Subjects:       Portraits, topography
Locations:      US - New York; Maryland; Pennsylvania
Studio:         US - Baltimore, Maryland
    Entries:
Sothebys NY (Strober Coll.) 2/7/70: 481 (lot,
    et al), 483 (lot, C-20 et al);
Rinhart NY Cat 1, 1971: 195 (lot, C et al);
Rinhart NY Cat 2, 1971: 451 (3);
Vermont Cat 5, 1973: 538 (lot, C et al);
Christies Lon 6/18/81: 78 (lot, C-4 et al);
Harris Baltimore 7/31/81: 128 (lot, C et al);
Harris Baltimore 3/26/82: 23 (lot, C-2 et al);
Harris Baltimore 5/28/82: 151 (lot, C-1 et al);
Harris Baltimore 12/10/82: 68 (lot, C et al);
Harris Baltimore 4/8/83: 7 (lot, C-13 et al), 69
    (lot, C et al), 72 (lot, C et al), 88 (lot,
    C et al);
Christies Lon 6/23/83: 44 (lot, C et al);
Harris Baltimore 9/16/83: 205 (lot, C-1 et al);
Swann NY 11/10/83: 334;
Harris Baltimore 12/16/83: 91 (lot, C et al), 141
    (lot, C et al), 143 (lot, C et al);
Harris Baltimore 6/1/84: 9 (lot, C et al), 156
    (lot, C et al);
Swann NY 11/8/84: 265 (lot, C et al);

**CHASE, W.M.** (continued)
Harris Baltimore 3/15/85: 7 (lot, C-4 et al), 11
    (lot, C et al), 75 (lot, C-2 et al), 111 (lot,
    C-7 et al);
Sothebys Lon 3/29/85: 47 (lot, C-9 et al);
Swann NY 11/14/85: 167 (lot, C et al), 168 (lot,
    C et al);

**CHATSWORTH & HADDON**
Photos dated: c1870
Processes:      Albumen
Formats:        Prints
Subjects:       Topography
Locations:
Studio:
    Entries:
White LA 1977: 250 (12);

**CHEDSON, W.** (British)
Photos dated: 1860s
Processes:      Albumen
Formats:        Prints
Subjects:
Locations:
Studio:         Great Britain (Amateur Photographic
                Association)
    Entries:
Sothebys Lon 10/29/80: 310 (album, C et al);

**CHENEY, Edward** (British)
Photos dated: 1850-1860
Processes:      Albumenized salt, albumen
Formats:        Prints
Subjects:       Topography
Locations:      Ireland
Studio:         Ireland
    Entries:
Lunn DC Cat QP, 1978: 11 ill(note);
Phillips NY 11/4/78: 16 ill(note), 17 (note), 18 ill
    (note), 19 (note);
Phillips Lon 3/13/79: 36 ill(2)(note);
Swann NY 4/23/81: 315 (note);
Christies NY 11/10/81: 9 ill, 10, 11;

**CHENEY, Robert Henry** (British, c1800-1866)
Photos dated: 1850s
Processes:      Albumenized salt, albumen
Formats:        Prints
Subjects:       Architecture
Locations:      England - Canterbury et al
Studio:         England
    Entries:
Christies Lon 3/10/77: 71 (2 ills)(album, 120)
    (note), 27 (album, 118)(note);
Christies Lon 3/16/78: 292 (album, C-3 et al);
Christies Lon 10/30/80: 160 ill(note), 161;
Swann NY 11/5/81: 293;
Swann NY 11/14/85: 54 (note), 55, 56, 57;

CHEONG, Hung (Chinese)
Photos dated: 1870s
Processes:      Albumen
Formats:        Cdvs
Subjects:       Topography
Locations:      Japan
Studio:         Japan - Yokohama
    Entries:
Swann NY 11/8/84: 240 (album, C-6 et al);

CHERBULIEZ, Victor (photographer or author?)
Photos dated: 1860
Processes:      Salt
Formats:        Prints
Subjects:       Documentary (art)
Locations:      Europe
Studio:         Europe
    Entries:
Vermont Cat 4, 1972: 608 ill;

CHERRIL, N.K. (British)
Photos dated: 1860s
Processes:      Albumen
Formats:        Prints
Subjects:
Locations:
Studio:         Great Britain (Amateur Photographic
                Association)
    Entries:
Sothebys Lon 10/29/80: 310 (album, C et al);
Christies Lon 10/27/83: 218 (albums, C-2 et al);

CHERRILL (see ROBINSON & CHERRILL)

CHERRY, Edgar
Photos dated: 1884
Processes:      Albumen
Formats:        Prints
Subjects:       Documentary (industrial)
Locations:      US - California
Studio:
    Entries:
Frontier AC, Texas 1978: 245 ill(book, 24)
    (attributed);

CHESSMAN (see PAGE & CHESSMAN)

CHEVALIER, Vincent (French)
Photos dated: c1840
Processes:      Daguerreotype
Formats:        Plates
Subjects:       Architecture
Locations:      France - Paris
Studio:         France
    Entries:
Drouot Paris 11/22/86: 107 ill;

CHEVOJON (French)
Photos dated: 1870s
Processes:      Photogravure
Formats:        Prints
Subjects:       Architecture
Locations:      France
Studio:         France
    Entries:
Rose Boston Cat 4, 1979: 22 ill(note), 23 ill,
    24 ill;
Rose Boston Cat 5, 1980: 49 ill(note);

CHICKERING, Elmer (American)
Photos dated: 1870s-1894
Processes:      Albumen
Formats:        Prints, cabinet cards
Subjects:       Topography, portraits
Locations:      US - Massachusetts; New Hampshire
Studio:         US - Boston, Massachusetts
    Entries:
Vermont Cat 2, 1971: 248 (lot, C-1 et al);
Swann NY 11/11/76: 479;
Witkin NY VI 1978: 35 ill;
Harris Baltimore 6/1/84: 255;
Swann NY 11/8/84: 149 (lot, C et al);

CHIDSON, W.D. (British)
Photos dated: 1860s
Processes:      Albumen
Formats:        Prints
Subjects:       Genre
Locations:
Studio:         Great Britain (Amateur Photographic
                Association)
    Entries:
Christies Lon 10/29/81: 359 (album, C-2 et al)
    (note);
Christies Lon 10/27/83: 218 (albums, C-2 et al);
Christies Lon 3/29/84: 202 (2)(note);
Christies Lon 6/27/85: 155 ill(album, C et al)
    (note);

CHILD (American)
Photos dated: 1860s
Processes:      Ambrotype
Formats:        Plates
Subjects:       Portraits
Locations:      Studio
Studio:         US - Taunton, Massachusetts
    Entries:
Vermont Cat 6, 1973: 596 ill;

CHILD, Thomas
Photos dated: c1870-c1889
Processes:      Albumen
Formats:        Prints
Subjects:       Topography
Locations:      China - Peking et al
Studio:         China - Peking
    Entries:
Sothebys NY 2/25/75: 164 (lot, C-7 et al);
Sothebys Lon 6/26/75: 142 ill(album, C-21 et al);
Christies NY 5/4/79: 62 (lot, C et al)(note);
Sothebys NY 5/20/80: 405 ill(album, C et al), 414
    (album, C-2 et al);
Sothebys Lon 10/29/80: 111 (album, C et al);
Christies Lon 3/26/81: 241 (album, C-9 et al);

CHIT, F.
Photos dated: c1868-1870s
Processes:      Albumen
Formats:        Prints, cdvs
Subjects:       Topography, portraits, ethnography
Locations:      Siam
Studio:         Siam - Bangkok
    Entries:
Christies Lon 3/24/83: 101 ill(4);

CHMIELEWSKI, J.
Photos dated: Nineteenth century
Processes:      Albumen
Formats:        Cdvs
Subjects:       Topography, portraits
Locations:      Russia
Studio:
    Entries:
Phillips NY 11/3/79: 128 (album, C et al);

CHOATE, J.N. (American)
Photos dated: 1870s-early 1890s
Processes:      Albumen
Formats:        Prints, cdvs
Subjects:       Ethnography, documentary (educational
                institutions)
Locations:      US - Carlisle, Pennsylvania
Studio:         US - Carlisle, Pennsylvania
    Entries:
Sothebys NY (Weissberg Coll.) 5/16/67: 179 (lot, C-3
    et al);
Swann NY 5/5/83: 271 ill(8)(note);

CHOLMONDELY, H.T. (British)
Photos dated: 1860s
Processes:      Albumen
Formats:        Prints
Subjects:
Locations:
Studio:         Great Britain (Amateur Photographic
                Association)
    Entries:
Christies Lon 10/27/83: 218 (albums, C-1 et al);

CHOW-KWA (Chinese)
Photos dated: 1860s
Processes:      Albumen
Formats:        Cdvs
Subjects:
Locations:
Studio:         China
    Entries:
Christies Lon 3/16/78: 101 (album, C et al);

CHRISTMANN, S.P. (German)(see also DEGOIX, G.)
Photos dated: 1867-1873
Processes:      Albumen
Formats:        Prints, stereos, cdvs
Subjects:       Topography, genre
Locations:      Germany; Italy
Studio:         Germany - Berlin; France - Paris
    Entries:
Christies Lon 3/11/82: 67 (lot, C et al);
Harris Baltimore 12/16/83: 128 (lot, C et al);
Swann NY 11/14/85: 86 (lot, C-1 et al);

CHILD, T. (continued)
Sothebys Lon 6/17/81: 188 (lot, C-1 et al);
Christies Lon 3/11/82: 197 (album, C-3 et al);
Sothebys Lon 10/29/82: 33 ill(album, C-26 et al)
    (note);
Christies Lon 10/27/83: 112 (album, C-1 et al);
Christies Lon 3/29/84: 81 ill(album, C-20 et al),
    82 ill(album, C-15 et al);
Christies Lon 6/28/84: 102 (lot, C-30 et al)(note),
    103 (album, C-1 et al), 135 (album, C et al);
Sothebys Lon 6/29/84: 89 (album, C et al), 90 ill
    (album, C-24 et al), 91 ill(albums, C et al);
Christies Lon 10/25/84: 98 (album, C et al);
Sothebys Lon 3/29/85: 95 (lot, C-6 et al);
Christies Lon 6/27/85: 79 (albums, C et al)(note);
Sothebys Lon 6/28/85: 72 ill(album, 45);
Swann NY 5/15/86: 94 (books, C et al)(note);
Christies Lon 10/30/86: 144 (album, C-15 et al);
Swann NY 11/13/86: 49 (books, C et al), 357 (lot,
    C et al);

CHILDE, A.M. (British)
Photos dated: 1860s
Processes:      Albumen
Subjects:       Genre
Locations:      Great Britain
Studio:         Great Britain
    Entries:
Christies Lon 10/28/76: 222 ill(album, C et al);

CHILDS, F.F. (American)
Photos dated: c1875
Processes:      Albumen
Formats:        Stereos
Subjects:       Topography
Locations:      US - Michigan
Studio:         US - St. Marquette, Michigan
    Entries:
Swann NY 10/18/79: 404 (16);

CHILTON (American)
Photos dated: 1850s
Processes:      Daguerreotype
Formats:        Plates
Subjects:       Portraits
Locations:      Studio
Studio:         US
    Entries:
Anderson NY (Gilsey Coll.) 1/20/03: 986;

CHISHOLM, C.R.
Photos dated: 1870s
Processes:      Albumen
Formats:        Stereos
Subjects:       Topography
Locations:      Canada
Studio:         Canada - Montreal
    Entries:
Swann NY 4/23/81: 523 (lot, C et al);

CHUCK (Australian)
Photos dated: 1880s
Processes:      Gelatin silver
Formats:        Prints
Subjects:       Topography
Locations:      Australia - Melbourne
Studio:         Australia - Melbourne
    Entries:
Christies Lon 10/30/86: 173 ill(album, 64);

CHURCH, W., Jr. (British)
Photos dated: 1860s
Processes:      Albumen
Formats:        Prints
Subjects:
Locations:
Studio:         Great Britain (Amateur Photographic
                Association)
    Entries:
Christies Lon 10/27/83: 218 (albums, C-2 et al);
Sothebys Lon 3/29/85: 159 (lot, C et al);

CHURCH, William (American)
Photos dated: 1860
Processes:      Ambrotype
Formats:        Plates
Subjects:       Portraits
Locations:      US
Studio:         US
    Entries:
Sothebys NY 5/20/80: 272 (note);

CHURCHILL & DENISON (American)
Photos dated: 1864
Processes:      Albumen
Formats:        Cdvs, prints
Subjects:       Portraits, documentary (public events)
Locations:      US - New York
Studio:         US - Albany, New York
    Entries:
Sothebys NY (Greenway Coll.) 11/20/70: 139 ill;
Sothebys NY 9/23/75: 88 ill(lot, C & D et al)(note);
Sothebys NY 11/9/76: 70 (book, 165)(note);
Phillips NY 11/4/78: 77 (album, 165);
Phillips NY 5/21/80: 292 (album, 15);
Rose Florida Cat 7, 1982: 85 ill;
Harris Baltimore 12/16/83: 209 (book, 15);

CHURCHILL, R.E. (American)
Photos dated: 1850s-1879
Processes:      Daguerreotype, albumen
Formats:        Plates, prints, stereos
Subjects:       Portraits
Locations:      US - Albany, New York
Studio:         US - Albany, New York
    Entries:
Sothebys Lon 10/18/74: 234 ill;
Swann NY 5/5/83: 60 (book, 35)(note);
Swann NY 5/9/85: 263 (book, 37)(note), 434
    (lot, C et al);

CHUTE & BROOKS
Photos dated: 1875
Processes:      Albumen
Formats:        Prints
Subjects:       Topography
Locations:      Uruguay - Montevideo
Studio:         Uruguay - Montevideo
    Entries:
California Galleries 6/19/83: 100 (book,
    C & B-1 et al);

CIAPPEI, Francesco (Italian)
Photos dated: 1880s-1890s
Processes:      Albumen
Formats:        Prints
Subjects:       Topography
Locations:      Italy
Studio:         Italy - Rome
    Entries:
Swann NY 12/8/77: 384 (lot, C et al);

CITY STEREOSCOPIC DEPOT (British)
Photos dated: c1855-1860s
Processes:      Albumen, collodion on glass
Formats:        Stereos
Subjects:       Topography, genre
Locations:      Great Britain
Studio:         Great Britain
    Entries:
Christies Lon 6/10/76: 107 ill(note), 108 ill;
Christies Lon 10/25/84: 40 (lot, C-2 et al);

CIVIALE, Aimé (French, 1821-1893)
Photos dated: 1857-1882
Processes:      Albumen, heliogravure
Formats:        Prints incl. panoramas
Subjects:       Topography
Locations:      France - Pyrenees, Alps; Switzerland;
                Italy
Studio:         France - Paris
    Entries:
Swann NY 4/1/82: 53 (book, 14)(note);

CLAPP, Edward H. (American)
Photos dated: 1860s
Processes:      Ambrotype
Formats:        Plates
Subjects:       Portraits
Locations:      Studio
Studio:         US - Springfield, Massachusetts
    Entries:
Vermont Cat 4, 1972: 401 ill;

CLARE, E.A. (British)
Photos dated: 1890s
Processes:
Formats:        Prints
Subjects:
Locations:      Great Britain
Studio:         England (West Kent Photographic
Society)
    Entries:
Christies Lon 6/27/85: 260 (lot, C et al);

**CLARIDGE, William** (British)
Photos dated: c1860
Processes:      Albumen
Formats:        Prints
Subjects:       Portraits, topography, genre
Locations:      England - Berkhampstead
Studio:         England - Berkhampstead
   Entries:
Sothebys Lon 3/14/79: 266 (4 ills)(4);
Sothebys Lon 3/25/83: 111 (2 ills)(album, 240)
   (note);
Sothebys Lon 6/28/85: 207 ill(album, 49);

**CLARK** (see CORWIN & CLARK) [CLARK 1]

**CLARK** [CLARK 2]
Photos dated: 1850s
Processes:      Daguerreotype
Formats:        Plates
Subjects:       Portraits
Locations:      Studio
Studio:         Canada - New Brunswick
   Entries:
Sothebys NY (Weissberg Coll.) 5/16/67: 162 (lot,
   C-1 et al);

**CLARK** (American) [CLARK 3]
Photos dated: 1860s
Processes:      Albumen
Formats:        Cdvs
Subjects:       Portraits
Locations:      Studio
Studio:         US
   Entries:
Sothebys NY (Greenway Coll.) 11/20/70: 235 (lot,
   C-1 et al);

**CLARK** (American) [CLARK 4]
Photos dated: 1870s
Processes:      Albumen
Formats:
Subjects:       Topography
Locations:      US - Colorado
Studio:         US
   Entries:
Swann NY 4/17/80: 366 (lot, C et al);

**CLARK & HOLMES** (American) [CLARK 5]
Photos dated: 1850s
Processes:      Daguerreotype, ambrotype
Formats:        Plates
Subjects:       Portraits
Locations:      Studio
Studio:         US - Troy, New York
   Entries:
Gordon NY 5/3/76: 268 (lot, C & H et al);
Christies Lon 10/31/85: 33 (lot, C & H-1 et al);

**CLARK, John** (also listed CLARKE, J.)
Photos dated: 1860s
Processes:      Albumen
Formats:        Stereos
Subjects:       Topography
Locations:      England
Studio:         England - Matlock
   Entries:
Sothebys Lon 10/29/80: 14 (lot, C et al);
Christies Lon 3/11/82: 82 (lot, C-1 et al);

**CLARK, L.H.** (American)
Photos dated: Nineteenth century
Processes:      Albumen
Formats:        Stereos
Subjects:       Topography
Locations:      US - Rhode Island
Studio:         US
   Entries:
Harris Baltimore 3/15/85: 86 (lot, C-3 et al);

**CLARK, R.H.**
Photos dated: 1880s-1902
Processes:      Albumen, silver
Formats:        Prints, cabinet cards
Subjects:       Topography, ethnography
Locations:      US - Arizona
Studio:         US - Whiteriver, Arizona
   Entries:
Christies NY 10/4/85: 111 (lot, C-15 et al), 113
   (lot, C-2 et al);

**CLARKE & Co.** (British) [CLARKE 1]
Photos dated: 1860s and/or 1870s
Processes:      Albumen
Formats:        Prints
Subjects:       Topography
Locations:      India
Studio:
   Entries:
Christies Lon 3/29/84: 68 (lot, C et al);
Sothebys Lon 10/26/84: 66 (album, C et al);

**CLARKE** (British) [CLARKE 2]
Photos dated: 1876
Processes:      Albumen
Formats:        Prints
Subjects:       Documentary (military)
Locations:      England - Lowestoft
Studio:         Great Britain
   Entries:
California Galleries 3/30/80: 300;

**CLARKE, George Calvert**
Photos dated: Nineteenth century
Processes:
Formats:
Subjects:       Genre (street life)
Locations:
Studio:
   Entries:
Christies Lon 10/25/79: 407 (album, C-4 et al);

CLARKE, J.H. [CLARKE, J.H. 1]
Photos dated: 1860s
Processes:      Albumen
Formats:        Prints, cdvs
Subjects:       Topography
Locations:      India - Allalabad and Mussoorie
Studio:
    Entries:
Sothebys Lon 11/18/77: 101 (album, C-2 et al);
Christies Lon 3/11/82: 176 (album, C et al);
Christies Lon 3/28/85: 329 (album, C-1 et al);
Christies Lon 6/27/85: 274 (lot, C et al);

CLARKE, J.H. (Canadian) [CLARKE, J.H. 2]
Photos dated: 1880s
Processes:      Albumen
Formats:        Prints
Subjects:       Topography
Locations:      Canada
Studio:         Canada - Manitoba
    Entries:
Phillips Can 10/4/79: 80 (2);

CLARKE, J. Palmer (British)
Photos dated: 1880s-1890s
Processes:      Albumen, carbon, platinum
Formats:        Cabinet cards
Subjects:       Portraits, topography
Locations:      England - Cambridge
Studio:         England
    Entries:
Sothebys NY 5/2/77: 161 (albums, C-8 et al)(note);
Christies Lon 10/25/79: 131 (9);

CLARKE, J.W. (British)
Photos dated: 1860s and/or 1870s
Processes:      Albumen
Formats:        Cdvs
Subjects:       Genre
Locations:      Great Britain
Studio:         England - Bury St. Edmunds
    Entries:
Christies Lon 3/10/77: 273 (lot, C-1 et al);

CLARKE, Captain Melville (British)
Photos dated: 1861-1862
Processes:      Albumen
Formats:        Prints
Subjects:       Topography
Locations:      India
Studio:
    Entries:
Colnaghi Lon 1976: 276 (note), 277;
Sothebys Lon 10/29/76: 158 ill(album, C-34 et al)
    (note);

CLARKE, W.V.E. (British)
Photos dated: 1890s
Processes:
Formats:        Prints
Subject:
Locations:      Great Britain
Studio:         England (West Kent Photographic
Society)
    Entries:
Christies Lon 6/27/85: 260 (lot, C et al);

CLARKINGTON (see BEARD, R.) [CLARKINGTON 1]

CLARKINGTON (British) [CLARKINGTON 2]
Photos dated: 1860s-c1865
Processes:      Ambrotype, albumen
Formats:        Plates, cdvs
Subjects:       Portraits
Locations:      Studio
Studio:         England - London
    Entries:
Vermont Cat 6, 1973: 598 ill;
Sothebys Lon 3/21/80: 234;

CLARK-KENNEDY, Alexander W.M. (British)
            (photographer?)
Photos dated: 1868
Processes:      Albumen
Formats:        Prints, cdvs
Subjects:       Documentary (animal life)
Locations:      England - Berkshire; Buckinghamshire
Studio:         England
    Entries:
Christies Lon 10/25/79: 274 (book, 4);
Christies Lon 6/26/80: 316 (book, 4)(note);
Swann NY 11/6/80: 114 (book, 4);
Christies Lon 3/29/84: 113 (book, 4);

CLARY & URIE (American)
Photos dated: c1877-1880s
Processes:      Albumen
Formats:        Stereos
Subjects:       Topography
Locations:      US - Hot Springs, Arkansas
Studio:         US - Hot Springs, Arkansas
    Entries:
Swann NY 10/18/79: 400 (10);

CLAUDE, F. May
Photos dated: 1870s
Processes:      Albumen
Formats:        Prints
Subjects:       Genre (animal life)
Locations:
Studio:
    Entries:
Sothebys Lon 6/25/82: 231 (3);

CLAUDER, H.T. (American)
Photos dated: 1860s-1870s
Processes:      Albumen
Formats:        Stereos
Subjects:       Topography
Locations:      US - Pennsylvania
Studio:         US
    Entries:
Harris Baltimore 3/26/82: 12 (lot, C et al);

CLAUDET, Antoine François-Jean (French, 1798-1867)
Photos dated: 1841-1863
Processes:      Daguerreotype, calotype, albumen
Formats:        Plates incl. stereo, prints, cdvs
Subjects:       Portraits, architecture, documentary,
                genre
Locations:      England - London; Portugal
Studio:         England - London
  Entries:
Swann NY 2/14/52: 85 (note);
Sothebys NY (Strober Coll.) 2/7/70: 126 (note);
Sothebys Lon 5/24/73: 141;
Christies Lon 6/14/73: 140 (lot, C-1 et al);
Sothebys Lon 12/4/73: 180 ill, 183, 184, 190 ill
  (note);
Vermont Cat 7, 1974: 495 ill;
Sothebys Lon 3/8/74: 139;
Sothebys Lon 6/21/74: 119a (lot, C-1 et al), 128,
  149 (2 ills)(2);
Christies Lon 7/25/74: 264 ill(8)(note);
Sothebys Lon 10/18/74: 195 (2 ills)(2), 198 ill,
  236, 243;
Vermont Cat 10, 1975: 537 ill;
Sothebys Lon 3/21/75: 205 (2), 211;
Sothebys Lon 6/26/75: 158a (lot, C-1 et al), 168,
  169, 181 ill;
Sothebys Lon 10/24/75: 25 ill, 26, 27, 52 ill, 53
  ill, 54 ill;
Colnaghi Lon 1976: 5 ill(note), 6;
Sothebys Lon 3/19/76: 60 ill, 61 ill, 96, 97, 98,
  102 ill(note), 103 ill(note), 104 ill(note), 105
  (note), 106 ill, 107 ill(note), 108 ill(note),
  157 (album, C et al);
Sothebys NY 5/4/76: 2, 3 (note), 4, 5 (3), 6, 7 ill
  (note), 8 ill, 9;
Christies Lon 6/10/76: 8, 9 ill;
Sothebys Lon 6/11/76: 88 (note), 147, 148 (note),
  150 ill;
Christies Lon 10/28/76: 18 ill, 19, 20 ill, 21 (2),
  22, 23 ill, 24 ill;
Sothebys Lon 10/29/76: 39, 40 (2), 195 (lot, C-1
  et al);
Gordon NY 11/13/76: 48 (albums, C et al);
Sothebys Lon 3/9/77: 14 ill, 15 ill, 16 ill, 108,
  109 ill;
Christies Lon 3/10/77: 13 ill, 14 (note), 15 (lot,
  C-1 et al), 195 ill;
Christies Lon 6/30/77: 6, 7 (2), 8, 9;
Sothebys Lon 7/1/77: 13, 14 ill, 15 ill, 16, 17,
  229, 230 (2);
Sothebys NY 10/4/77: 173;
Christies Lon 10/27/77: 5, 6, 186 ill, 187 ill, 188
  (2), 370 (albums, C et al);
Sothebys Lon 11/18/77: 25 ill, 26 ill, 165, 166,
  167, 168, 169;
Christies Lon 3/16/78: 5 (lot, C-1 et al), 155, 156
  ill, 157 ill, 158 ill, 159 ill;
Sothebys Lon 3/22/78: 145 ill;
Christies Lon 6/27/78: 3 (note), 47 ill, 48, 49;
Sothebys Lon 6/28/78: 6 ill, 7 ill, 8 (2), 10 ill,
  11 ill, 12 ill, 167 (lot, C-2 et al), 227 ill
  (note);
Christies Lon 10/26/78: 3, 75, 76, 77;
Sothebys Lon 10/27/78: 42 ill;
Witkin NY IX 1979: 1;
Sothebys Lon 3/14/79: 8;
Christies NY 5/4/79: 3;
Christies Lon 6/28/79: 65;
Sothebys Lon 6/29/79: 44 (lot, C-1 et al), 45 ill
  (note), 46, 47 (lot, C-1 et al), 48, 49 (lot,
  C-1 et al);

CLAUDET (continued)
Sothebys Lon 10/24/79: 65, 233, 234, 302;
Christies Lon 10/25/79: 1, 2, 3, 4, 394 (album,
  C-1 et al);
Phillips Lon 3/12/80: 98, 100 (lot, C-1 et al),
  105 ill;
Christies Lon 3/20/80: 9;
Sothebys Lon 3/21/80: 58 ill, 59, 60, 61 ill, 62,
  78 ill, 82 ill(note);
Phillips Lon 6/25/80: 87;
Christies Lon 6/26/80: 1, 2, 23 ill, 92 ill, 94, 476
  (album, C-1 et al);
Sothebys Lon 6/27/80: 28, 226;
Sothebys Lon 10/29/80: 23, 128 ill(note), 261
  (album, C et al);
Christies Lon 10/30/80: 6, 7, 8, 9, 429 (lot,
  C-1 et al);
Christies NY 11/11/80: 1 (note);
Phillips Lon 3/18/81: 98, 99 (lot, C-1 et al), 103B;
Christies Lon 3/26/81: 105 ill(note), 106 ill
  (note), 386 (album, C-3 et al);
Sothebys Lon 3/27/81: 183, 184, 185, 350 ill, 351
  ill, 352 ill, 353 ill;
Petzold Germany 5/22/81: 1798 ill;
Sothebys Lon 6/17/81: 24 ill, 42 (2), 72;
Christies Lon 6/18/81: 3, 55, 421 (albums,
  C-3 et al);
Phillips Lon 6/24/81: 74;
Phillips Lon 10/28/81: 142 (lot, C-1 et al);
Sothebys Lon 10/28/81: 45 ill, 46 ill, 50 ill, 292
  ill, 293 ill, 294 ill;
Christies Lon 3/11/82: 7 (2);
Sothebys Lon 3/15/82: 235 (lot, C et al);
Phillips Lon 6/23/82: 141 (lot, C-1 et al);
Christies Lon 6/24/82: 33;
Sothebys Lon 6/25/82: 19 ill, 21 ill, 39, 40, 41
  (attributed), 42;
Christies Lon 10/28/82: 201 (album, C et al);
Sothebys Lon 10/29/82: 7 ill, 8 (3), 12 ill(2);
Christies Lon 3/24/83: 20 ill(note);
Sothebys Lon 3/25/83: 6 ill, 13 ill(note), 15 ill;
Christies Lon 6/23/83: 116 ill(book, 15), 252
  (album, C et al);
Sothebys Lon 6/24/83: 6 ill, 7 ill(note), 9 ill, 10
  ill, 11 ill;
Christies Lon 10/27/83: 1 (lot, C-1 et al), 2 ill
  (lot, C-4 attributed, et al), 10 ill, 11 (2 ills)
  (2), 232 (album, C et al), 233 (album, C et al);
Swann NY 11/10/83: 203;
Sothebys Lon 12/9/83: 4 ill;
Christies Lon 3/29/84: 173 (book, 15), 337 (album,
  C et al);
Christies Lon 6/28/84: 13 ill(note), 14 (4 ills)(4)
  (note), 15 ill, 17 ill, 18 ill, 19 ill, 20;
Sothebys Lon 6/29/84: 27 ill, 28 ill, 29, 30, 31;
Phillips Lon 10/24/84: 80 (lot, C-1 et al), 82 ill,
  95 ill;
Christies Lon 10/25/84: 15, 16, 17, 28, 29 ill, 30,
  31 ill, 33, 178 (book, 15), 320 (album, C et al);
Sothebys Lon 10/26/84: 21 ill(note), 178 (albums,
  C et al);
Phillips Lon 3/27/85: 129 (2);
Christies Lon 3/28/85: 27, 27A ill, 28, 176 (lot,
  C et al)(note), 319 (album, C et al);
Sothebys Lon 3/29/85: 46, 47 (2), 48, 49 (2);
Phillips Lon 6/26/85: 162 (album, C et al);
Christies Lon 6/27/85: 18;
Sothebys Lon 6/28/85: 22 (2);
Phillips Lon 10/30/85: 32 (lot, C-1 et al);

**CLAUDET** (continued)
Christies Lon 10/31/85: 23 (lot, C-1 et al), 24
    (lot, C-1 et al), 25 (lot, C-1 et al)(note), 26,
    51 ill, 52, 53, 302 (album, C et al);
Sothebys Lon 11/1/85: 9 ill(note), 10 ill, 11 ill,
    12 ill(2);
Christies NY 11/11/85: 136 ill;
Phillips Lon 4/23/86: 205 (lot, C-1 et al), 226
    (album, C-1 et al);
Christies Lon 4/24/86: 321 (3)(note), 322 ill;
Sothebys Lon 4/25/86: 13 ill;
Christies Lon 6/26/86: 103 (albums, C et al);
Phillips Lon 10/29/86: 277 (lot, C-1 et al), 301
    (lot, C-1 et al);
Christies Lon 10/30/86: 20, 20A, 21, 217 (albums,
    C et al), 252 (album, C et al);
Christies NY 11/11/86: 125 ill(note);
Swann NY 11/13/86: 185 (lot, C-1 et al), 326;

**CLAYTON** (see BELL & CLAYTON)

**CLEMENS**
Photos dated: c1858
Processes:      Albumen
Formats:        Cdvs
Subjects:       Portraits
Locations:      Studio
Studio:         Germany - Frankfurt
    Entries:
Petzold Germany 11/7/81: 324 (album, C-1 et al);

**CLEMENT** (French)
Photos dated: 1850s
Processes:      Daguerreotype
Formats:        Plates
Subjects:       Portraits
Locations:      Studio
Studio:         France
    Entries:
Rauch Geneva 6/13/61: 40 (lot, C-1 et al);

**CLEMENT & Cie** (see BRAUN)

**CLEMENTS, Alfred**
Photos dated: 1896
Processes:      Photogravure
Formats:        Prints
Subjects:       Genre
Locations:      England - Surrey
Studio:
    Entries:
California Galleries 1/21/79: 418;
California Galleries 3/30/80: 278;

**CLERK, I.** (British)
Photos dated: 1860s-1869
Processes:      Albumen
Formats:        Prints
Subjects:
Locations:      Great Britain
Studio:         Great Britain (Amateur Photographic
                Association)
    Entries:
Sothebys Lon 10/18/74: 158 (album, C et al);
Sothebys Lon 10/29/80: 310 (album, C et al);

**CLERK, I.** (continued)
Christies Lon 10/27/83: 218 (albums, C-4 et al);
Sothebys Lon 3/29/85: 159 (lot, C et al);

**CLERQ, Louis de** (French)
Photos dated: 1859-1860
Processes:      Albumen
Formats:        Prints incl. panoramas
Subjects:       Topography
Locations:      Syria; Palestine; Egypt; Spain
Studio:
    Entries:
Christies NY 5/9/83: 47 ill(note);

**CLEVELAND, R.D.** (American)
Photos dated: 1883
Processes:      Albumen
Formats:        Prints
Subjects:       Topography
Locations:      Mexico; US - Nebraska, Colorado, New
                Mexico
Studio:
    Entries:
California Galleries 4/2/76: 165 (book, 33);
Swann NY 11/11/76: 292 (book, 33);
Swann NY 12/14/78: 231 (book, 33);
Sothebys NY 5/8/79: 19 (books, C et al);
Wood Conn Cat 49, 1982: 432 (book, 33)(note);

**CLIFFORD** (American)
Photos dated: 1850s
Processes:      Ambrotype
Formats:        Plates
Subjects:       Portraits
Locations:      Studio
Studio:         US - New York City
    Entries:
Christies Lon 3/11/82: 31 (lot, C-1 et al);

**CLIFFORD, Charles** (British, 1819 or 1820-1863)
Photos dated: 1852-1863
Processes:      Albumen
Formats:        Prints, stereos, cdvs
Subjects:       Topography, portraits
Locations:      Spain; Russia - Crimea
Studio:         Spain - Madrid
    Entries:
Rinhart NY Cat 2, 1971: 227;
Anderson & Hershkowitz Lon 1976: 17 ill, 18 ill, 19
    ill, 20 ill, 21 (4 ills)(album, 32)(note);
Sothebys Lon 6/11/76: 55 ill, 56 ill, 57 ill, 58 ill
    (note), 59 ill, 60 ill, 173 (album, C-1 et al);
Christies Lon 10/28/76: 172 (album, C-1 attributed
    et al);
Sothebys Lon 10/29/76: 111 (2 ills)(album, C-3 et
    al), 247 ill(note), 248 (2), 249 ill, 250 ill,
    251 ill, 252 ill, 253 ill, 254 (3), 255 (2), 256
    ill, 257 ill, 258 ill(2), 259 (5 plus 1
    attributed);
Christies Lon 3/10/77: 127 ill(note), 128 ill, 129
    ill, 130 ill, 131 ill, 132 ill;
Sothebys Lon 11/18/77: 248 ill;
California Galleries 1/21/78: 125 (lot, C et al);
Christies Lon 3/16/78: 65 ill(note), 66 ill;
Sothebys NY 5/2/78: 68, 69 ill, 70;
Christies Lon 10/26/78: 144 (note), 145 ill, 146
    ill, 147 ill, 148, 149 ill;

CLIFFORD (continued)
Sothebys Lon 10/27/78: 96 ill;
Sothebys NY 11/2/78: 207 ill(lot, C et al), 208 ill
(note);
Phillips NY 11/4/78: 20 ill(note), 21;
Christies Lon 3/15/79: 124 (note), 125, 126 ill
(note), 127 ill, 128, 129, 130 ill(lot, C-11
et al);
Christies NY 5/4/79: 16;
Sothebys NY 5/8/79: 63 ill(note);
Sothebys Lon 6/29/79: 133 ill(2);
Phillips NY 11/3/79: 174 (note);
Christies NY 5/16/80: 106 ill(note);
Phillips NY 5/21/80: 157;
Christies Lon 6/26/80: 408 ill(note), 409 ill, 410;
Sothebys Lon 6/27/80: 93 ill;
Christies Lon 10/30/80: 430 (lot, C-1 et al);
Christies NY 11/11/80: 26;
Christies Lon 3/26/81: 337 (lot, C-1 plus 10
attributed, et al), 338 ill, 339 ill, 340, 341
ill, 342, 396 (album, C-4 attributed, et al);
Sothebys Lon 3/27/81: 416 ill, 417 ill, 418, 419,
420 ill, 421 ill, 422 ill;
Swann NY 4/23/81: 316, 317, 358 (2)(attributed)
(note);
Sothebys Lon 6/17/81: 367 ill, 368, 369 ill,
370 ill;
Christies Lon 6/18/81: 169 ill(album, 14)(note),
170, 421 (albums, C-1 et al);
Sothebys Lon 10/28/81: 335 ill, 336 ill, 337 ill;
Christies Lon 10/29/81: 179, 180, 181 (2 ills)
(album, 56)(note);
Christies Lon 11/10/81: 15;
Christies Lon 6/24/82: 146 ill, 147 ill, 148 (2),
149 ill(2), 150 (2), 151 ill, 152 ill, 153 ill,
154 ill, 155, 156 ill, 157 ill, 158 (2), 159
(7), 160 (lot, C-1 plus 10 attributed, et al),
161 (2);
Bievres France 2/6/83: 43 (2);
Sothebys Lon 3/15/82: 347 ill, 348 (2);
Christies Lon 3/24/83: 86;
Christies Lon 6/23/83: 117 ill, 118, 119;
Christies Lon 10/27/83: 66 (album, C-13 et al);
Sothebys NY 11/9/83: 93 (2);
Sothebys Lon 12/9/83: 20 ill, 21 ill;
Fraenkel Cal 1984: 15 ill(note), 16 ill(note), 17,
18, 19, 20, 21, 22 ill(note), 23 ill, 24 ill,
25, 26, 27, 28 (7 ills)(album, 100)(note);
Christies Lon 3/29/84: 142, 143;
Swann NY 5/10/84: 327 (album, C-4 et al)(note);
Christies Lon 10/25/84: 170 (2), 323 (album,
C et al);
Sothebys Lon 10/26/84: 35, 36 ill;
Harris Baltimore 3/15/85: 161 (album, C-1 et al);
Phillips Lon 3/27/85: 272, 273 ill, 274;
Sothebys Lon 3/29/85: 70 (2);
Christies NY 5/6/85: 107 ill(note), 108 ill;
Phillips Lon 6/26/85: 227, 228, 229, 230 ill;
Christies Lon 6/27/85: 145 (8);
Phillips Lon 10/30/85: 114 (4 plus 4 attributed),
148 ill(10);
Christies Lon 10/31/85: 198 (lot, C-2 et al), 199
ill(5)(note);
Sothebys NY 11/12/85: 79 ill(4);
Phillips Lon 4/23/86: 306 (10 plus 2 attributed);
Christies Lon 4/24/86: 485 ill, 487 (2), 590 (album,
C et al);
Sothebys Lon 4/25/86: 38 ill;
Swann NY 5/15/86: 224;
Christies Lon 10/30/86: 85, 86, 87 ill, 88 (album,
C-8 et al);

CLIFFORD (continued)
Christies NY 11/11/86: 126 ill;
Phillips NY 11/12/86: 65 (2);

**CLIFFORD, D.A.** (American)
Photos dated: 1855-1872
Processes:     Salt, albumen
Formats:       Prints, stereos
Subjects:      Topography, documentary (educational
               institutions)
Locations:     US - Salem, Massachusetts; Hanover,
               New Hampshire
Studio:        US - St. Johnsbury, Vermont
   Entries:
Gordon NY 5/10/77: 777 ill(note);
Swann NY 10/18/79: 405 (15);
Harris Baltimore 12/10/82: 106 (lot, C et al);

**CLIFFORD, S.**
Photos dated: 1860s-c1880
Processes:     Albumen
Formats:       Prints, stereos, cdvs
Subjects:      Topography, ethnography
Locations:     Tasmania; Australia
Studio:        Tasmania - Hobart
   Entries:
Christies Lon 3/16/78: 107 (album, C-1 et al);
Christies Lon 3/20/80: 110 (lot, C-15 et al);
Christies Lon 3/11/82: 72 (11);
Phillips Lon 10/29/86: 228 (lot, C-1 et al);

**CLIMO, J.S.** (Canadian)
Photos dated: 1870s-1877
Processes:     Albumen
Formats:       Stereos
Subjects:      Topography, documentary (disasters)
Locations:     Canada
Studio:        Canada - St. John, New Brunswick
   Entries:
Vermont Cat 7, 1974: 610 ill(4);
Vermont Cat 11/12, 1977: 774 ill(4);
Harris Baltimore 12/16/83: 21 (lot, C-1 et al);
Christies Lon 3/29/84: 38 (lot, C-7 et al);

**CLINCH, W.**
Photos dated: c1885
Processes:     Albumen
Formats:       Cabinet cards
Subjects:      Portraits
Locations:
Studio:
   Entries:
California Galleries 12/13/80: 207 (lot, C et al);
California Galleries 6/28/81: 192 (lot, C et al);

**CLINTON, J.L.** (American)
Photos dated: c1880-1880s
Processes:     Albumen
Formats:       Prints, stereos
Subjects:      Ethnography, topography
Locations:     US - Colorado
Studio:        US - Colorado Springs, Colorado
   Entries:
Sothebys NY (Weissberg Coll.) 5/16/67: 179 (lot, C-2
et al);
California Galleries 3/29/86: 692 (lot, C-4 et al);

**CLOSCIONI** (Italian)
Photos dated: Nineteenth century
Processes:     Albumen
Formats:       Prints
Subjects:      Topography
Locations:     Italy
Studio:        Italy
    Entries:
Christies NY 5/16/80: 188 (lot, C et al);

**CLOSE** (see HUNTER & CLOSE)

**CLOUGH, A.F.** (American)
Photos dated: 1870s
Processes:     Albumen
Formats:       Stereos
Subjects:      Topography
Locations:     US - New Hampshire; Maine
Studio:        US - Warren, New Hampshire
    Entries:
Rinhart NY Cat 1, 1971: 246 (C & Kimball, 3);
Vermont Cat 2, 1971: 227 (lot, C & Kimball-1,
    et al);
California Galleries 9/27/75: 512 (lot, C et al);
California Galleries 1/23/77: 410 (lot, C et al);
Swann NY 4/14/77: 323 (lot, C et al);
Swann NY 12/14/78: 304 (13)(note), 305 (25)(note),
    306 (39)(note), 307 ill(5)(note);
Swann NY 10/18/79: 406 (C & Kimball, 33)(note), 435
    (lot, C et al)(note);
Swann NY 4/23/81: 524 (C & Kimball, 50);
Harris Baltimore 6/1/84: 99 (lot, C & Kimball-7,
    et al);

**CLOUZARD, A.** (French)(see also SOULIER)
Photos dated: 1854-1858
Processes:     Photoglyph
Formats:       Prints, stereos
Subjects:      Topography
Locations:     France - Paris
Studio:        France - Paris
    Entries:
Sothebys NY 2/25/75: 18 (lot, C & Soulier-1,
    attributed, et al);

**CLYMA, W.J.**
Photos dated: 1860s
Processes:     Albumen
Formats:       Stereos
Subjects:      Topography
Locations:
Studio:
    Entries:
Christies Lon 10/25/84: 41 (lot, C et al);

**COBB** (see EDOUART)

**COBB, F.**
Photos dated: 1860s
Processes:     Albumen
Formats:       Prints
Subjects:      Documentary (military)
Locations:
Studio:        England - Hythe
    Entries:
Christies Lon 6/24/82: 367 (5);

**COBB, George N.**
Photos dated: 1880
Processes:     Albumen
Formats:       Prints
Subjects:
Locations:
Studio:
    Entries:
Wood Boston Cat 58, 1986: 136 (books, C-1 et al);

**COBB, J.V.** (British)
Photos dated: Nineteenth century
Processes:     Albumen
Formats:       Prints
Subjects:      Topography
Locations:     Great Britain
Studio:        Great Britain
    Entries:
Christies Lon 6/26/80: 168 (lot, C-4 et al);

**COCHET, F.**
Photos dated: c1870
Processes:     Albumen
Formats:       Cdvs
Subjects:      Portraits
Locations:     Studio
Studio:        West Indies
    Entries:
California Galleries 1/21/79: 237 (lot, C et al);

**COCHRANE, Lord** (British)
Photos dated: late 1850s
Processes:     Albumen
Formats:       Prints
Subjects:      Portraits
Locations:     Great Britain
Studio:        Great Britain
    Entries:
Swann NY 2/14/52: 5 (album, C et al);

**COCKE, Archibald Lewis** (British)
Photos dated: 1840s
Processes:     Daguerreotype, calotype
Formats:       Plates, prints
Subjects:      Portraits
Locations:     Studio
Studio:        England
    Entries:
Swann NY 2/14/52: 4 (album, C et al), 113 (lot,
    C et al);

**COCKRELL** (American)
Photos dated: between 1870s and 1890s
Processes:      Albumen
Formats:        Cabinet cards
Subjects:       Topography
Locations:      Mexico
Studio:         US - Hot Springs, Arkansas
   Entries:
Swann NY 5/15/86: 167 (lot, C-6 et al);

**COELTE** (French)
Photos dated: 1850
Processes:      Daguerreotype
Formats:        Plates
Subjects:       Portraits
Locations:      Studio
Studio:         France - Paris
   Entries:
Sothebys Lon 3/29/85: 35 (lot, C-1 et al);

**COEN, C.**
Photos dated: 1860s-1870s
Processes:      Albumen
Formats:        Cdvs, stereos
Subjects:       Topography
Locations:      Italy - Venice and Trieste
Studio:         Italy
   Entries:
Christies Lon 3/11/82: 139 (lot, C et al);
Christies Lon 6/24/82: 138 (lot, C et al);

**COFFIN, Professor J.H.C.** (American)(photographer
                    or author?)
Photos dated: 1869
Processes:      Albumen
Formats:        Prints
Subjects:       Documentary (scientific)
Locations:      US
Studio:         US
   Entries:
Wood Conn Cat 49, 1982: 113 ill(book, 1)(note);
Wood Boston Cat 58, 1986: 43 (book, 1);

**COGHILL, Sir Joscelyn J.** (British)
Photos dated: 1855-1860s
Processes:      Salt, albumen
Formats:        Prints
Subjects:       Topography, genre (domestic)
Locations:      Great Britain; Germany; Switzerland
Studio:         Great Britain (Amateur Photographic
                Association, Photographic Club)
   Entries:
Swann NY 2/14/52: 6 (lot, C et al), 114 (lot,
   C et al)(note), 262 (album, C et al);
Sothebys Lon 12/4/73: 173 (book, C et al);
Sothebys Lon 3/8/74: 160 (2 ills)(albums, C et al);
Sothebys Lon 10/18/74: 145 (lot, C-1 et al);
Sothebys Lon 3/21/75: 286 (album, C-1 et al);
Sothebys Lon 3/14/79: 324 (album, C-1 et al);
Sothebys Lon 10/29/80: 310 (album, C et al);
Christies Lon 10/27/83: 218 (albums, C-3 et al);
Sothebys Lon 6/29/84: 194 (lot, C-1 et al);
Sothebys Lon 11/1/85: 59 (album, C-1 et al);

**COGNACQ, T.** (French)
Photos dated: between 1850s and 1870s
Processes:      Albumen, collotype
Formats:        Prints, cdvs
Subjects:       Portraits, documentary (engineering)
Locations:      France
Studio:         France - La Rochelle
   Entries:
Gordon NY 11/13/76: 48 (albums, C et al);
Sothebys LA 2/13/78: 121 (books, C et al)(note);

**COHEN** (see LEVY & COHEN)

**COKE** (British)
Photos dated: 1887
Processes:
Formats:        Prints
Subjects:
Locations:
Studio:         England - Clifton
   Entries:
Swann NY 11/6/80: 115 (book, C et al)(note);

**COKE, E.** (British)
Photos dated: 1856
Processes:
Formats:        Prints
Subjects:       Portraits
Locations:
Studio:         Great Britain
   Entries:
Christies Lon 3/16/78: 292 (album, C-1 et al);

**COKES, A.L.** (British)
Photos dated: 1860s
Processes:      Albumen
Formats:        Stereos
Subjects:       Topography
Locations:      England - Oxford
Studio:         Great Britain
   Entries:
California Galleries 4/3/76: 362 (lot, C et al);
Christies Lon 10/25/79: 91 (lot, C et al);
Christies Lon 10/30/80: 123 (lot, C-5 et al);
Sothebys Lon 3/27/81: 9 (lot, C et al);

**COLAMEDICI, De Bonis Giovanni Battista** (Italian)
Photos dated: between 1865 and 1877
Processes:      Albumen
Formats:        Prints
Subjects:       Topography
Locations:      Italy - Rome
Studio:         Italy
   Entries:
Christies Lon 4/24/86: 378 (lot, C-5 et al)(note);

COLE (American) [COLE 1]
Photos dated: late 1870s-1890s
Processes:    Albumen
Formats:      Prints
Subjects:     Topography
Locations:    US - Florida
Studio:       US - DeLand, Florida
    Entries:
Rinhart NY Cat 1, 1971: 324;
Rinhart NY Cat 6, 1973: 298 (2);
Swann NY 4/23/81: 468 (2);

COLE (American) [COLE 2]
Photos dated: Nineteenth century
Processes:    Albumen
Formats:      Stereos
Subjects:     Topography
Locations:    US - Maine
Studio:       US
    Entries:
Harris Baltimore 12/10/82: 53 (lot, C et al);

COLE, A.S. (British)(photographer or author?)
Photos dated: 1875
Processes:    Albumen
Formats:      Prints
Subjects:     Documentary
Locations:    Great Britain
Studio:       Great Britain
    Entries:
Edwards Lon 1975: 73 (book, 20);

COLE, Lieutenant Henry Hardy (British)(see also
              SHEPHERD, C)
Photos dated: 1869-1872
Processes:    Carbon, woodburytype
Formats:      Prints
Subjects:     Architecture
Locations:    India - Old Delhi
Studio:
    Entries:
Christies Lon 4/25/74: 211 (books, C et al);
Sothebys Lon 6/28/78: 24 (book, 29);
Christies NY 5/16/80: 207 (book, 29);

COLE, J.J. (British)
Photos dated: 1850s and/or early 1860s
Processes:    Albumen
Formats:      Prints
Subjects:     Topography
Locations:    England - London; Switzerland
Studio:       England
    Entries:
Christies Lon 3/29/84: 175 (note), 176 (note);

COLE, Roderick M. (American)
Photos dated: 1858-1860
Processes:    Ambrotype, salt, tintype, albumen
Formats:      Plates, prints
Subjects:     Portraits
Locations:    Studio
Studio:       US - Peoria, Illinois
    Entries:
Harris Baltimore 3/26/82: 347 (note);
Sothebys NY 11/9/82: 176 ill(attributed)(note);
Christies NY 11/8/83: 76 ill(attributed)(note);

COLE, R.M. (continued)
Christies NY 5/7/84: 22 ill(attributed)(note);
Harris Baltimore 9/27/85: 69 (note);

COLE, W.G. (British)
Photos dated: 1850s and/or 1860s
Processes:    Albumen
Formats:      Stereos
Subjects:     Genre
Locations:    Studio
Studio:       England
    Entries:
Christies Lon 10/25/84: 38 (lot, C-2 et al);

COLEMAN
Photos dated: Nineteenth century
Processes:    Albumen
Formats:      Cabinet cards
Subjects:     Portraits
Locations:
Studio:
    Entries:
California Galleries 1/21/78: 137 (lot, C et al);

COLLARD, A. (French, born before 1840, died after
              1887)
Photos dated: 1855-1876
Processes:    Albumen
Formats:      Prints
Subjects:     Topography, documentary (Paris
              Commune, engineering)
Locations:    France - Paris
Studio:       France - Paris
    Entries:
Rauch Geneva 6/13/61: 162 (lot, C et al);
Sothebys LA 2/13/78: 121 (books, C et al)(note);
Sothebys NY 5/2/78: 92 ill;
Christies Lon 3/15/79: 112 (lot, C-1 et al);
Rose Boston Cat 5, 1980: 50 ill(note);
Sothebys NY 10/21/81: 86 ill;

COLLET Frères (French)
Photos dated: 1860s
Processes:    Albumen
Formats:      Cdvs
Subjects:     Topography
Locations:    France
Studio:       France - Metz
    Entries:
Petzold Germany 11/7/81: 327 (lot, C et al);

COLLIAU, E. (French)
Photos dated: c1859-1862
Processes:    Albumen
Formats:      Prints
Subjects:     Topography, portraits, genre (still
              life)
Locations:    France
Studio:       France - Paris
    Entries:
Octant Paris 1982: 12 ill;

**COLLIER, C.T.** (American)
Photos dated: c1890
Processes:      Albumen
Formats:        Cabinet cards
Subjects:       Topography
Locations:      US - Riverside, California
Studio:         US - California
    Entries:
Frontier AC, Texas 1978: 65 (note);

**COLLIER, Joseph** (British)
Photos dated: 1860s-1874
Processes:      Albumen
Formats:        Prints, stereos, cdvs
Subjects:       Topography
Locations:      Scotland; US - Colorado
Studio:         Scotland; US - Denver, Colorado
    Entries:
Swann NY 2/14/52: 359 (book, 13)(note);
Rinhart NY Cat 6, 1973: 598, 602;
Wood Conn Cat 37, 1976: 46 (book, 10)(note);
Sothebys Lon 10/29/76: 30 (lot, C et al);
Swann NY 11/11/76: 251 (books, 17);
Vermont Cat 11/12, 1977: 775 ill(2), 776 ill;
Frontier AC, Texas 1978: 115 (book, 10)(note), 115b
    (book, 14), 115c ill(book, 14);
Wood Conn Cat 42, 1978: 132 (book, 10)(note);
Swann NY 4/26/79: 53 (book, 4)(note);
Sothebys NY 5/8/79: 18 (book, 10);
Swann NY 10/18/79: 49;
Swann NY 4/17/80: 366 (lot, C et al);
Harris Baltimore 3/26/82: 105 (book, 10)(note);
Swann NY 11/18/82: 65 (book, 4)(note);
Harris Baltimore 12/10/82: 29 (lot, C et al);
Harris Baltimore 4/8/83: 21 (lot, C et al);
Swann NY 11/10/83: 48 (book, 10);
Harris Baltimore 12/16/83: 29 (lot, C-1 et al);
Christies Lon 3/29/84: 78 (lot, C-4 et al);
Christies Lon 10/25/84: 92 (lot, C-4 et al);
Harris Baltimore 3/15/85: 24 (lot, C et al);
California Galleries 3/29/86: 693 (lot, C et al);

**COLLINGS, Esme** (British)
Photos dated: 1897
Processes:      Photogravures
Formats:        Prints
Subjects:       Portraits
Locations:      Studio
Studio:         England
    Entries:
Swann NY 4/17/80: 75 (book, C et al);
Swann NY 5/5/83: 78 (book, C et al);

**COLLINS** (American)
Photos dated: 1876
Processes:      Albumen, albertype
Formats:        Prints, stereos
Subjects:       Topography
Locations:      US - Lynn, Massachusetts; Portland,
Maine
Studio:         US
    Entries:
Rinhart NY Cat 1, 1971: 244 (4);
Rinhart NY Cat 7, 1973: 29 (book, 7);
Swann NY 4/17/80: 159 (book, 6)(note);

**COLLINS, Charles Miller** (British, 1820-1909)
Photos dated: c1860-1862
Processes:      Albumen
Formats:        Stereos
Subjects:       Topography
Locations:      China; Japan
Studio:
    Entries:
Phillips Lon 10/30/85: 29 ill(76)(note);

**COLLINS, Thomas P. & D.C.** (American)
Photos dated: c1848-1850s
Processes:      Daguerreotype
Formats:        Plates
Subjects:       Portraits
Locations:      Studio
Studio:         US - Philadelphia, Pennsylvania
    Entries:
Vermont Cat 5, 1973: 374 ill;
Christies Lon 10/26/78: 27;
Sothebys Lon 6/27/80: 23 ill;
Sothebys Lon 3/27/81: 340 ill;
Swann NY 4/23/81: 247 (lot, C-1 et al)(note);
Swann NY 5/15/86: 212 (lot, C-1 et al);

**COLLOM** (American)
Photos dated: c1880s-1890
Processes:      Albumen
Formats:        Prints
Subjects:       Topography
Locations:      US - California
Studio:         US
    Entries:
California Galleries 6/8/85: 190 (lot, C et al);

**COLLOT, Dr.**
Photos dated: 1893
Processes:
Formats:        Prints
Subjects:       Documentary (disasters)
Locations:      Syria
Studio:
    Entries:
Sothebys Lon 10/24/75: 253 (note);

**COLLS, Lebbeus** (British)
Photos dated: 1850s-1865
Processes:      Salt, photoglyphic engraving
Formats:        Prints
Subjects:       Topography
Locations:      England - Ludlow and Lynmouth
Studio:         England - London
    Entries:
Swann NY 2/14/52: 6 (lot, C et al);
Sothebys Lon 12/4/73: 173 (book, C et al);
Sothebys Lon 10/28/81: 193;
Sothebys Lon 10/29/82: 134;
Sothebys Lon 6/29/84: 140 ill;
Christies Lon 10/31/85: 187 (lot, C-5 et al);

**COLN**
Photos dated: Nineteenth century
Processes:      Albumen
Formats:        Stereos
Subjects:       Topography
Locations:      Europe
Studio:         Europe
   Entries:
Christies Lon 3/11/82: 94 (lot, C et al);

**COLTON, S.W.** (American)
Photos dated: 1850s
Processes:      Daguerreotype
Formats:        Plates
Subjects:       Portraits
Locations:      Studio
Studio:         US - Philadelphia, Pennsylvania
   Entries:
Christies Lon 6/10/76: 18;

**COMBES, C.** (British)
Photos dated: 1850s-c1860
Processes:      Ambrotype
Formats:        Plates
Subjects:       Portraits
Locations:      Studio
Studio:         England - Brighton
   Entries:
Christies Lon 3/16/78: 41 (lot, C-1 et al);
Christies Lon 3/20/80: 24 (lot, C-1 et al);
Phillips Lon 10/27/82: 12 (lot, C-1 et al);

**COMBS** (see WHITNEY)

**COMIANOS** (see also SAROLIDES)
Photos dated: Nineteenth century
Processes:      Albumen
Formats:        Prints
Subjects:       Topography
Locations:      Europe
Studio:         Europe
   Entries:
Christies Lon 3/28/85: 324 (album, C et al);
Swann NY 11/13/86: 239 (lot, C & Sarolides et al);

**CONART, W.** (American)
Photos dated: Nineteenth century
Processes:      Albumen
Formats:        Stereos
Subjects:       Topography
Locations:      US
Studio:         US - New York
   Entries:
Phillips Lon 4/23/86: 183 (lot, C-9 et al);

**CONAWAY, B.F.** (American)
Photos dated: c1880-c1890
Processes:      Albumen
Formats:        Prints
Subjects:       Genre
Locations:      US - Laguna Beach, California
Studio:         US
   Entries:
California Galleries 6/19/83: 312, 322, 376 (C-1,
   C & Hummel-1);
California Galleries 7/1/84: 658 (lot, C & Hummel
   et al);

**CONLY, C.F.**
Photos dated: 1885
Processes:      Albumen
Formats:        Prints, cabinet cards
Subjects:       Portraits
Locations:
Studio:
   Entries:
Vermont Cat 2, 1971: 249 (lot, C-1 et al);
Wood Boston Cat 58, 1986: 136 (books, C-1 et al);

**CONOLLY**
Photos dated: 1880s and/or 1890s
Processes:      Albumen
Formats:        Prints
Subjects:       Topography
Locations:      Tasmania and/or New Zealand
Studio:
   Entries:
Christies Lon 6/26/86: 108 (albums, C et al);

**CONRAD, Giorgio**
Photos dated: 1850s -1860s
Processes:      Albumen
Formats:        Stereos, cdvs
Subjects:       Topography, portraits
Locations:      Italy
Studio:         Italy - Naples
   Entries:
Christies Lon 3/20/80: 358 (album, C et al);
Christies Lon 3/26/81: 133 (lot, C-2 et al);
Christies Lon 6/18/81: 233 (album, C-4 et al);
Christies Lon 3/11/82: 231 (album, C-4 et al);

**CONROY, J.** (British)
Photos dated: 1850s and/or 1860s
Processes:      Albumen
Formats:        Prints
Subjects:       Documentary (military), topography
Locations:      Malta
Studio:
   Entries:
Christies Lon 10/25/79: 378 (album, C-1 et al)
   (note);
Christies Lon 3/28/85: 308 (album, C-1 et al);

**CONSTABLE, Colonel** (British)
Photos dated: 1880s
Processes:  Albumen
Formats:    Prints
Subjects:   Ethnography
Locations:  India
Studio:     India - Allalabad
    Entries:
Christies Lon 3/15/79: 161 (album, 60);

**CONSTABLE, William** (British)
Photos dated: 1842-1853
Processes:  Daguerreotype, albumen
Formats:    Plates, prints
Subjects:   Portraits, topography
Locations:  England - Brighton
Studio:     England - Brighton
    Entries:
Sothebys NY (Strober Coll.) 2/7/70: 189 ill(129)
    (note), 190 (4)(note), 191, 192 (note), 194 ill
    (note);
Sothebys Lon 12/21/71: 193 (lot, C-1 et al), 194 ill
    (note), 195 ill(note);
Edwards Lon 1975: 12 (album, C et al);

**CONSTANT, Eugène** (French)
Photos dated: c1848-c1852
Processes:  Salt, albumen
Formats:    Prints
Subjects:   Architecture
Locations:  Italy - Rome
Studio:     Italy - Rome
    Entries:
Christies Lon 10/27/77: 296 ill(note), 297 ill;
Swann NY 12/14/78: 385 (note);
Sothebys Lon 6/29/79: 150 ill;
Christies NY 5/16/80: 146 ill;
Lennert Munich Cat 6, 1981: 1 ill;
Sothebys NY 5/15/81: 93 ill(note);
Christies Lon 6/18/81: 172 ill;
Sothebys Lon 6/25/82: 210 ill;
Christies Lon 3/24/83: 67 ill(19)(attributed);
Phillips Lon 11/4/83: 125 ill(attributed);
Christies Lon 6/27/85: 143 ill;

**CONSTANTINE, Dimitris** (Greek)(aka COSTANTIN and
                COSTANTIN)
Photos dated: c1859-1860s
Processes:  Albumen
Formats:    Prints, cdvs, stereos
Subjects:   Topography, portraits
Locations:  Greece - Athens
Studio:     Greece - Athens
    Entries:
Sothebys NY 11/9/76: 125 ill(lot, C-1 et al);
Sothebys NY 2/9/77: 89 (lot, C-1 et al);
Sothebys Lon 11/18/77: 102 (album, C-3 et al);
Swann NY 12/8/77: 347 (lot, C et al);
Christies Lon 10/27/77: 365 (album, C-1 et al);
Sothebys Lon 11/18/77: 102 (album, C-3 et al);
Christies Lon 10/30/80: 174 (lot, C-1 et al), 179
    (lot, C-6 et al);
Swann NY 11/6/80: 325 (lot, C-1 et al);
Christies Lon 3/26/81: 259 (album, C-2 et al), 344
    (lot, C-1 et al);
Christies Lon 10/28/82: 57 (lot, C-24 et al), 218
    (album, C et al);
Christies Lon 10/29/81: 265 (album, C-4 et al);

**CONSTANTINE** (continued)
Christies Lon 3/11/82: 153;
Christies Lon 6/24/82: 170 ill(album, C et al);
Harris Baltimore 12/10/82: 351 (lot, C et al);
Swann NY 5/5/83: 359 (lot, C-3 et al);
Christies Lon 10/27/83: 66 (album, C-4 et al);
Phillips Lon 11/4/83: 53 (lot, C-4 et al);
Sothebys Lon 12/9/83: 25 ill(6);
Swann NY 5/10/84: 327 (album, C-2 et al)(note);
Christies Lon 6/28/84: 140 (album, C et al);
Sothebys Lon 10/26/84: 37 ill(5);
Swann NY 5/9/85: 378 (6), 379 (6);
Sothebys Lon 6/28/85: 47 ill(lot, C-8 et al);
Christies Lon 10/31/85: 95 (album, C-3 plus 8
    attributed);
Swann NY 11/14/85: 64 (21);
Sothebys Lon 4/25/86: 23 ill(6);
Sothebys NY 5/12/86: 403 ill(album, C-1 et al)
    (note);
Swann NY 5/15/86: 225 (11);

**CONWAY, C., Jr.** (British)
Photos dated: 1855-1857
Processes:  Albumen
Formats:    Prints
Subjects:   Genre
Locations:  Great Britain
Studio:     Great Britain (Photographic Club)
    Entries:
Sothebys Lon 3/21/75: 286 (album, C-1 et al);
Sothebys Lon 3/14/79: 324 (album, C-1 et al);
Sothebys Lon 11/1/85: 59 (album, C-1 et al);

**COOK, C.E.** (American)
Photos dated: 1879
Processes:  Albumen
Formats:    Prints
Subjects:   Topography
Locations:  US - Lynn, Massachusetts
Studio:     US - Lynn, Massachusetts
    Entries:
Swann NY 4/1/82: 58 (book, 24)(note);
Swann NY 11/8/84: 143 (lot, C et al);

**COOK, F.A.** (American)
Photos dated: c1878
Processes:  Albumen
Formats:    Stereos
Subjects:   Topography
Locations:  US - Santa Cruz, California
Studio:     US
    Entries:
California Galleries 5/23/82: 422 (5);

**COOK, George Smith** (American, 1819-1902)
Photos dated: 1850s-1863
Processes:  Daguerreotype, ambrotype, albumen
Formats:    Plates, prints, stereos, cdvs
Subjects:   Documentary (Civil War), portraits
Locations:  US - New Orleans, Louisiana; New York
            City; Civil War area
Studio:     US - Charleston, South Carolina;
            Richmond, Virginia
    Entries:
Anderson NY (Gilsey Coll.) 1/20/03: 349;
Sothebys NY (Strober Coll.) 2/7/70: 548 (lot,
    C attributed et al)(note);

**COOK, G.S.** (continued)
Sothebys NY 10/4/77: 22 ill(lot, C-2 et al);
Christies Lon 6/26/80: 84;
Swann NY 11/5/81: 448 (note);
Swann NY 1/4/82: 271 (lot, C-2 attributed et al)
  (note);
Harris Baltimore 5/28/82: 128 (lot, C-1 attributed
  et al), 154 (lot, C-1 et al), 165 (lot, C et al);
Christies NY 11/8/82: 177A ill(lot, C attributed
  et al);
Harris Baltimore 9/16/83: 131, 170 ill(note);
Harris Baltimore 3/15/85: 258;
Harris Baltimore 2/14/86: 67 (lot, C-1 et al);

**COOKE, C.**
Photos dated: Nineteenth century
Processes:
Formats:      Prints
Subjects:     Architecture
Locations:
Studio:
  Entries:
Halsted Michigan 1977: 610;

**COOKE, Charles**
Photos dated: 1892
Processes:    Albumen
Formats:      Prints
Subjects:     Topography
Locations:    Russia - Archangel
Studio:
  Entries:
Sothebys Lon 10/29/80: 98 (album, 46);

**COOKE, H.T.**
Photos dated: Nineteenth century
Processes:    Albumen
Formats:      Stereos
Subjects:     Topography
Locations:    England
Studio:
  Entries:
Harris Baltimore 12/16/83: 56 (lot, C-6 et al);
Harris Baltimore 6/1/84: 64 (lot, C et al);

**COOKE, W.** (British)
Photos dated: 1862
Processes:    Albumen
Formats:      Prints
Subjects:     Topography
Locations:    England - Yorkshire
Studio:       Great Britain
  Entries:
Rinhart NY Cat 7, 1973: 30 (book, 1);

**COOLEY, Otis H.** (American, died 1857)
Photos dated: 1849-1857
Processes:    Daguerreotype, albumen
Formats:      Plates, cdvs
Subjects:     Portraits
Locations:    Studio
Studio:       US - Springfield, Massachusetts
  Entries:
Sothebys NY (Weissberg Coll.) 5/16/67: 97 (lot,
  C-1 et al);

**COOLEY, O.H.** (continued)
Sothebys NY (Greenway Coll.) 11/20/70: 250 (lot,
  C-1 et al), 170 (lot, C-1 et al), 272 (lot,
  C-1 et al);
Rinhart NY Cat 2, 1971: 156;
Rose Boston Cat 3, 1978: 134 ill;
Swann NY 4/20/78: 302 (lot, C-1 et al);
Christies NY 5/4/79: 74 ill(note);
Christies Lon 10/30/80: 32;

**COOLEY, Samuel** (American)
Photos dated: 1860s
Processes:    Albumen
Formats:      Stereos, cdvs
Subjects:     Documentary (Civil War)
Locations:    US - Civil War area
Studio:       US - Beaufort, South Carolina
  Entries:
Sothebys NY (Strober Coll.) 2/7/70: 297 (lot, C et
  al), 298 (lot, C et al), 549 (lot, C-2 plus 2
  attributed);
Rinhart NY Cat 1, 1971: 48;
Vermont Cat 1, 1971: 217 (note);
California Galleries 1/21/79: 234 (lot, C-1 et al);
Harris Baltimore 5/28/82: 153 (lot, C et al)(note);
Harris Baltimore 9/16/83: 162 (2, attributed)(note);

**COOLIDGE, Baldwin** (American)(see also SWEET, H.N.)
Photos dated: 1870-1896
Processes:    Albumen, photogravures
Formats:      Prints
Subjects:     Topography, portraits
Locations:    US - Massachusetts
Studio:       US - Boston, Massachusetts
  Entries:
Rinhart NY Cat 6, 1973: 322;
Wood Conn Cat 37, 1976: 118 (book, C et al)(note);
Swann NY 11/11/76: 398 (album);
Swann NY 4/14/77: 111 (book, C & Sweet et al);
Swann NY 12/14/78: 140 (book, C & Sweet, 11)(note);
Sothebys NY 5/8/79: 19 (books, C et al);
Swann NY 5/10/84: 179 (note);

**COOMBS, Fred** (American)
Photos dated: 1846-1850
Processes:    Daguerreotype
Formats:      Plates
Subjects:     Portraits, topography
Locations:    US - Missouri; California; Illinois
Studio:       US - St. Louis, Missouri; San
              Francisco, California; Chicago,
              Illinois
  Entries:
Sothebys LA 2/4/81: 145 ill(note);

**COONLEY, J.F.** (American)
Photos dated: c1860s-1890s
Processes:    Albumen, silver gelatine
Formats:      Prints
Subjects:     Topography, documentary (Civil War)
Locations:    US - Civil War area and California;
              Cuba; Nassau
Studio:       Nassau
  Entries:
Swann NY 4/17/80: 247 (lot, C et al);
Swann NY 4/1/81: 249 (lot, C et al);

COONLEY, J.F. (continued)
Swann NY 11/10/83: 247 (21)(note);
Christies Lon 3/28/85: 79 (album, C-1 et al);

COOPER (see KIMBALL & COOPER) [COOPER 1]

COOPER & DEMAREST (American) [COOPER 2]
Photos dated: 1850s
Processes:      Daguerreotype
Formats:        Plates
Subjects:       Portraits
Locations:      Studio
Studio:         US - New York City
   Entries:
Rinhart NY Cat 6, 1973: 178;

COOPER, F. (British)
Photos dated: 1850s
Processes:      Ambrotype
Formats:        Plates
Subjects:       Portraits
Locations:      Studio
Studio:         England - London
   Entries:
Sothebys Lon 10/18/74: 217 (lot, C-1 et al);

COOPER, George (British)
Photos dated: 1891
Processes:
Formats:        Prints
Subjects:       Genre
Locations:      England
Studio:         England - Hull
   Entries:
Alexander Lon 1976: 77 ill, 78 ill;

COOPER, H., Jr. (British)
Photos dated: 1860s
Processes:      Albumen
Formats:        Prints
Subjects:
Locations:
Studio:         Great Britain (Amateur Photographic
                Association)
   Entries:
Sothebys Lon 10/29/80: 310 (album, C et al);
Christies Lon 10/27/83: 218 (albums, C-1 et al);

COOPER, Samuel
Photos dated: between 1850s and 1890s
Processes:
Formats:        Prints
Subjects:       Topography
Locations:
Studio:
   Entries:
Sothebys NY 5/8/85: 631 (lot, C et al);

COPELAND & FLEMING (American)
Photos dated: 1860s
Processes:      Albumen
Formats:        Stereos
Subjects:       Topography
Locations:      US - Pennsylvania
Studio:         US - Pithole City, Pennsylvania
   Entries:
Sothebys NY (Strober Coll.) 2/7/70: 477 (lot, C-3
   et al);

COPELIN, A. & Son (American)
Photos dated: 1871-mid 1870s
Processes:      Albumen
Formats:        Stereos, cdvs
Subjects:       Documentary (disasters)
Locations:      US - Chicago, Illinois
Studio:         US - Chicago, Illinois
   Entries:
Sothebys NY (Strober Coll.) 2/7/70: 490 (lot, C-26
   et al);
Sothebys NY 11/21/70: 366 (lot, C-4 et al);
California Galleries 9/27/75: 468 (lot, C & Hine et
   al), 486 (lot, C-2 et al);
California Galleries 1/23/77: 372 (lot, C & Hine et
   al), 392 (lot, C-2 et al);
California Galleries 1/21/79: 290 (lot, C-2 et al);
Swann NY 11/18/82: 447 (lot, C & Hine et al);
Harris Baltimore 6/1/84: 25 (lot, C & Hine et al);

CORDER, G.A.
Photos dated: 1881
Processes:      Albumen
Formats:        Prints
Subjects:       Documentary (maritime)
Locations:      China - Amoy
Studio:
   Entries:
Phillips Lon 6/27/84: 200 (book, 11);

CORLIES, S. Fisher (American)
Photos dated: 1882
Processes:      Albumen
Formats:        Prints
Subjects:       Genre
Locations:      US - Maryland
Studio:         US
   Entries:
Harris Baltimore 11/7/86: 245 (2);

CORNELISSE
Photos dated: 1860s-1870s
Processes:      Albumen
Formats:        Cdvs
Subjects:       Genre
Locations:      Studio
Studio:         Belgium - Brussels
   Entries:
Swann NY 12/14/78: 376 (lot, C et al);

**CORNELIUS, Robert** (American, 1809-1893)
Photos dated: 1839-1842
Processes:     Daguerreotype
Formats:       Plates
Subjects:      Portraits
Locations:     Studio
Studio:        US - Philadelphia, Pennsylvania
   Entries:
Swann NY 4/23/81: 233 (note);

**CORNELL, F.**
Photos dated: 1870s-1880s
Processes:     Albumen
Formats:       Prints
Subjects:      Topography
Locations:     Australia
Studio:        Australia - Sale
   Entries:
Christies Lon 10/30/86: 182 ill(album, 100);

**CORRAL**
Photos dated: 1870s-1890s
Processes:     Albumen
Formats:       Prints
Subjects:      Topography
Locations:
Studio:
   Entries:
Swann NY 12/8/77: 367 (lot, C et al);

**CORRIE, J.**
Photos dated: 1890s
Processes:     Bromide
Formats:       Prints
Subjects:      Topography, ethnography
Locations:     South Africa
Studio:
   Entries:
Christies Lon 3/20/80: 390 (lot, C-12 attributed
   et al);

**CORTELYOU, J.H.**
Photos dated: c1850
Processes:     Daguerreotype
Formats:       Plates
Subjects:      Portraits
Locations:
Studio:
   Entries:
Sothebys NY (Strober Coll.) 2/7/70: 121 ill;

**CORWIN & CLARK** (American)
Photos dated: c1870
Processes:     Albumen
Formats:       Stereos
Subjects:      Topography
Locations:     US - New Mexico
Studio:        US - Orrawa, Kansas
   Entries:
Rinhart NY Cat 6, 1973: 603;

**COTTON & WALL** (British)
Photos dated: c1850s-c1860
Processes:     Albumen
Formats:       Prints
Subjects:      Portraits
Locations:     Studio
Studio:        Great Britain - West City
   Entries:
Sothebys Lon 3/21/80: 276 (lot, C & W-1 et al);
Sothebys Lon 6/17/81: 242;

**COUBRET, A.** (French)
Photos dated: 1884
Processes:     Albumen
Formats:       Prints
Subjects:      Topography
Locations:     France - Nice; Monaco
Studio:        France - Nice
   Entries:
California Galleries 1/21/79: 419 (24);

**COUCH & BURNS** (American)
Photos dated: 1860s
Processes:     Albumen
Formats:       Cdvs
Subjects:      Portraits
Locations:     Studio
Studio:        US
   Entries:
Sothebys NY (Greenway Coll.) 11/20/70: 275 (lot,
   C & B et al)

**COUCH, C.M.** (American)
Photos dated: 1870s
Processes:     Albumen
Formats:       Stereos
Subjects:      Topography
Locations:     US - New Hampshire
Studio:        US - Concord, New Hampshire
   Entries:
California Galleries 9/27/75: 512 (lot, C et al);
California Galleries 1/23/77: 410 (lot, C et al);

**COULES & McBRIDE** (American)
Photos dated: 1880
Processes:     Albumen
Formats:       Stereos
Subjects:      Topography
Locations:     US - Deadwood, Dakota
Studio:        US - Deadwood, Dakota
   Entries:
Rinhart NY Cat 7, 1973: 202;

**COUPER, Charles Tennant** (photographer or author?)
Photos dated: 1879
Processes:     Albumen
Formats:       Prints
Subjects:      Documentary (public events)
Locations:     Scotland - Glasgow
Studio:        Great Britain
   Entries:
Swann NY 2/14/52: 93 (book, 10)(note);

**COURRET, Eugenio**
Photos dated: 1864-c1880
Processes:      Albumen
Formats:        Prints, cdvs, cabinet cards
Subjects:       Topography, ethnography, portraits
Locations:      Tahiti; Peru - Lima; Chile -
                Valparaiso
Studio:         Peru - Lima
    Entries:
Vermont Cat 1, 1971: 263 (29);
Christies Lon 6/10/76: 71 (album, 90);
Christies Lon 3/16/78: 99 (3 ills)(album, 30);
Wood Conn Cat 45, 1979: 280 (2 ills)(book, 16)
    (note);
Christies NY 5/4/79: 68 (album, C et al);
Rose Florida Cat 7, 1982: 51 ill(C & Rowsell);
Wood Conn Cat 49, 1982: 116 (book, 16)(note);
Sothebys Lon 4/25/86: 35 (2 ills)(album, 176)(note);
Swann NY 5/15/86: 294 (album, C & Rowsell-24,
    et al);
Christies Lon 10/30/86: 8 (lot, C-6, C & Rowsell-12,
    et al);

**COURT, H.** (British)
Photos dated: 1890s
Processes:
Formats:        Prints
Subjects:
Locations:      Great Britain
Studio:         England (West Kent Amateur
                Photographic Society)
    Entries:
Christies Lon 6/27/85: 260 (lot, C et al);

**COURTIN** (French)
Photos dated: Nineteenth century
Processes:      Woodburytype
Formats:        Prints
Subjects:       Portraits incl. Galerie Contemporaine
Locations:      Studio
Studio:         France - Paris
    Entries:
Christies NY 5/26/82: 36 (book, C et al);
Christies NY 5/7/84: 19 (book, C et al);

**COUTON, Claudins** (French)
Photos dated: between 1860s and 1890s
Processes:      Albumen
Formats:        Prints, cdvs, cabinet cards
Subjects:       Topography
Locations:      France - Vichy
Studio:         France
    Entries:
Swann NY 11/8/84: 199 (lot, C-17 et al);
Swann NY 11/13/86: 357 (lot, C et al);

**COUTURE, L.**
Photos dated: c1880
Processes:      Albumen
Formats:        Cabinet cards
Subjects:       Portraits
Locations:
Studio:
    Entries:
California Galleries 9/27/75: 374 (lot, C et al);

**COUTURIER, A.**
Photos dated: c1880
Processes:      Albumen
Formats:        Cabinet cards
Subjects:       Portraits
Locations:
Studio:
    Entries:
California Galleries 9/27/75: 374 (lot, C et al);

**COUTURIER, P.** (French)
Photos dated: c1870
Processes:      Albumen
Formats:        Prints
Subjects:       Documentary (military)
Locations:      France
Studio:         France - Le Mans
    Entries:
Bievres France 2/6/83: 157 (lot, C-1 et al);

**COWELL** (see MINNIS & COWELL) [COWELL 1]

**COWELL** (see ROCKWELL & COWELL) [COWELL 2]

**COWLEY, T.W.** (American)
Photos dated: c1875
Processes:      Albumen
Formats:        Prints
Subjects:       Portraits
Locations:      US - Canonsburg, Pennsylvania
Studio:         US - Canonsburg, Pennsylvania
    Entries:
California Galleries 12/13/80: 318;
California Galleries 6/28/81: 286;

**COWPER, H.** (British)
Photos dated: 1860s
Processes:      Albumen
Formats:        Prints
Subjects:
Locations:
Studio:         Great Britain (Amateur Photographic
                Association)
    Entries:
Christies Lon 10/27/83: 218 (albums, C-2 et al);

**COX & Son** [COX 1]
Photos dated: 1870s
Processes:      Albumen
Formats:        Prints
Subjects:       Topography
Locations:
Studio:
    Entries:
Sothebys NY 5/8/79: 93 (lot, C-1 et al);

COX & DURANT (British) [COX 2]
Photos dated: 1870s
Processes:    Albumen
Formats:      Prints
Subjects:     Topography
Locations:    England - Torquay
Studio:       Great Britain
   Entries:
Christies Lon 10/25/79: 125 (lot, C & D-1 et al);
Christies Lon 6/26/80: 166 (lot, C & D-1 et al);

COX, G.C. (American)
Photos dated: 1880s-1891
Processes:    Platinum, photogravure
Formats:      Prints
Subjects:     Portraits
Locations:    US
Studio:       US
   Entries:
California Galleries 1/21/78: 303 (3);
Swann NY 11/10/83: 245 (album, 7)(note), 246 (3);

COX, W.A. (American)
Photos dated: 1886-1887
Processes:    Photogravure, artotype
Formats:      Prints
Subjects:     Topography
Locations:    US - St. Augustine, Florida
Studio:       US
   Entries:
Swann NY 12/8/77: 67 (book, C et al);
California Galleries 3/30/80: 125 (book, C et al);

COXHEAD, Frank A.
Photos dated: 1860s-1890s
Processes:    Albumen
Formats:      Prints
Subjects:     Topography
Locations:    New Zealand - Dunedin
Studio:       New Zealand - Dunedin
   Entries:
Christies Lon 10/27/77: 151 (albums, C et al);
California Galleries 1/21/78: 215 (album, C et al);
Christies Lon 10/30/80: 269 (albums, C et al);
Christies Lon 6/23/83: 156 (lot, C et al);
Christies Lon 10/27/83: 136A (lot, C et al);

CRACE, J.G. (British)
Photos dated: 1857
Processes:    Salt, albumen
Formats:      Prints
Subjects:     Topography
Locations:    England - London; Spain - Seville
Studio:       Great Britain (Photographic Club)
   Entries:
Sothebys Lon 3/14/79: 324 (album, C-1 et al);
Sothebys Lon 3/27/81: 175 (2 ills)(album, C et al)
   (note);

CRACHES, W. (British)
Photos dated: 1840s and/or 1850s
Processes:
Formats:      Prints
Subjects:     Topography
Locations:    England - Oxford
Studio:       Great Britain
   Entries:
Christies Lon 6/18/81: 396 (album, C-3 et al)(note);

CRADDOCK, J. (British)
Photos dated: 1860s-1870s
Processes:    Albumen
Formats:      Prints, cdvs
Subjects:     Topography, portraits
Locations:    India; Ireland - Dublin
Studio:       Ireland - Dublin
   Entries:
Edwards Lon 1975: 23 (albums, C-1 et al);
Christies Lon 3/10/77: 138 (album, C-12 et al), 180
   (album, C et al);
Wood Conn Cat 42, 1978: 562 (album, C-10 et al)
   (note);
Christies NY 5/16/80: 206 (lot, C et al);
Christies Lon 10/30/80: 229 (lot, C-1 et al);
Christies Lon 10/29/81: 265 (album, C-2 et al);
Christies Lon 6/24/82: 364 (album, C et al);
Harris Baltimore 12/10/82: 395 (album, C et al);
Swann NY 11/8/84: 214 (album, C et al)(note);
Christies Lon 4/24/86: 406 (album, C-2 et al);

CRAIGIE, J.H. (British)
Photos dated: 1860s
Processes:    Albumen
Formats:      Prints
Subjects:     Topography
Locations:    England - Melrose Abbey
Studio:       Great Britain (Amateur Photographic
              Association)
   Entries:
Sothebys Lon 7/1/77: 163 (albums, C-4 et al);
Sothebys Lon 6/17/81: 122 (lot, C-2 et al);
Sothebys Lon 6/29/84: 193 ill(lot, C-6 et al);

CRAIK, J. (British)
Photos dated: 1889
Processes:    Albumen
Formats:      Prints
Subjects:     Topography
Locations:    England - Canterbury
Studio:       Great Britain
   Entries:
Sothebys Lon 3/21/75: 313 (book, 20);

CRAMB, John (British)
Photos dated: 1860
Processes:    Albumen
Formats:      Prints, stereos
Subjects:     Topography
Locations:    Palestine - Jerusalem
Studio:
   Entries:
Goldschmidt Lon Cat 52, 1939: 228 (book, 24)(note);
Swann NY 2/14/52: 197 (book, 24);
Sothebys Lon 7/1/77: 146 ill(book, 12);
Sothebys Lon 3/22/78: 86 (13);
Sothebys Lon 10/27/78: 121 (5);

**CRAMB, J.** (continued)
Christies Lon 6/26/80: 117 (lot, C et al);
Sothebys Lon 6/27/80: 77 (5);
Sothebys Lon 3/27/81: 58 (5);
Christies Lon 6/23/83: 133 (book, 24);
Sothebys NY 11/10/86: 389 (lot, C-2 et al);

**CRAMER, J.S.** (American)
Photos dated: 1876-1890
Processes:      Albumen
Formats:        Prints, stereos
Subjects:       Topography
Locations:      US - Washington, D.C.; Philadelphia,
                Pennsylvania
Studio:         US - Philadelphia, Pennsylvania
    Entries:
Swann NY 12/14/78: 386 (album, 19)(note);
Christies NY 5/14/80: 377 (book, C et al);
California Galleries 5/23/82: 257 (lot, C et al);
Christies Lon 6/23/83: 47 (lot, C et al);

**CRANE, J.S.** (American)
Photos dated: Nineteenth century
Processes:      Albumen
Formats:        Stereos
Subjects:       Topography
Locations:      US - New York State
Studio:         US
    Entries:
Harris Baltimore 3/26/82: 8 (lot, C et al);

**CRANE, T.F. & Co.** (American)
Photos dated: 1873
Processes:      Albumen
Formats:        Prints
Subjects:       Documentary
Locations:      US - northeast
Studio:         US
    Entries:
Phillips NY 11/29/79: 286 ill;

**CRANFIELD, T.**
Photos dated: 1880s-c1890
Processes:      Albumen
Formats:        Prints, cabinet cards
Subjects:       Portraits
Locations:      Studio
Studio:         Ireland - Dublin
    Entries:
California Galleries 1/21/78: 141 (album, C et al);
Sothebys Lon 10/28/81: 304 (lot, C-1 et al);

**CRAWFORD, J.G.**
Photos dated: 1870s-1880s
Processes:      Albumen
Formats:        Stereos
Subjects:       Topography
Locations:      US - Oregon
Studio:
    Entries:
Rinhart NY Cat 1, 1971: 242 (3);

**CRAWSHAY, Robert Thompson** (British, 1817-1879)
Photos dated: 1860s-1876
Processes:      Albumen
Formats:        Prints
Subjects:       Genre, portraits
Locations:      Wales
Studio:         Wales
    Entries:
Christies Lon 3/16/78: 41 (lot, C-3 et al);
Christies Lon 3/28/85: 178 ill(note), 179 ill, 180
    ill, 181;
Christies Lon 10/31/85: 212 (album, 71)(note), 213
    (48)(note), 214 (26)(note), 215 (album, C-2
    et al);

**CRAWLEY, C.** (British)
Photos dated: 1846
Processes:      Salt
Formats:        Prints
Subjects:       Genre, photogenic drawing
Locations:      Great Britain
Studio:         Great Britain
    Entries:
Christies Lon 10/31/85: 168 (2);

**CRAWLEY, F.**
Photos dated: 1840s
Processes:      Daguerreotype
Formats:        Plates
Subjects:       Architecture
Locations:      Italy - Florence
Studio:
    Entries:
Sothebys NY 12/19/79: 55 ill(attributed)(note);

**CREIFIELDS, Theodor** (German)
Photos dated: 1860s-1876
Processes:      Albumen
Formats:        Prints, stereos
Subjects:       Topography
Locations:      Germany - Frankfurt and Cologne;
                Switzerland
Studio:         Germany
    Entries:
California Galleries 4/3/76: 375 (lot, C et al);
Lennert Munich Cat 5, 1979: 34;
Christies Lon 3/20/80: 101 (lot, C et al);
California Galleries 3/30/80: 390 (6);
California Galleries 12/13/80: 362 (9);
California Galleries 6/28/81: 310 (9);
Christies Lon 10/29/81: 143 (lot, C et al);
Christies Lon 3/11/82: 94 (lot, C et al);
Harris Baltimore 12/10/82: 39 (lot, C-4 et al), 390
    (lot, C et al);
Harris Baltimore 3/15/85: 14 (lot, C-3 et al);
Harris Baltimore 2/14/86: 328 (lot, C et al);
Christies Lon 6/26/86: 182 (lot, C-1 et al);

**CRELIN, Philip, Jr.** (British)
Photos dated: 1869
Processes: Albumen
Formats: Prints
Subjects: Documentary (medical)
Locations: England - London
Studio: England - London
    Entries:
Wood Conn Cat 45, 1979: 104 ill(book, 2)(note);
Wood Conn Cat 49, 1982: 156 (book, 2);

**CREMER, James** (American)
Photos dated: late 1860s-1876
Processes: Albumen
Formats: Prints, stereos, cdvs
Subjects: Topography, genre
Locations: US - Philadelphia, Pennsylvania
Studio: US - Philadelphia, Pennsylvania
    Entries:
Sothebys NY (Strober Coll.) 2/7/70: 474 (lot,
    C-4 et al), 475 (lot, C-3 et al);
Rinhart NY Cat 2, 1971: 548, 564 (3);
Rinhart NY Cat 7, 1973: 384 (3);
Vermont Cat 7, 1974: 618 ill(2);
Vermont Cat 9, 1975: 561 ill(4);
Witkin NY IV 1976: S8 ill;
California Galleries 4/3/76: 355 (23);
California Galleries 1/23/77: 432 (lot, C et al);
California Galleries 1/21/78: 191 (23);
California Galleries 1/21/79: 311 (lot, C et al);
Christies Lon 3/15/79: 85 (lot, C-1 et al), 86 (lot,
    C et al);
Christies Lon 6/26/80: 115 (lot, C et al);
Christies Lon 10/30/80: 106 (lot, C-5 et al);
Swann NY 11/6/80: 268 (5)(note), 269 ill(6)(note),
    270 (6);
Christies Lon 3/26/81: 129 (lot, C-2 et al);
Swann NY 4/23/81: 444 (60);
Harris Baltimore 7/31/81: 95 (lot, C et al);
Christies Lon 3/11/82: 96 (lot, C et al);
Harris Baltimore 4/8/83: 88 (lot, C et al), 89 (lot,
    C et al);
Harris Baltimore 12/16/83: 24 (lot, C-4 et al), 107
    (lot, C et al);
Harris Baltimore 6/1/84: 119 (lot, C et al);
Harris Baltimore 3/15/85: 82 (lot, C-11 et al), 84
    (lot, C-9 et al), 111 (lot, C et al);
Harris Baltimore 2/14/86: 41 (lot, C et al);
Phillips Lon 10/29/86: 247B (lot, C et al);

**CREMIERE, Léon** (French)
Photos dated: 1861-1865
Processes: Albumen, carbon
Formats: Prints, cdvs
Subjects: Portraits, genre (animal life),
    ethnography
Locations: France
Studio: France - Paris
    Entries:
Rauch Geneva 12/24/58: 243 (lot, C et al);
Lennert Munich Cat 5, 1979: 22 (C & Hanfstaengl);
Octant Paris 3/1979: 22 ill(C & Hanfstaengl);
Sothebys NY 5/20/80: 367 (book, 12)(attributed)
Sothebys NY 5/24/82: 230 ill(C & Hanfstaengl);
Sothebys Lon 10/26/84: 88 ill(9), 89 (7);
Phillips NY 11/12/86: 68 (5);
Swann NY 11/13/86: 168 (album, C et al);

**CRERAR** (British)
Photos dated: Nineteenth century
Processes: Albumen
Formats: Cdvs
Subjects: Portraits
Locations: Studio
Studio: Great Britain
    Entries:
Sothebys NY 11/21/70: 330 (lot, C et al);

**CRESLEY, Major F.** (British)
Photos dated: 1868
Processes: Albumen
Formats: Prints
Subjects: Genre
Locations: Great Britain
Studio: Great Britain
    Entries:
Christies Lon 3/16/78: 300 ill(album, C attributed
    et al);

**CRESPON, A.** (French)
Photos dated: early 1850s-1860s
Processes: Salt, albumen
Formats: Prints
Subjects: Topography
Locations: France - Nimes
Studio: France
    Entries:
Christies Lon 10/27/77: 90;
Christies Lon 3/16/78: 70 ill(album, C-1 et al);
Sothebys Lon 3/22/78: 63 ill(album, C-1 et al);
Sothebys Lon 10/24/79: 338 (1 plus 1 attributed);
Phillips NY 5/9/81: 33;
Phillips Lon 11/4/83: 129 ill(8 plus 2 attributed);
Christies Lon 3/29/84: 133 ill(note);
Christies Lon 6/27/85: 137 ill(note);

**CRESSEY** (see McLEISH & CRESSEY)

**CRETTE, L.**
Photos dated: 1850s and/or 1860s
Processes: Albumen
Formats: Prints
Subjects: Topography, portraits, genre
Locations: France; Italy
Studio: France - Nice
    Entries:
Phillips Lon 10/24/84: 165 ill(album, C-15 et al)
    (note);
Christies Lon 10/25/84: 62 (lot, C-2 et al);
Christies Lon 3/28/85: 334 (lot, C-1 et al);
Phillips Lon 6/26/85: 147 (album, C-1 et al);
Sothebys Lon 4/25/86: 83 (lot, C et al)(note);

**CRETTLY, L.** (possibly C., L., q.v.)
Photos dated: c1860
Processes: Albumen
Formats: Prints
Subjects: Topography
Locations:
Studio:
    Entries:
Christies Lon 3/15/79: 183 (album, C et al);

CREWES & VAN LAUN
Photos dated: 1870s
Processes:     Albumen
Formats:      Prints incl. panoramas
Subjects:     Topography
Locations:     South Africa - Cape Town
Studio:
    Entries:
Christies Lon 10/31/85: 294 (album, C & V-2 et al);

CRISSMAN, J. (American)
Photos dated: 1883
Processes:     Albumen
Formats:      Prints
Subjects:     Topography
Locations:     US - American west
Studio:       US
    Entries:
Sothebys Lon 10/18/74: 133 ill(album, C-5 et al);

CROCKER, W.H. (American)
Photos dated: 1891
Processes:     Photogravure
Formats:      Prints
Subjects:     Genre (rural life)
Locations:     US - Vermont
Studio:       US
    Entries:
California Galleries 1/22/77: 283;

CROCKETT, F.H. (American)
Photos dated: 1870s
Processes:     Albumen
Formats:      Stereos
Subjects:     Topography
Locations:     US - Massachusetts; New York State
Studio:       US - Rockland, Massachusetts
    Entries:
California Galleries 4/3/76: 430 (lot, C et al);
California Galleries 1/21/78: 184 (lot, C et al);

CROCKETT, W.M. (British)
Photos dated: 1890s
Processes:     Bromide
Formats:      Prints
Subjects:     Documentary (maritime)
Locations:     Great Britain
Studio:       Great Britain
    Entries:
Christies Lon 6/26/80: 170 (3);

CROCKWELL, James A. (American)
Photos dated: c1875
Processes:     Albumen
Formats:      Prints
Subjects:     Topography
Locations:     US - Salt Lake City, Utah
Studio:       US
    Entries:
California Galleries 6/19/83: 507;

CROFT (British)
Photos dated: 1860s
Processes:     Albumen
Formats:      Cdvs
Subjects:     Topography
Locations:     England - Torquay
Studio:       England - Torquay
    Entries:
Sothebys Lon 6/26/75: 204 (album, C et al);

CROOKE (British)
Photos dated: c1895
Processes:
Formats:      Cabinet cards
Subjects:     Portraits
Locations:     Studio
Studio:       Scotland - Edinburgh
    Entries:
California Galleries 1/21/78: 140 (album, C et al);

CROS, Charles-Emile-Hortensius (French, 1842-1888)
Photos dated: 1881-1882
Processes:     Trichrome color
Formats:      Prints
Subjects:     Documentary (art)
Locations:     France
Studio:       France
    Entries:
Sothebys Lon 6/25/82: 232 ill(note);

CROSNIER, A.
Photos dated: 1850s and/or 1860s
Processes:     Albumen
Formats:      Prints
Subjects:     Documentary
Locations:
Studio:
    Entries:
Christies Lon 6/24/82: 357 ill(2);

CROSS, D.H. (American)
Photos dated: 1882
Processes:     Albumen
Formats:      Stereos
Subjects:     Documentary (disasters)
Locations:     US - Grinnell, Iowa
Studio:       US - Davenport, Iowa
    Entries:
Rinhart NY Cat 6, 1973: 421 (lot, C-2 et al);
California Galleries 393 (lot, C-1 et al);
Harris Baltimore 3/26/82: 18 (17);

CROSS, W.R. (American)
Photos dated: 1870s-1880s
Processes:     Albumen
Formats:      Stereos
Subjects:     Topography
Locations:     US - Yellowstone Park, Wyoming
Studio:       US - Niobrara, Nebraska
    Entries:
California Galleries 4/3/76: 492 (lot, C et al);
California Galleries 1/23/77: 378 (lot, C-3 et al);

CROUCH, William T. (American)
Photos dated: 1850s
Processes:     Ambrotype
Formats:       Plates
Subjects:      Portraits
Locations:     Studio
Studio:        US - Cincinnati, Ohio
    Entries:
Swann NY 4/23/81: 268 (lot, C-1 et al);

CROUCHER, John (British)
Photos dated: 1840s
Processes:     Energiatypes
Formats:
Subjects:      Genre (still life)
Locations:
Studio:
    Entries:
Swann NY 2/14/52: 4 (album, C et al), 113
    (lot, C et al);

CROWE, A. (British)
Photos dated: 1860s-1870s
Processes:     Albumen
Formats:       Stereos
Subjects:      Topography
Locations:     England
Studio:        England - Stirling
    Entries:
Christies Lon 6/24/82: 69 (lot, C et al);
Harris Baltimore 3/15/85: 117 (lot, C et al)(note);

CROWE, Levi (American)
Photos dated: c1850-1851
Processes:     Daguerreotype
Formats:       Plates
Subjects:      Portraits
Locations:     Studio
Studio:        US - Hemphill, Pennsylvania
    Entries:
Colnaghi Lon 1976: 14 (note);
Sothebys Lon 3/19/76: 93;
Christies Lon 6/27/78: 12;
Christies Lon 10/25/79: 13 ill;
Christies Lon 10/30/80: 14;

CROZIER, François (photographer or owner?)
Photos dated: c1880-1880s
Processes:     Albumen
Formats:       Prints
Subjects:      Topography
Locations:     Great Britain; France; Germany;
               Egypt; Aden; Reunion; Zanzibar;
               Comoros
Studio:
    Entries:
California Galleries 1/22/77: 284 (22), 285 (lot,
    C-9 et al), 286 (24);
Swann NY 11/14/85: 66 (album, 24);

CRUM (see GATES)

CRUM, R.D. (American)
Photos dated: 1860s-1880s
Processes:     Albumen
Formats:       Stereos, cdvs
Subjects:      Topography, portraits
Locations:     US - New York
Studio:        US - Watkins Glen, New York
    Entries:
Rinhart NY Cat 2, 1971: 366 (lot, C et al);
Rinhart NY Cat 6, 1973: 531;
California Galleries 4/3/76: 426 (lot, C et al);
California Galleries 1/21/78: 183 (lot, C et al);
California Galleries 1/21/79: 302 (lot, C et al);
California Galleries 3/30/80: 419 (lot, C et al);
California Galleries 6/28/81: 321 (lot, C et al);
Harris Baltimore 4/8/83: 68 (lot, C et al), 69 (lot,
    C et al);
Swann NY 11/10/83: 353 (lot, C et al);
Harris Baltimore 12/16/83: 91 (lot, C-19 et al);
Harris Baltimore 6/1/84: 101 (20);
Harris Baltimore 2/14/86: 38 (lot, C et al);

CRUPI, Giovanni (Italian)
Photos dated: 1860s-1880s
Processes:     Albumen
Formats:       Prints
Subjects:      Topography
Locations:     Italy - Sicily
Studio:        Italy - Sicily
    Entries:
Vermont Cat 7, 1974: 742 (album, C-2 et al);
Sothebys NY 10/4/77: 217 (lot, C-1 et al);
Christies NY 5/16/80: 188 (lot, C et al);
Swann NY 5/5/83: 344 (albums, C et al);
Sothebys NY 11/5/84: 105 (lot, C-4 et al);
Swann NY 11/13/86: 245 (lot, C-29 et al)(note);

CRUTTENDEN, J. (British)
Photos dated: 1868-1869
Processes:     Albumen
Formats:       Prints
Subjects:      Architecture
Locations:     England - Kent
Studio:        England - Maidstone
    Entries:
Christies Lon 10/4/73: 98 (book, 8);
Edwards Lon 1975: 130 (book, 8);
Swann NY 2/6/75: 108 (book, 8);
Sothebys Lon 10/29/76: 169 (book, 8);
Lehr NY Vol 1:4, 1978: 41 (book, 8);
Sothebys Lon 3/22/78: 33 (book, 8);
Christies Lon 10/30/80: 292 (book, 8);
Phillips Lon 11/4/83: 32 (book, 8);
Christies Lon 6/26/86: 120 (book, 8);

CUCCIONI, Tommaso (Italian, died 1864)
Photos dated: 1852-1864
Processes:     Albumen
Formats:       Prints, stereos
Subjects:      Topography
Locations:     Italy - Rome; Naples; Milan
Studio:        Italy - Rome
    Entries:
Andrieux Paris 1951(?): 20 (3);
Rinhart NY Cat 6, 1973: 345;
Sothebys Lon 12/4/73: 28 (album, C et al);
Sothebys Lon 6/21/74: 77 (3 ills)(3);
California Galleries 9/27/75: 333 (lot, C-1 et al);

## CUCCIONI, T. (continued)

Sothebys Lon 10/24/75: 115 ill(lot, C et al);
Rose Boston Cat 2, 1977: 55 ill(note);
Rose Boston Cat 3, 1978: 46 ill(note);
Sothebys Lon 10/24/79: 346 (2 plus 7 attributed);
Christies Lon 3/20/80: 145 (album, C-3 et al);
Christies Lon 10/30/80: 206;
Christies Lon 6/18/81: 185;
Christies Lon 3/11/82: 138 (lot, C et al);
California Galleries 5/23/82: 267 ill;
Sothebys Lon 6/25/82: 95 (lot, C et al);
Christies Lon 10/28/82: 54 (lot, C-4 et al);
Christies Lon 3/24/83: 70 (lot, C et al), 84 (lot, C-4 et al);
Christies Lon 6/23/83: 91 (lot, C-1 et al), 107 (lot, C et al);
Christies Lon 10/27/83: 73 (lot, C et al);
Christies Lon 3/29/84: 148 (lot, C et al);
Christies NY 2/13/85: 142 (lot, C et al);
Christies Lon 4/24/86: 344 (lot, C et al);

## CUDLIP (American)

Photos dated: Nineteenth century
Processes:      Albumen
Formats:        Stereos
Subjects:       Topography
Locations:      US - Washington, D.C.
Studio:         US
  Entries:
Harris Baltimore 7/31/81: 128 (lot, C et al);
Harris Baltimore 12/16/83: 143 (lot, C et al);
Harris Baltimore 3/15/85: 111 (lot, C et al);

## CULLEN, Henry (British)

Photos dated: 1840
Processes:      Calotype
Formats:        Prints
Subjects:       Portraits
Locations:      England
Studio:         England
  Entries:
Weil Lon Cat 10, 1949(?): 362 (album, C-2 et al) (note);

## CUNDALL, Joseph (British, 1818-1875)

Photos dated: 1844-1866
Processes:      Daguerreotype, albumen, photogalvanograph
Formats:        Plates, prints, cdvs
Subjects:       Topography, portraits
Locations:      England; France; Belgium; Rhine area; Spain
Studio:         England
  Entries:
Goldschmidt Lon Cat 52, 1939: 233 (book, C & Fleming, 15);
Weil Lon Cat 7, 1945: 116 (book, C & Fleming, 15), 117 (book, C & Fleming, 14);
Swann NY 2/14/52: 4 (album, C et al), 6 (lot, C et al), 104 (book, C et al), 173 (book, C & Fleming, 20)(note), 262 (album, C et al);
Sothebys NY 11/21/70: 349 (lot, C & Downes, et al);
Rinhart NY Cat 7, 1973: 32 (book, C & Fleming, 14);
Rinhart NY Cat 8, 1973: 6 (book, C & Downes, 1);
Sothebys Lon 5/24/73: 36 (books, C & Fleming-15, et al);
Sothebys Lon 12/4/73: 13 (lot, C & Fleming-13, et al), 173 (book, C et al);

## CUNDALL (continued)

Christies Lon 4/25/74: 207 (books, C & Fleming et al), 211 (books, C, Howlett & Downes, et al);
Edwards Lon 1975: 69 (book, C & Downes-1, et al), 88 (book, C & Downes, 8), 118 (book, 1), 177 (book, C & Fleming, 15), 178 (book, C & Fleming, 15), 179 (book, 25);
Swann NY 2/6/75: 74 (book, C & Fleming, 15);
Colnaghi Lon 1976: 88 ill(C & Howlett)(note);
Wood Conn Cat 37, 1976: 27 (book, C & Downes-1, et al), 48 (book, C & Fleming, 15)(note);
Sothebys Lon 3/19/76: 189 ill(C & Howlett)(note), 190 ill(C & Howlett, attributed), 191 ill(C & Howlett);
Gordon NY 5/3/76: 296 ill(books, C & Fleming-15, et al);
Gordon NY 5/10/77: 894 (books, C & Downes-25, C & Fleming-15, et al);
Christies Lon 6/30/77: 152 (lot, C & Downes-1, et al);
Sothebys Lon 7/1/77: 29 (book, C & Fleming, 14), 243 (album, C & Downes et al);
Christies Lon 10/27/77: 215 (book, 24)(note);
Sothebys Lon 11/18/77: 174 (book, C & Fleming);
Wood Conn Cat 42, 1978: 134 (book, C & Fleming, 15) (note), 463 (book, C & Fleming, 14)(note);
Swann NY 4/20/78: 140 (book, C & Fleming, 14);
Sothebys Lon 6/28/78: 26 (book, C & Fleming, 15);
Christies Lon 10/26/78: 287 ill(C & Howlett)(note);
Sothebys Lon 10/27/78: 213 (book, C & Fleming, 15);
Phillips NY 11/4/78: 25 (C & Howlett);
Wood Conn Cat 45, 1979: 69 (book, 15)(note), 310 ill (book, C & Fleming, 22)(note);
Sothebys Lon 3/14/79: 234 (book, 25), 235 (book, C & Fleming, 15), 324 (album, C-1 et al);
Swann NY 10/18/79: 206 (book, C & Fleming, 15);
Sothebys Lon 10/24/79: 344 (C & Delamotte, 3), 349 (C & Delamotte, 2);
Christies Lon 10/25/79: 76 (lot, C et al), 273 (book, C & Fleming, 15);
Sothebys Lon 3/21/80: 295 (C & Delamotte, 2), 296 (C & Delamotte, 2);
Christies NY 5/14/80: 302 (book, C & Fleming, 74);
Christies Lon 6/26/80: 309 (book, C & Fleming, 15);
Sothebys Lon 6/27/80: 95 (C & Downes, 7), 254 (C & Delamotte), 257 (C & Delamotte);
Christies Lon 10/30/80: 290 (book, C & Fleming, 15);
Sothebys Lon 3/27/81: 382 (C & Downes, 7);
Sothebys Lon 6/17/81: 327 (lot, C & Delamotte-17, et al), 438 (book, C & Fleming, 15), 440 (book, C & Fleming, 15), 441 (book, C & Fleming, 20);
Christies Lon 6/18/81: 71 (C & Delamotte), 77 (lot, C & Delamotte-2, et al), 418 (C & Howlett, 6) (attributed);
Sothebys Lon 10/28/81: 185 (C & Delamotte, 2), 186 (C & Delamotte, 2);
Wood Conn Cat 49, 1982: 118 (book, 15)(note), 403 (book, C & Fleming, 15)(note);
Christies Lon 3/11/82: 302 ill(C & Howlett);
Sothebys Lon 3/15/82: 322 (C & Delamotte, 5), 432 (book, C & Delamotte, 18);
Sothebys Lon 6/25/82: 51 (book, C & Fleming, 14), 186 ill(C & Downes);
Christies Lon 10/28/82: 52 (C & Delamotte, 2), 127 (books, C & Fleming et al);
Sothebys Lon 10/29/82: 116 ill(C & Downes, 14), 146 ill(C & Downes)
Christies Lon 6/23/83: 256 (lot, C & Downes et al);
Christies Lon 10/27/83: 162 (book, 30)(attributed) (note);

CUNDALL (continued)
Phillips Lon 11/4/83: 30 (book, C & Fleming), 145
(album, C-1 et al);
Christies Lon 3/29/84: 181 (C & Downes)(note), 182
ill(C & Downes)(note), 183 (C & Downes)(note),
184 ill(lot, C & Downes-8, et al);
Swann NY 5/10/84: 37 (book, C & Fleming, 15), 322
(albums, C et al)(note);
Christies Lon 10/25/84: 163 (C & Delamotte)(2);
Sothebys Lon 10/26/84: 34 (book, 22)(note), 162 ill
(lot, C & Downes-14, et al);
Christies Lon 3/28/85: 191 (lot, C-1 et al);
Sothebys Lon 3/29/85: 150 ill(C & Howlett), 151 ill
(C & Downes, 43);
Christies Lon 6/27/85: 132 (C & Delamotte, 2)
(note), 133 (C & Howlett, 6)(attributed), 246
(albums, C & Downes et al)(note);
Phillips Lon 10/30/85: 63 (lot, C & Downes-1,
et al);
Christies Lon 10/31/85: 150 (books, C & Fleming-15,
et al), 182 (lot, C-1 et al), 183 ill(2)(note),
185 (book, C-1 et al);
Sothebys Lon 11/1/85: 59 (album, C-1 et al);
Swann NY 11/14/85: 220 (book, C & Delamotte, 23)
(note);
Wood Boston Cat 58, 1986: 347 (book, C & Fleming,
22)(note), 351 (book, C & Fleming, 15)(note),
356 (book, C & Fleming, 15)(note);
Phillips Lon 4/23/86: 228 (album, C & Downes et
al), 244 (lot, C & Downes et al);
Christies Lon 4/24/86: 414 ill(book, C & Delamotte,
23)(note), 452 (C & Howlett);
Christies Lon 6/26/86: 27 (lot, C-1 et al), 175
(books, C & Fleming et al);
Christies Lon 10/30/86: 82 (lot, C-1 et al);

CUNDELL, Henry (British, 1810-1886)
Photos dated: 1842-1852
Processes:      Calotype
Formats:        Prints
Subjects:       Topography
Locations:      England; Wales; Scotland
Studio:         Great Britain
    Entries:
Christies Lon 10/28/76: 71 ill(5)(attributed);

CUNNINGHAM & Co. (American)
Photos dated: 1880s
Processes:      Albumen
Formats:        Stereos, cdvs
Subjects:       Topography, portraits
Locations:      US
Studio:         US - Colorado Springs, Colorado
    Entries:
California Galleries 1/21/79: 232 (lot, C et al);
Christies Lon 10/29/81: 147 (lot, C et al);
Swann NY 5/15/86: 167 (lot, C et al);

CUNNINGHAM, Alfred
Photos dated: c1895
Processes:      Albumen
Formats:        Prints
Subjects:       Portraits, documentary
Locations:      China - Hong Kong
Studio:
    Entries:
Phillips NY 5/5/79: 184 (book, 6);

CURREY
Photos dated: 1880s
Processes:      Albumen
Formats:        Prints
Subjects:       Portraits
Locations:
Studio:
    Entries:
Sothebys LA 2/6/80: 15 ill;

CURREY, Francis Edmund (British, 1814-1896)
Photos dated: 1855-1870s
Processes:      Albumen
Formats:        Prints
Subjects:       Architecture, genre (still life);
Locations:      England; Ireland
Studio:         Ireland (Amateur Photographic
                Association, Photographic Club)
    Entries:
Weil Lon Cat 4, 1944(?): 237 (album, C et al)(note);
Sothebys Lon 10/18/74: 158 (album, C et al);
Sothebys Lon 3/21/75: 286 (album, C-1 et al);
Sothebys Lon 10/29/80: 310 (album, C et al);
Sothebys Lon 3/27/81: 174 (2)(note), 175 (album,
C et al), 176 (2 ills)(album, 211), 177 (album,
C et al), 178 (album, 238), 179 (lot, C
attributed et al), 180 ill(lot, C-1 et al),
181 (attributed);
Sothebys Lon 6/17/81: 329;
Christies Lon 10/29/81: 359 (album, C-1 et al)
(note);
Sothebys Lon 3/15/82: 330 (11, attributed);
Christies Lon 6/24/82: 115 ill(7);
Sothebys Lon 6/25/82: 148 ill(6);
Christies Lon 10/28/82: 51 (7);
Christies Lon 6/23/83: 83 ill(4);
Christies Lon 10/27/83: 218 (albums, C-2 et al);
Christies Lon 3/29/84: 206 (8);
Sothebys Lon 6/29/84: 194 (lot, C-1 et al);
Christies Lon 10/25/84: 164;
Christies NY 5/6/85: 119 ill(2);
Sothebys Lon 11/1/85: 59 (album, C-1 et al);
Christies Lon 4/24/86: 495 ill(3);
Christies Lon 10/30/86: 95 ill, 96 (14);
Sothebys Lon 10/31/86: 75 (4);

CURSCHMANN, Dr. H. (photographer or author?)
Photos dated: 1894
Processes:      Heliogravure
Formats:        Prints
Subjects:       Documentary (medical)
Locations:
Studio:
    Entries:
Christies Lon 6/26/80: 344 (book, 57);
Christies Lon 3/26/81: 301 (book, 57);

CURTHS (see NICHOLAS & CURTHS)

**CURTIS** (British)
Photos dated: Nineteenth century
Processes:       Albumen
Formats:         Stereos
Subjects:        Topography
Locations:       England
Studio:          Great Britain
    Entries:
California Galleries 9/27/75: 479 (lot, C et al);
California Galleries 1/23/77: 384 (lot, C et al);

**CURTIS, C.C.** (American)
Photos dated: c1885
Processes:       Albumen
Formats:         Prints
Subjects:        Documentary (public events)
Locations:       US - California
Studio:          US
    Entries:
California Galleries 5/23/82: 268;
California Galleries 6/19/83: 503 (attributed);

**CURTIS, George E.** (American)
Photos dated: c1870-1890s
Processes:       Albumen
Formats:         Prints, stereos
Subjects:        Topography
Locations:       US - Niagara Falls, New York
Studio:          US - Niagara Falls, New York
    Entries:
Rinhart NY Cat 1, 1971: 238 (6), 239 (20), 241 (lot,
    C et al);
Rinhart NY Cat 2, 1971: 543 (lot, C-8 et al);
Vermont Cat 2, 1971: 231 (15);
Christies Lon 7/25/74: 242 (lot, C et al);
Sothebys Lon 10/18/74: 1 (lot, C et al);
California Galleries 9/26/75: 257 ill(attributed);
California Galleries 9/27/75: 533 (35);
Witkin NY IV 1976: 54 ill;
Swann NY 4/1/76: 221 (lot, C et al);
California Galleries 4/3/76: 341 (lot, C et al);
Christies Lon 10/28/76: 195 (lot, C-10 et al), 198
    (lot, C et al);
California Galleries 1/23/77: 423 (35);
Swann NY 12/8/77: 404 (lot, C et al);
California Galleries 1/21/78: 143 (lot, C et al),
    350 attributed;
Swann NY 12/14/78: 388 (2)(note);
Sothebys Lon 3/14/79: 1 (22);
Phillips NY 5/5/79: 105 ill(45);
Phillips Can 10/4/79: 33 ill(5), 34 ill(5), 35 ill,
    36 ill;
Christies NY 10/31/79: 135;
Sothebys NY 5/20/80: 323 ill, 324;
Christies Lon 10/30/80: 135 (lot, C-8 et al);
Swann NY 4/23/81: 324, 506 (attributed)(note);
Harris Baltimore 7/31/81: 112 (lot, C-13 et al);
Christies Lon 10/29/81: 147 (lot, C et al);
Harris Baltimore 3/26/82: 8 (lot, C et al), 10 (lot,
    C-10 et al), 14 (lot, C et al);
Swann NY 4/1/82: 357 (lot, C et al);
California Galleries 5/23/82: 269 (attributed);
Phillips NY 9/30/82: 964;
Harris Baltimore 12/10/82: 69 (lot, C et al);
Harris Baltimore 4/8/83: 75 (lot, C et al);
Christies Lon 10/27/83: 21 (lot, C-23 et al), 44
    (lot, C et al);
Swann NY 11/10/83: 353 (lot, C et al);
Harris Baltimore 12/16/83: 34 (77);

**CURTIS, G.** (continued)
Christies Lon 3/29/84: 30 (lot, C-3 et al), 38 (lot,
    C-6 et al);
Swann NY 5/10/84: 284 (attributed);
Harris Baltimore 6/1/84: 103 (lot, C et al), 109
    (lot, C et al);
Christies Lon 6/28/84: 37a (lot, C et al);
California Galleries 7/1/84: 200 (9);
Christies Lon 10/25/84: 48 (lot, C-2 et al);
Swann NY 11/8/84: 265 (lot, C et al);
Harris Baltimore 3/15/85: 69 (lot, C et al), 75
    (lot, C-22 et al), 76 (lot, C-6 et al);
Christies Lon 3/28/85: 45 (lot, C et al);
Swann NY 5/9/85: 434 (lot, C et al);
Swann NY 11/14/85: 168 (lot, C et al);
Harris Baltimore 2/14/86: 38 (lot, C et al);
Christies Lon 4/24/86: 310 (lot, C et al);
Swann NY 5/15/86: 162 (lot, C-2 et al);
Swann NY 11/13/86: 323 (lot, C-18 et al);

**CURTISS** (American)
Photos dated: Nineteenth century
Processes:       Albumen
Formats:         Cabinet cards
Subjects:        Portraits
Locations:       Studio
Studio:          US
    Entries:
Harris Baltimore 9/16/83: 149 (lot, C et al);

**CURWEN, R.E.** (British)
Photos dated: Nineteenth century
Processes:       Albumen
Formats:         Prints
Subjects:        Genre
Locations:       Great Britain
Studio:          Great Britain
    Entries:
Sothebys Lon 10/29/76: 49 (album, C et al);

**CUSHING** (American)
Photos dated: late 1870s
Processes:       Albumen
Formats:         Stereos
Subjects:        Topography
Locations:       US - Jacksonville, Florida; Vermont
Studio:          US
    Entries:
Rinhart NY Cat 6, 1973: 450;
Harris Baltimore 12/10/82: 106 (lot, C et al);
Harris Baltimore 3/15/85: 38 (lot, C-4 et al);

**CUTLER, H.E.** (American)
Photos dated: 1880-1895
Processes:       Albumen
Formats:         Prints
Subjects:        Documentary (public events)
Locations:       US - Hanover, New Hampshire
Studio:          US - Morrisville, Vermont
    Entries:
Swann NY 4/17/80: 64 (book, C-1 et al);

**CUTTING & BOWDOIN**
Photos dated: 1854-mid 1850s
Processes:      Ambrotype
Formats:        Plates
Subjects:       Portraits
Locations:
Studio:
   Entries:
Phillips Lon 3/17/82: 32 (note);
Swann NY 5/9/85: 342;
Swann NY 11/13/86: 184 (lot, C & B-1 et al);

**CUVELIER, Eugène** (French, died 1900)
Photos dated: 1850s-1863
Processes:      Albumen, photolithograph (Poitevin
                process)
Formats:        Prints
Subjects:       Topography
Locations:      France - Fontainebleau; Barbizon;
                Arras
Studio:         France
   Entries:
Octant Paris 3/1979: 12 ill(attributed);
Sothebys Lon 10/26/84: 86 ill(note);
Christies NY 11/6/84: 21 ill(note);
Sothebys Lon 6/28/85: 195 ill;

**CUYLER, Ben** (see McCANN, D.)

**CZICHNA, C.A.**
Photos dated: 1870s-c1880
Processes:      Albumen
Formats:        Prints
Subjects:       Topography, documentary (railroads)
Locations:      Austria
Studio:         Austria - Innsbruck
   Entries:
Rinhart NY Cat 6, 1973: 11 (album, 17);
Harris Baltimore 2/14/86: 328 (lot, C et al);

**D., Ch.** [Ch. D.] (French)
Photos dated: 1860s-c1872
Processes:     Albumen
Formats:       Stereos incl. tissue
Subjects:      Topography
Locations:     France - Paris
Studio:        France
   Entries:
Christies Lon 10/30/80: 109 (lot, D et al);
Harris Baltimore 7/31/81: 124;

**D., E.** [E.D.]
Photos dated: c1890
Processes:     Albumen
Formats:       Prints
Subjects:      Topography
Locations:     Norway
Studio:
   Entries:
Rinhart NY Cat 7, 1973: 424;

**D., G.** [G.D.] (French)
Photos dated: c1880
Processes:     Albumen
Formats:       Prints
Subjects:      Topography
Locations:     France - Rouen
Studio:        France
   Entries:
California Galleries 4/3/76: 313 (8);
Swann NY 11/11/76: 388 (albums, D et al), 389
   (albums, D et al), 395 (albums, D et al);

**D., J.** [J.D.]
Photos dated: 1895
Processes:     Albumen
Formats:       Prints
Subjects:      Architecture
Locations:     France; Italy
Studio:
   Entries:
Swann NY 11/11/76: 388 (albums, D et al), 389
   (albums, D et al), 395 (albums, D et al);
Swann NY 11/13/86: 218 (album, D et al);

**D., M.** [M.D.] (British)
Photos dated: mid 1850s
Processes:     Salt
Formats:       Prints
Subjects:      Topography
Locations:     England - Pellegare
Studio:        Great Britain
   Entries:
Sothebys Lon 7/1/77: 184 (album, D et al)(note);
Christies Lon 6/18/81: 395 (album, D-2 et al)(note);

**D., T.** [T.D.] (British)
Photos dated: Nineteenth century
Processes:     Albumen
Formats:       Stereos
Subjects:      Topography
Locations:     Great Britain
Studio:        Great Britain
   Entries:
Christies Lon 3/11/82: 82 (lot, D-6 et al);

**DABDOUB, Gabriel and Abrahim**
Photos dated: c1880
Processes:     Albumen
Formats:       Prints
Subjects:      Topography
Locations:     Palestine - Bethlehem and Jerusalem
Studio:        Middle East
   Entries:
Phillips NY 11/3/79: 182 (album, 21);

**DABS, B.L.H.** (American)
Photos dated: 1870s
Processes:     Albumen
Formats:       Prints, cdvs
Subjects:      Portraits, ethnography
Locations:     Studio
Studio:        US - Pittsburg, Pennsylvania
   Entries:
California Galleries 3/30/80: 220 (albums,
   D-1 et al);
Old Japan, England, Cat 8, 1985: 72;

**DAFT, Leo** (American)
Photos dated: 1870s-1880s
Processes:     Albumen
Formats:       Stereos
Subjects:      Topography
Locations:     US - Troy, New York
Studio:        US - Troy, New York
   Entries:
California Galleries 4/3/76: 357 (28);
California Galleries 1/21/78: 181 (28);

**DAGG, S.H.**
Photos dated: between 1875 and 1898
Processes:     Albumen
Formats:       Prints
Subjects:      Topography
Locations:     India
Studio:
   Entries:
Edwards Lon 1975: 30 (album, D et al);

**DAGGETT, B.B.** (American)
Photos dated: c1898
Processes:     Albumen
Formats:       Prints
Subjects:      Documentary (military)
Locations:     US - Fort Meade, Pennsylvania
Studio:        US
   Entries:
California Galleries 1/21/78: 351 (20);

**DAGRON, Prudent** (French, 1819-1900)
Photos dated: 1860-1870s
Processes:     Albumen, woodburytype
Formats:       Prints, microphotographs
Subjects:      Portraits incl. Galerie Contemporaine
Locations:     Studio
Studio:        France - Paris
   Entries:
Maggs Paris 1939: 502 ill(book, 118)(note);
Rauch Geneva 6/13/61: 151 (note);
Witkin NY I 1973: 427;
Christies Lon 3/10/77: 276 ill(note);
Christies Lon 6/30/77: 163;

**DAGRON, P.** (continued)
Cisties NY 5/4/79: 46 ill(note);
Christies NY 5/16/80: 138 ill(note);
Christies NY 5/26/82: 36 (book, D et al);
Christies NY 5/7/84: 19 (book, D et al);

**DAHLSTROM, F.A.**
Photos dated: 1886
Processes:    Woodburytype
Formats:     Prints
Subjects:    Portraits, genre
Locations:   Studio
Studio:      Germany - Hamburg
    Entries:
Christies Lon 6/26/80: 334 ill(book, 9);

**DAILLENCQ**
Photos dated: 1860s-1870s
Processes:    Albumen
Formats:     Cdvs
Subjects:    Portraits
Locations:
Studio:      Spain - Madrid
    Entries:
Swann NY 12/14/78: 376 (lot, D et al);

**DAILLON, L.** (French)
Photos dated: 1871
Processes:    Albumen
Formats:     Prints
Subjects:    Documentary (Paris Commune)
Locations:   France - Paris
Studio:      France
    Entries:
Vermont Cat 8, 1974: 577 ill;
Swann NY 11/14/85: 142 (lot, D et al);

**DAINTREE, Richard** (British, 1832-1878)
Photos dated: 1858-1865
Processes:    glass diapositive
Formats:     Plates
Subjects:    Topography
Locations:   Australia - North Queensland
Studio:      England; Australia
    Entries:
Phillips Lon 3/17/82: 90 ill(10)(note);

**DAIREAUX**
Photos dated: c1885
Processes:    Albumen
Formats:     Cabinet card
Subjects:    Portraits
Locations:
Studio:
    Entries:
Maggs Paris 1939: 529;

**DALGLEISH Brothers**
Photos dated: 1885-1890
Processes:    Albumen
Formats:     Prints
Subjects:    Topography
Locations:   US - Colorado
Studio:
    Entries:
Harris Baltimore 12/16/83: 305 (lot, D et al);

**DALLAS, E.W.**
Photos dated: between 1854 and 1857
Processes:    Salt
Formats:     Prints
Subjects:    Topography
Locations:   Europe
Studio:      Europe
    Entries:
Rauch Geneva 6/13/61: 47 (album, D et al);

**DALLEMAGNE** (see LAZERGUE & DALLEMAGNE)

**D'ALLESANDRI, Antonio** (Italian, 1818-1893)
Photos dated: early 1850s-1890
Processes:    Albumen
Formats:     Prints, cdvs, cabinet cards, stereos
Subjects:    Topography, portraits, documentary
             (military), genre
Locations:   Italy - Rome
Studio:      Italy - Rome
    Entries:
Rinhart NY Cat 3, 1973: 343;
California Galleries 9/27/75: 332 (lot, D-1 et al);
California Galleries 1/22/77: 125 (lot, D-1 et al);
Christies Lon 10/27/77: 107 (album, 17);
Swann NY 12/8/77: 384 (lot, D et al);
Christies Lon 10/26/78: 124 (album, D et al);
Christies Lon 3/15/79: 185 (album, D et al);
Sothebys NY 5/15/81: 104 ill(note);
Harris Baltimore 3/15/85: 286 (lot, D et al);
Harris Baltimore 11/7/86: 216 ill;

**DALTON & MICHALE** (photographers or publishers?)
Photos dated: 1863
Processes:    Albumen
Formats:     Prints
Subjects:    Topography
Locations:   China - Canton
Studio:
    Entries:
Christies Lon 6/24/82: 209;

**DAMION**
Photos dated: Nineteenth century
Processes:    Albumen
Formats:     Cdvs
Subjects:    Portraits
Locations:
Studio:
    Entries:
Phillips Lon 3/27/85: 212 (lot, D-1 et al);

**DAMMANN, C. & F.W.**
Photos dated: c1860-1880
Processes:      Albumen
Formats:        Prints
Subjects:       Ethnography
Locations:      Asia; South America; North America
Studio:         England - London
   Entries:
Swann NY 2/14/52: 123 (book, 150);
Sothebys NY 5/20/77: 66 ill(book, D et al);
Christies Lon 6/30/77: 169 (book, 24);
Swann NY 12/14/78: 69 ill(book, 24);
Sothebys Lon 3/25/83: 54 ill(book, 24);
Sothebys Lon 12/9/83: 26 ill(book, 24);

**DAMPF** (American)
Photos dated: 1860s
Processes:      Albumen
Formats:        Cdvs
Subjects:       Portraits
Locations:      Studio
Studio:         US
   Entries:
Sothebys NY (Greenway Coll.) 11/20/70: 272 (lot,
   D-1 et al);

**DANA** (American)
Photos dated: 1870s-1890s
Processes:      Albumen
Formats:        Cabinet cards, cdvs
Subjects:       Portraits
Locations:      Studio
Studio:         US - New York City
   Entries:
Sothebys NY (Weissberg Coll.) 5/16/67: 173 (lot,
   D et al);
Rinhart NY Cat 3, 1973: 241 (5), 628 (note);
Swann NY 11/11/76: 340 (lot, D et al), 362 (album,
   D et al);

**DANCER, John Benjamin** (British, 1812-1887)
Photos dated: 1853-1873
Processes:      Daguerreotype
Formats:        Plates incl. stereo, microphotographs
Subjects:       Genre, topography
Locations:      Studio
Studio:         England - Manchester
   Entries:
Sothebys Lon 10/24/74: 40 ill(note), 41 ill, 42
   ill, 43 ill(attributed)(note), 44 ill, 45,
   46 ill;
Christies Lon 10/27/77: 359 (6);
Christies Lon 10/26/78: 328 (6);
Christies Lon 3/15/79: 60 ill(note)(attributed);
Christies Lon 6/28/79: 79 ill, 80 ill;
Sothebys Lon 6/29/79: 53 ill;
Christies Lon 10/25/79: 101 ill, 102 ill, 103 ill,
   104 ill, 105 ill, 106 ill, 107 ill, 108 ill, 109
   ill, 110 ill;
Christies Lon 3/20/80: 117 ill(note), 118 ill, 119
   ill, 120 ill, 121 ill, 122 ill;
Auer Paris 5/31/80: 104 (note), 105, 106, 107
   (attributed);
Christies Lon 6/18/81: 58 ill(attributed)(note);
Christies Lon 3/29/84: 12 ill;
Christies Lon 10/25/84: 21 ill;
Phillips Lon 3/27/85: 154, 155, 156, 157 (2), 158;
Phillips Lon 6/26/85: 213, 214 (2), 215;

**DANCER, J.B.** (continued)
Phillips Lon 10/30/85: 89A, 89B (2), 90A (lot, D-2
   et al), 90B (lot, D-1 et al), 91 (3), 93 (lot,
   D-1 et al), 95 (lot, D-1 et al);
Christies Lon 10/31/85: 38 (lot, D-3 et al);
Phillips Lon 4/23/86: 289, 290 (2);

**DANCEY** (see DANSEY)

**DANIELS, A.E.** (American)
Photos dated: 1870s
Processes:      Albumen
Formats:        Cdvs, stereos
Subjects:       Portraits, topography
Locations:      US
Studio:         US - warren, Massachusetts
   Entries:
California Galleries 1/21/78: 125 (lot, D et al);

**DANNENBERG, J.C.A.** (British)
Photos dated: 1870s
Processes:      Albumen
Formats:        Prints
Subjects:       Ethnography
Locations:      India
Studio:
   Entries:
Sothebys Lon 10/18/74: 80 (book, D et al);
Christies Lon 3/11/82: 252 (books, D et al);

**DANSEY, George** (British)
Photos dated: early 1850s-early 1860s
Processes:      Albumen
Formats:        Prints
Subjects:       Topography
Locations:      England
Studio:         England
   Entries:
Sothebys Lon 3/8/74: 161 (album, D et al)(note);
Edwards Lon 1975: 2 (album, D et al)(note);

**D'AQUIN** (French)
Photos dated: Nineteenth century
Processes:      Albumen
Formats:        Cabinet cards
Subjects:       Topography
Locations:      France
Studio:         France
   Entries:
Christies Lon 6/26/80: 261 (lot, D et al);

**DARIES** (see FREDERICKS)

**DARLING** (American)(see also LANGILL)
Photos dated: 1888
Processes:      Albumen
Formats:        Prints
Subjects:       Documentary (public events)
Locations:      US - New York City
Studio:         US
   Entries:
Phillips NY 5/21/80: 295;

DAROGAH (see ALLI, D.)

DARWIN, Captain (British)
Photos dated: 1884
Processes:    Woodburytype
Formats:      Prints
Subjects:     Portraits
Locations:    Great Britain
Studio:
    Entries:
Sothebys NY 5/8/79: 73 (books, D-1 et al);

DA SILVA, Joaquim Possidonio Narcizo (Portuguese)
                    (photographer?)
Photos dated: 1862
Processes:    Albumen
Formats:      Prints
Subjects:     Topography
Locations:    Portugal
Studio:       Portugal
    Entries:
Swann NY 12/14/78: 453 (9)(note);
Swann NY 4/17/80: 348 (21)(note);

DATE, James (British)
Photos dated: 1859
Processes:    Ambrotype
Formats:      Plates incl. stereos
Subjects:     Portraits
Locations:    Studio
Studio:       England
    Entries:
Christies Lon 4/24/86: 323 (note);

DAUPHINOT, A. (French)
Photos dated: c1860
Processes:    Heliotype
Formats:      Prints
Subjects:     Architecture, genre
Locations:    France - Chartres
Studio:       France
    Entries:
Maggs Paris 1939: 503, 504 (D & Marguet);

DAVANNE, Louis-Alphonse (French, 1824-1912)
Photos dated: 1855-1898
Processes:    Daguerreotype, albumen, photogravure
Formats:      Plates, prints, stereos
Subjects:     Topography
Locations:    France - Nice, Cannes; Monte Carlo;
              Germany; Italy; Algeria
Studio:       France - Paris
    Entries:
Andrieux Paris 1950(?): 28 (book, 1);
Swann NY 2/14/52: 221 (book, 10)(note);
Colnaghi Lon 1976: 102 ill(note);
Christies Lon 6/30/77: 301 ill;
Lehr NY Vol 1:2, 1978: 11 ill;
Sothebys LA 2/13/78: 121 (books, D et al)(note);
Christies Lon 6/27/78: 221, 222;
Mancini Phila 1979: 3, 4;
Christies Lon 3/15/79: 114 (2)(note);
Sothebys Lon 10/24/79: 118 ill(7);
Sothebys LA 2/16/80: 129 ill;
Sothebys Lon 3/21/80: 148;
California Galleries 3/30/80: 292;

DAVANNE, A. (continued)
Christies NY 5/14/80: 60 (book);
Phillips NY 5/21/80: 213;
California Galleries 12/13/80: 238;
Phillips NY 5/9/81: 29 ill;
Sothebys Lon 10/29/80: 97 (lot, D-4 et al), 280;
Christies NY 5/14/81: 37 ill(note);
Sothebys NY 5/15/81: 102 ill;
Sothebys Lon 6/17/81: 335 (7);
California Galleries 6/28/81: 211;
Christies Lon 3/11/82: 139 (lot, D et al);
Sothebys Lon 3/15/82: 84 (7);
Christies Lon 6/24/82: 138 (lot, D et al);
Bievres France 2/6/83: 47 ill;
Christies NY 5/9/83: 126 (7);
Sothebys Lon 10/26/84: 91a (2);
Christies NY 2/13/85: 126 (7);
Sothebys Lon 4/24/86: 181 ill;

DAVEY Photo Co.
Photos dated: 1880s-1890s
Processes:    Albumen
Formats:      Prints
Subjects:     Topography
Locations:    Hawaii
Studio:       Hawaii
    Entries:
California Galleries 5/23/82: 316;
Swann NY 11/10/83: 282 (lot, D et al)(note);
Christies Lon 4/24/86: 410 (lot, D-2 et al);

DAVID, J. (French)
Photos dated: 1881-1888
Processes:    Bromide
Formats:      Prints
Subjects:     Documentary (educational institutions)
Locations:    England - London
Studio:       France - Paris
    Entries:
Christies Lon 3/20/80: 376 (albums, 56);
Christies Lon 10/30/80: 156 (albums, 56);

DAVIDSON, George (1856-1930)
Photos dated: c1890-mid 1890s
Processes:    Photogravure
Formats:      Prints, cabinet cards
Subjects:     Genre, portraits
Locations:    Great Britain
Studio:       Scotland - Edinburgh
    Entries:
Kingston Boston 1976: 73 ill(note);
California Galleries 1/21/78: 141 (album, D et al);

DAVIDSON, I.G. (American)
Photos dated: 1870s-1900
Processes:    Albumen
Formats:      Prints, stereos
Subjects:     Topography, ethnography
Locations:    US - Portland, Oregon
Studio:       US - Portland, Oregon
    Entries:
Rinhart NY Cat 7, 1973: 425 (3);
Swann NY 2/6/75: 193 (album, D et al);
Swann NY 4/20/78: 203 (3)(note), 204 (3);
Christies NY 5/16/80: 271 (lot, D et al);
Swann NY 11/6/80: 356 (6), 401 (7)(note);

DAVIDSON, I.G. (continued)
California Galleries 12/13/80: 323 (attributed),
324 (3), 325 (8, attributed);
California Galleries 6/28/81: 212 (3), 213 ill(3),
214 (3);
California Galleries 5/23/82: 281 (4);
Swann NY 11/8/84: 143 (lot, D et al);
Swann NY 5/9/85: 322 (lot, D et al);

DAVIE, Daniel D.T. (American, born 1819)
Photos dated: 1848-1859
Processes:    Daguerreotype, salt
Formats:     Plates, prints
Subjects:    Portraits
Locations:   US - Albany, New York
Studio:      US - Utica, New York
   Entries:
Swann NY 11/18/82: 73 (book, 35)(note);

DAVIES (British)
Photos dated: 1880s
Processes:    Albumen
Formats:
Subjects:    Portraits
Locations:
Studio:      Great Britain
   Entries:
Christies Lon 10/29/81: 385 (album, D et al);

DAVIES, C. Langdon
Photos dated: 1868
Processes:    Albumen
Formats:     Prints
Subjects:    Topography
Locations:   China
Studio:
   Entries:
Sothebys Lon 7/1/77: 58 (book, D et al);

DAVIES, D.D.
Photos dated: 1850s
Processes:    Daguerreotype
Formats:     Plates
Subjects:    Portraits
Locations:
Studio:
   Entries:
Christies Lon 3/11/82: 27;

DAVIES, George Christopher (British)
Photos dated: 1883-c1890
Processes:    Photogravures
Formats:     Prints
Subjects:    Topography
Locations:   England - Norfolk and Suffolk;
             Holland; Belgium
Studio:      England
   Entries:
Colnaghi Lon 1976: 345 (3 ills)(book, 24)(note),
   346 ill, 347, 348 ill, 349 ill, 350, 351;
Witkin NY IV 1976: OP 122 ill(book, 12)(note);
Wood Conn Cat 37, 1976: 50 (4 ills)(book, 12)(note);
Christies Lon 6/10/76: 200 ill(5);
Christies Lon 10/28/76: 336 ill(5);
Sothebys NY 11/9/76: 147 ill(book, 14)(note);
Christies Lon 3/10/77: 361 ill(book, 24);

DAVIES, G.C. (continued)
Sothebys NY 5/20/77: 86 ill(book, 12)(note);
Christies Lon 6/30/77: 216 ill(book, 12), 217
   ill(book, 24), 218 ill(book, 24), 218a (book, 1);
Christies Lon 10/27/77: 231 (book, 12), 232 ill
   (book, 48), 233 (book, 24), 234 ill(book, 24);
Wood Conn Cat 41, 1978: 110 ill(book, 48)(note);
Wood Conn Cat 42, 1978: 145 (book, 12)(note), 147
   (book, 12)(note), 148 (book, 1);
Christies Lon 3/16/78: 235 (book, 12), 236 ill
   (book, 48), 237 ill(book, 48);
Sothebys Lon 3/22/78: 35 ill(book, 12), 36
   (book, 12);
Sothebys Lon 6/28/78: 27 ill(book, 24);
Swann NY 12/14/78: 72 (book, 12)(note);
Wood Conn Cat 45, 1979: 80 (2 ills)(book, 12)
   (note), 81 (book, 48)(note), 82 (book, 12)(note);
California Galleries 1/21/79: 80 ill(book, 12)
   (note);
Sothebys Lon 3/14/79: 250 (book, 12), 251 (book, 1);
Phillips NY 5/5/79: 155 (5);
Christies Lon 6/28/79: 170 (book, 24), 171
   (book, 33);
Christies Lon 3/20/80: 235 (book, 12), 237
   (book, 37), 238 (book, 24);
Sothebys Lon 6/27/80: 115 ill(17);
Christies Lon 10/30/80: 303 ill(book, 24),
   304 (book, 7);
Christies Lon 3/26/81: 296 (book, 33);
Swann NY 4/23/81: 73 (book, 21)(note);
Sothebys Lon 6/17/81: 453 (book, 12);
Wood Conn Cat 49, 1982: 131 (book, 12)(note),
   132 (book, 48)(note), 133 (book, 12)(note);
Sothebys Lon 3/29/85: 178 (8);
Wood Boston Cat 58, 1986: 255 (book, 12);
Sothebys Lon 4/25/86: 152 (book, 48);
Swann NY 5/15/86: 83 ill(book, 48)(note);
Sothebys NY 10/13/86: 389 (lot, D-3 et al);

DAVIES, T. (British)
Photos dated: 1857
Processes:    Albumen
Formats:     Prints
Subjects:    Topography
Locations:   England - Cheshire
Studio:      Great Britain (Photographic Club)
   Entries:
Sothebys Lon 3/14/79: 324 (album, D-1 et al);

DAVIS (see THOMPSON, J.W.) [DAVIS 1]

DAVIS (British) [DAVIS 2]
Photos dated: between 1870s and 1880s
Processes:    Albumen
Formats:     Prints
Subjects:    Topography
Locations:   Great Britain
Studio:      Great Britain
   Entries:
Swann NY 5/5/83: 283 (albums, D et al);

DAVIS & SANFORD (American) [DAVIS 3]
Photos dated: c1885
Processes:      Photogravure
Formats:        Prints
Subjects:       Portraits
Locations:      Studio
Studio:         US - New York City
    Entries:
Harris Baltimore 6/1/84: 263;

DAVIS Brothers (American) [DAVIS 4]
Photos dated: 1850s-1870s
Processes:      Daguerreotype, ambrotype, albumen
Formats:        Plates, stereos
Subjects:       Portraits, topography
Locations:      US - Maine
Studio:         US - Boston, Massachusetts;
                Portsmouth, New Hampshire
    Entries:
Sothebys NY (Weissberg Coll.) 5/16/67: 103 (lot,
    D-1 et al);
Vermont Cat 4, 1972: 318 ill, 389 ill;
Rinhart NY Cat 7, 1973: 215;
Vermont Cat 6, 1973: 513 ill;
Rose Boston Cat 4, 1979: 148 ill;
Swann NY 11/8/84: 252 (lot, D et al);

DAVIS Brothers [DAVIS 5]
Photos dated: 1890s
Processes:      Albumen
Formats:        Prints
Subjects:       Topography
Locations:      South Africa
Studio:
    Entries:
Christies Lon 3/15/79: 193 (album, D et al);

DAVIS, Lieutenant Colonel Allan B. (photographer?)
Photos dated: 1865-1880
Processes:      Albumen
Formats:        Prints
Subjects:       Topography
Locations:      India
Studio:
    Entries:
California Galleries 9/26/75: 149 (album, 93);
California Galleries 1/22/77: 175 (album, 93);

DAVIS, James M. (American)
Photos dated: 1898
Processes:      Albumen
Formats:        Stereos
Subjects:       Topography, documentary (scientific)
Locations:      US - Alaska; Cuba
Studio:         US
    Entries:
Rinhart NY Cat 7, 1973: 287 (2);
Vermont Cat 5, 1973: 546 (lot, D-1 et al);
California Galleries 4/3/76: 465 (lot, D et al);

DAVIS, Robert M. (American)
Photos dated: c1880s-c1885
Processes:      Albumen
Formats:        Prints, cabinet cards
Subjects:       Topography
Locations:      US - Colorado
Studio:         US
    Entries:
Rinhart NY Cat 7, 1973: 426 (11), 427 (RM & WAD);
California Galleries 9/27/75: 375 (lot, D et al);
California Galleries 1/22/77: 112 (lot, D et al);
Frontier AC, Texas 1978: 85;
Swann NY 11/6/80: 266 (lot, D et al);
Harris Baltimore 3/26/82: 40 (RM & WAD, 19);
California Galleries 7/1/84: 350 (lot, D-1 et al);
Swann NY 11/13/86: 133 (lot, D et al);

DAVIS, S. (American)
Photos dated: 1883-1887
Processes:      Photogravure
Formats:        Prints
Subjects:       Documentary (engineering)
Locations:      US - New York City
Studio:         US
    Entries:
Witkin NY II 1974: 1254 (book, D et al);
Witkin NY III 1975: 667 (book, D et al);

DAVIS, Saul (Canadian)
Photos dated: c1855-1870s
Processes:      Ambrotype, glass diapositive, albumen
Formats:        Plates incl. stereo, stereo cards,
                cdvs
Subjects:       Topography, ethnography
Locations:      Canada - Niagara Falls; US - Niagara
                Falls, New York
Studio:         Canada
    Entries:
Rinhart NY Cat 1, 1971: 198;
Sothebys NY 9/23/75: 10 ill(note);
Swann NY 4/1/76: 221 (lot, D et al);
California Galleries 4/3/76: 435 (lot, D-1 et al);
Christies Lon 3/10/77: 206 (lot, D-3 et al);
Sothebys Lon 7/1/77: 10 (lot, D et al);
California Galleries 1/21/79: 332 (album, D et al);
Christies Lon 3/15/79: 82 (32);
Christies Lon 10/25/79: 80 (32);
Swann NY 11/6/80: 388 (lot, D et al);
Harris Baltimore 3/26/82: 14 (lot, D et al);
Harris Baltimore 3/15/85: 75 (lot, D-3 et al);
Christies Lon 3/28/85: 45;
Phillips Lon 6/26/85: 135 (lot, D et al);
Swann NY 11/13/86: 178 (attributed);

DAVIS, W.A. (see DAVIS, Robert M.)

**DAVISON** (see also AGIUS)
Photos dated: 1890s
Processes:      Albumen
Formats:        Prints
Subjects:       Topography
Locations:      Malta
Studio:         Malta
  Entries:
Sothebys Lon 6/26/75: 108 (albums, D-24 et al);
Swann NY 4/26/79: 282 (albums, D et al);
Phillips NY 9/30/82: 985 (album, D-1 et al);
Christies Lon 6/26/86: 92 (albums, D-9 et al),
  181 (3);

**DAVISON, Gordon** (British)
Photos dated: 1891
Processes:      Photogravure
Formats:        Prints
Subjects:       Topography
Locations:      England - Essex
Studio:         Great Britain
  Entries:
Sothebys Lon 10/18/74: 313 (3)(note);
Christies Lon 10/28/76: 337 ill;
Sothebys Lon 6/29/79: 266 ill(3);

**DAVISON, Jane & Margaret**
Photos dated: 1876
Processes:      Albumen
Formats:        Prints
Subjects:       Architecture
Locations:      England - Windsor
Studio:
  Entries:
Edwards Lon 1975: 188 (book, 177);

**DAVY** (see CASWELL & DAVY)

**DAWSON** (British)
Photos dated: 1857
Processes:      Albumen
Formats:        Stereos
Subjects:       Genre
Locations:      Scotland - Edinburgh
Studio:         Great Britain
  Entries:
Sothebys Lon 3/27/81: 30 (lot, D-1 et al);

**DAY & WHEELER** (British) [DAY 1]
Photos dated: Nineteenth century
Processes:      Albumen
Formats:        Stereos
Subjects:       Topography
Locations:      England - Oxford
Studio:         England
  Entries:
California Galleries 4/3/76: 362 (lot, D & W et al);
Christies Lon 10/27/83: 29 (lot, D & W-5, et al);
Christies Lon 3/29/84: 22 (lot, D & W et al);

**DAY** [DAY 2]
Photos dated: Nineteenth century
Processes:      Albumen
Formats:        Cdvs
Subjects:       Portraits
Locations:
Studio:
California Galleries 1/21/78: 122 (lot, D et al);

**DAYAL, Lala Din** (Indian, born 1844)
Photos dated: 1862-1890s
Processes:      Albumen
Formats:        Prints
Subjects:       Topography, architecture, portraits
Locations:      India
Studio:         India - Hyderabad
  Entries:
Christies Lon 10/28/76: 138 ill(album, 91), 143
  (albums, D et al);
Christies Lon 10/27/77: 178 (album, D-3 et al);
Christies Lon 6/27/78: 127 (albums, D-4 et al);
Swann NY 12/14/78: 418 (4)(attributed)(note);
Sothebys NY 11/2/79: 261 ill(note), 262 ill, 263
  ill, 264;
Sothebys NY 12/19/79: 69 (lot, D-8 et al);
Sothebys NY 5/20/80: 399 ill;
Sothebys Lon 10/29/80: 25 (album, 24);
Christies Lon 3/26/81: 225 (album, D-1 et al);
Christies Lon 6/24/82: 231 (lot, D et al);
Christies Lon 6/23/83: 139 (lot, D-2 et al);
Christies Lon 10/27/83: 109 (11);
Sothebys Lon 6/29/84: 94 ill(album, 24);
Swann NY 11/8/84: 214 ill(album, D et al)(note);
Sothebys Lon 3/29/85: 93 (album, D et al);
Christies Lon 10/31/85: 104 (album, 66);
Wood Boston Cat 58, 1986: 274 (book, 89)(note);
Christies Lon 4/24/86: 528 (album, 71);
Christies Lon 6/26/86: 46 (albums, D et al), 52
  (album, 24), 121 (albums, D et al);

**DAZIARO, J.**
Photos dated: 1870s-c1885
Processes:      Albumen
Formats:        Prints
Subjects:       Topography
Locations:      Russia - Moscow and St. Petersburg
Studio:         Russia
  Entries:
Sothebys NY 9/23/75: 75 ill(lot, D-5 et al);
Christies Lon 6/10/76: 70 (album, 12);
Rose Boston Cat 3, 1978: 86 ill(5);
Christies Lon 3/16/78: 79 ill(album, 18);
Phillips NY 11/3/79: 128 (lot, D-9 et al);
Christies Lon 10/28/82: 64;
Christies Lon 4/24/86: 526 (2);
Christies Lon 10/30/86: 229 (album, D et al);

**DEAN** (British)
Photos dated: 1860s
Processes:      Albumen
Formats:        Stereos
Subjects:       Topography
Locations:      England - Isle of Wight
Studio:         England
  Entries:
Christies Lon 6/18/81: 102 (lot, D-1 et al);
Christies Lon 10/27/83: 31 (lot, D et al);

DEAN, John, M.D. (American, 1831-1888)
Photos dated: 1864
Processes:    Albumen
Formats:      Prints
Subjects:     Documentary (medical)
Locations:
Studio:       US - Washington, D.C.
  Entries:
Wood Conn Cat 45, 1979: 281 ill(book, 36)(note);
Phillips NY 5/21/80: 41 (book, 4);
Wood Conn Cat 49, 1982: 134 (books, 52)(note);

DEANE, Dr. James (American)(photographer or
                author?)
Photos dated: 1861
Processes:    Albumen
Formats:      Prints
Subjects:     Documentary (scientific)
Locations:    US - New England
Studio:       US
  Entries:
Wood Conn Cat 49, 1982: 135 (book, 9)(note);

DEBAS
Photos dated: between 1880s and 1900
Processes:
Formats:      Cabinet cards
Subjects:     Portraits
Locations:
Studio:
  Entries:
Christies Lon 6/26/80: 477 (album, D-1 et al);
Swann NY 11/14/85: 147 (album, D et al);

DEBENHAM, A.
Photos dated: 1870s and/or 1880s
Processes:
Formats:      Prints
Subjects:     Portraits
Locations:
Studio:
  Entries:
Sothebys Lon 10/29/80: 46 ill(lot, D et al), 48
  (album, D et al);
Christies Lon 4/24/86: 407 (album, D-4 et al);

DEBITTE & HERVE (French)
Photos dated: 1860s
Processes:    Albumen
Formats:      Cdvs
Subjects:     Topography
Locations:    France - Paris and Rouen
Studio:       France
  Entries:
Vermont Cat 9, 1975: 563 ill(7);
Christies Lon 6/26/80: 475 (lot, D et al);

DECAGNY
Photos dated: Nineteenth century
Processes:    Albumen
Formats:      Stereos
Subjects:     Topography
Locations:    Switzerland
Studio:       Europe
  Entries:
Rauch Geneva 6/13/61: 223 (lot, D et al);

DECHAMPS (Belgian)
Photos dated: 1870s-c1880
Processes:    Albumen
Formats:      Cdvs
Subjects:     Topography, portraits
Locations:    Belgium
Studio:       Belgium - Brussels
  Entries:
California Galleries 6/8/85: 247 (lot, D et al);

DECKER, E. (American)
Photos dated: 1870s-1897
Processes:    Albumen, gelatin silver
Formats:      Prints, cdvs
Subjects:     Portraits
Locations:    Studio
Studio:       US - Cleveland, Ohio
  Entries:
Sothebys NY (Greenway Coll.) 11/20/70: 89 (lot,
  D-1 et al);
Harris Baltimore 3/26/82: 398 (lot, D-1 et al);
Harris Baltimore 6/1/84: 279;

DECROW, W.E. (photographer or author?)
Photos dated: 1882-1885
Processes:    Heliogravure
Formats:      Prints
Subjects:     Topography
Locations:    US - New Haven, Connecticut
Studio:       US
  Entries:
Rinhart NY Cat 2, 1971: 80 (book, 37);
Frontier AC, Texas 1978: 86 (book, 37);

DEDO, Angelo (Italian)
Photos dated: 1860s and/or 1870s
Processes:    Albumen
Formats:      Prints
Subjects:     Topography
Locations:    Italy - Rome
Studio:       Italy
  Entries:
Harris Baltimore 11/7/86: 279 (lot, D-1 et al);

DEFONDS, E. (see LAISNE & DEFONDS)

DEFFORGE, G.
Photos dated: Nineteenth century
Processes:    Albumen
Formats:      Prints
Subjects:     Genre (still life)
Locations:
Studio:
  Entries:
Rauch Geneva 6/13/61: 157 (lot, D-16 et al);

DEGAND, E. (French)
Photos dated: c1868
Processes:    Albumen
Formats:      Prints
Subjects:     Topography
Locations:    France - Annecy
Studio:       France
  Entries:
California Galleries 3/30/80: 293 ill;

**DEGOIX, Celestino**
Photos dated: 1860s-1870s
Processes:      Albumen
Formats:        Prints, cdvs, stereos
Subjects:       Topography
Locations:      Italy - Genoa
Studio:         Italy - Genoa
  Entries:
Rinhart NY Cat 2, 1971: 322 (3);
Sothebys Lon 6/26/75: 124 (lot, D-6 et al);
Rose Boston Cat 2, 1977: 56 ill(note), 57 ill;
California Galleries 1/21/78: 212 (albums, D-50
  et al);
Rose Boston Cat 4, 1979: 46 ill(note), 47 ill,
  48 ill;
Sothebys Lon 3/21/80: 151;
Sothebys NY 5/20/80: 383 ill(5);
Swann NY 4/23/81: 526 (lot, D & Christmann et al);
Sothebys Lon 6/17/81: 136 (lot, D-2 et al);
Petzold Germany 11/7/81: 309 (album, D et al), 326
  (lot, D et al);
Christies Lon 10/28/82: 30 (lot, D et al);
Swann NY 5/10/84: 187 (lot, D et al);

**DEGROFF** (see MITCHELL & DEGROFF)

**DEHME, G. & JAMRATH, F.** (German)
Photos dated: 1850s
Processes:      Daguerreotype
Formats:        Plates
Subjects:       Portraits
Locations:      Studio
Studio:         Germany - Berlin
  Entries:
Vermont Cat 4, 1972: 319 ill;

**DELAGER** (see LAGER, De)

**DELAHAYE**
Photos dated: Nineteenth century
Processes:      Albumen
Formats:        Cdvs
Subjects:       Topography
Locations:
Studio:
  Entries:
Christies Lon 3/20/80: 371 (lot, D et al);
Christies Lon 10/30/80: 456 (lot, D et al);

**DE LAMATER, R.S.** (American)
Photos dated: 1868-1892
Processes:      Autotypes
Formats:        Prints, cabinet cards, stereos
Subjects:       Topography, portraits
Locations:      US - Hartford, Connecticut
Studio:         US - Hartford, Connecticut
  Entries:
Rinhart NY Cat 3, 1973: 457 (lot, D-1 et al);
Wood Conn Cat 45, 1979: 84 (book, 35);
Harris Baltimore 9/16/83: 151 (lot, D et al);
Harris Baltimore 11/9/84: 87 (lot, D-3 et al), 133
  (lot, D-1 et al);

**DELAMOTTE, Philip H.** (British, 1821-1889)(see also
        CUNDALL)
Photos dated: late 1840s-1867
Processes:      Salt, albumen
Formats:        Prints, stereos
Subjects:       Topography, architecture, documentary
Locations:      England - London and Yorkshire
Studio:         England
  Entries:
Weil Lon Cat 4, 1943(?): 237 (album, D et al)(note);
Swann NY 2/14/52: 6, 95 (book, 80)(note), 104 (book,
  D et al)(note), 114 (lot, D et al)(note), 262
  (album, D et al);
Rauch Geneva 6/13/61: 49 (3);
Rinhart NY Cat 7, 1973: 34 ill(book, D et al);
Sothebys Lon 5/24/73: 14 (album, D et al);
Christies Lon 10/4/73: 104 ill(book, 80);
Sothebys Lon 6/21/74: 149 ill(album, 47)(note);
Sothebys Lon 10/18/74: 151 (book, 60);
California Galleries 9/27/75: 124 (book, 37);
Sothebys Lon 10/24/75: 80 (20);
Sothebys Lon 3/19/76: 109 ill(attributed)(note), 137
  ill(book, D & Cundall, 23);
Sothebys Lon 6/11/76: 156 ill(attributed)(note);
Swann NY 11/11/76: 274 (book, 38)(note);
Halsted Michigan 1977: 155 (book);
Swann NY 12/8/77: 111 (book, 38)(attributed)(note);
Sothebys LA 2/13/78: 96 (3)(attributed);
Christies Lon 3/16/78: 353 ill(album, 20);
Christies Lon 6/27/78: 155 (book, 1)(attributed),
  156 (book, 1)(attributed), 168 (book)
  (attributed);
Christies Lon 10/26/78: 222 (book)(attributed)
  (note);
Wood Conn Cat 45, 1979: 85 (book, 38)(note);
California Galleries 3/14/79: 324 (album, D-1
  et al);
Christies Lon 6/28/79: 173 (book, D et al);
Swann NY 10/18/79: 135 (book, 38)(attributed)(note);
Christies Lon 10/25/79: 76 (lot, D et al);
Witkin NY X 1980: 94 ill(book, 38)(note);
Christies Lon 3/20/80: 83 (lot, D-7 et al), 104
  (lot, D-1 et al), 216 (book, 1);
Sothebys Lon 3/21/80: 366 (2), 368;
Sothebys Lon 3/27/81: 175 (album, D et al), 374 ill
  (album, 47);
Christies Lon 6/18/81: 157 (12), 159 (3)
  (attributed), 408 (lot, D-4 attributed, et al),
  414 (album, D-1 attributed, et al);
Christies Lon 10/29/81: 117 (lot, D-1 et al), 165
  (lot, D-2 et al);
Wood Conn Cat 49, 1982: 138 ill(book, 26)(note);
Christies Lon 3/11/82: 60 (lot, D-12 et al);
Sothebys Lon 3/15/82: 313;
Christies NY 5/26/82: 11 ill(book, D & Cundall, 23);
Christies Lon 6/24/82: 112 (D & Cundall, 4);
Sothebys Lon 3/25/83: 109 ill(2), 110 ill;
Phillips Lon 6/15/83: 103 (lot, D-1 et al);
Christies Lon 6/23/83: 45 (lot, D-2 et al);
Christies Lon 10/27/83: 25 (lot, D-6 et al), 52
  (lot, D-14 et al), 162 ill(book, 30)(attributed)
  (note);
Swann NY 11/10/83: 105 (book, 38)(attributed)(note);
Sothebys Lon 6/29/84: 230 ill (album, 186)
  (attributed);
Sothebys Lon 3/29/85: 155 ill(47), 156 (7);
Swann NY 5/9/85: 208 (book, 38), 252 (book, 38)
  (note);
Christies Lon 6/27/85: 47 ill(20);
Sothebys Lon 6/28/85: 216 (3 ills)(64);
Christies Lon 6/27/85: 116 (3);

**DELAMOTTE, P.** (continued)
Sothebys Lon 11/1/85: 59 (album, D-1 et al);
Kraus NY Cat 2, 1986: 2.6 ill;
Christies Lon 4/24/86: 345 (lot, D et al), 449 (3),
   450 (2);
Sothebys Lon 4/25/86: 114;
Christies Lon 10/30/86: 19A (lot, D et al);
Sothebys Lon 10/31/86: 77 ill(3);

**DELANCY, W.J.A.** (American)
Photos dated: 1850s
Processes:    Daguerreotype
Formats:      Plates
Subjects:     Documentary (industrial)
Locations:    US
Studio:       US
   Entries:
Sothebys Lon 3/21/75: 179 ill;

**DELANOY, M.** (French)
Photos dated: 1850s
Processes:    Daguerreotype
Formats:      Plates
Subjects:     Portraits
Locations:    Studio
Studio:       France - Paris
   Entries:
Petzold Germany 11/7/81: 131 ill;

**DE LA RUE, Warren** (British, 1815-1889)
Photos dated: c1855-1862
Processes:    Daguerreotype, collodion on glass,
            albumen
Formats:      Stereo plates, cdvs
Subjects:     Documentary (scientific)
Locations:
Studio:       England
   Entries:
Christies Lon 3/10/77: 194 ill(attributed);
Christies Lon 10/26/78: 86 (6);
Christies Lon 10/25/79: 69 (lot, D-1 et al), 90
   (lot, D-1 et al);
Christies Lon 6/18/81: 83 (lot, D-6 et al)(note);
Phillips Lon 3/17/82: 11 (lot, D-1 et al);
Christies Lon 6/24/82: 50 (lot, D-2 et al);
Christies Lon 10/28/82: 23 (6), 200 (lot, D-1
   et al);
Christies Lon 3/24/83: 60 ill(note);
Christies Lon 10/27/83: 25 (lot, D-1 et al), 50
   (note);
Sothebys Lon 6/29/84: 10 (lot, D-1 et al);
Christies Lon 10/25/84: 42 (lot, D-1 et al), 173;
Phillips Lon 3/27/85: 153 (lot, D-2 et al);
Christies Lon 10/31/85: 54 (lot, D-1 et al);
Sothebys Lon 11/1/85: 7 (lot, D-1 et al);
Christies Lon 6/26/86: 196 (lot, D-1 et al);
Phillips Lon 10/29/86: 228 (lot, D-2 et al);

**DELATHOUWER, H.**
Photos dated: c1880s
Processes:    Albumen
Formats:      Prints
Subjects:     Topography
Locations:    Belgium; Netherlands
Studio:       Belgium - Antwerp
   Entries:
Harris Baltimore 2/14/86: 223 (album, D et al);

**DE LAVIETER**
Photos dated: c1880
Processes:    Albumen
Formats:      Cabinet cards
Subjects:     Portraits
Locations:    Studio
Studio:       Europe
   Entries:
Harris Baltimore 3/15/85: 279 (lot, D et al);

**DE LEGGIONE Frères**
Photos dated: 1850s
Processes:    Albumen
Formats:      Prints
Subjects:     Topography
Locations:    Spain
Studio:
   Entries:
Sothebys Lon 10/24/79: 114 (lot, D-1 et al);

**DELESSERT, Benjamin M.** (French, died 1868)
Photos dated: 1853
Processes:    Salt (Blanquart-Evrard)
Formats:      Prints
Subjects:     Documentary (art)
Locations:    France
Studio:       France
   Entries:
Sothebys LA 2/13/78: 86 (book, 12)(note);
Wood Conn Cat 49, 1982: 139 (book, 12)(note);
Sothebys Lon 189 (books, 24);

**DELIE, Hippolyte** (see BECHARD, H.)

**DELINTRAZ**
Photos dated: 1860s
Processes:    Albumen
Formats:      Cdvs
Subjects:     Portraits
Locations:    Studio
Studio:       Europe
   Entries:
Petzold Germany 11/7/81: 303 (album, D et al);

**DELL'EMILIA** (Italian)
Photos dated: 1870s
Processes:    Albumen
Formats:      Prints
Subjects:     Topography
Locations:    Italy - Bologna et al
Studio:       Italy - Bologna
   Entries:
Christies NY 10/4/83: 101 (albums, D et al);

**DELMAET & DURANDELLE** (French)
Photos dated: 1866-1888
Processes:    Albumen
Formats:      Prints
Subjects:     Topography, documentary (engineering)
Locations:    France - Paris
Studio:       France - Paris
   Entries:
Rauch Geneva 6/13/61: 162 (lot, D & D et al);
Christies Lon 6/27/78: 223 ill(3), 224 (3)(note);
White LA 1980-81: 25 ill(note), 26 ill;

**DELMAET & DURANDELLE** (continued)
Christies NY 11/11/85: 252 ill(note);
Christies NY 5/13/86: 93 ill(lot, D & D-3 et al);
Swann NY 11/13/86: 207;

**DELON** (French)
Photos dated: between 1850s and 1870s
Processes:    Collotype
Formats:     Prints
Subjects:    Documentary (engineering)
Locations:   France - Toulouse
Studio:      France - Toulouse
    Entries:
Sothebys LA 2/13/78: 121 (books, D et al)(note);

**DELPHIN, Veuve** (French)
Photos dated: Nineteenth century
Processes:    Woodburytypes, albumen
Formats:     Prints, cabinet cards
Subjects:    Portraits incl. Galerie Contemporaine
Locations:
Studio:
    Entries:
Swann NY 4/20/78: 321 (lot, D et al);
Christies NY 5/14/81: 41 (books, D-1 et al);
Harris Baltimore 3/15/85: 319 (lot, D et al);

**DELSART, J.** (French)
Photos dated: 1890s
Processes:    Bromide
Formats:     Prints
Subjects:    Topography
Locations:   France
Studio:      France - Valenciennes
    Entries:
Christies Lon 6/26/80: 502 (lot, D-8 et al);

**DELTON, Louis-Jean** (French, before 1820-after
                  1896)
Photos dated: 1862-1896
Processes:    Albumen
Formats:     Prints, cdvs, stereos
Subjects:    Genre (animal life, street life),
             portraits
Locations:   Studio
Studio:      France - Paris and Nice
    Entries:
Rauch Geneva 12/24/58: 212 ill(album, 20)(note);
Christies Lon 10/27/77: 365 (album, D-6 et al);
Christies Lon 3/15/79: 316 (2);
Christies Lon 6/28/79: 166 (book, 31);
Sothebys Lon 10/24/79: 321 (lot, D et al);
Christies Lon 10/25/79: 434 (2);
Christies Lon 3/20/80: 229 (book, 31);
Christies Lon 6/26/80: 519 (lot, D-2 et al);
Wood Conn Cat 49, 1982: 140 (book, 30)(note);
Christies Lon 3/24/83: 244 (lot, D-2 et al);
Phillips Lon 10/29/86: 326 (lot, D-5 et al);

**DE LUZE, L.P.** (American)
Photos dated: 1883-1887
Processes:    Photogravure
Formats:     Prints
Subjects:    Documentary (engineering)
Locations:   US - New York City
Studio:      US
    Entries:
Witkin II 1974: 1254 (book, D et al);
Witkin III 1975: 667 (book, D et al);

**DE MAN, J.** (Belgian)(photographer or author?)
Photos dated: 1875
Processes:    Albumen
Formats:     Prints
Subjects:    Topography
Locations:   Philippines
Studio:
    Entries:
Swann NY 11/18/82: 74 (book, 8);

**DE MAREST** (see COOPER & DE MAREST)

**DE MAUNY**
Photos dated: Nineteenth century
Processes:    Albumen
Formats:     Stereos
Subjects:    Topography
Locations:   Europe
Studio:      Europe
    Entries:
Christies Lon 3/11/82: 94 (lot, D et al);

**DE MAUS**
Photos dated: 1880s
Processes:    Albumen
Formats:     Prints
Subjects:    Topography
Locations:   New Zealand
Studio:
    Entries:
Christies Lon 3/28/85: 776 (album, D et al);

**DEMAY, L.** (French)
Photos dated: 1860s-c1870
Processes:    Albumen
Formats:     Cdvs
Subjects:    Topography
Locations:   France
Studio:      France - Aix-les-Bains
    Entries:
Rinhart NY Cat 2, 1971: 323 (7);
Swann NY 5/10/84: 306 (lot, D et al);

**DE MONTMORENCY, Lieutenant R.H.** (British)
Photos dated: c1870
Processes:    Albumen
Formats:     Prints
Subjects:    Ethnography
Locations:   India
Studio:
    Entries:
Sothebys Lon 10/18/74: 80 (book, D et al);
Christies Lon 3/11/82: 252 (books, D et al);

**DE MOTT, C.F.** (American)
Photos dated: c1870
Processes:    Albumen
Formats:      Cdvs
Subjects:     Portraits
Locations:    US
Studio:       US
   Entries:
California Galleries 5/23/82: 243 (lot, D et al);

**DE MOUXY, M.J.**
Photos dated: c1860
Processes:    Ambrotype
Formats:      Plates
Subjects:     Portraits
Locations:    Studio
Studio:       England - London
   Entries:
Sothebys Lon 3/27/81: 341;

**DENISON** (see CHURCHILL & DENISON)

**DENK**
Photos dated: Nineteenth century
Processes:    Albumen
Formats:      Cdvs
Subjects:     Ethnography
Locations:    Austria - Vienna
Studio:       Austria - Vienna
   Entries:
Rinhart NY Cat 2, 1971: 363 (lot, D et al);

**DENNIS** (American)
Photos dated: c1880s-c1890
Processes:    Albumen
Formats:      Prints
Subjects:     Topography
Locations:    US - Glenwood Springs, Colorado
Studio:       US - Glenwood Springs, Colorado
   Entries:
California Galleries 7/1/84: 353 (12);
Harris Baltimore 2/14/86: 277 (lot, D et al);

**DENNISON, D.** (American)
Photos dated: 1860-1867
Processes:    Albumenized salt, albumen
Formats:      Prints
Subjects:     Portraits
Locations:    Studio
Studio:       US - Albany, New York
   Entries:
Phillips NY 5/21/80: 291 (album, 36);
Swann NY 5/16/82: 86 (book, 35)(note);
Phillips NY 7/2/86: 330 (album, 32);

**DENTON, Frank J.** (born 1869)
Photos dated: 1880s-1890s
Processes:    Albumen
Formats:      Prints
Subjects:     Topography
Locations:    New Zealand
Studio:       New Zealand - Wanganui
   Entries:
Christies Lon 3/28/85: 76 (album, D et al);

**DEPLANQUE, Jules** (French)
Photos dated: 1860s-c1880
Processes:    Albumen
Formats:      Cdvs
Subjects:     Topography
Locations:    France - Paris
Studio:       France - Paris
   Entries:
Christies Lon 6/26/80: 475 (lot, D et al);
Petzold Germany 11/7/81: 328 (album, D et al);
California Galleries 6/8/85: 374 (6);

**DEREPAR Frères & BLANC** (French)
Photos dated: 1888
Processes:    Albumen
Formats:      Prints
Subjects:     Documentary (engineering)
Locations:    France - Paris; Panama
Studio:       France - Paris
   Entries:
California Galleries 1/21/79: 482 (37)(note);

**DEROCHE, Mathieu** (French)
Photos dated: 1878
Processes:    Collodion on enamel
Formats:      Plate
Subjects:     Portraits
Locations:    Studio
Studio:       France - Paris
   Entries:
Sothebys NY 11/21/70: 93 (2)(note);
Swann NY 11/5/81: 298 (2)(note);
Christies Lon 3/28/85: 345 ill(lot, D-2 et al);

**DEROCHE, H.** (French) **& HEYLAND, Francesco**
Photos dated: 1860s
Processes:    Albumen
Formats:      Prints
Subjects:     Topography, portraits
Locations:    Italy - Rome; Bologna; Milan
Studio:       Italy - Milan
   Entries:
Rinhart NY Cat 7, 1973: 428;
Sothebys Lon 6/21/74: 156 (23);
California Galleries 4/2/76: 262;
Christies Lon 10/26/78: 147 (lot, D & H et al);
Sothebys Lon 10/24/79: 143 (lot, D & H-2 et al);
Christies Lon 6/23/83: 107 (lot, D & H et al);
Christies Lon 3/29/84: 148 (lot, D & H et al);
Phillips Lon 10/29/86: 319 (lot, D & H-1 et al);

**DE ROS, Colonel the Honorable Baron Dudley F.**
        (British)
Photos dated: 1858-1860s
Processes:    Albumen
Formats:      Prints
Subjects:     Genre (domestic), portraits
Locations:    Great Britain
Studio:       Great Britain (Amateur Photographic
        Association)
   Entries:
Sothebys Lon 3/9/77: 123 (album, D et al);
Christies Lon 10/27/83: 218 (albums, D-3 et al);
Phillips Lon 11/4/83: 145 (album, D-5 et al)(note);
Sothebys Lon 3/29/85: 159 (lot, D et al);

DERUSSY (French)
Photos dated: 1840s-1850s
Processes:      Daguerreotype
Formats:        Plates
Subjects:       Portraits
Locations:      Studio
Studio:         France - Paris
    Entries:
Rauch Geneva 6/13/61: 40 (lot, D-1 et al);

DE SIMONE (Italian)
Photos dated: 1860
Processes:      Albumen
Formats:        Prints
Subjects:       Documentary (maritime)
Locations:      Italy - Naples
Studio:         Italy
    Entries:
Christies Lon 6/28/79: 214;

DESIRE, E. (French)
Photos dated: 1860s
Processes:      Albumen
Formats:        Prints, cdvs
Subjects:       Topography
Locations:      Egypt - Cairo
Studio:
    Entries:
Phillips NY 11/3/79: 127 (album, D et al);
Christies Lon 3/24/83: 98 ill(album, 25);
Phillips Lon 3/27/85: 213 (lot, D-1 et al);

DESMAISONS, E. (French)
Photos dated: 1860s
Processes:      Albumen
Formats:        Cdvs
Subjects:       Portraits
Locations:      Studio
Studio:         France - Paris
    Entries:
Sothebys NY 11/21/70: 340 (lot, D et al);
Christies Lon 6/10/76: 149 (album, D et al);
Christies Lon 10/30/80: 417 (album, D et al);

DESNON (French)
Photos dated: 1850s
Processes:      Daguerreotype
Formats:        Plates
Subjects:       Portraits
Locations:      Studio
Studio:         France
    Entries:
Drouot Paris 11/22/86: 104 ill;

DESPLANQUES, E.
Photos dated: 1850s
Processes:      Salt (Blanquart-Evrard)
Formats:        Prints
Subjects:       Topography
Locations:      Belgium - Brussels; Antwerp; Bruges
Studio:         Europe
    Entries:
Phillips Lon 3/13/79: 39 ill(note);

DETLOR & WADDELL (American)
Photos dated: 1879-1880s
Processes:      Albumen
Formats:        Stereos
Subjects:       Topography, documentary (industrial)
Locations:      US - Pennsylvania
Studio:         US
    Entries:
Harris Baltimore 4/8/83: 87 (lot, D & W-6 et al);
Harris Baltimore 6/1/84: 120 (lot, D & W-26 et al);

DETRAZ, A.
Photos dated: 1880s
Processes:      Albumen
Formats:        Prints
Subjects:       Documentary (railroads)
Locations:
Studio:         Switzerland - Lausanne
    Entries:
Christies Lon 3/26/81: 204;

DEVINE, H.T. and/or Harry L. (Canadian, 1865-1938)
Photos dated: 1886-1890s
Processes:      Albumen
Formats:        Prints
Subjects:       Topography
Locations:      Canada - Vancouver, British Columbia
Studio:         Canada - Vancouver, British Columbia
    Entries:
Edwards Lon 1975: 39 (album, 50)(note);
Phillips Can 10/4/79: 79 (album, 50)(note);
Phillips Can 10/9/80: 54 ill(album, D et al)(note);
Swann NY 5/10/84: 184 (album, 50)(note);

DEVINE, P.
Photos dated: Nineteenth century
Processes:      Albumen
Formats:        Cdvs
Subjects:       Portraits
Locations:
Studio:
    Entries:
Christies Lon 10/30/86: 221 (album, D et al);

DE WALDECK, M.
Photos dated: 1880
Processes:      Albumen
Formats:        Prints
Subjects:       Topography
Locations:      Mexico
Studio:
    Entries:
Vermont Cat 11/12, 1977: 525 (book, D-2 et al);

DEWEY, R.H. (American)
Photos dated: 1864
Processes:      Albumen
Formats:        Cdvs, stereos
Subjects:       Portraits, topography
Locations:      Studio
Studio:         US - Pittsfield, Massachusetts
    Entries:
Vermont Cat 4, 1972: 467 ill;
Swann NY 11/10/83: 240 (lot, D et al);

DEXTER, Mrs. (British)
Photos dated: 1860s
Processes:      Ambrotype
Formats:        Plates
Subjects:       Portraits
Locations:      Studio
Studio:         England - London
    Entries:
Vermont Cat 10, 1975: 596 ill;

DEXTER, S.A. (American)
Photos dated: 1840s-1860s
Processes:      Daguerreotypes, ambrotypes
Formats:        Plates
Subjects:       Portraits
Locations:      Studio
Studio:         US - Albany, New York
    Entries:
Swann NY 4/23/81: 249 (lot, D-1 et al)(note), 270
    (lot, D et al);

DEXTER, W. Southern
Photos dated: Nineteenth century
Processes:      Albumen
Formats:        Cabinet cards
Subjects:       Ethnography
Locations:      Studio
Studio:         US
    Entries:
Christies Lon 3/15/79: 303 (album, D-1 et al);

DEYOUNG (American)
Photos dated: c1890s
Processes:
Formats:
Subjects:       Portraits
Locations:      Studio
Studio:         US
    Entries:
Phillips NY 11/29/79: 246 (album, D et al);

DIAMOND, Dr. Hugh Welch (British, 1809-1886)
Photos dated: 1850-1860s
Processes:      Albumen, photogalvanic
Formats:        Prints, stereos
Subjects:       Documentary (medical), genre (still
                life)
Locations:      England
Studio:         England
    Entries:
Weil Lon Cat 4, 1943(?): 237 (album, D et al)(note);
Sothebys Lon 5/24/73: 14 (album, D et al);
Sothebys Lon 3/21/75: 286 (album, D-1 et al);
Anderson & Hershkowitz Lon 1976: 32 ill;
Christies Lon 10/26/78: 286 ill;
Sothebys Lon 3/14/79: 324 (album, D-1 et al)(note);
Christies Lon 3/15/79: 277 ill;
Sothebys Lon 3/27/81: 175 (album, D et al);
Christies Lon 6/24/82: 322 ill(note);
Sothebys Lon 6/29/84: 157 ill(note), 158 ill(note),
    159 ill, 160 ill(note), 161 ill, 162 ill, 163
    ill, 164 ill(note);
Sothebys Lon 10/26/84: 109 ill(note), 110 ill
    (note), 111 ill(note), 112 ill(note), 113 ill
    (note), 114 ill, 115 ill(note), 116 ill, 117 ill
    (note), 118 ill(note);
Christies Lon 3/28/85: 152 ill;

DIAMOND, H.W. (continued)
Sothebys Lon 6/28/85: 127 ill;
Christies Lon 10/31/85: 187 (lot, D-1 et al);
Sothebys Lon 11/1/85: 59 (album, D-1 et al);

DICKENS, C.S.S. (British)
Photos dated: 1852-1854
Processes:      Calotype
Formats:        Prints
Subjects:       Topography
Locations:      Great Britain
Studio:         Great Britain
    Entries:
Weil Lon Cat 14, 1949(?): 314 (30)(note);

DICKSON, M.
Photos dated: 1860s-c1880
Processes:      Albumen
Formats:        Cdvs, cabinet cards, stereos
Subjects:       Ethnography, topography
Locations:      Hawaii; Fiji
Studio:         Hawaii - Honolulu
    Entries:
Sothebys NY (Weissberg Coll.) 5/16/67: 178 (20);
Swann NY 4/23/81: 467 (lot, D et al);
Swann NY 11/5/81: 474 (lot, D et al);

DIHM, Carl (German)
Photos dated: 1856
Processes:      Daguerreotype
Formats:        Plates
Subjects:       Portraits
Locations:      Studio
Studio:         Germany - Stuttgart
    Entries:
Petzold Germany 11/7/81: 134 ill;

DIJON, E. (French)
Photos dated: c1854
Processes:      Calotype
Formats:        Prints
Subjects:       Topography
Locations:      France - Auvergne
Studio:         France
    Entries:
Maggs Paris 1939: 445;

DIKINSONS (British)
Photos dated: 1870s
Processes:      Albumen
Formats:        Prints
Subjects:       Genre
Locations:      England - London
Studio:         England - London
    Entries:
Christies Lon 3/24/83: 244 (lot, D-2 et al);

**DILLER, J.S.** (American)
Photos dated: 1899
Processes:
Formats:      Prints
Subjects:     Topography
Locations:    US - Oregon
Studio:       US
    Entries:
Swann NY 10/18/79: 360 (albums, D et al);

**DILLON, Luke G.** (American)
Photos dated: 1865
Processes:    Albumen
Formats:      Prints
Subjects:     Topography
Locations:    US
Studio:       US
    Entries:
Harris Baltimore 6/1/84: 354;

**DILLWYN, Lewis Llewelyn** (British, 1814-1892)
Photos dated: 1850s
Processes:    Salt
Formats:      Prints
Subjects:     Topography
Locations:    England; Wales
Studio:       Great Britain
    Entries:
Christies Lon 6/23/83: 206 (lot, D et al)(note);

**DILLWYN, Mary** (British, 1816-1906)
Photos dated: 1850s
Processes:    Salt
Formats:      Prints
Subjects:     Topography
Locations:    England; Wales
Studio:       Great Britain
    Entries:
Christies Lon 6/23/83: 206 (lot, D et al)(note);

**DIMBLE, E.T.** (American)
Photos dated: c1890
Processes:
Formats:      Prints
Subjects:     Documentary (scientific)
Locations:    US - Texas
Studio:       US
    Entries:
Swann NY 10/18/79: 356 (11)(note);

**DIMITRI** (Greek)
Photos dated: c1850
Processes:    Calotype
Formats:
Subjects:     Portraits
Locations:    Studio
Studio:       Greece - Athens
    Entries:
Sothebys Lon 10/29/76: 83 ill;

**DIMITRIOU, K.** (Greek)
Photos dated: 1870s-1880s
Processes:    Albumen
Formats:      Prints
Subjects:     Topography
Locations:    Greece - Athens and Piraeus
Studio:       Greece - Athens
    Entries:
Christies Lon 3/28/85: 68 (albums, D-2 et al);
Swann NY 11/14/85: 190 (lot, D et al);

**DINGMAN Brothers**
Photos dated: Nineteenth century
Processes:    Albumen
Formats:      Stereos
Subjects:     Topography
Locations:    Canada
Studio:
    Entries:
Harris Baltimore 6/1/84: 18 (lot, D-1 et al);

**DISDERI, André-Adolphe-Eugène** (French, 1819-1889)
Photos dated: c1848-1877
Processes:    Daguerreotype, albumen, carbon
Formats:      Plates incl. stereo, prints, cdvs,
              stereo cards
Subjects:     Portraits, genre, documentary (Paris
              Commune)
Locations:    France - Paris et al; England - Isle
              of Wight
Studio:       France - Brest; Nimes; Paris; St.
              Cloud; Nice
    Entries:
Weil Lon Cat 14, 1949(?): 358 (album, 32), 359
    (album, 48), 360 (album, 18);
Rauch Geneva 12/24/58: 243 (lot, D et al);
Sothebys NY (Weissberg Coll.) 5/16/67: 172 (lot,
    D-11 et al);
Sothebys NY (Strober Coll.) 2/7/70: 260 (lot, D et
    al), 262 (lot, D et al), 266 (lot, D-1 et al),
    268 (lot, D et al), 275 ill(lot, D-12 et al)
    (note), 277 (lot, D-1 et al)(note), 278 (lot,
    D et al), 324 (lot, D et al);
Sothebys NY 11/21/70: 333 (lot, D et al), 339 (lot,
    D-9 et al), 343 ill(lot, D-1 et al), 346 (lot,
    D-2 et al);
Rinhart NY Cat 7, 1973: 542;
Rinhart NY Cat 8, 1973: 104 (2);
Sothebys Lon 6/21/74: 105 (album, D et al);
Sothebys Lon 3/21/75: 164 (album, D et al);
Sothebys Lon 6/25/75: 98 (lot, D et al), 198
    (album, D et al), 259 (album, D et al), 261
    (lot, D et al);
Sothebys Lon 10/24/75: 175 (album, D et al);
Kingston Boston 1976: 686 ill(book, D et al)(note);
Sothebys Lon 3/19/76: 157 (album, D et al);
Sothebys NY 5/4/76: 99 (album, D et al), 100 (album,
    D et al);
Christies Lon 6/10/76: 150 (album, D et al);
Sothebys Lon 6/11/76: 180 (lot, D et al);
Sothebys Lon 10/29/76: 289 (lot, D-1 et al);
Swann NY 11/11/76: 349 (lot, D et al);
Gordon NY 11/13/76: 48 (albums, D et al);
Christies Lon 3/10/77: 248 (album, D et al), 249
    (album, D et al), 262 (lot, D-15 et al);
Swann NY 4/14/77: 244 (album, D et al);
Sothebys NY 5/20/77: 95 ill(album, D-40 et al)
    (note);

## DISDERI (continued)

Christies Lon 10/27/77: 358 (lot, D-1 et al), 371
   (lot, D-15 et al);
California Galleries 1/21/78: 122 (lot, D et al);
Christies Lon 3/16/78: 299 (album, D et al), 301
   (albums, D et al);
Sothebys Lon 3/22/78: 195 (album, D et al);
Sothebys NY 5/2/78: 124 ill(15);
Christies Lon 6/27/78: 84;
Christies Lon 10/26/78: 325 (album, D et al);
Swann NY 12/14/78: 470 (lot, D et al);
Lehr NY Vol 1:3, 1979: 18 ill;
Phillips Lon 3/13/79: 53 ill(note);
Sothebys Lon 3/14/79: 280, 298 (album, D et al);
Christies Lon 3/15/79: 303 (album, D et al), 308
   (albums, D et al), 309 (album, D et al);
Christies Lon 6/28/79: 218 (album, D-9 et al), 230
   (lot, D-1 et al);
Sothebys Lon 6/29/79: 172 (album, D et al), 257
   (lot, D et al);
Swann NY 10/18/79: 288;
Sothebys Lon 10/24/79: 319 (lot, D et al), 341;
Christies Lon 10/25/79: 383 (lot, D-1 et al), 394
   (album, D-3 et al), 395 (album, D-1 et al);
Sothebys LA 2/6/80: 131 (24);
Christies Lon 3/20/80: 373 (albums, D-1 et al);
Sothebys Lon 3/21/80: 363 (4);
Phillips NY 5/21/80: 138 (album, D et al);
Christies Lon 6/26/80: 210 (lot, D et al), 467
   (lot, D-1 et al), 471 (album, D-46 et al), 472
   (album, D-1 et al), 476 (album, D-4 et al), 477
   (album, D-1 et al), 485 (albums, D et al), 502
   (albums, D-1 et al);
Sothebys Lon 6/27/80: 220 (lot, D et al);
Christies Lon 10/30/80: 407 (album, D et al), 412
   (lot, D-1 et al), 416 (album, D-1 et al), 418
   (album, D-1 et al), 420 (album, D-8 et al), 425
   (album, D-4 et al), 438 (album, D-6 et al), 444
   (lot, D-2 et al), 447 (lot, D-1 et al);
Christies Lon 3/26/81: 116 (lot, D-2 et al), 200
   (album, D-3 et al), 395 (album, D-3 et al), 397
   (album, D-5 et al), 412 (lot, D-1 et al);
Sothebys Lon 3/27/81: 244 ill(album, 33);
Petzold Germany 5/22/81: 1856 (lot, D et al);
Christies Lon 6/18/81: 421 (albums, D-4 et al), 422
   (lot, D et al), 426 (album, D-8 et al);
Harris Baltimore 7/31/81: 134 (album, D et al);
Sothebys NY 10/21/81: 88 ill(2);
Christies Lon 10/29/81: 128 (lot, D-2 et al), 366
   (album, D-5 et al), 370 (album, D-11 et al), 371
   (album, D-8 et al);
Petzold Germany 11/7/81: 302 (album, D et al), 303
   ill(album, D et al), 310 (album, D et al);
Christies Lon 3/11/82: 316 (album, D et al);
Sothebys Lon 3/15/82: 226 (album, D et al);
Phillips Lon 3/17/82: 85 (albums, D et al);
Harris Baltimore 3/26/82: 395 (lot, D et al);
Phillips Lon 6/23/82: 78 (album, D et al);
Christies Lon 6/24/82: 37 ill, 366 (album, D et al),
   372 (album, D-11 et al), 381 (album, D et al);
Christies Lon 10/28/82: 211 (lot, D et al);
Bievres France 2/6/83: 132 (album, D-4 et al), 162
   (lot, D-3 et al)(note);
Christies Lon 3/24/83: 250 (album, D et al);
Harris Baltimore 4/8/83: 322 (lot, D et al);
Christies Lon 6/23/83: 242 (album, D et al), 252
   (album, D-24 et al), 256 (album, D et al), 262
   (album, D et al);
Christies Lon 10/27/83: 231 (album, D et al), 240
   (album, D et al);

## DISDERI (continued)

Christies Lon 3/29/84: 334 (album, D et al), 349
   (album, D et al);
Swann NY 5/10/84: 187 (lot, D et al), 291 (lot, D
   et al), 306 (lot, D et al), 321 (lot, D et al)
   (note);
Harris Baltimore 6/1/84: 327 (lot, D et al);
Christies Lon 6/28/84: 315 (album, D et al);
Phillips Lon 10/24/84: 101 (album, D et al);
Phillips Lon 3/28/85: 212 (lot, D-1 et al), 213
   (lot, D-1 et al);
Christies Lon 3/28/85: 309 (album, D et al), 320
   (album, 48);
Swann NY 5/9/85: 331 (lot, D et al);
Phillips Lon 6/26/85: 199 (lot, D et al), 201 (lot,
   D et al), 204 (lot, D et al);
Christies Lon 6/27/85: 270 (lot, D-3 et al), 272
   (album, D et al), 289 (album, D-1 et al);
Sothebys Lon 6/28/85: 194 ill(album, 40);
Phillips Lon 10/30/85: 32 (lot, D-7 et al), 35
   (lot, D-3 et al), 57 (lot, D et al), 63 (lot,
   D et al), 64 (lot, D et al), 108 (lot, D et al);
Christies Lon 10/31/85: 284 (albums, D et al), 302
   (album, D et al);
Phillips Lon 4/23/86: 226 (album, D-3 et al), 227
   (album, D-8 et al), 228 (album, D et al), 239
   (lot, D et al), 242 (album, D et al), 274
   (album, D et al);
Christies Lon 4/24/86: 420 (book, D et al), 481
   ill, 590 (album, D et al), 597 ill(album, D
   et al);
Sothebys Lon 4/25/86: 218 (2);
Swann NY 5/16/86: 201 (album, D et al);
Christies Lon 6/26/86: 103 (albums, D et al);
Phillips Lon 10/29/86: 297 (album, D et al), 307
   (lot, D et al);
Christies Lon 10/30/86: 217 (albums, D et al), 220
   (albums, D et al), 226 (album, D et al), 227
   (album, D et al);
Sothebys Lon 10/31/86: 127 (12);
Harris Baltimore 11/7/86: 219 (lot, D-2 et al), 223
   (lot, D-1 et al);
Swann NY 11/13/86: 169 (albums, D et al), 357 (lot,
   D et al);

**DISTON, Adam**
Photos dated: c1880-1880s
Processes:      Albumen, carbon
Formats:        Prints
Subjects:       Genre
Locations:
Studio:
   Entries:
Alexander Lon 1976: 55 ill;
Sothebys Lon 3/19/76: 129;
Christies Lon 3/11/82: 341 ill(2);

**DIXEY, C.W.** (British)
Photos dated: 1850s
Processes:      Daguerreotype
Formats:        Plates
Subjects:       Genre
Locations:
Studio:         England - London
   Entries:
Swann NY 11/10/83: 206;

**DIXON, Captain Henry** [DIXON, Henry 1]
Photos dated: c1865
Processes:    Albumen
Formats:     Prints
Subjects:    Topography
Locations:   India
Studio:
    Entries:
Sothebys Lon 6/27/80: 66 ill;
Sothebys Lon 10/29/80: 289 ill;

**DIXON, Henry and Alfred & John BOOL** (British,
                Dixon 1820-1893) [DIXON, Henry 2]
Photos dated: 1864-1886
Processes:    Carbon, albumen
Formats:     Prints
Subjects:    Architecture
Locations:   England - London
Studio:      England
    Entries:
Ricketts Lon 1974: 9 (2 ills)(album, 120);
Sothebys Lon 6/21/74: 92 ill(40);
Witkin NY III 1975: 65 ill(note);
Sothebys Lon 6/26/75: 97 ill(17);
Colnaghi Lon 1976: 337 (120)(note), 338 ill, 339,
    340 ill, 341, 342 ill, 343;
Sothebys Lon 3/19/76: 40 ill(17);
Sothebys Lon 10/29/76: 305 ill(7)(note), 306 (7),
    308 (4), 309 (10), 310 (11), 312 ill(13),
    313 (12);
Sothebys Lon 3/9/77: 50 ill(14)(note);
Gordon NY 5/10/77: 826 ill(attributed)(note);
Christies Lon 6/30/77: 83 ill(4);
Sothebys Lon 7/1/77: 170 ill(book, 120);
Christies Lon 10/27/77: 68;
Rose Boston Cat 3, 1978: 22 ill(note), 23 ill;
Witkin NY VI 1978: 44 ill(note);
Christies Lon 3/16/78: 57 (6), 58 (10), 59 ill(10);
Sothebys Lon 3/22/78: 187 (3);
Christies Lon 10/26/78: 163 (album, D et al);
Sothebys Lon 10/27/78: 146 ill(8)(note), 147 ill
    (5)(note), 148 (12)(note), 149 (6)(note), 150
    ill(6)(note), 151 ill(18)(note);
Witkin NY VIII 1979: 32 (4 ills)(4);
Christies Lon 3/15/79: 101 (lot, D-1 et al);
Sothebys Lon 6/29/79: 106 ill(8), 107 (2), 108 (2),
    109 (4), 110 (4);
Sothebys Lon 6/17/81: 338 (3);
Christies Lon 6/18/81: 153 (2 ills)(78)(note);
Sothebys Lon 10/28/81: 79 ill(25);
Christies Lon 10/29/81: 162 ill(52);
Christies Lon 3/11/82: 109 ill(34);
Sothebys Lon 3/15/82: 340 ill(32);
Christies Lon 3/24/83: 65 ill(95)(note);
Christies Lon 6/23/83: 88 (3);
Sothebys Lon 10/26/84: 165 ill(books, 36);
Christies Lon 3/28/85: 222 ill(5);
Sothebys Lon 6/28/85: 154 ill, 155 ill, 156 ill,
    157 ill;
Christies Lon 10/31/85: 225 (17);
Christies NY 11/11/85: 295 (lot, D & B-1 et al);
Sothebys Lon 4/25/86: 150 ill(10);
Christies Lon 10/30/86: 137 ill(18);

**DIXON, L.J.** (Canadian)
Photos dated: 1860s-1870s
Processes:    Albumen
Formats:     Cdvs
Subjects:    Portraits
Locations:   Studio
Studio:      Canada - Toronto
    Entries:
Phillips Can 10/4/79: 42 (lot, D-1 et al);

**DOANE, Thomas Coffin** (Canadian, 1814-1896)
Photos dated: 1846-1868
Processes:    Daguerreotype
Formats:     Plates
Subjects:    Portraits
Locations:   Studio
Studio:      Canada - Montreal
    Entries:
Phillips Can 10/9/80: 40 ill(note);

**DOBYNS & SPAULDING** (American)
Photos dated: 1850s
Processes:    Daguerreotype
Formats:     Plates
Subjects:    Portraits
Locations:   Studio
Studio:      US - St. Louis, Missouri
    Entries:
Rose Boston Cat 4, 1979: 141 ill;

**DODGE** (see WENDROTH & DODGE)

**DODGSON, Charles Lutwidge** (see CARROLL, Lewis)

**DOE**
Photos dated: 1860s
Processes:    Ambrotype
Formats:     Plates
Subjects:    Portraits
Locations:
Studio:
    Entries:
Vermont Cat 4, 1972: 441 ill;

**DOERR, H.A.** (American)
Photos dated: late 1860s-c1880
Processes:    Albumen
Formats:     Stereos
Subjects:    Topography, ethnography
Locations:   US - Texas; Mexico - Chihuahua
Studio:      US - San Antonio, Texas
    Entries:
Sothebys NY (Strober Coll.) 2/7/70: 503 (lot,
    D & Jacobson et al);
Rinhart NY Cat 7, 1973: 385;
Swann NY 4/14/77: 322 (lot, D et al);
California Galleries 1/21/79: 319 (lot, D &
    Jacobson-3, et al);

**DOLAMORE & BULLOCK**
Photos dated: 1855-1869
Processes:     Albumen
Formats:       Prints, stereos
Subjects:      Topography, documentary (engineering)
Locations:     England - Oxford
Studio:        England - London
   Entries:
California Galleries 9/27/75: 479 (lot, D et al);
Sothebys Lon 10/29/76: 51 (album, D & B et al);
California Galleries 1/23/77: 384 (lot, D et al);
Christies Lon 10/26/78: 97 (4);
Sothebys Lon 6/17/81: 331 (3);
Christies Lon 10/30/86: 101 (3)(note);

**DOLE** (American)
Photos dated: 1840s-1850s
Processes:     Daguerreotype
Formats:       Plates
Subjects:      Portraits
Locations:     Studio
Studio:        US
   Entries:
Swann NY 11/8/84: 180 (lot, D et al);

**DOLE, A.K.** (American)
Photos dated: 1870s-early 1880s
Processes:     Albumen
Formats:       Stereos
Subjects:      Topography
Locations:     US - Maine
Studio:        US - Bangor, Maine
   Entries:
Harris Baltimore 12/10/82: 53 (lot, D et al);

**DOMINGUEZ**
Photos dated: 1860s
Processes:     Albumen
Formats:       Cdvs
Subjects:      Ethnography
Locations:
Studio:
   Entries:
Christies Lon 3/26/81: 412 (album, D-1 et al);

**DOMINI** (French)
Photos dated: 1850s
Processes:     Salt
Formats:       Prints
Subjects:      Topography
Locations:     France - Lyon
Studio:        France - Lyon
   Entries:
Sothebys Lon 3/29/85: 210 ill(3);

**DONDEZ** (French)
Photos dated: 1852
Processes:     Daguerreotype
Formats:       Plates
Subjects:      Portraits
Locations:     Studio
Studio:        France
   Entries:
Gordon NY 5/3/76: 271 ill;

**DONTENVILLE, E.** (French)
Photos dated: 1860s
Processes:     Albumen
Formats:
Subjects:      Topography
Locations:     France - Paris
Studio:        France
   Entries:
Sothebys Lon 10/24/75: 137 (lot, D-3 et al);

**DOOLITTLE, A.B.**
Photos dated: 1850s
Processes:     Daguerreotype
Formats:       Plates
Subjects:      Portraits
Locations:
Studio:
   Entries:
Rose Boston Cat 2, 1977: 137 ill;

**DOREMUS, A.P.** (American)
Photos dated: 1860s-1886
Processes:     Albumen
Formats:       Prints, stereos
Subjects:      Documentary (military), topography
Locations:     US - New Jersey
Studio:        US - Patterson, New Jersey
   Entries:
Lehr NY Vol 1:3, 1979: 10 ill;

**DORIZZI, F.**
Photos dated: Nineteenth century
Processes:     Albumen
Formats:       Stereos
Subjects:      Topography
Locations:     France - Avignon
Studio:
   Entries:
Christies Lon 3/11/82: 94 (lot, D-12 et al);

**DORNACH**
Photos dated: 1860s-1890s
Processes:     Albumen
Formats:       Prints
Subjects:      Topography, portraits
Locations:     France; Italy - Rome
Studio:        France
   Entries:
Rauch Geneva 12/24/58: 269 ill;
Sothebys Lon 6/25/82: 95 (lot, D et al);
Sothebys NY 10/13/86: 103 ill(note);

**DOTTER, George C.** (American)
Photos dated: 1898
Processes:     Glass negatives
Formats:       Plates
Subjects:      Documentary (military)
Locations:     Philippines
Studio:
   Entries:
Sothebys NY 11/21/70: 376 (30);

**DOUFFET, L.E.**
Photos dated: 1870s
Processes:     Albumen
Formats:       Prints
Subjects:      Topography
Locations:     Ceylon
Studio:
   Entries:
Christies Lon 3/26/81: 224 (albums, D-2 et al);

**DOUGLAS, J.** (British)
Photos dated: 1860s
Processes:     Ambrotype
Formats:       Plates
Subjects:      Portraits
Locations:     Studio
Studio:        Scotland - Glasgow
   Entries:
Vermont Cat 10, 1975: 595 ill;
Christies Lon 6/28/79: 44 (lot, D-1 et al);
Christies Lon 3/20/80: 54 (lot, D-1 et al);

**DOVIZIELLI, Pietro** (Italian)
Photos dated: 1855-1867
Processes:     Albumen, albumen on glass
Formats:       Prints, plates
Subjects:      Topography
Locations:     Italy - Rome
Studio:        Italy - Rome
   Entries:
Christies NY 5/16/80: 148 ill, 149, 150, 151;
Christies NY 5/14/81: 39 (note);
Sothebys Lon 6/25/82: 95 (lot, D et al);
Christies NY 2/8/83: 7;
Christies NY 5/9/83: 136 (2);
Christies Lon 6/23/83: 92 ill(lot, D-1 et al);
Christies Lon 10/27/83: 69 (lot, D-1 et al);
Christies Lon 6/28/84: 73 (lot, D-1 et al);
Christies Lon 10/25/84: 63 (lot, D-1 et al);
Christies NY 2/13/85: 136 (2);
Christies Lon 6/27/85: 149 (lot, D-1 et al);
Sothebys Lon 4/25/86: 58 (lot, D et al), 59 ill(7);

**DOWE, L.** (American)
Photos dated: 1870s
Processes:     Albumen
Formats:       Stereos
Subjects:      Topography
Locations:     US - Yosemite, California
Studio:        US - Petaluma and San Francisco,
California
   Entries:
Harris Baltimore 12/10/82: 17 (lot, D-1 et al), 115
  (lot, D et al);

**DOWLING, D.B.**
Photos dated: between 1873 and 1890
Processes:
Formats:       Prints
Subjects:      Topography
Locations:     Canada
Studio:
   Entries:
Swann NY 10/18/79: 348 (album, D et al);

**DOWN & Son** (British)
Photos dated: 1860s
Processes:     Albumen
Formats:       Cdvs
Subjects:      Topography
Locations:     Great Britain
Studio:        Great Britain
   Entries:
Sothebys Lon 6/21/74: 65 (lot, D et al);

**DOWNER, Frederick** (British)
Photos dated: 1860s-1890s
Processes:     Albumen
Formats:       Cdvs, stereos, cabinet cards
Subjects:      Portraits, topography, genre (animal
            life)
Locations:     Great Britain
Studio:        England - Watford
   Entries:
Sothebys Lon 10/29/80: 14 (lot, D et al);
Sothebys Lon 3/15/82: 208 (lot, D-38 et al);
Christies Lon 10/30/86: 230 ill(album, 32)(note);

**DOWNES** (see CUNDALL & DOWNES, HOWLETT & DOWNES)

**DOWNES, George** (British)
Photos dated: 1857-1860
Processes:     Albumen
Formats:       Prints
Subjects:      Topography, documentary (expedition)
Locations:     England; Spain
Studio:        England - London (Photographic Club)
   Entries:
Sothebys Lon 3/14/79: 324 (album, D-1 et al);
Sothebys Lon 10/28/81: 194 ill(19), 195;

**DOWNEY, W. & D.** (British)
Photos dated: 1860s-1900
Processes:     Albumen, woodburytype, carbon
Formats:       Prints, cdvs, cabinet cards, stereos
Subjects:      Portraits
Locations:     Studio
Studio:        England - London
   Entries:
Maggs Paris 1939: 538, 556;
Sothebys NY (Strober Coll.) 2/7/70: 280 (lot, D-1
  et al);
Sothebys NY 11/21/70: 20 (books, 108), 333 ill(lot,
  D et al), 338 ill(lot, D et al), 338a ill(note),
  352 ill(lot, D-1 et al);
Sothebys Lon 12/21/71: 179 (lot, D et al);
Frumkin Chicago 1973: 50, 51, 52;
Rinhart NY Cat 7, 1973: 129 (books, D et al);
Sothebys Lon 5/24/73: 123 (lot, D-30 et al), 133;
Christies Lon 10/4/73: 102 (book), 173 (lot, D
  et al);
Sothebys Lon 3/8/74: 152 (album, D et al);
Sothebys Lon 6/21/74: 163 (lot, D et al);
Christies Lon 7/25/74: 329 (books, D et al);
Sothebys Lon 10/18/74: 156 (books, 4);
Swann NY 2/6/75: 37 (book, 36);
Sothebys NY 2/25/75: 125 (2 ills)(13), 126 (2 ills)
  (lot, D-5 et al), 127 ill (8);
Sothebys Lon 6/26/75: 198 (album, D et al);
California Galleries 9/26/75: 126 (books, 180);
Sothebys Lon 10/24/75: 172 (24), 175 (album,
  D et al), 261 (D-10 et al);

**DOWNEY** (continued)

Colnaghi Lon 1976: 202 (album, D et al)(note);
Witkin NY IV 1976: OP127 (book, 36);
California Galleries 4/2/76: 142 (books, 132), 171
   (books, D-2 et al);
Gordon NY 5/3/76: 304 (lot, D-3 et al);
Sothebys NY 5/4/76: 97 (album, D et al), 100 (album,
   D et al), 101 (books);
Christies Lon 6/10/76: 166 (55), 169, 171 (2);
Christies Lon 10/28/76: 309 (book, 108), 310
   (book, 36);
Sothebys Lon 10/29/76: 105 (album, D et al);
Halsted Michigan 1977: 159 (book, 36), 160
   (book, 48);
California Galleries 1/22/77: 287, 288 (25);
Sothebys Lon 3/9/77: 186, 190 (lot, D et al);
Christies Lon 3/10/77: 293 (lot, D-2 et al), 297
   ill, 341 (book, D et al);
Swann NY 4/14/77: 203 (lot, D et al)(note), 244
   (album, D et al), 62 ill (book, 144);
Gordon NY 5/10/77: 907 (album, D et al);
Christies Lon 6/30/77: 234 (book, 36), 235 (books,
   D-31 et al);
Christies Lon 10/27/77: 244 ill(book, 36), 245 ill
   (book, 180), 392 (lot, D-1 et al);
Sothebys Lon 11/18/77: 44 (book);
Frontier AC, Texas 1978: 93 (book, 36)(note);
California Galleries 1/21/78: 139 (lot, D et al),
   222;
California Galleries 1/22/78: 472 (book, D et al);
Christies Lon 3/16/78: 245 (book, 144), 251 (lot,
   D et al), 321 (lot, D-1 et al);
Drouot Paris 5/29/78: 77 (lot, D et al);
Christies Lon 6/27/78: 257 (2);
Sothebys Lon 6/28/78: 149 (book, 72);
Christies Lon 10/26/78: 228 (book, D-1 et al), 331
   (album, D & Mayall et al), 337 (album, D et al);
Swann NY 12/14/78: 367 (lot, D et al), 458 (lot,
   D et al);
Rose Boston Cat 4, 1979: 13 ill(note), 14 ill,
   15 ill;
California Galleries 1/21/79: 83 (book, 44), 187
   (book, D et al);
Sothebys Lon 3/14/79: 297 (album, D et al);
Swann NY 4/26/79: 350 ill;
Christies Lon 6/28/79: 244 (book, 36), 251;
Swann NY 10/18/79: 286, 337 (album, D et al)(note);
Sothebys Lon 10/24/79: 320 (lot, D-2 et al), 321
   (lot, D et al);
Christies Lon 10/25/79: 18 (lot, D et al), 301
   (book, 35), 394 (album, D et al), 412 (lot, D-1
   et al), 441 (lot, D-16 et al);
Phillips NY 11/29/79: 289;
Christies Lon 3/20/80: 243 (book, 180), 351 (album,
   D-1 et al), 352 (albums, D et al);
Swann NY 4/17/80: 77 (book, 77)(note);
Christies NY 5/16/80: 122 (book, 36);
Phillips NY 5/21/80: 247;
Christies Lon 6/26/80: 332 (book, D et al), 340
   (book, 180), 473 (album, D-20 et al), 477
   (album, D-4 et al), 496 (albums, D et al);
Sothebys Lon 10/29/80: 261 (album, D et al);
Christies Lon 10/30/80: 403 (lot, D-1 et al), 423
   (album, D-4 et al), 425 (album, D et al), 435
   (albums, D et al);
Christies NY 11/11/80: 83 (book, D et al);
Christies Lon 3/26/81: 161 (lot, D et al);
Swann NY 4/23/81: 415 (3), 514 (lot, D et al);
Sothebys Lon 6/17/81: 252 (lot, D-2 et al);
Christies Lon 6/18/81: 263 (book, D et al), 264
   (book, 42);

**DOWNEY** (continued)

California Galleries 6/28/81: 215;
Harris Baltimore 7/31/81: 299 (lot, D et al);
Swann NY 11/5/81: 427;
Christies Lon 3/11/82: 316 (album, D et al);
Sothebys Lon 3/15/82: 243 (36);
Harris Baltimore 3/26/82: 343, 350;
Swann NY 4/1/82: 263 (lot, D et al);
California Galleries 5/23/82: 282;
Phillips Lon 6/23/82: 71 (album, D et al);
Christies Lon 6/24/82: 381 (album, D et al);
Phillips Lon 10/27/82: 28 (albums, D et al),
   34 (lot, D et al);
Christies Lon 10/28/82: 217 (books, D-54 et al);
Swann NY 11/18/82: 78 (book, 108)(note), 254 (books,
   D et al);
Swann NY 5/5/83: 455 (albums, D et al)(note);
Phillips Lon 6/15/83: 135 (144)(note);
Christies Lon 6/23/83: 252 (album, D et al);
Christies Lon 10/27/83: 232 (album, D et al);
Swann NY 11/10/83: 33 (books, D et al);
Christies Lon 3/29/84: 337 (album, D et al);
Swann NY 5/10/84: 176 (lot, D et al), 291 (lot, D
   et al), 320 (album, D et al)(note), 321 (lot,
   D et al)(note), 322 (albums, D et al)(note);
Harris Baltimore 6/1/84: 295 (lot, D et al), 306;
Phillips Lon 6/27/84: 199 (albums);
Christies Lon 6/28/84: 372 (album, D et al);
Christies Lon 10/25/84: 320 (album, D et al), 325
   (albums, D et al), 330 (lot, D-140 et al);
Sothebys Lon 10/26/84: 166;
Harris Baltimore 3/15/85: 248 (lot, D et al), 267
   (lot, D-4 et al), 277 (lot, D et al), 303 (lot,
   D et al), 314 (lot, D et al), 317 (lot, D et al);
Christies Lon 3/28/85: 309 (album, D et al);
Sothebys Lon 3/29/85: 218 (album, D et al);
Phillips Lon 6/26/85: 144 (lot, D et al);
Christies Lon 6/27/85: 106 (books, 180);
Sothebys Lon 6/28/85: 217 (lot, D-1 et al);
Christies Lon 10/31/85: 291 (lot, D et al);
Swann NY 11/14/85: 147 (album, D et al);
Harris Baltimore 2/14/86: 64 (lot, D et al), 98
   (lot, D et al);
Swann NY 5/16/86: 313 (lot, D et al);
Christies Lon 6/26/86: 56 (lot, D et al);
Christies Lon 10/30/86: 237 (lot, D et al);
Harris Baltimore 11/7/86: 211 (lot, D et al);
Swann NY 11/13/86: 147 (lot, D-1 et al), 169
   (albums, D et al), 170 (albums, D et al);

**DOWNIE, D.C.** (British)
Photos dated: 1860s-1875
Processes:      Ambrotype, albumen
Formats:        Plates, cdvs
Subjects:       Portraits
Locations:      Studio
Studio:         Scotland - St. Andrews
   Entries:
Sothebys Lon 6/21/74: 175 (albums, D et al);
Christies Lon 6/28/79: 50 (lot, D-5 et al);

**DOWNS, George** (see HOWLETT, R.)

**DOZSAY**
Photos dated: 1886
Processes:      Albumen
Formats:        Prints
Subjects:       Topography
Locations:      Egypt - Cairo
Studio:
    Entries:
Swann NY 12/8/77: 398 (lot, D-1 et al)(note);

**DRAFFIN, J.** (British)
Photos dated: 1850s-1860s
Processes:      Albumen
Formats:        Prints, stereos
Subjects:       Topography
Locations:      England - York
Studio:         England
    Entries:
Christies Lon 10/27/77: 61;

**DRAKE, Samuel Adams** (American)
Photos dated: 1874
Processes:      Heliotype
Formats:        Prints
Subjects:       Topography
Locations:      US - Middlesex County, Massachusetts
Studio:         US
    Entries:
Christies NY 5/14/80: 108 (book, 20);
Swann NY 11/6/80: 67 (book, 20);

**DRAKE, W.R.** (photographer or author?)
Photos dated: 1868
Processes:      Albumen
Formats:        Prints
Subjects:       Documentary (industrial)
Locations:
Studio:
    Entries:
Sothebys Lon 11/10/77: 202 (book, 5);

**DRAPER, Dr. Henry** (see also RUTHERFORD)
Photos dated: 1862
Processes:      Albumen
Formats:        Prints, stereos
Subjects:       Documentary (scientific)
Locations:
Studio:
    Entries:
Vermont Cat 4, 1972: 595 ill(lot, D-1 et al);
Rinhart NY Cat 7, 1973: 386;
Christies Lon 3/15/79: 88 (lot, D-1 et al);
Phillips Lon 10/29/86: 247A (lot, D et al);

**DRESSER, A.R.** (British)
Photos dated: 1891
Processes:      Photogravure
Formats:        Prints
Subjects:       Genre (rural life)
Locations:      England
Studio:         England
    Entries:
California Galleries 1/22/77: 289;

**DREW, Frederick** (photographer or author?)
Photos dated: 1875
Processes:      Woodburytype
Formats:        Prints
Subjects:       Topography
Locations:      India - Kashmir
Studio:
    Entries:
Harris Baltimore 11/7/86: 158 (book, 4);

**DREYER, Louis** (American)
Photos dated: Nineteenth century
Processes:
Formats:        Prints
Subjects:       Topography
Locations:      US - New York City
Studio:         US
    Entries:
Phillips NY 5/21/80: 294 (lot, D-1 et al);

**DRIER** (French)
Photos dated: late 1850s-1860s
Processes:      Albumen
Formats:        Stereos
Subjects:       Topography
Locations:      France - Paris
Studio:         France - Paris
    Entries:
Harris Baltimore 3/15/85: 77 (lot, D-4 plus
    5 attributed, et al);

**DRURY**
Photos dated: 1885
Processes:      Albumen
Formats:        Prints
Subjects:       Topography
Locations:      Asia
Studio:
    Entries:
Christies Lon 10/30/86: 146 (albums, D et al);

**DUBOCE, Marcel**
Photos dated: 1869
Processes:      Albumen
Formats:        Stereos
Subjects:       Documentary (engineering)
Locations:      US - Springfield, Illinois
Studio:
    Entries:
California Galleries 4/3/76: 394 (lot, D-1 et al);

**DUBOSCQ, Louis-Jean** (French, 1817-1886)
Photos dated: c1852-1850s
Processes:      Daguerreotype, collodion on glass
Formats:        Plates incl. stereo
Subjects:       Genre
Locations:      Studio
Studio:         France - Paris
    Entries:
Christies Lon 6/10/76: 106 ill(note);

DU CAMP, Maxime (French, 1822-1894)
Photos dated: 1849-c1855
Processes:      Salt (Blanquart-Evrard)
Formats:        Prints, stereos
Subjects:       Topography
Locations:      Palestine; Egypt; Syria; Nubia; Italy
                - Rome
Studio:
  Entries:
Maggs Paris 1939: 446 (note);
Swann NY 2/14/52: 115 (lot, D et al);
Rauch Geneva 6/13/61: 67 (book, 49)(note), 68 (6);
Wood Conn Cat 37, 1976: 350 ill(attributed), 352
  ill(attributed);
Christies Lon 6/30/77: 274 ill(note);
Sothebys Lon 10/27/78: 176 ill;
Sothebys Lon 3/14/79: 87 ill(3)(note), 88 ill(2),
  90 ill(3), 91 ill, 92 ill, 93 ill(2), 94 ill(2),
  95 ill, 96 ill(2), 97 ill(4), 98 (2), 99 ill,
  100 ill(3);
Christies Lon 6/28/79: 36 (lot, D-2 et al);
Swann NY 10/18/79: 331 (note), 332 ill(note);
Sothebys Lon 10/24/79: 161 ill(2);
Sothebys Lon 3/21/80: 132 ill(note), 133 ill, 134
  ill, 135 ill, 136 ill, 137 ill, 138 ill, 139
  ill, 140 ill;
Swann NY 4/17/80: 259 (note), 260 ill;
Christies NY 5/16/80: 133 ill;
Sothebys NY 5/20/80: 388 ill;
Sothebys Lon 6/27/80: 78 ill(note), 79 ill, 80 ill,
  81 ill, 82 ill, 83 ill;
Christies Lon 10/30/80: 226 ill;
Christies NY 11/11/80: 50 ill(note), 51;
Sothebys NY 11/17/80: 92 ill;
Koch Cal 1981-82: 28 ill(note), 29 ill;
Sothebys Lon 3/27/81: 369 ill;
Phillips NY 5/9/81: 52 ill(note);
Christies Lon 6/18/81: 197 ill;
Sothebys NY 10/21/81: 92 ill, 93 ill;
Octant Paris 1982: 2 ill;
Sothebys NY 5/25/82: 385 ill(2);
Christies Lon 6/24/82: 307 ill;
Phillips NY 11/9/82: 93 ill, 94;
Drouot Paris 11/27/82: 24 ill;
Sothebys Lon 3/25/83: 78 ill(2)(note), 79 ill,
  80 ill(2);
Sothebys Lon 6/24/83: 71 ill(2)(note), 72 ill(2),
  73 ill(2);
Swann NY 11/10/83: 252 (note), 253 (note);
Sothebys Lon 12/9/83: 53 ill, 54 ill, 55 ill,
  56 ill;
Christies NY 5/7/84: 14 ill(4);
Sothebys Lon 6/29/84: 119 ill, 120 ill, 121 ill,
  122 ill, 123 ill;
Sothebys Lon 10/26/84: 92 ill;
Christies NY 11/6/84: 15 ill(3);
Drouot Paris 11/24/84: 117 ill;
Sothebys Lon 3/29/85: 197 ill(note), 198 ill, 199
  ill, 200 ill, 201 ill, 202 ill;
Christies NY 5/6/85: 50 (book, D et al);
Christies NY 11/11/85: 166 ill, 167 ill;
Christies Lon 4/24/86: 413 (9 ills)(book, 125)
  (note), 446 ill(note);
Sothebys Lon 4/25/86: 174 ill, 175 ill, 176 ill, 177
  ill(2), 178 ill, 179 ill, 180 ill(2);
Sothebys Lon 10/31/86: 157 ill, 158 ill;

DUCHENNE, Dr. Guillaume-Benjamin Amant de Boulogne
                (French, 1806-1875)
Photos dated: 1852-1862
Processes:      Albumen, heliotype
Formats:        Prints
Subjects:       Documentary (medical)
Locations:      France - Paris
Studio:         France
  Entries:
Andrieux Paris 1950(?): 29 (book, 9)(note);
Sothebys Lon 11/18/77: 196 ill(book, 21);
Phillips Can 10/4/79: 9 (note);
Sothebys NY 5/20/80: 371 ill(note), 372 ill, 373
  ill, 374 ill, 375 ill;
California Galleries 12/13/80: 240 (2)(note);
Swann NY 4/23/81: 325, 326 ill, 327, 328;
Swann NY 7/9/81: 103 (book, D et al), 104 (book,
  D et al);
Sothebys Lon 10/28/81: 178 ill;
Swann NY 11/5/81: 74 ill(book, 9)(note), 299 ill
  (note), 300 (note), 301;
Christies NY 11/10/81: 31 ill, 32;
Wood Conn Cat 49, 1982: 144 ill(book, 31)(note);
Christies Lon 3/24/83: 161 (book, D et al);
Christies NY 11/8/83: 90 ill(book, 21)(note);
Christies Lon 10/31/85: 206 ill;
Swann NY 11/14/85: 219 (book, 7)(note);
Wood Boston Cat 58, 1986: 51 (book, D et al);
Christies Lon 10/30/86: 79;

DUCLOS (French)
Photos dated: between 1850s and 1870s
Processes:      Collotype
Formats:        Prints
Subjects:       Documentary (engineering)
Locations:      France - Quimper
Studio:         France - Quimper
  Entries:
Sothebys LA 2/13/78: 121 (books, D et al)(note);

DUCOS DU HAURON, Louis (French, 1837-1920)
Photos dated: 1869-1893
Processes:      Three-color carbon
Formats:        Prints
Subjects:       Topography
Locations:      France - Paris; Algeria
Studio:         France
  Entries:
Sothebys NY 11/12/85: 147 ill(note);

DUFTY, F.H. a/o W & D.D. a/o Edward D.
Photos dated: late 1860s
Processes:      Albumen
Formats:        Cdvs
Subjects:       Ethnography
Locations:      Fiji
Studio
  Entries:
Christies Lon 10/30/80: 258 (lot, D-22 et al), 267
  (lot, W & DD-1, Edward D-1, et al);

**DUGDALE, J.** (British)
Photos dated: 1860s
Processes: Albumen
Formats: Prints
Subjects Topography
Locations: Great Britain
Studio: Great Britain
  Entries:
Christies Lon 10/28/82: 25 (lot, D-6 et al);
Swann NY 5/5/83: 283 (albums, D et al);
Christies Lon 3/28/85: 103 (album, D et al);

**DUGGAN-CRONING, A.M.**
Photos dated: 1890s
Processes: Bromide
Formats: Prints
Subjects: Ethnography
Locations: Switzerland
Studio
  Entries:
Christies Lon 6/24/82: 183 (2);

**DUHEM Brothers** (American)
Photos dated: c1875
Processes: Albumen
Formats: Stereos
Subjects: Topography
Locations: US - Colorado
Studio: US - Denver, Colorado
  Entries:
Rinhart NY Cat 7, 1973: 288;
Vermont Cat 11/12, 1977: 777 ill(2), 778 ill(14);
Harris Baltimore 12/10/82: 109 (lot, D et al);
Harris Baltimore 12/16/83: 29 (lot, D-2 et al);
Harris Baltimore 2/14/86: 55 (lot, D et al);
California Galleries 3/29/86: 693 (lot, D et al);

**DUMAS, Tancrède R. et Fils** (French, died 1905)
Photos dated: 1860-1888
Processes: Albumen
Formats: Prints
Subjects: Topography
Locations: Egypt; Lebanon
Studio: Lebanon - Beirut
  Entries:
White LA 1977: 24 ill, 25 ill;
Sothebys Lon 11/18/77: 105 (albums, D et al);
Christies Lon 6/27/78: 123 (albums, D et al);
Christies Lon 10/30/80: 219 (album, D et al);
Petzold Germany 5/22/81: 1948 (lot, D-1 et al);
Swann NY 5/5/83: 406 (lot, D-1 et al), 408 (lot,
  D et al)(note);
California Galleries 6/19/83: 330 (lot, D et al);
Christies Lon 3/29/84: 97 (album, D et al);
Christies Lon 10/25/84: 73 (lot, D-6 et al);
Christies Lon 10/31/85: 97 (album, D-6 et al);
Swann NY 11/13/86: 209;

**DUNCAN, I.T.** (American)
Photos dated: Nineteenth century
Processes: Albumen
Formats: Cabinet cards
Subjects: Ethnography
Locations: Studio
Studio: US
  Entries:
Vermont Cat 1, 1971: 246 (lot, D et al);

**DUNDAS, Lady E.** (British)
Photos dated: 1850s
Processes:
Formats: Prints
Subjects:
Locations: England
Studio: England
  Entries:
Sothebys Lon 6/21/74: 107 (album, D et al);

**DUNDEN** (see HARVEY & DUNDEN)

**DUNKLEE & FREEMAN** (American)
Photos dated: 1897
Processes:
Formats: Prints
Subjects: Documentary (public events)
Locations: US - Greenfield, Masschusetts
Studio: US
  Entries:
Swann NY 4/1/76: 164 (30);

**DUNMORE, J.L. & CRITCHERSON** (see BRADFORD,
  William)

**DUNMORE, George H.** (British)
Photos dated: 1874
Processes: Heliotype
Formats: Prints
Subjects: Topography
Locations: England - Stratford-upon-Avon
Studio: England
  Entries:
Witkin NY V 1977: 45 (book)(note);
Witkin NY IX 1979: 26 (book)(note);

**DUNN, G.D.** (American)
Photos dated: late 1860s
Processes: Albumen
Formats: Cabinet cards
Subjects: Portraits
Locations: Studio
Studio: US - Canastota, New York
  Entries:
Harris Baltimore 9/27/85: 53;

**DUNOT** (French)
Photos dated: 1850s
Processes: Daguerreotype
Formats: Plates
Subjects: Portraits
Locations: Studio
Studio: France - Paris
  Entries:
Christies Lon 3/15/79: 13;

**DUNSHEE, E.S.** (American)
Photos dated: 1853-1884
Processes: Daguerreotype, ambrotype, albumen
Formats: Plates, cdvs
Subjects: Portraits
Locations: Studio
Studio: US - Massachusetts; Rhode Island;
Rochester, New York
Entries:
Vermont Cat 4, 1972: 390 ill;
Rose Boston Cat 1, 1976: 83 ill;
Vermont Cat 11/12, 1977: 685 ill;
Swann NY 4/20/78: 259;
Christies Lon 6/28/79: 7;
Christies Lon 3/20/80: 18;
Harris Baltimore 4/8/83: 381 (lot, D et al);

**DUNSTERVILLE, F.**
Photos dated: 1880s
Processes: Albumen
Formats: Prints
Subjects: Genre
Locations: India - Madras
Studio
Entries:
Sothebys Lon 11/1/85: 45 (album, 19);

**DUPONT, Aimé** (French)
Photos dated: 1865-1880
Processes: Albumen
Formats: Cabinet cards
Subjects: Portraits
Locations: Studio
Studio: France - Paris; US - New York City
Entries:
Vermont Cat 1, 1971: 248 (lot, D-1 et al);
White LA 1980-81: 63 (lot, D-2 et al);
Swann NY 11/14/85: 20 (lot, D-1 et al);

**DUPPER, B.E.** (British)
Photos dated: 1854
Processes: Albumen
Formats: Prints
Subjects: Portraits
Locations: England
Studio: England
Entries:
Sothebys Lon 6/29/79: 177 (2 ills)(album, 44)(note);

**DURAND, Désiré** (French)
Photos dated: c1849
Processes: Daguerreotype
Formats: Plates
Subjects: Topography
Locations: France - Lyon
Studio: France
Entries:
Sothebys Lon 6/29/84: 36 ill(attributed);

**DURAND-BRAGER, Jean-Baptiste-Henri** (1814-1879)
**& LASSIMONE, M.** (French)
Photos dated: 1855-1856
Processes: Salt, albumenized salt
Formats: Prints
Subjects: Documentary (Crimean War)
Locations: Russia - Crimea
Studio: France
Entries:
Sothebys Lon 10/29/80: 114 ill(note), 115 ill, 116
ill, 117 ill, 118 ill;
Sothebys Lon 6/29/84: 109 ill;
Sothebys Lon 10/26/84: 91 ill;
Sothebys Lon 6/28/85: 193 ill;
Sothebys Lon 11/1/85: 113 ill;
Sothebys Lon 4/25/86: 184 ill, 185 ill;
Sothebys Lon 10/31/86: 162 ill(2), 163 ill;

**DURANDELLE, Edward** (French)
Photos dated: 1861-1888
Processes: Albumen
Formats: Prints, stereos
Subjects: Architecture
Locations: France - Paris
Studio: France - Paris
Entries:
Sothebys Lon 7/1/77: 284;
Lunn DC Cat QP, 1978: 18(note);
Phillips Lon 3/13/79: 90, 91 ill, 92 (4);
Christies NY 5/4/79: 53 (3)(note);
Sothebys NY 5/8/79: 96 ill(note);
Christies Lon 6/28/79: 101 (D & Delmaet,
attributed)(note);
Sothebys NY 12/19/79: 56 ill(album, 26);
California Galleries 3/30/80: 295 ill;
Swann NY 11/5/81: 302 (2)(note);
Bievres France 2/6/83: 47 ill;
Sothebys NY 5/11/83: 392 ill (57);
Swann NY 11/10/83: 254 (2);
Sothebys NY 5/7/85: 125 (2);
Sothebys Lon 4/25/86: 203 ill;
Swann NY 11/13/86: 210 (70)(note);

**DURAT, Pierre** (French)
Photos dated: c1870-1870s
Processes: Albumen
Formats: Prints
Subjects: Portraits
Locations: Studio
Studio: France
Entries
Christies Lon 3/15/79: 310 ill;

**DURBEC** (see OSBORN & DURBEC)

**DURGAN**
Photos dated: 1850s
Processes: Daguerreotype
Formats: Plates
Subjects: Portraits
Locations:
Studio:
Entries:
Christies NY 2/8/83: 76 (lot, D-2 et al);

**DURGIN, Frank** (American)
Photos dated: 1860s-1870s
Processes:      Albumen
Formats:        Stereos
Subjects:       Documentary (railroads)
Locations:      US - American west
Studio:         US - Sacramento, California
    Entries:
Sothebys NY (Strober Coll.) 2/7/70: 519 (lot,
    D et al);

**DURIEU, Jean-Louis-Marie-Eugène** (French,
                1800-1874)
Photos dated: 1853-1860s
Processes:      Daguerreotype, salt, albumen
Formats:        Plates, prints
Subjects:       Genre (nudes)
Locations:      Studio
Studio:         France - Paris
    Entries:
Bievres France 48 ill(2);
Sothebys NY 5/8/84: 127 ill(note);
Sothebys NY 11/12/85: 106 ill(note), 107 ill;
Sothebys NY 5/12/86: 142 ill(note), 143 ill;
Drouot Paris 11/22/86: 35 ill;

**DURONI & MURER** (French)
Photos dated: 1860s-1870s
Processes:      Albumen
Formats:        Prints, stereos
Subjects:       Topography
Locations:      France - Paris
Studio:         France - Paris
    Entries:
Sothebys NY 11/21/70: 45 ill(book, 8)(note);

**DURRANT** (see COX & DURRANT) [DURRANT 1]

**DURRAN** [DURRANT 2]
Photos dated: 1860s
Processes:      Albumen
Formats:        Cdvs
Subjects:       Portraits
Locations:
Studio:
    Entries:
Harris Baltimore 4/8/83: 318 (lot, D et al);

**DUSEIGNEUR, Edouard** (French)
Photos dated: 1855
Processes:      Salt
Formats:        Prints
Subjects:       Documentary (industrial)
Locations:      France
Studio:         France
    Entries:
Drouot Paris 11/22/86: 71 (book);

**DUTHIE, Andrew** (British)
Photos dated: Nineteenth century
Processes:      Albumen
Formats:        Stereos
Subjects:       Topography
Locations:      Scotland
Studio:         Scotland - Glasgow
    Entries:
Vermont Cat 4, 1972: 587 ill(4);
California Galleries 9/27/75: 479 (lot, D et al);
Vermont Cat 11/12, 1977: 779 ill(4);
California Galleries 1/23/77: 384 (lot, D et al);
Christies Lon 3/11/82: 65 (lot, D et al);

**DUTTON & MICHAELS**
Photos dated: 1863
Processes:      Salt, albumen
Formats:        Prints
Subjects:       Topography
Locations:      China
Studio:
    Entries:
Sothebys Lon 6/11/76: 41 (album, D & M-1 et al);
Sothebys Lon 3/22/78: 195 ill(album, D & M-1 et al);
Christies NY 5/16/80: 211 ill(album, D & M et al)
    (note);
Phillips NY 5/9/81: 64 (album, D & M attributed
    et al);
Christies Lon 3/29/84: 83 (lot, D & M-1 et al);
Swann NY 11/8/84: 185 (album, D & M et al)(note);
Sothebys Lon 10/31/86: 18 (album, D & M-1 et al);

**DUTTON, J.J.** (British)
Photos dated: 1860s-1870s
Processes:      Albumen
Formats:        Stereos
Subjects:       Topography
Locations:      England
Studio:         England - Bath
    Entries:
California Galleries 9/27/75: 479 (lot, D et al);
California Galleries 1/23/77: 384 (lot, D et al);

**DUVAL, C.A.** (British)
Photos dated: c1860s
Processes:      Albumen
Formats:        Cdvs
Subjects:       Portraits
Locations:      Studio
Studio:         Great Britain
    Entries:
Phillips Lon 10/30/85: 108 (lot, D et al);
Phillips Lon 4/23/86: 272 (lot, D-1 et al);

**DWIGHT**
Photos dated: c1875
Processes:      Albumen
Formats:        Cdvs
Subjects:       Portraits
Locations:
Studio:
    Entries:
California Galleries 1/22/77: 128 (lot, D et al);

DYER, Thomas H.
Photos dated: 1867
Processes:      Albumen
Formats:        Prints
Subjects:       Topography
Locations:      Italy - Pompeii
Studio:
    Entries:
Edwards Lon 1975: 82 (book, 18);
Swann NY 2/6/75: 145 (books, D-18 et al);
Christies Lon 6/26/80: 311 (book, 18);
Swann NY 11/6/80: 71 (book, 18);
Sothebys Lon 10/28/81: 94 (book, 18);

DYER, William B. (American)
Photos dated: 1899
Processes:
Formats:        Prints
Subjects:       Topography
Locations:      US - Indiana
Studio:         US
    Entries:
Witkin NY III 1975: 529 (book);

DYER, W.J.L.
Photos dated: Nineteenth century
Processes:      Albumen
Formats:        Prints
Subjects:       Portraits
Locations:
Studio:
    Entries:
Harris Baltimore 2/14/86: 329 (lot, D-1 et al);

E., C. [C.E.] (see NASMYTH & CARPENTER)

E., C. & C. [C.E. & C.]
Photos dated: late 1850s
Processes:
Formats:        Prints
Subjects:
Locations:      England
Studio:
    Entries:
Christies Lon 10/30/86: 251 (album, E-1 et al);

E., G.H. [G.H.E.]
Photos dated: 1877
Processes:      Albumen
Formats:        Prints
Subjects:       Topography
Locations:      Palestine
Studio:
    Entries:
Sothebys Lon 12/4/73: 30 (albums, E-77 et al);

E., J.H.T. [J.H.T.E.]
Photos dated: Nineteenth century
Processes:
Formats:        Prints
Subjects:       Topography
Locations:      Spain - Canary Islands
Studio:
    Entries:
Christies Lon 3/20/80: 176 (album, E .et al);

EAGLES, J.D. (American)
Photos dated: 1883
Processes:      Albumen
Formats:        Stereos
Subjects:       Topography
Locations:      US - Ithaca, New York
Studio:         US
    Entries:
Swann NY 11/11/76: 466 (7);
Harris Baltimore 7/31/81: 116 (lot, E et al);

EAKINS, Thomas (American, 1844-1916)
Photos dated: 1880-1891
Processes:      Albumen, platinum
Formats:        Prints
Subjects:       Genre
Locations:      Studio
Studio:         US - Philadelphia and Avondale,
                Pennsylvania
    Entries:
Sothebys NY 5/4/76: 189 ill(note);
Sothebys NY 11/10/77: 501 ill(note), 503 ill(note),
    504 ill(note), 505 ill(note), 506 ill(note), 507
    ill(note), 508 ill(note), 509 ill(note), 510 ill
    (note), 511 ill(note), 512 ill(note), 513 ill
    (note), 514 ill(note), 515 ill(note), 516 ill
    (note), 517 ill(note), 518 ill(note), 519 ill
    (note), 520 ill(note), 521 ill(note);
Lehr NY Vol 1:2, 1978: 12 ill(note);
Sothebys LA 2/13/78: 78 ill(note), 79 ill(note);
Lehr NY Vol 1:3, 1979: 13 ill;
Lehr NY Vol 2:2, 1979: 10 ill(note);
Sothebys NY 5/20/80: 320 ill(note);
Christies NY 11/11/80: 180A ill(note);

EAKINS, T. (continued)
Sothebys NY 11/17/80: 102 ill(note), 103 ill(note),
    104 ill(note);
Christies NY 5/14/81: 54 ill(note);
Sothebys NY 5/15/81: 121 ill;
Christies NY 5/9/83: 54 ill(note);
Sothebys NY 11/9/83: 128 ill(2)(note), 129 ill
    (note);
Sothebys NY 5/7/85: 126 ill(note);
Christies NY 5/13/86: 97 ill(attributed)(note);
Sothebys NY 11/10/86: 104 ill(attributed)(note);
Christies NY 11/11/86: 159 ill(note), 160 ill(note),
    161 ill(note);

EARL, F.C. (British)
Photos dated: c1860-1860s
Processes:      Albumen
Formats:        Prints, stereos
Subjects:       Topography
Locations:      England - Worcestershire et al
Studio:         England
    Entries:
Christies Lon 6/18/81: 102 (lot, E-1 et al);
Christies Lon 3/11/82: 85 (lot, E et al);
Christies Lon 10/28/82: 17 (lot, E et al);
Sothebys Lon 3/25/83: 4 (lot, E et al);
Christies Lon 3/29/83: 39 (lot, E-3 et al);
Christies Lon 10/25/84: 194 (2)(note);
Christies NY 5/6/85: 133 ill(note);

EASTABROOK (British)
Photos dated: 1850s
Processes:      Ambrotype
Formats:        Plates
Subjects:       Portraits
Locations:      Studio
Studio:         England
    Entries:
Sothebys Lon 3/14/79: 30;

EASTERLY, Thomas M. (American, 1809-1882)
Photos dated: 1846-1882
Processes:      Daguerreotype, albumen
Formats:        Plates, prints
Subjects:       Portraits
Locations:      Studio
Studio:         US - Liberty and St. Louis, Missouri
    Entries:
Christies Lon 10/25/79: 20 (lot, E-1 et al);

EASTHAM, John (British)
Photos dated: 1850s-1865
Processes:      Daguerreotype, ambrotype, albumen
Formats:        Plates, prints
Subjects:       Portraits, architecture
Locations:      England
Studio:         England - Manchester
    Entries:
Weil Lon Cat 7, 1945: 153 (book, E et al);
Vermont Cat 9, 1975: 459 ill;
Christies Lon 3/10/77: 45 (lot, E-1 et al);
Sothebys Lon 10/27/78: 29;
Sothebys Lon 10/29/80: 122;
Sothebys Lon 3/29/85: 24 (lot, E-1 et al);
Christies Lon 6/26/85: 53 (lot, E-3 et al);

**EASTLAKE, J.** (British)
Photos dated: Nineteenth century
Processes:     Albumen
Formats:       Stereos
Subjects:      Topography, genre
Locations:     Great Britain
Studio:        Great Britain
    Entries:
Christies Lon 6/28/84: 40 (lot, E et al);
Christies Lon 10/25/84: 37 (lot, E et al);

**EASTMAN, Seth** (American)
Photos dated: 1853-c1858
Processes:     Daguerreotype
Formats:       Plates
Subjects:      Documentary
Locations:     US - Taunton, Massachusetts
Studio:        US
    Entries:
Rinhart NY Cat 2, 1971: 164;
Christies NY 11/11/80: 101 ill(note);

**EASTMAN, W.B.** (American)
Photos dated: 1850s
Processes:     Daguerreotype
Formats:       Plates
Subjects:      Portraits
Locations:     Studio
Studio:        US - Boston, Massachusetts
    Entries:
Rinhart NY Cat 7, 1973: 568;
Vermont Cat 5, 1973: 375 ill;

**EATON, A.B.** (American)
Photos dated: 1868
Processes:     Albumen
Formats:       Prints
Subjects:      Portraits
Locations:     US - Boston, Massachusetts
Studio:        US - Lowell, Massachusetts
    Entries:
Wood Conn Cat 42, 1978: 171 (book, 278)(note);

**EATON, Cedric L.** (American, born 1835)
Photos dated: 1867-1892
Processes:     Albumen
Formats:       Cdvs
Subjects:      Ethnography, topography
Locations:     US - Omaha, Nebraska
Studio:        US - Omaha, Nebraska
    Entries:
Sothebys NY (Strober Coll.) 2/7/70: 308 (lot,
    E-2 et al);
Frontier AC, Texas 1978: 233 (2)(note);

**EATON, Robert** (British, 1819-1871)
Photos dated: c1850-1860s
Processes:     Albumen
Formats:       Prints
Subjects:      Topography
Locations:     England; Italy - Rome
Studio:
    Entries:
Christies Lon 6/27/78: 290 ill(note);
Sothebys Lon 6/28/78: 80 (album, E-3 et al);
Christies Lon 10/26/78: 298 ill, 299;

**EATON, R.** (continued)
Christies Lon 6/28/79: 93 (attributed);
Sothebys Lon 10/24/79: 335;
Christies Lon 3/20/80: 144 (2);
Christies Lon 6/26/80: 187 (note);
Christies Lon 3/26/81: 175;
Christies Lon 6/28/81: 158 (lot, E-2 et al);
Christies Lon 3/24/83: 51 (album, E-2 et al);
Christies Lon 6/23/84: 62 (lot, E-1 et al);
Christies Lon 6/28/84: 217 (lot, E-1 et al);
Sothebys Lon 11/1/85: 58 (book, E-1 et al);

**EATON, Thomas Damant** (British, 1800-1871)
Photos dated: 1845-c1855
Processes:     Calotype, albumen
Formats:       Prints
Subjects:      Topography
Locations:     England - Norwich
Studio:        England - Norwich (Photgraphic
               Exchange Club)
    Entries:
Weil Lon Cat 4, 1944(?): 237 (album, E et al)(note);
Sothebys Lon 3/21/80: 196 (attributed);
Sothebys Lon 6/28/85: 124 (2 ills);

**EBBAGE, Thomas** (British)
Photos dated: 1860s
Processes:     Albumen
Formats:       Prints
Subjects:
Locations:
Studio:        Great Britain (Amateur Photographic
               Association)
    Entries:
Christies Lon 10/27/83: 218 (albums, E-2 et al);

**ECKENRATH, C.** (German)
Photos dated: 1860s-1870s
Processes:     Albumen
Formats:       Stereos
Subjects:      Topography
Locations:     Germany - Berlin
Studio:        Germany - Berlin
    Entries:
Christies Lon 3/20/80: 101 (lot, E et al);

**ECKERSON & LYON** (Canadian)
Photos dated: 1880s
Processes:     Albumen
Formats:       Cabinet cards
Subjects:      Portraits
Locations:     Studio
Studio:        Canada
    Entries:
Phillips Can 10/4/79: 69 (album, E & L-1 et al);

**ECKERT**
Photos dated: between 1870s and 1890s
Processes:     Albumen
Formats:       Prints
Subjects:      Topography
Locations:     Europe
Studio:        Europe
    Entries:
Swann NY 5/16/86: 233 (lot, E et al);

**EDDY, Charles W.**
Photos dated: 1885
Processes:      Photogravure
Formats:        Prints
Subjects:       Topography
Locations:      US - Brimfield, Massachusetts
Studio:         US - Ware, Massachusetts
   Entries:
Witkin NY IV 1976: AL2;

**EDER, Josef Maria** (Austrian, 1855-1944)
Photos dated: 1886-1892
Processes:      Woodburytype, heliogravure
Formats:        Prints
Subjects:       Documentary
Locations:      Austria
Studio:         Austria - Vienna
   Entries:
Christies NY 5/14/80: 111 (4 ills)(book, E et al);
Christies Lon 3/24/83: 164 (book, 2);

**EDGE, Thomas** (British)(see also OGLE)
Photos dated: 1857-1860s
Processes:      Albumen
Formats:        Cdvs, stereos
Subjects:       Portraits, topography
Locations:      England - Preston, Lancashire
Studio:         England - Preston, Lancashire
   Entries:
Sothebys Lon 6/27/80: 221 (2 ills)(album,
   E et al)(note);
Sothebys Lon 6/17/81: 236 (album, E et al);
Christies Lon 3/29/84: 334 (album, E-4 et al);
Christies Lon 10/25/84: 325 (albums, E et al);
Christies Lon 6/27/85: 272 (album, E et al);

**EDGERTON, Philip H.** (British)
Photos dated: 1864
Processes:      Albumen
Formats:        Prints
Subjects:       Topography
Locations:      India
Studio:
   Entries:
Christies Lon 3/24/83: 124;
Christies Lon 6/23/83: 141;

**EDIMBOURG, Jenny d'**
Photos dated: c1856
Processes:      Salt
Formats:        Prints
Subjects:
Locations:
Studio:
   Entries:
Rauch Geneva 6/13/61: 47 (album, E et al);

**EDLER, A.** (German)
Photos dated: 1850s
Processes:      Daguerreotype
Formats:        Plates
Subjects:       Portraits
Locations:      Studio
Studio:         Germany - Munich
   Entries:
Petzold Germany 5/22/81: 1691 ill;

**EDMOND** (American)
Photos dated: 1890
Processes:
Formats:        Prints
Subjects:       Genre
Locations:      US - San Francisco, California
Studio:         US
   Entries:
California Galleries 1/21/78: 399 (2);

**EDOUART** (American)
Photos dated: 1860s-1870
Processes:      Albumen
Formats:        Cdvs
Subjects:       Portraits
Locations:      Studio
Studio:         US - San Francisco, California
   Entries:
Sothebys NY (Strober Coll.) 2/7/70: 260 (lot,
   E et al);
California Galleries 5/23/82: 256 (lot, E-7,
   E & Cobb-4, et al);

**EDWARD Brothers** (Canadian)
Photos dated: 1897
Processes:      Albumen, silver
Formats:        Prints
Subjects:       Topography, ethnography
Locations:      Canada
Studio:         Canada - Vancouver
   Entries:
Phillips Can 10/4/79: 58 (album, E-6 et al)(note);
Christies Lon 10/31/85: 119 (album, E-2 et al);

**EDWARDS, Ernest** (British, 1837-1903)
Photos dated: 1856-1894
Processes:      Albumen
Formats:        Prints, stereos, cdvs
Subjects:       Topography, portraits
Locations:      Switzerland; England - Isle of Wight
                and Cambridge
Studio:         England (Amateur Photographic
                Association)
   Entries:
Weil Lon Cat 4, 1944(?): 202 (book, 28);
Weil Lon Cat 7, 1945: 134 (book, 28);
Swann NY 2/14/52: 55 (book, 28), 119 (book, 143),
   303 (books, E-15 et al), 346 (book, 20)(note);
Andrieux Paris 1955(?): 716 (book, 28);
Sothebys NY 11/21/70: 24 ill(book, 28)(note);
Rinhart NY Cat 2, 1971: 69 (book, 20);
Vermont Cat 2, 1971: 245 (9), 246 (4);
Sothebys Lon 5/24/73: 8 (lot, E et al);
Vermont Cat 4, 1974: 750 (book, 28);
Christies Lon 4/25/74: 210 (books, E et al);
Sothebys Lon 10/18/74: 256 (book, 28);
Sothebys NY 11/2/74: 231 (book, 28);
Edwards Lon 1975: 94 (book, 28);
Witkin NY III 1975: 678 ill(book, 28);
Swann NY 2/6/75: 160 (book, 15);
Sothebys NY 2/25/75: 69 (books, E-28 et al);
Sothebys Lon 3/21/75: 170 (attributed)(note);
Colnaghi Lon 1976: 156 ill(note), 157 (note), 158
   ill, 159 ill;
Witkin NY IV 1976: OP135 (book, 28)(note);
Wood Conn Cat 37, 1976: 200 (book, 20)(note);
Sothebys NY 5/4/76: 85 (book, 28)(note);
Christies Lon 6/10/76: 182 (book, 15);

**EDWARDS, E.** (continued)
Swann NY 11/11/76: 261 (book, 28)(note);
Vermont Cat 11/12, 1977: 515 ill(book, 28);
Witkin NY V 1977: 46 ill(book, 15);
Sothebys Lon 3/9/77: 11 (lot, E-1 et al), 163a
    (book, 29);
Christies Lon 3/10/77: 323a (book, 28);
Swann NY 4/14/77: 66 (book, 15);
Sothebys NY 5/20/77: 64 (book, 28);
Christies Lon 6/30/77: 75 (album, 60), 152 (lot, E-1
    et al), 196 (book, 28);
Sothebys Lon 7/1/77: 30 (book, 28);
Sothebys NY 10/4/77: 175 (books, E-25 et al);
Sothebys Lon 11/18/77: 49 (books, 48), 194
    (book, 28), 197 (books, E-15 et al);
Swann NY 12/8/77: 59 (book, 15);
Christies Lon 3/16/78: 201 (book, 15);
Sothebys Lon 3/22/78: 25 (book, 28);
Sothebys Lon 6/28/78: 28 (book, 15);
Sothebys Lon 3/14/79: 143 (album, 60);
Sothebys NY 5/8/79: 78 ill(books, 48);
Christies Lon 6/28/79: 163 (book, 20);
Sothebys Lon 10/24/79: 41 (book, 28);
Christies NY 10/31/79: 24 (book);
Witkin NY X 1980: 27 ill(book, 24);
Christies Lon 3/20/80: 222 (book, 95);
Christies NY 5/14/80: 317 (2 ills)(books, E et al),
    335 (book, E et al);
Sothebys NY 5/20/80: 341 (books, E et al);
Sothebys Lon 6/27/80: 157 (book, E et al);
Christies Lon 10/30/80: 286 (book, 48);
Sothebys Lon 6/17/81: 122 (lot, E-1 et al), 218
    (books), 220 (2);
Christies Lon 6/18/81: 250 ill(book, 28);
Phillips Lon 10/28/81: 133 (albums, E et al);
Wood Conn Cat 49, 1982: 175 ill(book, 28)(note);
Christies Lon 3/11/82: 249 (book, 24), 250
    (book, 28);
Sothebys Lon 3/15/82: 213 (2), 327 (note);
Swann NY 11/18/82: 81 (book, 28)(note), 82
    (book, 20)(note);
Christies Lon 10/27/83: 19 (lot, E et al), 218
    (albums, E-2 et al);
Phillips Lon 11/4/83: 34 (book, 28);
Swann NY 5/10/84: 44 (book, 28)(note);
Christies Lon 6/28/84: 36 (lot, E-2 et al), 39
    (book, E et al)(note), 147 ill(book, 28);
Swann NY 5/9/85: 210 (book, 28), 211 (book, 15);
Sothebys Lon 6/28/85: 223 (book, 28);
Wood Boston Cat 58, 1986: 267 (book, 28)(note);
Phillips Lon 4/23/86: 224 (album, E-1 et al);
Christies Lon 4/24/86: 420 (book, E et al);
Phillips Lon 10/29/86: 296 (album, E-1 et al);

**EDWARDS, J.D.** (American)
Photos dated: c1860-1861
Processes:    Salt, albumen
Formats:      Prints, stereos
Subjects:     Documentary (Civil War), topography
Locations:    US - New Orleans, Louisiana; Florida
Studio:       US - New Orleans, Louisiana
    Entries:
Sothebys NY 2/25/75: 48 (2);
Sothebys Lon 3/15/82: 133 ill, 134 ill, 135 (3),
    136 ill, 137 (2), 138 (3), 139 ill, 140 (2), 141
    (3), 142 ill, 143 ill, 144 ill;
Sothebys Lon 6/25/82: 111 ill(note), 112 ill, 113
    ill, 114 ill, 115 ill, 116 ill(2), 117 ill, 118
    ill, 119 ill, 120 ill(2), 121 ill(2), 122 ill,

**EDWARDS, J.D.** (continued)
    123 ill, 124 ill, 125 ill, 126 ill, 127
    (attributed);
Harris Baltimore 9/16/83: 172 (note), 173 ill(note);

**EDWARDS, R.** (British)
Photos dated: Nineteenth century
Processes:    Albumen
Formats:      Stereos
Subjects:     Topography
Locations:    Great Britain
Studio:       Great Britain
    Entries:
Christies Lon 3/11/82: 65 (lot, E et al);

**EDWARDS, St. John**
Photos dated: late 1870s
Processes:    Albumen
Formats:      Prints
Subjects:     Topography
Locations:    China
Studio:       China - Amoy
    Entries:
Swann NY 5/16/86: 94 (books, E et al)(note);
Swann NY 11/13/86: 49 (books, E et al);

**EDWARDS, T.** (American)
Photos dated: Nineteenth century
Processes:    Albumen
Formats:      Stereos
Subjects:     Topography
Locations:    US - Saratoga Springs, New York
Studio:       US
    Entries:
Harris Baltimore 4/8/83: 67 (lot, E et al);

**EGERTON, John** (British)
Photos dated: 1850s
Processes:    Daguerreotype, ambrotype
Formats:      Plates
Subjects:     Portraits
Locations:    Studio
Studio:       England - London
    Entries:
Sothebys Lon 3/14/79: 61;
Christies Lon 10/31/85: 30 (lot, E-1 et al);
Christies Lon 6/26/86: 59 (lot, E-1 et al);

**EGREMONT, P. & S.**
Photos dated: c1880
Processes:    Albumen
Formats:      Prints
Subjects:     Topography
Locations:    Europe
Studio:       Europe
    Entries:
Harris Baltimore 4/8/83: 287 (album, E et al);

EHNINGER, John W. (American, 1827-1889)
Photos dated: 1859
Processes:      Albumen
Formats:        Prints
Subjects:       Cliché-verres
Locations:      US
Studio:         US
  Entries:
Weil Lon Cat 7, 1945: 92 (book, 12)(note);
Weil Lon Cat 14, 1949(?): 325 (book, 12)(note);
Sothebys NY 11/9/76: 15 (book, 12)(note);
Wood Conn Cat 41, 1978: 127 ill(book, 12)(note);
Wood Conn Cat 45, 1979: 94 ill(book, 12)(note);

EILENDER, Fritz
Photos dated: 1885
Processes:      Albumen
Formats:        Cabinet cards
Subjects:       Portraits
Locations:
Studio:
  Entries:
Wood Boston Cat 58, 1986: 136 (books, E et al);

EISEN, F.C. (German)(photographer or author?)
Photos dated: 1860s
Processes:      Albumen
Formats:        Prints, stereos
Subjects:       Architecture
Locations:      Germany - Cologne
Studio:         Germany - Cologne
  Entries:
Christies Lon 10/27/77: 88 (lot, E-1 et al);
Sothebys Lon 10/29/80: 95;

EISENMANN, Charles (American)
Photos dated: 1870s-1880s
Processes:      Albumen
Formats:        Cabinet cards, cdvs
Subjects:       Genre
Locations:      Studio
Studio:         US - New York City
  Entries:
Sothebys NY (Strober Coll.) 2/7/70: 259 (lot,
  E et al), 318 (lot, E et al);
Sothebys NY 11/21/70: 355 (lot, E et al);
Swann NY 4/1/76: 135 (album, E-1 et al);
California Galleries 1/22/77: 132 (lot, E-1 et al);
California Galleries 12/13/80: 220, 221 (lot
  E et al);
Harris Baltimore 4/8/83: 318 (lot, E et al), 381
  (lot, E et al), 382 (lot, E et al);
California Galleries 7/1/84: 746;
Harris Baltimore 3/15/85: 268 (lot, E-1 et al);

EL CHARZH'SEE
Photos dated: c1870-1880
Processes:      Albumen
Formats:        Prints
Subjects:       Topography
Locations:      Turkey - Constantinople
Studio:
  Entries:
Auer Paris 5/31/80: 67 (lot, E-1 et al);

ELEY, S. (American)
Photos dated: 1860s
Processes:      Albumen
Formats:        Prints
Subjects:       Documentary (Civil War)
Locations:      US - Fredricksburg
Studio:         US
  Entries:
Witkin NY II 1974: 1102 ill(attributed);

ELLERBECK
Photos dated: 1880s
Processes:      Albumen
Formats:        Prints
Subjects:       Topography
Locations:      Norway
Studio:         England - Liverpool
  Entries:
Christies Lon 6/24/82: 141 (album, E et al);

ELLICE, Edward (British)
Photos dated: 1850s
Processes:      Albumen
Formats:        Prints
Subjects:       Genre, portraits
Locations:      Great Britain
Studio:         Great Britain
  Entries:
Christies Lon 6/27/78: 229 (album, E et al)(note);
Harris Baltimore 3/15/85: 181 (note);
Harris Baltimore 2/14/86: 239 (album, E-1 et al);

ELLIOT (American)
Photos dated: 1860s
Processes:      Tintype
Formats:        Plates
Subjects:       Portraits
Locations:      Studio
Studio:         US - Johnstown, Pennsylvania
  Entries:
Rinhart NY Cat 2, 1971: 267 (lot, E et al);

ELLIOTT (American) [ELLIOTT 1]
Photos dated: Nineteenth century
Processes:      Albumen
Formats:        Cdvs
Subjects:       Portraits
Locations:      Studio
Studio:         US - Earlville, Illinois
  Entries:
Phillips Lon 3/27/85: 212 (lot, E-1 et al);

ELLIOTT & ARMSTEAD (American) [ELLIOTT 2]
Photos dated: Nineteenth century
Processes:      Albumen
Formats:        Cabinet cards
Subjects:       Portraits
Locations:      Studio
Studio:         US
  Entries:
Sothebys NY (Greenway Coll.) 11/20/70: 103 ill(lot,
  E & A-1 et al), 197 ill(lot, E & A-1 et al);

ELLIOTT & FRY (British) [ELLIOTT 3]
Photos dated: c1860-1890s
Processes:     Albumen, woodburytype, platinum
Formats:       Prints, cdvs, cabinet cards
Subjects:      Portraits, topography
Locations:     England - London; Cornwall; Devon
Studio:        England - London
   Entries:
Weil Lon Cat 7, 1945: 127 (5);
Sothebys Lon (Strober Coll.) 2/7/70: 273 (lot,
   E & F et al), 365 (lot, E & F et al);
Sothebys NY (Greenway Coll.) 11/20/70: 11 (lot,
   E & F-1 et al), 12 (lot, E & F-1 et al);
Sothebys NY 11/21/70: 321 (lot, E & F-1 et al), 328
   (lot, E & F et al);
Sothebys Lon 12/21/71: 179 (lot, E & F et al);
Christies Lon 6/14/73: 155 (book, E & F et al);
Sothebys Lon 12/4/73: 250 (lot, E & F et al);
Sothebys Lon 3/8/74: 152 (album, E & F et al);
Sothebys Lon 6/21/74: 105 (album, E & F et al), 163
   (lot, E & F et al);
Christies Lon 7/25/74: 328 (book, E & F et al), 368
   (albums, E & F et al);
Sothebys Lon 10/18/74: 139 (lot, E & F et al);
Edwards Lon 1975: 12 (album, E & F et al), 69 (book,
   E & F-1 et al);
Swann NY 2/6/75: 165 (book, E & F et al);
Sothebys Lon 6/26/75: 98 (lot, E & F et al), 198
   (album, E & F et al);
Sothebys Lon 10/24/75: 167 (book, E & F et al);
Witkin NY IV 1976: OP87 (book, 1);
Sothebys Lon 3/19/76: 163 (book, E & F et al);
Christies Lon 6/10/76: 150 (album, E & F et al),
   191 (book, E & F et al);
Christies Lon 10/28/76: 311 (book, E & F et al);
Sothebys Lon 10/29/76: 104 (book, E & F et al), 105
   (book, E & F et al);
Swann NY 11/11/76: 448 (4);
Halsted Michigan 1977: 621;
California Galleries 1/22/77: 291 ill;
Sothebys Lon 3/9/77: 197 (album, E & F et al);
Christies Lon 3/10/77: 339 (book, 12), 341 (book,
   E & F et al);
Christies Lon 10/27/77: 373 (2);
California Galleries 1/21/78: 122 (lot, E & F
   et al), 130 (album, E & F et al);
Christies Lon 6/27/78: 239 (album, E & F et al);
Sothebys Lon 6/28/78: 148 (book, E & F et al);
Christies Lon 10/26/78: 329 (album, E & F et al);
Sothebys Lon 10/27/78: 214 (book, 12);
Phillips NY 11/4/78: 37 (note);
Swann NY 12/14/78: 458 (lot, E & F et al);
Wood Conn Cat 37, 1979: 27 (book, E & F-1 et al);
Christies Lon 3/15/79: 226 (book, E & F-6 et al);
Sothebys Lon 6/29/79: 257 (lot, E & F et al);
Phillips Can 10/4/79: 21 (album, E & F et al);
Swann NY 10/18/79: 284;
Sothebys Lon 10/24/79: 45 (book, E & F et al);
Christies Lon 10/25/79: 18 (lot, E & F-1 et al);
Phillips NY 11/29/79: 241 (lot, E & F-1 et al);
Phillips Lon 3/12/80: 124 (lot, E & F et al);
Christies Lon 6/26/80: 358 (books, E & F-1 et al),
   474 (album, E & F et al), 478 (album, E & F
   et al);
Sothebys Lon 6/27/80: 243 (book, 12);
Christies Lon 10/30/80: 174 (lot, E & F-1 et al),
   317 (book, E & F et al), 405 (album, E & F-1
   et al), 431 (album, E & F-1 et al);
Christies NY 11/11/80: 198 (112);

ELLIOTT & FRY (continued)
Christies Lon 6/18/81: 263 (book, E & F et al), 366
   ill, 423 (album, E & F-1 et al), 431 (album, E &
   F et al);
California Galleries 6/28/81: 374 (lot, E & F
   et al);
Harris Baltimore 7/31/81: 299 (lot, E & F et al);
Christies Lon 10/29/81: 363 (lot, E & F-2 et al);
Swann NY 11/5/81: 564 (album, E & F et al)(note);
Christies Lon 3/11/82: 326 (album, E & F et al), 344
   (lot, E & F et al), 347 (album, E & F et al);
Swann NY 4/1/82: 263 (lot, E & F et al);
Phillips Lon 6/23/82: 68 (album, E & F et al);
Christies Lon 6/24/82: 364 (album, E & F et al);
Christies Lon 10/28/82: 211 (lot, E & F et al);
Swann NY 11/18/82: 254 (books, E & F et al);
Christies Lon 3/24/83: 237 (album, E & F et al);
Swann NY 11/10/83: 33 (books, E & F et al);
Christies Lon 3/29/84: 349 (album, E & F et al);
Swann NY 5/10/84: 321 (lot, E & F et al)(note), 322
   (albums, E & F et al)(note);
Harris Baltimore 6/1/84: 248 (lot, E & F-1 et al),
   295 (lot, E & F et al);
Christies Lon 6/28/84: 251 (book, 25);
California Galleries 7/1/84: 165 (lot, E & F et al);
Christies Lon 10/25/84: 325 (albums, E & F et al);
Sothebys Lon 10/26/84: 163 (lot, E & F-1 et al);
Harris Baltimore 3/15/85: 246 (lot, E & F-1 et al),
   255 (lot, E & F-4 et al), 267 (lot, E & F-1 et
   al), 276 (lot, E & F et al), 287 (lot, E & F et
   al), 295, 298 (lot, E & F et al), 302 (lot, E &
   F et al), 314 (E & F et al), 317 (lot, E & F et
   al), 319 (lot, E & F-6 et al);
Christies Lon 3/28/85: 309 (album, E & F et al);
Swann NY 11/14/85: 137 (album, E & F et al), 147
   (album, E & F et al);
Harris Baltimore 2/14/86: 71 (lot, E & F et al), 74
   (lot, E & F et al), 97, 98 (lot, E & F et al);
Swann NY 5/16/86: 313 (lot, E & F et al);
Harris Baltimore 11/7/86: 223 (lot, E & F-1 et al),
   225 (lot, E & F et al);

ELLIOTT, C.D.
Photos dated: Nineteenth century
Processes:     Albumen
Formats:       Stereos
Subjects:      Documentary (art)
Locations:     England - London
Studio:
   Entries:
Harris Baltimore 12/16/83: 42 (lot, E-1 et al);

ELLIOTT, James (British)
Photos dated: 1850s-1870
Processes:     Albumen
Formats:       Stereos incl. tissues
Subjects:      Genre
Locations:     Studio
Studio:        Great Britain
   Entries:
Rinhart NY Cat 6, 1973: 437;
Sothebys Lon 6/26/75: 8;
Christies Lon 3/15/79: 75 (lot, E-3 et al)(note), 78
   (lot, E-1 et al);
Christies Lon 10/25/79: 74 (lot, E-3 et al), 83
   (lot, E-1 et al);
Christies Lon 3/20/80: 102 (lot, E et al);
Christies Lon 6/26/80: 104 (lot, E-6 et al);
Sothebys Lon 6/27/80: 4 (lot, E et al);

**ELLIOTT, J.** (continued)
Christies Lon 10/30/80: 98 (lot, E-11 et al), 103
(lot, E-2 et al), 106 (lot, E-5 et al), 110
(lot, E-3 et al);
Christies Lon 3/26/81: 113 (lot, E-1 et al), 118
(lot, E et al);
Christies Lon 6/18/81: 85 (lot, E-30 et al), 95
(lot, E et al);
Harris Baltimore 7/31/81: 100 (lot, E et al)
(attributed);
Christies Lon 10/29/81: 120 (lot, E-1 et al), 121
(lot, E-1 et al), 125 (lot, E-1 et al), 130
(lot, E-13 et al), 131 (lot, E-2 et al), 146
(lot, E-1 et al), 147 (lot, E et al);
Christies Lon 3/11/82: 75 (lot, E-1 et al);
Sothebys Lon 3/15/82: 21 ill(lot, E et al);
Christies Lon 6/24/82: 52 (lot, E et al), 54 (lot,
E-1 et al), 67 (lot, E-1 et al), 70 (lot, E-6
et al);
Sothebys Lon 6/25/82: 6 (lot, E et al);
Christies Lon 10/28/82: 14 (lot, E et al), 15 (lot,
E et al);
Christies Lon 3/24/83: 28 (lot, E et al), 33 (lot,
E et al), 37 (lot, E-6 et al);
Christies Lon 6/23/83: 25 (lot, E-13 et al), 27
(lot, E et al), 32 (lot, E et al), 33 ill(lot,
E-2 et al), 35 (lot, E-1 et al), 40 (lot, E et
al), 56 (lot, E-1 et al);
Christies Lon 10/27/83: 34 (lot, E-2 et al), 36
(lot, E-1 et al), 37 (lot, E-1 et al), 39 (lot,
E-1 et al), 41 (lot, E et al);
Christies Lon 3/29/84: 16 (lot, E-2 et al), 28
(lot, E-2 et al), 35 (lot, E et al), 36 (lot,
E-1 et al), 40 (lot, E et al);
Christies Lon 6/28/84: 32 (lot, E et al), 34 (lot,
E etal), 26 (lot, E-1 et al), 37 (lot, E-3 et
al), 40 (lot, E et al), 48 (lot, E et al), 49
(lot, E-1 et al), 50 (lot, E et al);
Sothebys Lon 6/29/84: 11 (lot, E et al);
Phillips Lon 10/24/84: 92 (lot, E-3 et al);
Christies Lon 10/25/84: 37 (lot, E et al), 38 (lot,
E et al), 43 (lot, E-5 et al), 45 (lot, E-1 et
al), 46 (lot, E-1 et al);
Sothebys Lon 10/26/84: 6 (lot, E et al);
Phillips Lon 3/27/85: 143 (lot, E-1 et al);
Christies Lon 3/28/85: 35 ill(22), 36 (lot, E et
al), 37 (lot, E et al), 38 (lot, E et al), 39
ill(lot, E et al);
Christies Lon 6/27/85: 46 ill(32);
Sothebys Lon 6/28/85: 2 (lot, E et al), 7 (lot, E-1
et al);
Christies Lon 10/31/85: 59 (lot, E-2 et al), 60
(lot, E-1 et al), 69 (lot, E-1 et al);
Phillips Lon 4/23/86: 186 (lot, E-1 et al), 193
(lot, E-4 et al);
Christies Lon 4/24/86: 325 ill(23), 347 (lot, E-6
et al), 360 (lot, E et al), 366 (lot, E-7 et al);
Christies Lon 6/26/86: 30 (32), 66 (lot, E et al),
156 (lot, E et al);
Christies Lon 10/30/86: 27 (lot, E-2 et al), 29
(lot, E et al);

**ELLIOTT, W.H.**
Photos dated: Nineteenth century
Processes: Albumen
Formats: Cdvs
Subjects: Portraits
Locations:
Studio:
Entries:
California Galleries 1/21/79: 233 (lot, E et al);

**ELLIS, Alfred** (British)
Photos dated: 1880s-1897
Processes: Photogravure
Formats: Prints, cabinet cards
Subjects: Portraits
Locations: Studio
Studio: England - London
Entries:
Sothebys Lon 10/29/76: 105 (album, E et al);
Christies Lon 3/10/77: 341 (book, E et al);
Christies Lon 3/20/80: 383 (lot, E et al);
Sothebys Lon 3/21/80: 242 (book, E et al);
California Galleries 6/28/81: 191 (lot, E et al);
California Galleries 5/23/82: 266 (E & Walery);
Sothebys Lon 3/29/85: 218 ill(album, E et al);
Sothebys Lon 4/25/86: 168 (books, E et al), 206
(album, E et al);

**ELLIS, J.R.** (American)
Photos dated: c1880
Processes: Albumen
Formats: Prints
Subjects: Portraits
Locations: Studio
Studio: US - Giddings, Texas
Entries:
Swann NY 5/10/84: 273 (lot, E et al)(note);

**ELLIS, Lemuel** (American)
Photos dated: c1885
Processes: Albumen
Formats: Prints
Subjects: Topography
Locations: US - San Gabriel, California
Studio: US - California
Entries:
California Galleries 3/29/86: 755 (lot, E-1 et al);

**ELLIS, Richard** (British)
Photos dated: c1870-1886
Processes: Albumen
Formats: Prints
Subjects: Topography
Locations: Malta
Studio: Malta - Valetta
Entries:
Wood Conn Cat 37, 1976: 215 (album, 106)(note);
Sothebys Lon 10/29/76: 108 (35);
Wood Conn Cat 42, 1978: 560 (album, 106)(note);
Harris Baltimore 12/10/82: 402 (album, E et al);
Christies Lon 3/29/84: 105 (albums, E et al);
Christies Lon 10/25/84: 101 (albums, E et al);
Swann NY 11/13/86: 192 (album, E et al);

**ELLISSON & Co.** (Canadian)
Photos dated: c1852-1870s
Processes:     Albumen
Formats:       Cdvs, stereos
Subjects:      Portraits
Locations:     Studio
Studio:        Canada - Quebec
   Entries:
Swann NY 4/14/77: 322 (lot, E-2 et al);
Swann NY 4/26/79: 448 (lot, E-1 et al)(note);
Phillips Can 10/4/79: 42 (lot, E-2 et al);
Swann NY 10/18/79: 401 ill(7)(note);
Swann NY 4/23/81: 523 (lot, E-5 et al)(note);
Harris Baltimore 4/8/83: 15 (lot, E et al);
Swann NY 5/5/83: 291 (album, E et al);
Harris Baltimore 12/16/83: 21 (lot, E-1 et al);
Phillips Lon 10/24/84: 123 (lot, E-1 et al);
Harris Baltimore 3/15/85: 18 (lot, E et al);

**ELLOT, B.**
Photos dated: 1889
Processes:     Albumen
Formats:       Prints incl. panoramas
Subjects:      Topography
Locations:     South Africa - Johannesburg
Studio:
   Entries:
Christies Lon 10/25/84: 232 ill;

**ELLS**
Photos dated: Nineteenth century
Processes:
Formats:       Prints
Subjects:      Topography
Locations:     Canada
Studio:
   Entries:
Swann NY 10/18/79: 350 (books, E et al);

**ELPHINSTONE, Captain P.A.** (British)
Photos dated: 1860s
Processes:     Albumen
Formats:       Prints
Subjects:
Locations:
Studio:        Great Britain (Amateur Photographic
              Association)
   Entries:
Sothebys Lon 10/29/80: 310 (album, E et al);
Christies Lon 10/27/83: 218 (albums, E-5 et al);

**ELSON, A.W.** (American)
Photos dated: 1890
Processes:     Photogravure
Formats:       Prints
Subjects:      Topography
Locations:     US - New England
Studio:        US
   Entries:
Wood Conn Cat 37, 1976: 57 (book, 12)(note);
Witkin NY V 1977: 85 ill(book, 12);

**ELTON, G.M.**
Photos dated: 1876-1878
Processes:     Albumen
Formats:       Prints
Subjects:      Genre
Locations:
Studio:
   Entries:
California Galleries 7/1/84: 110 (book, 1);
Wood Boston Cat 58, 1986: 136 (books, E-1 et al);

**ELY, Cook**
Photos dated: 1878
Processes:     Albumen
Formats:       Prints
Subjects:
Locations:
Studio:
   Entries:
Wood Boston Cat 58, 1986: 136 (book, E et al);

**EMDEN, H.** (German)
Photos dated: 1860
Processes:     Albumen
Formats:       Prints
Subjects:      Documentary (art)
Locations:     Austria - Vienna
Studio:        Germany - Frankfurt
   Entries:
Edwards Lon 1975: 127 (book, 36);

**EMERSON, Peter Henry** (British, 1856-1936)
Photos dated: 1886-1900
Processes:     Platinum, photogravure, autogravure
Formats:       Prints
Subjects:      Topography, genre
Locations:     England - Norfolk and Suffolk
Studio:        England - Southwold, Suffolk
   Entries:
Weil Lon Cat 14, 1949(?): 366 (book, 30), 367
   (book, 30), 368 (book, 16), 369 (book, 16);
Ricketts Lon 1974: 50 ill(book, 50);
Witkin NY III 1975: 510 ill(book, E-27 et al)(note);
Sothebys NY 9/23/75: 315 ill(note), 316, 317 ill,
   318 ill, 319 ill(note), 320 ill(note), 321, 322,
   323;
Sothebys Lon 10/24/75: 234 (2), 235 (2), 236 ill,
   237 (2);
Alexander Lon 1976: 59, 60 ill, 61 ill, 62 ill, 63
   ill, 64 ill, 65 ill, 66 ill;
Colnaghi Lon 1976: 352 ill(note), 353 ill, 354, 355
   ill, 356, 357, 358, 359, 360, 361, 362 ill, 363
   ill(book, 12)(note), 364 ill(book, E-27 et al),
   365 ill(book, 16), 366 ill(book, 16);
Lunn DC Cat 6, 1976: 43 (book, 40)(note), 44.1 ill,
   44.2, 44.3, 44.4, 44.5, 45.1 ill(note), 45.2, 46
   ill(book, 54), 47 ill(book, 30)(note), 48 ill
   (book, 16)(note);
Witkin NY IV 1976: 108 ill, 109 ill, 110 ill, 111
   ill, 112 ill, OP140 ill(book, E-27 et al);
Wood Conn Cat 37, 1976: 60 (book, E-27 et al)(note);
California Galleries 4/2/76: 212 ill, 213 ill, 214,
   215;
Gordon NY 5/3/76: 329 ill, 330 ill(2), 331 ill
   (book, 27);
Sothebys NY 5/4/76: 268 ill(note), 269 ill, 270,
   271 ill(book, 20)(note), 272, 273, 274, 275,

EMERSON, P.H. (continued)
276, 277, 278, 279, 280 ill, 281 ill(book, 16)
  (note);
Christies Lon 6/10/76: 198 (4 ills)(book, 40)
  (note), 199 ill(note);
Christies Lon 10/28/76: 320 (2 ills)(book, 40)
  (note), 321 ill(book, 32)(note), 322 (2 ills)
  (book, 30)(note), 323 (2 ills)(book, 30), 324
  (2 ills)(book, 15)(note);
Sothebys NY 11/9/76: 136 (note), 137 (note), 138
  ill, 139 (note), 140, 141, 142, 143 (3)(note),
  144 ill(book, 29), 145 (note), 146 ill;
Swann NY 11/11/76: 294 (book, E et al)(note);
Gordon NY 11/13/76: 108 ill, 109 ill, 110 ill, 111
  ill, 112 ill;
Vermont Cat 11/12, 1977: 516 ill(book, 29)(note);
Halsted Michigan 1977: 622 ill(note), 623 ill, 624;
White LA 1977: 5 (2 ills)(book, 32)(note), 277
  (book, E-27 et al)
California Galleries 1/22/77: 292, 293 ill;
Sothebys NY 2/9/77: 30 (2)(note), 31 ill, 32 (2);
Sothebys Lon 3/9/77: 259 (5), 260 (5), 261 ill
  (book, 32), 262 (note);
Christies Lon 3/10/77: 362 (2 ills)(book, 40)
  (note), 363 ill(book, 32)(note), 364 ill(book,
  E-27 et al), 365 ill(book, 30)(note), 366 ill
  (book, 18), 367 ill(book, 16)(note);
Swann NY 4/14/77: 173 (book, E et al)(note);
Gordon NY 5/10/77: 881 ill(album, E-1 et al)(note),
  882 ill, 883 ill(note), 884 ill(note), 885 ill
  (note), 886 ill(note), 887 ill(note), 888 ill,
  889 ill, 890 ill, 891 ill, 892 ill(note), 893
  ill, 894 ill(book, E-27 et al);
Sothebys NY 5/20/77: 87 ill, 88 ill, 89 ill(book,
  E-27 et al), 91 ill(book, 16);
Christies Lon 6/30/77: 219 ill(book, 40)(note), 220
  ill (book, 32)(note), 221 ill(book, 12)(note),
  223 ill(book, 30);
Sothebys Lon 7/1/77: 319 ill(book, 18), 320 ill
  (book, 30), 321 ill(book, 16)(note);
Sothebys NY 10/4/77: 187, 188 ill(book, E-27 et
  al), 189 (4), 190 (3);
Christies Lon 10/27/77: 236 ill(book, 40)(note),
  237 ill(book, 32)(note);
Sothebys Lon 11/18/77: 204 ill(book, 16);
Swann NY 12/8/77: 184 (book, E et al), 271, 272,
  273;
Lunn DC Cat QP, 1978: 32 (book, 16)(note);
Rose Boston Cat 3, 1978: 24 ill(note), 25 ill;
Weston Cal 1978: 144 ill, 145 ill, 146 ill, 147
  ill, 148 (book, E-27 et al), 149 ill, 150 ill,
  151 ill;
Witkin NY VI 1978: 45 ill;
Wood Conn Cat 41, 1978: 111 ill(book, E-27 et al)
  (note), 112 (book, E-27 et al)(note), 113 ill
  (book, 32)(note), 114 ill(book, 29)(note);
California Galleries 1/21/78: 224, 225 ill, 226,
  227, 228 ill, 229, 230, 231;
Sothebys LA 2/13/78: 132 (2)(note), 133 (2);
Christies Lon 3/16/78: 239 ill(book, 40)(note), 240
  ill(book, 32)(note), 241 (8);
Sothebys Lon 3/22/78: 242 ill, 243 ill, 244 ill
  (book, 40), 245 ill(book, 32);
Swann NY 4/20/78: 206 ill(note);
Christies Lon 6/27/78: 174 ill(book, 32), 174a ill
  (book, 30);
Sothebys Lon 6/28/78: 352, 353, 354, 355, 356 ill
  (book, 20);
Christies Lon 10/26/78: 230 ill(book, 40), 234
  (book, 30);

EMERSON, P.H. (continued)
Sothebys Lon 10/27/78: 245 ill, 246 (25), 247 ill
  (book, 18), 248 (5);
Phillips NY 11/4/78: 119 ill, 120, 121, 122 (note),
  123 ill(note), 124 ill(note), 125 ill(note), 126
  ill(book, 54)(note), 127 (4);
Swann NY 12/14/78: 246 (book, E et al), 392;
Lennert Munich Cat 5, 1979: 35 ill;
Witkin NY IX 1979: 30 (book, 29)(note);
Wood Conn Cat 45, 1979: 97 (book, E-27 et al)
  (note), 98 (book, E-27 et al), 99 (book, 15)
  (note), 100 (book, 32)(note), 101 ill(book,
  29)(note);
California Galleries 1/21/79: 428;
Sothebys LA 2/7/79: 439 ill, 440 ill(note), 441,
  442 ill(book, E-27 et al);
Phillips Lon 3/13/79: 159 (note), 160 (note), 161
  ill(note);
Sothebys Lon 3/14/79: 248 (book, 10), 384 (4);
Christies Lon 3/15/79: 225 ill(book, 40);
Christies NY 5/4/79: 132 (2 ills)(note);
Phillips NY 5/5/79: 147, 148 (note), 149 ill, 150,
  151, 152, 153;
Sothebys NY 5/8/79: 79 (book, E-27 et al);
Christies Lon 6/28/79: 172 ill(book, E-27 et al);
Phillips Can 10/4/79: 101, 102, 103 ill, 104 ill,
  105 ill, 106 ill;
Sothebys Lon 10/24/79: 40 ill(book, 30);
Christies Lon 10/25/79: 289, 290 ill, 291 ill, 292,
  293 ill, 294, 295 ill(book, 32), 296 ill(book,
  12)(note), 297 ill(book, E-27 et al);
Christies NY 10/31/79: 122 ill, 123 ill, 124, 125,
  126 ill, 127, 128, 129 ill(book, E et al),
  130 (4);
Sothebys NY 11/2/79: 228 ill(note);
Phillips NY 11/3/79: 156 ill;
Sothebys NY 12/19/79: 57 ill(book, 16);
Sothebys LA 2/6/80: 157 ill(book, E-27 et al), 158,
  159;
Christies Lon 3/20/80: 246 (book, 18);
Sothebys Lon 3/21/80: 350 ill, 351, 352 ill(book,
  40), 353 ill(book, 54), 354 ill(book, 31),
  355 ill;
California Galleries 3/30/80: 298 ill;
Christies NY 5/14/80: 117 ill(book, E et al);
Christies NY 5/16/80: 304 ill(note), 305 ill, 306,
  307 ill(note), 308 ill, 309 ill(note), 310, 311
  ill, 311A, 312 (3);
Sothebys NY 5/20/80: 355 ill, 356 ill, 357, 358,
  359 ill;
Phillips NY 5/21/80: 175 ill, 176 ill, 177 ill;
Christies Lon 6/26/80: 335 (book, E-27 et al), 339
  ill(book, 26);
Sothebys Lon 6/27/80: 334 ill, 335 ill, 502 ill,
  503 ill, 504 ill;
Phillips Can 10/9/80: 24 ill(note), 25 ill(note),
  26 (note), 27 ill(note), 28 (5), 29 (12)(note);
Sothebys Lon 10/29/80: 239 ill(book, 32), 240 ill
  (book, 28), 241 ill, 242 ill, 243 ill, 244 ill,
  245 (book, 10);
Christies Lon 10/30/80: 338 ill, 339 ill, 340 ill
  (book, 12), 341 ill(10);
Christies NY 11/11/80: 181 ill(note), 182 ill, 183
  ill, 184 ill, 185, 186 ill, 187 188, 189, 190,
  191 (5);
Sothebys NY 11/17/80: 83 ill(note), 84 ill, 85, 86,
  87 ill;
Koch Cal 1981-82: 12 ill(note), 13 ill, 14 ill;
Sothebys LA 2/4/81: 188 (note);
Christies Lon 3/26/81: 324 ill(book, 27), 325 ill
  (book,12), 326 (book, 1), 419;

EMERSON, P.H. (continued)

Swann NY 4/23/81: 206 ill(book, E et al)(note);
Phillips NY 5/9/81: 18 ill, 19 ill(note), 20 ill (note), 21 (note), 22, 23 (note);
Sothebys NY 5/15/81: 90 ill, 91 ill, 92 ill;
Christies Lon 6/18/81: 280 (book, 32), 281 (book, 30), 282 (book, 16)(note), 284;
California Galleries 6/28/81: 218 ill;
Sothebys NY 10/21/81: 95 ill, 96 (book, E-27 et al);
Sothebys Lon 10/28/81: 395 ill(book, 18), 396 ill, 397 ill;
Christies Lon 10/29/81: 289 ill(book, 40), 290 ill (book, 13)(note), 291 (book, 27);
Swann NY 11/5/81: 303;
Christies NY 11/10/81: 84 ill, 85 ill, 86 ill, 87 ill, 88 ill, 89 ill;
Rose Florida Cat 7, 1982: 29 ill(note), 30 ill;
Weston Cat 1982: 24 ill, 25 ill, 26 ill;
Wood Conn Cat 49, 1982: 20 (2 ills)(book, 40), 150 (book, 20)(note), 151 (book, E-27 et al)(note), 152 (book, E-27 et al), 153 (book, 30)(note), 154 ill(book, 16)(note);
Sothebys LA 2/16/82: 171 ill(note);
Christies Lon 3/11/82: 289 (book, 30), 290, 291, 292;
Sothebys Lon 3/15/82: 365 ill, 366 ill, 367 ill;
Harris Baltimore 3/26/82: 241, 242;
Swann NY 4/1/82: 78 ill(book, E et al)(note);
Phillips NY 5/22/82: 734 ill(note), 735 ill, 736 ill (note), 737 (note), 738 ill, 739, 740;
California Galleries 5/23/82: 286, 287;
Sothebys NY 5/24/82: 237 ill(note);
Sothebys NY 5/25/82: 386 ill;
Christies NY 5/26/82: 19 ill, 20 ill, 21 ill, 22 ill, 23 ill, 24 ill(book, 54);
Christies Lon 6/24/82: 284 (13), 285, 286 ill, 287;
Sothebys Lon 6/25/82: 233 ill, 234 ill, 235 ill, 236 ill;
Phillips NY 9/30/82: 969 (2);
Christies Lon 10/28/82: 145, 146 ill, 147 ill, 147A (3)(note);
Sothebys Lon 10/29/82: 166, 167 ill, 168, 169 ill (book, 31);
Christies NY 11/8/82: 88 ill, 89 ill;
Sothebys NY 11/9/82: 196 ill, 197 ill(note);
Phillips NY 11/9/82: 99 ill(note), 100 ill, 101 ill (note);
Harris Baltimore 12/10/82: 216 (note), 217, 218, 219, 220, 221, 222;
Christies NY 2/8/83: 45 (2);
Christies Lon 3/24/83: 186 (book, 13)(note), 187 ill (book, 40)(note), 188 ill(book);
Swann NY 5/5/83: 89 ill(book, 32)(note), 90 (book, 32)(note), 342 (4)(note), 343 (4)(note);
Christies NY 5/9/83: 55 ill, 56 ill, 57 ill, 58 ill (book, 32);
Sothebys NY 5/11/83: 207 ill(note);
Sothebys Lon 6/24/83: 117 ill;
Christies Lon 10/27/83: 250 (13);
Phillips Lon 11/4/83: 105 ill;
Christies NY 11/8/83: 91 ill(note), 92 ill(note), 93 ill(note), 94 ill(note), 95 ill(book, 16) (note);
Sothebys NY 11/9/83: 130 ill, 131 ill;
Swann NY 11/10/83: 56 (book, 29)(note);
Sothebys Lon 12/9/83: 114, 115 ill, 116 ill, 117 ill, 118 ill, 119 ill;
Harris Baltimore 12/16/83: 319, 320, 321, 322, 323, 324, 325, 326;
Christies NY 2/22/84: 4 (3)(note);
Christies Lon 3/29/84: 220;

EMERSON, P.H. (continued)

Christies NY 5/7/84: 11 ill(note), 12 ill(note);
Sothebys NY 5/8/84: 129 ill, 130 ill, 131 ill, 132 ill, 133 ill, 134 ill, 135 ill(book, 29);
Christies Lon 6/28/84: 242 ill(book, 12)(note), 243 (6)(note), 244 ill(lot, E-6 et al)(note), 245 (book, E-27 et al);
Sothebys Lon 6/29/84: 233 ill;
California Galleries 7/1/84: 368, 369 ill;
Christies NY 9/11/84: 114 (album, E-1 et al);
Phillips Lon 10/24/84: 143;
Christies Lon 10/25/84: 127 (book, 12), 128 ill (book, 30)
Sothebys Lon 10/26/84: 167 ill(book, 31), 168 ill;
Sothebys NY 11/5/84: 84 ill, 85 (book, 29), 223 ill;
Christies NY 11/6/84: 11 ill(note), 12 ill(note);
Swann NY 11/8/84: 44 (book, E et al)(note);
Christies NY 2/13/85: 124 (3);
Harris Baltimore 3/15/85: 182;
Christies Lon 3/28/85: 112 ill(book, 40)(note), 113 (2 ills)(book, 32)(note), 114 (6)(note), 115 ill (book, 32)(note), 116 (book, 18), 117 ill(book, 16)(note), 118 ill(book, 16);
Sothebys Lon 3/29/85: 181 ill(book, 38), 182 ill, 183 ill, 184 ill, 185 ill, 186 ill(book, 16), 187 ill;
Sothebys NY 5/7/85: 384 ill;
Christies Lon 6/27/85: 192 ill;
Sothebys Lon 6/28/85: 177 ill, 178 ill, 179 (book, 11), 180 ill, 181 ill, 182 ill, 183 ill, 184 ill, 185 ill, 186 ill, 187 ill, 188 ill;
Christies Lon 10/31/85: 151 (book, E-27 et al), 152 ill(book, 30);
Sothebys Lon 11/1/85: 105 ill(5), 106 ill, 107 ill, 108 ill;
Christies NY 11/11/85: 168 ill, 169 ill, 170 ill;
Sothebys NY 11/12/85: 109 ill(note), 110 ill, 111 (book, E-27 et al);
Swann NY 11/14/85: 222 (book, E-27 et al)(note);
Phillips Lon 4/23/86: 308 (10);
Christies Lon 4/24/86: 421 ill(book, E-27 et al), 421A ill(book, 12), 422 ill(book, 40)(note), 422A ill(book, 12);
Sothebys Lon 4/25/86: 166 ill, 167 ill;
Sothebys NY 5/12/86: 147 ill(note), 148 ill(note), 149 ill(note), 150 ill;
Christies NY 5/13/86: 101 ill, 102 (note), 103 ill, 104 ill(5)(note);
Swann NY 5/16/86: 88 (2 ills)(book, 16)(note), 89 (book, E-27 et al)(note);
Christies Lon 6/26/86: 31A (book, 18);
Phillips Lon 10/29/86: 368 (book, 32);
Sothebys Lon 10/30/86: 130, 131 ill, 132 ill;
Sothebys NY 11/10/86: 311 ill;
Swann NY 11/13/86: 46 (2 ills)(book, 39)(note), 47 (book, E et al)(note), 219 (lot, E-4 et al);

EMILE
Photos dated: between 1860s and 1890s
Processes:      Albumen
Formats:        Cdvs
Subjects:       Topography
Locations:      Egypt and/or Algeria
Studio:
  Entries:
Swann NY 5/16/86: 203 (lot, E et al);

**EMILIA** (Italian)
Photos dated: 1860s-1870s
Processes:       Albumen
Formats:         Prints, stereos, cdvs
Subjects:        Topography
Locations:       Italy - Bologna
Studio:          Italy - Bologna
   Entries:
Christies Lon 3/26/81: 197 (73);
Petzold Germany 5/22/81: 1833 (lot, E-3 et al), 1946
  (lot, E-6 et al);
Petzold Germany 11/7/81: 231 (lot, E-1 et al);

**ENGLAND, William** (British, died 1896)
Photos dated: 1859-1866
Processes:       Albumen
Formats:         Prints, stereos, cdvs, cabinet cards
Subjects:        Topography, documentary
Locations:       Great Britain; Switzerland; France;
                Germany
Studio:          England
   Entries:
Rauch Geneva 6/13/61: 223 (lot, E et al);
Rinhart NY Cat 1, 1971: 281 (5);
Vermont Cat 5, 1973: 541 ill(7);
Sothebys Lon 10/18/74: 77 (lot, E et al), 13 (lot,
  E et al);
California Galleries 9/27/75: 443 (lot, E et al);
Wood Conn Cat 37, 1976: 236 (album, E et al), 250
  (album, E et al);
Sothebys Lon 3/19/76: 24 (album, 124)(attributed);
California Gallereis 4/3/76: 374 (lot, E et al);
Vermont Cat 11/12, 1977: 781 ill, 782 ill(7);
California Galleries 1/23/77: 380 (21);
Sothebys Lon 3/9/77: 6 (lot, E-4 et al);
Sothebys Lon 11/18/77: 5 (lot, E et al), 68
  (album, E-3 et al);
Swann NY 12/8/77: 369 (lot, E et al);
Christies Lon 3/15/79: 185 (lot, E et al);
Christies Lon 3/16/78: 112 (lot, E-1 et al), 167
  (lot, E-66 et al);
Christies Lon 6/27/78: 234 (lot, E-37 et al);
Christies Lon 10/26/78: 123 (5);
Sothebys Lon 10/27/78: 93 (7);
Phillips Lon 3/13/79: 141 ill(lot, E-1 et al);
Sothebys Lon 3/14/79: 236 (book, E et al);
Christies Lon 6/28/79: 74 (lot, E-25 et al);
Sothebys Lon 6/29/79: 3 (lot, E-11 et al), 134 (5);
Sothebys Lon 10/24/79: 52 (lot, E et al), 123 (9);
Christies Lon 10/25/79: 77 (165), 85 (lot, E-2 et
  al), 94 (lot, E-1 et al);
Christies NY 10/31/79: 26 (lot, E et al)(note);
White LA 1980-81: 35 ill(note), 36 ill, 37 ill;
Sothebys LA 2/6/80: 116 (5);
Christies Lon 3/20/80: 86 ill(46), 98 (lot, E-72 et
  al), 99 (lot, E-8 et al);
Christies NY 5/16/80: 107 (4);
Phillips NY 5/21/80: 211 ill(4);
Christies Lon 6/26/80: 98 (49), 103 (106), 110
  (23), 114 (lot, E-10 et al);
Sothebys Lon 6/27/80: 2 (34), 122 ill(album, 56);
Sothebys Lon 10/29/80: 96 (8);
Christies Lon 10/30/80: 107 (22), 116 (lot, E-10 et
  al), 129 (lot, E-4 et al), 137 (lot, E et al);
Phillips NY 11/13/80: 30 ill, 31 ill;
Sothebys Lon 6/17/81: 117 (5);
Christies Lon 6/18/81: 75 (lot, E-1 et al), 87
  (lot, E-23 et al), 103 (lot, E-5 et al), 104
  (lot, E et al), 105 (lot, E-7 et al), 106
  (lot, E-11 et al);

**ENGLAND** (continued)
Harris Baltimore 7/31/81: 92 (41)(note);
Christies Lon 10/29/81: 132 (58), 143 (lot, E et
  al), 147 (lot, E et al), 189 (3);
Wood Conn Cat 49, 1982: 499 (book, E-2 et al);
Christies Lon 3/11/82: 66 (lot, E et al), 76 (lot,
  E et al), 89 (lot, E et al), 90 (lot, E et al);
Sothebys Lon 3/15/82: 91 (8);
Christies Lon 6/24/82: 63 (lot, E et al), 64 (lot,
  E-32 et al), 65 (lot, E-8 et al);
Sothebys Lon 6/25/82: 92 ill(album, 56);
Phillips NY 9/30/82: 971;
Christies Lon 10/28/82: 17 (lot, E et al), 21 (lot,
  E et al), 25 (lot, E-4 et al);
Harris Baltimore 12/10/82: 43 (lot, E-10 et al), 389
  (album, E et al);
Harris Baltimore 4/8/83: 23 (35);
Christies NY 5/9/83: 55 ill, 56 ill, 57 ill, 58 ill
  (book, 32);
Christies Lon 6/23/83: 36 (lot, E-2 et al), 40 (lot,
  E et al), 48 (lot, E-3 et al);
Christies Lon 10/27/83: 21 (lot, E et al), 26 (lot,
  E-6 et al), 27 (13), 39 (lot, E et al), 43 (lot,
  E-12 et al);
Harris Baltimore 12/16/83: 42 (lot, E-16 et al),
  122 (lot, E-1 et al), 132 (lot, E et al);
Christies Lon 3/29/84: 19 (lot, E-2 et al), 24
  (lot, E-3 et al), 32 (11);
Swann NY 5/10/84: 306 (lot, E et al);
Harris Baltimore 6/1/84: 50 (6), 51 (23), 356;
Christies Lon 6/28/84: 49 (lot, E et al), 54
  (100)(note), 327 (album, E et al);
Sothebys Lon 6/29/84: 62 (23), 165 (album, E et al)
  (note);
Christies NY 9/11/84: 130 (album, E et al);
Christies Lon 10/25/84: 52 (lot, E-16 et al);
Sothebys Lon 10/26/84: 27 (albums, E et al);
Harris Baltimore 3/15/85: 13 (lot, E-1 et al)
  (note), 34 (lot, E-4 et al), 35 (11), 37 (lot,
  E-5 et al), 40 (lot, E et al);
Christies Lon 3/28/85: 139 (lot, E-16 et al), 41
  (lot, E et al), 42 (lot, E et al), 51 (lot, E et
  al), 174 (5)(note);
Christies Lon 6/27/85: 39 (lot, E et al), 40 (44),
  41 (lot, E-5 et al);
Sothebys Lon 6/28/85: 3 (lot, E et al);
Christies Lon 10/31/85: 58 (lot, E et al), 70 (lot,
  E-30 et al);
Swann NY 11/14/85: 27 (lot, E et al), 163 (lot,
  E et al);
Harris Baltimore 2/14/86: 17 (6), 297 (3), 339
  (lot, E-6 et al)(note), 340 (lot, E attributed
  et al);
Phillips Lon 4/23/86: 185 (lot, E-12 et al);
Christies Lon 4/24/86: 336 (lot, E et al), 344
  (lot, E et al), 352 (lot, E-6 et al), 369 (lot,
  E-29 et al);
Christies Lon 6/26/86: 2 (lot, E et al), 3 (lot,
  E et al), 150A (lot, E-29 et al);
Christies Lon 10/30/86: 19A (lot, E et al), 33 (lot,
  E et al), 34 (lot, E-7 et al);
Sothebys Lon 10/31/86: 2 (lot, E et al);
Harris Baltimore 11/7/86: 306 (lot, E-6 et al);

ENNIS (American)(see also VAN LOAN & ENNIS)
Photos dated: 1860s-1870s
Processes:      Albumen
Formats:        Stereos
Subjects:       Documentary (Civil War)
Locations:      US
Studio:         US
    Entries:
Harris Baltimore 2/14/86: 13 (lot, E et al);

ENNIS, T.L. (American)(see also ANDERSON)
Photos dated: 1850s
Processes:      Daguerreotype
Formats:        Plates
Subjects:       Portraits
Locations:      Studio
Studio:         US - Philadelphia, Pennsylvania
    Entries:
Sothebys Lon 3/19/76: 81 (3);
Sothebys Lon 10/29/76: 202 (lot, E-1 et al);

ENSMINGER (American)
Photos dated: 1890s
Processes:
Formats:        Cabinet cards
Subjects:       Portraits
Locations:      Studio
Studio:         US - Morristown, New Jersey
    Entries:
Swann NY 10/18/79: 383 (lot, E-5 et al);

ENTARNATAO
Photos dated: 1860s
Processes:      Albumen
Formats:        Cdvs
Subjects:
Locations:
Studio:         China
    Entries:
Christies Lon 3/16/78: 101 (album, E et al);

EPPLER (see SEE & EPPLER)

ERBACH (American)
Photos dated: Nineteenth century
Processes:
Formats:        Prints
Subjects:       Topography
Locations:      US - Virginia
Studio:         US
    Entries:
Swann NY 10/18/79: 350 (books, E et al);

ERDLEN (American)
Photos dated: 1870s and/or 1880s
Processes:      Albumen
Formats:        Prints
Subjects:       Topography
Locations:      US - Salida, California
Studio:         US
    Entries:
California Galleries 12/13/80: 234 (lot, E-1 et al);

EREKSON, O. (American)
Photos dated: 1861-1860s
Processes:      Albumen
Formats:        Cdvs
Subjects:       Portraits
Locations:      Studio
Studio:         US - Bridgeport, Connecticut
    Entries:
Swann NY 11/10/83: 241 (lot, E et al);
Swann NY 11/14/85: 60 (album, E et al);

ERICSON, Augustus William (1848-1927)
Photos dated: 1884-1890s
Processes:      Albumen
Formats:        Prints
Subjects:       Documentary (industrial), ethnography
Locations:      US - Eureka, California
Studio:         US - Arcata, California
    Entries:
California Galleries 4/4/76: 614 (lot, E et al);
White LA 1977: 248 ill(lot, E attributed et al);
California Galleries 1/22/77: 297;
Frontier AC, Texas 1978: 95 ill(2);
Wood Conn Cat 42, 1978: 184 (book, 24)(note);
Sothebys NY 5/8/79: 17 ill(book, 24)(note);

ERSKINE, Midshipman James (British)(photographer
                or owner?)
Photos dated: 1879-1881
Processes:      Albumen
Formats:        Prints
Subjects:       Topography
Locations:      Europe; Asia
Studio:
    Entries:
Swann NY 2/14/52: 16 (album, 70);

ERWIN
Photos dated: 1866
Processes:      Albumen
Formats:        Prints
Subjects:       Portraits
Locations:      Studio
Studio:         France - Paris
    Entries:
California Galleries 3/30/80: 84 (book, 1);
California Galleries 12/13/80: 67 (book, 1);

ESCUDIER, Léon (French)
Photos dated: c1850
Processes:      Salt
Formats:        Prints
Subjects:       Portraits
Locations:      Studio
Studio:         France
    Entries:
Drouot Paris 11/22/86: 38 ill

**ESPOSITO** (Italian)
Photos dated: 1870s-1880s
Processes:    Albumen
Formats:      Prints
Subjects:     Topography, architecture
Locations:    Italy - Capri
Studio:       Italy
    Entries:
Swann NY 4/1/76: 206 (lot, E et al);
Sothebys NY 5/4/76: 77 (7);
Swann NY 11/11/76: 389 (albums, E et al), 395
    (albums, E et al);
Phillips NY 5/9/81: 50 (album, E et al);
Harris Baltimore 12/10/82: 391 (albums, E et al);
Harris Baltimore 2/14/86: 210 (albums, E et al);

**ESSLINGEN, W. Mayer**
Photos dated: between 1859 and 1873
Processes:    Albumen
Formats:      Prints
Subjects:     Documentary (railroads)
Locations:    Europe
Studio:       Europe
    Entries:
Christies 4/24/86: 583 (lot, E-1 et al);

**ESSON, James** (Canadian)
Photos dated: 1875-1898
Processes:    Albumen
Formats:      Stereos
Subjects:     Topography
Locations:    Canada - Ottawa
Studio:       Canada - Preston, Ontario
    Entries:
Swann NY 12/14/78: 271 (12);
Harris Baltimore 2/14/86: 5 (lot, E-3 et al);

**ESTABROOKE** (American)
Photos dated: 1860s
Processes:    Tintypes, albumen
Formats:      Plates, cdvs
Subjects:     Portraits
Locations:    Studio
Studio:       US - Brooklyn, New York
    Entries:
Rinhart NY Cat 2, 1971: 245 (lot, E et al), 266
    (lot, E et al);
California Galleries 1/21/78: 130 (album, E et al);

**EURGARD**
Photos dated: 1860s-1870s
Processes:    Albumen
Formats:      Stereos
Subjects:     Topography
Locations:    Belgium - Brussels
Studio:       Belgium - Brussels
    Entries:
Rauch Geneva 6/13/61: 223 (lot, E et al);

**EURENIUS, W.A. & QUIST** (Swedish)
Photos dated: c1860-1874
Processes:    Albumen
Formats:      Prints, cdvs
Subjects:     Ethnography
Locations:    Sweden; Norway
Studio:       Sweden
    Entries:
Swann NY 2/14/52: 88 (30);
Christies Lon 6/28/79: 238 (18);
Sothebys Lon 3/15/82: 225 (album, 18);
Sothebys Lon 6/28/85: 226 (books, 36);
Swann NY 5/16/86: 202 (album, E & Q et al);

**EVANS & PRINCE** (American)
Photos dated: 1865-1867
Processes:    Albumen
Formats:      Cdvs
Subjects:     Portraits
Locations:    Studio
Studio:       US
    Entries:
California Galleries 1/21/79: 231 (lot,
    E & P et al);

**EVANS, E.D.** (American)
Photos dated: 1882
Processes:    Albumen
Formats:      Cabinet card
Subjects:     Genre (advertising)
Locations:    US - Ithaca, New York
Studio:       US - Ithaca, New York
    Entries:
Swann NY 4/1/82: 344 (lot, E-1 et al);

**EVANS, F.E.** (American)
Photos dated: 1880s
Processes:    Albumen
Formats:      Stereos
Subjects:     Topography
Locations:    US - New Mexico
Studio:       US - East Las Vegas, New Mexico
    Entries:
Frontier AC, Texas 1978: 88 (lot, E-1 et al);
Swann NY 11/14/85: 166 (10);

**EVANS, G.** (American)
Photos dated: 1850s
Processes:    Daguerreotype
Formats:      Plates
Subjects:     Portraits
Locations:    Studio
Studio:       US - Philadelphia, Pennsylvania
    Entries:
Vermont Cat 4, 1972: 320 ill;

**EVANS, George** (British)
Photos dated: 1860s
Processes:    Albumen
Formats:      Cdvs
Subjects:     Portraits
Locations:    Studio
Studio:       England - Worcester
    Entries:
Christies Lon 6/27/85: 277 (album, E et al);

**EVANS, O.B.**
Photos dated: 1860s
Processes:      Glass diapositive
Formats:        Stereo plates
Subjects:       Documentary (public events)
Locations:      US - Niagara Falls, New York
Studio:
    Entries:
Rinhart NY Cat 7, 1973: 348;

**EVEREST, D.** (British)
Photos dated: Nineteenth century
Processes:      Albumen
Formats:        Stereos
Subjects:       Topography
Locations:      Great Britain
Studio:         Great Britain
    Entries:
Christies Lon 3/11/82: 82 (lot, E-1 et al);

**EVERETT, R., Jr.** (American)
Photos dated: early 1850s
Processes:      Daguerreotype
Formats:        Stereo plates
Subjects:       Portraits
Locations:      Studio
Studio:         US - Utica, New York
    Entries:
Swann NY 4/23/81: 251 (lot, E-1 et al);

**EWING, D.B.** (American)
Photos dated: early 1890s
Processes:      Albumen
Formats:        Prints
Subjects:       Documentary (industrial)
Locations:      US - Everett, Washington
Studio:         US
    Entries:
Rinhart Cat 7, 1973: 429;
California Galleries 1/21/78: 410 (lot, E-1 et al);

**EWING, P.** (British)
Photos dated: 1860s-1870s
Processes:      Albumen
Formats:        Prints, stereos
Subjects:       Topography
Locations:      Scotland
Studio:         Great Britain
    Entries:
Sothebys Lon 10/18/74: 260 (book, E et al);
Edwards Lon 1975: 161 (book, E et al);
Christies Lon 6/28/84: 37a (lot, E et al);

**EYNARD-LULLIN, Jean Gabriel** (Swiss, 1775-1863)
Photos dated: c1845-1853
Processes:      Daguerreotype
Formats:        Plates
Subjects:       Portraits, topography
Locations:      Switzerland - Geneva; Greece
Studio:         Switzerland - Geneva; France - Paris
    Entries:
Vermont Cat 11/12, 1977: 544 ill(note), 545 ill,
    546 ill;
Auer Paris 5/31/80: 6 ill(note), 7 ill, 8 ill;
Sothebys Lon 10/28/81: 295 ill(note);
Christies Lon 4/24/86: 306 ill(note);

**EYTING & GENCHE**
Photos dated: 1850s and/or 1860s
Processes:      Albumen
Formats:        Prints
Subjects:       Topography
Locations:      Europe
Studio:         Europe
    Entries:
Christies Lon 10/30/86: 88 (album, E & G-1 et al);

**EYTON, Anna Maria** (British)
Photos dated: 1860s-1870s
Processes:      Albumen
Formats:        Prints
Subjects:       Topography, portraits
Locations:      England - Shropshire
Studio:         England - Shropshire
    Entries:
Sothebys Lon 6/29/84: 255 ill(album, E et al);

**EZAKI, T.** (Japanese)
Photos dated: 1880s-1890s
Processes:      Albumen
Formats:        Prints
Subjects:       Topography
Locations:      Japan
Studio:         Japan
    Entries:
Old Japan, England Cat 8, 1985: 41 (album, 48)
    (attributed);

**F., C.** [C.F.]
Photos dated: c1857-1860
Processes:      Photolithographs (Asser process)
Formats:        Prints
Subjects:       Topography
Locations:      Europe
Studio:         Europe
   Entries:
Drouot Paris 11/22/86: 75 (13);

**F., F.B.** [F.B.F.]
Photos dated: 1860s and/or 1870s
Processes:      Albumen
Formats:        Prints
Subjects:       Architecture
Locations:      Germany
Studio:
   Entries:
Christies Lon 3/26/81: 267 (album, F-1 et al);

**F., G.A.** [G.A.F.] (French)
Photos dated: 1850s-1870s
Processes:      Albumen
Formats:        Stereos (tissue)
Subjects:       Architecture
Locations:      France - Paris; US - Washington, D.C.
Studio:         France - Paris
   Entries:
California Galleries 4/3/76: 444 (lot, F et al);
Swann NY 12/14/78: 293 (lot, F-5 et al);
Christies Lon 10/30/80: 109 (lot, F-1 et al);
Christies Lon 10/29/81: 158 (lot, F et al);
Harris Baltimore 4/8/83: 103 (lot, F et al);
Swann NY 5/5/83: 431 (lot, F et al)(note);
Christies Lon 3/28/85: 53 (lot, F et al);
Christies Lon 10/31/85: 62 (lot, F-3 et al);
Christies Lon 4/24/86: 362 (lot, F-6 et al);

**F.C. & L.** [F.C. & L.] (American)
Photos dated: 1861-1865
Processes:      Albumen
Formats:        Stereos
Subjects:       Documentary (Civil War)
Locations:      US - Civil War area
Studio:         US
   Entries:
Swann NY 9/18/75: 299 (lot, F et al);

**F., J.H.** [J.H.F.]
Photos dated: 1850s
Processes:      Salt
Formats:        Prints
Subjects:
Locations:      Great Britain
Studio:
   Entries:
Sothebys Lon 7/1/77: 184 (album, F et al)(note);

**F., L.E.** [LEF] (French)
Photos dated: early 1850s
Processes:      Salt
Formats:        Stereo (tissue)
Subjects:       Topography
Locations:      France - Paris
Studio:         France
   Entries:
Vermont Cat 9, 1975: 577 ill;

**FABER** (American)
Photos dated: 1890
Processes:      Albumen
Formats:        Prints
Subjects:       Topography
Locations:      US - California
Studio:         US - San Francisco, California
   Entries:
Edwards Lon 1975: 172 (book, 15);

**FAGERSTEEN, Gustavus** (American)(see also WALKER &
              FAGERSTEEN)
Photos dated: 1870s
Processes:      Albumen
Formats:        Stereos
Subjects:       Topography
Locations:      US - Yosemite, California
Studio:         US
   Entries:
California Galleries 6/28/81: 351 (2);
California Galleries 5/23/82: 402 (lot, F et al);
Harris Baltimore 12/10/82: 115 (lot, F et al);
Harris Baltimore 6/1/84: 15 (lot, F et al);
Phillips Lon 10/29/86: 222 (lot, F et al);

**FAIREZ Brothers**
Photos dated: Nineteenth century
Processes:      Albumen
Formats:        Stereos
Subjects:       Topography
Locations:      Europe
Studio:         Europe
   Entries:
Christies Lon 10/27/83: 21 (lot, F et al);

**FALK, Benjamin J.** (American, 1853-1925)
Photos dated: 1883-1889
Processes:      Albumen
Formats:        Cabinet cards, prints
Subjects:       Portraits
Locations:      Studio
Studio:         US - New York City
   Entries:
Sothebys NY 11/21/70: 354 ill(lot, F-1 et al), 358
   ill(2);
Vermont Cat 2, 1971: 248 (lot, F-1 et al), 250
   ill(10);
Rinhart NY Cat 7, 1973: 430;
Swann 11/11/76: 340 (lot, F et al), 362 (album, F
   et al);
Sothebys Lon 3/9/77: 190 (lot, F et al);
Christies Lon 3/10/77: 296 ill;
California Galleries 1/21/78: 139 (lot, F-1 et al);
Swann NY 10/18/79: 442 (lot, F et al);
California Galleries 3/30/80: 257 (lot, F-4 et al);
Christies NY 5/14/80: 335 (book, F et al), 336
   (book, F et al);

**EVANS, O.B.**
Photos dated: 1860s
Processes:      Glass diapositive
Formats:        Stereo plates
Subjects:       Documentary (public events)
Locations:      US - Niagara Falls, New York
Studio:
   Entries:
Rinhart NY Cat 7, 1973: 348;

**EVEREST, D.** (British)
Photos dated: Nineteenth century
Processes:      Albumen
Formats:        Stereos
Subjects:       Topography
Locations:      Great Britain
Studio:         Great Britain
   Entries:
Christies Lon 3/11/82: 82 (lot, E-1 et al);

**EVERETT, R., Jr.** (American)
Photos dated: early 1850s
Processes:      Daguerreotype
Formats:        Stereo plates
Subjects:       Portraits
Locations:      Studio
Studio:         US - Utica, New York
   Entries:
Swann NY 4/23/81: 251 (lot, E-1 et al);

**EWING, D.B.** (American)
Photos dated: early 1890s
Processes:      Albumen
Formats:        Prints
Subjects:       Documentary (industrial)
Locations:      US - Everett, Washington
Studio:         US
   Entries:
Rinhart Cat 7, 1973: 429;
California Galleries 1/21/78: 410 (lot, E-1 et al);

**EWING, P.** (British)
Photos dated: 1860s-1870s
Processes:      Albumen
Formats:        Prints, stereos
Subjects:       Topography
Locations:      Scotland
Studio:         Great Britain
   Entries:
Sothebys Lon 10/18/74: 260 (book, E et al);
Edwards Lon 1975: 161 (book, E et al);
Christies Lon 6/28/84: 37a (lot, E et al);

**EYNARD-LULLIN, Jean Gabriel** (Swiss, 1775-1863)
Photos dated: c1845-1853
Processes:      Daguerreotype
Formats:        Plates
Subjects:       Portraits, topography
Locations:      Switzerland - Geneva; Greece
Studio:         Switzerland - Geneva; France - Paris
   Entries:
Vermont Cat 11/12, 1977: 544 ill(note), 545 ill,
   546 ill;
Auer Paris 5/31/80: 6 ill(note), 7 ill, 8 ill;
Sothebys Lon 10/28/81: 295 ill(note);
Christies Lon 4/24/86: 306 ill(note);

**EYTING & GENCHE**
Photos dated: 1850s and/or 1860s
Processes:      Albumen
Formats:        Prints
Subjects:       Topography
Locations:      Europe
Studio:         Europe
   Entries:
Christies Lon 10/30/86: 88 (album, E & G-1 et al);

**EYTON, Anna Maria** (British)
Photos dated: 1860s-1870s
Processes:      Albumen
Formats:        Prints
Subjects:       Topography, portraits
Locations:      England - Shropshire
Studio:         England - Shropshire
   Entries:
Sothebys Lon 6/29/84: 255 ill(album, E et al);

**EZAKI, T.** (Japanese)
Photos dated: 1880s-1890s
Processes:      Albumen
Formats:        Prints
Subjects:       Topography
Locations:      Japan
Studio:         Japan
   Entries:
Old Japan, England Cat 8, 1985: 41 (album, 48)
   (attributed);

**F., C.** [C.F.]
Photos dated: c1857-1860
Processes:      Photolithographs (Asser process)
Formats:        Prints
Subjects:       Topography
Locations:      Europe
Studio:         Europe
    Entries:
Drouot Paris 11/22/86: 75 (13);

**F., F.B.** [F.B.F.]
Photos dated: 1860s and/or 1870s
Processes:      Albumen
Formats:        Prints
Subjects:       Architecture
Locations:      Germany
Studio:
    Entries:
Christies Lon 3/26/81: 267 (album, F-1 et al);

**F., G.A.** [G.A.F.] (French)
Photos dated: 1850s-1870s
Processes:      Albumen
Formats:        Stereos (tissue)
Subjects:       Architecture
Locations:      France - Paris; US - Washington, D.C.
Studio:         France - Paris
    Entries:
California Galleries 4/3/76: 444 (lot, F et al);
Swann NY 12/14/78: 293 (lot, F-5 et al);
Christies Lon 10/30/80: 109 (lot, F-1 et al);
Christies Lon 10/29/81: 158 (lot, F et al);
Harris Baltimore 4/8/83: 103 (lot, F et al);
Swann NY 5/5/83: 431 (lot, F et al)(note);
Christies Lon 3/28/85: 53 (lot, F et al);
Christies Lon 10/31/85: 62 (lot, F-3 et al);
Christies Lon 4/24/86: 362 (lot, F-6 et al);

**F.C. & L.** [F.C. & L.] (American)
Photos dated: 1861-1865
Processes:      Albumen
Formats:        Stereos
Subjects:       Documentary (Civil War)
Locations:      US - Civil War area
Studio:         US
    Entries:
Swann NY 9/18/75: 299 (lot, F et al);

**F., J.H.** [J.H.F.]
Photos dated: 1850s
Processes:      Salt
Formats:        Prints
Subjects:
Locations:      Great Britain
Studio:
    Entries:
Sothebys Lon 7/1/77: 184 (album, F et al)(note);

**F., L.E.** [LEF] (French)
Photos dated: early 1850s
Processes:      Salt
Formats:        Stereo (tissue)
Subjects:       Topography
Locations:      France - Paris
Studio:         France
    Entries:
Vermont Cat 9, 1975: 577 ill;

**FABER** (American)
Photos dated: 1890
Processes:      Albumen
Formats:        Prints
Subjects:       Topography
Locations:      US - California
Studio:         US - San Francisco, California
    Entries:
Edwards Lon 1975: 172 (book, 15);

**FAGERSTEEN, Gustavus** (American)(see also WALKER &
                FAGERSTEEN)
Photos dated: 1870s
Processes:      Albumen
Formats:        Stereos
Subjects:       Topography
Locations:      US - Yosemite, California
Studio:         US
    Entries:
California Galleries 6/28/81: 351 (2);
California Galleries 5/23/82: 402 (lot, F et al);
Harris Baltimore 12/10/82: 115 (lot, F et al);
Harris Baltimore 6/1/84: 15 (lot, F et al);
Phillips Lon 10/29/86: 222 (lot, F et al);

**FAIREZ Brothers**
Photos dated: Nineteenth century
Processes:      Albumen
Formats:        Stereos
Subjects:       Topography
Locations:      Europe
Studio:         Europe
    Entries:
Christies Lon 10/27/83: 21 (lot, F et al);

**FALK, Benjamin J.** (American, 1853-1925)
Photos dated: 1883-1889
Processes:      Albumen
Formats:        Cabinet cards, prints
Subjects:       Portraits
Locations:      Studio
Studio:         US - New York City
    Entries:
Sothebys NY 11/21/70: 354 ill(lot, F-1 et al), 358
    ill(2);
Vermont Cat 2, 1971: 248 (lot, F-1 et al), 250
    ill(10);
Rinhart NY Cat 7, 1973: 430;
Swann 11/11/76: 340 (lot, F et al), 362 (album, F
    et al);
Sothebys Lon 3/9/77: 190 (lot, F et al);
Christies Lon 3/10/77: 296 ill;
California Galleries 1/21/78: 139 (lot, F-1 et al);
Swann NY 10/18/79: 442 (lot, F et al);
California Galleries 3/30/80: 257 (lot, F-4 et al);
Christies NY 5/14/80: 335 (book, F et al), 336
    (book, F et al);

**FALK, B.J.** (continued)
Phillips NY 5/21/80: 246 (lot, F-1 et al);
Sothebys NY 11/17/80: 38 (book, 1);
California Galleries 6/28/81: 367 ill, 402;
Harris Baltimore 7/31/81: 297 (lot, F et al);
Swann NY 4/1/82: 286 (note);
Harris Baltimore 9/16/83: 151 (lot, F et al);
Harris Baltimore 6/1/84: 201 (book, 10), 253;
Harris Baltimore 11/9/84: 133 (lot, F-1 et al), 135
    (lot, F et al);
Harris Baltimore 3/15/85: 284 (lot, F-1 et al);
Harris Baltimore 11/7/86: 211 (lot, F et al);

**FALKE**
Photos dated: 1860
Processes:      Albumen
Formats:        Prints
Subjects:       Documentary (art)
Locations:
Studio:
    Entries:
Swann NY 2/14/52: 126 (book, 8);
Swann NY 5/9/85: 216 (book, 8);

**FALKENSTEIN, H.**
Photos dated: 1860s
Processes:      Albumen
Formats:        Cdvs
Subjects:       Topography
Locations:      France
Studio:         France - Strasbourg
    Entries:
Petzold Germany 11/7/81: 327 (lot, F et al);

**FALKNER, R.** (British)
Photos dated: Nineteenth century
Processes:      Albumen
Formats:        Cdvs
Subjects:       Portraits
Locations:      Great Britain
Studio:         Great Britain
    Entries:
Christies Lon 3/26/81: 403 (album, F et al);

**FALL, T.** (British)
Photos dated: Nineteenth century
Processes:
Formats:
Subjects:       Portraits
Locations:      Studio
Studio:         England - London
    Entries:
Edwards Lon 1975: 12 (album, F et al);

**FALLS, Colonel A.V.** (British)
Photos dated: 1866-1875
Processes:      Albumen
Formats:        Prints
Subjects:       Topography
Locations:      India
Studio:
    Entries:
Christies Lon 10/26/78: 163 ill(album, F attributed
    et al);

**FALOR, A.C.** (American)
Photos dated: Nineteenth century
Processes:      Albumen
Formats:        Stereos
Subjects:       Topography
Locations:      US - midwest
Studio:         US
    Entries:
California Galleries 1/23/77: 370 (lot, F et al);

**FAMIN, Charles** (French)
Photos dated: late 1850s-1874
Processes:      Albumen
Formats:        Prints
Subjects:       Genre, topography
Locations:      France
Studio:         France - Paris
    Entries:
Weil Lon Cat 7, 1945: 129;
Goldschmidt Lon Cat 52, 1939: 197;
Rauch Geneva 6/13/61: 157 (lot, F-1 et al);
Gordon NY 5/10/77: 789 ill(2)(note);
Wood Conn Cat 41, 1978: 14 ill(note);
Sothebys NY 5/2/78: 106, 107, 108, 109 (2);
Sothebys Lon 6/28/78: 296 (lot, F-3 et al)(note);
Mancini Phila 1979: 10 ill;
Rose Boston Cat 4, 1979: 34 ill(note);
Phillips Lon 3/13/79: 93;
Sothebys Lon 10/24/79: 332 (3);
Rose Boston Cat 5, 1980: 51 ill(note), 52 ill;
Phillips NY 5/21/80: 209 (4), 210 (2);
Christies NY 11/11/80: 58;
Phillips NY 5/9/81: 30 ill;
Rose Florida Cat 7, 1982: 10 ill(note);
Swann NY 5/5/83: 351 (lot, F-2 et al);
Christies NY 10/4/83: 88 (F et al);
Christies Lon 6/28/84: 320 (lot, F-4 et al)(note);

**FAMIN, P. & Co.**
Photos dated: 1880s-1890s
Processes:      Albumen
Formats:        Prints
Subjects:       Topography
Locations:      Algeria - Algiers
Studio:         Algeria
    Entries:
Wood Conn Cat 37, 1976: 241 (album, F et al);
Swann NY 12/8/77: 409 (lot, F-1 et al);
Swann Lon 11/14/85: 77 (book, F et al);

**FARDON, George Robinson** (1806-1886)
Photos dated: 1849-1860s
Processes:      Salt, albumen
Formats:        Prints, stereos
Subjects:       Topography
Locations:      US - San Francisco, California;
                Canada -Vancouver, British Columbia
Studio:         Canada - Victoria, British Columbia
    Entries:
Swann NY 4/14/77: 317 (book, 25)(note);
Frontier AC, Texas 1978: 96 ill(album, 26)(note);
Wood Conn Cat 41, 1978: 124 ill(album, 31)(note);
California Galleries 1/21/79: 429 ill(note);
Christies NY 11/6/84: 37 ill;

**FAREY, R. & G.**
Photos dated: c1880s
Processes: Ambrotype
Formats: Plates
Subjects: Topography
Locations:
Studio:
    Entries:
Christies Lon 10/26/78: 63 (lot, F-1 et al);

**FARGIER, Adolphe** (French)
Photos dated: 1860s
Processes: Carbon
Formats: Prints
Subjects: Topography, portraits
Locations: France
Studio: France
    Entries:
Christies Lon 6/26/80: 261 (lot, F-4 attributed
    et al);

**FARIS, Thomas** (American)
Photos dated: c1844-1861
Processes: Daguerreotype, ambrotype, albumen
Formats: Plates, prints
Subjects: Portraits
Locations: Studio
Studio: US - Cincinnati, Ohio; New York City
    Entries:
Vermont Cat 5, 1973: 442 ill;
Vermont Cat 7, 1974: 553 ill;
California Galleries 6/28/81: 210 ill;
California Galleries 5/23/82: 278;
Harris Baltimore 6/1/84: 246;

**FARMER** (British)
Photos dated: 1850s
Processes: Ambrotype
Formats: Plates
Subjects: Portraits
Locations: Studio
Studio: England - Brighton
    Entries:
Sothebys Lon 3/14/79: 21;
Christies Lon 10/31/85: 3 (lot, F-1 et al);

**FARNDELL, F.**
Photos dated: c1870
Processes: Albumen
Formats: Cdvs
Subjects: Ethnography
Locations: Studio
Studio: Australia - Adelaide
    Entries:
California Galleries 7/1/84: 167;

**FARNSWORTH, Emma Justine** (American)
Photos dated: 1892
Processes: Photogravure
Formats: Prints
Subjects: Genre
Locations: US
Studio: US
    Entries:
Wood Conn Cat 45, 1979: 108 ill(book, 5)(note);

**FARQUHAR** (see BAKER & FARQUHAR)

**FARRACHE** (American)
Photos dated: 1860s-1870s
Processes: Albumen
Formats: Cdvs
Subjects: Portraits
Locations: Studio
Studio: US - Brooklyn, New York
    Entries:
Rinhart NY Cat 2, 1971: 366 (lot, F et al);

**FARRAND, Camillus**
Photos dated: c1868
Processes: Albumen
Formats: Stereos
Subjects: Topography
Locations: Ecuador
Studio:
    Entries:
Rinhart NY Cat 7, 1973: 387, 388;
California Galleries 9/27/75: 561 (lot, F et al);

**FARRE, Dr. A.** (British)
Photos dated: between 1851 and 1856
Processes: Calotype
Formats: Prints
Subjects: Topography
Locations: Great Britain
Studio: Great Britain
    Entries:
Sothebys Lon 12/21/71: 138 (album, F attributed
    et al);

**FARROUGIA, A.**
Photos dated: 1870s-1880s
Processes: Albumen
Formats: Prints
Subjects: Topography, ethnography
Locations: Greece - Corfu
Studio: Greece - Corfu
    Entries:
Rose Boston Cat 2, 1977: 85 (2 ills)(10)(note);
California Galleries 3/30/80: 303 (12);

**FARSARI, A. & Co.**
Photos dated: 1886-1924
Processes: Albumen
Formats: Prints
Subjects: Topography, ethnography
Locations: Japan - Yokohama
Studio: Japan - Yokohama
    Entries:
Sothebys Lon 10/18/74: 122 (albums, F-38 et al), 123
    (albums, 100);
California Galleries 9/26/75: 154 (album, 51), 155
    (album, 54);
Phillips Lon 3/12/80: 139 (album, 50);
Sothebys Lon 3/21/80: 96 (album, 50);
Christies Lon 6/26/80: 234 ill(album, 50);
Christies NY 11/11/80: 95 (album, 48)(attributed)
    (note);
Old Japan, England Cat 5, 1982: 7 ill(album, 50),
    8 ill(album, 50), 9 ill(lot, F et al), 10 (lot,
    F et al);
Christies Lon 3/11/82: 199 ill(album, 42);

**FARSARI, A.** (continued)
Christies Lon 10/28/82: 110 (album, 50);
Christies Lon 3/24/83: 113 (album, 36);
Swann NY 5/5/83: 387 (album, 27)(note);
Phillips Lon 11/4/83: 64 (album);
Sothebys Lon 12/9/83: 28 ill(51);
Christies Lon 6/28/84: 119 (lot, F-1 et al)(note);
Christies Lon 10/25/84: 80 (lot, F-1 et al)(note);
Phillips Lon 10/30/85: 87 (album, 63)(note);
Christies Lon 4/24/86: 394 ill(albums, 200);

**FASSETT, Samuel Montague** (American)
Photos dated: 1856-1870
Processes:      Daguerreotype, salt, albumen
Formats:        Plates, prints, stereos, cdvs
Subjects:       Portraits, topography
Locations:      US - Illinois
Studio:         US - Chicago, Illinois
   Entries:
Sothebys NY (Strober Coll.) 2/7/70: 263 (lot, F et
   al), 282 (lot, F et al);
Swann NY 11/14/85: 123 ill(note);

**FASSINA, F.** (Italian)
Photos dated: 1860s-c1870
Processes:      Albumen
Formats:        Stereos
Subjects:       Topography
Locations:      Italy
Studio:         Italy - Milan
   Entries:
California Galleries 4/3/76: 384 (lot, F et al);

**FASSITT** (see ABORDA & FASSITT)

**FASSOLD, Peter** (American)
Photos dated: 1880s-c1890
Processes:      Albumen
Formats:        Prints
Subjects:       Documentary (industrial)
Locations:      US - Eureka, California; Panama;
                Mexico; El Salvador
Studio:         US
   Entries:
Rinhart NY Cat 7, 1973: 434;
California Galleries 4/2/76: 176;
White LA 1977: 248 ill(lot, F-1 et al);
Swann NY 11/13/86: 294 (lot, F-10 et al)(note);

**FAUL, H.** (American)
Photos dated: c1864
Processes:      Albumen
Formats:        Prints
Subjects:       Topography
Locations:      US - Colorado
Studio:         US - Central City, Colorado
   Entries:
Sothebys NY (Strober Coll.) 2/7/70: 351 (lot,
   F-8 et al);

**FAULKNER, Robert** (British)
Photos dated: c1870-1870s
Processes:      Autotype
Formats:        Prints, cdvs
Subjects:       Portraits, genre (animal life)
Locations:      Studio
Studio:         England - London
   Entries:
Christies Lon 3/20/80: 357 (album, F et al);
Sothebys Lon 6/17/81: 234 (album, F-4 et al)(note);
Christies Lon 10/28/82: 213 (lot, F et al);
Christies Lon 3/24/83: 219 (2);

**FAUVIOT, A.**
Photos dated: Nineteenth century
Processes:
Formats:
Subjects:       Portraits
Locations:
Studio:
   Entries:
Christies Lon 6/27/85: 246 (albums, F-2 et al)
   (note);

**FAY** (British)
Photos dated: Nineteenth century
Processes:      Albumen
Formats:        Cdvs
Subjects:       Portraits
Locations:      Studio
Studio:         Great Britain
   Entries:
Sothebys NY 11/21/70: 333 (lot, F et al), 342 (lot,
   F-1 et al), 345 (lot, F-1 et al);

**FAY, W.D.** (American)
Photos dated: 1871
Processes:      Albumen
Formats:        Stereos
Subjects:       Documentary (disasters)
Locations:      US - Chicago, Illinois
Studio:         US - Joliet, Illinois
   Entries:
Rinhart NY Cat 7, 1973: 203;

**FAZE, W.A.** (American)
Photos dated: 1870s
Processes:      Albumen
Formats:        Stereos
Subjects:       Topography
Locations:      US
Studio:         US - Painsville, Ohio
   Entries:
Swann NY 4/17/80: 370 (lot, F-2 et al);

**FEARON, R.N.** (American)
Photos dated: Nineteenth century
Processes:      Albumen
Formats:        Stereos
Subjects:       Topography
Locations:      US - Minnesota
Studio:         US - Minnesota
   Entries:
California Galleries 9/27/75: 503 (lot, F et al);
California Galleries 1/23/77: 403 (lot, F et al);

**FECHNER**
Photos dated: c1875
Processes:      Albumen
Formats:        Cabinet cards
Subjects:       Portraits
Locations:
Studio:
    Entries:
Harris Baltimore 3/15/85: 246 (lot, F-1 et al);

**FEHRENBACK, E.**
Photos dated: 1840s-1850s
Processes:      Daguerreotype
Formats:        Plates
Subjects:       Portraits
Locations:      Studio
Studio:         England - London
    Entries:
Sothebys Lon 3/21/75: 196, 197 (2);
Christies Lon 6/10/76: 11;
Sothebys Lon 3/9/77: 107;
Sothebys Lon 3/22/78: 140 ill;

**FEILNER, J.E.** (German)
Photos dated: Nineteenth century
Processes:      Albumen
Formats:        Cdvs
Subjects:       Portraits
Locations:      Studio
Studio:         Germany
    Entries:
Petzold Germany 5/22/81: 1856 (lot, F et al);

**FEINBERG** (American)
Photos dated: between 1870s and 1890s
Processes:      Albumen
Formats:        Prints
Subjects:       Topography
Locations:      US - New York City
Studio:         US
    Entries:
Swann NY 4/1/82: 333 (lot, F et al);

**FELICI, Luigi** (Italian)
Photos dated: 1863
Processes:      Albumen
Formats:        Prints, stereos
Subjects:       Topography
Locations:      Italy
Studio:         Italy - Rome
    Entries:
Swann NY 4/26/79: 282 (albums, F et al);

**FELISCH, A.**
Photos dated: 1868-1875
Processes:      Albumen
Formats:        Cabinet cards, stereos
Subjects:       Topography, portraits
Locations:      Russia - St. Petersburg
Studio:         Russia - St. Petersburg
    Entries:
Kingston Boston 1976: 210 (2 ills)(11);
Christies Lon 10/31/85: 290 (album, F-32 et al);

**FELIX** (Austrian)
Photos dated: 1895
Processes:
Formats:        Cabinet cards
Subjects:       Portraits
Locations:      Studio
Studio:         Austria - Vienna
    Entries:
Sothebys NY (Greenway Coll.) 11/20/70: 45 ill
    (lot, F-1 et al);

**FELIX, M.**
Photos dated: 1840s
Processes:      Daguerreotype
Formats:        Plates
Subjects:       Portraits
Locations:      Studio
Studio:         Houge
    Entries:
Christies Lon 3/11/82: 6 ill;

**FELLOWS & GRAVES**
Photos dated: Nineteenth century
Processes:      Albumen
Formats:        Stereos
Subjects:       Topography
Locations:
Studio:
    Entries:
Sothebys Lon 10/18/74: 9 (lot, F & G et al);

**FENNEMORE, James** (American, 1849-1941)
Photos dated: 1870-c1874
Processes:      Albumen
Formats:        Stereos
Subjects:       Topography
Locations:      US - American west
Studio:         US - Salt Lake City, Utah
    Entries:
Swann NY 10/18/79: 425 (lot, F et al);

**FENNERAGH (?), E.**
Photos dated: 1850s
Processes:      Daguerreotype
Formats:        Plates
Subjects:       Portraits
Locations:      Studio
Studio:         England - London
    Entries:
Christies Lon 3/20/80: 43;

**FENTON, R.N.** (American)
Photos dated: 1870s
Processes:      Albumen
Formats:        Stereos
Subjects:       Topography
Locations:      US - Minnesota
Studio:         US - Minneapolis, Minnesota
    Entries:
Rinhart NY Cat 6, 1973: 506, 507;

**FENTON, Roger** (British, 1819-1869)
Photos dated: 1851-1862
Processes: Salt, albumen, photogalvanography, carbon
Formats: Prints, stereos
Subjects: Portraits, topography, documentary (Crimean War), genre (still life)
Locations: Great Britain; Russia; France; Italy
Studio: England
Entries:
Goldschmidt Lon Cat 52, 1939: 187 (3), 230 (book, F et al);
Weil Lon Cat 4, 1944(?): 197 (2)(note), 198 (book, F et al)(note), 253 (book, 20);
Weil Lon Cat 14, 1949(?): 315 (64)(note);
Weil Lon 1946: 68 (book, 46)(note);
Swann NY 2/14/52: 101 (book, 20)(note), 127 (19) (note), 128 (lot, F et al), 262 (album, R et al);
Andrieux Paris 1952(?): 719 (book, F et al);
Sothebys NY (Weissberg Coll.) 5/16/67: 70 (32) (note);
Frumkin Chicago 1973: 59 ill, 60 ill, 61 ill;
Rinhart NY Cat 6, 1973: 558 (attributed);
Rinhart NY Cat 7, 1973: 123 (book, F-1 et al), 124 (book, F-1 et al);
Rinhart Cat 8, 1973: 18 (book, F-1 et al);
Christies Lon 10/4/73: 99 (books, F et al), 107 (book, 20), 108 ill(album, 45)(note);
Sothebys Lon 12/4/73: 175 (books, F et al);
Ricketts Lon 1974: 8 (album, F-1 et al);
Vermont Cat 7, 1974: 752 (book, F et al);
Witkin NY II 1974: 206 (book, F et al), 1283 ill(2);
Sothebys Lon 3/8/74: 163 (book, F et al), 165 (book, F et al);
Sothebys Lon 6/21/74: 150 (books, F et al), 151 (book, F et al), 164;
Christies Lon 7/25/74: 257 (lot, F-2 et al);
Edwards Lon 1975: 78 (book, 20), 110 (book, F et al);
Sothebys NY 2/25/75: 14 (album, 9)(attributed) (note), 15 ill(attributed);
Sothebys Lon 3/21/75: 56 (2 ills)(album, F-46 et al) (note), 57 ill(note), 58 ill(note), 59 ill (note), 60 ill, 61 ill, 62 ill, 63 ill, 64 ill, 65 ill, 66 ill, 67 ill, 68 ill, 69 (book, 22), 286 (album, F-1 et al), 315 (book, F et al), 316 (books, F et al);
Sothebys NY 9/23/75: 25 (3), 26 ill;
California Galleries 9/26/75: 179 (book, F et al);
Sothebys Lon 10/24/75: 94 ill(book, 20), 192, 193 (2)(note), 194 ill, 195 ill, 196 ill, 197 ill, 198 ill, 199 ill, 200 ill;
Alexander Lon 1976: 67 ill;
Anderson & Hershkowitz Lon 1976: 22 ill, 23 ill;
Colnaghi Lon 1976: 39 ill(book, 22)(note), 40 ill (note), 41 ill, 42 ill, 43, 44, 45, 46, 47 ill, 48, 49 ill, 50 ill, 52, 53, 54, 55, 56 ill, 57 ill, 58 (lot, F-2 et al);
Lunn DC Cat 6, 1976: 1 ill(note), 2.1 ill(note), 2.2 ill, 2.3, 2.4;
Witkin NY IV 1976: 132 ill;
Wood Conn Cat 37, 1976: 277 ill(note);
Swann NY 4/1/76: 297 (book, 20)(note);
Sothebys NY 5/4/76: 42 (note), 43, 44, 45, 46, 47, 48 ill, 49, 50, 51, 52, 53;
Gordon NY 5/10/77: 817 ill;
Christies Lon 6/10/76: 35 ill(5)(note);
Sothebys Lon 10/29/76: 55 (book, F et al), 171 (book, F et al), 260, 261 ill, 262 ill, 263 ill (2), 264 ill, 265 ill, 266 ill(note), 267 ill;

**FENTON** (continued)
Sothebys NY 11/9/76: 24 (note), 25, 26, 27, 28, 29, 30, 31, 32 ill, 33, 34, 35, 36;
Swann NY 11/11/76: 269 (book, F et al)(note);
Gordon NY 11/13/76: 22 ill;
Vermont Cat 11/12, 1977: 523 (book, F et al);
California Galleries 1/22/77: 212 (book, F et al), 301 ill;
Sothebys NY 2/9/77: 7 ill(note), 8, 9, 10, 11, 12, 13;
Sothebys Lon 3/9/77: 8 ill(6)(note), 9 (5)(note), 100 (lot, F-5 attributed et al), 227 ill, 228 ill;
Christies Lon 3/10/77: 95 ill(note), 96 ill, 97 ill, 98, 99, 100;
Sothebys NY 5/20/77: 77 (lot, F et al);
Christies Lon 6/30/77: 115 (album, F-1 et al), 193 (book, F et al), 286 ill(note), 287 ill, 288 ill, 289 ill, 290 ill(note), 291 ill, 292 ill (note), 293 ill(note), 294 ill, 295 ill(note), 296 ill(note), 297 ill, 298, 299 (note);
Sothebys Lon 7/1/77: 6 (book, 20), 21 (book, F et al), 268, 269 ill, 270 ill(attributed);
Sothebys NY 10/4/77: 155 ill(3), 156 (4), 157 (3), 158 (3), 159;
Christies Lon 10/27/77: 209 (book, F et al), 310 ill (note), 311 ill, 312 ill(note), 313 ill, 314 ill, 315, 316 ill(note), 317 ill(note), 318 ill (note), 319 ill(note), 320 ill(8);
Sothebys Lon 11/18/77: 20 (book, 20), 175 (book, F et al), 195 (books, F et al), 207, 208 ill, 209 ill, 210, 211, 212, 213 ill(2)(note), 214 ill (2), 215 ill(2), 216 ill(2), 217 ill(2), 218 ill, 219 (note), 220, 221;
Lehr NY Vol 1:2, 1978: 14 ill(note);
Lunn DC Cat QP, 1978: 22 ill;
Rose Boston Cat 3, 1978: 16 ill(note);
Wood Conn Cat 41, 1978: 94 ill(note);
California Galleries 1/21/78: 233, 234, 235, 236, 237;
Sothebys LA 2/13/78: 92 (2)(note), 93 ill(2)(note), 94 (2), 95 (2);
Christies Lon 3/16/78: 97 (album, F-1 et al), 334 ill, 335 ill, 336 ill, 337, 338 ill, 339 ill, 340 ill(note), 341 ill(note), 342 ill, 343 ill (note), 344 ill(note), 345 ill(note), 346 ill (note);
Sothebys NY 5/2/78: 57 ill;
Christies Lon 6/27/78: 269 ill(note), 270, 271 ill (note), 272 ill(note), 273 ill, 274 ill(note), 275 ill, 276 ill, 277 ill(note), 278 ill(note), 279 ill, 280 ill(note), 281 ill(note), 282 ill, 283 ill, 284 ill, 285 ill, 286 ill(note), 287 (2), 288 ill(note), 289 ill;
Sothebys Lon 6/28/78: 21 (book, F et al), 41 ill, 42, 43 (2 ills)(67)(note), 44 (2 ills)(67) (note), 44a ill, 45 ill, 56 ill, 57 ill, 58 ill, 59 ill, 80 (album, F-1 et al);
Christies Lon 10/26/78: 264 ill(note), 265 ill, 266 ill(note), 267 ill(note), 268 ill(note), 269 ill, 270 ill(book, 226)(note), 271, 272 ill (note), 273 ill(note), 274 ill, 275 ill, 276 ill, 277 ill(note), 278, 279 ill, 280 ill, 282 (note), 282, 283, 284, 285;
Sothebys Lon 10/27/78: 104 (lot, F-1 et al), 116 (lot, F-1 et al), 142 ill(note), 143 ill(note), 154 (lot, F et al);
Phillips NY 11/4/78: 26 ill, 27, 28 (4), 29 ill (note), 30 ill, 31;
Lehr NY Vol 1:4, 1979: 38 (book, F et al);
Lennert Munich Cat 5, 1979: 10 ill, 17;

**FENTON** (continued)

California Galleries 1/21/79: 114A (book, F et al);
Phillips Lon 3/13/79: 65 ill(attributed)(note), 66
   ill, 67 ill, 68 (note), 69 ill, 70, 71, 72 ill
   (note);
Sothebys Lon 3/14/79: 324 (album, F-1 et al), 337
   ill, 338, 339, 340 ill, 341 ill, 342 ill, 343
   ill, 344 ill, 345 ill, 346 ill, 347 ill, 348
   ill, 349 ill, 350 ill, 351 ill(6), 352 ill(lot,
   F-8 et al);
Christies Lon 3/15/79: 93 (lot, F-1 et al), 94 ill
   (note)(attributed), 254 ill(note), 255 ill
   (note), 256 ill(note), 257 ill(note), 258 ill,
   259 (2 ills)(album, 132)(note), 260 ill(note),
   261 ill, 262 ill, 263 ill(note), 264 ill(note),
   265 ill, 266 ill, 267 ill, 268 ill, 296 ill, 270
   ill, 271 ill, 272 ill(note), 273, 274 ill, 275
   ill(note), 276;
Christies NY 5/4/79: 7 (2 ills), 8 ill, 9 ill, 10,
   11 ill;
Phillips NY 5/5/79: 132 (2);
Sothebys NY 5/8/79: 62;
Sothebys Lon 6/29/79: 195, 196, 197 ill, 198 (book,
   F-4 et al);
Phillips Can 10/4/79: 1 ill;
Sothebys Lon 10/24/79: 37 (book, F et al), 333, 354
   (lot, F et al);
Christies Lon 10/25/79: 265 ill(book, 20), 351 ill
   (note), 352 ill, 353 ill, 354 ill, 355, 356 ill,
   357, 358 ill, 359 ill, 360 ill, 361 ill, 363
   (note);
Christies NY 10/31/79: 10 ill, 11, 12, 25 (book,
   F et al);
Sothebys NY 11/2/79: 216 ill(note), 217 ill, 218
   ill;
Phillips NY 11/3/79: 145 ill, 146;
Sothebys NY 12/19/79: 59 ill, 60 ill, 61 ill, 62
   ill;
Rose Boston Cat 5, 1980: 28 ill(note);
White LA 1980-81: 2 ill(note);
Sothebys LA 2/6/80: 139 ill, 140 ill, 141 ill, 142
   ill, 143 ill;
Phillips Lon 3/12/80: 153, 158;
Christies Lon 3/20/80: 218 (book, F et al), 293
   ill, 294 ill(note), 295 ill, 296 ill, 297 ill,
   298 ill, 299 ill, 300 ill, 301 ill, 302 ill, 303
   ill, 304 ill;
Sothebys Lon 3/21/80: 298 ill, 299 ill(note), 300
   ill, 301 ill, 302 ill, 303 ill, 304 ill, 305 ill;
Christies NY 5/14/80: 317 (2 ills)(books, F et al);
Christies NY 5/16/80: 92 ill(19), 93 ill, 94 ill;
Sothebys NY 5/20/80: 340 (lot, F-3 et al), 341
   (book, F et al), 342 ill, 343 ill, 344 ill
   (attributed)(note);
Phillips NY 5/21/80: 154, 155 ill, 156 ill;
Christies Lon 6/26/80: 302 (book, F et al), 417
   ill, 418 ill, 420 ill, 421 ill, 422 ill, 423
   ill, 424 ill, 425 ill, 426 ill, 427 ill, 428
   (note), 429, 430, 431 ill(note), 432, 433 ill,
   434 ill;
Sothebys Lon 6/27/80: 9 ill(book, 20), 157 (book,
   F et al), 265 ill, 266 ill, 267 ill, 268 ill,
   269 ill, 270 ill, 271 ill, 272 ill, 273 ill, 274
   ill, 275 ill(note), 276 ill, 278 ill, 279 ill,
   280, 281, 282 ill, 283 ill, 284, 285 ill, 286
   ill, 287 ill, 288;
Sothebys Lon 10/29/80: 233 ill, 234 ill, 235 ill,
   236 ill, 237 ill, 238 ill;
Christies Lon 10/30/80: 144 (attributed), 184
   (book, F et al), 377 ill, 378 ill, 379 ill

**FENTON** (continued)

(note), 380 ill, 381 ill, 382 ill, 383 ill,
   384 ill;
Christies NY 11/11/80: 15 ill(note), 16 ill(note),
   17 ill;
California Galleries 12/13/80: 246, 247, 248, 249
   ill, 250;
Koch Cal 1981-82: 5 ill(note), 6 ill, 7 ill;
Phillips Lon 3/18/81: 88 (book, F et al);
Christies Lon 3/26/81: 141 (lot, F-1 attributed, et
   al), 343 (album, F-1 attributed, et al), 345 ill
   (note), 346 ill, 347 ill, 348 ill, 349 ill, 350,
   351 ill, 352 ill, 353 ill, 354 (2 ills)
   (2, attributed), 355 (2), 356 (note), 357, 380
   ill(lot, F-3 attributed, et al);
Sothebys Lon 3/27/81: 423, 424, 425 ill, 426 ill,
   427, 428 ill, 429 ill, 430 ill, 431 ill, 432
   ill, 433 ill, 434 (3), 435 ill, 436 ill, 437;
Phillips NY 5/9/81: 4 ill, 5 (3), 6 (note);
Christies NY 5/14/81: 6 ill(note), 7 ill(note),
   8 ill(note);
Sothebys NY 5/15/81: 86 ill(note);
Sothebys Lon 6/17/81: 156 (book, F et al), 157
   (book, F et al), 187 ill(note), 188 ill, 189,
   190 ill, 191 ill, 192 ill, 193 ill, 194 ill, 195
   ill, 196 ill, 197 ill, 198, 245 (lot, F et al),
   351 ill, 352 ill, 353 ill, 354 ill, 355 ill, 356
   ill, 357, 358 ill, 359, 360 ill, 361 ill, 362
   ill, 363 ill, 364 , 365 ill, 366 ill, 444 (book,
   F et al), 445 (book, F et al);
Christies Lon 6/18/81: 73 ill(lot, F-7 attributed
   et al), 74 ill(2), 156 (attributed), 158 ill
   (lot, F-2 et al), 285 ill, 286 ill, 287 ill, 288
   ill, 289 ill, 290 ill, 291 ill, 292 ill(book,
   3), 293 ill, 414 (album, F-1 et al);
California Galleries 6/28/81: 222 (note), 223 ill,
   224;
Harris Baltimore 7/31/81: 194 ill, 195;
Sothebys NY 10/21/81: 103 ill, 104 ill(note),
   105 ill;
Sothebys Lon 10/28/81: 192, 357 ill, 357a, 358,
   359, 360 ill, 361 ill, 362 ill;
Christies Lon 10/29/81:  113, 166 (attributed)
   (note), 320 ill, 321 ill, 322 ill, 323 ill, 324
   ill, 325 ill, 326 ill, 327 ill(3), 328 ill, 329
   (note), 330, 331 ill, 332 (2), 333, 334 ill;
Petzold Germany 11/7/81: 82 (book, F et al);
Christies NY 11/10/81: 8 (note);
Weston Cal 1982: 3 ill(note), 4 ill(note), 5 ill, 6
   ill, 7 ill, 8 ill;
Christies Lon 3/11/82: 293 ill, 294 ill, 295
   (2 ills)(6), 296 ill, 297 (2 ills)(2), 298 ill,
   299 ill, 300 ill, 301 ill, 316 (album, F et al)
   (note), 336 (lot, F-1 et al);
Sothebys Lon 3/15/82: 369 ill(note), 370, 371 ill,
   372 ill, 373 ill, 374 ill, 375 ill, 376, 377,
   378 ill, 379 ill, 436 (books, F et al);
Harris Baltimore 3/26/82: 243, 244, 245, 246, 247,
   248;
California Galleries 5/23/82: 294, 295 (attributed);
Sothebys NY 5/24/82: 241 ill;
Christies NY 5/26/82: 8 ill, 9 ill, 10 ill;
Christies Lon 6/24/82: 91 (album, F et al), 313 ill
   (note), 314 ill(note), 315 ill, 316 ill(note),
   317 ill(note), 318 ill, 319 ill, 320 ill(note),
   321, 322 ill, 323 ill, 324 ill, 325, 326, 327
   ill, 328 ill(note), 329 ill, 330 ill(note), 331
   ill, 353 ill;
Sothebys Lon 6/25/82: 10 ill(note), 11 (lot, F-1 et
   al), 12 (lot, F et al), 168 ill, 169 ill, 170
   ill, 171 ill, 172 ill, 173 ill, 174 ill, 175

**FENTON** (continued)
ill, 176 ill, 177 ill, 178 (4 ills)(album, 12)
(note), 179 (2 ills)(2)(note), 180
(2 ills)(album, 70)(note), 181 (2 ills)
(album, 29)(note);
Christies Lon 10/28/82: 19 (5), 154 ill(note), 155
ill, 156 ill(49)(note), 157 (note), 158, 159,
160, 161 (note), 162 ill, 163 ill, 164 ill, 193
ill(2, attributed);
Sothebys Lon 10/29/82: 119 ill(2), 120 ill(2), 121
ill, 122 ill(4), 123 ill, 124 ill(3), 125 (3),
126 (5), 127 (4), 128, 129 (4), 130 (3), 131
(4), 132 ill, 133 ill, 134 ill, 135, 136 ill,
137 ill, 138 ill, 139 ill, 140 ill, 141 ill,
142 ill;
Christies NY 11/8/82: 94 ill, 95 ill, 96 ill;
Drouot Paris 11/27/82: 49 ill;
Harris Baltimore 12/10/82: 234, 235, 236, 237, 238,
239;
Bievres France 2/6/83: 49 ill;
Christies NY 2/8/83: 9 (2);
Phillips Lon 3/23/83: 49;
Christies Lon 3/24/83: 42 (book, 22), 51 (album,
F-2 et al), 199 (note), 200 ill(note), 201, 202
ill, 203 ill(2), 204 ill, 205 ill(2), 206 ill,
207 ill, 208 ill;
Sothebys Lon 3/25/83: 117, 118, 119 ill, 120, 121,
122, 123 ill, 124 ill;
Harris Baltimore 4/8/83: 346, 347, 348, 349, 350,
351, 352, 353 ill, 354;
Swann NY 5/5/83: 352, 353 (2);
Sothebys NY 5/11/83: 403 ill;
Christies Lon 6/23/83: 60 ill(2, attributed), 63
(lot, F-1 et al), 210 ill(2), 211 ill, 212 ill,
213 ill(4), 214, 215 (6, attributed)(note), 216,
217 (2), 218, 219 (7 ills)(books, 218)(note),
220 ill, 221 (4), 222 ill(7)(note), 223 (2)
(note), 224 ill(3)(note);
Sothebys Lon 6/24/83: 97 ill, 98 (2 ills)(album, 63)
(note);
Christies NY 10/4/83: 77;
Christies Lon 10/27/83: 16 (book, 20), 17 (book,
20), 19 (lot, F et al), 42 (lot, F-1 et al), 163
(book, F et al), 191 (note), 192 ill, 193 ill,
194, 195 ill, 196 ill(note), 197 ill, 198 ill,
199;
Phillips Lon 11/4/83: 101, 128 ill, 145 (album, F-3
plus 1 attributed)(note);
Sothebys NY 11/9/83: 141;
Swann NY 11/10/83: 88 (book, F et al);
Sothebys Lon 12/9/83: 91 ill(note), 92 ill, 93 ill,
94 ill(7), 95 (8), 96 (4), 97 (3);
Harris Baltimore 12/16/83: 188 (book, F et al), 332
ill(note), 333, 334, 335, 336, 337;
Kraus New York Cat 1, 1984: 38 ill(note), 39 ill
(note), 40 ill(note);
Christies Lon 3/29/84: 190 (note), 191 (note), 192
ill(2)(note), 193 (note), 194 ill(note), 195 ill
(note), 196, 197 ill, 198, 199 ill, 200 ill
(note), 201 ill(note), 319 ill(lot, F-3 et al);
Christies NY 5/7/84: 3 ill;
Sothebys NY 5/8/84: 148 ill(note), 149 (note);
Phillips Lon 6/27/84: 210 (5), 211;
Christies Lon 6/28/84: 39 (book, F et al)(note), 46
(lot, F-2 et al), 176, 177 ill, 178 ill, 179
ill, 180 ill(note), 181 ill(11)(note), 182 ill,
183 ill, 185 ill(3), 186, 187 ill(2), 188 (5),
189, 190 ill, 191 ill, 192, 193 ill(attributed),
194 ill(lot, F attributed et al), 195 ill(lot, F
attributed et al)(note), 216 (3), 221 (lot, F-2
et al), 305 (lot, F-1 et al);

**FENTON** (continued)
Sothebys Lon 6/29/84: 151 ill, 168 ill(note), 169
ill, 170 ill, 171 ill, 172 ill, 173 ill(4), 174
ill, 175 ill(9), 177 ill(8), 179 ill(7), 180
ill(4), 181 (2), 182 (3 ills)(4);
California Galleries 7/1/84: 377, 378, 379, 380;
Phillips Lon 10/24/84: 142, 149, 152;
Christies Lon 10/25/84: 36 (lot, F-2 et al), 166 ill
(15), 167 ill(2), 168, 169 (2), 361
(attributed), 362 (7 ills)(13, attributed);
Sothebys Lon 10/26/84: 119 ill(6)(note), 120 ill
(7), 212 ill(8), 122 ill(3), 123 ill(7), 124
ill, 125 ill, 126 ill(3), 127 ill(note);
Harris Baltimore 3/15/85: 189 (note), 190;
Christies Lon 3/28/85: 99 ill(album, F-1 et al),
143 (5)(note), 144, 145, 146, 147, 148, 149 ill
(3), 150 ill(note), 151 (7 ills)(albums, F et al)
(note);
Sothebys Lon 3/29/85: 139 ill, 140 ill, 141 ill,
142 ill, 143 ill, 144 ill, 145 ill(8), 146 ill,
147 ill, 148 ill(lot,F-1 et al), 152 (albums,
F-1 et al);
Christies NY 5/6/85: 149 ill(13), 150 ill, 151 ill,
152 ill(2);
Sothebys NY 5/7/85: 199 ill;
Christies Lon 6/27/85: 124 ill, 125, 126 (note),
127, 128 ill, 129 ill(note), 130;
Sothebys Lon 6/28/85: 136 ill, 137 ill, 138 (2 ills)
(album, 12)(note);
Christies Lon 10/31/85: 180 ill, 181, 184 (1 plus 1
attributed), 185 (2 ills)(book, F-6 et al);
Sothebys Lon 11/1/85: 57 ill, 58 ill(book, F-1 et
al), 59 (album, F-1 et al);
Christies NY 11/5/85: 22 ill;
Swann NY 11/14/85: 78, 79 (note), 80 (10);
Harris Baltimore 2/16/86: 301 ill(note), 302;
Christies Lon 4/24/86: 459, 460, 461 (note), 462;
Sothebys Lon 4/25/86: 94 ill(note), 95, 96 ill, 97
ill, 98, 99 ill, 100 ill, 101 ill, 102 ill;
Swann NY 5/16/86: 190 (lot, F-2 attributed, et al);
Christies Lon 6/26/86: 14 (2), 15, 20, 35, 175
(books, F et al);
Christies Lon 10/30/86: 81 ill, 82 (lot, F-6 et al);
Sothebys Lon 10/31/86: 92, 93 ill, 94 ill, 95 (3),
96 (3), 97 (2 ills)(2), 98 ill, 99 ill, 100
ill(5), 101 ill, 102 ill(3), 103 ill(5);
Sothebys NY 11/10/86: 115 ill, 224 ill, 225 ill,
278 ill, 279 ill, 328 ill;
Swann NY 11/13/86: 219 (lot, F-1 et al), 223 (3);
Drouot Paris 11/22/86: 40 ill;

**FENWICK, George J.** (British)
Photos dated: 1855-1856
Processes:      Albumen
Formats:        Prints
Subjects:       Portraits, topography
Locations:      Great Britain; France; Italy;
Switzerland
Studio:         Scotland - Edinburgh
   Entries:
Phillips Lon 10/24/84: 165 (album, F-106 et al)
(note);

**FERGUS, John** (British)
Photos dated: 1862-1890
Processes:    Albumen
Formats:      Prints, stereos
Subjects:     Portraits, topography
Locations:    Scotland - Largs
Studio:       Scotland - Largs
   Entries:
Witkin NY III 1975: 749 (book, F-1 et al);
Christies Lon 3/15/79: 314;

**FERGUSSON, James** (British)
Photos dated: 1864-1869
Processes:    Autotype
Formats:      Prints
Subjects:     Topography
Locations:    India
Studio:
   Entries:
Swann NY 2/14/52: 129 (book, F-1 et al)(note), 130
  (book, 54)(note);
Christies Lon 6/23/83: 135 (lot, F et al);

**FERNIQUE, Albert** (French, died 1898)
Photos dated: 1878-c1884
Processes:    Albumen
Formats:      Prints
Subjects:     Documentary (art)
Locations:    France - Paris
Studio:       France - Paris
   Entries:
Bievres France 2/6/83: 168 (lot, F-1 et al);
Christies NY 11/11/86: 176 ill(note);

**FERRAND, C.**
Photos dated: 1860s and/or 1870s
Processes:    Albumen
Formats:      Stereos
Subjects:     Topography
Locations:    South America
Studio:
   Entries:
Christies Lon 3/16/78: 181 (lot, F-3 et al);

**FERRAND, L.** (American)
Photos dated: Nineteenth century
Processes:    Albumen
Formats:      Cdvs
Subjects:     Portraits
Locations:    Studio
Studio:       US - California; Nevada
   Entries:
Sothebys NY (Greenway Coll.) 11/20/70: 181 (lot,
  F-1 et al);

**FERRARI & IRMAO** (Portuguese)
Photos dated: c1880
Processes:    Albumen
Formats:      Prints
Subjects:     Topography
Locations:    Portugal - Porto Alegre
Studio:       Portugal
   Entries:
Swann NY 11/8/84: 49 ill(book, 14);

**FERRARIO, Achille** (Italian)
Photos dated: 1884-1894
Processes:    Albumen
Formats:      Prints
Subjects:     Architecture, portraits
Locations:    Italy
Studio:       Italy - Milan
   Entries:
Swann NY 11/11/76: 389 (albums, F et al);
Drouot Paris 11/24/84: 79 ill;

**FERRET** (French)
Photos dated: 1855
Processes:    Albumen
Formats:      Prints
Subjects:     Portraits
Locations:    Studio
Studio:       France - Nice
   Entries:
Phillips Lon 10/24/84: 165 (album, F-8 et al)(note);

**FERREZ, Marc** (Brazilian, 1843-1923)
Photos dated: 1865-1890s
Processes:    Albumen
Formats:      Prints, cdvs
Subjects:     Topography, ethnography
Locations:    Brazil
Studio:       Brazil - Rio de Janeiro; Argentina -
             Buenos Aires
   Entries:
Swann NY 11/11/76: 375 (lot, F et al);
Sothebys NY 2/9/77: 37 ill(lot, F-2 et al), 39
  (lot, F-2 et al);
Swann NY 4/14/77: 188 (album, F et al);
Wood Conn Cat 42, 1978: 559 (album, F-4 et al)
  (note);
Christies Lon 3/16/78: 151 (album, F-1 et al);
Sothebys NY 5/2/78: 133 (album, F et al);
Christies Lon 10/26/78: 185 (album, F-16 et al);
Swann NY 4/26/79: 302 ill(28, attributed)(note), 429
  (album, F et al);
Christies NY 10/31/79: 54 (3), 55 (3);
White LA 1980-81: 58 ill(note), 59 ill, 60 ill, 61
  ill, 62 ill;
Swann NY 4/17/80: 241 (note), 242 (5), 243 ill, 244
  (3)(note);
Christies NY 5/16/80: 194, 195 (3), 196 ill(note);
Christies Lon 10/30/80: 269 (albums, F-7 et al);
Swann NY 11/6/80: 256 (8);
Christies NY 11/11/80: 87 (5), 88 (2), 89 ill, 90,
  92 (album, F et al);
Swann NY 4/23/81: 420 (20), 517 (lot, F-2 et al),
  518 (album, F et al);
Swann NY 11/5/81: 311;
Rose Florida Cat 7, 1982: 52 ill(3)(note);
Christies Lon 3/11/82: 219 ill(attributed);
Phillips NY 5/22/82: 750 ill;
Swann NY 5/10/84: 221, 222;
Christies Lon 10/30/86: 151 (lot, F et al), 152
  (album, F et al);
Swann NY 11/13/86: 322 (album, F-12 et al);

**FERRIER, A.**
Photos dated: c1852
Processes:      Albumen
Formats:        Prints
Subjects:       Architecture
Locations:      France - Rouen and Chartres
Studio:
  Entries:
Rauch Geneva 6/13/61: 110 ill(3)(note);

**FERRIER, C.M.** (French)(see also SOULIER)
Photos dated: 1851-1870s
Processes:      Salt, glass diapositive
Formats:        Prints, stereos
Subjects:       Topography, documentary
Locations:      England - London; France; Switzerland
Studio:         France
  Entries:
Sothebys NY (Weissberg Coll.) 5/16/67: 33 (lot,
  F & Soulier et al);
Rinhart NY Cat 6, 1973: 452;
Rinhart NY Cat 7, 1973: 166, 167, 349;
Sothebys Lon 10/29/76: 47 ill(album, F et al)(note);
Wood Conn Cat 41, 1978: 29 ill(books, F et al)
  (note);
Wood Conn Cat 45, 1979: 124 (books, F et al)(note);
Christies Lon 3/15/79: 72 (lot, F & Soulier-1, et
  al), 76 (lot, F-10 et al);
Sothebys Lon 6/29/79: 230 ill(note), 231 ill, 232
  ill, 233 ill, 234 ill, 235 ill, 236 ill;
Christies Lon 10/25/79: 69 (lot, F & Soulier-1, et
  al), 88 (lot, F, Soulier & Levy et al), 89 (lot,
  F & Soulier-13, et al), 93 (lot, F, Soulier &
  Levy-6, et al);
Christies Lon 3/26/81: 139 (lot, F & Soulier et al);
Sothebys Lon 3/27/81: 175 (album, F et al);
Christies Lon 6/18/81: 59 ill(attributed)(note),
  114 (lot, F & Soulier et al), 115 (lot, F &
  Soulier et al), 116 (lot, F & Soulier et al);
Sothebys Lon 10/28/81: 165 ill;
Christies Lon 10/29/81: 107 (lot, F, Soulier & Levy
  et al), 108 (lot, F, Soulier & Levy et al), 109
  (lot, F, Soulier & Levy et al);
Sothebys Lon 3/15/82: 179 ill(note), 180 ill, 181
  ill, 182 ill, 183 ill, 184 ill, 185 ill, 186
  ill, 192 ill;
Phillips Lon 3/17/82: 11 (lot, F, Soulier & Levy
  et al);
Christies Lon 6/24/82: 79 (lot, F & Soulier-3,
  et al), 80 (lot, F & Soulier et al);
Sothebys Lon 6/25/82: 149 (2)(note), 150 ill(2),
  151 ill, 152 ill, 153 ill, 154 ill(2), 155 ill
  (F & Owen), 156 ill(F & Owen), 157 ill(F &
  Owen), 158 ill(F & Owen), 159 ill(F & Owen), 160
  ill(F & Owen), 161 (F & Owen);
Sothebys Lon 10/29/82: 74, 75, 76, 77 ill, 78 ill,
  79 ill;
Harris Baltimore 4/8/83: 29 (17);
Swann NY 5/5/83: 436 (lot, F & Soulier-3, et al);
Christies Lon 6/23/83: 52 (lot, F & Soulier et al);
Sothebys Lon 6/24/83: 4 (lot, F et al);
Harris Baltimore 12/16/83: 132 (lot, F et al);
Harris Baltimore 6/1/84: 90 (lot, F & Soulier-4,
  et al);
Harris Baltimore 3/15/85: 61 (lot, F & Soulier-4,
  et al);
Christies Lon 6/27/85: 48 (lot, F & Soulier-20,
  et al);
Christies Lon 10/30/86: 60 ill(F & Soulier,
  attributed);

**FESCOURT** (French)
Photos dated: c1865-c1870
Processes:      Albumen
Formats:        Stereos
Subjects:       Topography
Locations:      France - Nimes
Studio:         France
  Entries:
Rinhart NY Cat 7, 1973: 168;
Auer Paris 5/31/80: 113 (10);

**FESSENDEN, C.P.** (American)
Photos dated: c1880
Processes:      Albumen
Formats:        Cdvs
Subjects:       Topography
Locations:      US - California
Studio:         US - San Diego, California
  Entries:
Frontier AC, Texas 1978: 99;

**FETROUR** (see FREESE & FETROUR)

**FETZER, J.** (Swiss)
Photos dated: 1860s-1880s
Processes:      Albumen
Formats:        Prints, stereos, cdvs
Subjects:       Topography
Locations:      Switzerland; Yugoslavia - Ragaz
Studio:         Switzerland
  Entries:
Rauch Geneva 6/13/61: 223 (lot, F et al);
California Galleries 4/2/76: 84 (lot, F et al);
California Galleries 1/21/78: 238;
Rose Boston Cat 4, 1979: 63 ill(note), 64 ill;

**FEUARDENT, Fernand Félix** (French)
Photos dated: c1850
Processes:      Daguerreotype
Formats:        Plates
Subjects:       Portraits
Locations:      Studio
Studio:         France
  Entries:
Drouot Paris 11/24/84: 84 ill, 85 ill;

**FIELD, J.C.** (American)
Photos dated: c1880
Processes:
Formats:        Prints
Subjects:
Locations:      US - Florida
Studio:         US - Tampa, Florida
  Entries:
Swann NY 11/6/80: 291 (lot, F et al);

**FIELITZ, H.O.** (German)
Photos dated: 1856-1857
Processes:      Daguerreotype
Formats:        Plates
Subjects:       Portraits
Locations:      Studio
Studio:         Germany - Braunschweig
  Entries:
Petzold Germany 11/7/81: 140 ill(attributed)(note);

**FIERLANTS, Edmond** (Belgian, 1819-1869)
Photos dated: c1859-1870
Processes:      Albumen
Formats:        Prints, stereos
Subjects:       Topography, architecture
Locations:      Belgium - Antwerp
Studio:         Belgium - Brussels
    Entries:
Lehr NY Vol 1:2, 1978: 15 ill, 16 ill;
Christies NY 5/14/79: 54 ill(note);
Sothebys Lon 10/24/79: 119;
Lennert Munich Cat 6, 1981: 12 ill, 13 ill;

**FIETTA, Edouard**
Photos dated: 1860s
Processes:      Albumen
Formats:        Cdvs, stereos
Subjects:       Topography
Locations:      France
Studio:         France - Strasbourg
    Entries:
Christies Lon 10/30/80: 182 (lot, F-2 et al);
Christies Lon 6/18/81: 189 (album, F-2 et al);
Harris Baltimore 6/1/84: 53 (lot, F et al);

**FIFIELD, H.S.** (American)
Photos dated: 1864-1883
Processes:      Albumen
Formats:        Stereos
Subjects:       Topography
Locations:      US - White Mountains, New Hampshire
Studio:         US - Lincoln, New Hampshire
    Entries:
California Galleries 9/27/75: 512 (lot, F et al),
    513 (lot, F-3 et al);
California Galleries 1/23/77: 410 (lot, F et al),
    411 (lot, F-3 et al);
Swann NY 4/20/78: 370 (lot, F et al);
Swann NY 12/14/78: 309 ill(66)(note);
Swann NY 10/18/79: 435 (lot, F et al)(note);

**FIGGIS, Reverend J.B.** (British)(photographer or
                author?)
Photos dated: 1882
Processes:      Albumen
Formats:        Prints
Subjects:       Topography
Locations:      Italy; France - southern
Studio:
    Entries:
Sothebys Lon 6/27/80: 88 (book, 12);

**FIGLIO, E. GIACOMO** (see GIACOMO, E.)

**FILLON, A.**
Photos dated: 1860s-c1880
Processes:      Albumen
Formats:        Prints incl. panoramas, cabinet cards
Subjects:       Portraits, topography
Locations:      Portugal
Studio:         Portugal - Lisbon
    Entries:
Phillips Lon 11/4/83: 53E (album, 30);
Harris Baltimore 3/15/85: 300 (lot, F-1 et al);

**FILMER, Lady Mary Georgiana Caroline** (British,
    c1840-1903)
Photos dated: 1860-1864
Processes:      Photo collage
Formats:        Album pages
Subjects:       Genre
Locations:      England
Studio:         England
    Entries:
Frumkin Chicago 1973: 62 ill(note), 63 ill, 64 ill;
Lunn DC Cat 6, 1976: 40 ill(note);
Gordon NY 11/13/76: 23 ill(note);
Sothebys NY 10/4/77: 168 ill(album), 169 ill, 170;
Phillips Lon 3/13/79: 105 (note);

**FINDLOW, A.** (British)
Photos dated: 1860s-1870s
Processes:      Albumen
Formats:        Stereos
Subjects:       Topography
Locations:      England - Warwick; Wales
Studio:         England - Warwick
    Entries:
Sothebys Lon 10/24/75: 93 (lot, F et al);
California Galleries 4/3/76: 482 (lot, F et al);
California Galleries 1/21/78: 201 ill(lot, F et al);
Christies Lon 6/26/80: 107 (lot, F-9 et al), 108
    (lot, F et al);
Christies Lon 3/26/81: 127 (lot, F et al);
Christies Lon 3/29/84: 23 (lot, F et al);
Christies Lon 10/25/84: 41 (lot, F et al);

**FINLAYSON** (British)
Photos dated: Nineteenth century
Processes:      Albumen
Formats:        Cdvs
Subjects:       Portraits
Locations:      Studio
Studio:         Scotland
    Entries:
Christies Lon 6/24/82: 18 (lot, F-2 et al);

**FINLEY, M.** (American)
Photos dated: 1850s-1870
Processes:      Daguerreotype, albumen
Formats:        Plates, stereos
Subjects:       Portraits
Locations:      Studio
Studio:         US - Canandaigua, New York
    Entries:
Swann NY 4/23/81: 243 (lot, F-1 et al);

**FIORILLO, L.** (Italian)
Photos dated: 1860s-early 1900s
Processes:      Albumen
Formats:        Prints
Subjects:       Topography, documentary (military)
Locations:      Egypt - Alexandria and Cairo;
                Ethiopia; Palestine
Studio:         Egypt - Aswan
    Entries:
California Galleries 9/26/75: 127 (album, F et al),
    166 (album, F et al), 270 (8);
Wood Conn Cat 37, 1976: 240 (album, F et al);
California Galleries 4/2/76: 144 (album, F et al);
Christies Lon 10/28/76: 136 (album, F et al);
Sothebys LA 2/13/78: 139 (album, F-3 et al);

FIORILLO, L. (continued)
California Galleries 1/21/79: 340 (album, F et al);
Christies Lon 3/15/79: 155 (albums, F et al);
Christies Lon 10/25/79: 238 (albums, F et al);
Phillips NY 11/29/79: 275 (album, F et al);
Auer Paris 5/31/80: 89 (lot, F-2 et al);
Sothebys Lon 6/17/81: 114 (albums, F et al), 116
    (albums, F et al), 145 (album, F-13 et al);
Swann NY 11/5/81: 464 (album, F-20 et al)(note);
Christies Lon 3/11/82: 161 (lot, F-55 et al);
Christies Lon 6/24/82: 171 (album, F-3 et al), 173
    (album, F et al);
Christies Lon 10/28/82: 218 (album, F et al);
California Galleries 6/19/83: 330 (lot, F et al),
    358 (lot, F-1 et al);
Christies Lon 3/29/84: 65 (album, F et al);
Sothebys NY 5/8/84: 326 ill(album, F et al);
California Galleries 7/1/84: 381 (5);
Christies Lon 10/25/84: 104 (album, F et al);
Christies Lon 10/31/85: 98 (albums, F-2 et al);
Swann NY 11/14/85: 81 (album, F-20 et al)(note);
Christies Lon 6/26/86: 92 (albums, F-3 et al);
Swann NY 11/13/86: 246 (lot, F-3 et al)(note);

FISHBACK, Frederick
Photos dated: 1878
Processes:      Heliotype
Formats:        Prints
Subjects:       Documentary
Locations:
Studio:
    Entries:
Wood Conn Cat 49, 1982: 165 (book, 26)(note);

FISCHER, C.
Photos dated: 1845
Processes:      Daguerreotype
Formats:        Plates
Subjects:       Portraits
Locations:      Studio
Studio:         Spain
    Entries:
Fraenkel Cal 1984: 3 ill;

FISHER (see SELLECK, Silas) [FISHER 1]

FISHER [FISHER 2]
Photos dated: c1850
Processes:      Daguerreotype
Formats:        Plates
Subjects:       Portraits
Locations:
Studio:
    Entries:
Rinhart NY Cat 8, 1973: 109 ill;

FISHER Frères (French) [FISHER 3]
Photos dated: c1880
Processes:      Albumen
Formats:        Cabinet cards
Subjects:       Topography
Locations:      Europe
Studio:         France
    Entries:
Phillips Lon 6/23/82: 40 (lot, F et al);
Phillips Lon 10/27/82: 29 (lot, F et al);

FISHER Brothers (American) [FISHER 4]
Photos dated: Nineteenth century
Processes:      Albumen
Formats:        Cdvs
Subjects:       Portraits
Locations:      Studio
Studio:         US - Boston, Massachusetts
    Entries:
Sothebys NY (Strober Coll.) 2/7/70: 263 (lot,
    F et al), 449 (lot, F et al), 451 (lot, F et al);

FISHER, A.J. (American)
Photos dated: 1870s
Processes:      Albumen
Formats:        Stereos
Subjects:       Documentary (railroads)
Locations:      US - American west
Studio:         US - New York; Towanda, Pennsylvania
    Entries:
Vermont Cat 7, 1974: 649 (lot, F-1 et al);

FISHER, E.D. (British)
Photos dated: 1865-1875
Processes:      Albumen
Formats:        Prints
Subjects:       Topography
Locations:      England - Salisbury
Studio:         Great Britain
    Entries:
Sothebys Lon 3/14/79: 330 ill(album, 45), 331 ill
    (album, 105);

FISHER, S.R. (American)
Photos dated: 1870s-1887
Processes:      Albumen
Formats:        Prints, stereos
Subjects:       Topography
Locations:      US - Pennsylvania
Studio:         US - Norristown, Pennsylvania
    Entries:
Sothebys NY 11/21/70: 10 (album, F et al);
Swann NY 4/14/77: 302 (lot, F et al);

FISHER, W.T. (British)
Photos dated: 1860s
Processes:      Albumen
Formats:        Stereos
Subjects:       Topography
Locations:      England - Yarmouth
Studio:         England - Yarmouth
    Entries:
Edwards Lon 1975: 12 (album, F et al);
Sothebys Lon 3/27/81: 9 (lot, F et al);
Christies Lon 3/11/82: 85 (lot, F et al);
Christies Lon 6/24/82: 69 (lot, F et al);
Christies Lon 6/23/83: 45 (lot, F et al);

**FISKE, George** (American, 1835-1918)
Photos dated: late 1870s-1910
Processes: Albumen
Formats: Prints, cabinet cards
Subjects: Topography
Locations: US - Yosemite, California
Studio: US - California
  Entries:
Swann NY 2/14/52: 63 (album, 47)(note);
Rinhart NY Cat 2, 1971: 434 (album, F et al);
Witkin NY II 1974: 932 ill(lot, F-6 et al);
Sothebys NY 2/25/75: 179 (album, F et al), 181 ill
  (album, 47);
California Galleries 1/22/77: 271;
Sothebys NY 2/9/77: 82 ill(4), 83 (2 ills)(album,
  61)(note);
Sothebys NY 5/20/77: 12 ill(4);
Swann NY 12/8/77: 342 (albums, F-6 et al)(note);
California Galleries 1/21/78: 353 (2), 354 (2);
Swann NY 4/20/78: 382 (lot, F-2 et al), 384 ill(3);
Swann NY 12/14/78: 399 (album, F et al)(note);
Sothebys Lon 3/14/79: 110 (album, F-13 et al);
Christies NY 10/31/79: 87 (61);
Sothebys LA 2/6/80: 33 (lot, F-5 et al);
Sothebys Lon 3/21/80: 185 (album, F et al);
California Galleries 3/30/80: 304 ill(8);
Christies Lon 10/30/80: 270 (albums, F et al);
California Galleries 12/13/80: 251;
Koch Cal 1981-82: 42 ill(album, F-32 et al)(note);
Christies Lon 3/26/81: 267 (album, F-2 et al);
Swann NY 4/1/81: 249 (lot, F et al);
Sothebys Lon 6/17/81: 108 (album, F et al);
California Galleries 6/28/81: 156 (album, F-9 et
  al), 225 ill(11), 226 (3), 227 (note), 228, 346
  (lot, F-1 et al);
Swann NY 11/5/81: 312 (30);
Harris Baltimore 3/26/82: 209, 210, 223
  (4, attributed);
California Galleries 6/23/82: 298 (2), 299 ill(3);
Harris Baltimore 12/10/82: 240 (2);
Sothebys Lon 3/25/83: 34 (album, F-11 et al);
Harris Baltimore 12/16/83: 293 (lot, F et al),
  338 (3);
California Galleries 7/1/84: 383, 384, 385 (2),
  386, 387, 388, 389, 390 (2), 391, 392 (2), 393,
  394, 395 (2), 396 (4), 397 (attributed), 398 (2);
Christies NY 9/11/84: 152 (2);
Christies NY 2/13/85: 155 (lot, F et al);
California Galleries 6/8/85: 214, 215;
Sothebys NY 11/12/85: 129 ill(album, F et al);
California Galleries 3/29/86: 813 (album, F et al);
Swann NY 5/16/86: 192A (lot, F-3 et al);
Christies Lon 6/26/86: 123 (albums, F et al);
Phillips Lon 7/2/86: 331 (2);
Christies Lon 10/30/86: 150 (album, F-5 et al), 153
  (albums, F et al);

**FISLER, L.F.**
Photos dated: 1860s-late 1870s
Processes: Albumen
Formats: Prints
Subjects: Portraits, topography
Locations: China
Studio: China
  Entries:
Swann NY 5/16/86: 94 (books, F et al)(note);
Christies Lon 10/30/86: 114 (album, F-1 et al)
  (note);
Harris Baltimore 11/7/86: 241 (album, F et al);
Swann NY 11/13/86: 49 (books, F et al);

**FITZGAMEY**
Photos dated: Nineteenth century
Processes: Albumen
Formats: Prints
Subjects: Topography
Locations: India
Studio:
  Entries:
Christies Lon 3/29/84: 92 (albums, F-2 et al);

**FITZ-GEORGE, Captain** (photographer or author?)
Photos dated: 1871
Processes: Albumen
Formats: Prints
Subjects: Documentary (Franco-Prussian War)
Locations: France - Sedan
Studio:
  Entries:
Edwards Lon 1975: 84 (book, 11);
Christies Lon 3/16/78: 221 (book, 9);
Sothebys Lon 3/9/77: 164 (book, 7);

**FITZGERALD, Lord Otho** (British)
Photos dated: 1855-1860s
Processes: Albumen
Formats: Prints
Subjects: Portraits, topography
Locations: Great Britain; Ireland
Studio: Great Britain (Photographic Club)
  Entries:
Sothebys Lon 3/21/75: 286 (album, F-1 et al);
Sothebys Lon 3/14/79: 324 (album, F-1 et al);
Christies Lon 3/15/79: 299 (lot, F-1 et al);
Phillips Lon 3/27/85: 275 (album, F-14 et al);
Sothebys Lon 11/1/85: 59 (album, F-1 et al);

**FITZGERALD, P.G.**
Photos dated: 1857-1861
Processes: Albumen
Formats: Prints
Subjects: Topography
Locations: India
Studio: India
  Entries:
Sothebys Lon 10/29/80: 32 (note), 33 ill, 34 ill,
  35 (4), 36 ill, 37 ill, 38 ill, 39, 40, 41, 42,
  43 ill, 44, 45 (5), 46 (album, 24), 48 (album, F
  et al);
Sothebys Lon 6/17/81: 181 ill(note), 182 (note),
  183 ill(note), 184 ill(note), 186 (note);

**FITZGIBBON, John H.** (American, 1816-1882)
Photos dated: 1841-1882
Processes: Daguerreotype, albumen
Formats: Plates, prints
Subjects: Portraits, ethnography
Locations: Studio
Studio: US - St. Louis, Missouri
  Entries:
Sothebys NY (Strober Coll.) 2/7/70: 324 (lot,
  F et al);
Harris Baltimore 12/10/82: 421 (7, attributed);

FIZANNE, L. (French)
Photos dated: Nineteenth century
Processes:     Albumen
Formats:       Stereos
Subjects:      Topography
Locations:     Netherlands - Amsterdam
Studio:        France - Paris
   Entries:
California Galleries 9/27/75: 485 (lot, F-1 et al);

FIZEAU, Hippolyte Louis (French, 1819-1896)
Photos dated: c1840-1845
Processes:     Fizeau process, daguerreotype
Formats:       Prints, plates
Subjects:      Architecture, genre, documentary
Locations:     France - Paris
Studio:        France
   Entries:
Weil Lon Cat 2, 1944(?): 235 (note);
Weil Lon 1946: 70 (2)(note);
Weil Lon Cat 14, 1949(?): 370 (2)(note);
Weil Lon Cat 31, 1963: 188 (2)(note);
Sothebys NY (Strober Coll.) 2/7/70: 342 ill
   (album, 7)(note);

FLACH, G.A.
Photos dated: 1880
Processes:     Albumen
Formats:       Prints
Subjects:      Portraits
Locations:
Studio:
   Entries:
Rinhart NY Cat 1, 1971: 507 (book, 1);
Rinhart NY Cat 6, 1973: 87 (book, 1);

FLACHERON, Count Frédéric A. Jean-Francois-Charles-
              André (French, 1813-1883)
Photos dated: 1848-1852
Processes:     Salt
Formats:       Prints
Subjects:      Topography
Locations:     Italy - Rome
Studio:        Italy - Rome
   Entries:
Rauch Geneva 6/13/61: 61 ill(8)(note);
Sothebys Lon 10/29/76: 152 ill(5);
Lehr NY Vol 1:2, 1978: 17 ill;
Phillips NY 11/9/82: 110 ill;
Sothebys Lon 6/29/84: 54, 55;
Christies Lon 10/25/84: 156;
Drouot Paris 11/24/84: 77 ill;
Sothebys Lon 3/29/85: 120 ill(lot, F-2 et al);
Christies NY 5/6/85: 153 ill(note);
Christies Lon 10/30/86: 75 (lot, F-1 et al);

FLAMANT (French)
Photos dated: Nineteenth century
Processes:     Albumen
Formats:       Cabinet cards
Subjects:      Portraits
Locations:     Studio
Studio:        France
   Entries:
Harris Baltimore 3/15/85: 272 (lot, F et al);

FLANDERS, D.P. (American)
Photos dated: c1870
Processes:     Albumen
Formats:       Stereos
Subjects:      Topography
Locations:     US - Arizona
Studio:        US
   Entries:
Swann NY 4/17/80: 365 (lot, F-1 et al);

FLATEN & SKRIVSETH (American)
Photos dated: Nineteenth century
Processes:     Albumen
Formats:       Stereos
Subjects:      Topography
Locations:     US - Minnesota
Studio:        US
   Entries:
Sothebys NY (Strober Coll.) 2/7/70: 506 (lot,
   F & S et al);

FLEMING (see COPELAND & FLEMING) [FLEMING 1]

FLEMING (see CUNDALL) [FLEMING 2]

FLEMING, Lucy (British)
Photos dated: c1864
Processes:     Albumen
Formats:       Prints
Subjects:      Topography, genre
Locations:     England - southern
Studio:        England
   Entries:
Phillips Lon 6/27/84: 221 (4), 222 (3), 223, 224
   ill(2), 225 ill(2), 226 ill, 227 (2), 228 ill;

FLEURY (French)
Photos dated: Nineteenth century
Processes:     Woodburytype
Formats:       Prints
Subjects:      Portraits incl. Galerie Contemporaine
Locations:     Studio
Studio:        France
   Entries:
Christies NY 5/26/82: 36 (book, F et al);
Christies NY 5/7/84: 19 (book, F et al);

FLOWER, Fred
Photos dated: c1885
Processes:     Albumen
Formats:       Prints
Subjects:      Topography
Locations:     Australia; New Zealand; Aden; South
               America
Studio:
   Entries:
Swann NY 2/14/52: 30 (album, 70);

**FLOWER, Frederick William** (British)
Photos dated: 1850
Processes:      Calotype
Formats:        Negative print
Subjects:       Topography
Locations:      Portugal - Douro
Studio:
    Entries:
Christies Lon 10/27/83: 89 ill;

**FLOWER, G.** (British)
Photos dated: 1850s
Processes:      Ambrotype
Formats:        Plates
Subjects:       Portraits
Locations:      Studio
Studio:         England - London
    Entries:
Sothebys Lon 3/8/74: 131 (lot, F-1 et al);
Vermont Cat 9, 1975: 460 ill(note);

**FLOYD, William Prior** (British)
Photos dated: 1860s-1874
Processes:      Albumen
Formats:        Prints, stereos
Subjects:       Topography, documentary (disasters)
Locations:      China - Hong Kong
Studio:         China - Hong Kong
    Entries:
Christies Lon 10/26/78: 167 (album, F et al);
Sothebys Lon 10/24/79: 89 ill(album, F et al);
Christies Lon 10/25/79: 422 (album, F-2 et al);
Sothebys LA 2/6/80: 179 (lot, F attributed et al);
Swann NY 4/17/80: 58 ill(book, 22)(note);
Phillips Lon 6/25/80: 113 (album, F et al);
Sothebys Lon 10/29/80: 50 ill(album, F-3 et al);
Christies Lon 3/26/81: 234 ill(lot, F-1 et al);
Sothebys Lon 3/27/81: 82 ill(album, 50), 83 (album,
    F-1 et al);
Phillips NY 5/9/81: 64 (album, F attributed et al);
Sothebys Lon 3/15/82: 110 ill(lot, F-1 et al);
Sothebys Lon 6/25/82: 82 (lot, F-1 et al);
Christies Lon 10/27/83: 142 ill(album, 50);
Sothebys NY 5/8/85: 116 ill(album, F-6 et al);
Sothebys Lon 10/31/86: 16 (album, F-4, F attributed,
    et al);

**FLUKES** (British)
Photos dated: Nineteenth century
Processes:      Albumen
Formats:        Prints
Subjects:       Topography
Locations:      England - Wells
Studio:         England - Bath
    Entries:
Christies Lon 10/28/76: 78 (albums, F-1 et al);

**FLY, Camillus Sidney** (American, 1849-1901)
Photos dated: 1879-1894
Processes:      Albumen
Formats:        Prints
Subjects:       Ethnography, topography
Locations:      Studio
Studio:         US - Tombstone, Arizona
    Entries:
California Galleries 6/28/81: 258 (lot, F-1 et al);
Christies NY 5/13/86: 117 (16, attributed)(note);

**FLYNN, T.A.** (American)
Photos dated: c1880s
Processes:      Albumen
Formats:        Prints
Subjects:       Topography
Locations:      US - Harpers Ferry, West Virginia
Studio:         US
    Entries:
Harris Baltimore 4/8/83: 373 (2);

**FOARD, JAMES F.** (see also BEARD, R.)
Photos dated: 1850s
Processes:      Daguerreotype, ambrotype
Formats:        Plates
Subjects:       Portraits
Locations:      Locations
Studio:         England - Liverpool
    Entries:
Vermont Cat 10, 1975: 597 ill;
Phillips Lon 3/18/81: 100 (lot, F-1 et al);

**FOLEY, J.H.** (British)
Photos dated: 1861-1863
Processes:      Albumen
Formats:        Prints
Subjects:       Portraits
Locations:      Studio
Studio:         Great Britain
    Entries:
Christies Lon 10/4/73: 100 (books, F-1 et al);
Christies Lon 10/30/86: 249 (album, F-1 et al);

**FOLSOM, Augustine H.** (American)
Photos dated: c1865-1879
Processes:      Albumen
Formats:        Prints, cabinet cards
Subjects:       Topography, genre, documentary (public
                events)
Locations:      US - Virginia; Massachusetts;
                Connecticut
Studio:         US - Danbury, Connecticut
    Entries:
Rinhart NY Cat 7, 1973: 216;
Witkin NY IV 1976: 343;
Phillips NY 11/29/79: 247 (2);

**FONCELLE, A.** (French)
Photos dated: c1870
Processes:      Albumen
Formats:        Prints
Subjects:       Genre
Locations:      France
Studio:         France
    Entries:
Swann NY 5/5/83: 351 (lot, F-3 et al);

**FONCUEBA, Mme. de**
Photos dated: 1840s
Processes:      Daguerreotype
Formats:        Plates
Subjects:       Portraits
Locations:
Studio:
    Entries:
Christies Lon 3/11/82: 1 (lot, F et al);

**FONG, A.** (Chinese)
Photos dated: 1870s-1880s
Processes:    Albumen
Formats:      Prints
Subjects:     Topography
Locations:    China - Hong Kong, Macao, Canton,
              Peking
Studio:       China - Hong Kong
   Entries:
Rinhart NY Cat 7, 1973: 531;
Rose Boston Cat 4, 1979: 92 ill(note);
California Galleries 1/21/79: 235 (lot, F et al);
Christies Lon 6/28/79: 112 ill(album, 137);
Sothebys NY 5/20/80: 411 (2 ills)(album, F et al)
   (note);
Sothebys LA 2/4/81: 51 (album, F et al)(note);
Swann NY 11/18/82: 347 ill(lot, F et al)(note);
Sothebys NY 5/8/85: 124 (album, F et al);
Swann NY 11/13/86: 193 (lot, F-2 et al);

**FONTAINE, G.** (French)
Photos dated: 1855-1888
Processes:    Albumen, woodburytype
Formats:      Prints
Subjects:     Portraits incl. Galerie Contemporaine
Locations:    France - Paris and Nimes
Studio:       France - Paris
   Entries:
Sothebys NY 5/20/77: 44 (lot, F-1 et al);
Sothebys Lon 7/1/77: 259 (lot, F-1 et al);
Sothebys NY 10/4/77: 209 (lot, F-1 et al);
Sothebys LA 2/13/78: 115 (books, F et al)(note);
Swann NY 4/20/78: 321 (lot, F-1 et al)(note);
Christies NY 5/14/81: 41 (books, F-1 et al);
California Galleries 6/28/81: 238 (lot, F et al);
California Galleries 5/23/82: 312 (lot, F et al);
Christies NY 5/26/82: 36 (book, F-2 et al);
Christies Lon 6/24/82: 137 ill;
Christies Lon 10/27/83: 76;
Christies NY 5/7/84: 19 (book, F-2 et al);

**FONTAYNE, Charles** (American, 1814-1858)
Photos dated: 1848-1858
Processes:    Daguerreotype
Formats:      Plates
Subjects:     Portraits, topography
Locations:    US - Cincinnati, Ohio
Studio:       US - Cincinnati, Ohio
   Entries:
Rinhart NY Cat 2, 1971: 387 (lot, F et al);
California Galleries 1/22/77: 50 (F & Porter);
Christies Lon 3/16/78: 18 ill(F & Porter)(note);
Harris Baltimore 3/26/82: 151 (F & Porter);

**FOOTE, J.** (British)
Photos dated: 1860s
Processes:    Albumen
Formats:      Cdvs
Subjects:     Topography
Locations:    England - Lacock Abbey
Studio:       England - Bath
   Entries:
Sothebys Lon 4/25/86: 85 (2 ills)(lot, F-24 et al);

**FORBES Co.** (American)
Photos dated: c1887
Processes:    Albertype
Formats:      Prints
Subjects:     Topography
Locations:    US - Maine
Studio:       US
   Entries:
Harris Baltimore 12/10/82: 401 (lot, F-15 et al);

**FORD, J.** (British)
Photos dated: 1860s and/or 1870s
Processes:    Albumen
Formats:      Stereos
Subjects:     Topography
Locations:    Great Britain
Studio:       Great Britain
   Entries:
Christies Lon 6/24/82: 71 (lot, F et al);

**FORD, Leslie W.** (South African)
Photos dated: 1890s
Processes:    Albumen
Formats:      Cabinet cards
Subjects:     Topography
Locations:    South Africa
Studio:       South Africa - Queenstown
   Entries:
Swann 4/26/79: 428 (album, 64)(note);

**FORHEAD, E.** (British)
Photos dated: 1870s-c1880
Processes:    Albumen
Formats:      Prints, stereos
Subjects:     Topography
Locations:    England - Ventnor, Isle of Wight
Studio:       Great Britain
   Entries:
Rinhart NY Cat 7, 1973: 183;
Sothebys Lon 3/9/77: 46 (album, 13);
Christies Lon 6/30/77: 77 (lot, F-2 et al);
Phillips Lon 3/13/79: 123 (lot, F-2 et al);

**FORMOSA, C.L.**
Photos dated: 1882
Processes:    Albumen
Formats:      Prints
Subjects:     Documentary (art)
Locations:    Malta
Studio:       Malta
   Entries:
California Galleries 1/22/77: 200 (book, 38);

**FORREST, Thomas** (British)
Photos dated: Nineteenth century
Processes:    Albumen
Formats:      Prints
Subjects:     Architecture
Locations:    Great Britain
Studio:       Great Britain
   Entries:
Christies Lon 6/23/83: 13 (lot, F-1 et al);

FORRESTER, Baron Joseph James (British, 1809-1862)
Photos dated: 1855-late 1850s
Processes:      Salt, albumen
Formats:        Prints, stereos
Subjects:       Topography
Locations:      Portugal - Lisbon
Studio:         Portugal - Lisbon; Great Britain
                (Photographic Club)
   Entries:
Weil Lon Cat 4, 1944(?): 237 (album, F-2 et al)
   (note);
Rauch Geneva 6/13/61: 47 (album, F et al)(note);
Sothebys Lon 3/21/75: 286 (album, F-1 et al);
Sothebys Lon 3/14/79: 324 (album, F-1 et al);
Sothebys Lon 11/1/85: 59 ill(album, F-1 et al);

FORSTER, Reverend Charles
Photos dated: 1862
Processes:      Albumen
Formats:        Prints
Subjects:       Topography, documentary (scientific)
Locations:      Egypt - Sinai
Studio:
   Entries:
Rauch Geneva 6/13/61: 148 (book, 18)(note);
Sothebys Lon 5/24/73: 9 (lot, F et al);
Lehr NY Vol 1:4, 1978: 36 (album, 20);
Sothebys Lon 3/9/77: 166 (book, 8);
Sothebys Lon 10/24/79: 42 (book, 6)(note);

FORSYTH, Sir T.D. (British)
Photos dated: 1873
Processes:
Formats:
Subjects:       Topography
Locations:      China - Yarkund
Studio:
   Entries:
Rauch Geneva 6/13/61: 156 (book, 45);

FORTIER, François Alphonse (French, died 1882)
Photos dated: 1846-1856
Processes:      Daguerreotype, salt
                (Blanquart-Evrard), albumen,
                photolithograph (Poitevin process)
Formats:        Plates, prints
Subjects:       Architecture, topography
Locations:      France - Paris, Lyons, Blois
Studio:         France - Paris
   Entries:
Octant Paris 3/1979: 11 ill(attributed);
Sothebys Lon 6/29/79: 238;
Phillips NY 5/9/81: 25 (note);

FOSSEY, Thomas (British)
Photos dated: 1860s
Processes:      Albumen
Formats:
Subjects:       Portraits
Locations:      Studio
Studio:         England - London
   Entries:
Christies Lon 6/26/80: 466 (lot, F-2 et al);

FOSTER (see LOVEJOY & FOSTER) [FOSTER 1]

FOSTER (see MILES & FOSTER) [FOSTER 2]

FOSTER & MARTIN [FOSTER 3]
Photos dated: 1880s
Processes:      Albumen
Formats:        Prints
Subjects:       Topography
Locations:      Australia
Studio:
   Entries:
Christies Lon 10/30/86: 172 (album, F & M et al);

FOSTER, Captain (British) [FOSTER 4]
Photos dated: 1869
Processes:      Albumen
Formats:        Prints
Subjects:
Locations:      Great Britain
Studio:         Great Britain (Amateur Photographic
                Association)
   Entries:
Sothebys Lon 10/18/74: 158 (album, F et al);

FOSTER, B.F.
Photos dated: c1880
Processes:      Albumen
Formats:        Stereos
Subjects:       Topography
Locations:
Studio:
   Entries:
Rinhart NY Cat 7, 1973: 389;

FOSTER, J.R. (American)
Photos dated: 1861
Processes:      Albumen
Formats:        Prints
Subjects:       Documentary (Civil War)
Locations:      US - South Carolina
Studio:         US
   Entries:
White LA 1977: 2 ill(lot, F-8 et al)(note);

FOUNTAINE, C.G.
Photos dated: 1861-1862
Processes:      Albumen
Formats:        Prints
Subjects:       Topography
Locations:      Egypt; Greece
Studio:         Europe
   Entries:
Sothebys Lon 6/28/78: 124 ill(book, 36)(note);
Sothebys Lon 10/29/82: 29 ill;
Sothebys Lon 6/24/83: 36 (2 ills)(book, 36);

FOURVIERES, A. (French)
Photos dated: 1860s
Processes:      Albumen
Formats:        Stereos
Subjects:       Topography
Locations:      Europe
Studio:         France
   Entries:
Christies Lon 6/27/85: 30 (lot, F-4 et al);

FOWLER, G. (British)
Photos dated: Nineteenth century
Processes:      Albumen
Formats:        Stereos
Subjects:       Topography
Locations:      Great Britain
Studio:         Great Britain
    Entries:
Christies Lon 6/18/81: 105 (lot, F-2 et al);

FOWLER, S.J. (American)
Photos dated: 1860-1865
Processes:      Albumen
Formats:        Cdvs
Subjects:       Portraits
Locations:      Studio
Studio:         US - Auburn, New York
    Entries:
Swann NY 9/18/75: 186 (lot, F et al);

FOX (American)
Photos dated: 1850s
Processes:      Daguerreotype
Formats:        Plates
Subjects:       Portraits
Locations:      Studio
Studio:         US
    Entries:
Auer Paris 5/31/80: 27;

FOX, Edward (British)
Photos dated: 1860s-1880s
Processes:      Albumen
Formats:        Prints, stereos incl. tissues
Subjects:       Topography, genre (still life)
Locations:      England - Brighton
Studio:         England - Brighton
    Entries:
Sothebys Lon 10/24/75: 250;
Sothebys Lon 7/1/77: 164 (lot, F et al);
Christies Lon 3/26/81: 115 (lot, F-1 et al);
Christies Lon 6/18/81: 110 (lot, F-1 et al);
Christies Lon 6/23/83: 50 (lot, F et al);
Christies Lon 10/27/83: 37 (lot, F-10 et al);

FOX, Dr. George Henry (American)
Photos dated: 1880-1886
Processes:      Photogravure, autotype
Formats:        Prints
Subjects:       Documentary (medical)
Locations:      US - New York City
Studio:         US - New York City
    Entries:
Wood Conn Cat 37, 1976: 64A (book, 85)(note), 65 ill
    (book, F et al)(note);
Wood Conn Cat 42, 1978: 196 (book, 85)(note);
Wood Conn Cat 45, 1979: 111 ill(book, 48)(note);

FOX, S.P. (British)(photographer or author?)
Photos dated: 1864
Processes:
Formats:        Prints
Subjects:       Topography
Locations:      England - Kingsbridge
Studio:         Great Britain
    Entries:
Edwards Lon 1975: 87 (book, 26);

FOY, H. (British)
Photos dated: 1890s
Processes:
Formats:        Prints
Subjects:
Locations:      Great Britain
Studio:         England (West Kent Amateur
Photographic
                Society)
    Entries:
Christies Lon 6/27/85: 260 (lot, F et al);

FRADELLE (British)
Photos dated; c1880-1880s
Processes:      Albumen, woodburytype
Formats:        Prints, cdvs, cabinet cards
Subjects:       Portraits, documentary
Locations:      Studio
Studio:         Great Britain
    Entries:
Sothebys Lon 3/21/75: 154 (lot, F & Marshall et al);
Swann NY 11/11/76: 300 (book, F et al);
Christies Lon 3/10/77: 286;
Christies Lon 3/15/79: 313;
Swann NY 5/5/83: 455 (lot, F & Marshall et al)
    (note);
Harris Baltimore 3/15/85: 302 (lot, F et al);

FRANCIS, G.D. (American)
Photos dated: c1880
Processes:      Albumen
Formats:        Cabinet cards
Subjects:       Ethnography
Locations:      US - American west
Studio:         US - Miller, Dakota Territory
    Entries:
Rinhart NY Cat 2, 1971: 410 (note), 412;

FRANCIS, Henry (British)
Photos dated: 1854-c1860
Processes:      Salt, albumen
Formats:        Prints, stereos
Subjects:       Topography, documentary (industrial)
Locations:      England - London
Studio:         England - London
    Entries:
Rauch Geneva 6/13/61: 47 (album, F et al);
Christies Lon 10/29/81: 122;

FRANCK (François-Marie-Louis-Alexandre Govinet de
          Villecholle) (French, 1816-1906)
Photos dated: 1845-1882
Processes:    Daguerreotype, albumen, woodburytype
Formats:      Plates, prints, cdvs, cabinet cards,
             stereos
Subjects:     Architecture, portraits incl. Galerie
             Contemporaine, documentary (Paris
             Commune)
Locations:    Spain; France - Paris, Bourges, Caen
Studio:      Spain - Barcelona; France - Paris
  Entries:
Sothebys NY (Greenway Coll.) 11/20/70: 84 (lot,
    F-1 et al);
Witkin NY I 1973: 296 ill, 428;
Vermont Cat 8, 1974: 578 ill;
Gordon NY 11/13/76: 48 (albums, F et al);
Christies Lon 6/30/77: 93 (lot, F-1 et al);
Sothebys Lon 7/1/77: 254 (lot, F-1 et al);
Wood Conn Cat 41, 1978: 25 (book, F-25 et al)
    (note);
Wood Conn Cat 45, 1979: 186 (book, F-25 et al)
    (note);
Witkin NY IX 1979: 2/17 (books, F et al);
Christies Lon 3/15/79: 108 (2)(note);
Christies NY 10/31/79: 35 ill(book, F et al);
Phillips NY 11/3/79: 163 ill(2);
Christies Lon 6/26/80: 303 (book, 16);
Sothebys Lon 3/27/81: 128 (lot, F et al);
Christies NY 5/14/81: 41 (books, F-1 et al);
California Galleries 6/28/81: 238 (lot, F et al);
Wood Conn Cat 49, 1982: 332 (book, F-25 et al)
    (note);
California Galleries 5/23/82: 312 (lot, F et al);
Christies NY 5/26/82: 36 (book, F et al);
Bievres France 2/6/83: 132 (album, F-1 et al);
Christies Lon 6/23/83: 256 (lot, F et al);
Swann NY 11/10/83: 129 (book, F et al);
Christies NY 5/7/84: 19 (book, F et al);
Swann NY 5/10/84: 23 (book, F et al)(note), 51
    (book, F et al)(note), 223 (albums, F et al),
    315 (albums, F et al), 321 (lot, F et al)(note);
Harris Baltimore 3/15/85: 272 (lot, F et al);
Swann NY 5/9/85: 388 ill(albums, F-82 et al);
Christies Lon 6/27/85: 102 (books, F et al), 289
    (album, F-1 et al);
Swann NY 11/14/85: 142 (lot, F et al);
Wood Boston Cat 58, 1986: 326 (book, F-25 et al);
Christies Lon 4/24/86: 419 (books, F et al);
Christies Lon 10/30/86: 131 (lot, F-11 et al);

FRANK (French)
Photos dated: 1874
Processes:    Woodburytype
Formats:      Prints
Subjects:     Portraits
Locations:    Studio
Studio:      France
  Entries:
Sothebys NY 5/20/77: 43 (book, F-2 et al), 46 (lot,
    F et al), 95 ill(album, F et al)(note);
Swann NY 4/20/78: 119 (book, F et al);
Swann NY 12/14/78: 192 (book, F-1 et al);
Christies NY 5/26/82: 36 (book, F-4 et al);
Christies NY 5/7/84: 19 (book, F-4 et al);
Christies NY 2/13/85: 135 (lot, F et al);

FRANKENSTEIN, W.
Photos dated: 1860s-1890s
Processes:    Albumen
Formats:      Prints, stereos
Subjects:     Topography
Locations:    Austria
Studio:      Austria
  Entries:
California Galleries 5/23/82: 195 (album, F et al);
Christies NY 2/13/85: 145 (lot, F et al);

FRANKLIN (see HILL & FRANKLIN)

FRANKLIN, W.H. (British)
Photos dated: 1860s
Processes:    Albumen
Formats:      Stereos
Subjects:     Topography
Locations:    Great Britain
Studio:      Great Britain
  Entries:
Christies Lon 6/18/81: 75 (lot, F-11 et al);
Sothebys Lon 6/29/84: 9 (lot, F et al);

FRASER (see NOTMAN)

FRECHE, J.A. (American)
Photos dated: 1870s
Processes:    Albumen
Formats:      Stereos
Subjects:     Topography
Locations:    US - Mount Monadnock, New Hampshire
Studio:      US - Keene, New Hampshire
  Entries:
Rinhart NY Cat 2, 1971: 516 (5);

FREDERICKS E WEEKS [FREDERICKS 1]
Photos dated: 1850s
Processes:    Daguerreotype
Formats:      Plates
Subjects:     Portraits, topography
Locations:    Studio
Studio:      Brazil
  Entries:
Phillips Lon 4/23/86: 218 ill, 219 ill, 220 ill,
    221 ill;
Phillips Lon 10/29/86: 291 (2)(note);

FREDERICKS Y DARIES [FREDERICKS 2]
Photos dated: 1850s-1860s
Processes:    Albumen
Formats:      Cdvs
Subjects:     Portraits, topography
Locations:    Cuba
Studio:      Cuba - Havana
  Entries:
Sothebys NY (Greenway Coll.) 11/20/70: 268 (lot,
    F & D-1, et al);
Swann NY 11/18/82: 356 (13)(note);

FREDERICKS, Charles DeForest (American, 1823-1894)
Photos dated: 1843-1890
Processes:      Daguerreotype, salt, albumen
Formats:        Plates, prints, cdvs, stereos
Subjects:       Portraits, topography
Locations:      Cuba; US - New York City; France -
                Paris
Studio:         Cuba - Havana; US - New York City;
                France - Paris
    Entries:
Anderson NY (Gilsey Coll.) 1/20/03: 276, 278;
Anderson NY (Gilsey Coll.) 2/24/03: 1583;
Rauch Geneva 6/13/61: 25 ill(attributed)(note);
Sothebys NY (Strober Coll.) 2/7/70: 257 (lot, F-9
    et al)(note), 259 (lot, F et al), 260 (lot, F et
    al), 261 (lot, F-1 et al), 262 (lot, F et al),
    264 (lot, F et al), 265 (lot, F-1 et al), 266
    (lot, F et al), 271 (lot, F et al), 272 (lot,
    F et al), 273 (lot, F et al), 282 (lot, F et
    al), 288 (lot, F et al), 292 (lot, F et al), 293
    (lot, F-9 et al), 297 (lot, F et al), 318 (lot,
    F et al), 372 (lot, F-1 et al), 527 (lot, F-1
    et al);
Sothebys NY (Greenway Coll.) 11/20/70: 111 (lot,
    F-1 et al), 198 ill(lot, F-1 et al), 212 (lot,
    F-1 et al), 215 ill, 223 ill, 260 (lot, F-1 et
    al), 279 (lot, F-1 et al);
Sothebys NY 11/21/70: 341 (lot, F et al);
Rinhart NY Cat 2, 1971: 283 (lot, F et al), 325
    (lot, F-1 et al);
Vermont Cat 4, 1972: 486 ill(lot, F-1 et al), 487;
Rinhart NY Cat 7, 1973: 155 (album, F et al), 536
    (lot, F-1 et al), 545;
Swann NY 9/18/75: 186 (lot, F et al);
Swann NY 4/1/76: 160 (album, F et al);
Swann NY 11/11/76: 339 (lot, F et al), 358 (lot,
    F et al), 362 (album, F et al), 399 (album,
    F-1 et al);
California Galleries 1/22/77: 39, 155 (album,
    F et al);
Swann NY 4/14/77: 198 (lot, F et al);
Frontier AC, Texas 1978: 106 (note);
California Galleries 1/21/78: 124 (lot, F et al);
Swann NY 4/20/78: 262 ill(2);
Christies Lon 6/27/78: 26 (note);
Swann NY 12/14/78: 400, 470 (lot, F et al);
Sothebys LA 2/7/79: 406 ill(attributed)(note);
Christies Lon 3/15/79: 302 (album, F-2 et al)(note);
Phillips NY 5/5/79: 89;
Phillips Can 10/4/79: 28;
Christies NY 10/31/79: 58 ill(album, 10)(note);
Phillips NY 11/29/79: 246 (album, F et al);
Sothebys LA 2/6/80: 8 ill(album, 390);
Swann NY 4/23/81: 490 (lot, F-2 et al);
Harris Baltimore 3/26/82: 397 (lot, F et al);
Harris Baltimore 5/28/82: 115;
Swann NY 11/18/82: 399 (note);
Christies Lon 3/24/83: 247 (album, F et al);
Harris Baltimore 4/8/83: 315 (lot, F et al), 322
    (lot, F et al), 385 (lot, F et al);
Swann NY 5/5/83: 355 (lot, F-32 et al)(note);
Harris Baltimore 9/16/83: 136 (lot, F et al);
Harris Baltimore 12/16/83: 241, 296 (album,
    F et al);
Swann NY 5/10/84: 196 (albums, F et al);
Swann NY 11/8/84: 187 (album, F et al), 206 (note);
Old Japan, England Cat 8, 1985: 67 ill;
Swann NY 5/16/86: 163 (lot, F-1 et al), 222 (lot,
    F et al), 223 (album, F et al);
Christies Lon 10/30/86: 220 (albums, F-1 et al), 222
    (album, F et al);

FREDERICKS, C.D. (continued)
Harris Baltimore 11/7/86: 60 (lot, F-1 et al);
Swann NY 11/13/86: 173 ill, 200 (lot, F et al);

FREELAND (American)
Photos dated: 1877
Processes:      Albumen
Formats:        Prints
Subjects:       Documentary (disasters)
Locations:      US - New Jersey
Studio:         US - Milford, New Jersey
    Entries:
Swann NY 4/14/77: 311 (10)(note);

FREEMAN (see DUNKLEE & FREEMAN) [FREEMAN 1]

FREEMAN Brothers [FREEMAN 2]
Photos dated: Nineteenth century
Processes:      Albumen
Formats:        Cdvs
Subjects:       Portraits
Locations:      Studio
Studio:         Australia - Sydney
    Entries:
Edwards Lon 1975: 12 (album, F et al);
Christies Lon 10/25/79: 422 (album, F-7 et al);

FREEMAN, C.H. (American)
Photos dated: Nineteenth century
Processes:      Albumen
Formats:        Stereos
Subjects:       Topography
Locations:      US - northeast
Studio:         US
    Entries:
Harris Baltimore 6/1/84: 148 (lot, F et al);

FREEMAN, J. (American)
Photos dated: 1868-1878
Processes:      Albumen
Formats:        Stereos
Subjects:       Topography, documentary (maritime)
Locations:      US - Nantucket, Massachusetts
Studio:         US - Nantucket, Massachusetts
    Entries:
Witkin NY VI 1978: 58 (3 ills)(3)(note);
Rose Florida Cat 7, 1982: 95 ill(8);
Christies Lon 3/28/85: 327 (album, F-1 et al);

FREESE & FETROUR (American)
Photos dated: c1880
Processes:      Albumen
Formats:        Prints
Subjects:       Genre
Locations:      US - California
Studio:         US - Eureka, California
    Entries:
California Galleries 7/1/84: 385;

FRENCH (see BARTLETT & FRENCH) [FRENCH 1]

**FRENCH** (American) [FRENCH 2]
Photos dated: 1870-1883
Processes:      Woodburytype
Formats:        Prints
Subjects:       Documentary (medical)
Locations:      US - Washington, D.C.
Studio:         US
    Entries:
Swann NY 11/6/80: 128 (books, F et al)(note);

**FRENCH, J.A.** (American)
Photos dated: 1860s-1880s
Processes:      Albumen
Formats:        Stereos
Subjects:       Topography, genre
Locations:      US - New Hampshire; New York
Studio:         US - Keene, New Hampshire
    Entries:
Rinhart NY Cat 6, 1973: 506, 507;
California Galleries 9/27/75: 511 (20);
California Galleries 1/23/77: 409 (20);
Swann NY 12/14/78: 276 (F, F & Sawyer, 27)(note);
Harris Baltimore 12/16/83: 122 (lot, F & Sawyer
    et al);
Harris Baltimore 3/15/85: 73 (lot, F & Sawyer-1,
    et al);

**FRENCH, John**
Photos dated: 1870s-1880s
Processes:      Albumen
Formats:        Prints
Subjects:       Topography
Locations:      Ireland
Studio:         Ireland
    Entries:
Sothebys Lon 7/1/77: 162 (45)(note);

**FRENCH, Robert** (Irish, 1841-1917)(see LAWRENCE,
            William, and L., W.)

**FRIDRICH, Frantisek Josef Arnost** (1829-1892)
Photos dated: 1850s-1867
Processes:      Albumen
Formats:        Stereos
Subjects:       Topography
Locations:      Austria - Vienna; Czechoslovakia -
                Prague
Studio:         Czechoslovakia - Prague
    Entries:
Christies Lon 3/11/82: 94 (lot, F et al);
Harris Baltimore 12/10/82: 37 (81);
Swann NY 11/13/86: 217 (lot, F-1 et al);

**FRIEND, Herve** (American)
Photos dated: 1887
Processes:      Photogravure
Formats:        Prints
Subjects:       Topography
Locations:      US - San Diego, California
Studio:         US - California
    Entries:
Rinhart NY Cat 8, 1973: 9 (book, 72);
Phillips NY 5/5/79: 84 ill(books, F-72 et al);
California Galleries 7/1/84: 87 (book, 65);

**FRIPP**
Photos dated: c1895
Processes:      Photogravure
Formats:        Prints
Subjects:       Topography
Locations:      South Africa
Studio:         South Africa
    Entries:
Swann NY 4/26/79: 5 (book, F et al);

**FRISCH, A.**
Photos dated: 1865
Processes:      Albumen
Formats:        Prints
Subjects:       Topography, ethnography
Locations:      Brazil - Amazon area
Studio:
    Entries:
Christies Lon 3/16/78: 128 ill(album, 27);
Christies NY 10/31/79: 53 ill;
Swann NY 4/17/80: 240 (note);
Christies NY 5/16/80: 197 ill;

**FRITH, Francis** (British, 1822-1898)
Photos dated: c1850-c1890
Processes:      Albumen, platinum, bromide
Formats:        Prints, stereos, cdvs, cabinet cards
Subjects:       Topography, genre (still life)
Locations:      England; Wales; Egypt; Palestine;
                Greece; Ethiopia; Switzerland;
                France; Italy; Afghanistan; India;
                Japan; China
Studio:         England - London and Reigate
    Entries:
Goldschmidt Lon Cat 52, 1939: 226 (book, 76)(note),
    229 (20)(note), 232 (book, 12);
Weil Lon Cat 4, 1944(?): 199 (books, 76)(note), 252
    (book, 100)(note);
Weil Lon Cat 7, 1945: 131 (book, 24);
Swann NY 2/14/52: 48 (book, 100)(note), 140 (book,
    76)(note), 141 (book, 60), 142 (book, 15), 143
    (book, 16)(note), 144 (book, 24), 145 (book,
    15), 146 (book, 20), 147 (book, 100), 148 (book,
    37), 149 (book, 37), 150 (book, 20);
Sothebys NY 11/21/70: 22 ill(book, 76)(note);
Rinhart NY Cat 2, 1971: 408 (2), 478;
Sothebys Lon 12/21/71: 165 (lot, F-2 et al), 172
    (lot, F-4 et al);
Frumkin Chicago 1973: 65, 66, 67;
Witkin NY I 1973: 100 ill(book, 76), 101 (book, 20);
Sothebys Lon 5/24/73: 1 (book, 37), 2 (book, 60), 3
    (books, 72), 9 (lot, F-110 et al), 25 (books,
    F-24 et al), 29 (books, F-24 et al), 128 ill(72);
Christies Lon 6/14/73: 199 (album, F-13 et al), 209
    (lot, F-2 et al), 210 (3);
Christies Lon 10/4/73: 105 (book, 37), 106
    (book, 69);
Sothebys Lon 12/4/73: 30 (albums, F-21 et al), 31
    (album, 150), 32 (75), 33 (lot, F et al), 34
    (book, 37), 35 (book, 37), 36 ill(lot, F-33
    et al);
Ricketts Lon 1974: 49 ill(book, 15);
Vermont Cat 7, 1974: 620 ill(note), 621 ill, 622
    ill, 623 ill, 624 ill, 625 ill, 626 ill, 627
    ill, 628 ill, 629 ill, 630 ill, 631 ill, 742
    (album, F Series-17 et al), 747 (album, F Series
    et al);
Witkin NY II 1974: 99 ill(book, 76), 100 ill(book,
    20), 576 (book, 37), 809 ill, 1285 ill;

**FRITH** (continued)

Sothebys Lon 3/8/74: 29 (lot, F Series et al), 43
(book, 76), 44 ill(book, 60), 45 ill(book, 76),
166 (book, 24);
Sothebys Lon 6/21/74: 18 ill(90), 66 (lot, F-1 et
al), 94 (album, F et al), 156 (2 ills)(book, 24);
Christies Lon 7/25/74: 385 (2);
Sothebys Lon 10/18/74: 68 (album, F et al), 76
ill(book, 18), 89 (lot, F et al), 96 (albums, F et
al), 113 ill(book, 40), 115 ill(books, 76), 116
(book, 20), 117 ill(books, 58), 261 (book, 24);
Edwards Lon 1975: 24 (album, F et al), 36 (album,
F-1 et al), 75 (book, 31), 89 (book, 18), 90
(book, 18), 91 (book, 18), 92 (book, 43), 93
(book, 20), 97 (book, 15), 116 (book, F Series
et al), 123 (book, 24), 124 (book, 24), 129
(book, F et al), 149 (book, 2)(attributed), 162
(book, F et al), 163 (book, F et al);
Stern Chicago 1975(?): 30 ill(book, 76)(note);
Sothebys NY 2/25/75: 145 (F Series, 11), 147 (lot,
F et al), 159 ill(6);
Sothebys Lon 3/21/75: 91 (albums, F et al), 110
(album, F et al), 111 ill(book, 76), 118 ill
(book, 76), 134 (lot, F et al), 135 (albums,
F et al), 136 (lot, F et al), 139 (album, F et
al), 140 (book, 20), 143 (album, 30), 146 (book,
F-10 et al), 148 (album, F Series et al), 149
(album, F et al), 234 (lot, F-5 et al), 306
(books, F-24 et al), 318 (book, 56)(note);
Sothebys NY 9/23/75: 83 ill(book, 20), 96 (lot, F-1
et al);
California Galleries 9/26/75: 119 (lot, F Series et
al), 131 (album, F Series et al), 134 (album, F
Series et al), 189 (album, F Series et al), 248
(lot, F Series-2 et al), 261 (lot, F Series-1 et
al), 278 (8), 279, 280 (note), 281, 282, 283
ill, 284, 285;
California Galleries 9/27/75: 350 (lot, F-1 et al),
481 (8);
Sothebys Lon 10/24/75: 76 (lot, F et al), 85 (101),
133 ill(book, 19), 134 (30), 135 ill(book, 74),
143 (lot, F-4 et al), 152a (book, 24), 153
(book, 24), 249 (25), 268 (album, F Series-1
et al);
Colnaghi Lon 1976: 266 ill(note), 267 ill, 268, 269
(2), 270 (5 ills)(books, 148);
Kingston Boston 1976: 101 ill(12)(note), 452
(2 ills)(book, 76), 453 (2 ills)(book, 37);
Lunn DC Cat 6, 1976: 22 (3 ills)(book, 57)(note);
Rose Boston Cat 1, 1976: 18 ill(note), 33 ill,
34 ill;
Witkin NY IV 1976: 136a ill, 136b ill, AL7 ill
(book, 76), AL8 (album, F et al), AL20 ill
(book, 37);
Wood Conn Cat 37, 1976: 66 (book, 15)(note), 67
(book, F & Co-38 et al), 216 (album, 178)(note),
231 (album, F et al), 236 (album, F-4 et al),
243 (album, F Series et al), 249 (album, F
et al);
Swann NY 4/1/76: 300 (book, 24);
California Galleries 4/2/76: 148 (album, F et al),
151 (album, F Series et al), 217 (lot, F et al),
229, 230 (7);
Sothebys NY 5/4/76: 79 (album, F et al), 80 (8), 81
(album, F et al), 83 (album, F Series et al), 86
(45), 124 (F & Co, 5);
Christies Lon 6/10/76: 46 (album, 38), 47 (albums,
F et al), 76 ill(book, 76), 77 (4), 78 (8), 94
(album, F Series et al), 98 (lot, F Series et
al), 117 (lot, F et al);

**FRITH** (continued)

Christies Lon 10/28/76: 87 (album, F Series et al),
88 (albums, F Series et al), 89 (albums, F
Series et al), 91 (albums, F Series et al), 126
ill(book, 76), 127 ill(books, 148), 128 (11),
129 (7), 130 (book, 24);
Sothebys Lon 10/29/76: 33 (lot, F-9 et al), 55
(book, F et al), 62 (album, F Series, 50), 114
(albums, F et al), 130 (albums, F et al), 134 ill
(album, 27), 144 ill(book, 17), 175 (book, 24),
177 (book, 15);
Sothebys NY 11/9/76: 52, 53 ill(album, 50), 54 (4);
Swann NY 11/11/76: 260 (book, 24)(note), 380
(albums, F et al), 449 (lot, F et al), 456 (2);
Gordon NY 11/13/76: 32 ill(25), 33 ill(book, 24);
Halsted Michigan 1977: 640 ill;
Rose Boston Cat 2, 1977: 15 ill(note), 16 ill, 17
ill, 18 ill;
Vermont Cat 11/12, 1977: 517 ill(book, 30), 518 ill
(book, 15)(note), 783 ill, 844 ill(note), 845
ill, 846 ill, 847 ill, 848 ill, 849 ill, 850
ill, 851 ill, 852 ill, 853 ill, 854 ill, 855
ill, 856 ill, 857 ill, 858 ill, 859 ill, 860
ill, 861 ill, 862 ill, 863 ill, 864 ill, 865
ill, 866 ill, 867 ill, 868 ill;
White LA 1977: 26 ill(note), 27, 28;
Witkin NY V 1977: 60 (2 ills)(book, F et al)(note);
California Galleries 1/22/77: 161 (album, F Series
et al), 167 (album, F Series et al), 168 (album,
F Series et al), 171 (album, F et al), 195
(album, F Series et al), 277 (lot, F Series-2 et
al), 303 (F Series, 2), 304 (F Series, 3);
California Galleries 1/23/77: 386 (8);
Sothebys Lon 3/9/77: 42 (album, F-28 et al), 49
(58), 53 (album, F et al), 53a (albums, F Series
et al), 57 (20, attributed), 169 ill(book, 20);
Christies Lon 3/10/77: 83 (album, F Series et al),
107 (lot, F et al), 110 (album, F Series et al),
155 ill(book, 37)(note), 156 ill(book, 37), 157
(lot, F et al)(note), 158 ill(6), 159 (lot, F-7
et al), 160, 181 (albums, F Series et al);
Gordon NY 5/10/77: 807 ill(18), 808 ill, 809 ill;
Sothebys NY 5/20/77: 76 (6), 77 ill(lot, F et al),
101 (album, F Series-28 et al);
Christies Lon 6/30/77: 79 (album, F Series et al),
80 (album, F Series et al), 94 (album, F Series
et al), 106 ill(book, 75), 107, 108 ill(book,
20), 109 (book, 12), 110 (lot, F-2 et al), 111
(album, 64), 128 (lot, F et al), 181 (albums,
F et al);
Sothebys Lon 7/1/77: 40 ill(book, 56), 138 (29),
145 ill(18), 148 ill(book, 39), 150 ill(book,
76), 161 (lot, F et al), 164 (lot, F et al), 168
(album, F et al), 169 (albums, F Series et al);
Sothebys NY 10/4/77: 125 (album, F et al), 126
(album, F Series et al), 134 (album, F Series et
al), 182 (5), 183 (4), 184 (5), 185 (lot, F-6
et al);
Christies Lon 10/27/77: 62 (album, F Series-1 et
al), 114 (book, 37), 115 (18), 116 (book, 10),
117, 118 (2), 144 (album, F Series-2 et al),
195 (6);
Sothebys Lon 11/18/77: 4 ill(100), 66 (lot, F-9 et
al), 71 (book, 20), 73 (book, 23), 87 (lot, F et
al), 93 (album, F et al), 100 (lot, F et al),
108 ill(book, 20), 109 (2), 135 (lot, F-8 et
al), 190 (book, 15), 254 (album, F-4 et al);
Swann NY 12/8/77: 78 (book, 15), 276 (2), 325
(albums, F et al), 367 (lot, F et al);
Lehr NY Vol 1:2, 1978: 18 ill;
Lunn DC Cat QP, 1978: 24 (book, 57)(note);

## FRITH (continued)

Rose Boston Cat 3, 1978: 93 ill(note), 94 ill, 95 ill, 96 ill;

Weston Cal 1978: 139 (3 ills)(book, 76);

Witkin NY VI 1978: 60 (2 ills)(2), 61 (2 ills)(2);

Wood Conn Cat 41, 1978: 83 ill(note), 84, 85, 85a (book, 76), 86, 87 ill, 88 ill, 89, 90, 91, 92;

Wood Conn Cat 42, 1978: 200 (book, 15)(note);

California Galleries 1/21/78: 134 (lot, F-2 et al), 171 (lot, F et al), 209 (album, F et al), 213 (album, F-1 et al), 215 (album, F et al), 216 (album, F-9 et al), 240, 241 (2), 242 (2), 243 (2), 244 (2), 245 (3), 246 (3), 247 (3), 248 (3), 249 (3), 250 (3), 251 (3), 252 (3), 253 (4), 254 (4);

Sothebys LA 2/13/78: 97 (2 ills)(book, 20)(note), 98 ill(book, 76), 99 (3), 100 (3), 101 ill(3), 102 (4), 103 ill(book, 36), 104 (4), 106 (4);

Christies Lon 3/16/78: 74 (album, F Series-28 et al), 98 (album, 49), 112 (lot, F et al), 172 (lot, F et al), 215 (book, 15)(note);

Swann NY 4/20/78: 269 (album, F et al), 314 (lot, F et al);

Sothebys NY 5/2/78: 76 (4), 77 (5), 78 ill(4), 79 (4), 80 ill(2);

Christies Lon 6/27/78: 60 (albums, F Series et al), 65 (lot, F et al), 68 (album, F et al), 82 (F Series, 50), 83 (lot, F Series et al), 97 (album, F Series et al), 123 (lot, F Series-23 et al), 140 (lot, F-5 attributed et al), 144 (album, F Series, 350)(note), 158 ill(book, 111), 160 ill(book, 16)(note), 165 (book, 5) (attributed);

Sothebys Lon 6/28/78: 2 (lot, F-6 et al), 77 (12), 78 (11), 79 (34), 80 ill(album, F-16 et al), 81 (7), 82 ill(book, 20), 83 ill(album, 170), 83a (album, 27);

Christies Lon 10/26/78: 82 (100), 83 (14), 84 (11), 89 (lot, F et al), 106 (album, F Series et al), 108 (album, F-1 et al), 158 (2), 159 (lot, F-7 et al), 188 (album, F-16 et al), 192 (album, F Series et al), 194 (albums, F et al), 212 (book, 24), 217 (book, 148);

Sothebys Lon 10/27/78: 104 (lot, F-4 et al), 107 (album, F et al), 112a (album, F et al), 116 (lot, F et al), 117 (lot, F et al), 120 (10), 122 (2 ills)(books, 74);

Phillips NY 11/4/78: 35 (13), 36 (book, 24);

Swann NY 12/14/78: 473 (album, F et al);

Lehr NY Vol 1:4, 1979: 52;

Lennert Munich Cat 5, 1979: 15;

Lennert Munich Cat 5II, 1979: 15a;

Rose Boston Cat 4, 1979: 17 ill(note);

Witkin NY IX 1979: 2/34 (book, 15)(note);

Wood Conn Cat 45, 1979: 160 ill(book, 24)(note), 288 ill(book, 76)(note);

California Galleries 1/21/79: 96 (book, F et al), 279 (16), 407 (lot, F et al), 431, 432, 433, 434 (3), 435 (3), 436 (3), 437 (3), 438 ill(3), 439 (2);

Sothebys LA 2/7/79: 438 (10);

Phillips Lon 3/13/79: 133 ill(book, 37), 134 ill (book, 36)(attributed), 138 (albums, F et al);

Sothebys Lon 3/14/79: 133 ill(book, 37), 152 (album, F et al), 231 (book), 238 ill(book, 16);

Christies Lon 3/15/79: 72 (lot, F-1 et al), 87 (lot, F et al), 102 (lot, F et al), 184 (albums, F Series et al), 201 (book, 37), 202 (book, 37), 203 (book, 37), 204 (book, 72), 205 (book, 37), 206 (book, 37), 207 (book, 37), 208 (book, 37), 209 (book, 19);

## FRITH (continued)

Swann NY 4/26/79: 112 (book, 24), 363 (3), 462 (album, F et al)(note);

Christies NY 5/4/79: 4;

Phillips NY 5/5/79: 167 (15), 168 (10), 173 (lot, F et al), 180 (album, F et al);

Sothebys NY 5/8/79: 75 ill, 76 (6);

Sothebys Lon 6/29/79: 131 ill(album, 50);

Phillips Can 10/4/79: 10 ill(11), 18 (albums, F et al), 20 (2);

Swann NY 10/18/79: 139 (book, 12), 335 (lot, F et al);

Sothebys Lon 10/24/79: 113 (album, F et al), 159 ill (book, 37);

Christies Lon 10/25/79: 72 (lot, F-7 et al), 90 (lot, F-1 et al), 119 (lot, F-19 et al), 121 (lot, F-3 et al), 123 (album, F Series-14 et al), 128 (album, 74), 129 (albums, F et al), 133 (lot, F-25 et al), 134 (lot, F et al), 135 (albums, F et al), 147 (lot, F-1 et al), 161 (albums, F-2 et al), 245 (album, F et al), 268 (book, 39), 269 (book, 36), 270 (book, 50), 271 ill(book, 16)(note);

Christies NY 10/31/79: 7 (3 ills)(book), 8 (15), 9 (10);

Sothebys NY 11/2/79: 246 ill(books, 111), 247 ill (17);

Phillips NY 11/3/79: 131 (9), 159 (album, F et al), 180 (10), 181 (10);

Phillips NY 11/29/79: 259 (16), 269 (2), 271 (album, F-32 et al);

Sothebys NY 12/19/79: 63 ill, 64 ill, 65 ill, 95 ill (lot, F et al);

Rose Boston Cat 5, 1980: 29 ill(note), 30 ill;

Witkin NY X 1980: 33 (book, 15)(note), 95 (book, 18);

Sothebys LA 2/6/80: 111 (lot, F et al), 115 ill (album, 29), 161 ill, 162 ill(2), 163 (lot, F-1 et al);

Phillips Lon 3/12/80: 161 (9), 162 (lot, F-4 et al);

Christies Lon 3/20/80: 89 (lot, F-6 et al), 94 (lot, F-4 et al), 114 (lot, F-4 et al), 131 (albums, F Series et al), 132 (album, F et al), 134 (lot, F-9 et al), 135 (lot, F Series et al), 137 (album, F et al), 161, 202 (album, F et al), 219 ill(book, 37), 220 (book, 37), 364 (lot, F et al);

Sothebys Lon 3/21/80: 129 ill(book, 20), 163 (album, F et al), 166 (7);

California Galleries 3/30/80: 74 ill(book, 25), 211 (album, F Series-13 et al), 217 (album, F Series et al), 299 (lot, F et al), 308, 309, 310 ill (16), 311 (2), 312 (10), 313 (12), 314 (7);

Swann NY 4/17/80: 92 (books, 12);

Christies NY 5/16/80: 97 (book, 75), 98 (15), 99 (13), 100 (10), 101 (10), 102, 125 (lot, F et al);

Sothebys NY 5/20/80: 391 ill(book, 76), 392 ill, 393 ill(F Series);

Phillips NY 5/21/80: 122 (lot, F-3 et al), 174 (8), 231 (10), 232 (10);

Auer Paris 5/31/80: 65 (lot, F Series et al);

Christies Lon 6/26/80: 155 (3), 158 (lot, F et al), 162 (lot, F et al), 165 (albums, F et al), 168 (lot, F-16 et al), 261 (lot, F Series-10 et al), 298 (book, 75), 313 (book, 15), 317 (book, 12);

Sothebys Lon 6/27/80: 63 ill(albums, 96), 76 ill (book, 60), 105 (F Series, 18), 108 (5);

Phillips Can 10/9/80: 11 (10), 12 (10), 21 (album, F et al), 23 (lot, F-1 et al);

FRITH (continued)

Sothebys Lon 10/29/80: 59 ill, 60 ill, 61 ill, 62 ill, 63 ill(book, 37), 64 (book, 37), 65 (book, 24), 66 ill, 67 ill, 68 (album, F et al), 69 (album, 70), 73 (lot, F et al), 306 (album, F et al);

Christies Lon 10/30/80: 96 (54), 99 (74), 133 (45), 145 (lot, F-31 et al), 148 (albums, F et al), 149 (album, F et al), 150 (4), 152 (album, F Series-100 et al), 153 (albums, F Series et al), 154 (lot, F-9 et al), 187 (album, F Series, 50), 189 (album, F Series et al), 191 (albums, F Series et al), 198 (albums, F Series et al), 217 (10), 230 (F Series, 12), 188 (book, 15), 433 (albums, F-2 et al), 446 (lot, F et al);

Swann NY 11/6/80: 280 (lot, F-1 et al), 283 (lot, F et al);

Christies NY 11/11/80: 18 ill(note), 19 ill, 20 ill, 21 ill, 22, 23, 24 (10), 25 (10), 77 (lot, F et al);

California Galleries 12/13/80: 256 (5), 257 (5), 258 (4), 259 ill(4), 260 (7), 261 (7), 262 ill (3), 263 (2), 264, 267 (lot, F Series-2 et al), 286 (lot, F Series-1 et al);

Koch Cal 1981-82: 16 ill(note);

Sothebys LA 2/4/81: 216 ill(books, 74);

Christies Lon 3/26/81: 150 (9), 160 (albums, F et al), 161 (lot, F et al), 162 (albums, F et al), 163 (albums, F Series et al), 166 (lot, F-16 et al), 171 (lot, F-2 et al), 220, 266 (albums, F et al), 280 (albums, F et al), 283 (book, 75), 284 (book, 148), 413 (lot, F et al);

Sothebys Lon 3/27/81: 54 (8), 65 ill, 66, 69 ill, 94 ill(album, 60), 110 (album, F et al);

Swann NY 4/23/81: 476 (4, attributed)(note), 478 (F Series, 6)(note);

Phillips NY 5/9/81: 24 (albums, F et al), 51 (albums, F et al), 54 ill, 55 ill;

Christies NY 5/24/81: 12 ill(note), 13 ill, 14 ill;

Sothebys NY 5/15/81: 83 ill, 84 ill;

Sothebys Lon 6/17/81: 75 (lot, F-2 et al), 87 (album, F Series et al), 114 (lot, F et al), 137 (album, F-2 et al), 143 (albums, F Series et al), 144 (lot, F Series et al), 155 (book, 100), 156 ill(album, 20), 158 (book, 148), 159 (book, 37), 161 (book, 15), 162 ill, 163 ill, 164 ill, 165 ill, 166 ill, 167 ill, 168 ill, 169 ill, 170 (2);

Christies Lon 6/18/81: 79 (lot, F-9 et al), 119 (74), 158 (lot, F-3 et al), 161 (lot, F et al), 165 (lot, F Series-100 et al), 166 (lot, F et al), 192 (albums, F et al), 193 (albums, F et al), 234 (album, F Series-13 et al), 240 (albums, F et al), 248 (book, 37), 249 (book, 24), 417;

California Galleries 6/28/81: 231 (5), 232 (5), 233 (5), 234 (4), 235 ill(4), 236 ill(14), 237 (12);

Harris Baltimore 7/31/81: 94 (9), 199 (9), 200;

Phillips Lon 10/28/81: 146 (album, F et al), 155 (albums, F-10 et al), 160 (albums, F-1 et al);

Sothebys Lon 10/28/81: 65 (albums, F et al), 111 ill (book, 37), 112, 113 ill(book, 74), 114 ill (book, 37), 115 ill(book, 37), 116 ill, 117 ill (book, 37), 118 (book, 37), 119 ill, 120 ill, 121 ill;

Christies Lon 10/29/81: 124 (100), 147 (lot, F et al), 200 (album, F et al), 210 (2), 211, 212 (15), 215 (album, F-15 et al), 236 (album, F Series-10 et al), 286 (book, 37), 354 (albums, F et al);

FRITH (continued)

Swann NY 11/5/81: 113 ill(book, 15)(note), 313 (note), 478 (lot, F Series-1 et al), 517 (lot, F Series et al), 519 (lot, F Series et al), 546 (lot, F-1 et al), 565 (lot, F & Co-1, et al);

Christies NY 11/10/81: 16 ill, 17 (10);

Rose Florida Cat 7, 1982: 33 ill(note);

Weston Cal 1982: 11 ill;

Wood Conn Cat 49, 1982: 171 ill(book, 76), 172 (book, 37), 173 (book, 24)(note);

Christies Lon 3/11/82: 62 (25), 140 (lot, F-1 et al), 155 (10), 244 (book, 3), 336 (lot, F Series et al), 366 (lot, F et al);

Sothebys Lon 3/15/82: 24 ill(book, 100), 29 (lot, F-6 et al), 65 (lot, F et al), 70 ill, 71 ill, 72, 73 ill, 74 ill, 75 ill(books), 76, 77 (book, 37), 78, 86 (lot, F et al), 438 (book, 12);

Phillips Lon 3/17/82: 41 (albums, F-1 et al), 42 (albums, F-2 et al), 50 ill(album, 20), 53 (albums, F-18 et al), 54 (lot, F-4 et al), 58 (lot, F-1 et al), 60 (book, 15);

Harris Baltimore 3/26/82: 3 (6), 249 (note), 250 (7), 384 (album, F Series et al), 412 (attributed)(note);

Swann NY 4/1/82: 294 (lot, F, F Series, et al) (note), 329 (lot, F et al)(note);

Phillips NY 5/22/82: 763 ill, 764;

California Galleries 5/23/82: 228 (lot, F et al), 305 ill, 306, 307 (4), 308 (4), 309 (4), 310 (3), 311 (2), 446 (lot, F et al);

Sothebys NY 5/24/82: 242 ill;

Sothebys NY 5/25/82: 399 ill;

Christies NY 5/26/82: 12 ill(note);

Phillips Lon 6/23/82: 23 (lot, F-8 et al), 26 (lot, F-2 et al), 28 (lot, F et al), 30 (lot, F et al), 31 (lot, F-29 et al), 34 (albums, F et al), 37 (lot, F Series-4 et al), 38 (lot, F et al), 44 (albums, F et al);

Christies Lon 6/24/82: 57 (44), 79 (lot, F-1 et al), 98 (album, F Series, 44 attributed), 101 (albums, F Series et al), 140 (album, F Series et al), 178 (album, F Series et al), 188, 189 (8), 190 (book, 36), 191 (book, 37), 195 (F Series, 29), 224 (albums, F et al), 249 (books, F-6 et al);

Sothebys Lon 6/25/82: 88 ill(37), 89 ill(book), 93 (50);

Phillips NY 9/30/82: 974 ill(5), 975 (5), 976, 977 (7);

Phillips Lon 10/27/82: 34 (lot, F et al), 35 (lot, F Series et al), 36 (lot, F et al);

Christies Lon 10/28/82: 22 (63), 38 (lot, F-3 et al), 44 (album, F Series-1 et al), 55 (album, 42), 65 (lot, F Series et al), 126 (book, 39);

Sothebys Lon 10/29/82: 26;

Phillips NY 11/9/82: 117 ill;

Swann NY 11/18/82: 341 (lot, F et al), 367 (lot, F-2 et al)(note), 371 (lot, F Series et al), 373 (albums, F et al);

Harris Baltimore 12/10/82: 241 (note), 242 (note), 389 (lot, F Series et al);

Christies NY 2/8/83: 10, 34 (lot, F et al);

Christies Lon 3/24/83: 25 (lot, F et al), 51 (album, F-3 et al), 53 (album, F Series et al), 69 (lot, F Series et al), 95 ill, 96 (album, 50), 245 (F Series, 11);

Sothebys Lon 3/25/83: 1 (lot, F et al), 46 ill (book, 20);

Harris Baltimore 4/8/83: 370 (album, F Series et al);

## FRITH (continued)

Swann NY 5/5/83: 282 (album, F et al), 283 (albums, F et al), 284 (albums, F et al), 402 (albums, F et al)(note);

Christies NY 5/9/83: 69 ill;

Phillips Lon 6/15/83: 116 (album, F et al), 121 (album, F et al), 126A (albums, F et al), 128 (lot, F et al);

Christies Lon 6/23/83: 29 (lot, F-2 et al), 61 (album, F Series et al), 62 (lot, F-24 et al), 63 (lot, F Series-2, et al), 68 (albums, F Series et al), 128 ill, 129 (2), 130 ill;

Sothebys Lon 6/24/83: 4 (lot, F et al), 17 (lot, F et al), 21 (album, 50);

Christies NY 10/4/83: 109 (lot, F et al);

Christies Lon 10/27/83: 20 (lot, F-2 et al), 42 (lot, F-2 et al), 60 (albums, F et al), 100 (book, 42), 159 (album, F Series et al);

Phillips Lon 11/4/83: 28 (book), 38 (album, F et al), 43 (album, F-12 et al), 53A (albums, F et al), 54 (album, F et al), 60 (album, F et al), 62 (album, F et al), 68 (album, F et al), 71 (lot, F et al), 78A (lot, F-4 et al);

Christies NY 11/8/83: 109 ill(books, 74);

Sothebys NY 11/9/83: 152 ill, 399 ill;

Swann NY 11/10/83: 66A ill(book, 76)(note), 67 (book, 15)(note), 263 ill, 264, 265 (10)(note), 278 (album, F et al)(note), 359 (album, F et al);

Sothebys Lon 12/9/83: 9 (albums, F et al);

Harris Baltimore 12/16/83: 39 (7, attributed) (note), 178 (book, 24), 341 (15), 342, 343, 344, 345;

Christies Lon 3/29/84: 27 (lot, F-8 et al), 29 (lot, F-1 et al), 46 (book, 100), 52 (albums, F Series et al), 104 (albums, F et al), 114 (book, 56), 177 ill, 178 ill(books, 24), 179 (book, 42);

Christies NY 5/7/84: 5 ill, 6 ill;

Swann NY 5/10/84: 50 (book, 20), 210 (lot, F Series et al), 211 (lot, F Series et al), 225 (note), 226 (album, F Series, 50), 233 (albums, F et al), 234 (lot, F Series et al), 244 (lot, F Series et al), 246 (lot, F Series et al), 310 (lot, F-32 et al), 330 (lot, F Series et al);

Harris Baltimore 6/1/84: 355 (48, attributed), 360 (2);

Christies Lon 6/28/84: 36 (lot, F-1 et al), 149 (book, 15), 213 (2), 214 ill(lot, F-14 et al), 215 (album, 20), 219 ill(book, 15)(note), 220 (book, 15), 221 (lot, F-7, F Series-7, et al);

Sothebys Lon 6/29/84: 5 (lot, F et al);

California Galleries 7/1/84: 405, 406 ill(F Series, 3), 407, 408 (19), 409 (3);

Christies NY 9/11/84: 108, 109, 110 ill, 111, 112 (book, 100), 121 (album, F Series et al), 125 (album, F et al), 128 (album, F Series et al), 129 (album, F Series et al), 130 (album, F Series et al), 131 (album, F Series et al);

Phillips Lon 10/24/84: 118 (albums, F et al), 125 (lot, F et al);

Christies Lon 10/25/84: 47 (lot, F-1 et al), 58 (lot, F Series, F & Co, et al), 105 (album, F Series et al), 106 (album, F Series et al), 107 (albums, F et al), 117 (book, 15), 188 (books, 24), 189 (7), 190 (40), 191 ill(8);

Sothebys Lon 10/26/84: 27 (albums, F et al), 170 (album, F-1 et al);

Sothebys Lon 11/5/84: 99 (album, F et al);

Swann NY 11/8/84: 153 (album, F et al), 155 (albums, F et al), 201 (albums, F et al), 202 (albums, F et al), 228 (lot, F Series-1 et al), 284 (lot, F et al);

## FRITH (continued)

Christies NY 2/13/85: 133 (lot, F-1 et al), 144 (albums, F et al);

Harris Baltimore 3/15/85: 40 (lot, F-2 et al)(note);

Phillips Lon 3/27/85: 143 (lot, F-1 et al), 168 (album, F et al), 173 (album, F et al), 184 (album, F-10 et al), 186 (album, F et al), 239 (lot, F et al), 267 ill(lot, F et al), 268 (lot, F-28 et al);

Christies Lon 3/28/85: 55 (49), 60 (F Series, 15), 92 (albums, F et al), 99 (album, F et al), 108 (book, 24), 109 (book, 15), 170 (albums, F et al), 171 (F Series, 8), 311 (albums, F Series et al), 335 (lot, F Series et al), 337 (lot, F Series et al);

Sothebys Lon 3/29/85: 64 (lot, F et al), 79 ill;

Sothebys NY 5/7/85: 200 ill, 415 (lot, F-2 et al);

Sothebys NY 5/8/85: 631 (lot, F et al);

Swann NY 5/9/85: 386 (albums, F et al);

California Galleries 6/8/85: 211, 212 (2), 213 (2, attributed);

Phillips Lon 6/26/85: 139 (book, 24);

Christies Lon 6/27/85: 38 (lot, F-1 et al), 87 (album, F Series et al), 91 (lot, F Series et al), 94 (albums, F Series et al), 96 (album, F Series et al), 157 ill, 158 ill, 159 ill(book, 76), 160 (40);

Sothebys Lon 6/28/85: 53 (10)(note), 54 ill, 55 ill, 56 ill;

Phillips Lon 10/30/85: 13 (lot, F et al), 15 (lot, F-2 et al), 127 (lot, F et al);

Christies Lon 10/31/85: 61 (lot, F-1 et al), 71 (lot, F-2 et al), 72 (10), 73 (85), 74 (49), 77 (albums, F Series-3 et al), 93 (15), 130 (lot, F attributed et al), 132 (albums, F Series et al), 145 (book, 15), 146 (book, 24), 147 (books, F-24 et al), 185 (book, F-3 et al), 299 (album, F-2 et al);

Sothebys Lon 11/1/85: 30 ill, 31 ill, 32 ill, 33 ill (books, 148), 58 (book, F et al), 102 (lot, F Series-12 et al), 103 (lot, F et al);

Christies NY 11/11/85: 190 ill;

Swann NY 11/14/85: 27 (lot, F et al), 28 (albums, F et al), 74 (lot, F Series et al), 86 (lot, F et al), 129 (lot, F-1 et al);

Harris Baltimore 2/14/86: 200 (album, F et al), 203 (album, F Series et al), 204 (album, F et al), 206 (album, F et al), 213 (album, F et al), 299 (lot, F et al), 303 (48), 304, 305, 347 (lot, F Series et al);

Phillips Lon 4/23/86: 181 (lot, F-1 et al);

Christies Lon 4/24/86: 331 (lot, F-14 et al), 351 (lot, F-21 et al), 358 ill(lot, F-50 et al), 369 (lot, F-4 et al), 401 (albums, F et al), 402 (lot, F-1 et al), 406 (album, F Series et al), 475, 476 ill, 477 ill, 598 (lot, F Series et al);

Sothebys Lon 4/25/86: 25 ill, 26 (8), 27 ill, 125 ill(book, 15), 148 (100);

Swann NY 5/16/86: 233 (lot, F et al), 234 (album, F Series et al), 241 (lot, F-24 et al), 242 (30);

Christies Lon 6/26/86: 62 (albums, F Series et al), 106 (album, 30), 107 ill(book, 52), 118 (albums, F et al), 150A (lot, F-4 et al), 190 (album, F Series et al);

Christies Lon 10/30/86: 19A (lot, F et al), 36 (lot, F et al), 37 (lot, F-7 et al), 82 (lot, F-3 et al), 83 (lot, F-1 et al), 239 (album, F Series-2 et al);

Sothebys Lon 10/31/86: 39 ill(F Series, 9);

Harris Baltimore 11/7/86: 143 (book, F-24 et al), 237 (album, F-1 et al);

FRITH (continued)
Sothebys NY 11/10/86: 228 ill;
Phillips NY 11/12/86: 89 (8), 90 (18);
Swann NY 11/13/86: 52 ill(books, 108)(note), 219
    (lot, F et al), 319 (lot, F-2 et al), 327 (25),
    330 (lot, F et al), 356 (lot, F et al);

FROISSART (French)
Photos dated: 1856-1860s
Processes:    Albumen
Formats:      Stereos
Subjects:     Documentary (disasters)
Locations:    France - Lyon
Studio:       France - Lyon
    Entries:
Rauch Geneva 6/13/61: 127;
Sothebys Lon 3/9/77: 204;

FRONTI (see MORSE & FRONTI)

FROST, E.S.
Photos dated: c1875-c1880s
Processes:    Albumen
Formats:      Prints
Subjects:     Architecture
Locations:    US - Pasadena, California
Studio:       US
    Entries:
California Galleries 3/30/80: 379 (lot, F-1 et al);
California Galleries 6/19/83: 362 (lot, F et al);
Swann NY 11/13/86: 133 (lot, F et al);

FROST, George (British)
Photos dated: Nineteenth century
Processes:    Albumen
Formats:      Cdvs
Subjects:     Portraits
Locations:    England
Studio:       England - Alton, Hampshire
    Entries:
Rinhart NY Cat 6, 1973: 242;

FRY (see ELLIOTT & FRY) [FRY 1]

FRY & RAHN [FRY 2]
Photos dated: 1860s
Processes:    Albumen
Formats:      Prints
Subjects:     Portraits
Locations:    India
Studio:
    Entries:
Sothebys Lon 10/24/79: 92 (album, F & R-3 et al);

FRY, Herbert (British)
Photos dated: 1850s and/or 1860s
Processes:    Albumen
Formats:      Prints
Subjects:     Portraits
Locations:    Studio
Studio:       Great Britain
    Entries:
Sothebys Lon 3/27/81: 226 (lot, F et al);

FRY, Peter Wickens (British, died 1860)
Photos dated: 1847-1854
Processes:    Calotype
Formats:      Prints
Subjects:     Portraits, genre, topography
Locations:    England; France
Studio:       England
    Entries:
Sothebys Lon 7/1/77: 184 (album, F et al)(note);
Mancini Phila 1979: 20 ill, 21, 22 ill;
Sothebys Lon 3/14/79: 259 ill(attributed), 260 ill
    (lot, F attributed et al), 262 ill(lot, F
    attributed et al), 264 ill;
Sothebys Lon 10/24/79: 304 ill;
Sothebys Lon 3/27/81: 175 (album, F et al);
Sothebys Lon 10/28/81: 184 (3);
Christies Lon 6/23/83: 205;
Sothebys NY 11/9/83: 153;
Christies Lon 3/29/84: 129;
Sothebys Lon 10/31/86: 78 (2);

FRY, Samuel
Photos dated: 1860s
Processes:    Diapositive on glass
Formats:      Stereo plates
Subjects:     Portraits, documentary (scientific)
Locations:    England
Studio:       England - London
    Entries:
Christies Lon 6/18/81: 83 (lot, F-1 et al)(note);
Sothebys Lon 10/28/81: 304 (lot, F-1 et al);
Christies Lon 10/31/85: 54 (lot, F-1 et al);

FRY, W. & A.H. (British)
Photos dated: 1880s
Processes:    Albumen
Formats:      Prints
Subjects:     Portraits
Locations:    Studio
Studio:       England - Brighton
    Entries:
Edwards Lon 1975: 12 (album, F et al);
California Galleries 1/21/78: 134 (lot, F et al);
Christies Lon 6/28/84: 327 (album, F et al);

FUKAZAWA, Yokitsu (Japanese)
Photos dated: 1870s-1880s
Processes:    Albumen
Formats:      Prints
Subjects:
Locations:    Japan
Studio:       Japan - Kobe
    Entries:
Phillips NY 11/3/79: 185 (album, F-5 et al);
Swann NY 11/8/84: 215 (lot, F-3 et al);

FULLER (American)
Photos dated: c1865
Processes:    Albumen
Formats:      Stereos
Subjects:     Topography
Locations:    US - Madison, Wisconsin
Studio:       US - Madison, Wisconsin
    Entries:
Rinhart NY Cat 8, 1973: 48 (7);

**FULLER, George** (American, 1822-1884)
Photos dated: 1840-1847
Processes:      Daguerreotype
Formats:        Plates
Subjects:       Portraits
Locations:      Studio
Studio:         US - Boston, Massachusetts
    Entries:
Christies NY 5/4/79: 73 ill(note);

**FULLER, Cadet L.M.** (American)
Photos dated: 1890s
Processes:      Albumen
Formats:        Prints
Subjects:       Documentary (educational institutions)
Locations:      US - West Point, New York
Studio:         US - West Point, New York
    Entries:
Swann NY 11/13/86: 353 (lot, F-22 et al)(note);

**FURNALD, D.O.** (American)
Photos dated: 1860s
Processes:      Ambrotype
Formats:        Plates
Subjects:       Portraits
Locations:      Studio
Studio:         US - Manchester, New Hampshire
    Entries:
Vermont Cat 1, 1971: 156;
Vermont Cat 4, 1972: 495 ill(lot, F-9 et al);
Vermont Cat 5, 1973: 443 ill;

**FURNE Fils** (see TOURNIER, H.)

**FURNIANCE** (American)
Photos dated: 1880s
Processes:      Albumen
Formats:        Prints
Subjects:       Topography
Locations:      US - Philadelphia, Pennsylvania
Studio:         US - New York City
    Entries:
Christies Lon 10/31/85: 127 (album, F-2 et al);

**FUSETTI**
Photos dated: Nineteenth century
Processes:      Albumen
Formats:        Cabinet cards
Subjects:       Portraits
Locations:      Europe
Studio:         Europe
    Entries:
Harris Baltimore 3/15/85: 277 (lot, F et al);

**FUSSELL, W.A.**
Photos dated: 1856-1858
Processes:      Daguerreotype
Formats:        Plates
Subjects:       Genre
Locations:
Studio:
    Entries:
Christies Lon 3/24/83: 26 (lot, F-2 et al);

G. [same] (Italian)
Photos dated: 1880s
Processes:    Albumen
Formats:      Prints
Subjects:     Topography
Locations:    Italy - Palermo
Studio:       Italy - Palermo
   Entries:
Swann NY 4/1/82: 288 (album, G et al);
Swann NY 11/13/86: 245 (lot, G et al);

G., C. [C.G.](see G., Ch.)

G., Ch. [Ch. G.](aka G.,C.) (French)
Photos dated: 1860s
Processes:    Albumen
Formats:      Stereos incl. tissue
Subjects:     Topography, genre
Locations:    France - Paris
Studio:       France - Paris
   Entries:
Rinhart NY Cat 7, 1973: 371 ill;
California Galleries 9/27/75: 544 (lot, G et al);
California Galleries 4/3/76: 448 (lot, G et al);
California Galleries 1/21/78: 188 (lot, G et al);
Christies Lon 10/30/80: 109 (lot, G et al);
Christies Lon 10/29/81: 158 (lot, G et al);
Christies Lon 10/28/82: 32 (lot, G et al);
Harris Baltimore 4/8/83: 103 (lot, G et al);
Christies Lon 3/28/85: 53 (lot, G et al);

G., D. [D.G.]
Photos dated: 1850s
Processes:    Daguerreotype
Formats:      Stereo plates
Subjects:     Genre (still life)
Locations:
Studio:
   Entries:
Christies Lon 10/31/85: 44 (lot, G-1 et al);

G., F.R. [F.R.G.] (French)
Photos dated: c1860s
Processes:    Albumen
Formats:      Stereos (tissues)
Subjects:     Topography
Locations:    France
Studio:       France
   Entries:
Harris Baltimore 4/8/83: 103 (lot, G et al);

G., J. [J.G.]
Photos dated: Nineteenth century
Processes:    Albumen
Formats:      Prints
Subjects:     Topography
Locations:    Europe
Studio:       Europe
   Entries:
Harris Baltimore 11/7/86: 260 (lot, G et al);

G., J.W.G. (see GRACE, J.)

G., S.G.D. [S.G.D.G.] (French)
Photos dated: mid 1850s
Processes:    Collodion on glass
Formats:      Stereo plates
Subjects:     Topography
Locations:    France
Studio:       France
   Entries:
Rinhart NY Cat 6, 1973: 456;

G., T. [TG]
Photos dated: 1879-1882
Processes:    Albumen
Formats:      Prints
Subjects:     Documentary (Zulu War)
Locations:    South Africa
Studio:
   Entries:
Swann NY 11/14/85: 191 ill(lot, G et al);

G., W. [W.G.] (American)
Photos dated: 1864
Processes:    Albumen
Formats:      Prints
Subjects:     Documentary (Civil War)
Locations:    US - Virginia
Studio:       US
   Entries:
Witkin NY II 1974: 1100 ill;

GABLER, A. (Swiss)
Photos dated: 1860s-1890s
Processes:    Albumen
Formats:      Prints, stereos, cdvs
Subjects:     Topography
Locations:    Switzerland
Studio:       Switzerland - Interlaken
   Entries:
Rauch Geneva 6/13/61: 223 (lot, G et al);
Christies Lon 10/29/81: 144 (lot, G et al);
Christies Lon 3/11/82: 94 (lot, G et al);
Christies Lon 6/24/82: 56 (lot, G et al);
Harris Baltimore 4/8/83: 100 (lot, G et al);
Christies Lon 4/24/86: 344 (lot, G et al);

GAEL, Edgar (British)
Photos dated: c1870s
Processes:    Albumen
Formats:      Prints
Subjects:     Documentary (military)
Locations:
Studio:       England - Bromley, Kent
   Entries:
Rinhart NY Cat 8, 1973: 90;

GAENSLY, G.W.
Photos dated: 1870s
Processes:    Albumen
Formats:      Prints
Subjects:     Topography
Locations:    Brazil - Bahia
Studio:       Brazil - Bahia
   Entries:
Christies Lon 10/31/85: 84 (lot, G-9 et al);
Christies Lon 6/26/86: 25 (album, G et al);

GAGE, Franklin B. (American, 1824-1874)(see also
                    PRESCOTT)
Photos dated: 1846-1860s
Processes:      Daguerreotype, albumen
Formats:        Plates, stereos, cdvs
Subjects:       Topography
Locations:      US - Vermont
Studio:         US - St. Johnsbury, Vermont
    Entries:
Sothebys NY (Strober Coll.) 2/7/70: 538 (lot, G-1
    et al);
Sothebys NY 5/20/80: 282 ill(note);
Swann NY 11/10/83: 242 (lot, G & Prescott et al)
    (note);

GAINES (American)
Photos dated: Nineteenth century
Processes:
Formats:
Subjects:       Topography
Locations:      US
Studio:         US
    Entries:
Swann NY 11/8/84: 143 (lot, G et al);
Swann NY 5/9/85: 322 (lot, G et al);

GALBRAITH, JENNINGS & Co. (British)
Photos dated: c1870
Processes:      Albumen
Formats:        Prints
Subjects:       Architecture
Locations:      Great Britain - Northern Ireland
Studio:         Great Britain - Belfast, Northern
Ireland
    Entries:
White LA 1977: 38 ill;

GALE, J.
Photos dated: 1860s
Processes:      Photomezzotint
Formats:        Prints
Subjects:       Topography
Locations:
Studio:
    Entries:
Christies Lon 10/29/81: 168;

GALE, Colonel Joseph (British, died 1906)
Photos dated: 1883-1891
Processes:      Albumen, bromide, photogravure, carbon
Formats:        Prints
Subjects:       Genre (rural life)
Locations:      England - Cornwall
Studio:         Great Britain
    Entries:
Sothebys Lon 3/19/76: 130 ill(2)(note);
Sothebys Lon 3/9/77: 219;
Christies Lon 10/27/77: 406 ill(note);
Phillips Lon 3/13/79: 155 ill;
Sothebys Lon 6/29/79: 256 ill;
Sothebys Lon 6/27/80: 249 ill(album, 33)(note);
Sothebys Lon 3/27/81: 338 (4 ills)(58);
Sothebys Lon 6/25/82: 54 (books, G-1 et al);
Christies NY 11/8/83: 201 (book, G et al);

GALLE (French)
Photos dated: 1850s
Processes:      Daguerreotype
Formats:        Plates
Subjects:       Portraits
Locations:      Studio
Studio:         France
    Entries:
Rauch Geneva 6/13/61: 37 (lot, G-1 et al);

GALLIER
Photos dated: 1850s
Processes:      Daguerreotype
Formats:        Plates
Subjects:       Portraits
Locations:
Studio:
    Entries:
Sothebys Lon 10/28/81: 283;

GALLINE
Photos dated: 1870s
Processes:      Albumen
Formats:        Prints
Subjects:       Genre (animal studies)
Locations:
Studio:
    Entries:
Sothebys NY 5/8/79: 92 ill(lot, G-1 et al);

GALLOT, Charles (French)
Photos dated: 1860s-1885
Processes:      Carbon
Formats:        Prints, stereos
Subjects:       Portraits, topography
Locations:      Studio
Studio:         France - Cherbourg
    Entries:
Christies Lon 6/27/78: 172 (book, G et al);
Christies Lon 10/26/78: 431 (book, G et al);
Christies Lon 3/15/79: 315 (book, 25);

GALLUP, C.H. (American)
Photos dated: 1890-1900
Processes:
Formats:        "Stamp" portraits
Subjects:       Documentary (educational institutions)
Locations:      US - New York State
Studio:         US - Poughkeepsie, New York
    Entries:
Swann NY 10/18/79: 308 (album, 200)(note);
Swann NY 4/23/81: 441 (album)(note);

GALTON, Sir Francis (British)
Photos dated: 1881-1883
Processes:      Autotype
Formats:        Prints
Subjects:       Documentary (scientific)
Locations:      Great Britain
Studio:         Great Britain
    Entries:
Swann NY 2/14/52: 152 (book, 5)(note);

GAMBLE, D.C. (American)
Photos dated: 1862-1863
Processes:    Albumen
Formats:      Prints
Subjects:     Documentary (Civil War)
Locations:    US - Mississippi
Studio:       US
    Entries:
Swann NY 9/18/75: 185 (note);
White LA 1977: 88 ill;

GAMINO (Spanish)
Photos dated: c1880
Processes:    Albumen
Formats:      Prints
Subjects:     Topography
Locations:    Spain
Studio:       Spain
    Entries:
California Galleries 7/1/84: 256 (3);

GANAZZINI (Italian)
Photos dated: 1860s
Processes:    Albumen
Formats:      Cdvs
Subjects:     Topography
Locations:    Italy
Studio:       Italy - Bellagio
    Entries:
Petzold Germany 11/7/81: 309 (album, G et al);

GARCIN, A. (Swiss)
Photos dated: 1860s-1870s
Processes:    Albumen
Formats:      Prints, stereos, cdvs
Subjects:     Topography
Locations:    Switzerland - Geneva and Lucerne;
              France - Chamonix
Studio:       Switzerland - Geneva
    Entries:
Rauch Geneva 6/13/61: 223 (lot, G et al);
Sothebys NY 2/25/75: 138 (lot, G-1 et al);
California Galleries 4/2/76: 84 (lot, G et al);
California Galleries 4/3/76: 323 (lot, G-1 et al);
Swann NY 11/11/76: 450 (lot, G et al);
Swann NY 4/14/77: 245 (album, G et al);
Christies Lon 10/26/78: 152 (6);
Sothebys Lon 3/21/80: 364 (lot, G-4 et al);
Christies Lon 6/26/80: 213 (lot, G-6 et al);
Sothebys Lon 10/29/80: 94 (2);
Christies Lon 3/26/81: 202 (lot, G-1 et al), 206
    (lot, G-6 et al);
California Galleries 6/28/81: 220 (lot, G-1 et al);
Christies Lon 10/29/81: 144 (lot, G et al);
Petzold Germany 11/7/81: 309 (album, G et al);
California Galleries 5/23/82: 292 (lot, G-1 et al);
Sothebys Lon 6/24/83: 17 (lot, G et al);

GARD, E.R. (American)
Photos dated: Nineteenth century
Processes:    Albumen
Formats:      Cdvs
Subjects:     Portraits
Locations:    Studio
Studio:       US - Chicago, Illinois
    Entries:
Sothebys NY (Strober Coll.) 2/7/70: 293 (lot,
    G et al);

GARDINER, R.H. (American)
Photos dated: c1885
Processes:    Albumen
Formats:      Prints
Subjects:     Topography
Locations:    US - Oregon; Washington
Studio:       US - Walla Walla, Washington
    Entries:
California Galleries 4/2/76: 232;

GARDNER (see SMITH & GARDNER)

GARDNER, A.B. (American)
Photos dated: c1890
Processes:    Albumen
Formats:      Cabinet cards
Subjects:     Portraits
Locations:    Studio
Studio:       US - Utica, New York
    Entries:
Harris Baltimore 7/31/81: 244 (lot, G-1 et al);

GARDNER, Alexander (British, American, 1821-1882)
Photos dated: 1858-1882
Processes:    Albumen
Formats:      Prints, stereos, cdvs
Subjects:     Portraits, documentary (Civil War,
              railroads), ethnography
Locations:    US - Washington, D.C.; Civil War area;
              American west
Studio:       US - Washington, D.C.
    Entries:
Sothebys NY (Weissberg Coll.) 5/16/67: 71 (book,
    100)(note), 172 (lot, G et al);
Sothebys NY (Strober Coll.) 2/7/70: 22 (book, 100),
    267 (lot, G-1 et al), 287 (lot, G-1 et al), 297
    (lot, G et al), 310 (lot, G & Gibson-2, et al),
    324 (lot, G et al), 330, 357 (38)(note), 386
    (lot, G-1 et al), 389 (lot, G-1 et al), 395
    (lot, G-1 et al), 412 (lot, G-1 et al), 423
    (lot, G-2 et al)(note), 430 (3), 431 ill(note),
    480 (lot, G-1 et al), 535 (lot, G-3 et al), 540
    (lot, G & Gibson-1, et al), 541 (lot, G-3 et
    al), 545 (lot, G-1 attributed et al), 553 (lot,
    G et al)(note), 554 (16)(note), 555 (lot, G-3 et
    al), 557 (lot, G-5 et al), 560 (lot, G et al);
Sothebys NY (Greenway Coll.) 11/20/70: 175 (lot,
    G-1 et al), 176 (lot, G-3 et al), 177 (lot, G-3
    et al), 178 (lot, G-2 et al), 179 (lot, G-3
    et al), 181 (lot, G-2 et al), 182 (lot, G-2 et al),
    186 ill(lot, G-1 et al), 189 (lot, G-1 et al),
    191 (lot, G-1 et al), 196 (lot, G-1 et al), 205
    ill, 209 ill, 217 (lot, G-1 et al), 232 (lot,
    G-1 et al), 241 (lot, G-1 et al), 249 (lot, G-1
    et al), 251 (lot, G-1 et al), 267 (lot, G-1 et
    al), 268 (lot, G-1 et al), 278 (lot, G-1 et al);

Sothebys NY 11/21/70: 23 ill(books, 200);
Rinhart NY Cat 1, 1971: 188, 495 (2 ills)(book,
    G et al)(note);
Vermont Cat 1, 1971: 219 ill, 222 (2);
Vermont Cat 4, 1972: 461 ill(G & Gibson), 469 ill
    (lot, G-1 et al), 484 ill(lot, G-1 et al);
Lunn DC Cat 3, 1973: 57 ill(book, 100);
Rinhart NY Cat 7, 1973: 47 (book, 8), 333;
Vermont Cat 8, 1974: 559 ill;
Sothebys Lon 6/21/74: 162 (book, G et al);
Sothebys Lon 10/18/74: 137 (book, G et al);
Swann NY 2/6/75: 79 (book, 8)(note);
Sothebys NY 2/25/75: 108 ill(album, G et al);
Sothebys NY 9/23/75: 88 (lot, G-1 et al), 110
    (albums, G et al)(note);
California Galleries 9/26/75: 286;
California Galleries 9/27/75: 470 (lot, G et al);
Colnaghi Lon 1976: 241 (3 ills)(book, 100)(note);
Lunn DC Cat 6, 1976: 49.1 ill(note), 49.2, 49.3,
    49.4;
Witkin NY IV 1976: 344 ill;
Wood Conn Cat 37, 1976: 68 (3 ills)(book, G et al)
    (note), 278 ill;
California Galleries 4/2/76: 233 ill, 234, 235,
    236, 237, 238, 239, 240 ill;
Sothebys NY 11/9/76: 83 ill, 84;
Gordon NY 11/13/76: 48 (albums, G et al);
Halsted Michigan 1977: 641 (note), 642, 643, 644,
    645, 646, 647, 648, 649, 650, 651, 652;
California Galleries 1/22/77: 305, 306, 307, 308,
    309, 310, 311 ill;
Sothebys NY 2/9/77: 65 (3 ills)(books, 100), 69 ill
    (note), 71, 72 ill(27)(note);
Swann NY 4/14/77: 250A ill(book, G et al), 309
    (lot, G-2 et al);
Sothebys NY 10/4/77: 8 (2), 9 ill(note), 10 ill
    (note), 11 (note), 17 (lot, G-3 et al), 107
    (lot, G-2 attributed et al);
Frontier AC, Texas 1978: 107 (6)(note);
Lunn DC Cat QP, 1978: 37 (book, G et al)(note);
Witkin NY VI 1978: 63 ill(note);
Wood Conn Cat 41, 1978: 129 ill(book, G-16 et al)
    (note);
California Galleries 1/21/78: 355 ill, 356, 357;
Sothebys LA 2/13/78: 43 ill(attributed)(note);
Christies Lon 3/16/78: 126 ill;
Sothebys Lon 3/22/78: 98 ill(20)(note), 99 ill(20),
    100 (20), 101 ill(22), 102 ill(20), 103 ill(20);
Sothebys NY 5/2/78: 3;
Lehr NY Vol 1:4, 1979: 31 (book, G et al);
Lehr NY Vol 2:2, 1979: 11 ill, 12 ill;
Wood Conn Cat 45, 1979: 113 (book, G-16 et al)
    (note);
Swann NY 4/26/79: 476 ill(note);
Christies NY 5/4/79: 77 ill, 78 ill, 79 ill, 80 ill
    (note), 81 (attributed);
Phillips NY 5/5/79: 188 ill, 189;
Sothebys NY 5/8/79: 117 ill(note), 118, 119, 120,
    121 ill;
Sothebys Lon 6/29/79: 237 (4 ills)(4);
Swann NY 10/18/79: 306 ill(4)(note);
Christies NY 10/31/79: 61, 62;
Sothebys NY 11/2/79: 291 ill(album, G et al)(note);
Phillips NY 11/3/79: 187 ill;
Sothebys NY 12/19/79: 47 (2 ills)(albums, G-18
    et al);
Rose Boston Cat 5, 1980: 15 ill(note);
Sothebys LA 2/6/80: 24 ill, 25 (2);
Christies NY 5/16/80: 234 (6)(note);

Sothebys NY 5/20/80: 274 (lot, G et al), 277 ill
    (note), 278 ill(lot, G-1 et al), 279 ill(book,
    50), 280 ill(3);
Phillips NY 5/21/80: 254 ill(note), 263 ill
    (attributed)(note);
Swann NY 11/6/80: 87 (book, G et al);
Christies NY 11/11/80: 104 ill(attributed)(note),
    105 (attributed)(note), 106 ill(attributed), 112
    ill, 113 ill(note), 115 ill(5)(attributed)
    (note), 116 ill(3)(note), 117 (2)(note), 118
    (3)(note), 119 ill(3)(note), 120 ill(3)(note),
    121 (3)(note), 123 (2)(attributed)(note), 124
    (4)(note), 126 (attributed)(note);
California Galleries 12/13/80: 265, 266 (2);
Swann NY 4/23/81: 335 ill(note), 488 (note);
Petzold Germany 5/22/81: 1808 ill, 1809 ill;
Christies Lon 6/18/81: 78 (lot, G-2 et al);
California Galleries 6/28/81: 240 ill(note), 241
    (3), 242 (2), 307 (lot, G-1 et al), 374 (lot,
    G et al);
Harris Baltimore 7/31/81: 201;
Sothebys NY 10/21/81: 111 ill(27);
Swann NY 11/5/81: 314 (note);
Christies NY 11/10/81: 46 ill(attributed)(note);
Harris Baltimore 5/28/82: 35, 36, 37, 38, 39, 44,
    48, 59, 79 (attributed)(note), 80, 81, 82
    (attributed), 83 (attributed), 85, 86 (note), 87
    (note), 88 (lot, G-2 et al), 155 (6), 187
    (4, attributed), 194 (4, attributed);
Christies NY 11/8/82: 108 ill(note);
Sothebys NY 11/9/82: 236 ill(note);
Swann NY 11/18/82: 380;
Harris Baltimore 12/10/82: 249, 250, 251
    (attributed)(note), 252 (20), 253 (attributed),
    254 (note), 360 (lot, G-2 et al);
Christies NY 2/8/83: 17 ill(attributed)(note);
Swann NY 5/5/83: 107 ill(book, G et al)(note), 335;
Christies NY 5/9/83: 72 ill(note);
Harris Baltimore 9/16/83: 19, 20, 23, 24, 25, 27,
    28, 37, 38, 41 ill, 60, 62, 77, 78, 79, 177 ill
    (note), 178 ill(note), 179 (2), 189 (lot, A-1
    attributed et al);
Christies NY 11/8/83: 110 ill(note), 111 ill(note);
Harris Baltimore 12/16/83: 252 (note), 298 (album,
    G et al), 351;
Christies NY 5/7/84: 23 ill(3)(note);
Sothebys NY 5/8/84: 155 ill(book, G et al)(note);
Swann NY 5/10/84: 52 (book, G et al)(note);
Harris Baltimore 6/1/84: 30 (lot, G-3 et al), 157
    (lot, G-1 et al), 273, 364, 368, 371, 372;
California Galleries 7/1/84: 411, 412 (attributed),
    414;
Christies NY 9/11/84: 144;
Harris Baltimore 11/1/84: 8, 9, 15 ill, 21, 26, 27,
    31 (lot, G-5 et al), 53, 57 (attributed), 85
    (attributed), 93 (attributed), 127;
Christies NY 11/6/84: 34 ill(attributed)(note);
Swann NY 11/8/84: 270;
Christies NY 2/13/85: 154 ill(2);
Harris Baltimore 3/15/85: 192 (lot, G-2 et al);
California Galleries 6/8/85: 216, 217, 218;
Harris Baltimore 9/27/85: 10 ill(book, 50), 11 (2)
    (note), 30 (attributed)(note), 31 (2, attributed)
    (note), 36 (attributed), 71 (note);
Christies Lon 10/31/85: 204 ill;
Sothebys Lon 11/1/85: 4 ill(lot, G et al);
Christies NY 11/11/85: 192 ill(note);
Sothebys NY 11/12/85: 136 ill(note), 137 ill(note);
Swann NY 11/14/85: 298 ill(note), 199 (note);

**GARDNER, A.** (continued)
Harris Baltimore 2/14/86: 8 (lot, G et al), 11 (lot,
  G et al), 12 (5), 24;
California Galleries 3/9/86: 723;
Christies NY 5/13/86: 124 ill;
Swann NY 5/15/86: 243 (note), 244 ill(note);
Phillips NY 7/2/86: 332, 333;
Harris Baltimore 11/7/86: 71, 96 (attributed), 101,
  102 (lot, G-3 et al), 106, 110 (lot, G-1
  attributed et al);
Sothebys NY 11/10/86: 388 (lot, G-1 et al);
Christies NY 11/11/86: 61 ill(lot, G-2 et al)(note);
Phillips NY 11/12/86: 92;
Swann NY 11/13/86: 224;

**GARDNER, J.B.**
Photos dated: 1860s and/or 1870s
Processes:      Albumen
Formats:        Cdvs
Subjects:       Portraits
Locations:
Studio:
  Entries:
Harris Baltimore 3/26/82: 395 (lot, G et al);

**GARDNER, James** (American, born 1832)
Photos dated: 1862-1865
Processes:      Albumen
Formats:        Prints
Subjects:       Documentary (Civil War)
Locations:      US - Virginia; Maryland
Studio:         US
  Entries:
Sothebys NY (Strober Coll.) 2/7/70: 555 (lot, G-1
  et al)(note);
Sothebys Lon 6/21/74: 162 (book, G et al);
Sothebys Lon 10/18/74: 137 (book, G et al);
Lunn DC Cat 6, 1976: 49.5, 49.20;
Sothebys NY 11/9/76: 77 ill(note), 81;
Sothebys NY 10/4/77: 17 (lot, G-1 et al);
Wood Conn Cat 41, 1978: 129 (book, G-10 et al)
  (note);
Wood Conn Cat 45, 1979: 113 (book, G-10 et al)
  (note);
Sothebys NY 5/20/80: 278 (lot, G-2 et al);
Christies NY 11/11/80: 128 (2);
Harris Baltimore 3/26/82: 211;
Harris Baltimore 5/28/82: 41, 42, 43, 45, 50, 51, 84
  (note);
Harris Baltimore 12/10/82: 248;
Harris Baltimore 9/16/83: 18, 21, 26, 47, 48, 49,
  50, 55, 59, 64;
Swann NY 11/10/83: 269;
Harris Baltimore 12/16/83: 349 (lot, G-1 et al),
  350 (lot, G-1 et al), 352 (lot, G-1 et al);
Harris Baltimore 6/1/84: 367;
California Galleries 7/1/84: 415, 416;
Harris Baltimore 11/9/84: 7, 10, 18, 23;
Harris Baltimore 3/15/85: 192 (lot, G-1 et al);
Harris Baltimore 9/27/85: 12;
Harris Baltimore 2/14/86: 9 (lot, G-1 et al), 306
  (note);

**GARDNER, Walter** (American)
Photos dated: 1880s
Processes:      Albumen
Formats:        Prints
Subjects:       Topography
Locations:      US - Gloucester, Massachusetts
Studio:         US
  Entries:
Christies Lon 6/28/79: 118 (lot, G-4 et al);

**GARLIC, T.T.** (American)
Photos dated: Nineteenth century
Processes:      Albumen
Formats:        Cdvs
Subjects:       Portraits
Locations:      Studio
Studio:         US - Portsmouth, Ohio
  Entries:
Sothebys NY (Strober Coll.) 2/7/70: 261 (lot,
  G et al);

**GARNER** (American)
Photos dated: 1870s
Processes:      Albumen
Formats:        Cdvs
Subjects:       Portraits
Locations:      Studio
Studio:         US - Columbus, Mississippi
  Entries:
Swann NY 9/18/75: 229 (album, G et al);

**GARNETT, J.** (British)
Photos dated: 1867-1868
Processes:      Albumen
Formats:        Prints, stereos
Subjects:       Topography
Locations:      England - Lake District
Studio:         England - Windermere
  Entries:
Christies Lon 6/14/73: 96 (book, G & Sproat et al);
California Galleries 9/26/75: 171 (book, G &
  Sproat, 16);
California Galleries 1/22/77: 184 (book, 16);
Sothebys Lon 7/1/77: 31 (book, G & Sproat, 14);
Swann NY 4/20/78: 120 (book, G et al);
Christies Lon 10/26/78: 214 (book, G & Sproat, G &
  Bowers);
California Galleries 1/21/79: 153 (book, G &
  Sproat, 16);
Christies Lon 3/11/82: 65 (lot, G et al);
Christies Lon 10/25/84: 44 (lot, G et al);

**GARNETT, Captain R.E.**
Photos dated: 1850s
Processes:      Salt
Formats:        Prints
Subjects:       Portraits
Locations:
Studio:
  Entries:
Sothebys Lon 3/15/82: 409 (album, G-1 et al);
Christies Lon 6/24/82: 351A;
Christies Lon 10/28/82: 195;

**GARNIER, Arsène** (French)
Photos dated: 1860
Processes:
Formats:        Prints
Subjects:       Portraits, topography
Locations:      England - Guernsey
Studio:         England - Guernsey
    Entries:
Andrieux Paris 1950(?): 37 (book, 2)(note);

**GARNIER, Henry** (French)
Photos dated: 1858-1870
Processes:      Carbon
Formats:        Prints
Subjects:       Genre
Locations:      France - Chartres
Studio:         France
    Entries:
Christies NY 5/6/85: 50 (book, G et al);

**GARREAUD, Emilio & Co.**
Photos dated: 1855-1870
Processes:      Albumen
Formats:        Prints
Subjects:       Topography
Locations:      Peru; Chile - Valparaiso, Santiago,
                Tierra del Fuego
Studio:         Peru
    Entries:
Swann NY 11/14/85: 85 ill(album, G-78 et al)(note);

**GARRETT Brothers** (American)
Photos dated: c1875-1877
Processes:      Albumen
Formats:        Cabinet cards
Subjects:       Portraits, documentary (educational
                institutions)
Locations:      US - Philadelphia, Pennsylvania; New
                Haven, Connecticut
Studio:         US - Philadelphia, Pennsylvania;
                Wilmington, Delaware
    Entries:
California Galleries 1/21/79: 361 (album, G et al);
Swann NY 11/10/83: 244 (lot, G et al);

**GARRIGUES, J.**
Photos dated: 1860s-1870s
Processes:      Albumen
Formats:        Prints, stereos
Subjects:       Topography
Locations:      Tunisia
Studio:         Tunisia - Tunis
    Entries:
Swann NY 4/26/79: 282 (albums, G et al);
Christies Lon 10/29/81: 276 (album, G-5 et al);
Bievres France 2/6/83: 122 (albums, F et al), 145
    (lot, G-5 et al);
Sothebys Lon 3/29/85: 77 (albums, G et al);

**GARZON** (Spanish)
Photos dated: 1870s-c1890
Processes:      Albumen
Formats:        Prints
Subjects:       Topography
Locations:      Spain - Granada
Studio:         Spain
    Entries:
California Galleries 4/3/76: 319 (lot, G-2 et al);
Rose Boston Cat 3, 1978: 78 ill(note), 79 ill;
Christies Lon 10/26/78: 162 (lot, G-8 et al), 242
    (lot, G-15 et al);
Rose Boston Cat 4, 1979: 67 ill, 68 ill, 69 ill;
Sothebys NY 5/8/79: 103 (lot, G-3 et al);
Christies Lon 6/26/80: 213 (lot, G-8 et al);
Christies Lon 3/26/81: 206 (lot, G-8 et al);
California Galleries 5/23/82: 394 (17);
Christies Lon 10/27/83: 87 (albums, G et al);
Christies NY 2/22/84: 6 (album, G et al);
Swann NY 11/14/85: 154 (lot, G-5 et al);

**GASPAR** (see CARNEIRO & GASPAR)

**GATES, C.A.** (American)(see also GATES, G.F.)
Photos dated: c1870s
Processes:      Albumen
Formats:        Stereos
Subjects:       Topography
Locations:      US - Watkins Glen, New York
Studio:         US - Watkins, New York
    Entries:
California Galleries 4/3/76: 425 (20);

**GATES, George F.** (American)
Photos dated: 1860s-1870s
Processes:      Albumen
Formats:        Stereos
Subjects:       Topography
Locations:      US - New York City; India
Studio:         US - Watkins, New York
    Entries:
Rinhart NY Cat 1, 1971: 190 (3), 195 (lot, G et
    al), 305 (lot, G & Crum et al);
Rinhart NY Cat 7, 1973: 235;
California Galleries 9/27/75: 525 (lot, G et al);
California Galleries 4/3/76: 426 (lot, G et al);
California Galleries 1/23/77: 370 (lot, G et al),
    419 (lot, G et al);
California Galleries 1/21/78: 183 (lot, GF & CAG
    et al);
California Galleries 1/21/79: 301 (lot, G et al),
    302 (lot, GF & CAG et al);
California Galleries 3/30/80: 418 (lot, G et al),
    419 (lot, GF & CAG et al);
California Galleries 6/28/81: 321 (lot, GF & CAG
    et al), 322 (lot, G et al);
Harris Baltimore 4/8/83: 68 (lot, G et al), 69
    (lot, G et al), 86 (lot, G et al);
Harris Baltimore 12/16/83: 47 (lot, G-2 et al), 91
    (lot, G et al);
Harris Baltimore 6/1/84: 103 (lot, G et al);
Swann NY 11/8/84: 264 (lot, G et al);
Harris Baltimore 3/15/85: 69 (lot, G et al);
Swann NY 11/14/85: 157 (lot, G et al);
Harris Baltimore 2/14/86: 38 (lot, G et al);
Swann NY 11/13/86: 323 (lot, G-10 et al);

GATES, P. Tenney (American)
Photos dated: 1850s-1860s
Processes:      Ambrotype
Formats:        Plates
Subjects:       Portraits
Locations:      Studio
Studio:         US - Plattsburg, New York
    Entries:
Swann NY 4/23/81: 271 (lot, G-1 et al);

GATES, W.D. (American)
Photos dated: 1870s-1880s
Processes:      Albumen
Formats:        Stereos
Subjects:       Topography
Locations:      US - Watkins Glen, New York
Studio:         US - Syracuse, New York
    Entries:
Swann NY 5/5/83: 431 (lot, G et al)(note);
Swann NY 11/10/83: 353 (lot, G et al);
Christies Lon 3/29/84: 30 (lot, G-2 et al);
Swann NY 5/9/85: 434 (lot, G et al);

GAUDIN, Marc-Antoine-Augustin (French)
Photos dated: 1841-1840s
Processes:      Daguerreotype
Formats:        Plates
Subjects:       Topography, portraits
Locations:      France - Paris
Studio:         France - Paris
    Entries:
Christies Lon 3/20/80: 3 ill(note);

GAULD (American)
Photos dated: between 1870s and 1890s
Processes:      Albumen
Formats:
Subjects:       Topography
Locations:      US - American West
Studio:         US
    Entries:
Swann NY 4/1/82: 249 (lot, G et al);

GAUME, Dominique (French)
Photos dated: 1856
Processes:      Albumen
Formats:        Prints
Subjects:       Topography
Locations:      France - Paris and Le Mans
Studio:         France
    Entries:
Christies Lon 6/30/77: 283 ill;
Christies Lon 6/27/78: 74 ill;

GAUZI, François (French)
Photos dated: 1890s
Processes:
Formats:        Prints
Subjects:       Genre
Locations:      France
Studio:         France
    Entries:
Sothebys NY 5/12/86: 181 ill(lot, G-1 et al)(note);

GAY, D. (British)
Photos dated: 1857
Processes:      Albumen
Formats:        Prints
Subjects:       Documentary (maritime)
Locations:      England - Greenwich
Studio:         England - Greenwich
    Entries:
Sothebys Lon 6/26/75: 133 (lot, G-1 et al);

GEAKE, Thomas, Jr. (British)
Photos dated: 1850s
Processes:      Ambrotype
Formats:        Plates
Subjects:       Portraits
Locations:      Studio
Studio:         England - Sherborne
    Entries:
Sothebys Lon 3/8/74: 131 (lot, G-1 et al);
Sothebys Lon 6/11/76: 115 (lot, G-1 et al);

GEBBIE & HUSSON Co.
Photos dated: 1888
Processes:      Photogravure
Formats:        Prints
Subjects:       Topography
Locations:      Germany - Nuremberg
Studio:
    Entries:
Christies NY 5/14/80: 138 (book);

GEER, E. (American)
Photos dated: 1854
Processes:      Daguerreotype
Formats:        Plates
Subjects:       Portraits
Locations:      Studio
Studio:         US - New York City
    Entries:
Rinhart NY Cat 1, 1971: 74;

GEERING, Edmund (British)
Photos dated: 1880s
Processes:      Albumen
Formats:        Prints
Subjects:       Topography
Locations:      Great Britain
Studio:         Scotland - Aberdeen
    Entries:
Christies Lon 6/28/79: 2 (lot, G et al);

GEHRIG, J.W. (American)
Photos dated: 1880-1890s
Processes:      Albumen
Formats:        Prints, cabinet cards
Subjects:       Portraits
Locations:      Studio
Studio:         US - Chicago, Illinois
    Entries:
Sothebys NY 2/25/75: 105 ill(albums, G et al);
Wood Boston Cat 58, 1986: 136 (books, G et al);

**GEIGER, John Lewis**
Photos dated: 1874
Processes:      Autotype
Formats:        Prints
Subjects:       Topography
Locations:      Mexico
Studio:
    Entries:
Swann NY 2/14/52: 153 (book, G et al);
Witkin NY IV 1976: OP171 (book);
Swann NY 7/9/81: 216 (book, G et al);

**GEISLER, A.D.**
Photos dated: Nineteenth century
Processes:      Albumen
Fromats:        Stereos
Subjects:       Topography
Locations:      Europe
Studio:         Europe
    Entries:
Christies Lon 10/30/80: 120 (lot, G-4 et al);

**GELDMACHER** (German)
Photos dated: c1860
Processes:      Albumen
Formats:        Cdvs
Subjects:       Portraits
Locations:      Studio
Studio:         Germany - Frankfurt
    Entries:
Petzold Germany 11/7/81: 300 (album, G et al);

**GENCHE** (see EYTING & GENCHE)

**GENN**
Photos dated: c1877
Processes:      Albumen
Formats:        Prints
Subjects:       Topography
Locations:      Asia
Studio:
    Entries:
Harris Baltimore 11/7/86: 233 (album, G-1 et al);

**GEOFFRAY, Stephane** (French)
Photos dated: c1855-1870s
Processes:      Salt, albumen, photogravure
Formats:        Prints
Subjects:       Topography, documentary (art)
Locations:      France
Studio:         France
    Entries:
California Galleries 1/22/77: 199 (book, G-3 et al);
Drouot Paris 11/24/84: 75 ill;

**GEORGE, D.S.**
Photos dated: 1860s-1902
Processes:      Albumen
Formats:        Prints
Subjects:       Documentary (engineering)
Locations:      Egypt - Aswan
Studio:
    Entries:
Christies Lon 10/30/80: 248 (albums, G-5 et al);
Sothebys Lon 6/29/84: 79 (album, G et al);

**GEORGILADAKIS** (see GIORGILADAKI)

**GERARD, Charles** (aka G., C.)(French)
Photos dated: 1860s
Processes:      Albumen
Formats:        Stereos
Subjects:       Genre
Locations:      France - Paris; Germany; Greece
Studio:         France - Paris
    Entries:
Harris Baltimore 3/15/85: 42 (lot, G-36 et al);
Christies Lon 10/31/85: 68 (lot, G-16 et al);

**GERARD, Léon** (French)
Photos dated: 1857-1861
Processes:      Salt, albumen
Formats:        Prints
Subjects:       Topography
Locations:      Italy - Lombardy; Germany - Nuremberg,
                Bamberg, Rhine Valley; Switzerland
Studio:
    Entries:
Christies NY 5/26/82: 35;
Christies NY 11/8/83: 113 ill(note);

**GERLACH, Joseph** (German, 1820-1896)(photographer
                or author?)
Photos dated: 1863
Processes:
Formats:        Microphotographs
Subjects:       Documentary (scientific)
Locations:      Germany
Studio:         Germany
    Entries:
Weil Lon Cat 10, 1947(?): 336 (book, 7);
Swann NY 2/14/52: 156 (book, 7);

**GERLACH, Martin**
Photos dated: c1890
Processes:      Collotype
Formats:        Prints
Subjects:       Genre
Locations:      Studio
Studio:         Austria - Vienna
    Entries:
Swann NY 5/15/86: 97 ill(book, 141)(note), 98
    (book, 22);

**GERMON, Washington L.** (American)(see also
                McCLEES, J.E.)
Photos dated: 1850-c1865
Processes:      Daguerreotype, albumen
Formats:        Plates, stereos, cdvs
Subjects:       Portraits, topography
Locations:      US - Philadelphia, Pennsylvania
Studio:         US - Philadelphia, Pennsylvania
    Entries:
Sothebys NY (Strober Coll.) 2/7/70: 262 (lot,
    G et al);
Sothebys NY (Greenway Coll.) 11/20/70: 238 ill
    (lot, G-1 et al);
Swann NY 12/14/78: 403 (4)(note);
Swann NY 4/23/81: 501 ill(note);
Swann NY 4/1/82: 257 (note);
Swann NY 5/15/86: 222 (lot, G et al);

**GERSCHEL**
Photos dated: 1890s
Processes:       Albumen
Formats:         Cabinet cards
Subjects:        Portraits
Locations:       Studio
Studio:          France
    Entries:
Harris Baltimore 3/15/85: 269 (lot, G-1 et al);

**GERUZET** (Austrian)
Photos dated: 1890
Processes:
Formats:         Cabinet cards
Subjects:        Portraits
Locations:       Studio
Studio:          Austria - Vienna
    Entries:
Sothebys NY 11/20/84: 49 (lot, G-1 et al);

**GERVAIS-COURTELLEMENT** (French)
Photos dated: 1896
Processes:       Photogravure
Formats:         Prints
Subjects:        Genre (street life)
Locations:       France - Paris
Studio:          France
    Entries:
Sothebys NY 5/8/79: 97 ill(book)(note);
Sothebys LA 2/6/80: 188 (book);

**GETCHELL** (see CASE & GETCHELL)

**GETHING, G.B.** (British)
Photos dated: 1855-1857
Processes:       Albumen
Formats:         Prints
Subjects:        Topography
Locations:       Great Britain
Studio:          England - Newport (Photographic Club)
    Entries:
Sothebys Lon 3/21/75: 286 (album, G-1 et al);
Sothebys Lon 3/14/79: 324 (album, G-1 et al);
Sothebys Lon 11/1/85: 59 (album, G-1 et al);

**GETMAN** (American)
Photos dated: 1864-1866
Processes:       Tintype
Formats:         Plate
Subjects:        Portraits
Locations:       US - Richfield Springs, New York
Studio:          US - Richfield Springs, New York
    Entries:
Swann NY 11/11/76: 331;

**GEYER, A.H.**
Photos dated: 1898
Processes:       Woodburytype
Formats:         Prints
Subjects:        Documentary (medical)
Locations:       Scotland - Glasgow
Studio:
    Entries:
Wood Conn Cat 49, 1982: 353 ill(book, 18)(note);

**GHEMAR Frères** (Belgian)
Photos dated: 1860s
Processes:       Albumen
Formats:         Cdvs
Subjects:        Portraits
Locations:       Studio
Studio:          Belgium - Brussels
    Entries:
Sothebys Lon 3/21/75: 164 (album, G et al);
Sothebys Lon 6/26/75: 261 (albums, G et al);
Christies Lon 3/16/78: 299 (album, G et al);
Sothebys Lon 10/29/80: 261 (album, G et al);
Sothebys Lon 3/27/81: 226 (album, G et al);
Phillips Lon 3/17/82: 87 (album, G et al);
Christies Lon 6/24/82: 366 (album, G et al);
Harris Baltimore 3/15/85: 161 (album, G-1 et al);
Christies Lon 10/31/86: 217 (albums, G et al);

**GIACOMO, E.** (Italian)
Photos dated: c1860
Processes:       Albumen
Formats:         Prints
Subjects:        Documentary (art)
Locations:       Italy
Studio:          Italy
    Entries:
Sothebys Lon 4/25/86: 58 (lot, G et al);

**GIANNINI, Egidio** (Italian)
Photos dated: 1860s-1880s
Processes:       Albumen
Formats:         Prints
Subjects:        Topography
Locations:       Italy - Florence
Studio:          Italy
    Entries:
Phillips NY 5/21/80: 134 (album, 22);
Christies Lon 3/29/84: 55 (lot, G et al);

**GIBBARD, G.C.** (American)
Photos dated: 1870s
Processes:       Albumen
Formats:         Stereos
Subjects:        Topography, documentary
Locations:       US - New York City and Ossning, New York
Studio:          US - Auburn, New York
    Entries:
Harris Baltimore 7/31/81: 116 (lot, G et al);

**GIBBON** (see BAIRD & GIBBON)

**GIBBS, Reverend Heneage** (British)
Photos dated: 1850
Processes:       Calotype
Formats:         Prints
Subjects:        Topography
Locations:       England - Sidmouth
Studio:          England
    Entries:
Christies Lon 6/24/82: 91 ill(album, G-6 et al);
Christies Lon 6/23/83: 61 (album, G-6 et al);

**GIBBS, P.E.** (American)
Photos dated: 1840s-1850s
Processes:      Daguerreotype
Formats:        Plates
Subjects:       Portraits
Locations:      Studio
Studio:         US - Lynchburg, Virginia
    Entries:
Swann NY 4/23/81: 248 (lot, G-1 et al)(note);

**GIBSON** (American)
Photos dated: 1895
Processes:      Silver
Formats:        Prints, cabinet cards
Subjects:       Portraits
Locations:      Studio
Studio:         US - Chicago, Illinois; Ann Arbor,
Michigan
    Entries:
Swann NY 10/18/79: 383 (lot, G et al);
Swann NY 5/10/84: 289 (2);

**GIBSON, Alexander** (British, 1857-1944)
Photos dated: 1874-1900
Processes:      Albumen
Formats:        Prints
Subjects:       Topography, documentary (maritime)
Locations:      England - Cornwall
Studio:         England - Penzance, Cornwall
    Entries:
Rinhart NY Cat 8, 1973: 92 ill;
Edwards Lon 1975: 36 (album, G-1 et al);
Christies Lon 3/11/82: 119 ill(album, G et al)
    (note);
Phillips Lon 10/27/82: 51 ill(5), 52 (5), 53 (lot,
    G-1 et al)(note);
Phillips Lon 3/23/83: 43 (8);
Phillips Lon 10/24/84: 239 (lot, G et al);
Sothebys Lon 10/26/84: 181 (album, G et al);
California Galleries 6/8/85: 220 (2);
Phillips Lon 10/30/85: 127 (lot, G et al);
Christies Lon 4/24/86: 406 (album, G-3 et al);
Sothebys Lon 10/31/86: 79 ill(lot, G-67 et al);

**GIBSON, J.J.** (British)
Photos dated: 1850s
Processes:      Ambrotype
Formats:        Stereo plates
Subjects:       Topography
Locations:      England - Cumberland and Grassmere
Studio:         Great Britain
    Entries:
Christies Lon 6/28/84: 28 (lot, G-2 et al);

**GIBSON, J.P.** (British)
Photos dated: Nineteenth century
Processes:      Albumen
Formats:        Prints
Subjects:       Topography
Locations:      England
Studio:         England - Hexham
    Entries:
Sothebys Lon 3/14/79: 151 (album, 60);

**GIBSON, James F.** (American)(see also WOOD;
    BARNARD, G.)
Photos dated: 1862-1868
Processes:      Albumen
Formats:        Prints, cdvs
Subjects:       Documentary (Civil War)
Locations:      US - Washington, D.C.; Civil War area
Studio:
    Entries:
Sothebys NY (Strober Coll.) 2/7/70: 385 (lot, G et
    al), 386 (lot, G-3 et al), 553 (lot, G et al)
    (note), 555 (lot, G et al), 560 (lot, G et al);
Rinhart NY Cat 7, 1973: 334;
Sothebys Lon 6/21/74: 162 (book, G & Barnard, G &
    Wood, et al);
Swann NY 4/14/77: 250A (book, G et al);
Swann NY 11/6/80: 87 (book, G et al);
Sothebys NY 5/8/84: 155 ill(book, G et al)(note);
Harris Baltimore 6/1/84: 30 (lot, G-1 et al);
Harris Baltimore 11/9/84: 31 (lot, G-1 et al);

**GIERS, C.C.** (American)
Photos dated: 1870s
Processes:      Albumen
Formats:        Cdvs, stereos
Subjects:       Portraits, topography
Locations:      US - Tennessee
Studio:         US - Nashville, Tennessee
    Entries:
Vermont Cat 1, 1971: 251 (lot, G-1 et al);
Swann NY 9/18/75: 229 (album, G et al);

**GIFFORD, Benjamin A.** (American)
Photos dated: 1899
Processes:      Silver
Formats:        Prints
Subjects:       Ethnography
Locations:      US - Portland, Oregon
Studio:         US - Portland, Oregon
    Entries:
Swann NY 5/10/84: 228 (note);

**GIHON, John Lawrence** (American, 1839-1878)
Photos dated: 1860s-1871
Processes:      Albumen
Formats:        Prints, stereos
Subjects:       Topography
Locations:      US
Studio:         US - Philadelphia, Pennsylvania
    Entries:
California Galleries 9/26/75: 173 (book, G & Jones
    et al);
Swann NY 4/23/81: 159 (books, G & Jones et al)
    (note);
Wood Boston Cat 58, 1986: 136 (books, G-1, G &
    Jones-1, et al);

**GILBERT & BACON** (American)
Photos dated: 1870s-1890s
Processes:      Albumen
Formats:        Prints, cabinet cards, stereos
Subjects:       Portraits, topography
Locations:      US
Studio:         US - Philadelphia, Pennsylvania
  Entries:
Sothebys NY 11/21/70: 357 (lot, G & B et al);
Wood Boston Cat 58, 1986: 136 (books, G & B-1
  et al);

**GILBERT, G.K.** (American)
Photos dated: c1890s
Processes:
Formats:        Prints
Subjects:       Topography
Locations:      US - New York; Oregon
Studio:         US
  Entries:
Swann NY 10/18/79: 352 (album, 38), 360 (albums,
  G et al);

**GILCHRIST** (British)
Photos dated: 1860s
Processes:      Ambrotype
Formats:        Plates
Subjects:       Portraits
Locations:      Studio
Studio:         Scotland - Edinburgh
  Entries:
Christies Lon 10/30/80: 67 (lot, G-1 et al);

**GILCHRIST, George C.** (American)
Photos dated: c1849-1860s
Processes:      Daguerreotype, albumen
Formats:        Plates, cabinet card
Subjects:       Portraits
Locations:      Studio
Studio:         US - Lowell, Massachusetts
  Entries:
Sothebys NY 11/21/70: 351 (lot, G et al);
Swann NY 11/14/85: 46 (lot, G et al);

**GILFILLIAN, A.W.** (see PERRY, Ira)

**GILL, Major Robert** (British)
Photos dated: 1862-1864
Processes:      Albumen
Formats:        Stereos, prints
Subjects:       Topography, genre (animal life)
Locations:      India
Studio:
  Entries:
Swann NY 2/14/52: 129 (book, G-100 et al)(note);
Sothebys Lon 12/21/71: 144 (book, 100);
Sothebys Lon 12/4/73: 154 (book, 100);
Vermont Cat 11/12, 1977: 519 ill(book, 74)(note);
Sothebys NY 10/4/77: 140 (book, 100)(note);
Sothebys LA 2/7/79: 450 ill(book, 74)(note);
Christies NY 5/4/79: 61 ill(album);
Sothebys Lon 3/27/81: 10 ill(book, 100);
Swann NY 5/10/84: 57 (book, 73)(note);
Swann NY 5/15/86: 261 (lot, G attributed et al);

**GILLINGHAM, C.L.** (American)
Photos dated: 1880s
Processes:      Albumen
Formats:        Stereos
Subjects:       Topography
Locations:      US - American west
Studio:         US - Colorado Springs, Colorado
  Entries:
Rose Florida Cat 7, 1982: 90 (lot, G et al);

**GILLO, R.**
Photos dated: 1860s
Processes:      Albumen
Formats:        Cdvs
Subjects:       Topography
Locations:      England
Studio:
  Entries:
Sothebys Lon 10/18/74: 88 (albums, G et al);

**GILLOT, F.** (French)
Photos dated: Nineteenth century
Processes:      Woodburytype
Formats:        Prints
Subjects:       Portraits incl. Galerie Contemporaine
Locations:      Studio
Studio:         France
  Entries:
Christies NY 5/26/82: 36 (book, G-2 et al);
Christies NY 5/7/84: 19 (book, G-2 et al);

**GILMAN, John G.** (American)
Photos dated: 1870s-1885
Processes:      Albumen
Formats:        Cabinet cards, boudoir cards, stereos
Subjects:       Portraits, topography
Locations:      US - Mt. McGregor, New York
Studio:         US - Canajoharie, New York
  Entries:
Sothebys NY (Greenway Coll.) 11/20/70: 95 ill
  (lot, G-1 et al);
Swann NY 11/6/80: 299 (lot, G-4 et al);
Harris Baltimore 12/16/83: 244 (3);
Swann NY 5/10/84: 231 (lot, G et al);
Harris Baltimore 11/7/86: 69 (lot, G-1 et al);

**GIORGILADAKI** (see also PERIDIS)
Photos dated: c1880
Processes:      Albumen
Formats:        Prints
Subjects:       Topography
Locations:      Egypt - Port Saïd
Studio:         Egypt
  Entries:
Phillips Lon 3/17/82: 45 (album, G et al);

**GIRAUD**
Photos dated: c1870
Processes:      Albumen
Formats:        Cdvs
Subjects:       Portraits
Locations:      West Indies
Studio:
  Entries:
California Galleries 1/21/79: 237 (lot, G et al);

GIROUX, A. (French)
Photos dated: c1860s
Processes:      Albumen
Formats:        Cdvs
Subjects:       Documentary (art)
Locations:      France
Studio:         France
    Entries:
California Galleries 1/22/77: 127 (lot, G et al);

GLADWELL, T.H. (British)
Photos dated: 1850s
Processes:      Daguerreotype, albumen
Formats:        Plates incl. stereo, prints, stereo
                cards
Subjects:       Topography, genre
Locations:      England
Studio:         England - London
    Entries:
Sothebys Lon 11/18/77: 22;
Christies Lon 10/26/78: 241 (lot, G et al);

GLAISBY, W.P.
Photos dated: 1860s-1870s
Processes:      Albumen
Formats:        Stereos
Subjects:       Topography, portraits
Locations:      Great Britain
Studio:         England - York
    Entries:
Edwards Lon 1975: 12 (album, G et al);
Sothebys Lon 3/21/75: 231 (lot, G et al);
Sothebys Lon 10/29/80: 6 (lot, G et al);

GLAISTER
Photos dated: 1850s-1860s
Processes:      Daguerreotype, albumen
Formats:        Plates, prints
Subjects:       Portraits
Locations:      Studio
Studio:         Australia - Sydney
    Entries:
Anderson (Gilsey Coll.) 3/18/03: 2477, 2479, 2480,
    2481, 2482, 2483;
Christies Lon 3/26/81: 61 (lot, G-2 et al);

GLANVILLE, G. (British)
Photos dated: c1880
Processes:      Albumen
Formats:        Prints
Subjects:       Genre
Locations:      Great Britain
Studio:         Great Britain
    Entries:
Christies Lon 10/26/80: 192 (album, G-1 et al);

GLINIETTA (Italian)
Photos dated: 1850s
Processes:      Albumen
Formats:        Prints
Subjects:       Topography
Locations:      Italy - Venice
Studio:         Italy
    Entries:
Christies Lon 6/27/85: 151;
Christies Lon 10/31/85: 81 (album, G-1 et al);
Christies Lon 6/26/86: 97 (lot, G-1 et al)(note);

GLOEDEN, Baron Wilhelm Von (German, 1856-1931)
Photos dated: 1890-1920s
Processes:      Albumen, platinum, photogravure
Formats:        Prints
Subjects:       Genre (nudes)
Locations:      Italy - Taormina, Sicily
Studio:         Italy - Taormina, Sicily
    Entries:
Sothebys NY 9/23/75: 338 ill(note);
Gordon NY 5/3/76: 328 ill;
Witkin NY VI 1978: 64 (2 ills)(2)(note);
Sothebys Lon 3/22/78: 265 ill(note), 266, 267 ill,
    268, 269, 270 ill;
Christies Lon 6/27/78: 251 (lot, G-1 et al);
Phillips NY 11/4/78: 140 ill(3), 141 (3), 142 ill,
    143 (3), 144 (4);
Sothebys NY 11/9/78: 437 ill;
Swann NY 12/14/78: 355 (albums, G-1 et al);
Mancini Phila 1979: 25 ill;
Witkin NY VIII 1979: 40 (3 ills)(3);
Phillips Lon 3/13/79: 183 ill;
Christies NY 5/4/79: 133;
Sothebys NY 5/8/79: 295 (note), 296 ill, 297, 298,
    299, 300, 301, 302, 303;
Sothebys Lon 10/24/79: 377 (3), 378 (3);
Sothebys Lon 10/26/79: 634 ill;
Christies NY 10/31/79: 44;
Phillips Lon 3/12/80: 167 (2), 168 (2);
Sothebys Lon 3/21/80: 243 ill(7);
Swann NY 4/17/80: 236 (album, G-1 et al);
Sothebys NY 5/19/80: 13 ill;
Phillips NY 5/21/80: 227 (3);
Phillips Lon 6/25/80: 124 (2);
Christies Lon 10/30/80: 491 ill, 492 ill, 493 ill,
    494 ill, 495 ill, 496 ill;
Petzold Germany 5/22/81: 1810 ill, 1811, 1812
    (attributed);
Christies NY 11/11/80: 73;
Sothebys LA 2/5/81: 379 ill(lot, G-2 et al);
Christies Lon 3/26/81: 428 (lot, G-1 et al), 446
    (note), 447 ill, 448, 449, 450 ill(note), 451
    ill, 452 ill, 453 ill, 454, 455;
Christies Lon 6/18/81: 465 (2)(note), 466, 467;
Sothebys NY 10/21/81: 186 (lot, G-1 et al);
Christies Lon 10/29/81: 413, 414, 415 ill, 416,
    417, 418, 419 (note);
Swann NY 11/5/81: 318, 319;
Petzold Germany 11/7/81: 204 ill;
Christies NY 11/10/81: 81 ill(3), 82;
Sothebys LA 2/17/82: 273 ill(2), 274 ill;
Christies Lon 3/11/82: 370 (2), 371, 372;
Phillips NY 5/22/82: 951 ill(note), 952;
Sothebys NY 5/24/82: 243 ill, 244 ill, 245 ill
    (note), 246 ill;
Christies Lon 6/24/82: 144 (attributed), 418 (6),
    419, 420;
Christies Lon 10/28/82: 244 (2), 245 (4), 246,
    247 ill;

## GLOEDEN (continued)
Christies NY 11/8/82: 242 ill;
Phillips NY 11/9/82: 287;
Swann NY 11/18/82: 381;
Drouot Paris 11/27/82: 120 ill;
Harris Baltimore 12/10/82: 324 (note);
Bievres France 2/6/83: 52, 53, 54 ill, 55 ill;
Christies Lon 3/24/83: 264 ill(6), 265 ill;
Swann NY 5/5/83: 356 (3)(note);
Christies NY 5/9/83: 152 ill, 153 ill;
Sothebys NY 5/11/83: 412 ill, 413, 414 ill(3)
    (attributed);
Christies Lon 6/23/83: 277 (2);
Christies Lon 10/27/83: 261 ill(3);
Phillips Lon 11/4/83: 78 (2);
Christies Lon 10/25/84: 238 ill, 239 (10);
Sothebys Lon 10/26/84: 208;
Sothebys NY 11/5/84: 104 ill, 105 ill(lot, G et al),
    278 ill;
Swann NY 11/8/84: 209, 210;
Drouot Paris 11/24/84: 57 ill, 58 ill;
Christies NY 5/6/85: 365 ill(note);
Sothebys NY 5/7/85: 144 ill(lot, G et al), 145
    (lot, G-1 et al);
Sothebys NY 5/8/85: 520 ill(attributed);
Swann NY 5/9/85: 393 (2), 394 (3), 395 (7);
Phillips Lon 6/26/85: 196 (album, G-11 et al);
Christies Lon 10/31/85: 222 (attributed);
Christies NY 11/11/85: 435 ill;
Swann NY 11/14/85: 88 ill, 89;
Christies Lon 4/24/86: 527 ill;
Sothebys NY 5/12/86: 407A ill(5, attributed);
Swann NY 5/15/86: 246 (2), 247 ill(12)(note), 248
    (12)(note);
Harris Baltimore 11/7/86: 310 ill(note);
Sothebys NY 11/10/86: 205 ill;
Christies NY 11/11/86: 425 ill;
Swann NY 11/13/86: 229 (lot, G et al), 230 (lot,
    G et al);
Drouot Paris 11/22/86: 46 ill;

**GLOSSNER, M.** (German)
Photos dated: 1870s
Processes:      Albumen
Formats:        Prints
Subjects:       Genre
Locations:      Germany
Studio:         Germany - Munich
    Entries:
Sothebys NY 5/20/80: 385 ill(lot, G-23 et al), 386
    ill(35);
Swann NY 5/15/86: 271 (lot, G-3 et al);

**GLOSSOP, Reverend G.P.** (British)
Photos dated: 1850s-1860s
Processes:      Albumen
Formats:        Prints
Subjects:       Topography, genre
Locations:      Great Britain; France
Studio:         Great Britain
    Entries:
Sothebys Lon 3/29/85: 152 (4 ills)(albums, G et al);

## GLUCQ
Photos dated: 1878
Processes:      Photogravure
Formats:        Prints
Subjects:       Documentary (public events)
Locations:
Studio:
    Entries:
Christies Lon 6/26/80: 328 (books, G-104 et al);

**GODARD, Adolphe** (French)
Photos dated: c1855-1860s
Processes:      Albumen
Formats:        Prints, stereos
Subjects:       Topography
Locations:      Italy
Studio:         Italy - Genoa
    Entries:
California Galleries 1/21/79: 282 (7);
Christies Lon 3/26/81: 183 (album, G-9 et al);
Harris Baltimore 7/31/81: 100 (lot, G et al);
Petzold Germany 11/7/81: 326 (lot, G et al);
Christies Lon 3/11/82: 133 (album, G et al);
Harris Baltimore 3/26/82: 417 (attributed);

**GODBOLD** (British)
Photos dated: Nineteenth century
Processes:      Albumen
Formats:        Stereos
Subjects:       Topography
Locations:      Great Britain
Studio:         Great Britain
    Entries:
Christies Lon 3/29/84: 22 (lot, G et al);

**GODDARD, Paul Beck** (American)
Photos dated: 1842-1850s
Processes:      Daguerreotype
Formats:        Plates
Subjects:       Portraits
Locations:      Studio
Studio:         US
    Entries:
Sothebys NY (Weissberg Coll.) 5/16/67: 148 (lot, G-1
    et al);
Christies Lon 6/28/79: 21 (lot, G-1 et al);

**GODEFROY, L.** (French)
Photos dated: 1867-1890s
Processes:      Albumen
Formats:        Prints
Subjects:       Topography
Locations:      France - Paris
Studio:         France
    Entries:
Rauch Geneva 6/13/61: 162 (lot, G et al);

**GODET** (French)
Photos dated: 1881-1886
Processes:      Woodburytype
Formats:        Prints
Subjects:       Portraits incl. Galerie Contemporaine
Locations:      France
Studio:         France
    Entries:
Swann NY 4/14/77: 189 ill(book, G et al)(note);
Christies NY 5/14/81: 41 (books, G-2 et al);
Christies NY 5/26/82: 36 (book, G et al);
Christies NY 5/7/84: 19 (book, G et al);

**GODEUS, John D.** (American)
Photos dated: Nineteenth century
Processes:      Albumen
Formats:        Cdvs
Subjects:       Portraits
Locations:      Studio
Studio:         US - San Francisco, California
    Entries:
California Galleries 5/23/82: 248 (lot, G et al);

**GODFRAY, P.** (aka GODFREY)(British)
Photos dated: 1860s-1870s
Processes:      Albumen
Formats:        Prints, stereos
Subjects:       Topography
Locations:      England - Jersey, Guernsey, Sark
Studio:         England - Jersey
    Entries:
Rinhart NY Cat 7, 1973: 438;
Christies Lon 6/26/80: 164 (album, G-2 et al);
Christies Lon 6/28/84: 46 (lot, G-7 et al);
Christies Lon 10/25/84: 36 (lot, G-7 et al);

**GODFREY, Reverend E.** (British)
Photos dated: c1870
Processes:      Albumen
Formats:        Prints
Subjects:       Ethnography
Locations:      India
Studio:
    Entries:
Sothebys Lon 10/18/74: 80 (book, G et al);
Christies Lon 3/11/82: 252 (books, G et al);

**GODKIN, G.S.**
Photos dated: 1887
Processes:      Albumen
Formats:        Prints
Subjects:       Topography
Locations:      Italy - San Marco
Studio:
    Entries:
Swann NY 11/11/76: 263 (book, 20);

**GODKIN, W.R.** (American)
Photos dated: c1875-1888
Processes:      Albumen
Formats:        Prints
Subjects:       Ethnography
Locations:      US - Fort Laramie, Wyoming
Studio:         US
    Entries:
Sothebys NY 11/21/70: 106 ill;
Swann NY 11/5/81: 416;

**GOEDELGEE, J.** (Dutch)
Photos dated: Nineteenth century
Processes:
Formats:        Prints
Subjects:       Topography
Locations:      Netherlands - Leiden
Studio:         Netherlands
    Entries:
Christies Lon 6/26/80: 261 (lot, G-1 et al);

**GOFF, Orlando Scott** (American, 1843-1917)
Photos dated: c1870-1906
Processes:      Albumen
Formats:        Cabinet cards
Subjects:       Ethnography, genre
Locations:      US - Wisconsin; Oklahoma; Montana;
                North Dakota
Studio:         US - Bismark, North Dakota
    Entries:
Rinhart NY Cat 2, 1971: 415 (note);
Frontier AC, Texas 1978: 109 ill;
Christies Lon 3/15/79: 178 (lot, G-13 et al);
Swann NY 5/15/86: 166 (lot, G-1 et al);

**GOLDIN, John** (American)
Photos dated: 1865
Processes:      Albumen
Formats:        Cdvs
Subjects:       Portraits, topography
Locations:      US - Washington, D.C.
Studio:         US - Washington, D.C.
    Entries:
Sothebys NY (Strober Coll.) 2/7/70: 262 (lot,
    G et al);
Vermont Cat 4, 1972: 464 ill(lot, G-1 et al);
Christies NY 11/10/81: 45 (lot, G et al);

**GOLDSMITH & LAZELLE** (American)
Photos dated: 1870s
Processes:      Albumen
Formats:        Stereos
Subjects:       Topography
Locations:      US - New England
Studio:         US - Springfield, Massachusetts
    Entries:
Harris Baltimore 12/16/83: 86 (lot, G & L et al);

GOLDSMITH, C. (British)
Photos dated: 1890s
Processes:     Bromide
Formats:
Subjects:      Documentary (industrial)
Locations:     Great Britain
Studio:        Great Britain
   Entries:
Christies Lon 10/27/77: 71 (album, 10);

GOLDSTICKER (American)
Photos dated: early 1860s
Processes:     Albumen
Formats:       Cdvs
Subjects:      Portraits
Locations:     US - Civil War area
Studio:        US
   Entries:
Sothebys NY (Strober Coll.) 2/7/70: 297 (lot,
   G et al);

GOLL, F. (American)
Photos dated: 1850s
Processes:     Daguerreotype
Formats:       Plates
Subjects:      Portraits
Locations:     Studio
Studio:        US - Alabama
   Entries:
Sothebys NY 11/21/70: 246 ill;

GOLLAS
Photos dated: 1872
Processes:     Albumen
Formats:       Prints
Subjects:      Architecture
Locations:     France - Chartres
Studio:
   Entries:
Sothebys LA 2/13/78: 119 (3);

GOMEZ & CARRERA (Cuban)
Photos dated: 1890-1891
Processes:     Silver
Formats:       Prints
Subjects:      Topography
Locations:     Cuba - Havana
Studio:        Cuba - Havana
   Entries:
Witkin NY II 1974: 887 ill(20);

GONSALVES, J.
Photos dated: Nineteenth century
Processes:     Albumen
Formats:       Prints
Subjects:      Topography
Locations:
Studio:
   Entries:
Christies Lon 6/23/83: 180 (albums, G et al);

GONSALVES, S.A.
Photos dated: c1890
Processes:     Albumen
Formats:       Prints
Subjects:      Topography
Locations:     Hawaii
Studio:
   Entries:
California Galleries 6/19/83: 249 (lot, G-1 et al);

GONSE, Louis (French)(photographer or author?)
Photos dated: c1890
Processes:     Heliogravure
Formats:       Prints
Subjects:      Architecture
Locations:     France
Studio:        France
   Entries:
Wood Conn Cat 45, 1979: 121 (book)(note);

GONZALEZ (Spanish)(see also SENAN)
Photos dated: 1880s
Processes:     Albumen
Formats:       Prints
Subjects:      Topography
Locations:     Spain - Grenada
Studio:        Spain
   Entries:
Sothebys NY 5/8/79: 103 (lot, G et al);

GOOD, Frank Mason (British)
Photos dated: c1860-1890
Processes:     Albumen, autotypes
Formats:       Prints, stereos, cdvs
Subjects:      Topography, genre (still life)
Locations:     Turkey; Greece; Palestine; Egypt;
               England - York and Isle of Wight
Studio:        England - London and Hampshire
   Entries:
Swann NY 2/14/52: 349 (book, G et al);
Rinhart NY Cat 1, 1971: 135 (2);
Rinhart NY Cat 2, 1971: 507 (lot, G-13 et al);
Edwards Lon 1975: 197 (book, G-4 et al);
Sothebys Lon 6/26/75: 136 (albums, G-50 et al);
California Galleries 9/27/75: 568 (lot, G et al);
Sothebys Lon 10/24/75: 49 (album, G-4 et al);
Swann NY 11/11/76: 295 (book, G-4 et al);
Rose Boston Cat 2, 1977: 19 ill(attributed)(note);
Sothebys NY 10/4/77: 134 (album, G et al);
Sothebys Lon 3/22/78: 28 (book, G et al), 29 (book,
   G et al);
Sothebys Lon 10/27/78: 211 (book, G et al);
Wood Conn Cat 45, 1979: 250 (book, G et al)(note),
   289 (book, 127);
Sothebys Lon 3/14/79: 132 (album, G et al);
Christies Lon 3/15/79: 213 (book, 125);
Sothebys NY 5/8/79: 104 (12);
Sothebys NY 11/2/79: 250 (album, G et al)
   (attributed);
Christies Lon 3/20/80: 223 (book, G et al);
Sothebys Lon 3/21/80: 125 (album, G et al);
Phillips Lon 6/25/80: 116 (album, G et al);
Sothebys Lon 10/29/80: 57a ill(album, 45);
Christies Lon 10/30/80: 300 (book, 20);
Christies Lon 3/26/81: 116 (lot, G et al), 129
   (lot, G-2 et al);
Sothebys Lon 3/27/81: 437 (book, G et al);

## GOOD, F. (continued)

Sothebys Lon 6/17/81: 160 (lot, G-1 et al), 450
    (book, G et al);
Christies Lon 6/18/81: 102 (lot, G-1 et al);
Christies Lon 10/29/81: 128 (lot, G et al), 169
    (album, G et al)(note), 217 (album, 50);
Swann NY 11/5/81: 514 (4)(attributed);
Rose Florida Cat 7, 1982: 41 ill;
Wood Conn Cat 49, 1982: 499 (book, G-4 et al)(note);
Christies Lon 3/11/82: 306 ill;
Swann NY 4/1/82: 329 (lot, G et al)(note);
Christies Lon 6/24/82: 71 (lot, G et al), 178
    (album, G et al), 187 (album, 22);
Christies Lon 10/28/82: 26 (lot, G et al);
Swann NY 11/18/82: 446 (lot, G et al), 449 (lot,
    G et al), 454 (lot, G et al);
Christies Lon 3/24/83: 97 ill(albums, 72), 138
    (album, G et al);
Harris Baltimore 4/8/83: 36 (13);
Swann NY 5/5/83: 282 (album, G et al), 407 (lot,
    G-28 et al);
Christies Lon 6/23/83: 45 (lot, G et al), 63 (lot,
    G-1 et al), 132 (4);
Christies NY 10/4/83: 109 (lot, G et al);
Christies Lon 10/27/83: 21 (lot, G-5 et al);
Phillips Lon 11/4/83: 43 (album, G et al);
Harris Baltimore 12/16/83: 55 (24);
Harris Baltimore 6/1/84: 53 (lot, G et al), 61 (8),
    64 (lot, G et al);
Christies Lon 6/28/84: 221 (lot, G-8 attributed, et
    al), 222 ill(36);
Sothebys Lon 6/29/84: 5 (lot, G et al);
Christies Lon 10/25/84: 102 (lot, G-3 et al),
    185 (46);
Sothebys Lon 10/26/84: 54 (lot, G et al);
Sothebys Lon 3/29/85: 64 (lot, G et al), 161 ill;
Christies Lon 6/27/85: 281 (album, G et al);
Sothebys Lon 6/28/85: 57 ill(book, 25);
Christies Lon 10/31/85: 66 (lot, G-6 et al), 87
    (albums, G et al), 94 (23), 186 (lot, G-9 et al);
Swann NY 11/14/85: 162 (lot, G et al), 264 (books,
    G et al);
Christies Lon 4/24/86: 331 (lot, G et al), 358 (lot,
    G et al), 416 ill(album, 50)(note);
Sothebys Lon 4/25/86: 39 (31);
Christies Lon 6/26/86: 21 (book, 29), 183 (album,
    G et al);
Christies Lon 10/30/86: 36 (lot, G et al), 126 ill
    (album, 281);
Swann NY 11/13/86: 330 (lot, G et al);

## GOOD, J. (American)

Photos dated: c1860
Processes:      Salt, albumen
Subjects:       Portraits
Locations:      US - New Jersey
Studio:         US
    Entries:
Phillips NY 11/12/86: 99 (11);

## GOOD, S. (British)

Photos dated: Nineteenth century
Processes:      Albumen
Formats:        Cdvs
Subjects:       Topography
Locations:      Great Britain
Studio:         Great Britain
    Entries:
Christies Lon 3/20/80: 351 (album, G et al);

## GOODCHILD, J. (British)

Photos dated: 1860s
Processes:      Ambrotype
Formats:        Plates
Subjects:       Portraits
Locations:      Studio
Studio:         England - Scarborough
    Entries:
Vermont Cat 8, 1974: 527 ill;

## GOODE, H.

Photos dated: c1890
Processes:      Albumen
Formats:        Prints
Subjects:       Topography
Locations:      New Zealand
Studio:         New Zealand
    Entries:
Christies Lon 10/27/77: 151 (albums, G et al);
Sothebys Lon 10/31/86: 11 (albums, G et al);

## GOODMAN, C.E. (British)

Photos dated: 1850s-1860s
Processes:      Albumen
Formats:        Stereos, prints
Subjects:       Genre, topography, documentary (art)
Locations:      Great Britain
Studio:         Great Britain
    Entries:
Colnaghi Lon 1976: 58 (lot, G-4 et al);
Sothebys Lon 10/27/78: 104 ill (lot, G-1 et al);
Christies Lon 10/30/80: 102 (lot, G-4 et al), 103
    (lot, G-1 et al);
Christies Lon 6/18/81: 73 (lot, G-1 et al), 95 (lot,
    G-1 et al);
Christies Lon 3/11/82: 75 (lot, G-1 et al);
Christies Lon 6/24/82: 67 (lot, G-1 et al);
Sothebys Lon 6/25/82: 6 (lot, G et al), 8 (lot,
    G-2 et al);
Christies Lon 10/28/82: 14 (lot, G et al), 24 (lot,
    G-1 et al);
Christies Lon 3/24/83: 33 (lot, G et al), 34 (32),
    37 (lot, G et al), 51 (album, G-1 et al);
Christies Lon 6/23/83: 26 (lot, G et al), 27 (lot,
    G et al), 39 (lot, G-3 et al), 41 (lot, G-5 et
    al), 50 (lot, G-4 et al), 62 (lot, G-1 et al);
Christies Lon 10/27/83: 36 (lot, G et al);
Christies Lon 3/29/84: 29 (lot, G-2 et al), 35 (lot,
    G et al);
Sothebys Lon 6/29/84: 11 (lot, G et al);
Phillips Lon 4/23/86: 193 (lot, G-1 et al);
Phillips Lon 10/29/86: 249 (lot, G-1 et al);

## GOODURN (British)

Photos dated: 1858
Processes:      Collodion on glass
Formats:        Plates
Subjects:       Genre
Locations:      England
Studio:         England
    Entries:
Weil Lon Cat 7, 1945: 165 (note);

GORDON, R. (British)
Photos dated: 1861-c1870
Processes:      Albumen
Formats:        Prints
Subjects:       Topography
Locations:      England - Isle of Wight
Studio:         Great Britain
    Entries:
Sothebys Lon 10/29/80: 291 (2);

GORE, F. St. J. (British)
Photos dated: 1895
Processes:
Formats:
Subjects:       Topography
Locations:      Afghanistan; India
Studio:
    Entries:
Swann NY 4/26/79: 102 (book, 16);

GORHAM & TUCKER (American)
Photos dated: 1860s
Processes:      Ambrotype
Formats:        Plates
Subjects:       Portraits
Locations:      Studio
Studio:         US
    Entries:
Vermont Cat 4, 1972: 444 ill;

GORSELINE (American)
Photos dated: 1850s
Processes:      Daguerreotype
Formats:        Plates
Subjects:       Portraits
Locations:      Studio
Studio:         US - New Burch, New York
    Entries:
Christies Lon 6/28/79: 13;
Christies Lon 3/20/80: 22;

GOSLING, G.G. (American)
Photos dated: Nineteenth century
Processes:      Albumen
Formats:        Prints
Subjects:       Documentary (disasters)
Locations:      US - Iowa
Studio:         US - Le Mars, Iowa
    Entries:
Christies Lon 10/28/76: 78 (albums, G-3 et al);

GOSNEY, A. (British)
Photos dated: 1860s
Processes:      Albumen
Formats:        Stereos
Subjects:       Topography
Locations:      Great Britain
Studio:         Great Britain
    Entries:
Christies Lon 10/27/83: 33 (lot, G et al);

GOTTHEIL & Son (German)
Photos dated: 1865
Processes:      Albumen
Formats:        Prints
Subjects:       Topography
Locations:      Germany - Danzig
Studio:         Germany - Danzig
    Entries:
Petzold Germany 5/22/81: 1813, 1814, 1815;
Petzold Germany 11/7/81: 205 ill, 206 ill, 207, 208;

GOUBIE, J.R.
Photos dated: 1880
Processes:      Albumen
Formats:        Prints
Subjects:
Locations:
Studio:
    Entries:
Wood Boston Cat 58, 1986: 136 (book, G-1 et al);

GOUGH, J.B. (photographer?)
Photos dated: Nineteenth century
Processes:      Albumen
Formats:        Stereos
Subjects:       Portraits
Locations:
Studio:
    Entries:
Christies Lon 3/29/84: 24 (lot, G-2 et al);

GOUIN, A. (French)
Photos dated: c1853
Processes:      Daguerreotype
Formats:        Stereo plates
Subjects:       Portraits
Locations:      Studio
Studio:         France
    Entries:
Rauch Geneva 6/13/61: 218 ill(5);

GOULD, F.C. (British)
Photos dated: c1864
Processes:      Albumen
Formats:        Prints
Subjects:
Locations:
Studio:         England - Gravesend
    Entries:
Christies Lon 10/30/86: 113 (album, G-2 et al);

GOUPIL & Cie (French)
Photos dated: 1855-1860s
Processes:      Albumen, woodburytype
Formats:        Prints, cdvs
Subjects:       Portraits incl. Galerie Contemporaine,
                ethnography, documentary (art)
Locations:      France
Studio:         France
    Entries:
Goldschmidt Lon Cat 52, 1939: 216, 220, 224;
Weil Lon 1946: 78;
Swann NY 4/20/78: 323 (lot, G-1 et al), 324 (lot,
    G-1 et al);
Sothebys Lon 6/28/78: 136 (lot, G et al), 150a
    (book, G et al);

**GOUPIL** (continued)
California Galleries 1/21/79: 440 (5);
Sothebys Lon 6/29/79: 254;
Sothebys Lon 3/21/80: 238 (book, G et al);
Sothebys NY 5/20/80: 381 (lot, G-2 et al);
Christies Lon 3/26/81: 412 (album, G-1 et al);
Christies NY 5/26/82: 36 (book, G-5 et al);
Bievres France 2/6/83: 128 (lot, G-1 et al);
Phillips Lon 6/15/83: 137 (lot, G-1 et al);
Christies NY 5/7/84: 19 (book, G-5 et al);

**GOVE & NORTH**
Photos dated: 1870s-1884
Processes:      Albumen
Formats:        Prints
Subjects:       Topography, documentary (railroads)
Locations:      Mexico
Studio:         Mexico
   Entries:
California Galleries 1/21/79: 476 (lot, G & N-1
   et al);
Rose Boston Cat 5, 1980: 87, 88;

**GOWLAND, W.T. & R.** (British)
Photos dated: 1867
Processes:      Albumen
Formats:        Cdvs
Subjects:       Portraits
Locations:      Studio
Studio:         England - York
   Entries:
Rinhart NY Cat 7, 1973: 548;

**GRABILL, John C.H.** (American)
Photos dated: 1886-1891
Processes:      Albumen
Formats:        Prints
Subjects:       Topography, documentary (railroads,
                military)
Locations:      US - Wounded Knee, South Dakota;
                Nevada
Studio:         US - Dakota Territory; Chicago,
                Illinois
   Entries:
Frontier AC, Texas 1978: 235;
California Galleries 6/19/83: 242;
Christies NY 11/6/84: 51 ill(note);
California Galleries 6/8/85: 222;
Sothebys NY 11/12/85: 142 ill;

**GRACE, J.** (British)(aka J.W.G.G.)
Photos dated: between 1851 and 1856
Processes:      Calotype
Formats:        Prints
Subjects:       Topography
Locations:      Great Britain
Studio:         Great Britain
   Entries:
Sothebys Lon 12/21/71: 138 (album, G attributed
   et al);

**GRADT, L.W.** (American)
Photos dated: Nineteenth century
Processes:      Albumen
Formats:        Stereos
Subjects:       Topography
Locations:      US - Michigan
Studio:         US
   Entries:
California Galleries 4/3/76: 400 (lot, G et al);

**GRAF, Heinrich** (German)
Photos dated: 1865
Processes:      Albumen
Formats:        Cdvs
Subjects:       Portraits
Locations:      Studio
Studio:         Germany
   Entries:
Petzold Germany 11/7/81: 324 (album, G et al);

**GRAFF, Philip** (German)
Photos dated: c1850-1864
Processes:      Daguerreotype, albumen
Formats:        Plates, prints, cdvs
Subjects:       Portraits
Locations:      Studio
Studio:         Germany
   Entries:
Christies Lon 6/18/81: 5 (lot, G-1 attributed
   et al);
Petzold Germany 11/7/81: 307 (album, G et al);
Swann NY 5/15/86: 130 (book, G et al)(note);

**GRAHAM** (American)
Photos dated: 1893
Processes:
Formats:        Prints
Subjects:       Topography
Locations:      US - Los Angeles, California
Studio:         US - Los Angeles, California
   Entries:
Witkin NY II 1974: 927 (lot, G-6 et al), 929 (2),
   931 (lot, G-1 et al);

**GRAHAM, James** (British)
Photos dated: 1857-1864
Processes:      Albumen
Formats:        Prints incl. panoramas
Subjects:       Topography
Locations:      Palestine - Jerusalem; Italy -
                Florence
Studio:
   Entries:
Christies Lon 6/27/78: 112;
Christies Lon 6/23/83: 108 (lot, G-1 et al);

**GRAHAM, Colonel R.B.** (British)
Photos dated: 1886-1887
Processes:      Albumen
Formats:        Prints
Subjects:       Topography, documentary (military)
Locations:      Burma - Mandalay
Studio:
    Entries:
Vermont Cat 11/12, 1977: 520 ill(book, 59);
Swann NY 11/5/81: 110 ill(book, 59)(note);
Sothebys LA 2/6/80: 177 ill(book, 100)(note);

**GRAINER, Fr.** (Austrian)
Photos dated: 1874
Processes:      Albumen
Formats:        Prints, stereos
Subjects:       Topography
Locations:      Austria - Salzburg and Berchtesgaden
Studio:         Austria
    Entries:
Wood Conn Cat 49, 1982: 199 (book, G & Wurthle, 25)
    (note);
Christies Lon 3/11/82: 83 (lot, G et al);

**GRANGE, Baron Alexis de la** (French)
Photos dated: 1851
Processes:      Salt (Blanquart-Evrard)
Formats:        Prints
Subjects:       Topography
Locations:      India - Bombay and Delhi
Studio:         France
    Entries:
Rauch Geneva 6/13/61: 65 (lot, D et al);

**GRANHOFF, F.** (German)
Photos dated: 1871
Processes:      Albumen
Formats:        Prints
Subjects:       Portraits
Locations:      Studio
Studio:         Germany - Berlin
    Entries:
Swann NY 11/11/76: 164 (book, G et al);
Swann NY 12/14/78: 376 (lot, G et al);

**GRANT**
Photos dated: 1880s and/or 1890s
Processes:      Albumen
Formats:        Prints
Subjects:       Topography
Locations:      South Africa
Studio:
    Entries:
Christies Lon 3/26/81: 274 (album, G-1 et al);

**GRANT, A.G.** (American)
Photos dated: Nineteenth century
Processes:      Albumen
Formats:        Stereos
Subjects:       Topography
Locations:      US - southeastern
Studio:         US
    Entries:
Harris Baltimore 12/10/82: 92 (lot, G et al);

**GRANT, G.F.G.** (British)
Photos dated: 1890s
Processes:
Formats:        Prints
Subjects:
Locations:      Great Britain
Studio:         England (West Kent Amateur
                Photographic Society)
    Entries:
Christies Lon 6/27/85: 260 (lot, G et al);

**GRANT, L.W.** (American)
Photos dated: c1878
Processes:      Albumen
Formats:        Stereos
Subjects:       Topography
Locations:      US - Saginaw, Michigan
Studio:         US - Michigan
    Entries:
Rinhart NY Cat 2, 1971: 503 (5);
Rinhart NY Cat 6, 1973: 484 (5);

**GRANT-FRANCIS, Colonel** (British)
Photos dated: 1881
Processes:      Collotype
Formats:        Prints
Subjects:       Documentary (industrial)
Locations:      Wales - Swansea
Studio:         Great Britain
    Entries:
Swann NY 2/14/52: 160 (book, 14);

**GRASSHOFF, J.**
Photos dated: 1871
Processes:      Albumen
Formats:        Prints
Subjects:
Locations:
Studio:
    Entries:
Wood Boston Cat 58, 1986: 136 (books, G-1 et al);

**GRATL, Anton** (Austrian)
Photos dated: 1870s
Processes:      Albumen
Formats:        Cdvs, stereos
Subjects:       Ethnography
Locations:      Austria
Studio:         Austria - Innsbruck
    Entries:
Rinhart NY Cat 2, 1971: 299 (4);
Rinhart NY Cat 7, 1973: 540 (lot, G-3 et al);
California Galleries 9/27/75: 443 (lot, G et al);

**GRAVES** (see FELLOWS & GRAVES)

GRAVES, Jesse A. (American)
Photos dated: 1867-1870s
Processes:      Albumen
Formats:        Stereos, prints
Subjects:       Topography
Locations:      US - Delaware Water Gap
Studio:         US - Philadelphia, Pennsylvania
     Entries:
Swann NY 2/14/52: 105 (book, 10);
Rinhart Cat 1, 1971: 178 (3);
Rinhart NY Cat 8, 1973: 44;
California Galleries 4/3/76: 449 (lot, G et al);
Swann NY 11/11/76: 254 (book, 10)(note);
Witkin NY V 1977: 64 (book, 9);
Swann NY 4/14/77: 58 (book, 10)(note), 302 (lot,
     G et al);
California Galleries 1/21/78: 189 (lot, G et al);
California Galleries 1/21/79: 309 (lot, G et al);
California Galleries 3/30/80: 408 (lot, G et al);

GRAY & DAVIES (British)
Photos dated: Nineteenth century
Processes:      Albumen
Formats:
Subjects:       Portraits
Locations:      Great Britain
Studio:         Great Britain
     Entries:
Sothebys Lon 12/4/73: 250 (lot, G & D et al);

GRAY, William (American)
Photos dated: c1880-c1895
Processes:      Albumen
Formats:        Prints
Subjects:       Topography
Locations:      US - New York City; New England
Studio:         US - New York City
     Entries:
California Galleries 1/22/77: 332 (lot, G-1 et al);
California Galleries 1/21/78: 215 (album, G-2
     et al);
Swann NY 4/1/82: 333 (lot, G et al);
Swann NY 11/14/85: 136 (album, G et al);

GRAY Brothers (South African)
Photos dated: 1870s-1880s
Processes:      Albumen
Formats:        Prints
Subjects:       Topography, documentary (industrial)
Locations:      South Africa
Studio:         South Africa - Kimberley
     Entries:
Sothebys Lon 10/24/75: 108 (album, G et al);
Sothebys Lon 6/11/76: 46 ill(album, G et al), 46a
     (album, 20);
Swann NY 4/1/82: 318 (album, 115)(note);

GRAY, J.C. (American)
Photos dated: 1850s-1860s
Processes:      Tintype
Formats:        Plates
Subjects:       Portraits
Locations:      US
Studio:         US
     Entries:
Swann NY 4/23/81: 283 (lot, G-1 et al);

GRAYSON (British)
Photos dated: 1860s
Processes:      Albumen
Formats:        Cdvs
Subjects:       Topography
Locations:      England - London
Studio:         Great Britain
     Entries:
Phillips Lon 4/23/86: 272 (lot, G-1 et al);

GREEN (see ASPLET & GREEN) [GREEN 1]

GREEN (see KIRKMAN, GREEN & YORK) [GREEN 2]

GREEN (see LORING & GREEN) [GREEN 3]

GREEN, Arthur
Photos dated: 1860s
Processes:      Albumen
Formats:        Prints, stereos
Subjects:       Documentary (public events)
Locations:      South Africa
Studio:         South Africa - Capetown
     Entries:
Christies Lon 6/28/79: 154 (book, G-1 et al);
Christies Lon 3/20/80: 217 (book, G-1 et al);

GREEN, J.A. (American)
Photos dated: 1870s
Processes:      Albumen
Formats:        Stereos
Subjects:       Topography
Locations:      US - New England
Studio:         US - Buckfield, Maine
     Entries:
Harris Baltimore 6/1/84: 148 (lot, G et al);

GREEN, T.O. (British)
Photos dated: Nineteenth century
Processes:      Albumen
Formats:        Cdvs
Subjects:       Topography
Locations:      England
Studio:         England - Worthing
     Entries:
Christies Lon 6/27/85: 281 (album, G et al);

GREENE, John Buckley (American, 1832-1856)
Photos dated: c1852-1856
Processes:      Salt (Blanquart-Evrard)
Formats:        Prints
Subjects:       Topography
Locations:      Egypt; Algeria
Studio:         France - Paris
     Entries:
Koch Cal 1981-82: 34 ill(note), 35 ill;
Sothebys NY 5/15/81: 96 ill(note);
Octant Paris 1982: 1 ill;
Weston Cal 1982: 9 ill, 10 ill;
Christies NY 5/9/83: 73 ill, 74 ill;
Christies NY 5/6/85: 164 ill, 165 ill;
Christies NY 11/11/85: 196 ill;

**GREENE, Plyman B.** (American)
Photos dated: 1861-1892
Processes:     Albumen
Formats:       Stereos, cdvs
Subjects:      Documentary (disasters)
Locations:     US - Chicago, Illinois
Studio:        US - Chicago, Illinois
   Entries:
Sothebys NY 11/21/70: 368 (lot, G et al);
Rinhart NY Cat 6, 1973: 406;
California Galleries 9/27/75: 468 (lot, G et al);
Witkin NY IV 1976: S16 ill, S17 ill;
California Galleries 1/23/77: 372 (lot, G et al);
Swann NY 4/14/77: 322 (lot, G et al)(note);
Swann NY 11/18/82: 447 (lot, G et al);
California Galleries 6/19/83: 424 (10);
Harris Baltimore 6/1/84: 23 (lot, G-20 et al), 25
   (lot, G et al);
California Galleries 7/1/84: 199 (15);

**GREENE, William Friese** (British, 1855-1921)
Photos dated: 1870s-1895
Processes:     Albumen
Formats:       Cdvs, cabinet cards, glass plates
Subjects:      Portraits
Locations:     Studio
Studio:        England - Bath and London
   Entries:
Christies Lon 10/26/78: 403 (albums, G-2 et al)
   (note);
Christies Lon 6/26/80: 491 (lot, G-1 et al);
Christies Lon 6/18/81: 434 (lot, G-5 et al);
Sothebys Lon 11/1/85: 111 ill;

**GREGORY, C.** (American)
Photos dated: 1870
Processes:     Albumen
Formats:       Prints
Subjects:      Topography
Locations:     US - New York City
Studio:        US
   Entries:
Phillips NY 5/21/80: 293;

**GREGORY, W. & Co.** (British)
Photos dated: 1895
Processes:     Albumen, bromide
Formats:
Subjects:      Documentary (military)
Locations:     Great Britain
Studio:        Great Britain
   Entries:
Christies Lon 6/28/79: 91 (album, G et al);

**GREGGS, W.** (see WATERHOUSE)

**GRESLEY, Major F.** (British)
Photos dated: 1860s-c1870
Processes:     Albumen
Formats:       Prints
Subjects:      Topography
Locations:     England - Dovedale, Staffordshire
Studio:        Great Britain (Amateur Photographic
               Association)
   Entries:
Swann NY 2/14/52: 14 (lot, G et al);
Sothebys Lon 7/1/77: 163 (albums, G-1 et al);
Sothebys Lon 10/29/80: 310 (album, G et al);
Christies Lon 10/29/81: 359 (album, G-5 et al)
   (note);
Christies Lon 10/27/83: 218 (albums, G-8 et al);
Sothebys Lon 6/29/84: 192 (4);

**GREW** (see CHASE & GREW)

**GREY** (see REID & GREY)

**GRIBBLE, J.**
Photos dated: c1895
Processes:     Photogravure
Formats:       Prints
Subjects:      Topography
Locations:     South Africa
Studio:        South Africa - Paarl
   Entries:
Swann NY 4/26/79: 5 (book, G et al);

**GRICE, Le**
Photos dated: 1860s
Processes:     Albumen
Formats:       Prints
Subjects:
Locations:
Studio:        Great Britain (Amateur Photographic
               Association)
   Entries:
Sothebys Lon 10/29/80: 310 (album, G et al);

**GRIFFITH, Francis Robert**
Photos dated: c1859-1863
Processes:     Calotype
Formats:       Negatives
Subjects:      Topography
Locations:     India; Far East
Studio:        India
   Entries:
Sothebys Lon 3/8/74: 148 (10);
Sothebys Lon 10/18/74: 148 (10);
Edwards Lon 1975: 12 (album, G et al);
Vermont Cat 9, 1975: 590 ill(note), 591 ill, 592
   ill, 593 ill, 594 ill, 595 ill, 596 ill;
Sothebys Lon 6/26/75: 208 (10);
Sothebys Lon 10/24/75: 247 (10);
Sothebys Lon 6/29/79: 84 ill(note), 85 ill, 86 ill,
   87;
Sothebys Lon 10/24/79: 107 (3), 108 ill, 109 ill,
   110 ill, 111 (3), 112 ill;
Sothebys Lon 3/21/80: 116 ill(note), 117 (3), 118,
   119, 120, 121 ill;
Sothebys Lon 6/27/80: 67 ill, 68 ill, 69 ill(3), 70
   ill, 71 ill, 72 ill, 73 ill(4);
Sothebys Lon 10/29/80: 28 ill;

GRIFFITH, M.J. (American)
Photos dated: 1889-1890
Processes:      Albumen
Formats:        Prints
Subjects:       Topography
Locations:      US - Detroit, Michigan; New York City
Studio:
   Entries:
California Galleries 4/2/76: 164 (albums, G-12
   et al);

GRIFFITHS (British)
Photos dated: Nineteenth century
Processes:      Albumen
Formats:        Prints
Subjects:       Genre
Locations:      Great Britain
Studio:         England - Bow
   Entries:
Phillips Lon 10/24/84: 125 (lot, G-1 et al);

GRISWOLD, M.M. (American)
Photos dated: 1850-1890
Processes:      Albumen, gelatin
Formats:        Cdvs, stereos, prints
Subjects:       Portraits, topography
Locations:      US - Ohio
Studio:         US - Lancaster, Ohio
   Entries:
Sothebys NY (Greenway Coll.) 11/20/70: 263 (lot, G-1
   et al), 276 (lot, G-1 et al);
Christies Lon 10/30/80: 106 (lot, G-2 et al);
Harris Baltimore 3/26/82: 398 (lot, G-1 et al);

GROLL, A.
Photos dated: 1855-1860s
Processes:      Albumen
Formats:        Prints
Subjects:       Ethnography, documentary (art), genre
                (rural life)
Locations:      Poland; Austria - Vienna; Germany
Studio:         Europe
   Entries:
Edwards Lon 1975: 156 (book, 128);
Sothebys Lon 6/28/78: 316 (lot, G-3 et al);
Harris Baltimore 12/10/82: 260 (note);
Christies Lon 6/27/85: 101 (2 ills)(books, 128);
Sothebys Lon 11/1/85: 26 (3), 27 ill, 28 ill
   (lot, G-7 et al);

GROOM (American) [GROOM 1]
Photos dated: 1860s
Processes:      Albumen
Formats:        Cdvs
Subjects:       Portraits
Locations:      Studio
Studio:         US - Philadelphia, Pennsylvania
   Entries:
Sothebys NY (Greenway Coll.) 11/20/70: 240 (lot, G-1
   et al);

GROOM & Co. (British) [GROOM 2]
Photos dated: 1896-c1870
Processes:      Albumen
Formats:        Prints
Subjects:       Documentary (maritime)
Locations:      England - Plymouth
Studio:         England - Plymouth
   Entries:
Christies Lon 6/27/78: 61 (7)(note);

GROOM, J.
Photos dated: 1860s
Processes:      Albumen
Formats:        Cdvs
Subjects:       Topography
Locations:      England
Studio:
   Entries:
Sothebys Lon 6/21/74: 65 (lot, G et al);

GROS, Baron Jean-Baptiste-Louis (French,
1793-1870)
Photos dated: 1842-1850
Processes:      Daguerreotype, albumen
Formats:        Plates, prints
Subjects:       Topography
Locations:      England - London; France - Paris;
                Columbia - Bogota; Greece - Athens
Studio:         France
   Entries:
Rauch Geneva 6/13/61: 26 ill(4)(attributed)(note),
   119;

GROS, H.F.
Photos dated: 1869-1892
Processes:      Albumen
Formats:        Prints
Subjects:       Topography, portraits
Locations:      South Africa - Transvaal
Studio:
   Entries:
Sothebys Lon 10/24/75: 113 (album, G et al);
Sothebys Lon 6/11/76: 47a (album, 36);
Sothebys Lon 7/1/77: 124 (album, G et al);
California Galleries 1/21/79: 327 (2 ills)
   (album, 30);
Christies Lon 10/31/85: 107 (album, 50);
Christies Lon 10/30/86: 140 (album, 50);

GROVE (see WINDOW & GROVE)

GRUEY, L.J. (French)
Photos dated: 1892
Processes:      Albumen
Formats:        Prints
Subjects:       Documentary
Locations:      France - Besançon
Studio:         France
   Entries:
Christies NY 5/14/80: 151 ill(book);

GRUNDY, G. (British)
Photos dated: Nineteenth century
Processes:      Albumen
Formats:        Prints
Subjects:       Documentary (railroads)
Locations:      Great Britain
Studio:         Great Britain
    Entries:
Christies Lon 6/28/84: 65 (lot, G-8 et al);

GRUNDY, William Morris (British, 1806-1859)
Photos dated: c1857-1861
Processes:      Albumen
Formats:        Prints, stereos
Subjects:       Topography, genre
Locations:      Great Britain
Studio:         England - Sutton Coldfield
    Entries:
Rinhart NY Cat 6, 1973: 137 (book, 18);
Sothebys Lon 3/8/74: 169 ill(book, 22);
Edwards Lon 1975: 184 (book, 20);
Sothebys Lon 3/21/75: 311 ill(book, 20), 312 ill
    (book, 20);
Sothebys Lon 6/26/75: 217 (book, 20);
Christies Lon 3/16/78: 199 (book, 20);
Christies Lon 10/26/78: 266 (book, 20);
Sothebys Lon 3/14/79: 232 (book, 20);
Christies Lon 10/30/80: 119 (lot, G-2 et al);
Christies Lon 6/24/82: 238 (book, 21);
Sothebys Lon 6/28/85: 222 ill(books, G-20 et al);
Swann NY 11/14/85: 231 (book, 20)(note);
Wood Boston Cat 58, 1986: 275 (book, 20)(note);
Phillips Lon 4/23/86: 281 (book, 20);
Christies Lon 10/30/86: 27 (lot, G et al);

GRUPI (Italian)
Photos dated: 1850s-1890s
Processes:      Salt, albumen
Formats:        Prints
Subjects:       Topography
Locations:      Italy - Taormina, Sicily
Studio:         Italy - Taormina, Sicily
    Entries:
Christies Lon 10/30/80: 167 (2);
Swann NY 11/10/83: 304 (albums, G et al);

GRUT, T.A.
Photos dated: 1860s
Processes:      Albumen
Formats:        Prints incl. panoramas
Subjects:       Topography
Locations:      Belgium
Studio:
    Entries:
Christies Lon 3/26/81: 181 (lot, G-1 et al);

GSELL
Photos dated: 1870s
Processes:      Albumen
Formats:        Prints, cdvs
Subjects:       Topography, ethnography, genre
Locations:      Indochina - Saigon
Studio:         Indochina - Saigon
    Entries:
Christies NY 5/16/80: 209;
Swann NY 11/13/86: 297 (note);

GUAY & Co. (American)
Photos dated: 1860s
Processes:      Albumen
Formats:        Cdvs
Subjects:       Portraits
Locations:      Studio
Studio:         US - New Orleans, Louisiana
    Entries:
Sothebys NY (Strober Coll.) 2/7/70: 261 (lot,
    G et al);
Swann NY 11/10/83: 240 (lot, G et al);

GUBELMAN, Theo
Photos dated: 1870s-1880s
Processes:      Albumen
Formats:        Prints, cabinet cards, stereos
Subjects:       Topography, portraits
Locations:      US - New York City
Studio:         US - Newark, New Jersey
    Entries:
California Galleries 6/28/81: 374 (lot, G et al);
Christies Lon 10/31/85: 127 (album, G-4 et al);

GUDEWILL, C.E.
Photos dated: c1890s
Processes:
Formats:        Prints
Subjects:       Topography, documentary (industrial)
Locations:      US - New York City and Brooklyn, New
                York
Studio:         US
    Entries:
Swann NY 12/8/77: 405 ill(lot, G et al);

GUERARD, B. (French)
Photos dated: 1870s
Processes:      Albumen
Formats:        Stereos, cabinet cards
Subjects:       Topography, documentary (Paris
                Commune)
Locations:      France - Paris
Studio:         France
    Entries:
Rauch Geneva 6/13/61: 222 (lot, G et al);
Christies Lon 6/10/76: 72 (album, G et al);

GUERARD, Henri (French)
Photos dated: 1860s-1870s
Processes:      Albumen, glass transparencies
Formats:        Stereo plates, stereo cards
Subjects:       Topography
Locations:      France - Paris
Studio:         France - Paris
    Entries:
Petzold Germany 11/7/81: 290 (lot, G-24 et al);
Christies Lon 3/11/82: 83 (lot, G et al);
Swann NY 5/5/83: 436 (lot, G-1 et al)(note);
Christies Lon 4/24/86: 352 (lot, G-31 et al);

**GUFFAR, S. & Co.**
Photos dated: 1860s-1870s
Processes:
Formats:
Subjects:        Topography
Locations:       India
Studio:
   Entries:
Phillips NY 5/5/79: 173 (lot, G et al);

**GUIBERT, Maurice** (French)
Photos dated: c1892
Processes:       Silver
Formats:         Prints
Subjects:        Portraits
Locations:       France
Studio:          France
   Entries:
Sothebys NY 5/12/86: 232 ill(2)(note);

**GUIDA, Luigi** (Italian)
Photos dated: Nineteenth century
Processes:       Albumen
Formats:         Prints
Subjects:        Topography
Locations:       Italy
Studio:          Italy
   Entries:
Christies Lon 3/29/84: 55 (lot, G et al);

**GUIDI, P.** (Italian)
Photos dated: 1865-1880s
Processes:       Albumen
Formats:         Prints, cdvs
Subjects:        Documentary (scientific), topography
Locations:       Italy - Bordighera
Studio:          Italy - San Remo
   Entries:
Rinhart NY Cat 7, 1973: 261;
Rose Boston Cat 4, 1979: 49 ill;
Christies Lon 6/28/84: 137 (lot, G-1 et al)(note);
Christies Lon 10/25/84: 221;
Christies Lon 3/28/85: 93 (album, G et al);
Christies Lon 6/27/85: 154 (2);
Christies Lon 10/31/85: 122 (lot, G et al);

**GUILD, W.H., Jr.** (American)
Photos dated: 1864
Processes:       Albumen
Formats:         Prints
Subjects:        Documentary (engineering)
Locations:       US - New York City
Studio:          US - New York City
   Entries:
Rinhart NY Cat 1, 1971: 518 (book, 52);
Wood Conn Cat 37, 1976: 80 (book, 51)(note);
Swann NY 5/5/83: 181 (book, 51);
Sothebys NY 11/5/84: 110 (book, 52);

**GUERIN, F.W.** (American)
Photos dated: 1881-1890s
Processes:       Albumen, gelatin
Formats:         Prints
Subjects:        Portraits, genre
Locations:       US - St. Louis, Missouri
Studio:          US
   Entries:
Harris Baltimore 3/26/82: 398 (lot, G-1 et al);
California Galleries 6/8/85: 518;
Wood Boston Cat 58, 1986: 136 (books, G-1 et al);

**GUERINET, A.** (French)(photographer or publisher?)
Photos dated: 1860s
Processes:       Albumen
Formats:         Prints
Subjects:        Genre (still life)
Locations:       Studio
Studio:          France
   Entries:
Phillips NY 5/9/81: 31 (2);

**GUERNE** (French)
Photos dated: 1850s
Processes:       Salt
Formats:         Prints
Subjects:        Genre (still life)
Locations:       Studio
Studio:          France - Paris
   Entries:
Swann NY 5/5/83: 360;

**GUERNSEY, B.H.** (American, 1844-1890)
Photos dated: 1860s-1880s
Processes:       Albumen
Formats:         Stereos
Subjects:        Topography
Locations:       US - Iowa; Colorado
Studio:          US - Sioux City, Iowa; Colorado
Springs,
                 Colorado
   Entries:
Vermont Cat 2, 1971: 234 (11);
Vermont Cat 9, 1975: 564 ill(10);
Frontier AC, Texas 1978: 69;
Sothebys Lon 3/22/78: 188 (lot, G-2 et al);
Swann NY 4/26/79: 437 (14), 438 (11);
Swann NY 10/18/79: 410 (13);
Sothebys LA 2/6/80: 26 (lot, G et al);
Swann NY 4/17/80: 366 (lot, G et al);
Swann NY 4/1/82: 357 (lot, G et al);
Harris Baltimore 12/10/82: 30 (10);
Harris Baltimore 4/8/83: 21 (lot, G et al);
Swann NY 5/5/83: 431 (lot, G et al)(note);
California Galleries 6/19/83: 426 (lot, G et al),
   427 ill(17), 453 (lot, G et al);
Harris Baltimore 12/16/83: 29 (lot, G-1 et al);
Christies Lon 3/29/84: 38 (lot, G-5 et al);
Harris Baltimore 6/1/84: 153 (lot, G et al);
Harris Baltimore 3/15/85: 24 (lot, G et al), 106
   (lot, G et al);
Swann NY 11/14/85: 158 (lot, G et al);
California Galleries 3/29/86: 727 (7), 728 (5), 729
   (6), 730 (5), 731 (6), 732 (5), 733 (9), 734 ill
   (7), 735 (6);

**GUILLEMIN, E.** (French)
Photos dated: 1840s
Processes:     Daguerreotype
Formats:      Plates
Subjects:     Portraits
Locations:    Studio
Studio:       France
   Entries:
Christies Lon 10/31/85: 18 ill;

**GUINAN**
Photos dated: between 1870s and 1890s
Processes:
Formats:      Cabinet cards
Subjects:
Locations:
Studio:
   Entries:
Swann NY 12/8/77: 369 (lot, G et al);

**GULER, R.** (Swiss)
Photos dated: 1860s
Processes:     Albumen
Formats:      Prints
Subjects:     Topography
Locations:    Switzerland
Studio:       Switzerland - Zurich and St. Moritz
   Entries:
Christies Lon 3/29/84: 48 (lot, G-1 et al);

**GULMEZ Frères** (Turkish)
Photos dated: 1880s
Processes:     Albumen
Formats:      Prints
Subjects:     Topography
Locations:    Turkey
Studio:       Turkey - Istanbul
   Entries:
Sothebys Lon 6/26/75: 138 (note);
California Galleries 1/21/79: 477 (6);
Swann NY 5/5/83: 408 (lot, G et al)(note);
Christies Lon 3/29/84: 97 (album, G et al);
Christies Lon 6/28/84: 81 (lot, G et al);
Christies Lon 6/27/85: 65 (lot, G et al);

**GURENIUS, W.A.** (Swedish)
Photos dated: c1870-1870s
Processes:     Albumen
Formats:      Cdvs
Subjects:     Ethnography
Locations:    Sweden
Studio:       Sweden
   Entries:
Christies Lon 10/26/78: 339 (album, G et al);

**GURNEY, Jeremiah** (American)
Photos dated: c1839-1871
Processes:     Daguerreotype, salt, albumen
Formats:      Plates, prints, stereos, cdvs
Subjects:     Portraits, documentary (public events, art)
Locations:    US
Studio:       US - New York City
   Entries:
Anderson NY (Gilsey Coll.) 1/20/03: 658 (lot, G-1 et al);
Anderson NY (Gilsey Coll.) 2/24/03: 2068 (lot, G et al), 2069 (lot, G et al);
Rauch Geneva 6/13/61: 32 (lot, G-1 et al);
Sothebys NY (Weissberg Coll.) 5/16/67: 102 (lot, G-1 et al), 111 (lot, G-1 et al), 114 (lot, G-1 et al), 121 (lot, G-1 et al), 156 (lot, G-1 et al), 172 (lot, G et al);
Sothebys NY (Strober Coll.) 2/7/70: 140 (note), 141 (note), 145, 152 (lot, G-1 et al), 257 (lot, G-3 et al)(note), 260 (lot, G et al), 261 (lot, G-1 et al)(note), 262 (lot, G et al), 263 (lot, G-13 et al), 264 (lot, G et al), 266 (lot, G-24 et al), 269 (lot, G-1 et al), 271 (lot, G et al), 272 (lot, G et al), 273 (lot, G et al), 276 (lot, G-11 et al), 281 (lot, G et al), 284 (lot, G et al), 288 (lot, G et al), 292 (lot, G et al), 293 (lot, G et al), 318 (lot, G et al), 366 (lot, G et al), 376 ill(lot, G-2 et al), 423 (lot, G-2 et al), 425 (lot, G-2 et al), 444 (lot, G et al), 531 (lot, G et al);
Sothebys NY (Greenway Coll.) 11/20/70: 129 (lot, G-1 et al), 216 (lot, G-1 et al), 232 (lot, G-1 et al), 250 (lot, G-1 et al), 255 (lot, G-1 et al), 276 (lot, G-1 et al);
Sothebys NY 11/21/70: 321 (lot, G-1 et al), 323 (lot, G et al), 326 (lot, G et al), 331 (lot, G-13 et al), 355 (lot, G et al);
Rinhart NY Cat 2, 1971: 283 (lot, G et al), 294 (lot, G-1 et al);
Vermont Cat 4, 1972: 321 ill;
Rinhart NY Cat 7, 1973: 155 (album, G et al), 391;
Vermont Cat 6, 1973: 514 ill;
Vermont Cat 7, 1974: 496 ill;
Sothebys Lon 10/18/74: 139 (lot, G et al);
Vermont Cat 9, 1975: 410 ill;
Witkin NY III 1975: 645 (book, G-6 et al);
Sothebys NY 2/25/75: 40 (note), 41, 129 (lot, G-1 et al), 209 (lot, G-1 et al);
Swann NY 9/18/75: 147 (lot, G-1 et al), 186 (lot, G et al);
Witkin NY IV 1976: OP193 (book, G-6 et al);
Swann NY 4/1/76: 160 (album, G et al);
California Galleries 4/2/76: 75 (lot, G et al), 78 (lot, G et al);
Swann NY 11/11/76: 250 (book, G-6 et al), 304 (note), 313, 316 (2), 337 (50)(note), 338 (lot, G et al), 346 (lot, G et al);
Vermont Cat 11/12, 1977: 547 ill;
California Galleries 1/22/77: 314;
Christies Lon 3/10/77: 275;
Gordon NY 5/10/77: 775 ill;
Christies Lon 10/27/77: 191 (lot, G-1 et al);
Swann NY 12/8/77: 70 (book, 24)(note);
Swann NY 4/20/78: 297 ill, 298;
Christies Lon 10/26/78: 18 (note), 26;
Sothebys Lon 10/27/78: 9;
Swann NY 12/14/78: 470 (lot, G et al);
Lehr NY Vol 1:4, 1979: 34 (book, G-6 et al);
Witkin NY Stereo 1979: 4 ill(5)(note);
Swann NY 4/26/79: 346;

<div style="column-count:2">

## GURNEY (continued)

Sothebys NY 5/8/79: 106 (album, G et al);
Phillips NY 11/3/79: 114 (lot, G et al), 125 (album, 24);
California Galleries 3/30/80: 246;
Swann NY 11/6/80: 380 (lot, G-1 et al);
California Galleries 12/13/80: 195;
Swann NY 4/23/81: 220 ill, 228 (lot, G-1 et al), 242 (lot, G-1 et al);
Harris Baltimore 7/31/81: 104 (lot, G-3 et al), 134 (album, G et al), 297 (lot, G et al);
Wood Conn Cat 49, 1982: 200 ill(book, 11)(note);
Harris Baltimore 3/26/82: 395 (lot, G et al);
Swann NY 4/1/82: 106 (book, 63)(note);
California Galleries 5/23/82: 78 ill(book, 63);
Harris Baltimore 5/28/82: 125, 141 (lot, G-1 et al);
Christies Lon 6/24/82: 18 (lot, G-1 et al);
Phillips Lon 10/27/82: 11 ill;
Swann NY 11/18/82: 476 (lot, G et al);
Harris Baltimore 4/8/83: 322 (lot, G et al);
Swann NY 5/5/83: 122 (book, G-6 et al), 332 (lot, G et al);
Harris Baltimore 9/16/83: 136 (lot, G et al), 142 (lot, G-1 et al);
Swann NY 11/10/83: 186 (lot, G-2 et al)(note), 207 (note), 208, 233, 237 (lot, G-2 et al)(note);
Harris Baltimore 12/16/83: 110 (lot, G-17 et al), 235;
Christies NY 2/22/84: 1 ill(3, plus 1 attributed);
Swann NY 5/10/84: 196 (albums, G et al);
Harris Baltimore 6/1/84: 296;
Swann NY 11/8/84: 180 (lot, G et al), 187 (album, G et al), 275 (lot, G et al);
Harris Baltimore 11/9/84: 132 (lot, G-1 et al);
Harris Baltimore 3/15/85: 21 (lot, G et al), 296 (lot, G-3 et al), 304;
Christies Lon 3/28/85: 26;
Swann NY 5/9/85: 344 ill, 371 (lot, G-1 et al);
Swann NY 11/14/85: 11 (albums, G et al), 262 (book, G et al);
Swann NY 5/15/86: 222 (lot, G et al), 223 (album, G et al);
Christies Lon 10/30/86: 222 (album, G et al);
Harris Baltimore 11/7/86: 57, 66 (lot, G-1 et al), 80 (lot, G-3 et al), 84 (lot, G-1 et al);
Sothebys NY 11/10/86: 308 (lot, G-1 et al);
Swann NY 11/13/86: 174 (note), 183 (lot, G-1 et al), 185 (lot, G-1 et al);

## GUSTAVE (Belgian)

Photos dated: 1891
Processes: Albumen
Formats: Prints
Subjects: Documentary (railroads)
Locations: Belgium
Studio: Belgium - Brussels
  Entries:
Swann NY 4/20/78: 362 (2);

## GUTBIER, Ed. (German)

Photos dated: c1860
Processes: Albumen
Formats: Cdvs
Subjects: Portraits
Locations: Studio
Studio: Germany - Munich
  Entries:
Petzold Germany 11/7/81: 300 (album, G et al);

## GUTCH, Reverend John Wheeley Gough (British, died 1862)

Photos dated: 1850s-1859
Processes: Salt
Formats: Prints, stereos
Subjects: Architecture
Locations: Scotland
Studio: Scotland
  Entries:
Sothebys Lon 10/24/75: 239 ill, 240, 241 ill, 242 (2), 243 (2), 244 (2), 245, 246 (2);
Sothebys Lon 6/11/76: 82 ill(note), 83, 84 ill, 85 (2)(note), 86 (2);
Christies Lon 10/28/76: 73 ill(note), 74, 75 ill, 76 ill, 77 (3);
Christies Lon 3/10/77: 88, 89 ill, 90, 91, 92 ill, 93 ill, 94 (2);
Christies Lon 6/30/77: 50, 51, 52 (2), 53 ill (album, G-2 et al);
Sothebys Lon 7/1/77: 229 (3), 230, 231, 232 ill, 233 ill, 234 (2), 235 ill, 236, 237 ill;
Sothebys Lon 11/18/77: 229 (3), 230, 231, 232 ill, 233 ill, 234 (2), 235 ill, 236, 237 ill;
Sothebys Lon 10/27/78: 163 ill(album, 45);
Phillips Lon 3/13/79: 35 (2);
Sothebys Lon 6/29/79: 187 ill, 188, 189 ill, 190 (6), 191 ill, 192 ill(4), 193 ill, 194 ill;
Sothebys Lon 10/24/79: 266 ill(3), 267 (4), 268 (4), 269, 270 ill, 271 ill(2), 272 ill(2), 273 ill, 274 ill(2);
Sothebys Lon 3/21/80: 220 ill, 221, 222 (3), 223, 224 ill, 225 ill, 226 ill;
Christies Lon 6/26/80: 143 ill, 144, 145 ill;
Sothebys Lon 6/27/80: 146 ill;
Christies NY 11/11/80: 2;
Christies Lon 3/26/81: 140 (attributed);
Sothebys Lon 3/27/81: 355 ill, 356 (2), 410 (2 ills) (album, 50);
Christies Lon 6/18/81: 151 ill(note), 152;
Sothebys Lon 10/28/81: 191 ill;
Christies Lon 6/24/82: 107 ill, 108, 109 ill, 110, 111;
Sothebys Lon 10/29/82: 117 ill(album, 37);
Christies Lon 6/23/83: 74 (4);
Sothebys Lon 6/24/83: 87, 88 ill, 89 ill(5), 90 (5), 91 ill;
Christies Lon 10/27/83: 189 ill, 190;
Christies Lon 3/29/84: 180;
Christies Lon 10/25/84: 161 ill, 162;
Sothebys Lon 10/26/84: 106 ill;
Christies Lon 3/28/85: 135 ill(2);
Sothebys Lon 3/29/85: 152 (albums, G-5 et al);
Phillips Lon 10/30/85: 146 ill;
Sothebys Lon 11/1/85: 64 ill(15);
Swann NY 11/14/85: 91 (2);
Sothebys NY 5/12/86: 233 (2 ills)(album, 11);
Sothebys Lon 10/31/86: 82 ill, 83 ill, 84 ill(note), 85 ill, 86 ill, 87 ill;

</div>

**GUTEKUNST, Frederick** (American, 1831-1917)
Photos dated: c1853-1885
Processes:    Salt, albumen, phototypes, heliotypes
Formats:      Prints, stereos, cdvs, cabinet cards
Subjects:     Portraits, documentary (medical,
              expeditions, railroads)
Locations:    US - Pennsylvania; Alaska
Studio:       US - Philadelphia, Pennsylvania
   Entries:
Anderson NY (Gilsey Coll.) 2/24/03: 1154;
Sothebys NY (Weissberg Coll.) 5/16/67: 187 (lot,
   G-42 et al);
Sothebys NY (Strober Coll.) 2/7/70: 266 (lot, G et
   al), 269 (lot, G et al), 284 (lot, G et al), 291
   (lot, G-2 et al), 296 (lot, G-2 et al), 297 (lot,
   G et al), 324 (lot, G et al);
Sothebys NY (Greenway Coll.) 11/20/70: 78 (lot, G-1
   et al), 227 ill(lot, G-1 et al), 228 ill, 229,
   232 (lot, G-1 et al), 235 (lot, G-1 et al), 243
   (lot, G-1 et al), 251 (lot, G-2 et al), 264
   (lot, G-1 et al), 269 (lot, G-1 et al), 270
   (lot, G-1 et al);
Sothebys NY 11/21/70: 323 (lot, G et al);
Rinhart NY Cat 7, 1973: 439, 440;
Witkin NY I 1973: 300, 301;
Swann NY 9/18/75: 186 (lot, G et al), 257 (2), 400
   (book, 22);
Sothebys NY 9/23/75: 63 (lot, G-1 et al)(note);
Swann NY 4/1/76: 49 (book, 1);
Swann NY 11/11/76: 246 (book, 10), 440;
California Galleries 1/22/77: 315, 347a (lot, G-1
   et al);
Swann NY 4/14/77: 337 (lot, G-28 et al);
Sothebys Lon 6/28/78: 3 (lot, G-4 et al), 240
   (album, F & LG et al);
Swann NY 12/14/78: 100 ill(book, 21)(note), 405;
Wood Conn Cat 45, 1979: 209 ill(book, 22)(note);
California Galleries 1/21/79: 235 (lot, G et al),
   497;
Phillips NY 5/5/79: 215 (note);
Phillips NY 11/29/79: 241 (lot, G-1 et al);
Swann NY 11/6/80: 238 (lot, G et al);
Christies NY 11/11/80: 99 (2), 168 ill, 169;
Swann NY 4/23/81: 476;
Phillips NY 5/9/81: 78 ill;
Harris Baltimore 7/31/81: 208;
Wood Conn Cat 49, 1982: 374 (book, 22)(note);
Christies Lon 3/11/82: 84 (lot, G et al);
Harris Baltimore 3/26/82: 395 (lot, G et al);
Swann NY 4/1/82: 303, 323;
California Galleries 5/23/82: 243 (lot, G et al);
Christies Lon 10/28/82: 28 (lot, G et al);
Christies NY 2/8/83: 44;
Harris Baltimore 4/8/83: 300 (lot, G et al), 371;
Swann NY 5/5/83: 123 (book, 13);
Harris Baltimore 9/16/83: 154 (lot, G-2 et al);
Harris Baltimore 12/16/83: 245, 298 (album, G
   et al);
Harris Baltimore 6/1/84: 251 (lot, G et al), 302
   (lot, G et al);
Swann NY 11/8/84: 281 (lot, G-1 et al);
Harris Baltimore 3/15/85: 287 (lot, G et al), 307
   (lot, G-1 et al);
Swann NY 5/9/85: 371 (lot, G-1 et al);
California Galleries 6/8/85: 508;
Swann NY 11/14/85: 11 (albums, G et al), 263 (books,
   G et al), 264 (books, G et al);
Wood Boston Cat 58, 1986: 136 (books, G-2 et al);
Swann NY 5/15/86: 130 (book, G et al)(note), 251 ill
   (note);
Swann NY 11/13/86: 198 (lot, G-2 et al);

**GUTIERREZ, J.** (Brazilian)
Photos dated: c1890s
Processes:    Albumen
Formats:      Prints
Subjects:     Documentary (military)
Locations:    Brazil
Studio:       Brazil - Rio de Janeiro
   Entries:
Swann NY 10/18/79: 272 ill(8)(note);

**GUTTERES, Reverend F.G.** (British)
Photos dated: 1860s
Processes:    Albumen
Formats:      Prints
Subjects:
Locations:
Studio:       Great Britain - Amateur Photographic
              Association
   Entries:
Christies Lon 10/27/83: 218 (albums, G-1 et al);

**GUY & MOCKEL**
Photos dated: c1895
Processes:
Formats:      Cabinet cards
Subjects:     Portraits
Locations:
Studio:
   Entries:
Maggs Paris 1939: 546;

**GYDE**
Photos dated: Nineteenth century
Processes:    Albumen
Formats:      Cdvs
Subjects:     Portraits
Locations:
Studio:
   Entries:
Phillips Lon 10/29/86: 302 (lot, G et al);

**H., A.** [AH]
Photos dated: c1890
Processes:      Albumen
Formats:        Prints
Subjects:       Topography
Locations:      South Africa
Studio:
  Entries:
California Galleries 6/19/83: 386 (lot, H-6 et al);

**H., A.** [A.H.] (French)
Photos dated: Nineteenth century
Processes:      Albumen
Formats:        Stereos (tissue)
Subjects:       Documentary (engineering)
Locations:      France - Paris
Studio:         France
  Entries:
California Galleries 4/3/76: 446 (lot, H-4 et al);

**H., E.** [E.H.] (French)
Photos dated: c1870
Processes:      Albumen
Formats:        Stereos incl. tissues
Subjects:       Topography, genre
Locations:      France - Paris; Middle East
Studio:         France - Paris
  Entries:
Vermont Cat 11/12, 1977: 780 ill(6);
Christies Lon 6/24/82: 56 (lot, H et al);
Harris Baltimore 12/16/83: 136 (10);

**H., Ed.** [Ed. H.]
Photos dated: c1890
Processes:      Albumen
Formats:        Prints
Subjects:       Topography
Locations:      France - Paris
Studio:         Europe
  Entries:
California Galleries 6/28/81: 155 (album, H et al);

**H., G.** [G.H.]
Photos dated: 1890s
Processes:      Albumen, carbon
Formats:        Prints
Subjects:       Topography
Locations:      Belgium
Studio:         Europe
  Entries:
California Galleries 1/21/78: 210 (album, H et al);
California Galleries 12/13/80: 402;
California Galleries 5/23/82: 193 (album, H et al);
Swann NY 11/18/82: 373 (albums, H et al);
Christies Lon 3/28/85: 60 (lot, H-3 et al);
Swann NY 5/9/85: 386 (albums, H et al)(note);
Christies Lon 10/31/85: 137 (album, H et al);

**H., H.** [H.H.] (British)
Photos dated: 1850s
Processes:      Albumen
Formats:        Prints
Subjects:       Topography, genre (rural life)
Locations:      England - Peterborough
Studio:
  Entries:
Sothebys Lon 10/29/76: 292 (lot, H-4 et al), 293
  (4), 296 ill(2);
Christies Lon 3/16/78: 48 (lot, H-1 et al);

**H., J.** [J.H.]
Photos dated: c1870s
Processes:      Albumen
Formats:        Prints
Subjects:       Topography, portraits
Locations:      Hawaii; Fiji
Studio:
  Entries:
Swann NY 4/23/81: 520 (lot, H et al);

**H., R.H.** [R.H.H.]
Photos dated: early 1860s
Processes:      Albumen
Formats:        Prints
Subjects:       Topography
Locations:      India
Studio:
  Entries:
Christies Lon 3/28/85: 327 (album, H-1 et al);

**H., Z.T.** [ZTH] (American)
Photos dated: 1880s
Processes:      Albumen
Formats:        Prints
Subjects:       Genre, topography
Locations:      US
Studio:         US
  Entries:
Swann NY 5/9/85: 320 (album, 150)(note);

**HAACK, C.** (Austrian)
Photos dated: 1870s
Processes:      Albumen
Formats:        Prints, cdvs
Subjects:       Genre (animal life)
Locations:      Austria - Vienna
Studio:         Austria - Vienna
  Entries:
Sothebys NY 5/2/78: 115 ill;
Swann NY 4/23/81: 407 (5)(note), 461 (lot, H et al);

**HAAS, P.**
Photos dated: 1843
Processes:      Daguerreotype
Formats:        Plates
Subjects:       Portraits
Locations:      Studio
Studio:         US - Washington, D.C.
  Entries:
Vermont Cat 8, 1974: 470 ill;

**HAASE, L.** (German)
Photos dated: 1860-1890
Processes:       Albumen
Formats:         Cdvs, stereos
Subjects:        Portraits, topography
Locations:       Germany - Berlin, Cologne, Breslau
Studio:          Germany - Berlin
   Entries:
Sothebys NY (Strober Coll.) 2/7/70: 278 (lot,
   H et al);
Christies Lon 10/30/80: 417 (album, H et al);
Petzold Germany 5/22/81: 1982 (album, H et al);
Petzold Germany 11/7/81: 324 (album, H et al);

**HACKER, F.** (American)
Photos dated: c1875-c1880
Processes:       Albumen
Formats:         Prints, stereos, cdvs
Subjects:        Documentary (railroads), topography
Locations:       US - Rhode Island; Connecticut
Studio:          US - Providence, Rhode Island
   Entries:
California Galleries 9/26/75: 295;
Wood Conn Cat 37, 1976: 279 ill;
Swann NY 4/1/76: 231;
California Galleries 5/23/82: 293 (lot, H-1 et al);
Harris Baltimore 12/10/82: 60 (lot, H et al);
Harris Baltimore 3/15/85: 86 (lot, H-2 et al);

**HADDOCK, Mrs. James** (British)
Photos dated: 1860s
Processes:       Albumen
Formats:         Prints
Subjects:
Locations:
Studio:          Great Britain (Amateur Photographic
                 Association)
   Entries:
Christies Lon 10/27/83: 218 (albums, H-1 et al);

**HADEN, J.T.** (British)
Photos dated: 1860s
Processes:       Ambrotype
Formats:         Plates
Subjects:        Portraits
Locations:       Studio
Studio:          England - Birmingham
   Entries:
Vermont Cat 7, 1974: 554 ill;

**HAES, Frank** (British, 1832-1916)(see also McLEAN
                 & HAES)
Photos dated: 1850s-1870s
Processes:       Albumen
Formats:         Stereos, cdvs
Subjects:        Genre (animal life), topography
Locations:       England - London; Australia
Studio:          England
   Entries:
Christies Lon 3/26/81: 131 ill(30);
Christies Lon 6/23/83: 36 (lot, H-6 et al);
Christies Lon 3/29/84: 19 (lot, H-6 et al), 22
   (lot, H et al), 24 (lot, H-6 et al);
Christies Lon 3/28/85: 41 (lot, H et al);

**HAGEN** (German)
Photos dated: c1860
Processes:       Albumen
Formats:         Cdvs
Subjects:        Portraits
Locations:       Studio
Studio:          Germany - Waren
   Entries:
Petzold Germany 11/7/81: 300 (album, H et al);

**HAHN, Johann** (German)
Photos dated: 1871
Processes:       Albumen
Formats:         Prints
Subjects:        Topography
Locations:       Germany - Nuremberg
Studio:          Germany
   Entries:
Sothebys NY 2/25/75: 62 (book, 29);
Christies Lon 6/27/85: 86 (albums, H et al);

**HAINES, Eugene S.M.** (American)
Photos dated: 1865-1882
Processes:       Albumen
Formats:         Prints, stereos, cdvs
Subjects:        Documentary (engineering), portraits,
                 genre
Locations:       US - Albany, New York; Colorado
Studio:          US - Albany, New York
   Entries:
Rinhart NY Cat 7, 1973: 289;
California Galleries 9/27/75: 505 (22);
California Galleries 1/22/77: 129 (lot, H et al);
Swann NY 12/8/77: 406 (album, H & Wickes);
Christies NY 5/7/84: 24 (21);

**HAKIM, Suleiman**
Photos dated: 1880s-1890s
Processes:       Albumen
Formats:         Prints
Subjects:        Topography
Locations:       Syria - Damascus; Saudi Arabia - Mecca
Studio:          Syria - Damascus
   Entries:
Swann NY 12/8/77: 380 (album, H et al), 398 (lot,
   H et al)(note);
Sothebys NY 5/8/79: 106 (lot, H et al);
Sothebys NY 12/19/79: 46 ill(lot, H et al);
Swann NY 11/6/80: 300 (12)(note);
Swann NY 11/5/81: 481 (lot, H et al);
Swann NY 5/5/83: 279 (album, H-3 et al);

**HALE, H.A.** (American)
Photos dated: 1899
Processes:       Silver
Formats:         Prints
Subjects:        Topography
Locations:       US - Oregon
Studio:          US
   Entries:
California Galleries 5/23/82: 360;

**HALE, Luther H.** (American)
Photos dated: 1850s
Processes:      Daguerreotype
Formats:        Plates
Subjects:       Portraits
Locations:      Studio
Studio:         US - Boston, Massachusetts
   Entries:
Sothebys NY (Strober Coll.) 2/7/70: 137 (lot,
   H-1 et al)(note);
Vermont Cat 8, 1974: 471 ill;
Auer Paris 5/31/80: 26;
Christies NY 2/8/83: 78 (lot, H-1 et al);

**HALL** (see HOWARD & HALL) [HALL 1]

**HALL** (American) [HALL 2]
Photos dated: Nineteenth century
Processes:      Albumen
Formats:        Stereos
Subjects:       Topography
Locations:      US
Studio:         US
   Entries:
Rauch Geneva 6/13/61: 224 (lot, H et al);

**HALL, G.R.** (British)
Photos dated: 1860s
Processes:      Albumen
Formats:        Prints
Subjects:
Locations:
Studio:         Great Britain (Amateur Photographic
                Association)
   Entries:
Christies Lon 10/27/83: 218 (albums, H-2 et al);

**HALL, George P.** (American)
Photos dated: 1893-1897
Processes:      Albumen
Formats:        Prints
Subjects:       Topography, documentary (engineering)
Locations:      US - New York City
Studio:         US - New York City
   Entries:
Sothebys NY 11/9/76: 133 (50)(note);
Swann NY 4/20/78: 343 (note);
Swann NY 11/13/86: 286 ill(11)(note);

**HALL, I.E.** (British)
Photos dated: 1882-1890s
Processes:      Albumen, silver
Formats:        Prints
Subjects:       Topography, documentary (maritime)
Locations:      England
Studio:         England
   Entries:
Sothebys Lon 3/27/81: 411 (album, 24), 412
   (albums, 50);
Sothebys Lon 10/28/81: 82 (albums, 50), 83
   (album, 24);

**HALL, J.** (British)
Photos dated: 1860s
Processes:      Albumen
Formats:        Cdvs
Subjects:       Topography
Locations:      Great Britain
Studio:         Great Britain
   Entries:
Swann NY 11/6/80: 284 (lot, H et al);

**HALL, Thomas**
Photos dated: 1891
Processes:      Platinotype
Formats:        Prints
Subjects:       Portraits
Locations:
Studio:
   Entries:
Sothebys Lon 10/28/81: 296 (lot, H-1 et al);

**HALL, W.F.**
Photos dated: 1880s
Processes:      Albumen
Formats:        Stereos
Subjects:       Topography
Locations:      Australia
Studio:
   Entries:
Christies Lon 6/18/81: 88 (lot, H-6 et al);

**HALLET & Brother** (American)
Photos dated: 1860s
Processes:      Albumen
Formats:        Cdvs
Subjects:       Portraits
Locations:      Studio
Studio:         US - New York City
   Entries:
Swann NY 5/10/84: 194 (lot, H & M-1 et al);

**HALLIWELL** (see HUMPHREYS & HALLIWELL)

**HAMAKER** (see HARTWELL)

**HAMILTON, Frederick Fitzroy** (photographer or
                author?)
Photos dated: 1871
Processes:
Formats:
Subject:        Documentary (scientific)
Locations:      Studio
Studio:         Italy - Bordighera
   Entries:
Swann NY 2/14/52: 49 (book, 25);

**HAMILTON, George D.** (American)
Photos dated: 1852-1859
Processes: Daguerreotype, ambrotype
Formats: Plates
Subjects: Portraits
Locations: Studio
Studio: US - Boston, Massachusetts
    Entries:
Sothebys NY (Weissberg Coll.) 5/16/67: 90 (lot,
    H-1 et al);
California Galleries 9/26/75: 24;
Rose Boston Cat 2, 1977: 138 ill;
Vermont Cat 11/12, 1977: 548 ill(note), 687 ill;
California Galleries 1/21/79: 247 (lot, H-1 et al);
Swann NY 11/14/85: 47 (lot, H et al);

**HAMILTON, James H.** (American, born 1833)
Photos dated: 1867-1879
Processes: Albumen
Formats: Cdvs
Subjects: Ethnography
Locations: Studio
Studio: US - Omaha City, Nebraska Territory
    Entries:
Sothebys NY (Strober Coll.) 2/7/70: 308 (lot, H-6
    et al);

**HAMILTON, J.R.**
Photos dated: 1869-1874
Processes: Albumen
Formats: Prints, cdvs
Subjects: Topography, portraits
Locations: Canada - New Brunswick
Studio: Canada
    Entries:
Swann NY 2/14/52: 73 (book, 11);
Christies Lon 10/30/80: 405 (album, H et al);
Christies Lon 6/18/81: 423 (album, H et al);

**HAMMERSCHMIDT, W.** (German)
Photos dated: late 1850s-1870s
Processes: Albumen
Formats: Prints, cdvs
Subjects: Topography, ethnography
Locations: Germany - Berlin; Egypt; Palestine
Studio: Germany - Berlin
    Entries:
Maggs Paris 1939: 506, 507, 508, 509, 510, 511, 512;
Rinhart NY Cat 7, 1973: 91 (book, H et al)(note);
Sothebys Lon 12/4/73: 20 (lot, H et al), 24 (lot,
    H et al);
Christies Lon 7/25/74: 348 (album, H et al);
Edwards Lon 1975: 3 (album, H-6 et al), 17 (album,
    H-1 et al);
California Galleries 4/3/76: 302 (lot, H-1 et al);
Christies Lon 10/28/76: 133 (album, H et al);
Sothebys Lon 10/29/76: 142 (22), 143 ill(lot, H-10
    et al);
Christies Lon 6/30/77: 121 (8), 135 (album, H-20
    et al);
Christies Lon 10/27/77: 127 (album, H et al);
Sothebys Lon 6/28/78: 118 (album, H-25 et al);
Christies Lon 10/26/78: 164 (7), 165 (9);
Sothebys Lon 10/27/78: 76 (album, H et al);
Christies Lon 3/15/79: 184 (albums, H-7 et al);
Christies Lon 10/25/79: 240 (lot, H-2 et al);
Sothebys NY 11/2/79: 244 ill(lot, H-1 et al);
White LA 1980-81: 53 ill(note);

**HAMMERSCHMIDT** (continued)
Sothebys LA 2/6/80: 164 (3), 165 ill(4);
Christies Lon 3/20/80: 163 (albums, H-28 et al), 199
    (albums, H et al), 352 (albums, H-1 et al);
Sothebys Lon 3/21/80: 124 ill(12);
California Galleries 3/30/80: 55 (album, H et al),
    211 (album, H et al);
Christies NY 5/16/80: 203 ill(19), 203A (10);
Phillips Can 10/9/80: 14 ill(6);
Sothebys Lon 10/29/80: 57 ill;
Christies Lon 10/30/80: 178 (lot, H-1 et al), 215
    (3), 435 (albums, H-4 et al);
California Galleries 12/13/80: 271;
Christies Lon 3/26/81: 259 (album, H-9 et al);
Phillips NY 5/9/81: 65 (album, H-3 et al);
Christies Lon 6/18/81: 200 ill;
California Galleries 6/28/81: 247;
Christies Lon 10/29/81: 207, 208 (3);
Christies Lon 3/11/82: 154, 157 (lot, H-1 et al);
Harris Baltimore 3/26/82: 251 ill;
Phillips NY 5/22/82: 778 (2);
California Galleries 5/23/82: 314, 315;
Christies Lon 6/24/82: 168, 197 (lot, H et al);
Harris Baltimore 12/10/82: 270;
Swann NY 5/5/83: 405 (album, H-1 et al);
Christies Lon 6/23/83: 166 (albums, H et al);
Sothebys Lon 6/24/83: 34 (albums, H et al);
Christies Lon 10/27/83: 234 (album, H-11 et al);
California Galleries 7/1/84: 445, 446, 447 ill, 448;
Christies Lon 10/25/84: 97 (lot, H-5 et al),
    193 (7);
Sothebys Lon 10/26/84: 53 ill(11);
Christies Lon 3/28/85: 95 (album, H-5 et al);
Christies Lon 6/27/85: 83 (lot, H et al), 84
    (lot, H-1 et al);
Christies Lon 10/31/85: 95 ill(album, H-22 et al),
    120 (album, H-8 et al);
Swann NY 11/14/85: 71 (albums, H-6 et al), 188
    (album, H et al);
Christies Lon 6/26/86: 193 (lot, H-2 et al);
Sothebys Lon 10/31/86: 23 (lot, H-2 et al);

**HAMMOND, T.C.** (British)
Photos dated: 1860s
Processes: Ambrotype
Formats: Plates
Subjects: Portraits
Locations: England
Studio: England - Ripon, Yorkshire
    Entries:
Swann NY 4/23/81: 263 (note);

**HAMOR, A.B.** (American)
Photos dated: 1867-1883
Processes: Albumen
Formats: Stereos, cdvs
Subjects: Topography, documentary (industrial)
Locations: US - Massachusetts
Studio: US - Lawrence, Massachusetts
    Entries:
Rinhart NY Cat 8, 1973: 45 ill(10);
Swann NY 11/5/81: 552 (lot, H et al);

**HANAFORD, S.R.** (American)
Photos dated: c1870
Processes:     Albumen
Formats:       Stereos
Subjects:      Topography
Locations:     US - Milford, New Hampshire
Studio:        US
  Entries:
Rinhart NY Cat 7, 1973: 217;

**HANDY, Levin C.** (American)
Photos dated: 1865-c1898
Processes:     Albumen, gelatin silver
Formats:       Prints, cabinet cards
Subjects:      Portraits, architecture
Locations:     US - Washington, D.C.
Studio:        US - Washington, D.C.
  Entries:
Sothebys NY (Strober Coll.) 2/7/70: 367 (lot,
  H et al);
Wood Conn Cat 37, 1976: 280 (6);
Christies NY 11/11/80: 132 (note);
California Galleries 6/28/81: 248 (13);
Harris Baltimore 4/8/83: 372 (6);
Harris Baltimore 9/16/83: 145 (5);
Harris Baltimore 12/16/83: 364;
Harris Baltimore 6/1/84: 251 (lot, H-1 et al);
Harris Baltimore 11/9/84: 130;
Harris Baltimore 9/27/85: 68;

**HANFSTAENGL, Franz S.** (German, 1804-1877) or
               Hanns or Teich (see also CREMIERE)
Photos dated: 1855-1870s
Processes:     Salt, albumen, chromotype
Formats:       Prints, cdvs, stereos
Subjects:      Portraits, topography, documentary
Locations:     Germany - Munich
Studio:        Germany - Munich
  Entries:
Rauch Geneva 6/13/61: 214 (note);
Sothebys NY (Greenway Coll.) 11/20/70: 13 (lot,
  H-1 et al);
Swann NY 4/14/76: 89 (book, 12);
California Galleries 3/30/80: 320 (10);
California Galleries 12/30/80: 272 (11);
Swann NY 4/23/81: 514 (lot, H et al)(note);
Sothebys Lon 6/17/81: 334 (11);
Petzold Germany 11/7/81: 294 (lot, H et al), 300
  (album, H et al), 307 (album, H et al), 324
  (album, H et al);
Sothebys NY 5/24/82: 230 ill(H & Cremiere);
Swann NY 11/14/85: 86 (lot, H-5 et al);
Sothebys Lon 4/25/86: 221 ill(lot, H-3 et al);

**HANG TAI** (Chinese)
Photos dated: 1870s
Processes:     Albumen
Formats:       Cdvs
Subjects:      Portraits
Locations:     Studio
Studio:        China - Shanghai
  Entries:
Swann NY 5/5/83: 324 (8);

**HANNAY** (American)
Photos dated: Nineteenth century
Processes:     Tintype
Formats:       Plates
Subjects:      Portraits
Locations:     Studio
Studio:        US - Brooklyn, New York
  Entries:
Vermont Cat 2, 1971: 213 ill;

**HANRIOT** (French)
Photos dated: 1871
Processes:     Albumen
Formats:       Stereos (tissue)
Subjects:      Documentary (Paris Commune)
Locations:     France - Paris
Studio:        France
  Entries:
Vermont Cat 7, 1974: 651 ill, 652 ill;

**HANSARD, J.W.** (American)
Photos dated: 1880s
Processes:     Albumen
Formats:       Stereos
Subjects:      Topography
Locations:     US - Arkansas; Texas
Studio:        US - Fayettville, Arkansas
  Entries:
Frontier AC, Texas 1978: 16 (H & Osborn, 5);
Harris Baltimore 6/1/84: 7 (lot, H et al);

**HANSEN, Georg E.** (Danish, 1833-1872)
Photos dated: 1852-1872
Processes:     Albumen
Formats:       Prints, cabinet cards
Subjects:      Documentary (art), portraits
Locations:     Denmark - Copenhagen
Studio:        Denmark - Copenhagen
  Entries:
Swann NY 12/14/78: 406 (6)(note), 458 (lot, H et al)
  (note);
California Galleries 1/21/79: 499 (lot, H-1 et al);
Harris Baltimore 6/1/84: 292;

**HANSEN, N.C.** (Danish)
Photos dated: 1860s-1890s
Processes:     Albumen
Formats:       Cdvs, cabinet cards
Subjects:      Portraits
Locations:     Denmark; Greenland
Studio:        Denmark - Copenhagen
  Entries:
Swann NY 12/8/77: 354 (10);
Christies Lon 10/27/83: 234 (album, H-28 et al);
Harris Baltimore 3/15/85: 261 (lot, H et al);

**HANSON, William** (British)
Photos dated: Nineteenth century
Processes:     Albumen
Formats:       Stereos
Subjects:      Topography
Locations:     England - Yorkshire
Studio:        Great Britain
  Entries:
Christies Lon 3/11/82: 85 (lot, H et al);

**HARBEN, Henry**
Photos dated: 1890s
Processes:
Formats:          Prints
Subjects:         Genre
Locations:        Italy - San Remo
Studio:
    Entries:
Sothebys Lon 10/24/79: 357 (lot, H-1 et al);

**HARDEN, H.B.** (American)
Photos dated: c1890s
Processes:
Formats:          Prints
Subjects:         Topography, documentary (industrial)
Locations:        US - Pennsylvania
Studio:           US
    Entries:
Swann NY 10/18/79: 354 (49)(note);

**HARDESTY, J.H.** (American)
Photos dated: 1870s-c1890
Processes:        Albumen
Formats:          Prints, stereos
Subjects:         Topography
Locations:        US - Texas; California
Studio:           US - San Antonio, Texas
    Entries:
Harris Baltimore 12/10/82: 109 (lot, H et al);
California Galleries 6/19/83: 190 (H & Wright);

**HARDIE Brothers** (American)(photographers or
                publishers?)
Photos dated: 1863
Processes:        Albumen
Formats:          Prints
Subjects:         Documentary (Civil War)
Locations:        US - Civil War area
Studio:           US
    Entries:
Harris Baltimore 9/16/83: 183;

**HARDIE, Fred K.**
Photos dated: c1870
Processes:        Albumen
Formats:          Prints
Subjects:         Ethnography
Locations:        Morocco
Studio:
    Entries:
Christies Lon 6/23/83: 137 (lot, H-1 et al);

**HARDING**
Photos dated: 1860s
Processes:        Ambrotype
Formats:          Plates
Subjects:         Portraits
Locations:        Studio
Studio:           Ireland - Cork
    Entries:
Sothebys Lon 3/9/77: 117;

**HARDY, Dr. A.** (see MONTMEJA & HARDY)

**HARDY, A.N.** (American)
Photos dated: 1870s-1879
Processes:        Albumen
Formats:          Prints, cabinet cards
Subjects:         Portraits, topography
Locations:        US - Massachusetts
Studio:           US - Boston, Massachusetts
    Entries:
Swann NY 11/5/81: 451 (52);

**HARDY, James W.** (British)
Photos dated: 1854
Processes:        Daguerreotype
Formats:          Plates
Subjects:         Portraits
Locations:        Studio
Studio:           England
    Entries:
Harris Baltimore 12/10/82: 374;

**HARGRAVE, J.J.** (American)
Photos dated: 1889-1890
Processes:        Albumen
Formats:          Boudoir cards
Subjects:         Documentary (public events)
Locations:        US - Guthrie, Oklahoma
Studio:           US - Guthrie, Oklahoma
    Entries:
Swann NY 11/14/85: 140 (lot, H et al)(note);

**HARLAN** (American)
Photos dated: between 1870s and 1890s
Processes:        Albumen
Formats:
Subjects:         Topography
Locations:        US - American west
Studio:           US
    Entries:
Swann NY 4/1/82: 249 (lot, H et al);

**HARLEY & METCALF** (American)
Photos dated: 1850s
Processes:        Daguerreotype
Formats:          Plates
Subjects:         Portraits
Locations:        Studio
Studio:           US
    Entries:
Gordon NY 5/3/76: 267 (lot, H & M et al);
Gordon NY 11/13/76: 2 (lot, H & M et al);

**HARMAN, A.**
Photos dated: between 1850s and 1870s
Processes:        Albumen
Formats:          Stereos
Subjects:         Topography
Locations:
Studio:
    Entries:
Sothebys Lon 6/24/83: 4 (lot, H et al);

**HARMER, John** (British)
Photos dated: 1860s
Processes: Albumen
Formats: Stereos
Subjects: Topography
Locations: Great Britain
Studio: Great Britain
   Entries:
Christies Lon 3/20/80: 90 ill(13);

**HARPER, George** (British)
Photos dated: 1840s
Processes: Calotype
Formats: Prints
Subjects: Topography
Locations: England - Norwich
Studio: Great Britain
   Entries:
Sothebys Lon 6/28/85: 123 (lot, H-1 et al);

**HARRIMAN** (American)
Photos dated: 1860s
Processes: Ambrotype
Formats: Plates
Subjects: Portraits
Locations: Studio
Studio: US - Georgetown, Massachusetts
   Entries:
Vermont Cat 4, 1972: 391 ill;

**HARRINGTON & NORMAN**
Photos dated: c1860-1870
Processes: Albumen
Formats: Prints
Subjects: Topography
Locations: India
Studio: India - Bombay
   Entries:
Wood Conn Cat 37, 1976: 256B (lot, H & N-4 et al);

**HARRINGTON, J.H.** (American)
Photos dated: c1888
Processes: Albumen
Formats: Prints
Subjects: Topography
Locations: US - Lamar, Nebraska
Studio: US
   Entries:
Frontier AC, Texas 1978: 116 ill;

**HARRINGTON, John** (British)
Photos dated: 1868-1871
Processes: Albumen, carbon
Formats: Prints
Subjects: Architecture, topography
Locations: England - London, Eton,
    Northamptonshire
Studio: England - Brighton
   Entries:
Swann NY 2/14/52: 168 (book, 17);
Rinhart NY Cat 2, 1971: 26 (album, 40);
Rinhart NY Cat 7, 1973: 53 (book, 25);
Edwards Lon 1975: 99 (book, 19), 100 (book, 18);
Swann NY 2/6/75: 196 (album, 40);
California Galleries 9/26/75: 142 (book, 18), 143
   (book, 12);

**HARRINGTON, J.** (continued)
Christies Lon 10/28/76: 81 ill(album, 16);
California Galleries 1/22/77: 203 (book, 18), 204
   (book, 12);
Sothebys NY 10/4/77: 167 (books, H-5 et al);
Sothebys Lon 11/18/77: 193 (book, 40);
Harris Baltimore 12/10/82: 154 (book, 7);
Sothebys Lon 6/28/85: 230 (book, 17);

**HARRIS** (British)
Photos dated: 1850s
Processes: Ambrotype
Formats: Plates
Subjects: Portraits
Locations: Studio
Studio: England - Portsea
   Entries:
Sothebys Lon 3/19/76: 66 (lot, H-2 et al);

**HARRIS, E.G.** (American)
Photos dated: c1895
Processes:
Formats: Prints
Subjects: Topography
Locations: US - Florida
Studio: US - Daytona, Florida
   Entries:
California Galleries 7/1/84: 400 (lot, H-6 et al);

**HARRIS, R.**
Photos dated: 1880s-1890s
Processes: Albumen
Formats: Prints
Subjects: Topography
Locations: South Africa
Studio: South Africa - Port Elizabeth
   Entries:
Christies Lon 6/27/78: 126 (album, 104);
Christies Lon 3/15/79: 193 (album, H-1 et al);
Christies Lon 6/26/80: 230 (lot, H-2 et al);
Christies Lon 6/24/82: 181 (albums, H-110 et al);

**HARRIS, W.** (American)
Photos dated: 1866-1868
Processes: Albumen
Formats: Prints
Subjects: Topography
Locations: US - Yosemite, California
Studio: US
   Entries:
Wood Conn Cat 41, 1978: 151 (book, H-4 et al)(note);
Swann NY 4/20/78: 178 (book, H-4 et al);
Christies NY 5/26/82: 49 (book, H-4 et al);
Sothebys NY 5/8/84: 340 (book, H-4 et al)(note);
California Galleries 7/1/84: 450 ill(note);
Christies NY 11/6/84: 45 (book, H-4 et al);
Christies NY 11/11/85: 442 (book, H-4 et al);
Phillips NY 7/2/86: 362 (book, H-4 et al);

**HARRIS, W.A. and/or RIVINGTON** (British)
Photos dated: 1860s
Processes:      Albumen
Formats:        Prints
Subjects:       Topography
Locations:      US; Canada
Studio:
   Entries:
Goldschmidt Lon Cat 52, 1939: 237 (book, 71)(note);

**HARRISON** (American)
Photos dated: c1890
Processes:      Albumen
Formats:        Prints
Subjects:       Genre
Locations:      US - St. Louis, Missouri
Studio:         US - Chicago, Illinois
   Entries:
Swann NY 4/1/82: 344 (lot, H-1 et al);

**HARRISON, C.H.**
Photos dated: 1890s
Processes:      Platinum
Formats:        Prints
Subjects:       Topography
Locations:      Kashmir; India
Studio:
   Entries:
Swann NY 4/23/81: 475 (albums, 100)(note);

**HARRISON, J.T.** (American)
Photos dated: 1850s-1857
Processes:      Daguerreotype
Formats:        Plates
Subjects:       Portraits
Locations:      Studio
Studio:         US - Brooklyn, New York
   Entries:
Sothebys NY (Weissberg Coll.) 5/16/67: 152 (lot, H &
   Hill-1, et al);
Vermont Cat 4, 1972: 322 ill(H & Hill), 323 ill(H &
   Hill);
Witkin NY III 1975: D9 ill(H & Hill);
Vermont Cat 11/12, 1977: 549 ill(H & Hill);
Swann NY 5/5/83: 287 (note);

**HART** (see BUSHBY & HART) [HART 1]

**HART** (see LALLEMAND) [HART 2]

**HART** (American) [HART 3]
Photos dated: 1893
Processes:      Albumen
Formats:        Prints
Subjects:       Genre
Locations:      US - New York City
Studio:         US
   Entries:
Swann NY 4/17/80: 343;

**HART, Alfred A.** (American, born 1816)
Photos dated: 1865-c1869
Processes:      Albumen
Formats:        Prints, stereos, cdvs
Subjects:       Topography, documentary (railroads)
Locations:      US - California; Nevada; Utah
Studio:         US - Sacramento, California
   Entries:
Sothebys NY (Strober Coll.) 2/7/70: 314 (lot,
   H et al), 511 (lot, H et al), 515 (30)(note),
   516 (25), 523 ill(lot, H-1 et al);
Rinhart NY Cat 1, 1971: 197;
Vermont Cat 1, 1971: 232 (8);
Vermont Cat 7, 1974: 649 (lot, H-1 et al);
Lehr NY Vol 1:2, 1978: 19 ill;
Lehr NY Vol 2:2, 1979: 13 ill;
California Galleries 3/30/80: 321;
Christies Lon 3/28/85: 44 (lot, H-32 et al);

**HART, A.P** (American)
Photos dated: c1860
Processes:      Daguerreotype
Formats:        Plates
Subjects:       Portraits
Locations:      Studio
Studio:         US - Elmira, New York
   Entries:
Sothebys Lon 3/27/81: 322;
Sothebys Lon 10/28/81: 268;

**HART, E.H.** (American)
Photos dated: c1891
Processes:      Albumen
Formats:        Prints
Subjects:       Documentary (maritime)
Locations:      US - New York City
Studio:         US - New York City
   Entries:
Swann NY 11/10/83: 336 (lot, H et al);
Swann NY 5/10/84: 235 (lot, H-2 et al);

**HART, Ludovico W.**
Photos dated: 1870s
Processes:      Albumen
Formats:        Stereos
Subjects:       Topography
Locations:      Australia
Studio:         Australia
   Entries:
Sothebys Lon 3/12/82: 9 (19);

**HARTOW, W.H.** (British)
Photos dated: 1860s
Processes:      Albumen
Formats:        Prints
Subjects:
Locations:
Studio:         Great Britain (Amateur Photographic
                Association)
   Entries:
Christies Lon 10/27/83: 218 (albums, H-2 et al);

HARTSHORN
Photos dated: 1850s
Processes:    Daguerreotype
Formats:      Plates
Subjects:     Portraits
Locations:
Studio:
    Entries:
Rinhart NY Cat 1, 1971: 54;

HARTWELL (American)
Photos dated: c1880s-c1890
Processes:    Albumen
Formats:      Prints
Subjects:     Topography, documentary (public
              events)
Locations:    US - Phoenix, Arizona
Studio:       US - Phoenix, Arizona
    Entries:
Frontier AC, Texas 1978: 117 (8)(note), 118;
California Galleries 6/28/81: 258 (lot, H &
    Hamaker-1, et al);

HARVEY & DUNDEN
Photos dated: 1870s
Processes:    Albumen
Formats:      Prints
Subjects:     Topography
Locations:    Australia
Studio:       Australia - Geelong
    Entries:
Sothebys Lon 11/1/85: 20 (lot, H & D et al);

HARVEY, Martha Hale (American)
Photos dated: 1898-1899
Processes:    Platinum
Formats:      Prints
Subjects:     Genre, topography
Locations:    US - Massachusetts
Studio:       US - Annisquam, Massachusetts
    Entries:
Phillips NY 11/29/79: 292 ill(note), 293 ill;

HARWOOD, G.W. (American)
Photos dated: c1860-1865
Processes:    Albumen
Formats:      Prints
Subjects:     Topography
Locations:    US - Salem, Massachusetts
Studio:       US - Salem, Massachusetts
    Entries:
Wood Conn Cat 37, 1976: 281 ill;

HASE (German)
Photos dated: 1860s
Processes:    Albumen
Formats:      Cdvs
Subjects:     Portraits
Locations:    France
Studio:       Germany - Freiburg
    Entries:
Petzold Germany 11/7/81: 327 (lot, H et al);

HASKINS, F. W. (American)
Photos dated: 1840s-1850s
Processes:    Daguerreotype
Formats:      Plates
Subjects:     Portraits
Locations:    Studio
Studio:       US - Boston, Massachusetts
    Entries:
Gordon NY 5/3/76: 267 (lot, H et al);
Gordon NY 11/13/76: 1 (lot, H et al);
Swann NY 11/8/84: 180 (lot, H et al);

HASLEM, John
Photos dated: 1879
Processes:    Woodburytype
Formats:      Prints
Subjects:     Documentary (industrial)
Locations:
Studio:
    Entries:
Wood Conn Cat 45, 1979: 130 (book, 3)(note);

HASLEWOOD, Reverend Francis (British)
              (photographer or author?)
Photos dated: 1875
Processes:    Albumen
Formats:      Prints
Subjects:     Documentary (art)
Locations:    England - Smarden, Kent
Studio:       England
    Entries:
Christies Lon 6/27/78: 162 (book, 40);

HASTINGS (American)
Photos dated: c1870
Processes:    Albumen
Formats:      Cabinet cards
Subjects:     Portraits
Locations:    Studio
Studio:       US - Boston, Massachusetts
    Entries:
California Galleries 1/21/78: 137 (lot, H et al);
Harris Baltimore 12/10/82: 423;

HATCH (see CASE & HATCH) [HATCH 1]

HATCH (American) [HATCH 2]
Photos dated: Nineteenth century
Processes:    Albumen
Formats:      Stereos
Subjects:     Topography
Locations:    US - Minnesota
Studio:       US
    Entries:
Harris Baltimore 6/1/84: 93 (lot, H et al);

HATTON (American)
Photos dated: between 1870s and 1890s
Processes:    Albumen
Formats:      Prints
Subjects:     Topography
Locations:    US - New York City
Studio:       US
    Entries:
Swann NY 4/1/82: 333 (lot, H et al);

**HAUTECOEUR, Albert** (French)
Photos dated: 1871-1889
Processes: Albumen
Formats: Prints, cabinet cards, stereos
Subjects: Topography, documentary (Paris Commune)
Locations: France - Paris; Switzerland
Studio: France - Paris
  Entries:
Rauch Geneva 6/13/61: 222 (lot, H et al);
California Galleries 9/26/75: 189 (album, H et al);
California Galleries 1/22/77: 195 (album, H et al);
California Galleries 1/21/78: 212 (albums, H-25 et al);
Christies Lon 3/20/80: 113 (lot, H-18 et al);
California Galleries 3/30/80: 217 (album, H et al);
Christies Lon 6/26/80: 208 (lot, A & Jules H, et al);
Sothebys Lon 6/27/80: 7 (lot, H et al);
Swann NY 11/6/80: 151 (book, 50);
California Galleries 12/13/80: 254 (lot, H et al);
Christies Lon 3/26/81: 268 (lot, H et al);
Christies Lon 10/29/81: 143 (lot, H et al);
Phillips NY 2/9/82: 491 (album, 50);
Christies Lon 3/11/82: 94 (lot, H et al), 139 (lot, H et al);
Harris Baltimore 3/26/82: 430;
Christies Lon 6/24/82: 138 (lot, H et al);
Christies Lon 10/27/83: 77 (album, 30);
Christies Lon 3/29/84: 62 (albums, H et al);
Christies Lon 6/28/84: 327 (album, H et al);
California Galleries 7/1/84: 215 (lot, H-5 et al);
Christies Lon 10/25/84: 70 (albums, 23);
Christies Lon 3/28/85: 53 (lot, H et al);

**HAUTMANN**
Photos dated: c1870s
Processes:
Formats:
Subjects: Topography
Locations: Italy
Studio:
  Entries:
Harris Baltimore 12/10/82: 399 (lot, H et al);

**HAVENS, O. Pierre** (American)(see also WILSON, J.N.)
Photos dated: Nineteenth century
Processes: Albumen
Formats: Stereos
Subjects: Topography
Locations: US - Georgia; Florida
Studio: US - Savannah, Georgia
  Entries:
Sothebys NY 2/7/70: 526 (lot, H et al);
Vermont Cat 1, 1971: 228 (lot, H et al);
California Galleries 4/3/76: 463 (lot, H et al);
Harris Baltimore 3/15/85: 104 (lot, H attributed et al), 105 (lot, H-10 attributed et al);
Swann NY 11/14/85: 170 (lot, H et al);

**HAWARDEN, Lady Clementina Eliphinstone** (British, 1822-1865)
Photos dated: c1860-1865
Processes: Albumen
Formats: Prints
Subjects: Genre
Locations: England - London
Studio: England - London
  Entries:
Sothebys Lon 3/9/77: 211 ill;
Sothebys Lon 3/21/80: 306 ill;
Sothebys Lon 10/29/80: 275 ill, 276 ill;
Sothebys Lon 3/27/81: 438 ill;
Sothebys Lon 10/28/81: 344 ill, 345 ill;
Sothebys Lon 3/29/82: 150 ill;
Sothebys NY 5/25/82: 412 ill;
Sothebys Lon 6/25/82: 187 ill;
Sothebys Lon 3/25/83: 115 ill, 116 ill;
Christies NY 11/6/84: 5 ill(note);
Sothebys Lon 11/1/85: 68 ill;

**HAWES** (see CHACE & HAWES)

**HAWES, C.E.** (American)
Photos dated: c1865
Processes: Ambrotype
Formats: Plates
Subjects: Portraits
Locations: Studio
Studio: US - New Bedford, Massachusetts
  Entries:
California Galleries 1/21/78: 7;

**HAWES, Josiah Johnson** (American, 1808-1901)(see also SOUTHWORTH & HAWES)
Photos dated: 1840-1872
Processes: Daguerreotype, albumen
Formats: Plates, prints, cdvs, stereos, cabinet cards
Subjects: Portraits
Locations: Studio
Studio: US - Boston, Massachusetts
  Entries:
Sothebys NY (Strober Coll.) 2/7/70: 311 (lot, H-1 et al), 324 (lot, H et al);
Rinhart NY Cat 2, 1971: 288 (lot, H et al);
Rinhart NY Cat 7, 1973: 549;
Gordon NY 11/13/76: 107 ill;
Swann NY 4/14/77: 29 (book, 8)(note);
Lehr NY Vol 1:3, 1979: 20 ill;
Swann NY 11/18/82: 392;
Christies NY 2/8/83: 40 (lot, H-3 et al);
Sothebys NY 11/5/84: 337 ill(note);
Harris Baltimore 11/7/86: 219 (lot, H-1 et al);

**HAWORTH & McCOLLIN** (American)
Photos dated: Nineteenth century
Processes: Albumen
Formats: Stereos
Subjects: Topography
Locations: US - Yosemite, California
Studio: US
  Entries:
Harris Baltimore 12/10/82: 115 (lot, H & M et al);

**HAWKE, J.** (British)
Photos dated: 1860s
Processes:     Albumen
Formats:       Cdvs
Subjects:      Portraits
Locations:     Studio
Studio:        England - Devon
    Entries:
Christies Lon 10/30/80: 349 (album, H et al);

**HAWKINS, B.E.** (American)
Photos dated: c1875
Processes:     Albumen
Formats:       Prints
Subjects:      Topography
Locations:     US - Colorado
Studio:        US - Denver, Colorado
    Entries:
California Galleries 1/21/78: 360;
California Galleries 1/21/79: 441;

**HAWKINS, C.** (British)
Photos dated: Nineteenth century
Processes:     Albumen
Formats:       Cdvs
Subjects:      Portraits
Locations:     Studio
Studio:        England - Brighton
    Entries:
Christies Lon 6/26/80: 483 (lot, H et al);
Phillips Lon 10/29/86: 313 (album, H et al);

**HAWKINS, E.** (British)
Photos dated: 1890s
Processes:
Formats:       Prints
Subjects:
Locations:     Great Britain
Studio:        England (West Kent Amateur
               Photographic Society)
    Entries:
Christies Lon 6/27/85: 260 (lot, H et al);

**HAWKINS, Ezekial C.** (American)
Photos dated: 1844-1860
Processes:     Daguerreotype, ambrotype, "solograph"
Formats:       Plates, prints
Subjects:      Portraits
Locations:     Studio
Studio:        US - Cincinnati, Ohio
    Entries:
Swann NY 4/23/81: 232 (2)(note);
Christies Lon 10/25/84: 10 (lot, H-1 et al);

**HAY & Co.** (Canadian)
Photos dated: 1870
Processes:     Albumen
Formats:       Cdvs
Subjects:      Portraits
Locations:     Studio
Studio:        Canada - Toronto
    Entries:
Phillips Lon 10/24/84: 123 (lot, H-3 et al);

**HAY, G. & D.** (British)
Photos dated: 1850s-1860s
Processes:     Ambrotype, albumen
Formats:       Plates, cdvs
Subjects:      Portraits
Locations:     Studio
Studio:        Scotland - Edinburgh
    Entries:
Christies Lon 10/28/76: 46 (lot, H-1 et al);
Sothebys Lon 3/22/78: 153 (lot, H-1 et al);
Christies Lon 3/20/80: 40 (lot, H-1 et al);
Sothebys Lon 6/25/82: 44 (lot, H-2 et al);
Christies Lon 6/23/83: 20 ill(2);
Phillips Lon 6/26/85: 205 (lot, H-1 et al);
Phillips Lon 10/30/85: 57 (lot, H et al);
Christies Lon 10/31/85: 302 (album, H et al);
Phillips Lon 4/23/86: 239 (lot, H et al);
Christies Lon 10/30/86: 252 (album, H et al);

**HAYES & HAYES** (American)
Photos dated: between 1870s and 1890s
Processes:     Albumen
Formats:       Cabinet cards
Subjects:      Portraits
Locations:     Studio
Studio:        US - Portland, Oregon
    Entries:
Swann NY 4/26/79: 284 (lot, H & H-1 et al);

**HAYES, Dr. Isaac**
Photos dated: 1861-1869
Processes:     Albumen
Formats:       Prints
Subjects:      Topography, ethnography
Locations:     Iceland
Studio:
    Entries:
Anderson NY (Gilsey Coll.) 1/20/03: 61 (21)(note);

**HAYNES, Frank Jay** (American, 1853-1921)
Photos dated: 1874-1916
Processes:     Albumen, photogravure, collotype,
               silver, platinum, bromide
Formats:       Prints, stereos, cdvs, lantern slides
Subjects:      Topography, ethnography, documentary
               (railroads)
Locations:     US - American west; Yellowstone Park,
               Wyoming; Alaska
Studio:        US - Moorhead, Minnesota; Fargo, North
               Dakota; Yellowstone Park, Wyoming
    Entries:
Sothebys NY (Weissberg Coll.) 5/16/67: 74 (book, 12)
    (note);
Sothebys NY (Strober Coll.) 2/7/70: 508 (lot, H et
    al), 510 (lot, H et al);
Rinhart NY Cat 2, 1971: 435 (album, H et al),
    587 (2);
Vermont Cat 4, 1972: 590 ill(5);
Rinhart NY Cat 6, 1973: 4 (album, 24), 449;
Rinhart NY Cat 7, 1973: 290, 291;
Vermont Cat 5, 1973: 523 ill(note), 524 ill(11);
Sothebys Lon 12/4/73: 213 (album, H et al);
Witkin NY II 1974: 933 (3), 935 ill(3);
Christies Lon 7/25/74: 245, 341 (albums, H et al);
Sothebys NY 2/21/75: 180 ill(album, 48)(note);
Sothebys NY 9/23/75: 165 ill(12)(note), 166 (album,
    12), 167 ill(book, 25), 168 (album, 36);

**HAYNES** (continued)
Kingston Boston 1976: 103 ill(note), 104 (4 ills)
(book, 12), 185 (2 ills)(album, 24)(attributed);
Rose Boston Cat 1, 1976: 1 ill(note);
Swann NY 4/1/76: 145 (album, H-27 et al), 197 (33);
California Galleries 4/3/76: 492 (lot, H et al);
Sothebys NY 5/4/76: 151 ill(album, 104)(note), 152
(album, 24), 153 (book, 24);
Sothebys Lon 6/11/76: 3 (lot, H-6 et al);
Christies 10/28/76: 161 (lot, H-1 et al);
Sothebys Lon 10/29/76: 30 (lot, H et al);
Swann NY 11/11/76: 512 (24);
Gordon NY 11/13/76: 97 ill, 98 ill, 99 ill;
Rose Boston Cat 2, 1977: 4 ill(note), 5 ill;
Vermont Cat 11/12, 1977: 785 ill, 786 ill(12), 787
ill, 788 ill, 789 ill(13);
White LA 1977: 89 ill(note), 90;
California Galleries 1/22/77: 316 (11);
Sothebys Lon 3/9/77: 28 (album, H-13 et al);
Swann NY 4/14/77: 338 (lot, H et al), 342 (lot,
H et al);
Gordon NY 5/10/77: 873 ill, 874 ill(book, 12);
Sothebys NY 5/20/77: 11 (3);
Swann NY 12/8/77: 281, 379 (22);
Frontier AC, Texas 1978: 121 (12), 122 (book, 12)
(note), 122b (book, 12), 123 (book, 26)(note),
124 ill(book, 40)(note), 125 (28);
Lehr NY Vol 1:2, 1978: 20 ill;
Rose Boston Cat 3, 1978: 10 ill(note);
Wood Conn Cat 42, 1978: 230 (book, 12), 231
(book, 25);
California Galleries 1/21/78: 361, 362 (11),
363 (11);
Sothebys LA 2/13/78: 58 ill;
Swann NY 4/20/78: 75 (book);
Phillips NY 11/4/78: 88, 89;
Swann NY 12/14/78: 277 (34)(note); 343 (album, H-56
et al), 407 (note), 408 (3), 409, 491 (31)
(attributed);
Lehr NY Vol 2:2, 1979: 14 ill;
Wood Conn Cat 45, 1979: 132 (book, 12);
California Galleries 1/21/79: 442;
Swann NY 4/26/79: 92 (book, 25), 370 ill(album, 24)
(note);
Christies Lon 6/28/79: 76 (lot, H-14 et al);
Swann NY 10/18/79: 361 (album, H attributed et al);
Christies Lon 10/25/79: 226 (album, 12)(note);
Christies NY 10/31/79: 88 (book), 88A;
Phillips NY 11/3/79: 134 ill(141)(note), 202 ill;
Phillips NY 11/29/79: 283 (2)(attributed);
California Galleries 3/30/80: 323;
Swann NY 4/17/80: 109 (book, 26), 213 (book, 25),
274 (25), 389 (16)(attributed);
Christies NY 5/14/80: 160 (book);
Sothebys NY 5/20/80: 297 ill(4);
Phillips NY 5/21/80: 63 (book, 25), 121 (lot, H-15
et al);
Swann NY 11/6/80: 309 ill, 310 (9)(note);
Christies NY 11/11/80: 172A (12);
Sothebys NY 11/17/80: 118 (book, 12);
California Galleries 12/13/80: 273 (20), 274, 275;
Sothebys LA 2/4/81: 242 (3);
Swann NY 4/23/81: 347 (2);
Phillips NY 5/9/81: 77 ill;
Christies Lon 6/18/81: 408 (lot, H-17 et al);
California Galleries 6/28/81: 250 (20), 251, 252
(attributed), 307 (lot, H-1 et al), 394 (3);
Christies Lon 10/29/81: 279 (album, H et al);
Swann NY 11/5/81: 568 (6);
Phillips NY 2/9/82: 138 (book, 25);
California Galleries 5/23/82: 82 (book, 25), 318;

**HAYNES** (continued)
Sothebys NY 5/25/82: 413;
Christies Lon 6/24/82: 34 (lot, H-20 et al);
Phillips NY 11/9/82: 134 (12);
Harris Baltimore 12/2/82: 46 (19);
Christies NY 2/8/83: 25 (lot, H-9 et al);
Harris Baltimore 4/8/83: 374;
Swann NY 5/5/83: 361, 362 (album, 24)(note);
Phillips Lon 6/15/83: 131 (lot, H et al);
California Galleries 6/19/83: 250 (album, 48), 251
(20), 429 (lot, H-1 et al), 506 (lot, H-1 et al);
Phillips Lon 11/4/83: 85 (lot, H et al);
Swann NY 11/10/83: 349 (note);
Harris Baltimore 12/16/83: 365;
Christies NY 2/22/84: 31 (attributed);
Swann NY 5/10/84: 61 (book, 25), 314 (lot, H et al);
Harris Baltimore 6/1/84: 153 (lot, H et al);
California Galleries 7/1/84: 203 (18), 204 (16),
451, 452, 453 (7), 454 (1 plus 1 attributed),
455 (album, H-29 et al);
Christies NY 9/11/84: 148 (11);
Swann NY 11/8/84: 57 (book, 25), 211, 253 (lot,
H et al);
Christies NY 2/13/85: 161, 162 (2);
Harris Baltimore 3/15/85: 106 (lot, H et al);
Christies NY 5/6/85: 169 ill;
California Galleries 6/8/85: 239 ill, 240, 428
(18), 429 (12), 430 (21), 431 ill(18);
Swann NY 11/14/85: 12 (lot, H et al), 135 (album,
H et al);
Harris Baltimore 2/14/86: 314 (note);
California Galleries 3/29/86: 736 (4), 737 (3), 738
(9), 739 (7), 740 (7), 741 (7);
Swann NY 5/15/86: 252 (33);
Phillips NY 7/2/86: 334, 335, 336;
Swann NY 11/13/86: 134 (lot, H-11 et al), 329 (123);

**HAYNES, S.** (American)
Photos dated: c1880
Processes:   Albumen
Formats:     Prints
Subjects:    Topography
Locations:   US - Monterey, California
Studio:      US
 Entries:
California Galleries 1/21/79: 479;

**HAYWARD, Robert** (British)
Photos dated: 1864
Processes:   Albumen
Formats:     Prints
Subjects:    Topography
Locations:   Great Britain
Studio:      Great Britain
 Entries:
Sothebys Lon 3/12/82: 430 (book, 8);
Christies Lon 3/28/85: 182 (13)(note);

**HAYWARD & MUZZELL** (American)
Photos dated: 1870s
Processes:      Albumen
Formats:        Stereos, cdvs
Subjects:       Topography, ethnography
Locations:      US - American west
Studio:         US - Santa Barbara, California
    Entries:
Swann NY 4/1/82: 249 (lot, H & M et al);
California Galleries 5/23/82: 421 (lot,
    H, H & M et al);

**HAYWOOD, John** (American)
Photos dated: 1860s
Processes:      Albumen
Formats:        Stereos
Subjects:       Topography
Locations:      US - White Mountains, New Hampshire
Studio:         US - Boston, Massachusetts
    Entries:
Swann NY 12/14/78: 310 (58);

**HAZARD**
Photos dated: Nineteenth century
Processes:      Albumen
Formats:        Stereos
Subjects:       Topography
Locations:      US
Studio:
    Entries:
Swann NY 11/10/83: 346 (lot, H et al);

**HAZARD, John Bevan** (British, died 1892)
Photos dated: 1847-1857
Processes:      Salt
Formats:        Prints
Subjects:       Topography, genre
Locations:      England - Bristol
Studio:         England - Bristol
    Entries:
Sothebys Lon 3/29/82: 80 (14), 81 ill(6), 82 ill
    (3), 83 ill(2), 84 ill, 85 ill, 86 ill(20), 87
    ill(15), 88 ill(6), 89 ill(16), 90 ill(80);
Sothebys Lon 6/24/83: 85 (11), 86 (8);
Swann NY 5/10/84: 237 (3)(note);
Sothebys Lon 6/29/84: 148 (lot, H et al), 149 ill;
Sothebys Lon 10/31/86: 91 (5);

**HAZELTINE, Martin M.** (American)
Photos dated: 1870s-1880s
Processes:      Albumen
Formats:        Prints, stereos
Subjects:       Topography
Locations:      US - American west
Studio:         US - Stockton, California
    Entries:
Sothebys NY (Strober Coll.) 2/7/70: 502 (lot,
    H et al);
California Galleries 9/27/75: 580 (lot, H et al);
California Galleries 1/23/77: 454 (lot, H et al);
Sothebys NY 11/2/79: 305 (2);
Harris Baltimore 12/10/82: 17 (lot, H-1
    et al)(note);

**HAZELTON, B.C.** (American)
Photos dated: c1859
Processes:      Daguerreotype
Formats:        Plates
Subjects:       Portraits
Locations:      Studio
Studio:         US - Boston, Massachusetts
    Entries:
Gordon NY 5/3/76: 267 (lot, H et al);

**HEALD** (see WARREN & HEALD)

**HEATH, Vernon** (British, 1819-1895)
Photos dated: 1860s-c1880
Processes:      Calotype, albumen, carbon
Formats:        Prints, cdvs
Subjects:       Topography, portraits
Locations:      England; Scotland
Studio:         Great Britain (Amateur Photographic
                Association)
    Entries:
Sothebys Lon 6/21/74: 88 (32)(note);
Phillips NY 5/9/81: 16 ill(note);
Christies NY 5/14/81: 83 ill;
Christies Lon 10/27/83: 218 (albums, H-1 et al);
Christies Lon 3/28/85: 210 ill(note);
Christies Lon 4/24/86: 494 ill(note);
Sothebys Lon 10/31/86: 114, 115 ill(lot, H-1 et al);

**HEATH, W.** (British)
Photos dated: 1860s
Processes:      Albumen
Formats:        Stereos, cdvs
Subjects:       Topography, portraits
Locations:      Great Britain
Studio:         Great Britain
    Entries:
Swann NY 12/14/78: 367 (lot, H et al);
Sothebys Lon 10/26/84: 3 (lot, H et al);

**HEATHCOTE, John Moyer** (British, 1800-1892)
Photos dated: early 1850s
Processes:      Calotype
Formats:        Negatives
Subjects:       Architecture, topography
Locations:      England
Studio:         Great Britain
    Entries:
Christies Lon 6/24/82: 86 ill(4);
Kraus NY Cat 1, 1984: 27 (2 ills)(78)(note);
Christies Lon 10/31/85: 175 (6);
Christies Lon 10/30/86: 70 (6);

**HECHT, A.**
Photos dated: Nineteenth century
Processes:      Albumen
Formats:        Stereos
Subjects:       Topography
Locations:      Germany
Studio:
    Entries:
Christies Lon 10/29/81: 150 (lot, H et al);

**HEDDERLY, James** (British, c1815-1885)
Photos dated: 1858-1870s
Processes:     Albumen
Formats:       Prints
Subjects:      Topography
Locations:     England - London
Studio:        England - London
   Entries:
Christies Lon 7/13/72: 48;
Sothebys Lon 3/21/75: 142;
Sothebys Lon 9/23/75: 69 (lot, H-1 et al);
Christies Lon 6/27/78: 55;
Sothebys Lon 6/28/78: 315;
Christies Lon 3/29/84: 48 (lot, H-1 et al), 49 (9);

**HEER, Samuel** (Swiss)
Photos dated: 1839-1851
Processes:     Daguerreotype
Formats:       Plates
Subjects:      Portraits
Locations:     Studio
Studio:        Switzerland - Lausanne
   Entries:
Vermont Cat 11/12, 1977: 550 ill(note);

**HEERING**
Photos dated: Nineteenth century
Processes:     Albumen
Formats:       Stereos
Subjects:      Topography
Locations:     US - California
Studio:
   Entries:
Harris Baltimore 12/10/82: 17 (lot, H-1 et al);

**HEFFER**
Photos dated: c1880
Processes:     Albumen
Formats:       Prints
Subjects:      Topography
Locations:     Peru
Studio:
   Entries:
Swann NY 4/26/79: 429 ill(album, H et al);

**HEGGER, Frank**
Photos dated: 1874
Processes:     Albumen
Formats:       Prints
Subjects:      Portraits
Locations:
Studio:
   Entries:
Christies NY 11/11/80: 171;

**HEILBRONN**
Photos dated: 1860s-1870s
Processes:     Albumen
Formats:       Cdvs
Subjects:      Topography
Locations:     England - Hastings
Studio:
   Entries:
Phillips Lon 10/29/86: 310 (lot, H-4 et al);

**HEILMANN, J.J.**
Photos dated: 1855
Processes:     Salt
Formats:       Prints
Subjects:      Topography, genre
Locations:     France - Pau
Studio:        Great Britain (Photographic Club)
   Entries:
Sothebys Lon 10/24/75: 286 (album, H-1 et al);
Sothebys Lon 10/29/76: 119 (lot, H-4 et al)(note);
Sothebys Lon 3/12/82: 320 (2);
Sothebys Lon 11/1/85: 59 (album, H-1 et al);
Christies Lon 6/26/86: 182 (lot, H-1 et al)(note);
Sothebys Lon 10/31/86: 159;

**HELD, Louis** (German)
Photos dated: 1896
Processes:     Albumen
Formats:       Prints
Subjects:      Topography
Locations:     Germany
Studio:        Germany
   Entries:
Christies NY 9/11/84: 130 (album, H et al);

**HELIA** (American)
Photos dated: 1850s
Processes:     Daguerreotype
Formats:       Plates
Subjects:      Portraits
Locations:     Studio
Studio:        US
   Entries:
Sothebys NY (Weissberg Coll.) 5/16/67: 159 (lot,
   H-1 et al);

**HELIOS** (aka MUYBRIDGE, E., q.v.) [HELIOS 1]

**HELIOS** [HELIOS 2]
Photos dated: 1870s
Processes:     Albumen
Formats:       Prints
Subjects:      Topography
Locations:     Egypt - Cairo
Studio:
   Entries:
Swann NY 5/5/83: 339 (lot, H et al)(note);
Harris Baltimore 2/14/86: 293;

**HELLIS & Sons** (British)
Photos dated: 1880s
Processes:     Albumen
Formats:       Prints, cabinet cards
Subjects:      Genre
Locations:     Great Britain
Studio:        Great Britain
   Entries:
Sothebys Lon 6/17/81: 246 (album, 20);

**HELME, J.C.** (American)
Photos dated: 1850s
Processes:   Daguerreotype
Formats:     Plates
Subjects:    Portraits
Locations:   Studio
Studio:      US - New York City
   Entries:
Sothebys NY (Weissberg Coll.) 5/16/67: 111 (lot,
   H-1 et al);

**HELMORE, Frederick**
Photos dated: 1874
Processes:   Heliotype
Formats:     Prints
Subjects:    Documentary (scientific)
Locations:
Studio:
   Entries:
Christies Lon 3/15/79: 217 (book, 8);

**HELSBY, Thomas C.** (aka Tomas H.) (British)
Photos dated: 1846-1870s
Processes:   Daguerreotype, albumen
Formats:     Plates, prints, cdvs
Subjects:    Portraits, topography
Locations:   England; Mexico; Argentina; Chile
Studio:      England - Liverpool; Argentina -
             Buenos Aires; Chile - Valparaiso
   Entries:
Christies Lon 6/30/77: 30 (note);
Christies Lon 10/26/78: 7 ill(note);
Christies Lon 6/28/79: 16 (lot, H-1 et al);
Christies Lon 3/20/80: 17 (lot, H-1 et al);
Christies Lon 6/23/83: 161 (album, 15);
Swann NY 5/10/84: 193 (album, 15);
Phillips Lon 4/23/86: 226 (album, H-2 et al);

**HELSEY, W.G.** (British)
Photos dated: 1860s
Processes:   Ambrotype, albumen
Formats:     Plates, stereos
Subjects:    Portraits, topography
Locations:   England; Chile
Studio:      England - Liverpool; Chile
   Entries:
Vermont Cat 9, 1975: 461 ill;

**HEMMENT, John C.**
Photos dated: 1891
Processes:   Photogravure
Formats:     Prints
Subjects:    Genre
Locations:
Studio:
   Entries:
California Galleries 1/21/79: 443;

**HEMPHILL, William Despard, M.D.** (British)
Photos dated: 1861-1871
Processes:   Ambrotype, albumen
Formats:     Plates incl. stereo, prints
Subjects:    Architecture, topography, genre
Locations:   Great Britain; Ireland; Italy - Spezia
Studio:      Great Britain (Amateur Photographic
             Association)
   Entries:
Sothebys Lon 12/4/73: 175 (books, H et al);
Vermont Cat 7, 1974: 753 (book, H et al);
Sothebys Lon 6/21/74: 150 (books, H et al);
Sothebys Lon 10/18/74: 254 (book, H et al);
Edwards Lon 1975: 110 (book, H et al);
California Galleries 9/26/75: 180 (book, H et al);
Sothebys Lon 6/11/76: 158 (book, H et al);
Christies Lon 10/28/76: 276 (book, H et al);
Swann NY 11/11/76: 269 (book, H et al)(note);
Vermont Cat 11/12, 1977: 524 (book, H et al);
Christies Lon 3/19/77: 269 ill(albums, H-1 et al);
Sothebys Lon 7/1/77: 22 (book, H et al);
Sothebys Lon 11/18/77: 176 (book, H et al), 195
   (books, H et al);
Sothebys Lon 6/28/78: 19 (book, H et al), 20 (book,
   H et al);
Christies Lon 10/26/78: 208 (book, H et al);
Witkin NY IX 1979: 2/41 (book, H-5 et al);
California Galleries 3/30/80: 85 (book, H et al);
Sothebys Lon 10/29/80: 310 (album, H et al);
Phillips NY 1/29/81: 85 (book, H et al);
Sothebys Lon 6/17/81: 444 (book, H et al), 445
   (book, H et al);
Sothebys Lon 3/12/82: 436 (books, H et al);
Christies Lon 3/24/83: 146 (book);
Harris Baltimore 4/8/83: 195 (book, H et al);
Christies Lon 10/27/83: 218 (albums, H-7 et al);
Sothebys Lon 6/29/84: 194 (lot, H-1 et al);
Christies Lon 6/26/86: 175 (books, H et al);
Christies Lon 10/30/86: 18 ill(3)(note), 18A, 19
   ill(80);

**HENDEE, J.S.** (American)
Photos dated: 1860s
Processes:   Ambrotype
Formats:     Plates
Subjects:    Portraits
Locations:   Studio
Studio:      US
   Entries:
Vermont Cat 4, 1972: 392 ill;

**HENDERSON** (see MELANDER & HENDERSON) [HENDERSON 1]

**HENDERSON & MULLINS** (British) [HENDERSON 2]
Photos dated: 1890s
Processes:
Formats:     Prints
Subjects:    Genre (animal life)
Locations:   Great Britain
Studio:      Great Britain
   Entries:
Christies Lon 3/24/83: 237 (lot, H & M et al);
Swann NY 11/10/83: 276 (album, H & M et al);

HENDERSON, A.L. (British, died c1900)
Photos dated: 1865-1886
Processes:      Albumen, photoceramic
Formats:        Prints, cdvs, stereos, ceramic support
Subjects:       Topography, portraits
Locations:      England
Studio:         England - London (Amateur Photographic
                Association)
    Entries:
Christies Lon 6/26/80: 129 ill(19);
Sothebys Lon 10/29/80: 310 (album, H et al);
Christies Lon 10/27/83: 62 (album, H et al), 218
    (albums, H-1 et al);
Christies Lon 3/28/85: 41 (lot, H et al);

HENDERSON, Alexander (Canadian)
Photos dated: 1859-c1890
Processes:      Albumen
Formats:        Prints, stereos
Subjects:       Topography
Locations:      Canada - Montreal
Studio:         Canada - Montreal
    Entries:
Swann NY 2/14/52: 14 (lot, H et al), 70 (book, 18)
    (note), 71 (book, 20)(note), 72 (book, 20)
    (note), 75 (albums, H et al);
Rinhart NY Cat 1, 1971: 479 (book, 19);
Rinhart NY Cat 6, 1973: 397;
Sothebys Lon 6/21/74: 93 (album, H-3 et al);
Sothebys Lon 6/26/75: 189 (album, H et al);
Swann NY 4/1/76: 199 (14);
Sothebys NY 11/9/76: 57;
Christies Lon 10/27/77: 174 (album, H-1 et al);
Sothebys Lon 11/18/77: 247 (lot, H-2 et al);
Phillips Can 10/4/79: 77 (3)(note), 78 ill(note);
Sothebys Lon 10/24/79: 184 (2);
Christies Lon 6/26/80: 116 (lot, H-3 et al);
Phillips Can 10/9/80: 55 (lot, H-2 et al);
Christies Lon 3/26/81: 264 (album, H et al);
Swann NY 4/23/81: 523 (lot, H et al);
Christies Lon 6/18/81: 228 (3);
Christies Lon 3/11/82: 84 (lot, H et al), 221 (lot,
    H-3 et al);
Christies Lon 6/24/82: 28 (lot, H et al);
Sothebys Lon 3/25/83: 32 (album, H-1 et al);
Harris Baltimore 3/15/85: 18 (lot, H et al);

HENDERSON, J. (American)
Photos dated: 1850s
Processes:      Daguerreotype
Formats:        Plates
Subjects:       Portraits
Locations:      Studio
Studio:         US - New York City
    Entries:
Vermont Cat 11/12, 1977: 551 ill;

HENDERSON, James (British)
Photos dated: 1850s
Processes:      Daguerreotype
Formats:        Plates
Subjects:       Portraits
Locations:      Studio
Studio:         England - London
    Entries:
Sothebys Lon 10/18/74: 237;
Sothebys Lon 10/29/76: 195 (lot, H-1 et al);

HENDERSON, J. (continued)
Sothebys Lon 6/28/78: 174;
Christies Lon 3/28/85: 7 (lot, H-1 et al);

HENDLEY (British)
Photos dated: 1850s
Processes:      Ambrotype
Formats:        Plates
Subjects:       Portraits
Locations:      Studio
Studio:         England - Cheltenham
    Entries:
Christies Lon 10/25/84: 10 (lot, H-1 et al);

HENKEL
Photos dated: 1860s
Processes:      Albumen
Formats:        Cdvs
Subjects:       Portraits
Locations:
Studio:
    Entries:
Harris Baltimore 4/8/83: 381 (lot, H et al);

HENNAH (see SACHE)

HENNAH, T.H. (British)
Photos dated: 1855-c1875
Processes:      Salt, albumen
Formats:        Prints, cdvs
Subjects:       Portraits, topography, documentary
                (public events)
Locations:      England - Dorsetshire
Studio:         England - Brighton
    Entries:
Goldschmidt Lon Cat 52, 1939: 294 (H & Kent, 2);
Sothebys Lon 6/21/74: 172 (4);
Sothebys Lon 3/21/75: 164 (album, H & Kent et al);
Sothebys Lon 10/24/75: 286 (album, H-1 et al);
Sothebys Lon 10/29/76: 295 ill(note);
Sothebys Lon 6/27/80: 219 (album, H & Kent et al);
Sothebys Lon 3/12/82: 226 (album, H & Kent et al);
Christies Lon 6/28/84: 304 (lot, H & Keary-1,
    et al);
Sothebys Lon 11/1/85: 59 (album, H-1 et al);
Christies Lon 4/24/86: 482 ill(note);

HENNEMAN, Nicolaas (Dutch, 1813-1898)(see also
    MALONE)
Photos dated: c1840-1852
Processes:      Calotype, daguerreotype
Formats:        Prints, plates
Subjects:       Topography, documentary, genre (still
                life)
Locations:      England - London; Italy - Venice
Studio:         England - London
    Entries:
Weil Lon Cat 4, 1944(?): 254 (book, 66)(note);
Weil Lon Cat 14, 1949(?): 307 (book, 66)(note);
Weil Lon Cat 21, 1953: 298 (book, 66)(note);
Colnaghi Lon 1976: 31 ill(note), 32 (9 ills)(books,
    H, Ferrier & Owen, 154)(note);
Christies Lon 10/27/77: 284 ill;
Christies Lon 10/28/76: 72;
Wood Conn Cat 41, 1978: 29 ill(books, H et al)
    (note);

**HENNEMAN, N.** (continued)
Christies Lon 3/16/78: 191 (book, 1)(attributed);
Sothebys Lon 6/28/78: 309 (H & Malone);
Wood Conn Cat 45, 1979: 124 (books, H et al)(note);
Christies Lon 6/28/79: 211;
Sothebys Lon 6/17/81: 98 ill;
Christies Lon 6/18/81: 303 (lot, H & Malone-1,
    et al);
Christies Lon 10/29/81: 72 (lot, H-1 et al);
Sothebys Lon 3/29/82: 72 ill;
Christies Lon 6/24/82: 349 (H & Malone);
Sothebys Lon 3/25/83: 103 ill;
Kraus NY Cat 1, 1984: 10 ill(note);
Sothebys Lon 6/29/84: 132 ill(attributed), 133 ill
    (attributed), 134 ill(attributed), 135 ill
    (attributed), 136 ill(attributed);
Christies Lon 10/25/84: 113 ill(book, 1)(note), 154
    ill(H & Malone)(note);
Sothebys Lon 10/26/84: 99 ill;
Christies Lon 3/28/85: 30;
Sothebys Lon 6/28/85: 83 ill, 84;

**HENRI** (French)
Photos dated: 1876
Processes:      Albumen
Formats:        Prints
Subjects:       Architecture
Locations:      France - Paulhac
Studio:         France
    Entries:
Christies Lon 3/16/78: 75 (6);

**HENRY, Captain** (British)
Photos dated: 1857-c1860
Processes:      Albumen
Formats:        Prints, stereos
Subjects:       Topography
Locations:      Great Britain; Iceland - Reykjavik
Studio:         Great Britain (Photographic Club)
    Entries:
Sothebys Lon 3/9/77: 11 (lot, H-1 et al);
Sothebys Lon 3/14/79: 324 (album, H-1 et al);

**HENSHEL**
Photos dated: Nineteenth century
Processes:      Albumen
Formats:        Cabinet cards
Subjects:       Portraits
Locations:
Studio:
    Entries:
Harris Baltimore 4/8/83: 383 (lot, H et al);

**HENSZY** (aka HENSZEY)(American)
Photos dated: 1865
Processes:      Albumen
Formats:        Cdvs
Subjects:       Portraits, documentary (public events)
Locations:      US
Studio:         US
    Entries:
Sothebys NY (Greenway Coll.) 11/20/70: 203 ill(lot,
    H-1 et al);
California Galleries 1/21/78: 122 (lot, H et al);

**HERBERT**
Photos dated: 1860s and/or 1870s
Processes:      Albumen
Formats:        Stereos
Subjects:       Genre (animal life)
Locations:      South Africa
Studio:
    Entries:
Sothebys Lon 10/24/75: 95 (lot, H-1 et al);

**HERBERT, Franco Martinez de**
Photos dated: 1861-c1879
Processes:      Albumen
Formats:        Prints
Subjects:       Topography, portraits
Locations:      Spain - Madrid and Salamanca;
Philippines
Studio:         Spain - Madrid
    Entries:
Fraenkel Cat 1984: 48 (3 ills)(album, 54)(note);

**HERBERT, Lady Mary** (British)(photographer?)
Photos dated: c1870
Processes:      Albumen
Formats:        Prints
Subjects:       Portraits, genre
Locations:      England
Studio:         England
    Entries:
Christies Lon 6/10/76: 150 (album, H et al);

**HERBRUGER, E.**
Photos dated: 1860s
Processes:      Albumen
Formats:        Stereos, cdvs
Subjects:       Topography
Locations:      Panama
Studio:         Panama
    Entries:
California Galleries 9/27/75: 466 (lot, H et al);
Christies Lon 3/29/84: 21 (lot, H-2 et al);

**HERING, H.** (British)
Photos dated: 1860s
Processes:      Albumen
Formats:        Prints, cdvs
Subjects:       Portraits
Locations:      Studio
Studio:         Great Britain
    Entries:
Sothebys NY (Greenway Coll.) 11/20/70: 125 ill;
Christies Lon 3/16/78: 292 (album, H-2 et al);
Christies Lon 10/31/85: 302 (album, H et al);
Christies Lon 10/30/86: 252 (album, H et al);

**HERMES, Wilhelm H.** (German)
Photos dated: 1881-1882
Processes:      Albumen
Formats:        Prints
Subjects:       Topography, portraits
Locations:      Germany
Studio:         Germany
    Entries:
California Galleries 4/2/76: 242 (lot, H-1 et al);
California Galleries 3/30/80: 317 (lot, H-1 et al);
Christies Lon 6/26/86: 125 (book, 133);

HERRIN, D.C. (American)
Photos dated: c1890
Processes:      Albumen
Formats:        Prints
Subjects:       Ethnography
Locations:      US
Studio:         US
    Entries:
California Galleries 1/21/78: 370 (lot, H-2 et al);

HERSCHEL, Sir John Frederick William (British,
                1792-1871)
Photos dated: 1839-1845
Processes:      Ferro-cyanure
Formats:        Prints
Subjects:       Photogenic drawing
Locations:      England
Studio:         England
    Entries:
Rauch Geneva 6/13/61: 42i (note), 42k (attributed);

HERSOM, C.E. & A.R. (American)
Photos dated: c1880s
Processes:      Albumen
Formats:        Prints, boudoir cards
Subjects:       Topography
Locations:      US - Colorado
Studio:         US
    Entries:
Phillips NY 5/21/80: 121 (lot, H-11 et al);
Harris Baltimore 2/14/86: 277 (lot, H et al);

HERTEL, Frederich (German)
Photos dated: 1880s
Processes:      Albumen
Formats:        Prints
Subjects:       Topography
Locations:      Germany
Studio:         Germany - Weimar
    Entries:
Christies NY 9/11/84: 119 (album, H et al), 120
    (album, H et al);

HERTL, O.
Photos dated: 1880s
Processes:      Albumen
Formats:        Prints
Subjects:       Topography
Locations:      Europe
Studio:         Europe
    Entries:
Auer Paris 5/31/80: 65 (lot, H-2 et al);
Swann NY 5/9/85: 386 (albums, H et al)(note);

HERTZL, G.
Photos dated: 1880s
Processes:      Albumen
Formats:        Prints
Subjects:       Topography
Locations:      Europe
Studio:         Europe
    Entries:
Swann NY 11/13/86: 216 (albums, H et al);

HERVE & DEBITTE (French)
Photos dated: 1860s-1890s
Processes:      Albumen
Formats:        Prints, stereos, cdvs
Subjects:       Topography, documentary (Paris
Commune)
Locations:      France - Paris
Studio:         France - Paris
    Entries:
Rose Boston Cat 3, 1978: 74 ill(note);
Christies Lon 6/24/82: 363 (album, H & D-9 et al);

HERZOG & HIGGINS
Photos dated: 1880s
Processes:
Formats:        Prints
Subjects:       Portraits
Locations:      India
Studio:         India
    Entries:
Sothebys Lon 6/28/78: 138 (lot, H & H et al);

HERZOG, L. (German)
Photos dated: 1860s-1870s
Processes:      Albumen
Formats:        Stereos, cdvs
Subjects:       Topography, portraits
Locations:      Germany - Dresden et al
Studio:         Germany - Bremen
    Entries:
Sothebys Lon 6/21/74: 17 (lot, H et al);
Petzold Germany 5/22/81: 1856 (lot, H et al);
Christies Lon 10/29/81: 150 (lot, H et al);
Harris Baltimore 12/10/82: 39 (lot, H-5 et al);

HESLER, Alexander (American, 1829-1895)
Photos dated: 1847-1895
Processes:      Daguerreotype, albumen
Formats:        Plates, prints, stereos
Subjects:       Portraits, topography
Locations:      US - Mississippi River
Studio:         US - Madison, Wisconsin; Chicago,
                Illinois
    Entries:
Sothebys NY (Strober Coll.) 2/7/70: 31 (books, H et
    al), 267 (lot, H-1 et al), 324 (lot, H et al),
    339 (lot, H-1 et al);
Sothebys NY (Greenway Coll.) 11/20/70: 206 (lot, H-2
    et al);
Rinhart NY Cat 1, 1971: 397;
Wood Conn Cat 37, 1976: 282 ill(note);
Sothebys LA 2/13/78: 41 (note);
Sothebys NY 5/2/78: 6 ill(note);
Christies NY 11/10/81: 41 ill(note);
Harris Baltimore 3/26/82: 349 (note);
Swann NY 4/1/82: 321 (note);
Christies NY 10/4/83: 106;
Harris Baltimore 12/16/83: 253 (note);
Sothebys NY 5/8/84: 166;
Harris Baltimore 6/1/84: 270, 271;
Harris Baltimore 2/14/86: 83, 88;

**HEWETSON, H.T.** (photographer or owner?)
Photos dated: c1860
Processes:
Formats:        Prints
Subjects:       Topography
Locations:      US; Canada
Studio:
    Entries:
Andrieux Paris 1950(?): 35 (album, 125);

**HEWITT & NETTLETON**
Photos dated: c1860
Processes:      Ambrotype
Formats:        Plates
Subjects:       Portraits
Locations:      Studio
Studio:         Australia - Melbourne
    Entries:
Christies Lon 3/16/78: 40;
Christies Lon 10/27/78: 28 ill;

**HEYL, J.B.**
Photos dated: 1870s
Processes:      Albumen
Formats:        Stereos
Subjects:       Topography
Locations:      Bermuda
Studio:         Bermuda - Hamilton
    Entries:
Harris Baltimore 4/8/83: 10 (lot, H-6 et al);

**HEYLAND, Francis** (see also DEROCHE & HEYLAND)
Photos dated: 1857-1884
Processes:      Daguerreotype, albumen
Formats:        Plates, prints
Subjects:       Topography, documentary
Locations:      Italy - Milan, Rome
Studio:         Italy - Milan
    Entries:
Sothebys Lon 12/21/71: 145 (book, 52);
Sothebys Lon 6/21/74: 80 (book, 52);
Christies NY 5/16/80: 185 (lot, H et al);
Petzold Germany 11/7/81: 309 (album, H et al);
Sothebys NY 5/24/82: 248 ill(album, 50);
Swann NY 11/18/82: 403 (lot, H et al);
Christies Lon 6/23/83: 107 (lot, H & Deroche et al);

**HEYN & Co.** (American)
Photos dated: 1870s-1900
Processes:      Albumen, platinum
Formats:        Stereos, prints
Subjects:       Ethnography, topography
Locations:      US - Nebraska
Studio:         US - Omaha, Nebraska
    Entries:
Sothebys LA 2/6/80: 73;

**HEYWOOD, J.D.** (American)
Photos dated: c1857-1869
Processes:      Daguerreotype, albumen
Formats:        Plates, cdvs, stereos
Subjects:       Portraits, topography
Locations:      US - Boston, Massachusetts; New
                Hampshire; Vermont; New York
Studio:         US - Boston, Massachusetts; New
                Berne, North Carolina
    Entries:
Rinhart NY Cat 2, 1971: 448 (lot, H et al), 521
    (lot, H-1 et al), 539 (10);
Rinhart NY Cat 6, 1973: 504;
Rinhart NY Cat 7, 1973: 218;
California Galleries 9/27/75: 513 (lot, H-3 et al);
California Galleries 4/3/76: 435 (lot, H-5 et al);
California Galleries 1/23/77: 411 (lot, H-3 et al),
    419 (lot, H et al);
California Galleries 1/21/79: 301 (lot, H et al);
California Galleries 3/30/80: 418 (lot, H et al);
California Galleries 6/28/81: 322 (lot, H et al);
Harris Baltimore 12/10/82: 102 (lot, H et al);
Harris Baltimore 4/8/83: 109 (lot, H et al);
Harris Baltimore 6/1/84: 885 (lot, H-2 et al), 99
    (lot, H et al);
California Galleries 7/1/84: 627;
Harris Baltimore 3/15/85: 11 (lot, H et al), 75
    (lot, H-3 et al);

**HIBBARD, C.B.** (American)
Photos dated: c1870s
Processes:      Albumen
Formats:        Stereos
Subjects:       Topography
Locations:      US - New Hampshire
Studio:         US - Lisbon, New Hampshire
    Entries:
Rinhart NY Cat 2, 1971: 512 (lot, H-1 et al);

**HIBBERT, Herbert**
Photos dated: 1899
Processes:
Formats:        Prints
Subjects:       Topography
Locations:      Norway
Studio:         Norway - Bradford
    Entries:
Swann NY 2/6/75: 89 (album, 66);

**HICKLING**
Photos dated: 1860s
Processes:      Ambrotype
Formats:        Plates
Subjects:       Portraits
Locations:
Studio:
    Entries:
Vermont Cat 7, 1974: 555 ill;

HIDEUX, Charles (French)
Photos dated: 1862
Processes:      Albumen
Formats:        Prints
Subjects:       Topography
Locations:      France - Pierrefonds
Studio:         France
    Entries:
Christies Lon 3/15/79: 111;

HIESTAND, J.G. (American)
Photos dated: c1880-1880s
Processes:      Albumen
Formats:        Prints, boudoir cards
Subjects:       Topography, documentary (railroads)
Locations:      US - Colorado
Studio:         US - Colorado
    Entries:
California Galleries 1/21/79: 444;
Phillips NY 5/21/80: 121 (lot, H-5 et al);
California Galleries 12/13/80: 276, 277;
California Galleries 6/28/81: 253, 254;
Swann NY 4/1/82: 249 (lot, H et al);
California Galleries 5/23/82: 319 (2);
California Galleries 6/19/83: 365 (lot, H-1 et al);
California Galleries 6/8/85: 200 (lot, H-5 et al);
Phillips NY 7/2/86: 337;

HIGBEE (see KINER, HIGBEE & BERNARD)

HIGGINS (see HERZOG & HIGGINS) [HIGGINS 1]

HIGGINS (American) [HIGGINS 2]
Photos dated: 1850s-c1860
Processes:      Daguerreotype
Formats:        Plates
Subjects:       Portraits
Locations:      Studio
Studio:         US
    Entries:
California Galleries 1/22/77: 77 (lot, H-1 et al);
Christies NY 2/8/83: 76 (lot, H-1 et al);

HIGGINSON, Thomas Wentworth (American)
              (photographer or author?)
Photos dated: 1873
Processes:      Heliotypes
Formats:        Prints
Subjects:       Topography
Locations:      US - Newport, Rhode Island
Studio:         US
    Entries:
Witkin NY V 1977: 67 (book, 10)(note);

HIGHSCHOOL, Professor (British)
Photos dated: 1850s
Processes:      Daguerreotype
Formats:        Plates
Subjects:       Portraits
Locations:      Studio
Studio:         England - London
    Entries:
Phillips Lon 4/23/86: 211 ill;

HIGINBOTHAM, H.D. (American)
Photos dated: 1893
Processes:      Photogravure
Formats:        Prints
Subjects:       Documentary (public events)
Locations:      US - Chicago, Illinois
Studio:         US
    Entries:
California Galleries 3/29/86: 633 (book, H et al);

HILL (see HARRISON, J.T.) [HILL 1]

HILL (see WATKINS & HILL) [HILL 2]

HILL & FRANKLIN (American) [HILL 3]
Photos dated c1890
Processes:      Albumen
Formats:        Prints
Subjects:       Topography
Locations:      US - San José, California
Studio;         US
    Entries:
California Galleries 5/23/82: 347;
California Galleries 6/8/85: 321, 322 (H & F-1,
    H & Watkins-1);

HILL, Arthur (photographer or author?)
Photos dated: 1870
Processes:      Albumen
Formats:        Prints
Subjects:       Architecture
Locations:      Ireland
Studio:
    Entries:
Edwards Lon 1975: 106 (book, 3);

HILL, David Octavius (British, 1802-1870)
              (see also HILL & ADAMSON)
Photos dated: 1843
Processes:      Calotype
Formats:        Prints
Subjects:       Portraits
Locations:      Scotland
Studio:         Scotland - Edinburgh
    Entries:
Weil Lon Cat 4, 1944(?): 207, 208, 209 (note), 210,
    211, 212, 213, 214;
Weil Lon Cat 7, 1945: 74 ill(50)(note), 75 (54)
    (note), 76 (44)(note), 78 (4)(note), 80, 81, 82;
Weil Lon 1946: 4, 5, 6, 7, 8 (note), 9, 10, 11, 12;
Weil Lon Cat 14, 1949(?): 309 (album, 150)(note),
    310 ill(54);
Andrieux Paris 1950(?): 36;
Weil Lon Cat 31, 1963: 193 ill, 194 (note);
Sothebys NY (Weissberg Coll.) 5/16/67: 12 (album,
    34)(attributed)(note), 73;
California Galleries 4/2/76: 254 (attributed)(note);
California Galleries 1/22/77: 317 ill;
California Galleries 1/21/79: 445;
Christies Lon 10/30/80: 348 ill(H & M'Glashon,
    attributed)(note);
Petzold Germany 5/22/81: 1818;
Sothebys Lon 4/25/86: 91 ill(H & M'Glashon, 3
    attributed);

HILL, David Octavius (British, 1802-1870) &
 ADAMSON, Robert (British, 1821-1848)
Photos dated: c1843-c1848
Processes:   Calotype
Formats:    Prints
Subjects:    Portraits, topography
Locations:   Scotland - Edinburgh
Studio:    Scotland - Edinburgh
 Entries:
Goldschmidt Lon Cat 52, 1939: 148 ill(album, 56)
 (note), 149 ill(54), 150, 151, 152, 153, 154,
 155, 156, 157, 158, 159, 160, 161, 162, 163,
 164, 165, 290, 291, 292, 293;
Maggs Paris 1939: 450 (note), 451 ill, 452 (note),
 453 ill(note), 454 (note), 455, 456 (note), 457,
 458;
Weil Lon Cat 1, 1943: 142 (lot, H & A-10 et al);
Swann NY 2/14/52: 176 (2)(note), 177;
Rauch Geveva 6/13/61: 44 (7)(note), 45 (2 ills)
 (album, 137)(note);
Sothebys NY 11/21/70: 107 ill;
Christies Lon 7/13/72: 49 ill;
Frumkin Chicago 1973: 68 ill, 69 ill, 70 ill, 71,
 72 ill, 73 ill;
Lunn DC Cat 3, 1973: 71 ill, 72 ill, 73 ill;
Vermont Cat 5, 1973: 476 ill(note), 477 ill, 478
 ill, 479 ill, 480 ill, 481 ill, 482 ill;
Witkin NY I 1973: 302, 303;
Sothebys Lon 5/24/73: 38 (3 ills)(album, 35)(note),
 40, 41, 42, 43 ill, 44 ill, 45, 46, 47, 48 ill,
 49 ill, 50 ill, 51 ill, 52 ill, 53 ill, 54 ill,
 55 ill, 56 ill, 57 ill, 58 ill, 59 ill, 60 ill,
 61 ill, 62 ill, 63 ill, 64 ill, 65 ill, 66 ill,
 67 ill, 68 ill, 69 ill, 70 ill, 71 ill, 72 ill,
 73, 74, 75 ill, 76 ill, 77 ill, 78 ill, 79 ill,
 80 ill, 81, 82, 83 ill, 84 ill, 85 ill, 86 ill,
 87 ill, 88 ill, 89, 90 ill, 91 ill, 92 ill, 93
 ill, 94, 95, 96, 97 ill, 98 ill, 99 ill, 100
 ill, 101 ill, 102 ill;
Christies Lon 6/14/73: 208 ill;
Christies Lon 10/4/73: 180 ill;
Sothebys Lon 12/4/73: 73 (2), 77 ill, 78 ill, 79
 ill, 80 ill, 81 ill, 82 ill, 83 ill, 84 ill, 85
 ill, 86 ill, 87 (3), 88 (5), 89 (3), 90 (4), 91,
 92, 93, 94 ill, 95 ill, 96 ill, 97 ill, 98 ill,
 99 ill, 100 ill, 101 ill, 102 ill, 103 ill, 104
 ill, 105 ill, 106, 107 ill, 108 ill, 109 ill,
 110 ill, 111 ill, 112 ill, 113, 114 ill, 115
 ill, 116 ill, 117 ill, 118 ill, 119 ill, 120
 ill, 121 ill, 122 ill, 123, 124 ill, 125, 126,
 127, 128 ill, 129 ill, 130 ill, 131 ill, 132
 ill, 133 ill, 134, 136, 137, 138 (2 ills)
 (album, 23)(note);
Ricketts Lon 1974: 27 ill, 28 ill;
Witkin NY II 1974: 827, 828;
Sothebys Lon 3/8/74: 56 ill(note), 57 ill, 58 ill,
 59 ill, 60 ill, 61 ill, 62 ill, 63 ill, 64 ill,
 65 ill, 66 ill, 67 ill, 68 ill, 69 ill, 70 ill,
 71 ill, 72 ill, 73 ill, 74 ill, 75 ill, 76 ill,
 77 ill, 78 ill, 79 ill, 80 ill, 81 ill, 82 ill,
 83 ill, 84, 85 ill;
Sothebys Lon 6/21/74: 189 ill, 190 ill, 191, 192
 ill, 193 ill, 194 ill, 195 ill, 196 ill, 197 ill;
Sothebys Lon 10/18/74: 265 ill;
Witkin NY III 1975: 147 ill(note), 148 ill, 149 ill,
 150 ill;
Sothebys NY 2/25/75: 22 ill(note), 23 ill(note), 24
 ill(note), 25 ill(note), 26 ill(note), 27 ill
 (note), 28 ill(note), 29 ill;

HILL & ADAMSON (continued)
Sothebys Lon 3/21/75: 44 ill(book, 1), 45 ill, 46
 ill, 47 ill, 48 ill, 49 ill, 50 ill, 51 ill, 52
 ill, 53 ill, 54 ill, 55 ill;
Sothebys Lon 6/26/75: 231 ill(note), 232 ill, 233
 ill, 234 ill, 235 ill, 236 ill, 237, 238, 239
 ill, 240 ill;
Sothebys NY 9/23/75: 17 ill(note), 18 ill, 19 ill
 (note), 20 ill(note), 21 ill(note), 22 ill(note);
Sothebys Lon 10/24/75: 183 ill(note), 184 ill, 185
 ill, 186 ill, 187 ill, 189 ill;
Alexander Lon 1976: 69 ill;
Anderson & Hershkowitz Lon 1976: 9 ill, 10 ill, 11
 ill, 12 ill, 13 ill;
Colnaghi Lon 1976: 33 ill(note), 34 ill, 35 ill, 36
 ill(note), 37 (note);
Lunn DC Cat 6, 1976: 35 ill;
Witkin NY IV 1976: 151 ill, 152 ill;
Sothebys Lon 3/19/76: 184 ill, 185 ill, 188 ill;
Gordon NY 5/3/76: 274 ill, 275 ill;
Sothebys NY 5/4/76: 25 (note), 26, 27 (note), 28
 ill, 29 (note);
Christies Lon 6/10/76: 32 ill(note), 33 ill(note);
Sothebys Lon 6/11/76: 204 (book, 1), 206, 207 ill,
 208 ill, 214 ill, 215 ill(note), 216 ill, 217
 ill, 218 ill, 219 ill, 220 ill, 221 ill, 222
 ill, 223 ill;
Christies Lon 10/28/76: 65 ill(note), 66 (note), 67
 (note), 68 (note), 69 (note), 70 ill(note);
Sothebys Lon 10/29/76: 237 ill, 238 ill;
Sothebys NY 11/9/76: 16, 17 (note);
Gordon NY 11/13/76: 9 ill, 10 ill(note), 11 ill,
 12 ill;
Halsted Michigan 1977: 658;
Sothebys NY 2/9/77: 1 ill(note), 2;
Sothebys Lon 3/9/77: 71 ill, 72 ill;
Christies Lon 3/10/77: 62 ill(note), 63 ill(note),
 64 ill, 65 ill(note), 66 ill, 67 ill(note);
Sothebys NY 5/20/77: 68 (note), 69 ill(note);
Christies Lon 6/30/77: 262 ill(note), 263 ill
 (note), 264 ill(note), 265 ill(note), 266 ill
 (note), 267 ill(note), 268 ill(note), 269 ill
 (note), 270 (note), 271 ill(note), 272 (note),
 273 ill(note);
Sothebys Lon 7/1/77: 83 ill, 84 ill, 85 ill, 86
 ill, 87 ill(note), 88 ill;
Sothebys NY 10/4/77: 149A (note), 150 ill, 151
 (note), 152 (note), 153 ill, 154 ill;
Christies Lon 10/27/77: 285 ill(note), 286 ill, 287
 ill(note), 288 ill(note), 289 ill(note), 290 ill
 (note), 291 ill(note), 292 (note), 293 (note),
 294 (note), 295 (note);
Sothebys Lon 11/18/77: 58 (8), 59, 60 ill, 61 ill,
 62 ill, 63 ill, 64 (11), 65 (12), 65a (11), 251
 ill(album, H & A-2 et al)(note);
Weston Cal 1978: 124 ill(note), 125 ill, 126 ill;
Witkin NY IV 1978: 69 ill(note), 70 ill(note);
Christies Lon 3/16/78: 279 ill(note), 280 ill, 281
 ill(note), 282 ill(note), 283 ill(note), 284
 ill, 285 ill(note), 286 ill(note), 287 (note),
 288 ill;
Sothebys Lon 3/22/78: 49 ill;
Christies Lon 6/26/78: 258 ill(note), 259 ill
 (note), 260 ill(note), 261 ill(note), 262 ill
 (note), 263 ill(note);
Christies Lon 6/27/78: 190 ill(note), 191 ill
 (note), 192 ill(note), 193 (note);
Sothebys Lon 6/28/78: 60, 61, 62 ill, 63 ill, 64
 ill, 65 ill, 66 ill, 67 ill;

## HILL & ADAMSON (continued)

Christies Lon 10/26/78: 258 ill(note), 259 ill
    (note), 260 ill(note), 261 ill(note), 262 ill
    (note), 263 ill(note);
Sothebys Lon 10/27/78: 67 ill;
Phillips NY 11/4/78: 13, 14 ill(note), 15 ill(note);
Swann NY 12/14/78: 410 ill, 411;
Lennert Munich Cat 5, 1979: 5;
Sothebys LA 2/7/79: 424 ill(note);
Phillips NY 3/13/79: 21 ill(note), 22 ill(note),
    24 ill(note), 25 ill(note), 26 ill(note), 27 ill
    (note), 28 ill, 29 ill(note), 30 ill(note), 31
    ill(note), 32 ill(note);
Sothebys Lon 3/14/79: 76 ill, 77 ill, 78 ill, 79
    ill, 80 ill, 81 ill, 82 ill, 83 ill, 84 ill, 85
    ill, 86 ill;
Christies Lon 3/15/79: 241 (note);
Christies NY 5/4/79: 2 ill;
Phillips NY 5/5/79: 120, 121 ill, 123 (2 ills),
    124, 125, 126 (7);
Sothebys NY 5/8/79: 58 ill(note), 59 ill;
Sothebys Lon 6/29/79: 74 ill, 75 ill, 76 ill, 77
    ill, 78 ill, 79 ill, 80 ill;
Phillips Can 10/4/79: 2;
Swann NY 10/18/79: 365 ill;
Sothebys Lon 10/24/79: 72 ill, 73 (2), 74, 75 ill,
    76 ill, 77 ill, 78 (3 ills)(album, 29)(note), 79
    ill, 80 ill, 81, 82 ill, 83 ill, 84 ill, 85 ill,
    86 ill;
Christies Lon 10/25/79: 339 ill, 340 ill(note);
Christies NY 10/31/79: 4 (note);
Sothebys NY 11/2/79: 221 ill;
Phillips NY 11/3/79: 144 ill(note);
Rose Boston Cat 5, 1980: 31 ill(note);
White LA 1980-81: 1 ill(note);
Sothebys LA 2/6/80: 137 ill, 138 ill;
Christies Lon 3/20/80: 286 ill(note), 287 ill;
Sothebys Lon 3/21/80: 201 ill, 202 ill, 203 ill,
    204 ill, 205 ill, 206 ill, 207 ill, 208 ill, 209
    ill, 210 ill, 211 ill, 212;
Christies NY 5/16/80: 3 ill(note), 4 (note);
Sothebys NY 5/20/80: 329 ill(note), 330 ill(note);
Phillips NY 5/21/80: 153 ill;
Christies Lon 6/26/80: 411 ill(note), 412 ill, 413
    ill(note), 414;
Sothebys Lon 6/27/80: 129 ill, 130 ill, 131 ill,
    132 ill, 133, 134 ill, 135 ill, 137 ill;
Phillips Can 10/9/80: 1 ill(note), 2 ill;
Sothebys Lon 10/29/80: 177 ill, 178;
Christies Lon 10/30/80: 143 (lot, H & A-3
    attributed, et al)(note), 346 ill, 347 ill;
Christies NY 11/11/80: 5, 6, 7 ill(note);
Koch Cal 1981-82: 1 ill(note), 2 ill;
Sothebys Lon 3/27/81: 161, 163 ill, 164a, 165 ill;
Swann NY 4/23/81: 349 ill;
Phillips NY 5/9/81: 1 ill(note);
Christies NY 5/14/81: 2 ill(note), 3 ill(note),
    4 ill(note), 5 ill(note);
Petzold Germany 5/22/81: 1817 ill;
Sothebys Lon 6/17/81: 99, 100;
Sothebys NY 10/21/81: 118 ill(note), 119 ill(note),
    120 ill(note);
Sothebys Lon 10/28/81: 162 ill, 163;
Christies Lon 10/29/81: 309 ill, 310;
Christies NY 11/10/81: 6 ill(note);
Rose Florida Cat 7, 1982: 20 ill(note);
Weston Cal 1982: 2 ill;
Sothebys Lon 3/12/82: 178 ill;
Sothebys Lon 3/29/82: 73 ill;
Swann NY 4/1/82: 305 ill(note);
Phillips NY 5/22/82: 783 ill(note);

## HILL & ADAMSON (continued)

Sothebys NY 5/24/82: 249 ill, 250 ill(note), 251 ill
    (note), 252 ill(note);
Christies NY 5/26/82: 2 ill(note);
Christies Lon 6/24/82: 148 ill, 149 ill, 150, 151;
Sothebys Lon 6/25/82: 128 ill, 129 ill;
Christies Lon 11/8/82: 123 ill(note);
Harris Baltimore 12/10/82: 271 ill(note);
Christies NY 2/8/83: 1;
Christies Lon 3/24/83: 192 (note), 193 (note), 194
    (note);
California Galleries 6/19/83: 252;
Christies Lon 6/23/83: 197 ill(note), 198 ill, 199
    ill(note), 200 ill(note);
Sothebys Lon 6/24/83: 72 ill, 73 ill(note), 74 ill,
    75 ill, 76 ill, 77 ill, 78 ill, 79, 80 ill, 81
    ill, 82 (2), 83 (2), 84 ill, 85 ill, 86 ill;
Phillips Lon 11/4/83: 108 ill;
Christies NY 11/8/83: 121 ill(note);
Sothebys NY 11/9/83: 167 (note);
Kraus NY Cat 1, 1984: 23 ill(note), 24 ill(note),
    25 ill(note), 26 ill(note);
Christies Lon 3/29/84: 124 ill(note), 125 ill
    (note), 126 ill(note), 127 ill(note), 128
    (2 ills)(book, 9)(note);
Christies NY 5/7/84: 2 ill(note);
Sothebys NY 5/8/84: 167 (3)(note);
Christies Lon 6/28/84: 170 ill(note), 171 ill
    (note), 172 ill(note), 173 ill;
Christies Lon 10/25/84: 155 (note);
Sothebys Lon 10/26/84: 102 ill, 103 ill, 104 ill,
    105;
Sothebys NY 11/5/84: 113;
Christies NY 11/6/84: 2 ill(note);
Christies NY 2/13/85: 111 (2)(attributed);
Christies Lon 3/28/85: 132 ill(note), 133 ill(note);
Christies NY 5/6/85: 172 ill(note);
Sothebys NY 5/7/85: 156 ill(2)(note), 201 ill
    (note), 202 ill, 393 ill;
Phillips Lon 6/26/85: 233 ill;
Sothebys Lon 6/28/85: 98 ill, 100 ill, 101 ill, 102
    ill, 103 ill, 104 ill, 105 ill;
Christies Lon 10/31/85: 170 ill, 171 (2)(note);
Sothebys Lon 11/5/85: 56;
Christies NY 11/11/85: 203 ill(note), 204 ill(note);
Sothebys NY 11/12/85: 152 ill(note), 153 ill(note);
Christies Lon 4/24/86: 440 ill, 441 ill(note), 442
    (note);
Sothebys Lon 4/25/86: 86 ill(3)(note), 87 ill, 88
    ill(note);
Christies NY 5/13/86: 211 ill(note), 208 ill, 238
    ill(note);
Sothebys NY 5/13/86: 207 ill(note), 208 ill, 238 ill
    (note);
Christies Lon 10/30/86: 61 ill, 62 ill, 63 ill, 64
    ill, 65 ill, 66 ill, 67 ill(album, 27)(note);
Christies NY 11/11/86: 222 ill(note);
Swann NY 11/13/86: 232 ill, 233 (2, attributed)
    (note);

**HILL, D.W.** (British)
Photos dated: early 1860s
Processes:       Albumen
Formats:         Prints
Subjects:
Locations:
Studio:          Great Britain (Amateur Photographic
                 Association)
   Entries:
Christies Lon 10/27/83: 218 (albums, H-1 et al);
Sothebys Lon 6/28/85: 134 (album, H et al);

**HILLARD, E.B.** (American)(photographer or author?)
Photos dated: 1864
Processes:       Albumen
Formats:         Prints
Subjects:        Portraits
Locations:       US
Studio:          US
   Entries:
Swann NY 4/26/79: 93 (book, 6);

**HILLERS, John K.** (American, 1843-1925)
Photos dated: c1871-1919
Processes:       Albumen, glass transparency, heliotype
Formats:         Prints, stereos, cdvs
Subjects:        Topography, ethnography
Locations:       US - American west
Studio:          US
   Entries:
Sothebys NY (Strober Coll.) 2/7/70: 511 (lot, H-2
   et al);
Sothebys NY 11/21/70: 108 ill, 109 ill, 110, 111,
   112, 113 ill, 114 ill;
Rinhart NY Cat 1, 1971: 191;
Rinhart NY Cat 2, 1971: 411 (note), 576 (note), 577
   (H & Beaman, 5), 578 (lot, H-1 et al), 579;
Rinhart NY Cat 6, 1973: 586;
Rinhart NY Cat 7, 1973: 293, 301 (2, attributed),
   302 (2, attributed);
Rinhart NY Cat 8, 1973: 77 ill(2);
Vermont Cat 5, 1973: 525 ill(note), 526 ill;
Witkin NY I 1973: 309, 310, 311;
Witkin III 1975: 151 ill(note);
Witkin IV 1976: 345 ill;
California Galleries 4/2/76: 251;
Halsted Michigan 1977: 659 (note), 660;
White LA 1977: 332 (book, 4);
Sothebys NY 10/4/77: 65 ill;
Swann NY 12/8/77: 282, 283, 284 ill;
Frontier AC, Texas 1978: 130 (6)(note);
Lehr NY Vol 1:2, 1978: 21 ill, 22 ill, 23 ill;
Witkin VI 1978: 72 ill(note);
Wood Conn Cat 41, 1978: 198 ill(note), 199 ill,
   200, 201, 202, 203, 204 (lot, H-48 et al)(note);
California Galleries 1/21/78: 364;
Sothebys LA 2/3/78: 60 ill(note), 61, 62, 63, 64;
Swann NY 12/14/78: 278 (8)(note);
Lehr NY Vol 2:2, 1979: 15 ill;
Witkin NY VIII 1979: 44 ill;
Witkin NY Stereo 1979: 5 (2 ills)(15)(note);
Christies NY 5/4/79: 107 (17), 108 (2)(attributed);
Phillips NY 5/5/79: 218, 219 ill;
Sothebys NY 5/8/79: 33 ill, 34, 35, 36 ill
   (attributed), 37 (attributed), 38 ill
   (attributed), 39 (attributed);
Swann NY 10/18/79: 355 (3)(note), 361 (album, H et
   al), 411 (17)(attributed), 425 (lot, H et al);

**HILLERS** (continued)
Christies NY 10/31/79: 89 ill(6), 89A ill, 89B,
   89C, 89D, 89E, 90;
Phillips NY 11/3/79: 208;
White LA 1980-81: 68 ill(note), 69 ill, 70 ill, 71
   ill, 72 ill;
Sothebys LA 2/6/80: 48 ill, 49, 50 ill(2), 51 (2),
   52 ill(2), 53 (2)(attributed), 54 ill(2)
   (attributed), 55 (2)(attributed);
California Galleries 3/30/80: 409 (lot, H-5 et al),
   410 (9);
Christies NY 5/11/80: 256 ill, 257 (note);
Christies NY 11/11/80: 148 ill, 149 (note), 150, 151
   (note);
Sothebys NY 11/17/80: 119 ill(attributed), 120, 121;
Koch Cal 1981-82: 39 ill(note), 40 ill;
Sothebys LA 2/4/81: 247 ill, 248;
Christies NY 5/14/81: 49 ill;
Swann NY 11/5/81: 133 (book, attributed H et al);
Christies NY 11/10/81: 57 ill;
Sothebys LA 2/17/82: 215 (lot, attributed H et al);
Christies Lon 3/11/82: 93 (lot, H-1 et al);
Phillips NY 5/22/82: 784 ill(11), 785 ill(12);
Sothebys NY 5/24/82: 253 ill;
Sothebys NY 5/25/82: 414 ill(2)(note), 415 ill, 416
   ill, 417 ill(4);
Christies NY 5/26/82: 54 ill(3);
Christies Lon 6/24/82: 28 (lot, H et al);
Christies NY 11/8/82: 124 ill, 125 ill;
Sothebys NY 11/9/82: 251 ill(20), 252 ill(2)(note);
Swann NY 5/5/83: 363, 364, 365, 366 (2)(note);
Sothebys NY 5/11/83: 424 ill;
California Galleries 6/19/83: 353 ill(attributed);
Sothebys NY 11/9/83: 170 ill(4), 171 ill(4), 172
   ill(4);
Harris Baltimore 12/16/83: 366;
Sothebys NY 5/8/84: 169 ill, 170 ill(2);
Swann NY 5/10/84: 238, 309 (17);
California Galleries 7/1/84: 456 ill;
Christies NY 9/11/84: 147;
Harris Baltimore 3/15/85: 50 (lot, H-1 et al);
Sothebys NY 3/28/85: 157 ill(44);
Christies NY 5/6/85: 173 ill;
Swann NY 5/9/85: 433 (lot, H-1 et al);
California Galleries 6/8/85: 241 ill, 242, 243, 244
   ill, 245, 246;
Christies NY 11/11/85: 205 ill;
California Galleries 3/29/86: 742 (attributed);
Sothebys NY 5/13/86: 239 (3 ills)(album, 25)(note);
Phillips NY 7/2/86: 338;
Harris Baltimore 11/7/86: 286 (note);
Christies NY 11/11/86: 223 ill;
Swann NY 11/13/86: 129 (lot, H-1 et al), 235, 236
   ill(3), 237 (2)(note);

**HILLMAN** (American)
Photos dated: Nineteenth century
Processes:       Albumen
Formats:         Stereos
Subjects:        Topography
Locations:       US - New York State
Studio:          US
   Entries:
Harris Baltimore 2/14/86: 38 (lot, H et al);

HILLS (British) [HILLS 1]
Photos dated: c1860
Processes:      Ambrotype
Formats:        Plates
Subjects:       Portraits
Locations:      Studio
Studio:         England - Oxford
    Entries:
Christies Lon 10/28/76: 34;

HILLS & BOWERS (American) [HILLS 2]
Photos dated: 1870s
Processes:      Albumen
Formats:        Stereos
Subjects:       Topography
Locations:      US - Vermont
Studio:         US - Burlington, Vermont
    Entries:
Harris Baltimore 12/10/82: 106 (lot, H & B et al);

HILLS & SAUNDERS (British) [HILLS 3]
Photos dated: 1858-c1880
Processes:      Albumen
Formats:        Prints, stereos, cdvs
Subjects:       Portraits, genre, topography
Locations:      England
Studio:         England - London, Oxford, Cambridge,
Eton
    Entries:
Edwards Lon 1975: 12 (album, H & S et al), 125
    (book, H & S et al);
Sothebys Lon 3/21/75: 164 (album, H & S et al);
Sothebys Lon 10/24/75: 175 (album, H & S et al);
Colnaghi Lon 1976: 202 (album, H & S et al)(note);
Sothebys Lon 3/9/77: 189 (20);
Sothebys Lon 7/1/77: 168 (album, H & S et al), 234
    (album, H & S et al);
Sothebys Lon 6/28/78: 147 (lot, H & S et al);
Swann NY 10/12/78: 367 (lot, H & S et al);
Christies Lon 10/25/79: 149 (lot, H & S-1 et al),
    399 (albums, H & S et al);
Christies Lon 3/20/80: 363 (album, H & S et al),
    366 (lot, H & S-1 et al);
Christies Lon 6/26/80: 196 (lot, H & S-1 et al),
    479 (lot, H & S-1 et al), 480 (albums, H & S
    et al);
Sothebys Lon 10/29/80: 261 (album, H & S et al);
Christies Lon 10/30/80: 438 (album, H & S et al),
    440 (album, H & S et al);
Christies Lon 3/26/81: 165 (5), 184 (lot, H & S-1
    et al), 403 (album, H & S et al);
Christies Lon 6/18/81: 431 (album, H & S et al);
Christies Lon 10/29/81: 385 (album, H & S et al);
Christies Lon 3/11/82: 326 (album, H & S et al);
Sothebys Lon 3/12/82: 207 (56), 226 (album, H & S
    et al), 230 (album, H & S et al);
Christies Lon 6/24/82: 205 (album, H & S et al),
    361;
Christies Lon 3/24/83: 237 (lot, H & S et al);
Harris Baltimore 4/8/83: 322 (lot, H & S et al);
Christies Lon 6/23/83: 43 (lot, H & S et al);
Christies Lon 10/27/83: 240 (album, H & S et al);
Swann NY 11/10/83: 277 (album, H & S et al);
Christies Lon 3/29/84: 337 (album, H & S et al);
Harris Baltimore 6/1/84: 295 (lot, H & S et al);
Christies Lon 10/25/84: 320 (album, H & S et al),
    323 (album, H & S et al), 325 (albums, H & S
    et al);
Phillips Lon 3/27/85: 265 ill(8)(note);

HILLS & SAUNDERS (continued)
Christies Lon 3/28/85: 41 (lot, H & S, H & Sons, et
    al), 92 (albums, H & S et al), 103 (albums, H &
    S et al), 309 (album, H & S et al), 321 (album,
    H & S et al);
Christies Lon 6/27/85: 246 (albums, H & S et al);
Phillips Lon 10/30/85: 129 (8);
Christies Lon 10/31/85: 303 (lot, H & S-1 et al);
Phillips Lon 4/23/86: 241 (albums, H & S et al),
    298 (lot, H & S-4 et al);
Christies Lon 4/24/86: 405 (album, H & S-1 et al);
Christies Lon 6/26/86: 149 (album, H & S et al),
    158 (lot, H & S-1 et al);
Christies Lon 10/30/86: 217 (albums, H & S et al);

HIME (see BEERE & HIME)

HIMES, Charles F. (American)
Photos dated: 1868
Processes:      Albumen
Formats:        Prints
Subjects:       Photogenic drawings
Locations:      US
Studio:         US
    Entries:
Swann NY 4/1/76: 50 (book, 3);
Swann NY 11/11/76: 267 (book, 3)(note);
Wood Boston Cat 58, 1986: 83 (book, 1);

HINDKETTE (American)
Photos dated: c1880
Processes:      Albumen
Formats:        Prints
Subjects:       Topography
Locations:      US - Kennebunkport, Maine
Studio:         US
    Entries:
Harris Baltimore 2/14//86: 324;

HINDS, A.L. (American)
Photos dated: 1870s
Processes:      Albumen
Formats:        Stereos
Subjects:       Topography
Locations:      US - New England
Studio:         US - Benton, Maine
    Entries:
Harris Baltimore 6/1/84: 148 (lot, H et al);

HINE (see COPELIN) [HINE 2]

HINE, HUMPHREY LLOYD (see BEERE) [HINE 2]

HINE, T.C. (British)(photographer or author?)
Photos dated: 1876
Processes:      Albumen
Formats:        Prints
Subjects:       Architecture
Locations:      England - Nottingham
Studio:         Great Britain
    Entries:
Edwards Lon 1975: 107 (book, 17);

HINES, C.F. (American)
Photos dated: c1860
Processes:      Albumen
Formats:        Stereos
Subjects:       Topography
Locations:      US - Troy, New York
Studio:         US - Pennsylvania Photographic Society
   Entries:
Sothebys Lon 6/17/81: 20 (lot, H-1 et al);

HING-QUA, John
Photos dated: 1860s
Processes:      Albumen
Formats:        Cdvs
Subjects:
Locations:
Studio:         China
   Entries:
Christies Lon 3/16/78: 101 (album, H et al);

HINKLE, D. (American)
Photos dated: c1870
Processes:      Albumen
Formats:        Cdvs
Subjects:       Portraits
Locations:      Studio
Studio:         US - Germantown Pennsylvania
   Entries:
Harris Baltimore 6/1/84: 290;

HIRSCH
Photos dated: 1870s
Processes:      Albumen
Formats:        Cdvs
Subjects:       Portraits
Locations:      Europe
Studio:         Europe
   Entries:
Harris Baltimore 6/1/84: 295 (lot, H et al);

HIRSHBERG
Photos dated: Nineteenth century
Processes:      Albumen
Formats:        Cabinet cards
Subjects:       Portraits
Locations:
Studio:
   Entries:
California Galleries 1/21/78: 134 (lot, H et al);

HITCHLER
Photos dated: Nineteenth century
Processes:      Albumen
Formats:        Cabinet cards
Subjects:       Portraits
Locations:
Studio:
   Entries:
Vermont Cat 2, 1971: 248 (lot, H-1 et al);

HOAG & QUICK (American)
Photos dated: 1860s
Processes:      Albumen
Formats:        Cdvs
Subjects:       Portraits
Locations:      Studio
Studio:         US - Cincinnati, Ohio
   Entries:
Sothebys NY (Strober Coll.) 2/7/70: 285 (lot,
   H & Q-1 et al);
Sothebys NY (Greenway Coll.) 11/20/70: 267 (lot,
   H & Q et al);
Rinhart NY Cat 6, 1973: 253;
Swann NY 4/26/79: 413 ill(note);

HOARD & TENNEY (American)
Photos dated: c1870
Processes:      Albumen
Formats:        Stereos
Subjects:       Ethnography
Locations:      US
Studio:         US
   Entries:
Rinhart NY Cat 7, 1973: 342;

HOBBS, W.H. (American)
Photos dated: late 1860s-1870s
Processes:      Albumen
Formats:        Stereos, cdvs
Subjects:       Topography
Locations:      US - New Hampshire
Studio:         US - Exeter, New Hampshire
   Entries:
Rinhart NY Cat 2, 1971: 365;

HOBDAY (American)
Photos dated: 1854
Processes:      Daguerreotype
Formats:        Stereo plates
Subjects:       Portraits
Locations:      Studio
Studio:         US
   Entries:
Gordon NY 5/10/77: 776 ill;

HOBSON, W.S. (British)
Photos dated: 1860s-1887
Processes:      Albumen
Formats:        Prints
Subjects:
Locations:      Great Britain
Studio:         Great Britain (Amateur Photographic
                Association)
   Entries:
Sothebys Lon 3/21/80: 255 (album, H-1 et al);
Sothebys Lon 10/29/80: 310 (album, H et al);
Christies Lon 10/27/83: 218 (albums, H-1 et al);

**HODCEND**
Photos dated: c1870
Processes:      Albumen
Formats:        Cdvs
Subjects:       Topography
Locations:      Italy; Switzerland
Studio:         Italy - Genoa
    Entries:
California Galleries 4/2/76: 84 (lot, H et al);
Petzold Germany 11/7/81: 309 (album, H et al), 328
    (album, H et al);

**HODGES, G.H.** (British)
Photos dated: 1860s
Processes:      Albumen
Formats:        Prints
Subjects:
Locations:
Studio:         Great Britain (Amateur Photographic
                Association)
    Entries:
Christies Lon 10/29/81: 359 (album, H-1 et al)
    (note);
Christies Lon 10/27/83: 218 (albums, H-1 et al);

**HODGKINSON, J.** (British)
Photos dated: Nineteenth century
Processes:      Albumen
Formats:        Cdvs
Subjects:       Portraits
Locations:      Studio
Studio:         England - Birkinhead
    Entries:
Sothebys NY (Strober Coll.) 2/7/70: 265 (lot,
    B et al);

**HODSON** (American)
Photos dated: between 1860 and 1880s
Processes:
Formats:
Subjects:       Portraits
Locations:      Studio
Studio:         US - Sacramento, California
    Entries:
Swann NY 11/11/76: 358 (lot, H et al);

**HOELKE & BENEKE** (American)
Photos dated: 1860s and/or 1870s
Processes:      Albumen
Formats:        Stereos
Subjects:       Topography
Locations:      US
Studio:         US
    Entries:
Christies Lon 6/18/81: 78 (lot, H & B et al);

**HOFF**
Photos dated: Nineteenth century
Processes:      Albumen
Formats:        Stereos
Subjects:       Topography
Locations:      US - New York City
Studio:
    Entries:
Harris Baltimore 12/10/82: 68 (lot, H et al);

**HOFF, Philip** (German)
Photos dated: c1860
Processes:      Albumen
Formats:        Cdvs
Subjects:       Portraits
Locations:      Studio
Studio:         Germany - Frankfurt
    Entries:
Petzold Germany 11/7/81: 300 (album, H et al);

**HOFFERT, W.** (German)
Photos dated: Nineteenth century
Processes:      Albumen
Formats:        Cabinet cards
Subjects:       Portraits
Locations:      Studio
Studio:         Germany - Hannover
    Entries:
Edwards Lon 1975: 12 (album, H et al);
Harris Baltimore 3/15/85: 277 (lot, H et al);

**HOFFMAN** (see JOHNSTON & HOFFMAN) [HOFFMAN 1]

**HOFFMAN** (British) [HOFFMAN 2]
Photos dated: 1890s
Processes:      Platinum
Formats:        Prints
Subjects:       Topography
Locations:      India
Studio:
    Entries:
Christies NY 10/31/79: 47 (album, H et al);

**HOFFMAN, Dr. J.R.** (American)
Photos dated: 1890-1893
Processes:      Gelatin
Formats:        Prints
Subjects:       Documentary (educational institutions)
Locations:      US - Boydton, Virginia
Studio:         US - Morristown, New Jersey
    Entries:
Swann NY 11/14/85: 116 ill(134)(note);

**HOFFMEISTER** (American)
Photos dated: 1863
Processes:      Albumen
Formats:        Cabinet cards
Subjects:       Portraits
Locations:      Studio
Studio:         US - Columbus, Mississippi
    Entries:
Harris Baltimore 12/10/82: 364;

**HOGAN** (American)
Photos dated: 1890s
Processes:      Albumen
Formats:        Cabinet cards
Subjects:       Topography
Locations:      US - California
Studio:         US
    Entries:
Sothebys LA 2/17/82: 376 ill(lot, H et al);

**HOGG, J.J.**
Photos dated: between 1870s and 1890s
Processes:     Albumen
Formats:       Prints
Subjects:      Topography
Locations:     New Zealand
Studio:
  Entries:
Swann NY 10/18/79: 386 (album, H et al);

**HOGG, Jabez H.** (British, 1817-1899)
Photos dated: c1843-1890s
Processes:     Daguerreotype, ambrotype, albumen
Formats:       Plates, prints, cabinet cards
Subjects:      Portraits, genre
Locations:     England
Studio:        England
  Entries:
Sothebys NY 5/2/78: 161 ill(album, H-12 et al)
  (note);
Christies NY 10/31/79: 6 ill(note);
Sothebys Lon 3/27/81: 298;
Phillips Lon 10/27/82: 13 (lot, H-2 et al);

**HOGGARD** (British)
Photos dated: c1860
Processes:     Albumen
Formats:       Cdvs
Subjects:      Portraits
Locations:     Studio
Studio:        England - York
  Entries:
Sothebys Lon 3/19/76: 66 (lot, H-2 et al);

**HOHLENBERG**
Photos dated: between 1875 and 1890
Processes:
Formats:
Subjects:      Portraits
Locations:     Europe
Studio:        Europe
  Entries:
Harris Baltimore 3/15/85: 261 (lot, H et al), 277
  (lot, H et al);

**HOLCOMBE, James W.** (British)
Photos dated: c1890-1890s
Processes:     Platinum
Formats:       Prints
Subjects:      Topography, genre
Locations:     Italy - Venice
Studio:        Italy - Venice
  Entries:
Rose Boston Cat 3, 1978: 146 ill(note), 147 ill;
Phillips NY 5/21/80: 228 (7), 229 (3);

**HOLDEN, Reverend H.** (British)
Photos dated: 1856-1857
Processes:     Albumen
Formats:       Prints
Subjects:      Topography
Locations:     England
Studio:        England (Amateur Photographic
               Association, Photographic Club)
  Entries:
Swann NY 2/14/52: 6 (lot, H et al);
Sothebys Lon 12/4/73: 173 (book, H et al);
Sothebys Lon 3/14/79: 324 (album, H-1 et al);
Sothebys Lon 10/29/80: 310 (album, H et al);

**HOLDER, Lieutenant Colonel Charles** (British)
Photos dated: 1855-early 1860s
Processes:     Albumen
Formats:       Prints
Subjects:      Topography, genre (rural life)
Locations:     France
Studio:        Great Britain (Amateur Photographic
               Association)
  Entries:
Christies Lon 10/27/83: 218 (albums, H-4 et al);
Christies Lon 6/28/84: 229 (lot, H-5 et al);
Sothebys Lon 6/28/85: 134 (album, H et al);

**HOLFERTY, Harlan** (American)
Photos dated: 1887
Processes:     Albumen
Formats:       Prints
Subjects:      Documentary (disasters)
Locations:     US - Illinois
Studio:        US - Eureka, Illinois
  Entries:
California Galleries 7/1/84: 616 (2);

**HOLIDAY, Henry** (British)
Photos dated: 1860s
Processes:     Albumen
Formats:       Prints
Subjects:      Portraits
Locations:     Studio
Studio:        England
  Entries:
Christies Lon 3/24/83: 233 ill(lot, H et al);

**HOLLISTER, H.** (Canadian)
Photos dated: 1860s
Processes:     Ambrotype, collodion on glass
Formats:       Plates, stereos
Subjects:      Topography
Locations:     Canada - Niagara Falls
Studio:        Canada - Niagara Falls
  Entries:
Swann NY 11/8/84: 170A ill;
Phillips Lon 6/26/85: 135 (lot, H et al);

**HOLLYER, Frederick** (British, 1837-1933)
Photos dated: 1869-1900
Processes:  Albumen, carbon, platinum
Formats:    Prints, cdvs, cabinet cards
Subjects:   Portraits, genre (still life, animal
            life), documentary (art)
Locations:  Great Britain
Studio:     Great Britain
    Entries:
Weil Lon Cat 27, 1959: 251 (note);
Weil Lon Cat 31, 1963: 192 (note);
Sothebys Lon 10/18/74: 167 ill(lot, H et al);
Sothebys Lon 6/11/76: 181 (note);
Christies Lon 10/28/76: 343 ill(note), 344;
Christies Lon 3/10/77: 381 ill(note), 382, 383;
Sothebys Lon 7/1/77: 262;
Christies Lon 10/27/77: 407 ill(note), 408, 409
    (2), 410 (lot, H-1 et al), 411 (5), 412;
Christies Lon 3/16/78: 320 (lot, H-1 et al), 321
    (lot, H-1 et al);
Sothebys NY 5/2/78: 161 (albums, H-19 et al)(note);
Phillips NY 11/4/78: 46 ill(note);
California Galleries 1/21/79: 449 (2);
Christies Lon 3/20/80: 403 (2);
Christies Lon 3/26/81: 442 (lot, H-1 plus H
    attributed, et al);
Christies Lon 3/11/82: 339 (lot, H-1 et al);
Christies Lon 6/24/82: 97 (album, 12), 213 (lot,
    H et al);
Christies Lon 3/24/83: 234 (lot, H et al);
Sothebys Lon 3/25/83: 61 (attributed);
Sothebys Lon 6/24/83: 112 (6);
Sothebys Lon 10/26/84: 169 ill(attributed);
Sothebys Lon 3/29/85: 148 (lot, H-1 et al);
Sothebys NY 5/8/85: 631 (lot, H et al);
Christies Lon 4/24/86: 523 (lot, H-25 et al)(note);
Sothebys Lon 10/31/86: 143;

**HOLLYLAND** (American)
Photos dated: 1860s
Processes:  Albumen
Formats:    Cdvs
Subjects:   Portraits
Locations:  Studio
Studio:     US
    Entries:
Sothebys NY (Greenway Coll.) 11/20/70: 273 (lot,
    H-1 et al);

**HOLMES** (see CLARK & HOLMES) [HOLMES 1]

**HOLMES & WOODBERRY** (American) [HOLMES 2]
Photos dated: 1860s
Processes:  Albumen
Formats:    Stereos
Subjects:   Documentary (Civil War)
Locations:  US - Civil War area
Studio:     US
    Entries:
Sothebys NY (Strober Coll.) 2/7/70: 553 (lot, H & W
    et al)(note);

**HOLMES, Burton**
Photos dated: 1895-1899
Processes:  Photogravures
Formats:    Prints, stereos
Subjects:   Portraits, topography
Locations:  Europe; Asia
Studio:
    Entries:
Rinhart NY Cat 7, 1973: 85 (book, H et al);
Phillips NY 11/29/79: 294 (lot, H-3 et al);

**HOLMES, D.R.** (American)
Photos dated: 1865-1867
Processes:  Albumen
Formats:    Cdvs
Subjects:   Portraits
Locations:  Studio
Studio:     US
    Entries:
California Galleries 1/21/79: 231 (lot, H et al);

**HOLMES, R.B.**
Photos dated: 1880s-c1890
Processes:  Carbon
Formats:    Prints, cdvs
Subjects:   Portraits, topography
Locations:  India - Peshawar
Studio:     India - Peshawar
    Entries:
Christies Lon 6/28/79: 144 (lot, H-4 et al);
Christies Lon 6/26/80: 238 (4);
Christies Lon 3/26/81: 228 (lot, H-1 et al), 242
    (albums, H-3 et al);

**HOLMES, Silas A.** (American, died 1886)
Photos dated: 1847-c1858
Processes:  Daguerreotype, ambrotype, salt,
            albumen
Formats:    Plates, cdvs
Subjects:   Topography, portraits
Locations:  US - Niagara Falls, New York; Canada -
            Montreal
Studio:     US - New York City
    Entries:
Maggs Paris 1939: 459, 460, 461, 462, 463 ill, 464
    ill, 465 ill, 466;
Sothebys NY (Weissberg Coll.) 5/16/67: 148 (lot, H-1
    et al);
Vermont Cat 4, 1972: 393 ill;
Rinhart NY Cat 7, 1973: 569;
Rinhart NY Cat 8, 1973: 110;
Vermont Cat 9, 1975: 411 ill;
Sothebys NY 2/25/75: 167 ill(attributed)(note);
Vermont Cat 11/12, 1977: 552 ill;
Swann NY 4/14/77: 231 (2);
Swann NY 12/8/77: 362 (lot, H-1 et al);
Phillips NY 11/3/79: 114 (lot, H et al);
Auer Paris 5/31/80: 29, 30;
Sothebys Lon 10/29/80: 168;
Christies Lon 10/29/81: 58;
Christies Lon 6/24/82: 19 (lot, H-1 et al);
Swann NY 11/8/84: 180 (lot, H et al);
Swann NY 5/9/85: 347 (note);
Christies Lon 4/24/86: 305 (lot, H-2 et al);

HOLMES, T. (American)
Photos dated: c1870s
Processes:    Albumen
Formats:      Cdvs, stereos
Subjects:     Topography
Locations:    US - New England; New York State
Studio:       US
      Entries:
Sothebys NY (Strober Coll.) 2/7/70: 311 (lot, H-2
    et al), 463 (lot, H et al);

HOLMES, William B. (American)
Photos dated: 1873-c1875
Processes:    Albumen
Formats:      Prints
Subjects:     Topography
Locations:    US - New York City
Studio:       US - New York City
      Entries:
Rinhart NY Cat 1, 1971: 374, 375;
Witkin NY I 1973: 313;
Witkin NY II 1974: 838;

HOLMES-BATES
Photos dated: Nineteenth century
Processes:    Albumen
Formats:      Stereos
Subjects:     Topography
Locations:
Studio:
      Entries:
Sothebys NY (Weissberg Coll.) 5/16/67: 196 (lot,
    H et al);

HOLT, Robert (British)
Photos dated: 1860s
Processes:    Ambrotype
Formats:      Plates
Subjects:     Portraits
Locations:    Studio
Studio:       England - Liverpool
      Entries:
Sothebys Lon 10/24/79: 214 (lot, H-1 et al);

HOLZ
Photos dated: Nineteenth century
Processes:    Albumen
Formats:      Cdvs
Subjects:     Portraits
Locations:    Studio
Studio:       Europe
      Entries:
Gordon NY 11/13/76: 48 (albums, H et al);

HOLZAMER (German)
Photos dated: c1860
Processes:    Albumen
Formats:      Cdvs
Subjects:     Documentary (art)
Locations:    Germany
Studio:       Germany - Worms
      Entries:
Petzold Germany 11/7/81: 326 (lot, H et al);

HOMAN, C. (American)
Photos dated: 1870s
Processes:    Albumen
Formats:      Stereos
Subjects:     Topography
Locations:    US
Studio:       US - New Haven, Connecticut
      Entries:
Swann NY 4/14/77: 323 (lot, H et al);

HOME-ROSENBERG, F. (photographer or author?)
Photos dated: 1899
Processes:    Photogravure
Formats:      Prints
Subjects:     Topography
Locations:    Italy - Venice
Studio:
      Entries:
Christies Lon 3/15/79: 229 (book, 50);

HOOD, T.
Photos dated: 1860s and/or 1870s
Processes:    Albumen
Formats:      Cdvs
Subjects:     Portraits
Locations:
Studio:
      Entries:
Phillips Lon 6/26/85: 202 (lot, H-1 et al);
Phillips Lon 10/30/85: 57 (lot, H et al);
Phillips Lon 4/23/86: 239 (lot, H-1 et al);

HOOK, William E. (American)
Photos dated: c1875-1897
Processes:    Albumen
Formats:      Prints, stereos, boudoir cards
Subjects:     Topography
Locations:    US - Wisconsin; Colorado; New Mexico
Studio:       US - Wisconsin; Colorado
      Entries:
Vermont Cat 1, 1971: 256 ill(7), 257 (17), 262 (16);
Wood Conn Cat 37, 1976: 284 (6);
California Galleries 4/3/76: 354 (lot, H et al);
Swann NY 12/8/77: 352 (lot, H-5 et al);
Frontier AC, Texas 1978: 135 (note), 136 ill;
California Galleries 1/21/78: 417 (lot, H et al);
Swann NY 12/14/78: 415 (19)(note);
Christies Lon 10/25/79: 251 (album, H-10 et al);
Sothebys NY 11/2/79: 293 ill(album, H-3 et al);
California Galleries 3/30/80: 279 (lot, H-3 et al);
Sothebys Lon 10/29/80: 106 (lot, H-2 et al);
California Galleries 12/13/80: 233 (7), 234 (lot,
    H-3 et al);
Petzold Germany 5/22/81: 1819 (lot, H-1 et al);
California Galleries 6/28/81: 204 (lot, H-3 et al),
    255 ill(9), 345 (lot, H-1 et al);
Sothebys LA 2/17/82: 230 (lot, H et al);
Swann NY 4/1/82: 249 (lot, H et al);
California Galleries 5/23/82: 320 (9), 321 (7), 322
    (7), 323 (2);
Christies NY 2/8/83: 25 (lot, H et al), 36 (lot, H
    et al);
California Galleries 6/19/83: 254 ill(9), 255 (4),
    256 (3), 456 (lot, H-1 et al);
Harris Baltimore 12/16/83: 29 (lot, H-6 et al), 303
    (8), 305 (lot, H et al);
Harris Baltimore 3/15/85: 165 (lot, H et al);
California Galleries 6/8/85: 250;

**HOOK** (continued)
Swann NY 11/14/85: 12 (lot, H et al);
Swann NY 5/15/86: 168 (album, H et al);
Swann NY 11/13/86: 134 (lot, H-21 et al);

**HOOPER, Willoughby Wallace** (British, 1837-1912)
Photos dated: 1876-1878
Processes:      Albumen
Formats:        Prints
Subjects:       Documentary (disasters, military)
Locations:      India - Madras; Burma; England - London
Studio:
   Entries:
Sothebys Lon 10/18/74: 70 (book, 100), 71 (albums, H-160 et al), 72 (album, 12), 73 ill(albums, 146), 80 (book, H et al);
Christies Lon 6/10/76: 92 (3 ills)(album, 27)(note);
Swann NY 12/14/78: 419 (attributed)(note);
Sothebys Lon 3/14/79: 118 (album, H-2 et al);
Christies Lon 6/18/81: 213 ill(book, 100)(note);
Christies Lon 10/29/81: 236 ill(album, H-12 attributed et al), 364 (album, H-1 attributed, et al);
Christies Lon 3/11/82: 183 (album, H-12 et al), 252 (books, H et al);
Sothebys Lon 3/29/82: 31 ill(album, 12);
Christies Lon 6/24/82: 290 (3)(attributed), 204A ill (album, H-16 et al);
Sothebys Lon 6/25/82: 65 ill(albums, H attributed et al), 66 ill(album, 56), 67 ill(album, H et al);
Sothebys Lon 3/25/83: 29 (album, H attributed et al);
Christies Lon 6/23/83: 142 (7);
Sothebys Lon 6/24/83: 26 ill(album, H et al);
Christies Lon 3/29/84: 68 ill(lot, H-1 et al);
Christies Lon 3/28/85: 223 (8);
Sothebys Lon 6/28/85: 79 ill(album, H et al);
Christies Lon 10/31/85: 221 (8);
Christies Lon 6/26/86: 47 (lot, H-7 et al);

**HOPE** (see WELLS & HOPE)

**HOPE, J.D.** (American)
Photos dated: 1868-1880s
Processes:      Albumen
Formats:        Stereos
Subjects:       Topography
Locations:      US - Watkins Glen, New York
Studio:         US
   Entries:
California Galleries 4/3/76: 378 (10);
California Galleries 1/21/78: 163 (10);
Sothebys NY 5/2/78: 25 (lot, H-1 et al);
Rose Boston Cat 4, 1979: 1 ill(note);
Harris Baltimore 4/8/83: 69 (lot, H et al);
Swann NY 11/10/83: 353 (lot, H et al);

**HOPITAL** (French)
Photos dated: c1870
Processes:      Albumen
Formats:        Prints
Subjects:       Topography
Locations:      France
Studio:         France
   Entries:
Sothebys Lon 3/25/83: 74 (lot, H-2 et al);

**HOPKINS, Benjamin S.** (see ROSE & HOPKINS)

**HOPKINS & STEVENSON** (American)
Photos dated: Nineteenth century
Processes:
Formats:        Prints
Subjects:       Topography
Locations:      US - Pennsylvania
Studio:         US
   Entries:
Swann NY 10/18/79: 350 (books, H & S et al);

**HOPWOOD, R.** (British)
Photos dated: 1870s-1890s
Processes:      Albumen
Formats:        Prints, stereos
Subjects:       Topography
Locations:      Wales
Studio:         Great Britain
   Entries:
Rinhart NY Cat 7, 1973: 441;
California Galleries 4/3/76: 331 (lot, H-1 et al);

**HORNBY, D.** (British)
Photos dated: 1860s
Processes:      Albumen
Formats:        Prints
Subjects:
Locations:
Studio:         Great Britain (Amateur Photographic Association)
   Entries:
Sothebys Lon 10/29/80: 310 (album, H et al);
Christies Lon 10/27/83: 218 (albums, H-1 et al);

**HORNE & THORNWAITE** (British)
Photos dated; 1860s and/or 1870s
Processes:      Albumen
Formats:        Cdvs
Subjects:       Portraits
Locations:      Studio
Studio:         England - Newcombe
   Entries:
Phillips Lon 3/27/85: 211 (lot, H & T-1 et al);

**HORNE, Fallon** (British, died 1858)
Photos dated: 1853-1855
Processes:      Salt
Formats:        Prints
Subjects:       Documentary (engineering), topography, genre, portraits
Locations:      England - Sydenham
Studio:         Great Britain (Photographic Club)
   Entries:
Sothebys Lon 3/21/75: 286 (album, H-1 et al);

**HORNE, F.** (continued)
Sothebys Lon 6/29/84: 150 ill;
Sothebys Lon 11/1/85: 59 (album, H-1 et al);
Phillips Lon 4/23/86: 317 ill(albums, 12)
  (attributed);
Sothebys Lon 10/31/86: 76 ill;

**HORNER, M.** (British)
Photos dated: 1860s
Processes:    Albumen
Formats:     Stereos
Subjects:    Topography
Locations:   England
Studio:     England
  Entries:
Christies Lon 10/27/77: 69 (lot, H et al);
Christies Lon 6/28/79: 69 (lot, H et al);
Christies Lon 3/26/81: 122 (lot, H et al);
Christies Lon 6/24/82: 71 (lot, H et al);

**HORNING & Brother** (American)
Photos dated: 1866
Processes:    Albumen
Formats:     Prints
Subjects:    Topography
Locations:   US - Philadelphia, Pennsylvania
Studio:     US - Philadelphia, Pennsylvania
  Entries:
Harris Baltimore 12/16/83: 401;

**HORNUNG**
Photos dated: between 1860s and 1890s
Processes:    Albumen
Formats:     Cdvs
Subjects:    Topography
Locations:   Europe
Studio:     Europe
  Entries:
Swann NY 5/15/86: 203 (lot, H et al);

**HORROBINE, E.**
Photos dated: 1869
Processes:    Albumen
Formats:     Prints
Subjects:    Topography
Locations:   Upper Wharfdale
Studio:
  Entries:
Swann NY 10/18/79: 101 (book, 5)(note);

**HORSBURGH, J.** (British)
Photos dated: c1860-c1890
Processes:    Ambrotype, albumen
Formats:     Plates, cabinet cards
Subjects:    Portraits
Locations:   Studio
Studio:     Scotland - Edinburgh
  Entries:
Sothebys Lon 7/1/77: 212 (lot, H-1 et al);
California Galleries 1/21/78: 141 (album, H et al);
Sothebys Lon 3/22/78: 133 (lot, H-1 et al)(note);

**HORSEY, John G.** (British)
Photos dated: 1882
Processes:    Albumen
Formats:     Prints
Subjects:    Topography
Locations:   England
Studio:     England - Kent
  Entries:
Alexander Lon 1976: 56 ill, 57 ill, 58 ill;
Sothebys Lon 3/19/76: 131 (3);
Christies Lon 3/10/77: 84 (2);
Christies Lon 6/26/80: 547 (2);

**HORTON** (see ALLEN)

**HORTON, J.A.** (American)
Photos dated: 1890
Processes:    Albumen
Formats:     Prints
Subjects:    Documentary
Locations:   US - Salinas, California
Studio:     US - California
  Entries:
Frontier AC, Texas 1978: 137 (note);

**HORTON, R.** (American)
Photos dated: Nineteenth century
Processes:
Formats:     Prints
Subjects:    Topography
Locations:   US - New York City
Studio:     US
  Entries:
Phillips NY 5/21/80: 294 (lot, H-1 et al);

**HOSKINS**
Photos dated: 1880s
Processes:    Albumen
Formats:     Prints
Subjects:    Portraits
Locations:
Studio:
  Entries:
Sothebys Lon 12/4/73: 176 (book, H et al);

**HOSMER, A.W.** (American)
Photos dated: 1880s-1897
Processes:    Photogravures
Formats:     Prints, stereos
Subjects:    Topography
Locations:   US - Massachusetts
Studio:     US - Concord, Massachusetts
  Entries:
Swann NY 11/11/76: 211;
Swann NY 4/14/77: 164 (book, H et al);
Swann NY 12/8/77: 177 (book, H et al);
Swann NY 4/26/79: 194 (book);

**HOTCHKISS, A.E.** (American)
Photos dated: 1870s-1890s
Processes:      Albumen
Formats:        Stereos
Subjects:       Topography
Locations:      US - Norwich, New York
Studio:         US - Norwich, New York
    Entries:
Phillips NY 11/3/79: 137 (37);

**HOUDET** (French)
Photos dated: c1845
Processes:      Daguerreotype
Formats:        Plates
Subjects:       Portraits
Locations:      Studio
Studio:         France - Paris
    Entries:
Christies Lon 6/10/76: 12 ill;

**HOUDLETTE, B.** (American)
Photos dated: Nineteenth century
Processes:      Albumen
Formats:        Prints
Subjects:       Topography
Locations:      US - Maine
Studio:         US
    Entries:
Harris Baltimore 3/26/82: 425 (lot, H et al);

**HOUGHTON, Major** (British)
Photos dated: c1870
Processes:      Albumen
Formats:        Prints
Subjects:       Ethnography
Locations:      India
Studio:
    Entries:
Sothebys Lon 10/18/74: 80 (book, H et al);
Christies Lon 3/11/82: 252 (books, H et al);

**HOULDON** (British)
Photos dated: Nineteenth century
Processes:      Albumen
Formats:        Stereos
Subjects:       Topography
Locations:      Great Britain
Studio:         Great Britain
    Entries:
Christies Lon 6/18/81: 105 (lot, H-1 et al);

**HOUSEWORTH, Thomas** (American, 1829-1915)(see also
                LAWRENCE & HOUSEWORTH)
Photos dated: c1864-1872
Processes:      Albumen
Formats:        Stereos, cabinet cards, cdvs
Subjects:       Topography, genre (nature);
Locations:      US - San Francisco, California
Studio:         US - San Francisco, California
    Entries:
Sothebys NY (Strober Coll.) 2/7/70: 497 (20), 501
    (lot, H et al), 502 (lot, H et al), 512 (lot,
    H et al), 518 (38)(note), 524 (lot, H-23 et al);
Rinhart NY Cat 1, 1971: 193 (4), 194 (5), 260 (3);
Rinhart NY Cat 2, 1971: 484;
Rinhart NY Cat 6, 1973: 500;

**HOUSEWORTH, T.** (continued)
Rinhart NY Cat 7, 1973: 292;
Witkin NY I 1973: 315, 316;
Vermont Cat 9, 1975: 583 ill;
Sothebys NY 2/25/75: 172 (lot, H-1 et al);
California Galleries 9/26/75: 148 (album, 39);
California Galleries 9/27/75: 457 (lot, H et al),
    460 (lot, H-1 et al);
California Galleries 4/3/76: 499 (10);
White LA 1977: 86;
Vermont Cat 11/12, 1977: 790 ill(2), 791 ill(3),
    792 ill(3), 794 ill(2);
California Galleries 1/22/77: 174 (album, 39);
California Galleries 1/23/77: 364 (lot, H et al);
Swann NY 4/14/77: 342 (lot, H et al);
California Galleries 1/21/78: 139 (lot, H et al);
Swann NY 12/14/78: 280 (6);
Rose Boston Cat 4, 1979: 2 ill(note);
Witkin NY Stereo 1979: 6 ill(5)(note);
Sothebys Lon 6/29/79: 275 ill(book, H et al);
Phillips Lon 3/12/80: 172 (lot, H-17 et al);
California Galleries 3/30/80: 208 (album, 39), 387
    ill(lot, H-1 et al);
Swann NY 4/17/80: 280 ill(attributed)(note), 371
    (lot, H-4 et al);
Sothebys Lon 10/29/80: 99 ill, 100 ill, 101 ill,
    102 ill, 103, 104;
Swann NY 11/6/80: 378 (lot, H-4 et al);
Swann NY 4/23/81: 422 (lot, H-8 et al)(note), 540
    (lot, H et al);
Sothebys Lon 6/17/81: 349 ill, 350 ill;
California Galleries 6/28/81: 256, 319 (3);
Wood Conn Cat 49, 1982: 499 (book, H-1 et al);
Swann NY 4/1/82: 357 (lot, H et al);
California Galleries 5/23/82: 191 (album, H et al),
    257 (lot, H et al), 325 (3), 326;
Christies Lon 6/24/82: 82 (lot, H-12 et al);
Sothebys Lon 6/25/82: 109 ill, 110 ill;
Swann NY 11/18/82: 453 (lot, H-1 et al);
Sothebys Lon 3/25/83: 35 ill, 36 ill;
Harris Baltimore 4/8/83: 14 (lot, H attributed et
    al), 41 (6);
Swann NY 5/5/83: 374 (48)(note), 437 (5)(note);
Christies Lon 6/23/83: 44 (lot, H et al);
Sothebys Lon 6/24/83: 1 (lot, H et al);
Christies Lon 10/27/83: 145 (lot, H-1 et al);
Harris Baltimore 12/16/83: 18 (lot, H et al), 20
    (lot, H-4 et al);
Christies Lon 3/29/84: 116 (4 ills)(book, 200);
Harris Baltimore 6/1/84: 67 (17), 153 (lot, H
    et al);
Sothebys Lon 6/29/84: 68 ill;
Sothebys Lon 10/26/84: 76 ill(2);
Swann NY 11/8/84: 253 (lot, H et al);
Harris Baltimore 3/15/85: 108 (lot, H-9 et al);
Sothebys Lon 3/29/85: 71 (lot, H-1 et al);
Sothebys Lon 11/1/85: 3 (lot, H et al);
Swann NY 11/14/85: 158 (lot, H et al);
Harris Baltimote 11/7/86: 69 (lot, H-1 et al);
Swann NY 11/13/86: 196 (lot, H-1 et al);

**HOWARD & HALL** (American) [HOWARD 1]
Photos dated: 1860s
Processes:     Albumen
Formats:       Cdvs
Subjects:      Portraits
Locations:     Studio
Studio:        US
   Entries:
Sothebys NY (Greenway Coll.) 11/20/70: 43 (lot,
   H & H-1 et al), 244 (lot, H & H-1 et al);

**HOWARD** (American) [HOWARD 2]
Photos dated: c1877
Processes:     Albumen
Formats:       Prints, cdvs
Subjects:      Topography, ethnography
Locations:     US - Nebraska; Wyoming
Studio:        US - Fort Sanders, Wyoming
   Entries:
Swann NY 10/18/79: 451 ill(4)(note), 452 (6)(note),
   453 (4)(note), 454 (4)(note), 455 (4)(note);

**HOWARD, W.D.** [HOWARD, W.D. 1]
Photos dated: 1860s
Processes:     Albumen
Formats:       Prints, cdvs
Subjects:      Architecture, topography
Locations:     India - Agra
Studio:
   Entries:
Christies Lon 10/26/78: 172 (lot, H et al);
Christies NY 5/4/79: 64 (attributed)(note);

**HOWARD, W.D. & LLOYD, F.H.** (British) [HOWARD,
   W.D. 2]
Photos dated: 1860s-1865
Processes:     Albumen
Formats:       Prints
Subjects:      Topography
Locations:     Europe - Dolomites
Studio:        Great Britain (Amateur Photographic
               Association)
   Entries:
Swann NY 2/14/52: 184 (book, 23);
Vermont Cat 7, 1974: 760 (2 ills)(book, 20);
Vermont Cat 11/12, 1977: 522 ill(book, 20);
Christies Lon 10/27/77: 213 (book, 23);
Christies Lon 3/16/78: 71 (23);
Christies Lon 3/15/79: 211 (book, 23);
Christies Lon 10/27/83: 218 (albums, H-4, H & L-2,
   et al);

**HOWE** (see TURTON & HOWE)

**HOWE, C.L.** (American)
Photos dated: 1856-1870s
Processes:     Ambrotype ("spereotype"), albumen
Formats:       Plates, stereos
Subjects:      Portraits
Locations:     Studio
Studio:        US - Brattleboro, Vermont
   Entries:
Vermont Cat 8, 1974: 528 ill;
Swann NY 11/6/80: 372 (note);
Harris Baltimore 6/1/84: 148 (lot, H et al);

**HOWE, F.L.** (American)
Photos dated: 1875-1890s
Processes:     Albumen
Formats:       Prints
Subjects:      Topography, documentary (military)
Locations:     US - Cumberland Gap
Studio:        US - New York City; Atlanta, Georgia
   Entries:
Rinhart NY Cat 1, 1971: 323;
California Galleries 9/26/75: 298;
Swann NY 11/5/81: 458 (8);
Christies NY 2/8/83: 36 (lot, H et al);

**HOWE, George M.** (American)
Photos dated: c1848-1854
Processes:     Daguerreotype
Formats:       Plates
Subjects:      Portraits
Locations:     Studio
Studio:        US - Portland, Maine
   Entries:
Rinhart NY Cat 2, 1971: 168;
Vermont Cat 6, 1973: 516 ill;
Witkin IV 1976: D3 ill, D27 ill, D68 ill;
Gordon NY 5/3/76: 268 (lot, H et al);
Vermont Cat 11/12, 1977: 553 ill, 554 ill;

**HOWELL** (American) [HOWELL 1]
Photos dated: 1860s-1876
Processes:     Albumen
Formats:       Cdvs, cabinet cards, stereos
Subjects:      Portraits
Locations:     Studio
Studio:        US - New York City
   Entries:
Sothebys NY 11/21/70: 326 ill(lot, H et al);
Frontier AC, Texas 1978: 81 ill(lot, H-1 et al)
   (note);
Harris Baltimore 12/10/82: 90 (lot, H-1 et al);
Swann NY 11/8/84: 275 (lot, H et al);
Swann NY 11/13/86: 205;

**HOWELL, JAMES & Co.** (British) [HOWELL 2]
Photos dated: 1850s
Processes:     Daguerreotype
Formats:       Plates
Subjects:      Portraits
Locations:     Studio
Studio:        England - London
   Entries:
Christies Lon 3/28/85: 176 (lot, HJ et al), 177 ill
   (note);

**HOWES, C.H.**
Photos dated: c1890
Processes:     Albumen
Formats:       Prints
Subjects:      Topography
Locations:
Studio:
   Entries:
California Galleries 7/1/84: 463;

**HOWIE, James** (British)
Photos dated: 1880s
Processes:      Albumen
Formats:
Subjects:       Topography
Locations:      Great Britain
Studio:         Scotland - Edinburgh
     Entries:
Sothebys Lon 12/4/73: 2 (lot, H et al);
Phillips Lon 3/12/80: 100 (lot, H-1 et al);

**HOWIE, Junior** (British)
Photos dated: 1840s-1850s
Processes:      Daguerreotype
Formats:        Plates
Subjects:       Portraits
Locations:      Studio
Studio:         Scotland - Edinburgh
     Entries:
Christies Lon 3/10/77: 6 (note);

**HOWLAND** (see TABER, I.W.)

**HOWLETT, Robert** (British, 1831-1858)(see also
          CUNDALL)
Photos dated: 1855-1858
Processes:      Albumen, collodion on glass
Formats:        Prints, stereos incl. glass plates,
                cdvs
Subjects:       Documentary (engineering), topography,
                portraits
Locations:      Great Britain; France - Rouen
Studio:         Great Britain
     Entries:
Weil Lon Cat 4, 1944(?): 237 (album, H et al)(note);
Swann NY 2/14/52: 115 (lot, H et al);
Rinhart NY Cat 6, 1973: 279 ill(attributed);
Sothebys Lon 5/24/73: 14 (album, H et al), 132 ill
     (note);
Sothebys Lon 10/24/75: 286 (album, H-1 et al);
Sothebys Lon 10/29/76: 48 (book, H et al);
Sothebys Lon 3/9/77: 11 (lot, H-4 et al), 123
     (album, H et al);
Christies Lon 6/30/77: 300 ill(note);
Sothebys Lon 7/1/77: 271 ill(note);
Sothebys Lon 11/18/77: 238 ill(note);
Christies Lon 3/16/78: 204 (book, 25);
Phillips NY 11/4/78: 25 (H & Cundall);
Phillips Lon 3/13/79: 75 (2 ills)(album, H-2 et al);
Sothebys Lon 3/14/79: 101 ill(note);
Christies Lon 3/15/79: 278 ill(note), 279 ill
     (note), 280, 281 ill, 282 ill(11)(attributed);
Christies Lon 6/28/79: 185 ill(note), 186 ill(note);
Sothebys Lon 6/29/79: 6 ill(H & Downes), 7 ill(H &
     Downes, 7)(note), 199 ill;
Sothebys Lon 10/24/79: 289 ill;
Christies Lon 10/25/79: 73 ill(lot, H et al)(note),
     364 ill(note), 365 ill, 366 ill;
Christies Lon 3/20/80: 305 ill;
Christies NY 5/14/80: 317 (2 ills)(books, H et al);
Sothebys NY 5/20/80: 341 (books, H et al), 345 ill
     (attributed, 3);
Christies Lon 3/26/81: 112 (H & Downes);
Christies Lon 6/18/81: 80 (2)(attributed);
Christies Lon 10/29/81: 312 ill;
Christies NY 11/10/81: 13 ill(note), 14 ill;
Sothebys Lon 3/12/82: 220 (album, H-1 et al);
Christies Lon 6/24/82: 58 ill(H & Downes, 15)(note);

**HOWLETT** (continued)
Sothebys Lon 6/25/82: 9 ill(H & Downes), 11 (lot,
     H-3 et al);
Christies NY 11/8/82: 126 ill;
Christies Lon 3/24/83: 43 (lot, H & Downes-3,
     et al);
Phillips Lon 6/15/83: 98 (lot, H & Downes-15,
     et al);
Christies Lon 10/27/83: 19 ill(lot, H et al),
     22 ill;
Christies Lon 6/28/84: 39 (book, H et al)(note);
Sothebys Lon 6/29/84: 184 (H & Downes);
Sothebys NY 5/7/85: 205 ill(note);
Phillips Lon 6/26/85: 131 ill(H & Downes, 6);
Sothebys Lon 6/28/85: 139 ill(note);
Sothebys Lon 11/1/85: 59 ill(album, H-1 et al);
Christies Lon 4/24/86: 370 (lot, H-1 et al);

**HOWLAND, B.F.** (American)
Photos dated: c1860s-1870
Processes:      Albumen
Formats:        Cdvs
Subjects:       Portraits
Locations:      Studio
Studio:         US - San Francisco, California
     Entries:
California Galleries 6/28/81: 142 (album, H et al);
California Galleries 5/23/82: 256 (lot, H-12 et al);

**HOYER, H.** (German)
Photos dated: 1880
Processes:
Formats:        Prints
Subjects:       Topography
Locations:      Germany - Goettingen
Studio:         Germany - Goettingen
     Entries:
Swann NY 11/6/80: 91 (book, 12)(note);

**HOYT**
Photos dated: 1865
Processes:      Albumen
Formats:        Cdvs
Subjects:       Portraits
Locations:
Studio:
     Entries:
California Galleries 1/21/78: 128 ill(lot,
     H-1 et al);

**HOYTZ** (American)
Photos dated: Nineteenth century
Processes:      Albumen
Formats:
Subjects:       Ethnography
Locations:      Studio
Studio:         US - Washington, D.C.
     Entries:
Christies Lon 3/15/79: 178 (lot, H-3 et al);

HUARD
Photos dated: 1860-1865
Processes:      Albumen
Formats:        Prints
Subjects:       Topography
Locations:      Russia - St. Petersburg
Studio:
  Entries:
Kingston Boston 1976: 211 (2 ills)(7);
Phillips Lon 3/13/79: 57 ill(album, 23);
Christies Lon 6/18/81: 188 (6);
Christies Lon 6/24/82: 126;
Christies Lon 10/30/86: 104;

HUBBARD & SMITH (American) [HUBBARD 1]
Photos dated: Nineteenth century
Processes:      Albumen
Formats:        Stereos
Subjects:       Topography
Locations:      US
Studio:         US
  Entries:
Sothebys NY (Strober Coll.) 2/7/70: 514 (lot,
  H & S et al);

HUBBARD [HUBBARD 2]
Photos dated: Nineteenth century
Processes:      Albumen
Formats:        Stereos
Subjects:       Topography
Locations:      Australia
Studio:
  Entries:
Phillips Lon 10/29/86: 228 (lot, H-1 et al);

HUBBARD, Lucius L. (American)(photographer or
                author?)
Photos dated: 1879
Processes:      Woodburytype
Formats:        Prints
Subjects:       Topography
Locations:      US - Maine
Studio:         US
  Entries:
Frontier AC, Texas 1978: 140 (book, 24);

HUDSON, Frederick (British)
Photos dated: c1860-1880s
Processes:      Albumen
Formats:        Prints, stereos, cdvs
Subjects:       Topography, portraits, genre
Locations:      England - Isle of Wight; Ireland
Studio:         England - Ventnor, Isle of Wight
  Entries:
Rinhart NY Cat 7, 1973: 98 (book, 10);
California Galleries 9/27/75: 387 (lot, H et al);
Swann NY 12/8/77: 431 (lot, H et al);
Christies Lon 10/26/78: 108 (album, H et al);
Christies Lon 10/25/79: 46 ill;
Christies Lon 3/20/80: 107 (lot, H et al), 135 (lot,
  H et al);
Christies Lon 6/26/80: 490;
Christies Lon 6/18/81: 164 (lot, H et al);
Christies Lon 10/29/81: 128 (lot, H et al);
Sothebys Lon 6/25/82: 4 (lot, H et al);
Sothebys Lon 3/25/83: 4 (lot, H et al);
Christies Lon 3/29/84: 327 (lot, H et al);

HUDSON, F. (continued)
Christies Lon 3/28/85: 175 ill(H & Purnell, 3);
Swann NY 5/9/85: 233 (book, H et al)(note);
Harris Baltimore 2/14/86: 215 (album, H-13 et al);

HUDSON, John (British)
Photos dated: 1860s-1872
Processes:      Albumen
Formats:        Stereos, prints
Subjects:       Topography
Locations:      Ireland - Killarney et al
Studio:
  Entries:
Sothebys Lon 3/21/74: 145 (book, 12);
Vermont Cat 9, 1975: 565 ill(6);
California Galleries 4/3/76: 382 (25);
Christies Lon 10/28/76: 87 (album, H et al);
Christies Lon 6/26/80: 106 (lot, H et al);
Christies Lon 3/26/81: 116 (lot, H et al), 125 (lot,
  H-4 et al);
Christies Lon 6/24/82: 59 (lot, H et al), 71 (lot,
  H et al);
Christies Lon 6/23/83: 43 (lot, H et al);
Harris Baltimore 12/16/83: 63 (lot, H et al);
Sothebys Lon 6/29/84: 4 (lot, H et al);
California Galleries 7/1/84: 74 ill(book, 13)
  (attributed);
Sothebys Lon 10/26/84: 5 (lot, H et al);
Harris Baltimore 3/15/85: 45 (lot, H et al), 184
  (album, H-3 et al);

HUFF (American)
Photos dated: 1874
Processes:      Albumen
Formats:        Prints
Subjects:       Documentary (industrial)
Locations:      US
Studio:         US - Newark, New Jersey
  Entries:
Swann NY 2/14/52: 341 (book, 100)(note);

HUFFMAN, Laton Alton (American, 1854-1931)
Photos dated: 1878-1931
Processes:      Albumen, collotype, silver
Formats:        Prints, stereos, cdvs
Subjects:       Ethnography, genre
Locations:      US - Montana
Studio:         US - Fort Keogh, Billings and Miles
                City, Montana
  Entries:
Sothebys NY 5/4/76: 155 (note), 156, 157, 158, 159,
  160 ill;
Sothebys NY 11/9/76: 124 (4);
Sothebys NY 5/20/77: 14 ill, 15, 16, 17, 18 ill(4);
Sothebys NY 10/4/77: 66 ill(5), 67 (5), 68 ill
  (note), 69, 70, 71 ill, 72 ill;
Frontier AC, Texas 1978: 88 (lot, H-81 attributed
  et al), 141 (lot, H et al);
Witkin NY VI 1978: 75 ill(note);
Sothebys LA 2/13/78: 72 ill(4)(note), 73 (4);
Sothebys LA 2/7/79: 474 ill(2), 475 ill(2), 476
  (2), 477 (2), 478 (5), 479 ill(4), 480 (5), 481
  ill(3);
Swann NY 4/26/79: 387 (3), 388 ill(2), 389 (2), 390
  (3);
Christies NY 5/4/79: 112A (7);
Sothebys NY 5/8/79: 28 ill(2)(note), 29 (4)(note),
  30 (3)(note), 31 (4), 32 ill;

**HUFFMAN** (continued)
Christies NY 10/31/79: 120 ill(10);
Phillips NY 11/3/79: 207;
Sothebys LA 2/6/80: 63 ill(3), 64 ill(3), 65 (4),
   66 (2), 67 ill;
Swann NY 4/17/80: 281 (note);
Christies NY 5/16/80: 297 (13), 298 (3);
Sothebys NY 5/20/80: 417 (3)(note);
Phillips Can 10/9/80: 33 ill(4)(note);
Sothebys NY 11/17/80: 122 (5), 123 (4), 124 (4);
Sothebys LA 2/4/81: 255 (2);
Christies NY 11/10/81: 69 ill(2), 70, 71, 72 ill;
California Galleries 6/19/83: 258, 259, 260, 261,
   262 (2), 263 (2), 264 (3), 265 (5);
Harris Baltimore 12/16/83: 60 ill(26)(note);
California Galleries 7/1/84: 464, 465 ill, 466,
   467, 468, 469, 470 ill, 471, 472, 473, 474 (4),
   475 (4), 476 (5), 477 (5), 478 (6), 479 (6);
Harris Baltimore 3/15/85: 49 (note);
California Galleries 6/8/85: 253 ill, 254, 255, 256
   (2), 257 (3), 258, 259 (4), 260, 261 (4), 262,
   263 (4);
California Galleries 3/29/86: 744;

**HUGGON, W.** (British)
Photos dated: 1860s
Processes:      Ambrotype
Formats:        Plates
Subjects:       Portraits
Locations:      Studio
Studio:         England - Leeds
   Entries:
Vermont Cat 4, 1972: 394 ill;

**HUGHES** (see MINSHULL & HUGHES) [HUGHES 1]

**HUGHES & MULLINS** (British) [HUGHES 2]
Photos dated: 1880s-1900s
Processes:      Albumen, photogravure
Formats:        Prints
Subjects:       Portraits, topography
Locations:      England
Studio:         England - Ryde
   Entries:
Christies Lon 3/16/78: 317 (lot, H & M-1 et al);
Sothebys Lon 10/24/79: 358 (lot, H & M-23 et al);
Christies Lon 3/20/80: 388 (lot, H & M-1 et al);
Sothebys Lon 6/24/83: 105 ill(album, 83);

**HUGHES, Alice** (British, died 1920)
Photos dated: c1889-1905
Processes:      Platinum, photogravure
Formats:        Prints
Subjects:       Portraits
Locations:      England
Studio:         England - London
   Entries:
Sothebys Lon 3/21/80: 242 (book, H et al);
Swann NY 4/17/80: 75 (book, H et al);
Swann NY 5/5/83: 78 (book, H et al);
Sothebys Lon 10/26/84: 163 (lot, H-1 et al);

**HUGHES, Cornelius Jabez** (British, 1819-1884)
Photos dated: 1849-1882
Processes:      Daguerreotype, albumen, woodburytype
Formats:        Plates, prints, cdvs, cabinet cards
Subjects:       Portraits, topography
Locations:      England - London, Isle of Wight;
                Scotland - Glasgow
Studio:
   Entries:
Sothebys Lon 6/21/74: 124 (2);
Sothebys Lon 10/24/75: 23;
Christies Lon 10/28/76: 208 ill(2);
Sothebys Lon 10/29/76: 132 ill(album, 100);
Christies Lon 3/10/77: 244 (lot, H-4 et al), 279
   (albums, H-1 et al);
Christies Lon 6/30/77: 159 (album, H-1 et al);
Sothebys Lon 7/1/77: 234 (album, H et al), 243
   (album, H et al);
Christies Lon 10/27/77: 21 (note), 37 (lot, H-1
   et al), 367 (album, H-2 et al), 369 (album,
   H et al);
Christies Lon 6/27/78: 24 ill;
Sothebys Lon 6/28/78: 171;
Christies Lon 10/26/78: 8 (note), 102 (album, 45),
   228 (book, H-1 et al), 329 (album, H et al);
Phillips Can 10/4/79: 21 (album, H et al);
Christies Lon 10/25/79: 6 ill, 401 (album, H et
   al), 421 (album, H-1 et al), 426 (lot, H-1
   et al);
Christies Lon 3/20/80: 356;
Christies Lon 6/26/80: 152 (lot, H-1 et al), 485
   (albums, H et al);
Sothebys Lon 6/27/80: 37;
Sothebys Lon 10/29/80: 160;
Christies Lon 10/30/80: 438 (album, H et al);
Christies NY 11/11/80: 83 (book, H et al);
Christies Lon 3/26/81: 19 (lot, H-1 et al), 20
   (lot, H-1 et al), 42 (lot, H-1 et al), 403
   (album, H et al);
Sothebys Lon 10/28/81: 288, 289, 290 (lot, H-1 et
   al), 291;
Christies Lon 3/11/82: 11;
Sothebys Lon 3/12/82: 293;
Christies Lon 6/24/82: 366 (album, H et al);
Christies Lon 6/23/83: 242 (album, H et al);
Sothebys Lon 6/24/83: 116;
Christies Lon 10/25/84: 318 (albums, H et al), 325
   (albums, H et al);
Phillips Lon 3/27/85: 238 (lot, H-1 et al);
Christies Lon 3/28/85: 183 (lot, H-11 et al), 319
   (album, H et al);
Christies Lon 6/27/85: 246 (albums, H et al)(note);
Phillips Lon 10/30/85: 11 ill;
Christies Lon 6/26/86: 149 (album, H et al);
Christies Lon 10/30/86: 221 (album, H et al);

**HUGO, Charles Victor** (French, 1826-1871) &
              **VACQUERIE, Auguste** (French,
              1819-1895)
Photos dated: c1852-1855
Processes:      Daguerreotype, salt
Formats:        Plates, prints
Subjects:       Genre (domestic)
Locations:      Island of Guernsey
Studio:         Island of Guernsey
   Entries:
Goldschmidt Lon Cat 52, 1939: 171 (note);
Rauch Geneva 6/13/61: 66 (3)(note);
Frumkin Chicago 1973: 77;
Rinhart NY Cat 6, 1973: 306 ill(note);

**HUGO & VAQUERIE** (continued)
Sothebys NY 11/9/76: 61 ill(lot, H-1 et al);
Christies Lon 6/27/78: 21 (4 ills)(2)(note);
Octant Paris 10/1981: 1 ill(note), 2 ill, 3 ill, 4
    ill, 5 ill, 6 ill, 7 ill(note), 9 ill, 10 ill,
    11 ill, 12 ill, 13 ill, 14 ill, 15 ill, 17 ill
    (note), 18 ill, 19 ill(note), 20 ill(note), 21
    ill, 22 ill, 23 ill, 24 ill;
Sothebys Lon 3/12/82: 197 ill(note);
Drouot Paris 11/24/84: 81 ill;

**HUGO, Thomas** (British)(photographer or author?)
Photos dated: 1859
Processes:
Formats:          Prints
Subjects:         Architecture
Locations:        England - Somerset
Studio:           Great Britain
    Entries:
Swann NY 2/14/52: 186 (book, 13);

**HUGUET**
Photos dated: 1870s
Processes:        Albumen
Formats:          Prints
Subjects:         Topography
Locations:        Europe
Studio:           Europe
    Entries:
Christies Lon 6/26/86: 43;

**HULL, Edward** (British)
Photos dated: 1872
Processes:        Woodburytype
Formats:          Prints
Subjects:         Documentary (industrial)
Locations:        Great Britain
Studio:           Great Britain
    Entries:
Wood Conn Cat 42, 1978: 265 (book, 2);

**HUMMEL** (see CONAWAY, B.F.)

**HUMPHREY, J.G.**
Photos dated: Nineteenth century
Processes:        Albumen
Formats:          Prints incl. panoramas
Subjects:         Topography
Locations:        North America
Studio:
    Entries:
Christies Lon 10/25/79: 224 (lot, H-1 et al);

**HUMPHREYS & HALLIWELL** (British)
Photos dated: c1855-c1860
Processes:        Daguerreotype, ambrotype
Formats:          Plates
Subjects:         Portraits
Locations:        Studio
Studio:           Scotland - Edinburgh
    Entries:
Rinhart NY Cat 6, 1973: 203 ill;
Vermont Cat 5, 1973: 445 ill;
Sothebys Lon 7/1/77: 204 (lot, H & H-1 et al);

**HUMPHREYS, H.** (British)
Photos dated: 1860s and/or 1870s
Processes:        Albumen
Formats:          Stereos
Subjects:         Topography
Locations:        England
Studio:           England
    Entries:
Sothebys Lon 10/18/74: 13 (lot, H et al);

**HUMPIDGE**
Photos dated: 1860s
Processes:        Albumen
Formats:          Cdvs
Subjects:         Portraits
Locations:        India - Calcutta
Studio:
    Entries:
Phillips Lon 4/23/86: 272 (lot, H-1 et al);

**HUNNEMAN, C.** (British)
Photos dated: 1860s
Processes:        Albumen
Formats:          Cdvs
Subjects:         Portraits
Locations:        Studio
Studio:           Great Britain
    Entries:
Phillips Lon 6/27/84: 188 ill;

**HUNT, Charles, W.** (American)
Photos dated: 1856
Processes:        Daguerreotype
Formats:          Plates
Subjects:         Documentary (disasters)
Locations:        US - Lawrence, Kansas
Studio:           US - Kansas
    Entries:
California Galleries 6/8/85: 206;

**HUNT, E.** (American)
Photos dated: 1857-1858
Processes:        Salt
Formats:
Subjects:         Documentary (educational institutions)
Locations:        US - Chapel Hill, North Carolina
Studio:           US
    Entries:
Swann NY 5/9/85: 375 ill(album, 38)(note);

**HUNT, William Howes** (British)
Photos dated: 1840s
Processes:        Calotype
Formats:          Prints
Subjects:         Portraits
Locations:        Great Britain
Studio:           Great Britain
    Entries:
Sothebys Lon 6/28/85: 123 (lot, H-1 et al);

**HUNTER & CLOSE [HUNTER 1]**
Photos dated: Nineteenth century
Processes:     Albumen
Formats:       Cdvs
Subjects:      Portraits
Locations:
Studio:
   Entries:
California Galleries 1/21/78: 122 (lot,
  H & C et al);

**HUNTER** (American) [HUNTER 2]
Photos dated: 1887
Processes:
Formats:       Prints
Subjects:      Architecture
Locations:     US - New York City
Studio:        US - New York City
   Entries:
Swann NY 9/18/75: 281 (lot, H-2 et al);

**HUNTER, Robert E.** (British)(photographer or
                   author?)
Photos dated: 1864
Processes:     Albumen
Formats:       Prints
Subjects:      Topography
Locations:     England - Stratford-upon-Avon
Studio:        Great Britain
   Entries:
Edwards Lon 1975: 112 (book, 4);

**HUNTINGTON**
Photos dated: c1870s
Processes:     Albumen
Formats:       Cabinet cards, stereos
Subjects:      Ethnography
Locations:     Studio
Studio:        US - St. Paul, Minnesota
   Entries:
California Galleries 1/22/77: 110;

**HURD, L.F.** (American)
Photos dated: c1870-1870s
Processes:     Albumen
Formats:       Stereos
Subjects:      Topography
Locations:     US - New York
Studio:        US - Greenwich, New York
   Entries:
Sothebys NY (Strober Coll.) 2/7/70: 514 (lot, H &
  Smith et al);
Rinhart NY Cat 7, 1973: 254 (4);
Rinhart NY Cat 8, 1973: 57 (H & Winsor), 58 (H &
  Winsor);
Harris Baltimore 12/16/83: 86 (lot, H et al);

**HURFORD** (see VOGNOS)

**HURLEY, R.C.**
Photos dated: 1899
Processes:     Albumen
Formats:       Prints, cdvs
Subjects:      Topography
Locations:     China - Canton, Hong Kong, Macao,
              Shanghai, Peking
Studio:
   Entries:
Sothebys Lon 10/27/78: 136 (book, 60);
Swann NY 11/13/86: 35 (books, H-60 et al), 195 (lot,
  H attributed et al);

**HUSSON** (see GEBBIE & HUSSON)

**HUTCHINSON**
Photos dated: 1850s
Processes:     Daguerreotype
Formats:       Plates
Subjects:      Portraits
Locations:
Studio:
   Entries:
Vermont Cat 9, 1975: 412 ill;

**HUTTON, Captain Morland** (British)
Photos dated: 1860s
Processes:     Albumen
Formats:       Prints
Subjects:
Locations:
Studio:        Great Britain (Amateur Photographic
              Association)
   Entries:
Christies Lon 10/27/83: 218 (albums, H-4 et al);

**HUTTON, T.B.** (British)
Photos dated: 1860s-c1870
Processes:     Albumen
Formats:       Stereos
Subjects:      Topography
Locations:     England - Guernsey, Sark
Studio:        England - Guernsey
   Entries:
Christies Lon 10/30/80: 131 (27);
Christies Lon 3/11/82: 82 (lot, H-5 et al);

**HYDE, John George** (British)
Photos dated: 1860s-1880s
Processes:     Albumen
Formats:       Prints
Subjects:      Topography
Locations:     US - American west
Studio:        Great Britain (Amateur Photographic
              Association)
   Entries:
Frontier AC, Texas 1978: 194a (2 ills)(book, 66)
  (note);
Swann NY 10/18/79: 219 (book, 62)(note);
Christies Lon 10/27/83: 218 (albums, H-1 et al);
Swann NY 11/8/84: 68 ill(book, 62)(note);
Christies Lon 10/30/86: 50 (book, 62);

**I., E. [I.E.]**
Photos dated: 1890s
Processes:      Albumen
Formats:        Stereos (tissues)
Subjects:       Topography
Locations:      France - Paris
Studio:         Europe
　　Entries:
Christies Lon 10/29/81: 158A (lot, I et al);
Christies Lon 6/24/82: 61 (lot, I et al);

**IBARRA, J.**
Photos dated: c1860s-1870
Processes:      Albumen
Formats:        Stereos
Subjects:       Topography
Locations:      Mexico
Studio:         Mexico
　　Entries:
California Galleries 12/13/80: 373 (lot, I et al);

**IDDINGS** (American)
Photos dated: Nineteenth century
Processes:
Formats:        Prints
Subjects:       Topography
Locations:      US - Yellowstone Park, Wyoming
Studio:         US
　　Entries:
Swann NY 10/18/79: 350 (books, I et al);

**IGNATZ, Julius**
Photos dated: c1885
Processes:      Albumen
Formats:        Cabinet cards
Subjects:       Portraits
Locations:
Studio:
　　Entries:
Maggs Paris 1939: 551;

**ILLIER** (French)
Photos dated: 1847
Processes:      Daguerreotype
Formats:        Plates
Subjects:       Topography
Locations:      Italy - Florence
Studio:
　　Entries:
Drouot Paris 11/24/84: 87 ill;

**ILLINGWORTH, William H.** (American)
Photos dated: 1862-1888
Processes:      Albumen
Formats:        Stereos
Subjects:       Topography, ethnography
Locations:      US - St. Paul, Minnesota
Studio:         US - St. Paul, Minnesota
　　Entries:
Rinhart NY Cat 7, 1973: 343;
California Galleries 9/27/75: 475 (lot, I-1 et al),
　　503 (lot, I et al);
California Galleries 1/23/77: 378 (lot, I-1 et al),
　　403 (lot, I et al);
Harris Baltimore 6/1/84: 93 (lot, I et al);

**IMAGLIO**
Photos dated: Nineteenth century
Processes:      Albumen
Formats:        Stereos
Subjects:       Topography
Locations:      Russia - Moscow
Studio:
　　Entries:
Christies Lon 10/30/80: 120 (lot, I-9 et al);

**IMPEY, Major** (British)
Photos dated: 1860-1869
Processes:      Albumen
Formats:        Prints
Subjects:       Topography
Locations:      India
Studio:         Great Britain (Amateur Photographic
                Association)
　　Entries:
Sothebys Lon 10/18/74: 158 (lot, I et al);
Sothebys NY 11/2/79: 274 (album, I et al)(note);

**INGERSOLL, Truman Ward** (American, 1862-1922)
Photos dated: 1881-1909
Processes:      Albumen
Formats:        Stereos
Subjects:       Topography
Locations:      Minnesota; Yellowstone Park, Wyoming
Studio:         St. Paul, Minnesota
　　Studio:
Rinhart NY Cat 7, 1973: 344;
California Galleries 9/27/75: 578 (lot, I-10 et al);
Harris Baltimore 6/1/84: 153 (lot, I et al);
California Galleries 7/1/84: 205 (lot, I-7 et al);
Harris Baltimore 3/15/85: 90 (37);
Christies Lon 10/31/85: 57 (lot, I-9 et al);

**INGLIS** (American)
Photos dated: 1860s
Processes:      Albumen
Formats:        Prints
Subjects:
Locations:      US
Studio:         US
　　Entries:
Swann NY 11/14/85: 262 (book, I et al);

**INGLIS, Alexander A.** (British)
Photos dated: early 1850s-1880s
Processes:      Salt, albumen
Formats:        Prints
Subjects:       Topography
Locations:      Scotland - Edinburgh
Studio:         Scotland - Edinburgh
　　Entries:
Sothebys Lon 6/26/75: 89 (album, I et al)(note);
Sothebys Lon 6/28/78: 114 (album, 12);
Sothebys NY 5/15/81: 82 ill(album, I et al);

**INGLIS, James** (Canadian)
Photos dated: 1869
Processes:      Albumen
Formats:        Cdvs, stereos
Subjects:       Portraits, topography
Locations:      Canada - Montreal
Studio:         Canada - Montreal
    Entries:
Phillips Can 10/4/79: 43 (lot, I et al);
Phillips Can 10/9/80: 44 (album, I et al);
Harris Baltimore 12/16/83: 21 (lot, I-1 et al);
Phillips Lon 6/12/85: 153 (albums, I et al);

**INNES, Alexander Mitchell** (1811-1886)
Photos dated: 1860s
Processes:      Platinum
Formats:        Prints
Subjects:       Topography
Locations:      Switzerland
Studio:
    Entries:
Sothebys Lon 6/28/85: 218 (album, 11)(note);

**INNES, Major P.R.** (British)
Photos dated: 1860s
Processes:      Albumen
Formats:        Prints
Subjects:
Locations:
Studio:         Great Britain (Amateur Photographic
                Association)
    Entries:
Christies Lon 10/27/83: 218 (albums, I-1 et al);

**INSETSU** (see RIOKU, Insetsu)

**INSKIPP, H.G.** (British)
Photos dated: 1860s-c1875
Processes:      Albumen
Formats:        Prints, stereos, cdvs
Subjects:       Architecture, topography
Locations:      England; Scotland
Studio:         England - Sevenoaks
    Entries:
Sothebys Lon 10/29/76: 114 (album, I et al);
California Galleries 1/21/79: 351 ill(album, I-8
    et al);
California Galleries 3/30/80: 213 (album, I-8
    et al);
Christies Lon 10/30/80: 114 (lot, I-49 et al);
Christies Lon 10/30/86: 256 (albums, I et al);

**INSLEY, Henry E.** (American)
Photos dated: c1844-c1860
Processes:      Daguerreotype
Formats:        Plates
Subjects:       Portraits
Locations:      Studio
Studio:         Canada - Toronto; US - New York City
    Entries:
Sothebys NY (Weissberg Coll.) 5/16/67: 101 (lot,
    I-1 et al);
Sothebys NY (Strober Coll.) 2/7/70: 138 ill(note);
Vermont Cat 5, 1973: 376 ill;
Vermont Cat 6, 1973: 515 ill;
Christies Lon 6/10/76: 17 (note);

**INSLEY, H.E.** (continued)
Vermont Cat 11/12, 1977: 555 ill;
Sothebys Lon 7/1/77: 223 (lot, I-1 et al);

**IRANIAN, M.**
Photos dated: 1880s-1890s
Processes:      Albumen
Formats:        Prints
Subjects:       Topography
Locations:      Turkey - Constantinople
Studio:
    Entries:
Swann NY 4/14/77: 191 (lot, I et al);
California Galleries 1/21/78: 221 (9);
Christies Lon 10/25/79: 244 (album, I-8 et al);
Christies Lon 6/26/80: 272 (albums, I-8 et al);
Phillips NY 5/9/81: 61 ill(albums, I et al);
Swann NY 11/18/82: 336 (album, I et al);

**IRIS** (see NORTON & IRIS)

**IRISH, George S.** (American)
Photos dated: 1870s
Processes:      Albumen
Formats:        Stereos
Subjects:       Topography
Locations:      US - Lake George, New York
Studio:         US - Glen Falls, New York
    Entries:
Rinhart NY Cat 2, 1971: 537 (5);
Vermont Cat 4, 1972: 591 ill(10);
Rinhart NY Cat 6, 1973: 530 (4);
California Galleries 9/27/75: 521 (lot, I et al);
California Galleries 1/23/77: 417 (lot, I et al);

**IRMAO** (see FERRARI & IRMAO)

**IRVING, J.** (American)
Photos dated: 1870s-c1883
Processes:      Albumen
Formats:        Prints, stereos
Subjects:       Topography, documentary
Locations:      US
Studio:         US - Troy, New York
    Entries:
Wood Conn Cat 37, 1976: 217 (album, 432)(note);

**ISAACS, Reverend Albert Augustus** (British)
Photos dated: 1856
Processes:      Salt, albumen
Formats:        Prints
Subjects:       Topography
Locations:      Palestine - Jerusalem
Studio:         England - London
    Entries:
Sothebys Lon 6/11/76: 173 (album, I-2 et al);
Sothebys Lon 12/9/83: 34 (2 ills)(album, I-150 et
    al)(note);
Sothebys Lon 6/29/84: 81 ill(note), 82 ill, 83 ill,
    84 ill;

ISINGS (American)
Photos dated: 1850s
Processes:      Daguerreotype
Formats:        Plates
Subjects:       Portraits
Locations:      Studio
Studio:         US - Philadelphia, Pennsylvania
   Entries:
Vermont Cat 11/12, 1977: 556 ill;

ISRAEL, Gebr. (German)
Photos dated: 1880
Processes:
Formats:        Prints
Subjects:       Topography
Locations:      Germany - Hamburg
Studio:         Germany - Hamburg
   Entries:
Swann NY 11/6/80: 92 (albums, I-12 et al);

ITIER, Jules (French, 1802-1877)
Photos dated: 1844-1845
Processes:      Daguerreotype
Formats:        Plates
Subjects:       Topography
Locations:      France - Montpellier; Egypt
Studio:
   Entries:
Christies Lon 3/26/81: 7 ill(note), 8 ill;
Christies Lon 10/29/81: 1 ill(note), 2;
Sothebys Lon 11/1/85: 17 ill(note);

IVES, Frederick Eugene (American, 1856-1937)
Photos dated: 1874-1890s
Processes:      Albumen
Formats:        Stereos
Subjects:       Topography
Locations:      US - Ithaca, New York
Studio:         US - Ithaca, New York
   Entries:
Harris Baltimore 12/16/83: 91 (lot, I-7 et al);

J., C.R. [C.R.J.] (see JONES, Reverend Calvert)

J., E. [E.J.]
Photos dated: 1850-1855
Processes:     Calotype
Formats:       Negatives
Subjects:      Topography
Locations:
Studio:
    Entries:
Rauch Geneva 6/13/61: 46 (2)(note);

J., G. [GJ Phot] (French)
Photos dated: 1870s-1880s
Processes:     Albumen
Formats:       Prints
Subjects:      Topography
Locations:     France - southern; Italy
Studio:        France
    Entries:
Swann NY 4/1/76: 206 (lot, J et al);
Swann NY 11/11/76: 389 (albums, J et al), 395
    (albums, J et al);
Christies Lon 3/26/81: 195 (album, J-12 et al);
Phillips Lon 6/23/82: 42 (album, 21);
Christies Lon 6/23/83: 178 (album, J et al);
California Galleries 7/1/84: 402 (lot, J et al);

J., H. [H.J.] (French)
Photos dated: 1860s and/or 1870s
Processes:     Albumen
Formats:       Stereos incl. tissues
Subjects:      Topography, genre
Locations:     France; Switzerland; Germany
Studio:        France - Paris
    Entries:
Christies Lon 10/30/80: 116 (lot, J et al);
Harris Baltimore 12/16/83: 49 (lot, J-10 et al), 132
    (lot, J et al);
Phillips Lon 10/24/84: 88 (lot, J-18 et al), 90
    (lot, J-45 et al);
Harris Baltimore 3/15/85: 42 (lot, J-2 et al), 95
    (lot, J-20 et al);
Harris Baltimore 2/14/86: 48 (lot, J-20 et al);

J., N. [N.J.]
Photos dated: 1860s and/or 1870s
Processes:     Albumen
Formats:       Prints
Subjects:      Topography
Locations:     England
Studio:
    Entries:
Christies Lon 10/31/85: 120 (album, J-1 et al);

J., W.D. [W D J]
Photos dated: 1863
Processes:     Albumen
Formats:       Prints
Subjects:      Topography
Locations:     Canada - Halifax, Nova Scotia
Studio:
    Entries:
Christies Lon 6/28/84: 315 (album, J-4 et al);

J., W.W.W. [W.W.W.J.]
Photos dated: 1860s
Processes:     Albumen
Formats:       Stereos
Subjects:      Topography
Locations:     West Indies
Studio:
    Entries:
Christies Lon 10/28/82: 30 (lot, J-6 et al);

JACKMAN, L.E. (American)
Photos dated: 1870s
Processes:     Albumen
Formats:       Stereos
Subjects:      Topography
Locations:     US - New England
Studio:        US - Springfield, Vermont
    Entries:
Harris Baltimore 12/16/83: 86 (lot, J et al);

JACKSON (British) [JACKSON 1]
Photos dated: mid 1850s
Processes:
Formats:       Prints
Subjects:      Topography
Locations:     Wales - Penllegare
Studio:        Great Britain
    Entries:
Christies Lon 6/18/81: 395 (album, J-1 et al);

JACKSON (see also PHILPOT, J.) [JACKSON 2]
Photos dated: 1850s-1860s
Processes:     Albumen
Formats:       Prints
Subjects:      Architecture
Locations:     Italy
Studio:        Italy - Florence
    Entries:
Christies NY 5/16/80: 189 (lot, J et al);

JACKSON Brothers (see JACKSON, W.H.)

JACKSON, J.H.
Photos dated: 1860s-1871
Processes:     Albumen
Formats:       Prints
Subjects:      Topography
Locations:     Burma - Rangoon
Studio:
    Entries:
Christies Lon 10/25/79: 190 (lot, J-1 et al);
Christies Lon 6/26/80: 224 (lot, J-1 et al), 254;
Christies Lon 6/18/81: 210 ill(album, J-5 et al);
Swann NY 5/5/83: 376 (album, J et al)(note);
Christies Lon 3/29/84: 73 (album, J et al);

JACKSON, Reverend J.E. (British)(photographer?
Photos dated: 1879
Processes:
Formats:       Prints
Subjects:      Topography
Locations:     England
Studio:        Great Britain
    Entries:
Christies Lon 6/26/80: 308 (books, J-2 et al);

JACKSON, John P.
Photos dated: 1890
Processes:
Formats:        Prints
Subjects:       Documentary (public events)
Locations:      Germany - Oberammergau
Studio:
  Entries:
Christies Lon 6/28/79: 173 (book, 42);

JACKSON, Sheldon (American)
Photos dated: 1890-1893
Processes:
Formats:        Prints
Subjects:
Locations:      US - Alaska
Studio:         US - Alaska
  Entries:
Witkin NY I 1973: 130 (book, 15);
Witkin NY II 1974: 127 (book, 15);
Witkin NY III 1975: 597 (book, 15);

JACKSON, William Henry (American, 1843-1942)
Photos dated: 1857-1895
Processes:      Albumen, photogravure, albertype,
                photochrome
Formats:        Prints, stereos, cabinet cards,
                boudoir cards, cdvs
Subjects:       Topography, ethnography
Locations:      US - American west; Mexico; Ceylon
Studio:         US - Omaha, Nebraska; Denver, Colorado
  Entries:
Sothebys NY (Weissberg Coll.) 5/16/67: 185 (lot,
  J-10 et al);
Sothebys NY (Strober Coll.) 2/7/70: 352 (lot, J-1 et
  al)(note), 354 (lot, J et al), 510 (lot, J et
  al), 520 (lot, J-15 et al)(note), 522 (lot, J-1
  et al);
Sothebys NY 11/21/70: 10 (album, J et al), 115, 116
  ill, 117 ill, 118, 119 ill, 120 ill, 121 ill,
  122, 123, 124, 125, 126 ill, 127 ill, 128, 129,
  130 ill, 131, 132, 133, 134 ill(note), 135 ill,
  136, 137 ill, 138, 139, 140, 141, 142 ill(note),
  143, 144 (note), 145 ill(note), 146 ill(note),
  147 ill(note), 148 (note), 149 ill, 150 ill
  (note), 151, 152 ill, 153, 154, 155 (note), 156
  ill, 157 ill(note), 157a, 158 ill, 369 ill(lot,
  J-1 et al);
Rinhart NY Cat 1, 1971: 199, 208 (2), 209 (2), 210
  (2), 211 (2), 310 (13), 331, 332, 333, 334, 335,
  336, 337, 338, 339, 340, 341 ill, 342, 343, 344
  ill, 345, 346, 347, 348, 349, 350, 351, 352,
  353, 354, 355, 356, 357, 358, 359 ill, 360, 361,
  362, 363;
Rinhart NY Cat 2, 1971: 392 (album, J et al), 417,
  418, 434 (2 ills)(Album, J-550 et al);
Vermont Cat 1, 1971: 234 ill(10);
Vermont Cat 2, 1971: 223 ill(10), 224 (8);
Vermont Cat 4, 1972: 592 ill(4), 593 ill;
Rinhart NY Cat 6, 1973: 310, 311, 312, 313, 314, 366
  (attributed), 557 (2), 587, 588, 589, 590, 591,
  592, 593 (2), 606 (2)(note);
Rinhart NY Cat 7, 1973: 143 (album, J et al), 297,
  442;
Rinhart Cat 8, 1973: 78;
Vermont Cat 5, 1973: 527 (4 ills)(4)(note), 528 ill,
  529 ill;
Witkin NY I 1973: 317, 319, 320, 321, 322 ill, 323,
  324 ill, 325, 326, 327;

JACKSON, W.H. (continued)
Vermont Cat 7, 1974: 632 ill, 649 (lot, J
  Brothers-1, et al);
Christies Lon 4/25/74: 252 ill(50);
Witkin NY III 1975: 164 ill(note), 165 ill, 166
  ill, 167 ill, 168 ill, 169 ill;
Sothebys NY 2/25/75: 175 (lot, J-1 et al), 197
  (10), 203 (lot, J-1 attributed, et al);
Sothebys Lon 3/21/75: 86 ill(album, J et al), 87
  (album, J et al), 88 ill(album, J-14 et al);
Sothebys Lon 6/26/75: 110 (album, J attributed
  et al);
Swann NY 9/18/75: 265 (3);
Sothebys NY 9/23/75: 122 (3 ills)(album, J-7
  attributed, et al), 129 (note), 130 ill, 131
  (note), 132 (note), 133 ill(note), 134 ill
  (note), 135 ill, 136 ill(note), 137 ill(note),
  138 ill(note), 139 (lot, J-3 et al), 140 ill
  (2), 141 ill(3), 142 ill, 143 (lot, J-1 et al),
  144, 145 (note), 146, 147 (lot, J-1 plus 5
  attributed, et al), 148, 149 ill, 150, 151, 152,
  153 ill, 154 ill(lot, J-1 et al), 155 ill(lot,
  J-1 et al), 156 ill, 157 ill(note), 158, 159
  ill, 160 ill, 161, 162 ill, 163, 164 ill(lot,
  J-2 et al);
California Galleries 9/26/75: 256 (lot, J-1 et al);
California Galleries 9/27/75: 302, 491 (6);
Colnaghi Lon 1976: 250 ill(note), 251, 252;
Lunn DC Cat 6, 1976: 53 ill(note), 54 (note),
  55 ill;
Rose Boston Cat 1, 1976: 2 ill(note);
Witkin NY IV 1976: 346 ill, 347 ill, 348 ill, 349
  ill, 350 ill, 351 ill, 352 ill, 353 ill, 354
  ill, 355 ill, 356 ill, OP230 (book, 18);
Wood Conn Cat 37, 1976: 110 (book, 80)(note), 111
  (book, 12)(note), 285 (6), 286 ill(note), 287 ill
  (attributed), 288 ill(attributed);
Sothebys Lon 3/19/76: 33 (lot, J-20 et al);
Swann NY 4/1/76: 131 (book, 1), 207 (17);
California Galleries 4/2/76: 264 ill, 265 ill, 266,
  267;
Gordon NY 5/3/76: 313 ill;
Sothebys NY 5/4/76: 136 (4)(note), 137 (4), 138
  (3), 139 (4), 140 ill(4), 141 ill(2)(note), 142
  (5), 143 ill(2), 144 ill(4), 145 (3), 146 ill
  (3), 147 ill(4), 148 (3);
Sothebys Lon 6/11/76: 3 (lot, J-6 et al);
Sothebys NY 11/9/76: 95 (4)(note), 96 (5)(note), 97
  (4)(note), 98 (4), 99 (4), 100 (3), 101 ill
  (note), 102 ill(2), 103 ill(2)(note), 104 (4),
  105 (note);
Gordon NY 11/13/76: 78 ill, 79 ill, 80 ill, 81 ill,
  82 ill, 83 ill, 84 ill, 100 (album, J attributed
  et al);
Halsted Michigan 1977: 664 (note), 665, 666;
Rose Boston Cat 2, 1977: 6 ill(note);
Vermont Cat 11/12, 1977: 795 ill(4), 796 ill(8),
  797 ill(3), 798 ill(8), 799 ill(6), 800 ill(4),
  801 ill(2), 802 ill, 803 ill, 804 ill, 805 ill,
  869 ill, 870 ill, 871 ill, 872 ill, 873 ill, 874
  ill, 875 ill, 876 ill(attributed), 877 ill, 878
  ill, 879 ill, 880 ill, 881 ill(attributed), 882
  ill, 883 ill, 884 ill(attributed), 885 ill
  (attributed), 886 ill(attributed), 887 ill
  (attributed), 888 ill(attributed), 889 ill
  (attributed), 890 ill, 891 ill(attributed), 892
  ill(attributed), 893 ill, 894 ill, 895 ill, 896
  ill, 897 ill(attributed), 898 ill(attributed),
  899 ill, 900 ill(attributed), 901 ill, 902 ill
  (attributed), 903 ill(attributed), 904 ill
  (attributed), 905 ill(attributed), 906 ill

JACKSON, W.H. (continued)
(attributed), 907 ill(attributed), 908 ill
(attributed), 909 ill(attributed), 910 ill
(attributed), 911 ill, 912 ill, 913 ill, 914
ill, 915 ill, 916 ill, 917 ill, 918 ill;
White LA 1977: 91 (note), 92, 93 ill(note), 94, 256
ill(12), 257 ill(20), 258 ill(24);
California Galleries 1/22/77: 323;
California Galleries 1/23/77: 397 ill(5);
Sothebys NY 2/9/77: 78 (2 ills)(album, 37)(note),
79 ill, 80 (4), 81 (lot, J-2 et al);
Christies Lon 3/10/77: 169 (albums, J-16 et al), 183
(album, J-3 et al);
Swann NY 4/14/77: 188 (album, J et al), 278 (2),
279 (8), 341 (lot, J-1 et al);
Gordon NY 5/10/77: 844 ill, 845 ill, 846 ill, 847
ill, 848 ill, 849 ill(note), 850 ill, 851 ill
(note), 852 ill, 853 ill(attributed), 854 ill
(attributed);
Sothebys NY 5/20/77: 9 ill(2)(note), 10 ill;
Sothebys Lon 7/1/77: 39 (book, 4), 126 ill;
Sothebys NY 10/4/77: 49 ill(note), 50 (2), 51 (2),
52 (2), 54 ill;
Christies Lon 10/27/77: 169 (lot, J-3 et al);
Sothebys Lon 11/18/77: 83 ill(album, 16)
(attributed);
Swann NY 12/8/77: 288 (2), 352 (lot, J-1 et al);
Frontier AC, Texas 1978: 114 (note), 146 (book,
20), 147, 148 ill, 149, 150, 151 ill, 152, 154
ill, 155, 156, 157, 158 (11)(note), 159 ill,
162, 163 (4), 164 ill, 165 ill, 166 (2), 167,
168 ill, 169, 170, 171, 172, 173, 174 ill(note),
175 ill, 176 ill, 177, 178, 180, 181, 182 ill,
183, 184 (5), 186 ill(2), 187, 189, 190 (2), 191
ill(note), 192 (album, 78)(note), 193 ill(9)
(note);
Lehr NY Vol 1:2, 1978: 24 ill, 25 ill;
Rose Boston Cat 3, 1978: 152 ill(note);
Witkin NY VI 1978: 76 (2 ills)(2)(note);
Wood Conn Cat 41, 1978: 184 ill(note), 185 ill,
186, 187, 188, 189, 190 ill(note), 191 ill, 192
ill, 193, 194, 195, 196 ill, 197;
California Galleries 1/21/78: 278 (album, J-20 et
al), 279 (album, J et al), 302 (J & Hook, 7),
372, 373, 374 (2), 375 (2), 376 (2), 377 (2),
378 (2), 417 (lot, J et al);
California Galleries 1/22/78: 447 (book, 12);
Sothebys LA 2/13/78: 50 ill(note), 51, 52, 53, 54,
55, 56, 57 ill;
Christies Lon 3/16/78: 129 ill, 133 (album, J et
al), 134;
Swann NY 4/20/78: 220 (2), 221 (2);
Christies Lon 6/27/78: 136 (2), 137, 148 (album, J
et al);
Christies Lon 10/26/78: 182;
Swann NY 12/14/78: 422 (2)(note), 423 (2)(note),
424 (lot, J-14 et al);
Lehr NY Vol 2:2, 1979: 16 ill, 17 ill, 18 ill, 19
ill, 20 ill, 21 ill;
Rose Boston Cat 4, 1979: 3 ill(note), 4 ill;
Witkin NY VIII 1979: 48 ill;
Witkin NY Stereo 1979: 7 (2 ills)(25)(note), 8
(2 ills)(13)(note), 9 ill(12)(note);
California Galleries 1/21/79: 116 (book, J-10 et
al), 456 ill, 458, 463, 464 (2), 465 ill(2), 466;
Sothebys LA 2/7/79: 412 ill, 413 (2), 417 (album,
J et al);
Sothebys NY 2/11/79: 289 ill, 290 ill, 291 (3 ills)
(album, J et al)(note), 239 ill(lot, J-2
attributed, et al);
Christies Lon 3/15/79: 177, 180 (album, J-6 et al);

JACKSON, W,H, (continued)
Swann NY 4/26/79: 393, 394, 395, 396 ill, 397 (5),
398 (7), 440 (7)(note);
Christies NY 5/4/79: 100 (5), 101 (5), 102 ill, 103;
Phillips NY 5/5/79: 194 ill, 196, 197;
Sothebys NY 5/8/79: 20, 21, 22 ill(note);
Sothebys Lon 6/29/79: 125 (3);
Phillips Can 10/4/79: 31, 32 ill;
Swann NY 10/18/79: 361 (album, J et al), 412 (6)
(note), 413 (16), 414 (9);
Sothebys Lon 10/24/79: 176 (album, J et al), 183 (2,
attributed);
Christies Lon 10/25/79: 223;
Christies NY 10/31/79: 81 ill, 82, 83, 84;
Phillips NY 11/3/79: 59 ill(lot, J-35 et al), 61
(books, J-4 et al), 205, 206;
Phillips NY 11/29/79: 281;
Sothebys NY 12/19/79: 66 ill, 67 ill;
Rose Boston Cat 5, 1980: 2 ill(note), 3 ill;
Sothebys LA 2/6/80: 37, 38 ill, 39, 40 ill, 41, 42,
43 ill, 44, 45;
California Galleries 3/30/80: 331 ill(note), 332 ill
(4), 333 (3), 334;
Christies Lon 3/20/80: 189, 190, 192 ill(lot, J-1
et al), 200 (album, J et al), 382 (lot, J-1
et al);
Swann NY 4/17/80: 285 ill, 286 (note), 287 (2), 288
(3), 289 (4), 290 (4), 291 (4), 292 (4), 293 (3)
(note), 294 (7), 295 (7), 253, 366 (lot, J
et al);
Christies NY 5/14/80: 334 (book, J et al), 377
(book, J et al);
Christies NY 5/16/80: 267 ill, 268, 269, 270 (2)
(note), 271 (lot, J et al);
Sothebys NY 5/20/80: 298 ill, 299 ill, 300 ill;
Phillips NY 5/21/80: 121 (lot, J-1 et al), 275 ill
(note), 276, 177 (2), 278;
Swann NY 11/6/80: 237 (lot, J & Smith-1, et al)
(note), 328 ill(5)(note), 384 (8);
Sothebys NY 11/17/80: 116 ill, 117;
California Galleries 12/13/80: 295, 296 (5), 297 ill
(4), 298 (3, attributed), 361 ill(lot, J-1 et
al), 372 (5);
Sothebys LA 2/4/81: 264 ill, 265 (3), 266, 267
ill(2);
Christies Lon 3/26/81: 256 (2);
Sothebys Lon 3/27/81: 70, 73 ill;
Swann NY 4/23/81: 68 (book, 4)(note), 540 (lot, J
et al);
Sothebys NY 5/15/81: 117 ill(note), 118 ill, 119;
Petzold Germany 5/22/81: 1819 (lot, J-6 et al);
California Galleries 6/28/81: 156 (album, J-1 plus J
attributed, et al), 262 (2), 263 (2), 264 ill
(note), 265 ill(note), 266 ill, 267 (3), 268
ill, 269 (3), 270 (2), 271 (2);
Harris Baltimore 7/31/81: 224;
Sothebys NY 10/21/81: 129 ill, 130 ill(album, 195)
(note), 131 ill(note), 132 ill, 273 (2 ills)
(album, 40(note);
Sothebys Lon 10/28/81: 102 ill;
Christies Lon 10/29/81: 147 (lot, J et al);
Swann NY 11/5/81: 524 (album, J-6 et al)(note);
Christies NY 11/10/81: 58 ill;
Rose Florida Cat 7, 1982: 1 ill(note), 2 ill, 86
ill, 87 ill, 90 (lot, J et al);
Sothebys LA 2/17/82: 230 ill(album, J et al), 231
ill, 232 ill;
Christies Lon 3/11/82: 217, 224 (album, J-1 et al);
Harris Baltimore 3/26/82: 212;
Swann NY 4/1/82: 57 (book, 4)(note), 249 (lot, J
et al);

## JACKSON, W.H. (continued)

Phillips NY 5/22/82: 794 ill(7), 795, 796 ill(6);
California Galleries 5/23/82: 336 ill(4), 337, 338
ill, 339 (3), 340, 341, 342 ill;
Christies NY 5/26/82: 267 (ill), 268, 269, 270 (2)
(note), 271 (lot, J et al);
Phillips NY 9/30/82: 995 ill;
Phillips NY 11/9/82: 144 ill, 260 ill(11), 261 ill
(note);
Swann NY 11/18/82: 75 ill(book, J-1 et al), 404
ill, 405 (11)(note), 478 (album, J et al)(note);
Harris Baltimore 12/10/82: 116 (lot, J et al), 279
(note), 280 ill, 281, 282, 283 (7);
Christies NY 2/8/83: 25 (lot, J-10 et al);
Christies Lon 3/24/83: 142 (album, J et al);
Swann NY 5/5/83: 382 (note), 383 (2)(note),
438 (13);
California Galleries 6/19/83: 276, 277 ill, 278,
279, 280 ill, 281, 282, 283, 284, 285, 286, 287
ill, 288 ill, 289, 290, 291 ill, 292, 293, 294
ill, 295 ill, 296, 297, 298, 299 ill, 300 (2),
301 (3), 302, 303 (2), 304 (3), 305 (3), 306 (4);
Christies NY 10/4/83: 103 ill(2);
Christies Lon 10/27/83: 158 (album, J et al);
Sothebys NY 11/9/83: 173 (2 ills)(book, 37);
Swann NY 11/10/83: 286, 287 ill, 288 (5)(note);
Christies NY 2/22/84: 28 (note), 29 (note), 30 (2);
Christies NY 5/7/84: 30 ill;
Sothebys NY 5/8/84: 178 ill, 179 ill, 180 ill
(attributed);
Swann NY 5/10/84: 13 (album, J et al)(note), 314
(lot, J et al);
Harris Baltimore 6/1/84: 75 (9), 393, 394 (7), 395;
Christies Lon 6/28/84: 237 (lot, J-1 attributed
et al);
California Galleries 7/1/84: 185 (5), 186 (5), 187
(6), 188 (6), 189 (6), 190 (6), 209 (11), 210
(9), 211 (10), 350 (lot, J-3 et al), 455 ill
(album, J-11 et al), 497 (4), 498 (2), 499 (3),
500, 501, 502, 503, 504, 505, 506 (3)(note),
507 (7);
Christies NY 9/11/84: 124 (albums, J et al), 146;
Sothebys NY 11/5/84: 242 ill;
Christies NY 11/6/84: 46 ill(note), 47 ill, 48 ill
(note);
Christies NY 2/13/85: 163 (2);
Harris Baltimore 3/15/85: 20 (lot, J-3 et al), 24
(lot, J et al), 205 (7), 206 (note);
Christies Lon 3/28/85: 163 ill(11);
Sothebys NY 5/7/85: 163 ill(11);
Sothebys NY 5/8/85: 531 ill(note), 532 ill, 533 ill
(note), 630 (lot, J et al);
Swann NY 5/9/85: 403 (note), 404 (2), 442 ill(32)
(note);
California Galleries 6/8/85: 200 (lot, J-5 et al),
270 ill, 271, 272 (4), 273 (2), 274, 275 (5),
276 (4), 277, 278 (2), 279, 280 (3), 281 (3),
282 (4), 283, 284 (3), 285 (3), 286 (4), 287
(5), 288 ill, 289, 290, 291, 292, 293 ill, 294
ill, 295 (4), 296, 297, 298, 299, 300, 301 (6),
302, 303 ill, 304 (4), 305;
Phillips Lon 6/26/85: 133 (lot, J-6 et al);
Christies Lon 10/31/85: 129 (album, J et al);
Christies NY 11/11/85: 217 ill;
Sothebys NY 11/12/85: 161 ill(note), 162 ill(note);
Swann NY 11/14/85: 106 (note), 107 ill(6), 108
(59), 136 (album, J et al), 158 (lot, J et al);
Harris Baltimore 2/14/86: 317, 318 (attributed)
(note);
California Galleries 3/29/86: 692 (lot, J-1 et al),
747 (attributed), 813 (album, J et al);

## JACKSON, W.H. (continued)

Sothebys Lon 4/25/86: 24 (7);
Sothebys NY 5/12/86: 249 ill, 250 ill(6)(note);
Swann NY 5/16/86: 166 (lot, J-1 et al), 167 (lot,
J-12 et al), 168 (album, J et al);
Phillips NY 7/2/86: 339;
Phillips NY 11/12/86: 105 (album, 44);
Sothebys NY 11/13/86: 153 ill(7)(note), 153A ill
(lot, J-7 et al);
Swann NY 11/13/86: 129 (lot, J-1 et al), 130 (lot, J
et al), 132 (lot, J-1 et al), 248, 249 ill(23),
323 (lot, J-11 et al);

## JACOBETTE

Photos dated: c1890
Processes:    Albumen
Formats:      Cabinet cards
Subjects:     Portraits
Locations:
Studio:
  Entries:
California Galleries 1/21/78: 141 (album, J et al);

## JACOBI, C.H.

Photos dated: 1860s
Processes:    Albumen
Formats:      Stereos
Subjects:     Topography
Locations:    Europe
Studio:       Europe
  Entries:
Christies Lon 6/27/85: 30 (lot, J et al);

## JACOBS, E. (American)

Photos dated: 1860s
Processes:    Albumen, ivorytype
Formats:      Cdvs
Subjects:     Portraits
Locations:    Studio
Studio:       US - New Orleans, Louisiana
  Entries:
Sothebys NY (Strober Coll.) 2/7/70: 289 (lot,
J et al), 298 (lot, J et al), 424 (note);
Sothebys NY (Greenway Coll.) 11/20/70: 239 (lot,
J-1 et al);
Swann NY 11/10/83: 241 (lot, J et al);

## JACOBSON (see DOERR & JACOBSON)

## JACOBSON (American)

Photos dated: 1880s
Processes:    Albumen
Formats:      Prints
Subjects:     Ethnography
Locations:    US
Studio:       US
  Entries:
Sothebys LA 2/6/80: 71 (lot, J-2 et al);

**JACOBY & BARNES** (American)
Photos dated: c1880
Processes:      Albumen
Formats:        Prints
Subjects:       Topography
Locations:      US - Iowa
Studio:         US - West Liberty, Iowa
   Entries:
Frontier AC, Texas 1978: 194b ill(2);

**JACOBY, W.H.** (American)
Photos dated: c1868-1890
Processes:      Albumen, gelatin
Formats:        Stereos, prints
Subjects:       Topography
Locations:      US - Minnesota
Studio:         US - Minneapolis, Minnesota
   Entries:
Rinhart NY Cat 6, 1973: 205;
Harris Baltimore 3/26/82: 398 (lot, J-1 et al);
Harris Baltimore 6/1/84: 93 (lot, J et al);

**JACOTIN** (see also CHARLET & JACOTIN)
Photos dated: 1890s-c1895
Processes:      Albumen
Formats:        Cabinet cards
Subjects:       Portraits
Locations:      Studio
Studio:         France
   Entries:
California Galleries 12/13/80: 159 (album, J et al);
California Galleries 6/28/81: 138 (album, J-1
   et al);

**JACQUITH**
Photos dated: 1850s
Processes:      Daguerreotype
Formats:        Plates
Subjects:       Portraits
Locations:
Studio:
   Entries:
California Galleries 1/22/77: 72 (lot, J-1 et al);

**JAEGER, H.** (American)
Photos dated: c1873
Processes:      Albumen
Formats:        Prints
Subjects:       Documentary (engineering)
Locations:      US - New Jersey
Studio:         US
   Entries:
Swann NY 4/20/78: 222;

**JAEGER, Joh.**
Photos dated: 1860s-1880s
Processes:      Albumen
Formats:        Prints
Subjects:       Topography
Locations:      Sweden - Stockholm
Studio:         Sweden - Stockholm
   Entries:
Christies NY 5/4/79: 69;

**JAGEMANN, G.**
Photos dated: Nineteenth century
Processes:      Albumen
Formats:        Stereos, cdvs
Subjects:       Topography
Locations:      Germany and/or Austria
Studio:         Germany and/or Austria
   Entries:
Christies Lon 3/20/80: 101 (lot, J et al);
Petzold Germany 11/7/81: 328 (album, J et al);

**JAGER, A.** (Dutch)
Photos dated: 1860s-1890
Processes:      Albumen
Formats:        Prints, cdvs, cabinet cards
Subjects:       Topography, ethnography
Locations:      Netherlands - Amsterdam and Rotterdam
Studio:         Netherlands - Amsterdam
   Entries:
Swann NY 2/14/52: 91 (album, 12);
Rinhart NY Cat 2, 1971: 298 (17);
Swann NY 9/18/75: 189 (lot, J et al);
Rose Boston Cat 1, 1976: 19 ill(note);
California Galleries 1/22/77: 125 (lot, J-1 et al);
Christies Lon 3/16/78: 311 (album, 12);
Petzold Germany 5/22/81: 1976 (12);
Christies Lon 6/27/85: 275 (lot, J-9 et al);
Swann NY 11/14/85: 65 (lot, J et al);

**JAMBLIN, John** (British)
Photos dated: 1860s
Processes:      Ambrotype
Formats:        Plates
Subjects:       Portraits
Locations:      Studio
Studio:         England - Peterborough
   Entries:
Sothebys Lon 3/9/77: 116;

**JAMES, C.H.** (American)
Photos dated: 1884
Processes:      Albumen
Formats:        Prints, stereos
Subjects:       Topography
Locations:      US - Luray, Virginia
Studio:         US
   Entries:
Rinhart NY Cat 6, 1973: 288;
Harris Baltimore 12/16/83: 23 (29);
Harris Baltimore 6/1/84: 20 (6)(note);
Harris Baltimore 3/15/85: 19 (7);

**JAMES, D.E.** (American)
Photos dated: c1855-1858
Processes:      Daguerreotype, ambrotype
Formats:        Plates
Subjects:       Portraits
Locations:      Studio
Studio:         US - Boston, Massachusetts
   Entries:
Rinhart NY Cat 2, 1971: 236;
Vermont Cat 2, 1971: 196 ill;
Christies Lon 7/13/72: 44 (lot, J-1 et al);

JAMES, Colonel H.C. (British)
Photos dated: 1850s
Processes:    Albumen
Formats:      Prints
Subjects:     Topography, genre
Locations:    India - Darjeeling
Studio:       India - Darjeeling
    Entries:
Sothebys Lon 10/28/81: 147 ill(album, 34)(note);

JAMES, Colonel Sir Henry (British)
Photos dated: 1860-1867
Processes:    Albumen
Formats:      Prints
Subjects:     Topography
Locations:    England - Stonehenge; Ireland
Studio:       Great Britain
    Entries:
Swann NY 2/14/52: 316 (book, 8)(note);
Swann NY 4/14/77: 109 (book, J et al)(note);
Wood Conn Cat 49, 1982: 231 (book, 8)(note);
Christies Lon 4/24/86: 499;

JAMES, William E.
Photos dated: 1866-1870s
Processes:    Albumen
Formats:      Stereos
Subjects:     Topography
Locations:    Greece - Athens and Patmos; Turkey -
              Constantinople and Ephesus;
              Gibraltar; Italy
Studio:       US - Brooklyn, New York
    Entries:
Rinhart NY Cat 2, 1971: 500 (8);
Rinhart NY Cat 7, 1973: 173;
California Galleries 9/27/75: 568 (lot, J et al);
California Galleries 4/3/76: 388 (lot, J et al);
California Galleries 1/23/77: 405 (lot, J et al);
California Galleries 1/21/78: 171 (lot, J et al);
Harris Baltimore 4/8/83: 55 (13);
Harris Baltimore 12/16/83: 103 (lot, J et al);

JAMIESON (British)
Photos dated: 1850s
Processes:    Ambrotype
Formats:      Plates
Subjects:     Portraits
Locations:    Studio
Studio:       Scotland - Edinburgh
    Entries:
Christies Lon 10/31/85: 28 (lot, J-1 et al);

JAMRATH (see DEHME & JAMRATH)

JANDA, J.C. (German)
Photos dated: c1860
Processes:    Albumen
Formats:      Cdvs
Subjects:     Portraits
Locations:    Studio
Studio:       Germany - Kassel
    Entries:
Petzold Germany 11/7/81: 300 (album, J et al);

JANES (American)
Photos dated: Nineteenth century
Processes:    Albumen
Formats:      Stereos
Subjects:     Topography
Locations:    US
Studio:       US
    Entries:
Christies Lon 6/23/83: 44 (lot, J et al);

JANIN, Jules (French)(photographer?)
Photos dated: 1859-1871
Processes:    Albumen
Formats:      Stereos
Subjects:     Documentary (Paris Commune), portraits
Locations:    France - Paris
Studio:       France
    Entries:
Goldschmidt Lon Cat 52, 1939: 227 (book, 10);
Rauch Geneva 6/13/61: 136 (book, 10), 222 (lot,
    J et al);

JANKOVITCH, G.
Photos dated: 1880s
Processes:    Albumen
Formats:      Prints
Subjects:     Architecture
Locations:    Italy - Venice
Studio:       Italy - Venice
    Entries:
Rose Boston Cat 3, 1978: 47 ill(note);

JAQUITH, Nathaniel C. (American)
Photos dated: 1848-1850s
Processes:    Daguerreotype
Formats:      Plates
Subjects:     Portraits
Locations:    Studio
Studio:       US - New York City
    Entries:
Sothebys Lon 3/21/75: 174 ill;

JARBOE, John R. (American)
Photos dated: 1875
Processes:    Albumen
Formats:      Prints
Subjects:     Topography
Locations:    US - San Diego, California
Studio:       US
    Entries:
Rinhart NY Cat 7, 1973: 86 (book, J et al);

JARVIS (Canadian)
Photos dated: 1860s-1880s
Processes:    Albumen
Formats:      Cdvs
Subjects:     Portraits
Locations:    Studio
Studio:       Canada - Ottawa
    Entries:
Phillips Can 10/4/79: 42 (lot, J-1 et al), 43 (lot,
    J et al);

JARVIS, John F. (American, born 1850)
Photos dated: c1871-c1890
Processes:     Albumen
Formats:       Prints, stereos, cdvs
Subjects:      Topography
Locations:     US - Washington, D.C., New York,
               California; Greece; England
Studio:        US - Washington, D.C.
   Entries:
Sothebys NY (Strober Coll.) 2/7/70: 451 (lot,
   J et al), 481 (lot, J et al), 485 (lot, J et al);
Rinhart NY Cat 1, 1971: 293 (4);
Rinhart NY Cat 7, 1973: 206;
Sothebys Lon 10/18/74: 1 (lot, J-19 et al);
Sothebys NY 9/23/75: 96 (lot, J-12 et al);
California Galleries 1/23/77: 382 (lot, J et al);
California Galleries 1/21/79: 321 (lot, J-18 et al);
California Galleries 3/30/80: 261 (lot, J-1 et al);
Harris Baltimore 7/31/81: 95 (lot, J et al), 106
   (lot, J et al), 120 (lot, J et al), 129 (lot,
   J et al);
Swann NY 4/1/82: 357 (lot, J et al), 361 (lot,
   J et al);
Christies NY 2/8/83: 36 (lot, J et al);
Harris Baltimore 4/8/83: 17 (lot, J et al), 100
   (lot, J et al), 113 (lot, J et al);
California Galleries 6/19/83: 362 (lot, J-1 et al);
Harris Baltimore 12/16/83: 143 (lot, J et al);
Harris Baltimore 6/1/84: 66 (lot, J et al), 156
   (lot, J et al), 157 (lot, J et al);
Swann NY 11/8/84: 252 (lot, J et al);
Harris Baltimore 3/15/85: 45 (lot, J et al), 111
   (lot, J-14 et al), 112 (lot, J et al), 113 (lot,
   J et al);
Swann NY 5/9/85: 434 (lot, J et al), 440 (lot,
   J et al);
Harris Baltimore 2/14/86: 41 (lot, J et al);
Swann NY 5/15/86: 165 (lot, J-12 et al);

JEANNE, J.
Photos dated: c1860
Processes:     Ambrotype
Formats:       Plates
Subjects:      Portraits
Locations:     Studio
Studio:        US - Wilmington, Delaware
   Entries:
California Galleries 1/21/78: 27 (lot, J-1 et al);

JEANNERET, F.C.
Photos dated: 1864
Processes:     Albumen
Formats:       Stereos
Subjects:      Topography
Locations:
Studio:
   Entries:
Phillips Lon 10/29/86: 247B (lot, J et al);

JEANNON, L. (French)
Photos dated: 1868
Processes:     Albumen
Formats:       Prints
Subjects:      Topography
Locations:     France - Versailles
Studio:        France
   Entries:
Sothebys Lon 6/28/78: 280 ill(album, 15);
Sothebys Lon 6/29/79: 173 ill(album, 15);
Sothebys Lon 3/21/80: 256 (album, 15);
Sothebys Lon 3/27/81: 123 (album, 15);
Christies Lon 6/27/85: 50 (albums, J-13 et al);

JEANRENAUD, A. (French)
Photos dated: c1860
Processes:     Albumen
Formats:       Prints
Subjects:      Topogrraphy
Locations:     France - Paris
Studio:        France
   Entries:
Sothebys Lon 3/14/79: 369;

JEFFREY, W. (British)
Photos dated: 1860s-c1870
Processes:     Albumen
Formats:       Prints
Subjects:      Portraits
Locations:     Studio
Studio:        England - London
   Entries:
Sothebys Lon 3/22/78: 170;
Sothebys Lon 11/1/85: 80 (3);

JEISER, J.
Photos dated: Nineteenth century
Processes:     Albumen
Formats:       Cdvs
Subjects:      Topography
Locations:     Algeria - Algiers
Studio:
   Entries:
Christies Lon 10/26/78: 334 (albums, J et al);

JEKYLL, Gertrude (British, 1843-1942)
Photos dated: 1890s-early 1900s
Processes:     Platinum
Formats:       Prints
Subjects:      Topography
Locations:     England - Surrey
Studio:        England
   Entries:
Christies Lon 3/10/77: 386 (album, 60)(note);

JELLASCA, A.
Photos dated: c1870s
Processes:     Albumen
Formats:       Prints
Subjects:      Topography
Locations:     Yugoslavia
Studio:        Europe
   Entries:
Christies Lon 10/25/84: 100 (album, J-9 et al);

**JENKINS, H. & F.** (British)
Photos dated: 1898
Processes: Albumen
Formats: Prints
Subjects: Topography
Locations: England - Norfolk and Suffolk
Studio: Great Britain
  Entries:
California Galleries 6/28/81: 145 ill(album, J-48 et al);

**JENNEY, J.A.** (American)
Photos dated: 1865-1875
Processes: Albumen
Formats: Stereos
Subjects: Genre (animal life)
Locations: US - Detroit, Michigan
Studio: US - Detroit, Michigan
  Entries:
Rinhart NY Cat 2, 1971: 466 (lot, J-3 et al);

**JENNINGS, J. Payne** (British)
Photos dated: 1860s-1900
Processes: Albumen, collotype, platinum, silver
Formats: Prints, stereos
Subjects: Topography, genre (nature)
Locations: England - Norfolk, Suffolk,
    Derbyshire; Ireland
Studio: England
  Entries:
Sothebys NY (Strober Coll.) 2/7/70: 186 (book, 10);
Wood Conn Cat 37, 1976: 112A (book, 100)(note);
Christies Lon 10/28/76: 300 ill(book, 8);
White LA 1977: 39 ill(note), 40;
Christies Lon 3/10/77: 338 (book, 8);
Christies Lon 6/30/77: 213 (book, 6), 214 (book, 18), 215 (book, 6);
Sothebys Lon 7/1/77: 45 (book, 12), 46 (book, 9);
Sothebys Lon 11/18/77: 246 (2);
Wood Conn Cat 41, 1978: 115 ill(book, 60)(note);
Wood Conn Cat 42, 1978: 270 (book, 25)(note), 273 (book, 50), 274 (book, 99)(note);
California Galleries 1/21/78: 216 (album, J-2 et al);
Christies Lon 10/26/78: 227 (book, 7);
Sothebys Lon 10/27/78: 169 (2)(note);
Wood Conn Cat 45, 1979: 147 (book, 60)(note), 148 (book, 8)(note), 292 (book, 25)(note);
Christies Lon 3/15/79: 102 (lot, J et al);
Swann NY 4/26/79: 105 (book, 5);
Sothebys Lon 10/24/79: 31 (book, 7);
Christies Lon 3/20/80: 231 (lot, J-7 et al), 234 (books, J-11 et al);
Christies NY 5/14/80: 181 (book, 100), 182 (book, 9);
Christies Lon 6/26/80: 306 (book, J et al);
Christies Lon 10/30/80: 291 (book), 301 (book, 7), 307 (books, J-11 et al);
Sothebys Lon 3/27/81: 120 ill(album, 24), 121 ill (album, 24);
Swann NY 4/23/81: 114 (book, 6);
Sothebys Lon 6/17/81: 337 (5);
Christies Lon 6/18/81: 251 (books, J et al);
Sothebys Lon 10/28/81: 67 (5);
Swann NY 11/5/81: 135 (book, 10), 136 (5);
Rose Florida Cat 7, 1982: 24 ill(note);
Wood Conn Cat 49, 1982: 232 (book, 60)(note), 233 (book, 100), 234 (book, 100);

**JENNINGS, J.P.** (continued)
Christies Lon 3/11/82: 115 (lot, J-3 et al), 116 ill (5), 117 ill(6);
Sothebys Lon 3/15/82: 161 (6);
Phillips Lon 3/17/82: 62 (book, 100);
Swann NY 4/1/82: 131 (book, 6);
Phillips NY 5/22/82: 797 (5, attributed);
Christies Lon 6/24/82: 94 ill(4), 226 (album, J et al);
Phillips NY 9/30/82: 1003 (2);
Christies Lon 10/28/82: 39 (lot, J-3 et al);
Christies Lon 6/23/83: 86 (4), 87 ill(4);
Christies Lon 6/28/84: 35 (lot, J-14 et al), 153 (book, 19);
Christies Lon 10/25/84: 55 (lot, J-14 et al), 126 (books, J-7 et al);
Christies NY 11/6/84: 13 ill(album, 60);
Christies Lon 3/28/85: 213 (album, J et al);
Sothebys NY 5/7/85: 415 (lot, J-1 et al);
Christies Lon 6/27/85: 85 (albums, J et al), 95 (album, J et al);
Phillips Lon 10/30/85: 103 (book);
Phillips Lon 4/23/86: 278 (book);
Sothebys NY 5/12/86: 251 ill(4);
Swann NY 5/16/86: 108 (book, 8);

**JENNINGS, W.N.** (American)
Photos dated: 1893
Processes: Platinum
Formats: Prints
Subjects: Documentary
Locations: US
Studio: US
  Entries:
Christies NY 10/4/83: 109 (lot, J et al);

**JEPHSON, John Mounteney**
Photos dated: 1859
Processes: Albumen
Formats: Stereos
Subjects: Topography
Locations: France - Brittany
Studio:
  Entries:
Sothebys Lon 6/27/80: 157 (book, J et al), 169 (book, 90);
Sothebys Lon 6/28/85: 221 (book, 90);
Christies Lon 10/31/85: 67 (book, 90);
Sothebys Lon 11/1/85: 122 ill(book, 90);

**JEWELL, J.** (American)
Photos dated: 1880s
Processes: Tintype
Formats: Plates
Subjects: Portraits
Locations: Studio
Studio: US
  Entries:
Christies Lon 6/26/80: 90 (lot, J et al);

JOAILLIER (see also SEBAH)
Photos dated: 1860s-1870s
Processes:    Albumen
Formats:      Prints
Subjects:     Topography
Locations:    Turkey
Studio:       Turkey - Constantinople
   Entries:
Christies Lon 3/24/83: 163 (books, J et al);

JOB, Charles (British)
Photos dated: late 1890s-1905
Processes:    Platinum, silver
Formats:      Prints
Subjects:     Topography, genre
Locations:    England; Italy - Florence
Studio:       Great Britain
   Entries:
Christies Lon 6/14/73: 211 (11);
Halsted Michigan 1977: 667, 668, 669, 670, 671;
Sothebys Lon 10/27/78: 243 (album, 42), 244 (13);

JOBARD, E. (French)
Photos dated: 1854-1863
Processes:    Photolithograph (Poitevin process)
Formats:      Prints
Subjects:     Topography
Locations:    France - Dijon
Studio:       France - Dijon
   Entries:
Lunn DC Cat QP, 1978: 38 (book, J et al)(note);

JOCELYN, Viscountess Fanny (British, 1820-1880)
Photos dated: 1850s-1860s
Processes:    Albumen
Formats:      Prints, cdvs
Subjects:     Topography, portraits
Locations:    England - Hampshire and Wiltshire
Studio:       England (Amateur Photographic
              Association)
   Entries:
Sothebys Lon 10/24/75: 265 ill(album, 82);
Alexander Lon 1976: 84 ill(album, 82);
Sothebys Lon 6/11/76: 173 (album, J attributed et
   al), 174 (album, J attributed et al)(note);
Sothebys Lon 6/26/78: 283 (album, J attributed
   et al);
Sothebys Lon 3/14/79: 327 ill(album, J et al);
Christies Lon 10/29/81: 353 ill(album, J attributed
   et al);
Christies Lon 10/27/83: 218 (albums, J-1 et al);
Sothebys Lon 6/29/84: 231 (album, 40)(attributed);

JOGUET, Muzet (French)
Photos dated: 1860s
Processes:    Albumen, collotype
Formats:      Prints
Subjects:     Topography, documentary (engineering)
Locations:    France - Lyon and Chartreuse
Studio:       France - Lyon
   Entries:
Sothebys LA 2/13/78: 121 (books, J et al)(note);
Sothebys Lon 6/24/83: 76 ill(2);
Sothebys Lon 12/9/83: 66 ill;

JOHANNES & Co.
Photos dated: 1870s
Processes:    Albumen
Formats:      Prints
Subjects:     Topography
Locations:    Burma - Mandalay et al
Studio:       Burma - Mandalay
   Entries:
Rose Boston Cat 4, 1979: 84 ill, 85 ill;
Swann NY 11/5/81: 482;
Rose Florida Cat 7, 1982: 61 ill;
Christies Lon 4/24/86: 405 (album, J-1 et al);
Swann NY 11/13/86: 242 (lot, J et al);

JOHANNES, Bernard (German)
Photos dated: c1870-c1885
Processes:    Albumen
Formats:      Prints, cdvs
Subjects:     Documentary (public events),
              topography
Locations:    Germany - Oberammergau; Italy -
              Fiesole
Studio:       Germany
   Entries:
Gordon NY 5/3/76: 299 ill(38);
Gordon NY 5/10/77: 717 (book, 38);
California Galleries 12/13/80: 290 (lot, J-1 et al);
Christies Lon 3/11/82: 149 (album, 17);
Christies Lon 6/24/82: 246 (17)(note);
Swann NY 11/14/85: 138 (lot, J et al);

JOHANS, Karl
Photos dated: 1886
Processes:    Albumen
Formats:      Prints
Subjects:     Topography
Locations:    Norway
Studio:       Europe
   Entries:
California Galleries 9/26/75: 169 (album,
   J-1 et al);
California Galleries 1/21/79: 350 (album,
   J-1 et al);

JOHNSON (American)
Photos dated: Nineteenth century
Processes:    Albumen
Formats:      Prints
Subjects:     Topography
Locations:    US - American west
Studio:
   Entries:
Swann NY 4/14/77: 338 (lot, J et al);
Christies NY 5/16/80: 271 (lot, J et al);
Rose Florida Cat 7, 1982: 4 ill(6);

JOHNSON, C. (British)
Photos dated: Nineteenth century
Processes:    Albumen
Formats:      Stereos
Subjects:     Topography
Locations:    Great Britain
Studio:       England - Ely
   Entries:
Christies Lon 10/31/85: 69 (lot, J et al);

JOHNSON, C.W.J. (American)
Photos dated: c1875-1890
Processes:      Albumen
Formats:        Prints, stereos
Subjects:       Topography, documentary (disasters);
                genre
Locations:      US - Monterey, California
Studio:         US - Monterey, California
   Entries:
Swann NY 2/14/52: 64 (album, J-17 et al);
Swann NY 2/6/75: 193 (album, J et al);
California Galleries 4/2/76: 201 (10);
Swann NY 4/14/77: 338 (lot, J et al);
California Galleries 1/21/78: 278 (album,
   J-6 et al);
Christies NY 5/16/80: 271 (lot, J et al);
California Galleries 6/19/83: 423 (lot, J-1 et al);
Harris Baltimore 12/16/83: 293 (lot, J et al);
California Galleries 7/1/84: 552;
California Galleries 6/8/85: 188 (lot, J-1 et al),
   190 (lot, J et al), 340 (11);
Swann NY 11/14/85: 185 (lot, J-1 et al);
Christies Lon 4/24/86: 395 (album, J et al);
Swann NY 5/16/86: 167 (lot, J et al);

JOHNSON, Clifton (American), 1865-1940)
Photos dated: 1896
Processes:      Photogravures
Formats:        Prints
Subjects:       Topography
Locations:      Scotland - Logiealmond; US - southwest
Studio:         US - Massachusetts
   Entries:
Witkin NY V 1977: 73 ill(book, 23)(note);
California Galleries 3/30/80: 90 (book, 23);
Christies NY 5/14/80: 183 (book, 17);

JOHNSON, D. (British)
Photos dated: 1854
Processes:
Formats:        Prints
Subjects:       Topography
Locations:      England
Studio:         England
   Entries:
Sothebys Lon 6/26/75: 209;

JOHNSON, E.W.
Photos dated: Nineteenth century
Processes:      Albumen
Formats:        Cdvs
Subjects:       Portraits
Locations:
Studio:
   Entries:
California Galleries 1/22/77: 129 (lot, J et al);

JOHNSON, Edward (British)
Photos dated: c1870
Processes:      Albumen
Formats:        Prints
Subjects:       Architecture, topography
Locations:      England
Studio:         England
   Entries:
Christies Lon 3/10/77: 329 (book, 17);
Sothebys Lon 10/27/78: 209 (books, J-16 et al);
Sothebys Lon 6/29/79: 274 (book, 16);
Christies Lon 6/23/83: 66 ill(book, 48);

JOHNSON, Edward E. (American)
Photos dated: late 1860s-1870s
Processes:      Albumen
Formats:        Prints
Subjects:       Topography, documentary (industrial)
Locations:      US - Sacramento, California
Studio:         US - Sacramento, California
   Entries:
Sothebys NY 5/8/79: 16 (2);
Swann NY 4/17/80: 300, 301;

JOHNSON, F.B.
Photos dated: 1891
Processes:      Albumen
Formats:        Prints
Subjects:       Topography
Locations:      US - Kentucky
Studio:
   Entries:
Rinhart NY Cat 6, 1973: 320;

JOHNSON, Frederick (British)
Photos dated: 1860s
Processes:      Ambrotype
Formats:        Plates
Subjects:       Portraits
Locations:      Studio
Studio:         England - Manchester
   Entries:
Christies Lon 10/26/78: 58;
Christies Lon 10/25/79: 42 (lot, J-1 et al);

JOHNSON, George H. (American)
Photos dated: c1850-1860s
Processes:      Daguerreotype, albumen
Formats:        Plates, stereos, cdvs
Subjects:       Documentary (industrial), topography
Locations:      US - California
Studio:         US - Sacramento, California
   Entries:
Vermont Cat 4, 1972: 324 ill;
Sothebys Lon 3/22/78: 149;
Sothebys LA 2/7/79: 403;
Sothebys Lon 6/29/84: 43 ill;

JOHNSON, N.G.
Photos dated: 1870s
Processes:     Albumen
Formats:       Stereos
Subjects:      Topography
Locations:     US - Washington, D.C.; Mount Vernon,
               Virginia
Studio:        US - Washington, D.C.
    Entries:
California Galleries 9/27/75: 572 (lot, J-10 et al);
California Galleries 1/21/79: 320 (lot, J-10 et al);
Harris Baltimore 12/16/83: 143 (lot, J et al);

JOHNSON, J.M.
Photos dated: 1858
Processes:     Ambrotype
Formats:       Plates
Subjects:      Portraits
Locations:
Studio:
    Entries:
Swann NY 4/23/81: 270 (lot, J-1 et al);

JOHNSON, J.S. (American)
Photos dated: 1880s-1894
Processes:     Albumen
Formats:       Prints, stereos
Subjects:      Topography, documentary (maritime)
Locations:     US - New York City
Studio:        US - New York City
    Entries:
Sothebys NY 11/21/70: 38 (album, J et al);
Rinhart NY Cat 8, 1973: 87;
Swann NY 12/14/78: 283 (25);
Christies Lon 3/24/83: 142 (album, J et al);
Sothebys Lon 11/9/83: 174 ill(attributed, 12);
Swann NY 11/10/83: 336 (lot, J et al);

JOHNSON, T.H. (American)
Photos dated: Nineteenth century
Processes:     Albumen
Formats:       Stereos
Subjects:      Topography
Locations:     US
Studio:        US
    Entries:
Sothebys NY (Strober Coll.) 2/7/70: 514 (lot,
    J et al);

JOHNSON, W.J.
Photos dated: 1863-1860s
Processes:     Albumen
Formats:       Prints
Subjects:      Topography, ethnography
Locations:     India
Studio:
    Entries:
Sothebys Lon 10/24/79: 253 ill(book, 26);
Sothebys Lon 10/31/86: 32 (lot, J-1 et al);

JOHNSTON & HOFFMAN (British)
Photos dated: 1865-1890s
Processes:     Albumen, platinum, silver
Formats:       Cdvs, prints
Subjects:      Topography, ethnography
Locations:     India - Darjeeling, Simla, Dacca;
               Burma
Studio:        India - Calcutta
    Entries:
Sothebys NY (Strober Coll.) 2/7/70: 34 (album, J & H
    et al);
Gordon NY 11/13/76: 35 (46)(attributed)(note);
Christies NY 10/31/79: 47 (album);
Christies NY 5/16/80: 205 (album, 62)(attributed);
Sothebys Lon 6/27/80: 65 ill(album, 58);
Christies Lon 3/26/81: 227 (album, 58);
Sothebys Lon 3/27/81: 87 ill(album, 58);
Sothebys Lon 6/17/81: 176 (27);
Sothebys Lon 10/26/81: 144 (lot, H & J-8 et al);
Sothebys Lon 3/15/82: 118 (19);
Christies NY 10/4/83: 102 (lot, J & H-62 attributed
    et al);
Christies Lon 6/28/84: 250 (54);
California Galleries 7/1/84: 484 (lot, J & H-1
    attributed et al);
Sothebys Lon 10/26/84: 172 (album, J & H et al);
Harris Baltimore 3/15/85: 199 (lot, J & H et al);

JOHNSTON, Frances Benjamin (American, 1864-1952)
Photos dated: late 1880s-1920s
Processes:     Platinum, silver
Formats:       Prints
Subjects:      Documentary
Locations:     US - Hampton, Virginia; Washington,
               D.C.
Studio:        US - Washington, D.C.
    Entries:
Christies NY 5/14/80: 336 (book, J et al);

JOHNSTON, J.S. (American)
Photos dated: c1875-1894
Processes:     Albumen
Formats:       Prints
Subjects:      Topography, genre (animal life)
Locations:     US - New York City; Boston,
Massachusetts
Studio:        US - New York City
    Entries:
Witkin NY IV 1976: 357 ill, 358 ill;
Swann NY 4/1/76: 217 (lot, J-4 et al), 218 (lot,
    J-2 et al);
Christies Lon 10/26/78: 193 (album, J-1 et al);
Christies Lon 3/15/79: 190 (album, J-4 et al);
California Galleries 6/28/81: 189;
Harris Baltimore 12/10/82: 415;
Harris Baltimore 6/1/84: 324 (attributed);
Swann NY 5/9/85: 324 (lot, J-1 et al)(note);
Swann NY 5/16/86: 286 (lot, J-1 et al);
Phillips NY 7/2/86: 153 (albums, J et al);

**JOHNSTON, James**
Photos dated: 1893
Processes:      Photogravure
Formats:        Prints
Subjects:       Topography, ethnography
Locations:      Africa - central
Studio:
   Entries:
Swann NY 7/9/81: 11 (book, 50);

**JOHNSTONE** [JOHNSTONE 1]
Photos dated: 1860s-1887
Processes:      Albumen
Formats:        Prints, cdvs
Subjects:       Topography, portraits
Locations:      Australia
Studio:         Australia - Melbourne
   Entries:
Phillips Lon 4/23/86: 224 (album, J &
   O'Shaunnessy-1, et al);
Phillips NY 7/2/86: 175 (album, J et al), 177
   (album, J et al), 181 (album, J & O'Shaunnessy,
   67)(note);
Phillips Lon 10/29/86: 296 (album, J &
   O'Shaunnessy-1, et al);

**JOHNSTONE, Major** (British) [JOHNSTONE 2]
Photos dated: 1860s
Processes:      Albumen
Formats:        Prints
Subjects:       Topography
Locations:      India
Studio:
   Entries:
Sothebys Lon 10/24/79: 95 ill(album, J et al);

**JOHNSTONE, John** (British)
Photos dated: 1840s
Processes:      Calotype
Formats:        Prints
Subjects:       Portraits
Locations:      Studio
Studio:         England - Birmingham
   Entries:
Swann NY 2/14/52: 4 (album, J et al);

**JOLY, John** (1857-1933)
Photos dated: 1890s
Processes:      Polychrome diapositive
Formats:        Glass plates
Subjects:
Locations:      Ireland
Studio:         Ireland - Dublin
   Entries:
Christies Lon 6/26/80: 124 (9);

**JONAS** (see ROEMMLER & JONAS)

**JONES** (see GIHON & JONES) [JONES 1]

**JONES** (see VANNERSON & JONES) [JONES 2]

**JONES** [JONES 3]
Photos dated: 1880s-1890s
Processes:      Albumen
Formats:        Prints, stereos
Subjects:       Topography
Locations:      Australia
Studio:         Australia
   Entries:
Swann NY 4/23/81: 546 (album, J et al);
Christies Lon 10/28/82: 33 (lot, J-9 et al);
Christies Lon 4/24/86: 369 (lot, J-9 et al);
Sothebys Lon 4/25/86: 150A (lot, J-9 et al);

**JONES** (American) [JONES 4]
Photos dated: 1860s
Processes:      Albumen
Formats:        Cdvs
Subjects:       Portraits
Locations:      Studio
Studio:         US
   Entries:
Sothebys NY 11/21/70: 323 (lot, J et al);

**JONES** (British) [JONES 5]
Photos dated: 1850s
Processes:      Daguerreotype, ambrotype
Formats:        Plates
Subjects:       Portraits
Locations:      Studio
Studio:         England - London
   Entries:
Vermont Cat 4, 1972: 395 ill;
Sothebys Lon 6/11/76: 124;
Christies Lon 3/20/80: 21 (lot, J-1 et al);
Sothebys Lon 6/27/80: 34;

**JONES, Baynham** (British)
Photos dated: 1860s
Processes:      Albumen
Formats:        Prints
Subjects:
Locations:
Studio:         Great Britain (Amateur Photographic
                Association)
   Entries:
Sothebys Lon 10/29/80: 310 (album, J et al);
Christies Lon 10/29/81: 359 (album, J-1 et al)
   (note);
Christies Lon 10/27/83: 218 (albums, J-3 et al);

**JONES, Reverend Calvert Richard** (British,
                1804-1877)
Photos dated: 1845-1850s
Processes:      Calotypes
Formats:        Prints
Subjects:       Topography
Locations:      England; Malta; Italy - Naples and
                Rome
Studio:
   Entries:
Weil Lon Cat 7, 1945; 71 (lot, J et al)(note);
Weil Lon Cat 14, 1949(?): 308 (lot, J attributed
   et al)(note);
Vermont Cat 5, 1973: 483 ill(note), 484 ill;
Sothebys Lon 3/2/75: 273 (10)(attributed);
Colnaghi Lon 1976: 26 (note), 27 ill, 28, 29,
   30 ill;

**JONES, C.** (continued)
Sothebys Lon 3/19/76: 110 (attributed);
Christies Lon 3/10/77: 60 ill, 61 ill;
Christies Lon 10/27/77: 283 ill;
Sothebys Lon 3/22/78: 44 ill(note);
Phillips NY 11/4/78: 12;
Phillips Lon 3/13/79: 8 (2)(note);
Sothebys NY 5/8/79: 57 ill(attributed);
Sothebys Lon 6/29/79: 62 ill, 63 (3);
Christies Lon 10/25/79: 342;
Christies Lon 3/20/80: 288;
Christies Lon 6/26/80: 416;
Sothebys Lon 6/17/81: 93 ill, 94 ill, 95 ill, 96
    ill, 97 ill;
Christies Lon 10/29/81: 175;
Christies NY 11/10/81: 5 ill(2)(note);
Christies Lon 6/24/82: 145 ill;
Sothebys Lon 6/25/82: 130 (album, J et al)(note);
Sothebys Lon 3/25/83: 102 ill(attributed);
Christies Lon 6/23/83: 206 (lot, J et al)(note);
Christies Lon 10/27/83: 187 (2 ills)(album, J-8 et
    al)(note);
Kraus NY Cat 1, 1984: 13 ill(note);
Christies Lon 10/25/84: 153 ill;
Sothebys Lon 3/29/85: 130 ill;
Christies Lon 6/27/85: 112 (album, J-8 et al)(note);

**JONES, E.E.** (British)
Photos dated: 1890s
Processes:
Formats:        Prints
Subjects:       Topography
Locations:      Great Britain
Studio:         England (West Kent Amateur
                Photographic Society)
   Entries:
Christies Lon 6/27/85: 260 (lot, J et al);

**JONES, Frederick** (British)
Photos dated: 1850s-1860s
Processes:      Albumen
Formats:        Stereos, cdvs
Subjects:       Topography
Locations:      Ireland; England
Studio:         England - London
   Entries:
Sothebys NY 11/21/70: 332 ill(lot, J et al);
Rinhart NY Cat 7, 1973: 544 (lot, J-2 et al);
Sothebys Lon 10/18/74: 88 (albums, J et al);
Sothebys Lon 3/9/77: 5 (lot, J-10 et al);
Christies Lon 10/28/82: 17 (lot, J et al);
Harris Baltimore 6/1/84: 64 (lot, J et al);
Christies Lon 6/28/84: 31 (lot, J-1 et al);
Christies Lon 10/25/84: 51 (lot, J-1 et al), 52
    (lot, J et al);
Christies Lon 6/27/85: 38 (lot, J et al);

**JONES, J.L.**
Photos dated: Nineteenth century
Processes:      Albumen
Formats:        Stereos
Subjects:       Topography
Locations:      Canada - Quebec
Studio:         Canada
   Entries:
Christies Lon 10/28/76: 198 (lot, J-10 et al);

**JONES, N.P.** (American)
Photos dated: c1870
Processes:      Albumen
Formats:        Prints, stereos
Subjects:       Topography
Locations:      US - Madison, Wisconsin
Studio:         US - Madison, Wisconsin
   Entries:
Rinhart NY Cat 8, 1973: 50 (6);
Swann NY 5/10/84: 42 (book, 19)(note);

**JONES, S.S.** (American)
Photos dated: late 1850s-early 1860s
Processes:      Ambrotype
Formats:        Plates
Subjects:       Portraits, documentary (works of art)
Locations:      Studio
Studio:         US - New York City
   Entries:
Sothebys NY (Strober Coll.) 2/7/70: 206;
Phillips NY 5/5/78: 93 (2);
Phillips Can 10/4/79: 30;

**JONES, W.S.** (American)
Photos dated: Nineteenth century
Processes:      Albumen
Formats:        Stereos
Subjects:       Topography
Locations:      US - Watkins Glen, New York
Studio:         US
   Entries:
Witkin NY Stereo 1979: 10 (2 ills)(17)(note);

**JONGHI Frères, de**
Photos dated: 1897
Processes:      Silver
Formats:        Prints
Subjects:       Documentary (industrial)
Locations:      France - Choisy-le-Roi
Studio:
   Entries:
Sothebys NY 5/19/80: 17 ill(14);

**JORDAN Brothers** (American)
Photos dated: 1860s
Processes:      Tintypes
Formats:        Plates
Subjects:       Portraits
Locations:      Studio
Studio:         US - Utica, New York
   Entries:
Rinhart NY Cat 2, 1971: 267 (lot, J et al);

**JORDAN, J. Murray**
Photos dated: 1899
Processes:
Formats:        Prints
Subjects:       Topography
Locations:      Cuba; Venezuela - Caracas
Studio:
   Entries:
Swann NY 4/14/77: 219 (17)(note);
Christies Lon 3/28/85: 79 (album, J-27 et al);
Swann NY 5/16/86: 272 (lot, J et al);

JOSLIN, A.J.T. (see BONINE, E.A.)

JOUAN (French)
Photos dated: Nineteenth century
Processes:    Albumen
Formats:      Cdvs
Subjects:     Portraits
Locations:    Studio
Studio:       France
    Entries:
Christies Lon 6/26/80: 261 (lot, J et al);

JOUANT Hermanos
Photos dated: Nineteenth century
Processes:    Albumen
Formats:      Cdvs
Subjects:     Ethnography
Locations:    Studio
Studio:       Uruguay - Montevideo
    Entries:
Phillips NY 7/2/86: 218 (album, J-2 et al);

JOUBERT, F. (French)
Photos dated: c1860
Processes:    Albumen, collodion on glass
Formats:      Cdvs, plates
Subjects:     Portraits
Locations:    Studio
Studio:       France
    Entries:
Sothebys NY 11/21/70: 337 (lot, J et al);
Phillips NY 11/3/79: 161 (attributed)(note);
Phillips Lon 10/30/85: 32 (lot, J-1 et al);
Phillips Lon 4/23/86: 272 (lot, J-1 et al);

JOUVAIN, I. (French) (aka JOUVIN, Hippolyte)
Photos dated: 1860-1868
Processes:    Albumen
Formats:      Stereos
Subjects:     Topography
Locations:    France - Normandy; England; Italy
Studio:       France - Paris
    Entries:
California Galleries 4/3/76: 391 (31);
Christies Lon 6/24/82: 56 (lot, J et al);

JOUVE, Noel
Photos dated: c1880
Processes:    Albumen
Formats:      Prints
Subjects:     Architecture
Locations:    Algeria - Algiers
Studio:
    Entries:
Christies Lon 6/28/79: 102 (album, J-7 et al);

JOUX, C.S. de
Photos dated: c1880s
Processes:    Albumen
Formats:      Prints
Subjects:     Topography
Locations:    Zanzibar
Studio:
    Entries:
Phillips Lon 3/13/79: 146 (23);

JOY, B.F. (American)
Photos dated: 1870s
Processes:    Albumen
Formats:      Stereos, cabinet cards
Subjects:     Ethnography
Locations:    US - American west
Studio:       US - Ellsworth, Maine
    Entries:
Christies NY 10/4/83: 113 (2);

JOY, John F. (American)
Photos dated: Nineteenth century
Processes:    Albumen
Formats:      Stereos
Subjects:     Topography
Locations:    US - Philadelphia, Pennsylvania
Studio:       US
    Entries:
Harris Baltimore 12/16/83: 107 (lot, J-16 et al);

JOYCE, Reverend James Gerald (British)
                    (photographer or author?)
Photos dated: 1872
Processes:    Albumen
Formats:      Prints
Subjects:     Documentary (art)
Locations:    England - Fairford
Studio:       Great Britain
    Entries:
Wood Conn Cat 45, 1979: 149 (book, 2)(note);
Wood Conn Cat 49, 1982: 236 (book, 35)(note);

JUBE, T.S. (American)
Photos dated: 1850s-c1858
Processes:    Daguerreotype, Ambrotype
Formats:      Plates
Subjects:     Portraits
Locations:    Studio
Studio:       US - New York City
    Entries:
Rinhart NY Cat 1, 1971: 91;
Vermont Cat 7, 1974: 497 ill;

JUDD, J.L.
Photos dated: c1853
Processes:    Daguerreotype
Formats:      Plates
Subjects:     Portraits
Locations:
Studio:
    Entries:
California Galleries 4/2/76: 29;

JUDD, M.E. & McLEISH (American)
Photos dated: 1868-1878
Processes:    Albumen
Formats:      Stereos
Subjects:     Topography
Locations:    US - Syracuse, New York
Studio:       US - Syracuse, New York
    Entries:
Sothebys NY 5/20/80: 322 ill(lot, J & M-103
    et al)(note);

**JUDGES Ltd.** (British)
Photos dated: c1890
Processes:      Carbon
Formats:        Prints
Subjects:       Topography, genre
Locations:      England - Whitby
Studio:         Great Britain
   Entries:
Christies Lon 6/27/78: 66;
Phillips Lon 5/16/83: 116 (album, J et al);
Phillips Lon 11/4/83: 68 (album, J et al);

**JUDSON, A.**
Photos dated: 1890s
Processes:      Tintype
Formats:        Plates
Subjects:       Portraits
Locations:
Studio:
   Entries:
Sothebys Lon 3/27/81: 279 (lot, J-1 et al);

**JULLIEN**
Photos dated: c1895
Processes:      Albumen
Formats:        Prints
Subjects:       Topography
Locations:      Europe
Studio:         Europe

   Entries:
California Galleries 5/23/82: 194 (album, J et al);
Swann NY 5/16/86: 233 (lot, J et al), 235 (albums,
   J et al);

**JUNG, C.**
Photos dated: 1871
Processes:      Albumen
Formats:        Prints
Subjects:       Documentary (Paris Commune)
Locations:      France - Paris
Studio:         Europe
   Entries:
Sothebys Lon 3/21/75: 107 (lot, J-2 et al);
Phillips Lon 11/4/83: 77 (lot, J et al);

**JUNGHAENDEL, R.M.** (see MULLER, L.C.)

**JUNIOR, Christiano**
Photos dated: 1880s
Processes:      Albumen
Formats:        Cdvs
Subjects:       Portraits
Locations:      Studio
Studio:         Latin America
   Entries:
Sothebys NY 10/4/77: 138 (lot, J et al);;

**K. & K.** [K. und K.]
Photos dated: c1880
Processes:      Albumen
Formats:        Cabinet cards
Subjects:       Portraits
Locations:
Studio:
    Entries:
California Galleries 9/27/75: 374 (lot, K et al);

**K., B.** [B.K.] (French)(possibly B. Kuhn, q.v.)
Photos dated: 1860s-1889
Processes:      Albumen
Formats:        Stereos incl. tissues, prints,
                cabinet cards
Subjects:       Topography, documentary (public
                events, Paris Commune), genre
Locations:      France - Paris
Studio:         France - Paris
    Entries:
Sothebys NY 11/21/70: 41 (book, 50);
Vermont Cat 2, 1971: 222 ill(17);
Rinhart NY Cat 8, 1973: 38 (3);
Vermont Cat 5, 1973: 555 ill(5);
Vermont Cat 7, 1974: 653 ill(17);
Witkin NY II 1974: 580 (album, 48);
Witkin NY III 1975: 688 (album, 48);
California Galleries 9/27/75: 542 ill(41), 543
    (lot, K et al), 544 (lot, K et al);
California Galleries 4/3/76: 443 (22);
Vermont Cat 11/12, 1977: 768 ill(6);
California Galleries 1/21/78: 187 (5);
Swann NY 12/14/78: 293 (lot, K-27 et al);
Swann NY 10/18/79: 430 (12);
Auer Paris 5/31/80: 112 (12);
Sothebys Lon 3/27/81: 396 (37);
Swann NY 4/23/81: 525 (lot, K-1 et al);
Sothebys Lon 10/28/81: 19 (14), 202 (37);
Christies Lon 10/29/81: 156 (lot, K et al), 158
    (lot, K et al);
Swann NY 4/1/82: 358 (lot, K-12 et al);
Christies Lon 10/28/82: 32 (lot, K et al);
Harris Baltimore 4/8/83: 103 (lot, K et al);
Swann NY 5/10/84: 311 (lot, K et al);
Phillips Lon 10/24/84: 96 (10);
Christies Lon 10/25/84: 40 ill(lot, K-11 et al);
Swann NY 11/8/84: 267 (lot, K et al);
Harris Baltimore 2/14/86: 19 (lot, K et al);

**K., Justin** [Justin K ...]
Photos dated: 1860s and/or 1870s
Processes:      Albumen
Formats:        Prints
Subjects:       Topography
Locations:      Egypt
Studio:
    Entries:
Christies Lon 10/31/85: 120 (album, K-1 et al);

**K., W.H.** [W.H.K.]
Photos dated: c1890s
Processes:
Formats:
Subjects:       Topography
Locations:      US - Washington, D.C.
Studio:
    Entries:
Swann NY 12/14/78: 480;

**KAJIMA, Seibei** (Japanese)
Photos dated: 1890s
Processes:      Collotype
Formats:        Prints
Subjects:       Topography, documentary (public
                events)
Locations:      Japan
Studio:         Japan
    Entries:
Swann NY 4/23/81: 111 ill(book, K et al)(note);
Swann NY 11/18/82: 186 (book, K et al);
Swann NY 5/10/84: 104 (book, K et al);

**KALLSTROM**
Photos dated: Nineteenth century
Processes:      Albumen
Formats:        Cdvs
Subjects:       Topography and/or ethnography
Locations:
Studio:
    Entries:
Christies Lon 10/27/83: 234 (album, K-1 et al);

**KAPP, F. & Co.**
Photos dated: 1897
Processes:      Albumen
Formats:        Prints
Subjects:       Documentary (disasters)
Locations:      India - Calcutta and Darjeeling
Studio:
    Entries:
Christies Lon 6/24/82: 206 ill (album, 12);
Christies Lon 10/28/82: 87 ill (album, 79);

**KARGOPOULOS, Basil** (Greek)
Photos dated: 1850-1880
Processes:      Albumen
Formats:        Prints, stereos
Subjects:       Topography
Locations:      Turkey; Greece - Athens
Studio:         Turkey - Constantinople
    Entries:
Christies Lon 3/20/80: 199 (albums, K et al);
Christies Lon 10/30/80: 272 (album, K et al);
Christies NY 11/11/80: 71 (albums, K et al);

**KAROLY**
Photos dated: Nineteenth century
Processes:      Albumen
Formats:        Cabinet cards
Subjects:       Portraits
Locations:      Europe
Studio:         Europe
    Entries:
Harris Baltimore 3/15/85: 309 (lot, K et al);

**KASER, J.** (German)
Photos dated: 1850s
Processes:      Daguerreotype
Formats:        Plates
Subjects:       Genre
Locations:      Studio
Studio:         Germany - Stuttgart
    Entries:
Sothebys NY (Weissberg Coll.) 5/16/67: 165 (lot,
    K-1 et al)(note);
Petzold Germany 5/22/81: 1710 ill;

**KATER, E.**
Photos dated: Nineteenth century
Processes:      Albumen
Formats:        Prints
Subjects:
Locations:
Studio:         Great Britain (Photographic Exchange
                Club)
    Entries:
Weil Lon Cat 4, 1944(?): 237 (album, K et al)(note);

**KEARY** (see HENNAH)

**KEATE, Margaret** (British)
Photos dated: 1854
Processes:
Formats:
Subjects:       Portraits
Locations:      Great Britain
Studio:         Great Britain
    Entries:
Christies Lon 10/28/76: 219 (album, K-1 et al);

**KEE, Pow** (Chinese)
Photos dated: 1870s-1880s
Processes:      Albumen
Formats:        Prints, cabinet cards
Subjects:       Topography
Locations:      China - Shanghai and Peking
Studio:         China - Shanghai
    Entries:
California Galleries 3/30/80: 256 (lot, K-1 et al);
California Galleries 6/28/81: 193 (lot, K et al);
Christies Lon 3/29/84: 82 ill(album, P et al);
Swann NY 5/9/85: 368 (lot, K-2 et al);

**KEELY, R.N.** (American)
Photos dated: 1850s-1860s
Processes:      Daguerreotype, ambrotype
Formats:        Plates
Subjects:       Portraits
Locations:      Studio
Studio:         US - Philadelphia, Pennsylvania
    Entries:
Sothebys NY (Weissberg Coll.) 5/16/67: 141 (lot,
    K-1 et al), 149 (lot, K-1 et al);
Rinhart NY Cat 2, 1971: 166;

**KEENAN** (American)
Photos dated: 1853
Processes:      Daguerreotype
Formats:        Plates
Subjects:       Portraits
Locations:      Studio
Studio:         US - Philadelphia, Pennsylvania
    Entries:
Vermont Cat 10, 1975: 538 ill;
California Galleries 4/2/76: 30;
Petzold Germany 5/22/81: 1711;

**KEENE** (British)
Photos dated: 1860s
Processes:      Albumen
Formats:        Stereos
Subjects:       Topography
Locations:      Great Britain
Studio:         Great Britain
    Entries:
Christies Lon 10/28/82: 25 (lot, K et al);

**KEENE, Richard** (British)
Photos dated: 1886
Processes:      Platinum, platinotype
Formats:        Prints, cdvs
Subjects:       Topography, genre, portraits
Locations:      England - Derbyshire
Studio:         England
    Entries:
Christies Lon 6/24/82: 380 (albums, K et al);
Christies Lon 6/23/83: 73 (lot, K-9 et al);
Christies Lon 10/27/83: 62 (album, K et al);

**KEET, A.G.**
Photos dated: c1864
Processes:      Albumen
Formats:        Cdvs
Subjects:       Portraits
Locations:
Studio:
    Entries:
Harris Baltimore 9/16/83: 111;

**KEIG, T.** (British)
Photos dated: Nineteenth century
Processes:      Albumen
Formats:        Stereos
Subjects:       Topography
Locations:      Great Britain
Studio:         Great Britain
    Entries:
Harris Baltimore 7/31/81: 97 (lot, K & Callister
    et al);
Christies Lon 3/11/82: 82 (lot, K-1 et al);

**KEITH, Dr. Thomas** (British, 1827-1895)
Photos dated: 1852-c1856
Processes:      Calotype
Formats:        Prints
Subjects:       Topography
Locations:      Scotland - Edinburgh
Studio:         Scotland
    Entries:
Rauch Geneva 6/13/61: 50 (36)(attributed)(note);
Sothebys NY 10/21/81: 140 ill(note);

KEITH, W. (British)
Photos dated: c1855-1866
Processes:    Ambrotype ("hyalograph"), albumen
Formats:      Plates incl. stereo, cdvs, cabinet
              cards
Subjects:     Portraits
Locations:    Studio
Studio:       England - Liverpool
  Entries:
Christies Lon 10/28/76: 29 (note);
Christies Lon 10/27/77: 32 (lot, K-1 et al);
Sothebys Lon 6/28/78: 314 (note);
Christies Lon 10/30/80: 63 (note);
California Galleries 12/13/80: 239 ill;
Sothebys Lon 3/27/81: 269 (2), 273 (lot, K-1 et al);
Phillips Lon 10/24/84: 80 (lot, K-3 et al);
Christies Lon 10/31/85: 50 (lot, K-1 et al);

KEITH, William (American, 1839-1911)
Photos dated: c1898
Processes:    Bromide
Formats:      Prints
Subjects:     Portraits
Locations:    US - San Francisco, California
Studio:       US - San Francisco, California
  Entries:
White LA 1977: 95 ill(note);
California Galleries 5/23/82: 346 ill;

KELLOGG (American)
Photos dated: 1860s
Processes:    Albumen
Formats:      Cdvs, stereos
Subjects:     Portraits, topography
Locations:    US - New England
Studio:       US
  Entries:
California Galleries 1/21/78: 132 (lot, K et al);
Harris Baltimore 12/16/83: 86 (lot, K et al);
Swann NY 11/14/85: 170 (lot, K & Campbell et al);
Swann NY 5/16/86: 222 (lot, K et al);

KELLEY, L.C. (American)
Photos dated: Nineteenth century
Processes:    Albumen
Formats:      Cabinet cards
Subjects:     Ethnography
Locations:    Studio
Studio:       US
  Entries:
Vermont Cat 1, 1971: 246 (lot, K et al);

KELHAM, Augustus (British)
Photos dated: c1860-1870s
Processes:    Albumen
Formats:      Prints
Subjects:     Architecture, topography, genre
Locations:    England; Scotland
Studio:       England
  Entries:
Sothebys Lon 3/21/75: 135 (albums, K-35 et al), 150
  (albums, 265);
Sothebys Lon 3/14/79: 376 (12);
Phillips NY 5/21/80: 159 (14);
Christies Lon 6/27/80: 152 (lot, K-1 et al);
Wood Conn Cat 49, 1982: 240 (book, 35)(note);
Christies Lon 6/24/82: 99 (11);

KELHAM, A. (continued)
Sothebys Lon 6/25/82: 108 ill(40);
Christies Lon 10/27/83: 56 (book, 11);
Christies Lon 3/29/84: 117 (book, K-11 et al);

KEMP (see WALCOTT)

KEMP, A. (British)
Photos dated: 1897
Processes:    Silver
Formats:      Prints
Subjects:     Genre
Locations:    Great Britain
Studio:       Great Britain
  Entries:
Sothebys Lon 6/17/81: 344 ill;

KEMP, J.M. (American)
Photos dated: c1880-c1890s
Processes:    Albumen
Formats:      Prints
Subjects:     Topography, documentary (railroads,
              industrial)
Locations:    US - Idaho, Montana
Studio:       US
  Entries:
Swann NY 10/18/79: 349 (album, K et al), 360
  (albums, K et al);
Harris Baltimore 3/15/85: 231;

KEMPHILL, W.D. (British)
Photos dated: 1860s
Processes:    Albumen
Formats:      Prints
Subjects:
Locations:    Great Britain
Studio:       Great Britain (Amateur Photographic
              Association)
  Entries:
Christies Lon 10/29/81: 359 (album, K-1 et al)
  (note);

KEN, Alexandre (French)
Photos dated: 1860-1860s
Processes:    Albumen
Formats:      Cdvs
Subjects:     Portraits
Locations:    Studio
Studio:       France - Paris
  Entries:
Christies Lon 6/27/78: 210 (lot, K et al);
Petzold Germany 11/7/81: 310 (album, K et al);

KENDALL, Colonel (British)
Photos dated: 1860s
Processes:    Ambrotype
Formats:      Plates
Subjects:     Portraits
Locations:    Studio
Studio:       Great Britain
  Entries:
Christies Lon 10/30/80: 403 (lot, K-1 et al);

**KENDALL, George H.**
Photos dated: 1872
Processes:      Albumen
Formats:        Prints, cdvs
Subjects:       Portraits, topography
Locations:      Australia - Echuca
Studio:
     Entries:
Christies Lon 10/27/77: 132 (book, 40);
Christies Lon 3/16/78: 224 (book, 40);

**KENNEDY** (British)
Photos dated: 1850s
Processes:      Daguerreotype
Formats:        Plates
Subjects:       Portraits
Locations:      Studio
Studio:         Scotland - Glasgow
     Entries:
Sothebys Lon 11/18/77: 143 (lot, K-1 et al);

**KENNEDY, Alexander W.M. Clark** (see CLARK-KENNEDY)

**KENNEY** (American)
Photos dated: 1850s
Processes:      Daguerreotype
Formats:        Plates
Subjects:       Portraits
Locations:      Studio
Studio:         US
     Entries:
Gordon NY 5/3/76: 267 (lot, K et al);

**KENSETT, J.W.** (British)
Photos dated: 1857
Processes:      Albumen
Formats:        Prints
Subjects:       Documentary (public events)
Locations:      England
Studio:         England
     Entries:
Sothebys Lon 12/4/73: 238 ill(lot, K-2 et al)(note);

**KENT** (see HENNAH)

**KENT, J.H.** (American)
Photos dated: 1867-1870s
Processes:      Albumen
Formats:        Prints, stereos
Subjects:       Portraits
Locations:      Studio
Studio:         US - Rochester, New York
     Entries:
Swann NY 11/11/76: 164 (book, K et al)(note);
Harris Baltimore 4/8/83: 386 (lot, K et al);
California Galleries 6/19/83: 93 (book, K-1 et al),
     94 (book, K-1 et al);
Wood Boston Cat 58, 1986: 136 (books, K-1 et al);

**KENT, S.G.** (American)
Photos dated: Nineteenth century
Processes:      Albumen
Formats:        Prints
Subjects:       Genre
Locations:      US - Hannibal, Missouri
Studio:         US
     Entries:
Christies NY 5/4/79: 124;

**KENT, W.H.** (British)
Photos dated: c1850-1856
Processes:      Daguerreotype
Formats:        Plates incl. stereo
Subjects:       Portraits
Locations:      Studio
Studio:         England - London
     Entries:
Christies Lon 6/10/76: 15;
Christies Lon 10/28/76: 3;
Christies Lon 3/10/77: 20 (lot, K-1 et al);
Christies Lon 3/16/78: 43 (lot, K-1 et al);
Christies Lon 10/26/78: 20;
Christies Lon 6/28/79: 20 (lot, K-2 et al);
Christies Lon 10/30/80: 87 (note);
Christies Lon 3/26/81: 9 (lot, K-1 et al);
Sothebys Lon 6/17/81: 37 (lot, K-1 et al);
Christies Lon 6/18/81: 57 (note);
Christies Lon 6/24/82: 364 (album, K et al);

**KERLIN, T.J.** (American)
Photos dated: c1870
Processes:      Albumen
Formats:        Prints
Subjects:       Topography
Locations:      US - Sacramento, California
Studio:         US
     Entries:
California Galleries 9/27/75: 353 (lot, K-1 et al);

**KERN** (see OBERMULLER & KERN)

**KERR, the Honorable A.S.** (British)
Photos dated: 1844-1855
Processes:      Salt
Formats:        Prints
Subjects:       Genre
Locations:      Great Britain - Eashing
Studio:         Great Britain (Photographic Club)
     Entries:
Sothebys Lon 3/21/75: 286 (album, K-1 et al);
Sothebys Lon 11/1/85: 59 (lot, K-1 et al);
Phillips Lon 10/29/86: 373 (lot, K-3 et al);

**KERRY** (Australian)
Photos dated: 1880s-1890s
Processes:      Albumen
Formats:        Prints, stereos
Subjects:       Topography, documentary
Locations:      Australia - Sydney et al
Studio:         Australia - Sydney
     Entries:
Rose Boston Cat 1, 1976: 69 (3 ills)(album,
37)(note);
Sothebys Lon 5/18/77: 94 (album, K et al);
Sothebys Lon 11/18/77: 94 (album, K et al);

**KERRY** (continued)
Christies Lon 3/15/79: 193 (album, K-7 et al);
Christies Lon 3/20/80: 111 (lot, K et al);
Swann NY 4/23/81: 546 (album, 37)(note);
Christies Lon 6/18/81: 236 (album, K et al), 238
  (lot, K-4 et al);
Christies Lon 3/11/82: 237 (lot, K-4 et al);
Christies Lon 10/28/82: 121 (albums, K et al);
Christies Lon 3/29/84: 77 (album, K et al), 100
  (albums, K & Jones et al);
Phillips Lon 6/27/84: 174 (album, K et al);
Christies Lon 10/25/84: 89 (album, 47);
Phillips Lon 3/27/85: 195 (album, K et al), 196
  (album, K et al);
Christies Lon 6/26/86: 112 (albums, K et al);

**KERSTING, Rudolf**
Photos dated: 1897
Processes:    Albumen
Formats:    Prints
Subjects:    Documentary
Locations:    US - New York City
Studio:    US
  Entries:
Swann NY 12/14/78: 176 (book, 28)(note);

**KERTSON, M.** (American)
Photos dated: 1850s-1863
Processes:    Daguerreotype, albumen
Formats:    Plates, cdvs
Subjects:    Portraits
Locations:    Studio
Studio:    US - New York City
  Entries:
Christies Lon 3/26/81: 80 (lot, K-1 et al);
Sothebys Lon 10/28/81: 280;

**KERTZMAR, Bruno**
Photos dated: 1880s
Processes:    Albumen
Formats:    Prints
Subjects:    Topography
Locations:    Greece - Corfu
Studio:
  Entries:
Sothebys Lon 11/1/85: 25 (50);
Sothebys Lon 4/25/86: 219 (50);

**KESEKIEL, Adolf** (German)
Photos dated: 1880s
Processes:    Albumen
Formats:    Prints
Subjects:    Topography
Locations:    Germany
Studio:    Germany - Hamburg
  Entries:
Sothebys NY 5/20/80: 387 (lot, K-1 et al);

**KESSLER** (American)
Photos dated: 1850s
Processes:    Daguerreotype
Formats:    Plates
Subjects:    Portraits
Locations:    Studio
Studio:    US - Chicago, Illinois
  Entries:
Sothebys Lon 10/24/75: 34 (lot, K-1 et al);

**KEUBLER**
Photos dated: c1880s
Processes:    Albumen
Formats:    Cabinet cards
Subjects:    Portraits
Locations:
Studio:
  Entries:
California Galleries 6/28/81: 191 (lot, K et al);

**KEY**
Photos dated: 1850s-1860s
Processes:    Ambrotype
Formats:    Plates
Subjects:    Portraits
Locations:
Studio:
  Entries:
Swann NY 4/23/81: 267 (lot, K-1 et al);

**KEYES, Colonel**
Photos dated: Nineteenth century
Processes:
Formats:
Subjects:    Topography
Locations:    India
Studio:
  Entries:
Christies Lon 6/27/85: 155 ill(album, K et al)
  (note);

**KIDDER, Daniel** (American)
Photos dated: Nineteenth century
Processes:    Albumen
Formats:    Stereos
Subjects:    Topography
Locations:    US - Franklin, New Hampshire
Studio:    US - Franklin, New Hampshire
  Entries:
California Galleries 4/3/76: 412 (lot, K-6 et al);

**KILBURN, Benjamin West,** (1827-1909) & **Edward**
          (American)
Photos dated: 1865-1909
Processes:    Albumen
Formats:    Stereos
Subjects:    Topography, documentary (disasters),
          genre (still life, animal life)
Locations:    US - New Hampshire, New York,
          Pennsylvania; Mexico
Studio:    US - Littleton, New Hampshire
  Entries:
Rauch Geneva 6/13/61: 224 (lot, K et al);
Sothebys NY (Weissberg Coll.) 5/16/67: 184 (lot,
  K-1 et al), 196 (lot, K-18 et al)(note);

## KILBURN, B.W. & E. (continued)

Sothebys NY (Strober Coll.) 2/7/70: 467 (lot, K et al), 481 (lot, K et al), 482 (lot, K-1 et al), 485 (lot, K et al), 501 (lot, K et al), 513 (lot, K-1 et al), 567 (lot, K-1 et al);

Rinhart NY Cat 1, 1971: 243 (5), 253 (5), 292 (lot, K et al), 312 (lot, K-8 et al), 313 (10), 316 (2);

Rinhart NY Cat 2, 1971: 74 (book, 12 attributed), 447 (lot, K et al), 449 (5), 469 (lot, K-6 et al), 470 (lot, K et al), 471 (6), 472 (lot, K et al), 486, 487 (2), 502 (5), 505 (2), 508, 510 (6), 511 (6), 512 (lot, K-3 et al), 513 (4), 514 (3), 515 (lot, K-2 et al), 519 (11), 520 (lot, K-3 et al), 521 (lot, K-2 et al), 522 (lot, K-2 et al), 534 (6), 538 (4), 547 (10), 549 (3), 551 (2), 552 (lot, K-1 et al), 558, 560 (2), 561 (2);

Vermont Cat 1, 1971: 235 (lot, K et al);

Vermont Cat 2, 1971: 227 (lot, K et al);

Rinhart NY Cat 6, 1973: 396, 400, 404, 443, 483, 545, 546 (5), 550, 581 (lot, K-1 et al);

Rinhart NY Cat 7, 1973: 11 (book, K-3 et al), 219, 220, 221, 356, 357 (2), 393, 394, 395, 396;

Rinhart NY Cat 8, 1973: 46, 70 (lot, K-1 et al);

Vermont Cat 5, 1973: 543 ill(4), 561 (lot, K-3 et al);

Vermont Cat 9, 1975: 567 ill(11), 568 ill(4), 569 ill(12), 570 ill(22);

Sothebys Lon 6/26/75: 15 (lot, K et al);

California Galleries 9/26/75: 173 (book, K et al);

California Galleries 9/27/75: 495 (11), 501 (lot, K-9 et al), 510 (13), 548 (lot, K et al), 552 (lot, K-2 et al), 580 (lot, K et al);

Swann NY 4/1/76: 221 (lot, K et al);

California Galleries 4/3/76: 410 (36), 411 (15), 414 (lot, K et al), 434 (13), 465 (lot, K et al), 487 (lot, K et al);

Sothebys Lon 10/29/76: 41 ill, 42, 43, 44;

Swann NY 11/11/76: 499 (lot, K et al);

Vermont Cat 11/12, 1977: 525 (book, K-2 et al), 806 ill;

California Galleries 1/23/77: 395 (lot, K et al), 404 (lot, K et al), 405 (lot, K et al), 408 (13), 432 (lot, K et al), 454 (lot, K et al);

Frontier AC, Texas 1978: 197;

California Galleries 1/21/78: 145 (lot, K et al), 166 (27), 178 (36);

Swann NY 4/20/78: 372 (lot, K et al);

Sothebys Lon 10/27/78: 73 (book, K-13 et al);

Swann NY 12/14/78: 308 (lot, K et al), 311 (10) (note);

Wood Conn Cat 45, 1979: 19 (book, 13)(note);

California Galleries 1/21/79: 296 (13), 311 (lot, K et al);

Swann NY 4/26/79: 441 (230), 442 (47), 443 ill(75), 444 (85), 445 (138)(note), 446 (250)(note);

Sothebys NY 5/8/79: 19 (books, K et al);

Swann NY 10/18/79: 371 (15)(note), 416 (200), 417 (400), 435 (lot, K et al)(note);

California Galleries 3/30/80: 30 (book, K-2 et al), 394 (lot, K-12 et al), 420 (lot, K-5 et al);

Christies Lon 6/26/80: 115 (lot, K et al), 117 (lot, K et al), 126 (lot, K et al);

Christies Lon 10/30/80: 124 (lot, K-15 et al);

Swann NY 11/6/80: 383 (lot, K et al);

Sothebys Lon 3/27/81: 24 (60);

Swann NY 4/23/81: 527 (500), 528 (600), 529 (26), 531 (lot, K et al), 534 (72), 542 (lot, K et al);

Harris Baltimore 7/31/81: 95 (lot, K et al), 120 (lot, K et al), 129 (lot, K et al);

Swann NY 11/5/81: 553 (lot, K et al);

## KILBURN, B.W. & E. (continued)

Wood Conn Cat 49, 1982: 34 (book, 13);

Swann NY 4/1/82: 357 (lot, K et al);

California Galleries 5/23/82: 19 (book, 13), 402 (lot, K et al), 409 (lot, K-13 et al), 425 (lot, K-10 et al);

Harris Baltimore 5/28/82: 165 (lot, K et al), 168 (lot, K-1 et al);

Christies Lon 6/24/82: 60 (lot, K et al), 80 (lot, K et al);

Swann NY 11/18/82: 447 (lot, K-1 et al);

Harris Baltimore 12/10/82: 59 (lot, K-1 et al), 60 (lot, K et al);

Harris Baltimore 4/8/83: 60 (lot, K et al), 62 (lot, K et al), 81 (lot, K et al), 113 (lot, K et al);

Swann NY 5/5/83: 439 (75), 446 (lot, K et al);

Swann NY 11/10/83: 346 (lot, K et al);

Harris Baltimore 12/16/83: 20 (lot, K-4 et al), 27 (lot, K et al), 30 (100), 72 (350), 73 (64), 80 (29), 88 (lot, K-13 attributed et al);

Harris Baltimore 6/1/84: 34 (lot, K et al), 35 (lot, K et al), 77 (lot, K et al), 78 (475), 79 (lot, K-1 et al), 194 (book, 20);

California Galleries 7/1/84: 212 (lot, K et al);

Harris Baltimore 11/9/84: 88 (lot, K et al);

Harris Baltimore 3/15/85: 24 (lot, K et al), 25 (lot, K et al), 26 (lot, K et al), 54 (92), 67 (lot, K et al), 68 (lot, K et al), 75 (lot, K-5 et al), 102 (lot, K et al), 112 (lot, K et al);

Phillips Lon 3/27/85: 142 (48);

Christies Lon 3/28/85: 45 (lot, K et al);

Swann NY 5/9/85: 434 (lot, K et al);

Sothebys Lon 11/1/85: 3 (lot, K et al);

Swann NY 11/14/85: 163 (lot, K et al);

Harris Baltimore 2/14/86: 31 (56);

California Galleries 3/29/86: 722 (2);

Swann NY 5/15/86: 165 (lot, K et al);

Phillips Lon 10/29/86: 247 (lot, K-1 et al);

Swann NY 11/13/86: 324 (lot, K et al);

## KILBURN, D.T.

Photos dated: 1856
Processes: Salt
Formats: Prints
Subjects: Genre
Locations:
Studio:
Entries:
Sothebys Lon 3/19/76: 114;

## KILBURN, William Edward (British)

Photos dated: 1846-1862
Processes: Daguerreotype, ambrotype, albumen
Formats: Plates incl. stereo, cdvs
Subjects: Portraits
Locations: Studio
Studio: England - London
Entries:
Sothebys Lon 12/21/71: 200 (2), 202, 203 (2), 204 ill(2);
Vermont Cat 4, 1972: 325 ill(note);
Christies Lon 6/14/73: 141;
Sothebys Lon 3/8/74: 152 (album, K et al);
Sothebys Lon 6/21/74: 123 (lot, K-1 et al);
Sothebys Lon 10/18/74: 199 ill, 242;
Sothebys NY 2/25/75: 1 (lot, K-1 et al);
Sothebys Lon 3/21/75: 206, 207;
Sothebys Lon 6/26/75: 170, 171 (2), 172;

## KILBURN, W.E. (continued)

Sothebys Lon 10/24/75: 28 ill, 29 ill, 30, 176
(lot, K et al);
Colnaghi Lon 1976: 10 (note), 11;
Witkin NY IV 1976: D80 ill, AL21 (album, K et al);
Sothebys Lon 3/19/76: 57 ill, 99, 100;
Sothebys NY 5/4/76: 99 (album, K et al);
Christies Lon 6/10/76: 14;
Christies Lon 10/28/76: 25 ill(note);
Sothebys Lon 3/9/77: 18 ill, 19, 20 ill, 21, 22, 23;
Christies Lon 3/10/77: 249 (album, K et al);
Sothebys Lon 5/18/77: 170;
Christies Lon 6/30/77: 26 ill;
Sothebys Lon 7/1/77: 250 (lot, K-1 et al);
Christies Lon 10/27/77: 189 ill, 190 ill, 370
(albums, K et al);
Sothebys Lon 11/18/77: 170;
California Galleries 1/21/78: 131 (album, K et al);
Christies Lon 3/16/78: 20 ill, 22, 23;
Sothebys Lon 3/22/78: 141 ill, 142 ill, 143;
Christies Lon 6/27/78: 7, 8, 9, 10, 11 ill, 50 ill,
228;
Sothebys Lon 6/28/78: 164, 173 ill, 192 ill(note),
193 ill(note), 194 ill(note);
Christies Lon 10/26/78: 16, 21, 22, 23, 24, 72, 73
ill, 74;
Sothebys Lon 10/27/78: 17 ill, 54;
Sothebys Lon 3/14/79: 6, 46, 47 (lot, K-1 et al),
48 ill, 49, 307 (album, K-1 et al);
Christies Lon 3/15/79: 19 ill, 20, 61 (attributed);
Christies Lon 6/28/79: 66 ill, 67, 185;
Sothebys Lon 6/29/79: 50, 51 (2), 52;
Sothebys Lon 10/24/79: 245 ill;
Christies Lon 10/25/79: 7, 14, 15, 16, 21 ill(lot,
K-1 et al)(note), 62 ill;
Christies Lon 3/20/80: 8 (2), 81 ill(note), 82;
Sothebys Lon 3/21/80: 57;
Phillips NY 5/21/80: 138 (album, K et al);
Christies Lon 6/26/80: 17, 24, 93, 472 (album, K-2
et al);
Sothebys Lon 6/27/80: 38 ill;
Sothebys Lon 10/29/80: 15 ill, 16 ill, 17, 147 ill,
157, 158, 261 (album, K et al), 262 (album, K
et al);
Christies Lon 10/30/80: 11, 12, 13, 429 (lot, K-5
et al);
Christies Lon 3/26/81: 18 (lot, K-1 et al), 399
(album, K-1 et al), 403 (album, K et al);
Sothebys Lon 3/27/81: 182 ill(note), 348;
Petzold Germany 5/22/81: 1745 ill;
Sothebys Lon 6/17/81: 28 ill, 31 ill, 56, 241;
Christies Lon 6/18/81: 45 (2), 64 ill, 65 ill, 263
(book, K et al), 421 (albums, K-3 et al), 434
(lot, K-4 et al);
Phillips Lon 10/28/81: 140 (lot, K-1 et al);
Sothebys Lon 10/28/81: 282 (K-1 plus 1 attributed);
Christies Lon 10/29/81: 98;
Petzold Germany 11/7/81: 168 ill;
Christies Lon 3/11/82: 10 (lot, K-1 et al), 52, 54;
Sothebys Lon 3/15/82: 54 ill, 235 (lot, K et al);
Phillips Lon 3/17/82: 25 (lot, K-1 et al);
Phillips Lon 6/23/82: 20 (lot, K-1 et al);
Christies Lon 10/28/82: 3 ill;
Sothebys Lon 3/25/83: 7 ill, 8 ill;
Swann NY 5/5/83: 299;
Christies Lon 6/23/83: 1, 15 (lot, K-1 et al), 252
(album, K et al), 259 (album, K et al);
Christies Lon 10/27/83: 224A (album, K et al), 231
(album, K et al), 232 (album, K et al);
Christies Lon 3/29/84: 2 (3), 29 (lot, K-1 et al),
349 (album, K et al);

## KILBURN, W.E. (continued)

Phillips Lon 6/27/84: 163 ill, 167 ill, 171 (lot,
K et al);
Christies Lon 6/28/84: 203, 302 (album, K et al),
304 (lot, K-1 et al);
Sothebys Lon 6/29/84: 25 ill, 26 ill, 39 (lot, K-1
et al);
Christies Lon 10/25/84: 325 (albums, K et al);
Sothebys Lon 10/26/84: 20 (lot, K-1 et al);
Christies Lon 3/28/85: 14, 15, 16 (lot, K et al),
309 (album, K et al);
Sothebys Lon 3/29/85: 44 (3);
Sothebys Lon 6/28/85: 13 ill, 23;
Phillips Lon 10/30/85: 32 (lot, K-1 et al), 35
(lot, K-1 et al), 63 (lot, K et al);
Christies Lon 10/31/85: 17 (lot, K-1 et al), 22
(lot, K-1 et al)(note);
Sothebys Lon 11/1/85: 16 (lot, K-2 et al);
Swann NY 11/14/85: 167 (lot, K et al);
Phillips Lon 4/23/86: 199 (lot, K-1 et al), 228
(album, K et al);
Christies Lon 4/24/86: 324, 590 (album, K et al);
Sothebys Lon 4/25/86: 14 ill;
Christies Lon 6/26/86: 81A (lot, K-1 et al), 91
(lot, K-1 et al), 148 (lot, K-1 et al);
Christies Lon 10/30/86: 10, 22;

## KILDARE, E.J.

Photos dated: between 1860s and 1890s
Processes:     Albumen
Formats:       Prints
Subjects:      Topography
Locations:     Guatemala
Studio:
  Entries:
Swann NY 5/16/86: 272 (lot, K-5 et al);

## KILGORE

Photos dated: Nineteenth century
Processes:     Albumen
Formats:       Stereos
Subjects:      Topography
Locations:     US - Maine
Studio:
  Entries:
Harris Baltimore 12/10/82: 53 (lot, K et al);

## KILGOURE, Captain (British)

Photos dated: 1876
Processes:     Albumen
Formats:       Prints
Subjects:      Architecture
Locations:     India - Madura
Studio:
  Entries:
Phillips Lon 10/30/85: 100 (book, 6)(note);

## KILLICK, J.H.

Photos dated: c1885-1895
Processes:     Albumen
Formats:       Cabinet cards
Subjects:      Portraits
Locations:
Studio:
  Entries:
California Galleries 6/28/81: 374 (lot, K et al);

**KILLIE, C.A.**
Photos dated: c1880-1900
Processes:      Bromide
Formats:        Prints
Subjects:       Topography
Locations:      China
Studio:
    Entries:
Christies Lon 10/28/76: 141 (album, 71);

**KIMBALL, Howard A.** (see also CLOUGH, A.F.)
Photos dated: 1870s
Processes:      Albumen
Formats:        Stereos
Subjects:       Topography
Locations:      US - New Hampshire
Studio:         US - Concord, New Hampshire
    Entries:
California Galleries 9/27/75: 512 (lot, K et al);
California Galleries 1/23/77: 410 (lot, K et al);

**KIMBALL, J.A.** (American)
Photos dated: 1853-c1860
Processes:      Daguerreotype, ambrotype
Formats:        Plates
Subjects:       Portraits
Locations:      Studio
Studio:         US - New York City
    Entries:
Vermont Cat 8, 1974: 529 ill;
Sothebys Lon 10/29/76: 72 (lot, K-1 et al);
Swann NY 11/13/86: 187 (lot, K & Cooper-2, et al);

**KIMBALL, M.H.** (American)
Photos dated: 1863-1865
Processes:      Albumen
Formats:        Cdvs
Subjects:       Portraits, documentary (slavery)
Locations:      US
Studio:         US - New York City
    Entries:
California Galleries 1/21/78: 132 (lot, K et al);
Swann NY 11/10/83: 236 (lot, K-2 et al);
Swann NY 11/14/85: 63 (lot, K et al);

**KIMBALL, W.G.C.** (American)
Photos dated: 1868-c1890
Processes:      Albumen, platinum
Formats:        Prints, cdvs, stereos
Subjects:       Portraits, topography, genre
Locations:      US - Concord, New Hampshire
Studio:         US - Concord, New Hampshire
    Entries:
Sothebys NY (Greenway Coll.) 11/20/70: 180 (lot, K-1
    et al);
California Galleries 1/23/77: 8, 325;
Swann NY 12/14/78: 312 (12)(note);
California Galleries 6/28/81: 290 (lot, K-3 et al);

**KIMBEI** (see KUSAKABE, Kimbei)

**KIMBERLEY Brothers** (American)
Photos dated: Nineteenth century
Processes:      Albumen
Formats:        Cdvs
Subjects:       Portraits
Locations:      Studio
Studio:         US - Fortress Monroe
    Entries:
Sothebys NY (Strober Coll.) 2/7/70: 295 (lot,
    K et al), 296 (lot, K et al);

**KINDLER, F.** (American)
Photos dated: 1850s-1870s
Processes:      Albumen
Formats:        Stereos
Subjects:       Topography
Locations:      US - New England
Studio:         US - Providence, Rhode Island
    Entries:
Harris Baltimore 6/1/84: 148 (lot, K et al);

**KINDERMANN**
Photos dated: 1873
Processes:      Heliotype
Formats:        Prints
Subjects:       Documentary (medical)
Locations:
Studio:
    Entries:
Swann NY 7/9/81: 103 (book, K et al), 104 (book,
    K et al);
Wood Conn Cat 49, 1982: 123 (book, K et al);

**KING** [KING 1]
Photos dated: 1875
Processes:      Woodburytype
Formats:        Prints
Subjects:       Topography
Locations:
Studio:
    Entries:
Wood Conn Cat 49, 1982: 499 (book, K-1 et al)(note);

**KING Brothers** [KING 2]
Photos dated: between 1870s and 1890s
Processes:      Albumen
Formats:        Prints
Subjects:       Topography
Locations:      Hawaii
Studio:         Hawaii - Honolulu
    Entries:
Swann NY 11/13/86: 274 (lot, K-3 et al);

**KING, Henry**
Photos dated: c1880-1898
Processes:      Albumen
Formats:        Prints
Subjects:       Topography, ethnography
Locations:      Australia - Sydney
Studio:         Australia - Melbourne and Sydney
    Entries:
Swann NY 11/11/76: 366 (albums, K et al);
Christies Lon 10/26/78: 195 (album, K et al);
Christies Lon 6/28/79: 147 (albums, K-35 et al);
Christies Lon 10/30/80: 274 (album, K-11 et al);
Sothebys Lon 3/15/82: 66 (album, K-7 et al);

**KING, Henry** (continued)
Christies Lon 10/27/83: 158 (album, K et al);
Christies Lon 6/28/84: 139 (album, K-4 et al);
Sothebys NY 5/8/85: 631 (lot, K et al);
Christies Lon 10/31/85: 125 (albums, K-9 et al);

**KING, Horatio Nelson** (British, 1830-1895)
Photos dated: 1850s-1860s
Processes:      Albumen
Formats:        Cdvs
Subjects:       Portraits, genre
Locations:      Studio
Studio:         England - Bath
   Entries:
Colnaghi Lon 1976: 140 ill(note), 141 ill;
Christies Lon 10/30/86: 143 (albums, K-10 et al);

**KING, Horatio P.** (American)(see also EASTMAN, S.)
Photos dated: 1849-1859
Processes:      Daguerreotype
Formats:        Plates
Subjects:       Portraits
Locations:      Studio
Studio:         US - Taunton, Massachusetts
   Entries:
Sothebys NY (Weissberg Coll.) 5/16/67: 145 (lot,
  K-1 et al);
Christies NY 11/11/80: 101 (note);

**KING, W.F.** (American)
Photos dated: 1868-1881
Processes:      Albumen
Formats:        Prints, stereos, cdvs
Subjects:       Documentary (railroads)
Locations:      US - Maine
Studio:         US - Portland, Maine
   Entries:
Sothebys NY 11/9/76: 134 (2)(note);

**KING, Thomas Starr** (American)
Photos dated: 1869
Processes:      Albumen
Formats:        Prints
Subjects:       Topography
Locations:      US - White Hills
Studio:         US
   Entries:
Witkin NY IX 1979: 2/47 (book, K-3 et al);
Witkin NY X 1980: 41 (book, 4);

**KING, W.** (American)(photographer?)
Photos dated: 1877
Processes:      Albumen
Formats:        Prints
Subjects:       Topography
Locations:      Canada; US - Massachusetts, New York,
   New Jersey, New Hampshire, Rhode
   Island, Washington, D.C.
Studio:         US
   Entries:
Swann NY 2/14/52: 21 (album, 24)(note);

**KINGHAM, J.B.** (American)
Photos dated: 1889-1890
Processes:      Albumen
Formats:        Boudoir cards
Subjects:       Documentary (public events)
Locations:      US - Oklahoma City, Oklahoma
Studio:         US - Oklahoma City, Oklahoma
   Entries:
Swann NY 11/14/85: 140 (lot, K et al)(note);

**KINGRAVE** (British)
Photos dated: 1860s
Processes:      Albumen
Formats:        Stereos
Subjects:       Topography
Locations:      Great Britain
Studio:         Great Britain
   Entries:
Christies Lon 3/26/81: 115 (lot, K-1 et al);

**KINGSBURY, J.D.** (American)
Photos dated: Nineteenth century
Processes:      Albumen
Formats:        Prints
Subjects:       Topography
Locations:      US - Bradford, Massachusetts
Studio:         US
   Entries:
Stern Chicago 1975(?): 40 (book, 53);

**KINGSLEY, Reverend William Fowler** (British)
Photos dated: 1850s
Processes:      Albumen
Formats:        Prints
Subjects:       Architecture, documentary (scientific)
Locations:      England - Cambridge
Studio:         Great Britain
   Entries:
Sothebys Lon 7/1/77: 277 (12);
Sothebys Lon 3/21/80: 371;

**KINGSMILL, L.T.** (British)
Photos dated: 1850s
Processes:      Daguerreotype
Formats:        Plates
Subjects:       Portraits
Locations:      Studio
Studio:         England - Ashford
   Entries:
Petzold Germany 11/7/81: 147 ill;

**KINSEY, Darius** (American)
Photos dated: 1885-c1910
Processes:      Albumen, bromide
Formats:        Prints
Subjects:       Documentary (industrial)
Locations:      US
Studio:         US
   Entries:
California Galleries 1/21/79: 470 ill(3), 471;

**KIRK, Lieutenant Colonel J.W.C.**
Photos dated: 1858-1859
Processes: Albumen
Formats: Prints
Subjects: Topography
Locations: Africa - central
Studio:
  Entries:
Sothebys Lon 4/24/86: 37 (2)(note);

**KIRK, James**
Photos dated: 1857
Processes: Ambrotype
Formats: Plates
Subjects: Portraits
Locations:
Studio:
  Entries:
Sothebys Lon 10/29/80: 174;

**KIRK, Dr. John** (British)
Photos dated: c1855
Processes: Albumen
Formats: Prints
Subjects: Topography
Locations: Russia - Crimea
Studio:
  Entries:
Sothebys Lon 3/22/78: 191 ill(album, K et al)(note);

**KIRKLAND, Charles D.** (American)
Photos dated: c1868-1890s
Processes: Albumen
Formats: Prints, stereos
Subjects: Topography, genre
Locations: US - Cheyenne, Wyoming; Colorado
Studio: US - Cheyenne, Wyoming
  Entries:
Sothebys NY (Strober Coll.) 2/7/70: 507 (lot,
  K et al);
Christies Lon 10/29/81: 261 (26);
Swann NY 11/14/85: 115 ill(24);

**KIRKHORN**
Photos dated: c1870s-1880
Processes: Albumen
Formats: Prints
Subjects: Topography
Locations: Europe - Scandinavia
Studio: Europe - Scandinavia
  Entries:
California Galleries 12/13/80: 340 (lot, K et al);

**KIRKMAN**
Photos dated: 1860
Processes: Albumen
Formats: Prints
Subjects: Documentary (public events)
Locations: South Africa
Studio:
  Entries:
Sothebys Lon 7/1/77: 174 (book, K, Green & York,
  17);
Christies Lon 6/28/79: 154 (book, K et al);
Christies Lon 3/20/80: 217 (book, K-17 et al);

**KITCH**
Photos dated: Nineteenth century
Processes: Albumen
Formats: Prints
Subjects: Topography
Locations:
Studio:
  Entries:
Christies Lon 10/27/83: 158 (album, K et al);

**KITCHENER, Lieutenant H.H.** (British)
Photos dated: 1870-1880
Processes: Albumen
Formats: Prints
Subjects: Topography
Locations: Palestine
Studio:
  Entries:
Christies Lon 4/25/74: 210 (books, K et al);
Wood Conn Cat 37, 1976: 119 (book, 12)(note);
Sothebys Lon 10/29/76: 146 (book, 12);
Wood Conn Cat 42, 1978: 288 (book, 12)(note);
Wood Conn Cat 45, 1979: 153 (book, 12)(note);
Wood Conn Cat 49, 1982: 246 (book, 12)(note);

**KIU KANG** (Chinese)(photographer?)
Photos dated: 1870s
Processes: Albumen
Formats: Prints
Subjects: Topography
Locations: China
Studio: China
  Entries:
Christies Lon 3/29/84: 82 ill(album, K et al);

**KLAIN, N.M.**
Photos dated: 1868
Processes: Albumen
Formats: Prints
Subjects: Topography
Locations: US - San Francisco, California
Studio:
  Entries:
Christies NY 11/11/85: 237 ill;

**KLARY** (French)
Photos dated: Nineteenth century
Processes: Woodburytype
Formats: Prints
Subjects: Portraits incl. Galerie Contemporaine
Locations: Studio
Studio: France
  Entries:
Swann NY 4/20/78: 323 (lot, K-1 et al);
Christies Lon 6/26/80: 329 (book, K et al);
Christies Lon 3/26/81: 293 (book, K et al);
Christies NY 5/14/81: 41 (books, K-1 et al);
Christies NY 5/26/82: 36 (book, K, K & Benque,
  et al);
Christies NY 5/7/84: 19 (book, K, K & Benque,
  et al);

**KLAUBER & CAMPBELL** (American)
Photos dated: Nineteenth century
Processes:    Albumen
Formats:      Cdvs
Subjects:     Portraits
Locations:    Studio
Studio:       US - Louisville, Kentucky
  Entries:
Sothebys NY (Strober Coll.) 2/7/70: 290 (lot,
  K & C et al);

**KLAUFUSS**
Photos dated: 1890s
Processes:    Albumen
Formats:      Prints
Subjects:     Topography
Locations:    Malaya
Studio:       Malaya - Penang
  Entries:
Sothebys NY 12/19/79: 96 (2 ills)(lot, K et al);
Christies Lon 10/25/84: 110 (album, K-6 et al);

**KLECKNER, M.A.** (American)
Photos dated: c1875
Processes:    Albumen
Formats:      Stereos
Subjects:     Topography
Locations:    US - Pennsylvania
Studio:       US
  Entries:
Sothebys NY (Strober Coll.) 2/7/70: 513 (lot,
  K et al);
Rinhart NY Cat 7, 1973: 267;
California Galleries 9/27/75: 546 (lot, K et al);
Harris Galleries 4/8/83: 86 (lot, K et al);
Harris Baltimore 6/1/84: 119 (lot, K et al);
Harris Baltimore 3/15/85: 81 (lot, K et al), 84
  (lot, K et al);

**KLEIN** (see WIELE & KLEIN)

**KLIER, P.**
Photos dated: 1880s
Processes:    Albumen
Formats:      Prints
Subjects:     Topography
Locations:    Burma
Studio:       Burma - Rangoon
  Entries:
Sothebys NY 5/8/79: 110 ill(35);
Phillips Lon 3/17/82: 45 (album, K-1 et al);
Harris Baltimore 11/7/86: 236 (lot, K et al);
Swann NY 11/13/86: 156 (lot, K et al);

**KLINER, HIGBEE & BERNARD** (American)
Photos dated: c1880
Processes:    Albumen
Formats:      Prints
Subjects:     Topography
Locations:    US
Studio:       US
  Entries:
California Galleries 7/1/84: 351 (6);

**KLIOSZ, Gyorgy** (Hungarian)
Photos dated: 1860s-1870s
Processes:    Albumen
Formats:      Prints
Subjects:     Topography
Locations:    Hungary - Budapest
Studio:       Hungary - Budapest
  Entries:
Christies Lon 6/24/82: 135 (album, K-1 et al);

**KLUGE** (see SPALKE & KLUGE)

**KNAFFL Brothers** (American)
Photos dated: 1898
Processes:    Silver
Formats:      Parlor print
Subjects:     Genre
Locations:    US - Tennessee
Studio:       US - Knoxville, Tennessee
  Entries:
Christies NY 5/4/79: 135A (note);

**KNAPP, A.H.** (American)
Photos dated: 1850s
Processes:    Daguerreotype
Formats:      Plates
Subjects:     Portraits
Locations:    Studio
Studio:       US - Boston, Massachusetts
  Entries:
Sothebys NY (Strober Coll.) 2/7/70: 188 (lot,
  K-1 et al)(note);

**KNAPP, William R.** (American)
Photos dated: 1840s-c1851
Processes:    Daguerreotype
Formats:      Plates
Subjects:     Portraits
Locations:    Studio
Studio:       US - New York City
  Entries:
Sothebys NY (Weissberg Coll.) 5/16/67: 148 (lot,
  K-1 et al);
Swann NY 5/5/83: 316 (lot, K et al)(note);

**KNAPPS** (see BRIGGS & KNAPPS)

**KNIGHT** (see MANNING & KNIGHT)

**KNIGHT, Charles** (British)
Photos dated: 1870-1898
Processes:    Albumen
Formats:      Prints, cabinet cards
Subjects:     Topography, portraits
Locations:    England - Isle of Wight
Studio:       Great Britain
  Entries:
Christies Lon 10/27/77: 224 (book, 16);
Swann NY 4/26/79: 108 (book, 16);
Christies Lon 10/25/79: 432 ill;
Christies Lon 3/20/80: 356 (albums, K et al);
Christies Lon 6/26/80: 509;
Christies Lon 6/24/82: 71 (lot, K et al);

**KNIGHT, C.** (continued)
Christies Lon 6/27/85: 288 (lot, K-1 et al);
Christies Lon 4/24/86: 338 (lot, K et al);

**KNIGHT, George H.** (American)
Photos dated: 1890s
Processes: Albumen
Formats: Cabinet cards
Subjects: Topography
Locations: US - California
Studio: US
    Entries:
Sothebys LA 2/17/82: 376 ill(lot, K et al);

**KNIGHT, James** (British)
Photos dated: early 1850s-1855
Processes: Salt, albumen
Formats: Prints
Subjects: Topography, genre
Locations: Great Britain
Studio: Great Britain (Photographic Club)
    Entries:
Sothebys Lon 3/21/75: 286 (album, K-1 et al);
Sothebys Lon 7/1/77: 184 (album, K et al), 185
    (album, K-1 et al);
Christies Lon 10/29/81: 165 (lot, K-1 et al);
Christies Lon 6/23/83: 206;
Sothebys Lon 11/1/85: 59 (lot, K-1 et al);
Kraus NY Cat 2, 1986: 2.2 ill(note), 2.17 ill
    (attributed)(note), 2.19 ill, 2.28 ill(note),
    2.62 ill(attributed);

**KNIGHTS, J.F.**
Photos dated: Nineteenth century
Processes: Albumen
Formats: Cdvs
Subjects: Portraits
Locations:
Studio:
    Entries:
California Galleries 1/22/77: 129 (lot, K et al);

**KNOWLES, Reverend E.H.** (British)
Photos dated: 1872
Processes: Albumen
Formats: Prints
Subjects: Architecture
Locations: England - Kenilworth
Studio: Great Britain
    Entries:
Sothebys Lon 7/1/77: 41 (book, 24);
Sothebys Lon 11/18/77: 203 (book, 24);
Lehr NY Vol 1:4, 1979: 40 (book, 23);
Swann NY 11/5/81: 144 (book, 24);
Wood Conn Cat 58, 1986: 293 (book, 24);

**KNOWLTON Brothers** (American)
Photos dated: 1868-1878
Processes: Albumen
Formats: Stereos, cdvs
Subjects: Topography, documentary (disasters)
Locations: US - Massachusetts
Studio: US - Northampton, Massachusetts
    Entries:
Witkin NY IV 1976: S12 ill;
Rose Florida Cat 7, 1982: 91 ill(4);
Harris Baltimore 4/8/83: 109 (lot, K et al);
Harris Baltimore 6/1/84: 148 (lot, K et al);

**KNOWLTON, W.** (American)
Photos dated: c1885
Processes: Albumen
Formats: Prints
Subjects: Topography
Locations: US - New York
Studio: US
    Entries:
Sothebys NY 9/23/75: 95 (lot, K-1 et al);

**KNOX, David** (American)
Photos dated: 1862-1865
Processes: Albumen
Formats: Prints
Subjects: Documentary (Civil War)
Locations: US - Civil War area
Studio: US
    Entries:
Wood Conn Cat 41, 1978: 129 (book, K-4 et al)(note);
Wood Conn Cat 45, 1979: 113 (book, K-4 et al)(note);
Sothebys LA 2/4/81: 217 (lot, K-1 et al);
Harris Baltimore 5/28/82: 54;
Harris Baltimore 9/16/83: 69, 70;
Harris Baltimore 6/1/84: 369;

**KNUDSEN, K.** (Norwegian)
Photos dated: 1860s-1890s
Processes: Albumen
Formats: Prints, stereos, cdvs
Subjects: Topography
Locations: Norway - Bergen
Studio: Norway - Bergen
    Entries:
Rinhart NY Cat 7, 1973: 443;
Sothebys NY 2/25/75: 165 (albums, K et al);
California Galleries 4/3/76: 294 (lot, K et al);
Sothebys NY 5/4/76: 84 (album, 12);
Christies Lon 10/28/76: 119 (albums, K et al);
Christies Lon 10/27/77: 105 (album, K-2 et al);
Swann NY 12/8/77: 411 (lot, K-2 et al);
Rose Boston Cat 3, 1978: 85 ill(note);
California Galleries 1/21/78: 211 (album, K et al);
Christies Lon 3/16/78: 84 (album, K et al);
Christies Lon 6/27/78: 153 (album, K et al);
Christies Lon 10/26/78: 193 (album, K et al), 198
    (album, K et al);
Christies Lon 3/15/79: 190 (album, K et al);
California Galleries 12/13/80: 340 (lot, K et al);
Christies Lon 3/26/81: 196 (album, K et al);
Phillips NY 5/9/81: 51 (albums, K et al);
Petzold Germany 5/22/81: 1954 (lot, K et al);
Christies Lon 6/24/82: 142 ill(15);
Christies Lon 6/23/83: 48 (lot, K et al), 169
    (albums, K et al);
Christies Lon 10/27/83: 84 (albums, K et al);

KNUDSEN, K. (continued)
Harris Baltimore 12/16/83: 47 (lot, K-4 et al);
Christies Lon 10/25/84: 108 (albums, K-31 et al);
Christies Lon 3/28/85: 62 (album, K et al);
Christies Lon 4/24/86: 384 ill(album, K-2 et al);
Swann NY 11/13/86: 216 (albums, K et al);

KOBAYASHI, C. (Japanese)
Photos dated: c1890s
Processes:    Albumen
Formats:     Prints
Subjects:    Topography
Locations:   Japan
Studio:      Japan
   Entries:
Old Japan, England Cat 8, 1986: 27 (lot, K et al);

KOCH & WILZ
Photos dated: 1846-1871
Processes:    Daguerreotype, albumen
Formats:     Plates, prints
Subjects:    Documentary (Paris Commune)
Locations:   France - Paris
Studio:      France - Paris
   Entries:
Rauch Geneva 6/13/61: 155 (2);

KOCH, G.J. (German)
Photos dated: 1865-1880
Processes:    Albumen
Formats:     Cdvs
Subjects:    Portraits
Locations:   Studio
Studio:      Germany - Heide
   Entries:
Petzold Germany 11/7/81: 305 ill(album,
   K et al)(note);

KOCH, M. (German)
Photos dated: Nineteenth century
Processes:    Collotype
Formats:     Prints
Subjects:    Genre (nudes)
Locations:   Studio
Studio:      Germany
   Entries:
Swann 5/9/85: 415 (lot, K et al)(note);

KOENIG (see BOEHL & KOENIG) [KOENIG 1]

KOENIG [KOENIG 2]
Photos dated: 1850s
Processes:    Daguerreotype, ambrotype
Formats:     Plates
Subjects:    Portraits
Locations:   Studio
Studio:      England - London
   Entries:
Sothebys Lon 3/21/75: 182 (lot, K-1 et al);
Christies Lon 10/25/79: 46 (lot, K-1 et al);

KOERNER, Alfred (photographer?)
Photos dated: 1874
Processes:    Woodburytype
Formats:     Prints
Subjects:    Documentary (military)
Locations:
Studio:
   Entries:
Wood Conn Cat 49, 1982: 252 (book, 3)(note);

KOOP, Franz (German)
Photos dated: 1850s
Processes:    Ambrotype
Formats:     Plates
Subjects:    Portraits
Locations:   Studio
Studio:      Germany
   Entries:
Petzold Germany 11/7/81: 178 ill;

KOPPEL, H.
Photos dated: 1870s
Processes:    Albumen
Formats:     Prints
Subjects:    Topography
Locations:   Germany and/or Austria
Studio:      Germany and/or Austria
   Entries:
Christies Lon 3/24/83: 76 (lot, K et al);
Christies Lon 10/27/83: 82 (lot, K et al);

KOPPMANN, G. (German)
Photos dated: 1860s-1897
Processes:    Albumen, carbon, photogravure
Formats:     Prints
Subjects:    Topography
Locations:   Germany - Hamburg
Studio:      Germany - Hamburg
   Entries:
Sothebys Lon 10/18/74: 87 ill(album, 24);
Sothebys Lon 3/9/77: 55 (book, 32);
Christies Lon 3/10/77: 107 (lot, K-1 et al);
Swann NY 11/18/82: 111 (12, plus book, 12)(note);

KOPSCH & MAY
Photos dated: 1850s
Processes:    Daguerreotype
Formats:     Plates
Subjects:    Portraits
Locations:
Studio:
   Entries:
Christies Lon 6/28/79: 32 (lot, K & M-1, et al);

KOTZSCH, A.
Photos dated: 1860s
Processes:    Albumen
Formats:     Prints
Subjects:    Genre
Locations:   Germany
Studio:      Germany - Dresden
   Entries:
Christies Lon 6/27/85: 153 ill(3);

**KOUTNIK, W.F.** (Austrian)
Photos dated: 1864
Processes: Albumen
Formats: Prints
Subjects: Topography
Locations: Austria
Studio: Austria - Vienna
　Entries:
Petzold Germany 11/7/81: 316 ill(album, 17);

**KOZLOWSKI, Justyn** (Polish)
Photos dated: 1869
Processes: Albumen
Formats: Prints
Subjects: Topography
Locations: Egypt - Suez Canal
Studio:
　Entries:
Swann NY 4/14/77: 322 (5)(note);
Christies Lon 10/30/86: 127 (album, K et al);

**KRAFT, L.**
Photos dated: c1890
Processes: Albumen
Formats: Prints
Subjects: Genre
Locations:
Studio:
　Entries:
California Galleries 4/2/76: 182;

**KRAL, W.**
Photos dated: between 1870s and 1890s
Processes: Albumen
Formats: Prints
Subjects: Topography
Locations: Austria - Vienna
Studio:
　Entries:
Swann NY 12/8/77: 367 (lot, K et al), 411 (lot,
　K et al);

**KRAMER, Oscar** (Austrian)
Photos dated: 1867-1890s
Processes: Albumen
Formats: Prints, stereos, cdvs
Subjects: Topography, architecture
Locations: Austria - Vienna
Studio: Austria - Vienna
　Entries:
Rose Boston Cat 4, 1979: 58 ill(note), 59 ill;
Auer Paris 5/31/80: 101 (12);
Phillips NY 9/30/82: 993 (album, K-7 et al);
Christies NY 9/11/84: 120 (album, K et al);
Christies NY 2/13/85: 145 (lot, K et al);
Swann NY 11/13/86: 218 (lot, K et al);

**KRAUSSE, Carl** (German)
Photos dated: Nineteenth century
Processes: Albumen
Formats: Stereos
Subjects:
Locations:
Studio: Germany
　Entries:
Christies Lon 10/29/81: 150 (lot, K et al);

**KRAUSZ, Sigmund**
Photos dated: 1891
Processes: Gelatin
Formats: Prints
Subjects: Genre
Locations: US - Chicago, Illinois
Studio: US - Chicago, Illinois
　Entries:
Sothebys Lon 6/27/80: 231 ill(36)(note);

**KREBS, A.R.** (American)
Photos dated: c1850
Processes: Daguerreotype
Formats: Plates
Subjects: Portraits
Locations: Studio
Studio: US
　Entries:
Vermont Cat 6, 1973: 517 ill;
Swann NY 4/20/78: 306 (lot, K-1 et al);

**KRIEGER**
Photos dated: Nineteenth century
Processes: Albumen
Formats:
Subjects: Portraits
Locations:
Studio:
　Entries:
California Galleries 5/23/82: 189 (album, K et al);

**KROEHLE, Charles**
Photos dated: c1895
Processes: Albumen
Formats: Prints
Subjects: Ethnography
Locations: Columbia; Paraguay; Peru - Lima
Studio:
　Entries:
Christies NY 11/11/80: 91 (lot, K-2 et al);
Christies Lon 3/28/85: 75 (album, K-1 et al);

**KRONE, Hermann** (German, 1827-1916)
Photos dated: early 1860s
Processes: Albumen
Formats: Prints, stereos, cdvs
Subjects: Topography
Locations: Germany - Dresden
Studio: Germany - Dresden
　Entries:
Lennert Munich Cat 5, 1979: 20;
Christies Lon 3/20/80: 101 (lot, K et al);
Phillips Lon 10/24/84: 106 (album, K-4 et al);

**KRUGER, Fred**
Photos dated: c1860s
Processes: Albumen
Formats: Prints
Subjects: Ethnography
Locations: Australia - Victoria
Studio:
　Entries:
Swann NY 12/8/77: 388 ill(note);

**KRUSS, A.** (German)
Photos dated: 1850s-1870s
Processes:     Albumen
Formats:       Stereos
Subjects:      Topography
Locations:     Germany
Studio:        Germany - Hamburg
    Entries:
Christies Lon 3/26/81: 124 ill(lot, K-4 et al);

**KUBALEK**
Photos dated: c1870s-1880
Processes:     Albumen
Formats:       Cdvs
Subjects:      Portraits
Locations:
Studio:
    Entries:
California Galleries 12/13/80: 221 (lot, K et al);

**KUELNER**
Photos dated: c1895
Processes:     Albumen
Formats:       Prints
Subjects:      Ethnography
Locations:     Peru; Columbia; Paraguay
Studio:
    Entries:
Christies NY 11/11/80: 91 (lot, K-2 et al);

**KUHN Brothers** (American)
Photos dated: 1886
Processes:     Albumen
Formats:       Prints
Subjects:      Portraits
Locations:     Studio
Studio:        US - St. Louis, Missouri
    Entries:
Harris Baltimore 6/1/84: 300;

**KUHN, B.** (French)(see also K., B.)
Photos dated: 1870s-1890s
Processes:     Albumen
Formats:       Stereos
Subjects:      Topography, genre
Locations:     France - Paris; Italy
Studio:        France - Paris
    Entries:
Swann NY 12/8/77: 325 (albums, K et al);
Swann NY 4/26/79: 282 (albums, K et al);
Christies Lon 10/25/79: 78 (lot, K-6 et al);
Christies Lon 3/20/80: 93 (lot, K-2 et al), 113
    (lot, K-8 et al);
Christies Lon 6/26/80: 120 (10);
Christies Lon 10/30/80: 111 (lot, K-1 et al), 125
    (lot, K-3 et al);
Christies Lon 3/26/81: 119 (lot, K-14 et al), 133
    (lot, K-1 et al);
Christies Lon 6/18/81: 112 (lot, K et al);
Phillips Lon 6/24/81: 92 (lot, K et al);
Phillips Lon 10/28/81: 160 (albums, K et al);
Christies Lon 10/29/81: 144 (lot, K et al);
Swann NY 4/1/82: 360 (lot, K et al);
Christies Lon 6/24/82: 66 (lot, K-50 et al);
Christies Lon 3/24/83: 44 (lot, K et al);
Christies Lon 6/23/83: 48 (lot, K et al);
Christies Lon 3/29/84: 23 (lot, K et al);

**KUHN, B.** (continued)
Harris Baltimore 3/15/85: 99 (lot, K-2 et al);
Harris Baltimore 2/14/86: 50 (lot, K et al), 205
    (albums, K et al);
Christies Lon 4/24/86: 349 (lot, K et al);

**KUHN, Conrad** (German)
Photos dated: 1850s
Processes:     Daguerreotype
Formats:       Plates
Subjects:      Portraits
Locations:     Studio
Studio:        Germany
    Entries:
Petzold Germany 11/7/81: 150 ill(attributed)(note);

**KUHN, J.** (French)
Photos dated: 1867-1870s
Processes:     Albumen
Formats:       Prints, stereos
Subjects:      Topography
Locations:     France - Paris
Studio:        France - Paris
    Entries:
Sothebys Lon 3/21/75: 104 (album, K-7 et al);

**KUHN, J.M.** (American)
Photos dated: c1889
Processes:     Albumen
Formats:       Cabinet card
Subjects:      Portraits
Locations:     Studio
Studio:        US - Stillwater, Minnesota
    Entries:
Swann NY 4/26/79: 478 (note);

**KUNG TAI** (Chinese)
Photos dated: 1870s
Processes:     Albumen
Formats:       Prints incl. panoramas
Subjects:      Topography
Locations:     China - Shanghai
Studio:        China
    Entries:
Sothebys Lon 10/24/75: 120;
Sothebys Lon 10/27/78: 108 (note);

**KUNTZ, L.**
Photos dated: 1888
Processes:     Albumen
Formats:       Prints
Subjects:      Documentary
Locations:     Switzerland - Prangins
Studio:
    Entries:
Swann NY 4/26/79: 459 (album, 12);

**KURTZ, William** (American, 1834-1904)
Photos dated: 1865-1883
Processes:       Albumen, artotype
Formats:         Prints, cabinet cards
Subjects:        Portraits
Locations:       Studio
Studio:          US - New York City
    Entries:
Sothebys NY (Strober Coll.) 2/7/70: 195 (book, 1);
Sothebys NY (Greenway Coll.) 11/20/70: 239 (lot, K-1
    et al), 241 (lot, K-1 et al);
Rinhart NY Cat 2, 1971: 137 (book, 1);

**KUSAKABE, Kimbei** (Japanese)
Photos dated: 1880s-1912
Processes:       Albumen
Formats:         Prints
Subjects:        Topography, genre
Locations:       Japan
Studio:          Japan - Yokohama
    Entries:
Christies Lon 3/15/79: 165 (album, 50);
Christies Lon 3/20/80: 172 (album, K-3 et al);
Swann NY 4/17/80: 296 ill(note);
Christies Lon 6/26/80: 237 (album, K attributed
    et al);
Christies Lon 10/30/80: 244 (albums, K attributed
    et al), 245 (album, K-1 et al), 247 (album, K
    et al);
Christies NY 11/11/80: 93 ill(album, K et al), 94
    ill(album, K et al);
Christies Lon 3/26/81: 245 (album, 100);
Christies NY 5/14/81: 79 (album, K et al)(note), 80
    (album, 50)(attributed);
Christies NY 11/10/81: 79 (album, K et al)(note), 80
    (album, 50)(attributed);
Old Japan, England Cat 5, 1982: 2 (lot, K-47 et
    al), 3 (lot, K-46 et al), 4 (lot, K-47 et al),
    5 (lot, K-47 et al), 6 (lot, K-82 et al);
Swann NY 11/18/82: 411 (album, K-1 et al)(note);
Christies NY 2/8/83: 16 (3)(attributed);
Christies Lon 3/24/83: 107 (album, K et al), 112
    (album, K et al);
Christies NY 5/9/83: 84 ill(album, K et al);
Christies Lon 6/23/83: 151 (album, K et al);

Swann NY 11/10/83: 292 (album, K-1 et al)(note);
Christies Lon 3/29/84: 88 ill(album)(attributed);
Swann NY 5/10/84: 252 (albums, K et al);
Christies Lon 6/28/84: 105 (lot, K-6 attributed, et
    al), 111 (album, K-1 et al)(note), 119 (lot, K-1
    et al)(note), 125 (lot, K-2 et al)(note);
California Galleries 7/1/84: 513 (2, attributed);
Christies Lon 10/25/84: 80 (lot, K-1 et al)(note),
    81 (albums, K-1 et al);
Sothebys Lon 10/26/84: 62 (albums, K-24 et al);
Christies NY 5/6/85: 189 ill (album, 40)
    (attributed);
Christies Lon 6/27/85: 73 (albums, K et al), 88
    (lot, K attributed et al);
Sothebys Lon 6/28/85: 65 ill(album, K attributed
    et al);
Swann NY 11/14/85: 111 (album, K attributed et al)
    (note), 112 (album, K-2 attributed, et al)(note);
Old Japan, England Cat 8, 1986: 21 (album, K-50 et
    al), 25 (album, K et al), 39 (lot, K et al);
Christies Lon 6/26/86: 191 (lot, K et al), 198
    (lot, K et al);
Christies Lon 10/30/86: 111 (album, K et al);

**KUTHRUFF, A.** (Austrian)
Photos dated: Nineteenth century
Processes:       Albumen
Formats:
Subjects:        Portraits
Locations:       Studio
Studio:          Austria - Konstanz
    Entries:
Petzold Germany 5/22/81: 1980 (album, K et al);

**KYUICHI, Uchida** (Japanese)
Photos dated: Nineteenth century
Processes:
Formats:
Subjects:
Locations:       Japan
Studio:          Japan
    Entries:
Sothebys Lon 11/1/85: 42 ill(2)(note);

**L & F** [same] (French)
Photos dated: 1870s
Processes:      Diapositives
Formats:        Glass stereo plates
Subjects:       Documentary (Paris Commune)
Locations:      France - Paris
Studio:         France
   Entries:
Christies Lon 6/27/78: 87 (lot, L & F-1 et al);
Christies Lon 3/15/79: 70 (lot, L-8 et al);

**L.S. & P.** [L.S. & P.]
Photos dated: c1880
Processes:      Albumen
Formats:        Prints
Subjects:       Topography
Locations:      Europe
Studio:         Europe
   Entries:
Harris Baltimore 4/8/83: 287 (album, L et al);

**L., A.** [A.L.]
Photos dated: 1856
Processes:      Salt
Formats:        Prints
Subjects:       Genre (rural life)
Locations:      Europe
Studio:         Europe
   Entries:
Sothebys Lon 6/24/83: 80 ill(3);

**L., B.** [B.L.]
Photos dated: Nineteenth century
Processes:      Albumen
Formats:        Stereos (tissue)
Subjects:       Genre
Locations:      Europe
Studio:         Europe
   Entries:
Vermont Cat 7, 1974: 650 ill(3);

**L., C.** [C.L.] [L., C. 1]
Photos dated; 1850s
Processes:      Daguerreotype
Formats:        Plates
Subjects:       Portraits
Locations:      Studio
Studio:         France (?)
   Entries:
Sothebys Lon 3/21/80: 7 ill;

**L., C.** [C.L.] [L., C. 2]
Photos dated: 1897
Processes:      Silver
Formats:        Prints
Subjects:       Documentary (public events)
Locations:      China - Shanghai
Studio:
   Entries:
Swann NY 11/18/82: 472 (album, 40);

**L., E.** [E.L.] (French)(possibly E. Lamy, q.v.)
Photos dated: 1850s-c1870
Processes:      Albumen
Formats:        Stereos incl. tissue
Subjects:       Genre, architecture, topography
Locations:      France - Paris; Italy - Naples
Studio:         France
   Entries:
Rinhart NY Cat 7, 1973: 373, 374, 375, 376, 377, 378;
California Galleries 9/27/75: 544 (lot, L et al);
Christies Lon 10/30/80: 108 (lot, L-1 et al);
Christies Lon 10/29/81: 156 (lot, L et al), 158 (lot, L et al);
Swann NY 4/1/82: 358 (lot, L-4 et al);
Christies Lon 10/28/82: 32 (lot, L et al);
Harris Baltimore 4/8/83: 103 (lot, L et al);
Christies Lon 3/29/84: 35 (lot, L-5 et al);
Christies Lon 10/31/85: 62 (lot, L-5 et al);
Christies Lon 10/30/86: 28 (lot, L et al);

**L., F.** [F.L.]
Photos dated: Nineteenth century
Processes:      Albumen
Formats:        Prints
Subjects:       Topography
Locations:
Studio:
   Entries:
Christies Lon 6/28/84: 221 (lot, L et al);

**L., F.B.** [F.B.L.] (French)
Photos dated: 1850s
Processes:      Daguerreotype
Formats:        Stereo plates
Subjects:       Documentary (art)
Locations:      France
Studio:         France
   Entries:
Sothebys Lon 10/18/74: 193 ill(note);

**L., L.** [L.L.] (French)(possibly Léon & Levy, q.v.)
Photos dated: 1860s-1880s
Processes:      Albumen
Formats:        Stereos incl. tissue, prints
Subjects:       Topography, genre
Locations:      England; Scotland; France; Germany; Spain
Studio:         France - Paris
   Entries:
California Galleries 4/3/76: 445 (12);
Swann NY 11/11/76: 395 (albums, L et al);
Swann NY 4/14/77: 188 (L & X et al);
Christies Lon 6/30/77: 97 (album, 12);
Christies Lon 3/16/78: 76 ill(album, 12);
Christies Lon 3/15/79: 120 (album, L-1 et al);
Christies Lon 10/25/79: 161 (albums, L et al);
Rose Boston Cat 5, 1980: 53 ill(note), 54 ill, 55 ill;
Swann NY 4/17/80: 245 (lot, L et al), 335 (lot, L et al);
Auer Paris 5/31/80: 110 (11);
Sothebys Lon 3/27/81: 23 (12);
California Galleries 5/23/82: 395 (lot, L et al);
Swann NY 11/18/82: 373 (albums, L et al);
Harris Baltimore 4/8/83: 103 (lot, L et al), 104 (27);
Swann NY 5/5/83: 344 (albums, L et al);

**L., L.** (continued)
Christies Lon 10/25/84: 55 (lot, L-24 et al);
California Galleries 6/8/85: 141 (album, L et al);
Swann NY 11/14/85: 190 (lot, L et al);

**L., M.** [M.L.]
Photos dated: 1880s and/or 1890s
Processes:    Albumen
Formats:      Prints
Subjects:     Topography
Locations:    England - London
Studio:       Europe
    Entries:
Christies Lon 6/24/82: 103 (album, L et al);

**L., M.W.** [M.W.L.]
Photos dated: 1870s-c1880
Processes:    Albumen
Formats:      Prints
Subjects:     Architecture
Locations:    Ireland
Studio:       Europe
    Entries:
Rinhart NY Cat 2, 1971: 416 (album, L et al);
Rinhart NY Cat 7, 1973: 149 (album, L et al);

**L., P.** [P.L.] [L., P. 1]
Photos dated: 1850s
Processes:    Albumen
Formats:      Prints
Subjects:     Topography
Locations:    Spain - Seville
Studio:
    Entries:
Sothebys Lon 6/29/79: 137 (lot, L-2 et al);

**L., P.** [P.L.] [L., P. 2] (French)(possibly P.
              Loubère, q.v.)
Photos dated: 1870s
Processes:    Albumen
Formats:      Stereos, prints
Subjects:     Topography, architecture, documentary
              (Paris Commune)
Locations:    France - Paris
Studio:       France - Paris
    Entries:
Swann NY 11/11/76: 388 (albums, L et al), 389
    (albums, L et al), 395 (albums, L et al);
Swann NY 12/8/77: 413 (lot, L et al);
Swann NY 4/26/79: 357 (album, 20)(note);
Christies Lon 10/30/80: 134 (49);
Christies Lon 3/29/84: 27 (lot, L-47 et al);

**L., P.S. & A.C.** [P.S. & A.C.L.]
Photos dated: Nineteenth century
Processes:    Albumen
Formats:      Prints
Subjects:     Topography
Locations:    Asia
Studio:
    Entries:
California Galleries 7/1/84: 484 (lot, L-1 et al);

**L., R.W.S.** [RWSL] (see LUTWIDGE, R.)

**L., S.** [S.L.] (French)
Photos dated: 1860s
Processes:    Albumen
Formats:      Stereos (tissues)
Subjects:     Genre
Locations:    Studio
Studio:       France
    Entries:
Christies Lon 3/11/82: 70 (lot, L-13 et al);
Christies Lon 6/24/82: 68 (7);
Christies Lon 4/24/86: 349 (lot, L et al);

**L., T.M.** [T.M.L.] (British)
Photos dated: 1850s
Processes:    Salt
Formats:      Prints
Subjects:
Locations:    Great Britain
Studio:       Great Britain
    Entries:
Sothebys Lon 7/1/77: 184 (album, L et al)(note);

**L., T.P.** [T.P.L.]
Photos dated: c1865-1875
Processes:    Albumen
Formats:      Prints
Subjects:     Topography
Locations:    Scotland
Studio:       Europe
    Entries:
Wood Conn Cat 37, 1976: 233 (album, L et al);

**L., W.** [W.L.] (British)
Photos dated: c1887
Processes:    Albumen
Formats:      Prints
Subjects:     Topography
Locations:    Great Britain; Ireland
Studio:       Great Britain
    Entries:
Swann NY 12/8/77: 367 (lot, L et al);
Sothebys Lon 3/14/79: 157 (album, 20);
Christies Lon 10/25/79: 136 (album, L et al), 246
    (albums, L-14 et al);
Phillips NY 5/21/80: 139 (albums, L et al);
Christies Lon 3/26/81: 156 (album, L et al);
Harris Baltimore 3/26/82: 415 (11);
Swann NY 5/5/83: 284 (albums, L et al);
Christies NY 9/11/84: 123 (album, L et al);
California Galleries 6/8/85: 141 (album, L et al);
Christies Lon 10/31/85: 132 (albums, L et al);
Christies Lon 4/24/86: 410 (lot, L-6 et al);

**LABAURE, L.**
Photos dated: Nineteenth century
Processes:    Albumen
Formats:      Prints
Subjects:     Topography
Locations:    Ecuador - Guayaquil
Studio:
    Entries:
Harris Baltimore 12/16/83: 47 (lot, L-1 et al);

**LABRADOR, de** (French)
Photos dated: between 1850s and 1870s
Processes: Collotype
Formats: Prints
Subjects: Documentary (engineering)
Locations: France - Bayonne
Studio: France - Bayonne
  Entries:
Sothebys LA 2/13/78: 121 (books, D et al)(note);

**LADD, J. Henry** (American)(photographer?)
Photos dated: 1860
Processes: Salt
Formats: Prints
Subjects: Portraits
Locations: US - Schenectady, New York
Studio: US - Schenectady, New York
  Entries:
Swann NY 5/5/83: 152 (album, 300)(note);

**LADMORE and Son** (British)
Photos dated: 1863
Processes: Albumen
Formats: Prints, stereos
Subjects: Topography
Locations: England - Hereford
Studio: England
  Entries:
Christies Lon 3/11/82: 88 (lot, L et al);
Christies Lon 3/28/85: 165 ill(lot, L et al)(note);

**LADREY, E.** (French)
Photos dated: 1870s-c1890
Processes: Albumen
Formats: Cabinet cards
Subjects: Topography, portraits
Locations: France - Paris
Studio: France
  Entries:
Phillips Lon 11/4/83: 78A (lot, L-36 et al);
Harris Baltimore 3/15/85: 273 (lot, L et al);

**LAEFFLER, A.**
Photos dated: 1896
Processes:
Formats: Prints
Subjects: Documentary (maritime)
Locations:
Studio:
  Entries:
Swann NY 12/14/78: 357;

**LAFAYETTE, J.** (French)
Photos dated: c1880-1897
Processes: Photogravure, woodburytype, bromide
Formats: Prints, cabinet cards
Subjects: Portraits
Locations: Studio
Studio: England - London; Ireland - Dublin
  Entries:
California Galleries 1/21/78: 140 (album, L et al),
  141 (album, L et al);
Christies Lon 3/20/80: 344;
Swann NY 4/17/80: 75 (book, L et al);
Sothebys Lon 6/17/81: 248 (lot, L-1 et al);
Christies Lon 10/29/81: 293 (book, L et al), 384;

**LAFAYETTE, J.** (continued)
Swann NY 5/5/83: 78 (book, L et al);
Swann NY 5/10/84: 176 (lot, L et al);
Sothebys Lon 4/25/86: 168 (books, L et al);

**LAFON, L.** (French)
Photos dated: c1890
Processes: Albumen
Formats: Prints
Subjects: Topography
Locations: France - Paris
Studio: France
  Entries:
California Galleries 6/28/81: 155 (album, L et al);

**LAFON DE CAMARSAC** (French)
Photos dated: 1855-1880
Processes: Collodion on enamel and porcelain
Formats: Plaques
Subjects: Portraits
Locations: Studio
Studio: France - Paris
  Entries:
Auer Paris 5/31/80: 37 (note);

**LAFRANCHINI**
Photos dated: between 1850s and 1870s
Processes: Albumen
Formats: Prints
Subjects: Topography
Locations: Europe
Studio: Europe
  Entries:
Sothebys Lon 3/15/82: 65 (lot, L et al);

**LAGGER, de** (French)
Photos dated: 1860s
Processes: Albumen
Formats: Cdvs
Subjects: Portraits
Locations: Studio
Studio: France - Toulouse
  Entries:
Petzold Germany 310 (album, D et al);

**LAGRIFFE, Dre.**
Photos dated: 1860s
Processes: Albumen
Formats: Cdvs
Subjects: Portraits
Locations:
Studio:
  Entries:
Christies Lon 10/30/80: 420 (album, L-1 et al);
Christies Lon 6/18/81: 426 (album, L-1 et al);

**LAI YONG** (see YONG, Lai)

**LAI, Afong** (Chinese)
Photos dated: 1859-1900
Processes:      Albumen
Formats:        Prints
Subjects:       Topography, portraits
Locations:      China - Hong Kong
Studio:         China
    Entries:
Phillips NY 5/9/81: 64 (album, L attributed et al);
Christies Lon 3/28/85: 164 (2)(note);

**LAILLER, C.** (French)
Photos dated: 1878
Processes:      Photochrome
Formats:        Prints
Subjects:       Documentary
Locations:      France
Studio:         France
    Entries:
Christies Lon 3/24/83: 158 ill (book, 2)(note);

**LAIS, Filipo** (Italian)
Photos dated: 1860s and/or 1870s
Processes:      Albumen
Formats:        Prints
Subjects:       Topography
Locations:      Italy - Rome
Studio:         Italy
    Entries:
Christies Lon 4/24/86: 378 (lot, L-3 et al)(note);

**LAISNE, Victor & E. DEFONDS** (French)
Photos dated: 1853-mid 1850s
Processes:      Salt (Blanquart-Evrard process)
Formats:        Prints
Subjects:       Portraits
Locations:      Studio
Studio:         France
    Entries:
Andrieux Paris 1950(?): 19;
Sothebys Lon 6/28/78: 300;
Sothebys NY 5/8/79: 83 ill(note);

**LAI YOUNG**
Photos dated: Nineteenth century
Processes:      Albumen
Formats:        Cdvs
Subjects:       Portraits
Locations:      Studio
Studio:         US - San Francisco, California
    Entries:
Sothebys NY (Strober Coll.) 2/7/70: 279 (lot,
    L-1 et al);

**LA LIEURE**
Photos dated: 1868
Processes:      Albumen
Formats:        Cdvs
Subjects:       Portraits
Locations:      Studio
Studio:         Italy - Turin
    Entries:
Sothebys NY 11/20/84: 106 ill(lot, L-1 et al);

**LALL, Chuni & RAM, Bhawani** (Indian)
Photos dated: c1870-c1875
Processes:      Albumen
Formats:        Prints
Subjects:       Topography
Locations:      India
Studio:         India - Muttra
    Entries:
Sothebys Lon 10/28/81: 140 (11);
Christies Lon 6/23/83: 136 (6);

**LALLEMAND & HART**
Photos dated: 1860s
Processes:      Albumen
Formats:        Stereos
Subjects:
Locations:
Studio:
    Entries:
Christies Lon 6/24/82: 67 (lot, L & H-1 et al);
Sothebys Lon 3/29/85: 228 (18);
Christies Lon 6/28/85: 224 (album, 20);

**LALLEMAND, Charles** (French)
Photos dated: late 1850s-1865
Processes:      Albumen
Formats:        Prints, stereos
Subjects:       Ethnography
Locations:      Syria; Germany - Baden and Black
                Forest
Studio:
    Entries:
Edwards Lon 1975: 86 (book, 21);
Sothebys Lon 3/22/78: 200 (book, 19);
Swann NY 4/20/78: 90 (book, 18)(note);
Sothebys Lon 6/29/84: 80 ill(book, 19);

**LALOUE, A.** (French)
Photos dated: 1860s
Processes:      Ambrotype
Formats:        Plates overpainted in oils
Subjects:       Portraits
Locations:      Studio
Studio:         France
    Entries:
Christies Lon 3/20/80: 344;

**LAMA**
Photos dated: Nineteenth century
Processes:      Albumen
Formats:        Cdvs
Subjects:       Portraits
Locations:
Studio:
    Entries:
Sothebys NY 11/21/70: 350 (lot, L-1 et al);

**LAMB, Colby** (American)
Photos dated: c1860
Processes:      Ambrotype
Formats:        Plates
Subjects:       Portraits
Locations:      Studio
Studio:         US - Newburyport, Massachusetts
    Entries:
California Galleries 3/30/80: 232 (lot, L-1 et al);

**LAMB, Ernest** (British)
Photos dated: c1898
Processes: Albumen
Formats: Stereos, prints
Subjects: Topography, architecture
Locations: Great Britain
Studio: Great Britain
   Entries:
Phillips NY 5/21/80: 193 ill(note), 194, 195 (2);
Christies Lon 6/23/83: 43 (lot, L et al);

**LAMB, H.W.**
Photos dated: 1850s and/or 1860s
Processes: Albumen
Formats: Stereos
Subjects: Topography
Locations: Great Britain
Studio: Great Britain
   Entries:
Christies Lon 6/18/81: 106 (lot, L-1 et al);
Christies Lon 10/28/82: 17 (lot, L et al);

**LAMB, J.**
Photos dated: 1860s
Processes: Ambrotype
Formats: Plates
Subjects: Portraits
Locations:
Studio:
   Entries:
Christies Lon 10/25/79: 43 (lot, L-1 et al);

**LAMBERT, G.R.** (and/or C.R., C.J.)(British)
Photos dated: c1868-1880s
Processes: Albumen, carbon
Formats: Prints, cdvs
Subjects: Topography, documentary (scientific)
Locations: Singapore; Thailand
Studio: Singapore
   Entries:
Edwards Lon 1975: 12 (album, L et al);
California Galleries 1/21/79: 341 (lot, L-1 et al),
   347 (album, L-11 et al);
Christies Lon 3/15/79: 169 (lot, L et al);
Christies Lon 10/25/79: 203 (9), 403 (albums,
   L-1 et al);
Sothebys NY 12/19/79: 96 (2 ills)(lot, L et al);
Phillips NY 5/21/80: 143 (album, 23);
Christies Lon 6/26/80: 239 (9);
Christies Lon 3/26/81: 244 (album, L-10 et al),
   248 (9);
Christies Lon 6/18/81: 235 (lot, L-1 et al);
Swann NY 11/5/81: 490 (lot, L-5 et al);
Swann NY 4/1/82: 355 (lot, L-11 et al);
Swann NY 11/18/82: 445 (lot, L-19 et al);
Christies Lon 6/23/83: 166 (albums, L et al);
Harris Baltimore 12/16/83: 410 (album, L et al);
Christies Lon 3/29/84: 105 (albums, L et al);
Christies NY 9/11/84: 136 (album, L et al);
Christies Lon 10/25/84: 110 (albums, L et al);
Harris Baltimore 3/15/85: 235 (album, 20);
Swann NY 5/9/85: 367 (lot, L et al);
Swann NY 11/13/86: 156 (lot, L et al);

**LAMOISSE, E.**
Photos dated: c1860
Processes: Albumen
Formats: Prints
Subjects: Documentary (disasters)
Locations: Guadalupe
Studio:
   Entries:
White LA 1980-81: 57 ill(12)(note);

**LAMP** (see McALPIN & LAMP)

**LAMPREY, M.S.** (American)
Photos dated: 1850s-1860s
Processes: Daguerreotype, ambrotype
Formats: Plates
Subjects: Portraits
Locations: Studio
Studio: US - Manchester, New Hampshire
   Entries:
Vermont Cat 4, 1972: 495 ill(lot, L-1 et al);

**LAMPUE** (French)
Photos dated: c1860
Processes: Albumen
Formats: Prints
Subjects: Architecture
Locations: France
Studio: France - Paris
   Entries:
Bievres France 2/6/83: 64;

**LAMSON, J.H.** (American)
Photos dated: 1878-1885
Processes: Albumen, heliotype
Formats: Prints, stereos
Subjects: Portraits, genre, topography
Locations: US - Maine
Studio: US - Portland, Maine
   Entries:
Swann NY 9/18/75: 269;
White LA 1977: 96 ill;

**LAMY, E.** (French)(see also L., E.)
Photos dated: 1860s-1870s
Processes: Albumen
Formats: Stereos, cdvs
Subjects: Topography
Locations: France - Savoy; Switzerland; Italy
Studio: France
   Entries:
Rauch Geneva 6/13/61: 223 (lot, L et al);
Rinhart NY Cat 1, 1971: 181 (6), 235 (3), 256 (2);
California Galleries 9/27/75: 443 (lot, L et al);
California Galleries 4/3/76: 393 (23);
California Galleries 1/21/78: 167 (23);
Christies Lon 3/16/78: 166 (lot, L-11 et al), 167
   (lot, L-7 et al);
Christies Lon 10/25/79: 78 (lot, L-12 et al);
Christies Lon 6/26/80: 114 (lot, L-2 et al);
Christies Lon 10/30/80: 137 (lot, L et al);
Christies Lon 6/29/81: 143 (lot, L et al);
Harris Baltimore 7/31/81: 106 (lot, L-20 et al);
Christies Lon 10/29/81: 144 (lot, L et al)(note);
Swann NY 11/5/81: 550 (lot, L et al);
Christies Lon 3/11/82: 66 (lot, L et al);

**LAMY, E.** (continued)
Harris Baltimore 3/26/82: 14 (lot, L et al);
Harris Baltimore 4/8/83: 100 (lot, L et al);
Swann NY 11/10/83: 348 (lot, L et al);
Harris Baltimore 12/16/83: 47 (lot, L-9 attributed
   et al), 131 (lot, L-3 et al), 132 (lot, L et al);
Christies Lon 3/29/84: 24 (lot, L-3 et al);
Swann NY 5/10/84: 306 (lot, L et al);
Phillips Lon 4/24/84: 94 (lot, L-2 et al);
Harris Baltimore 6/1/84: 53 (lot, L et al), 54 (90);
Harris Baltimore 3/15/85: 55 (34);
Harris Baltimore 2/14/86: 48 (lot, L-10 et al);
Christies Lon 4/24/86: 344 (lot, L et al), 349 (lot,
   L et al);
Swann NY 11/13/86: 324 (lot, L et al);

**LANCASTER** (British)
Photos dated: Nineteenth century
Processes:      Albumen
Formats:        Stereos
Subjects:       Genre
Locations:      England
Studio:         England - Birmingham
   Entries:
Phillips Lon 10/24/84: 92 (lot, L-1 et al);

**LANCK, J.A.** (American)
Photos dated: c1868
Processes:      Albumen
Formats:        Stereos
Subjects:       Topography
Locations:      US - Zanesville, Ohio
Studio:         US
   Entries:
Harris Baltimore 6/1/84: 64 (lot, L et al);

**LANDERKIN & WINTER**
Photos dated: 1880s
Processes:
Formats:        Boudoir cards
Subjects:       Topography
Locations:      US - Alaska
Studio:         US - Juneau, Alaska
   Entries:
Swann NY 11/8/84: 136 (lot, L & W-4 et al);

**LANDY, James M.** (American, 1838-1887)
Photos dated: c1865-c1890
Processes:      Albumen, gelatin
Formats:        Prints, stereos, cdvs, cabinet cards
Subjects:       Documentary (public events),
                portraits, topography, genre
Locations:      US - Cincinnati, Ohio; Chicago,
                Illinois; New York City
Studio:         US - Cincinnati, Ohio
   Entries:
Swann NY 2/14/52: 83 (book, 127)(note);
Gordon NY 5/3/76: 298 (books, L et al);
Swann NY 11/11/76: 273 (book, 7);
Swann NY 12/8/77: 45 ill(book, 126)(note);
Swann NY 4/17/80: 59 ill(book, 130)(note);
California Galleries 12/13/80: 226, 227;
Harris Baltimore 3/26/82: 398 (lot, L-1 et al);
Harris Baltimore 9/16/83: 148 (lot, L et al), 149
   (lot, L et al);
Harris Baltimore 6/1/84: 268;

**LANDY, J.** (continued)
Sothebys Lon 6/28/85: 227 (book, 7);
Wood Boston Cat 58, 1986: 136 (books, L-2 et al);

**LANE** (American) [LANE 1]
Photos dated: 1870s
Processes:      Albumen
Formats:        Stereos
Subjects:       Topography
Locations:      US - Maine
Studio:
   Entries:
Harris Baltimore 12/10/82: 53 (lot, L et al);

**LANE** (American) [LANE 2]
Photos dated: Nineteenth century
Processes:      Albumen
Formats:        Cabinet cards
Subjects:       Portraits
Locations:      Studio
Studio:         US - Chattanooga, Tennessee
   Entries:
Harris Baltimore 9/16/83: 154 (lot, L-1 et al);

**LANE, W.** (British)
Photos dated: 1860s
Processes:      Ambrotype ("verreotype")
Formats:        Plates
Subjects:       Portraits
Locations:      Studio
Studio:         England - Brighton
   Entries:
Christies Lon 10/30/80: 73 (2);

**LANG, Charles B.** (American)
Photos dated: 1896-1899
Processes:      Photogravures, collotype
Formats:        Prints
Subjects:       Topography, ethnography
Locations:      Mexico
Studio:         US - Bluff City, Utah
   Entries:
Witkin NY I 1973: 195 (book, L et al);
Witkin NY II 1974: 217 (book, L et al);
Witkin NY III 1975: 750 (book, L et al);
Swann NY 11/5/81: 200 ill(book, L et al)(note);
Swann NY 4/1/82: 205 ill(book, L et al)(note);
Swann NY 11/18/82: 232 (book, L et al)(note);
Swann NY 11/13/86: 97 (book, L et al)(note);

**LANG, G.G.** (German)
Photos dated: c1880
Processes:      Albumen
Formats:        Cdvs
Subjects:       Topography
Locations:      Germany
Studio:         Germany
   Entries:
Rinhart NY Cat 7, 1973: 546 (3);

**LANGAKI** (see ZANGAKI)

**LANGDON & TALLMAN**
Photos dated: Nineteenth century
Processes:      Albumen
Formats:        Stereos
Subjects:       Topography
Locations:      US - Niagara Falls, New York
Studio:
    Entries:
Harris Baltimore 7/31/81: 111 (lot, L & T et al);

**LANGE, Emilio**
Photos dated: 1860s-1900
Processes:      Albumen
Formats:        Cdvs, cabinet cards
Subjects:
Locations:      Mexico
Studio:         Mexico
    Entries:
Swann NY 9/18/75: 180 (60);

**LANGE, Paul**
Photos dated: 1893
Processes:      Photogravure
Formats:        Prints
Subjects:       Topography
Locations:      Norway
Studio:
    Entries:
Sothebys Lon 7/1/77: 143 (book, 43);
Sothebys NY 10/4/77: 132 ill(book, 50);
Sothebys Lon 10/27/78: 91 (book, 50);
Christies Lon 10/30/80: 311 (book, 38);
Christies Lon 10/28/82: 120 (lot, L-20 et al);

**LANGENHEIM, Frederick** (1809-1879) **& William**
                (1807-1874)(American)
Photos dated: c1842-1856
Processes:      Daguerreotype, calotype, glass
                transparency, albumen
Formats:        Plates incl. stereo, stereo cards,
                prints
Subjects:       Portraits, topography, genre
Locations:      Germany; Egypt; US - New York and New
                Hampshire; England; France; Italy;
Studio:         US - Philadelphia, Pennsylvania
    Entries:
Sothebys NY (Weissberg Coll.) 5/16/67: 90 (lot, L-1
    et al), 97 (lot, L-1 et al)(note), 193 (lot, L-1
    et al);
Sothebys NY (Strober Coll.) 2/7/70: 199, 432 (3)
    (note), 433 (2)(note), 434 (3)(note), 435 (3),
    436 ill(2)(note), 437 (3);
Vermont Cat 1, 1971: 225;
Vermont Cat 4, 1972: 594 ill;
Rinhart NY Cat 6, 1973: 478 (L, Lloyd);
Rinhart NY Cat 7, 1973: 255 (L, Lloyd);
Vermont Cat 9, 1975: 571 ill(L, Lloyd), 527 ill(2);
Sothebys NY 2/25/75: 113 ill;
Sothebys NY 9/23/75: 87 ill(4);
California Galleries 9/27/75: 496 (5);
Colnaghi Lon 1976: 239 ill(note);
Swann NY 4/1/76: 196;
California Galleries 4/3/76: 375 (lot, L et al);
Sothebys NY 11/9/76: 12 (3), 13 (lot, L-2 et al),
    14 (lot, L-5 et al);
Gordon NY 11/13/76: 44 (lot, L-1 et al), 57 ill;
Vermont Cat 11/12, 1977: 807 ill(L, Lloyd, 2);
California Galleries 1/23/77: 399 (5);

**LANGENHEIM** (continued)
Swann NY 12/14/78: 313 (note), 314 (10);
California Galleries 1/21/79: 291 (note);
Christies Lon 6/28/79: 6;
Christies Lon 3/20/80: 15;
Christies Lon 3/26/81: 117 (lot, L et al);
Swann NY 4/23/81: 241 ill(lot, L-1 et al);
Sothebys Lon 6/17/81: 20 (lot, L-8 et al);
Wood Conn Cat 49, 1982: 266 (book, L-1 et al)(note);
Christies Lon 6/24/82: 73 (lot, L-3 et al);
Harris Baltimore 12/10/82: 12 (note), 107 ill(note);
Harris Baltimore 4/8/83: 48, 49 (3);
Swann NY 5/5/83: 432 (2);
Swann NY 11/10/83: 354 (lot, L & Lloyd et al)(note);
Phillips Lon 6/26/85: 134 (lot, L-1 et al);
Christies Lon 10/31/85: 54 (lot, L-2 et al);
Swann NY 11/14/85: 168 (lot, L et al);
Swann NY 11/13/86: 328 (lot, L-2 et al);

**LANGEROCK**
Photos dated: 1871
Processes:      Albumen
Formats:        Prints
Subjects:       Documentary (Paris Commune)
Locations:      France - Paris
Studio:
    Entries:
Sothebys Lon 10/18/74: 168 ill(lot, L et al);
Swann NY 4/26/79: 358 (album, L et al);
Sothebys NY 11/10/86: 386 (lot, L-7 et al);

**LANGILL** (American)(see also DARLING)
Photos dated: 1888-c1890
Processes:      Albumen
Formats:        Prints
Subjects:       Documentary (public events,
                engineering)
Locations:      US - New York City
Studio:         US
    Entries:
Phillips NY 5/21/80: 295;
Swann NY 11/5/81: 518;

**LANGILL, Howard H.H.** (American)
Photos dated: 1852-1884
Processes:      Daguerreotype, albumen
Formats:        Plates, prints, cdvs
Subjects:       Portraits, documentary (educational
                institutions), topography
Locations:      US - Hanover, New Hampshire; Vermont
Studio:         US - Hanover, New Hampshire
    Entries:
Swann NY 10/18/79: 307;
Harris Baltimore 12/10/82: 106 (lot, L et al);
Harris Baltimore 4/8/83: 109 (lot, L et al);

**LANGLEY** (American)
Photos dated: Nineteenth century
Processes:      Albumen
Formats:        Cabinet cards
Subjects:       Portraits
Locations:      Studio
Studio:         US - Manchester, New Hampshire
    Entries:
Harris Baltimore 4/8/83: 311 (lot, L-1 et al);

**LAPPANE, Professor** (French)
Photos dated: 1850s
Processes:      Daguerreotype
Formats:        Plates
Subjects:       Portraits
Locations:      Studio
Studio:         France - Paris
    Entries:
Petzold Germany 11/7/81: 152 ill;

**LAPORTE** (French)
Photos dated: 1850s
Processes:      Daguerreotype
Formats:        Plates incl. stereo
Subjects:       Portraits
Locations:      Studio
Studio:         France
    Entries:
Rose Boston Cat 2, 1977: 139 ill;

**LARANJO** (Portuguese)
Photos dated: 1880s
Processes:      Albumen
Formats:        Cdvs
Subjects:       Ethnography
Locations:      Azores - Fayal
Studio:         Azores - Fayal
    Entries:
Swann NY 11/5/81: 425 ill(lot, L-1 et al)(note);

**LARCO**
Photos dated: Nineteenth century
Processes:      Albumen
Formats:        Cdvs
Subjects:       Portraits
Locations:
Studio:
    Entries:
Sothebys NY 11/21/70: 328 (lot, L et al);

**LARKIN** (see MOULTON & LARKIN)

**LARKIN, J.E.** (American)
Photos dated: 1870s
Processes:      Albumen
Formats:        Stereos
Subjects:       Topography
Locations:      US - New York State
Studio:         US - Elmira, New York
    Entries:
Harris Baltimore 2/14/86: 38 (lot, L et al);

**LA ROCHE, F.** (American)
Photos dated: c1892-c1900
Processes:      Albumen, platinum, bromide
Formats:        Prints
Subjects:       Topography, ethnography
Locations:      US - Alaska; Washington; Oregon
Studio:         US - Seattle, Washington
    Entries:
Rinhart NY Cat 8, 1973: 93 (2);
White LA 1977: 97 ill;
California Galleries 1/21/78: 370 (lot, L-1 et al);
California Galleries 3/30/80: 338;
California Galleries 12/13/80: 300, 301 (4);

**LA ROCHE, F.** (continued)
California Galleries 6/28/81: 273 (4);
Swann NY 11/10/83: 173 (3);
Swann NY 11/13/86: 126 (lot, L et al), 262 (3)
    (note);

**LAROCHE, Sylvester** (aka M. LAROCHE?)
Photos dated: 1853-1860s
Processes:      Albumen
Formats:        Stereos, prints
Subjects:       Genre, documentary (public events)
Locations:
Studio:
    Entries:
Sothebys Lon 10/29/76: 29 (lot, L-13 et al);
Christies NY 10/31/79: 14 (note);
Sothebys Lon 3/27/81: 385 ill;
Christies Lon 3/24/83: 36 (lot, L et al);
Christies Lon 6/23/83: 26 (lot, L et al);
Christies Lon 10/27/83: 36 (lot, L-1 et al);
Christies Lon 6/28/84: 40 (lot, L et al), 48 (lot,
    L et al), 49 (lot, L et al);
Christies Lon 10/25/84: 37 (lot, L et al);
Sothebys Lon 6/28/85: 120 ill;
Christies Lon 4/24/86: 360 (lot, L-2 et al);
Swann NY 11/13/86: 262 (3)(note);

**LASSAVE**
Photos dated: late 1880s
Processes:      Albumen
Formats:        Prints
Subjects:       Ethnography
Locations:      Tunis
Studio:         Tunis
    Entries:
Rinhart NY Cat 7, 1973: 444;

**LASSIMONE** (see DURAND-BRAGER & LASSIMONE)

**LATCHMORE, T.**
Photos dated: 1881
Processes:      Albumen
Formats:        Cdvs
Subjects:       Portraits
Locations:      St. Hitchin
Studio:
    Entries:
Swann NY 11/10/83: 316;

**LATHAM** (British)
Photos dated: c1855-1860s
Processes:      Daguerreotype, ambrotype
Formats:        Plates
Subjects:       Portraits
Locations:      Studio
Studio:         England - Bristol
    Entries:
Christies Lon 3/15/79: 25 (lot, L-1 et al);
Christies Lon 10/25/79: 45 (lot, L-1 et al);

**LATHAM, Charles** (British)
Photos dated: 1894
Processes: Collotype
Formats: Prints
Subjects: Architecture
Locations: England
Studio: Great Britain
   Entries:
Swann NY 11/10/83: 102 (book, 145);

**LATHAM, John** (British)
Photos dated: 1860s
Processes: Albumen
Formats: Stereos
Subjects: Topography
Locations: England - Matlock
Studio: Great Britain
   Entries:
Sothebys Lon 10/29/80: 14 (lot, L et al);
Christies Lon 10/30/80: 113 (lot, L-16 et al);
Harris Baltimore 7/31/81: 97 (lot, L et al);
Christies Lon 3/11/82: 88 (lot, L et al);
Christies Lon 6/24/82: 71 (lot, L et al);
Christies Lon 10/28/82: 17 (lot, L et al), 21
   (lot, L et al);
Sothebys Lon 3/25/83: 4 (lot, L et al);
Christies Lon 10/25/84: 44 (lot, L et al);
Sothebys Lon 6/28/85: 1 (lot, L et al);

**LATOURETTE, A.V.**
Photos dated: Nineteenth century
Processes: Albumen
Formats: Stereos
Subjects: Topography
Locations: US - Texas
Studio:
   Entries:
Sothebys NY (Strober Coll.) 2/7/70: 504 (lot,
   L et al);

**LAUDER Brothers**
Photos dated: 1850s
Processes: Daguerreotype, ambrotype
Formats: Plates
Subjects: Portraits
Locations: Studio
Studio: Ireland - Dublin
   Entries:
Sothebys Lon 6/17/81: 50, 75;

**LAURENT, J.** (French)
Photos dated: 1860s-1880s
Processes: Albumen
Formats: Prints, cdvs
Subjects: Topography, ethnography, genre
Locations: Gibraltar; Spain; Portugal; France
Studio: Spain - Madrid; France - Paris
   Entries:
Sothebys NY (Strober Coll.) 2/7/70: 265 (lot,
   L-2 et al);
Rinhart NY Cat 1, 1971: 528 ill(books, 700);
Rinhart NY Cat 2, 1971: 376 (12);
Rinhart NY Cat 7, 1973: 71 ill(album, 116);
California Galleries 9/26/75: 160 (album, 107);
California Galleries 9/27/75: 307 (4), 308 (7);

**LAURENT** (continued)
Colnaghi Lon 1976: 261 (attributed)(note), 262 ill
   (attributed), 263 ill(attributed), 264
   (attributed), 265;
Christies Lon 10/28/76: 116 (album, 33), 117
   (album, L et al);
White LA 1977: 41 (note), 42 ill;
California Galleries 1/22/77: 171 (album, L et al),
   205 (album, 107), 327 (6);
Sothebys NY 5/20/77: 101 (album, L-77 et al);
Christies Lon 6/30/77: 101 (album, L-21 et al);
Christies Lon 10/27/77: 365 (album, L et al);
Lunn DC Cat QP, 1978: 36 (album, 111);
Christies Lon 3/16/78: 305 (lot, L et al)(note);
Christies Lon 6/27/78: 91 (album, L-130 et al), 92
   (album, L et al);
Sothebys NY 11/2/78: 207 ill(lot, L et al)(note);
California Galleries 1/21/79: 473 ill(7), 474 (2);
Christies Lon 3/15/79: 120 (album, L-5 et al);
Swann NY 4/26/79: 282 (albums, L et al);
Christies Lon 10/25/79: 155 (albums, L-90 et al),
   234 (album, L-9 et al);
Sothebys LA 2/6/80: 113 ill(album, 22);
Christies NY 5/16/80: 201 (lot, L-3 et al);
Phillips NY 5/21/80: 128 (albums, L et al)(note),
   136 ill(album, L-5 et al);
Christies Lon 6/26/80: 207 (lot, L et al), 477
   (album, L-1 et al);
Christies Lon 10/30/80: 192 (album, L et al), 420
   (album, L-3 et al);
California Galleries 12/13/80: 302 (11), 303 (3),
   304 (2);
Christies Lon 3/26/81: 163 (albums, L-2 et al), 180
   (album, 50), 199 (albums, L et al), 412 (album,
   L-18 et al);
Swann NY 4/23/81: 405 (lot, L-2 et al);
Christies Lon 6/18/81: 426 (album, L-3 et al);
Swann NY 11/5/81: 467 (album, L-7 et al), 517 (lot,
   L et al), 546 (lot, L-1 et al);
Rose Florida Cat 7, 1982: 68 ill(10)(note);
Christies Lon 3/11/82: 126 (10), 145 (lot, L-2
   et al);
Swann NY 4/1/82: 288 (albums, L et al)(note);
California Galleries 5/23/82: 189 (album, L et al),
   392 (lot, L-2 et al);
Phillips NY 9/30/82: 1043 ill(albums, L et al);
Sothebys Lon 3/25/83: 49 ill(album, 100);
Christies Lon 6/23/83: 120 ill(15);
Christies Lon 10/27/83: 80 (album, L-18 et al);
Swann NY 11/10/83: 304 (albums, L-50 et al);
Fraenkel Cal 1984: 30 ill(note), 31, 32, 33, 34, 35
   ill, 36, 37 ill, 38 ill, 39, 40 ill, 41 ill, 42,
   43, 44 (2 ills)(album, 80)(note), 45 (2 ills)
   (album, 17)(note), 46 ill(album, 115);
Christies NY 2/22/84: 8 (lot, L et al);
Swann NY 5/10/84: 322 (albums, L et al)(note);
Harris Baltimore 6/1/84: 327 (lot, L et al), 400;
Christies Lon 6/28/84: 140 (album, L et al);
Sothebys Lon 10/26/84: 33 (album, L et al);
Christies Lon 6/27/85: 66 ill(album, 16), 67
   ill(album, L et al);
Sothebys Lon 6/28/85: 46 (albums, 75);
Swann NY 11/14/85: 162 (lot, L et al);
Harris Baltimore 2/14/86: 221 (album, 95);
Christies Lon 4/24/86: 383 ill(album, 55);
Sothebys NY 5/12/86: 403 (album, L et al);
Swann NY 5/16/86: 233 (lot, L et al);
Christies Lon 10/30/86: 147 (22);
Phillips NY 11/12/86: 120 (6);

LAURENT, J.B. (German)
Photos dated: c1860
Processes:      Albumen
Formats:        Cdvs
Subjects:       Portraits
Locations:      Studio
Studio:         Germany - Mainz
    Entries:
Petzold Germany 11/7/81: 300 (album, L-1 et al);

LAURIE & Co.
Photos dated: 1874-1880s
Processes:      Albumen
Formats:        Prints incl. panoramas
Subjects:       Topography, documentary (railroads)
Locations:      India
Studio:
    Entries:
Christies Lon 10/25/79: 195 (album, L-2 et al);
Sothebys Lon 10/28/81: 138 (album, L et al);
Christies Lon 10/29/81: 276 (albums, L-2 et al);
Christies Lon 6/24/82: 198 (albums, L & Lloyd-1,
    et al);
Phillips Lon 6/26/85: 177 (album, L et al);

LAURO, E. (Italian)
Photos dated: 1884
Processes:      Albumen
Formats:        Prints
Subjects:       Topography
Locations:      Italy - Pompeii
Studio:         Italy
    Entries:
Rinhart NY Cat 1, 1971: 519 (book, L et al);
Rinhart Cat 6, 1973: 105 (book, 23);
California Galleries 1/21/79: 126 (book, 40);
California Galleries 6/8/85: 109 (book, 39);

LAVENDER (British)
Photos dated: Nineteenth century
Processes:
Formats:
Subjects:       Portraits
Locations:      Studio
Studio:         England - Bromley
    Entries:
Edwards Lon 1975: 12 (album, L et al);

LAVIS, G.& R. (British)
Photos dated: 1860s
Processes:      Albumen, woodburytype
Formats:        Prints, stereos
Subjects:       Topography, portraits
Locations:      England
Studio:         England - Eastbourne
    Entries:
Edwards Lon 1975: 12 (album, L et al);
Christies Lon 6/26/80: 331 (book, 1);
Sothebys Lon 10/29/80: 14 (lot, L et al);
Sothebys Lon 6/29/84: 9 (lot, L et al);
Christies NY 2/13/85: 119 (lot, L et al)(note);
Christies Lon 10/31/85: 305 (album, L-4 et al);

LAW, W.W. (British)
Photos dated: c1880
Processes:      Albumen
Formats:        Cdvs
Subjects:       Topography
Locations:      England - London
Studio:         Great Britain
    Entries:
California Galleries 6/8/85: 323 (lot, L-2 et al);

LAWRENCE [LAWRENCE 1](American)
Photos dated: 1870s
Processes:      Albumen
Formats:        Stereos, cabinet cards
Subjects:       Topography, portraits
Locations:      US - New Hampshire
Studio:         US - Lawrence, Massachusetts
    Entries:
Swann NY 11/5/81: 553 (lot, L et al);
Swann NY 11/8/84: 225 (album, L et al);

LAWRENCE & HOUSEWORTH [LAWRENCE 2] (American)
Photos dated: 1865-1870
Processes:      Albumen
Formats:        Stereos, cdvs
Subjects:       Topography, documentary (industrial)
Locations:      US - San Francisco, California
Studio:         US - San Francisco, California
    Entries:
Sothebys NY (Strober Coll.) 2/7/70: 496 (26), 523
    (lot, L & H-18 et al);
Rinhart NY Cat 1, 1971: 311 (lot, L & H-1 et al);
Rinhart NY Cat 2, 1971: 389, 562;
Rinhart NY Cat 6, 1973: 600, 614;
Rinhart NY Cat 7, 1973: 298 ill;
Vermont Cat 9, 1975: 537 ill;
Swann NY 4/14/76: 323 (lot, L & H et al);
California Galleries 1/21/78: 131 (album, L & H
    et al);
Swann NY 10/18/79: 418 ill(8)(note);
California Galleries 3/30/80: 387 (lot, L & H-1
    et al), 399 (3);
Swann NY 11/18/82: 453 (lot, L & H-2 et al);

LAWRENCE, Amos (American, died c1857)
Photos dated: 1854-1857
Processes:      Calotype
Formats:        Prints
Subjects:       Topography, portraits
Locations:      US - New England; New York
Studio:         US - New York City
    Entries:
Sothebys NY (Strober Coll.) 2/7/70: 31 (books,
    L et al), 344 (lot, L et al)(note);
Sothebys NY 11/21/70: 31 ill(book, 22)(note);

LAWRENCE, D.T. (American)
Photos dated: c1858
Processes:      Daguerreotype, ambrotype
Formats:        Plates
Subjects:       Portraits, documentary (industrial)
Locations:      Studio
Studio:         US - Newburgh, New York
    Entries:
Sothebys NY (Strober Coll.) 2/7/70: 158 (lot,
    L-1 et al), 209 (lot, L-1 et al);
Rinhart NY Cat 1, 1971: 89;

**LAWRENCE, D.T.** (continued)
Rinhart NY Cat 2, 1971: 196 (lot, L-1 et al);
Vermont Cat 7, 1974: 556 ill;
California Galleries 6/28/81: 169 (lot, L-1 et al);

**LAWRENCE, John**
Photos dated: 1860s
Processes:      Ambrotype
Formats:        Plates
Subjects:       Portraits
Locations:      Studio
Studio:         Ireland - Dublin
  Entries:
Vermont Cat 4, 1972: 396 ill;

**LAWRENCE, Martin M.** (American, born 1808)
Photos dated: 1842-c1854
Processes:      Daguerreotype, salt
Formats:        Plates, prints
Subjects:       Portraits
Locations:      Studio
Studio:         US - New York City
  Entries:
Swann NY 4/23/81: 421 (note);

**LAWRENCE, T.C.** (British)
Photos dated: 1860s
Processes:      Ambrotype
Formats:        Plates
Subjects:       Portraits
Locations:      Studio
Studio:         England - Greenwich
  Entries:
Vermont Cat 9, 1975: 462 ill, 463 ill(attributed);

**LAWRENCE, William M.** (British)
Photos dated: c1860-1882
Processes:      Albumen
Formats:        Prints, stereos
Subjects:       Topography, documentary (military,
                art)
Locations:      Great Britain; Ireland - Dublin
Studio:         Northern Ireland - Belfast
  Entries:
Rinhart NY Cat 1, 1971: 486 (46);
Vermont Cat 4, 1972: 530 ill(note), 531 ill, 532
  ill, 533 ill, 534 ill, 535 ill, 536 ill, 537
  ill, 538 ill;
Rinhart NY Cat 7, 1973: 149 (album, L et al);
California Galleries 9/27/75: 489 (lot, L-5 et al);
Wood Conn Cat 37, 1976: 122 (book, 10)(note);
California Galleries 1/23/77: 396 (lot, L-5 et al);
Rose Boston Cat 3, 1978: 26 ill(note);
Sothebys Lon 10/24/79: 33 (book, 7);
Christies Lon 3/20/80: 149 (album, L et al), 204
  (lot, L et al);
Christies Lon 6/26/80: 200 (album, L et al), 270
  (album, L-18 et al);
Christies Lon 10/30/80: 117 (lot, L-17 et al), 191
  (albums, L et al);
Christies Lon 3/26/81: 151 (lot, L et al);
California Galleries 6/28/81: 188 (lot, L et al);
Christies Lon 10/29/81: 170 (lot, L et al);
Christies Lon 6/24/82: 226 (album, L et al);
Harris Baltimore 4/8/83: 42 (lot, L et al);
Christies Lon 10/27/83: 60 (albums, L et al);
Christies Lon 3/29/84: 342 ill(album, L-26 et al);

**LAWRENCE, W.L.**
Phillips Lon 10/24/84: 99 (album, 87);
Swann NY 11/8/84: 154 (albums, L et al), 155
  (albums, L et al);
Christies Lon 3/28/85: 213 (album, L et al);
Swann NY 5/9/85: 386 (albums, L et al)(note);
Christies Lon 6/27/85: 95 (album, L et al);
Wood Boston Cat 58, 1986: 136 (books, L-1 et al);

**LAWRENCE, W.H.** (American)
Photos dated: 1880s-1890
Processes:      Albumen
Formats:        Prints, cabinet cards
Subjects:       Topography
Locations:      US - Colorado
Studio:         US
  Entries:
Christies Lon 3/10/77: 173 (lot, L-3 et al);
Christies Lon 6/30/77: 133 (lot, L et al);
Christies Lon 10/27/77: 166 (lot, L-3 et al);
California Galleries 6/19/83: 227 (lot, L-1 et al);
Harris Baltimore 12/16/83: 305 (lot, L et al);
Harris Baltimore 2/14/86: 329 (lot, L-1 et al);
Swann NY 11/13/86: 133 (lot, L et al);

**LAWRIE, D.** (British)
Photos dated: 1860s
Processes:      Albumen
Formats:        Prints
Subjects:
Locations:
Studio:         Great Britain (Amateur Photographic
                Association)
  Entries:
Christies Lon 10/27/83: 218 (albums, L-1 et al);

**LAWRIE, G.W.**
Photos dated: c1870s
Processes:      Albumen
Formats:        Cdvs
Subjects:       Portraits
Locations:      Studio
Studio:         India - Lucknow
  Entries:
Edwards Lon 1975: 23 (albums, L-1 et al);
Christies Lon 6/26/86: 92 (albums, L-4 et al);

**LAWS, P.M.** (British)
Photos dated: Nineteenth century
Processes:      Albumen
Formats:        Stereos
Subjects:       Topography
Locations:      Great Britain
Studio:         Great Britain
  Entries:
Christies Lon 3/11/82: 82 (lot, L-1 et al);

**LAWSON**
Photos dated: 1870s and/or 1880s
Processes:      Albumen
Formats:        Cdvs
Subjects:       Portraits
Locations:
Studio:
  Entries:
Christies Lon 3/11/82: 339 (lot, L-1 et al);

**LAWTON** (British)
Photos dated: 1860s-early 1880s
Processes:      Albumen
Formats:        Prints
Subjects:       Topography
Locations:      Ceylon
Studio:
   Entries:
Sothebys NY 11/2/79: 249 (books, L et al)(note);
Christies Lon 3/26/81: 224 (album, L-16 et al);
Sothebys Lon 3/27/81: 96 (lot, L et al);
Sothebys Lon 6/17/81: 177 (lot, L et al);
Phillips Lon 6/23/82: 68 (album, L et al);
Christies Lon 3/24/83: 100 (5);
Christies Lon 6/28/84: 93 (lot, L et al);
Sothebys Lon 6/29/84: 49 (5 ills)(album, L-1 et al);
Christies Lon 3/28/85: 97 (album, L-45 et al);
Sothebys Lon 4/25/86: 34 (lot, L-1 et al);

**LAZELLE** (see GOLDSMITH & LAZELLE)

**LAZERGUE & DALLEMAGNE** (French)
Photos dated: 1864
Processes:      Albumen
Formats:        Prints
Subjects:       Portraits
Locations:      Studio
Studio:         France
   Entries:
Colnaghi Lon 1976: 103 ill(note), 104 ill;
Lunn DC Cat QP, 1978: 2 ill(note);
Phillips Lon 3/13/79: 130 ill, 131;

**LAZIER** (American)
Photos dated: Nineteenth century
Processes:      Albumen
Formats:        Cdvs
Subjects:       Portraits
Locations:      Studio
Studio:         US - Syracuse, New York
   Entries:
Harris Baltimore 11/9/84: 100 (lot, L-1 et al);

**LEA** (see McDONALD)

**LEACH, W.L.** (American)
Photos dated: 1880s
Processes:      Albumen
Formats:        Stereos
Subjects:       Topography
Locations:      US - Florida
Studio:         US - St. Augustine, Florida
   Entries:
Harris Baltimore 12/10/82: 41 (lot, L et al);

**LEAMAN & LEE** (American)
Photos dated: c1865-1870s
Processes:      Albumen
Formats:        Prints, stereos
Subjects:       Documentary (industrial)
Locations:      US - Reading, Pennsylvania
Studio:         US - Reading, Pennsylvania
   Entries:
Wood Conn Cat 42, 1978: 213 (book, 12)(note);

**LEAVER, B.** (British)
Photos dated: 1859
Processes:      Ambrotype
Formats:        Plates
Subjects:       Portraits
Locations:      Studio
Studio:         England - Manchester
   Entries:
Christies Lon 3/10/77: 32 (lot, L-1 et al);

**LE BEAU**
Photos dated: 1850s
Processes:      Daguerreotype
Formats:        Plates
Subjects:       Portraits
Locations:      Studio
Studio:         England - London
   Entries:
Christies Lon 10/4/73: 83 (lot, L-1 et al);
Petzold Germany 11/7/81: 153 ill;

**LEBLANC, C.L.** (French)
Photos dated: 1850s-c1880
Processes:      Albumen
Formats:        Prints
Subjects:       Topography
Locations:      France - Paris; South America
Studio:         France
   Entries:
Swann NY 4/26/79: 429 (album, L et al);
Christies Lon 6/27/85: 139;
Christies Lon 6/26/86: 187;

**LE BLONDEL, A.** (French)
Photos dated: c1849-c1860
Processes:      Daguerreotype, salt, albumen
Formats:        Plates, prints
Subjects:       Genre (still life), topography
Locations:      France
Studio:         France - Lille
   Entries:
Rauch Geneva 6/13/61: 36 (lot, L-1 et al);
Weston Cal 1978: 131 ill(note), 132 ill, 133 ill,
   134 ill;
Sothebys Lon 3/14/79: 56 ill;
Christies NY 5/4/79: 40 ill(note), 41;
Christies NY 5/14/81: 25 ill(note), 26 ill;
Octant Paris 1982: 7 ill;
Sothebys Lon 6/25/82: 37 ill;
Sothebys Lon 10/31/86: 164 ill;

**LECCHI, S.** (Italian)
Photos dated: 1844-1851
Processes:      Salt
Formats:        Prints
Subjects:       Topography
Locations:      Italy - Rome
Studio:         Italy
   Entries:
Sothebys Lon 10/29/76: 149 ill(5);

**LECOCQ-FRENE** (French)
Photos dated: Nineteenth century
Processes:    Albumen
Formats:      Stereos
Subjects:     Topography
Locations:
Studio:
   Entries:
Christies Lon 3/29/84: 29 (lot, L-11 et al);

**LECOQ, E.A.**
Photos dated: c1880
Processes:    Albumen
Formats:      Prints
Subjects:     Documentary (railroads)
Locations:    Argentina - Tucuman
Studio:
   Entries:
Swann NY 11/5/81: 423 (3);

**LE CONTE, Joseph** (photographer or author?)
Photos dated: 1875
Processes:    Albumen
Formats:      Prints
Subjects:     Topography
Locations:    US - California
Studio:
   Entries:
Frontier AC, Texas 1978: 202 ill(book, 9)(note);

**LECOURY, Adolphe**
Photos dated: 1890s
Processes:    Albumen
Formats:      Prints
Subjects:     Topography
Locations:    Europe
Studio:       Europe
   Entries:
Swann NY 11/13/86: 214 (album, L et al);

**LEDGER, Henry** (British, died 1869)
Photos dated: 1860s
Processes:    Salt, albumen
Formats:      Prints
Subjects:     Topography
Locations:    England
Studio:       England
   Entries:
Sothebys Lon 6/26/75: 204 ill(album, L et al), 205
   (album, 58), 207 ill(35, attributed);

**LE DUC** (French)
Photos dated: c1855
Processes:    Salt
Formats:      Prints
Subjects:     Topography
Locations:
Studio:       France
   Entries:
Rauch Geneva 6/13/61: 47 (album, L et al)(note);

**LEE** (see PATTON & LEE) [LEE 1]

**LEE** (American) [LEE 2]
Photos dated: 1860s
Processes:    Albumen
Formats:      Cdvs
Subjects:     Portraits
Locations:    US - Virginia; Jefferson, Texas
Studio:       US - Richmond, Virginia
   Entries:
Sothebys NY (Weissberg Coll.) 5/16/67: 172 (lot,
   L et al);
Sothebys NY (Strober Coll.) 2/7/70: 259 (lot,
   L et al), 295 (lot, L et al);

**LEE** (British) [LEE 3]
Photos dated: 1857-c1860
Processes:    Daguerreotype, ambrotype
Formats:      Plates
Subjects:     Portraits
Locations:    Studio
Studio:       England - Liverpool
   Entries:
Vermont Cat 9, 1975: 464 ill;
Sothebys Lon 3/19/76: 69 (lot, L-2 et al);
Christies Lon 6/10/76: 24;
Christies Lon 10/28/76: 36;
Christies Lon 10/27/77: 27 (lot, L-1 et al);
Christies Lon 10/30/80: 61 (lot, L-1 et al);
Christies Lon 6/18/81: 49 (lot, L-1 et al)(note);
Christies Lon 10/30/86: 13 ill;

**LEE, John Edward** (British)
Photos dated: 1874
Processes:    Albumen
Formats:      Prints
Subjects:     Documentary
Locations:    England
Studio:       England
   Entries:
Wood Conn Cat 37, 1976: 124 (book, 40)(note);

**LEE, Pow** (Chinese)
Photos dated: 1880s-1890s
Processes:    Albumen
Formats:      Prints
Subjects:     Topography
Locations:    China
Studio:       China - Hankow
   Entries:
Swann NY 4/23/81: 546 (album, L et al);

**LEFEVRE, G. Shaw** (British)
Photos dated: 1855
Processes:    Albumen
Formats:      Prints
Subjects:     Documentary (Crimean War)
Locations:    Russia - Crimea
Studio:
   Entries:
Christies Lon 3/29/84: 188 ill(book, 12);
Christies Lon 6/28/84: 175 ill(book, 11)(note);
Christies Lon 4/24/86: 465 ill(book, 12);

LEGE (French)
Photos dated: 1870-1871
Processes:    Albumen
Formats:      Cdvs
Subjects:     Documentary (Paris Commune)
Locations:    France - Paris
Studio:       France
    Entries:
Sothebys Lon 6/11/76: 180 (lot, L-1 et al);

LE GRAY, Gustave (French, 1820-1882)
Photos dated: 1847-1864
Processes:    Daguerreotype, salt, albumenized
              salt, albumen
Formats:      Plates, prints, stereos, cdvs
Subjects:     Topography, portraits, documentary
              (military)
Locations:    France - Paris et al; Italy - Palermo
Studio:       France
    Entries:
Goldschmidt Lon Cat 52, 1939: 195 (4)(note);
Maggs Paris 1939: 467 (note), 513;
Weil Lon Cat 14, 1949(?): 373 (book, L et al);
Andrieux Paris 1950(?): 41, 42 (2), 43, 44;
Rauch Geneva 12/24/58: 243 (lot, L et al);
Rauch Geneva 6/13/61: 62 ill, 121 ill(note), 122,
    123 ill(note), 124 (4), 125 (note);
Colnaghi Lon 1976: 91 ill(note);
Christies Lon 6/30/77: 284 ill(note), 285 ill;
Sothebys Lon 11/18/77: 39 (lot, L-1 et al), 241 ill;
Lunn DC Cat QP, 1978: 15 (note), 16 (note), 17 ill;
Christies Lon 6/27/78: 200 ill;
Sothebys Lon 6/28/78: 325 ill, 326 ill;
Christies Lon 10/26/78: 297 ill(note);
Sothebys Lon 10/27/78: 144 ill(note), 145 ill(note);
Phillips NY 11/4/78: 51 ill, 52 ill(note);
Lehr NY Vol 1:4, 1979: 30 (book, 16)(note);
Lennert Munich Cat 5, 1979: 16;
Mancini Phila 1979: 1 ill, 2 ill;
Sothebys Lon 3/14/79: 278 ill, 279 ill;
Christies NY 5/4/79: 42 ill;
Christies Lon 6/28/79: 227 (albums, L-3 et al);
Sothebys Lon 6/29/79: 164 ill, 165 ill, 166 ill;
Sothebys Lon 10/24/79: 87 ill;
Christies NY 5/16/80: 130 ill;
Sothebys NY 5/20/80: 366 ill;
Phillips NY 5/21/80: 197a ill;
Christies Lon 6/26/80: 210 (lot, L et al);
Sothebys Lon 10/29/80: 283 ill;
Christies Lon 10/30/80: 358 ill, 420 (album,
    L-2 et al);
Christies NY 11/11/80: 57 ill;
Koch Cal 1981-82: 24 ill(note), 25 ill, 26 ill
    (L & Mestral)(note);
Christies NY 5/14/81: 34 ill(note), 35 ill, 36
    ill(note);
Sothebys NY 5/15/81: 97 ill;
Sothebys Lon 6/17/81: 202 ill;
Christies Lon 6/18/81: 426 (album, L-2 et al);
Sothebys Lon 10/28/81: 164 ill;
Octant Paris 1982: 8 ill, 9 ill, 14 ill;
Sothebys Lon 3/15/82: 194 ill;
Sothebys NY 5/24/82: 260 ill;
Christies NY 5/26/82: 32 ill(note), 33 ill;
Christies Lon 6/24/82: 345 ill, 345A, 372
    (album, L-4 et al);
Sothebys Lon 6/25/82: 208 ill;
Christies Lon 10/28/82: 152 ill(note), 153 ill,
    196 ill(attributed)(note);
Phillips NY 11/9/82: 163 ill;

LE GRAY (continued)
Drouot Paris 11/27/82: 68 ill, 69 ill;
Bievres France 2/6/83: 66 ill;
Christies Lon 6/23/83: 225;
Christies NY 10/4/83: 86 ill(19)(attributed);
Christies Lon 10/27/83: 94 ill, 95 ill;
Sothebys Lon 12/9/83: 70 ill;
Christies Lon 3/29/84: 168 ill(note);
Sothebys Lon 6/29/84: 126 ill;
Sothebys Lon 10/26/84: 87 ill(note);
Christies Lon 3/28/85: 139;
Sothebys NY 5/7/85: 215 ill;
Christies NY 11/11/85: 289 ill;
Swann NY 11/12/85: 143 ill;
Sothebys Lon 4/25/86: 170 ill, 171 (2), 172 ill;
Christies Lon 10/30/86: 77 ill, 78 ill;
Sothebys Lon 10/31/86: 171 ill, 172 ill, 173 ill;
Sothebys NY 11/10/86: 136 ill;
Phillips NY 11/12/86: 121 (attributed);
Drouot Paris 11/22/86: 64 ill;

LE GRICE, R.
Photos dated: 1860s-c1874
Processes:    Albumen
Formats:      Prints
Subjects:     Genre
Locations:    France - Aix-la-Chapelle
Studio:       Great Britain (Amateur Photographic
              Association)
    Entries:
Christies Lon 10/27/83: 218 (albums, L-1 et al);

LEGROS, V. (French)
Photos dated: 1891
Processes:    Aristotype
Formats:      Prints
Subjects:     Topography
Locations:    France
Studio:
    Entries:
Sothebys NY 11/21/70: 14 ill(book, 1);

LEHMANN (German)
Photos dated: 1860s-1870s
Processes:    Albumen
Formats:      Cdvs
Subjects:     Portraits
Locations:    Studio
Studio:       Germany - Berlin
    Entries:
Swann NY 4/14/77: 293 (lot, L et al);
Swann NY 12/14/78: 377 (lot, L et al);

LEHMAN, Henri (French)(photographer or author?)
Photos dated: 1854
Processes:    Salt
Formats:      Prints
Subjects:     Documentary (art)
Locations:    France - Paris
Studio:       France - Paris
    Entries:
Christies Lon 6/27/78: 157 (book, 56)(note);

321

**LEIBERTH** (French)
Photos dated: 1870s
Processes:      Albumen
Formats:        Cabinet cards
Subjects:       Portraits
Locations:      France
Studio:         France
  Entries:
Swann NY 11/11/76: 349 (lot, L et al);

**LEIGHTON, John** (British)
Photos dated: 1863
Processes:      Albumen
Formats:        Prints
Subjects:       Architecture
Locations:      England - London
Studio:         Great Britain
  Entries:
Christies Lon 6/26/80: 304 (book, L et al);
Christies Lon 10/30/86: 43 (book, L et al);

**LEJEUNE** (French)
Photos dated: Nineteenth century
Processes:      Woodburytype, carbon
Formats:        Prints, cdvs, cabinet cards
Subjects:       Portraits incl. Galerie Contemporaine
Locations:      Studio
Studio:         France - Paris
  Entries:
Swann NY 4/20/78: 323 (lot, L-1 et al);
Christies Lon 6/26/80: 210 (lot, L et al), 329
  (book, L et al), 477 (album, L-1 et al);
Christies NY 5/14/81: 41 (books, L-1 et al);
Christies NY 5/26/82: 36 (book, L et al);
Christies NY 5/7/84: 19 (book, L et al);
Harris Baltimore 3/15/85: 272 (lot, L et al);

**LEKEGIAN, G.**
Photos dated: 1860s-early 1900s
Processes:      Albumen
Formats:        Prints, stereos
Subjects:       Topography, ethnography
Locations:      Egypt
Studio:         Egypt
  Entries:
Christies Lon 10/4/73: 164 (album, L et al);
Sothebys Lon 10/18/74: 114 (albums, L-89 et al);
Sothebys NY 2/25/75: 157 (lot, L et al);
California Galleries 9/26/75: 127 (album, L et al),
  128 (albums, L et al);
California Galleries 4/2/76: 144 (album, L et al);
Swann NY 4/14/77: 240 (album, L et al);
Sothebys NY 5/2/78: 132 (album, L et al);
Christies Lon 10/26/78: 172 (lot, L-1 et al), 173
  (lot, L et al), 195 (album, L et al);
California Galleries 1/21/79: 340 (album, L et al),
  423 (15);
Sothebys NY 12/19/79: 46 ill(lot, L et al);
Christies NY 5/16/80: 204 (3);
Christies Lon 6/26/80: 275 (album, L et al);
Christies Lon 10/30/80: 220 (lot, L-5 et al);
California Galleries 12/13/80: 305, 306 (3), 307
  (3), 308 (2);
Christies Lon 3/26/81: 271 (album, L et al), 276
  (album, L et al);
Swann NY 4/23/81: 453 (album, L et al), 455 (album,
  L et al);
Phillips NY 5/9/81: 59 ill(album, L-26 et al);

**LEKEGIAN** (continued)
California Galleries 6/28/81: 216 (lot, L et al),
  280 (lot, L et al);
Christies Lon 10/29/81: 219 (album, L et al);
Swann NY 11/5/81: 462 (lot, L et al), 463 (album,
  L et al)(note);
Rose Florida Cat 7, 1982: 44 ill;
Christies Lon 3/11/82: 159 (lot, L et al), 161
  (lot, L et al);
Phillips Lon 6/23/82: 43 (lot, L et al);
Christies Lon 6/24/82: 179 (lot, L-4 et al), 231
  (lot, L-20 et al);
Harris Baltimore 12/10/82: 385 (album, L-4 et al);
Christies Lon 3/24/83: 139 (albums, L et al), 143
  (albums, L et al);
Swann NY 5/5/83: 340 (lot, L-11 et al);
Christies Lon 3/29/84: 98 (album, L-10 et al);
Christies Lon 6/28/84: 89 (lot, L et al);
California Galleries 7/1/84: 548 (lot, L-1 et al);
Sothebys Lon 10/26/84: 50 (album, L et al);
Christies Lon 3/28/85: 67 (lot, L et al);
Sothebys Lon 3/29/85: 77 (albums, L et al);
Swann NY 5/9/85: 384 (lot, L et al);
Christies Lon 10/31/85: 96 (album, L-11 et al);
Harris Baltimore 2/14/86: 328 (lot, L et al);
Christies Lon 4/24/86: 385 (lot, L-1 et al), 409
  (albums, L-11 et al), 598 (lot, L et al);
Sothebys Lon 4/25/86: 41 (albums, L et al);
Christies Lon 6/26/86: 72 (lot, L et al), 118
  (albums, L et al);
Swann NY 11/13/86: 212 (lot, L et al);

**LE LIEURE, Henri**
Photos dated: 1850-1878
Processes:      Albumen
Formats:        Prints, cabinet cards
Subjects:       Portraits, topography
Locations:      Italy - Turin
Studio:         Italy - Turin and Rome
  Entries:
Sothebys NY 9/23/75: 65 (lot, L-1 et al)(note);
Christies Lon 10/28/76: 78 (albums, L-4 et al);
Harris Baltimore 3/15/85: 286 (lot, L et al);

**LEMENAGER, H.V.**
Photos dated: 1871
Processes:      Albumen
Formats:        Prints
Subjects:       Topography
Locations:      "Moor Park"
Studio:
  Entries:
Christies Lon 3/16/78: 223 (books, L-8 et al);

**LEMERCIER, Joseph** (French, 1803-1887)
Photos dated: 1850s
Processes:      Photolithograph (Poitevin process)
Formats:        Prints
Subjects:       Portraits, topography
Locations:      France - Paris
Studio:         France - Paris
  Entries:
Sothebys NY 11/21/70: 213, 214;
Christies NY 10/31/79: 35 ill(book, L et al);
Christies Lon 3/20/80: 230 (book, L et al);
Bievres France 2/6/83: 67 ill, 68 ill, 69;

**LE MERE, Thomas** (American)
Photos dated: early 1860s
Processes:    Albumen
Formats:      Cdvs
Subjects:     Portraits
Locations:    Studio
Studio:       US
    Entries:
Christies Lon 11/11/86: 61 ill(lot, L-1 et al)
    (note);

**LE MOINE, J.M.** (Canadian)(photographer?)
Photos dated: 1865
Processes:    Albumen
Formats:      Prints
Subjects:     Topography
Locations:    Canada - Quebec
Studio:       Canada
    Entries:
Rinhart NY Cat 2, 1971: 13 (book, 21);

**LEMON, E.R.** (American)
Photos dated: 1890s
Processes:    Platinum
Formats:      Prints
Subjects:     Topography
Locations:    US
Studio:       US
    Entries:
Rose Boston Cat 3, 1978: 11 ill(note);

**L'EMPEREUR**
Photos dated: Nineteenth century
Processes:    Albumen
Formats:      Stereos
Subjects:     Topography
Locations:    Switzerland
Studio:
    Entries:
Christies Lon 3/29/84: 24 (lot, L-3 et al);

**LENNIE** (British)
Photos dated: 1860s
Processes:    Albumen
Formats:      Stereos, cdvs
Subjects:     Topography
Locations:    Scotland - Edinburgh
Studio:       Scotland - Edinburgh
    Entries:
Sothebys NY 11/21/70: 332 (lot, L et al);
Sothebys Lon 10/24/75: 71 (lot, L et al);
Swann NY 11/6/80: 284 (lot, L et al);

**LENNOX, Captain Augustus**
Photos dated: 1850s
Processes:    Salt
Formats:      Prints
Subjects:     Topography
Locations:    Wales
Studio:       Great Britain
    Entries:
Christies Lon 6/23/83: 206 (lot, L et al)(note);

**LENNOX, Lady Jocelyn** (British)
Photos dated: 1850s
Processes:    Albumen
Formats:      Prints
Subjects:     Genre
Locations:    Great Britain
Studio:       Great Britain
    Entries:
Sothebys Lon 10/29/82: 148 ill(3);

**LENTHALL**
Photos dated: Nineteenth century
Processes:    Albumen
Formats:      Cdvs
Subjects:     Portraits
Locations:
Studio:
    Entries:
Phillips Lon 6/26/85: 205 (lot, L-1 et al);

**LENZ, Robert**
Photos dated: 1880s
Processes:    Albumen, gelatin
Formats:      Prints
Subjects:     Topography, ethnography
Locations:    Thailand; Singapore
Studio:       Thailand - Bangkok; Singapore
    Entries:
Christies Lon 3/29/84: 105 (albums, L et al);
Sothebys Lon 4/25/86: 36 ill(album, 47);

**LEON, H.**
Photos dated: Nineteenth century
Processes:    Albumen
Formats:      Cdvs
Subjects:     Ethnography
Locations:    Egypt
Studio:
    Entries:
Christies Lon 6/18/81: 233 (album, L-7 et al);
Christies Lon 3/11/82: 231 (album, L-7 et al);

**LEON, M. & LEVY, J.** (French)(see also L. L.)
Photos dated: 1867-1870s
Processes:    Albumen
Formats:      Cdvs, stereos
Subjects:     Documentary (public events),
              topography
Locations:    France - Paris; Italy; Russia
Studio:       France
    Entries:
Rinhart NY Cat 2, 1971: 318 (2);
Rinhart NY Cat 6, 1973: 442 (2);
California Galleries 4/3/76: 447 (lot, L & L-10
    et al);
Christies Lon 10/28/76: 105 (albums, L & L-200
    et al);
Christies Lon 3/10/77: 206 (lot, L & L-8 et al);
Christies Lon 6/28/79: 74 (lot, L & L-5 et al);
Christies Lon 10/25/79: 93 (lot, L & L-14 et al);
Christies Lon 6/18/81: 114 (lot, L & L et al);
Petzold Germany 11/7/81: 289 (lot, L & L-10 et al);
Christies Lon 6/24/82: 66 (lot, L & L et al), 80
    (lot, L & L et al);
Christies Lon 10/28/82: 21 (lot, L & L et al);
Harris Baltimore 3/15/85: 99 (lot, L & L-6 et al);

**LEON & LEVY** (continued)
Swann NY 11/14/85: 163 (lot, L & L et al);
Christies Lon 4/24/86: 336 (lot, L & L et al), 362
    (lot, L & L-13 et al);

**LEONARD & MARTIN** (American)
Photos dated: c1887
Processes:      Albumen
Formats:        Stereos
Subjects:       Topography
Locations:      US - Topeka, Kansas
Studio:         US - Topeka, Kansas
    Entries:
Rinhart NY Cat 7, 1973: 207;

**LEONE, T.** (Italian)
Photos dated: 1889
Processes:      Albumen
Formats:        Prints
Subjects:       Topography
Locations:      Mediterranean area
Studio:
    Entries:
Swann NY 5/5/83: 402 (albums, L et al)(note);

**LE PESCHEUR** (aka LE PECHEUR)
Photos dated: c1850
Processes:      Daguerreotype
Formats:        Plates
Subjects:       Portraits
Locations:      Studio
Studio:         Austria - Vienna
    Entries:
Petzold Germany 11/7/81: 154 (note);
Sothebys Lon 6/29/84: 38 ill;

**LE PETIT** (French)
Photos dated: Nineteenth century
Processes:      Albumen
Formats:        Cdvs
Subjects:       Portraits
Locations:      Studio
Studio:         France
    Entries:
Christies Lon 6/26/80: 261 (lot, L et al);

**LEREBOURS, Noel-Marie Paymal** (French, 1807-1873)
Photos dated: c1849-c1850
Processes:      Calotype
Formats:        Prints
Subjects:       Topography, architecture
Locations:      France - Paris
Studio:         France - Paris
    Entries:
Maggs Paris 1939: 470 ill(note);
Rauch Geneva 6/13/61: 63 ill;

**LERMOYER**
Photos dated: 1890s-1900
Processes:      Silver
Formats:        Prints
Subjects:       Topography
Locations:      France - Paris
Studio:         France - Paris
    Entries:
Sothebys NY 10/21/81: 153 ill(2);

**LE ROCHE, J.** (French)
Photos dated: Nineteenth century
Processes:      Albumen
Formats:        Cdvs
Subjects:       Portraits, topography
Locations:      Studio
Studio:         France
    Entries:
Christies Lon 6/26/80: 261 (lot, L et al);
Swann NY 5/16/86: 190 (lot, L-1 et al);

**LEROUX, A.**
Photos dated: 1870s-1880s
Processes:      Albumen
Formats:        Prints
Subjects:       Topography
Locations:      Algeria
Studio:
    Entries:
Christies Lon 7/25/74: 356 (albums, L et al);
Phillips NY 11/3/79: 179 (album, L et al);
Phillips NY 5/9/81: 61 (albums, L et al);
Christies Lon 3/11/82: 164 (album, L et al);
Phillips Lon 6/23/82: 23 (lot, L-9 et al);
Phillips Lon 10/27/82: 33 (lot, L et al);
Christies Lon 10/27/83: 87 (albums, L et al);

**LEROUX Laboratory** (French)
Photos dated: 1896
Processes:      X-ray
Formats:        Prints
Subjects:       Documentary (medical)
Locations:      France
Studio:         France
    Entries:
Swann NY 2/14/52: 165 (17)(attributed);

**LE ROY** (American)
Photos dated: 1860s
Processes:      Tintypes
Formats:        Plates
Subjects:       Portraits
Locations:      Studio
Studio:         US - Newburgh, New York
    Entries:
Rinhart, NY Cat 2, 1971: 267 (lot, L et al);

**LE ROY, F.N.** (photographer or author?)
Photos dated: c1858
Processes:      Albumen
Formats:        Prints
Subjects:       Topography
Locations:      Switzerland - Geneva
Studio:
    Entries:
Rauch Geneva 6/13/61: 137 (book, 19);

**LE SECQ, Henri** (Jean-Louis-Henry Le Secq
Destournelles)(French, 1818-1882)
Photos dated: c1848-1870
Processes: Salt, photolithograph, cyanotype
Formats: Prints
Subjects: Architecture, topography, genre
(still life)
Locations: France - Paris, Strasbourg, Chartres,
Rheims
Studio: France - Paris
Entries:
Maggs Paris 1939: 468, 469;
Rauch Geneva 6/13/61: 54 (2)(note), 55 ill(10)
(note), 56 (2)(note), 57 ill;
Sothebys NY 11/21/70: 215 ill;
Gordon NY 5/10/77: 778 ill(book, 25)(note);
Sothebys NY 10/4/77: 197 ill;
Lehr NY Vol 1:2, 1978: 26 ill, 27 ill;
Lunn DC Cat QP, 1978: 12 ill;
Christies Lon 3/16/78: 333 ill(note);
Sothebys NY 5/2/78: 88 ill(note), 89 ill, 90 ill;
Christies Lon 6/27/78: 198 ill;
Phillips NY 11/4/78: 48, 49 ill;
Phillips Lon 3/13/79: 41 ill, 42 ill, 43 ill, 44 ill
(note), 45 ill(note);
Sothebys Lon 3/27/81: 203 ill;
Phillips Lon 10/28/81: 177 ill(2, attributed);
Christies Lon 3/11/82: 123 ill;
Christies Lon 6/24/82: 289, 290 ill, 291 ill;
Sothebys Lon 6/25/82: 209 ill(note);
Sothebys Lon 3/25/83: 75 ill, 76 ill(2), 77 ill;
Sothebys Lon 6/24/83: 77 ill, 78 ill;
Sothebys Lon 12/9/83: 68 ill;
Harris Baltimore 12/16/83: 374 (note);
Sothebys Lon 6/29/84: 105 ill;
Sothebys Lon 10/26/84: 90 ill;
Swann NY 11/13/86: 263 ill(note);
Drouot Paris 11/22/86: 65 ill;

**LETALLE**
Photos dated: 1860s-1870s
Processes: Albumen
Formats: Cdvs
Subjects: Portraits
Locations: Studio
Studio: England - Birmingham
Entries:
Swann NY 12/14/78: 377 (lot, L et al);

**LETELLIER, E.** (French)
Photos dated: 1869-1896
Processes: Albumen, photogravure, collotype
Formats: Prints
Subjects: Architecture, topography, documentary
(engineering)
Locations: France - Normandy
Studio: France - Le Havre
Entries:
Sothebys LA 2/13/78: 121 (books, L et al)(note);
Christies Lon 3/16/78: 253 (book);
Sothebys Lon 6/27/80: 259 (attributed);
Phillips NY 5/9/81: 27;

**LETHEBY, Richard** (British)(photographer or
author?)
Photos dated: 1866
Processes: Albumen
Formats: Prints
Subjects: Topography
Locations: England - Sidmouth
Studio: Great Britain
Entries:
California Galleries 3/30/80: 94 (book, 8);

**LETZTER**
Photos dated: Nineteenth century
Processes: Albumen
Formats: Cabinet cards
Subjects: Portraits
Locations: Studio
Studio: Europe
Entries:
Harris Baltimore 3/15/85: 309 (lot, L et al);

**LEUZINGER, G.**
Photos dated: 1860s-1870s
Processes: Albumen
Formats: Prints, cdvs
Subjects: Topography
Locations: Brazil
Studio: Brazil
Entries:
Christies Lon 10/30/86: 151 (lot, L et al);

**LE VENGEUR-D'ORSAN, Dr. A.**
Photos dated: 1862
Processes: Albumen
Formats: Prints
Subjects: Documentary (scientific)
Locations:
Studio:
Entries:
Wood Conn Cat 49, 1982: 260 (book, 9)(note);

**LEVINSKI, A.S.**
Photos dated: 1871
Processes: Albumen
Formats: Cdvs
Subjects: Ethnography
Locations: Fiji
Studio: Fiji - Levuka
Entries:
Swann NY 4/23/81: 467 ill(lot, L et al);
Swann NY 11/5/81: 474 (lot, L-7 et al);

**LEVITSKY, Sergei Luvovich** (Russian, 1819-1898)
Photos dated: 1860s-1870s
Processes: Albumen
Formats: Cdvs
Subjects: Portraits
Locations: Studio
Studio: Russia - St. Petersburg; France -
Paris
Entries:
Sothebys NY (Strober Coll.) 2/7/70: 282 (lot,
L et al);
Sothebys NY 11/21/70: 338 (lot, L et al);
Swann NY 4/14/77: 244 (album, L et al);
Swann NY 4/20/78: 320 (album, L et al);

**LEVITSKY** (continued)
Christies Lon 6/18/81: 421 (albums, L-4 et al);
Swann NY 5/16/86: 201 (album, L et al);

**LE VOT** (French)
Photos dated: Nineteenth century
Processes:     Albumen
Formats:       Cdvs
Subjects:      Portraits
Locations:     Studio
Studio:        France
   Entries:
Christies Lon 6/26/80: 261 (lot, L et al);

**LEVY & COHEN** (American)
Photos dated: 1865
Processes:     Albumen
Formats:       Prints, cdvs
Subjects:      Documentary (Civil War)
Locations:     US - Richmond, Virginia
Studio:        US
   Entries:
Sothebys NY 10/4/77: 20 (lot, L & C-1 et al);
Swann NY 11/10/83: 239 (lot, L & C-11 et al)(note);
Swann NY 11/14/85: 261 (book, L & C et al), 262
   (book, L & C et al);

**LEVY, Albert** (American)
Photos dated: c1870-1886
Processes:     Albumen
Formats:       Prints
Subjects:      Topography, architecture
Locations:     US - New York, Massachusetts,
               Pennsylvania, Rhode Island; France
Studio:        US - New York City
   Entries:
Swann NY 4/1/76: 142 (album, L et al);
Swann NY 12/8/77: 392 ill(note);
Swann NY 12/14/78: 150 ill(book, 24), 151 (book,
   24), 152 (30), 153 (24), 154 (30);
Christies Lon 10/29/81: 194 (33);

**LEVY, J.** (see also FERRIER, C.M.; LEON & LEVY)
Photos dated: c1880
Processes:     Collodion on glass
Formats:       Lantern slides
Subjects:      Topography
Locations:     France
Studio:        France
   Entries:
California Galleries 9/27/75: 406 (lot, L et al);
Phillips Lon 3/13/79: 178 (lot, L et al);

**LEWIS, A.** (British)
Photos dated: 1883
Processes:     Woodburytype
Formats:       Prints
Subjects:      Portraits
Locations:     Studio
Studio:        England
   Entries:
Swann NY 11/11/76: 300 (book, L et al);

**LEWIS, Edward** (American)
Photos dated: 1860s-1870s
Processes:     Albumen
Formats:       Stereos
Subjects:      Topography
Locations:     US - New York State
Studio:        US - Kingston, New York
   Entries:
Rinhart NY Cat 6, 1973: 529;
Phillips Lon 4/23/86: 183 (lot, L-1 et al);

**LEWIS, R.A.** (American)
Photos dated: 1860s
Processes:     Albumen
Formats:       Cdvs
Subjects:      Portraits
Locations:     Studio
Studio:        US
   Entries:
Sothebys NY (Greenway Coll.) 11/20/70: 239 (lot,
   L-1 et al);
Rinhart NY Cat 7, 1973: 644 ill;
Harris Baltimore 4/8/83: 315 (lot, L et al);

**LEWIS, R.J.** (American)
Photos dated: 1860s
Processes:
Formats:       Miniature prints
Subjects:      Portraits
Locations:     Studio
Studio:        US - New York City
   Entries:
Swann NY 9/18/75: 271 (album, L-1 et al);

**LEWIS, Thomas** (American)
Photos dated: 1879
Processes:     Albumen
Formats:       Prints
Subjects:      Topography
Locations:     US - Waltham, Massachusetts
Studio:        US - Cambridge, Massachusetts
   Entries:
Swann NY 2/14/52: 246 (book, 55)(note);
California Galleries 4/2/76: 174 (book, 55);
Wood Conn Cat 45, 1979: 189 (book, 55)(attributed)
   (note);
Wood Conn Cat 49, 1982: 314 (book, 55)(note);

**LEWIS, W. & W.H.** (American)
Photos dated: 1850s
Processes:     Daguerreotype
Formats:       Plates
Subjects:      Portraits
Locations:     Studio
Studio:        US - Chatham, New York
   Entries:
Vermont Cat 11/12, 1977: 557 ill(note);

**LEWIS, W.C.** (British)
Photos dated: 1874
Processes:      Albumen
Formats:        Prints
Subjects:       Genre
Locations:      England - Bath
Studio:         England - Bath
    Entries:
Christies Lon 6/26/80: 491 (lot, L-1 et al);

**LEYDE**
Photos dated: Nineteenth century
Processes:      Albumen
Formats:        Cabinet cards
Subjects:       Portraits
Locations:      Studio
Studio:         Europe
    Entries:
Harris Baltimore 3/15/85: 277 (lot, L et al);

**LEYGOME**
Photos dated: c1870
Processes:      Albumen
Formats:        Prints
Subjects:       Topography
Locations:      Europe
Studio:
    Entries:
Christies Lon 4/24/86: 380 (album, L-2 et al);

**LEYGONIER, Francisco de** (Spanish)
Photos dated: 1846-1879
Processes:      Daguerreotype, calotype, albumen
Formats:        Plates, prints, cdvs
Subjects:       Topography
Locations:      Spain - Seville
Studio:         Spain - Seville
    Entries:
Fraenkel Cal 1984: 47 ill(note);

**LHOSTE** (see BARNES & LHOSTE)

**LIBBY, C.B.** (American)
Photos dated: c1865
Processes:      Albumen
Formats:        Cdvs
Subjects:       Portraits
Locations:      Studio
Studio:         US - Iowa
    Entries:
California Galleries 1/22/77: 159 (album, L et al);

**LIEBERT, Alphonse J.** (French, 1827-1914)
Photos dated: 1853-1874
Processes:      Albumen, woodburytype
Formats:        Prints, cdvs, stereos
Subjects:       Portraits, documentary (Paris Commune)
Locations:      France - Paris
Studio:         US - San Francisco, California;
                France - Paris
    Entries:
Anderson NY (Gilsey Coll.) 2/24/03: 1962;
Maggs Paris 1939: 515 (book, 100)(note), 557;
Rauch Geneva 12/24/58: 207 (albums, 100)(note);
Rauch Geneva 6/13/61: 153 (book, 100)(note);

**LIEBERT** (continued)
Sothebys NY (Greenway Coll.) 11/20/70: 264 (lot,
    L-1 et al);
Vermont Cat 4, 1972: 610 (4 ills)(book, 100);
Vermont Cat 8, 1974: 579 ill;
Sothebys NY 9/23/75: 71 ill(5)(note);
Sothebys Lon 10/24/75: 136 ill(albums, 100);
Colnaghi Lon 1976: 116 ill(note), 117 ill, 118, 119,
    120, 121;
Kingston Boston 1976: 686 ill(book, L et al)(note);
Swann NY 4/1/76: 72 (book, 18);
California Galleries 4/3/76: 446 (lot, L et al);
Swann NY 11/11/76: 131 (book, 8);
Gordon NY 5/10/77: 793 ill(note), 794 ill, 795 ill;
Sothebys NY 10/4/77: 123 (book, 7);
Wood Conn Cat 41, 1978: 25 (book, L-56 et al)
    (note), 28 (2 ills)(book, 100)(note);
Swann NY 4/20/78: 119 (book, L et al);
Swann NY 12/14/78: 192 (book, L-1 et al);
Wood Conn Cat 45, 1979: 186 (book, L-56 et al)
    (note);
Sothebys Lon 3/14/79: 316 (lot, L et al);
Christies Lon 3/15/79: 140, 141, 142, 143;
Christies Lon 10/25/79: 177 (note), 178, 179, 180
    ill, 181, 182;
Christies Lon 3/20/80: 224 (book, L et al);
Phillips NY 5/21/80: 129 ill(album, 20)(note);
Auer Paris 5/31/80: 81, 82;
Christies Lon 3/26/81: 187;
Sothebys Lon 3/27/81: 128 (lot, L et al);
Wood Conn Cat 49, 1982: 332 (book, L-56 et al)
    (note);
Christies Lon 3/11/82: 142 ill(book, 100);
Drouot Paris 11/27/82: 70 ill;
Christies NY 3/8/83: 32 (2);
Sothebys Lon 3/25/83: 45 ill(book, 100);
Swann NY 5/5/83: 275, 417 (album, 20)(note);
Swann NY 11/10/83: 104 ill(book, 50)(note), 129
    (book, L et al);
Swann NY 5/10/84: 23 (book, L et al)(note);
Swann NY 5/9/85: 331 (lot, L et al);
Sothebys Lon 11/1/85: 118 ill(books, 100);
Swann NY 11/14/85: 142 (lot, L et al), 264 (books,
    L et al);
Wood Boston Cat 58, 1986: 326 (book, L-56 et al);
Sothebys Lon 4/25/86: 202 ill(books, 50);
Christies Lon 6/26/86: 86 (lot, L et al);
Christies Lon 10/30/86: 131 (lot, L-3 et al);
Swann NY 11/13/86: 219 (lot, L-1 et al);

**LIEBICH** (American)
Photos dated: 1870s
Processes:      Albumen
Formats:        Stereos, cdvs
Subjects:       Topography
Locations:      US
Studio:         US - Cleveland, Ohio
    Entries:
California Galleries 1/23/77: 370 (lot, L et al);
Christies Lon 10/29/81: 147 (lot, L et al);

**LIENHARD & SALZBORN**
Photos dated: 1890s
Processes:      Albumen
Formats:        Prints
Subjects:       Topography
Locations:      Switzerland - St. Moritz
Studio:
   Entries:
Witkin NY II 1974: 577 (book, 18);
Witkin NY III 1975: 618 (book, 18);
Witkin NY IV 1976: AL18 (book, 18);

**LIETZE, Ernst**
Photos dated: 1888
Processes:
Formats:        Prints
Subjects:       Documentary
Locations:
Studio:
   Entries:
Sothebys NY 2/25/75: 70 (book, L-10 et al);

**LILIENTHAL, Theodore** (American)
Photos dated: 1860s-1870s
Processes:      Albumen
Formats:        Cdvs, prints, stereos
Subjects:       Portraits, topography
Locations:      US - New Orleans, Louisiana
Studio:         US - New Orleans, Louisiana
   Entries:
Sothebys NY (Strober Coll.) 2/7/70: 291 (lot,
   L et al), 321 (lot, L et al);
Sothebys NY (Greenway Coll.) 11/20/70: 271 (lot,
   L-1 et al), 275 (lot, L-1 et al), 278 (lot,
   L-1 et al);
Swann NY 9/18/75: 229 (album, L et al);
Swann NY 11/6/80: 264 (lot, L-1 et al);
Swann NY 11/10/83: 240 (lot, L et al);
Christies Lon 3/28/85: 46 (lot, L et al);
Sothebys Lon 3/29/85: 74 (album, L-1 et al);
Harris Baltimore 11/7/86: 70 (note);

**LILLEY, I.I.** (British)
Photos dated: 1850s
Processes:      Albumen
Formats:        Prints
Subjects:       Topography
Locations:      St. Helena
Studio:
   Entries:
Colnaghi Lon 1976: 90 (3 ills)(album, 33)(note);

**LINARES, F.** (Spanish)
Photos dated: 1870s
Processes:      Albumen
Formats:        Prints
Subjects:       Topography
Locations:      Spain - Granada
Studio:         Spain
   Entries:
Christies Lon 3/15/79: 187 (albums, L-6 et al);

**LINCOLN, Edwin Hale** (American, 1848-1938)
Photos dated: 1870s-1923
Processes:      Albumen, platinum
Formats:        Prints
Subjects:       Genre (still life, rural life)
Locations:      US - Massachusetts; Connecticut
Studio:         US - Massachusetts
   Entries:
Lehr NY Vol 6:4, 1984: 12 ill(note), 13 ill, 14 ill,
   15 ill, 16 ill, 17 ill;
Swann NY 5/10/84: 274;
Swann NY 5/16/86: 274 (4);

**LINDAHL, Axel** (Norwegian)
Photos dated: 1880s-1890s
Processes:      Albumen, platinum
Formats:        Prints incl. panoramas
Subjects:       Architecture, topography
Locations:      Norway; Sweden - Stockholm
Studio:         Norway
   Entries:
Edwards Lon 1975: 37 (album, L et al);
California Galleries 9/26/75: 125 (album,
   L-42 et al);
California Galleries 4/3/76: 293 (lot, L-1
   et al), 294 (lot, L et al);
California Galleries 1/22/77: 164 (album, L et al);
Swann NY 4/14/77: 191 (lot, L et al);
Christies Lon 6/30/77: 96;
California Galleries 1/21/78: 211 (album, K et al);
Christies Lon 6/27/78: 89 (albums, L et al), 151
   (album, L et al);
Christies Lon 10/26/78: 193 (album, L et al);
Christies Lon 3/15/79: 189 (albums, L-1 et al), 190
   (album, L et al), 317 (album, L-1 et al);
Christies Lon 6/28/79: 144 (lot, L et al);
Christies Lon 10/25/79: 250 (albums, L-1 et al);
California Galleries 12/13/80: 340 (lot, L et al),
   341 (lot, L et al);
Phillips NY 5/9/81: 51 (albums, L et al);
Petzold Germany 5/22/81: 1954 (lot, L et al);
Christies Lon 10/29/81: 280 (lot, L et al);
Harris Baltimore 12/10/82: 391 (albums, L et al);
Christies Lon 6/23/83: 169 (albums, L et al);
Christies NY 10/4/83: 110 (lot, L et al);
Swann NY 5/10/84: 272 (5)(note);
Christies Lon 10/27/83: 84 (albums, L et al);
Christies Lon 6/28/84: 140 (album, L et al);
California Galleries 7/1/84: 68 (2);
Christies Lon 10/25/84: 103 (album, L et al);
Phillips Lon 3/27/85: 203 (albums, L et al);
Christies Lon 3/28/85: 62 (album, L et al);
Christies Lon 10/31/85: 137 (album, L et al);
Harris Baltimore 2/14/86: 210 (albums, L et al);
Swann NY 11/13/86: 216 (albums, L et al);

**LINDE, E. & Co.**
Photos dated: c1865-1880s
Processes:      Albumen
Formats:        Cdvs, stereos
Subjects:       Topography, documentary (scientific),
                genre
Locations:      Germany; England - London
Studio:         Germany - Berlin
   Entries:
Rinhart NY Cat 2, 1971: 444 (lot, L et al);
Rinhart NY Cat 7, 1973: 358;
Harris Baltimore 7/31/81: 131 (lot, L-1 et al);

**LINDE** (continued)
Christies Lon 10/29/81: 150 (lot, L et al);
Swann NY 11/5/81: 550 (lot, L et al);
Sothebys NY 11/9/83: 193A (album, 50);

**LINDLEY & WARREN**
Photos dated: 1868
Processes:    Albumen
Formats:     Prints, cdvs
Subjects:    Topography, portraits
Locations:   India
Studio:      India - Bombay
   Entries:
Christies Lon 6/28/79: 162 ill(book, 20);
Christies Lon 10/25/79: 422 (album, L & W et al);
Phillips Lon 3/27/85: 269 (album, 20);

**LINDNER, Amalie** (German)
Photos dated: 1860s
Processes:    Albumen
Formats:     Cdvs
Subjects:    Topography
Locations:   France
Studio:      Germany - Bitsch
   Entries:
Petzold Germany 11/7/81: 327 (lot, L et al);

**LINDSAY, Sir Coutts** (British)
Photos dated: 1855-1865
Processes:    Albumen
Formats:     Prints
Subjects:    Topography
Locations:   Italy - Rome
Studio:
   Entries:
Goldschmidt Lon Cat 52, 1939: 190 (25)(note);

**LINDSEY** (American)
Photos dated: 1880s
Processes:    Albumen
Formats:     Cdvs, cabinet cards
Subjects:    Portraits, topography
Locations:   US
Studio:      US - Nashua, New Hampshire
   Entries:
Swann NY 11/8/84: 143 (lot, L et al), 225 (album, L
   et al)(note);
Swann NY 5/9/95: 322 (lot, L et al);

**LINDSEY, T.H. & BROWN** (American)
Photos dated: 1870s-c1880
Processes:    Albumen
Formats:     Prints, boudoir cards
Subjects:    Portraits, documentary
Locations:   US - Asheville, North Carolina
Studio:      US - Asheville, North Carolina
   Entries:
Rinhart NY Cat 7, 1973: 445, 446, 447, 448;
Swann NY 11/11/76: 483 (lot, L & B-2 et al);

**LINDSLY, H.R.** (American)
Photos dated: 1870s
Processes:    Albumen
Formats:     Stereos
Subjects:    Topography
Locations:   US - New York
Studio:      US - Auburn, New York
   Entries:
California Galleries 4/3/76: 430 (lot, L et al);
California Galleries 1/21/78: 184 (lot, L et al);

**LINDT, J.W.** (Australian)
Photos dated: c1880-1887
Processes:    Albumen, autotype
Formats:     Prints
Subjects:    Topography, ethnography
Locations:   Australia - Melbourne; New Guinea;
Fiji
Studio:      Australia - Melbourne
   Entries:
Swann NY 11/11/76: 366 (albums, L et al)(note);
Wood Conn Cat 42, 1978: 310 (book, 50)(note);
Sothebys Lon 10/27/78: 100 ill(album, L et al);
California Galleries 1/21/79: 132 ill(book, 50);
Christies Lon 3/20/80: 174 (albums, L et al);
Phillips Lon 10/28/81: 156 (lot, L-3 et al);
Christies Lon 10/30/86: 172 (album, L et al), 178
   (album, 24), 179 (book, 50)(note);

**LINFORD, J.** (British)
Photos dated: 1860s
Processes:    Albumen
Formats:     Stereos
Subjects:    Topography
Locations:   Great Britain
Studio:      Great Britain
   Entries:
Sothebys Lon 3/25/83: 4 (lot, L et al);
Harris Baltimore 6/1/84: 64 (lot, L et al);

**LING, Shun** (Chinese)
Photos dated: c1890-1908
Processes:    Silver
Formats:     Prints
Subjects:    Portraits
Locations:   China
Studio:      China
   Entries:
Phillips NY 5/5/79: 183;

**LINN, J.B.** (American)
Photos dated: 1870s
Processes:    Albumen
Formats:     Prints, stereos
Subjects:    Topography
Locations:   US - Tennessee
Studio:      US - Lookout Mountain, Tennessee
   Entries:
California Galleries 9/27/75: 566 (lot, L et al);
Harris Baltimore 12/10/82: 92 (lot, L et al);
Harris Baltimore 11/7/86: 98 (lot, L-2 et al);

**LINN, Royan M.** (American)
Photos dated: 1864
Processes: Albumen
Formats: Prints, cdvs
Subjects: Documentary (Civil War), portraits
Locations: US - Tennessee
Studio: US - Tennessee
  Entries:
Swann NY 12/14/78: 378 ill (lot, L-1 et al);
Harris Baltimore 11/9/84: 65 (lot, L attributed
  et al)
  (note);

**LINSAY, Harvey B.** (American)
Photos dated: 1860s-1870s
Processes: Albumen
Formats: Stereos
Subjects: Topography
Locations: US
Studio: US - Auburn, New York
  Entries:
Swann NY 11/6/80: 378 (lot, L-7 et al);

**LINTON, W.J.** (British)
Photos dated: 1868
Processes: Albumen
Formats: Prints
Subjects: Topography
Locations: England - Lake District
Studio: Great Britain
  Entries:
Christies Lon 10/4/73: 96 (book, L et al);

**LITCHFIELD** (American)
Photos dated: 1870s
Processes: Albumen
Formats: Cabinet cards
Subjects: Portraits
Locations: Studio
Studio: US - Boston, Massachusetts
  Entries:
Harris Baltimore 9/27/86: 60;

**LITTLE, David Mason** (American)
Photos dated: 1883
Processes:
Formats: Prints
Subjects: Topography
Locations: US - New England
Studio: US
  Entries:
Swann NY 11/6/80: 122 (book, 20);

**LITTLE, J.W.**
Photos dated: 1887
Processes: Gelatin silver
Formats: Prints
Subjects: Topography, ethnography
Locations: Australia - Ballarat
Studio:
  Entries:
Christies Lon 10/30/86: 180 (album, 18);

**LITTLETON**
Photos dated: 1880s and/or 1890s
Processes: Albumen
Formats: Prints
Subjects: Topography
Locations: Tasmania and/or New Zealand
Studio:
  Entries:
Christies Lon 6/26/86: 108 (album, L et al);

**LIVERNOIS, J.E.** (Canadian)
Photos dated: 1865-1880s
Processes: Albumen
Formats: Prints, cdvs, cabinet cards
Subjects: Topography, portraits, genre
Locations: Canada - Quebec
Studio: Canada
  Entries:
Rinhart NY Cat 7, 1973: 73 (book, 22);
Phillips Can 10/4/79: 69 (album, L-1 et al);
Phillips Can 10/9/80: 44 (album, L et al);
California Galleries 6/28/81: 421;

**LIVERSAY, Ino G.** (British)
Photos dated: 1850s and/or 1860s
Processes: Albumen
Formats: Stereos
Subjects: Topography
Locations: England - Isle of Wight
Studio: Great Britain
  Entries:
Christies Lon 10/29/81: 114 ill(lot, L et al);

**LLEWELYN, John Dillwyn** (British, 1810-1887)
Photos dated: 1853-1859
Processes: Daguerreotype, calotype, albumen
Formats: Plates, prints
Subjects: Topography, portraits
Locations: Wales; England; Scotland
Studio: Wales - Penllergare
  Entries:
Weil Lon Cat 4, 1944(?): 237 (album, L et al)(note);
Swann NY 2/14/52: 6 (2);
Sothebys Lon 3/21/75: 286 (album, L-1 et al);
Sothebys Lon 7/1/77: 183 ill(album, 17)(note), 184
  (6 ills)(album, L et al)(note), 185 (2 ills)
  (album, L et al), 186 ill(album, 52), 187 ill
  (album, 64), 188 ill(album, 61);
Weston Cal 1978: 127 ill(note), 128 ill, 129 ill,
  130 ill;
Sothebys Lon 6/28/78: 240 (2 ills)(album, L et al)
  (note), 247 ill(album, L-1 attributed, et al),
  263 (3), 264, 265 ill(6), 266 (note), 267 ill,
  268 ill, 269 ill, 270, 271 (4), 272 ill, 273 ill
  (2), 274 ill(2), 275 ill, 276 ill;
Sothebys Lon 3/14/79: 324 (album, L-1 et al);
Christies NY 5/4/79: 13 (note), 14, 15;
Sothebys NY 5/8/79: 66 ill(note);
Sothebys Lon 6/29/79: 81, 82 ill, 83 ill;
Sothebys Lon 6/27/80: 245 ill;
Christies Lon 3/26/81: 172;
Sothebys Lon 3/27/81: 380;
Christies Lon 6/18/81: 387 (17)(attributed), 390
  ill(2), 392, 393 (2 ills)(album, L et al)(note),
  394 (2 ills)(album, 25), 395 ill(album, L, TDL,
  et al)(note);
California Galleries 6/28/81: 198 ill;
Sothebys Lon 10/28/81: 189 (2), 190 ill;

**LLEWELYN, J.E.** (continued)
Sothebys Lon 3/15/82: 317;
California Galleries 5/23/82: 238;
Christies Lon 6/24/82: 89 (2)(attributed);
Christies Lon 10/28/82: 47 ill, 48 ill, 49;
Christies Lon 6/23/83: 206 (8 ills)(lot, L
  et al)(note), 207;
Sothebys Lon 6/24/83: 83 ill;
Christies Lon 10/27/83: 186 ill, 187 (album,
  L-13 et al)(note), 188 (2 ills)(album, L-24
  et al)(note);
Harris Baltimore 12/16/83: 375 ill(attributed)
  (note), 376 (attributed);
Harris Baltimore 3/15/85: 219 (attributed);
Christies Lon 6/27/85: 112 ill(album, L-14
  et al)(note), 113 ill(album, L et al);
Sothebys Lon 6/28/85: 118 ill;
Sothebys Lon 11/1/85: 59 (album, L-1 et al);
Kraus NY Cat 2, 1986: 2.33 ill, 2.35 ill, 2.51 ill,
  2.52 ill, 2.60 ill, 3.3 ill, 3.4 ill, 3.13 ill,
  3.18 ill, 3.19 ill(note), 3.22 ill(note), 49 ill
  (JD & TDL), 50 ill(note), 51 ill(note), 52 ill,
  53 ill(note), 54 ill(note), 55 ill, 56 ill
  (note), 57 ill, 58 ill(note), 59 ill(note),
  60 ill, 61 ill(note);
Christies Lon 4/24/86: 451 ill;
Sothebys Lon 4/25/86: 83 ill(lot, L et al)(note),
  84 ill(album, L et al);
Christies Lon 10/30/86: 71, 251 (album, L-1
  attributed et al);
Sothebys Lon 10/31/86: 80 (lot, L-1, MDL-1, et al);

**LLEWELYN, Sir John Talbot** (British, 1836-1927)
Photos dated: 1855
Processes:      Salt
Formats:        Prints
Subjects:       Genre
Studio:         Wales
Locations:      Wales
  Entries:
Kraus NY Cat 2, 1986: 2.40 ill(attributed)(note);

**LLEWELYN, M.D.** (see LLEWELYN, J.D.)

**LLEWELYN, Thereza Mary Dillwyn** (British,
            1834-1926)(see also LLEWELYN, J.D.)
Photos dated: 1855
Processes:      Salt
Formats:        Prints
Subjects:       Topography
Locations:      Great Britain
Studio:         Great Britain
  Entries:
Kraus NY Cat 2, 1986: 2.5 ill, 2.8 ill;

**LLOYD** (see LANGENHEIM)

**LLOYD** (see LAURIE)

**LLOYD, F.G.** (British)
Photos dated: 1890s
Processes:
Formats:        Prints
Subjects:
Locations:      Great Britain
Studio:         England (West Kent Amateur
                Photographic Society)
  Entries:
Christies Lon 6/27/85: 260 (lot, L et al);

**LLOYD, F.H.** (British)(see also HOWARD, W.D.)
Photos dated: 1860s
Processes:      Albumen
Formats:        Prints
Subjects:
Locations:
Studio:         Great Britain (Amateur Photographic
                Association
  Entries:
Christies Lon 10/27/83: 218 (albums, L-1, L &
  Howard-2, et al);
Sothebys Lon 3/29/85: 159 (lot, L et al);

**LLOYD, John** (British)
Photos dated: 1861
Processes:      Albumen
Formats:        Prints, cdvs
Subjects:       Topography
Locations:      Wales - Rhagatt
Studio:         Wales - Rhagatt
  Entries:
Sothebys Lon 3/21/75: 136 (lot, L et al);
Sothebys Lon 10/24/75: 190 (3);
Christies Lon 3/16/78: 154 ill(lot, L-3 et al)
  (note), 355 (2);
Christies Lon 3/26/81: 144 ill(album, 130);

**LOBB, C.R.**
Photos dated: 1860s
Processes:      Albumen
Formats:        Stereos
Subjects:       Topography
Locations:      England
Studio:         England
  Entries:
Christies Lon 3/26/81: 122 (lot, L et al);
Christies Lon 3/11/82: 65 (lot, L et al);
Christies Lon 6/24/82: 72 (lot, L-1 et al);
Christies Lon 10/28/82: 17 (lot, L et al);
Christies Lon 10/25/84: 44 (lot, L et al);
Christies Lon 4/24/86: 345 (lot, L et al);

**LOCHERER, Alois** (German, 1815-1863)
Photos dated: 1850-late 1850s
Processes:      Salt, albumenized salt
Formats:        Prints
Subjects:       Portraits, architecture
Locations:      Germany - Munich
Studio:         Germany - Munich
  Entries:
Phillips NY 5/9/81: 47 ill(attributed)(note), 48
  (attributed);
Sothebys Lon 6/25/82: 204 ill(3), 205 (3), 206 (3);
Sothebys Lon 10/29/82: 91 (4), 92 (4), 93 ill(4), 94
  ill(4);
Sothebys Lon 12/9/83: 42 ill;

## LOCHERER (continued)

Sothebys Lon 10/26/84: 204 ill(4), 205 (4), 206 (4);
Sothebys Lon 3/29/85: 226 ill(4), 227 (4);
Phillips Lon 10/30/85: 121 (8);
Phillips Lon 4/23/86: 294 (8);
Christies Lon 4/24/86: 448 ill;
Sothebys Lon 4/25/86: 222 ill;

## LOCHET

Photos dated: Nineteenth century
Processes:    Woodburytype
Formats:      Prints
Subjects:     Portraits incl. Galerie Contemporaine
Locations:
Studio:
   Entries:
Christies NY 5/14/81: 41 (books, L-1 et al);
Christies NY 5/26/82: 36 (book, L et al);
Christies NY 5/7/84: 19 (book, L et al);

## LOCK (British)

Photos dated: 1850s
Processes:    Albumen (over-painted)
Formats:      Prints
Subjects:     Portraits
Locations:    Studio
Studio:       England - London
   Entries:
Sothebys Lon 10/24/79: 310 (lot, L-1 et al);

## LOCK & WHITFIELD (British)

Photos dated: 1857-1890
Processes:    Salt, albumen, woodburytype
Formats:      Prints, cdvs
Subjects:     Portraits
Locations:    Studio
Studio:       England - London
   Entries:
Anderson NY (Gilsey Coll.) 2/24/03: 2068 (lot,
   L & W et al);
Weil Lon Cat 7, 1945: 155 (books, 250)(note);
Weil Lon Cat 14, 1949(?): 402 (books, 252)(note);
Swann NY 2/14/52: 230 (books, 254)(note);
Weil Lon Cat 31, 1963: 199 (books, 252)(note);
Christies Lon 7/13/72: 54 (book, 35);
Rinhart NY Cat 7, 1973: 82 (book, 34), 449 (4);
Christies Lon 7/25/74: 329 (books, L & W et al);
Sothebys Lon 10/14/74: 154 (books, 216), 155
   (book, 37);
Edwards Lon 1975: 12 (album, L & W et al);
Witkin NY III 1975: 704 (book, 1);
Sothebys NY 2/25/75: 64 (book, 36), 126 (lot,
   L & W-1 et al);
Sothebys Lon 3/21/75: 152 (book, 36), 154 (lot,
   L & W et al);
Sothebys Lon 10/24/75: 169 (books, 144), 173 (37);
Witkin NY IV 1976: OP331 (book, 1);
California Galleries 4/3/76: 308 (20);
Sothebys Lon 6/11/76: 183 (books, 108), 184
   (books, 216), 185 (books, 144);
Swann NY 11/11/76: 300 (book, L & W et al), 510
   (lot, L & W et al);
Halsted Michigan 1977: 689, 690, 691, 692, 693,
   694, 695;
Christies Lon 3/10/77: 336 (book, 72);
Swann NY 4/14/77: 126 (book, 72);
Christies Lon 6/30/77: 210 (lot, L & W-36 et al);
Sothebys NY 10/4/77: 174 ill;

## LOCK & WHITFIELD (continued)

IMP/GEH 10/20/77: 445 (book, 252)(note);
Christies Lon 10/27/77: 225 (book, 252);
Sothebys Lon 11/18/77: 45 (book, 144);
Christies Lon 6/27/78: 169 (book, 72);
Christies Lon 10/26/78: 223 (book, 213), 224
   (book, 144), 225 (book, 72), 226 (book, 36);
Lehr NY Vol 1:3, 1979: 43 ill;
Wood Conn Cat 45, 1979: 294 (book, 145)(note);
Sothebys Lon 3/14/79: 243 (4);
Christies Lon 3/15/79: 308 (albums, L & W et al);
Sothebys Lon 10/24/79: 316 (30), 317 (lot, L & W-13
   et al);
Christies Lon 10/25/79: 48 (lot, L & W-1 et al), 285
   (book, 144), 286 (book, 36);
Christies Lon 3/20/80: 225 (books, L & W-72 et al),
   232 (book, 37);
Christies Lon 6/26/80: 327 (book, 144), 330 (book,
   37), 481 (album, L & W-4 et al);
Christies Lon 10/30/80: 296 (book, 109);
Christies Lon 6/18/81: 254 (37), 261 (book, 146);
Sothebys Lon 10/28/81: 237 (book, 37);
Wood Conn Cat 49, 1982: 265 (book, 145)(note);
Christies Lon 3/11/82: 256 (book, 144), 257 (book,
   144);
Phillips Lon 3/17/82: 61 (books, L & W-36 et al);
Harris Baltimore 3/26/82: 352;
Christies Lon 6/24/82: 245 (book);
Swann NY 11/18/82: 162 (book, 36), 254 (books, L & W
   et al);
Christies Lon 6/23/83: 259 (lot, L & W et al);
Christies Lon 10/27/83: 240 (album, L & W et al);
Christies Lon 10/25/84: 123 (book, 36);
Harris Baltimore 3/15/85: 290 (32), 314 (lot, L & W
   et al);
Christies Lon 3/28/85: 111 (books, 72);
Christies Lon 6/27/85: 246 (albums, L & W et al);
Harris Baltimore 2/14/86: 87 (32), 98 (lot, L & W
   et al);
Phillips Lon 4/23/86: 224 (album, L & W-1 et al);
Christies Lon 6/26/86: 149 (album, L & W et al);
Phillips Lon 10/29/86: 296 (album, L & W-1 et al);
Swann NY 11/13/86: 194 (lot, L & W-1 et al);

## LOCKE, I.S. (American)

Photos dated: 1860s-1870s
Processes:    Albumen
Formats:      Cdvs
Subjects:     Portraits
Locations:    Studio
Studio:       US - Stockton, California
   Entries:
Swann NY 4/14/77: 246 (album, L-1 et al);

## LOCKET

Photos dated: Nineteenth century
Processes:    Albumen
Formats:      Prints
Subjects:     Topography
Locations:    Great Britain
Studio:       Great Britain
   Entries:
Christies Lon 3/20/80: 131 (albums, L et al);
Christies Lon 10/30/80: 148 (albums, L & Mansell
   et al);

LOCKETT (British)
Photos dated: 1860s-1870s
Processes:      Albumen
Formats:        Prints
Subjects:       Genre (nudes)
Locations:      Studio
Studio:         England - London
    Entries:
Christies Lon 3/10/77: 261 ill(album, L et al);
Christies Lon 6/27/78: 241 (album, L et al);
Phillips NY 5/21/80: 133 ill(album, L et al);

LOCKLE, C. (American)
Photos dated: 1850s
Processes:      Daguerreotype
Formats:        Plates
Subjects:       Portraits
Locations:      Studio
Studio:         US - Philadelphia, Pennsylvania
    Entries:
Sothebys NY 11/21/70: 252 ill;

LEOFFLER, A. (American)
Photos dated: 1895-1908
Processes:      Gelatin
Formats:        Prints
Subjects:       Topography
Locations:      US - New York City
Studio:         US - New York City
    Entries:
Swann NY 11/13/86: 287 (10);

LOEFFLER, J. (American)
Photos dated: 1862-1870s
Processes:      Albumen
Formats:        Prints, stereos, cdvs
Subjects:       Topography
Locations:      US - New York
Studio:         US - Tompkinville, New York
    Entries:
Sothebys Lon (Strober Coll.) 2/7/70: 444 (lot,
    L-5 et al);
Rinhart NY Cat 1, 1971: 157 (7);
California Galleries 9/27/75: 517 (lot, L-8 et al);
California Galleries 1/23/77: 414 (lot, L-8 et al);
Christies Lon 3/24/83: 136 (album, L et al);
Swann NY 11/8/84: 264 (lot, L et al);
Christies Lon 10/31/85: 138 (album, L-1 et al)
Harris Baltimore 2/14/86: 255 (lot, L-1 plus 1
    attributed, et al);

LOEHE (see PILOTY & LOEHE)

LOESCHER & PETSCH (German)
Photos dated: 1867-c1895
Processes:      Albumen
Formats:        Prints, stereos, cdvs, cabinet cards
Subjects:       Genre, portraits
Locations:      Studio
Studio:         Germany - Berlin
    Entries:
Gordon NY 5/3/76: 298 (books, L & P et al);
Swann NY 10/18/79: 337 (album, L & P et al);
Swann NY 4/23/81: 159 (books, L & P et al)(note),
    514 (lot, L & P et al)(note);
Petzold Germany 11/7/81: 324 (album, L & P et al);

LOESCHER & PETSCH (continued)
Swann NY 11/18/82: 454 (lot, L & P et al);
Christies Lon 6/23/83: 28 (lot, L & P-5 et al);
California Galleries 7/1/84: 104 (book, 1), 106
    (book);
Harris Baltimore 3/15/85: 21 (lot, L & P et al);
Swann NY 11/14/85: 147 (album, L & P et al), 263
    (books, L & P et al);
Wood Boston Cat 58, 1986: 136 (books, L & P-1
    et al);
Harris Baltimore 2/14/86: 43 (lot, L & P et al);
Swann NY 5/16/86: 131 (book, L & P et al), 132
    (book, L & P et al), 133 (book, L & P et al);

LOEWY, M.M. & PUISEUX
Photos dated: 1894-1896
Processes:      Photogravure
Formats:        Prints
Subjects:       Documentary (scientific)
Locations:
Studio:         France - Paris
    Entries:
Sothebys NY 5/20/80: 377 (note), 378;

LOGAN (American)
Photos dated: c1895
Processes:      Albumen
Formats:        Prints
Subjects:       Topography
Locations:      US - Stockton, California
Studio:         US - Stockton, California
    Entries:
California Galleries 1/21/78: 296A;
California Galleries 6/28/81: 197;

LOMBARD, W.W. (American)
Photos dated: Nineteenth century
Processes:      Albumen
Formats:        Stereos
Subjects:       Topography
Locations:      US - Rhode Island
Studio:         US
    Entries:
Harris Baltimore 3/15/85: 86 (lot, L-2 et al);

LOMBARDI
Photos dated: Nineteenth century
Processes:
Formats:
Subjects:       Portraits
Locations:      Studio
Studio:         England - London
    Entries:
Edwards Lon 1975: 12 (album, L et al);

LOMBARDI, Paolo (born 1827) & Galileo (Italian)
Photos dated: 1849-1899
Processes:      Albumen
Formats:        Prints
Subjects:       Topography
Locations:      Italy - Siena
Studio:         Italy - Siena
    Entries:
Sothebys NY 2/25/75: 141 (lot, L et al);
Christies Lon 10/28/76: 109 (album, L et al);
California Galleries 1/22/77: 322 (lot, L-1 et al);

**LOMBARDI, P. & G.** (continued)
Christies Lon 10/26/78: 120 (4);
Christies Lon 10/25/79: 147 (lot, L et al);
Christies Lon 6/26/80: 483 (lot, L et al);
Swann NY 11/6/80: 324 (lot, L-1 et al);
Phillips Lon 10/27/82: 33 (lot, L et al);
Swann NY 5/16/86: 265 (lot, L et al);
Swann NY 11/13/86: 245 (lot, L et al);

**LOMER, H.**
Photos dated: 1880s
Processes:   Albumen
Formats:     Prints
Subjects:    Topography
Locations:   Australia
Studio:
   Entries:
Christies Lon 10/30/86: 172 (album, L et al);

**LONDE, Albert** (French, 1858-1917)
Photos dated: 1897
Processes:   Silver
Formats:     Prints
Subjects:    Documentary
Locations:   Studio
Studio:      France
   Entries:
Drouot Paris 11/27/82: 72 ill;

**LONDON SCHOOL OF PHOTOGRAPHY**
Photos dated: 1850s
Processes:   Daguerreotype, ambrotype
Formats:     Plates
Subjects:    Portraits
Locations:   Studio
Studio:      England - London
   Entries:
Sothebys Lon 10/24/75: 34 (lot, L-1 et al);
Sothebys Lon 10/29/76: 221 (lot, L-3 et al);
Christies Lon 6/23/83: 4 (lot, L-1 et al);
Christies Lon 10/25/84: 8 (lot, L-1 et al);

**LONDON STEREOSCOPIC (AND PHOTOGRAPHIC) COMPANY**
Photos dated: 1854-1898
Processes:   Daguerreotype, albumen, carbon,
             platinum, silver
Formats:     Plates incl. stereo, stereo cards,
             cdvs, prints, "pigeon letters"
Subjects:    Topography, portraits, genre,
             documentary (public events)
Locations:   England - London; US; Canada; Greece
Studio:      England - London
   Entries:
Anderson NY (Gilsey Coll.) 2/24/03: 2069 (lot,
   L et al);
Swann NY 2/14/52: 333 (book, 12);
Sothebys NY (Weissberg Coll.) 5/16/67: 196 (lot, L-1
   et al);
Sothebys NY (Strober Coll.) 2/7/70: 537 (22)(note);
Rinhart NY Cat 1, 1971: 459 (book, 57);
Rinhart NY Cat 2, 1971: 38 (book, 12), 363 (lot, L-1
   et al), 492 (lot, L-2 et al)(note), 493 (8);
Vermont Cat 1, 1971: 238 ill(2);
Vermont Cat 4, 1972: 602 ill(14);
Rinhart NY Cat 6, 1973: 425, 427, 428, 439, 440;
Rinhart NY Cat 7, 1973: 551 (3);
Vermont Cat 5, 1973: 544 ill(12), 545 ill(3);

**LONDON STEREOSCOPIC COMPANY** (continued)
Vermont Cat 7, 1974: 617 ill(13), 634 ill(7);
Christies Lon 4/25/74: 205 (books, L et al);
Sothebys Lon 6/21/74: 91 (lot, L et al), 105
   (album, L et al);
Christies Lon 7/25/74: 368 (albums, L et al);
Sothebys Lon 10/18/74: 93 (2 ills)(album, 61);
Edwards Lon 1975: 12 (album, L et al), 52
   (book, 1), 66 (book, 1);
Vermont Cat 9, 1975: 574 ill;
Sothebys NY 2/25/75: 107 (lot, L et al);
Sothebys Lon 3/21/75: 138 (album, L et al), 209 ill;
Sothebys Lon 6/26/75: 180;
California Galleries 9/27/75: 477 (lot, L et al),
   478 (lot, L et al), 497 (27);
Rose Boston Cat 1, 1976: 20 ill(note);
Sothebys Lon 3/19/76: 163 (book, L et al);
California Galleries 4/2/76: 135 (books, 2);
Christies Lon 6/10/76: 170 (4);
Christies Lon 10/28/76: 233 (lot, L et al)(note),
   237 ill(note);
Swann NY 11/11/76: 340 (lot, L et al);
California Galleries 1/23/77: 381 (lot, L et al),
   400 (27);
Sothebys NY 5/20/77: 38;
Christies Lon 6/30/77: 156 (lot, L-1 et al), 164;
Christies Lon 10/27/77: 191 ill(lot, L-7 et al), 370
   (albums, L-1 et al);
Sothebys Lon 11/18/77: 21 ill;
Swann NY 12/8/77: 349 (lot, L et al), 431 (album,
   L et al);
Sothebys LA 2/13/78: 140 (2);
Phillips NY 11/4/78: 47 (note);
Swann NY 12/14/78: 458 (lot, L et al);
Vermont Cat 11/12, 1977: 808 ill, 809 ill(2), 810
   ill, 812 ill, 813 ill, 814 ill, 815 ill, 816
   ill, 817 ill, 818 ill, 819 ill(2), 820 ill(2);
Sothebys Lon 3/14/79: 288 (60);
Christies Lon 3/15/79: 79 (lot, L-90 et al), 112
   (lot, L-2 et al);
Phillips NY 5/5/79: 98 (20);
Christies Lon 6/28/79: 70 (lot, L-2 et al), 236
   (lot, L-2 et al);
Phillips Can 10/4/79: 21 (album, L et al);
Christies Lon 10/25/79: 71 (lot, L-11 et al), 84
   (lot, L-6 et al), 396 (album, L-22 et al);
Christies NY 10/31/79: 30 (note);
Rose Boston Cat 5, 1980: 32 ill(note);
Sothebys LA 2/6/80: 13;
Christies Lon 3/20/80: 89 (lot, L-3 et al), 91
   (lot, L-10 et al), 95 (lot, L-2 et al), 104
   (lot, L-2 et al), 158 (albums, L-30 et al),
   345 ill, 352 (albums, L et al), 368 (albums,
   L-1 et al), 372 (lot, L et al);
Sothebys Lon 3/21/80: 164 (12);
Swann NY 4/17/80: 14 (book, L et al);
Christies NY 5/14/80: 204 (book, 12);
Christies Lon 6/26/80: 97 (lot, L-2 et al), 100
   (lot, L-3 et al), 104 (lot, L-4 et al), 119
   (lot, L-2 et al), 332 (book, L et al), 474
   (album, L-16 et al), 476 (album, L-10 et al),
   477 (album, L-3 et al), 478 (album, L et al),
   481 (album, L-2 et al), 489 (albums, L et al),
   507 (albums, L et al);
Sothebys Lon 6/27/80: 252;
Sothebys Lon 10/29/80: 12 (17);

**LONDON STEREOSCOPIC COMPANY** (continued)
Christies Lon 10/30/80: 97 (lot, L attributed et
al), 98 (lot, L et al), 102 (lot, L et al), 103
(lot, L-2 et al), 105 (lot, L et al), 106 (lot,
L-3 et al), 137 (lot, L et al), 149 (album, L et
al), 153 (albums, L et al), 430 (lot, L-3 et
al), 435 (albums, L et al), 447 (lot, L-1 et
al), 453 (albums, L et al);
Swann NY 11/6/80: 261 (lot, L-1 et al);
Christies Lon 3/26/81: 107 (3 ills)(5), 113 (lot,
L et al), 118 (lot, L et al), 387 ill, 402
(albums, L et al);
Sothebys Lon 3/27/81: 390 ill;
Christies Lon 6/18/81: 110 (lot, L-1 et al), 161
(lot, L et al);
Sothebys Lon 10/28/81: 3 (5), 15 (lot, L-1 et al),
203 ill;
Christies Lon 10/29/81: 121 (lot, L-1 et al), 131
(lot, L et al), 147 (lot, L et al);
Christies Lon 3/11/82: 65 (lot, L et al), 69 (82),
76 (lot, L-7 et al), 85 (lot, L et al);
Sothebys Lon 3/15/82: 240 (lot, L-1 et al);
Phillips Lon 3/17/82: 85 (albums, L et al);
Swann NY 4/1/82: 359 (46);
California Galleries 5/23/82: 231 (lot, L et al),
254 (lot, L et al);
Christies NY 5/26/82: 17 ill(note);
Christies Lon 6/24/82: 42, 64 (lot, L-8 et al), 244
(book, L-27 et al), 379 (album, L-1 et al);
Sothebys Lon 6/25/82: 61 ill(note), 62 ill;
Phillips Lon 10/27/82: 14 (lot, L-5 et al);
Christies Lon 10/28/82: 29 ill(lot, L-6 et al);
Swann NY 11/18/82: 254 (books, L et al);
Harris Baltimore 12/10/82: 42 (lot, L-2 et al),
90 (lot, L-2 et al);
Christies Lon 3/24/83: 36 (lot, L et al), 237
(album, L et al);
Harris Baltimore 4/8/83: 52 (lot, L et al), 105
(lot, L-7 et al);
Phillips Lon 6/15/83: 97 (lot, L et al);
Christies Lon 6/23/83: 68 (album, L et al);
Phillips Lon 11/4/83: 39 (album);
Swann NY 11/10/83: 274 (25), 277 (album, L et al),
279 (lot, L et al), 354 (lot, L-2 et al);
Harris Baltimore 12/16/83: 32 (37, attributed), 77
(41), 110 (lot, L-4 plus 4 attributed), 377 (6);
Christies Lon 3/29/84: 340;
Swann NY 5/10/84: 291 (lot, L et al), 322 (albums,
L et al)(note);
Harris Baltimore 6/1/84: 53 (lot, L et al), 64
(lot, L-15 et al), 137 (lot, L et al), 164 (lot,
L et al), 261;
California Galleries 7/1/84: 165 (lot, L et al);
Swann NY 11/8/84: 202 (albums, L et al);
Harris Baltimore 3/15/85: 76 (lot, L-1 attributed
et al), 255 (lot, L-1 et al), 270 (lot, L et
al), 276 (lot, L et al), 277 (lot, L et al),
279 (lot, L et al);
Phillips Lon 3/27/85: 182 (album);
Christies Lon 3/28/85: 321 (album, L et al);
Swann NY 5/9/85: 419 (note);
California Galleries 6/8/85: 324 (15);
Phillips Lon 10/30/85: 28 (5);
Swann NY 11/14/85: 137 (album, L et al);
Harris Baltimore 2/14/86: 71 (lot, L et al), 74
(lot, L et al);
Phillips Lon 4/23/86: 192 (lot, L-31 et al), 194
(lot, L-16 et al);
Christies Lon 4/24/86: 336 (lot, L et al), 356
(78)(note), 362 (lot, L-10 et al), 591
(album, 74);

**LONDON STEREOSCOPIC COMPANY** (continued)
Swann NY 5/16/86: 313 (lot, L et al);
Christies Lon 6/26/86: 6 (50), 58 (lot, L et al);
Phillips Lon 10/29/86: 222 (lot, L-1 et al), 228
(lot, L-1 et al), 244 (lot, L-15 et al);
Christies Lon 10/30/86: 26 (lot, L-49 et al), 217
(albums, L et al);
Sothebys Lon 10/31/86: 89;
Harris Baltimore 11/7/86: 225 (lot, L et al);
Swann NY 11/13/86: 169 (albums, L et al);

**LONG, Charles A.** (British)
Photos dated: 1880s
Processes: Woodburytype
Formats: Prints
Subjects: Portraits
Locations: Great Britain
Studio: Great Britain
Entries:
Sothebys Lon 3/9/77: 190 (lot, L et al);

**LONG, Enoch** (American, born 1823)
Photos dated: 1846-1860s
Processes: Daguerreotype, tintype
Formats: Plates
Subjects: Portraits
Locations: Studio
Studio: US - St. Louis, Missouri; Illinois
Entries:
Sothebys NY 11/21/70: 298 ill;
Vermont Cat 4, 1972: 326 ill(note);

**LONG, H.H.** (American)
Photos dated: 1846-1865
Processes: Daguerreotype
Formats: Plates
Subjects: Portraits
Locations: Studio
Studio: US - St. Louis, Missouri
Entries:
Sothebys NY (Weissberg Coll.) 5/16/67: 94 (lot,
L-1 et al);

**LOOF, H.** (British)
Photos dated: 1860s
Processes: Albumen
Formats: Stereos
Subjects: Topography
Locations: Great Britain
Studio: Great Britain
Entries:
Christies Lon 6/23/83: 43 (lot, L et al);
Sothebys Lon 6/29/84: 9 (lot, L et al);

**LOOMIS** (American)
Photos dated: 1860s
Processes: Albumen
Formats: Cdvs
Subjects: Portraits
Locations: Studio
Studio: US - Boston, Massachusetts
Entries:
Sothebys NY (Strober Coll.) 2/7/70: 263 (lot,
L et al);

**LOOP, H.W.**
Photos dated: 1870s and/or 1880s
Processes:  Albumen
Formats:    Prints
Subjects:   Topography
Locations:  India
Studio:
   Entries:
Christies Lon 10/27/77: 178 (album, L-2 et al);

**LORD, R.H.** (British)
Photos dated: 1890s
Processes:  Silver
Formats:    Prints
Subjects:   Genre
Locations:  England - Cambridge
Studio:     England - Cambridge
   Entries:
Sothebys Lon 6/29/79: 258;

**LORENS, A.**
Photos dated: c1860-1880s
Processes:  Albumen
Formats:    Prints, stereos
Subjects:   Topography
Locations:  Russia - St. Petersburg and Moscow
Studio:     Russia - St. Petersburg
   Entries:
Swann NY 5/10/84: 293 (13);
Sothebys Lon 6/28/85: 11 ill(23);
Christies Lon 6/26/86: 199 (lot, L-10 et al);

**LORENT, Jakob August** (German, 1813-1884)
Photos dated: 1853-1860s
Processes:  Salt, albumen
Formats:    Prints
Subjects:   Topography, architecture
Locations:  Italy - Venice; Greece - Athens;
           Spain; Algeria; Egypt
Studio:
   Entries:
Petzold Germany 5/22/81: 1822 ill(note);
Christies Lon 6/28/84: 197;

**LORING** (American) [LORING 1]
Photos dated: 1891
Processes:  Albumen
Formats:    Prints
Subjects:   Topography
Locations:  US - Eastport, Maine
Studio:     US - Eastport, Maine
   Entries:
Harris Baltimore 12/16/83: 383 (6);

**LORING & GREEN** (American) [LORING 2]
Photos dated: 1871
Processes:  Albumen
Formats:    Prints
Subjects:   Topography
Locations:  US - Syracuse, New York
Studio:     US - Syracuse, New York
   Entries:
Wood Conn Cat 37, 1976: 398 ill;
Harris Baltimore 12/10/82: 414;

**LOTZE, Maurizio** (German, 1809-1890)
Photos dated: 1840s-1860s
Processes:  Salt, albumen
Formats:    Prints, cdvs
Subjects:   Topography
Locations:  Italy - Verona; Germany - Bavaria
Studio:     Italy - Verona
   Entries:
Christies Lon 10/27/77: 88 (lot, L-3 et al);
Petzold Germany 11/7/81: 326 (lot, M et al);
Sothebys Lon 10/29/82: 118 ill;

**LOUBERE, P.** (French)(see also L., P.)
Photos dated: 1871
Processes:  Albumen
Formats:    Prints
Subjects:   Documentary (Paris Commune)
Locations:  France - Paris
Studio:     France
   Entries:
White LA 1977: 260 (3 ills)(21);
Auer Paris 5/31/80: 73 (album, 16);
Christies Lon 6/26/80: 199 (album, 24);
Christies Lon 3/26/81: 186 (album, 24);
Swann NY 11/14/85: 245 (book, 21);

**LOUD** (American)
Photos dated: 1850s
Processes:  Ambrotype
Formats:    Plates
Subjects:   Portraits
Locations:  Studio
Studio:     US - New York City
   Entries:
Swann NY 4/23/81: 264;

**LOUREIRO** (Portuguese)
Photos dated: 1880s
Processes:  Albumen
Formats:    Cdvs
Subjects:   Ethnography
Locations:  Azores - Fayal
Studio:     Azores
   Entries:
Swann NY 11/5/81: 425 ill(lot, L-1 et al)(note);

**LOUVIOT, A.** (French)
Photos dated: 1856-1859
Processes:  Albumen
Formats:    Prints
Subjects:   Architecture
Locations:  France - Fontainebleau
Studio:     France
   Entries:
Rauch Geneva 6/13/61: 196 (8);
Sothebys Lon 3/21/75: 106 (album, 16);

**LOVE, J.W.** (American)
Photos dated: 1860s-1870s
Processes:  Albumen
Formats:    Stereos
Subjects:   Topography
Locations:  US - Washington, D.C. et al
Studio:     US
   Entries:
Swann NY 4/14/77: 322 (lot, L et al);

**LOVE, R.** (British)
Photos dated: 1850s
Processes:      Daguerreotype
Formats:        Plates
Subjects:       Portraits
Locdations:     Studio
Studio:         England - Cheltenham
    Entries:
Christies Lon 3/16/78: 43 (lot, L-1 et al);

**LOVEJOY, C.L.** (American)
Photos dated: 1860s-1870s
Processes:      Albumen
Formats:        Stereos, cdvs
Subjects:       Topography, portraits
Locations:      US - New York
Studio:         US - Utica, New York
    Entries:
Harris Baltimore 4/8/83: 17 (lot, L et al);

**LOVEJOY, E. & FOSTER** (American)
Photos dated: early 1870s
Processes:      Albumen
Formats:        Stereos, cdvs
Subjects:       Documentary (disasters)
Locations:      US - Chicago, Illinois
Studio:         US - Chicago, Illinois
    Entries:
Sothebys NY (Strober Coll.) 2/7/70: 489 (lot,
    L & F-5 et al), 491 (lot, L & F-20 et al);
Sothebys NY 11/21/70: 368 (lot, L & F et al);
Rinhart NY Cat 2, 1971: 452 (lot, L & F-1 et al);
Sothebys Lon 10/18/74: 2 (lot, L & F-5 et al);
Swann NY 12/14/78: 273 (7);
Christies Lon 10/29/81: 147 (lot, L, L & F et al);
Swann NY 11/18/82: 447 (lot, L & F et al);
Harris Baltimore 6/1/84: 23 (lot, L & F-11 et al),
    25 (lot, L & F-34 et al), 302 (lot, L & F et al);
Swann NY 11/14/85: 157 (lot, L & F et al);

**LOVELL, J.L.** (American)
Photos dated: 1861-1870
Processes:      Salt, albumen
Formats:        Prints, cdvs, stereos
Subjects:       Portraits, documentary (educational
                institutions)
Locations:      US - Amherst, Massachusetts;
                Annapolis, Maryland
Studio:         US - Amherst, Massachusetts
    Entries:
Rinhart NY Cat 1, 1971: 128 (7);
Wood Conn Cat 37, 1976: 94 (book, 7)(note);
Sothebys NY 10/4/77: 106 (album, 47);
Wood Conn Cat 42, 1978: 242 (book, 7)(note);
Swann NY 4/20/78: 284 (album, 80);
Wood Conn Cat 45, 1979: 135A (book, 7)(note);
Wood Conn Cat 49, 1982: 215 (book, 20)(note);
Swann NY 11/18/82: 153 (book, 14);
Harris Baltimore 4/8/83: 54 (10);
Harris Baltimore 3/15/85: 60 (lot, L et al), 221
    (albums, L et al);
Swann NY 11/14/85: 60 (album, L et al), 61 (album,
    L et al);

**LOVELL, J.S.** (American)
Photos dated: 1882
Processes:      Albumen
Formats:        Stereos
Subjects:       Documentary (disasters)
Locations:      US - Grinnell, Iowa
Studio:         US - Davenport, Iowa
    Entries:
Rinhart NY Cat 6, 1973: 421 (lot, L-4 et al);
California Galleries 1/23/77: 393 (lot, L et al);

**LOW** (British)
Photos dated: Nineteenth century
Processes:      Albumen
Formats:        Cdvs
Subjects:       Portraits
Locations:      Studio
Studio:         Great Britain
    Entries:
Sothebys NY 11/21/70: 338 (lot, L et al);

**LOWE, R.** (British)
Photos dated: 1850s
Processes:      Daguerreotype
Formats:        Plates
Subjects:       Portraits
Locations:      Studio
Studio:         England - Cheltenham
    Entries:
Sothebys Lon 3/21/75: 199 (3);
Sothebys Lon 3/21/80: 1, 47 (5);
Sothebys Lon 3/15/82: 291 ill;
Christies Lon 10/25/84: 18 ill;
Sothebys Lon 10/31/86: 5 (lot, L-2 et al);

**LOWELL, Percival**
Photos dated: 1886-1888
Processes:      Photogravure
Formats:        Prints
Subjects:       Topography
Locations:      Korea
Studio:
    Entries:
Swann NY 11/6/80: 116 (book);
Swann NY 5/10/84: 79 (book, 25);

**LOWY, J.** (Austrian)
Photos dated: 1860s-1895
Processes:      Albumen, collotype, heliogravure
Formats:        Prints, stereos, cabinet cards
Subjects:       Topography, documentary
Locations:      Austria - Vienna; Sudan;
                Mediterranean area; Aegean area
Studio:         Austria - Vienna
    Entries:
Sothebys NY 5/20/80: 397 ill(book, 103);
Christies Lon 6/26/80: 343 ill(book, 130);
Harris Baltimore 3/15/85: 309 (lot, L et al);

**LOYDREAU, Edouard** (French)
Photos dated: 1852
Processes:      Salt (Blanquart-Evrard)
Formats:        Prints
Subjects:       Genre (rural life)
Locations:
Studio:
   Entries:
Gordon NY 5/10/77: 780 ill;

**LUCAS, Arthur** (British)
Photos dated: 1869
Processes:      Albumen
Formats:        Prints
Subjects:       Topography, genre (animal life)
Locations:      Tibet
Studio:
   Entries:
Swann NY 2/14/52: 338 (book, 12)(note);
Christies NY 10/31/79: 28 (book);
Wood Conn Cat 49, 1982: 245 (book, 3)(note);

**LUCAS, J.T.** (British)
Photos dated: 1859
Processes:      Albumen
Formats:        Prints
Subjects:       Topography
Locations:
Studio:         Great Britain
   Entries:
Sothebys Lon 3/8/74: 170 (book, L et al);

**LUCAS, R.C.** (British)
Photos dated: 1875
Processes:      Albumen
Formats:        Prints
Subjects:       Genre
Locations:      Studio
Studio:         Great Britain
   Entries:
Christies Lon 10/27/77: 223 ill(book, 12);

**LUCKE, Ernst & Co.** (German)
Photos dated: c1870
Processes:      Albumen
Formats:        Prints
Subjects:       Documentary (Franco-Prussian war)
Locations:      France
Studio:         Germany - Berlin
   Entries:
Sothebys NY 2/25/75: 51 ill(12)(note);
Swann NY 10/18/79: 341 ill(note);

**LUCKHARDT, Fritz** (Austrian)
Photos dated: 1860s-1892
Processes:      Albumen
Formats:        Cdvs, cabinet cards, stereos
Subjects:       Portraits, genre
Locations:      Studio
Studio:         Austria - Vienna
   Entries:
Sothebys NY (Greenway Coll.) 11/20/70: 47 (lot,
   L-1 et al);
Rinhart NY Cat 2, 1971: 497 (14);
Christies Lon 10/28/76: 238;
Petzold Germany 11/7/81: 307 (album, L et al);
Old Japan, England Cat 8, 1985: 56 ill;
Harris Baltimore 3/15/85: 21 (lot, L et al);

**LUCOCK, J.** (British)
Photos dated: 1860s
Processes:      Albumen
Formats:        Stereos
Subjects:       Topography
Locations:      England - London
Studio:         England (Amateur Photographic
                Association)
   Entries:
Christies Lon 10/27/83: 30 (lot, L-1 et al);

**LUDWICH & Co.**
Photos dated: Nineteenth century
Processes:      Albumen
Formats:        Cdvs and/or cabinet cards
Subjects:       Portraits
Locations:      Studio
Studio:         England - Brighton
   Entries:
Phillips Lon 10/29/86: 313 (album, L et al);

**LUKE, W.H.** (British)
Photos dated: 1850s and/or 1860s
Processes:      Albumen
Formats:        Stereos
Subjects:       Topography
Locations:      Great Britain
Studio:         England - Plymouth
   Entries:
Christies Lon 10/28/82: 17 (lot, L et al);
Christies Lon 10/25/84: 52 (lot, L et al);
Christies Lon 4/24/86: 363 (lot, L-2 et al);

**LUKS**
Photos dated: 1870s-c1880
Processes:      Albumen
Formats:        Cdvs, cabinet cards
Subjects:       Portraits
Locations:      Studio
Studio:         Europe
   Entries:
Harris Baltimore 6/1/84: 295 (lot, L et al);
Swann NY 11/14/85: 147 (album, L et al);

**LUMHOLTZ, Dr. Carlos** (photographer or author?)
Photos dated; 1890-1893
Processes:
Formats:          Prints
Subjects:         Documentary
Locations:        US - New York; Mexico - Chihuhuahua
Studio:
  Entries:
Frontier AC, Texas 1978: 205 (album, 52)(note);

**LUMIERE, Louis** (French, 1864-1948)
Photos dated: 1896-1900s
Processes:        Collodion, autochrome
Formats:          Kinetiscope reel, glass plates
Subjects:         Genre
Locations:        Studio
Studio:           France - Lyon
  Entries:
Sothebys Lon 3/22/78: 171 (9);
Sothebys NY 5/2/78: 139 ill;

**LUMMIS, Charles Fletcher** (American, 1859-1928)
Photos dated: 1886-1894
Processes:        Cyanotype
Formats:          Prints
Subjects:         Ethnography
Locations:        US - New Mexico, Arizona; Peru
Studio:           US - New Mexico
  Entries:
Sothebys NY 9/23/75: 97 ill(3);
Sothebys NY 5/4/76: 164 (2);
Frontier AC, Texas 1978: 206 (7), 207 ill
  (attributed);
Sothebys NY 5/15/81: 122 ill(note);
Sothebys NY 5/8/84: 404 ill(120)(note);
Swann NY 11/8/84: 222 (attributed);
Swann NY 5/9/85: 408 (2)(note);
Swann NY 11/13/86: 265 (2);

**LUMPKIN, E.S.** (American)
Photos dated: 1860s-1870s
Processes:        Albumen
Formats:          Cdvs, stereos
Subjects:         Portraits, topography
Locations:        US - Richmond, Virginia
Studio:           US - Richmond, Virginia
  Entries:
Swann NY 2/6/75: 169 (lot, L et al);
Swann NY 5/16/86: 222 (lot, L & Tomlinson et al);

**LUNDBERGH, J.**
Photos dated: 1860s-1870s
Processes:        Albumen
Formats:          Cdvs
Subjects:         Topography and/or ethnography
Locations:
Studio:
  Entries:
Christies Lon 10/27/83: 234 (album, L-1 et al);

**LUNGHI, P.** (Italian)
Photos dated: between 1870s and 1890s
Processes:        Albumen
Formats:          Prints
Subjects:         Topography
Locations:        Italy
Studio:           Italy
  Entries:
Swann NY 11/13/86: 245 (lot, L et al);

**LUSHER, M.E.**
Photos dated: 1870s-1895
Processes:        Albumen, bromide
Formats:          Prints
Subjects:         Topography, documentary (scientific)
Locations:        Bermuda
Studio:           Bermuda - Hamilton
  Entries:
Wood Conn Cat 37, 1976: 218 (album, 79)(note);
Swann NY 4/14/77: 202 (lot, L-1 et al)(note);
Wood Conn Cat 42, 1978: 554 (album, 79)(note);
Christies Lon 10/30/80: 277 (album, L-1 et al);
Christies Lon 4/24/86: 395 (album, L et al);

**LUSWERGH, Angelo** (see LUSWERGH, Giacomo)

**LUSWERGH, Giacomo** (Italian, 1819-1891)
Photos dated: 1851-1860s
Processes:        Calotype, albumen
Formats:          Prints, stereos, cdvs
Subjects:         Architecture, topography
Locations:        Italy - Rome, Venice
Studio:           Italy - Rome
  Entries:
Christies Lon 3/15/79: 107 (8);
Sothebys Lon 3/15/82: 93 ill(lot, L-3 et al)(note);
Christies Lon 3/24/83: 68 (3)(note);
Sothebys Lon 4/25/86: 58 (lot, Antonio L et al)
  (note), 65 (lot, L-4 et al);
Sothebys Lon 10/31/86: 60 (lot, L et al);

**LUTWIDGE, Robert Wilfred Skeffington** (British,
                1802-1873)
Photos dated: 1855-1858
Processes:        Albumen
Formats:          Prints
Subjects:         Topography, genre (still life)
Locations:        England - Salisbury, Cornwall
Studio:           Great Britain (Photographic Club)
  Entries:
Weil Lon Cat 4, 1944(?): 237 (album, L et al)(note);
Sothebys Lon 3/21/75: 286 (album, L-1 et al);
Sothebys Lon 3/14/79: 265 ill(note), 324 (album, L-1
  et al);
Sothebys Lon 11/1/85: 59 (album, L-1 et al);

**LUTZE & WITTE** (German)
Photos dated: 1857
Processes:        Salt
Formats:          Prints
Subjects:         Topography
Locations:        Germany - Berlin
Studio:           Germany
  Entries:
Lennert Munich Cat 5, 1979: 13 ill;

**LUYS, Georges**
Photos dated: 1888
Processes:      Albumen
Formats:        Prints
Subjects:       Documentary (scientific)
Locations:
Studio:
    Entries:
Christies Lon 3/24/83: 160 ill(book, 28);

**LYFORD** (British)
Photos dated: c1860
Processes:      Albumen
Formats:        Stereos
Subjects:       Topography
Locations:
Studio:
    Entries:
Christies Lon 3/28/85: 42 (lot, L et al);

**LYNN** (American)
Photos dated: early 1860s
Processes:      Albumen
Formats:        Stereos
Subjects:       Documentary (Civil War)
Locations:      US
Studio:         US
    Entries:
Harris Baltimore 2/14/86: 13 (lot, L et al);

**LYNN, Mary Emma** (British, born 1813)
Photos dated: 1855
Processes:      Albumen
Formats:        Prints
Subjects:       Topography
Locations:      England - Suffolk
Studio:         England
    Entries:
Sothebys Lon 3/21/75: 286 (album, L-1 et al);

**LYON** (see ECKERSON & LYON)

**LYON, E.D.**
Photos dated: 1870s and/or 1880s
Processes:      Albumen
Formats:        Prints
Subjects:       Topography
Locations:      India
Studio:
    Entries:
Sothebys Lon 10/29/80: 48 ill(album, L et al);

**LYTE, Farnham Maxwell** (British, 1828-1906)
Photos dated: 1853-1860
Processes:      Salt, albumen
Formats:        Prints, stereos
Subjects:       Topography
Locations:      France - Pyrenees
Studio:         France - Pau
    Entries:
Sothebys Lon 3/8/74: 161 (album, L-1 et al);
Sothebys NY 10/4/77: 161 ill(note);
Phillips Lon 3/13/79: 37;
Sothebys Lon 6/17/81: 348 ill;
Octant Paris 1982: 10 ill;
Sothebys Lon 3/15/82: 319 (13, attributed);
Sothebys Lon 10/26/84: 93 ill, 93a (2);
Sothebys Lon 3/29/85: 203 ill(3);
Sothebys Lon 6/28/85: 190 ill;
Christies Lon 6/26/86: 182 (lot, L-1 et al);
Sothebys Lon 10/31/86: 7 (lot, L-2 et al);
Swann NY 11/13/86: 267, 357 (lot, L et al);

**M. & Co.** [same]
Photos dated: 1860s and/or 1870s
Processes:      Albumen
Formats:        Prints
Subjects:       Topography
Locations:      Europe
Studio:         Europe
    Entries:
Wood Conn Cat 37, 1976: 249 (album, M et al);

**M., C.** [C.M.]
Photos dated: 1870
Processes:      Albumen
Formats:        Prints
Subjects:       Topography
Locations:      Portugal - Cintra
Studio:
    Entries:
Sothebys Lon 6/11/76: 161 (book, 15);

**M., D.** [D.M.] (American)
Photos dated: 1873
Processes:      Albumen
Formats:        Prints
Subjects:       Architecture
Locations:      US - Pennsylvania
Studio:         US - New York City
    Entries:
Wood Conn Cat 37, 1976: 127 (book, 11)(note);
Wood Conn Cat 42, 1978: 316 (book, 11)(note);

**M., E.** [E.M.] (British)
Photos dated: Nineteenth century
Processes:
Formats:        Microphotographs
Subjects:       Documentary (scientific)
Locations:
Studio:         England - London
    Entries:
Phillips Lon 10/30/85: 94 (lot, M-1 et al);

**M., J.** [J.M.] (French) [M., J. 1]
Photos dated: Nineteenth century
Processes:      Albumen
Formats:        Stereos (tissue)
Subjects:       Genre
Locations:      France
Studio:         France
    Entries:
California Galleries 9/27/75: 545 (lot, M et al);

**M., J.** [J.M.] (possibly MARTIN, J., q.v.)
                    [M., J 2]
Photos dated: 1880s-1890s
Processes:      Albumen
Formats:        Prints
Subjects:       Topography
Locations:      New Zealand
Studio:
    Entries:
Christies Lon 3/28/85: 76 (album, M et al), 77
(lot,
    M et al);
Christies Lon 10/31/85: 116 (lot, M et al);
Christies Lon 4/24/86: 410 (lot, M et al);

**M., J.** (continued)
Christies Lon 6/26/86: 112 (albums, M et al);
Sothebys Lon 10/31/86: 11 (albums, M et al);

**M., J.E.** [J.E.M.]
Photos dated: c1880
Processes:      Albumen
Formats:        Prints
Subjects:       Ethnography
Locations:      South Africa
Studio:
    Entries:
California Galleries 12/13/80: 151 (2);
California Galleries 6/28/81: 131 (lot, M-1 et al);

**M., O.** [O.M.]
Photos dated: 1860s
Processes:      Albumen
Formats:        Prints
Subjects:       Topography
Locations:      India
Studio:
    Entries:
Christies Lon 4/24/86: 508 (lot, M-7 et al);

**M., P.** [P.M.]
Photos dated: 1850s
Processes:      Salt
Formats:        Stereos
Subjects:       Topography
Locations:      France - Paris
Studio:         Europe
    Entries:
Christies Lon 3/24/83: 38 (lot, M et al);

**M., W.** [W.M.] (British)
Photos dated: Nineteenth century
Processes:
Formats:        Microphotographs
Subjects:       Portraits
Locations:      Studio
Studio:         Great Britain
    Entries:
Phillips Lon 10/30/85: 90;

**MACAGNO**
Photos dated: 1875
Processes:      Albumen
Formats:        Prints
Subjects:       Topography
Locations:      France - Soissons and Coucy
Studio:
    Entries:
Andrieux Paris 1952(?): 726 (book, 15);

**MacDONALD** (American)
Photos dated: c1890
Processes:      Silver
Formats:        Prints
Subjects:       Topography
Locations:      US - San Francisco, California
Studio:         US
    Entries:
California Galleries 6/19/83: 371 (lot, M-1 et al);

**MacDONALD, A.J.** (American)
Photos dated: c1875
Processes:     Albumen
Formats;       Stereos
Subjects:      Topography
Locations:     US - California
Studio:        US
   Entries:
California Galleries 6/19/83: 423 (lot, M-1 et al);

**MACDONALD, Hugh** (British)(photographer or author?)
Photos dated: 1870
Processes:     Albumen
Formats:       Prints
Subjects:      Topography
Locations:     Scotland
Studio:        Scotland
   Entries:
Christies Lon 3/16/78: 216 (book, 13);

**MACEWEN, William** (British)(photographer or
                        author?)
Photos dated: 1893
Processes:     Photogravure
Formats:       Prints
Subjects:      Documentary (medical)
Locations:     Studio
Studio:        Great Britain
   Entries:
Wood Conn Cat 49, 1982: 14 ill(book, 53)(note);

**MACINTOSH, H.P.** (American)
Photos dated: 1880s
Processes:     Albumen
Formats:       Cabinet cards
Subjects:      Portraits
Locations:     Studio
Studio:        US - Newburyport, Massachusetts
   Entries:
Sothebys NY (Strober Coll.) 2/7/70: 284 (lot,
   M et al);
Phillips Can 10/4/79: 85 (lot, M-1 et al);

**MACK, John** (British)
Photos dated: 1860s and/or 1870s
Processes:     Albumen
Formats:       Stereos
Subjects:      Topography
Locations:     Great Britain
Studio:        Great Britain
   Entries:
Christies Lon 3/26/81: 128 (lot, M-1 et al);
Christies Lon 10/29/81: 138 (lot, M-1 et al);

**MACKENZIE, G.A.F.** (British)
Photos dated: 1884
Processes:     Albumen
Formats:       Prints
Subjects:      Genre
Locations:     Scotland
Studio:        Scotland
   Entries:
Christies Lon 3/29/84: 208 (lot, M-2 et al);

**MACKEY, J.E.** (American)
Photos dated: 1880s
Processes:     Albumen
Formats:       Stereos
Subjects:      Topography
Locations:     US - Florida
Studio:        US - Jacksonville, Florida
   Entries:
Harris Baltimore 2/14/86: 22 (lot, M attributed
   et al);

**MACKINLAY, Thomas G.** (British, c1809-1865)
Photos dated: early 1840s-1857
Processes:     Salt, albumen
Formats:       Prints
Subjects:      Topography
Locations:     England - Sussex
Studio:        Great Britain (Photographic Club,
               Photographic Exchange Club)
   Entries:
Weil Lon Cat 4, 1944(?): 237 (album, M et al)(note);
Sothebys Lon 3/21/75: 286 (album, M-1 et al);
Sothebys Lon 3/14/79: 324 (album, M-1 et al);
Sothebys Lon 11/1/85: 59 ill(album, M-1 et al);

**MacKINTOSH** (British)
Photos dated: 1881
Processes:     Albumen
Formats:       Prints
Subjects:
Locations:     Scotland
Studio:        Scotland
   Entries:
California Galleries 1/22/77: 213 (book, M et al);

**MACLEAY, K.** (British)(photographer or author?)
Photos dated: 1873
Processes:     Albumen
Formats:       Prints
Subjects:      Documentary (art)
Locations:
Studio:
   Entries:
Christies Lon 6/26/86: 10 (book, 31);

**MACNAB** (British)
Photos dated: 1850s-c1860
Processes:     Daguerreotype, albumen
Formats:       Plates, prints, cdvs
Subjects:      Portraits
Locations:     Studio
Studio:        Scotland - Glasgow
   Entries:
Edwards Lon 1975: 128 (book, 1);
Christies Lon 10/25/79: 24 (lot, M-1 et al);
Phillips Lon 6/23/82: 73 (4);

**MACPHERSON, Robert** (British, 1811-1872)
Photos dated: 1851-1872
Processes:    Salt, albumen
Formats:      Prints
Subjects:     Architecture, topography
Locations:    Italy - Rome
Studio:       Italy - Rome
  Entries:
Andrieux Paris 1951(?): 46 (5);
Swann NY 2/14/52: 223 (10), 224 (album, 126);
Rinhart NY Cat 6, 1973: 347 (note);
Sothebys Lon 12/4/73: 27 (33), 28 (album, M et al),
    29 ill(30)(note);
Sothebys NY 2/25/75: 133 ill(note), 134, 135 ill,
    136, 137 ill;
Sothebys Lon 3/21/75: 101;
Sothebys Lon 6/26/75: 123;
Colnaghi Lon 1976: 205 ill(note), 206 ill, 207,
    208, 209, 210, 211 ill, 212, 213 ill, 214, 215,
    216, 217, 218 ill;
Lunn DC Cat 6, 1976: 23 ill(note), 24 ill, 25 ill,
    26 ill, 27 ill, 28, 29, 30 ill, 31, 32;
Wood Conn Cat 37, 1976: 299 ill, 300 ill, 301 ill
    (attributed);
Sothebys NY 5/4/76: 69, 70, 71, 72 (2 ills)(album,
    M-24 et al);
Christies Lon 6/10/76: 57 (2 ills)(album, 50)(note);
Sothebys Lon 10/29/76: 154 ill(4);
Gordon NY 11/13/76: 21 ill;
Halsted Michigan 1977: 696 ill(note), 697 ill;
Sothebys NY 2/9/77: 20 (note), 21, 22, 23 ill, 24
    ill, 25, 26 ill;
Sothebys Lon 3/9/77: 35, 36 (3), 37;
Christies Lon 3/10/77: 124 ill(note), 125, 126;
Gordon NY 5/10/77: 811 ill, 812 ill;
Christies Lon 6/30/77: 86, 87 ill, 88 (8), 89
    (book, M-1 et al);
Sothebys NY 10/4/77: 213 ill, 214 (lot, M-1 et al),
    215 (attributed);
Christies Lon 10/27/77: 76 (note), 77 ill, 78, 79,
    80, 81 (lot, M-3 et al), 89 (132);
Lehr NY Vol 1:2, 1978: 28 ill;
Rose Boston Cat 3, 1978: 48 ill(note);
Wood Conn Cat 41, 1978: 48 ill(note), 49 ill;
Christies Lon 3/16/78: 67, 70 ill(album, M et al);
Sothebys Lon 3/22/78: 71 ill;
Sothebys NY 5/2/78: 71 ill, 72, 73;
Christies Lon 6/27/78: 81 ill(album, M-19 et al)
    (note);
Sothebys Lon 6/28/78: 289 ill(1 plus 6 attributed)
    (note), 299;
Christies Lon 10/26/78: 150 ill(21), 151, 152;
Sothebys Lon 10/27/78: 86;
Phillips NY 11/4/78: 34 ill;
Swann NY 12/14/78: 428 (4);
Lennert Munich Cat 5II, 1979: 21a ill, 21b;
Sothebys LA 2/7/79: 446, 447 ill(lot, M-1 et al);
Phillips Lon 3/13/79: 76 ill, 77, 78 ill, 79 (2);
Christies Lon 3/15/79: 109 (5), 110 (lot, M
    attributed et al);
Christies NY 5/4/79: 23 (4)(note), 24 (2), 26 ill
    (attributed)(note);
Phillips NY 5/5/79: 159 ill(2)(note), 160 (2);
Christies Lon 6/28/79: 97, 98 ill(6)(note), 99
    (lot, M-1 et al);
Sothebys Lon 6/29/79: 156 ill, 157, 158 ill(album,
    31), 159 ill(album, 33), 160 ill(album, 30), 162
    ill(album, 39), 163 ill;
Phillips Can 10/4/79: 7 ill;
Sothebys Lon 10/24/79: 154 ill, 155 ill;
Christies Lon 10/25/79: 141, 142;

**MACPHERSON, Robert** (continued)
Christies NY 10/31/79: 39, 40;
Phillips NY 11/3/79: 167 ill(note), 168
    (attributed)(note);
Sothebys LA 2/6/80: 119 (attributed);
Phillips Lon 3/12/80: 157;
Christies Lon 3/20/80: 145 ill(album, M-9 et al)
    (note);
California Galleries 3/30/80: 340;
Christies NY 5/16/80: 152 ill, 153 ill, 154, 155,
    156 ill, 157, 158, 159, 160, 161 (2), 162 ill,
    163;
Phillips NY 5/21/80: 215 (note), 216 ill, 217, 230
    (lot, M attributed et al);
Christies Lon 6/26/80: 174 ill(16)(note), 194
    (album, M attributed, et al);
Sothebys Lon 6/27/80: 99 ill, 100, 101, 102 ill,
    103 ill;
Phillips Can 10/9/80: 6;
Sothebys Lon 10/29/80: 77 ill, 78 ill, 79 ill, 80,
    81, 82 ill, 83, 84, 85, 86, 87;
Christies NY 11/11/80: 64;
Sothebys NY 11/17/80: 88, 89 ill;
Lennert Munich Cat 6, 1981: 4 ill, 5, 6 ill, 7 ill;
Christies Lon 3/26/81: 209 ill(40)(note), 210 ill,
    211 ill, 213 ill, 214 ill, 215 ill, 216 ill
    (album, M-14 plus 13 attributed), 261 (albums,
    M-1 et al);
Sothebys Lon 3/27/81: 49 (10), 135 ill, 136, 137,
    138 ill, 139, 140, 141, 142, 143, 144, 145;
Phillips NY 5/9/81: 36 ill(note), 37 ill, 38 ill,
    39;
Christies NY 5/14/81: 15 ill, 16;
Petzold Germany 5/22/81: 1824 ill, 1825 ill;
Sothebys Lon 6/17/81: 144 (3), 145 ill(2), 146 ill
    (2), 147 ill(attributed), 148, 149, 150 ill, 151
    ill, 152, 153 ill, 154, 155;
Christies Lon 6/18/81: 178, 179;
Sothebys NY 10/21/81: 160 ill;
Sothebys Lon 10/28/81: 99;
Christies Lon 10/29/81: 183, 269 (albums, M-1
    et al);
Swann NY 11/5/81: 355 ill(9);
Petzold Germany 11/7/81: 243 (lot, M-2 attributed
    et al);
Christies Lon 3/11/82: 125 ill(albums, 72)(note);
Sothebys Lon 3/15/82: 95, 96 ill, 97, 98 (2);
Harris Baltimore 3/26/82: 252;
Swann NY 4/1/82: 324 (10)(note);
Phillips NY 5/22/82: 829 ill, 830, 831, 832;
Sothebys NY 5/24/82: 265 ill(2);
Christies Lon 6/24/82: 162 ill, 163 ill(42)(note);
Sothebys Lon 6/25/82: 97 ill, 98 ill, 99 ill, 100
    ill, 101 ill(2), 102 ill, 103, 104;
Christies Lon 10/28/82: 67, 68, 69 ill(album, 27)
    (note), 70 (albums, 72)(note);
Sothebys Lon 10/29/82: 27;
Swann NY 11/18/82: 417 (5)(note);
Christies NY 2/8/83: 8 (2);
Christies Lon 3/24/83: 81 ill(25)(note), 82 (lot, M
    et al)(note), 83 (attributed);
Swann NY 5/5/83: 377 (lot, M-2 attributed, et al)
    (note), 396 (4)(note), 301 (7)(note);
Christies Lon 6/23/83: 91 (lot, M-1 et al), 106 ill
    (lot, M-23 et al)(note), 107 ill(lot, M-26 et al)
    (note), 108 (lot, M-3 et al), 109;
Sothebys Lon 6/24/83: 47 ill, 48 ill, 49 ill, 50
    ill, 51 ill(album, M et al);
Christies NY 10/4/83: 97 (2);
Christies Lon 10/27/83: 73 (lot, M-3 et al);

**MACPHERSON, Robert** (continued)
Phillips Lon 11/4/83: 113 ill(note), 114 ill, 115,
116, 117 ill, 118, 119 ill, 120 ill, 122
(attributed);
Swann NY 11/10/83: 299 (5)(note), 300 (5)(note),
301 (7)(note);
Sothebys Lon 12/9/83: 23 ill(lot, M-23 et al), 24
ill(28);
Harris Baltimore 12/16/83: 382 (2);
Christies Lon 3/29/84: 145, 146 ill(album, M-38 et
al)(note), 147 ill(album, 23)(note), 148 (lot,
M-26 et al)(note);
Sothebys Lon 5/29/84: 56, 57 (2);
Harris Baltimore 6/1/84: 402, 403, 404, 405 ill
(attributed), 406 (attributed), 407
(attributed), 408 (attributed), 409
(attributed), 410 (attributed), 411
(attributed);
Christies Lon 6/28/84: 206 (29)(note), 207 ill;
California Galleries 7/1/84: 536 (attributed), 537
(attributed), 538 (attributed), 539 (attributed);
Christies Lon 10/25/84: 179 (lot, M-23 et al)(note);
Sothebys Lon 10/26/84: 47 ill, 48 ill(album, 34);
Swann NY 11/8/84: 199 (lot, M-1 et al);
Christies NY 2/13/85: 137 (2), 138 ill(2), 139,
140 (2);
Harris Baltimore 3/15/85: 220 (2, attributed);
Christies Lon 3/28/85: 215 (9 plus 15 attributed)
(note), 216 (lot, M-6 et al), 217 ill(note);
Sothebys Lon 3/29/85: 111 ill(lot, M et al), 113
(lot, M-4 et al), 114 ill(lot, M-12 et al), 115
(lot, M-3 et al), 116 ill(17), 117 ill(lot, M-1
et al), 118 ill(album, 26)(attributed);
Swann NY 5/9/85: 409 (2);
California Galleries 6/8/85: 326;
Phillips Lon 6/26/85: 135 (lot, M et al);
Christies Lon 6/27/85: 147 (lot, M-4 et al), 148
ill(M-20 plus 23 attributed), 149 (lot, M-2
et al);
Sothebys Lon 6/28/85: 49 (lot, M-3 et al);
Phillips Lon 10/30/85: 117 ill(5), 118 (2 ills)(5),
119 (9), 120 ill(lot, M-9 et al);
Christies Lon 10/31/85: 192 (lot, M-6 et al);
Sothebys NY 11/12/85: 357 ill(lot, M-3 et al);
Swann NY 11/14/85: 127 (23);
Harris Baltimore 2/14/86: 323;
Phillips Lon 4/23/86: 293 (5);
Sothebys Lon 4/25/86: 65 (lot, M-1 et al), 66 ill;
Sothebys NY 5/12/86: 286 ill(4)(note);
Sothebys Lon 10/31/86: 54 (lot, M-2 et al), 56
ill(2);
Christies NY 11/11/86: 275 ill;
Sothebys NY 11/13/86: 229 ill(4), 329 ill(lot, M-1
et al), 387 ill(2 plus 7 attributed);
Swann NY 11/13/86: 268 (3, attributed), 357 (lot,
M et al);

**MacWILLIAMS, A.R.** (British)
Photos dated: Nineteenth century
Processes:      Albumen
Formats:        Stereos
Subjects:       Topography
Locations:      Great Britain
Studio:         Great Britian
  Entries:
Harris Baltimore 7/31/81: 97 (lot, M et al);

**MADDISON, A.**
Photos dated: 1873
Processes:      Albumen
Formats:        Prints
Subjects:       Documentary (public events)
Locations:
Studio:
  Entries:
Christies Lon 3/16/78: 223 (books, M-100 et al);

**MADDOX, Dr. Richard Leach** (British, 1816-1902)
Photos dated: 1868
Processes:      Albumen
Formats:        Prints
Subjects:       Documentary (scientific)
Locations:      England
Studio:         England
  Entries:
Wood Conn Cat 42, 1978: 319 (book, 1)(note);

**MAES, J.** (Belgian)
Photos dated: 1864
Processes:      Albumen
Formats:        Prints, cdvs
Subjects:       Portraits, documentary (art)
Locations:      Studio
Studio:         Belgium - Brussels
  Entries:
Sothebys NY 11/21/70: 342 (lot, M-1 et al), 350
(lot, M-1 et al);
Sothebys Lon 7/1/77: 177 (book, 57);

**MAGALHAES, A.S.** (Portuguese)
Photos dated: c1872
Processes:      Albumen
Formats:        Prints
Subjects:       Topography
Locations:      Portugal - Coimbra and Thomar
Studio:         Portugal
  Entries:
Swann NY 2/14/52: 278 (album, 25);
Swann NY 4/17/80: 350 (album, 12);

**MAGE, E.**
Photos dated: c1870
Processes:      Albumen
Formats:        Prints
Subjects:       Topography
Locations:      Europe
Studio:         Europe
  Entries:
Christies Lon 4/24/86: 380 (album, M-2 et al);

**MAGGI, Giovanni Battista** (Italian)
Photos dated: 1850-1885
Processes:      Albumen
Formats:        Prints, cdvs
Subjects:       Topography, genre (nudes)
Locations:      Italy - Turin and Rome
Studio:         Italy - Turin and Rome
  Entries:
Swann NY 11/11/76: 450 (lot, M et al);
Sothebys NY 2/9/77: 36 (lot, M et al);
Swann NY 4/14/77: 245 (album, M et al);
Christies Lon 3/26/81: 183 (album, M-3 et al);
Christies Lon 3/11/82: 133 (album, M-3 et al);

**MAGILL, James**
Photos dated: 1860s-1870s
Processes:      Albumen
Formats:        Cdvs, stereos
Subjects:       Portraits, topography
Locations:      Ireland
Studio:         Northern Ireland - Belfast
   Entries:
Christies Lon 10/30/80: 419 (albums, M et al);
Christies Lon 6/18/81: 425 (album, M et al);

**MAGNON, Henri** (French)
Photos dated: 1896
Processes:      Heliogravure
Subjects:       Architecture
Locations:      France - Mont St. Michel
Studio;         France
   Entries:
Harris Baltimore 12/10/82: 136 (book, 24);

**MAGNY** (French)
Photos dated: 1850s-1870s
Processes:      Albumen
Formats:        Prints
Subjects:       Documentary (engineering)
Locations:      France - Coutances
Studio:         France - Coutances
   Entries:
Sothebys LA 2/13/78: 121 (books, M et al);

**MAITLAND, Reverend Dr.** (British)
Photos dated: 1860s
Processes:      Albumen
Formats:        Prints
Subjects:       Topography
Locations:      Great Britain - Glen Ken
Studio:         Great Britain
   Entries:
Sothebys NY 5/20/77: 62 (albums, M et al);

**MAJOR, Reverend John Richardson** (British,
           1797-1876 or 1821-1871)
Photos dated: 1855-1857
Processes:      Albumenized salt
Formats:        Prints
Subjects:       Architecture
Locations:      England - Lancashire
Studio:         England (Photographic Club)
   Entries:
Sothebys Lon 3/21/75: 286 (album, M-1 et al);
Sothebys Lon 3/14/79: 324 (album, M-1 et al);
Sothebys Lon 11/1/85: 59 ill(album, M-1 et al);

**MALACRIDA, Jules**
Photos dated: 1853
Processes:      Daguerreotype
Formats:        Plates
Subjects:       Portraits, genre (nudes)
Locations:      Studio
Studio:         France - Toulon and Paris
   Entries:
Christies Lon 10/30/80: 15 ill;
Sothebys Lon 6/17/81: 52 (2);

**MALBY** (British)
Photos dated: 1870s
Processes:      Albumen
Formats:        Prints
Subjects:       Genre
Locations:      Great Britain
Studio:         Great Britain
   Entries:
Sothebys Lon 3/21/80: 373 (2);

**MALEGUE, Hippolyte** (French)
Photos dated: 1850s
Processes:      Salt (Blanquart-Evrard)
Formats:        Prints
Subjects:       Documentary
Locations:      France
Studio:         France
   Entries:
Swann NY 4/23/81: 359 ill(note);

**MALLETT, Alfred**
Photos dated: 1890s
Processes:      Albumen
Formats:        Prints
Subjects:       Topography
Locations:
Studio:
   Entries:
Christies Lon 3/28/85: 92 (lot, M et al), 103
   (albums, M et al);

**MALLITE, Oscar** (photographer or author?)
Photos dated: 1877
Processes:      Albumen
Formats:        Prints
Subjects:       Documentary
Locations:      India
Studio:
   Entries:
Sothebys Lon 6/27/80: 60 ill(album, 20);

**MALONE, Thomas Augustine** (see HENNEMAN, N.)

**MALVAUX, Jean** (Belgian)
Photos dated: c1895
Processes:      Photogravure
Subjects:       Portraits
Locations:      Studio
Studio:         Belgium - Brussels
   Entries:
California Galleries 3/30/80: 357 (lot, M-1 et al);

**MANCEL, H.**
Photos dated: c1887
Processes:      Albumen
Formats:        Cabinet cards
Subjects:       Ethnography
Locations:      US - Fort Pickens, Florida
Studio:         US - Pensacola, Florida
   Entries:
Swann NY 11/8/84: 208 ill(note);

**MANCHESTER, Henry N. & Edwin H.** (American)
Photos dated: 1848-1860s
Processes:      Daguerreotype, albumen
Formats:        Plates, stereos, cdvs
Subjects:       Topography, portraits
Locations:      US - New England
Studio:         US - Providence, Rhode Island
    Entries:
Swann NY 11/5/81: 552 (lot, M et al);
Harris Baltimore 3/15/85: 86 (lot, M-4 et al);

**MANDERS**
Photos dated: c1880
Processes:      Albumen
Formats:        Cabinet cards
Subjects:       Portraits
Locations:
Studio:
    Entries:
California Galleries 9/27/75: 374 (lot, M et al);

**MANELLI** (Italian)
Photos dated: between 1875 and 1895
Processes:      Albumen
Formats:        Prints
Subjects:       Topography, architecture
Locations:      Italy
Studio:         Italy
    Entries:
Swann NY 11/11/76: 388 (albums, M et al), 389
    (albums, M et al), 394 (albums, M et al), 395
    (albums, M et al);
Phillips NY 5/9/81: 28 (albums, M et al);

**MANENIZZA, M.**
Photos dated: c1895
Processes:      Albumen
Formats:        Prints
Subjects:       Documentary (engineering)
Locations:      Austria - Vienna
Studio:         Europe
    Entries:
California Galleries 3/30/80: 435 (2);

**MANG, Michele**
Photos dated: 1860s-1870s
Processes:      Albumen
Formats:        Prints, stereos, cdvs
Subjects:       Topography, portraits
Locations:      Italy - Rome
Studio:         Italy - Rome
    Entries:
Wood Conn Cat 37, 1976: 226 (album, M et al)(note);
Swann NY 11/11/76: 393 (albums, M et al), 407
    (album, M et al);
Sothebys Lon 10/24/79: 147 (lot, M-1 et al);
Swann NY 4/23/81: 526 (lot, M et al);
Swann NY 5/5/83: 379 (albums, M et al);
Christies Lon 10/31/85: 86 (lot, M-15 et al);
Swann NY 11/13/86: 243 (album, M et al), 356 (lot, M
    et al):

**MANGOLD, J.G.** (American)
Photos dated: 1870s-1880s
Processes:      Albumen
Formats:        Stereos
Subjects:       Topography
Locations:      US - Florida
Studio:         US - Palatka, Florida
    Entries:
Swann NY 11/6/80: 291 (lot, M-2 et al);
Harris Baltimore 12/10/82: 41 (lot, M et al);
Christies Lon 6/23/83: 44 (lot, M et al);
Swann NY 11/8/84: 143 (lot, M et al);
Swann NY 5/9/85: 322 (lot, M et al);

**MANLEY, G.P.** (British)
Photos dated: 1863
Processes:      Albumen
Formats:        Stereos
Subjects:       Topography
Locations:      England - Westerham
Studio:         Great Britain
    Entries:
Sothebys Lon 10/29/76: 28 ill(lot, M-12 et al);

**MANN, F.S.** (British)
Photos dated: 1860s-1890s
Processes:      Albumen
Formats:        Prints, stereos, cdvs
Subjects:       Topography
Locations:      England - Hastings, Sussex
Studio:         Great Britain
    Entries:
Swann NY 2/14/52: 113 (lot, M et al);
Rinhart NY Cat 6, 1973: 435;
Rinhart NY Cat 7, 1973: 552;
California Galleries 9/27/75: 386 (lot, M et al);
Christies Lon 10/26/78: 339 (album, M et al);
Christies Lon 3/15/79: 83 (lot, M et al);
Christies Lon 6/26/80: 111 (lot, M-44 et al);
Christies Lon 3/26/81: 128 (lot, M-3 et al), 129
    (lot, M-1 et al);
Sothebys Lon 3/27/81: 12 (lot, M et al);
Christies Lon 10/29/81: 138 (lot, M-3 et al), 147
    (lot, M et al);
Christies Lon 3/11/82: 82 (lot, M-4 et al);
Sothebys Lon 3/25/83: 4 (lot, M et al);
Christies Lon 6/23/83: 43 (lot, M et al);
Christies Lon 6/28/84: 46 (lot, M-12 et al), 56
    (lot, M et al);
Christies Lon 10/25/84: 36 (lot, M-12 et al);
Christies Lon 4/24/86: 350 (lot, M-21 et al);
Phillips Lon 10/29/86: 223 (lot, M et al);

**MANN, J.H.** (British)
Photos dated: 1860s-1870
Processes:      Albumen
Formats:        Prints, stereos
Subjects:       Topography
Locations:      Gibraltar
Studio:
    Entries:
Swann NY 2/14/52: 158 (book, 16);
Wood Conn Cat 37, 1976: 132 (book, 4);
Swann NY 11/11/76: 262 (book, 4);
Sothebys Lon 7/1/77: 24 (book, M-16 et al);
Wood Conn Cat 42, 1978: 323 (book, 4);

**MANNING & KNIGHT** [MANNING 1]
Photos dated: 1860s
Processes:    Albumen
Formats:      Cdvs
Subjects:     Ethnography
Locations:    Australia
Studio:
    Entries:
Harris Baltimore 3/15/85: 161 (album, M & K-1
    et al);

**MANNING** (American) [MANNING 2]
Photos dated: 1890s
Processes:    Silver
Formats:      Prints
Subjects:     Topography, ethnography
Locations:    US - American west
Studio:       US
    Entries:
Sothebys NY 2/25/75: 211 (16);

**MANNUCCI**
Photos dated: c1890
Processes:    Silver
Formats:      Prints
Subjects:     Genre (nature)
Locations:
Studio:
    Entries:
California Galleries 7/1/84: 540 (3);

**MANSELL** (see LOCKET)

**MANSELL, Thomas Lukis** (British, 1809-1879)
Photos dated: early 1850s-1857
Processes:    Calotype, albumen
Formats:      Prints
Subjects:     Topography
Locations:    England - Argyleshire, Sark, Guernsey;
              France - Brittany
Studio:       England - Guernsey (Photographic Club)
    Entries:
Sothebys Lon 3/14/79: 324 (album, M-1 et al);
Sothebys Lon 11/1/85: 59 ill(album, M-1 et al);

**MANSELL, W.A.& Co.** (British)
Photos dated: 1860s-c1870
Processes:    Albumen
Formats:      Prints
Subjects:     Topography, documentary (art)
Locations:    England - London
Studio:       Great Britain
    Entries:
Wood Conn Cat 37, 1976: 236 (album, M-9 et al);
Swann NY 11/11/76: 380 (albums, M et al);
Sothebys Lon 6/29/79: 105 (albums, M-100 et al);
Christies Lon 3/20/80: 131 (albums, M et al), 135
    (lot, M et al);
Christies Lon 3/24/83: 52 (115);
Swann NY 5/16/86: 191 ill(100);

**MANSEN, W.A.** (British)
Photos dated: 1870s
Processes:    Albumen
Formats:      Prints
Subjects:     Topography
Locations:    Great Britain
Studio:       Great Britain
    Entries:
Christies Lon 6/26/80: 164 (album, M et al);

**MANSFIELD** (see BEERS, C.F.)

**MANSURY, A.** (French)
Photos dated: 1860s
Processes:    Albumen
Formats:      Prints
Subjects:     Topography
Locations:    France - Paris
Studio:       France
    Entries:
Sothebys Lon 10/24/75: 137 (lot, M-16 et al);

**MANUEL, Henri** (French)
Photos dated: 1880s-c1890
Processes:    Albumen, bromide
Formats:      Cabinet cards, prints
Subjects:     Portraits
Locations:    Studio
Studio:       France - Paris
    Entries:
White LA 1980-81: 63 (lot, M-1 et al);
Bievres France 2/6/83: 161 (lot, M-1 et al), 162
    (lot, M-1 et al);
Swann NY 11/14/85: 20 (lot, M-1 et al);

**MANVILLE, C.B.** (American)
Photos dated: c1880
Processes:    Albumen
Formats:      Stereos
Subjects:     Topography
Locations:    US - Dakotas
Studio:       US
    Entries:
California Galleries 6/19/83: 429 (lot, M-4 et al);

**MANZONI, Renzo** (Italian, 1852-1918)
Photos dated: 1877-1880
Processes:    Albumen
Formats:      Prints
Subjects:     Topography, ethnography
Locations:    Yemen
Studio:
    Entries:
Christies Lon 3/20/80: 168 ill(album, 28)(note);

**MARC & SCHLUM**
Photos dated: 1885
Processes:    Albumen
Formats:      Prints
Subjects:
Locations:
Studio:
    Entries:
Wood Boston Cat 58, 1986: 136 (books, M & S-1
    et al);

MARCHI (French)(photographer?)
Photos dated: c1852
Processes:      Daguerreotype
Formats:        Stereo plates
Subjects:       Documentary (art)
Locations:      France
Studio:         France
    Entries:
Rinhart NY Cat 2, 1971: 149 ill;
Swann NY 5/9/85: 438;

MARCONI
Photos dated: 1870s
Processes:      Albumen
Formats:        Prints, cabinet cards
Subjects:       Genre (nudes)
Locations:      Studio
Studio:         Europe
    Entries:
Sothebys Lon 10/24/79: 329 ill(15);

MARDON, Major Evelyn John (British)(photographer?)
Photos dated: 1890s
Processes:      Gelatin
Formats:        Stereos
Subjects:       Topography
Locations:      China; Japan; Kashmir; Tibet; India;
                Canada
Studio:
    Entries:
Sothebys Lon 3/29/85: 65 (480);

MARES, Frederick H.
Photos dated: c1860-c1880
Processes:      Ambrotype, albumen
Formats:        Plates, prints
Subjects:       Portraits, topography
Locations:      Ireland - Wicklow
Studio:         Ireland - Dublin
    Entries:
Weil Lon Cat 7, 1945: 154 (book, 12);
Swann NY 2/14/52: 196 (books, 54)(note);
Sothebys Lon 12/4/73: 6 (book, 15);
Swann NY 2/6/75: 104 (book, 12);
California Galleries 4/2/76: 154 (book, 13);
Sothebys Lon 11/18/77: 76 (book, 12);
Sothebys Lon 6/17/81: 76;

MAREY, Etienne Jules (French, 1830-1904)
Photos dated: c1882-1895
Processes:      Silver, collotype, collodion on glass
Formats:        Prints, glass plates
Subjects:       Documentary (scientific)
Locations:      France
Studio:         France
    Entries:
Weil Lon 1946: 50 (book, 1);
Andrieux Paris 1951(?): 48 (book, 1)(note), 49
    (book, 3)(note);
Andrieux Paris 1952(?): 729 (book, 1);
Sothebys NY 5/15/81: 105 ill(2)(note);
Wood Conn Cat 49, 1982: 282 ill(book, 29)(note);
Sothebys NY 5/12/86: 297 ill(note);
Sothebys NY 11/13/86: 176 ill(note);

MARGARITIS, Philippos (Greek, 1810-1892)
Photos dated: early 1850s-c1863
Processes:      Daguerreotype, salt, albumenized salt,
                albumen
Formats:        Plates, prints, cdvs
Subjects:       Portraits, topography
Locations:      Greece - Athens
Studio:         Greece - Athens
    Entries:
Rauch Geneva 6/13/61: 142 (album, 22)(attributed)
    (note);
Sothebys Lon 4/25/86: 19 ill(attributed);

MARIANECCI (Italian)
Photos dated: 1864
Processes:      Albumen
Formats:        Prints
Subjects:
Locations:      Italy
Studio:         Italy
    Entries:
Christies Lon 10/30/86: 83 (lot, M et al);

MARION & Co.
Photos dated: c1880
Processes:      Albumen, photogravure
Formats:        Prints
Subjects:       Topography
Locations:      India; South Africa
Studio:
    Entries:
Christies Lon 10/25/79: 192 (album, M-1 et al);
Phillips Lon 10/24/84: 135 (book);

MARION, Auguste (French)
Photos dated: 1860s-1880s
Processes:      Salt, albumen, cyanotype
Formats:        Stereos, cdvs
Subjects:       Documentary (public events), portraits
Locations:      France; England
Studio:         France - Paris; England - London
    Entries:
Swann NY 11/8/84: 267 (lot, M et al);
Phillips Lon 10/29/86: 307 (lot, M et al);

MARKS (see BARBER & MARKS) [MARKS 1]

MARKS (see SHEW & MARKS) [MARKS 2]

MARKS [MARKS 3]
Photos dated: c1870
Processes:      Albumen
Formats:        Prints
Subjects:       Topography
Locations:      Chile
Studio:         Chile - Concepcion
    Entries:
Christies NY 5/4/79: 67 (2);

MARKS, A.J. (American)
Photos dated: 1871
Processes:      Albumen
Formats:        Prints
Subjects:       Documentary (disasters)
Locations:      US - Chicago, Illinois
Studio:         US
   Entries:
Swann NY 11/11/76: 430 (lot, M-1 et al);
Sothebys NY 5/2/78: 24 (lot, M-1 et al);

MARKS, H.R. (American)
Photos dated: c1850
Processes:      Daguerreotype
Formats:        Plates
Subjects:       Portraits
Locations:      Studio
Studio:         US - Baltimore, Maryland
   Entries:
Christies Lon 10/27/77: 26 (lot, M-1 et al);

MARKSVILLE, S. (American)
Photos dated: c1880
Processes:      Albumen
Formats:        Prints
Subjects:       Topography
Locations:      US - Bridgeport, Connecticut
Studio:         US
   Entries:
Harris Baltimore 4/8/83: 409 (4);

MARLE (French)
Photos dated: 1850s
Processes:      Salt
Formats:        Prints
Subjects:       Genre
Locations:
Studio:
   Entries:
Christies NY 5/26/82: 30 ill;

MARNAS, Marius
Photos dated: c1890s
Processes:      Photogravure
Formats:        Prints
Subjects:       Architecture
Locations:      France - Pierrefonds
Studio:
   Entries:
Swann NY 4/26/79: 77 (book, 35);

MARQUES, Francisco Gomes (Portuguese)
Photos dated: 1860s-1870s
Processes:      Albumen
Formats:        Prints
Subjects:       Topography
Locations:      Portugal
Studio:         Portugal
   Entries:
Swann NY 4/17/80: 349(lot, M et al);

MARQUIS
Photos dated: Nineteenth century
Processes:      Albumen
Formats:        Prints
Subjects:       Topography
Locations:      Australia
Studio:
   Entries:
Christies Lon 6/26/86: 96 (lot, M-1 et al);

MARRIOTT, W.H.
Photos dated: 1883
Processes:      Albumen
Formats:        Prints
Subjects:       Topography
Locations:      St. Helena
Studio:
   Entries:
Swann NY 4/17/80: 104 (book, M-2 et al);

MARSH, C.M. (American)
Photos dated: c1865-1870s
Processes:      Tintype, albumen
Formats:        Plates, stereos
Subjects:       Portraits, topography
Locations:      US - New York State
Studio:         US - Havana, New York
   Entries:
California Galleries 12/13/80: 395 (lot, M-1 et al);
Harris Baltimore 2/14/86: 38 (lot, M et al);

MARSH, D. (American)
Photos dated: Nineteenth century
Processes:      Albumen
Formats:        Stereos
Subjects:       Topography
Locations:      US - Yellowstone Park, Wyoming
Studio:         US
   Entries:
California Galleries 4/3/76: 492 (lot, M et al);

MARSH, W.P. (British)
Photos dated: 1870s-1900
Processes:      Albumen
Formats:        Prints
Subjects:       Topography
Locations:      England - Bognor Regis
Studio:         England - Bognor Regis
   Entries:
Goldschmidt Lon Cat 52, 1939: 239 (book, 20);
Sothebys Lon 10/29/76: 130 (albums, M et al);

MARSHALL & PORTER (American)
Photos dated: c1853
Processes:      Daguerreotype
Formats:        Plates
Subjects:       Portraits
Locations:      Studio
Studio:         US - Philadelphia, Pennsylvania
   Entries:
Rinhart NY Cat 2, 1971: 165;
Sothebys Lon 10/28/81: 284;

**MARSHALL, A.** (American)
Photos dated: 1871
Processes:      Albumen
Formats:        Prints, stereos, cdvs
Subjects:       Portraits
Locations:      US - Boston, Massachusetts; New
                Hampshire
Studio:         US - Boston, Massachusetts
    Entries:
Rinhart NY Cat 2, 1971: 524;
Rinhart Cat 7, 1973: 223;
California Galleries 1/21/78: 129 (lot, M et al);
Swann NY 12/14/78: 161 (album, 23);
Harris Baltimore 12/10/82: 60 (lot, M et al);
Swann NY 11/13/86: 272 (album, 23);

**MARSHALL, Reverend A.F.S.** (British)
Photos dated: 1855
Processes:      Talbotype, albumen
Formats:        Prints
Subjects:       Architecture
Locations:      England - Peterborough
Studio:         Great Britain (Photographic Club)
    Entries:
Sothebys Lon 3/21/75: 286 (album, M-1 et al);
Sothebys Lon 11/1/85: 59 ill(album, M-1 et al);
Sothebys Lon 4/25/86: 113 ill;

**MARSHALL, W.C.** (British)
Photos dated: c1860
Processes:      Ambrotype
Formats:        Stereo plates
Subjects:       Documentary
Locations:      England - London
Studio:         Great Britain
    Entries:
Christies Lon 6/10/76: 114;

**MARSHALL, W.I.** (American)
Photos dated: c1876
Processes:      Albumen
Formats:        Stereos
Subjects:       Topography
Locations:      US - Yellowstone Park, Wyoming
Studio:         US - Fitchburg, Massachusetts
    Entries:
Rinhart NY Cat 6, 1973: 607;
Swann NY 12/14/78: 282 (lot, 14);
Harris Baltimore 6/1/84: 153 (lot, M-1 et al);

**MARSTERS** (American)
Photos dated: 1850s
Processes:      Daguerreotype
Formats:        Plates
Subjects:       Portraits
Locations:      Studio
Studio:         US - Baltimore, Maryland
    Entries:
Vermont Cat 5, 1973: 378 ill;
Vermont Cat 11/12, 1977: 558 ill;
Harris Baltimore 3/26/82: 136;

**MARTENS** (see VON MARTENS)

**MARTIN** (see FOSTER & MARTIN) [MARTIN 1]

**MARTIN** (see LEONARD & MARTIN) [MARTIN 2]

**MARTIN** (French) [MARTIN 3]
Photos dated: c1860
Processes:      Albumen
Formats:        Cdvs
Subjects:       Portraits
Locations:      Studio
Studio:         France - Toulouse
    Entries:
Petzold Germany 11/7/81: 310 (album, M et al);

**MARTIN, A.T.** (British)
Photos dated: c1850
Processes:      Daguerreotype
Formats:        Plates
Subjects:       Portraits
Locations:      Studio
Studio:         England - Birmingham
    Entries:
Sothebys Lon 6/29/79: 43;

**MARTIN, Alexander** (American)
Photos dated: c1875-1890s
Processes:      Albumen
Formats:        Prints, cabinet cards, stereos
Subjects:       Topography
Locations:      US - Colorado
Studio:         US - Denver, Colorado
    Entries:
Sothebys NY (Strober Coll.) 2/7/70: 274 (lot, M-1
    et al), 507 (lot, M & Peers et al);
California Galleries 4/3/76: 354 (lot, M et al);
Swann NY 11/11/76: 438 (lot, M-2 et al)(note);
Christies Lon 3/10/77: 173 (lot, M-2 et al);
Christies Lon 10/27/77: 166 (lot, M-2 et al), 169
    (lot, M-1 et al);
Frontier AC, Texas 1978: 210 ill(3), 210b;
Swann NY 4/17/80: 366 (lot, M et al);
California Galleries 12/13/80: 361 (lot, M et al);
Swann NY 4/1/82: 249 (lot, M et al), 357 (lot,
    M et al);
Harris Baltimore 4/8/83: 114 (lot, M-6 et al);
Harris Baltimore 12/16/83: 305 (lot, M et al);
Harris Baltimore 3/15/85: 24 (lot, M et al);

**MARTIN, Clara Barnes** (American)
Photos dated: 1879
Processes:      Albumen
Formats:        Prints (half stereos)
Subjects:       Topography
Locations:      US - Mt. Desert, Maine
Studio:         US
    Entries:
Swann NY 11/6/80: 125 (book, 5);
Swann NY 10/10/83: 108 (book, 5);

MARTIN, Henry (American)
Photos dated: early 1860s
Processes:     Albumen
Formats:       Prints
Subjects:      Topography
Locations:     US - Niagara Falls, New York
Studio:        US (Amateur Photographic Exchange
Club)
   Entries:
Rinhart NY 2, 1971: 437;

MARTIN, James (aka M., J., q.v.)
Photos dated: 1880s-1890s
Processes:     Albumen
Formats:       Prints
Subjects:      Topography
Locations:     New Zealand
Studio:
   Entries:
Christies Lon 10/28/82: 121 (albums, M et al);
Christies Lon 3/24/83: 136 (albums, M et al);
Christies Lon 4/24/86: 410 (lot, M et al);

MARTIN, James E. (American, born 1824)
Photos dated: 1862-1870s
Processes:     Albumen
Formats:       Stereos, cdvs
Subjects:      Topography, ethnography
Locations:     US - Minnesota
Studio:        US - St. Paul, Minnesota
   Entries:
Lehr NY Vol 1:4, 1979: 60 (album, M et al);
Christies Lon 3/29/84: 18 (lot, M-10 et al);

MARTIN, Josiah (New Zealander, 1843-1916)
Photos dated: 1885-1890s
Processes:     Albumen
Formats:       Prints
Subjects:      Topography
Locations:     New Zealand
Studio:        New Zealand
   Entries:
Christies Lon 10/27/77: 151 (albums, M et al);
Swann NY 11/18/82: 159 (book, 30)(note);

MARTIN, Paul (British, 1864-1944)
Photos dated: 1880s-1932
Processes:     Platinum, silver, carbon
Formats:       Prints
Subjects:      Genre, topography
Locations:     England - London et al; Switzerland;
               France
Studio:        England
   Entries:
Sothebys NY 2/25/75: 296 ill(note), 297 ill,
   298 ill;
Sothebys NY 9/23/75: 355 ill, 356, 357, 358 ill;
Sothebys NY 5/4/76: 288, 289, 290, 291, 292, 293,
   294 (note);
Gordon NY 11/13/76: 127 ill, 128 ill, 129 ill, 130
   ill, 131 ill;
Sothebys Lon 3/29/77: 224;
Weston Cal 1978: 165 ill, 166 ill;
Christies NY 5/4/79: 134;
Sothebys Lon 3/21/80: 390 (2 ills)(547)(note);
Phillips Lon 11/4/83: 75 (lot, M-2 et al);

MARTINET (French)(photographer or publisher?)
Photos dated: 1870s
Processes:     Albumen
Formats:       Prints
Subjects:      Topography
Locations:     France - Chartres and Amiens
Studio:        France - Paris
   Entries:
Christies Lon 3/26/81: 195 (album, M et al);

MARVILLE, Charles (French, 1816-c1879)
Photos dated: 1852-1875
Processes:     Salt (Blanquart-Evrard), albumen
Formats:       Prints, stereos
Subjects:      Topography, portraits incl. Galerie
               Contemporaine, documentary (art)
Locations:     France - Paris, Pyreneees et al;
               Germany - Cologne and Heidelberg;
               Algeria
Studio:        France - Paris
   Entries:
Maggs Paris 1939: 471 (note), 472 (note), 473, 474;
Andrieux Paris 1951(?): 51, 52;
Rauch Geneva 6/13/61: 65 (lot, M et al)(note), 100
   ill(3)(note), 138 (2), 162 (lot, M et al);
Vermont Cat 1, 1971: 254 ill(album, M-2 et al);
Witkin NY I 1973: 342 ill;
Witkin NY III 1975: 83 ill(note), 84 ill;
Anderson & Hershkowitz Lon, 1976: 14 ill;
Wood Conn Cat 37, 1976: 303 ill;
Christies Lon 6/30/77: 275 ill(note);
Christies Lon 10/27/77: 82;
Lehr NY Vol 1:2, 1978: 29 ill;
Octant Paris 11/1978: 1 ill(note), 2 ill, 3 ill, 4
   ill, 5 ill, 6 ill, 7 ill, 8 ill, 9 ill, 10 ill,
   11 ill, 12 ill, 13 ill, 14 ill, 15 ill, 16 ill;
Christies Lon 6/27/78: 195 ill(note), 196 ill
   (note), 197 ill(note);
Phillips NY 11/4/78: 57 ill(note), 58;
Swann NY 12/14/78: 429 (note);
Lennert Munich Cat 5, 1979: 1 ill;
Mancini Phila 1979: 6;
Phillips Lon 3/13/79: 47 ill(note), 48 ill, 49 ill
   (note), 50 ill, 51, 52 ill;
Sothebys Lon 3/14/79: 281, 282 (2), 283 (2), 284;
Christies Lon 3/15/79: 106 ill(attributed)(note),
   243 (note), 244 ill(note), 245 ill, 246 ill,
   247, 248 ill(note), 249 ill(note);
Sothebys NY 5/8/79: 88 ill;
Christies Lon 6/28/79: 92 (attributed)(note),
   180 ill;
Sothebys Lon 6/29/79: 167 ill, 168 ill, 169;
Sothebys NY 12/19/79: 70 ill;
White LA 1980-81: 22 ill(note);
Sothebys LA 2/6/80: 124 (2);
Phillips Lon 3/12/80: 149;
Sothebys Lon 3/21/80: 376;
Sothebys NY 5/20/80: 360 ill;
Phillips Lon 6/25/80: 125;
Christies Lon 6/26/80: 396 ill(note), 397 ill, 398;
Sothebys Lon 6/27/80: 154 ill;
Sothebys Lon 10/29/80: 286 ill;
Christies Lon 10/30/80: 360 ill, 361 (2);
Christies Lon 11/11/80: 53 ill(attributed), 54 ill,
   55 ill;
California Galleries 12/13/80: 314 ill(attributed),
   315;
Koch Cal, 1981-82: 30 ill(note), 31 ill;
Lennert Munich Cat 6, 1981: 2 ill;
Christies NY 5/14/81: 27 ill, 28 ill(note), 29 ill;

## MARVILLE (continued)

Sothebys NY 5/15/81: 101 ill;
Christies Lon 6/18/81: 173 ill;
Sothebys Lon 10/28/81: 72 (album, M-1 attributed et al);
Christies Lon 10/29/81: 178 ill;
Octant Paris, 1982: 11 ill;
Weston Cal 1982: 13 ill;
Sothebys NY 5/25/82: 447 ill;
Christies NY 5/26/82: 36 (book, M et al);
Christies Lon 6/24/82: 292 ill, 293 ill, 294 ill, 295 ill, 296 (9);
Sothebys Lon 10/29/82: 95 ill;
Sothebys NY 11/10/82: 300 ill;
Drouot Paris 11/27/82: 74 ill;
Bievres France 2/6/83: 76 ill, 77 ill(note), 78 ill, 79 ill(attributed), 80 ill(attributed);
Christies NY 10/4/83: 78;
Sothebys Lon 12/9/83: 49 ill, 50 ill;
Christies NY 5/7/84: 19 (book, M et al);
Sothebys NY 5/8/84: 224;
Swann NY 5/10/84: 275;
Christies NY 11/6/84: 17 ill(note), 18 ill;
Sothebys Lon 3/29/85: 212 ill(lot, M-1 et al);
Christies NY 5/6/85: 262 ill, 263 ill(attributed) (note);
Phillips Lon 6/26/85: 225 (lot, M-2 et al);
Christies Lon 6/27/85: 140 ill(note), 141 ill;
Christies NY 11/11/85: 330 ill;
Christies Lon 4/24/86: 502 ill, 503, 504 (4 ills) (album, M-34 et al)(note);
Sothebys NY 11/13/86: 177 ill(note);
Drouot Paris 11/22/86: 55 ill(attributed);

## MARVIN (American)

Photos dated: 1870s-1890s
Processes: Albumen
Formats: Prints
Subjects: Topography
Locations: US - New York City
Studio: US
  Entries:
Swann NY 4/1/82: 333 (lot, M et al);

## MASCHER, John F.

Photos dated: 1852
Processes: Daguerreotype, ambrotype, albumen
Formats: Plates incl. stereo, stereo cards
Subjects: Portraits
Locations: Studio
Studio: US - Philadelphia, Pennsylvania
  Entries:
Gordon NY 5/3/76: 270 ill;
Gordon NY 11/13/76: 5 ill;
Frontier AC, Texas 1978: 211 (note);
Sothebys LA 2/6/80: 10;
Petzold Germany 11/7/81: 170 ill;

## MASKELYNE, Nevil Story (British, 1823-1911)

Photos dated: c1846-1850s
Processes: Calotype, "bromide of silver"
Formats: Prints, stereos
Subjects: Portraits, documentary (scientific), topography, photogenic drawing
Locations: England
Studio: Great Britain
  Entries:
Christies Lon 6/18/81: 294 ill(note), 295 ill, 296 ill, 297 ill, 298 ill(2), 299 ill(2), 300 ill, 302 (note), 303 (lot, M-3 et al), 304 ill(4) (note), 305 ill(note), 306 ill(4), 307 ill(3), 308 ill, 309 ill(5), 310 ill(3), 311 ill, 312 (2 ills)(album, M et al)(note), 313 ill(note), 314 ill(5)(note), 315 ill, 316 ill, 317 ill(3), 318 ill(3)(note), 319 ill(2), 320, 321 ill(3), 322 ill(4), 323 ill(2), 324 (2 ills)(2), 325 (3 ills)(3), 326 ill, 327 ill(2), 328 (2 ills)(2) (note), 329 ill(2)(note), 330 ill(note), 331 ill, 332 ill, 333 ill, 334 (2)(note), 335 ill (3), 336 ill(2), 337 ill(2), 338 ill(2), 339 ill, 340 ill, 341 ill(3), 342 ill, 343 ill, 344 ill, 345 ill(note), 346 ill(note), 347 (4 ills) (21)(note), 349, 350, 351, 352 (2), 353, 354 ill, 355 ill(2), 356 ill, 357 ill, 358 ill, 359 ill(2), 360 ill(note), 361 ill, 362 ill, 363, 364 ill, 367, 368, 369 ill(2), 370 (3), 371 ill (3)(note), 372 ill, 373 (2), 374 ill(2), 375 (2), 376 (3), 377, 378, 379, 380 (2 ills), 381 (2), 282 ill, 383 ill, 384 ill(2), 385 (note), 386 ill(album, 50), 396 ill(album, M et al) (note), 414 ill(album, M-1 et al);
Christies Lon 3/11/82: 107 (2);
Christies Lon 6/24/82: 106;
Sothebys Lon 6/25/82: 147 ill(2);
Christies Lon 10/28/82: 46;
Christies Lon 6/23/83: 204;
Christies Lon 10/27/83: 188 (album, M-1 attributed et al);
Sothebys Lon 12/9/83: 87 ill;
Kraus New York Cat 1, 1984: 20 ill(note), 21 (2 ills)(2)(note);
Christies Lon 3/29/84: 130;
Christies Lon 6/27/85: 113 ill(album, M attributed et al);
Kraus NY Cat 2, 1986: 1.1 ill, 1.6 ill(note), 1.13 ill, 1.15 ill(note), 12 ill(attributed)(note), 13 ill, 16 ill(note), 22 ill(note), 29A ill (note), 30A ill, 30B ill, 32A ill(note), 35 ill, 40A ill, 41 ill(attributed), 42 ill, 43 ill, 47A ill, 47B ill, 48 ill;
Christies Lon 4/24/86: 444 ill, 445;

## MASON & Co. (British)

Photos dated: 1860s
Processes: Albumen
Formats: Cdvs
Subjects: Portraits
Locations: Studio
Studio: England - London
  Entries:
Christies Lon 10/26/78: 325 (album, M et al);
Harris Baltimore 3/15/85: 296 (lot, M-1 et al);
Phillips Lon 3/27/85: 278 (lot, M-1 et al);
Phillips Lon 10/30/85: 63 (lot, M et al);
Phillips Lon 4/23/86: 228 (album, M et al);
Christies Lon 4/24/86: 593 (lot, M-2 et al);
Swann NY 5/16/86: 313 (lot, M et al);

**MASON, O.G.** (American)
Photos dated: 1881-1885
Processes:    Heliotype, photogravure, artotype
Formats:      Prints
Subjects:     Documentary (medical)
Locations:    US - New York City
Studio:       US - New York City
  Entries:
Wood Conn 37, 1976: 65 (book, M et al);
Swann NY 4/23/81: 130 (books, 48);
Wood Conn Cat 49, 1982: 137 (book, 8)(note);

**MASON, R.H.** (British)
Photos dated: 1865-1886
Processes:    Albumen
Formats:      Prints
Subjects:     Topography
Locations:    England - Norfolk
Studio:       England - Norwich and London
  Entries:
Christies Lon 10/27/77: 214 ill(book, 78);
Christies Lon 6/24/82: 52 (lot, M et al);
Christies Lon 10/27/83: 55 (book, 75), 62 (album,
  M et al);

**MASON, Samuel J.** (American)
Photos dated: late 1850s-c1875
Processes:    Albumen, glass transparency
Formats:      Prints, glass stereo plates
Subjects:     Topography
Locations:    US - Niagara Falls, New York
Studio:       US - Niagara Falls, New York
  Entries:
Sothebys NY (Strober Coll.) 2/7/70: 465 (lot,
  M et al);
Rinhart NY Cat 2, 1971: 481 (5)(note);
Sothebys NY 2/25/75: 172 (lot, M-1 et al);
California Galleries 9/27/75: 400 (lot, M-1 et al);
California Galleries 4/3/76: 435 (lot, M-2 et al);
Harris Baltimore 12/10/82: 61 (lot, M-1 et al);
Swann NY 11/8/84: 261 (lot, M-1 et al);
Swann NY 11/13/86: 328 (lot, M-1 et al);

**MASON, Captain W.H.** (British)
Photos dated: 1850s-1870s
Processes:    Albumen
Formats:      Prints, stereos, cdvs
Subjects:
Locations:    Great Britain
Studio:       Great Britain (Amateur Photographic
              Association)
  Entries:
Christies Lon 3/20/80: 94 (lot, M-1 et al);
Christies Lon 6/18/81: 91 (lot, M-2 et al);
Christies Lon 10/27/83: 218 (albums, M-2 et al);
Swann NY 11/10/83: 277 (album, M et al)(note);
Sothebys Lon 10/26/84: 6 (lot, M et al);

**MASON, William M.** (British)
Photos dated: 1850s-1864
Processes:    Albumen
Formats:      Stereos
Subjects:     Topography, genre (animal life)
Locations:    England
Studio:       England - Brighton
  Entries:
Christies Lon 3/10/77: 207 (lot, M-2 et al);
Christies Lon 3/16/78: 51 (lot, M-1 et al);
Christies Lon 6/27/78: 88 (lot, M-1 et al);
Christies Lon 3/26/81: 115 (lot, M-1 et al);
Christies Lon 6/18/81: 91 (lot, M-2 et al);
Christies Lon 10/29/81: 130 (lot, M-1 et al),
  133 (lot, M-4 et al);
Christies Lon 6/24/82: 52 (lot, M et al);
Christies Lon 6/23/83: 22 (lot, M-1 et al), 26
  (lot, M et al), 42 (lot, M et al), 43 (lot,
  M et al), 57 (lot, M-1 et al);
Christies Lon 3/29/84: 35 (lot, M et al), 36 (lot,
  M-1 et al), 40 (lot, M-1 et al);
Sothebys Lon 6/28/85: 2 (lot, M et al);

**MASSARI, Alejandro** (Spanish)
Photos dated: 1853-1871
Processes:    Salt, albumen
Formats:      Prints, stereos, cdvs
Subjects:     Topography
Locations:    Spain - Seville
Studio:       Spain - Seville
  Entries:
Sothebys Lon 6/29/79: 136 (1 plus 5 attributed);
Sothebys Lon 10/24/79: 114 (lot, M-2 et al);
Sothebys Lon 3/27/81: 107 (2);
Fraenkel Cal 1984: 49 ill(note), 50 ill, 51, 52;

**MASSON, Luis Leon** (Spanish, died c1874)
Photos dated: 1858- early 1870s
Processes:    Salt, albumen
Formats:      Prints, stereos, cdvs
Subjects:     Topography, portraits, documentary
              (public events)
Locations:    Spain - Seville, Madrid, Cordova,
              Malaga, Pyrenees; Gibraltar
Studio:       Spain - Seville
  Entries:
Christies Lon 3/10/77: 109;
Christies Lon 10/27/77: 98;
Christies Lon 10/26/78: 155 (albums, M-18 et al);
Sothebys Lon 10/24/79: 336 (lot, M-1 et al);
Christies Lon 3/24/83: 72 (5);
Fraenkel Cal 1984: 2 ill(attributed)(note), 53
  (note), 54, 55, 56, 57 ill(note);
Christies Lon 6/27/85: 144 (6);
Christies Lon 10/31/85: 64 (lot, M-9 et al), 201
  ill;
Swann NY 11/14/85: 154 (lot, M-4 et al);
Christies Lon 4/24/86: 377 (lot, M-2 et al), 496
  ill;
Christies Lon 6/26/86: 28 (lot, M-9 et al), 58 (lot,
  M et al);
Christies NY 11/11/86: 292 ill(11)(note);

**MASURY, Samuel & SILSBEE**
Photos dated: 1852-c1855
Processes:      Salt, albumen, tintype
Formats:        Plates, prints, cdvs
Subjects:       Portraits
Locations:      Studio
Studio:         US - Boston, Massachusetts
  Entries:
Sothebys NY (Strober Coll.) 2/7/70: 31 (books, M & S
  et al), 262 (lot, M et al);
Christies NY 11/11/80: 97 (note);

**MATHER, John A.** (American)
Photos dated: 1860s-1880s
Processes:      Woodburytype, albumen
Formats:        Prints, stereos
Subjects:       Documentary (industrial)
Locations:      US - Pennsylvania
Studio:         US - Titusville, Pennsylvania
  Entries:
Sothebys NY (Strober Coll.) 2/7/70: 477 (lot, M-11
  et al)(note);
Swann NY 11/11/76: 266 (book, M-1 et al)(note);
Swann NY 12/4/78: 117 (book, M-1 et al)(note);
Harris Baltimore 12/10/82: 81 (lot, M-7 et al);
Harris Baltimore 6/1/84: 120 (lot, M-1 et al);

**MATHERS, C.W.** (Canadian)
Photos dated: Nineteenth century
Processes:      Albertype
Formats:        Prints
Subjects:       Topography, ethnography
Locations:      Canada - EdMonton
Studio:         Canada - Edmonton
  Entries:
Edwards Lon 1975: 132 (book, 28);

**MATHESON, Lady** (British)
Photos dated: c1855
Processes:      Salt, albumenized salt
Formats:        Prints
Subjects:       Genre (domestic)
Locations:      France
Studio:         Great Britain
  Entries:
Phillips Lon 10/29/86: 387 (album)(note);

**MATHEWS, Mrs.** (British)
Photos dated: 1850s
Processes:      Calotype
Formats:        Prints
Subjects:       Topography
Locations:      Great Britain
Studio:         Great Britain
  Entries:
Sothebys Lon 12/21/71: 138 (album, M attributed
  et al);

**MATSUSABURO** (see YOKOYAMA)

**MATTESON, Sumner W.** (American, 1867-1920)
Photos dated: 1898-1909
Processes:      Albumen
Formats:        Prints
Subjects:       Ethnography
Locations:      US - Denver, Colorado
Studio:         US - Denver, Colorado
  Entries:
California Galleries 6/28/81: 258 (lot, M-1 et al);

**MAUDE, F.H.** (American)
Photos dated: c1880
Processes:      Albumen
Formats:        Prints
Subjects:       Topography, ethnography
Locations:      US - California; New Mexico; Arizona
Studio:         US - Los Angeles, California
  Entries:
Frontier AC, Texas 1978: 213 (3 ills)(7)(note);

**MAUDSLAY, Alfred Percival**
Photos dated: 1880s
Processes:      Albumen
Formats:        Prints, cabinet cards
Subjects:       Architecture
Locations:      Mexico
Studio:
  Entries:
Sothebys Lon 3/22/78: 211;
Sothebys Lon 3/14/79: 380 (6)(note);

**MAULL & Co.** (British)
Photos dated: 1854-1860s
Processes:      Albumen
Formats:        Prints, cdvs
Subjects:       Portraits, architecture
Locations:      England - London
Studio:         England - London
  Entries:
Goldschmidt Lon Cat 52, 1939: 209 (M & Polyblank)
  (note), 211 (M & Polyblank), 217 (M & Polyblank)
  (note), 223 (M & Polyblank)(note);
Weil Lon Cat 1, 1943: 142 (lot, M & Polyblank et
  al), 147 (book, M & Polyblank, 40)(note);
Weil Lon 1946: 104 (M & Polyblank);
Sothebys NY (Greenway Coll.) 11/20/70: 121 ill
  (lot, M & Polyblank, et al);
Sothebys NY 11/21/70: 337 (lot, M et al), 338 (lot,
  M et al);
Christies Lon 4/25/72: 206 (books, M & Polyblank
  et al);
Rinhart NY Cat 6, 1973: 291 (M & Fox);
Christies Lon 6/13/73: 155 (book, M & Fox et al);
Sothebys Lon 12/4/73: 249 (book, M & Polyblank, 39);
Sothebys Lon 6/21/74: 214 ill(M & Polyblank)(note),
  215 ill(M & Polyblank), 216 ill(M & Polyblank,
  19), 217 ill(M & Polyblank);
Christies Lon 7/25/74: 328 (book, M & Fox et al);
Sothebys Lon 10/18/74: 144 ill(album, M &
  Polyblank, 45);
Sothebys NY 2/25/75: 107 (lot, M et al), 122 ill
  (M and Fox);
Sothebys Lon 3/21/75: 137 (lot, M & Polyblank  et
  al), 161 (album, M & Polyblank-6, et al), 172
  (album, M & Polyblank, 40);
Sothebys Lon 6/26/75: 262 ill(books, M & Polybank,
  38), 263 (M & Polyblank, 7);

## MAULL (continued)

Sothebys Lon 10/24/75: 163 (M & Polyblank), 259 (lot, M & Polyblank et al);
Colnaghi Lon 1976: 155 ill(M & Polyblank)(note);
Sothebys Lon 3/19/76: 157 (album, M & Polyblank et al), 158 (M & Polyblank, 2);
Sothebys Lon 6/11/76: 170 (album, M et al), 182 ill (books, M & Polyblank, 38);
Sothebys Lon 10/29/76: 88 (M & Polyblank, 2), 133 (lot, M & Fox-1, et al);
Sothebys Lon 3/9/77: 181 (lot, M-1 et al);
Christies Lon 3/10/77: 247 (M & Polyblank), 249 (album, M, M & Polyblank, et al);
Gordon NY 5/10/77: 816 ill(M & Polyblank);
Christies Lon 6/30/77: 152 (lot, M & Polyblank et al);
Sothebys Lon 7/1/77: 250 (lot, M & Polyblank-1, et al), 41 (M & Polyblank);
Sothebys NY 10/4/77: 175 (books, M & Polyblank-37, et al);
Sothebys Lon 11/18/77: 41 (M & Polyblank);
Christies Lon 3/16/78: 198 (M & Polyblank, 2);
Sothebys Lon 3/22/78: 164 (album, M & Polyblank-20, et al);
Swann NY 4/20/78: 223 (M & Polyblank);
Sothebys Lon 6/28/78: 260 (lot, M-3 et al);
Christies Lon 10/26/78: 321 (2 ills)(album, M & Polyblank, 40), 323 ill(M & Polyblank, 10), 329 (album, M et al), 337 (album, M et al), 398 (album, M-1 et al), 399 (album, M et al);
Phillips NY 11/4/78: 32 (M & Polyblank)(note);
Rose Boston 4, 1979: 18 ill (M & Polyblank)(note);
Phillips Lon 3/13/79: 75 (album, M & Polyblank et al);
Sothebys Lon 3/14/79: 311 (M & Polyblank, 2);
Christies Lon 6/28/79: 218 (album, M & Polyblank-1, et al);
Sothebys Lon 10/24/79: 311 ill(book, 11)(note);
Christies Lon 3/20/80: 347 (albums, M & Polyblank et al), 351 (album, M-2 et al), 352 (albums, M et al), 363 (album, M & Fox et al), 370 (albums, M et al);
California Galleries 3/30/80: 344 ill(M & Polyblank);
Phillips NY 5/21/80: 138 (album, M & Polyblank et al);
Sothebys Lon 6/27/80: 228 (M & Polyblank);
Christies Lon 10/30/80: 407 (album, M & Polyblank et al), 435 (albums, M et al), 440 (album, M & Fox et al);
Sothebys Lon 3/27/81: 228 (M & Polyblank);
Sothebys Lon 6/17/81: 215 (M & Polyblank), 216 (M & Polyblank), 217 (M & Fox), 222 ill (M & Polyblank);
Christies Lon 6/18/81: 421 (albums, M-6 et al), 422 (lot, M & Polyblank et al), 431 (album, M & Polyblank et al), 433 (lot, M & Polybank-1 et al);
Harris Baltimore 7/31/81: 263 (lot, M-2 et al);
Sothebys Lon 10/28/81: 297 (M & Polyblank), 298 (M & Polyblank), 311 ill(M & Polyblank, 3)(note), 311a (M & Polyblank, 3), 312 (M & Polyblank, 7), 312a (M & Polyblank, 6);
Christies Lon 3/11/82: 326 (album, M & Polyblank et al);
Sothebys Lon 3/15/82: 234 (album, 81), 306 (lot, M & Polyblank-1, et al);
Phillips Lon 3/17/82: 85 (albums, M et al);
Harris Baltimore 3/26/82: 353 (M & Polyblank);
Phillips Lon 6/23/82: 71 (album, M & Fox et al);

## MAULL (continued)

Phillips Lon 10/27/82: 28 (albums, M et al), 34 (lot, M & Fox et al);
Christies Lon 10/28/82: 201 (album, M & Polyblank et al);
Christies Lon 3/24/83: 237 (album, M et al);
Christies Lon 6/23/83: 259 (lot, M et al);
Christies Lon 10/27/83: 224A (album, M & Polyblank et al), 231 (album, M & Polyblank et al), 240 (album, M et al);
Phillips Lon 11/4/83: 96 (M & Polyblank);
Swann NY 11/10/83: 279 (lot, M et al);
Harris Baltimore 12/16/83: 256 (M & Polyblank);
Christies Lon 3/29/84: 110 ill (book, M & Polyblank, 40), 334 (album, M & Polyblank et al), 337 (album, M et al), 338 (albums, M et al), 349 (album, M et al);
Phillips Lon 6/27/84: 206 (lot, M & Polyblank-2, et al);
Christies Lon 6/28/84: 302 (album, M & Polyblank et al);
Phillips Lon 10/24/84: 101 (album, M et al);
Christies Lon 10/25/84: 323 (album, M & Polyblank et al);
Christies NY 2/13/85: 114 (M & Polyblank, 5);
Phillips Lon 3/27/85: 214 (lot, M et al), 227 (lot, M & Polyblank-2, et al);
Swann NY 5/9/85: 396 (lot, M & Polyblank-2, et al), 421 (lot, M & Polyblank-2, et al)( note);
Christies Lon 6/27/85: 246 (albums, M & Polyblank et al), 277 (album, M et al);
Phillips Lon 10/30/85: 32 (lot, M & Polyblank-1, et al), 33 (lot, M et al);
Christies Lon 10/31/85: 205, 284 (albums, M & Polyblank et al), 302 (album, M & Polyblank et al);
Phillips Lon 4/23/86: 226 (album, M & Polyblank-2 et al);
Christies Lon 4/24/86: 590 (album, M & Polyblamk et al);
Christies Lon 6/26/86: 149 (album, M & Polyblank et al);
Christies Lon 10/30/86: 42 ill(M & Polyblank, 4), 98, 217 (albums, M et al), 220 (albums, M & Polyblank et al), 226 (album, M & Polyblank et al), 227 (album, M & Polyblank et al), 252 (album, M & Polyblank et al);
Harris Baltimore 11/7/86: 232;

## MAURI, Achille (Italian)

Photos dated: late 1860s-1895
Processes: Albumen
Formats: Prints
Subjects: Architecture, documentary (engineering)
Locations: Italy; France
Studio: Italy - Foggia and Naples
Entries:
California Galleries 9/26/75: 151 (album, M et al);
Swann NY 11/11/76: 388 (albums, M et al);
Swann NY 11/10/83: 304 (albums, M et al)(note);
Christies Lon 6/28/84: 139 (album, M-4 et al);
Christies Lon 10/30/86: 127 (album, M et al);
Harris Baltimore 11/7/86: 279 (lot, M-1 et al);
Swann NY 11/13/86: 217 (lot, M-1 et al), 244 (album, M et al), 245 (lot, M et al);

MAURICE, E. (French)
Photos dated: 1860s
Processes:      Albumen
Formats:        Prints
Subjects:       Genre
Locations:
Studio:
    Entries:
Phillips NY 5/21/80: 204 ill;

MAUSS, Charles (1829-1914)
Photos dated: Nineteenth century
Processes:      Albumen
Formats:        Prints
Subjects:       Topography
Locations:      Palestine
Studio:
    Entries:
Christies Lon 10/29/81: 209 (3)(attributed)(note);

MAX (French)
Photos dated: 1870s
Processes:      Carbon
Formats:        Prints
Subjects:       Topography
Locations:      France - Vichy
Studio:         France
    Entries:
Rose Boston Cat 2, 1977: 39 ill(note), 40 ill;

MAXHAM, Benjamin D.
Photos dated: 1850s
Processes:      Daguerreotype
Formats:        Plates
Subjects:       Portraits
Locations:
Studio:
    Entries:
Vermont Cat 5, 1973: 380 ill;

MAXMILIEN
Photos dated: 1860s
Processes:      Albumen
Formats:        Prints
Subjects:       Topography
Locations:      Algeria - Monzaiaville and Blida
Studio
    Entries:
Swann NY 11/14/85: 9 (lot, M-5 et al);

MAY (see KOPSCH & MAY)

MAY, C.F. (American)
Photos dated: 1862
Processes:      Albumen
Formats:        Prints
Subjects:       Portraits
Locations:      US
Studio:         US
    Entries:
Sothebys NY (Strober Coll.) 2/7/70: 428 (lot,
    M-1 et al);

MAY, Charles (British)
Photos dated: 1862-1866
Processes:      Albumen
Formats:        Prints
Subjects:       Architecture
Locations:      England - Oxford
Studio:         England - Aylesbury
    Entries:
Edwards Lon 1975: 133 (book, 21);
Sothebys Lon 10/27/78: 216 (book, 74);
Christies Lon 3/11/82: 248 (lot, M-6 et al);

MAY, William (British)
Photos dated: 1860-1865
Processes:      Albumen
Formats:        Stereos
Subjects:       Topography, documentary (engineering)
Locations:      Great Britain
Studio:         England - Devonport
    Entries:
Christies Lon 6/18/81: 105 (lot, M-5 et al), 106
    (lot, M-1 et al);
Christies Lon 10/28/82: 17 (lot, M et al);
Harris Baltimore 6/1/84: 64 (lot, M et al);
Sothebys Lon 10/26/84: 7 ill(lot, M-1 et al);
Sothebys Lon 6/28/85: 1 (lot, M et al);

MAYALL, John Jabez Edwin (American, 1810-1901)
Photos dated: 1845-1864
Processes:      Daguerreotype, albumen, carbon,
                "ivorytype"
Formats:        Plates incl. stereo, prints, cdvs
Subjects:       Portraits
Locations:      Studio
Studio:         US - Philadelphia; England - London
    Entries:
Swann NY 2/14/52: 262 (album, M et al);
Sothebys NY (Weissberg Coll.) 5/16/67: 138 (lot, M-1
    et al);
Sothebys NY (Strober Coll.) 2/7/70: 187 ill, 276
    (lot, M-3 et al)(note), 280 (lot, M-8 et al);
Sothebys NY 11/21/70: 333 (lot, M et al), 337 ill
    (lot, M et al), 338 (lot, M et al), 347 (lot,
    M et al);
Rinhart NY Cat 2, 1971: 374 (lot, M-1 et al);
Christies Lon 4/25/72: 172 (lot, M-1 et al);
Rinhart NY Cat 7, 1973: 450;
Vermont Cat 5, 1973: 379 ill;
Sothebys Lon 5/24/73: 123 (lot, M et al), 142 (lot,
    M-1 et al);
Sothebys Lon 12/4/73: 189;
Vermont Cat 7, 1974: 498 ill;
Sothebys Lon 3/8/74: 152 (album, M et al);
Sothebys Lon 6/21/74: 105 (album, M et al), 126,
    130;
Sothebys Lon 10/18/74: 239 (2), 240, 241 (2);
Sothebys Lon 3/21/75: 137 (lot, M et al), 161
    (album, M et al), 210 ill;
Sothebys Lon 6/26/75: 173 (2), 183 ill(lot, M-1 et
    al), 261 (albums, M et al);
Sothebys Lon 10/24/75: 175 (album, M et al), 254;
Colnaghi Lon 1976: 7 (note), 202 (album, M et al)
    (note);
Witkin NY IV 1976: A21 (album, M et al);
Sothebys Lon 3/19/76: 101, 157 (album, M et al);
Sothebys NY 5/4/76: 100 (album, M et al);
Christies Lon 6/10/76: 140 (lot, M et al), 149
    (album, M et al), 150 (album, M et al);
Sothebys Lon 6/11/76: 170 (album, M et al);

## MAYALL (continued)

Christies Lon 10/28/76: 8, 224 (album, M et al), 225 (album, M et al);
Sothebys Lon 10/29/76: 99 (2);
Gordon NY 11/13/76: 48 (albums, M et al);
White LA 1977: 261 ill(lot, M et al);
California Galleries 1/22/77: 169 (album, M-2 plus 1 attributed, et al);
Sothebys Lon 3/9/77: 110 ill;
Christies Lon 3/10/77: 262 (lot, M et al);
Sothebys Lon 7/1/77: 238 (album, M et al), 243 (album, M et al), 247;
Christies Lon 10/27/77: 358 (lot, M-1 et al), 368 (album, M-1 et al), 369 (album, M-1 et al), 371 (lot, M-7 et al);
Sothebys Lon 11/18/77: 222 ill(49)(note), 223 (41), 224 (65);
Swann NY 12/8/77: 349 (lot, M et al);
Witkin NY VI 1978: 86 ill(note);
Christies Lon 6/27/78: 4 ill, 5 (lot, M-1 et al), 51 ill;
Sothebys Lon 6/28/78: 156 (lot, M-1 et al), 180 ill;
Christies Lon 10/26/78: 4, 42 (lot, M-1 et al), 325 (album, M et al), 327 (album, M et al), 438 (album, M et al);
Sothebys Lon 10/27/78: 10, 183 (note), 184 (note), 185 ill(note), 186 (note), 187 (note), 188 ill (note);
Swann NY 12/14/78: 367 (lot, M et al);
Sothebys Lon 3/14/79: 297 (album, M et al), 298 (album, M et al), 307 (album, M-2 et al), 324 (album, M-1 et al);
Christies Lon 3/15/79: 8, 9, 10, 11 (2), 308 (albums, M et al), 309 (album, M-1 et al);
Swann NY 4/26/79: 12 (book, 25)(note);
Phillips NY 5/5/79: 88 ill;
Christies Lon 6/28/79: 10, 218 (album, M-7 et al), 221 (albums, M-2 et al);
Sothebys Lon 6/29/79: 172 (album, M et al), 222 (19) (note), 223, 224 (34), 225 (15), 226 (10), 227 ill(30), 228 (24), 229 (60);
Phillips Can 10/4/79: 27;
Sothebys Lon 10/24/79: 231, 232, 306 (10), 307 (60);
Christies Lon 10/25/79: 59, 395 (album, M-8 et al);
Phillips NY 11/29/79: 241 (lot, M-3 et al);
Christies Lon 3/20/80: 347 (albums, M et al), 352 (albums, M et al), 357 (album, M et al), 363 (album, M et al);
Sothebys Lon 3/21/80: 66, 67, 230;
California Galleries 3/30/80: 214 (album, M-2 plus 1 attributed, et al);
Phillips NY 5/21/80: 138 (album, M et al);
Christies Lon 6/26/80: 10 (2)(note), 16, 28 (lot, M-1 et al), 452 ill, 472 (album, M-1 et al), 473 (album, M-4 et al), 474 (album, M et al), 476 (album, M-2 et al), 477 (album, M-1 et al), 479 (lot, M-1 et al), 486 (albums, M et al), 489 (albums, M et al), 494 (albums, M-7 et al);
Sothebys Lon 6/27/80: 156 (lot, M-1 et al), 214 (album, M et al);
Sothebys Lon 10/29/80: 155 ill, 261 (album, M et al), 262 (album, M et al);
Christies Lon 10/30/80: 410, 417 (album, M et al), 419 (album, M et al), 422 (album, M-4 et al), 425 (album, M et al), 429 (lot, M-3 et al), 430 (lot, M-3 et al), 435 (albums, M et al), 438 (album, M et al), 439 (lot, M et al), 440 (album, M et al);
Phillips Lon 3/18/81: 103A;
Christies Lon 3/26/81: 48, 108, 386 (album, M et al), 394 (lot, M-2 et al), 395 (album, M-8 et

## MAYALL (continued)

al), 397 (album, M-2 et al), 402 (albums, M et al), 405 (album, M et al);
Sothebys Lon 3/27/81: 344, 345, 345a;
Petzold Germany 5/22/81: 1717 ill(3);
Sothebys Lon 6/17/81: 40, 68, 214 ill(note);
Christies Lon 6/18/81: 263 (book, M et al), 365 ill, 419 (album, M et al), 421 ill(albums, M-13 et al), 422 (lot, M et al), 425 (album, M et al), 431 (album, M et al), 434 (lot, M-9 et al);
Phillips Lon 10/28/81: 140 (lot, M-1 et al);
Christies Lon 10/29/81: 8 (lot, M-1 et al), 10 (2), 56 (lot, M-1 et al), 362 (album, M et al), 366 (album, M-2 et al), 368 (lot, M-2 et al), 371 (album, M-2 et al);
Christies Lon 3/11/82: 10 (lot, M-1 et al), 49 (lot, M-1 et al), 316 (album, M et al), 326 (album, M et al), 372 (album, M et al);
Sothebys Lon 3/15/82: 271;
Phillips Lon 3/17/82: 76 (album, M-1 et al), 87 (album, M et al);
Phillips Lon 6/23/82: 68 (album, M et al);
Christies Lon 6/24/82: 19 (lot, M-1 et al), 363 (album, M et al), 366 (album, M et al), 381 (album, M et al);
Sothebys Lon 6/25/82: 20 ill, 34;
Phillips Lon 10/27/82: 14 (lot, M-2 et al), 28 (albums, M et al);
Christies Lon 10/28/82: 211 (lot, M et al);
Swann NY 11/18/82: 482 (note);
Christies Lon 3/24/83: 237 (album, M et al);
Harris Baltimore 4/8/83: 322 (lot, M et al);
Christies Lon 6/23/83: 19 (lot, M-1 et al), 243 (album, M et al), 245 (album, M et al), 252 (album, M-23 et al), 259 (album, M et al), 262 (album, M et al);
Christies Lon 10/27/83: 224A (album, M et al), 231 (album, M et al), 234A (album, M et al);
Phillips Lon 11/4/83: 145 (4 ills)(album, M-9 plus 6 attributed)(note);
Swann NY 11/10/83: 33 (books, M et al);
Christies Lon 3/29/84: 325 (album, M et al), 337 (album, M et al), 349 (album, M et al), 350 (album, M et al);
Swann NY 5/10/84: 194 (lot, M-1 et al), 291 (lot, M et al), 320 (album, M et al), 321 (lot, M et al) (note), 322 (albums, M et al)(note);
Christies Lon 6/28/84: 12 (lot, M-3 et al), 23 ill (note), 302 (album, M et al), 314 (album, M et al);
Sothebys Lon 6/29/84: 183 ill;
Phillips Lon 10/24/84: 101 (album, M et al), 121 (lot, M-1 et al);
Christies Lon 10/25/84: 174, 320 (album, M et al), 323 (album, M et al), 325 (albums, M et al);
Sothebys Lon 10/26/84: 23;
Harris Baltimore 3/15/85: 161 (album, M et al), 308 (lot, M et al);
Phillips Lon 3/27/85: 137 ill, 209 (lot, M-1 et al), 212 (lot, M et al), 213 (lot, M-1 et al);
Christies Lon 3/28/85: 309 (album, M et al), 321 (album, M et al);
Sothebys Lon 3/29/85: 52 ill, 53, 157 ill;
Swann NY 5/9/85: 454 (album, M et al);
Phillips Lon 6/26/85: 162 (album, M et al), 205 (lot, M et al);
Christies Lon 6/27/85: 246 (albums, M et al)(note), 271 (album, M et al), 279 (album, M et al);
Sothebys Lon 6/28/85: 24 ill(2)(note), 25 (lot, M-1 et al), 121 ill, 202 (album, M-1 et al);

## MAYALL (continued)

Phillips Lon 10/30/85: 32 (lot, M-1, M &
    Southwell-8, et al), 33 (lot, M et al), 37 (lot,
    M et al), 63 (lot, M et al);
Christies Lon 10/31/85: 11 ill(4), 12, 13, 14, 15
    (lot, M-1 et al), 282 (albums, M et al), 284
    (albums, M et al), 289 (lot, M et al), 302
    (album, M et al);
Sothebys Lon 11/1/85: 123 (album, M et al);
Swann NY 11/14/85: 137 (album, M et al);
Phillips Lon 4/23/86: 222 (lot, M et al), 228 (lot,
    M et al), 238 (lot, M et al), 242 (album, M et
    al), 272 (lot, M et al);
Christies Lon 4/24/86: 590 (album, M et al);
Sothebys Lon 4/25/86: 151, 168 (books, M et al), 206
    (album, M et al);
Swann NY 5/16/86: 313 (lot, M et al);
Christies Lon 6/26/86: 103 (albums, M et al), 145
    (lot, M et al), 146 (lot, M et al);
Phillips Lon 10/29/86: 307 (lot, M et al), 308
    (lot, M et al), 313 (album, M et al);
Christies Lon 10/30/86: 11 (lot, M-1 et al), 23
    (2), 217 (albums, M et al), 220 (albums, M et
    al), 224 (album, M et al), 226 (album, M et al),
    227 (album, M et al), 237 (lot, M et al), 244
    (album, M-3 et al), 252 (album, M et al);
Swann NY 11/13/86: 169 (albums, M et al);

## MAYBERRY, J.H. (American)
Photos dated: c1880-1890s
Processes:      Albumen
Formats:        Cabinet cards
Subjects:       Topography, genre
Locations:      US - Wyoming
Studio:         US
    Entries:
Christies Lon 6/27/78: 140 (lot, M-4 et al);

## MAYER Brothers
Photos dated: 1860s-1870s
Processes:      Albumen
Formats:        Cdvs
Subjects:       Portraits
Locations:      Studio
Studio:         England - London
    Entries:
Christies Lon 3/26/81: 412 (album, M-1 et al);
Phillips Lon 4/23/86: 224 (lot, M-1 et al);
Sothebys Lon 4/25/86: 186;
Phillips Lon 10/29/86: 296 (album, M-1 et al);
Sothebys Lon 10/31/86: 161;

## MAYER, Ernest & PIERSON (French)
Photos dated: c1852-1870
Processes:      Albumen
Formats:        Prints, stereos, cdvs
Subjects:       Portraits
Locations:      Studio
Studio:         France - Paris
    Entries:
Sothebys NY 11/21/70: 346 ill(lot, M & P-1 et al);
Sothebys NY 2/25/75: 115 (lot, M & P et al);
Sothebys NY 11/9/76: 37 ill(note);
Christies Lon 10/27/77: 365 (album, M & P-1 et al);
Sothebys Lon 6/28/78: 133 ill(note);
Christies Lon 3/15/79: 301 (lot, M & P-1 et al);
Auer Paris 5/31/80: 129 (lot, M & P-1 et al);
Christies Lon 6/26/80: 471 (album, M & P-13 et al);

## MAYER & PIERSON (continued)

Sothebys Lon 10/29/80: 261 (album, M & P et al);
Petzold Germany 11/7/81: 302 (album, M & P et al);
Sothebys Lon 3/15/82: 230 (album, M & P et al);
Christies Lon 4/24/86: 458 (2);
Sothebys Lon 4/25/86: 187 ill;

## MAYER, Gustav R. (American)
Photos dated: Nineteenth century
Processes:      Albumen
Formats:        Prints
Subjects:       Topography
Locations:      US - American west
Studio:         US
    Entries:
Ricketts Lon 1974: 12 (2 ills)(album, 81)(note);

## MAYER, J.S. (American)
Photos dated: c1850-1860s
Processes:      Daguerreotype, Ambrotype
Formats:        Plates
Subjects:       Portraits
Locations:      Studio
Studio:         US - New York City
    Entries:
Swann NY 12/8/77: 332 (lot, M et al);
Bievres France 2/6/83: 44;

## MAYER, Louise (French)
Photos dated: c1860
Processes:      Salt
Formats:        Prints
Subjects:       Portraits
Locations:      Studio
Studio:         France
    Entries:
Sothebys Lon 10/26/84: 82 ill;

## MAYHEW, W.C. (British)
Photos dated: 1850-late 1850s
Processes:      Daguerreotype, albumen
Formats:        Plates, stereos
Subjects:       Portraits, genre
Locations:      Great Britain
Studio:         Great Britain
    Entries:
Christies Lon 6/28/84: 37 (lot, M-2 et al);

## MAYLAND, William (British)
Photos dated: 1850s-c1880
Processes:      Albumen
Formats:        Prints, stereos
Subjects:       Portraits, topography
Locations:      England - Cambridge
Studio:         England - Cambridge
    Entries:
Edwards Lon 1975: 69 (book, M-1 et al);
Swann NY 2/6/75: 116 (book, 2);
Wood Conn Cat 37, 1976: 27 (book, M-2 et al);
Christies Lon 10/28/76: 244 (album, M-1 et al);
Christies Lon 3/20/80: 107 (lot, M et al);
Christies Lon 6/26/86: 158 (lot, M-1 et al);

**MAYNARD, R.**
Photos dated: 1885
Processes:      Albumen
Formats:        Prints
Subjects:       Architecture
Locations:      Canada - Victoria, British Columbia
Studio:         Canada - Victoria, British Columbia
   Entries:
Rinhart NY Cat 7, 1973: 157;

**MAYO & WEED** (American)
Photos dated: c1890
Processes:      Albumen
Formats:        Prints, cabinet cards
Subjects:       Topography, portraits
Locations:      Mexico; US - Alaska, Colorado, Utah;
               Canada
Studio:         US - Chicago, Illinois
   Entries:
California Galleries 12/13/80: 213 (17);
California Galleries 6/28/81: 278 ill(36), 279
   ill(42);
California Galleries 5/23/82: 198 ill(album, 173);
Swann NY 5/16/86: 275 ill(album, 125);

**MAYOW, H.C.** (American)
Photos dated: c1860
Processes:      Daguerreotype
Formats:        Plates
Subjects:       Portraits
Locations:      US
Studio:         US
   Entries:
Christies Lon 6/30/77: 2 (lot, M-1 et al);

**MAYS** (British)
Photos dated: 1860s
Processes:      Albumen
Formats:        Prints
Subjects:       Topography
Locations:      England - Buckinghamshire
Studio:         Great Britain
   Entries:
Sothebys Lon 10/27/78: 216 (book, 74);

**McCAFFREY**
Photos dated: 1860s
Processes:      Albumen
Formats:        Cdvs
Subjects:       Portraits
Locations:
Studio:
   Entries:
Harris Baltimore 4/8/83: 381 (lot, M et al);

**McALLISTER, Dr. A.M.** (American)
Photos dated: c1859
Processes:      Albumen
Formats:        Prints
Subjects:       Topography
Locations:      US - Philadelphia, Pennsylvania
Studio:         US - Philadelphia, Pennsylvania
   Entries:
Rinhart NY Cat 6, 1973: 542, 543;
Wood Conn Cat 37, 1976: 302 ill;

**McALLISTER, T.H.**
Photos dated: c1850-1880
Processes:      Collodion on glass, albumen
Formats:        Lantern slides, cdvs
Subjects:       Topography, genre, portraits
Locations:      US; Europe
Studio:         US
   Entries:
California Galleries 9/27/75: 406 (lot, M & Thompson
   et al), 407 (lot, M et al);
Swann NY 12/8/77: 391 (16)(note);
Harris Baltimore 4/8/83: 315 (lot, M et al);

**McALPIN & LAMP** (American)
Photos dated: c1890
Processes:      Albumen
Formats:        Prints
Subjects:       Ethnography
Locations:      US
Studio:         US
   Entries:
California Galleries 1/21/78: 370 (lot, M & L-1
   et al);

**McBRIDE** (see COULES & McBRIDE) [McBRIDE 1]

**McBRIDE, H.** (American) [McBRIDE 2]
Photos dated: 1852
Processes:      Daguerreotype
Formats:        Plates
Subjects:       Portraits
Locations:      Studio
Studio:         US - Albany, New York
   Entries:
Sothebys Lon 10/18/74: 238 ill (2);

**McCANN, P.** (American)
Photos dated: 1870s
Processes:      Albumen
Formats:        Stereos
Subjects:       Topography
Locations:      US - Romeo, Michigan
Studio:         US
   Entries:
Harris Baltimore 12/16/83: 81 (M & Cuyler, 3);

**McCARTNEY**
Photos dated: 1850s
Processes:      Daguerreotype
Formats:        Plates
Subjects:       Portraits
Locations:
Studio:
   Entries:
Sothebys Lon 10/24/75: 35 (lot, M-1 et al);

**McCAY**
Photos dated: 1880s
Processes:      Albumen
Formats:        Prints
Subjects:       Ethnography
Locations:      US - American west
Studio:
   Entries:
Swann NY 4/23/81: 406 (lot, M-2 et al);

**McCLEES, James Earle** (American, 1821-1887)
Photos dated: c1850-1860
Processes:      Daguerreotype, ambrotype, albumen
Formats:        Plates incl. stereo, prints, cdvs,
                stereos
Subjects:       Portraits, architecture
Locations:      US - Pennsylvania
Studio:         US - Philadelphia, Pennsylvania;
                Washington, D.C.
    Entries:
Sothebys NY (Strober Coll.) 2/7/70: 292 (lot,
    M et al);
Sothebys Lon 12/21/71: 189 (lot, M-1 et al);
Vermont Cat 4, 1972: 327 ill;
Rinhart NY Cat 7, 1973: 570 ill;
Rinhart NY Cat 8, 1973: 106;
Vermont Cat 5, 1973: 381 ill, 382 ill(M & Germon);
Vermont Cat 6, 1973: 519 ill(M & Germon);
Vermont Cat 11/12, 1977: 559 ill(M & Germon)(note);
California Galleries 1/22/77: 131 (2), 347a (lot,
    M & Germon-1, et al);
California Galleries 1/21/78: 78 (lot, M & Germon-1,
    et al);
Swann NY 4/20/78: 306 (lot, M & Germon-1, et al);
Christies Lon 10/26/78: 29 (M & Germon);
Swann NY 12/14/78: 390 (2)(M & Germon)(note);
Christies Lon 3/20/80: 20 (M & Germon);
Christies Lon 6/26/80: 42;
Swann NY 4/23/81: 244 (lot, M & Germon-1, et al),
    256 ill(lot, M-1 et al)(note);
California Galleries 6/19/83: 216 (lot, M-1 et al);
Christies NY 2/22/84: 16 ill;
Harris Baltimore 11/9/84: 100 (lot, M-1 et al);
Swann NY 5/16/86: 222 (lot, M et al);

**McCLELLAN, George, M.D.**
Photos dated: 1891
Processes:
Formats:        Prints
Subjects:       Documentary (medical)
Locations:      US
Studio:         US
    Entries:
Wood Conn Cat 37, 1976: 137 ill(book, 97)(note);
Wood Conn Cat 42, 1978: 329 (book, 97)(note);
Wood Conn Cat 45, 1979: 165 ill(book, 97)(note);
Wood Conn Cat 49, 1982: 274 (book, 97)(note);

**McCLURE, James** (Canadian)
Photos dated: 1870s-1880
Processes:      Albumen
Formats:        Stereos, cdvs
Subjects:       Topography, documentary (disasters)
Locations:      Canada - New Brunswick
Studio:         Canada - St. John
    Entries:
Kingston Boston 1976: 554 (book, M-9 et al);
Christies Lon 3/29/84: 38 (lot, M et al);
Harris Baltimore 6/1/84: 18 (lot, M-1 et al);

**McCOLLINS** (see HAWORTH & McCOLLINS)

**McCRARY & BRANSON** (American)
Photos dated: 1880s
Processes:      Albumen
Formats:        Stereos
Subjects:       Topography
Locations:      US - Knoxville, Tennessee
Studio:         US - Knoxville, Tennessee
    Entries:
Swann NY 10/18/79: 429 (15);

**McCULLUM & BUTTERFIELD** (American)
Photos dated: Nineteenth century
Processes:      Albumen
Formats:        Stereos
Subjects:       Topography
Locations:      US
Studio:         US
    Entries:
Harris Baltimore 5/22/82: 161 (lot, M & B et al);

**McDONALD** (see NEEDHAM & McDONALD)

**McDONALD & STERRY** (American)
Photos dated: c1883
Processes:      Albumen
Formats:        Prints
Subjects:       Portraits
Locations:      Studio
Studio:         US - Albany, New York
    Entries:
Harris Baltimore 4/8/83: 67 (lot, M & S et al);
Harris Baltimore 12/16/83: 240;
Harris Baltimore 3/15/85: 88 (lot, M & S-6 et al);

**McDONALD, A.J.** (American)
Photos dated: c1870-c1894
Processes:      Albumen
Formats:        Prints, cabinet cards
Subjects:       Topography
Locations:      US - San Francisco, California
Studio:         US - San Francisco, California
    Entries:
California Galleries 1/21/78: 402;
California Galleries 12/13/80: 337;
Harris Baltimore 12/16/83: 293 (lot, M et al);
California Galleries 7/1/84: 535;
California Galleries 6/8/85: 404 (2);
California Galleries 3/29/86: 751 (2);

**McDONALD, D.** (Australian)
Photos dated: 1866-c1880
Processes:      Albumen
Formats:        Prints, cabinet cards
Subjects:       Topography
Locations:      Australia - Sandhurst
Studio:         Australia - North Melbourne
    Entries:
Christies Lon 10/26/78: 160 (album, 24);
Sothebys Lon 10/27/78: 101 (11);
Sothebys Lon 11/1/85: 20 ill (lot, M et al);

**McDONALD, George A. & LEA, D.P.** (American)
Photos dated: 1870s
Processes:      Albumen
Formats:        Prints
Subjects:       Topography
Locations:      US - San Francisco, California
Studio:         US
    Entries:
Swann NY 4/14/77: 316 (lot, M & L et al);

**McDONALD, Captain H.C.** (British)
Photos dated: c1870
Processes:      Albumen
Formats:        Prints
Subjects:       Ethnography
Locations:      India
Studio:
    Entries:
Sothebys Lon 10/18/74: 80 (book, M et al);
Christies Lon 3/11/82: 252 (books, M et al);

**McDONALD, Seargeant James** (British)
Photos dated: 1864-1869
Processes:      Albumen
Formats:        Prints
Subjects:       Topography
Locations:      England; Palestine - Jerusalem
Studio:
    Entries:
Colnaghi Lon 1976: 89 ill(book, 12)(note);
Swann NY 4/14/77: 299 (book, 77)(note);
Rose Boston Cat 3, 1978: 99 ill(note), 100 ill;
Christies Lon 6/27/78: 161 (book, M-73 et al);
Sothebys Lon 3/27/81: 61 ill(book, 78);
Sothebys Lon 6/25/82: 90 ill;
Christies Lon 6/23/83: 134;
Christies NY 11/6/84: 8 ill(4)(note);
Christies Lon 6/27/85: 163 ill(6);
Phillips Lon 4/23/86: 314 ill(album, 33);

**McDONELL, Donald** (American)
Photos dated: 1850
Processes:      Daguerreotype
Formats:        Plates
Subjects:       Portraits
Locations:      Studio
Studio:         US - Buffalo, New York
    Entries:
Sothebys NY (Weissberg Coll.) 5/16/67: 105 (lot,
    M-1 et al);
Vermont Cat 7, 1974: 499 ill;

**McDOUGALL** (see SANDS & McDOUGALL)

**McELROY, John** (American)
Photos dated: 1850s
Processes:      Daguerreotype
Formats:        Plates
Subjects:       Portraits
Locations:      Studio
Studio:         US - New York State
    Entries:
Sothebys NY (Weissberg Coll.) 5/16/67: 113 (lot,
    M-1 et al);
Rinhart NY Cat 1, 1971: 56, 76, 82;
California Galleries 1/22/77: 72 (lot, M-1 et al);

**McELROY, J.** (continued)
Christies Lon 6/26/80: 29;
Christies Lon 3/26/81: 30;
Christies NY 2/8/83: 82 (lot, M-1 et al);

**McGHIE, J.** (British)
Photos dated: 1868
Processes:      Albumen
Formats:        Prints
Subjects:       Topography
Locations:      Scotland - Tweed
Studio:         Scotland - Hamilton
    Entries:
Christies Lon 3/28/85: 211 (book, 25);

**McGLASHON, A.**
Photos dated: 1874
Processes:      Albertype
Formats:        Prints
Subjects:       Documentary (art)
Locations:
Studio:
    Entries:
California Galleries 3/30/80: 134 (book, 32);

**McGOWAN, Joseph H.** (see MITCHELL & McGOWAN)

**McGREER, John** (see SMITH, Joshua)

**McGREGOR** (American)
Photos dated: Nineteenth century
Processes:      Albumen
Formats:        Stereos
Subjects:       Topography
Locations:      US
Studio:         US
    Entries:
Harris Baltimore 4/8/83: 57 (lot, M et al);

**McHENRY**
Photos dated: c1875
Processes:      Albumen
Formats:        Cdvs
Subjects:       Portraits
Locations:
Studio:
    Entries:
California Galleries 1/22/77: 128 (lot, M et al);

**McINTOSH, R.M.** (American)
Photos dated: 1850s-c1880
Processes:      Ambrotype, albumen
Formats:        Plates, stereos
Subjects:       Portraits, topography
Locations:      US - New York State
Studio:         US - Lowell, Massachusetts; Vermont
    Entries:
Rinhart NY Cat 2, 1971: 535 (lot, M-4 et al);
Rinhart NY Cat 6, 1973: 524;
California Galleries 4/3/76: 406 (lot, M et al), 413
    (lot, M et al);
Vermont Cat 11/12, 1977: 688 ill;
California Galleries 1/21/78: 175 (lot, M et al),
    179 (lot, M et al);

## McINTOSH, R.M. (continued)
Rose Florida Cat 7, 1982: 97 ill(15);
Harris Baltimore 2/14/86: 2 (lot, M et al);

## McINTYRE, A.C. (Canadian)
Photos dated: 1870s-1880s
Processes:      Albumen
Formats:        Stereos
Subjects:       Topography, ethnography
Locations:      US - New York State
Studio:         US - Alexandria Bay, New York
   Entries:
Rinhart NY Cat 6, 1973: 471, 559, 561, 562, 563;
Christies Lon 6/26/80: 115 (lot, M et al);
Christies Lon 10/30/80: 124 (lot, M-5 et al);
Swann NY 5/5/83: 431 (lot, M et al)(note);
Christies Lon 10/27/83: 44 (lot, M et al);
Swann NY 11/13/86: 323 (lot, M-10 et al);

## McINTYRE, S.A. (American)
Photos dated: 1886
Processes:      Albumen
Formats:        Prints, cdvs
Subjects:       Portraits
Locations:      Studio
Studio:         US - Philadelphia, Pennsylvania
   Entries:
Harris Baltimore 3/15/85: 247;

## McKECKNIE & OSWALD (American)
Photos dated: Nineteenth century
Processes:      Albumen
Formats:        Cabinet cards
Subjects:       Portraits
Locations:      Studio
Studio:         US - Toledo, Ohio
   Entries:
Harris Baltimore 6/1/84: 251 (lot, M & O-1 et al);
Harris Baltimore 11/4/84: 133 (lot, M & O-1 et al);

## McKENNEY (see REED & McKENNEY)

## McKENNY & PARSONS (Canadian)
Photos dated: 1870s
Processes:      Albumen
Formats:        Prints
Subjects:       Documentary (maritime)
Locations:      Canada
Studio:         Canada - St. Johns
   Entries:
Swann NY 5/10/84: 168;

## McKERNON
Photos dated: 1850s
Processes:      Daguerreotype
Formats:        Plates
Subjects:       Portraits
Locations:
Studio:
   Entries:
Christies Lon 3/26/81: 57 ill;

## McKERNON, P.H. & ALDEN (American)
Photos dated: 1870s
Processes:      Albumen
Formats:        Stereos
Subjects:       Topography
Locations:      US - Saratoga Springs, New York
Studio:         US - Saratoga Springs, New York
   Entries:
Harris Baltimore 3/15/85: 88 (lot, M & A et al);

## M'CLASHON (British)
Photos dated: Nineteenth century
Processes:      Albumen
Formats:        Stereos
Subjects:       Topography
Locations:      Scotland
Studio:         Scotland
   Entries:
Christies Lon 3/11/82: 85 (lot, M et al);

## McLAUGHLIN, Samuel (Canadian, 1824-1914)
Photos dated: 1859-1870s
Processes:      Albumen
Formats:        Prints
Subjects:       Architecture, topography
Locations:      Canada - Ottawa; Niagara Falls; Quebec
Studio:         Canada
   Entries:
Christies Lon 3/24/83: 129 (note);
Christies Lon 6/28/84: 238 ill, 239 ill;

## McLEAN & HAES, Frank (British)
Photos dated: 1860s
Processes:      Albumen
Formats:        Prints, stereos
Subjects:       Genre, genre (animal life)
Locations:      England - London
Studio:         Great Britain
   Entries:
Sothebys Lon 3/9/77: 220;
Christies Lon 6/30/77: 157 (lot, M & H-2 et al);
Harris Baltimore 6/1/84: 5 (lot, M & H-2 et al);
Sothebys Lon 6/28/85: 7 (lot, M & H-2 et al);

## McLEAN & MELHUISH, A.J. (British)
Photos dated: 1862
Processes:      Albumen
Formats:        Prints, stereos
Subjects:       Topography
Locations:      Great Britain
Studio:         Great Britain
   Entries:
Goldschmidt Lon Cat 52, 1939: 230 (book, M & M
   et al);
Weil Lon Cat 4, 1944(?): 198 (book, M & M et al)
   (note);
Sothebys Lon 3/8/74: 163 (book, M & M et al), 165
   (book, M & M et al);
Edwards Lon 1975: 110 (book, M & M et al);
California Galleries 9/26/75: 179 (book, M & M
   et al);
Swann NY 11/11/76: 269 (book, M & M et al)(note);
Christies Lon 6/30/77: 193 (book, M & M et al);
Christies Lon 10/27/77: 209 (book, M & M et al);
Lehr NY Vol 1:4, 1978: 38 (book, M & M-2 et al);
Witkin NY IX 1979: 2/40 (book, M & M-2 et al);

## McLEAN & MELHUISH
Christies Lon 6/28/79: 156 (book, M & M et al), 157 (book, M & M et al);
Christies Lon 3/20/80: 218 (book, M & M et al);
Christies Lon 6/26/80: 302 (book, M & M et al);
Christies Lon 10/30/80: 284 (book, M & M et al);
Swann NY 11/10/83: 88 (book, M & M et al);

## McLEAN, L. (American)
Photos dated: 1860s-1880s
Processes:  Albumen
Formats:    Prints, stereos
Subjects:   Portraits, topography
Locations:  US - Colorado
Studio:     US - Georgetown, Colorado
    Entries:
Sothebys NY (Strober Coll.) 2/7/70: 507 (lot, M et al);
Vermont Cat 5, 1973: 530 ill;
California Galleries 1/23/77: 373 (27);
Christies Lon 10/25/79: 386;

## McLEISH (see JUDD & McLEISH) [McLEISH 1]

## McLEISH & CRESSEY (American) [McLEISH 2]
Photos dated: 1871
Processes:  Albumen
Formats:    Stereos
Subjects:   Documentary (disasters)
Locations:  US - Chicago, Illinois
Studio:     US - St. Paul, Minnesota
    Entries:
Harris Baltimore 6/1/84: 25 (lot, M & C et al);

## McNELLIE, A. (British)
Photos dated: Nineteenth century
Processes:  Albumen
Formats:    Cdvs
Subjects:   Topography
Locations:  England - Brighton
Studio:     Great Britain
    Entries:
Phillips Lon 10/29/86: 300 (lot, M-1 et al);

## McPHERSON & OLIVER (American)
Photos dated: 1863-1865
Processes:  Albumen
Formats:    Prints, cdvs
Subjects:   Documentary (Civil War)
Locations:  US - Louisiana
Studio:     US - Baton Rouge, Louisiana
    Entries:
Swann NY 4/23/81: 434 (note);
Sothebys NY 5/15/81: 112 ill(albums, M & O et al);

## McPHERSON, J. (American)
Photos dated: 1850s-1860s
Processes:  Collodion on glass
Formats:    Stereo plates
Subjects:   Topography
Locations:  US - Niagara Falls, New York
Studio:     US - Niagara Falls, New York
    Entries:
Sothebys NY (Strober Coll.) 2/7/70: 438 (lot, M-2 et al);
Christies Lon 3/10/77: 207 (lot, M-1 et al);
Harris Baltimore 12/10/82: 74 (12);

## MEADE, Charles Richard (American, died 1858)
Photos dated: 1841-1858
Processes:  Daguerreotype, coated salt, albumen
Formats:    Plates, prints, stereos
Subjects:   Portraits
Locations:  US; France
Studio:     US - Albany, New York
    Entries:
Anderson NY (Gilsey Coll.) 1/20/03: 273 ill;
Sothebys NY (Strober Coll.) 2/7/70: 115 (note), 217 (lot, M-1 et al), 261 (lot, M et al), 281 (lot, M et al), 297 (lot, M et al), 324 (lot, M et al), 344 (lot, M et al)(note);
Sothebys Lon 3/21/75: 261 ill(M & brother)(note);
Swann NY 11/11/76: 315;
Gordon NY 11/13/76: 4 ill;
Christies Lon 6/30/77: 48 ill(M & brother);
Christies NY 5/4/79: 75 ill;
Auer Paris 5/31/80: 9;
Christies NY 11/11/80: 98 ill(after Brady);

## MEARS, J.P. (American)
Photos dated: 1870s
Processes:  Albumen
Formats:    Stereos
Subjects:   Topography
Locations:  US - Florida
Studio:     US - Palatka, Florida
    Entries:
California Galleries 9/27/75: 480 (lot, M et al);
California Galleries 1/23/77: 385 (lot, M et al);

## MEDER, L. (German)
Photos dated: 1850s-1870s
Processes:  Albumen
Formats:    Prints, stereos, cdvs
Subjects:   Topography
Locations:  Germany - Heidelberg
Studio:     Germany - Heidelberg
    Entries:
California Galleries 4/3/76: 375 (lot, M et al);
Christies Lon 3/16/78: 68 ill;
Sothebys Lon 3/22/78: 3 (lot, M-10 et al);
Christies Lon 6/27/78: 76 ill;
Christies Lon 10/26/78: 118;
Christies Lon 10/30/80: 120 (lot, M-4 et al);
Christies Lon 3/26/81: 130 (lot, M-3 et al), 191 (3);
Christies Lon 10/29/81: 139 (lot, M-3 et al);
Petzold Germany 11/7/81: 309 (album, M et al), 328 (album, M et al);
Christies Lon 3/11/82: 94 (lot, M et al);

MEDLER (American)
Photos dated: c1885
Processes:     Albumen
Formats:       Stereos
Subjects:      Topography
Locations:     US
Studio:        US - Spencer, Iowa
    Entries:
California Galleries 1/21/79: 498 (27);

MEGKOVSKI, Ivan (Polish)
Photos dated: 1888
Processes:     Albumen
Formats:       Prints
Subjects:      Documentary (public events)
Locations:     Russia - Moscow
Studio:        Poland - Warsaw
    Entries:
Christies NY 5/4/79: 71 (2 ills)(album, 45)(note);

MEISENBACH Y GOMEZ POLO (Spanish)
Photos dated: 1885
Processes:     Heliogravure
Formats:       Prints
Locations:     Spain
Studio:        Spain
    Entries:
White LA 1977: 370 (book, M et al);

MEISSNER, F
Photos dated: 1860s and/or 1870s
Processes:     Albumen
Formats:       Prints
Subjects:      Topography
Locations:     Egypt
Studio:
    Entries:
Christies Lon 10/31/85: 120 (album, M-1 et al);

MELANDER, L.M. & Silas (American)
Photos dated: 1860s-1880s
Processes:     Albumen
Formats:       Stereos
Subjects:      Genre, documentary (disasters)
Locations:     US - Chicago, Illinois
Studio:        US - Chicago, Illinois
    Entries:
Harris Baltimore 7/31/81: 86 (M & Henderson, 30);
Swann NY 11/18/82: 448 (lot, M et al);
Harris Baltimore 12/16/83: 33 (lot, M et al);
Harris Baltimore 6/1/84: 23 (lot, M-1 et al), 25
    (lot, M & Henderson-6, et al), 38 (lot, M et al);
Harris Baltimore 3/15/85: 29 (lot, M-5 et al);

MELANDRI (French)
Photos dated: 1860s-c1883
Processes:     Albumen, woodburytype
Formats:       Prints, cabinet cards
Subjects:      Portraits incl. Galerie Contemporaine
Locations:     Studio
Studio:        France
    Entries:
Gordon NY 11/13/76: 132 ill;
Christies Lon 10/27/77: 380 (album, M-2 et al);
Christies Lon 3/16/78: 321 (lot, M-1 et al);
Witkin NY IX 1979: 2/17 (books, M et al);

MELANDRI (continued)
Christies NY 5/14/81: 41 (books, M-1 et al);
Christies NY 5/26/82: 36 (book, M et al);
Christies NY 5/7/84: 19 (book, M et al);

MELLEN, George E. (American)
Photos dated: early 1870s-c1885
Processes:     Albumen
Formats:       Prints, stereos
Subjects:      Topography
Locations:     US - Colorado
Studio:        US - Colorado Springs, Colorado
    Entries:
Swann NY 4/1/82: 249 (lot, M et al);
California Galleries 5/23/82: 264 (lot, M-1 et al);
California Galleries 7/1/84: 252 (10);
Swann NY 11/13/86: 133 (lot, M et al);

MELHUISH, A.J. (British)(see also McLEAN &
                MELHUISH)
Photos dated: 1850s-1860s
Processes:     Albumen
Formats:       Cdvs, stereos
Subjects:      Portraits
Locations:     Studio
Studio:        England
    Entries:
Sothebys Lon 3/21/75: 154 (lot, M et al);
Christies Lon 10/30/80: 431 (album, M et al);

MELVILLE, R. Leslie (British)
Photos dated: 1860s
Processes:
Formats:       Prints
Subjects:
Locations:
Studio:        Great Britain (Amateur Photographic
                Association)
    Entries:
Sothebys Lon 10/29/80: 310 (album, M et al);

MENDELSSOHN, H.S.
Photos dated: 1870s-1890s
Processes:     Albumen, platinum
Formats:       Prints, cabinet cards
Subjects:      Portraits
Locations:     Studio
Studio:        England - London; Newcastle;
                Sunderland
    Entries:
California Galleries 1/21/78: 141 (album, M et al);
Sothebys NY 5/2/78: 161 (albums, M-1 et al);
Christies Lon 3/26/81: 420 ill(album, M et al);
California Galleries 6/28/81: 389;
Christies Lon 6/24/82: 381 (album, M et al);
Christies Lon 10/25/84: 218 ill;
Harris Baltimore 3/15/85: 303 (lot, M et al);

MENDHAM (see POWELSON & MENDHAM)

**MENNS, W.K.**
Photos dated: c1870s
Processes:      Albumen
Formats:        Stereos
Subjects:       Topography
Locations:      US - Vermont
Studio:
   Entries:
Rinhart NY Cat 1, 1971: 290 (3);

**MENTAL, Angel** (Cuban)
Photos dated: 1898
Processes:
Formats:        Prints
Subjects:       Topography
Locations:      Cuba - Havana
Studio:         Cuba - Havana
   Entries:
Swann NY 4/23/81: 448 (7);

**MERENESS** (American)
Photos dated: 1860s and/or 1870s
Processes:      Albumen
Formats:        Cdvs
Subjects:       Portraits
Locations:      Studio
Studio:         US - Oneonta, New York
   Entries:
Rinhart NY Cat 2, 1971: 366 (lot, M et al);

**MERLIN, C.M.**
Photos dated: 1880s-1899
Processes:      Albumen
Formats:        Prints, cabinet cards
Subjects:       Topography, portraits
Locations:      Greece - Athens
Studio:         Greece - Athens
   Entries:
Christies Lon 10/27/83: 87 (albums, M et al);
Harris Baltimore 3/15/85: 277 (lot, M et al);
Christies Lon 3/28/85: 29 (albums, M et al);

**MERRIAM**
Photos dated: c1895
Processes:      Photogravure
Formats:        Prints
Subjects:       Topography
Locations:      US - Kodiak, Alaska
Studio:
   Entries:
California Galleries 3/30/80: 196;

**MERRICK & Co.** (British)
Photos dated: 1853-c1870
Processes:      Ambrotype, salt
Formats:        Plates incl. stereo, prints
Subjects:       Portraits
Locations:      Studio
Studio:         England - Brighton
   Entries:
Vermont Cat 5, 1973: 446 ill;
Christies Lon 10/27/77: 37 (lot, M-1 et al);
Sothebys Lon 3/14/79: 17 (note);
Sothebys Lon 3/15/82: 307;

**MERRIFIELD, W.**
Photos dated: 1850s and/or 1860s
Processes:      Albumen
Formats:        Stereos
Subjects:       Topography
Locations:
Studio:
   Entries:
Christies Lon 10/25/84: 52 (lot, M et al);

**MERRILL** (see MILLER & MERRILL) [MERRILL 1]

**MERRILL** (see STODDARD) [MERRILL 2]

**MERTENS, Dr. E & Co.** (German)
Photos dated: c1893
Processes:      Albumen, bromide
Formats:        Prints
Subjects:       Topography
Locations:      Germany
Studio:         Germany - Berlin
   Entries:
California Galleries 4/2/76: 242 (lot, M-2 et al);
Christies Lon 10/28/76: 121 (book, 20);
Swann NY 11/18/82: 373 (albums, M et al);

**MESQUICH**
Photos dated: c1898
Processes:
Formats:        Kinetiscope reel
Subjects:       Genre
Locations:      US - New York City
Studio:         US
   Entries:
Sothebys NY 5/2/78: 140;

**MESSINA** (Italian)
Photos dated: 1875-1895
Processes:      Albumen
Formats:        Prints
Subjects:       Architecture
Locations:      Italy; France
Studio:         Italy
   Entries:
Swann NY 11/11/76: 389 (albums, M et al);

**MESTRAL, O.** (see LE GRAY)

**METCALF** (see HARLEY & METCALF)

**METCALFE, H.J.** (British)
Photos dated: 1893
Processes:      Albumen
Formats:        Prints
Subjects:       Documentary (scientific)
Locations:      England - Yorkshire
Studio:         England - Yorkshire
   Entries:
Wood Conn Cat 45, 1979: 308 (book, 2)(note);
Wood Conn Cat 49, 1982: 375 (book, 2)(note);

**METEYARD** (British)
Photos dated: 1860s
Processes: Albumen
Formats: Prints
Subjects: Topography
Locations: England - Isle of Wight
Studio: Great Britain
   Entries:
Sothebys Lon 11/18/77: 80 (album, M-1 et al);
Christies Lon 6/28/84: 217 (lot, M-2 et al);

**METEYARD, Elizabeth** (British)
Photos dated: 1879
Processes: Woodburytype
Formats: Prints
Subjects: Documentary (industrial)
Locations: Great Britain
Studio: Great Britain
   Entries:
Swann NY 2/14/52: 354 (book, 28);

**MEURER, Louis** (German)
Photos dated: 1852
Processes: Daguerreotype
Formats: Plates
Subjects: Portraits
Locations: Studio
Studio: Germany - Ludwigsburg
   Entries:
Petzold Germany 5/22/81: 1721;

**MEVES, I.C.** (British)
Photos dated: 1860s
Processes: Ambrotype
Formats: Plates
Subjects: Portraits
Locations: Studio
Studio: England - London
   Entries:
Christies Lon 3/20/80: 66 (lot, M-1 et al);

**MEYER, Charles Eugene** (American)
Photos dated: 1864
Processes: Albumen
Formats: Prints, stereos
Subjects: Topography
Locations: US - Chambersburg, Pennsylvania
Studio: US
   Entries:
Rinhart NY Cat 7, 1973: 335, 336;
Swann NY 5/16/86: 130 (book, M et al)(note);

**MEYER, Julius** (American)
Photos dated: c1870
Processes: Albumen
Formats: Cdvs
Subjects: Ethnography
Locations: US - American west
Studio: US - Omaha, Nebraska
   Entries:
Swann NY 5/5/83: 269;

**M'GHIE, J.** (British)
Photos dated: c1865
Processes: Albumen
Formats: Prints
Subjects: Topography, architecture
Locations: Great Britain - Lanarkshire
Studio: Great Britain - Hamilton
   Entries:
Vermont Cat 7, 1974: 759 (4 ills)(book, 33);
Sothebys Lon 3/21/75: 124 (album, 34);
Vermont Cat 11/12, 1977: 526 ill(book, 33);

**MICALLEF & BORG**
Photos dated: 1860s and/or 1870s
Processes: Albumen
Formats: Prints
Subjects: Topography
Locations:
Studio:
   Entries:
Christies Lon 3/28/85: 324 (album, M & B et al);

**MICHAELES, B.** (German)
Photos dated: Nineteenth century
Processes: Albumen
Formats:
Subjects: Portraits
Locations: Studio
Studio: Germany - Magdeburg
   Entries:
Petzold Germany 5/22/81: 1980 (album, M et al);

**MICHAELS** (see DUTTON & MICHAELS)

**MICHAELIDES, D.** (Greek)
Photos dated: 1885
Processes: Albumen
Formats: Prints
Subjects: Topography
Locations: Greece - Thessaly
Studio: Greece - Adrianopolis
   Entries:
Christies Lon 6/27/78: 90 (album, 30);

**MICHAUD, Julio** (see also CHARNAY)
Photos dated: 1860s-1870s
Processes: Albumen
Formats: Prints, stereos, cdvs
Subjects: Topography, ethnography
Locations: Mexico
Studio: Mexico
   Entries:
California Galleries 9/27/75: 502 (13);
Christies Lon 10/26/78: 336 (6);
California Galleries 12/13/80: 373 (lot, M et al);
Sothebys Lon 6/24/83: 22 (4);
Sothebys Lon 10/26/84: 97 (5);
Sothebys Lon 3/29/85: 68 ill(5);
Sothebys Lon 6/28/85: 37 ill(lot, M-5 et al);
Sothebys Lon 11/1/85: 24 ill(4);
Christies Lon 10/30/86: 129 (lot, M-12 et al), 130 (lot, M-4 et al);

**MICHELEZ, Charles** (French)
Photos dated: 1850s-1886
Processes:      Albumen, woodburytype
Formats:        Prints
Subjects:       Portraits incl. Galerie Contemporaine,
                documentary (art)
Locations:      Studio
Studio:         France - Paris
    Entries:
Swann NY 4/14/77: 189 ill(book, M et al)(note);
Christies NY 5/26/82: 36 (book, M et al);
Christies NY 5/7/84: 19 (book, M et al);

**MICHIELS, Joh. Franz** (German)
Photos dated: 1853-c1860
Processes:      Albumen
Formats:        Prints
Subjects:       Architecture
Locations:      Germany - Cologne
Studio:         Germany
    Entries:
Sothebys Lon 10/29/76: 116;
Sothebys Lon 10/24/79: 345;
Christies Lon 3/24/83: 73 ill(4)(note);

**MICKLETHWAITE** (Canadian)
Photos dated: 1880s
Processes:      Albumen
Formats:        Prints
Subjects:       Topography
Locations:      Canada - Toronto
Studio:         Canada - Toronto
    Entries:
Sothebys Lon 3/21/75: 89 (album, M et al);
Christies Lon 10/26/78: 186 (album, M-2 et al);
Christies Lon 3/15/79: 180 (album, M-1 et al);
Phillips Can 10/4/79: 56 (lot, M-2 et al);
Phillips Can 10/9/80: 55 (lot, M-6 et al);
Swann NY 11/5/81: 524 (album, M-1 et al)(note);
Christies Lon 10/31/85: 138 (album, M-1 et al);

**MIDDLEBROOK, J.E.**
Photos dated: 1892
Processes:      Albumen
Formats:        Cabinet cards
Subjects:       Documentary (industrial)
Locations:      South Africa
Studio:         South Africa - Kimberley
    Entries:
Christies Lon 10/30/80: 223 (album, 22);

**MIDDLETON, John** (British)
Photos dated: 1852
Processes:      Albumen
Formats:        Prints
Subjects:       Topography
Locations:      England - Norfolk
Studio:         Great Britain
    Entries
Sothebys Lon 6/28/85: 125 ill

**MIECZKOWSKI** (Polish)
Photos dated: 1870s
Processes:      Albumen
Formats:        Cdvs
Subjects:       Portraits
Locations:      Studio
Studio:         Poland - Warsaw
    Entries:
Harris Baltimore 6/1/84: 295 (lot, M et al);
Harris Baltimore 11/7/86: 222 (lot, M-1 et al);

**MIETHKE & WAWRA**
Photos dated: 1870s
Processes:      Albumen
Formats:        Stereos, cdvs
Subjects:       Topography
Locations:      Austria - Vienna
Studio:         Austria - Vienna
    Entries:
Harris Baltimore 12/10/82: 39 (lot, M & W-3 et al);

**MIEUSEMENT, Médéric** (French)
Photos dated: 1850s-c1890
Processes:      Albumen, woodburytype, heliogravure
Formats:        Prints, cdvs, cabinet cards
Subjects:       Architecture
Locations:      France - Blois; Amiens; Nevers et al
Studio:         France
    Entries:
Rinhart NY Cat 7, 1973: 83 (book, 21);
Christies Lon 6/27/78: 79 (4);
Sothebys Lon 6/28/78: 294 (lot, M et al), 296
    (lot, M & Souance-1, et al);
Sothebys Lon 10/27/78: 95 (2);
Rose Boston Cat 4, 1979: 35 ill(note), 36 ill,
    37 ill;
Sothebys Lon 10/24/79: 353 (2);
Swann NY 4/23/81: 360 (note);
Swann NY 11/5/81: 517 (album, M-25 et al);
Swann NY 5/10/84: 306 (lot, M et al);
Harris Baltimore 3/15/85: 385 (book, 120);
Swann NY 11/14/85: 82 (lot, M et al);
Christies Lon 4/24/86: 469 ill;

**MILES & FOSTER** (American)
Photos dated: 1860s
Processes:      Albumen
Formats:        Cdvs
Subjects:       Portraits
Locations:      Studio
Studio:         US
    Entries:
Swann NY 5/5/83: 329 (lot, M & F et al);

**MILES, Arthur** (British)
Photos dated: c1860
Processes:      Albumen
Formats:        Prints
Subjects:       Portraits
Locations:      Studio
Studio:         England - Exeter
    Entries:
Christies Lon 10/27/77: 360 (2);

**MILEY, Michael** (American)
Photos dated: 1860s-1870s
Processes:     Albumen
Formats:       Prints, cabinet cards
Subjects:      Portraits, topography
Locations:     US
Studio:        US
    Entries:
Sothebys NY 2/25/75: 45 (5 ills)(lot, M et al);
Swann NY 5/10/84: 195 (lot, M-3 et al);
Christies NY 2/13/85: 155 (lot, M et al);
Christies Lon 4/24/86: 401 (albums, M et al);
Swann NY 11/13/86: 277 (lot, M-1 et al);

**MILLAIS, G.W.**
Photos dated: 1890s
Processes:     Platinum
Formats:       Prints
Subjects:      Topography
Locations:     India
Studio:
    Entries:
Sothebys Lon 4/25/86: 33 ill(album, 30);

**MILLAR, A.H.** (British)(photographer or author?)
Photos dated: 1888
Processes:     Carbon
Formats:       Prints
Subjects:      Architecture
Locations:     Great Britain
Studio:        Great Britain
    Entries:
Sothebys Lon 10/29/82: 55 (book, 65);

**MILLARD** (see SIMONTON & MILLARD)

**MILLER, Hugh** (British)
Photos dated: 1857
Processes:
Formats:       Prints
Subjects:      Portraits
Locations:     Great Britain
Studio:        Great Britain
    Entries:
Edwards Lon 1975: 135 (book, 1);

**MILLER, J.G.** (British)
Photos dated: 1860s and/or 1870s
Processes:     Albumen
Formats:       Stereos
Subjects:      Topography
Locations:     Great Britain
Studio:        Great Britain
    Entries:
Christies Lon 6/24/82: 71 (lot, M et al);

**MILLER, J. Sidney** (American)
Photos dated: 1850s
Processes:     Daguerreotype, ambrotype
Formats:       Plates
Subjects:      Portraits
Locations:     Studio
Studio:        US - Nashua, New Hampshire; Boston,
               Massachusetts
    Entries:
Sothebys NY (Weissberg Coll.) 5/16/67: 159 (lot,
    M-1 et al);
Vermont Cat 2, 1971: 199 ill;
Swann NY 4/23/81: 268 (lot, M & Merrill et al);
California Galleries 6/8/85: 207;

**MILLER, Milton M.** (American)
Photos dated: 1850s-1875
Processes:     Albumen,
Formats:       Prints, stereos, cdvs
Subjects:      Portraits, ethnography, topography
Locations:     Studio
Studio:        China - Hong Kong
    Entries:
Sothebys Lon 10/18/74: 126 ill(album, M-2 et al);
Christies Lon 6/30/77: 118 (lot, M-3 et al);
Christies Lon 10/26/78: 167 (album, M-1 et al);
Swann NY 12/14/78: 374 (albums, M et al)(note);
Sothebys NY 5/8/79: 116 (album, M-1 et al), 124
    (album, M et al);
Sothebys Lon 10/24/79: 89 (album, M-2 et al);
Sothebys NY 11/2/79: 275 ill(album, M et al);
Phillips NY 11/3/79: 182a ill(album, M et al)(note);
Sothebys LA 2/6/80: 171 (lot, M-1 attributed et al);
Christies NY 5/16/80: 214 ill(note), 215, 216;
Sothebys NY 5/20/80: 406 ill(album, M et al), 411
    (2 ills)(album, M et al)(note);
Sothebys Lon 10/29/80: 50 (album, M-1 et al);
Koch Cal 1981-82: 36 ill(note), 37 ill, 38 ill;
Sothebys LA 2/4/81: 51 (album, M et al)(note);
Christies Lon 3/26/81: 236 (lot, M et al)(note);
Phillips NY 5/9/81: 64 (album, M-2 plus M
    attributed, et al);
Sothebys Lon 6/17/81: 196 (note), 197, 198;
Christies Lon 6/18/81: 218 ill(album, M et al);
Sothebys Lon 10/28/81: 338, 339 ill, 340, 341;
Sothebys Lon 3/15/82: 343, 344, 345, 346;
Swann NY 4/1/82: 331 ill;
Christies Lon 6/24/82: 210 (album, M et al);
Sothebys Lon 6/25/82: 86 ill(4), 87 (4);
Sothebys Lon 10/29/82: 39 ill(6), 40 (6);
Christies Lon 3/24/83: 123 ill(6);
Sothebys NY 5/11/83: 459 ill;
California Galleries 6/9/83: 221;
Christies Lon 6/23/83: 159 ill(10);
Christies NY 11/8/83: 139 ill(note);
Swann NY 11/10/83: 306 (5)(note);
Christies Lon 6/28/84: 102 (lot, M-3 et al)(note);
Sothebys Lon 6/29/84: 89 ill(album, M et al), 91
    (album, M-1 attributed et al);
Christies NY 9/11/84: 138 (note);
Sothebys Lon 10/26/84: 65 (albums, M-1 et al), 67
    ill(9);
Swann NY 11/8/84: 185 (album, M et al)(note);
Drouot Paris 11/24/84: 122 ill;
Christies Lon 6/27/85: 80 (album, M attributed
    et al);
Sothebys Lon 6/28/85: 69 ill(album, M attributed
    et al);
Christies Lon 10/31/85: 133 (albums, M-1 et al);
Sothebys Lon 4/25/86: 22 ill(2);

**MILLER, M.** (continued)
Sothebys Lon 10/31/86: 7 ill(lot, M-1 attributed
et al), 16 (album, M-1 et al);
Christies NY 11/11/86: 296 ill(note);
Swann NY 11/13/86: 196 (lot, M attributed et al),
276 (6, attributed)(note);

**MILLER, T.C.** (American)
Photos dated: 1870s and/or 1880s
Processes:    Albumen
Formats:      Stereos
Subjects:     Topography
Locations:    US - Colorado
Studio:       US
    Entries:
California Galleries 4/3/76: 354 (lot, M et al);

**MILLET, Jean-François** (French, 1814-1875)
Photos dated: 1855
Processes:    Daguerreotype
Formats:      Plate
Subjects:     Portraits
Locations:    Studio
Studio:       France - Paris
    Entries:
Rauch Geneva 6/13/61: 40 (lot, M-1 et al);
Sothebys Lon 12/4/73: 178 ill(2);
Drouot Paris 5/29/78: 46;
Christies Lon 3/15/79: 21 ill;
Phillips Lon 10/27/82: 17 ill, 18;

**MILLHOLLAND, J.A.** (American)
Photos dated: 1860s-1870s
Processes:    Albumen
Formats:      Stereos
Subjects:     Topography
Locations:    US - Pennsylvania
Studio:       US - Mt. Savage, Maryland
    Entries:
Harris Baltimore 3/26/82: 12 (lot, M et al);

**MILLICHAP, G.T.** (British)
Photos dated: c1860
Processes:    Ambrotype
Formats:      Plates
Subjects:     Portraits
Locations:    Studio
Studio:       England - Liverpool
    Entries:
Sothebys Lon 10/27/78: 32;

**MILLIKEN** (American)
Photos dated: 1860s-1870s
Processes:    Albumen
Formats:      Stereos
Subjects:     Topography
Locations:    US - northeast
Studio:       US
    Entries:
Swann NY 4/20/78: 370 (lot, M et al);

**MILN, James**
Photos dated: 1854-1857
Processes:    Salt
Formats:      Prints
Subjects:     Topography
Locations:    Europe
Studio:       Europe
    Entries:
Rauch Geneva 6/13/61: 47 (album, M et al)(note);

**MILNE** (British)
Photos dated: 1887
Processes:    Albumen
Formats:      Prints
Subjects:
Locations:    Great Britain
Studio:       Great Britain
    Entries:
Sothebys Lon 3/21/80: 255 (album, M-1 et al);

**MILNE, R.** (Canadian)
Photos dated: 1869
Processes:    Albumen
Formats:      Cdvs
Subjects:     Portraits
Locations:    Canada
Studio:       Canada - Hamilton
    Entries:
Christies Lon 10/30/80: 405 (album, M et al);
Christies Lon 6/18/81: 423 (album, M et al);

**MILSCHELL, L.**
Photos dated: 1858
Processes:    Albumen
Formats:      Prints
Subjects:     Architecture
Locations:    India - Madras
Studio:       India
    Entries:
Sothebys Lon 10/31/86: 33 (2)(note);

**MING, Sze Yuen** (Chinese)
Photos dated: c1880-1890s
Processes:    Albumen
Formats:      Prints
Subjects:     Topography
Locations:    China
Studio:       China - Nanking
    Entries:
Swann NY 11/5/81: 445 (lot, M-1 et al);
Swann NY 11/18/82: 347 ill(lot, M et al)(note);

**MINNIS & COWELL** (American)
Photos dated: 1862
Processes:    Albumen
Formats:      Prints
Subjects:     Portraits
Locations:    Studio
Studio:       US - Richmond, Virginia
    Entries:
Harris Baltimore 12/16/83: 250;

**MINSHELL & HUGHES** (British)
Photos dated: 1860s
Processes:      Albumen
Formats:        Stereos
Subjects:       Topography
Locations:      Great Britain
Studio:         England - Chester
    Entries:
Harris Baltimore 7/31/81: 97 (lot, M & H et al);

**MIRDUA, M.G.** (Indian)
Photos dated: 1880s
Processes:
Formats:        Prints
Subjects:       Portraits
Locations:      Studio
Studio:         India
    Entries:
Sothebys Lon 6/28/78: 138 (lot, M-1 et al);

**MITCHELL AND DEGROFF** [MITCHELL 1] (American)
Photos dated: 1889-1890
Processes:      Albumen
Formats:        Prints, boudoir cards
Subjects:       Topography, documentary (public
                events)
Locations:      US - Guthrie, Oklahoma
Studio:         US - Guthrie, Oklahoma
    Entries:
California Galleries 6/8/85: 357 ill(6);
Swann NY 11/14/85: 140 ill(lot, M & D et al)(note);

**MITCHELL** [MITCHELL 2] (American)
Photos dated: c1880
Processes:      Albumen
Formats:        Prints
Subjects:       Topography
Locations:      US - Niagara Falls, New York
Studio:         US
    Entries:
Sothebys NY 9/23/75: 93 (lot, M-2 attributed et al);

**MITCHELL, Dr. Charles L.** (American)
Photos dated: 1882-1894
Processes:      Albumen, photogravure, platinum,
                silver
Formats:        Prints
Subjects:       Topography, architecture
Locations:      England; Netherlands
Studio:         US - Philadelphia, Pennsylvania
    Entries:
Wood Conn Cat 37, 1976: 67 (book, M-13 et al)
    (note), 141 (book, 45)(note);
Wood Conn Cat 42, 1978: 34 (book, 45)(note);
California Galleries 1/21/79: 96 (book, M et al);
Swann NY 4/17/80: 144 (book, 8);
Christies NY 10/4/83: 108 (40)(note);

**MITCHELL, Daniel S.** (born 1837) **& McGOWAN,**
                **Joseph H.** (American)
Photos dated: 1876-1886
Processes:      Albumen
Formats:        Stereos, cdvs
Subjects:       Ethnography
Locations:      US - American west
Studio:         US - Omaha, Nebraska
    Entries:
Frontier AC, Texas 1978: 223 (note);
Sothebys NY 11/2/79: 292 ill(album, 37)(note);

**MITCHELL, F. & WHITE, George** (British)
Photos dated: 1875-1876
Processes:      Woodburytype
Formats:        Prints
Subjects:       Documentary (expeditions)
Locations:      Arctic Ocean
Studio:
    Entries:
Sothebys Lon 3/27/81: 242 ill(books);
Christies Lon 3/24/83: 157 ill(books);
Christies Lon 10/27/83: 166 (books);

**MITCHELL, J.S.** (American)
Photos dated: c1880
Processes:      Albumen
Formats:        Cabinet cards
Subjects:       Topography
Locations:      US - Jacksonville, Florida
Studio:         US
    Entries:
Harris Baltimore 12/16/83: 339 (9);

**MITCHELL, Reuben** (British)
Photos dated: 1864
Processes:      Albumen
Formats:        Prints
Subjects:       Topography, genre
Locations:      Scotland
Studio:         Scotland
    Entries:
Sothebys Lon 10/27/78: 110 ill(album, 155);

**MIX** (see HUBBARD & MIX)

**MOCO, S.**
Photos dated: c1860
Processes:      Albumen
Formats:        Prints
Subjects:       Topography
Locations:      Island of Maurice
Studio:         Island of Maurice
    Entries:
Sothebys Lon 3/21/80: 181 ill(album, 26);

**MOEGLE, T**
Photos dated: 1880s-1890s
Processes:      Albumen
Formats:        Prints
Subjects:       Ethnography
Locations:
Studio:
    Entries:
Swann NY 11/14/85: 65 (lot, M et al);

**MOFFAH Brothers** (American)
Photos dated: 1880s
Processes: Albumen
Formats: Prints
Subjects: Topography
Locations: US - Key West, Florida
Studio: US - Key West, Florida
    Entries:
Swann NY 11/18/82: 378 (lot, M et al)(note);

**MOFFAT, John** (British, died 1894)
Photos dated: 1854-1870s
Processes: Ambrotype, albumen
Formats: Plates, prints, stereos, cdvs,
    cabinet cards
Subjects: Portraits
Locations: Studio
Studio: Scotland - Edinburgh
    Entries:
Goldschmidt Lon Cat 52, 1939: 186 (note);
Weil Lon Cat 1, 1943: 142 (lot, M et al);
Swann NY 2/14/52: 113 (lot, M et al);
Sothebys NY 11/21/70: 330 (lot, M et al), 333 (lot,
    M et al);
Vermont Cat 9, 1975: 466 ill;
Sothebys Lon 6/26/75: 185 (2 ills)(2);
Sothebys Lon 3/19/76: 165 ill(note), 166 ill(note);
Christies Lon 3/10/77: 35 (lot, M-1 et al);
California Galleries 1/21/78: 140 (album, M et al),
    141 (album, M et al);
Sothebys Lon 3/22/78: 153 (lot, M-1 et al);
Lehr NY Vol 1:3, 1979: 7 ill, 41 ill(note);
Swann NY 10/18/79: 281 ill;
Christies Lon 10/25/79: 50 (lot, M-1 et al), 380
    (album, M-4 et al), 420 (album, M et al);
Christies Lon 3/20/80: 347 (albums, M et al);
Christies Lon 6/26/80: 486 (album, M et al);
Christies Lon 10/30/80: 407 (album, M et al), 433
    (albums, M -4 et al);
Christies Lon 6/18/81: 106 (lot, M et al);
Swann NY 11/5/81: 471 (albums, M-1 et al)(note);
Christies Lon 10/27/83: 233 (album, M et al);
Phillips Lon 6/26/85: 201 (lot, M et al), 202 (lot,
    M et al);
Christies Lon 6/27/85: 251 (albums, M et al);
Phillips Lon 10/30/85: 57 (lot, M et al);
Christies Lon 10/31/85: 55 (8), 302 (album,
    M et al);
Phillips Lon 4/23/86: 239 (lot, M et al);
Christies Lon 4/24/86: 351 (lot, M et al);
Sothebys Lon 4/25/86: 82 (lot, M-1 et al)(note);
Christies Lon 10/30/86: 221 (album, M et al), 235
    ill(note), 252 (album, M et al);

**MOFFET, C.R.** (American)
Photos dated: 1848
Processes: Daguerreotype
Formats: Plates
Subjects: Portraits
Locations: Studio
Studio: US - Danville, Missouri
    Entries:
Sothebys NY (Weissberg Coll.) 5/16/67: 102 (lot,
    M-1 et al);

**MOLARD, Louis-Adolphe Hubert de** (French,
    1800-1874)
Photos dated: 1850s
Processes: Daguerreotype, salt
Formats: Plates, prints
Subjects: Portraits, topography
Locations: France
Studio: France - Paris
    Entries:
Sothebys Lon 6/26/75: 243 ill(note);
Drouot Paris 11/22/86: 103;

**MOLINA, Tomas** (Spanish)
Photos dated: 1870s-1880s
Processes: Albumen
Formats: Prints
Subjects: Topography
Locations: Spain
Studio: Spain
    Entries:
Sothebys Lon 3/25/83: 48 ill(album, M &
    Albareda, 10);
Christies Lon 10/27/83: 87 (albums, M et al);

**MOLINARI** (see CAVILLA)

**MOLINE, Huguet** (French)
Photos dated: late 1840s
Processes: Daguerreotype
Formats: Plates
Subjects: Portraits
Locations: Studio
Studio: France - Montpellier
    Entries:
Petzold Germany 11/7/81: 143 ill;

**MOLINS, Pompeo** (Italian, born 1827)
Photos dated: 1860s-1893
Processes: Albumen
Formats: Prints, stereos, cdvs
Subjects: Topography, documentary (art)
Locations: Italy - Rome
Studio: Italy - Rome
    Entries:
Sothebys Lon 10/24/79: 147 (lot, M-2 et al);
Swann NY 11/18/82: 403 (lot, M et al);
Christies Lon 6/23/83: 107 (lot, M & Altobelli et
    al), 110 ill(M & Altobelli, 21)(note);
Christies Lon 10/27/83: 98 ill(M & Altobelli, 3)
    (attributed);
Christies Lon 3/29/84: 148 (lot, M & Altobelli et
    al), 149 (M & Altobelli)(note), 150 ill(M &
    Altobelli)(note), 151 ill(M & Altobelli)(note),
    152 (M & Altobelli)(note);
Sothebys Lon 6/29/84: 48 (lot, M-5, M & Altobelli-1,
    et al);
Sothebys Lon 3/29/85: 119 ill(M & Altobelli, 23);

**MOLLARD, R.** (French)(photographer or publisher?)
Photos dated: 1860s
Processes:      Albumen
Formats:        Stereos
Subjects:       Documentary (scientific)
Locations:
Studio:         France - Paris
    Entries:
Christies Lon 6/18/81: 111 (11);

**MOLLER**
Photos dated: 1873
Processes:      Autotype
Formats:        Prints
Subjects:       Topography
Locations:      New Zealand
Studio:
    Entries:
Christies Lon 6/26/80: 323 (book, M et al);

**MOLLOY, Reverend Gerald** (American)(photographer
                or author?)
Photos dated: 1871-1872
Processes:      Albumen
Formats:        Prints
Subjects:       Documentary (public events)
Locations:      Germany - Oberammergau
Studio:
    Entries:
Christies Lon 10/28/76: 291 (book, 12)(note);
Wood Conn Cat 49, 1982: 301 (book, 11)(note);
Swann NY 5/9/85: 257 (book, 12)(note);

**MOLSBERGER**
Photos dated: c1880
Processes:      Albumen
Formats:        Cabinet cards
Subjects:       Portraits
Locations:      Studio
Studio:         Europe
    Entries:
Harris Baltimore 3/15/85: 279 (lot, M et al);

**MONCKTON, Robert** (British)
Photos dated: 1860s
Processes:      Albumen
Formats:        Prints
Subjects:       Topography
Locations:      Australia; North America; Carribean
Studio:         Australia
    Entries:
Sothebys Lon 6/29/84: 64 (2 ills)(albums, M-250
    et al), 65 (2 ills)(album, M et al);

**MONKHOUSE, Cosmo** (British)(photographer or
                author?)
Photos dated: 1870
Processes:      Woodburytype
Formats:        Prints
Subjects:       Documentary (art)
Locations:      Great Britain
Studio:         Great Britain
    Entries:
Edwards Lon 1975: 137 (book, 20);

**MONKHOUSE, William** (British)
Photos dated: c1870
Processes:      Albumen
Formats:        Prints
Subjects:       Topography
Locations:      England
Studio:         England - York
    Entries:
Sothebys Lon 7/1/77: 283;
Swann NY 11/13/86: 88 (books, M-8 et al);

**MONSHTEJN, I.** (Russian)
Photos dated: c1860s
Processes:      Albumen
Formats:        Cdvs
Subjects:       Genre
Locations:      Russia
Studio:         Russia
    Entries:
Swann NY 5/10/84: 294 (16);

**MONSON, E.** (British)
Photos dated: 1840s-1855
Processes:      Daguerreotype
Formats:        Plates
Subjects:       Portraits
Locations:      Studio
Studio:         England - Ipswich
    Entries:
Sothebys Lon 6/21/74: 121 (2);
Petzold Germany 5/22/81: 1723 ill;

**MONSON, M.K. Philip** (British)
Photos dated: 1840s-1850s
Processes:      Daguerreotype
Formats:        Plates
Subjects:       Portraits
Locations:      Studio
Studio:         Great Britain
    Entries:
Sothebys Lon 3/21/80: 31 ill(note), 32 ill
    (attributed);

**MONTABONE, Luigi** (Italian, died 1877)
Photos dated: 1856-1877
Processes:      Albumen
Formats:        Prints, cdvs, cabinet cards
Subjects:       Portraits, topography
Locations:      Italy; Persia
Studio:         Italy - Turin; Milan; Florence; Rome
    Entries:
Sothebys Lon 6/21/74: 105 (album, M et al);
Swann NY 12/14/78: 458 (lot, M et al);
Auer Paris 5/31/80: 179 (book, M et al);
Swann NY 4/23/81: 514 (lot, M et al);
Harris Baltimore 3/15/85: 286 (lot, M et al);

**MONTECCHI** (see CALDESI & MONTECCHI)

**MONTIZON, Count de**
Photos dated: 1853-1855
Processes:      Albumen
Formats:        Prints
Subjects:       Genre (animal life)
Locations:      England - London
Studio:         England - Brompton (Photographic Club)
    Entries:
Sothebys Lon 3/21/75: 286 (album, M-1 et al);
Sothebys Lon 11/1/85: 59 ill(album, M-1 et al);

**MONTMEJA, Dr. A. de & HARDY, Dr. A.** (French)
Photos dated: 1868-1875
Processes:      Albumen, carbon
Formats:        Prints
Subjects:       Documentary (medical)
Locations:      France - Paris
Studio:         France - Paris
    Entries:
Swann NY 12/8/77: 119 (book, 50)(note);
Wood Boston Cat 58, 1986: 125 (book, 36)(note), 283
    (book, 50)(note);
Sothebys Lon 4/25/86: 204 ill(book, M & Hardy, 60)
    (note);

**MONROE, George H.** (American)
Photos dated: 1870s
Processes:      Albumen
Formats:        Stereos
Subjects:       Topography
Locations:      US - New York State
Studio:         US - Rochester, New York
    Entries:
Harris Baltimore 3/26/82: 8 (lot, M et al);

**MONZA**
Photos dated: Nineteenth century
Processes:      Albumen
Formats:        Prints
Subjects:
Locations:
Studio:
    Entries:
Christies Lon 3/20/80: 156 (albums, M et al);

**MOODIE** (see MUIR & MOODIE)

**MOODY**
Photos dated: c1880-1900
Processes:      Albumen, gelatin silver
Formats:        Prints
Subjects:       Topography
Locations:      Argentina - Buenos Aires
Studio:         Argentina - Buenos Aires
    Entries:
Sothebys NY 5/2/78: 133 (album, M et al);
Swann NY 4/26/79: 429 (album, M et al);
Swann NY 4/23/81: 410 (lot, M et al)(note);
Christies Lon 10/25/84: 111 (album, M-16 et al);

**MOON, William**
Photos dated: 1873
Processes:      Albumen
Formats:        Prints
Subjects:       Portraits
Locations:
Studio:
    Entries:
Christies Lon 6/30/77: 210 (lot, M-1 et al);

**MOONSHEE, Amir Ali Khan Bahadoor** (Indian)
Photos dated: 1870
Processes:      Albumen
Formats:        Prints
Subjects:       Topography
Locations:      India
Studio:         India
    Entries:
Kingston Boston 1976: 359 (book, 14)(attributed);

**MOOR, F.** (British)
Photos dated: 1860s
Processes:      Albumen
Formats:        Stereos
Subjects:       Topography
Locations:      England - Isle of Wight
Studio:         England - Isle of Wight
    Entries:
Sothebys Lon 10/26/84: 3 (lot, M-27 et al);

**MOORE Brothers** (American)
Photos dated: 1860s
Processes:      Ambrotype
Formats:        Plates
Subjects:       Portraits
Locations:      Studio
Studio:         US - Springfield, Massachusetts
    Entries:
Vermont Cat 4, 1972: 397 ill;
Vermont Cat 5, 1973: 447 ill;

**MOORE, E.W.** (American)
Photos dated: c1880
Processes:      Albumen
Formats:        Cabinet cards
Subjects:       Ethnography
Locations:      US
Studio:         US - Portland, Oregon
    Entries:
Frontier AC, Texas 1978: 224 (note);

**MOORE, Henry P.** (American)
Photos dated: 1861-c1870
Processes:      Salt, albumen, "silver type"
Formats:        Prints
Subjects:       Portraits, documentary (Civil War),
                genre
Locations:      US - New Hampshire; South Carolina;
                Georgia
Studio:         US - New Hampshire
    Entries:
Rinhart NY Cat 2, 1971: 619 (note);
White LA 1977: 2 (3 ills)(lot, M-17 plus 2
    attributed, et al)(note);
Harris Baltimore 9/16/83: 190 (3)(note), 191 ill(2);

**MOORE, H.P.** (continued)
Harris Baltimore 11/9/84: 69 (note);
Swann NY 11/14/85: 261 (book, M et al);

**MOORE, John Robert** (American)
Photos dated: 1860s-1870s
Processes:      Albumen
Formats:        Stereos
Subjects:       Topography
Locations:      US - Trenton Falls, New York
Studio:         US - Jamestown, New York
   Entries:
Rinhart NY Cat 2, 1971: 540 (5);
Rinhart NY Cat 7, 1973: 256 (2);
Vermont Cat 7, 1974: 635 ill(7);
California Galleries 9/27/75: 524 (lot, M-7 et al);
California Galleries 4/3/76: 405 (23);
California Galleries 1/21/78: 173 (23);
Witkin NY Stereos 1979: 11 ill(5)(note);
California Galleries 1/21/79: 294 (23);
Harris Baltimore 4/8/83: 69 (lot, M et al);
Harris Baltimore 12/16/83: 92 (lot, M et al);

**MOORE, N.A. & R.A.** (American)
Photos dated: c1863
Processes:      Albumen
Formats:        Cdvs
Subjects:       Portraits
Locations:      Studio
Studio:         US
   Entries:
Vermont Cat 1, 1971: 225 (note);

**MOOSEBRUGGER, P.** (German)
Photos dated: c1860-1870s
Processes:      Albumen
Formats:        Print, stereos
Subjects:       Topography
Locations:      Germany - Meran
Studio:         Germany; France - Nice
   Entries:
Sothebys Lon 10/26/84: 95;

**MORA**
Photos dated: 1880s
Processes:      Albumen
Formats:        Cdvs,
Subjects:       Portraits
Locations:      Studio
Studio:         Mexico - Guadalajara
   Entries:
Swann NY 5/9/85: 410 (album, M-1 et al);

**MORA, Jose Maria** (American, born 1849)
Photos dated: 1870-1890s
Processes:      Albumen
Formats:        Cdvs, cabinet cards
Subjects:       Portraits
Locations:      Studio
Studio:         US - New York City
   Entries:
Anderson NY (Gilsey Coll.) 2/24/03: 2068 (lot,
   M et al);
Sothebys NY (Weissberg Coll.) 5/16/67: 173 (lot,
   M et al);

**MORA, J.M.** (continued)
Sothebys NY (Strober Coll.) 2/7/70: 366 (lot,
   M et al), 367 (lot, M et al);
Sothebys NY 11/21/70: 347 (lot, M et al), 351
   ill(lot, M et al), 355 (lot, M et al), 357
   (lot, M et al);
Rinhart NY Cat 2, 1971: 283 (lot, M et al);
Vermont Cat 2, 1971: 251 (7), 252 (7);
Rinhart NY Cat 6, 1973: 272 (lot, M-1 et al),
   273 (3);
Rinhart NY Cat 7, 1973: 451 (note), 554, 555;
California Galleries 9/27/75: 377 (lot, M et al);
California Galleries 4/2/76: 75 (lot, M et al);
Swann NY 11/11/76: 338 (180), 339 (lot, M et al),
   352 (lot, M et al);
California Galleries 1/21/78: 139 (lot, M et al);
California Galleries 12/13/80: 205;
Harris Baltimore 7/31/81: 297 (lot, M et al);
Harris Baltimore 6/1/84: 265, 282;
Swann NY 11/8/84: 275 (lot, M et al);
Swann NY 11/14/85: 147 (album, M et al);
Harris Baltimore 11/7/86: 211 (lot, M et al);

**MORAES, J.A. da Cunha** (Portuguese)(photographer?)
Photos dated: 1885
Processes:      Heliogravure
Formats:        Prints
Subjects:       Topography, ethnography
Locations:      Portuguese Congo
Studio:
   Entries:
Swann NY 12/14/78: 4 (book, 38);

**MORAITES, Petros** (Greek, 1835-1905)
Photos dated: late 1850s-1870s
Processes:      Albumen
Formats:        Prints, cdvs, cabinet cards
Subjects:       Topography, portraits, ethnography
Locations:      Greece
Studio:         Greece - Athens
   Entries:
Colnaghi Lon 1976: 237, 238;
Sothebys Lon 10/29/76: 117 ill(album, 24);
Christies Lon 10/25/79: 437 (album, 10);
Christies Lon 6/26/80: 271 (albums, M-2 et al);
Christies Lon 10/30/80: 171, 194 (album, M et al);
Christies NY 2/13/85: 146 (lot, M-1 et al);

**MORAN, John** (American)
Photos dated: 1863-1870s
Processes:      Albumen
Formats:        Prints, stereos, cdvs
Subjects:       Topography
Locations:      US - New Hampshire; Pennsylvania
Studio:         US - Philadelphia, Pennsylvania
   Entries:
Swann NY 12/14/78: 315 (15)(note);
Swann NY 11/14/85: 262 (book, M et al);
Wood Boston Cat 58, 1986: 136 (books, M-3 et al);
Swann NY 5/16/86: 130 (book, M et al)(note);

**MORAND, Augustus & G.H.** (American)
Photos dated: 1840-1850s
Processes:      Daguerreotype, albumen
Formats:        Plates, cdvs, stereos
Subjects:       Portraits, topography
Locations:      Brazil; US
Studio:         US - Brooklyn, New York
   Entries:
Sothebys NY (Greenway Coll.) 11/20/70: 177 (lot,
  M-1 et al);
Sothebys Lon 6/28/78: 162 (lot, M et al);

**MORESBY**
Photos dated: Nineteenth century
Processes:
Formats:        Prints
Subjects:
Locations:      Great Britain
Studio:
   Entries:
Sothebys Lon 3/8/74: 161 (album, M et al)(note);

**MORETTI**
Photos dated: 1880s
Processes:      Albumen
Formats:        Cabinet cards
Subjects:       Portraits
Locations:      Studio
Studio:         France - Paris
   Entries:
Swann NY 4/23/81: 514 (lot, M et al);

**MORGAN, John H.** (British)
Photos dated: 1850s
Processes:      Albumen
Formats:        Prints
Subjects:       Topography, portraits
Locations:      England - Bristol
Studio:         Great Britain
   Entries:
Edwards Lon 1975: 12 (album, M et al);
Christies NY 5/6/85: 274 ill (note);

**MORGAN, Lewis H.** (American)(photographer or
        author?)
Photos dated: 1881
Processes:      Heliotype
Formats:        Prints
Subjects:       Ethnography
Locations:      US - American west
Studio:         US
   Entries:
Frontier AC, Texas 1978: 225 (book, 4)(note);

**MORGAN, Octavius** (British)(photographer or
        author?)
Photos dated: 1872
Processes:      Albumen
Formats:        Prints
Subjects:       Documentary (art)
Locations:      Wales - Abergavenny
Studio:         Great Britain
   Entries:
Swann NY 2/14/52: 237 (book, 13)(note);

**MORGAN, Rufus** (American)
Photos dated: Nineteenth century
Processes:      Albumen
Formats:        Stereos
Subjects:       Topography
Locations:      US - Charlotte, North Carolina
Studio:         US - Charlotte, North Carolina
   Entries:
Sothebys NY (Strober Coll.) 2/7/70: 526 (lot,
  M et al);

**MORIN, Felix**
Photos dated: c1870-1880s
Processes:      Albumen, bromide
Formats:        Prints, cdvs
Subjects:       Topography, ethnography
Locations:      Trinidad
Studio:         Trinidad - Port of Spain
   Entries:
Christies Lon 10/25/79: 234 (album, M-4 et al);
Christies Lon 10/3/80: 277 (album, M-4 et al);
Swann NY 4/23/81: 547 (4)(note);
Rose Florida Cat 7, 1982: 50 ill(M & Anselme);

**MORRILL, F.** (American)
Photos dated: 1870s
Processes:      Albumen
Formats:        Stereos
Subjects:       Topography
Locations:      US - Maine
Studio:         US - Maine
   Entries:
Harris Baltimore 12/10/82: 53 (lot, M et al);

**MORRIS** (American)
Photos dated: 1860s
Processes:      Albumen
Formats:        Cdvs, cabinet cards
Subjects:       Portraits
Locations:      Studio
Studio:         US - Pittsburgh, Pennsylvania
   Entries:
Sothebys NY (Greenway Coll.) 11/20/70: 150 ill, 180
  (lot, M-1 et al);
Harris Baltimore 4/8/83: 318 (lot, M et al), 385
  (lot, M et al);

**MORRIS, A. & Co.** (Australian)
Photos dated: 1858-1862
Processes:      Albumen
Formats:        Prints
Subjects:       Documentary (railroads)
Locations:      Australia
Studio:         Australia - Melbourne
   Entries:
Christies Lon 4/24/86: 585 ill(10);

**MORRIS, S. Hall** (American)
Photos dated: 1870s
Processes:      Albumen
Formats:        Stereos
Subjects:       Topography
Locations:      US - Auburn, New York
Studio:         US - Auburn, New York
   Entries:
California Galleries 1/23/77: 418 (lot, M-7 et al);

MORRISON (see MOWLL & MORRISON) [MORRISON 1]

MORRISON [MORRISON 2]
Photos dated: Nineteenth century
Processes:    Albumen
Formats:      Cabinet cards
Subjects:     Portraits
Locations:
Studio:
    Entries:
Vermont Cat 1, 1971: 248 (lot, M-2 et al);

MORROW, Stanley J. (American, 1843-1921)
Photos dated: 1864-1883
Processes:    Albumen
Formats:      Stereos, cdvs
Subjects:     Portraits, ethnography, documentary
              (expeditions, disasters)
Locations:    US - Dakota Territory
Studio:       US - Yankton, Dakota Territory
    Entries:
Sothebys NY (Strober Coll.) 2/7/70: 510 (lot,
    M-6 et al), 522 (lot, M-2 et al);
Sothebys NY 11/21/70: 369 (lot, M-2 et al);
Swann NY 11/11/76: 438 (lot, M-4 et al)(note);
Frontier AC, Texas 1978: 226 (4), 227 (4)(note);
Witkin NY Stereos 1979: 12 (2 ills)(6)(note), 13
    (2 ills)(9)(note), 14 (2 ills)(9)(note);
Harris Baltimore 12/10/82: 109 (lot, M et al);

MORSE & FRONTI (American) [MORSE 1]
Photos dated: 1850s-1860s
Processes:    Albumen
Formats:      Stereos
Subjects:     Topography
Locations:    US - New York State
Studio:       US - New York City
    Entries:
Harris Baltimore 3/26/82: 8 (lot, M & F et al);

MORSE (American) [MORSE 2]
Photos dated: 1860s-c1870
Processes:    Albumen
Formats:      Cdvs
Subjects:     Portraits
Locations:    Studio
Studio:       US - Nashville, Tennessee
    Entries:
Sothebys NY (Strober Coll.) 2/7/70: 285 (lot,
    M-1 et al), 288 (lot, M-1 et al);
Sothebys NY (Greenway Coll.) 11/20/70: 283 (lot,
    M-1 et al);
Swann NY 12/14/78: 378 (lot, M-1 et al);
California Galleries 1/21/79: 235 (lot, M et al);

MORSE, George D. (American)
Photos dated: c1870-c1880
Processes:    Albumen
Formats:      Prints, cdvs
Subjects:     Portraits
Locations:    Studio
Studio:       US - San Francisco, California
    Entries:
White LA 1977: 98 ill;
Frontier AC, Texas 1978: 38 (book, M et al);
California Galleries 5/23/82: 253 (24);

MORSE, George W. (American)
Photos dated: 1885
Processes:    Albumen
Formats:      Prints
Subjects:     Topography
Locations:    US - south; Cuba
Studio:
    Entries:
Sothebys NY 11/9/83: 211A (album, 44)(attributed);

MORTIMER, S. (British)
Photos dated: 1860s
Processes:    Albumen
Formats:      Prints
Subjects:
Locations:
Studio:       Great Britain (Amateur Photographic
              Association)
    Entries:
Christies Lon 10/27/83: 218 (albums, M-1 et al;

MORTON (American)
Photos dated: Nineteenth century
Processes:    Albumen
Formats:      Cdvs
Subjects:     Portraits
Locations:    Studio
Studio:       US - Providence, Rhode Island
    Entries:
California Galleries 6/28/81: 202 (lot, M-1 et al);

MORTON, H.Q. (American)
Photos dated: Nineteenth century
Processes:    Albumen
Formats:      Stereos
Subjects:     Topography
Locations:    US - New England
Studio:       US
    Entries:
California Galleries 4/3/76: 406 (lot, M et al);
California Galleries 1/21/78: 175 (lot, M et al);

MORTON, Professor Henry (American)
Photos dated: 1869
Processes:    Albumen
Formats:      Prints
Subjects:     Documentary (scientific)
Locations:    US
Studio:       US
    Entries:
California Galleries 6/19/83: 95 (book, M-4
    attributed et al);
Wood Boston Cat 58, 1986: 136 (books, M-1 et al);

MOSCIONI, Romualdo (Italian)
Photos dated: 1868-1895
Processes:    Albumen
Formats:      Prints
Subjects:     Topography, architecture
Locations:    Italy
Studio:       Italy - Rome
    Entries:
Swann NY 11/11/76: 389 (albums, M et al), 394
    (albums, M et al), 395 (albums, M et al);
Bievres France 2/6/83: 136 (5);

**MOSCIONI, R.** (continued)
Swann NY 5/5/83: 381 (albums, M et al);
Harris Baltimore 2/14/86: 219 (album, M et al);

**MOSER** (German)
Photos dated: c1870
Processes:     Albumen
Formats:      Cdvs
Subjects:     Topography
Locations:    Germany
Studio:       Germany - Berlin
  Entries:
California Galleries 4/2/76: 84 (lot, M et al);
Petzold Germany 11/7/81: 328 (album, M et al);

**MOSES, B.** (American)
Photos dated: 1864
Processes:     Albumen
Formats:      Prints, cdvs
Subjects:     Portraits, documentary (Civil War)
Locations:    US
Studio:       US - New Orleans, Louisiana
  Entries:
Sothebys NY (Greenway Coll.) 11/20/70: 252 (lot,
  M-1 et al);
Sothebys NY 5/2/78: 2 (M & Piffet);
Swann NY 11/10/83: 240 (lot, M et al);

**MOSLEY, R.E.**
Photos dated: Nineteenth century
Processes:     Albumen
Formats:      Stereos
Subjects:     Topography
Locations:    England
Studio:       Great Britain
  Entries:
California Galleries 9/27/75: 479 (lot, M et al);
California Galleries 1/23/77: 384 (lot, M et al);

**MOSS, Captain C.**
Photos dated: 1896-1897
Processes:     Albumen, bromide
Formats:      Prints
Subjects:     Documentary (disasters)
Locations:    India - Bombay
Studio:       India
  Entries:
Rinhart NY Cat 7, 1973: 84 ill(book, M et al);
Christies Lon 10/30/80: 234 ill(album, M et al);

**MOSS, J.S.R.** (British)
Photos dated: 1860s
Processes:     Albumen
Formats:      Prints
Subjects:
Locations:
Studio:       Great Britain (Amateur Photographic
              Association)
  Entries:
Christies Lon 10/27/83: 218 (albums, M-3 et al);

**MOSTYN, Lady Augusta** (British)
Photos dated: 1856
Processes:     Salt, albumen
Formats:      Prints
Subjects:     Genre, topography
Locations:    England - Sussex and Kent
Studio:       England
  Entries:
Weil Lon Cat 4, 1944(?): 237 (album, M et al)(note);
Sothebys Lon 5/24/73: 14 (album, M et al);

**MOTE & SWAIN**
Photos dated: Nineteenth century
Processes:     Albumen
Formats:      Stereos
Subjects:     Topography
Locations:    North America
Studio:
  Entries:
Christies Lon 6/23/83: 47 (lot, M & S et al);

**MOTES, C.W.** (American)
Photos dated: 1890s
Processes:     Gelatin
Formats:      Prints
Subjects:     Portraits
Locations:    Studio
Studio:       US - Atlanta, Georgia
  Entries:
Harris Baltimore 3/26/82: 398 (lot, M-1 et al);

**MOTTE FOUQUET, de la** (French)
Photos dated: 1840s
Processes:     Daguerreotype
Formats:      Plates
Subjects:     Portraits
Locations:    Studio
Studio:       France - Boulogne
  Entries:
Christies Lon 10/27/83: 3;

**MOULD, W.** (American)
Photos dated: 1870s
Processes:     Albumen
Formats:      Stereos
Subjects:     Topography
Locations:    US - New York State
Studio:       US - Keeseville, New York
  Entries:
Rinhart NY Cat 7, 1973: 258 (4);

**MOULDEN, H.G.** (British)
Photos dated: c1880
Processes:     Albumen
Formats:      Prints
Subjects:     Architecture
Locations:
Studio:       Great Britain - Hitchin
  Entries:
Christies Lon 10/28/76: 84;

**MOULIN, A.M.**
Photos dated: c1860
Processes:      Albumen
Formats:        Prints
Subjects:       Topography, ethnography, portraits
Locations:      Algeria
Studio:
    Entries:
Christies Lon 3/20/80: 162 ill(albums, 143)(note);

**MOULIN, F. Jacques** (French, born c1800, died
                    after 1868)
Photos dated: 1851-1868
Processes:      Daguerreotype, salt, albumen
Formats:        Plates, prints, stereos
Subjects:       Genre (nudes et al), topography
Locations:      France - Boulogne and Cherbourg;
                Algeria
Studio:         France - Paris
    Entries:
Phillips Lon 3/13/79: 55 ill;
Christies Lon 3/15/79: 74 (13);
Christies NY 10/31/79: 13 ill(note);
Sothebys NY 5/20/80: 368 ill(note), 369 ill, 370 ill
    (note);
Sothebys Lon 3/27/81: 211 ill(note);
Sothebys NY 5/15/81: 99 (note);
Christies Lon 6/18/81: 415 ill(note);
Christies NY 11/8/83: 142 ill;
Sothebys NY 11/9/83: 212;
Phillips Lon 10/24/84: 165 ill(album, M-10 et
al)(note);
Sothebys Lon 6/28/85: 191 ill(note), 192 ill;
Christies Lon 4/24/86: 483 ill;
Sothebys Lon 10/31/86: 81 (album, M-2 et al);
Swann NY 11/13/86: 280 (attributed);

**MOULTON & LARKIN** (American)
Photos dated: 1864
Processes:      Albumen
Formats:        Cdvs
Subjects:       Architecture
Locations:      US - Elmira, New York
Studio:         US
    Entries:
Rinhart NY Cat 7, 1973: 537;

**MOULTON, Henry DeWitt** (American, 1828-1893)
Photos dated: 1859-1867
Processes:      Albumen
Formats:        Prints
Subjects:       Topography
Locations:      Peru - Lima
Studio:         US - New York City; Peru - Lima
    Entries:
Sothebys NY 10/4/77: 136 ill(2), 137 (3);
Swann NY 11/13/86: 281 ill(7)(note);

**MOULTON, J.C.** (American)
Photos dated: 1870s-1888
Processes:      Albumen
Formats:        Stereos
Subjects:       Topography
Locations:      US - Ausable River Chasm, New York
Studio:         US - Fitchburg, Massachusetts
    Entries:
Wood Conn Cat 37, 1976: 304 ill;
California Galleries 4/3/76: 414 (lot, M et al),
    449 (lot, M et al), 452 (lot, M-1 et al);
Swann NY 11/11/76: 426 (11);
Swann NY 4/23/81: 542 (lot, M et al);
Harris Baltimore 7/31/81: 102 (lot, M et al), 128
    (lot, M et al), 129 (lot, M et al);
Swann NY 11/5/81: 552 (lot, M et al);
Swann NY 5/5/83: 446 (lot, M et al);

**MOULTON, John S.** (American)
Photos dated: 1870s-1880s
Processes:      Albumen
Formats:        Stereos, cdvs
Subjects:       Topography, portraits
Locations:      US - Massachusetts; New York; New
                Hampshire; California
Studio:         US - Salem, Massachusetts
    Entries:
Rinhart NY Cat 1, 1971: 314 (3);
Rinhart NY Cat 2, 1971: 535 (lot, M-3 et al),
    536 (11);
Rinhart NY Cat 6, 1973: 525 (6), 544;
Rinhart NY Cat 7, 1973: 259, 452, 453;
Witkin NY IV 1976: S13 ill;
California Galleries 1/21/78: 189 (lot, M et al);
California Galleries 1/21/79: 309 (lot, M et al);
California Galleries 3/30/80: 408 (lot, M et al);
Harris Baltimore 5/28/82: 163 (lot, M-1 et al);
Harris Baltimore 12/10/82: 68 (lot, M et al), 115
    (lot, M et al);
Harris Baltimore 4/8/83: 86 (lot, M et al);
Harris Baltimore 9/16/83: 157;
Harris Baltimore 12/16/83: 10 (lot, M et al), 86
    (lot, M et al), 128 (lot, M et al);
Harris Baltimore 6/1/84: 99 (lot, M et al), 105
    (lot, M et al);
Harris Baltimore 3/15/85: 7 (lot, M-1 et al), 73
    (lot, M et al), 106 (lot, M et al);
Harris Baltimore 9/27/85: 15 (lot, M attributed
    et al);
Harris Baltimore 2/14/86: 41 (lot, M-2 et al);

**MOUNTFORD, J.** (American)
Photos dated: 1860s and/or 1870s
Processes:      Albumen
Formats:        Stereos
Subjects:       Topography
Locations:      US
Studio:         US
    Entries:
Christies Lon 3/28/85: 46 (lot, M et al);

**MOWBRAY, A.R.** (British)
Photos dated: 1850s-1860s
Processes: Albumen
Formats: Cdvs, stereos
Subjects: Portraits, topography
Locations: England - Oxford
Studio: England - Oxford
   Entries:
California Galleries 4/3/76: 362 (lot, M et al);
Harris Baltimore 4/8/83: 322 (lot, M et al);

**MOWLL & MORRISSON** (British)
Photos dated: 1890s
Processes: Albumen
Formats: Prints
Subjects: Architecture
Locations: England - Liverpool
Studio: England - Liverpool
   Entries:
Christies Lon 10/31/85: 228 (2);

**MOXHAM, B.D.**
Photos dated: 1850s
Processes: Daguerreotype
Formats: Plates
Subjects: Portraits
Locations:
Studio:
   Entries:
Vermont Cat 6, 1973: 518 ill;

**MOXHAM, E.** (British)
Photos dated: 1859-1860
Processes: Albumen
Formats: Stereos
Subjects: Topography
Locations: Belgium - Ghent; Great Britain
Studio: Great Britain
   Entries:
Christies Lon 10/27/83: 19 (lot, M et al);
Christies Lon 6/28/84: 39 (book, M et al)(note);

**MOYSTON** (American)
Photos dated: Nineteenth century
Processes: Albumen
Formats: Cdvs
Subjects: Portraits
Locations: Studio
Studio: US - Memphis, Tennessee
   Entries:
Sothebys NY (Strober Coll.) 284 (lot, M et al);

**MUCHA, Alphonse Maria** (Czech, 1860-1939)
Photos dated: c1896-1900s
Processes: Albumen
Formats: Prints
Subjects: Genre
Locations: Studio
Studio: France - Paris
   Entries:
Frumkin Chigago 1973: 88, 89 ill, 90 ill, 91 ill;
Lunn DC Cat 3, 1973: 101 ill;
Sothebys Lon 3/8/74: 180 ill(note), 181 ill,
   182 ill;
Sothebys NY 9/23/75: 337 ill(note);
Colnaghi Lon 1976: 204 ill(album)(note);

**MUCHA** (continued)
Gordon NY 5/3/76: 325 ill, 326 ill, 327 ill;
Sothebys NY 11/9/76: 152 ill;
Gordon NY 11/13/76: 133 ill, 134 ill;
Sothebys NY 5/20/77: 117 ill, 118;
Sothebys NY 10/4/77: 233, 234 ill, 235;
Sothebys LA 2/13/78: 158 ill(note);
Sothebys NY 5/2/78: 145 ill;
Phillips NY 11/4/78: 145 ill(note), 146, 147 ill;
Swann NY 10/18/79: 378 ill;
Phillips NY 5/9/81: 156 ill;
Christies Lon 6/18/81: 463;
Christies NY 11/8/83: 143 ill(note);
Christies NY 9/11/84: 116 (book);
Christies NY 11/6/84: 95 ill(note);

**MUDD, James** (British)
Photos dated: 1852-1901
Processes: Calotype, albumen, collodion on glass,
   platinum
Formats: Prints, cdvs, cabinet cards
Subjects: Topography, portraits, documentary
   (industrial, railroads), architecture
Locations: England - Sheffield et al
Studio: England - Manchester
   Entries:
Rinhart NY Cat 6, 1973: 3 (album, M et al);
Edwards Lon 1975: 12 (album, M et al);
California Galleries 4/2/76: 161 (album, M-1 et al);
Sothebys Lon 3/9/77: 212 (note);
Sothebys Lon 3/22/78: 189 (lot, M-1 et al);
Sothebys Lon 10/27/78: 155;
Christies Lon 3/15/79: 98 (lot, M-1 et al);
Christies Lon 10/25/79: 387 (album, M-1 et al), 402
   (album, M-2 et al);
California Galleries 3/30/80: 343 (lot, M-1 et al);
Christies Lon 6/26/80: 445 ill(3)(note), 446 ill
   (3), 447 ill(3), 448 ill(3), 449 ill(3), 450
   ill(3), 451 ill(4), 498 (album, M-1 et al);
Christies Lon 3/26/81: 375A;
Christies Lon 3/11/82: 330 ill(album, 42)(note),
   331 (13);
Sothebys Lon 3/25/83: 136 ill(albums, 420), 137 ill
   (36)(attributed);
Christies Lon 6/23/83: 259 (lot, M et al);
Christies Lon 6/28/84: 65 (lot, M-47 et al);
Christies Lon 10/25/84: 318 (albums, M et al);
Christies Lon 3/28/85: 151 (albums, M-1 et al)
   (note);
Christies Lon 6/27/85: 135 (lot, M-1 et al);
Christies Lon 10/31/85: 303 (lot, M-4 et al);
Christies Lon 6/26/86: 146 (lot, M-57 et al);
Christies Lon 10/30/86: 240 (album, M-1 et al);

**MUGNIER, George François** (American, 1857-1938)
Photos dated: 1870s-1880s
Processes: Albumen
Formats: Prints, stereos
Subjects: Topography, documentary (industrial)
Locations: US - New Orleans, Louisiana
Studio: US
   Entries:
Rinhart NY Cat 6, 1973: 570;
Swann NY 11/11/76: 495 (lot, M-10 et al);
Swann NY 11/6/80: 291 (lot, M-3 et al);
Harris Baltimore 2/14/86: 37 (lot, M-8 et al);

**MUHRMAN**
Photos dated: Nineteenth century
Processes:    Albumen
Formats:      Stereos
Subjects:     Topography
Locations:    US - Chicago, Illinois
Studio:
   Entries:
Harris Baltimore 4/8/83: 81 (lot, M et al);

**MUIR & MOODIE, George** (New Zealander, c1865-1947)
Photos dated: 1890s-1916
Processes:    Albumen
Formats:      Prints
Subjects:     Topography
Locations:    New Zealand
Studio:       New Zealand - Dunedin
   Entries:
Sothebys Lon 6/11/76: 50 (album, M & M et al);
Christies Lon 3/15/79: 195 (albums, M & M et al);
Phillips NY 5/9/81: 69 (albums, M & M et al);

**MULAC**
Photos dated: 1897
Processes:
Formats:      Cabinet cards
Subjects:     Portraits
Locations:
Studio:
   Entries:
Sothebys NY 11/20/84: 47 (lot, M-1 et al);

**MULHERAN, J.** (British)
Photos dated: 1870s
Processes:    Albumen
Formats:      Prints
Subjects:     Ethnography
Locations:    India
Studio:
   Entries:
Sothebys Lon 10/18/74: 80 (book, M et al);
Christies Lon 3/11/82: 252 (books, M et al);

**MULLEN, James**
Photos dated: c1850
Processes:    Daguerreotypes
Formats:      Plates
Subjects:     Portraits
Locations:
Studio:
   Entries:
Sothebys LA 2/6/80: 11 ill(attributed)(note);

**MULLENS** (see HENDERSON & MULLENS)

**MULLER** (British)
Photos dated: 1887
Processes:    Albumen
Formats:      Prints
Subjects:
Locations:    Great Britain
Studio:       Great Britain
   Entries:
Sothebys Lon 3/21/80: 255 (album, M-1 et al);

**MULLER, Frederick**
Photos dated: 1885
Processes:    Albumen
Formats:      Prints
Subjects:
Locations:
Studio:
   Entries:
Wood Boston Cat 58, 1986: 136 (books, M-1 et al);

**MULLER, Leopold Carl**
Photos dated: 1880s-c1893
Processes:    Albumen, heliogravure
Formats:      Prints
Subjects:     Topography, genre
Locations:    Egypt
Studio:
   Entries:
Sothebys Lon 3/21/75: 279 ill(lot, M-35 et al);
Christies Lon 3/20/80: 178 (album, M &
   Junghaendel, 25);
Christies Lon 10/30/80: 224 (album, M &
   Junghaendel, 27);
Sothebys NY 5/24/82: 274 (book, M &
   Junghaendel, 27);

**MULLINS** (See HUGHES and MULLINS) [MULLINS 1]

**MULLINS** (British) [MULLINS 2]
Photos dated: 1850s-1860s
Processes:    Daguerreotype, albumen
Formats:      Plates, cdvs
Subjects:     Portraits
Locations:    Studio
Studio:       England - Jersey
   Entries:
Sothebys Lon 6/17/81: 65;
Phillips Lon 4/23/86: 244 (album, M-1 et al);
Christies Lon 4/24/86: 315;
Phillips Lon 10/29/86: 296 (album, M-1 et al);

**MULLINS, Gustav** (British)
Photos dated: 1890s
Processes:
Formats:      Prints
Subjects:     Genre (animal life)
Locations:    England
Studio:       Great Britain
   Entries:
Swann NY 11/10/83: 276 (note);

**MULLOCK, Ben R.** (American)
Photos dated: 1858-1861
Processes:    Albumen
Formats:      Prints incl. panoramas
Subjects:     Topography
Locations:    Brazil - Bahia
Studio:
   Entries:
Swann NY 12/8/77: 341 ill(40)(note);
Christies NY 10/31/79: 52 (3);
Swann NY 4/17/80: 239 (2)(attributed);
Christies NY 5/16/80: 193 (3);
Phillips NY 5/21/80: 252 ill;
Christies NY 11/11/80: 86 (3);

**MULLOCK, B.R.** (continued)
California Galleries 12/13/80: 317 (note);
Swann NY 4/23/81: 419 (attributed);

**MULNIER, Ferdinand** (French)
Photos dated: c1870-1876
Processes:      Albumen, woodburytype
Formats:        Prints, cdvs, cabinet cards
Subjects:       Portraits incl. Galerie Contemporaine
Locations:      Studio
Studio:         France - Paris
    Entries:
Maggs Paris 1939: 537;
Sothebys NY (Greenway Coll.) 11/20/70: 10 ill(lot,
    M-2 et al), 13 ill(lot, M-1 et al);
Witkin NY I 1973: 251 ill(book, M et al), 429;
Colnaghi Lon 1976: 113;
Swann NY 11/11/76: 349 (lot, M et al);
Gordon NY 11/13/76: 56 (lot, M-1 et al);
White LA 1977: 43;
Sothebys NY 2/9/77: 53 ill(lot, M-1 et al);
Sothebys NY 5/20/77: 44 (lot, M-1 et al);
Christies Lon 6/30/77: 165;
Sothebys Lon 7/1/77: 261 (lot, M-1 et al);
Sothebys LA 2/13/78: 115 (books, M et al)(note);
Swann NY 4/20/78: 321 (lot, M-2 et al), 322 (lot,
    M-1 et al);
Sothebys Lon 6/28/78: 136 (lot, M et al);
Christies NY 10/31/79: 35 ill(book, M et al);
Christies Lon 3/20/80: 224 (book, M et al), 228
    (book, M et al);
Sothebys Lon 3/21/80: 238 (book, M et al);
Christies Lon 6/26/80: 210 (lot, M et al), 329
    (book, M et al);
Christies Lon 10/30/80: 450 (lot, M-2 et al);
California Galleries 12/13/80: 57 (books, M et al),
    212 (lot, M-1 et al);
Christies Lon 3/26/81: 293 (book, M et al);
Swann NY 4/23/81: 472 (lot, M et al);
Christies NY 5/14/81: 41 (books, M-27 et al);
California Galleries 6/28/81: 238 (lot, M et al);
California Galleries 5/23/82: 312 (lot, M et al);
Christies NY 5/26/82: 36 (book, M-57 et al);
Christies NY 5/7/84: 19 (book, M-57 et al);
Swann NY 5/10/84: 23 (book, M et al)(note), 51
    (book, M et al)(note);
Christies NY 2/13/85: 135 (lot, M et al);
Christies Lon 6/26/86: 86 (lot, M et al);

**MUMMERY, A.F.** (photographer or author?)
Photos dated: 1895
Processes:      Photogravure
Formats:        Prints
Subjects:       Topography
Locations:      Europe - Alps, Caucasus
Studio:
    Entries:
Rinhart NY Cat 2, 1971: 44 (book, 9);

**MUMPER, L.** (American)
Photos dated: c1863-1865
Processes:      Albumen
Formats:        Prints, stereos
Subjects:       Topography
Locations:      US - Gettysburg, Pennsylvania
Studio:         US - Gettysburg, Pennsylvania
    Entries:
Harris Baltimore 5/28/82: 156 (7), 161 (lot,
    M et al);
Harris Baltimore 4/8/83: 20 (lot, M-3 et al);
Harris Baltimore 12/16/83: 299;

**MUNDERT** (French)
Photos dated: c1868
Processes:      Woodburytype
Formats:        Prints
Subjects:       Portraits incl. Galerie Contemporaine
Locations:      Studio
Studio:         France
    Entries:
Sothebys NY 2/25/75: 120;
Witkin NY IV 1976: 141 ill;
Gordon NY 5/3/76: 303 (lot, M-1 et al);

**MUNDY, David Louis** (New Zealander)
Photos dated: 1850s-1875
Processes:      Albumen, autotype
Formats:        Prints
Subjects:       Topography
Locations:      New Zealand
Studio:         New Zealand - Christchurch
    Entries:
Sothebys Lon 6/26/75: 114 (album, M et al);
Sothebys Lon 10/29/76: 122 (book, 36);
Wood Conn Cat 45, 1979: 183 ill(book, 16)(note);
Sothebys Lon 3/14/79: 164 (albums, M et al);
Christies Lon 6/26/80: 323 (book, M-73 et
    al)(note)
Wood Conn Cat 49, 1982: 306 (book, 16)(note);
Christies Lon 6/23/83: 169 (albums, M-30 et al);
Wood Boston Cat 58, 1986: 315 (book, 16)(note);

**MUNGER, D.G.** (American)
Photos dated: 1870s
Processes:      Albumen
Formats:        Stereos
Subjects:       Topography
Locations:      US - Wisconsin
Studio:         US - Oconomowoc, Wisconsin
    Entries:
Harris Baltimore 6/1/84: 163 (lot, M et al);

**MUNSON** (American)
Photos dated: Nineteenth century
Processes:      Albumen
Formats:        Stereos
Subjects:       Topography
Locations:      US - Sioux Falls, South Dakota
Studio:         US
    Entries:
California Galleries 9/27/75: 475 (lot, M-1 et al);
California Galleries 1/23/77: 378 (lot, M et al);

**MURDOCK**
Photos dated: 1898
Processes:      Photogravure
Formats:
Subjects:
Locations:      US
Studio:         US
    Entries:
Swann NY 4/14/77: 16 (book, 3);

**MUREV** (see DURONI & MUREV)

**MURIEL, Auguste** (French)
Photos dated: 1860s
Processes:      Albumen
Formats:        Prints
Subjects:       Documentary (railroads)
Locations:      Spain; France - Paris
Studio:         France - Paris
    Entries:
Fraenkel Cal 1984: 58 ill(album, 36)(note);

**MURRAY & BUSHNELL** (American)
Photos dated: Nineteenth century
Processes:      Albumen
Formats:        Cabinet cards
Subjects:       Portraits
Locations:      Studio
Studio:         US
    Entries:
Swann NY 4/14/77: 309 (lot, M & B-2, et al);

**MURRAY, Colin** (British)
Photos dated: 1870-1882
Processes:      Albumen, woodburytype
Formats:        Prints
Subjects:       Portraits, topography
Locations:      India
Studio:
    Entries:
Wood Conn Cat 41, 1978: 64 ill(note), 65 ill, 66,
    67, 68;
Sothebys NY 11/2/79: 250 (album, M et al)(note);
Christies NY 11/11/80: 83 (book, M et al);

**MURRAY, E.E.**
Photos dated: 1889
Processes:      Albumen
Formats:        Stereos
Subjects:       Documentary (disasters)
Locations:      US - Johnstown, Pennsylvania
Studio:
    Entries:
Harris Baltimore 3/15/85: 53 (lot, M-3 et al);

**MURRAY, Reverend G.** (British)
Photos dated: 1860s
Processes:      Albumen
Formats:        Prints
Subjects:       Topography
Locations:      Great Britain - Glenken
Studio:         Great Britain
    Entries:
Sothebys NY 5/20/77: 62 (albums, M et al);

**MURRAY, Dr. John** (British, 1809-1898)(see also
                SACHE)
Photos dated: c1849-1864
Processes:      Salt, albumen
Formats:        Prints
Subjects:       Topography
Locations:      India - Agra, Benares, Allabad,
                Cawnpore, Delhi, NW Provinces
Studio:         India - Agra
    Entries:
Sothebys Lon 10/24/75: 131 ill(19)(note);
Christies Lon 10/27/77: 119 ill(note), 120 ill,
    121, 122, 123 ill;
Christies Lon 3/16/78: 89 ill(note), 90 (2), 91
    ill, 92, 93 ill, 94 ill, 95 ill, 96 ill;
Christies Lon 10/26/78: 153 ill(note), 154, 155,
    156 ill, 157;
Christies Lon 3/15/79: 174 (note), 175;
Christies Lon 6/28/79: 133 ill(note), 134, 135 ill,
    136 ill;
Christies Lon 10/25/79: 221;
Christies Lon 6/26/80: 219;
Sothebys Lon 6/27/80: 61 ill;
Christies Lon 6/18/81: 207 ill;
Christies Lon 3/11/82: 166 ill(note), 167 ill, 168
    ill, 169 ill, 170;
Christies Lon 10/28/82: 94 ill;
Sothebys Lon 3/25/83: 39 ill(note), 40 ill, 41, 42
    (2), 43 ill;
Christies Lon 6/23/83: 140;
Sothebys NY 5/8/84: 236 ill(note);
Sothebys Lon 4/25/86: 42 ill, 43 ill, 44 ill, 45
    ill, 46 ill, 47 ill;
Sothebys Lon 10/31/86: 42 ill, 43 ill, 44 ill, 45
    ill, 46 (2 ills)(2), 47 ill, 48 ill, 49 ill, 50
    ill, 51 ill;

**MURRAY, R.** (British)
Photos dated: 1860s
Processes:      Albumen
Formats:        Prints
Subjects:
Locations:
Studio:         Great Britain (Amateur Photographic
                Association)
    Entries:
Sothebys Lon 10/29/80: 310 (album, M et al);
Christies Lon 10/29/81: 359 (album, M-1 et al)
    (note);

**MURRAY, Samuel** (American)
Photos dated: 1887-1891
Processes:      Albumen
Formats:        Prints
Subjects:       Portraits
Locations:      US - New Jersey
Studio:         US
    Entries:
Sothebys NY 11/13/86: 104 ill(attributed)(note);

**MURRAY, Captain W.G.** (British)
Photos dated: 1860s-1870s
Processes: Albumen
Formats: Prints
Subjects: Topography
Locations: England; Italy; Germany; Switzerland;
India
Studio:
Entries:
Sothebys Lon 6/26/75: 106 (album, 1,100);

**MUSSINS** (see HENDERSON & MUSSINS)

**MUYBRIDGE, Eadweard** (British, American, 1830-1904)
Photos dated: 1868-1887
Processes: Albumen, collotype, heliogravure,
collodion on glass
Formats: Prints, stereos, cdvs
Subjects: Topography, documentary (scientific),
ethnography
Locations: US - California, Alaska, Pennsylvania;
Guatemala; Panama
Studio: US - California, Pennsylvania
Entries:
Andrieux Paris 1951(?): 736 (book, 96), 737
(book, 92);
Swann NY 2/14/52: 238 (716)(note);
Sothebys NY (Weissberg Coll.) 5/16/67: 184 (lot, M-1
et al);
Sothebys NY (Strober Coll.) 2/7/70: 519 (lot, M-7
et al)(note);
Sothebys NY 11/21/70: 159 ill(note), 160 ill(note),
161 ill(note), 162 (4), 163 ill(14), 164 (5),
165 (5), 166 (6), 167 ill(5), 168 (8), 169 (4),
170 (5), 171 ill(5), 172 (6), 173 (6), 174 (7),
175 (9), 176 (13), 177 ill(6), 178 ill(2), 179
ill(4), 180 (3), 181, 182 ill(9), 183 (2), 184
(9), 185 ill(5), 186, 187, 188 (6), 189 (4), 190
ill(15), 191 (3);
Rinhart NY Cat 1, 1971: 230 (2), 231, 232 (2), 233
(2), 234 (2), 369 ill;
Vermont Cat 1, 1971: 236 (3);
Frumkin Chicago 1973: 92, 93 ill, 94;
Lunn DC Cat 3, 1973: 104 ill;
Rinhart NY Cat 6, 1973: 328 ill, 329, 330, 331,
332, 333, 367 (attributed), 388, 613;
Rinhart NY Cat 7, 1973: 86 (book, M et al), 299,
300, 454, 455, 456;
Rinhart NY Cat 8, 1973: 79;
Vermont Cat 6, 1973: 728 ill(note), 729 ill, 730
ill, 731 ill, 732 ill, 733 ill, 734 ill, 735
ill, 736 ill, 737 ill, 738 ill, 739 ill, 740
ill, 741 ill, 742 ill, 743 ill, 744 ill, 745
ill, 746 ill, 747 ill, 748 ill;
Witkin NY I 1973: 343 ill;
Sothebys Lon 5/24/73: 168 (note), 169, 170, 171,
172, 173, 174, 175, 176 ill, 177;
Sothebys Lon 12/4/73: 255 (note), 256, 257 ill,
258, 259, 260, 261, 262, 263, 264, 265;
Ricketts Lon 1974: 51 ill(book, 21);
Vermont Cat 7, 1974: 698 ill(note), 699 ill, 700
ill, 701 ill, 702 ill, 703 ill, 704 ill, 704A
ill, 705 ill, 706 ill, 707 ill, 708 ill, 709
ill, 710 ill, 711 ill, 712 ill;
Witkin II 1974: 852 ill, 853 ill, 854 ill, 1225 ill;
Sothebys Lon 6/21/74: 220 ill(note), 221, 222, 223,
224, 225, 226, 227, 228, 229;
Sothebys Lon 10/18/74: 75 (album, M-6 et al), 310,
311, 312;

**MUYBRIDGE** (continued)
Vermont Cat 9, 1975: 575 ill;
Witkin NY III 1975: 186 ill(note), 187 ill, 188 ill,
189 ill;
Sothebys NY 2/25/75: 99 (2), 198 ill(note);
Sothebys Lon 3/21/75: 366, 367, 368, 369, 370 ill;
Sothebys Lon 6/26/75: 222 (2), 223 (2), 224 (2),
225 (2), 226 (2), 227 (2);
Swann NY 9/18/75: 279;
Sothebys NY 9/23/75: 91 (lot, M-6 et al);
California Galleries 9/27/75: 315;
Sothebys Lon 10/24/75: 239 (2)(note), 240 (2), 241
(2), 242 ill, 243 (2), 244 (2), 245 (2);
Alexander Lon 1976: 68 ill;
Colnaghi Lon 1976: 253 (7 ills)(books)(note), 254,
255, 256, 257;
Kingston Boston 1976: 162 ill(note), 163 ill;
Lunn DC Cat 6, 1976: 57.1 ill(note);
Rose Boston Cat 1, 1976: 3 ill(note), 4 ill;
Witkin NY IV 1976: 359 ill, 360 ill, 361 ill(note);
Wood Conn Cat 37, 1976: 143 (book, 5)(note), 305 ill
(note);
Sothebys Lon 3/19/76: 260 (3), 261 (31), 262 ill,
263 (2);
Gordon NY 5/3/76: 314 ill, 315 ill(2), 316 ill(2),
317 ill(2), 318 ill(4);
Sothebys NY 5/4/76: 181 (3), 182 (3), 183 (3), 184
ill(3), 185 (3), 187 (note);
Sothebys Lon 10/29/76: 315 ill(42);
Sothebys NY 11/9/76: 125 (4), 126 (4), 127 (4), 128
(3), 129 (4);
Gordon NY 11/13/76: 89 ill(attributed), 90 ill(2),
92 ill(2), 93 ill(2), 94 ill(2);
Halsted Michigan 1977: 701 ill(note), 702 ill, 703;
White LA 1977: 100 ill(note), 101 ill, 102 ill, 103
ill, 104;
California Galleries 1/22/77: 331 ill;
Sothebys NY 2/9/77: 86 ill(lot, M-7 et al), 87
(lot, M-4 et al), 88 (lot, M-5 et al), 89 (lot,
M-5 et al), 90 (lot, M-6 et al), 91 (lot, M-7
et al);
Swann NY 4/14/77: 294 (note);
Gordon NY 5/10/77: 855 ill, 856 ill(2), 857 ill(2),
858 ill(2), 859 ill(2), 860 ill(2), 861 ill(2);
Sothebys NY 5/20/77: 7 (book, 100);
Sothebys NY 10/4/77: 97 (2)(note), 98 (2), 99 (2),
100 ill;
IMP/GEH 10/20/77: 319 ill, 320 ill, 321 ill, 322
ill, 323 ill, 324 ill, 325 ill, 326 ill, 327
ill, 328 ill, 329 ill, 330 ill;
Swann NY 12/8/77: 424 (lot, M-1 et al);
Frontier AC, Texas 1978: 38 (book, M et al), 229
(note), 232 (book, 5)(note), 313 (book, 1);
Lehr NY Vol 1:2, 1978: 30 ill, 31 ill, 32 ill;
Lunn DC Cat QP, 1978: 33 (book, 71);
Witkin NY VI 1978: 92 (2 ills)(2), 93 (2 ills)
(781), 94 ill, 95 ill(note);
Sothebys LA 2/13/78: 81 (2)(note), 82 (2), 83 (2),
84 (2);
Swann NY 4/20/78: 224 (3), 225 (3), 226 (3), 227
(3), 228 (3);
Christies Lon 6/27/78: 328 ill(note), 329, 330, 331;
Sothebys Lon 6/28/78: 364, 365 ill(note), 366 (10),
367;
Phillips NY 11/4/78: 90 ill(note), 92 (3), 93 ill
(3), 94 ill(2);
Lehr NY Vol 2:2, 1979: 22 ill, 23 ill;
Lennert Munich Cat 5, 1979: 36 ill;
Lennert Munich Cat 5II, 1979: 36a, 36b;
Mancini Phila 1979: 28 ill(4);
Witkin NY Stereos 1979: 15 (2 ills)(6)(note);

MUYBRIDGE (continued)
Sothebys LA 2/7/79: 419 ill, 420 (2 ills)(11)(note);
Swann NY 4/26/79: 414 (2)(note);
Christies NY 5/4/79: 114 ill(68), 115 ill(78), 116
  ill(71), 117 (3), 118 (3), 119 (3), 120 (3);
Phillips NY 5/5/79: 211 (4), 212 ill(4), 213 ill(4),
  214 (2);
Sothebys NY 5/8/79: 53 (3);
Sothebys Lon 6/29/79: 261 ill;
Phillips Can 10/4/79: 37 ill, 38;
Swann NY 10/18/79: 381 (16);
Christies NY 10/31/79: 66 ill(attributed);
Sothebys NY 11/2/79: 306 ill(attributed)(note), 307
  (5), 308 (5), 309 (5), 310 (3);
Phillips NY 11/3/79: 132 (4);
Rose Boston Cat 5, 1980: 4 ill(note), 5 ill, 6 ill,
  7 ill;
Sothebys LA 2/6/80: 56 ill, 57 ill, 58 ill(87), 60
  ill(5), 61 ill(5), 62 ill(5);
Christies Lon 3/20/80: 407;
Swann NY 4/17/80: 337 ill(book, 97)(note);
Phillips NY 5/4/80: 282 (5);
Christies NY 5/16/80: 265 (attributed), 271 (lot, M
  et al), 300 ill(5), 301 (4), 302 (3);
Sothebys NY 5/20/80: 301 ill(note), 302 ill, 303
  ill, 304 ill, 305 ill, 306 ill, 307 ill, 308
  ill, 309 ill, 310 ill, 311 ill, 312 ill, 313
  ill, 314 ill, 315 ill, 316 (11), 317 (11), 318
  (11), 319 ill;
Christies Lon 6/26/80: 548;
Phillips Can 10/9/80: 31 (3);
Christies NY 11/11/80: 173 ill(2), 174 (2), 175 (2),
  176 (2);
California Galleries 12/13/80: 319 ill(13)(note),
  320;
Sothebys Lon 3/27/81: 394;
Swann NY 4/23/81: 159 (books, M et al);
Christies NY 5/14/81: 55 (2 ills)(200);
Sothebys NY 5/15/81: 120 ill(28);
Petzold Germany 5/22/81: 1829 ill(4);
Christies Lon 6/18/81: 193 (albums, M attributed
  et al);
California Galleries 6/28/81: 287 ill;
Harris Baltimore 7/31/81: 245 (2), 246 (2), 247;
Sothebys NY 10/21/81: 173 ill(attributed)(note),
  174 ill, 175 ill, 176 ill;
Swann NY 11/5/81: 359 (attributed)(note);
Christies NY 11/10/81: 56 ill;
Weston Cal 1982: 15 ill;
Wood Conn Cat 49, 1982: 309 (book, 5)(note);
Sothebys LA 2/17/82: 291 (8 ills)(129)(note), 292
  (2 ills)(61);
Harris Baltimore 3/26/82: 213, 214, 215, 216;
California Galleries 5/23/82: 354 ill(note);
Sothebys NY 5/24/82: 275 (3), 276 (attributed);
Sothebys NY 5/25/82: 460 ill(70);
Christies NY 5/26/82: 55 ill(note);
Christies NY 11/8/82: 164 ill;
Phillips NY 11/9/82: 210 ill;
Sothebys NY 11/10/82: 313 (attributed)(note);
Drouot Paris 11/27/82: 84, 85;
Harris Baltimore 12/10/82: 285, 286, 287, 288, 289,
  290, 291, 292, 293, 294, 295, 296, 297, 298,
  299, 300;
Christies Lon 3/24/83: 261 ill(14);
Swann NY 5/5/83: 409, 410, 411 (2), 412
  (attributed);
Sothebys NY 5/11/83: 464 ill(70);
California Galleries 6/19/83: 96 ill(book, M-1 et
  al)(note), 342 (note), 343, 344, 345, 346, 347,
  436 ill(7);

MUYBRIDGE (continued)
Christies NY 10/4/83: 107 (6);
Christies Lon 10/27/83: 154 ill(album, M-7 et al)
  (note);
Christies NY 11/8/83: 145 ill(107), 146 ill(117),
  147 ill(105), 148 ill(29), 149 ill(162);
Sothebys NY 11/9/83: 218 ill(books, 781)(note);
Swann NY 11/10/83: 314 (12)(note);
Harris Baltimore 12/16/83: 386 ill(note), 387, 388,
  389, 390, 391, 392, 393, 394, 395;
Christies Lon 3/29/84: 217 ill(144)(note);
Christies NY 5/7/84: 31 ill(note), 32 ill(note), 33
  ill(145);
Sothebys NY 5/8/84: 237 ill(note), 238 ill(67);
Swann NY 5/10/84: 280 (note);
Harris Baltimore 6/1/84: 419, 420, 421, 422, 423,
  424, 425, 426, 427;
California Galleries 7/1/84: 561, 562, 563, 564,
  565 ill, 566 ill, 567, 568;
Sothebys Lon 10/26/84: 77 ill;
Sothebys NY 11/5/84: 166 ill(15);
Christies NY 11/6/84: 49 ill(note), 50 ill;
Drouot Paris 11/24/84: 126 ill;
Christies NY 2/13/85: 166 (4);
Harris Baltimore 3/15/85: 106 (lot, M-1 et al),
  222, 223, 224;
Christies Lon 3/28/85: 227 ill(2);
Sothebys NY 5/7/85: 257 ill(lot, 15), 411 (lot, M-1
  et al);
Sothebys NY 5/8/85: 567 ill(8);
California Galleries 6/8/85: 344 ill, 345 ill, 346,
  347, 348, 349 ill, 350, 351, 435;
Christies Lon 10/31/85: 227;
Sothebys Lon 11/1/85: 3 (lot, M et al);
Christies NY 11/11/85: 344 ill(12);
Sothebys NY 11/12/85: 299 ill(60)(note), 300 ill
  (100);
Swann NY 11/14/85: 158 (lot, M et al);
Wood Boston Cat 58, 1986: 316 (note);
Harris Baltimore 2/14/86: 332 (5);
California Galleries 3/29/86: 758, 759, 760, 761,
  762;
Sothebys NY 5/12/86: 315 ill(140), 315A ill(140);
Christies NY 5/13/86: 249 ill(200), 250 ill;
Phillips NY 7/2/86: 340, 341;
Christies Lon 10/30/86: 38 ill(lot, M-10 et al);
Sothebys Lon 10/31/86: 151 ill(book, 21);
Christies NY 11/11/86: 308 ill(144), 309 ill(4);
Sothebys NY 11/13/86: 338 ill(12), 338A ill(12);
Swann NY 11/13/86: 284 (4);
Drouot Paris 11/22/86: 120 ill, 121 ill;

MUZIET
Photos dated:  1860s
Processes:     Albumen
Formats:       Prints
Subjects:      Topography
Locations:     Europe
Studio:        Europe
  Entries:
Christies Lon 6/24/82: 125 ill;

MUZZALL (see HAYWARD & MUZZALL)

MYERS (see TIPTON) [MYERS 1]

MYERS [MYERS 2]
Photos dated: 1850s
Processes:    Daguerreotype
Formats:      Plates
Subjects:     Portraits
Locations:
Studio:
   Entries:
California Galleries 1/22/77: 35;

MYERS, Mrs. Eveleen W.H. (British)
Photos dated: c1888-1890s
Processes:    Platinum, photogravure
Formats:      Prints
Subjects:     Genre
Locations:    England
Studio:       England
   Entries:
Sothebys Lon 10/18/74: 315 ill(73);
Sothebys Lon 3/21/75: 378, 379, 380 ill;
Sothebys Lon 10/24/75: 251a, 251b;
Sothebys Lon 10/29/76: 317, 318, 319 (2);
Christies Lon 3/10/77: 379 ill, 380 (2);
Christies Lon 6/30/77: 338 (2), 339;
Sothebys Lon 11/18/77: 260 (lot, M-4 et al);
Christies Lon 3/16/78: 316 ill(4);
Sothebys Lon 3/22/78: 204 (lot, M-2 et al);
Christies Lon 6/27/78: 332 ill, 333, 334;
Christies Lon 10/26/78: 375, 376 (3);
Sothebys Lon 6/27/80: 337 (note), 338 ill, 339, 340
   (2), 341 ill, 342 (2), 343 (2);
Sothebys Lon 6/25/82: 54 (books, M-1 et al);
Harris Baltimore 12/10/82: 301 (note);
Christies NY 11/8/83: 201 (book, M et al);
Christies Lon 10/31/85: 230

MYLIUS, Carl Friedrich (German, 1827-1916)
Photos dated: c1860
Processes:    Albumen
Formats:      Prints
Subjects:     Topography
Locations:    Germany - Frankfurt
Studio:       Germany
   Entries:
Lennert Munich Cat 5, 1979;
Christies Lon 4/24/86: 493 (4)(note);

N. & O. [same]
Photos dated: 1880s-1890s
Processes:    Albumen
Formats:      Prints
Subjects:     Topography
Locations:    Europe
Studio:
  Entries:
Swann NY 11/8/84: 200 (albums, N & O et al);

N., C. [C.N.]
Photos dated: 1860s-1870s
Processes:    Albumen
Formats:      Prints
Subjects:     Topography
Locations:    England
Studio:       Great Britain
  Entries:
Witkin NY II 1974: 889 (lot, N et al);
Wood Conn Cat 37, 1976: 236 (album, N-2 et al);
California Galleries 4/2/76: 151 (album, N et al);
Christies Lon 6/26/80: 205 (album, N et al);
Christies Lon 6/18/81: 240 (album, N et al);
Christies Lon 10/27/83: 80 (album, N et al);
Christies Lon 3/29/84: 97 (album, N et al);
Christies Lon 3/28/85: 103 (albums, N et al);
Swann NY 11/14/85: 28 (albums, N et al);

ND (French)(see also Neurdein)
Photos dated: c1880-1891
Processes:    Albumen
Formats:      Prints incl. panoramas
Subjects:     Topography, documentary (public
              events)
Locations:    France - Paris, Cannes, Villefranche,
              Nice, Menton; Monaco; Algeria; Italy;
Studio:       France
  Entries:
Rinhart NY Cat 7, 1973: 457, 458, 459;
Witkin NY II 1974: 575 (album, N et al);
California Galleries 9/26/75: 96 (lot, N et al),
  271 (lot, N-1 et al), 274 (lot, N-4 et al);
Wood Conn Cat 37, 1976: 241 (album, N et al);
Swann NY 4/1/76: 206 (album, N et al);
Christies Lon 6/10/76: 69 ill(album, 18);
California Galleries 4/2/76: 180 (2), 226 (2), 227
  (lot, N-1 et al);
California Galleries 4/3/76: 288 (lot, N-2 et al);
Swann NY 11/11/76: 382 (lot, N et al), 388 (albums,
  N et al), 389 (albums, N et al), 395 (albums, N
  et al), 449 (lot, N et al);
Rose Boston Cat 2, 1977: 126 ill(album, N et al);
Christies Lon 3/10/77: 117 (album, N et al);
Swann NY 12/8/77: 367 (lot, N et al), 372 ill(60, N
  & X), 413 (lot, N et al);
Wood Conn Cat 42, 1978: (album, 24);
California Galleries 1/21/78: 210 (album, N et al);
Christies Lon 10/26/78: 158 (13), 249 (albums,
  N et al);
Rose Boston Cat 4, 1979: 38 ill, 39 ill, 40 ill,
  41 ill;
California Galleries 1/21/79: 343 (album, N-1
  et al);
Swann NY 4/26/79: 282 (albums, N et al);
Sothebys NY 5/8/79: 103 (lot, N-8 et al);
Christies Lon 6/28/79: 139 (albums, N et al), 144
  (lot, N et al);
Christies Lon 3/20/80: 150 (album, N et al), 151
  (albums, N et al);

ND (continued)
California Galleries 3/30/80: 306 (lot, N-2 et al);
Auer Paris 5/31/80: 80 (album, 24);
Christies Lon 6/26/80: 201 (lot, N et al), 206
  (album, N et al);
Christies Lon 10/30/80: 276 (album, N et al);
Swann NY 11/6/80: 283 (lot, N et al);
California Galleries 12/13/80: 155 (album, N et al);
Phillips NY 5/9/81: 28 (albums, N et al), 61
  (albums, N et al);
Christies Lon 6/18/81: 204 (album, N et al), 414
  (album, N et al);
California Galleries 6/28/81: 133 (album, N et al),
  155 (album, N et al);
California Galleries 5/23/82: 193 (album, N et al);
Swann NY 11/18/82: 373 (albums, N et al), 433;
Harris Baltimore 4/8/83: 290 (album, N et al), 357
  (album, 50);
Christies Lon 6/23/83: 178 (album, N et al);
Swann NY 11/10/83: 304 (albums, N et al)(note);
Swann NY 5/10/84: 276 (albums, N et al);
Christies Lon 6/28/84: 77 (album, N et al);
California Galleries 7/1/84: 402 (lot, N et al);
Swann NY 11/8/84: 201 (albums, N et al), 284 (lot,
  N et al);
Harris Baltimore 3/15/85: 184 (album, N-31 et al);
Phillips Lon 3/27/85: 204 (albums, N et al);
Christies Lon 3/28/85: 60 (lot, N-4 et al);
Swann NY 5/9/85: 386 (albums, N et al)(note);
Phillips Lon 6/26/85: 188 (albums, N et al);
Christies Lon 6/27/85: 93 (lot, N et al);
Christies Lon 10/31/85: 85 (lot, N-36 et al);
Swann NY 11/14/85: 65 (lot, N et al), 82 (lot,
  N et al), 190 (lot, N et al);
Christies Lon 4/24/86: 385 (lot, N-3 et al);
Swann NY 5/15/86: 235 (albums, N et al);
Christies Lon 6/26/86: 137 (albums, N et al);
Harris Baltimore 11/7/86: 260 (lot, N et al);
Swann NY 11/13/86: 214 (album, N et al), 216
  (albums, N et al);

NABHOLZ (see SCHERER)

NADAR, Félix (Gaspard Félix Tournachon)(French,
              1820-1910)
Photos dated: 1853-1892
Processes:    Salt, albumen, photolithograph
              (Poitevin Process), carbon,
              heliogravure, enamel
Formats:      Prints, stereos, cdvs, cabinet cards
Subjects:     Portraits incl. Galerie
              Contemporaine, documentary
Locations:    France
Studio:       France - Paris
  Entries:
Maggs Paris 1939: 475 (note), 516 (note), 530, 532,
  533, 534, 541, 550, 553, 555, 561;
Andrieux Paris 1951(?): 27, 57;
Swann NY 2/14/52: 115 (lot, N et al);
Rauch Geneva 12/24/58: 213 ill(lot, N-1 et al), 237
  ill(note), 243 (lot, N et al), 245 ill, 260
  (note);
Rauch Geneva 6/13/61: 130 ill(note), 131, 132
  (note), 133 (2), 161, 178 (34)(note);
Sothebys NY (Weissberg Coll.) 5/16/67: 172 (lot,
  N et al), 173 (lot, N et al);
Sothebys NY (Strober Coll.) 2/7/70: 268 (lot,
  N et al), 274 (lot, N-4 et al);

Sothebys NY 11/21/70: 340 ill(lot, N et al), 341
(lot, N et al), 352 (lot, N-1 et al);
Sothebys Lon 12/21/71: 179 (lot, N et al);
Frumkin Chicago 1973: 95 ill;
Rinhart NY Cat 6, 1973: 357;
Witkin NY I 1973: 251 ill(book, N et al), 344, 430,
431, 432, 433, 434, 435, 436, 437, 438 ill, 439,
440, 441, 442, 443, 444;
Sothebys Lon 12/4/73: 176 (book, N et al);
Sothebys Lon 6/21/74: 163 (lot, N et al), 165 (6),
167b ill(lot N et al);
Sothebys Lon 10/18/74: 139 (lot, N et al);
Sothebys NY 2/2/75: 116 ill(note), 117 ill(note);
Sothebys Lon 3/21/75: 171 (lot, N-3 et al);
Sothebys Lon 10/24/75: 173a;
Colnaghi Lon 1976: 105 (5 ills)(5)(note), 106 ill,
107, 108 ill, 109 ill, 110;
Kingston Boston 1976: 686 ill(book, N et al)(note);
Sothebys Lon 3/19/76: 161 (note), 162 (lot, N-2
et al);
Gordon NY 5/3/76: 301 ill, 304 ill(lot, N-4 et al);
Sothebys NY 5/4/76: 100 (album, N et al);
Christies Lon 10/28/76: 234 (album, N et al), 266
ill, 267 (5), 268;
Sothebys Lon 10/29/76: 87 (lot, N-1 et al);
Swann NY 11/11/76: 345 (lot, N-1 et al), 453 (lot,
N-1 et al), 454 (lot, N-1 et al), 482 (lot, N-1
et al);
Gordon NY 11/13/76: 50 ill, 51 (lot, N-1 et al), 55
ill(4), 56 (lot, N-3 et al);
Halsted Michigan 1977: 704, 705;
White LA 1977: 44 ill(note), 45 ill;
Sothebys NY 2/9/77: 52 (lot, N-4 et al), 53 (lot,
N-1 et al)
Christies Lon 3/10/77: 242, 243 (8), 244 (lot, N-2
et al);
Swann NY 4/14/77: 203 (lot, N et al);
Gordon NY 5/10/77: 796 ill(5);
Sothebys NY 5/20/77: 42 ill, 45 (lot, N-2 et al),
46 (lot, N et al);
Sothebys Lon 7/1/77: 255 ill(note), 256 (2), 261
(lot, N-1 et al);
Sothebys NY 10/4/77: 207 ill, 208;
Christies Lon 10/27/77: 325 ill(note), 326, 327, 365
(album, N-4 et al)(note), 377 (album, N-1 et
al), 380 (album, N-41 et al), 410 (lot, N-1
et al);
Lunn DC Cat QP, 1978: 4 ill, 5 (5)(note);
Witkin NY VI 1978: 62 ill(lot, N-1 et al), 96 ill,
97 (2)(2 ills);
Wood Conn Cat 41, 1978: 24 ill(note), 25 ill(book,
N-2 et al)(note)
Sothebys LA 2/13/78: 112, 115 (2 ills)(books, N-25
et al)(note);
Christies Lon 3/16/78: 305 (lot, N-4 et al)(note),
311a (book, N-5 et al), 312 (lot, N-1 et al),
313 (lot, N-1 et al), 320 (lot, N-1 et al);
Swann NY 4/20/78: 320 (album, N et al), 321 (lot,
N-2 et al);
Sothebys NY 5/2/78: 120 (5 ills)(note), 121 ill,
122 (4);
Drouot Paris 5/29/78: 77 (lot, N et al);
Christies Lon 6/27/78: 220 ill(note), 243 (album,
N-1 et al), 247 (lot, N-1 et al)(note), 252 (2),
259 (lot, N-1 et al)(note);
Sothebys Lon 6/28/78: 136 (lot, N et al), 150a
(book, N et al), 323 ill, 324 ill;
Christies Lon 10/26/78: 352 (2), 372 ill, 373, 374
(5), 375 (2), 396 ill(album, N-3 et al);

Swann NY 12/14/78: 175 (book, 1)(note), 192 (book,
N-1 et al), 434;
Lennert Munich Cat 5, 1979: 11 ill;
Octant Paris 3/1979: 8 ill;
Rose Boston Cat 4, 1979: 26 ill(note), 27 ill, 28
ill, 29 ill;
Witkin NY VIII 1979: 61 ill;
Wood Conn Cat 45, 1979: 186 (book N-2 et al)(note);
California Galleries 1/21/79: 480;
Sothebys LA 2/7/79: 432 ill, 435 (lot, N-3 et al);
Sothebys Lon 3/14/79: 312, 316 (lot, N et al);
Phillips Lon 3/13/79: 126 ill, 127 ill, 128 ill;
Swann NY 4/26/79: 415 (4), 416 (6);
Phillips NY 5/5/79: 97 ill(9);
Sothebys NY 5/8/79: 86 (album, N et al), 87 (books,
N-21 et al);
Christies Lon 6/28/79: 227 (albums, N-1 et al);
Sothebys Lon 6/29/79: 253 ill;
Phillips Can 10/4/79: 23, 24 ill;
Swann NY 10/18/79: 294, 382 ill(note);
Sothebys Lon 10/24/79: 296 ill, 297 (note), 298
(2 ills)(10)(note), 299 (4), 320 (lot, N-1
et al);
Sothebys NY 11/2/79: 238 ill, 238A ill(note), 239
ill(note), 240 (lot, N-1 et al);
Phillips NY 11/29/79: 263;
Sothebys LA 2/6/80: 123 (lot, N-1 et al);
Christies Lon 3/20/80: 227 (book, N et al), 228
(book, N et al), 230 (book, N et al), 348
(album, N-1 et al), 353 (lot, N-1 et al),
369 (2);
Sothebys Lon 3/21/80: 238 (book, N et al);
California Galleries 3/30/80: 349 (2);
Swann NY 4/17/80: 17 (book, 1);
Christies NY 5/16/80: 141 (2 ills)(note), 142 ill;
Sothebys NY 5/20/80: 379 ill, 380(3), 381 (lot, N-4
et al);
Auer Paris 5/31/80: 62 (album, N et al);
Phillips Lon 6/25/80: 107 (2), 127 ill;
Christies Lon 6/26/80: 329 (book, N et al), 479
(album, N-1 et al), 492, 493, 515 (lot, N-1
et al);
Sothebys Lon 6/27/80: 222 (6);
Christies Lon 10/30/80: 416 (album, N-2 et al), 420
(album, N-1 et al), 423 (album, N-1 et al), 439
(album, N-7 et al), 444 (lot, N-2 et al), 450
(lot, N-1 et al), 457;
Swann NY 11/6/80: 345;
Sothebys NY 11/17/80: 93 ill(6);
California Galleries 12/13/80: 57 (books, N et al);
Koch Cal 1981-82: 33 ill(book, N et al)(note);
Lennert Munich Cat 6, 1981: 11 ill;
Christies Lon 3/26/81: 293 (book, N et al), 397
(album, N-1 et al);
Sothebys Lon 3/27/81: 217 (lot, N-2 et al), 231 (2);
Swann NY 4/23/81: 471 (lot, N et al), 502 (9);
Phillips NY 5/9/81: 34;
Christies NY 5/14/81: 38 ill(note), 41 (books, N-19
et al);
Christies Lon 6/18/81: 426 (album, N-1 et al), 439;
California Galleries 6/28/81: 410 ill;
Sothebys NY 10/21/81: 177 ill(note);
Christies Lon 10/29/81: 366 (album, N-1 et al), 380
ill(lot, N-15 et al);
Swann NY 11/5/81: 564 (album, N et al)(note);
Petzold Germany 11/7/81: 230 ill, 302 (album,
N et al);
Christies NY 11/10/81: 26 ill, 27 (note);
Rose Florida Cat 7, 1982: 81 ill;
Wood Conn Cat 49, 1982: 332 (book, N-2 et al)(note);

**NADAR, F.** (continued)
Sothebys Lon 3/15/82: 235 (lot, N et al);
Phillips Lon 3/17/82: 76 (album, N-12 et al);
Swann NY 4/1/82: 263 (lot, N et al);
Sothebys NY 5/24/82: 277 ill(2)(note);
Christies NY 5/26/82: 36 (book, N-28 et al);
Christies Lon 6/24/82: 346, 372 (album, N-1 et al);
Sothebys Lon 6/25/82: 207 ill;
Christies Lon 10/28/82: 212;
Swann NY 11/18/82: 476 (lot, N et al);
Drouot Paris 11/27/82: 87 ill;
Bievres France 2/6/83: 128 (lot, N-1 et al), 161
    (lot, N-1 et al), 162 (lot, N-4 et al);
Christies Lon 3/24/83: 162 (book), 228 ill, 250
    (album, N et al);
Christies Lon 6/23/83: 256 (lot, N et al), 264;
Christies Lon 10/27/83: 224;
Swann NY 11/10/83: 33 (books, N et al), 129 (book,
    N et al);
Sothebys Lon 12/9/83: 71 ill;
Christies NY 2/22/84: 2(3), 3;
Christies Lon 3/29/84: 167 ill;
Christies NY 5/7/84: 19 (book, N-28 et al);
Swann NY 5/10/84: 23 (book, N et al)(note), 51
    (book, N et al)(note), 223 (albums, N et al),
    315 (albums, N et al);
Sothebys Lon 6/29/84: 228 ill(album, N-1 et al);
Phillips Lon 10/24/84: 121 (lot, N-1 et al);
Sothebys Lon 10/26/84: 85 ill;
Drouot Paris 11/24/84: 80 ill;
Old Japan, England Cat 8, 1985: 64 ill, 65 ill;
Christies NY 2/13/85: 135 (lot, N et al);
Harris Baltimore 3/15/85: 250, 272 (lot, N et al),
    294 (5);
Christies Lon 3/28/85: 309 (album, N et al);
Sothebys NY 5/7/85: 414 (lot, N-1 et al);
Swann NY 5/9/85: 411;
Phillips Lon 6/26/85: 205 (lot, N et al);
Christies Lon 6/27/85: 102 (books, N et al), 246
    (albums, N-1 et al);
Phillips Lon 10/30/85: 37 (lot, N et al);
Christies Lon 10/31/85: 215 (album, N-1 et al);
Sothebys Lon 11/1/85: 120 (album, N-1 et al);
Christies NY 11/11/85: 345 ill(note);
Wood Boston Cat 58, 1986: 326 (book, N-2 et al);
Harris Baltimore 2/14/86: 66;
Phillips Lon 4/23/86: 238 (lot, N-2 et al);
Christies Lon 4/24/86: 419 (books, N et al), 506;
Sothebys NY 5/12/86: 215 ill(note), 403 ill(album,
    N-3 et al)(note);
Swann NY 5/15/86: 190 (lot, N-2 et al);
Christies Lon 6/26/86: 103 (albums, N et al);
Phillips Lon 10/29/86: 306;
Christies Lon 10/30/86: 159;
Harris Baltimore 11/7/86: 287 (2);
Sothebys NY 11/10/86: 285 ill(note), 286 ill(note),
    287 ill(note);
Phillips NY 11/12/86: 143 (3);
Swann NY 11/13/86: 53 (book, N et al), 147 (lot, N-2
    et al), 168 (album, N et al);

**NADAR Jeune** (see TOURNACHON)

**NADAR, Paul** (French, 1856-1939)
Photos dated: 1880-1927
Processes:      Albumen
Formats:        Prints
Subjects:       Portraits
Locations:      Studio
Studio:         France - Paris
    Entries:
Sothebys NY (Greenway Coll.) 11/20/70: 30 ill
    (lot, N-1 et al), 54 ill;
Sothebys Lon 10/24/79: 301 ill;
Phillips Lon 3/12/80: 116;
Sothebys Lon 3/21/80: 239;
California Galleries 12/13/80: 321 ill;
Sothebys Lon 3/27/81: 233 (2);
Petzold Germany 5/22/81: 1830;
Petzold Germany 11/7/81: 229 ill(12);
Drouot Paris 11/24/84: 2 ill;

**NAEGLI**
Photos dated: Nineteenth century
Processes:      Albumen
Formats:        Cabinet cards
Subjects:       Portraits
Locations:
Studio:
    Entries:
Harris Baltimore 9/16/83: 148 (lot, N et al);

**NALL, John Greaves** (British)
Photos dated: 1860s-1867
Processes:      Albumen
Formats:        Stereos
Subjects:       Topography
Locations:      England - Great Yarmouth
Studio:         Great Britain
    Entries:
Swann NY 2/14/52: 243 (book, 70);
Christies Lon 6/26/80: 312 (book);
Christies Lon 6/23/83: 57 (lot, N-9 et al);
Christies Lon 10/25/84: 52 (lot, N et al);

**NAPIER, Captain** (British)
Photos dated: early 1860s
Processes:      Albumen
Formats:        Prints
Subjects:
Locations:
Studio:         Great Britain (Amateur Photographic
                Association)
    Entries:
Christies Lon 10/27/83: 218 (albums, N-1 et al);
Sothebys Lon 6/28/85: 134 (album, N et al);

**NAPPER, R.P.** (British)
Photos dated: c1860
Processes:      Albumen
Formats:        Prints
Subjects:       Topography, ethnography
Locations:      Spain - Seville and Granada;
                Gibraltar; Wales
Studio:         England
    Entries:
Fraenkel Cal 1984: 59 (note), 60, 61, 62 ill,
    63 ill;

**NARAMORE, William** (American)
Photos dated: c1849-1850s
Processes:      Daguerreotype
Formats:        Plates
Subjects:       Portraits
Locations:      Studio
Studio:         US - Bridgeport, Connecticut
    Entries:
Swann NY 4/23/81: 252 (lot, N-1 et al)(note);

**NARES, Captain Sir G.S.** (British)(photographer or
                author?)
Photos dated: 1875-1876
Processes:      Woodburytype
Formats:        Prints
Subjects:       Documentary (expeditions)
Locations:      "Polar Sea"
Studio:
    Entries:
Swann NY 2/14/52: 244 (book, 6);
Sothebys Lon 3/19/76: 144 (book, 6);
Sothebys Lon 3/14/79: 244 (books, 6);

**NASH, H.** (British)
Photos dated: 1890s
Processes:
Formats:        Prints
Subjects:       Topography
Locations:      Great Britain
Studio:         England (West Kent Amateur
                Photographic Society)
    Entries:
Christies Lon 6/27/85: 260 (album, N et al);

**NASMYTH, James** (British, 1808-1890) **& CARPENTER**
Photos dated: 1874-1875
Processes:      Woodburytype, heliotype
Formats:        Prints
Subjects:       Documentary (scientific)
Locations:      England
Studio:         England
    Entries:
Vermont Cat 2, 1971: 612 ill(book, 26);
Edwards Lon 1975: 140 (book, 25);
Kingston Boston 1976: 549 (2 ills)(book, 25)(note);
Christies Lon 3/10/77: 333 (book, 4)(note);
Swann NY 4/14/77: 130 (book, 24);
Witkin NY IX 1979: 2/53 (book, 25);
Sothebys Lon 3/14/79: 247 (book, 26);
Christies Lon 3/15/79: 216 (book, 12);
Swann NY 4/26/79: 128 (book)(note);
Sothebys Lon 10/24/79: 34 (book, 26);
Wood Conn Cat 49, 1982: 312 (book, 24)(note);
Sothebys Lon 3/15/82: 445 (book, 24);
Christies Lon 3/24/83: 152 (book, 24);
Christies Lon  10/27/83: 165 (book, 24);
Swann NY 11/10/83 113 (book, 25);
Christies Lon 3/29/84: 117 (book,24);
California Galleries 7/1/84: 95 (book, 24);
Swann NY 11/8/84: 88 (book)(note);
Swann NY 5/9/85: 112 (book, 25)(note);
Christies Lon 10/31/85: 150 (books, N & C-24 et al);
Swann NY 5/15/86: 122 (book, 21)(note);

**NAYA, Carlo** (Italian, 1816-1882)
Photos dated: early 1860s-c1880
Processes:      Albumen, carbon
Formats:        Prints, stereos, cdvs
Subjects:       Topography, genre
Locations:      Italy - Venice
Studio:         Italy - Venice
    Entries:
Vermont Cat 5, 1973: 565 (3 ills)(album, 24)(note);
Sothebys Lon 6/26/75: 124 (lot, N-10 et al);
Sothebys NY 9/23/75: 74 (albums, N et al);
California Galleries 9/27/75: 506 (9);
Kingston Boston 1976: 164 ill(note), 184 ill(album,
    N-23 et al);
Wood Conn Cat 37, 1976: 249 (album, N et al);
Sothebys NY 5/4/76: 75 (10)(note);
Rose Boston Cat 2, 1977: 58 ill(note), 59 ill,
    60 ill;
Christies Lon 3/10/77: 107 (lot, N-1 et al);
Christies Lon 6/30/77: 98 (album, N et al);
Christies Lon 10/27/77: 100 (albums, N-12 et al);
Swann NY 12/8/77: 383 (album, N et al);
Rose Boston Cat 3, 1978: 49 ill(note), 50 ill,
    51 ill;
California Galleries 1/21/78: 263 ill;
Swann NY 4/20/78: 328 (lot, N et al);
Christies Lon 10/26/78: 165 (album, N et al);
Swann NY 12/14/78: 421 (lot, N-1 et al);
Rose Boston Cat 4, 1979: 50 ill(note), 51 ill;
Sothebys Lon 3/14/79: 160 (lot, N et al);
Christies Lon 3/15/79: 84 (lot, N et al), 116 (8);
Christies Lon 6/28/79: 104 (album, N et al);
Sothebys Lon 6/29/79: 142 (lot, N-4 et al);
Sothebys NY 12/19/79: 71 ill(9)(note);
White LA 1980-81: 33 ill(note), 34 ill;
Christies Lon 3/20/80: 156 (albums, N et al), 366
    (lot, N-1 et al);
Sothebys Lon 3/21/80: 153 (6);
Christies Lon 5/16/80: 188 (lot, N et al);
Phillips NY 5/21/80: 222, 230 (lot, N et al);
Christies Lon 6/26/80: 195 (album, N et al);
Phillips Can 10/9/80: 7;
Sothebys Lon 10/29/80: 71 (6);
Christies Lon 10/30/80: 191 (albums, N et al);
Christies NY 11/11/80: 67 ill(10);
Christies Lon 3/26/81: 178 (album, N-9 et al), 183
    (album, N-12 et al), 267 (album, N et al);
Swann NY 4/23/81: 361 (note);
Petzold Germany 5/22/81: 1833 ill(lot, N-7 et al),
    1946 (lot, N-3 et al);
Sothebys Lon 6/17/81: 132 (album, 21), 136 (lot,
    N-3 et al), 140 (lot, N et al);
Sothebys NY 10/21/81: 178 ill(attributed);
Phillips Lon 10/28/81: 157 (lot, N-87 et al);
Sothebys Lon 10/28/81: 93 (album, 12);
Christies Lon 10/29/81: 193 (album, N et al);
Swann NY 11/5/81: 500 (albums, N et al);
Petzold Germany 11/7/81: 231 (lot, N-1 et al);
Rose Florida Cat 7, 1982: 37 ill(attributed);
Wood Conn Cat 49, 1982: 499 (book, N-1 et al)(note);
Christies Lon 3/11/82: 133 (album, N-12 et al), 136
    (album, N-9 et al);
Harris Baltimore 3/26/82: 7 (22);
Christies Lon 6/24/82: 130 (lot, N-3 et al), 134
    (album, N et al);
Phillips Lon 10/27/82: 42 (lot, N-3 et al);
Christies Lon 10/28/82: 30 (lot, N et al);
Swann NY 11/18/82: 454 (lot, N et al);
Harris Baltimore 12/10/82: 399 (lot, N et al);
Christies NY 2/8/83: 34 (lot, N et al);
Phillips Lon 3/23/83: 32 (lot, N-3 et al);

## NAYA (continued)

Christies Lon 3/24/83: 85 (lot, N-2)(attributed);
Sothebys Lon 3/25/83: 47 ill(N & Schoefft, 3);
Christies Lon 6/23/83: 48 (lot, N et al), 94 (lot,
  N-20 et al), 107 (lot, N et al), 169 (albums,
  N-20 et al), 174 (albums, N-33 et al);
Sothebys Lon 6/24/83: 60 ill(N & Schoefft, 3), 61
  (N & Schoefft, 2);
Christies NY 10/4/83: 101 (albums, N et al);
Christies Lon 10/27/83: 21 (lot, N et al), 43 (lot,
  N-6 et al);
Swann NY 11/10/83: 315 (20);
Sothebys Lon 12/9/83: 19 (N & Schoefft, 2);
Christies NY 2/2/84: 5 (album, N-12 et al), 10
  (albums, N et al);
Christies Lon 3/29/84: 140 (album, 15), 141
  (albums, N-10 et al), 148 (lot, N et al);
Christies Lon 6/28/84: 240 (album, 20);
Sothebys Lon 6/29/84: 60 ill(N & Schoefft, 3);
California Galleries 7/1/84: 570 (lot, N-3 et al);
Christies Lon 10/25/84: 67 (lot, N-1 et al);
Christies NY 2/13/85: 143 (lot, N-1 et al);
Christies Lon 6/27/85: 184 (album, 20);
Sothebys Lon 6/28/85: 50 ill(albums, N-27 et al),
  52 (lot, N-2 et al);
Swann NY 11/14/85: 133 (17);
Christies Lon 4/24/86: 377 (lot, N et al), 403
  (album, N attributed et al), 408 (albums, N et
  al), 498 ill;
Swann NY 5/15/86: 264 (lot, N et al);
Christies Lon 6/26/86: 134 (albums, N-21 et al);
Christies Lon 10/30/86: 148 (album, 26)(note);
Sothebys Lon 10/31/86: 8 (lot, N et al);
Swann NY 11/13/86: 245 (lot, N et al), 357 (lot,
  N et al);

## NAYLOR, Henry (British)
Photos dated: 1850s-1860s
Processes:     Salt
Formats:       Prints
Subjects:      Topography
Locations:     Great Britain
Studio:        England - Leeds
  Entries:
Christies Lon 3/10/77: 73 (album, N-1 et al);

## NEALE, H.
Photos dated: 1850s
Processes:     Ambrotype
Formats:       Plates inc. stereo
Subjects:      Portraits
Locations:
Studio:
  Entries:
Christies Lon 10/31/85: 54 (lot, N-1 et al);

## NEEDHAM & McDONALD (American)
Photos dated: 1889-1890
Processes:     Albumen
Formats:       Boudoir cards
Subjects:      Documentary (public events)
Locations:     US - Oklahoma
Studio:        US - Oklahoma City, Oklahoma
  Entries:
Swann NY 11/14/85: 140 (lot, N & M et al)(note);

## NEELAND Brothers (Canadian)(see also BAILY & NEELAND)
Photos dated: 1890s
Processes:     Albumen
Formats:       Prints
Subjects:      Topography
Locations:     Canada
Studio:        Canada - Vancouver, British Columbia
  Entries:
Phillips Can 10/9/80: 54 ill(album, N-23 et al);

## NEGRE, Charles (French, 1820-1880)
Photos dated: 1851-1865
Processes:     Calotype, albumen, heliogravure
Formats:       Prints
Subjects:      Topography, architecture, documentary
Locations:     France - Paris; Nice; Grasse et al
Studio:        France - Paris
  Entries:
Maggs Paris 1939: 476, 477, 478, 479, 480 ill, 481,
  482, 483, 484, 485 ill, 485bis;
Goldschmidt Lon Cat 52, 1939: 169 (note);
Rauch Geneva 12/24/58: 252 ill(note);
Rauch Geneva 6/13/61: 88 ill(note), 89 ill(4)
  (note), 90 (3)(note), 91 (2)(note), 92 (9)
  (note), 93, 206 (9)(note);
Rinhart NY Cat 6, 1973: 6 (album, N et al);
Sothebys NY 5/20/77: 94 ill;
Lunn DC Cat QP, 1978: 13;
Wood Conn Cat 41, 1978: 9 (book, 2)(note), 9a ill;
Lennert Munich Cat 5, 1979: 7 ill;
Wood Conn Cat 45, 1979: 300 ill(book, 2)(note);
Sothebys LA 2/6/80: 125 ill;
Phillips Lon 3/13/79: 40 ill(note);
Christies Lon 10/30/80: 356 ill(note), 357 ill
  (note);
Christies Lon 3/26/81: 328A ill;
Christies Lon 6/18/81: 171 (note);
Octant Paris 1982: 17 ill;
Christies NY 11/8/82: 165 ill;
Drouot Paris 11/27/82: 88 ill;
Drouot Paris 11/24/84: 115 ill;
Phillips Lon 10/30/85: 101 (book, 5);
Sothebys Lon 4/25/86: 180A ill;
Sothebys NY 11/10/86: 339 ill(note);
Drouot Paris 11/22/86: 126 ill;

## NEGRETTI, Henry (Italian, 1818-1879) & ZAMBRA, Joseph (Italian, born 1822)
Photos dated: 1855-1860s
Processes:     Daguerreotype, ambrotype, albumen
Formats:       Plates incl. stereo, stereos, cdvs
Subjects:      Topography, documentary, portraits
Locations:     England - London et al; Ireland -
               Dublin; Northern Ireland - Belfast
Studio:        England - London
  Entries:
Weil Lon Cat 7, 1945: 158 (book, 7);
Rinhart NY Cat 6, 1973: 401;
Edwards Lon 1975: 10 (album, N & Z-1 et al), 12
  (album, N & Z et al), 169 (book, 7), 170
  (book, 11);
Vermont Cat 10, 1975: 598 ill;
Sothebys NY 2/25/75: 107 (lot, N & Z et al);
California Galleries 9/27/75: 478 (lot, N & Z
  et al);
Swann NY 4/1/76: 216 (album, 6);
Christies Lon 6/10/76: 113, 115, 178 (book, 7);
Sothebys Lon 6/11/76: 145 ill;

## NEGRETTI & ZAMBRA (continued)

Christies Lon 10/28/76: 187 ill(attributed),
191 ill;
Christies Lon 3/10/77: 196, 197 ill, 199 ill;
Christies Lon 6/30/77: 38 (2);
Sothebys Lon 7/1/77: 205 (lot, N & Z-2 et al);
Christies Lon 10/27/77: 35 (2), 193;
Sothebys Lon 3/22/78: 1 (lot, N & Z-2 et al);
Sothebys Lon 3/14/79: 18, 19 (2);
Christies Lon 3/15/79: 59, 297;
Sothebys Lon 10/24/79: 218 (2);
Phillips Lon 3/12/80: 124 (lot, N & Z et al);
Christies Lon 3/20/80: 80 ill(attributed), 84 (20),
363 (album, N & Z et al), 366 (lot, N & Z et al);
Sothebys Lon 3/21/80: 79 (lot, N & Z-1 et al),
86 ill;
Christies Lon 6/26/80: 91 ill(attributed), 472
(album, N & Z-1 et al), 474 (album, N & Z et
al), 478 (lot, N & Z-1 et al);
Christies Lon 10/30/80: 110 (lot, N & Z-4 et al),
423 (album, N & Z-12 et al), 433 (albums, N &
Z-1 et al), 440 (album, N & Z et al), 444 (lot,
N & Z-1 et al);
Christies NY 11/11/80: 8 ill(2);
Sothebys LA 2/4/81: 23 (4)(attributed);
Sothebys LA 2/5/81: 249 (4);
Christies Lon 6/18/81: 61 ill(attributed);
Sothebys Lon 10/28/81: 47 ill, 48 ill, 49 ill, 51,
52 (2), 53, 54 (3);
Christies Lon 10/29/81: 102, 103 (lot, N & Z-1
et al);
Christies Lon 3/11/82: 58 (attributed);
Christies Lon 6/24/82: 45 ill(7)(attributed)(note),
48 ill(5)(attributed), 50 (lot, N & Z-2 et al),
59 (lot, N & Z-1 et al), 60 (lot, N & Z-8 et
al), 64 (lot, N & Z-8 et al);
Christies Lon 10/28/82: 10 (3 ills)(38)(attributed);
Christies Lon 3/24/83: 49 (lot, N & Z et al);
Sothebys Lon 3/25/83: 14 ill(note);
Phillips Lon 6/15/83: 103 (lot, N & Z-1 et al);
Christies Lon 10/27/83: 240 (album, N & Z et al);
Swann NY 11/10/83: 279 (lot, N & Z et al);
Harris Baltimore 12/16/83: 63 (lot, N & Z et al);
Harris Baltimore 6/1/84: 41 (note), 299 (lot, N & Z
et al);
Phillips Lon 10/24/84: 101 (album, N & Z et al);
Christies Lon 6/27/85: 29 (2);
Sothebys Lon 6/28/85: 4 ill(40);
Phillips Lon 4/23/86: 244 (lot, N & Z et al);
Christies Lon 4/24/86: 359 (18);
Sothebys Lon 4/25/86: 11;
Phillips Lon 10/29/86: 326 (lot, N & Z-1 et al);

## NEILL, Dr. A.C.B. (British)
Photos dated: 1850s-1869
Processes: Albumen, autotype
Formats: Prints
Subjects: Topography
Locations: India
Studio:
  Entries:
Christies Lon 6/23/83: 135 (lot, N et al);
Wood Boston Cat 58, 1986: 263 (book, N et al);
Christies Lon 10/30/86: 106 (lot, N-3 et al);

## NEILSON, George B.
Photos dated: 1880s-1910
Processes: Albumen
Formats: Stereos
Subjects: Documentary (industrial)
Locations: Guyana; South Africa
Studio:
  Entries:
Christies Lon 3/15/79: 909 (lot, N et al);

## NELSON, Sir Thomas James (British)
Photos dated: 1883
Processes: Woodburytype
Formats: Prints
Subjects: Topography
Locations: England - Richmond Park
Studio: England
  Entries:
Wood Conn Cat 42, 1978: 360 (book, 5);
Wood Conn Cat 49, 1982: 315 (book, 5)(note);

## NESBITT (British)
Photos dated: Nineteenth century
Processes: Albumen
Formats:
Subjects: Portraits
Locations: Studio
Studio: England - Bournemouth
  Entries:
Phillips Lon 6/23/82: 68 (album, B-2 et al)(note);

## NESEMAN, L. (American)
Photos dated: 1880s
Processes: Albumen
Formats: Stereos
Subjects: Topography
Locations: US - Yosemite, California
Studio: US - Marysville, California
  Entries:
California Galleries 9/27/75: 580 (lot, N et al);
California Galleries 1/23/77: 454 (lot, N et al);

## NESS, H. (American)
Photos dated: 1870s and/or 1880s
Processes: Albumen
Formats: Stereos
Subjects: Topography
Locations: US - Pennsylvania
Studio: US
  Entries:
California Galleries 4/3/76: 449 (lot, N et al);
California Galleries 1/21/78: 189 (lot, N et al);
California Galleries 1/21/79: 309 (lot, N et al);
California Galleries 3/30/80: 408 (lot, N et al);

NESSI (Italian)
Photos dated: 1860s-c1890
Processes: Albumen
Formats: Prints, stereos, cdvs
Subjects: Topography
Locations: Italy - Lake Como
Studio: Italy - Como
　Entries:
Rose Boston Cat 2, 1977: 61 ill(note);
Harris Baltimore 12/10/82: 391 (albums, N et al);
Christies Lon 6/28/84: 74 (lot, N et al);
Harris Baltimore 2/14/86: 210 (albums, N et al);

NETTLETON, South C. (see also HEWITT & NETTLETON)
Photos dated: 1880s
Processes:
Formats: Prints
Subjects:
Locations: Australia
Studio: Australia
　Entries:
Christies Lon 10/30/86: 177 (album, N et al);

NEURDEIN, E. (French)(aka ND, q.v.)
Photos dated: 1860s-1910
Processes: Albumen, woodburytype, photogravure,
　　　　　　 silver
Formats: Prints incl. panoramas, cdvs, stereos
Subjects: Topography, portraits incl. Galerie
　　　　　 Contemporaine, genre
Locations: France - Paris; Versailles;
　　　　　　 Marseilles; Bordeaux; Pau
Studio: France - Paris
　Entries:
California Galleries 4/2/76: 91 (lot, N et al);
Swann NY 4/14/77: 244 (album, N et al);
Swann NY 4/20/78: 324 (lot, N-1 et al);
California Galleries 3/30/80: 270 (lot, N et al);
Phillips NY 5/21/80: 132 ill(album, 100);
California Galleries 12/13/80: 254 (lot, N et al);
California Galleries 6/28/81: 293 (lot, N et al);
Swann NY 7/9/81: 229 (book, 50);
Christies Lon 3/11/82: 94 (lot, N et al);
California Galleries 5/23/82: 195 (album, N et al),
　　303 (lot, N-3 et al);
Sothebys NY 5/24/82: 279 ill(2)(attributed);
Christies NY 5/26/82: 36 (book, N et al);
Bievres France 2/6/83: 121 (album, N et al), 122
　　(albums, N et al), 135 (7), 155 (lot, N-1 et al);
Christies Lon 6/23/83: 38 (lot, N-3 et al);
Christies NY 5/7/84: 19 (book, N et al);
Sothebys Lon 6/29/84: 46 (albums, 22);
California Galleries 7/1/84: 572 (6);
Christies Lon 6/27/85: 102 (books, N et al), 289
　　(album, N-16 et al);
Harris Baltimore 2/14/86: 213 (album, N et al), 334
　　(21), 247 (lot, N et al);
Christies Lon 4/24/86: 352 (lot, N-10 et al), 419
　　(books, N et al);

NEVILL, Lady Caroline (British)
Photos dated: 1855-1856
Processes: Albumen
Formats: Prints
Subjects: Topography
Locations: England
Studio: England (Photographic Exchange Club)
　Entries:
Weil Lon Cat 4, 1944(?): 237 (album, N et al)(note);
Sothebys Lon 5/24/73: 14 (album, N et al);
Swann NY 4/26/79: 417 ill(note);

NEVINS
Photos dated: c1880
Processes: Albumen
Formats: Prints
Subjects: Topography
Locations: US - Colorado
Studio:
　Entries:
California Galleries 7/1/84: 349 (lot, N-10 et al);

NEWBOLD, George
Photos dated: Nineteenth century
Processes: Albumen
Formats: Prints
Subjects: Portraits
Locations:
Studio:
　Entries:
Harris Baltimore 6/1/84: 269 ill;

NEWCOMBE, C.T. (British)
Photos dated: Nineteenth century
Processes: Albumen
Formats:
Subjects: Portraits
Locations: England - London
Studio: England - London
　Entries:
Edwards Lon 1975: 12 (album, N et al);

NEWCOMER, T.H. (American)
Photos dated: 1840s and/or 1850s
Processes: Daguerreotype
Formats: Plates
Subjects: Portraits
Locations: Studio
Studio: US - Philadelphia, Pennsylvania
　Entries:
Sothebys NY (Weissberg Coll.) 5/16/67: 161 (lot, N-1
　　et al);
Vermont Cat 7, 1974: 500 ill;
Swann NY 5/5/83: 317 (lot, N-2 et al);

**NEWELL, R.** (American)
Photos dated: 1863-c1880
Processes:       Albumen
Formats:         Prints, stereos, cdvs
Subjects:        Topography, documentary (public
   events)
Locations:       US - Philadelphia, Pennsylvania
Studio:          US - Philadelphia, Pennsylvania
   Entries:
Sothebys NY (Strober Coll.) 2/7/70: 474 (lot,
   N-6 et al);
Rinhart NY Cat 7, 1973: 397;
Witkin NY V 1977: 97 (book, 3);
California Galleries 1/22/77: 121;
Swann NY 4/14/77: 302 (lot, N et al);
Sothebys Lon 7/1/77: 62 ill(book, 5);
Witkin NY X 1980: 49 (book, 3);
Sothebys Lon 6/17/81: 20 (lot, N-9 et al);
Harris Baltimore 4/8/83: 88 (lot, N et al), 89 (lot,
   N et al);
Swann NY 5/9/85: 260 (book, 3)(note);
Swann NY 11/14/85: 262 (book, N et al);
Wood Boston Cat 58, 1986: 136 (books, N-1 et al);
Swann NY 5/15/86: 130 (book, N et al)(note);

**NEWLAND**
Photos dated: 1850s
Processes:       Daguerreotype
Formats:         Plates incl. stereo
Subjects:        Portraits
Locations:       Studio
Studio:          India - Calcutta
   Entries:
Christies Lon 10/30/80: 17 (note), 93 (2 ills);
Sothebys Lon 6/17/81: 55;
Christies Lon 10/31/85: 21 (note);
Christies Lon 10/30/86: 12;

**NEWLING**
Photos dated: late 1860s
Processes:       Albumen
Formats:         Cdvs
Subjects:        Portraits
Locations:       Studio
Studio:          Belgium - Waterloo
   Entries:
Rinhart NY Cat 2, 1971: 317 (4);

**NEWMAN** [NEWMAN 1]
Photos dated: c1850
Processes:       Daguerreotype
Formats:         Plates
Subjects:        Portraits
Locations:
Studio:
   Entries:
Christies Lon 10/26/78: 48 (lot, N-1 et al);

**NEWMAN** [NEWMAN 2]
Photos dated: 1860s
Processes:       Albumen
Formats:         Cdvs
Subjects:        Portraits
Locations:
Studio:
   Entries:
Harris Baltimore 4/8/83: 381 (lot, N et al);

**NEWNHAM-DAVIS, Henry** (British)
Photos dated: 1850s
Processes:
Formats:         Prints
Subjects:        Topography, genre
Locations:       England; France
Studio:          England
   Entries:
Sothebys Lon 6/26/75: 200 ill(album, 235);

**NEWSHALL, Sir John** (British)
Photos dated: 1840s
Processes:       Cyanotype
Formats:         Prints
Subjects:
Locations:
Studio:          Great Britain
   Entries:
Swann NY 2/14/52: 4 (album, N et al);

**NEWTON, Prof. Henry Jotham** (American, 1823-1895)
Photos dated: Nineteenth century
Processes:
Formats:         Prints
Subjects:        Topography
Locations:       US - New York City
Studio:          US
   Entries:
Phillips NY 5/21/80: 294 (lot, N-1 et al);

**NEWTON, Sir William J.** (British)
Photos dated: 1850s
Processes:       Calotype
Formats:         Prints
Subjects:        Topography
Locations:       Great Britain
Studio:          Great Britain (Photographic Exchange
Club)
   Entries:
Weil Lon Cat 4, 1944(?): 237 (album, N et al)(note);
Andrieux Paris 1951(?): 58 (11);

**NICHOLAS & CURTHS** (British)
Photos dated: 1873-1890s
Processes:       Albumen, autotype
Formats:         Prints
Subjects:        Ethnography, documentary (industrial)
Locations:       India - Madras
Studio:          India - Madras
   Entries:
Swann NY 11/11/76: 270 (book, N & C et al)(note);
Swann NY 4/14/77: 121 (book, N & C et al)(note);
Wood Conn Cat 42, 1978: 65 (book, N & C et al)
   (note), 66 (book, N & C et al);
Sothebys Lon 11/1/85: 44 ill(album)(note);

**NICHOLL, Spencer Percival Talbot** (British, 1841-1908)
Photos dated: 1859-c1875
Processes: Albumen
Formats: Prints
Subjects: Topography
Locations: Italy; India
Studio:
    Entries:
Sothebys Lon 3/21/80: 107 ill(album, N et al), 157 ill(album, N et al)(note);
Sothebys Lon 3/27/81: 409 ill(album, N attributed et al);

**NICHOLL, W.H.** (British)
Photos dated: 1855-1857
Processes: Albumen
Formats: Prints
Subjects: Topography
Locations: England - Windsor and Monmouthshire;
Studio: Great Britain (Photographic Club)
    Entries:
Sothebys Lon 3/21/75: 286 (album, N-1 et al);
Sothebys Lon 10/24/79: 356 (lot, N-1 et al);
Sothebys Lon 11/1/85: 59 (album, N-1 et al);

**NICHOLLS, A.** (British)
Photos dated: Nineteenth century
Processes: Albumen
Formats:
Subjects: Portraits
Locations: England - Sansdown, Isle of Wight
Studio: England - Sansdown, Isle of Wight
    Entries:
Edwards Lon 1975: 12 (album, N et al);
Phillips Lon 10/29/86: 304 (lot, N-1 et al);

**NICHOLLS, G.A.** (British)
Photos dated: c1860
Processes: Albumen
Formats: Prints
Subjects: Topography
Locations: Great Britain
Studio: Great Britain
    Entries:
Sothebys Lon 10/28/81: 211 (N-1 plus 1 attributed);

**NICHOLLS, Horace Walter** (British, 1867-1941)
Photos dated: 1887-1918
Processes: Silver
Formats: Prints
Subjects: Documentary (Boer War)
Locations: Chile; England; South Africa
Studio:
    Entries:
Sothebys Lon 12/4/73: 237 (12);
Sothebys Lon 6/21/74: 173 (10);

**NICHOLS** (American)
Photos dated: Nineteenth century
Processes: Albumen
Formats: Cdvs
Subjects: Portraits
Locations: Studio
Studio: US - St. Louis, Missouri
    Entries:
Sothebys NY (Strober Coll.) 2/7/70: 290 (lot, N et al);

**NICHOLS, C.A.** (British)
Photos dated: 1860s and/or 1870s
Processes: Albumen
Formats: Prints
Subjects: Documentary (public events)
Locations: England
Studio: Great Britain - Stamford and Lincoln
    Entries:
Christies Lon 10/25/84: 195 (2);

**NICHOLS, C.W.** (American)
Photos dated: 1870s
Processes: Albumen
Formats: Stereos
Subjects: Topography
Locations: US - Rutland, Vermont
Studio: US
    Entries:
Rinhart NY Cat 6, 1973: 480;

**NICHOLS, Sheldon K.** (American)
Photos dated: 1850s
Processes: Daguerreotype
Formats: Plates
Subjects: Portraits
Locations: Studio
Studio: US - Hartford, Connecticut; San Francisco, California
    Entries:
Vermont Cat 10, 1975: 539 ill(attributed);

**NICHOLS, William** (British)
Photos dated: 1864-1891
Processes: Albumen, woodburytype
Formats: Prints, stereos
Subjects: Topography
Locations: England - Cambridge and Essex
Studio: Great Britain
    Entries:
Sothebys Lon 10/29/76: 31 (lot, N-7 et al), 54 (album, 53)(note);
California Galleries 1/22/77: 206 (book, 11);

**NICHOLSON** (British)
Photos dated: 1860s-1870s
Processes: Albumen
Formats: Prints, stereos
Subjects: Topography
Locations: England - Isle of Wight
Studio: Great Britain
    Entries:
Sothebys Lon 10/24/75: 93 (lot, N-1 et al);
Christies Lon 10/30/80: 113 (lot, N-10 et al);
Christies Lon 3/26/81: 116 (lot, N et al);
Christies Lon 6/18/81: 164 (lot, N et al);

**NICHOLSON** (continued)
Christies Lon 10/29/81: 128 (lot, N et al);
Christies Lon 10/25/84: 41 (lot, N et al);
Christies Lon 4/24/86: 336 (lot, N et al);

**NICKERSON, Lieutenant G.H.** (American)
Photos dated: 1863-1880s
Processes:      Albumen
Formats:        Prints, stereos
Subjects:       Documentary (military), topography
Locations:      US - North Carolina; Massachusetts
Studio:         US - Provincetown, Massachusetts
    Entries:
California Galleries 4/2/76: 204;
Swann NY 11/5/81: 436 (lot, N et al);
Swann NY 5/15/86: 304 (lot, N et al);

**NICOL, J.** (British)
Photos dated: 1860s
Processes:      Albumen
Formats:        Cdvs
Subjects:       Portraits
Locations:      Studio
Studio:         Great Britain
    Entries:
Christies Lon 6/27/85: 272 (album, N et al);

**NIELSON, C.H.** (American)
Photos dated: 1880s-c1890
Processes:      Albumen
Formats:        Prints
Subjects:       Topography
Locations:      US - Niagara Falls, New York
Studio:         US
    Entries:
Sothebys NY 9/23/75: 93 (lot, N-1 et al);
Sothebys NY 11/9/83: 222A ill(7);
Phillips NY 7/2/86: 342 (6);

**NIEPCE, Joseph-Nicéphore** (French, 1765-1833)
Photos dated: 1826-1869 (incl. reprints)
Processes:      Heliogravure
Formats:        Prints
Subjects:       Documentary (art)
Locations:      Studio
Studio:         France - Chalons-sur-Saone
    Entries:
Christies Lon 6/24/82: 348A (2 ills)(attributed)
    (note);
Sothebys Lon 10/29/82: 59 ill(note);
Christies NY 5/6/85: 50 ill(book, N et al)(note);

**NIEPCE DE SAINT-VICTOR, Claude Félix Abel** (French,
                1805-1870)
Photos dated: 1853-1859
Processes:      Albumen
Formats:        Prints
Subjects:       Topography, documentary (art)
Locations:      France
Studio:         France
    Entries:
Maggs Paris 1939: 517 (attributed)(note);
Drouot Paris 11/27/82: 90 ill;

**NILSON & MARSHALL**
Photos dated: c1860
Processes:      Ambrotype, albumen
Formats:        Plates, cdvs
Subjects:       Portraits
Locations:      Studio
Studio:         Ireland - Dublin
    Entries:
Sothebys Lon 10/27/78: 35 ill;
Christies Lon 6/24/82: 364 (album, N & M et al);

**NIMS, F.A.** (American)
Photos dated: 1870s-1880s
Processes:      Albumen
Formats:        Prints, stereos
Subjects:       Topography
Locations:      US - Colorado; New Mexico
Studio:         US - Leadville, Colorado
    Entries:
Swann NY 11/6/80: 266 (lot, N-4 et al);
Harris Baltimore 12/10/82: 109 (lot, N et al);

**NINCI, Giuseppe** (Italian, 1823-1890)
Photos dated: 1860s-1870s
Processes:      Albumen
Formats:        Prints
Subjects:       Topography, architecture
Locations:      Italy - Rome
Studio:         Italy - Rome
    Entries:
Rose Boston Cat 2, 1977: 62 ill(note), 63 ill;
Christies Lon 6/28/79: 102 (album, N-36 et al);
Christies NY 5/16/80: 166 (3);
Christies Lon 10/30/80: 177 (attributed);
Christies NY 11/11/80: 68 (3)(attributed);
Phillips NY 5/9/81: 41;
Christies Lon 6/23/83: 97 (lot, N-36 et al);
Sothebys Lon 3/29/85: 111 (lot, N-1 et al);
Sothebys Lon 4/25/86: 65 (lot, N-7 et al);

**NINET, Alphonse**
Photos dated: early 1850s
Processes:      Salt
Formats:        Prints
Subjects:       Genre (nudes)
Locations:
Studio:
    Entries:
Sothebys Lon 10/24/79: 356 (lot, N-1 et al);
Christies Lon 3/28/85: 154 ill(2);

**NINET, V.** (French)
Photos dated: 1860
Processes:      Albumen
Formats:        Stereos
Subjects:       Ethnography
Locations:      Oceania
Studio:
    Entries:
Sothebys Lon 3/27/81: 4 ill(7, attributed);
Sothebys Lon 3/15/82: 4 ill(7);

**NIVEN** (see BOOTE)

**NOACK, Alfred** (1833-1896)
Photos dated: 1860s-1880s
Processes:      Albumen
Formats:        Prints, stereos, cdvs
Subjects:       Topography, documentary (art)
Locations:      Italy - Genoa et al; France - Menton
Studio:         Italy - Genoa
   Entries:
Wood Conn Cat 37, 1976: 249 (album, N et al), 250
   (album, N et al);
California Galleries 4/3/76: 437 (13);
Christies Lon 10/26/78: 235 (lot, N et al);
Christies NY 5/16/80: 188 (lot, N et al);
Christies Lon 10/30/80: 189 (albums, N et al);
Sothebys Lon 10/28/81: 66 (album, 20);
Christies Lon 3/26/81: 262 (lot, N et al);
Swann NY 11/18/82: 403 (lot, N et al);
Swann NY 5/5/83: 344 (albums, N et al), 377 (lot,
   N et al)(note);
Christies Lon 3/29/84: 99 (albums, N-14 et al);
Swann NY 5/10/84: 276 (albums, N et al);
Christies Lon 6/28/84: 140 (album, N et al);
California Galleries 7/1/84: 165 (lot, N et al);
Christies NY 9/11/84: 117 ill(album, N et al);
Swann NY 11/8/84: 284 (lot, N et al);
Christies NY 2/13/85: 115;
Christies Lon 6/27/85: 89 (albums, N et al);
Christies Lon 4/24/86: 500;
Christies Lon 6/26/86: 137 (albums, N et al), 157A;
Swann NY 11/13/86: 216 (albums, N et al);

**NOEL** (see ADDIS & NOEL)

**NOHRING, Johan** (German)
Photos dated: 1860s-c1871
Processes:      Albumen
Formats:        Prints, stereos
Subjects:       Topography
Locations:      Germany - Lubeck
Studio:         Germany - Lubeck
   Entries:
Phillips NY 5/9/81: 49 ill(13);
Petzold Germany 11/7/81: 232 ill(3);

**NORDEN, H.** (Austrian)
Photos dated: c1865-1870s
Processes:      Albumen
Formats:        Cdvs
Subjects:       Genre
Locations:      Studio
Studio:         Austria - Wieden
   Entries:
Swann NY 12/14/78: 377 (lot, N et al);

**NORMAN** (see HARRINGTON & NORMAN)

**NORMAN, Carl** (British)
Photos dated: 1880s
Processes:      Albumen
Formats:        Prints
Subjects:       Topography
Locations:      England - Torquay
Studio:         Great Britain
   Entries:
Christies Lon 10/27/77: 143 (albums, N-155 et al);
Christies Lon 6/27/78: 62 (lot, N et al), 67 (lot,
   N-1 et al);
California Galleries 6/28/81: 136 (album, N et al);
California Galleries 5/23/82: 184 (album, N et al);

**NORTH** (see GORE & NORTH) [NORTH 1]

**NORTH & OSWALD** (American) [NORTH 2]
Photos dated: 1870s
Processes:      Albumen
Formats:        Stereos
Subjects:       Topography
Locations:      US - Toledo, Ohio
Studio:         US - Toledo, Ohio
   Entries:
Harris Baltimore 12/16/83: 36 (lot, N & O-3 et al);

**NORTH** (American) [NORTH 3]
Photos dated: 1850s
Processes:      Daguerreotype
Formats:        Plates
Subjects:       Portraits
Locations:      Studio
Studio:         US - Cleveland, Ohio
   Entries:
Vermont Cat 8, 1974: 472 ill;

**NORTH, Walter C.** (American)
Photos dated: 1871-1880s
Processes:      Albumen
Formats:        Prints
Subjects:       Topography
Locations:      North America
Studio:         North America
   Entries:
Christies Lon 3/11/82: 224 (album, N-1 et al);
Wood Boston Cat 58, 1986: 136 (books, N-2 et al);

**NORTON & IRIS** (British) [NORTON 1]
Photos dated: Nineteenth century
Processes:      Albumen
Formats:        Cdvs
Subjects:       Portraits
Locations:      Studio
Studio:         England - Islington
   Entries:
Phillips Lon 6/26/85: 199 (lot, N & I et al);

**NORTON & LUTHER** (American) [NORTON 2]
Photos dated: Nineteenth century
Processes:      Albumen
Formats:        Prints
Subjects:       Portraits
Locations:      Studio
Studio:         US - Cleveland, Ohio
    Entries:
Anderson NY (Gilsey Coll.) 1/20/03: 274;

**NORTON Brothers** [NORTON 3]
Photos dated: 1879
Processes:      Albumen, woodburytype
Formats:        Prints
Subjects:       Topography, ethnography
Locations:      British Guyana
Studio:
    Entries:
Sothebys Lon 10/24/75: 102 (album, N et al);
Christies Lon 3/11/82: 254 (4 ills)(album, 55);
Christies Lon 6/28/84: 99 (album, 40);

**NOTHJUNG, P.** (German)
Photos dated: c1860
Processes:      Albumen
Formats:        Prints
Subjects:       Portraits
Locations:      Studio
Studio:         Germany - Breslau
    Entries:
Petzold Germany 280 ill;

**NOTMAN, Charles F.** (Canadian)
Photos dated: c1890s
Processes:      Collodion on glass
Formats:        Lantern slides
Subjects:       Topography
Locations:      Canada
Studio:         Canada
    Entries:
California Galleries 3/30/80: 337 (lot, N et al);

**NOTMAN, James** (Canadian)
Photos dated: early 1870s-c1890
Processes:      Albumen
Formats:        Stereos, cabinet cards
Subjects:       Topography, portraits
Locations:      Canada - New Brunswick
Studio:         Canada - New Brunswick
    Entries:
Phillips Can 10/4/79: 72 ill;

**NOTMAN, William McFarlane** (British, 1826-1891)
Photos dated: 1856-1889
Processes:      Albumen, cyanotype, photogravure,
                bromide
Formats:        Prints, cdvs, stereos, cabinet cards
Subjects:       Topography, genre, portraits,
                documentary (railroads)
Locations:      Canada; US
Studio:         Canada - Montreal; US - Boston
    Entries:
Weil Lon Cat 4, 1944(?): 191 (book, 8);
Weil Lon Cat 7, 1945: 107 (book, 8);

**NOTMAN, W.** (continued)
Swann NY 2/14/52: 69 (book, 10), 74 (book, 30), 251
    (book, 48)(note), 252 (book, 38)(note), 448
    (book, 12)(note);
Sothebys NY (Strober Coll.) 2/7/70: 376 (lot, N-2
    et al), 475 (lot, N-3 et al), 509 (lot, N-10 et
    al), 528 (lot, N-2 et al);
Rinhart Cat 1, 1971: 158 (lot, N-7 et al), 390, 511
    (book, 30), 512 (book, 30);
Rinhart NY Cat 2, 1971: 544;
Vermont Cat 2, 1971: 233 (5), 249 (lot, N-2 et al),
    613 ill(book, 5);
Rinhart NY Cat 6, 1973: 548;
Rinhart NY Cat 7, 1973: 88 (book, 1), 89 (book, 8),
    90 (book, 4), 158, 557;
Witkin NY I 1973: 168 (book, 8);
Ricketts Lon 1974: 8 (album, N et al);
Witkin NY II 1974: 173 (book, 8);
Christies Lon 4/25/74: 134 (84);
Sothebys Lon 10/18/74: 135 (album, N et al);
Edwards Lon 1975: 35 (album, N-2 et al), 193 (book,
    30)(note);
Vermont Cat 9, 1975: 576 ill(8), 622 ill(note), 623
    ill, 624 ill, 625 ill, 626 ill, 627 ill, 628
    ill, 629 ill, 630 ill, 631 ill, 632 ill, 633
    ill, 634 ill, 635 ill, 636 ill, 637 ill, 638
    ill, 639 ill, 640 ill, 641 ill, 642 ill, 643
    ill, 644 ill, 645 ill, 646 ill, 647 ill, 648
    ill, 649 ill, 650 ill, 651 ill, 652 ill, 653
    ill, 654 ill, 655 ill, 656 ill, 657 ill, 658
    ill, 659 ill, 660 ill, 661 ill, 662 ill;
Witkin NY III 1975: 677 (book, 8);
Swann NY 2/6/75: 83A (album, 36), 128 (book, 5),
    169 (lot, N-12 et al);
Sothebys NY 2/25/75: 47 (lot, N-1 et al)(note), 170
    (books, N-8 et al);
Sothebys NY 9/23/75: 169 ill, 170 ill;
California Galleries 9/26/75: 173 (book, N et al);
California Galleries 9/27/75: 320 (4);
Colnaghi Lon 1976: 260 (5 ills)(album, 132);
Kingston Boston 1976: 166 ill(note), 553 (2 ills)
    (book, 8), 554 (book, N-2 et al);
Witkin NY IV 1976: OP290 (book, 8);
Gordon NY 5/3/76: 306 ill;
Sothebys Lon 6/11/76: 38a (album, N et al);
Christies Lon 10/28/76: 157 (album, N-9 et al), 195
    (lot, N-5 et al), 283 (book, 8);
Sothebys Lon 10/29/76: 51 (album, N et al), 59
    (albums, N et al), 60 (books, N-12 et al), 110
    ill(albums, N-7 attributed, et al), 124 (album,
    N-19 et al);
Swann NY 11/11/76: (books, 18), 352 (lot, N et al);
Gordon NY 11/13/76: 95 ill, 96 ill;
Halsted Michigan 1977: 707 ill;
Vermont Cat 11/12, 1977: 821 ill(3), 822 ill(2), 823
    ill(2);
White LA 1977: 263 ill(65), 264 (lot, N-16 et al),
    273 ill(album, 194), 274 (album, 120);
California Galleries 1/22/77: 208 (5);
California Galleries 1/23/77: 368 (lot, N et al);
Sothebys NY 2/9/77: 54 ill, 84, 85 (4);
Sothebys Lon 3/9/77: 25 (album, N et al), 27, 28
    (album, N-3 et al), 187 (album, N-19 et al), 196
    (albums, N et al);
Christies Lon 3/10/77: 167, 179 (album, N-1 et al),
    278 (16);
Swann NY 4/14/77: 266 (album, 245)(note), 187
    (book, N et al);
Christies Lon 6/30/77: 133 (lot, N et al), 134
    (album, N-2 et al);
Sothebys Lon 7/1/77: 10 (lot, N-4 et al);

**NOTMAN, W.** (continued)

Sothebys NY 10/4/77: 109 ill;
Christies Lon 10/27/77: 370 (albums, N et al), 372 (lot, N-1 et al);
Sothebys Lon 11/18/77: 14 (50), 93 (album, N et al), 247 ill(lot, N-3 et al);
Swann NY 12/8/77: 345 (N & Son, 4);
Frontier AC, Texas 1978: 343 ill(30);
Lehr NY Vol 1:2, 1978: 33 ill;
Wood Conn Cat 42, 1978: 150 (book, 34);
California Galleries 1/21/78: 129 (lot, N et al), 382, 383;
Sothebys NY 2/5/78: 29 ill(note);
Sothebys LA 2/13/78: 49 (album, N-2 plus N attributed, et al);
Christies Lon 3/16/78: 175 (lot, N et al);
Swann NY 4/20/78: 167 ill(book, 30)(note);
Christies Lon 6/27/78: 145 (album, N-3 et al);
Sothebys Lon 6/28/78: 128 ill(album, N & Fraser, 83);
Christies Lon 10/26/78: 186 (album, N-19 et al), 190 (album, N-18 et al), 193 (album, N-6 et al), 329 (album, N-9 et al), 335 (lot, N et al), 378 (album, N-18 et al), 387 (album, N-1 et al);
Phillips NY 11/4/78: 96 ill(attributed)(note), 97 ill(4), 98 (4), 99 ill(4)(note), 100 (books, 18);
Swann NY 12/14/78: 436 (album, N-6 et al);
Lehr NY Vol 1:4, 1979: 45 ill(book, 14)(note);
Witkin NY IX 1979: 2/60 (book, 8);
California Galleries 1/21/79: 146 (book, 30), 147 (book, 5);
Sothebys Lon 3/14/79: 377 (album, N-1 et al);
Christies Lon 3/15/79: 176 (note), 190 (album, N-6 et al), 224 (book, 14);
Swann NY 4/26/79: 326 (album, 200), 419 (note), 420 ill(2)(note), 448 (7)(note);
Christies NY 5/4/79: 113 ill;
Christies Lon 6/28/79: 115 (lot, N et al), 218 (album, N-1 et al), 224 (albums, N-3 et al), 230 (lot, N-1 et al);
Phillips Can 10/4/79: 42 (lot, N-2 et al), 54 (lot, N et al) 55 ill(album, N-18 et al), 56 ill (album, N-16 et al), 58 (lot, N-6 et al)(note), 59 ill, 60, 61 (2)(attributed), 62 ill(24, plus 4 attributed)(note), 63 (3)(note), 64 (2), 65 ill (2), 66 (4), 67 (3), 68 (13)(note), 69 (album, N-20 et al), 70 (lot, N-4 et al), 71 (books, 40), 73 (book, 8), 76 ill(lot, N-2 et al);
Swann NY 10/18/79: 285, 387, 388 ill(note);
Sothebys Lon 10/24/79: 175 (album, N et al), 182 ill (album, N et al), 262 (book, 47);
Christies Lon 10/25/79: 222 ill(4), 224 (lot, N-3 et al), 225 (lot, N-4 et al);
Christies NY 10/31/79: 134 (attributed);
Sothebys NY 11/2/79: 316 ill(album, N et al);
Phillips NY 11/29/79: 246 (album, N et al), 248 (4);
Sothebys LA 2/6/80: 16 ill(5);
Christies Lon 3/20/80: 193 (2)(attributed), 195 (16), 200 (album, N attributed, et al);
Sothebys Lon 3/21/80: 185 (album, N et al), 235 (album, N et al);
Swann NY 4/17/80: 229 (album, N-2 et al), 282 (2) (note), 283 ill(2)(note), 344 (lot, N et al);
Christies NY 5/14/80: 234 (book, 8);
Christies NY 5/16/80: 327 ill(album, N et al), 328 (lot, N et al);
Phillips NY 5/21/80: 37 (books, N-28 et al);
Christies Lon 6/26/80: 96 (15), 116 (lot, N-5 et al), 250 (4), 485 (albums, N et al);
Phillips Can 10/9/80: 44 (album, N & Fraser et al), 47 ill(books, 71)(note), 48 ill(album, N-52 et

**NOTMAN, W.** (continued)

al)(note), 49 ill(album, N-13 et al)(note), 50 (10), 51 (5), 52 (note), 53 (book, 11);
Sothebys Lon 10/29/80: 111 ill(album, N et al);
Christies Lon 10/30/80: 136 (lot, N-2 et al), 269 (albums, N-10 et al), 405 (album, N et al);
Swann NY 11/6/80: 335 (lot, N-2 et al);
Christies NY 11/11/80: 178 ill(album, 83), 179 (album, 113), 180:
Sothebys Lon 3/27/81: 71 (lot, N et al), 393;
Swann NY 4/23/81: 154 (book, 8), 159 (books, N et al), 523 (lot, N et al);
Christies Lon 6/18/81: 229 (lot, N-33 et al), 421 (albums, N-2 et al), 423 (album, N et al);
Harris Baltimore 7/31/81: 299 (lot, N-7 et al);
Sothebys Lon 10/28/81: 100 ill(album, 20);
Christies Lon 10/29/81: 149 (lot, N et al), 385 (album, N et al);
Swann NY 11/5/81: 167 ill(book, 30)(note);
Wood Conn Cat 49, 1982: 317 (book, 15)(note);
Phillips NY 2/9/82: 193 (book, 30);
Christies Lon 3/11/82: 218 (5), 221 (lot, N-33 et al);
Sothebys Lon 3/15/82: 229 (albums, N et al), 428 (book, 8);
Harris Baltimore 3/26/82: 217 (2);
Swann NY 4/1/82: 162 (book, 30)(note);
California Galleries 5/23/82: 110 (book, 30), 288;
Sothebys NY 5/24/82: 278 ill(attributed);
Christies Lon 6/24/82: 222;
Sothebys Lon 6/25/82: 2 (lot, N-4 et al);
Christies Lon 10/28/82: 113;
Swann NY 11/18/82: 175 (book, 30)(note), 316 (lot, N-1 et al)(note), 427 (10)(note);
Harris Baltimore 12/10/82: 363 (lot, N-1 et al);
Christies NY 2/8/83: 27, 40 (lot, N-1 et al);
Christies Lon 3/24/83: 135 (album, N et al), 136 (album, N et al), 142 (album, N et al), 235 ill;
Harris Baltimore 4/8/83: 15 (lot, N et al), 315 (lot, N & Fraser-1, et al);
Christies NY 10/4/83: 111 (lot, N-4 et al);
Christies Lon 10/27/83: 44 (album, N-25 et al), 146 (album, N et al), 152 (lot, N et al), 154 (album, N-2 et al);
Swann NY 11/10/83: 320 (N & Son, 16);
Harris Baltimore 12/16/83: 21 (lot, N-10 et al);
Christies Lon 3/29/84: 18 (lot, N-13 et al), 83 (lot, N-4 et al), 337 (album, N et al), 348 (album, N et al);
Harris Baltimore 6/1/84: 18 (lot, N-1 et al), 277, 278;
Christies Lon 6/28/84: 37a (lot, N et al), 141 (album, N et al), 315 (album, N et al);
Sothebys Lon 6/29/84: 2 (lot, N et al), 92 (album, N et al);
California Galleries 7/1/84: 105 (book, 1), 198 (lot, N et al), 334 (2), 576 (2);
Phillips Lon 10/24/84: 123 (lot, N-1 et al);
Christies NY 2/13/85: 165 (4, plus 1 attributed);
Harris Baltimore 3/15/85: 18 (lot, N et al), 291 (2);
Phillips Lon 3/27/85: 180 (albums, N-4 et al);
Christies Lon 3/28/85: 45 (lot, N et al), 79 (album, N-9 et al), 324 (album, N et al);
Sothebys Lon 3/29/85: 230 (book, 46);
Swann NY 5/9/85: 265 (book, 48)(note);
Phillips Lon 6/26/85: 134 (lot, N-15 et al), 157 (lot, N et al);
Christies Lon 6/27/85: 39 (lot, N-1 et al);
Sothebys Lon 6/28/85: 35 (lot, N et al);
Phillips Lon 10/30/85: 32 (lot, N-1 et al);

**NOTMAN, W.** (continued)
Christies Lon 10/31/85: 138 (album, N-4 et al), 300
    (album, N-30 et al);
Sothebys NY 11/12/85: 303;
Swann NY 11/14/85: 135 (album, N et al), 136
    (album, N et al), 168 (lot, N et al), 262 (book,
    N et al), 263 (books, N et al);
Harris Baltimore 2/14/86: 5 (lot, N-5 et al);
Christies Lon 4/24/86: 395 (album, N et al);
Sothebys Lon 4/25/86: 20 (lot, N et al);
Swann NY 5/15/86: 131 (book, N et al)(note);
Phillips Lon 10/29/86: 312 (album, N et al), 319
    (albums, N et al), 376 (lot, N-1 et al);
Christies Lon 10/30/86: 153 (albums, N et al);
Sothebys Lon 10/31/86: 14 (albums, N et al);
Swann NY 11/13/86: 256 (lot, N et al), 289 (note);

**NOTT, J. Fortune** (British)
Photos dated: 1886
Processes:      Phototype
Formats:        Prints
Subjects:       Genre (animal life)
Locations:
Studio:
    Entries:
Christies Lon 3/10/77: 340 (book, 35);
Christies Lon 10/29/81: 292 (book);

**NOTTAGE, Charles G.** (photographer or author?)
Photos dated: 1894
Processes:      Photomezzotint
Formats:        Prints
Subjects:       Topography
Locations:      US - Hawaii; California,;New Mexico
Studio:
    Entries:
Swann NY 2/14/52: 253 (book, 30);

**NOVERRE, W.L.** (British)
Photos dated: 1860s
Processes:      Albumen
Formats:        Prints
Subjects:
Locations:
Studio:         Great Britain (Amateur Photographic
                Association)
    Entries:
Christies Lon 10/27/83: 218 (albums, N-1 et al);

**NOWACK, M.** (American)
Photos dated: 1870s-1880s
Processes:      Albumen
Formats:        Stereos
Subjects:       Topography
Locations:      US - Minnesota
Studio:         US - Minneapolis, Minnesota
    Entries:
Harris Baltimore 44/8/83: 57 (lot, N et al);
Harris Baltimore 6/1/84: 93 (lot, N et al);

**NOWELL, F.A.** (American)
Photos dated: Nineteenth century
Processes:      Albumen
Formats:        Stereos
Subjects:       Topography
Locations:      US - Charleston, South Carolina
Studio:         US
    Entries:
Sothebys NY (Strober Coll.) 2/7/70: 486 (lot,
    N et al);
Harris Baltimore 12/10/82: 13 (lot, N-1 et al);

**NUMA BLANC** (French)(see also BLANC, NUMA)
Photos dated: 1870s
Processes:      Woodburytype
Formats:        Prints
Subjects:       Portraits incl. Galerie Contemporaine
Locations:      Studio
Studio:         France
    Entries:
Maggs Paris 1939: 518 (note);
Rauch Geneva 12/24/58: 239;
Christies Lon 6/26/78: 239 (album, N et al);
Swann NY 5/9/85: 331 (lot, N et al);

**NUMA Fils** (French)
Photos dated: 1870s
Processes:      Albumen
Formats:        Cabinet cards
Subjects:       Portraits
Locations:      Studio
Studio:         France
    Entries:
Swann NY 11/11/76: 349 (lot, N et al);
Christies NY 5/14/81: 41 (books, N-1 et al);
Bievres France 2/6/83: 132 (album, N-1 et al);
Swann NY 5/10/84: 223 (albums, N et al);

**NUNN, Major** (British)
Photos dated: 1860s
Processes:      Albumen
Formats:        Prints
Subjects:
Locations:
Studio:         Great Britain (Amateur Photographic
                Association)
    Entries:
Christies Lon 10/27/83: 218 (albums, N-5 et al);
Sothebys Lon 10/26/84: 108 (lot, N-5 et al);

**NYBLIN, R.**
Photos dated: 1880s-1896
Processes:      Albumen
Formats:        Prints, cabinet cards
Subjects:       Topography, portraits
Locations:      Europe
Studio:         Europe
    Entries:
Maggs Paris 1939: 536;
Christies Lon 10/27/83: 84 (albums, N et al);

**OAKES, Captain** (British)
Photos dated: 1870s
Processes:      Albumen
Formats:        Prints
Subjects:       Ethnography
Locations:      India
Studio:
   Entries:
Sothebys Lon 10/18/74: 80 (book, O et al);
Sothebys Lon 7/1/77: 56 (books, O et al);
Christies Lon 3/11/82: 252 (books, O et al);

**OAKLEY, A.** (American)
Photos dated: 1870s
Processes:      Albumen
Formats:        Stereos
Subjects:       Topography
Locations:      US
Studio:         US
   Entries:
Harris Baltimore 5/28/82: 161 (lot, O et al);

**OATES, W.E.**
Photos dated: 1880s and/or 1890s
Processes:      Albumen
Formats:        Prints
Subjects:       Portraits
Locations:      England; South Africa
Studio:
   Entries:
Christies Lon 3/26/81: 274 (album, O et al), 275
   ill(album, O et al)(note);
Christies Lon 6/18/81: 239 (album, O et al)(note);

**OBERMILLER**
Photos dated: Nineteenth century
Processes:      Albumen
Formats:        Cabinet cards
Subjects:       Portraits
Locations:
Studio:
   Entries:
Harris Baltimore 4/8/83: 382 (lot, O et al);

**OBERMULLER & KERN** (American)
Photos dated: c1885
Processes:      Albumen
Formats:        Prints
Subjects:       Portraits
Locations:      US - New York
Studio:         US - New york
   Entries:
Rinhart NY Cat 8, 1973: 97;

**O'DONALDSON, T.**
Photos dated: 1857
Processes:      Albumen
Formats:        Prints
Subjects:       Documentary (railroads)
Locations:
Studio:
   Entries:
Christies Lon 6/24/82: 113;

**OEHME**
Photos dated: 1870s and/or 1880s
Processes:      Albumen
Formats:        Prints
Subjects:       Topography
Locations:      India
Studio:
   Entries:
Christies Lon 6/28/84: 131 (album, O-4 et al);

**OGAWA, Kazumasa** (Japanese, 1860-1929)
Photos dated: 1880s-1918
Processes:      Collotype, photogravure
Formats:        Prints
Subjects:       Genre (still life), documentary
                (disasters)
Locations:      Japan; China - Peking
Studio:         Japan - Tokyo
   Entries:
Sothebys Lon 12/4/73: 244 (book);
Swann NY 4/1/76: 316 (book, 29);
White LA 1977: 278 (2 ills)(book, 40), 279 ill
   (book, 30);
Wood Conn Cat 42, 1978: 372 (book, O et al), 374
   (book, O et al);
Wood Conn Cat 45, 1979: 301 (book, 47)(note);
Swann NY 11/6/80: 147 (book, 40);
Christies Lon 10/30/80: 254 (book, O-10 et al);
Swann NY 11/6/80: 147 (book, 40);
Swann NY 4/23/81: 111 ill(book, O et al)(note);
Old Japan, England Cat 5, 1982: 16 ill(book, 30),
   29 ill(lot, O-1 et al)(note);
Swann NY 4/1/82: 170 (book, O et al)(note);
Sothebys NY 5/24/82: 280;
Christies Lon 6/24/82: 216 (book);
Swann NY 11/18/82: 185 ill(books, 29), 186 (book, O
   et al);
Swann NY 11/10/83: 125 ill(book, 166)(note);
Swann NY 5/10/84: 103 (book, 14), 104 (book, O et
   al), 105 (book, 23);
Old Japan, England Cat 8, 1985: 22 (book, 50);
Swann NY 5/9/85: 116 (book, 38);
Christies Lon 10/31/85: 112 (13), 135 (lot,
   O et al);
Swann NY 11/13/86: 84 (book, 14);

**OGLE, Thomas** (British)
Photos dated: 1850s-1871
Processes:      Albumen
Formats:        Prints, stereos
Subjects:       Topography, architecture
Locations:      England; Ireland; Scotland
Studio:         Great Britain
   Entries:
Goldschmidt Lon Cat 52, 1939: 230 (book, 13);
Weil Lon Cat 4, 1944(?): 235 (book, 13)(note);
Weil Lon Cat 7, 1945: 159 (book, 13)(note);
Weil Lon 1946: 122 (book, O et al);
Weil Lon Cat 14, 1949(?): 409 (book, 13)(note);
Swann NY 2/14/52: 301 (book, O-13 et al);
Sothebys NY 11/21/70: 26 (book, O et al);
Rinhart NY Cat 6, 1973: 429 (O & Edge);
Christies Lon 6/14/73: 199 (album, O et al);
Christies Lon 10/4/73: 103 (books, O-13 et al);
Sothebys Lon 12/4/73: 175 (books, O et al);
Vermont Cat 7, 1974: 753 (book, O et al), 762 ill
   (book, 13)(note), 763 ill(book, 8);
Witkin NY II 1974: 206 (book, O et al), 1245 (book,
   O-13 et al);

## OGLE (continued)

Sothebys Lon 3/8/74: 164 (book, O-13 et al);
Sothebys Lon 6/21/74: 150 (books, O et al);
Sothebys Lon 10/18/74: 254 (book, O et al), 258 (book, 12);
Edwards Lon 1975: 110 (book, O et al), 204 (book, 13), 205 (book, 8);
Stern Chicago 1975(?): 45 (book, 13)
Witkin NY III 1975: 679 (book, 13), 613 (book, O-13 et al);
Swann NY 2/6/75: 156 (book, O-12 et al);
Sothebys Lon 3/21/75: 316 (books, O et al);
Swann NY 9/18/75: 386 (book, O-12 et al);
California Galleries 9/26/75: 180 (book, O et al);
Witkin NY IV 1976: OP296 (book), 297 (book, 13);
Wood Conn Cat 37, 1976: 150 (book, 8);
Sothebys Lon 6/11/76: 158 (book, O et al);
Christies Lon 10/28/76: 275 (books, O et al), 276 (book, O et al), 277 (book, O-13 et al), 287 (book, 8);
Swann NY 11/11/76: 269 (book, O et al)(note);
Halsted Michigan 1977: 194 (book, O et al), 195 (book, O et al);
Vermont Cat 11/12, 1977: 29 (books, O et al);
California Galleries 1/22/77: 209 (book, 8);
Sothebys Lon 3/9/77: 162a (book, 8);
Christies Lon 6/30/77: 202 (book, 8);
Sothebys Lon 7/1/77: 22 (book, O et al), 34 (book, O et al), 37 (book, 13);
Christies Lon 10/27/77: 211 (book, O et al);
Sothebys Lon 11/18/77: 176 (book, O et al), 177 (book, O-13 et al), 179 (book, O et al), 182 (book, 13), 195 (books, O et al);
Swann NY 12/8/77: 134 (book, 13)(note);
Wood Conn Cat 42, 1978: 376 (book, 8);
Christies Lon 3/16/78: 202 (book, 13), 208 (book, O et al);
Swann NY 4/20/78: 139 (book, O-12 et al);
Christies Lon 6/27/78: 63 (lot, O et al), 159 (book, O et al);
Sothebys Lon 6/28/78: 18a (book, 13), 19 (book, O et al), 20 (book, O et al);
Christies Lon 10/26/78: 206 (book, O-13 et al), 207 (book, 13), 208 (book, O et al);
Witkin NY IX 1979: 2/41 (book, O-2 et al);
Wood Conn Cat 45, 1979: 141 (book, O et al);
California Galleries 1/21/79: 150 (book, 8);
Swann NY 4/26/79: 144 (book, 13)(note);
Christies Lon 6/28/79: 160 (book, O et al);
Sothebys Lon 10/24/79: 47 (book, 8);
Witkin NY X 1980: 52 ill(book, O-13 et al);
California Galleries 3/30/80: 85 (book, O et al);
Sothebys NY 5/20/80: 347 (books, O-13 et al);
Christies Lon 10/30/80: 291 (books, O-13 et al);
California Galleries 12/13/80: 100 ill(book, 13);
Phillips NY 1/29/81: 85 (book, O et al);
Sothebys Lon 6/17/81: 444 (book, O et al), 445 (book, O et al);
California Galleries 6/28/81: 95 (book, 10);
Sothebys Lon 3/15/82: 426 (books, O-8 et al), 436 (books, O et al);
Swann NY 11/18/82: 188 (book, 13), 189 (book, 13)(note);
Christies Lon 3/24/83: 146 (book);
Harris Baltimore 4/8/83: 195 (book, O et al);
Phillips Lon 11/4/83: 29 (books, O et al);
Christies Lon 6/28/84: 44 (albums, O & Edge, 230)(attributed), 152 (book, 8);
Sothebys Lon 6/29/84: 9 (lot, O & Edge et al);
California Galleries 7/1/84: 100A (book, 13);
Christies Lon 3/28/85: 42 (lot, O & Edge et al);

## OGLE (continued)

Sothebys Lon 3/29/85: 64 (lot, O & Edge et al);
Swann NY 5/9/85: 117 (book, 8);
Christies Lon 10/31/85: 147 (books, O-13 et al);
Wood Boston Cat 58, 1986: 322 (book, 13)(note);
Phillips Lon 4/23/86: 283 (book, 13);
Christies Lon 4/24/86: 350 (lot, O & Edge-5, et al), 351 (lot, O & Edge-9, et al);
Christies Lon 6/26/86: 175 (books, O et al);
Phillips Lon 10/29/86: 352 (book, 13);

## OKELY, H.G. (British)
Photos dated: 1870s
Processes: Albumen
Formats: Prints
Subjects: Topography
Locations: Norway
Studio: England - Isle of Wight
Entries:
Sothebys Lon 10/29/76: 118 (book, O et al);

## OLDEN, SAWYER & Co. (American)
Photos dated: c1860
Processes: Albumen
Formats: Prints
Subjects: Documentary (Civil War)
Locations: US
Studio: US
Entries:
Phillips NY 11/12/86: 148;

## OLDROYD, W.O.
Photos dated: 1870s
Processes: Albumen
Formats: Stereos
Subjects: Topography
Locations: US - American west
Studio: US
Entries:
Harris Baltimore 4/8/83: 21 (lot, O et al);
Harris Baltimore 12/16/83: 21 (lot, O et al);

## OLLIVER (American)
Photos dated: 1870s
Processes: Albumen
Formats: Cabinet cards
Subjects: Portraits
Locations: Studio
Studio: US - New York City
Entries:
Swann NY 4/17/80: 338 (note);
Christies Lon 10/25/79: 412 (lot, O-1 et al);

## OLLIVIER
Photos dated: 1850s
Processes: Daguerreotype
Formats: Plates
Subjects: Portraits
Locations:
Studio:
Entries:
Drouot Paris 11/22/86: 94;

O'NEIL (American)
Photos dated: Nineteenth century
Processes:      Albumen
Formats:        Cdvs, cabinet cards
Subjects:       Portraits
Locations:      Studio
Studio:         US
    Entries:
Sothebys NY 11/21/70: 328 (lot, O et al);
Harris Baltimore 9/16/83: 149 (lot, O et al), 162
   (2, attributed)(note);

ONGANIA, Ferdinando (Italian, 1842-1911)
              (photographer or publisher?)
Photos dated: 1870-1900
Processes:      Photogravure, heliogravure
Formats:        Prints
Subjects:       Topography, architecture
Locations:      Italy - Venice
Studio:         Italy - Venice
    Entries:
Sothebys Lon 12/4/73: 159 (14), 247 (book, 100);
Edwards Lon 1975: 674 ill(note);
Colnaghi Lon 1976: 232 (2 ills)(book, 100)(note);
Rose Boston Cat 1, 1976: 21 ill(note), 22 ill;
Sothebys NY 11/9/76: 49 ill(4)(note);
Rose Boston Cat 2, 1977: 64 ill(note), 65 ill, 66
   ill, 67 ill;
Sothebys NY 2/9/77: 27 ill(book, 100), 28 (8),
   29 (5);
Sothebys Lon 3/9/77: 162 (book, 50);
Christies Lon 3/10/77: 123 (4);
Gordon NY 5/10/77: 815 ill(book, 100);
Sothebys NY 5/20/77: 98 (51), 99 (8);
Sothebys NY 10/4/77: 222 (book, 100);
Christies Lon 10/27/77: 113 (4);
Swann NY 12/8/77: 135 (book, 260)(note), 136
ill(book, 100);
Rose Boston Cat 3, 1978: 52 ill(note), 53 ill, 54
   ill, 55 ill, 56 ill;
Wood Conn Cat 41, 1978: 122 ill(book, 100)(note),
   123 (book, 50);
Christies Lon 3/16/78: 83 (lot, O-1 et al);
Christies Lon 10/26/78: 332 (album, O-1 et al);
Phillips NY 11/4/78: 73 (4), 74 (4);
Swann NY 12/14/78: 187 (book, 100);
Rose Boston Cat 4, 1979: 52 ill(note), 53 ill;
Wood Conn Cat 45, 1979: 194 (book, 100)(note), 195
   (book, 100);
Sothebys LA 2/7/79: 448 (8);
Christies Lon 3/15/79: 122 (29);
Christies Lon 6/28/79: 105 (14);
Sothebys Lon 6/29/79: 273 (books, 200);
Sothebys NY 11/2/79: 206 (book, 50);
Rose Boston Cat 5, 1980: 63 ill(note), 64 ill,
   65 ill;
Sothebys Lon 3/21/80: 160 (book, 100);
California Galleries 3/30/80: 114 ill(book, 100);
Sothebys Lon 6/27/80: 87 (150);
Christies Lon 10/30/80: 203 (lot, O-12 et al), 316
   (books, O-50 et al);
Christies NY 11/11/80: 72;
Phillips NY 1/29/81: 115 (book, 260);
Christies Lon 3/26/81: 299 (book, 100);
Swann NY 4/23/81: 481 (9);
Phillips NY 5/9/81: 46 (books, 190);
Christies Lon 6/18/81: 265 (book, 50);
Rose Florida Cat 7, 1982: 66 ill(book, 50)(note);
Wood Conn Cat 49, 1982: 325 (book, 100);
Swann NY 4/1/82: 171 (book, 50);

ONGANIA (continued)
Swann NY 5/10/84: 106 (book, 76);
Christies Lon 6/24/82: 143 (17);
California Galleries 6/19/83: 90A (98);
Swann NY 11/10/83: 126 (100), 127 (100)(note);
Swann NY 11/8/84: 97 (book, 50);
Christies Lon 3/28/85: 119 (100);
Christies Lon 6/27/85: 108 (book, 50);
Swann NY 11/14/85: 255 (book, 100);
Wood Boston Cat 58, 1986: 323 (book, 100)(note);
Christies Lon 4/24/86: 423 (book, 100);
Sothebys Lon 10/31/86: 52 (book, 100);
Sothebys NY 11/10/86: 329 (lot, O-5 et al);

ON-QUA (Chinese)
Photos dated: 1870s
Processes:      Albumen
Formats:        Cdvs
Subjects:       Topography
Locations:      China
Studio:
    Entries:
Swann NY 11/8/84: 240 (lot, O-3 et al);

ON YA (see YA, ON)

OPPENHEIM, F.A. (German)
Photos dated: c1850-c1855
Processes:      Albumen
Formats:        Prints
Subjects:       Architecture, topography
Locations:      Germany - Brunswick; England
Studio:         Germany
    Entries:
California Galleries 9/26/75: 288;
California Galleries 4/2/76: 216;

OPPENHEIM, William George
Photos dated: c1894
Processes:      Photogravure
Formats:        Prints
Subjects:
Locations:
Studio:
    Entries:
California Galleries 5/23/82: 359;

OPPENHEIMER, Ben (American)
Photos dated: Nineteenth century
Processes:      Albumen
Formats:        Stereos
Subjects:       Topography
Locations:      US - American west
Studio:         US
    Entries:
Sothebys NY (Strober Coll.) 2/7/70: 508 (lot,
   O et al)(note);

ORD (British)
Photos dated: 1850s
Processes:      Ambrotype
Formats:        Plates
Subjects:       Portraits
Locations:      Studio
Studio:         England - Norwich
    Entries:
Sothebys Lon 3/14/79: 34;

O'REILLY
Photos dated: 1850s
Processes:      Ambrotype
Formats:        Plates
Subjects:       Portraits
Locations:
Studio:
    Entries:
Rauch Geneva 6/13/61: 112 (lot, 0-1 et al)(note);

ORLOV (Russian)
Photos dated: 1880s-1890s
Processes:      Albumen
Formats:        Prints
Subjects:       Topography
Locations:      Russia - Yalta and Alupka
Studio:         Russia - Yalta
    Entries:
Swann NY 5/5/83: 429 (albums, 0 et al);

OROLOGIO
Photos dated: 1870s-1890s
Processes:      Albumen
Formats:        Prints
Subjects:       Topography       •
Locations:
Studio:
    Entries:
Swann NY 12/8/77: 367 (lot, 0 et al);

ORR (see BARTON & ORR)

OSBON, C. (American)
Photos dated: 1870s
Processes:      Albumen
Formats:        Prints
Subjects:       Topography
Locations:      US - Grand Canyon
Studio:         US - Flagstaff, Arizona
    Entries:
Swann NY 4/14/77: 265 (14);

OSBORN & DUBEC (American)
Photos dated: 1861
Processes:      Albumen
Formats:        Stereos
Subjects:       Topography
Locations:      US - South Carolina
Studio:         US
    Entries:
Harris Baltimore 5/28/82: 154 (lot, 0 & D et al);

OSBORNE, J.W. (American)
Photos dated: 1867
Processes:      Photolithograph
Formats:        Prints
Subjects:
Locations:      US
Studio:         US
    Entries:
California Galleries 6/19/83: 93 (book, 0-1 et al);

OSGOOD, Horace C
Photos dated: 1889
Processes:      Albumen
Formats:        Prints
Subjects:       Topography
Locations:      Jamaica
Studio:
    Entries:
Wood Conn Cat 37, 1976: 151 (book, 100)(note);
Wood Conn Cat 42, 1978: 378 (book, 100)(note);

O'SHAUNESSY (see also JOHNSTONE)
Photos dated: 1880s
Processes:
Formats:        Prints
Subjects:       Topography
Locations:      Australia
Studio:
    Entries:
Christies Lon 10/30/86: 175 (album, 0 et al), 177
    (album, 0 et al);

OSTERHOUT, H. (American)
Photos dated: c1870
Processes:      Albumen
Formats:        Cabinet cards
Subjects:       Portraits
Locations:      Studio
Studio:         US - Middletown, Connecticut
    Entries:
Vermont Cat 1, 1971: 250 (lot, 0 et al);

O'SULLIVAN, Timothy (American, 1840-1882)
Photos dated: c1862-1875
Processes:      Salt, albumen
Formats:        Prints, stereos
Subjects:       Documentary (Civil War), topography,
                ethnography
Locations:      US - Civil War area and American
                west; Panama
Studio:         US
    Entries:
Sothebys NY (Strober Coll.) 2/7/70: 353 ill(7), 354
    (lot, 0 et al), 389 (lot, 0-1 et al), 390 (lot,
    0-3 et al), 391 (lot, 0-1 et al), 412 (lot, 0-1
    et al), 522 (lot, 0-4 et al), 553 (lot, 0 et al)
    (note), 555 (lot, 0-14 et al), 556 (20)(note),
    557 (lot, 0-6 et al), 560 (lot, 0 et al);
Sothebys NY 11/21/70: 192 ill(note), 193 ill, 195,
    196, 197, 198 ill, 199, 200 ill, 201 ill, 202,
    203 ill, 204 ill, 205 ill, 206 ill, 207 ill,
    208, 209, 210, 211 ill, 370 ill(4);
Rinhart NY Cat 2, 1971: 580 (5), 581, 582 (3);
Vermont Cat 1, 1971: 224, 531 ill(note), 532 ill;
Lunn DC Cat 3, 1973: 107 ill;

Rinhart NY Cat 6, 1973: 462 (note), 463, 464, 465
(note), 466, 469 (note), 537 (2), 538, 539 (3),
540 (3), 594 (note), 595 (note);
Witkin NY I 1973: 345, 346, 347, 348, 349, 350,
351, 352 ill, 353, 354, 355, 356, 357, 358, 359,
360, 361, 362, 363, 364, 365, 366, 367, 368 ill,
369, 370 (attributed);
Vermont Cat 8, 1974: 560 ill(note), 561 ill, 562,
ill, 563 ill, 564 ill, 565 ill, 566 ill
(attributed), 567 ill(attributed), 568 ill
(attributed), 569 ill(attributed);
Witkin NY II 1974: 1090 ill(attributed), 1091 ill
(attributed), 1103 ill(attributed), 1106 ill
(attributed), 1108 ill(attributed), 1125
(attributed), 1127 (attributed), 1128
(attributed);
Sothebys Lon 6/21/74: 162 (book, O et al);
Sothebys Lon 10/18/74: 137 (book, O et al);
Witkin NY III 1975: 191 ill(note), 192 ill, 193
ill, 362 ill, 363 ill(attributed), 364 ill, 365
ill, 366 ill, 367 ill, 368 ill;
Sothebys NY 2/25/75: 199 ill(note), 200, 201;
Sothebys Lon 6/26/75: 14 ill(lot, O-85 et al);
Sothebys NY 9/23/75: 124 ill, 125 ill;
California Galleries 9/27/75: 322;
Sothebys Lon 10/24/75: 139 ill(54)(note);
Colnaghi Lon 1976: 246 ill(note), 247 ill, 248 ill,
249;
Lunn DC Cat 6, 1976: 49.9 ill, 49.10, 49.11, 49.12
ill, 49.13, 49.14, 49.18 ill, 49.19, 51.1 ill
(note), 51.2 ill, 51.3, 51.4 ill, 51.5;
Gordon NY 5/3/76: 310 ill;
Sothebys NY 11/9/76: 79 (note), 80, 90 (note), 91
ill, 92, 93 (note), 94;
Swann NY 11/11/76: 457, 459;
Gordon NY 11/13/76: 71 ill, 72 ill, 73 ill, 74 ill,
75 ill, 76 ill, 77 ill;
Halsted Michigan 1977: 708, 709, 710;
Vermont Cat 11/12, 1977: 824 ill;
Sothebys NY 2/9/77: 67 (note), 68 ill(note), 70
(note), 73 (note), 74 ill, 75, 76, 77 (note);
Swann NY 4/14/77: 25A (book, O et al);
Christies Lon 6/30/77: 131 ill;
Sothebys NY 10/4/77: 4 ill(2)(note), 5 (2), 6 (2),
7 ill(lot, O-1 et al), 31 ill(3)(note), 32 ill(3)
(note), 33 (3), 34 (3), 35 ill(2)(note), 36 (3),
37 (2), 38 ill(2), 39 (2), 40 (2), 41 ill, 42
(2 ills)(book, 25)(note), 43 (2)(note), 44 (2),
45, 46 ill, 47 ill;
Swann NY 12/8/77: 277 (note);
Frontier AC, Texas 1978: 88 (lot, O-1 et al);
Lehr NY Vol 1:2, 1978: 34 ill, 35 ill;
Lunn DC Cat QP 1978: 28 (note);
Rose Boston Cat 3, 1978: 12 ill(note), 13 ill,
14 ill;
Witkin NY VI 1978: 99 ill;
Wood Conn Cat 41, 1978: 129 ill(book, O-45 et al)
(note), 152 ill(note), 153 ill, 154 ill, 155,
156, 157, 158 (note), 159, 160, 161, 162 ill,
163, 164, 165 (note), 166, 167, 168, 169 ill,
170, 171 ill, 178 (2 ills)(lot, O et al)(note);
California Galleries 1/21/78: 384;
Christies Lon 3/16/78: 130 ill;
Swann NY 4/20/78: 283 (2 ills)(album, O attributed
et al)(note);
Sothebys NY 5/2/78: 10 (2), 11 (2 ills)(book, 25)
(note);
Phillips NY 11/4/78: 84 ill(note), 85, 86 ill, 87
(note);
Swann NY 12/14/78: 438 (note);

Lehr NY Vol 2:2, 1979: 24 ill, 25 ill, 26 ill,
27 ill;
Witkin NY VIII 1979: 64 (2 ills)(2);
Wood Conn Cat 45, 1979: 113 (book, O-45 et al)
(note);
Sothebys LA 2/7/79: 407 ill, 408 ill, 409, 410 ill,
411 ill(14)(note);
Sothebys Lon 3/14/79: 360 ill(2)(note), 361 (2),
362 (2), 363 ill(2), 364 ill(2), 365 ill, 366
ill, 367 (2);
Christies NY 5/4/79: 92 ill, 93, 94, 95 ill (note),
96, 97 ill, 98, 99;
Phillips NY 5/5/79: 193 ill;
Sothebys NY 5/8/79: 11 ill, 12, 13 ill, 14, 15 ill;
Swann NY 10/18/79: 423 ill(4);
Sothebys Lon 10/24/79: 185 ill, 186 (2), 187 ill,
188 ill;
Christies Lon 10/25/79: 229 (note), 230;
Christies NY 10/31/79: 63 (3 ills)(3), 75 ill (7),
76 ill (7), 77 ill, 78 (2), 79;
Sothebys NY 11/2/79: 286 ill, 287 ill, 288;
Phillips NY 11/3/79: 203 ill, 204;
Sothebys LA 2/6/80: 18 ill, 19 ill, 20 ill, 21, 22,
23 ill;
California Galleries 3/30/80: 407 (5);
Christies NY 5/16/80: 233 ill(6)(note), 258 ill,
259 ill, 260, 261, 262, 263;
Sothebys NY 5/20/80: 287 ill, 288, 289;
Phillips NY 5/21/80: 256 (note), 257 ill(note),
258 (2);
Christies Lon 6/26/80: 259, 260;
Swann NY 11/6/80: 87 (book, O et al), 263;
Christies NY 11/11/80: 115 ill(5)(attributed)
(note), 122 (2)(note), 123 (2)(attributed)
(note), 127 ill, 134, 135 (2), 136 (2), 137 (2);
Sothebys NY 11/17/80: 113 ill, 114 ill, 115 (2);
California Galleries 12/13/80: 326 (3);
Sothebys LA 2/5/81: 357 ill, 358 ill;
Swann NY 4/23/81: 362 ill(27)(note);
Phillips NY 5/9/81: 76 ill(note);
Christies Lon 10/29/81: 148 ill(45)(note);
Christies NY 11/10/81: 49 ill(note), 50 ill;
Sothebys LA 2/17/82: 298 ill(note), 299 ill, 300
ill, 301 ill(2);
Sothebys NY 5/24/82: 281 ill;
Sothebys NY 5/25/82: 464 ill(note), 465 ill(note),
466 ill(note), 467 ill;
Christies NY 5/26/82: 38 ill, 39 ill;
Harris Baltimore 5/28/82: 40, 46, 49, 52, 55, 56,
57, 58, 61, 83 (attributed), 88 (lot, O-1 et
al), 89 (attributed), 93, 94 ill, 95, 96, 97,
98, 99 (attributed), 100, 101, 102, 103, 104, 144
(attributed)(note), 162 (2), 179 (4, attributed),
180 (3, attributed), 198 ill(3), 199 ill(3), 200
(5, attributed), 201 (3), 202 (4, attributed);
Phillips NY 9/30/82: 1016 (note);
Phillips NY 11/9/82: 218 ill;
Sothebys NY 11/10/82: 317 ill, 318 ill(note), 319
ill(note), 320 ill(2);
Swann NY 11/18/82: 450 ill(13)(note);
Harris Baltimore 12/10/82: 302, 303, 304 (3), 305
(attributed);
Christies NY 2/8/83: 20 (2), 21;
Harris Baltimore 4/8/83: 359, 367, 368, 369;
Swann NY 5/5/83: 107 (book, O et al)(note);
California Galleries 6/19/83: 355, 356, 454 (lot,
O-2 et al);
Harris Baltimore 9/16/83: 3, 22, 29, 30, 31, 32,
33, 34, 35, 36, 39, 40, 42, 43, 44, 45, 46 ill,
51, 52, 53, 54, 56, 57, 58, 61, 63, 65, 68, 71,

O'SULLIVAN (continued)
72, 73, 74, 75, 84, 85, 86, 192, 193
(attributed), 194 (note), 204 (lot, O-1
attributed et al);
Christies NY 10/4/83: 93, 94;
Christies NY 11/8/83: 151 ill, 152 ill(note);
Sothebys NY 11/9/83: 224 ill(note);
Harris Baltimore 12/16/83: 346, 347 (3), 348, 349
(lot, O-1 et al), 350 (lot, O-1 et al), 352
(lot, O-1 et al), 353, 354, 399 (note);
Christies NY 2/22/84: 26, 27;
Christies NY 5/7/84: 26 ill(3);
Sothebys NY 5/8/84: 155 ill(book, O et al)(note);
Swann NY 5/10/84: 52 (book, O et al)(note);
Harris Baltimore 6/1/84: 332, 363, 365, 366, 370;
California Galleries 7/1/84: 417, 418, 593
(attributed);
Harris Baltimore 11/9/84: 11 ill, 12, 13 ill, 14,
16, 17, 19, 20, 22, 25, 29, 50 (attributed), 63
(5, attributed), 68 (lot, O-1 et al), 71 ill, 72
(4), 73, 74, 75 ill, 76, 77 (attributed), 78
ill, 79, 80 (attributed), 81 (9), 96 (8), 97, 98
ill(attributed);
Christies NY 2/13/85: 159 (4), 160 (5);
Harris Baltimore 3/15/85: 227 (8);
Christies Lon 3/28/85: 220 (5 ills)(album, O-23 et
al)(note);
Sothebys NY 5/7/85: 264 ill, 265 ill;
Sothebys Lon 5/8/85: 576 ill;
Swann NY 5/9/85: 416, 443 ill(lot, O-6 et al)(note);
California Galleries 6/8/85: 365, 366 ill, 367,
368, 369, 370;
Harris Baltimore 9/27/85: 9, 18 (note), 19 (note),
20, 21 ill, 22 (2)(note), 23 (5)(note), 24 (3)
(note), 25 (2)(note), 26 (note), 27
(attributed), 79;
Christies Lon 10/31/85: 216 (2 ills)(album, O-35 et
al)(note), 217 (2);
Sothebys NY 11/12/85: 304 ill(album, O-23 et al)
(note), 305 ill(3);
Swann NY 11/14/85: 256 (book, O et al)(note);
Harris Baltimore 2/14/86: 8 (lot, O et al), 9 (lot,
O-6 et al), 10 (9), 11 (lot, O-1 et al);
California Galleries 3/29/86: 764, 765, 766, 767,
768;
Sothebys NY 5/12/86: 405 (lot, O-7 et al);
Christies NY 5/13/86: 294 ill(lot, O-2 et al);
Phillips NY 7/2/86: 343, 344, 345 (3), 346, 347
ill, 348, 349;
Harris Baltimore 11/7/86: 92, 93, 100 ill, 103, 108
(attributed);
Christies NY 11/11/86: 314 ill(note), 315 ill;
Phillips NY 11/12/86: 150;
Swann NY 11/13/86: 292 (note), 293 ill(note), 331
(lot, O-8 et al);
Drouot Paris 11/22/86: 128 ill;

OSWALD (see McKECKNIE & OSWALD) [OSWALD 1]

OSWALD (see NORTH & OSWALD) [OSWALD 2]

OTTINGER, Gerorge Martin (see SAVAGE, C.R.)

OTTO (American) [OTTO 1]
Photos dated: 1875-1880
Processes:      Albumen
Formats:        Cdvs
Subjects:       Portraits
Locations:      Studio
Studio:         US - San Francisco, California
  Entries:
California Galleries 1/21/79: 232 (lot, O et al);

OTTO (French) [OTTO 2]
Photos dated: 1875-c1900
Processes:      Albumen
Formats:        Prints
Subjects:       Portraits
Locations:      Studio
Studio:         France
  Entries:
Rauch Geneva 6/13/61: 160 ill;
Drouot Paris 11/22/86: 129 ill, 130 ill;

OUTLEY, J.J. (American)
Photos dated: 1859
Processes:      Ambrotype
Formats:        Plates
Subjects:       Portraits
Locations:      Studio
Studio:         US - St. Louis, Missouri
  Entries:
Vermont Cat 11/12, 1977: 689 ill;

OUTON, C.
Photos dated: Nineteenth century
Processes:      Albumen
Formats:        Cdvs
Subjects:       Portraits
Locations:      Studio
Studio:         Landport
  Entries:
Christies Lon 6/26/80: 505 (lot, O et al);

OVERBECK, Fr.
Photos dated: 1878
Processes:      Autotype
Formats:        Prints
Subjects:
Locations:      Great Britain
Studio:
  Entries:
Swann NY 2/6/75: 155 (books, O-12 et al);

OWEN, Sir Hugh (British, 1804-1881)
Photos dated: 1847-1852
Processes:      Talbotype (Reading Establishment),
                calotype
Formats:        Prints
Subjects:       Documentary (public events),
                topography
Locations:      England; India; Portugal
Studio:         England
  Entries:
Ricketts Lon 1974: 15 ill(albums, O & Ferrier, 154);
Sothebys Lon 10/29/76: 47 ill(album, O et al)(note);
Wood Conn Cat 41, 1978: 29 ill (books, O et al)
(note);
Wood Conn Cat 45, 1979: 124 (books, O et al)(note);

OWEN, H. (continued)
Sothebys Lon 3/14/79: 263 ill;
Sothebys Lon 3/21/80: 213 ill(books, O & Ferrier,
    154)(note), 214 ill(O & Ferrier), 215 ill(O &
    Ferrier), 216 (O & Ferrier), 217 (O & Ferrier),
    218 ill(O & Ferrier), 219 ill(O & Ferrier);
Sothebys Lon 6/27/80: 138 ill(O & Ferrier), 139
    (O & Ferrier), 140 ill(O & Ferrier), 141 ill
    (O & Ferrier), 142 ill(O & Ferrier), 143 ill
    (O & Ferrier);
Sothebys Lon 10/29/80: 179 ill(O & Ferrier, 2), 180
    ill(O & Ferrier), 181 ill(O & Ferrier), 182 ill
    (O & Ferrier), 183 (O & Ferrier), 184 (O &
    Ferrier);
Sothebys Lon 3/27/81: 155 ill(O & Ferrier)(note),
    156 ill(O & Ferrier), 157 ill(O & Ferrier), 158
    (O & Ferrier), 159 (O & Ferrier), 160 (O &
    Ferrier);
Sothebys Lon 6/17/81: 101 (O & Ferrier), 102 ill(O &
    Ferrier), 103 ill(O & Ferrier), 104 ill(O &
    Ferrier), 105 (O & Ferrier);
Christies Lon 3/11/82: 108 ill(O & Ferrier);
Sothebys Lon 3/15/82: 187 ill(O & Ferrier)(note),
    188 ill(O & Ferrier), 189 ill(O & Ferrier), 190
    ill(O & Ferrier), 191 (O & Ferrier);
Christies Lon 6/24/82: 288 ill(book, O & Ferrier,
    154)(note);
Sothebys Lon 10/29/82: 69 (O & Ferrier, 4)(note), 70
    (O & Ferrier, 5)(note), 71 (lot, O-2 plus 1
    attributed, et al);
Sothebys Lon 3/25/83: 108 (O & Ferrier, 4);
Christies NY 10/4/83: 76;
Sothebys Lon 6/29/84: 143 ill(note), 144 ill, 145
    ill, 146 ill(attributed);
Sothebys Lon 11/1/85: 55 ill(O & Ferrier);
Phillips NY 11/12/86: 151 ill(O & Ferrier);

OWLSLEY, H.B.
Photos dated: c1895
Processes:      Photogravure
Formats:        Prints
Subjects:       Portraits
Locations:
Studio:
    Entries:
California Galleries 3/30/80: 357 (lot, O-1 et al);

**P., A.** [A.P.] (British)
Photos dated: 1870s-1880
Processes:      Albumen
Formats:        Prints
Subjects:       Topography
Locations:      England - Lake District
Studio:         Great Britain
    Entries:
Sothebys Lon 10/24/79: 137 (lot, P et al);
Sothebys Lon 3/15/82: 156 (12);
Christies Lon 6/26/86: 137 (albums, P et al);

**P., C.** [C.P.] (French)
Photos dated: 1870s and/or 1880s
Processes:      Albumen
Formats:        Stereos
Subjects:       Topography
Locations:      France - Paris
Studio:         France
    Entries:
California Galleries 4/3/76: 448 (lot, P et al);
California Galleries 1/21/78: 188 (lot, P et al);

**P., C.W.** [W.C.P.]
Photos dated: 1853
Processes:      Daguerreotype
Formats:        Stereo plates
Subjects:       Genre (still life)
Locations:
Studio:
    Entries:
Swann NY 11/18/82: 306;

**P., H.** [H.P.] (possibly POLLOCK, Henry, q.v.)
Photos dated: 1850s-1856
Processes:      Salt
Formats:        Prints, stereos
Subjects:       Topography
Locations:      France - Paris; England
Studio:         Great Britain
    Entries:
Sothebys Lon 5/24/73: 14 (album, P et al);
Christies Lon 3/15/79: 76 (lot, P et al);
Christies Lon 3/24/83: 38 (lot, P et al);

**P., J.** [J.P.]
Photos dated: 1880s-1890s
Processes:      Albumen
Formats:        Prints, documentary (public events)
Subjects:       Topography
Locations:      Europe; Australia; India
Studio:         Europe
    Entries:
California Galleries 1/22/77: 269 (2);
Christies Lon 10/30/80: 192 (album, P et al);
Phillips NY 5/9/81: 69 (albums, P-26 et al);
Christies Lon 3/29/84: 77 (album, P et al);
Christies Lon 10/25/84: 105 (album, P et al);
Christies Lon 3/28/85: 77 (lot, P et al);
Christies Lon 6/26/86: 54 (album, P et al);

**P., J.E.** [J.E.P.]
Photos dated: 1860s
Processes:      Ambrotype
Formats:        Plates
Subjects:       Architecture
Locations:      England - Wells
Studio:
    Entries:
Christies Lon 10/29/81: 82 (lot, P-1 et al);

**P., L.** [P.L.]
Photos dated: 1880s
Processes:      Albumen
Formats:        Prints
Subjects:       Topography
Locations:      France - Paris; Italy
Studio:         France
    Entries:
Christies Lon 10/25/79: 132 (lot, P et al);
California Galleries 12/13/80: 252 (lot, P-3 et al);
Christies Lon 3/26/81: 268 (lot, P et al);
Phillips NY 5/9/81: 28 (albums, P et al);
California Galleries 6/28/81: 155 (album, P et al);
California Galleries 7/1/84: 402 (lot, P et al);
Swann NY 11/8/84: 201 (albums, P et al);
Christies Lon 6/27/85: 249 (album, P-4 et al);
Swann NY 11/14/85: 82 (lot, P et al);
Swann NY 5/15/86: 233 (lot, P et al);
Harris Baltimore 11/7/86: 260 (lot, L et al);
Swann NY 11/13/86: 218 (lot, P et al);

**P., L.S.&** [L.S. & P.] (British)
Photos dated: c1880
Processes:      Platinum
Formats:        Prints
Subjects:       Topography
Locations:      England - Canterbury
Studio:         Great Britain
    Entries:
California Galleries 4/2/76: 145 ill(album,
    P-17 et al);

**P., M.** [M.P.]
Photos dated: c1870s
Processes:      Albumen
Formats:        Prints
Subjects:       Topography
Locations:      Albania - Cettinje
Studio:
    Entries:
Christies Lon 10/25/84: 100 (album, P-1 et al);

**P., P. & Co.** [P.P.Co.]
Photos dated: Nineteenth century
Processes:
Formats:        Prints
Subjects:       Portraits
Locations:
Studio:
    Entries:
Phillips NY 5/21/80: 246 (lot, P-1 et al);

**PACAULT, M.** (French)
Photos dated: c1870
Processes:     Albumen, collotype
Formats:      Prints
Subjects:     Topography, documentary (engineering)
Locations:    France - Pau
Studio:       France - Pau
   Entries:
California Galleries 1/22/77: 300 (lot, P-1 et al);
Sothebys LA 2/13/78: 121 (books, P et al)(note);

**PACH, G.W. & Brothers** (American)
Photos dated: 1866-c1885
Processes:     Albumen, photogravure
Formats:      Prints, stereos, cabinet cards
Subjects:     Portraits, documentary (educational
              institutions, engineering)
Locations:    US - New York City and West Point,
              New York; New Jersey
Studio:       US - New York City
   Entries:
Sothebys NY (Strober Coll.) 2/7/70: 449 (lot,
   P et al), 463 (lot, P et al), 531 (lot, P et al);
Rinhart NY Cat 7, 1973: 87 (book, P-1 et al), 558,
   559;
Witkin NY III 1975: 138 (lot, P-2 et al);
Swann NY 2/6/75: 206 (album, 348);
Swann NY 9/18/75: 285 (album, 55);
Rose Boston Cat 1, 1976: 5 ill(note);
Swann NY 4/1/76: 253 (35);
Swann NY 11/11/76: 362 (lot, P et al), 432 (note);
Swann NY 4/14/77: 267 ill(album, 108);
Sothebys NY 5/20/77: 47 ill(9)(note);
Swann NY 12/8/77: 412 ill(book, 35);
Swann NY 4/20/78: 289 (album, 188), 290 (107);
Swann NY 12/14/78: 382 (album);
Sothebys Lon 3/14/79: 303 (album, 90);
Swann NY 4/26/79: 327 ill(album, 105)(note);
Phillips NY 5/5/79: 104 (lot, P et al);
Phillips NY 11/3/79: 130 (album, 101);
Phillips NY 11/29/79: 246 (album, P et al);
Christies NY 5/14/80: 378 (book, P et al);
Sothebys Lon 10/29/80: 269 (album, 90);
Harris Baltimore 7/31/81: 116 (lot, P et al);
Swann NY 11/5/81: 453 (album, 175);
Swann NY 11/18/82: 425 ill(album, 24);
Swann NY 5/5/83: 358 (4);
Harris Baltimore 9/16/83: 149 (lot, P et al), 151
   (lot, P et al), 152 (lot, P et al);
Swann NY 11/10/83: 354 (lot, P-1 et al);
Swann NY 5/10/84: 231 (lot, P et al), 279 (album,
   P et al);
Harris Baltimore 6/1/84: 305 ill;
Swann NY 11/8/84: 263;
Harris Baltimore 11/9/84: 110 (lot, P-1 et al);
Harris Baltimore 3/15/85: 115 (5), 246 (lot,
   P-1 et al);
Swann NY 11/14/85: 157 (lot, P et al);
Christies Lon 4/24/86: 340 (lot, P et al);
Harris Baltimore 11/7/86: 295 (lot, P-94 et al);
Swann NY 11/13/86: 202 (album, 33), 204 (album,
   P et al), 353 (lot, P-7 et al);

**PAGANORI, V.** (Italian)
Photos dated: c1870s-c1880
Processes:     Albumen
Formats:      Prints, cabinet cards
Subjects:     Topography
Locations:    Italy - Florence
Studio:       Italy - Florence
   Entries:
California Galleries 1/22/77: 171 (album, P et al);
Swann NY 12/8/77: 371 (album, P et al);
Christies NY 5/16/80: 185 (lot, P et al), 189 (lot,
   P et al);
California Galleries 12/13/80: 291 (4), 350 (lot,
   P et al);
Harris Baltimore 12/10/82: 399 (lot, P-1 et al);

**PAGE** (see WOODBURY, W.B.) [PAGE 1]

**PAGE & CHESSMAN** (American) [PAGE 2]
Photos dated: 1850s-c1860
Processes:     Daguerreotype, ambrotype
Formats:      Plates
Subjects:     Portraits
Locations:    Studio
Studio:       US - Cambridgeport, Massachusetts
   Entries:
California Galleries 4/2/76: 45 (lot, P & C-1
   et al), 65 (lot, P & C et al);
Gordon NY 5/3/76: 267 (lot, P & C et al);

**PAGE, William**
Photos dated: 1860s
Processes:     Albumen
Formats:      Prints
Subjects:
Locations:
Studio:       Great Britain (Amateur Photographic
              Association)
   Entries:
Christies Lon 10/27/83: 218 (albums, P-1 et al);

**PAGET, I.** (British)
Photos dated: 1860s
Processes:     Albumen
Formats:      Prints
Subjects:
Locations:
Studio:       Great Britain (Amateur Photographic
              Association)
   Entries:
Christies Lon 10/27/83: 218 (albums, P-1 et al);

**PAIER, C.**
Photos dated: 1870s
Processes:     Albumen
Formats:      Prints
Subjects:     Topography
Locations:    Egypt
Studio:
   Entries:
Christies Lon 10/31/85: 120 (album, P-1 et al);
Christies Lon 10/30/86: 134 (album, P-1 et al);

**PAIGE** (American)
Photos dated: 1870s
Processes:      Albumen
Formats:
Subjects:       Portraits
Locations:      Studio
Studio:         US - Buffalo, New York
   Entries:
Swann NY 11/6/80: 400 (lot, P-1 et al)(note);

**PAIN, Robert Tucker** (British)
Photos dated: 1863-1877
Processes:      Albumen
Formats:        Prints
Subjects:       Topography
Locations:      England
Studio:         England - Frimley
   Entries:
Sothebys Lon 3/21/80: 336 (note), 337 ill, 338 ill,
  339 ill, 340, 341;
Christies Lon 3/26/81: 143 ill(note);
Christies Lon 3/29/84: 205;
Sothebys Lon 4/25/86: 128 (2);

**PAINE, J.**
Photos dated: 1880s
Processes:      Albumen
Formats:        Prints
Subjects:       Topography
Locations:      Australia
Studio:
   Entries:
Christies Lon 10/29/81: 120 (album, P et al);

**PAINE, J.W.** (American)
Photos dated: 1870s
Processes:      Albumen
Formats:        Stereos
Subjects:       Topography
Locations:      US - Jackson, Michigan
Studio:         US
   Entries:
Rinhart NY Cat 1, 1971: 207 (3);
California Galleries 4/3/76: 400 (lot, P et al);

**PAIRE**
Photos dated: 1880s
Processes:      Albumen
Formats:        Prints
Subjects:       Topography
Locations:      Turkey - Constantinople
Studio:
   Entries:
Phillips NY 5/21/80: 235 (10);

**PALMER, A.H.** (American)
Photos dated: 1897
Processes:      Photogravure
Formats:        Prints
Subjects:       Portraits
Locations:      Studio
Studio:         US
   Entries:
Rinhart NY Cat 1, 1971: 503 (book, 1);

**PALMER, H.S.** (British)(see WILSON, C.W.)

**PALMER, J.A.** (American)
Photos dated: 1870s
Processes:      Albumen
Formats:        Stereos
Subjects:       Topography
Locations:      US - Aiken, South Carolina; Savannah,
             Georgia
Studio:         US - Aiken, South Carolina
   Entries:
Sothebys NY (Strober Coll.) 2/7/70: 526 (lot,
  P et al);
Rinhart NY Cat 6, 1973: 503;
Rinhart NY Cat 7, 1973: 338;
Phillips NY 5/5/79: 104 (lot, P et al);
Harris Baltimore 12/10/82: 92 (lot, P et al);
Christies Lon 6/23/83: 44 (lot, P et al);
Harris Baltimore 12/16/83: 14 (lot, P et al);
Christies Lon 6/28/84: 37a (lot, P et al);
Swann NY 11/14/85: 170 (lot, P et al);

**PALMER, William** (British)
Photos dated: 1860s
Processes:      Albumen
Formats:        Stereos
Subjects:       Topography
Locations:      Great Britain
Studio:         Great Britain - Lynton
   Entries:
California Galleries 9/27/75: 479 (lot, P et al);
Sothebys Lon 10/24/75: 71 (lot, P et al);
California Galleries 1/23/77: 384 (lot, P et al);
Christies Lon 6/26/80: 111 (lot, P-12 et al);
Christies Lon 3/26/81: 105 (lot, P-1 et al);
Harris Baltimore 7/31/81: 97 (lot, P et al);
Christies Lon 10/29/81: 137 (lot, P et al);
Christies Lon 3/11/82: 65 (lot, P et al);
Christies Lon 10/27/83: 21 (lot, P-1 et al);
Harris Baltimore 6/1/84: 64 (lot, P et al);
Christies Lon 10/25/84: 52 (lot, P et al);
Christies Lon 4/24/86: 345 (lot, P et al);

**PANCOAST, Charles R.**
Photos dated: 1881
Processes:      Albumen
Formats:        Prints
Subjects:       Topography
Locations:      India - Bombay
Studio:
   Entries:
Swann NY 4/26/79: 391 (note);

**PAPOZZI** (Italian)
Photos dated: c1870
Processes:      Albumen
Formats:
Subjects:       Topography
Locations:      Italy
Studio:         Italy
   Entries:
Harris Baltimore 12/10/82: 399 (lot, P et al);

**PARANT & RONDEAU** (French)
Photos dated: 1861
Processes:      Albumen
Formats:        Prints incl. panoramas, stereos
Subjects:       Topography
Locations:      France - Bourbon
Studio:         France
    Entries:
Phillips NY 11/3/79: 162 (5);

**PARET** (American)
Photos dated: 1850s
Processes:      Ambrotype
Formats:        Plates
Subjects:       Portraits
Locations:      Studio
Studio:         US - New York City
    Entries:
Swann NY 4/23/81: 266 (lot, P-1 et al);

**PARIS, Emile** (French)
Photos dated: 1870s
Processes:      Albumen
Formats:        Prints
Subjects:       Topography
Locations:      France - Amiens
Studio:         France
    Entries:
Rose Boston Cat 5, 1980: 56 ill(note);

**PARIS, L.L.**
Photos dated: 1850s and/or 1860s
Processes:      Albumen
Formats:        Stereos
Subjects:       Topography, genre
Locations:      Great Britain
Studio:         Great Britain
    Entries:
Christies Lon 6/28/84: 35 (lot, P-24 et al), 36
    (lot, P-4 et al);

**PARK & Co.** (American)
Photos dated: late 1890s
Processes:      Silver
Formats:        Prints
Subjects:       Topography
Locations:      US - Los Angeles, California
Studio:         US - Los Angeles, California
    Entries:
Witkin NY II 1974: 927 (lot, P-2 et al), 928 (lot,
    P-1 et al), 930 (2);

**PARKER, C.** (American)
Photos dated: early 1880s
Processes:      Albumen
Formats:        Prints, cabinet cards
Subjects:       Portraits
Locations:      Studio
Studio:         US - Washington, D.C.
    Entries:
Harris Baltimore 9/16/83: 148 (lot, P et al);
Swann NY 5/10/84: 298;

**PARKER, Francis** (American)
Photos dated: 1870s-c1890
Processes:      Albumen
Formats:        Prints, stereos, cdvs, cabinet cards
Subjects:       Ethnography
Locations:      US - Needles, California
Studio:         US - San Diego, California
    Entries:
Swann NY 2/6/75: 248 (note);
Wood Conn Cat 37, 1976: 306 ill(note);
California Galleries 1/21/78: 371 (lot, P-1 et al);
Sothebys LA 2/6/80: 71 (lot, P-4 et al);
California Galleries 3/30/80: 379 (lot, P-1 et al);
Phillips Can 10/9/80: 32 (lot, P et al);
Harris Baltimore 12/10/82: 17 (lot, P-1 et al);
California Galleries 6/19/83: 364 (2), 365 (lot, P-1
    et al), 370 (lot, P-2 et al);
California Galleries 7/1/84: 628 (lot, P-2 et al);
Swann NY 11/14/85: 158 (lot, P & Parker et al);

**PARKER, H.R.** (American)
Photos dated: 1870s
Processes:      Albumen
Formats:        Stereos
Subjects:       Topography
Locations:      US - New York State
Studio:         US - Sherburn, New York
    Entries:
California Galleries 4/3/76: 430 (lot, P et al);
California Galleries 1/21/78: 184 (lot, P et al);

**PARKER, John Henry**
Photos dated: 1874-1877
Processes:      Albumen, photogravure
Formats:        Prints
Subjects:       Topography
Locations:      Italy - Rome
Studio:
    Entries:
Swann NY 2/14/52: 258 (book)(note);
Gordon NY 5/3/76: 297 (books, P-30 et al);
Christies NY 10/4/83: 101 (albums, P et al);

**PARKINSON, M.B.** (American)
Photos dated: 1886-1890
Processes:      Photogravure
Formats:        Prints
Subjects:       Portraits, genre
Locations:      Studio
Studio:         US - New York City
    Entries:
Christies Lon 10/27/77: 391 ill;
Christies Lon 3/16/78: 318;
California Galleries 1/21/79: 483;

**PARKS, J.G.** (Canadian)
Photos dated: 1864-1895
Processes:      Albumen
Formats:        Prints, stereos
Subjects:       Topography
Locations:      Canada - Montreal; Ottawa
Studio:         Canada - Montreal
    Entries:
Sothebys NY (Strober Coll.) 2/7/70: 509 (lot,
    P et al);
Rinhart NY Cat 6, 1973: 395;

**PARKS, J.G.** (continued)
Rinhart NY Cat 7, 1973: 156 (lot, P-1 et al), 159, 160;
Sothebys Lon 10/18/74: 1 (lot, P-6 et al);
Swann NY 4/1/76: 224 (12);
Swann NY 12/8/77: 346 (12)(note);
California Galleries 1/21/78: 145 (lot, P et al);
Christies Lon 3/15/79: 180 (album, P-7 et al);
Christies Lon 3/20/80: 200 (album, P attributed et al);
Phillips Can 10/9/80: 46 ill(5)(note);
Christies Lon 10/30/80: 136 (lot, P-1 et al);
Swann NY 4/23/81: 523 (lot, P et al);
Harris Baltimore 7/31/81: 111 (lot, P et al);
Swann NY 11/5/81: 524 (album, P-7 et al)(note);
Christies Lon 3/11/82: 60 (lot, P et al);
Harris Baltimore 4/8/83: 15 (lot, P et al);
Christies Lon 10/27/83: 44 (lot, P-2 et al);
Harris Baltimore 6/1/84: 18 (lot, P-3 et al);
California Galleries 7/1/84: 198 (lot, P et al);
Harris Baltimore 3/15/85: 18 (lot, P-18 et al);
Christies Lon 10/31/85: 127 (album, P-6 et al);

**PARRET**
Photos dated: 1875
Processes:      Woodburytype
Formats:        Prints
Subjects:       Topography
Locations:
Studio:
   Entries:
Wood Conn Cat 49, 1982: 499 (book, P-1 et al)(note);

**PARRY, William S.** (British)
Photos dated: c1850
Processes:      Waxed paper negative
Formats:        Negatives
Subjects:       Topography
Locations:      Great Britain
Studio:         England - Newcastle
   Entries:
Christies Lon 6/28/79: 233 (5);

**PARSHLEY, F.E.** (American)
Photos dated: 1890s-1905
Processes:      Albumen
Formats:        Prints
Subjects:       Architecture
Locations:      US - New York City
Studio:         US - Brooklyn, New York
   Entries:
Phillips NY 5/22/82: 616 ill(3), 617 (3);
Swann NY 11/10/83: 317;
Swann NY 11/8/84: 241 ill(note), 242;

**PARSONS, G.W.** (American)
Photos dated: c1880
Processes:      Albumen
Formats:        Cabinet cards
Subjects:       Ethnography
Locations:      US - Pawhuska, Indian Territories
Studio:         US
   Entries:
Harris Baltimore 4/8/83: 383 (lot, P-2 et al);

**PARSONS, S.H.** (Canadian)(see also McKENNEY & PARSONS)
Photos dated: 1870s
Processes:      Albumen
Formats:        Stereos
Subjects:       Topography
Locations:      Canada - St, Johns, Newfoundland
Studio:         Canada
   Entries:
Christies Lon 10/30/80: 136 (lot, P-2 et al);

**PARSONS, T.** (British)
Photos dated: 1850s and/or 1860s
Processes:      Albumen
Formats:        Stereos
Subjects:       Topography
Locations:      England
Studio:         England - Leicester
   Entries:
Christies Lon 10/30/86: 27 (lot, P-4 et al);

**PARTRIDGE** (American) [PARTRIDGE 1]
Photos dated: 1860s
Processes:      Albumen
Formats:        Cdvs
Subjects:       Portraits
Locations:      Studio
Studio:         US - Wheeling, West Virginia
   Entries:
Sothebys NY (Strober Coll.) 2/7/70: 282 (lot, P et al), 292 (lot, P et al);

**PARTRIDGE Brothers** (American) [PARTRIDGE 2]
Photos dated: 1880s-c1890
Processes:      Albumen
Formats:        Prints, boudoir cards, cabinet cards
Subjects:       Topography
Locations:      US - Alaska; California; Oregon; Massachusetts
Studio:         US - Portland, Oregon
   Entries:
Rinhart NY Cat 1, 1971: 225 (4);
California Galleries 5/23/82: 180 (lot, P-2 et al);
California Galleries 7/1/84: 250 (12)(note);
Swann NY 11/8/84: 136 (lot, P-6 et al);
Harris Baltimore 3/15/85: 131 (3);

**PARTRIDGE, T.** (British)
Photos dated: Nineteenth century
Processes:      Albumen
Formats:        Cdvs
Subjects:       Portraits
Locations:      Studio
Studio:         Great Britain
   Entries:
Christies Lon 3/20/80: 354 (album, P et al);

**PASONOZILL**
Photos dated: Nineteenth century
Processes:      Albumen
Formats:        Prints
Subjects:       Topography
Locations:      France - Cannes
Studio:         Europe
   Entries:
Christies NY 10/4/83: 101 (albums, P et al);

**PASTORINO, Luis** (Uruguayan)
Photos dated: c1870
Processes:      Albumen
Formats:        Prints
Subjects:       Topography
Locations:      Uruguay - Montevideo
Studio:         Uruguay - Montevideo
   Entries:
Swann NY 4/23/81: 548 (5)(note);

**PATESON, Robert** (British)
Photos dates: 1860s
Processes:      Albumen
Formats:        Prints
Subjects:       Architecture
Locations:      England - Lancashire
Studio:         England
   Entries:
Christies Lon 3/10/77: 74 (8);

**PATRICK, J.** (British)
Photos dated: c1870-1889
Processes:      Albumen, carbon
Formats:        Prints
Subjects:       Topography, portraits, documentary
                (engineering)
Locations:      Scotland
Studio:         Scotland - Edinburgh
   Entries:
California Galleries 4/3/76: 315 (lot, P-1 et al);
Christies Lon 10/28/76: 239 (lot, P-1 et al);
Wood Conn Cat 37, 1976: 233 (album, P attributed,
   et al)
Christies Lon 3/10/77: 192 (albums, P et al);
Christies Lon 10/26/78: 108 (album, P et al);
Witkin NY IX 1979: 2/91 (book, P-2 et al);
Christies Lon 10/25/79: 244 (albums, P-2 et al);
Christies Lon 6/26/80: 264 (album, P-1 et al), 272
   (album, P-2 et al);
Christies Lon 3/26/81: 263 (album, P-1 et al);
Harris Baltimore 12/16/83: 238;

**PATTERSON** (British) [PATTERSON 1]
Photos dated: Nineteenth century
Processes:      Albumen
Formats:        Cdvs
Subjects:       Portraits
Locations:      Studio
Studio:         Scotland - Edinburgh
   Entries:
Christies Lon 6/10/76: 148 (album, P et al);

**PATTERSON** (British) [PATTERSON 2]
Photos dated: 1890
Processes:      Albumen
Formats:        Prints
Subjects:       Topography
Locations:      England - Isle of Man
Studio:         England - Ramsay, Isle of Man
   Entries:
Christies Lon 10/30/86: 176 (album, P-5 et al);

**PATTON & LEE** (American)
Photos dated: 1860s
Processes:      Albumen
Formats:        Cdvs
Subjects:       Portraits
Locations:      Studio
Studio:         US - Reading, Pennsylvania
   Entries:
Harris Baltimore 11/9/84: 106 (lot, P & L-1 et al);

**PATTON, Horace B.** (American)
Photos dated: 1890s
Processes:
Formats:        Prints
Subjects:       Topography
Locations:      US - Golden, Colorado
Studio:         US
   Entries:
Swann NY 10/18/79: 360 (albums, P et al);

**PAUL, J.**
Photos dated: 1850s
Processes:      Daguerreotype
Formats:        Plates
Subjects:       Portraits
Locations:
Studio:
   Entries:
Sothebys Lon 10/29/76: 203 (lot, P-1 et al);

**PAXSON, Charles** (American)
Photos dated: 1864
Processes:      Albumen
Formats:        Cdvs
Subjects:       Portraits
Locations:      Studio
Studio:         US - New York City
   Entries:
California Galleries 5/23/82: 190 (lot, P-1 et al);

**PAYNE & BAGLEY** (American)
Photos dated: Nineteenth century
Processes:      Albumen
Formats:        Cdvs
Subjects:       Portraits
Locations:      Studio
Studio:         US - San Francisco, California
   Entries:
California Galleries 6/28/81: 142 (album,
   P & B et al);

**PAYNE, H.T.** (American)
Photos dated: 1870s-1880s
Processes:      Albumen
Formats:        Stereos
Subjects:       Topography
Locations:      US - San Diego and Anaheim, California
Studio:         US - Los Angeles, California
   Entries:
Harris Baltimore 12/10/82: 17 (lot, P et al);
California Galleries 6/19/83: 420 (2), 443 (3);

**PAYNE, J.**
Photos dated: between 1870s and 1890s
Processes:      Albumen
Formats:        Prints
Subjects:       Topography
Locations:      Australia
Studio:         Australia - Sydney
   Entries:
Swann NY 11/13/86: 140 (lot, P et al);

**PAYNE, James** (British)(photographer?)(see GARNETT
                & SPROAT)
Photos dated: 1870-1872
Processes:      Albumen
Formats:        Prints
Subjects:       Topography, architecture
Locations:      England - Lake District
Studio:         Great Britain
   Entries:
Edwards Lon 1975: 142 (book, 14);
Christies Lon 10/27/77: 221 (book, 24);
Christies Lon 10/26/78: 218 (book, 18);
Christies Lon 3/15/79: 214 (book, 18);
Sothebys Lon 3/15/82: 443 (book, 10);
Christies Lon 3/29/84: 115 (book, P-25 et al);

**PAYNE, Sam Glen**
Photos dated: c1880
Processes:      Albumen
Formats:        Prints
Subjects:       Topography
Locations:      Mentmore
Studio:
   Entries:
Sothebys NY 11/5/84: 262 ill;

**PAYNTER** (see RUDD & PAYNTER)

**PAYOT**
Photos dated: Nineteenth century
Processes:      Albumen
Formats:        Stereos
Subjects:       Topography
Locations:      Switzerland
Studio:         Europe
   Entries:
Harris Baltimore 4/8/83: 100 (lot, P et al);

**PEABLES, W.W.** (American)
Photos dated: 1860s
Processes:      Ambrotype
Formats:        Plates
Subjects:       Portraits
Locations:      Studio
Studio:         US - Livermore Falls, Maine
   Entries:
Vermont Cat 6, 1973: 599 ill;

**PEABODY, Henry Greenwood** (American, 1855-1951)
Photos dated: 1886-1900s-early 1890s
Processes:      Albumen
Formats:        Prints
Subjects:       Topography
Locations:      US - Massachusetts; Arizona;
                California
Studio:         US - Boston, Masachusetts; California
   Entries:
Sothebys LA 2/6/80: 36 (lot, P-1 et al);

**PEABODY, Dr. J.H.** (American)
Photos dated: 1865-1885
Processes:      Albumen
Formats:        Prints
Subjects:       Topography
Locations:      US - Omaha, Nebraska
Studio:         US - Omaha, Nebraska
   Entries:
Sothebys NY 2/25/75: 178 (lot, P-1 et al);

**PEACH, R.E.** (photographer or author?)
Photos dated: 1883
Processes:      Woodburytype
Formats:        Prints
Subjects:       Topography
Locations:      England - Bath
Studio:
   Entries:
Sothebys Lon 3/15/82: 427 (book, 2);

**PEACOCK, Laurence F.** (British)
Photos dated: 1860s
Processes:      Albumen
Formats:        Stereos
Subjects:       Topography
Locations:      England - Sheffield
Studio:         Great Britain
   Entries:
Christies Lon 10/27/83: 28 (lot, P-7 et al);
Christies Lon 6/28/84: 52 (lot, P-7 et al);

**PEARCE** (British)
Photos dated: Nineteenth century
Processes:      Albumen
Formats:        Prints
Subjects:       Genre
Locations:      Great Britain
Studio:         Great Britain
   Entries:
Christies Lon 3/24/83: 237 (lot, P et al)(note);

**PEARSALL, Alva**
Photos dated: 1865-1881
Processes:      Albumen
Formats:        Prints, stereos
Subjects:       Portraits
Locations:      US
Studio:         US - Brooklyn, New York
   Entries:
Lehr NY Vol 1:3, 1979: 19 ill;
Wood Boston Cat 58, 1986: 136 (books, P-1 et al);

**PEASE, N.W.** (American)
Photos dated: early 1870s
Processes:      Albumen
Formats:        Stereos
Subjects:       Topography
Locations:      US - White Mountains, New Hampshire
Studio:         US - North Conway, New Hampshire
  Entries:
Rinhart NY Cat 1, 1971: 312 (lot, P-2 et al);
Rinhart NY Cat 2, 1971: 523 (12);
Vermont Cat 2, 1971: 227 (lot, P et al);
California Galleries 9/27/75: 512 (lot, P et al);
Swann NY 11/11/76: 499 (lot, P et al);
California Galleries 1/23/77: 410 (lot, P et al);
Swann NY 12/14/78: 319 (165), 320;
Swann NY 10/18/79: 424 (45), 435 (lot, P et al)
   (note);
Swann NY 4/23/81: 531 (lot, P et al), 533 (155);
Swann NY 5/5/83: 446 (lot, P et al);
Swann NY 11/10/83: 346 (lot, P et al);
Harris Baltimore 12/16/83: 88 (lot, P-18 et al);
Harris Baltimore 3/15/85: 68 (lot, P et al);

**PEC, Emile M.** (E.M. Pecquerel) (French)
Photos dated: c1851-c1852
Processes:      Calotype
Formats:        Prints
Subjects:       Topography
Locations:      France - Nimes; Spain; Italy; Greece
Studio:         France
  Entries:
Goldschmidt Lon Cat 52, 1939: 170 (4)(note);
Maggs Paris, 1939: 487
Rauch Geneva 6/13/61: 60 ill(5);
Mancini Phila 1979: 8 ill;
Phillips Lon 3/13/79: 46 ill;
Sothebys Lon 6/29/79: 239;
Christies Lon 3/26/81: 181 (lot, P-2 et al);
Sothebys NY 11/9/83: 234 (note);
Sothebys Lon 3/29/85: 211 ill;

**PECK, Samuel** (American)
Photos Dated: 1847-1860
Processes:      Daguerreotype
Formats:        Plates
Subjects:       Portraits
Locations:      Studio
Studio:         US - New Haven, Connecticut
  Entries:
Witkin NY III 1975: D74 ill;
Gordon NY 5/3/76: 267 (lot, P et al);
Gordon NY 11/13/76: (lot, P et al);

**PEDROTTI, L.** (photographer or author?)
Photos dated: c1890s
Processes:      Photogravures
Formats:        Prints
Subjects:       Topography
Locations:      Northern Rhodesia - Victoria Falls;
Bulawayo
Studio:
  Entries:
Wood Conn Cat 37, 1976: 153 (book, 12)(note);
Wood Conn Cat 42, 1978: 394 (book, 12)(note;

**PEERS** (see MARTIN & PEERS)

**PEIGNE**
Photos dated: 1875-1895
Processes:      Albumen
Formats:        Prints
Subjects:       Architecture
Locations:      France; Italy
Studio:
  Entries:
Swann NY 11/11/76: 388 (albums, P et al);

**PEITZ, H.** (American)
Photos dated: 1884
Processes:      Albumen
Formats:        Prints
Subjects:       Architecture
Locations:      US - Springfield, Illinois
Studio:         US
  Entries:
Sothebys NY 11/2/79: 315: (books, P-23 et al);

**PENABERT, G.**
Photos dated: c1859
Processes:      Albumen
Formats:        Prints
Subjects:       Portraits
Locations:      Spain - Madrid
Studio:
  Entries:
Sothebys NY 11/12/85: 309 ill;

**PENDELTON** (American)
Photos dated: 1860s
Processes:      Albumen
Formats:        Cdvs
Subjects:       Portraits
Locations:      Studio
Studio:         US
  Entries:
Sothebys NY (Greenway Coll.) 11/20/70: 250 (lot,
   P-1 et al);

**PENLY, Aaron**
Photos dated: 1855-1856
Processes:
Formats:
Subjects:       Portraits
Locations:      England - Croydon
Studio:         Great Britain
  Entries:
Sothebys Lon 3/8/74: 159 ill(28)(note);

**PENLY, Charles M.** (British)
Photos dated: c1870
Processes:      Albumen
Formats:        Prints
Subjects:       Portraits
Locations:      Great Britain
Studio:         Great Britain
  Entries:
California Galleries 5/23/82: 363;

**PENN** (British)
Photos dated: 1860s-c1880
Processes:      Albumen, photogravures
Formats:        Prints
Subjects:       Topography
Locations:      Burma; India
Studio:
   Entries:
Sothebys Lon 6/26/75: 128 (album, P-6 et al);
Christies Lon 3/16/78: 106 (album, P-16 et al), 206
   (books, P-50 et al);
Sothebys Lon 10/24/79: 92 (album, P-2, P attributed
   et al);
Christies Lon 10/29/81: 232 (lot, P-10 et al);
Christies Lon 10/27/83: 104 (album, P et al);
Sothebys Lon 6/28/85: 80 ill(albums, P et al);
Christies Lon 6/26/86: 49 ill(album, 71);

**PENNELL & ZELLNER** (American)
Photos dated: 1896
Processes:      Albumen
Formats:        Cabinet cards
Subjects:       Portraits
Locations:      Studio
Studio:         US - Junction City, Kansas
   Entries:
Frontier AC, Texas 1978: 251;

**PENNY, G.** (British)
Photos dated: 1860s
Processes:      Albumen
Formats:        Prints
Subjects:
Locations:
Studio:         Great Britain (Amateur Photographic
                Association)
   Entries:
Christies Lon 10/27/83: 218 (albums, P-1 et al);

**PENNY, W.** (American)
Photos dated: c1860
Processes:      Albumen with collage
Formats:        Prints
Subjects:       Portraits
Locations:      US
Studio:         US
   Entries:
California Galleries 12/13/80: 180;

**PEPIN** (French)
Photos dated: 1850s
Processes:      Daguerreotype
Formats:        Plates
Subjects:       Portraits
Locations:      Studio
Studio:         France
   Entries:
Drouot Paris 11/22/86: 87;

**PEPPE, Tosco F.**
Photos dated: between 1861 and 1875
Processes:      Albumen
Formats:        Prints
Subjects:       Topography
Locations:      India
Studio:
   Entries:
Edwards Lon 1975: 16 (album, P-12 et al);

**PEPPER, Charles**
Photos dated: 1870s
Processes:      Albumen
Formats:        Prints
Subjects:       Topography
Locations:      Portugal - Cintra
Studio:
   Entries:
Christies Lon 3/11/82: 145 (lot, P-1 et al);

**PERCY, Dr. J.** (British)
Photos dated: 1855-1857
Processes:      Albumen
Formats:        Prints
Subjects:       Topography
Locations:      England - Devon
Studio:         Great Britain (Photographic Club,
                Photographic Exchange Club)
   Entries:
Weil Lon Cat 4, 1943(?): 237 (album, P et al)(note);
Sothebys Lon 3/21/75: 286 (album, P-1 et al);
Sothebys Lon 3/14/79: 324 ill(album, P-1 et al);

**PERCY, Sidney Richard** (British, 1821-1886)
Photos dated: 1850-1857
Processes:      Salt, albumen
Formats:        Prints
Subjects:       Topography, portraits, genre
                (domestic)
Locations:      England
Studio:         England - Barnes
   Entries:
Christies Lon 4/24/86: 453 ill(albums, 70)(note);

**PERIDIS** (Greek?)
Photos dated: c1875-c1890s
Processes:      Albumen
Formats:        Prints
Subjects:       Topography
Locations:      Egypt
Studio:
   Entries:
Sothebys Lon 6/21/74: 60 (lot, P et al);
Sothebys Lon 10/18/74: 111 (album, P et al);
California Galleries 9/26/75: 259 (lot, P-1 et al);
Christies Lon 3/10/77: 148 (albums, P et al);
Sothebys LA 2/13/78: 138 (lot, P-6 et al);
California Galleries 1/21/79: 421 (4);
Phillips Lon 3/13/79: 63 (album, P et al);
Swann NY 4/23/81: 546 (album, P et al);
California Galleries 5/23/82: 351 (lot, P &
   Georgiladakis-2, et al);
Christies Lon 6/24/82: 175 (lot, P et al), 232
   (albums, P et al);
Harris Baltimore 12/10/82: 391 (albums, P et al);
Christies Lon 10/25/84: 110 (albums, P-1 et al);
Harris Baltimore 2/14/86: 210 (albums, P et al);

**PERIER, C.J. Paul** (French)
Photos dated: 1850s
Processes: Albumen
Formats: Prints
Subjects: Topography
Locations: France
Studio: France
   Entries:
Lunn DC Cat QP, 1978: 8 ill(note);
Christies NY 5/9/83: 106 ill(note);

**PERINI, Fortunato Antonio** (Italian, 1830-1879)
Photos dated: 1853-1878
Processes: Salt, albumenized salt, albumen
Formats: Prints, stereos
Subjects: Architecture, topography
Locations: Italy - Venice
Studio: Italy - Venice
   Entries:
Edwards Lon 1975: 57 (book, 14);
Christies Lon 6/10/76: 54 (lot, P et al);
Swann NY 4/20/78: 329 (album, P et al);
Sothebys Lon 6/28/78: 102 (album, P et al);
Christies NY 10/31/79: 36;
Christies NY 5/16/80: 184 (album, P et al); 185
   (lot, P et al);
Christies Lon 6/26/80: 191 (lot, P-3 et al);
Christies Lon 10/30/80: 168;
Christies Lon 3/26/81: 183, 267 (album, P et al);
Harris Baltimore 7/31/81: 100 (lot, P et al);
Christies Lon 10/25/84: 66 (lot, P-1 et al);
Harris Baltimore 3/15/85: 109 (lot, P-12 et al);
Sothebys Lon 6/28/85: 51 (lot, P-2 et al);

**PERKINS, A.J.**
Photos dated: 1880s
Processes: Albumen
Formats: Prints, cabinet cards
Subjects: Topography, portraits
Locations: US - San Francisco, California
Studio: US - Vallejo, California
   Entries:
Frontier AC, Texas 1978: 252 (2);
Swann NY 12/14/78: 399 (album, P et al);
Sothebys Lon 3/21/80: 188 (20);
Swann NY 4/17/80: 276 (lot, P et al);
Harris Baltimore 12/16/83: 293 (lot, P et al);

**PERKINS, E.R.**
Photos dated: 1860s
Processes: Ambrotype
Formats: Plates
Subjects: Portraits
Locations:
Studio:
   Entries:
Vermont Cat 4, 1972: 398;

**PERRAUD** (French)
Photos dated: c1855
Processes: Daguerreotype
Formats: Plates
Subjects: Portraits
Locations: Studio
Studio: France
   Entries:
Drouot Paris 11/27/82: 92 ill;

**PERRIGO, O.M.** (American)
Photos dated: Nineteenth century
Processes: Albumen
Formats: Stereos
Subjects: Documentary (industrial)
Locations: US - Medford, Massachusetts
Studio: US
   Entries:
Rinhart NY Cat 6, 1973: 473;

**PERRIN, Charles** (French)
Photos dated: 1850s
Processes: Daguerreotype
Formats: Plates
Subjects: Genre (educational institutions)
Locations: France
Studio: France - Nantes
   Entries:
Sothebys Lon 3/29/85: 36 ill;

**PERRY & BOHM** (American)
Photos dated: 1870s
Processes: Albumen
Formats: Stereos
Subjects: Topography
Locations: US - Colorado
Studio: US - Colorado
   Entries:
Swann NY 4/1/76: 239 (lot, P & B et al);

**PERRY, C.H.** (American)
Photos dated: c1870
Processes: Albumen
Formats: Prints
Subjects: Portraits
Locations: Studio
Studio: US - Greenville, Tennessee
   Entries:
Harris Baltimore 6/1/84: 399;

**PERRY, Ira C.** (American)
Photos dated: c1880-1890
Processes: Albumen
Formats: Prints
Subjects: Topography, documentary (industrial)
Locations: US - California
Studio: US
   Entries:
California Galleries 3/30/80: 261 (lot, P-1 et al);
California Galleries 12/13/80: 310 ill(lot, P-5
   et al);
California Galleries 6/19/83: 318 (P &
   Gilfillian, 7);

**PERRY, J.S.** (British)
Photos dated: 1860s
Processes: Albumen
Formats: Stereos
Subjects: Topography
Locations: England
Studio: Great Britain (Amateur Photographic
   Association)
   Entries:
Christies Lon 10/27/83: 30 (lot, P-1 et al);

**PERRY, Oliver Hazard, Jr.** (American)
Photos dated: late 1860s-1870s
Processes: Collodion on glass
Formats: Negative plates
Subjects: Genre (domestic)
Locations: US
Studio: US
 Entries:
Harris Baltimore 3/15/85: 228 (19);

**PERRY, W.A.** (American)
Photos dated: 1840s
Processes: Daguerreotype
Formats: Plates
Subjects: Portraits
Locations: Studio
Studio: US - Boston, Massachusetts
 Entries:
Rinhart NY Cat 2, 1971: 167 (lot, P-1 et al);
Gordon NY 5/3/76: 268 (lot, P et al);
Rose Boston Cat 5, 1980: 165 ill;

**PESME & VARUN** (French)
Photos dated: 1850s-1870s
Processes: Albumen
Formats: Cdvs
Subjects: Portraits
Locations: Studio
Studio: France
 Entries:
Swann NY 5/10/84: 315 (lot, P & V et al);

**PETER, F.** (France)
Photos dated: 1860s-c1890
Processes: Albumen
Formats: Prints
Subjects: Topography
Locations: France; Germany
Studio: France - Strasbourg
 Entries:
California Galleries 9/26/75: 272 (lot, P,
 P & Saglio, et al);
California Galleries 1/21/79: 489 (P & Saglio, 3);
Christies Lon 3/24/83: 76 (lot, P et al);
Christies Lon 10/27/83: 82 (lot, P et al);

**PETERSEN, P.** (Danish)
Photos dated: c1864-1865
Processes: Albumen
Formats: Prints, cdvs
Subjects: Portraits, documentary (military)
Locations: Denmark
Studio: Denmark - Agershus
 Entries:
Rinhart NY Cat 6, 1973: 248 (lot, P et al);
Sothebys Lon 10/29/80: 210;
Sothebys Lon 3/27/81: 386;
Sothebys Lon 6/17/81: 330;
Christies Lon 10/29/81: 208 (12);
Christies Lon 6/24/82: 123;
Christies Lon 10/25/84: 187 (2);
Christies Lon 6/27/85: 152 (2);

**PETIOT-GROFFIER, Fortuné-Joseph** (French,
 1788-1855)
Photos dated: 1840-1855
Processes: Daguerreotype, salt
Formats: Plates, prints
Subjects: Topography
Locations: France
Studio: France
 Entries:
Rauch Geneva 6/13/61: 69 (2)(note), 70 (2)(note),
 71, 72 (2)(note), 73 (3);

**PETIT, Pierre** (French, born 1832)
Photos dated: 1849-c1885
Processes: Daguerreotype, salt, albumen,
 woodburytype
Formats: Plates, prints, cdvs, cabinet cards
Subjects: Portraits incl. Galerie Contemporaine,
 architecture, ethnography, documentary
 (public events)
Locations: France; Italy - Rome
Studio: France - Paris
 Entries:
Anderson NY (Gilsey Coll.) 2/24/03: 1961;
Goldschmidt Lon Cat 52, 1939: 219;
Maggs Paris, 1939: 519, 545, 560;
Rauch Geneva 12/24/58: 235, 255 ill;
Sothebys NY (Strober Coll.) 2/7/70: 274 (lot,
 P-1 et al);
Sothebys NY 11/21/70: 340 (lot, P et al), 342 ill
 (lot, P-1 et al);
Witkin NY I 1973: 445;
Kingston Boston 1976: 686 ill(book, P et al)(note);
California Galleries 4/2/76: 78 (lot, P et al);
Sothebys Lon 10/29/76: 87 (lot, P & Trinquart-1,
 et al);
Sothebys NY 2/9/77: 51 (lot, P-2 et al);
Sothebys NY 5/20/77: 45 (lot, P-4 et al), 46 (lot,
 P et al);
Christies Lon 10/27/77: 365 (album, P &
 Trinquart-1, et al);
Swann NY 12/8/77: 118 (book, P-1 et al);
Wood Conn Cat 41, 1978: 25 (book, P-9 et al)(note);
Sothebys LA 2/13/78: 115 (books, P et al)(note);
Christies Lon 3/16/78: 305 (album, P-2 et al)(note);
Swann NY 4/20/78: 119 (book, P et al), 231 ill, 232
 (note), 322 (lot, P-1 et al), 324 (lot, P-2
 et al);
Drouot Paris 5/29/78: 79 (9)(note);
Sothebys Lon 6/28/78: 291 (lot, P-1 et al);
Swann NY 12/17/78: 192 (book, P-1 et al), 441;
Octant Paris 3/1979: 23 ill, 24 ill, 25 ill;
Rose Boston Cat 4, 1979: 32 ill(book);
Witkin NY IX 1979: 2/17 (books, P et al);
Wood Conn Cat 45, 1979: 186 (book, P-9 et al)(note);
Phillips Lon 3/13/79: 125 ill;
Sothebys Lon 3/14/79: 313;
Christies NY 10/31/79: 35 ill (book, P et al);
Christies Lon 3/20/80: 227 (book, P et al), 228
 (book, P et al), 230 (book, P et al);
Sothebys NY 5/20/80: 381 (lot, P-1 et al);
Phillips NY 5/21/80: 200 (note);
Auer Paris 5/31/80: 77 (lot, P et al), 129 (lot,
 P-1 et al);
Christies Lon 6/26/80: 210 (lot, P et al);
Swann NY 4/23/81: 364 (note), 471 (lot, P et al);
Christies NY 5/14/81: 41 (books, P-4 et al);
Petzold Germany 11/7/81: 296 (album, P et al), 302
 (album, P et al);
Wood Conn Cat 49, 1982: 332 (book, P-9 et al)(note);

## PETIT (continued)
Swann NY 4/1/82: 343 (2)(note);
Christies NY 5/26/82: 36 (book, P-7 et al);
Christies Lon 6/24/82: 372 (album, P-1 et al);
Bievres France 2/6/83: 85 ill, 132 (album, P-7 et al), 165 (lot, P-1 et al);
Christies Lon 3/24/83: 239, 250 (album, P et al);
Sothebys Lon 3/25/83: 86 ill;
Christies Lon 6/23/83: 256 (lot, P et al);
Christies Lon 10/27/83: 240 (album, P et al);
Swann NY 11/10/83: 129 (book, P et al);
Christies NY 5/7/84: 19 (book, P-7 et al);
Swann NY 5/10/84: 23 (book, P et al)(note), 51 (book, P et al)(note), 223 (albums, P et al), 315 (albums, P et al);
Christies NY 11/6/84: 22 ill;
Christies NY 5/6/85: 291 ill(note);
Swann NY 5/9/85: 331 (lot, P et al);
Christies Lon 6/27/85: 102 (books, P et al);
Sothebys NY 11/12/85: 316 ill(note);
Wood Boston Cat 58, 1986: 326 (book, P-9 et al);
Christies Lon 4/24/86: 419 (lot, P et al);
Sothebys NY 5/12/86: 403 (album, P & Trinquart-1, et al);
Christies Lon 6/26/86: 86 (lot, P et al);
Christies NY 11/11/86: 326 ill;
Swann NY 11/13/86: 53 (book, P et al), 169 (albums, P et al), 170 (albums, P et al);
Drouot Paris 11/22/86: 132 ill;

## PETLEY, Lieutenant (British)
Photos dated: 1855
Processes:
Formats:       Prints
Subjects:      Architecture
Locations:     England
Studio:        Great Britain
   Entries:
Sothebys Lon 3/21/75: 286 (album, P-1 et al);
Sothebys Lon 11/1/85: 59 (album, P-1 et al);

## PETRIE, Sir William Matthew Flinders (British)
Photos dated: 1887
Processes:     Albumen
Formats:       Prints
Subjects:      Documentary (scientific)
Locations:
Studio:
   Entries:
Sothebys LA 2/13/78: 134 (book, 190)(note);
Swann NY 11/14/85: 260 (book, 190)(note);

## PETSCH (see LOESCHER & PETSCH)

## PETSCHLER, H.
Photos dated: 1858-1865
Processes:     Albumen
Formats:       Stereos
Subjects:      Topography
Locations:     England - Buxton
Studio:        England - Manchester
   Entries:
Sothebys Lon 10/24/75: 71 (lot, P et al);
Christies Lon 6/26/80: 106 (lot, P-2 et al);
Christies Lon 10/30/80: 113 (lot, P-12 et al);
Harris Baltimore 7/31/81: 98 (28);

## PETSCHLER, H. (continued)
Christies Lon 10/29/81: 119 (lot, P et al), 147 (lot, P et al);
Christies Lon 3/11/82: 80 (lot, P-51 et al);
Christies Lon 6/24/82: 63 (lot, P et al), 71 (lot, P et al), 72 (lot, P et al), 364 (lot, P et al);
Christies Lon 10/28/82: 17 (lot, P et al);
Sothebys Lon 3/25/83: 4 (lot, P et al);
Harris Baltimore 4/8/83: 37 (lot, P-7 et al);
Christies Lon 6/23/83: 37 (lot, P-2 et al), 45 (lot, P et al), 57 (lot, P-1 et al);
Christies Lon 10/27/83: 21 (lot, P-1 et al), 28 (lot, P-8);
Harris Baltimore 12/16/83: 42 (lot, P-3 et al);
Christies Lon 3/29/84: 22 (lot, P et al);
Harris Baltimore 6/1/84: 64 (lot, P-8 et al);
Christies Lon 6/28/84: 37a (lot, P-29 et al), 52 (lot, P-8 attributed, et al);
Christies Lon 10/25/84: 44 (lot, P et al);
Christies Lon 4/24/86: 345 (lot, P et al);
Phillips Lon 10/29/86: 223 (lot, P et al);

## PETTIS
Photos dated: c1890
Processes:     Albumen
Formats:       Prints
Subjects:      Topography
Locations:
Studio:
   Entries:
California Galleries 3/30/80: 207 (album, P et al);

## PETTITT, Alfred (British)
Photos dated: 1860s-1880s
Processes:     Albumen, platinum
Formats:       Prints, stereos
Subjects:      Architecture, topography
Locations:     England - Lake District
Studio:        England - Keswick
   Entries:
Rinhart NY Cat 6, 1973: 6 (album, P et al);
Edwards Lon 1975: 40 (album, P et al);
California Galleries 9/26/75: 263 (lot, P-1 et al);
Kingston Boston 1976: 173 ill(9);
Witkin NY IV 1976: AL8 (album, P et al);
California Galleries 4/2/76: 217 (lot, P et al);
Sothebys NY 5/4/76: 79 (albums, P et al);
California Galleries 1/22/77: 295 (lot, P-1 et al);
Swann NY 4/14/77: 188 (album, P et al);
Christies Lon 3/20/80: 131 (albums, P et al), 150 (album, P et al);
California Galleries 3/30/80: 299 (lot, P et al);
Christies Lon 10/30/80: 148 (albums, P et al), 155 (album, P et al);
California Galleries 6/28/81: 145 (album, P-11 et al), 188 (lot, P et al);
Christies Lon 3/24/83: 55 (lot, P-9 et al);
Harris Baltimore 4/8/83: 288 (album, P et al);
Christies NY 10/4/83: 110 (lot, P et al);
Christies Lon 10/27/83: 159 (album, P et al);
Phillips Lon 6/27/84: 183 (albums, P et al);
Christies Lon 6/28/84: 35 (lot, P-3 et al);
Phillips Lon 10/24/84: 128 (albums, P et al);
Christies Lon 10/25/84: 55 (lot, P-3 et al);
Harris Baltimore 3/15/85: 83 (8)(note);
Phillips Lon 3/27/85: 193 (albums, P et al);
Phillips Lon 10/30/85: 41 (albums, P et al);
Swann NY 5/15/86: 233 (lot, P et al);
Swann NY 11/13/86: 214 (album, P et al);

PETTY
Photos dated: 1860s
Processes:      Albumen
Formats:        Cdvs
Subjects:       Portraits
Locations:
Studio:
    Entries:
Harris Baltimore 4/8/83: 381 (lot, P et al);

PEZZANA, Henry (Italian)
Photos dated: c1875
Processes:
Formats:        Prints
Subjects:       Documentary (art)
Locations:      Italy - Parma
Studio:         Italy
    Entries:
Swann NY 11/11/76: 374 (20);

PHARES, M.E. (American)
Photos dated: 1890s
Processes:      Albumen
Formats:        Cabinet cards
Subjects:       Topography
Locations:      US - California
Studio:         US
    Entries:
Sothebys LA 2/17/82: 376 ill(lot, P et al);

PHILLIPS (American)
Photos dated: Nineteenth century
Processes:      Albumen
Formats:        Cabinet cards
Subjects:       Portraits
Locations:      Studio
Studio:         US
    Entries:
Harris Baltimore 9/16/83: 149 (lot, P et al);

PHILLIPS, Philip J.
Photos dated: 1884-1885
Processes:      Albumen
Formats:        Prints
Subjects:       Documentary (engineering)
Locations:      Scotland
Studio:         Great Britain
    Entries:
Christies Lon 3/28/85: 225 ill(25);

PHILLIPS, R. (British)
Photos dated: 1867-1873
Processes:      Albumen
Formats:        Prints, cdvs
Subjects:       Topography, portraits, ethnography
Locations:      India - Darjeeling; Tibet
Studio:         India - Darjeeling
    Entries:
Sothebys Lon 12/4/73: 25 ill(album, P et al);
Sothebys Lon 6/26/75: 128 (album, P-12 et al);
Christies Lon 10/30/80: 228 ill(album, P et al);
Sothebys Lon 6/17/81: 173 (album, P et al);
Swann NY 5/5/83: 376 (album P et al)(note);
Christies Lon 6/23/83: 137 (lot, P-1 et al);
Christies Lon 3/29/84: 99 (albums, P-1 et al);

PHILLIPS, R. (continued)
Swann NY 5/9/85: 401 (11)(note);
Christies Lon 6/26/86: 116 (lot, P et al);

PHILLIPS, T.W. (British)
Photos dated: 1870-1873
Processes:      Albumen
Formats:        Prints
Subjects:       Architecture
Locations:      England - Wells
Studio:         Great Britain
    Entries:
Sothebys Lon 10/24/79: 257 ill(album, 160);
Christies Lon 3/26/81: 413 (album, P et al);

PHILP & SOLOMON (American)
Photos dated: c1855-1860s
Processes:      Salt, albumen
Formats:        Cdvs, stereos
Subjects:       Portraits
Locations:      Studio
Studio:         US - Washington, D.C.
    Entries:
Anderson NY (Gilsey Coll.) 1/20/03: 841;
Sothebys NY (Greenway Coll.) 11/20/70: 275 (lot,
    P & S-1 et al);
California Galleries 6/28/81: 294;
Harris Baltimore 7/31/81: 255, 256;
Harris Baltimore 5/22/82: 130;
California Galleries 5/23/82: 364;
Harris Baltimore 6/1/84: 267;
California Galleries 7/1/84: 602;

PHILPOT, J.B.
Photos dated: 1850s-1860s
Processes:      Albumen
Formats:        Prints
Subjects:       Topography, documentary (art),
                architecture
Locations:      Italy - Pisa
Studio:         Italy - Florence
    Entries:
Swann NY 11/11/76: 450 (lot, P & Jackson et al);
Swann NY 12/14/78: 442;
Christies NY 5/16/80: 189;
Christies Lon 3/26/81: 180 (2 ills)(8);
Sothebys Lon 6/17/81: 134;
Christies Lon 6/27/85: 63 (lot, P-1 et al);

PHIPPS-LUCAS, C. (British)
Photos dated: 1880s
Processes:      Albumen
Formats:        Prints
Subjects:       Topography
Locations:      England
Studio:         Great Britain
    Entries:
Christies Lon 10/27/83: 62 (album, P et al);

PHIZ (British)(aka KNIGHT, Hablot)
Photos dated: 1850s-1860s
Processes:      Albumen
Formats:        Stereos
Subjects:       Genre
Locations:      Studio
Studio:         Great Britain
   Entries:
Christies Lon 10/25/79: 83 (lot, P-1 et al);
Christies Lon 6/23/83: 27 (lot, P et al);
Christies Lon 6/28/84: 34 (lot, P et al);
Christies Lon 10/25/84: 47 (lot, P et al);
Phillips Lon 3/27/85: 143 (lot, P-1 et al);
Christies Lon 3/28/85: 36 (lot, P et al), 37 (lot,
   P et al), 38 ( lot, P et al);
Christies Lon 4/24/86: 326 (lot, P-2 et al);

PHOEBUS (British)
Photos dated: 1856-1860s
Processes:      Albumen
Formats:        Prints
Subjects:       Topography
Locations:      Turkey - Constantinople
Studio:         Turkey - Constantinople
   Entries:
Swann NY 2/14/52: 6 (lot, P et al)(note);
Sothebys Lon 12/4/73: 173 (book, P et al);
Christies Lon 10/28/82: 58 (lot, P et al);

PHOTOGLOB Co.
Photos dated: 1890s
Processes:      Albumen
Formats:        Prints
Subjects:       Topography, documentary
Locations:      Switzerland
Studio:         Switzerland
   Entries:
California Galleries 9/26/75: 128 (albums, P et al);
Sothebys NY 5/20/77: 103 ill(album, P et al);

PIARD (see BECKERS & PIARD)

PIAT, C.E.
Photos dated: c1890
Processes:      Albumen
Formats:        Prints
Subjects:       Topography
Locations:
Studio:
   Entries:
California Galleries 3/29/86: 726;

PICKERSGILL, F.R. (British)
Photos dated: 1856
Processes:
Formats:
Subjects:
Locations:
Studio:         Great Britain
   Entries:
Swann NY 2/14/52: 6 (lot, P et al)(note);

PICOT, J.
Photos dated: 1850s
Processes:      Daguerreotype
Formats:        Plates
Subjects:       Portraits
Locations:      Studio
Studio:         England
   Entries:
Sothebys Lon 10/18/74: 245 (lot, P-1 et al);

PIERCE (British) [PIERCE 1]
Photos dated: c1855-1858
Processes:      Salt, albumen
Formats:        Prints
Subjects:       Portraits
Locations:      Great Britain
Studio:         Great Britain
   Entries:
Phillips Lon 11/4/83: 145 (album, P-5 plus 1
   attributed)(note);

PIERCE [PIERCE 2]
Photos dated: 1880s
Processes:
Formats:        Prints
Subjects:       Topography
Locations:      Australia
Studio:
   Entries:
Christies Lon 10/30/86: 175 (album, P et al), 177
   (album, P et al);

PIERCE & BLANCHARD (American) [PIERCE 3]
Photos dated: 1870s-1880s
Processes:      Albumen
Formats:        Prints
Subjects:       Topography
Locations:      US - Los Angeles, California
Studio:         US
   Entries:
Swann NY 11/11/76: 495 (lot, P & B-7 et al);

PIERCE, J.A. (American)
Photos dated: 1871-1870s
Processes:      Albumen
Formats:        Stereos
Subjects:       Documentary (disasters)
Locations:      US - Chicago, Illinois
Studio:         US
   Entries:
Swann NY 11/18/82: 447 (lot, P et al);

PIERPONT, J.L.G. (American)
Photos dated: 1865-1872
Processes:      Albumen
Formats:        Prints
Subjects:       Documentary (Civil War)
Locations:      US - Virginia
Studio:         US
   Entries:
Sothebys NY 10/4/77: 20 (lot, P et al);

PIERSON, George (American)
Photos dated: Nineteenth century
Processes:    Albumen
Formats:      Stereos
Subjects:     Topography
Locations:    US - Florida
Studio:       US
    Entries:
California Galleries 9/27/75: 480 (lot, P et al);
California Galleries 1/23/77: 385 (lot, P et al);

PIERSON, H.F. (American)
Photos dated: c1880
Processes:    Albumen
Formats:      Prints
Subjects:     Topography
Locations:    US - Colorado
Studio:       US
    Entries:
California Galleries 9/27/75: 326;

PIERSON, Louis (French, 1818-1913)(see also MAYER)
Photos dated: 1848-1860
Processes:    Albumen
Formats:      Cdvs, prints
Subjects:     Portraits
Locations:    Studio
Studio:       France - Paris
    Entries:
Rauch Geneva 12/24/58: 210 ill(lot, P-1 et al);
Rauch Geneva 6/13/61: 140 ill(note);
Sothebys NY (Weissberg Coll.) 5/16/67: 76 (note),
    172 (lot, P et al);
Sothebys NY 11/21/70: 341 (lot, P et al), 345 (lot,
    P-1 et al);
Sothebys Lon 12/21/71: 188 (lot, P-1 et al);
Sothebys Lon 6/11/76: 180 (lot, P et al);
Christies Lon 3/16/78: 305 (album, P et al)(note);
Lehr NY Vol 1:3, 1979: 8 ill;

PIFFARD, Henry G. (American)
Photos dated: 1876
Processes:    Albertype
Formats:      Prints
Subjects:     Documentary (medical)
Locations:    US
Studio:       US
    Entries:
Wood Conn Cat 37, 1976: 158 (book, 5)(note, 159 ill
    (book, 50)(note;

PIFFET (see MOSES, B.)

PIGGOTT, W.J. (British)
Photos dated: 1879
Processes:    Albumen
Formats:      Prints
Subjects:     Documentary (scientific)
Locations:    Great Britain
Studio:       Great Britain
    Entries:
California Galleries 7/1/84: 116 (book, 2);

PIGOU, Dr. W.H.
Photos dated: 1854-1857
Processes:    Albumen
Formats:      Prints
Subjects:     Topography
Locations:    India - Hullabeed et al
Studio:       India - Bombay
    Entries:
Christies Lon 10/30/86: 106 (lot, P-2 et al)(note);

PIKE, Lawrence
Photos dated: 1896-1897
Processes:    Bromide
Formats:      Prints
Subjects:     Genre (animal life)
Locations:    England
Studio:       England
    Entries:
Christies Lon 6/27/78: 253 (album, 175);
Christies Lon 10/26/78: 350 (album, 175);

PILCHER (British)
Photos dated: 1860s
Processes:    Ambrotype, albumen
Formats:      Plates incl. stereo, prints
Subjects:     Topography, genre
Locations:    Great Britain
Studio:       England - Gloucester
    Entries:
Christies Lon 10/27/83: 159 (album, P et al);
Phillips Lon 3/27/85: 139 ill(P & Bettesworth);

PILLAS (French)
Photos dated: 1850s
Processes:    Daguerreotypes
Formats:      Plates
Subjects:     Portraits
Locations:    Studio
Studio:       France - Paris
    Entries:
Sothebys Lon 3/29/85: 34 ill;

PILOTY, Karl von (German, 1826-1886) & LOCLHE
                (German)
Photos dated: c1865
Processes:    Albumen
Formats:      Prints, cdvs
Subjects:     Documentary (art)
Locations:    Germany
Studio:       Germany - Munich
    Entries:
California Galleries 3/30/80: 129 (books, 250);
Phillips Lon 3/27/85: 213 (lot, P & L-38 et al);

PINE & BELLS (American)
Photos dated: c1858
Processes:    Ambrotype
Formats:      Plates
Subjects:     Portraits
Locations:    Studio
Studio:       US - Troy, New York
    Entries:
Rinhart NY Cat 1, 1971: 90;

**PINYON, Peter** (British)
Photos dated: 1856-1857
Processes:     Albumen
Formats:       Prints
Subjects:      Topography
Locations:     England; Tasmania
Studio:        Great Britain
    Entries:
Sothebys Lon 10/29/76: 52 (album, 17);

**PIOT, Eugène** (French, 1812-1890)
Photos dated: 1851-1853
Processes:     Salt
Formats:       Prints
Subjects:      Architecture
Locations:     France; Italy; Greece
Studio:        France
    Entries:
Octant Paris 1982: 3 ill;

**PIPER**
Photos dated: 1850s
Processes:     Daguerreotype
Formats:       Plates
Subjects:      Portraits
Locations:
Studio:
    Entries:
Christies Lon 6/28/79: 43 ill(lot, P-6 et al);

**PIPER, J.C.** (American)
Photos dated: c1880
Processes:     Albumen
Formats:       Stereos
Subjects:      Topography
Locations:     US - New York City
Studio:        US - Bath, Maine
    Entries:
Rinhart NY Cat 6, 1973: 518;

**PIROU, Eugène** (French)
Photos dated: c1860-1890
Processes:     Albumen, woodburytype
Formats:       Cdvs, prints, cabinet cards
Subjects:      Portraits incl. Galerie Contemporaine
Locations:     Studio
Studio:        France - Paris
    Entries:
Maggs Paris 1939: 527;
Sothebys NY (Greenway Coll.) 11/20/70: 23 ill, 29
    ill(lot, P-1 et al);
Sothebys Lon 6/21/74: 163 (lot, P et al);
Swann NY 4/20/78: 324 (lot, P-2 et al);
Swann NY 4/26/79: 362 (lot, P et al);
Christies NY 5/14/81: 41 (books, P-1 et al);
Harris Baltimore 3/15/85: 263 (lot, P-1 et al);

**PITCAIRN-KNOWLES, Andrew** (British, 1871-1956)
Photos dated: 1895-c1900
Processes:     Gelatin silver
Formats:       Prints
Subjects:      Genre
Locations:
Studio:        England
    Entries:
Christies NY 9/11/84: 114 (album, P et al);

**PITTMAN, J.A.W.** (American)
Photos dated: 1870s-1883
Processes:     Albumen
Formats:       Stereos
Subjects:      Topography
Locations:     US - Chicago, Illinois
Studio:        US - Carthage and Springfield,
               Illinois
    Entries:
Rinhart NY Cat 7, 1973: 460 (4);
California Galleries 9/27/75: 486 (lot, P-3 et al);
California Galleries 4/3/76: 394 (lot, P-1 et al);
California Galleries 1/23/77: 392 (lot, P-3 et al);
California Galleries 1/21/79: 290 (lot, P-3 et al);

**PITTWAY ART PHOTO** (Canadian)
Photos dated: 1894
Processes:     Albumen
Formats:       Prints
Subjects:      Portraits
Locations:     Canada - Ottawa
Studio:        Canada - Ottawa
    Entries:
Phillips Can 10/4/79: 83;

**PLACET, Emile** (French)
Photos dated: 1860-1864
Processes:     Heliogravure
Formats:       Prints
Subjects:      Topography
Locations:     France - Chartres
Studio:        France
    Entries:
Rauch Geneva 6/13/61: 210 (4)(note);

**PLATE**
Photos dated: 1880s
Processes:     Albumen
Formats:       Prints
Subjects:      Topography
Locations:     Ceylon
Studio:
    Entries:
Sothebys NY 5/8/79: 117 (lot, P et al);

**PLATT, J.B.** (British)
Photos dated: 1859
Processes:     Ambrotype
Formats:       Plates
Subjects:      Portraits
Locations:     Studio
Studio:        England - Boston
    Entries:
Christies Lon 10/26/76: 30 (6);

**PLATZ, Max** (American)
Photos dated: c1880s
Processes:     Albumen
Formats:       Cabinet cards
Subjects:      Portraits
Locations:     Studio
Studio:        US - Chicago, Illinois
    Entries:
California Galleries 6/28/81: 191 (lot, P et al);
California Galleries 5/23/82: 234 (lot, P et al),
    440 (4);

**PLAUSZEWSKI, P.** (French)
Photos dated: c1890-1900
Processes: Collotype
Formats: Prints
Subjects: Genre (still life), documentary (scientific)
Locations: Studio
Studio: France
Entries:
Phillips NY 9/30/82: 102;
Swann NY 5/9/85: 275 ill(book, 25);
Swann NY 5/15/86: 136 (book, 25);

**PLAUT, H.** (French)
Photos dated: 1850s-1870s
Processes: Daguerreotype, albumen
Formats: Plates, stereos, cdvs
Subjects: Portraits, topography
Locations: Studio
Studio: France - Paris; Belgium - Brussels
Entries:
California Galleries 4/2/76: 91 (lot, P et al);
Christies Lon 3/16/78: 19;
California Galleries 3/30/80: 270 (lot, P et al);
Swann NY 5/15/86: 201 (album, P et al);

**PLUMB GALLERY** (American)
Photos dated: 1860s
Processes: Albumen
Formats: Cdvs
Subjects: Portraits
Locations: Studio
Studio: US
Entries:
Swann NY 10/18/79: 304 (lot, P et al);

**PLUMBE, John, Jr.** (American, 1809-1857)
Photos dated: 1840-1849
Processes: Daguerreotype
Formats: Plates
Subjects: Portraits, topography
Locations: Washington, D.C.; Philadelphia, Pennsylvania; Baltimore, Maryland; Boston, Massachusetts; Cincinnati, Ohio; Lexington, Kentucky
Studio: US - New York
Entries:
Sothebys NY (Weissberg Coll.) 5/16/67: 99 (lot, P-1 et al), 101 (lot, P-1 et al), 144 (lot, P-1 et al), 161 (lot, P-1 et al);
Sothebys NY (Strober Coll.) 2/7/70: 125 ill(note);
Rinhart NY Cat 2, 1971: 169;
Vermont Cat 2, 1971: 152 ill;
Vermont Cat 6, 1973: 520 ill;
Sothebys NY 2/25/75: 1 (lot, P-1 et al);
Gordon NY 5/3/76: 267 (lot, P et al);
Gordon NY 11/13/76: 1 (lot, P et al);
Vermont Cat 11/12, 1977: 560 ill(note);
Swann NY 4/14/77: 234 (2);
Rose Boston Cat 3, 1978: 138, 139 ill;
Rose Boston Cat 4, 1979: 134 ill;
Phillips NY 11/29/79: 278 (book, P-1);
Swann NY 11/5/81: 460 (lot, P-1 et al)(note);
Harris Baltimore 3/26/82: 218 (note);
Christies NY 2/8/83: 75 (lot, P-1 et al);
Swann NY 11/10/83: 217 (2);
Christies Lon 3/28/85: 18 (lot, P et al);

**PLUMBE, J.** (continued)
Swann NY 5/9/85: 353 (attributed)(note), 354 ill (note);
Phillips NY 7/2/86: 351;
Phillips Lon 10/29/86: 262 ill, 285A;

**PLUMIER, Victor** (French)
Photos dated: 1840s-1855
Processes: Daguerreotypes, heliotypes
Formats: Plates, prints, cdvs
Subjects: Portraits
Locations: Studio
Studio: France - Paris
Entries:
Rauch Geneva 6/13/61: 40 ill(lot, P-1 et al);
Anderson & Hershkowitz Lon 1976: 15 (book, 1);
Christies Lon 10/26/76: 217 ill(note);
Sothebys Lon 6/28/78: 221 ill(lot, P-1 et al);
Sothebys Lon 3/29/85: 33 ill;

**PLUNKETT, W.C.** (British)
Photos dated: 1855-1857
Processes: Albumen
Formats: Prints
Subjects: Topography
Locations: Switzerland - Grindelwald
Studio: Great Britain (Photographic Club)
Entries:
Sothebys Lon 3/21/75: 286 (album, P-1 et al);
Sothebys Lon 3/14/79: 324 (album, P-1 et al);
Sothebys Lon 11/1/85: 59 (album, P-1 et al);

**PLUSCHOW, Guglielmo** (Italian)
Photos dated: 1880s-c1915
Processes: Albumen, platinum
Formats: Prints
Subjects: Genre (nudes)
Locations: Italy
Studio: Italy - Rome
Entries:
Sothebys Lon 3/22/78: 271 ill, 272 ill, 273 ill, 274, 275, 276;
Mancini Phila 1979: 23 ill, 24 ill;
Sothebys Lon 10/24/79: 379, 380;
Christies Lon 3/20/80: 402 ill(8);
California Galleries 3/30/80: 358 ill;
Sothebys NY 5/19/80: 11 ill, 12;
Christies NY 11/11/80: 74, 75, 76 ill;
Sothebys LA 2/5/81: 379 (lot, P-4 et al);
Christies Lon 3/26/81: 376 (album, P-1 et al);
Phillips NY 5/9/81: 44 ill, 45;
Sothebys NY 10/21/81: 186 (lot, P-1 et al);
Christies NY 11/8/82: 183 ill;
Drouot Paris 11/27/82: 95 ill;
Christies NY 11/8/83: 162 ill;
Christies Lon 3/29/84: 55 (lot, P et al);
Sothebys NY 11/5/84: 105 (lot, P et al);
Sothebys NY 5/7/85: 144 (lot, P et al), 145 (lot, P-1 et al);
Swann NY 5/9/85: 420 (4)(note);
California Galleries 6/8/85: 382 ill, 383 (2);
Christies Lon 10/31/85: 222 (attributed);
Swann NY 5/15/86: 288 (2);
Swann NY 11/13/86: 229 (lot, P et al), 230 (lot, P et al);

**POCHE, Albert**
Photos dated: 1878
Processes:      Albumen
Formats:        Prints
Subjects:       Topography
Locations:      Syria - Aleppo
Studio:
   Entries:
White LA 1977: 266 (2 ills)(23);
Swann NY 11/14/85: 267 ill(book, 23);

**POCHEE, B.S.** (Indian)
Photos dated: 1888
Processes:      Albumen
Formats:        Prints
Subjects:       Portraits
Locations:      Studio
Studio:         India
   Entries:
Sothebys Lon 6/27/80: 234;

**POETTINGER** (German)
Photos dated: 1860s
Processes:      Albumen
Formats:        Cdvs
Subjects:       Topography
Locations:      Germany - Bavaria
Studio:         Germany - Tegernsee
   Entries:
Petzold Germany 325 (lot, P et al);

**POINTER, R.** (British)
Photos dated: c1875
Processes:      Albumen
Formats:        Cdvs
Subjects:       Genre (animal life)
Locations:      Studio
Studio:         England - Brighton
   Entries:
Christies Lon 10/26/76: 241 (album, 30);
Christies Lon 3/10/77: 282 ill(album, P-9 et al);
Christies Lon 10/27/77: 381 (8);
Christies Lon 3/11/82: 339 (lot, P-7 et al);
Christies Lon 10/28/82: 213 (lot, P et al);
Sothebys Lon 6/24/83: 106 (6), 107 (5), 108 (6);
Christies Lon 4/24/86: 366 (lot, P-2 et al);

**POITEVIN, Alphonse-Louis** (French, 1819-1882)
Photos dated: 1842-1865
Processes:      Daguerreotype, salt, photolithograph
               (Poitevin process), carbon
Formats:        Plates, prints
Subjects:       Topography, genre
Locations:      France - Paris et al
Studio:         France - Paris
   Entries:
Octant Paris 3/1979: 1 ill(note), 2 ill, 3 ill,
   4 ill, 7 ill, 10 ill, 15 ill, 16 ill, 17 ill,
   20 ill;
Sothebys Lon 3/15/82: 196 ill;
Drouot Paris 11/27/82: 94 ill;
Bievres France 2/6/83: 71 (attributed)(note);
Sothebys NY 5/8/85: 50 (book, P et al);
Christies Lon 4/24/86: 443;

**POLITZKY** (German)
Photos dated: c1870
Processes:      Albumen
Formats:        Cdvs
Subjects:       Topography
Locations:      Germany
Studio:         Germany - Swinemunde
   Entries:
Rinhart NY Cat 2, 1971: 328 (6);

**POLLACK** (American)
Photos dated: 1850s
Processes:      Daguerreotype, ambrotype
Formats:        Plates
Subjects:       Portraits
Locations:      Studio
Studio:         US - Baltimore, Maryland
   Entries:
Gordon NY 5/3/76: 267 (lot, P et al);
Gordon NY 11/13/76: 1 (lot, P et al);
California Galleries 6/19/83: 151;

**POLLOCK** (American)
Photos dated: 1880s
Processes:      Albumen
Formats:        Prints
Subjects:       Topography
Locations:      US - California
Studio:         US
   Entries:
Sothebys Lon 3/21/75: 89 (album, P et al);
Sothebys LA 2/6/80: 35 (lot, P-1 et al);

**POLLOCK, Alfred Julius** (British, 1835-1890)
Photos dated: 1855-1857
Processes:      Albumen
Formats:        Prints
Subjects:       Topography, documentary (medical),
               genre
Locations:      England - Hereford; Devon
Studio:         Great Britain (Photographic Club,
               Photographic Exchange Club)
   Entries:
Weil Lon Cat 4, 1943(?): 237 (album, P et al)(note);
Sothebys Lon 3/21/75: 286 (album, P-1 et al);
Sothebys Lon 3/14/79: 324 (album, P-1 et al);
Sothebys Lon 11/1/85: 59 (album, P-1 et al);

**POLLOCK, Charles** (American)
Photos dated: 1860s-1872
Processes:      Albumen
Formats:        Stereos
Subjects:       Topography
Locations:      US - Boston, Massachusetts
Studio:         US - Boston, Massachusetts
   Entries:
Harris Baltimore 12/10/82: 79 (lot, P-5 et al);
Harris Baltimore 12/16/83: 16 (lot, P et al), 105
   (lot, P-6 et al), 109 (lot, P-3 et al);
Harris Baltimore 6/1/84: 107 (lot, P et al), 150
   (lot, P et al);
Harris Baltimore 3/15/85: 11 (lot, P et al), 12
   (lot, P et al);

**POLLOCK, Henry Alexander Radclyffe** (British,
1826-1889)
Photos dated: 1855-1857
Processes: Albumen
Formats: Prints
Subjects: Topography
Locations: England - Windsor; Devon
Studio: Great Britain (Photographic Club,
Photographic Exchange Club)
   Entries:
Weil Lon Cat 4, 1943(?): 237 (album, P et al)(note);
Sothebys Lon 3/21/75: 286 (album, P-1 et al);
Sothebys Lon 3/14/79: 324 (album, P-1 et al);

**POLLOCK, Sir Jonathan Frederick** (British,
1783-1870)
Photos dated: 1857
Processes:
Formats: Prints
Subjects:
Locations: Great Britain
Studio: Great Britain
   Entries:
Swann NY 2/14/52: 262 (album, P et al);

**POLLEN, John Hungerford** (British)(photographer or
author?)
Photos dated: 1874
Processes: Woodburytype
Formats: Prints
Subjects: Documentary (art)
Locations: England - London
Studio: England
   Entries:
Rinhart NY Cat 2, 1971: 54 (book, 15);

**POLYBLANK** (see MAULL)

**PONCY, F.** (Swiss)
Photos dated: 1855
Processes: Salt
Formats: Prints
Subjects: Portraits
Locations: Studio
Studio: Switzerland - Geneva
   Entries:
Christies Lon 3/16/78: 295;

**POND** (see WINTER, Lloyd)

**POND, C.L.** (American)
Photos dated: 1870s
Processes: Albumen
Formats: Stereos
Subjects: Topography
Locations: US - Niagara Falls, New York
Studio: US - Buffalo, New York
   Entries:
Rinhart NY Cat 6, 1973: 596 (54);
Rinhart NY Cat 8, 1973: 61;
California Galleries 9/27/75: 457 (lot, P-9 et al),
  461 (lot, P-3 et al), 583 (45);
California Galleries 4/3/76: 430 (lot, P et al), 435
  (lot, P-1 et al);

**POND, C.L.** (continued)
California Galleries 1/23/77: 364 (lot, P-9 et al),
  367 (lot, P-3 et al), 402 (lot, P et al), 455
  (45);
California Galleries 1/21/78: 184 (lot, P et al),
  198 (lot, P et al);
California Galleries 3/30/80: 387 (lot, P-1 et al);
Harris Baltimore 4/8/83: 13 (lot, P et al);
Harris Baltimore 12/16/83: 19 (7), 152 (lot, P-4
  et al);
California Galleries 7/1/84: 197 (lot, P-2 et al);
Swann NY 11/8/84: 265 (lot, P et al);
California Galleries 6/8/85: 438 (lot, P et al);

**PONSONBY, Captain A.** (British)
Photos dated: 1859
Processes: Albumen
Formats: Prints
Subjects: Topography, portraits
Locations: Greece - Corfu
Studio:
   Entries:
Christies Lon 10/26/78: 115 ill(album, P et al);

**PONT, V.**
Photos dated: 1872-1880
Processes: Albumen
Formats: Prints
Subjects: Documentary (railroads)
Locations:
Studio:
   Entries:
Swann NY 11/13/86: 239 (lot, P-3 et al);

**PONTI, Carlo** (Italian)
Photos dated: 1858-1875
Processes: Albumen
Formats: Prints, cdvs, cabinet cards
Subjects: Topography, genre
Locations: Italy - Venice et al; Egypt; Greece;
Germany; Switzerland
Studio: Italy - Venice
   Entries:
Swann NY 2/14/52: 115 (lot, P et al);
Rinhart NY Cat 1, 1971: 204 (3);
Rinhart NY Cat 2, 1971: 371 (8);
Rinhart NY Cat 7, 1973: 560, 637 (attributed), 638;
Sothebys NY 2/25/75: 139 ill(8), 140 (2);
Sothebys Lon 3/21/75: 11 (lot, P-6 et al)(note), 12
  (lot, P-59 et al);
Sothebys Lon 6/26/75: 18 (160), 117 ill(13)(note);
Sothebys NY 9/23/75: 68 (8), 74 (albums, P et al);
California Galleries 9/27/75: 389 (lot, P et al);
Sothebys Lon 10/24/75: 114 (7), 115 (lot, P et al),
  118 ill(albums, P et al)(note);
Witkin NY IV 1976: AL3 (album, P et al);
Wood Conn Cat 37, 1976: 307 ill(10), 308 ill(20),
  309 ill(attributed), 310 ill(attributed), 311 ill
  (attributed);
Sothebys Lon 3/19/76: 20 ill(lot, P-9 et al), 22
  (lot, P-1 et al);
California Galleries 4/3/76: 384 (lot, P et al);
Sothebys Lon 6/11/76: 51 (album, P et al);
Christies Lon 10/26/76: 107 (album, P-37 et al);
Swann NY 11/11/76: 450 (lot, P et al);
Rose Boston Cat 2, 1977: 68 ill(note), 69 ill, 70
  ill, 71 ill;
White LA 1977: 48 ill(note), 49, 50, 51, 52;

## PONTI (continued)

California Galleries 1/22/77: 335 ill, 336 (2);
Swann NY 4/14/77: 245 (album, P et al);
Gordon NY 5/10/77: 813 ill, 814 (album, P attributed et al);
Sothebys Lon 7/1/77: 129 ill(10);
Sothebys NY 10/4/77: 220, 221;
Christies Lon 10/27/77: 95 (lot, P attributed et al);
Swann NY 12/8/77: 414 (album, 25);
Lehr NY Vol 1:2, 1978: 36 ill;
Wood Conn Cat 41, 1978: 117 ill(note), 118 ill (album, 22)(note), 119 ill, 120 (attributed), 121;
California Galleries 1/2/78: 258 (lot, P-1 et al);
Sothebys Lon 3/22/78: 1 (lot, P et al);
Swann NY 4/20/78: 329 (album, P et al), 353 ill(42);
Sothebys Lon 10/27/78: 83 ill(album, 12);
Phillips NY 11/4/78: 69, 70;
Swann NY 12/14/78: 421 (lot, P-1 et al), 444;
Lennert Munich Cat 5, 1979: 12;
Phillips Lon 3/13/79: 62 ill(album, P et al);
Christies Lon 3/15/79: 110 (lot, P et al);
Christies NY 5/4/79: 25 (album, P et al), 27 (lot, P et al);
Phillips NY 5/5/79: 163 ill(album, 20), 164 (attributed);
Sothebys NY 5/8/79: 102;
Sothebys Lon 6/29/79: 137 (lot, P-1 et al), 138;
Sothebys Lon 10/24/79: 143 (lot, P-4 attributed et al), 145 (lot, P et al), 146 (6);
Christies Lon 10/25/79: 143 (6), 144 ill(4), 145 (lot, P attributed et al);
Christies NY 10/31/79: 41 (18), 42 ill(5);
Phillips NY 11/3/79: 170 (2), 171 (2);
Phillips NY 11/29/79: 257, 258 (album, 62) (attributed);
Sothebys NY 12/19/79: 72 ill(11), 73 ill(11), 74 ill (11), 75 ill(3 plus 1 attributed), 95 ill(lot, P et al);
Rose Boston Cat 5, 1980: 66 ill(note), 67 ill, 68 ill;
Christies Lon 3/20/80: 371 (lot, P et al);
Sothebys Lon 3/21/80: 152 (10);
California Galleries 3/30/80: 359 ill(11), 360, 361 ill;
Christies NY 5/16/80: 179 (5), 180, 185 (lot, P et al), 189 (lot, P et al);
Sothebys NY 5/20/80: 340 (lot, P-5 et al);
Phillips NY 5/21/80: 134 (album, 24)(attributed), 223 (5), 224 (3)(attributed), 225;
Christies Lon 6/26/80: 191 (lot, P-4 et al);
Phillips Can 10/9/80: 21 (album, P et al);
Sothebys Lon 10/29/80: 92 (lot, P-8 et al);
Christies Lon 10/30/80: 176 (albums, P et al), 178 (lot, P-1 et al), 456 (lot, P et al);
Swann NY 11/6/80: 323 (lot, P-1 et al);
Christies NY 11/11/80: 65 (4), 67 ill(lot, P et al);
Christies Lon 3/26/81: 178 (album, P-32 et al), 186 (12), 192 (album, P et al), 267 (album, P et al);
Sothebys Lon 3/27/81: 131 (2), 135 (5, attributed);
Phillips NY 5/9/81: 65 (album, P-1 et al);
Petzold Germany 5/22/81: 1847 (2), 1848 (9), 1849 (4), 1850 (4), 1851 (2);
Sothebys Lon 6/17/81: 110 (album, P-5 et al), 138 (8)(attributed), 140 (lot, P et al), 141 (13);
California Galleries 6/28/81: 295 ill(20);
Harris Baltimore 7/31/81: 115 (3), 131 (lot, P-1 et al);
Christies Lon 10/29/81: 193 ill(album, P et al);
Petzold Germany 11/7/81: 326 (lot, P et al);

## PONTI (continued)

Wood Conn Cat 49, 1982: 346 (book, 18)(note);
Christies Lon 3/11/82: 136 (album, P-32 et al), 138 (lot, P et al), 235 (lot, P-2 attributed, et al);
Sothebys Lon 3/15/82: 87 (lot, P-10 et al), 94 (lot, P et al), 128 (album, P attributed et al);
Harris Baltimore 3/26/82: 262, 406 (attributed);
Phillips NY 5/22/82: 865 (2);
California Galleries 5/23/82: 370;
Sothebys Lon 6/25/82: 95 (lot, P-16 et al), 96 (lot, P-6 et al);
Phillips NY 9/30/82: 1023;
Christies Lon 10/28/82: 54 (lot, P et al);
Swann NY 11/18/82: 403 (lot, P et al);
Christies NY 2/8/83: 34 (lot, P et al);
Christies Lon 3/24/83: 85 (lot, P-2 plus 2 attributed);
Swann NY 5/5/83: 291 (album, P et al);
Christies Lon 6/23/83: 93 (lot, P-18 et al), 95 (lot, P-1 et al), 115 (25);
Sothebys Lon 6/24/83: 18 (lot, P et al), 52 ill(51);
Christies NY 10/4/83: 101 (albums, P et al);
Christies Lon 10/27/83: 73 (lot, P et al);
Phillips Lon 11/4/83: 121 (note), 123 (note), 124 ill, 127;
Harris Baltimore 12/16/83: 67 (lot, P-1 et al), 128 (lot, P-2 et al), 402 (5), 403 (4);
Christies Lon 3/29/84: 136 (note), 137 (note), 138 (note), 139 (note);
Swann NY 5/10/84: 187 (lot, P et al), 287, 288 (album, 12);
Harris Baltimore 6/1/84: 391 (2, attributed), 430 ill(attributed);
Christies Lon 6/28/84: 74 (lot, P et al), 317 (lot, P-1 et al);
Sothebys Lon 6/29/84: 58 (3);
California Galleries 7/1/84: 605 ill, 606 (2);
Phillips Lon 10/24/84: 162 (lot, P-9 et al);
Christies Lon 10/25/84: 222 (lot, P-15 et al), 223 (lot, P-25 et al);
Sothebys Lon 10/26/84: 43 (lot, P-2 et al), 46 ill(51);
Christies NY 2/13/85: 145 (lot, P et al);
Harris Baltimore 3/15/85: 40 (lot, P-3 et al), 109 (lot, P-2 et al), 202 (albums, P attributed et al);
Sothebys Lon 3/29/85: 124 ill(lot, P-41 et al);
Sothebys NY 5/7/85: 415 (lot, P-1 attributed et al);
California Galleries 6/8/85: 384 ill, 385;
Sothebys Lon 6/28/85: 52 (lot, P-2 et al);
Phillips Lon 10/30/85: 113 (2);
Christies Lon 10/31/85: 200 (6);
Christies NY 11/11/85: 295 (lot, P-1 et al);
Swann NY 11/14/85: 103 (lot, P-2 et al);
Harris Baltimore 2/14/86: 335, 336;
Christies Lon 4/24/86: 403 (album, P attributed et al);
Sothebys Lon 4/25/86: 63 (lot, P et al), 64 (4);
Swann NY 5/15/86: 264 (lot, P et al), 265 (lot, P et al), 289 (14);
Christies Lon 6/26/86: 134 (albums, P-19 et al), 135 (album, 14);
Phillips Lon 10/29/86: 342 (lot, P et al);
Christies Lon 10/30/86: 133 (album, 20);
Sothebys Lon 10/31/86: 8 (lot, P et al), 54 (lot, P-1 et al);
Harris Baltimore 11/7/86: 273 (attributed);
Swann NY 11/13/86: 143 (lot, P-2 et al);

**POOLE, O.A. & O.M.**
Photos dated: 1890s
Processes:       Collotype
Formats:         Prints
Subjects:
Locations:       Japan
Studio:
    Entries:
Swann 11/8/84: 96 (book);

**POOLEY, C.** (British)
Photos dated: 1853
Processes:       Calotype
Formats:         Prints
Subjects:        Topography
Locations:       Great Britain
Studio:          Great Britain
    Entries:
Sothebys Lon 10/24/79: 351;

**POPOVITZ**
Photos dated: 1850s
Processes:       Daguerreotype
Formats:         Plates
Subjects:        Portraits
Locations:
Studio:
    Entries:
Christies Lon 10/30/86: 11 (lot, P-1 et al);

**PORTER & Co.** (see also MARSHALL & PORTER)
Photos dated: 1854-1850s
Processes:       Daguerreotype, ambrotype
Formats:         Plates
Subjects:        Portraits
Locations:
Studio:
    Entries:
Rinhart NY Cat 8, 1973: 111;
Harris Baltimore 3/26/82: 61;
Swann NY 11/18/82: 295 ill;

**PORTER, T.C.** (photographer or author?)
Photos dated: 1899
Processes:
Formats:         Stereos
Subjects:        Topography
Locations:       US - American west
Studio:
    Entries:
Swann NY 2/14/52: 360 (book, 43)(note);

**PORTER, Samuel J.** (British)
Photos dated: 1894
Processes:       Albumen
Formats:         Prints
Subjects:        Topography
Locations:       England - Ventnor, Isle of Wight
Studio:          England - Ventnor, Isle of Wight
    Entries:
Christies Lon 7/25/74: 332 (albums, P-60 et al);

**PORTER, W.** (British)
Photos dated: Nineteenth century
Processes:       Albumen
Formats:         Cdvs
Subjects:        Genre
Locations:       Great Britain
Studio:          England - Fleetwood; Blackpool
    Entries:
Phillips Lon 10/29/86: 302 (album, P-2 et al);

**PORTER, William Southgate** (see FONTAYNE & PORTER)

**PORTIER, C.**
Photos dated: 1865-1880
Processes:       Albumen
Formats:         Prints, cdvs
Subjects:        Topography, ethnography
Locations:       Algeria - Algiers
Studio:          Algeria - Algiers
    Entries:
Swann NY 11/11/76: 419 (5), 420 (3);
Swann NY 4/20/78: 255 (album, 29);
Christies Lon 10/26/78: 334 (albums, P et al);
Sothebys Lon 10/24/79: 156 (lot, P-7 et al);
Phillips NY 11/3/79: 179 (album, P et al);
Swann NY 4/23/81: 405 (lot, P-3 et al);
California Galleries 7/1/84: 255;
Swann NY 11/14/85: 77 (book, P et al);

**POST, W.B.**
Photos dated: 1886
Processes:       Photogravure
Subjects:        Genre
Locations:
Studio:
    Entries:
California Galleries 1/21/79: 485;

**POTTER, E.T.** (British)
Photos dated: 1850s-c1860
Processes:       Daguerreotype, ambrotype
Formats:         Plates
Subjects:        Portraits
Locations:       Studio
Studio:          England - Sidmouth
    Entries:
Sothebys Lon 6/28/78: 187 (lot, P-1 et al);
Rose Boston Cat 4, 1979: 138 ill;

**POTTER, H.** (Canadian)
Photos dated: 1860s-1870s
Processes:       Albumen
Formats:         Cdvs
Subjects:        Portraits
Locations:       Studio
Studio:          Canada - Montreal
    Entries:
Phillips Lon 10/29/86: 314 (album, P-1 et al);

**POTTER, Rupert** (British)
Photos dated: 1870s
Processes:    Albumen
Formats:      Prints
Subjects:     Portraits
Locations:    Great Britain
Studio:       Great Britain
  Entries:
Sothebys Lon 3/9/77: 182 (4);

**POULSON, Paul C.** (Australian)
Photos dated: 1888
Processes:    Albumen
Formats:      Prints
Subjects:     Topography
Locations:    Australia - Queensland
Studio:       Australia - Brisbane
  Entries:
Wood Conn Cat 37, 1976: 161 (book, 9)(note);
Wood Conn Cat 42, 1978: 425 (book, 9)(note);
Christies Lon 10/26/78: 108 (album, P et al);

**POULTON, S.** (British)
Photos dated: 1857-1889
Processes:    Albumen
Formats:      Prints, stereos, cdvs
Subjects:     Topography, portraits, documentary
              (scientific)
Locations:    England - London and Chatsworth
Studio:       England - London
  Entries:
Rinhart NY Cat 7, 1973: 97 (book, 6), 461, 462, 541;
Christies Lon 10/4/73: 103 (books, P-6 et al);
Sothebys Lon 12/4/73: 13 (lot, P-5 et al);
Sothebys Lon 10/18/74: 88 (album, P et al), 102
  (album, P et al);
Edwards Lon 1975: 136 (book, 5), 165 (book, 6);
Swann NY 2/6/75: 32 (album, 10);
Sothebys Lon 3/21/75: 305 (books, P-5 et al);
California Galleries 9/27/75: 479 (lot, P et al);
Halsted Michigan 1977: 238 (book, 6);
California Galleries 1/23/77: 384 (lot, P et al);
Sothebys Lon 11/18/77: 184 (book, 6);
Rose Boston Cat 3, 1978: 27 ill(note);
Sothebys Lon 3/22/78: 78 (lot, P et al);
Christies Lon 6/27/78: 67 (lot, P-1 et al);
Christies Lon 10/25/79: 134 (lot, P-7 et al);
Phillips NY 11/29/79: 272 (3)(note);
Christies Lon 3/20/80: 233 (book, 4), 348 (album,
  P et al);
Phillips NY 5/21/80: 139 (albums, P et al);
Christies Lon 6/26/80: 265 (lot, P et al), 306
  (books, P et al);
Christies Lon 3/26/81: 102 (lot, P-3 et al), 122
  (lot, P et al), 128 (lot, P-1 et al), 240
  (album, P et al), 273 (album, P et al);
Sothebys Lon 3/27/81: 12 (lot, P et al), 27 (lot,
  P-1 et al), 28 (lot, P-1 et al), 30 (lot, P-1 et
  al), 109;
Swann NY 4/23/81: 458 (11)(note);
Phillips NY 5/9/81: 24 (albums, P et al), 51
  (album, P et al);
Christies Lon 10/29/81: 119 (lot, P et al), 121
  (lot, P -1 et al), 138 (lot, P-1 et al);
Christies Lon 3/11/82: 82 (lot, P-7 et al);
Swann NY 4/1/82: 182 (book, 5);
Christies Lon 6/24/82: 63 (lot, P et al), 224
  (albums, P et al);
Harris Baltimore 12/10/82: 389 (album, P et al);

**POULTON, S.** (continued)
Sothebys Lon 3/25/83: 4 (lot, P et al);
Christies Lon 6/23/83: 50 (lot, P-3 et al), 68
  (albums, P et al);
Harris Baltimore 12/16/83: 42 (lot, P, P attributed,
  et al);
Christies Lon 3/29/84: 22 (lot, P et al), 52
  (album, P et al), 104 (album, P et al);
Christies Lon 6/28/84: 43 (lot, P-1 et al);
California Galleries 7/1/84: 608 (2);
Christies Lon 10/25/84: 41 (lot, P et al);
Harris Baltimore 3/15/85: 34 (lot, P-3 et al), 288;
Phillips Lon 3/27/85: 210 (lot, P-1 et al);
Christies Lon 3/28/85: 309 (album, P et al);
Christies Lon 6/27/85: 279 (album, P et al);
Christies Lon 10/31/85: 140 (album, P et al);
Harris Baltimore 2/14/86: 214A (album, P et al);
Christies Lon 6/26/86: 188 (books, P-6 et al);

**POUNCY, John** (British, c1820-1894)
Photos dated: 1857-1860s
Processes:    Photolithography
Formats:      Prints, cdvs
Subjects:     Topography, genre
Locations:    England - Dorsetshire
Studio:       England - Dorchester
  Entries:
Sothebys Lon 3/27/81: 108 (2)(note);
Wood Conn Cat 49, 1982: 347 (book, 39)(note);
Wood Boston Cat 58, 1986: 329 (book, 19)(note);

**POW** (see KEE, Pow)

**POWEL, Samuel & Mary** (American)
Photos dated: 1858-1878
Processes:    Salt, albumen, cyanotype
Formats:      Stereos
Subjects:     Genre
Locations:    US - Newport, Rhode Island
Studio:       US - Newport, Rhode Island
  Entries:
Swann NY 4/23/81: 535 (3 ills)(177)(note);

**POWELL & Co.** (American)
Photos dated: 1865
Processes:    Albumen
Formats:      Prints
Subjects:     Portraits
Locations:    Studio
Studio:       US - New York City
  Entries:
Rinhart NY Cat 7, 1973: 463 ill;
Harris Baltimore 11/9/84: 99;

**POWELL, S.** (British)
Photos dated: c1860
Processes:    Albumen
Formats:      Stereos
Subjects:     Genre
Locations:    Studio
Studio:       Great Britain
  Entries:
Christies Lon 3/28/85: 42 (lot, P et al);

**POWELL, Thomas Harcourt** (British)
Photos dated: 1866-c1870
Processes:      Albumen
Formats:        Prints
Subjects:       Topography, portraits
Locations:      England; Norway
Studio:         Great Britain (Amateur Photographic
                Association)
    Entries:
Sothebys Lon 3/9/77: 180;
Sothebys Lon 10/29/82: 48 (album);
Christies Lon 10/27/83: 218 (albums, P-1 et al);

**POWELSON** (American)
Photos dated: c1850-c1865
Processes:      Daguerreotype, albumen
Formats:        Plates, cdvs
Subjects:       Portraits
Locations:      Studio
Studio:         US - Newark, New Jersey
    Entries:
Christies Lon 10/27/77: 18 (P & Mendham)(note);
California Galleries 1/21/79: 332 (album, P et al);
Swann NY 10/18/79: 330 ill;

**POWERS** (American)
Photos dated: c1885
Processes:      Albumen
Formats:        Prints
Subjects:       Topography
Locations:      US - Morris Canal, New Jersey
Studio:         US - New Jersey (Newark Camera Club)
    Entries:
Sothebys NY 2/25/75: 182 (album, 42);

**POWERS, L.** (American)
Photos dated: 1860s
Processes:      Albumen
Formats:        Prints, stereos
Subjects:       Documentary (art)
Locations:      Italy - Florence
Studio:         Italy - Florence
    Entries:
Sothebys NY (Strober Coll.) 2/7/70: 269 (lot,
    P et al);
Sothebys Lon 10/29/80: 201 (album, 48);
Swann NY 11/6/80: 238 (lot, P-1 et al);
Swann NY 4/23/81: 526 (lot, P et al);
Swann NY 11/18/82: 454 (lot, P et al);

**POWERS, Samuel A.** (American)(photographer or
                author?)
Photos dated: 1882
Processes:      Heliotype
Formats:        Prints
Subjects:       Documentary (medical)
Locations:      US - Boston, Massachusetts
Studio:         US
    Entries:
Swann NY 4/14/77: 124 (book, 21);
Wood Conn Cat 42, 1978: 426 (book, 21);
Wood Conn Cat 49, 1982: 348 (book, 21)(note);

**POWKEE** (Chinese)(see KEE, Pow)

**POZZI, Pompeo** (Italian, born 1817)
Photos dated: c1850-c1880
Processes:      Albumen
Formats:        Prints
Subjects:       Topography
Locations:      Italy - Milan
Studio:         Italy - Milan
    Entries:
Rinhart NY Cat 1, 1971: 447 (album, P et al);
Sothebys Lon 6/26/75: 124 (lot, P-2 et al);
California Galleries 1/22/77: 171 (album, P et al);
Sothebys Lon 3/22/78: 67 (lot, P et al);
Swann NY 4/20/78: 329 (album, P et al);
Christies Lon 10/25/79: 147 (lot, P et al);
California Galleries 3/30/80: 327 (lot, P-1 et al);
California Galleries 5/23/82: 331 (lot, P-1 et al);
Sothebys Lon 10/31/86: 54 (lot, P-1 et al);

**PRAETORIUS, Charles**
Photos dated: 1876
Processes:      Albumen
Formats:        Prints
Subjects:       Portraits
Locations:      Studio
Studio:         England - London
    Entries:
Christies Lon 6/28/79: 239 ill;
Christies Lon 3/20/80: 362;

**PRASAD, Madho** (Indian)
Photos dated: 1880s and/or 1890s
Processes:      Albumen
Formats:        Prints
Subjects:       Topography
Locations:      India - Benares
Studio:         India - Benares
    Entries:
Swann NY 11/14/85: 144 (album, 41);

**PRATT, William A.** (American, born 1818)
Photos dated: 1846-1856
Processes:      Daguerreotype
Formats:        Plates
Subjects:       Portraits
Locations:      Studio
Studio:         US - Richmond, Virginia
    Entries:
Harris Baltimore 3/26/82: 140;
Swann NY 11/8/84: 172;

**PRENDERGAST, J.W.** (American)
Photos dated: 1860s and/or 1870s
Processes:      Albumen
Formats:        Stereos
Subjects:       Topography
Locations:      US
Studio:         US
    Entries:
Christies Lon 3/28/85: 46 (lot, P et al);

**PRENDEVILLE, James** (photographer or author?)
Photos dated: 1857
Processes:     Albumen
Formats:       Prints
Subjects:      Documentary (art)
Locations:
Studio:
   Entries:
Christies Lon 10/27/77: 202 (book, 243);

**PRENTICE & VAIL** (American)
Photos dated: 1860s
Processes:     Albumen
Formats:       Cdvs
Subjects:      Portraits
Locations:     Studio
Studio:        US - Marion, Ohio
   Entries:
Sothebys NY (Strober Coll.) 2/7/70: 321 (lot,
   P & V-1 et al);

**PRESCOTT** (American)(see also GAGE)
Photos dated: 1860s
Processes:     Albumen
Formats:       Stereos, cdvs
Subjects:      Topography, portraits
Locations:     US - New England
Studio:        US
   Entries:
Sothebys NY (Strober Coll.) 2/7/70: 265 (lot,
   P & G et al);
Rinhart NY Cat 6, 1973: 457 (lot, P & White-1,
   et al);
Swann NY 11/5/81: 552 (lot, P et al);
Swann NY 11/10/83: 242 (lot, P & Gage et al)(note);

**PRESTON, William G.** (American)
Photos dated: 1872
Processes:     Albumen
Formats:       Stereos
Subjects:      Documentary (public events)
Locations:     US - Boston, Massachusetts
Studio:        US
   Entries:
Rinhart NY Cat 2, 1971: 585 (7);
Harris Baltimore 12/16/83: 105 (lot, P-3 et al);

**PRETSCH, Paul** (Austrian, 1803-1873)
Photos dated: 1854-1857
Processes:     Photogalvanograph
Formats:       Prints
Subjects:      Genre
Locations:     England
Studio:        England
   Entries:
Phillips NY 11/4/78: 23 ill(note);
Sothebys Lon 3/27/81: 392 (8);

**PREUSS, J.A.** (Swiss)(photographer or publisher?)
Photos dated: 1880s
Processes:     Carbon
Formats:       Prints
Subjects:      Topography
Locations:     Switzerland
Studio:        Switzerland - Zurich
   Entries:
Sothebys Lon 10/27/78: 215 (book, 36);

**PRICAM, Emile** (Swiss)
Photos dated: 1860s
Processes:     Albumen
Formats:       Prints
Subjects:      Documentary (engineering)
Locations:     Switzerland
Studio:        Switzerland - Geneva
   Entries:
Christies Lon 10/28/82: 57 (lot, P-11 et al);

**PRICE, Daniel** (American)
Photos dated: c1878
Processes:     Albumen
Formats:       Prints
Subjects:      Portraits
Locations:     Studio
Studio:        US - Newark, New Jersey
   Entries:
Harris Baltimore 6/1/84: 247 (lot, P-1 et al);
Wood Boston Cat 58, 1986: 136 (books, P-1 et al);

**PRICE, J.** (British)
Photos dated: 1850s
Processes:     Ambrotype
Formats:       Plates
Subjects:      Portraits
Locations:     Studio
Studio:        England - Ramsgate
   Entries:
Sothebys Lon 6/11/76: 115 (lot, P-1 et al);

**PRICE, J.W.** (British)
Photos dated: late 1870s-early 1880s
Processes:     Albumen
Formats:       Prints, cdvs
Subjects:      Portraits
Locations:     England - Derby
Studio:        England - Derby
   Entries:
Gordon NY 5/3/76: 298 (books, P et al);
Christies Lon 6/24/82: 380 (albums, P et al);

**PRICE, Hugh** (British)
Photos dated: 1897
Processes:     Platinum
Formats:       Prints
Subjects:
Locations:
Studio:        Great Britian
   Entries:
Christies Lon 3/16/78: 323 (lot, P et al);

**PRICE, William Lake** (British, 1810-1896)
Photos dated: 1854-1862
Processes:      Albumen
Formats:        Prints, stereos
Subjects:       Genre (still life)
Locations:      England; Italy - Rome
Studio:         England
    Entries:
Weil Lon Cat 4, 1943(?): 237 (album, P et al)(note);
Sothebys Lon 5/24/73: 14 (album, P et al);
Sothebys Lon 10/18/74: 158 (album, P et al);
Sothebys Lon 3/21/75: 286 (album, P-1 et al), 359
    ill(note);
Colnaghi Lon 1976: 134 ill(note);
Sothebys Lon 6/11/76: 174 ill(album, P-1 et al)
    (note);
Sothebys Lon 10/29/76: 26 (lot, P-1 et al), 29 ill
    (lot, P-3 et al);
Christies Lon 3/16/78: 293 ill;
Sothebys Lon 6/28/78: 2 (lot, P et al), 283 (album,
    P-1 et al)(note);
Phillips NY 11/4/78: 33 ill(attributed)(note);
Christies Lon 3/15/79: 284 ill(note);
Sothebys Lon 10/29/80: 196;
Christies Lon 10/30/80: 119 (lot, P-1 et al);
Christies NY 11/11/80: 9 ill(note);
Sothebys Lon 6/17/81: 10 ill(lot, P-1 attributed,
    et al);
Christies Lon 6/24/82: 335;
Christies Lon 10/28/82: 166;
Phillips Lon 6/15/83: 136;
Christies Lon 6/23/83: 39 (lot, P-1 et al);
Christies Lon 3/29/84: 204;
Christies Lon 6/27/85: 38 (lot, P-2 et al);
Sothebys Lon 11/1/85: 59 (album, P-1 et al), 65
    ill, 66 ill(note);
Sothebys Lon 4/25/86: 112 ill;

**PRIDEAUX, Walter** (British)
Photos dated: 1860s
Processes:      Albumen
Formats:        Prints
Subjects:
Locations:
Studio:         Great Britain (Amateur Photographic
                Association)
    Entries:
Christies Lon 10/27/83: 218 (albums, P-1 et al);

**PRIEST** (see ABELL & PRIEST)

**PRINCE** (see EVANS & PRINCE)

**PRINCE, G.** (American)
Photos dated: 1895
Processes:      Platinum
Formats:        Prints
Subjects:       Portraits, topography
Locations:      US - Washington, D.C.; Virginia
Studio:         US - Washington, D.C.
    Entries:
Swann NY 11/11/76: 436;
Harris Baltimore 12/10/82: 393;
Harris Baltimore 9/27/85: 34;

**PRINCE, L.I.** (American)
Photos dated: 1860s
Processes:      Albumen
Formats:        Cdvs
Subjects:       Portraits
Locations:      Studio
Studio:         US - New Orleans, Louisiana
    Entries:
Sothebys NY (Strober Coll.) 2/7/70: 298 (lot,
    P et al);
Swann NY 11/10/83: 240 (lot, P et al);

**PRINGLE** (see ROSS & THOMSON)

**PRINGLE, Andrew** (British)
Photos dated: 1870s-1880s
Processes:      Platinum
Formats:        Prints
Subjects:       Topography
Locations:      Great Britain
Studio:         Scotland - Edinburgh
    Entries:
Christies Lon 10/27/83: 62 (lot, P et al);
Christies Lon 3/29/84: 338 (albums, P & Ross et al);

**PRINGLE, Thomas**
Photos dated: 1890s
Processes:      Carbon
Formats:        Prints
Subjects:       Ethnography
Locations:
Studio:         New Zealand - Wellington
    Entries:
Christies Lon 10/25/79: 442 ill(album, 13);

**PRINGLE, W.J.** (British)
Photos dated: 1870
Processes:      Albumen
Formats:        Prints
Subjects:       Topography
Locations:      England - Melrose
Studio:         Great Britain
    Entries:
Witkin NY IV 1976: OP318 (book, 12);
California Galleries 6/28/81: 98A ill(book, 12);
Christies Lon 6/24/82: 240 (book, 12);
Swann NY 5/9/85: 276 (book, 12);

**PROCTOR, Edwin W.**
Photos dated: 1860s
Processes:      Ambrotype, albumen
Formats:        Plates, cdvs
Subjects:       Portraits
Locations:
Studio:
    Entries:
Christies Lon 10/25/79: 47 (lot, P-3 et al);
Christies Lon 6/26/80: 87 (lot, P-2 et al);

PROCTOR, G.K. (American)
Photos dated: 1870s
Processes:      Albumen
Formats:        Stereos
Subjects:       Topography
Locations:      US - New England
Studio:         US - Salem, Massachusetts
    Entries:
Harris Baltimore 7/31/81: 107 (lot, P et al);
Harris Baltimore 12/16/83: 86 (lot, P et al);

PROMPT (French)
Photos dated: between 1850s and 1870s
Processes:      Collotype
Formats:        Prints
Subjects:       Documentary (engineering)
Locations:      France - Albi
Studio:         France - Albi
    Entries:
Sothebys LA 2/13/78: 121 (books, P et al)(note);

PROUT, Victor A. (British)
Photos dated: 1850s-1864
Processes:      Albumen
Formats:        Prints incl. panoramas, stereos, cdvs
Subjects:       Topography, architecture
Locations:      England - London et al
Studio:         England
    Entries:
Colnaghi Lon 1976: 199 (2 ills)(book, 23)(note);
Sothebys Lon 3/22/78: 196 ill(album, 70)(note);
Sothebys Lon 6/17/81: 226 (lot, P et al);
Sothebys Lon 10/28/81: 221 ill(book, 40);
Sothebys Lon 3/15/82: 435 (book, 3);
Christies Lon 6/24/82: 116 (book, 23), 117
    (book, 35);
Sothebys Lon 3/25/83: 112 ill(book, 36), 113 ill
    (album, 70);
Christies Lon 6/23/83: 89 (27);
Sothebys Lon 6/24/83: 109 ill(book, 40);

PROVOST (French) [PROVOST 1]
Photos dated: 1860s-1870s
Processes:      Albumen
Formats:        Prints, cdvs
Subjects:       Topography
Locations:      France - Toulouse; Beziers
Studio:         France - Toulouse
    Entries:
Sothebys LA 2/13/78: 121 (books, P et al)(note);
Petzold Germany 11/7/81: 310 (album, P et al);
Christies Lon 10/29/81: 54 (lot, P-1 et al);
Sothebys NY 6/29/84: 130 ill;

PROVOST & Co. (British) [PROVOST 2]
Photos dated: 1870s
Processes:      Albumen
Formats:        Cdvs
Subjects:
Locations:
Studio:
    Entries:
Swann NY 11/10/83: 277 (album, P et al)(note);

PRUDDAH
Photos dated: c1860
Processes:      Albumen
Formats:        Stereos
Subjects:       Topography
Locations:
Studio:
    Entries:
Christies Lon 3/28/85: 42 (lot, P et al);

PRUD'HOMME, John Francis Eugene (American)
Photos dated: 1851
Processes:      Daguerreotype
Formats:        Plates
Subjects:       Portraits
Locations:      Studio
Studio:         US - New York City
    Entries:
Vermont Cat 10, 1975: 540 ill(note);

PRUEMM, Theodor (German)
Photos dated: c1885
Processes:      Albumen
Formats:        Cabinet cards
Subjects:       Portraits
Locations:      Studio
Studio:         Germany - Berlin
    Entries:
Swann NY 10/18/79: 337 (album, P et al);

PRYCE, T. (British)
Photos dated: 1860s
Processes:      Albumen
Formats:        Prints
Subjects:
Locations:
Studio:         Great Britain (Amateur Photographic
                Association)
    Entries:
Christies Lon 10/29/81: 359 (album, P-2 et al)
    (note);
Christies Lon 10/27/83: 218 (albums, P-5 et al);

PUDUMJEE, Dorabjec
Photos dated: 1860s
Processes:      Albumen
Formats:        Prints
Subjects:
Locations:
Studio:         Great Britain (Amateur Photographic
                Association)
    Entries:
Christies Lon 10/27/83: 218 (albums, P-2 et al);

PUISEUX (see LOEWY & PUISEUX)

**PULMAN, G. & E.**
Photos dated: 1860s-1870s
Processes:    Albumen
Formats:      Prints
Subjects:     Topography, ethnography
Locations:    New Zealand
Studio:       New Zealand - Aukland
    Entries:
Christies NY 11/11/80: 92 (album, P et al);
California Galleries 5/23/82: 373, 374 ill;

**PUMPHREY, William** (British)
Photos dated: 1840s-1860s
Processes:    Daguerreotype, calotype, albumen
Formats:      Plates, prints, stereos
Subjects:     Topography, portraits
Locations:    England - York
Studio:       England - York
    Entries:
Ricketts Lon 1974: 7 ill(album, 59);
Christies Lon 6/10/76: 34 ill(4)(note);
Christies Lon 3/10/77: 70 (4);
Phillips Lon 3/13/79: 33 (note);
Christies Lon 10/25/79: 79 (lot, P-1 et al);
Christies Lon 3/20/80: 106 (lot, P-2 et al);
Sothebys Lon 3/27/81: 29 (lot, P-1 et al);
Sothebys Lon 10/28/81: 322 (2), 323, 324 ill,
    325 (2);
Sothebys Lon 6/25/82: 184 ill, 185 (2);
Christies Lon 6/23/83: 43 (lot, P et al);
Harris Baltimore 12/16/83: 43 (lot, P et al);

**PUN-KY** (Chinese)
Photos dated: 1870s
Processes:    Albumen
Formats:      Cdvs
Subjects:     Ethnography
Locations:    China
Studio:       China
    Entries:
Swann NY 11/18/82: 346 (lot, P-3 et al);

**PUN-LUN** (Chinese)
Photos dated: Nineteenth century
Processes:    Albumen
Formats:      Cdvs
Subjects:     Portraits
Locations:    Studio
Studio:       China - Hong Kong
    Entries:
Sothebys NY (Strober Coll.) 2/7/70: 279 (lot,
    P et al);

**PURDY** (American)
Photos dated: c1880
Processes:    Tintype
Formats:      Plates
Subjects:     Portraits
Locations:    Studio
Studio:       US - Boston, Massachusetts
    Entries:
California Galleries 1/22/77: 134;

**PURRIS, John**
Photos dated: 1845
Processes:    Calotype
Formats:      Prints
Subjects:     Genre
Locations:    Europe
Studio:       Europe
    Entries:
Rauch Geneva 6/13/61: 42i (note);

**PURVIANCE, William T.** (American)
Photos dated: 1864-1889
Processes:    Albumen
Formats:      Stereos, prints
Subjects:     Documentary (disasters, railroads)
Locations:    US - Illinois; Pittsburg,
              Pennsylvania; New York
Studio:       US - Pittsburg, Pennsylvania
    Entries:
Sothebys NY (Strober Coll.) 2/7/70: 514 (lot,
    P et al);
Sothebys NY 11/21/70: 368 (lot, P et al);
Rinhart NY Cat 1, 1971: 126 (4), 306 (15);
Rinhart NY Cat 2, 1971: 555;
Rinhart NY Cat 7, 1973: 464 (4);
California Galleries 4/3/76: 456 (26);
Christies Lon 3/26/81: 252;
Harris Baltimore 3/26/82: 219 (13)(note);
Harris Baltimore 12/10/82: 307 (17);
Harris Baltimore 4/8/83: 91 (42);
Harris Baltimore 12/16/83: 111 (9);
Harris Baltimore 6/1/84: 25 (lot, P et al), 103
    (lot, P et al), 119 (lot, P et al);
Harris Baltimore 3/15/85: 53 (lot, P-1 et al), 69
    (lot, P et al), 84 (lot, P-2 et al);
Swann NY 11/14/85: 135 (album, P et al);
Harris Baltimore 2/14/86: 38 (lot, P et al);

**PYWELL, William R.** (American)
Photos dated: 1862
Processes:    Albumen
Formats:      Prints
Subjects:     Documentary (Civil War)
Locations:    US - Civil War area
Studio:       US
    Entries:
Sothebys Lon 6/21/74: 162 (book, P et al);
Sothebys Lon 10/18/74: 137 (book, P et al);
Sothebys NY 11/9/76: 78 (note);
Swann NY 4/14/77: 250A (book, P et al);
Sothebys NY 5/20/77: 2;
Wood Conn Cat 41, 1978: 129 (book, P-3 et al)(note);
Wood Conn Cat 45, 1979: 113 (book, P-3 et al)(note);
Harris Baltimore 12/10/82: 244;
Swann NY 5/5/83: 107 (book, P et al)(note);
Harris Baltimore 9/16/83: 1, 2;
Sothebys NY 5/8/84: 155 ill(book, P et al)(note);
Swann NY 5/10/84: 52 (book, P et al)(note);
Harris Baltimore 6/1/84: 361;

**QUETIER, E.** (French)
Photos dated: c1856-1870s
Processes: Albumen
Formats: Prints
Subjects: Topography, architecture
Locations: France - Amiens, Bourges, Chartres,
Chenonceaux; Italy - Rome;
Switzerland - Berne
Studio: France - Paris
Entries:
Edwards Lon 1975: 13 (album, Q-1 et al);
Christies Lon 6/10/76: 64 (lot, Q et al);
Sothebys NY 11/9/76: 59 ill(3);
Gordon NY 11/13/76: 40 ill;
Sothebys NY 5/15/81: 103 (2);
Christies Lon 3/24/83: 69 (lot, Q et al);

**QUEVAL, J.** (French)
Photos dated: c1868-1872
Processes: Albumen
Formats: Stereos
Subjects: Topography
Locations: Belgium; France; Great Britain
Studio: France - Paris; England - London
Entries:
Rauch Geneva 6/13/61: 223 (lot, Q et al);
Auer Paris 5/3/80: 111 (9);

**QUICK** (see HOAG & QUICK)

**QUINBY** (American)
Photos dated: c1855-1860
Processes: Daguerreotype
Formats: Plates
Subjects: Portraits
Locations: Studio
Studio: US - New York City
Entries:
Rinhart NY Cat 2, 1971: 170;
Sothebys Lon 7/1/77: 219 (lot, Q-1 et al);
California Galleries 1/21/78: 61 (lot, Q-1 et al);
Phillips NY 11/3/79: 114 (lot, Q et al);

**QUINBY, S.D.** (American)
Photos dated: 1860s-1870s
Processes: Albumen
Formats: Cdvs, stereos
Subjects: Portraits, topography
Locations: US
Studio: US - Charleston, South Carolina
Entries:
Sothebys NY (Strober Coll.) 2/7/70: 287 (lot, Q-1
et al), 295 (lot, Q et al), 486 (lot, Q et al);
Sothebys NY (Greenway Coll.) 11/20/70: 170 ill;
Petzold Germany 5/22/81: 1728;
California Galleries 6/28/81: 166 (lot, Q-1 et al);
Christies Lon 6/28/84: 37a (lot, Q et al);

**QUINET, Achille** (French)
Photos dated: 1851-c1871
Processes: Salt, albumen
Formats: Prints, stereos
Subjects: Topography, genre (rural life),
portraits
Locations: France - Paris et al
Studio: France - Paris
Entries:
Sothebys Lon 10/24/75: 137 (lot, Q-3 et al);
Wood Conn Cat 37, 1976: 312 ill, 313 ill, 314 ill,
315, 316;
Sothebys NY 11/9/76: 58 (2 ills)(2)(note);
Swann NY 11/11/76: 450 (lot, Q et al);
Rose Boston Cat 2, 1977: 41 ill(note), 42 ill;
White LA 1977: 53 ill(note), 54 ill, 267 (2 ills)
(38);
California Galleries 1/22/77: 338;
Christies Lon 3/10/77: 106 (4);
Swann NY 4/14/77: 245 (album, Q et al);
Sothebys Lon 11/18/77: 250 (3);
Wood Conn Cat 41, 1978: 12 ill(note), 13 ill, 25
(book, Q-10 et al)(note);
California Galleries 1/21/78: 266 (2);
Christies Lon 3/16/78: 72 (4);
Sothebys NY 5/2/78: 101 ill, 102 ill, 103, 104, 105;
Christies Lon 6/27/78: 78 (4);
Phillips NY 11/4/78: 62 ill(7);
Lehr NY Vol 1:4, 1979: 46 (album, 30)(note);
Wood Conn Cat 45, 1979: 186 (book, Q-10 et al)
(note);
Phillips Lon 3/13/79: 94 ill(note), 95 (7);
Christies NY 5/4/79: 45 ill(album)(note);
Sothebys NY 5/8/79: 93 (lot, Q-2 et al);
Sothebys Lon 10/24/79: 117 ill(album, 40);
Witkin NY X 1980: 57 (2 ills)(album, 40)(note);
Sothebys LA 2/6/80: 126 (6);
Christies NY 5/16/80: 136 (21);
Phillips NY 5/21/80: 205 ill(3), 206 (4), 207 (4),
208 ill(4);
Christies Lon 10/30/80: 172 (2);
Sothebys Lon 3/27/81: 130 ill(album, 24);
Swann NY 4/23/81: 365;
Christies Lon 6/18/81: 103 (lot, Q et al);
Wood Conn Cat 49, 1982: 332 (book, Q-10 et al)
(note);
Christies Lon 3/11/82: 90 (lot, Q et al), 143 ill
(albums, Q et al);
Christies Lon 6/24/82: 305 (4), 306;
Christies Lon 10/28/82: 30 (lot, Q et al);
Drouot Paris 11/27/82: 16 (album, Q-5 et al);
Christies NY 2/8/83: 13 (2);
Sothebys Lon 3/25/83: 80a (2);
Swann NY 5/5/83: 422 (8)(note);
Sothebys Lon 6/24/83: 68 ill(4), 69 ill(3);
Christies NY 10/4/83: 87 (2);
Christies Lon 10/27/83: 99 ill(album, 99);
Phillips Lon 11/4/83: 112;
Christies Lon 3/29/84: 58A (album, Q-14 et al);
Sothebys Lon 6/29/84: 106 (4);
Phillips Lon 10/24/84: 145;
Christies NY 2/13/85: 127 (11), 128 (11);
Christies Lon 3/28/85: 219 ill(8);
Christies Lon 6/28/85: 183 ill(album);
Phillips Lon 10/30/85: 116 (lot, Q-1 et al);
Wood Boston Cat 58, 1986: 326 (book, Q-10 et al);
Christies Lon 6/26/86: 189 (lot, Q-1 et al);
Sothebys NY 11/10/86: 284 ill;
Swann NY 11/13/86: 277 (lot, Q-1 et al), 301,
302 (6);

QUIST, P.E. (Swedish)(see also EURENIUS & QUIST)
Photos dated: c1870
Processes:      Albumen
Formats:        Cdvs
Subjects:       Ethnography
Locations:      Studio
Studio:         Sweden
   Entries:
Christies Lon 10/26/78: 339 (album, Q et al);

QUITH, J.A. (American)
Photos dated: 1840s
Processes:      Daguerreotype
Formats:        Plates
Subjects:       Portraits
Locations:      Studio
Studio:         US - New York City
   Entries:
Rinhart NY Cat 2, 1971: 167 (lot, Q-1 et al);

R., A. [A.R.] (British)
Photos dated: Nineteenth century
Processes:
Formats:      Microphotographs
Subjects:     Genre
Locations:    Studio
Studio:       Great Britain
   Entries:
Phillips Lon 10/30/85: 90B (lot, R-2 et al);

R., C. [C.R.] (British)
Photos dated: 1860s-1880s
Processes:    Albumen
Formats:      Prints
Subjects:     Genre (animal life)
Locations:
Studio:
   Entries:
Phillips NY 5/21/80: 139;
Christies Lon 10/28/82: 207 (lot, R et al);
Christies Lon 10/25/84: 360 (lot, R-1 et al);

R., E. [E.R.]
Photos dated: 1861
Processes:    Albumen
Formats:      Prints
Subjects:     Topography
Locations:    France - Paris
Studio:
   Entries:
Christies Lon 6/26/80: 190 (2);

R., F. & Co. [F.R. & Co.]
Photos dated: Nineteenth century
Processes:    Albumen
Formats:      Prints
Subjects:     Topography
Locations:    Great Britain
Studio:
   Entries:
Witkin NY II 1974: 889 (lot, R-2 et al);

R., G. [G.R.]
Photos dated: 1850s and/or 1860s
Processes:    Albumen
Formats:      Stereos incl. tissue
Subjects:     Genre
Locations:    Studio
Studio:       Great Britain
   Entries:
Christies Lon 6/27/85: 34 (lot, R-1 et al), 36 (lot,
   R-4 et al);
Phillips Lon 4/23/86: 187 (lot, R-1 et al);
Christies Lon 4/24/86: 366 (lot, R-3 et al);

R., G.W. [G.W.R.]
Photos dated: between 1860s and 1880s
Processes:    Albumen
Formats:      Stereos
Subjects:     Topography
Locations:    Canada
Studio:
   Entries:
Phillips Lon 10/29/86: 227 (lot, R et al);

R., H. [H.R.]
Photos dated: 1888
Processes:    Albumen
Formats:      Prints
Subjects:     Architecture
Locations:    Germany - Berlin
Studio:
   Entries:
Harris Baltimore 6/1/84: 388 (lot, R-1 et al);

R., J. [J.R.] (French)
Photos dated: 1871
Processes:    Albumen
Formats:      Prints, stereos
Subjects:     Documentary (Paris Commune)
Locations:    France - Paris
Studio:       France
   Entries:
Christies Lon 6/30/77: 93 (lot, R-1 et al);
California Galleries 1/21/79: 488 (3);
Sothebys Lon 3/27/81: 128 (lot, R et al);
Swann NY 4/23/81: 511 (5);
Petzold Germany 11/7/81: 290 (lot, R-9 et al);
Swann NY 5/10/84: 311 (lot, R et al);
Swann NY 11/14/85: 142 (lot, R et al), 161 (lot,
   R et al);

R, W. [W.R.]
Photos dated: c1855
Processes:    Albumen
Formats:      Prints
Subjects:     Topography
Locations:    Russia - Crimea
Studio:
   Entries:
Sothebys Lon 3/22/78: 191 (album, R et al)(note);

RADCLIFFE, E. (British)
Photos dated: 1850s
Processes:    Calotypes
Formats:      Prints
Subjects:     Portraits
Locations:    Great Britain
Studio:       Great Britain - Rudding Park
   Entries:
Sothebys Lon 5/24/73: 116 (attributed);

RADCLYFFE (British)
Photos dated: Nineteenth century
Processes:
Formats:      Prints
Subjects:     Topography
Locations:    Wales
Studio:       Great Britain
   Entries:
Swann NY 2/14/52: 345 (books, R-51 et al);

RADIGUET (French)
Photos dated: c1870
Processes:    Albumen
Formats:      Stereos
Subjects:     Genre
Locations:    France
Studio:       France
   Entries:
Auer Paris 5/31/80: 115 (10);

RADOULT, Arthur
Photos dated: 1860s
Processes:      Albumen
Formats:        Stereos
Subjects:       Genre (nudes)
Locations:
Studio:
   Entries:
Sothebys Lon 6/29/84: 13 ill(lot, R et al);

RADOUX (Belgian)
Photos dated: 1852-c1855
Processes:      Calotype
Formats:        Prints
Subjects:       Topography
Locations:      Belgium - Louvain, Bruges, Ghent,
Antwerp
Studio:         Belgium - Brussels
   Entries:
Maggs Paris 1939: 488, 489;
Rauch Geneva 6/13/61: 97 ill(3)(note);
Sothebys Lon 10/31/86: 150 ill(2);

RAE, A. & Son (British)
Photos dated: 1860s
Processes:      Albumen
Formats:        Prints, cdvs
Subjects:       Topography
Locations:      Great Britain - Banff
Studio:         Great Britain - Banff
   Entries:
Witkin NY X 1980: 58 (book, 4);

RAGON, Henri (French)
Photos dated: c1880
Processes:      Albumen
Formats:        Prints
Subjects:       Topography
Locations:      France - Bayonne
Studio:         France
   Entries:
Christies Lon 10/28/76: 111 ill(album, R et al);

RAHN (see FRY & RAHN)

RALL, William H.
Photos dated: Nineteenth century
Processes:      Albumen
Formats:        Stereos
Subjects:       Topography
Locations:      North America
Studio:
   Entries:
Christies Lon 10/29/81: 147 (lot, R et al);

RALSTON (British)
Photos dated: 1860s
Processes:      Ambrotype
Formats:        Plates
Subjects:       Portraits
Locations:      Studio
Studio:         Scotland - Glasgow
   Entries:
Christies Lon 6/18/81: 263 (book, R et al);

RAM (see LALL & RAM)

RAMBAUD, Charles
Photos dated: Nineteenth century
Processes:      Albumen
Formats:        Cabinet cards
Subjects:       Topography
Locations:      Europe
Studio:         Europe
   Entries:
Swann NY 5/10/84: 306 (lot, R et al);

RAMAGE (British)
Photos dated: 1897
Processes:
Formats:        Prints
Subjects:       Documentary (public events)
Locations:      England - Sheffield
Studio:         England - Sheffield
   Entries:
Swann NY 4/23/81: 550 (album, 15)(note);

RAMSDEN, H.M. (American)
Photos dated: Nineteenth century
Processes:      Albumen
Formats:        Stereos
Subjects:       Topography
Locations:      US - North Adams, Massachusetts
Studio:         US - North Adams, Massachusetts
   Entries:
Harris Baltimore 6/1/84: 87 (18);

RAMSDEN, J.W. (British)
Photos dated: 1850s-1871
Processes:      Salt, albumen
Formats:        Prints
Subjects:       Topography, documentary (educational
                institutions)
Locations:      Great Britain
Studio:         England - Leeds
   Entries:
Sothebys Lon 10/29/76: 65 (book, 11);
Christies Lon 6/27/85: 118 (lot, R-1 et al);
Christies Lon 4/24/86: 492 (2);
Christies Lon 10/30/86: 251 (album, R-1 et al);

RANDALL (American)
Photos dated: 1870s
Processes:      Albumen
Formats:        Cabinet cards
Subjects:       Portraits
Locations:      Studio
Studio:         US - Detroit, Michigan
   Entries:
Frontier AC, Texas 1978: 81 ill(lot, R-1 et al);

**RANDALL, A. Frank** (American)
Photos dated: 1870s-1886
Processes: Albumen
Formats: Cabinet cards, boudoir cards
Subjects: Ethnography
Locations: US - Arizona; New Mexico
Studio: US - Las Cuecas, New Mexico
   Entries:
Phillips NY 5/21/80: 120 (lot, R-3 et al);
Swann NY 11/5/81: 419;

**RANDEGGAR, F.**
Photos dated: Nineteenth century
Processes: Albumen
Formats: Stereos
Subjects: Topography
Locations: Europe
Studio: Europe
   Entries:
Christies Lon 3/11/82: 94 (lot, R et al);

**RANKING, Dr.** (British)
Photos dated: 1857
Processes: Albumen
Formats: Prints
Subjects: Topography
Locations: England - Norwich
Studio: Great Britain (Photographic Club)
   Entries:
Sothebys Lon 3/14/79: 324 (album, R-1 et al);

**RANSOM** (American)
Photos dated: Nineteenth century
Processes: Albumen
Formats: Stereos
Subjects: Topography
Locations: US - Minnesota
Studio: US - Minnesota
   Entries:
Harris Baltimore 6/1/84: 93 (lot, R et al);

**RANSOME, R.C.** (British)
Photos dated: 1854-1857
Processes: Albumen
Formats: Prints, stereos
Subjects: Genre (rural life)
Locations: Great Britain
Studio: Great Britain (Photographic Club)
   Entries:
Sothebys Lon 6/28/78: 236 (lot, R-3 et al);
Sothebys Lon 3/14/79: 324 (album, R-1 et al);

**RAOULT, J.X.**
Photos dated: 1870s
Processes: Albumen
Formats: Prints
Subjects: Topography, documentary
Locations: Egypt - Sinai
Studio: Russia - Odessa
   Entries:
Sothebys Lon 11/1/85: 34 (50);

**RAPIER, Richard C.** (photographer or author?)
Photos dated: 1878
Processes: Carbon
Formats: Prints
Subjects: Documentary (railroads)
Locations: China - Shanghai
Studio:
   Entries:
Sothebys Lon 10/27/78: 212 (book, 8);

**RAPOZO, A.J.** (Portuguese)
Photos dated: 1880s
Processes: Albumen
Formats: Cdvs
Subjects: Ethnography
Locations: Azores
Studio: Azores - St. Miguel
   Entries:
Swann NY 11/6/81: 425 ill(lot, R-24 et al)(note);

**RASCHOW, N., Jr.** (German)
Photos dated: 1870s
Processes: Albumen
Formats: Cdvs, cabinet cards
Subjects: Portraits
Locations: Studio
Studio: Germany - Breslau
   Entries:
Sothebys Lon 10/27/78: 198 (42)(note);

**RAU, William H.** (American, 1855-1920)
Photos dated: 1877-1904
Processes: Cyanotype, albumen, platinum, collodion on glass, silver
Formats: Prints incl. panoramas, stereos, lantern slides
Subjects: Architecture, topography, documentary (disasters)
Locations: US - Pennsylvania and California; Europe
Studio: US - Philadelphia, Pennsylvania
   Entries:
Swann NY 2/6/75: 135 (book)(attributed);
California Galleries 9/27/75: 407 (lot, R et al), 580 (lot, R et al);
California Galleries 4/3/76: 374 (lot, R et al);
California Galleries 1/23/77: 454 (lot, R et al);
Frontier AC, Texas 1978: 259;
California Galleries 1/21/79: 167 (book, 6);
Sothebys NY 5/20/80: 321 ill(album, 24)(attributed);
Swann NY 11/6/80: 365 (5)(note);
Harris Baltimore 7/31/81: 120 (lot, R et al);
Harris Baltimore 12/10/82: 64 (lot, R et al);
Christies NY 2/8/83: 38 ill;
Harris Baltimore 6/1/84: 77 (lot, R et al);
Christies NY 5/6/85: 301 ill;
Christies NY 11/11/85: 357 ill(2);
Swann NY 11/14/85: 264 (books, R et al);
Harris Baltimore 2/16/86: 327 (lot, R-1 et al);

**RAUDNITZ, J.**
Photos dated: 1870
Processes:      Albumen
Formats:        Prints, cabinet cards
Subjects:       Topography
Locations:      France - Paris; Italy - Rome
Studio:
    Entries:
Harris Baltimore 12/16/83: 400 (lot, R-1 et al);

**RAVEN, Reverend E. Millville** (British)
Photos dated: late 1850s-1860s
Processes:      Albumen
Formats:        Prints
Subjects:       Topography
Locations:      Great Britain - River Goite
Studio:         Great Britain
    Entries:
Christies Lon 3/26/81: 149;
Christies Lon 4/24/86: 478;

**REA, W.J.** (American)
Photos dated: c1885
Processes:      Albumen
Formats:        Prints
Subjects:       Topography
Locations:      US - Santa Barbara, California
Studio:         US - California
    Entries:
California Galleries 3/29/86: 755 (lot, R-1 et al);

**READE, Reverend Joseph Bancroft** (British,
                1801-1870)
Photos dated: c1839
Processes:      Salt
Formats:        Prints
Subjects:       Photogenic drawing
Locations:      Studio
Studio:         Great Britain
    Entries:
Sothebys NY 5/20/80: 340 (lot, R-1 attributed
    et al);

**RECORD** (see BAKER & RECORD)

**REDFIELD, Robert S.** (American, 1849-1923)
Photos dated: 1881-1900
Processes:      Platinum
Formats:        Prints
Subjects:       Genre (rural life)
Locations:      US - northeast
Studio:         US - Philadelphia, Pennsylvania
    Entries:
Lehr NY Vol 6:4, 1984: 18 ill(note), 19 ill, 20
    ill, 21 ill, 22 ill, 23 ill, 24 ill, 25 ill, 26
    ill, 27 ill, 28 ill, 29 ill;

**REDMAN, T.** (British)
Photos dated: 1849
Processes:      Calotype
Formats:        Prints
Subjects:       Photogenic drawing
Locations:      Great Britain
Studio:         Great Britain
    Entries:
Swann NY 2/14/52: 4 (album, R et al);

**REED & McKENNEY** (American) [REED 1]
Photos dated: Nineteenth century
Processes:      Albumen
Formats:        Stereos
Subjects:       Topography
Locations:      US - Colorado
Studio:         US - Central City, Colorado
    Entries:
Vermont Cat 11/12, 1977: 825 ill;

**REED** (British) [REED 2]
Photos dated: 1860s and/or 1870s
Processes:      Albumen
Formats:        Stereos
Subjects:       Topography
Locations:      Great Britain
Studio:         Great Britain
    Entries:
Christies Lon 6/18/81: 102 (lot, R-1 et al);

**REED** [REED 3]
Photos dated: c1890
Processes:      Albumen
Formats:        Cabinet cards
Subjects:       Portraits
Locations:
Studio:
    Entries:
California Galleries 9/27/75: 375 (lot, R et al);
California Galleries 1/22/77: 112 (lot, R et al);

**REED, D.T. & S.C.** (American)
Photos dated: c1880
Processes:      Albumen
Formats:        Stereos
Subjects:       Topography
Locations:      US - Newburyport, Massachusetts
Studio:         US
    Entries:
Harris Baltimore 7/31/81: 89 (17);

**REED, M.** (American)
Photos dated: c1880-1890s
Processes:      Albumen
Formats:        Prints
Subjects:       Topography, genre
Locations:      US - Santa Barbara, California
Studio:         US - Santa Barbara, California
    Entries:
Rose Boston Cat 1, 1976: 6 ill(note);
California Galleries 3/30/80: 261 (lot, R-1 et al)
    (note);
Swann NY 4/1/82: 249 (lot, R et al);
California Galleries 6/19/83: 377 (note);
Swann NY 5/10/84: 314 (lot, R et al);

**REED, W.A.** (American)
Photos dated: 1880s
Processes:     Albumen
Formats:      Daguerreotype, prints, stereos
Subjects:     Plates, portraits
Locations:    Studio
Studio:       US - Mobile, Alabama
    Entries:
Sothebys NY (Weissberg Coll.) 5/16/67: 144 (lot, R-1
    et al);
Sothebys NY (Strober Coll.) 2/7/70: 419 (lot, R-1
    et al);

**REED, William G.** (American)
Photos dated: 1884-1885
Processes:     Albumen
Formats:      Prints
Subjects:     Topography
Locations:    US - North Carolina; West Virginia
Studio:       US
    Entries:
Wood Conn Cat 37, 1976: 164 (book, 16)(note);
Wood Conn Cat 42, 1978: 438 (book, 16)(note);
Harris Baltimore 11/9/84: 56;

**REEKIE, John** (American)
Photos dated: early 1860s-1865
Processes:     Salt, albumen
Formats:      Prints
Subjects:     Topography, documentary (Civil War)
Locations:    US - Virginia
Studio:       US
    Entries:
Lunn DC Cat 6, 1976: 49.6 ill;
Swann NY 11/11/76: 458 (note);
Gordon NY 11/13/76: 70 ill;
Wood Conn Cat 41, 1978: 129 (book, R-7 et al)(note);
Wood Conn Cat 45, 1979: 113 (book, R-7 et al)(note);
Sothebys LA  2/4/81: 217 (lot, R-1 et al);
Harris Baltimore 5/28/82: 53, 60, 88 (lot, R-1 et
    al), 89 (attributed);
Harris Baltimore 9/16/83: 66, 67, 76, 80, 81, 82,
    83, 196 (note);
California Galleries 7/1/84: 419;
Harris Baltimore 11/9/84: 24, 28, 67 (lot, R-2
    et al);
Harris Baltimore 11/7/86: 105;

**REEKS** (British)
Photos dated: 1870s
Processes:     Albumen
Formats:      Prints
Subjects:     Architecture
Locations:    Great Britain
Studio:       Great Britain
    Entries:
Christies Lon 3/26/81: 413 (album, R et al);

**REES, Charles R.** (American)
Photos dated: 1862-1880s
Processes:     Albumen
Formats:      Prints, cdvs
Subjects:     Portraits, documentary (Civil War),
              genre (animal life)
Locations:    US - Richmond, Virginia
Studio:       US - Richmond, Virginia
    Entries:
Swann NY 11/11/76: 439;
California Galleries 5/23/82: 203 (album, 10);
Harris Baltimore 9/27/85: 28 ill(note);

**REESE** (American) [REESE 1]
Photos dated: 1870s-1888
Processes:     Albumen
Formats:      Prints, stereos, cabinet cards
Subjects:     Topography, portraits
Locations:    US - Santa Cruz, California
Studio:       US - California
    Entries:
Frontier AC, Texas 1978: 260 (2);
California Galleries 5/23/82: 423 (lot, R et al);
Swann NY 11/14/85: 84 (2)(note);
Swann NY 5/15/86: 192A (lot, R-2 et al);

**REESE & Co.** (American) [REESE 2]
Photos dated: 1853-1850s
Processes:     Daguerreotype
Formats:      Plates
Subjects:     Portraits
Locations:    Studio
Studio:       US - New York City
    Entries:
Sothebys NY (Weissberg Coll.) 5/16/67: 104 (lot,
    R-1 et al);
Vermont Cat 2, 1971: 167 ill;
Witkin NY II 1974: 1202;
Witkin NY IV 1976: D55;
Swann NY 11/11/76: 322 (lot, R-1 et al);
Swann NY 12/8/77: 362 (lot, R-1 et al);
Sothebys Lon 3/27/81: 272 (note);
Swann NY 11/14/85: 47 (lot, R et al);

**REEVE, Lovell** (British)
Photos dated: 1859-1862
Processes:     Albumen
Formats:      Prints, stereos
Subjects:     Topography
Locations:    France - Brittany
Studio:       England - London
    Entries:
Swann NY 2/14/52: 204 (book, 90);
Edwards Lon 1975: 113 (book, 90);
Sothebys Lon 11/18/77: 192 ill(book, 90)(note);
Sothebys NY 5/20/80: (books, R et al);
Swann NY 11/13/86: 134 (lot, R et al);

**REEVES** (British)
Photos dated: c1850
Processes:      Daguerreotype
Formats:        Plates
Subjects:       Portraits
Locations:      Studio
Studio:         England - London
    Entries:
Sothebys Lon 6/11/76: 125 (lot, R-1 et al);
Christies Lon 6/27/78: 19 ill;

**REEVES, H.** (American)
Photos dated: 1871
Processes:      Albumen
Formats:        Stereos
Subjects:       Documentary (disasters)
Locations:      US - Chicago, Illinois
Studio:         US
    Entries:
California Galleries 9/27/75: 468 (lot, R et al);
California Galleries 1/23/77: 372 (lot, R et al);

**REGNAULT, Henri-Victor** (French, 1810-1878)
Photos dated: 1845-1854
Processes:      Calotype, salt (Blanquart-Evrard)
Formats:        Prints
Subjects:       Topography, portraits, genre
Locations:      France - Sèvres
Studio:         France - Sèvres
    Entries:
Sothebys Lon 10/29/80: 121 ill(note);
Christies Lon 10/30/80: 166 ill(note);
Sothebys Lon 3/27/81: 204 ill;
Sothebys Lon 3/15/82: 195 ill(note);
Sothebys Lon 6/24/83: 67 ill(note);
Sothebys Lon 4/25/86: 173 ill(note);

**REHN, Isaac A.** (American)
Photos dated: 1849-1859
Processes:      Daguerreotype, ambrotype
Formats:        Plates
Subjects:       Portraits
Locations:      Studio
Studio:         US - Philadelphia, Pennsylvania
    Entries:
Vermont Cat 4, 1972: 399 ill;
Vermont Cat 8, 1974: 530 ill;
Swann NY 12/8/77: 327 ill(note);
Swann NY 4/23/81: 268 (lot, R-1 et al);
Swann NY 11/8/84: 180 (lot, R et al);

**REID & GRAY**
Photos dated: 1890s
Processes:      Albumen
Formats:        Prints
Subjects:       Topography
Locations:      Australia and/or New Zealand
Studio:
    Entries:
Christies Lon 3/28/85: 77 (lot, R & G et al);
Christies Lon 10/31/85: 116 (lot, R & G et al);

**REID, Charles** (British)
Photos dated: Nineteenth century
Processes:      Albumen
Formats:        Prints
Subjects:       Genre (animal life)
Locations:      England
Studio:         England - Wishaw
    Entries:
Christies Lon 10/4/73: 124 (album, 100);

**REID, J.** (American)
Photos dated: 1866-1874
Processes:      Albumen
Formats:        Prints, stereos
Subjects:       Documentary (railroads, engineering)
Locations:      US - New York; New Jersey;
                Pennsylvania
Studio:         US - Patterson, New Jersey
    Entries:
Sothebys NY 9/23/75: 90 (lot, R-3 et al);
Wood Conn Cat 37, 1976: 317 ill, 318 ill;
Swann NY 4/20/78: 233, 234 ill, 235;
Swann NY 5/15/86: 131 (book, R et al);

**REID, William** (British)
Photos dated: late 1850s
Processes:      Daguerreotype, ambrotype
Formats:        Plates
Subjects:       Portraits
Locations:      Studio
Studio:         Scotland - Aberdeen
    Entries:
Sothebys Lon 11/18/77: 149 (lot, R-1 et al);
Petzold Germany 11/7/81: 156 ill;

**REILLY, G.S.** (British)
Photos dated: c1890
Processes:      Albumen
Formats:        Prints
Subjects:       Architecture
Locations:      England - Clovelly
Studio:         Great Britain
    Entries:
Sothebys Lon 10/27/78: 102;

**REILLY, J.J.** (American)
Photos dated: 1860s-1875
Processes:      Albumen
Formats:        Prints, stereos
Subjects:       Topography
Locations:      US - Niagara Falls, New York;
                California
Studio:         US - San Francisco, California
    Entries:
Sothebys NY (Strober Coll.) 2/7/70: 500 (18)(note);
Rinhart NY Cat 1, 1971: 259, 287 (lot, R &
    Spooner-1, et al);
Rose Boston Cat 2, 1977: 7 ill(note);
Vermont Cat 11/12, 1977: 826 ill(R & Spooner, 4);
Swann NY 4/14/77: 323 (lot, R & Spooner et al);
Christies Lon 10/30/80: 135 (lot, R-1 et al);
Swann NY 11/6/80: 388 (lot, R et al);
California Galleries 12/13/80: 383 (lot, R-1 et al);
California Galleries 6/28/81: 323 (lot, R-1 et al);
Harris Baltimore 7/31/81: 111 (lot, R et al);
Christies Lon 10/29/81: 151 (22);
Christies Lon 3/11/82: 96 (lot, R et al);

**REILLY, J.J.** (continued)
Swann NY 4/1/82: 357 (lot, R et al);
California Galleries 5/23/82: 431 (lot, R-3 et al);
Christies Lon 6/24/82: 54 (lot, R-22 et al);
Harris Baltimore 12/10/82: 116 (lot, R et al);
Harris Baltimore 4/8/83: 122 (10);
California Galleries 6/19/83: 453 (lot, R et al);
Christies Lon 10/27/83: 44 (lot, R-3 et al);
Harris Baltimore 12/16/83: 18 (lot, R-2 et al);
Harris Baltimore 6/1/84: 15 (lot, R et al);
California Galleries 7/1/84: 197 (lot, R-3 et al);
Harris Baltimore 3/15/85: 24 (lot, R et al), 75
   (lot, R-2 et al);
Christies Lon 3/28/85: 45 (lot, R et al);
California Galleries 6/8/85: 438 (lot, R et al);
Christies Lon 6/27/85: 32 (lot, R-5 et al);
Christies Lon 10/31/85: 71 (lot, R-24 et al);
Phillips Lon 10/29/86: 247B (lot, R-1 et al);

**REIN, J.J.** (German)(photographer or author?)
Photos dated: 1888
Processes:     Phototype
Formats:       Prints
Subjects:      Topography
Locations:     Japan
Studio:
   Entries:
Wood Conn Cat 37, 1976: 165 (book, 5)(note);
Wood Conn Cat 42, 1978: 439 (book, 5)(note);

**REISER, A.D. & Co.**
Photos dated: 1870s
Processes:     Albumen
Formats:       Prints
Subjects:      Topography
Locations:     Roumania
Studio:        Roumania - Bucharest
   Entries:
Christies Lon 3/29/84: 65 (album, R et al);
Swann NY 5/9/85: 425 ill(album, R et al)(note);

**REISENER, Louis** (French)
Photos dated: 1842
Processes:     Daguerreotype
Formats:       Plates
Subjects:      Portraits
Locations:     Studio
Studio:        France - Frepillon
   Entries:
Drouot 11/27/82: 102 ill(attributed)(note);

**REISSER, Carl** (Austrian)
Photos dated: 1843-1844
Processes:     Daguerreotype
Formats:       Plates
Subjects:      Portraits
Locations:     Studio
Studio:        Germany - Munich
   Entries:
Christies Lon 6/27/85: 1 ill(note);

**REJLANDER, Oscar Gustave** (Swedish, 1813-1875)
Photos dated: 1853-1870s
Processes:     Albumen, heliotype
Formats:       Prints, cdvs
Subjects:      Portraits, genre, documentary
               (medical)
Locations:     Studio
Studio:        England - Wolverhampton and London
   Entries:
Goldschmidt Lon Cat 52, 1939: 199 (6)(note), 200
   (10)(note), 201 (26)(note), 202 (note), 203 ill;
Weil Lon Cat 1, 1943: 142 (lot, R-6 et al);
Weil Lon Cat 7, 1945: 167 (3)(note);
Swann NY 2/14/52: 262 (album, R et al), 284 (50)
   (note), 285 (20)(note);
Sothebys NY (Weissberg Coll.) 5/16/67: 77;
Lunn DC Cat 3, 1973: 32 (3 ills)(album, R et al);
Rinhart NY Cat 6, 1973: 116 (book, R et al);
Sothebys Lon 5/24/73: 14 (album, R et al);
Sothebys Lon 6/21/74: 27 (album, R et al), 207 ill
   (note, 208 ill, 209 ill, 210 ill, 211 ill(note);
Christies Lon 7/25/74: 368 (albums, R et al), 391
   ill, 392, 393;
Sothebys Lon 10/18/74: 298 ill(note), 299 ill
   (attributed), 300 ill(attributed), 301 ill
   (attributed), 302;
Edwards Lon 1975: 77 (book, 7);
Witkin NY III 1975: 712 (2 ills)(book, 7);
Sothebys NY 2/25/75: 63 (book);
Sothebys Lon 3/21/75: 349 ill(note), 350 ill(note),
   351 ill, 352 ill, 353 ill, 354 ill;
Sothebys Lon 6/26/75: 52 (album, R-1 attributed et
   al), 245 ill, 246 ill, 247 ill, 248 ill;
Sothebys NY 9/23/75: 82 (book);
Sothebys Lon 10/24/75: 146 (book, 7), 165 ill
   (attributed);
Alexander Lon 1976: 71 ill;
Anderson & Hershkowitz Lon 1976: 24 ill, 25 ill, 26
   (2 ills)(2);
Colnaghi Lon 1976: 135 (note), 136 ill(note), 137
   ill, 138 ill(note), 139 ill(attributed)(note);
Wood Conn Cat 37, 1976: 166 (book, 7)(note);
Sothebys Lon 3/19/76: 113 (lot, R-1 attributed et
   al), 216 (note), 217 ill(attributed)(note), 218
   ill, 219 ill(note), 220 ill(note), 221
   (attributed)(note), 222 ill(note), 223 ill;
Gordon NY 5/3/76: 276 ill(note);
Christies Lon 6/10/76: 120 (2 ills)(15)(note), 121
   ill, 122 ill(note), 123 ill(note), 124 ill
   (note), 125 ill(note), 126 ill(note), 127 ill,
   128 ill(note), 129 ill, 130 ill, 131 ill(note),
   132 ill, 150 (album, R et al);
Sothebys Lon 6/11/76: 163 (book, 7), 224, 225 ill
   (attributed)(note), 226, 227 (lot, R-1 attributed
   et al)(note), 229 ill(attributed), 230 ill
   (attributed);
Christies Lon 10/28/76: 200 ill, 201 ill(note), 202
   ill(note), 203 ill(note), 204, 205 ill, 206, 207
   ill(note), 290 (book, 7);
Sothebys Lon 10/29/76: 89 ill(attributed)(note), 90
   ill(attributed), 91 ill(attributed), 279 ill
   (note), 280 ill(note), 281 ill(note), 282 ill,
   283 ill(note), 284 ill, 285 ill, 286 ill, 287
   ill, 288 ill, 289 (lot, R-1 et al);
Christies NY 10/31/76: 22 (attributed);
Sothebys NY 11/9/76: 39 (book);
Swann NY 11/11/76: 253;
Witkin NY V 1977: 109 (book, 7);
White LA 1977: 55 ill(note);

## REJLANDER (continued)

Sothebys Lon 3/9/77: 241 ill, 242 ill(note), 243
ill, 244 ill, 245 ill, 246 ill, 247, 248 ill,
249 ill, 250 ill, 251 ill;
Christies Lon 3/10/77: 213 ill(note), 214 ill, 215
ill, 216 ill, 217 ill, 218 ill, 325 (book, R
et al);
Swann NY 4/14/77: 109 (book, R-1 et al);
Gordon NY 5/10/77: 820 ill;
Sothebys NY 5/20/77: 70 ill(lot, R-1 et al);
Christies Lon 6/30/77: 206 (book, 7), 305 ill
(note), 306 ill(note), 307, 308, 309 ill(note),
310 (note);
Sothebys Lon 7/1/77: 234 (album, R-1 et al), 290 ill
(note), 291 ill(note), 292 ill(note), 293 ill,
294 ill, 295 ill, 296 ill, 297 ill(note), 298
ill, 299 ill, 300 ill, 301 ill, 302 ill(note);
Christies Lon 10/27/77: 220 (book, 7), 363 (album,
R-3 et al), 379;
Sothebys Lon 11/18/77: 267 ill, 268 ill, 269 ill;
Wood Conn Cat 42, 1978: 440 (book, 7)(note);
Christies Lon 3/16/78: 147 (albums, R-1 et al), 356
ill(note), 357 ill;
Christies Lon 6/27/78: 293 ill(note), 294 ill, 295
ill(note), 296 ill(note);
Sothebys Lon 6/28/78: 328, 329 ill, 330 ill, 331
ill, 332 ill, 333 ill;
Christies Lon 10/26/78: 305 ill, 306 ill(note), 307
ill, 308 ill(note);
Swann NY 12/14/78: 70 (book), 71 (books);
Lehr NY Vol 1:3, 1979: 57;
Lehr NY Vol 1:4, 1979: 84 (book, 7);
Wood Conn Cat 45, 1979: 72A (book, 7)(note);
Phillips Lon 3/13/79: 96 ill, 97 ill, 99 ill, 100
ill(note), 101 ill(note), 102 (note), 103 (5)
(note), 104 (7)(note);
Sothebys Lon 3/14/79: 298 (album, R et al), 324
(album, R-1 et al), 373 ill(attributed);
Christies Lon 3/15/79: 285, 286 (note), 287 (lot,
R-1 et al), 288 (2 ills)(album, 32)(note);
Swann NY 4/26/79: 56 (book);
Christies NY 5/4/79: 32;
Phillips NY 5/5/79: 142 ill;
Sothebys NY 5/8/79: 72 (book, 7);
Christies Lon 6/28/79: 212 (lot, R-1 et al);
Sothebys Lon 6/29/79: 178 (album, R-1 et al), 220
ill, 221 ill;
Sothebys Lon 10/24/79: 290 ill(3), 291, 292, 293,
294 ill, 295 ill;
Christies Lon 10/25/79: 370 ill, 388 (album, R-1 et
al)(note);
Sothebys NY 11/2/79: 222 ill;
Witkin NY X 1980: 59 (book, 7);
Christies Lon 3/20/80: 306;
Sothebys Lon 3/21/80: 288 (book, 7), 356 ill(note),
357 (book, 7);
Swann NY 4/17/80: 73 (book, 7);
Christies NY 5/4/80: 282 (book);
Christies NY 5/16/80: 112;
Christies Lon 6/26/80: 453 (2);
Sothebys Lon 6/27/80: 322, 323, 327 ill, 328 ill;
Sothebys Lon 10/29/80: 199, 200, 201 ill(note), 202
ill, 203 ill;
Christies Lon 10/30/80: 293 (book, 7), 396 (2), 397
ill(note), 400 (lot, R-3 et al), 409 ill(album,
R-1 et al)(note);
Sothebys NY 11/17/80: 47 (book, R et al);
California Galleries 12/13/80: 42 (book, 7);
Phillips NY 1/29/81: 49 (book, 7);
Christies Lon 3/26/81: 390 (note), 391, 392 ill;

## REJLANDER (continued)

Sothebys Lon 3/27/81: 451, 452, 453 (note), 454,
455, 456 ill, 457, 458, 459 ill, 460, 461, 462,
463 ill, 464, 465, 466, 467;
Sothebys Lon 6/17/81: 382 (4), 383, 384, 385 ill,
386 ill, 387 ill, 388, 389, 390 ill, 391, 392
(2), 393 ill, 394, 395 ill(note), 396
(attributed), 397 ill(album, R-2 et al), 451
(book, 7);
Christies Lon 6/18/81: 263 (book, R et al);
Sothebys NY 10/21/81: 212 (books, R et al);
Sothebys Lon 10/28/81: 363 ill, 364, 365 ill, 366
ill, 367 ill, 368, 369, 370 ill, 371, 372, 373
ill, 374 (3), 375 ill;
Christies Lon 10/29/81: 336 ill;
Wood Conn Cat 49, 1982: 123 (book, R et al);
Phillips NY 2/9/82: 210 (book, 7);
Sothebys Lon 3/15/82: 383 (note), 384, 385, 386,
387, 388, 389, 449 (book, 7);
Harris Baltimore 3/26/82: 253 ill(note);
California Galleries 5/23/82: 55 (book, 7)(note);
Sothebys Lon 6/25/82: 56 (book, 7), 187a, 188 (4)
(note), 189 (4);
Christies Lon 10/28/82: 197 (attributed);
Christies Lon 3/24/83: 161 (book, R et al), 209
ill, 209A, 209B (5), 243 (album, R et al);
Christies Lon 10/27/83: 201, 202, 203 (note),
204 (5);
Sothebys Lon 12/9/83: 88 ill, 89 ill, 90;
Kraus NY Cat 1, 1984: 45 (2 ills)(2)(note);
Christies Lon 3/29/84: 318 (lot, R-2 et al);
Swann NY 5/10/84: 320 (album, R et al)(note);
Sothebys Lon 6/29/84: 185, 186 ill, 187 ill, 188
ill, 189 ill, 190 ill, 191 ill;
Christies NY 9/11/84: 107 ill(attributed);
Phillips Lon 10/24/84: 199 (lot, R-1 et al);
Sothebys Lon 10/26/84: 155 ill, 156;
Sothebys NY 11/5/84: 177 ill;
Christies NY 11/6/84: 6 ill(note);
Christies NY 2/13/85: 118 (2);
Christies Lon 3/28/85: 151 (albums, R et al)(note),
184 ill, 185 (note), 186 ill, 186A ill, 187 ill,
188 (3)(attributed), 189 ill(attributed)(note);
Sothebys Lon 3/29/85: 174;
Sothebys NY 5/7/85: 276 ill;
Christies Lon 6/27/85: 170 ill;
Sothebys Lon 6/28/85: 135 ill;
Christies Lon 10/31/85: 218 (2), 219 (note), 220 ill
(attributed);
Sothebys Lon 11/1/85: 59 (album, R-1 et al);
Sothebys NY 11/12/85: 318 ill(2)(note);
Wood Boston Cat 58, 1986: 51 (book, R et al);
Christies Lon 4/24/86: 593 ill(lot, R-2 et al)
(note);
Sothebys Lon 4/25/86: 126 ill, 127 ill, 154 (album,
R-2 attributed et al);
Swann NY 5/15/86: 290 ill(note);
Christies Lon 6/26/86: 44, 149 (album, R et al);
Christies Lon 10/30/86: 97 ill, 245 (album, R-1
et al);
Sothebys Lon 10/31/86: 12 (album, R-1 et al);
Sothebys NY 11/10/86: 230 ill(2);
Swann NY 11/11/86: 332 ill(2);
Phillips NY 11/12/86: 161 (2);

**RELVAS, Carlos** (Portuguese)
Photos dated: 1860s-1874
Processes:      Albumen
Formats:        Prints, stereos
Subjects:       Topography
Locations:      Portugal - Lisbon
Studio:         Portugal - Lisbon
    Entries:
Swann NY 11/5/81: 181 (books, R et al), 182 (book, R et al)(note);

**REMELE, P.H.**
Photos dated: 1875
Processes:      Albumen
Formats:        Prints
Subjects:       Topography
Locations:      Libya
Studio:
    Entries:
Sothebys NY 10/4/77: 133 (book, 16);

**REMICK & RICE**
Photos dated: 1867
Processes:      Tintype
Formats:        Plates
Subjects:       Portraits
Locations:
Studio:
    Entries:
Sothebys NY 11/21/70: 11 (album, 168);

**RENARD, F.A.** (French)
Photos dated: 1852
Processes:      Calotype
Formats:        Prints
Subjects:       Topography, documentary (art)
Locations:      France - Paris
Studio:         France
    Entries:
Maggs Paris 1939: 490;
Weil Lon Cat 4, 1944(?): 181 (album, R et al)(note);
Rauch Geneva 6/13/61: 64 ill(3), 65 (lot, R et al) (note);

**RENARD, G.** (German, 1814-1885)
Photos dated: 1847-1851
Processes:      Daguerreotype
Formats:        Plates
Subjects:       Portraits
Locations:      Studio
Studio:         Germany - Kiel
    Entries:
Petzold Germany 5/22/81: 1729 ill, 1730 (attributed);

**RENAUD, Alphonse Jean** (French)
Photos dated: c1859
Processes:      Albumen
Formats:        Prints
Subjects:       Genre, architecture
Locations:      France
Studio:         France
    Entries:
Phillips NY 5/21/80: 199 ill;
Christies NY 11/6/84: 20 ill(note);

**RENJIO** (Japanese)
Photos dated: 1870s
Processes:      Albumen
Formats:        Cdvs
Subjects:       Portraits
Locations:      Studio
Studio:         Japan - Yokohama
    Entries:
Christies Lon 10/30/80: 243 (lot, R-4 et al);

**REUTLINGER, Charles** (1816-after 1880) **and/or Emile Auguste** (1825-1907)(French)
Photos dated: c1855-1890s
Processes:      Albumen, carbon
Formats:        Prints, cdvs, cabinet cards
Subjects:       Portraits, topography
Locations:      France - Paris
Studio:         France - Paris
    Entries:
Anderson NY (Gilsey Coll.) 2/24/03: 1957;
Maggs Paris 1939: 552;
Sothebys NY (Strober Coll.) 2/7/70: 268 (lot, R et al), 274 (lot, R et al);
Sothebys NY (Greenway Coll.) 11/20/70: 10 (lot, R-2 et al);
Sothebys NY 11/21/70: 337 (lot, R et al), 340 (lot, R et al), 345 (lot, R-1 et al);
Witkin NY I 1973: 372, 373;
Sothebys Lon 6/11/76: 180 (lot, R et al);
Swann NY 11/11/76: 349 (lot, R et al);
Swann NY 4/14/77: 14 (lot, R et al);
Christies Lon 3/16/78: 305 (album, R et al);
Swann NY 4/20/78: 119 (book, R et al), 320 (album, R et al);
Christies Lon 6/27/78: 239 (album, R et al), 259 (lot, R et al)(note);
California Galleries 1/21/79: 486 (3);
Auer Paris 5/31/80: 56 ill(6), 62 (album, R et al);
Phillips NY 5/21/80: 248 (lot, R-1 et al);
Christies Lon 10/30/80: 439 (lot, R-3 et al);
Swann NY 4/23/81: 159 (books, R et al)(note), 545 (18);
Swann NY 11/5/81: 564 (album, R et al)(note);
California Galleries 5/23/82: 304 (3);
Bievres France 2/6/83: 132 (lot, R-1 et al), 162 (lot, R-3 et al);
Christies Lon 3/24/83: 237 (album, R et al), 250 (album, R et al);
Christies Lon 6/23/83: 256 (lot, R et al);
Swann NY 5/10/84: 176 (lot, R et al), 315 (album, R et al);
Harris Baltimore 3/15/85: 300 (lot, R-1 et al);
Wood Boston Cat 58, 1986: 136 (books, R-1 et al);
Swann NY 5/15/86: 201 (album, R et al);
Christies Lon 10/30/86: 222 (album, R et al);

**REVINGTON, E.** (British)
Photos dated: 1860s
Processes:      Albumen
Formats:        Prints
Subjects:
Locations:
Studio:         Great Britain (Amateur Photographic Association)
    Entries:
Christies Lon 10/27/83: 218 (albums, R-1 et al);

**REYES, J.**
Photos dated: 1898-1899
Processes:
Formats:
Subjects:      Documentary (military)
Locations:     Philippines
Studio:        Philippines
    Entries:
California Galleries 1/22/77: 351a (lot, R-1 et al);

**REYMAN & PRICAM**
Photos dated: 1860s-1870s
Processes:     Albumen
Formats:       Stereos
Subjects:      Topography
Locations:     Switzerland
Studio:        Switzerland
    Entries:
Christies Lon 10/29/81: 143 ( lot, R & P et al);

**REYNOLDS, J.** (British)
Photos dated: 1850s and/or 1860s
Processes:     Albumen
Formats:       Stereos
Subjects:      Genre
Locations:     Great Britain
Studio:        Great Britain
    Entries:
Christies Lon 10/25/84: 43 (lot, R-1 et al);

**RHOMAIDES Frères** (Konstantinos & Aristotelis)
                (Greek)
Photos dated: c1869-1900
Processes:     Albumen
Formats:       Prints incl. panoramas, cdvs, cabinet
               cards
Subjects:      Topography, portraits, documentary
               (scientific)
Locations:     Greece - Athens et al
Studio:        Greece - Athens
    Entries:
Christies Lon 10/25/79: 242 (lot, R-1 et al);

**RIBOT**
Photos dated: 1880s
Processes:     Albumen
Formats:       Prints
Subjects:      Topography
Locations:     Europe
Studio:        Europe
    Entries:
Christies Lon 10/27/83: 87 (albums, R et al);

**RICALTON, James** (American)
Photos dated: 1890s-1904
Processes:     Albumen
Formats:       Stereos
Subjects:      Topography, documentary
Locations:     Japan
Studio:
    Entries:
Old Japan, England Cat 8, 1985: 92 (30);

**RICCI, Luigi** (Italian)
Photos dated: 1870s-1880s
Processes:     Albumen
Formats:       Prints
Subjects:      Architecture
Locations:     Italy - Ravenna
Studio:        Italy - Ravenna
    Entries:
Christies NY 5/16/80: 191 (3)(attributed);
Sothebys Lon 6/27/80: 98 (album, 50);

RICE (see REMICK & RICE)

**RICE, Moses P.** (American)
Photos dated: 1860s-1880s
Processes:     Albumen
Formats:       Prints, stereos, cabinet cards
Subjects:      Portraits, topography
Locations:     Studio
Studio:        US - Washington, D.C.
    Entries:
Swann NY 12/14/78: 376 (lot, R et al);
Christies NY 11/11/80: 129 ill;
Harris Baltimore 9/16/83: 112 (lot, R-1 et al);
Sothebys NY 5/8/84: 260;
Harris Baltimore 2/14/86: 76;
Harris Baltimore 11/7/86: 73;

**RICHARD & BETTS**
Photos dated: 1854
Processes:
Formats:       Prints
Subjects:
Locations:
Studio:
    Entries:
Sothebys NY (Strober Coll.) 2/7/70: 32 (book,
    R & B et al);

**RICHARD, Franz** (German)
Photos dated: 1860s-1870s
Processes:     Albumen
Formats:       Prints, stereos
Subjects:      Topography
Locations:     Germany - Heidelberg; Switzerland
Studio:        Germany - Heidelberg
    Entries:
Rose Boston Cat 5, 1980: 99 ill(note), 100 ill,
    101 ill;
Christies Lon 3/11/82: 94 (lot, R et al);
Harris Baltimore 4/8/83: 100 (lot, R et al);
Christies Lon 6/27/85: 30 (lot, R et al);

**RICHARD, T.** (German)
Photos dated: 1870s
Processes:     Albumen
Formats:       Prints, cdvs
Subjects:      Ethnography
Locations:     Germany; Switzerland
Studio:        Germany - Maenedorf
    Entries:
Swann NY 9/18/75: 309 (40), 310 (40);
Harris Baltimore 6/1/84: 341 (lot, R et al);

**RICHARDS, Messrs & Co.**
Photos dated: 1879-1880
Processes:      Albumen
Formats:        Prints
Subjects:       Documentary (public events)
Locations:      Australia - Sydney
Studio:         Australia - Sydney
    Entries:
Christies Lon 10/25/79: 76 (lot, R-2 et al);
Christies Lon 3/20/80: 169 (album, 34);
Christies Lon 10/30/86: 177 (album, R et al);

**RICHARDS, Frederick Debourg** (American)
Photos dated: 1848-1866
Processes:      Daguerreotype, salt
Formats:        Plates, prints
Subjects:       Architecture
Locations:      US
Studio:         US - Philadelphia, Pennsylvania
    Entries:
Christies NY 2/22/84: 17 ill, 18, 19 (2), 20 ill(2);
Christies Lon 3/24/83: 5 ill(note);
Swann NY 5/15/86: 164 ill(lot, R-1 attributed
    et al);
Swann NY 11/13/86: 307 (note);

**RICHARDSON, D.** (British)
Photos dated: 1860s
Processes:      Albumen
Formats:        Prints
Subjects:       Documentary (railroads)
Locations:      England
Studio:         England - Darlington
    Entries:
Sothebys Lon 10/29/76: 297 (lot, D-1 et al);

**RICHARDSON, Edward A.** (American)(see WRIGHT,
        William A.)

**RICHARDSON, I.W.** (British)
Photos dated: 1860s
Processes:      Albumen
Formats:        Prints
Subjects:
Locations:
Studio:         Great Britain (Amateur Photographic
                Association)
    Entries:
Christies Lon 10/27/83: 218 (albums, R-3 et al);
Sothebys Lon 6/29/84: 194 (lot, R-1 et al);

**RICHARDSON, J.C.** (American)
Photos dated: 1860-1860s
Processes:      Albumen
Formats:        Stereos, cdvs
Subjects:       Topography, portraits
Locations:      US - Massachusetts
Studio:         US - Boston, Massachusetts
    Entries:
Swann NY 9/18/75: 186 (lot, R et al);
California Galleries 4/3/76: 395 (lot, R et al);

**RICHARDSON, T.G.** (American)
Photos dated: 1870s
Processes:      Albumen
Formats:        Stereos
Subjects:       Topography
Locations:      US - New England
Studio:         US - St. Albans, Vermont
    Entries:
Harris Baltimore 6/1/84: 148 (lot, R et al);

**RICHEBOURG, A.** (French, before 1830-after 1872)
Photos dated: 1844-1870s
Processes:      Daguerreotype, ambrotype, albumen
Formats:        Plates, prints, cdvs, stereos
Subjects:       Architecture, topography, portraits,
                genre (rural life)
Locations:      France; Portugal; Russia
Studio:         France - Paris
    Entries:
Swann NY 12/14/78: 454 (note);
Christies Lon 10/30/80: 439 (lot, R-5 et al);
Swann NY 11/5/81: 536 (3)(note);
Bievres France 2/6/83: 86 ill, 87 (lot, R-7 et al);

**RICHER, Paul** (French)
Photos dated: 1885
Processes:
Formats:        Prints
Subjects:       Portraits
Locations:      Studio
Studio:         France - Paris
    Entries:
Goldschmidt Lon Cat 52, 1939: 213 (note);
Weil Lon Cat 2, 1943(?): 249 (note);
Weil Lon Cat 4, 1944(?): 229 (note);

**RICHTER** (German)
Photos dated: c1860
Processes:      Albumen
Formats:        Cdvs
Subjects:       Portraits
Locations:      Studio
Studio:         Germany - Dresden
    Entries:
Petzold Germany 11/7/81: 298 (album, R et al);

**RICHTER, Reverend G.** (British)
Photos dated: between 1868 and 1875
Processes:      Albumen
Formats:        Prints
Subjects:       Ethnography
Locations:      India
Studio:
    Entries:
Sothebys Lon 10/18/74: 80 (book, R et al);
Christies Lon 3/11/82: 252 (books, R et al)(note);

**RICORDI** (see TAGLIANO & RICORDI)

**RIDDLE, J.R.** (American)
Photos dated: between 1870s and 1890s
Processes:    Albumen
Formats:      Stereos, boudoir cards
Subjects:     Topography
Locations:    US - American west
Studio:       US
   Entries:
Swann NY 5/15/86: 167 (lot, R-6 et al);

**RIDER, G.W.** (American)
Photos dated: 1850s
Processes:    Daguerreotype
Formats:      Plates
Subjects:     Portraits
Locations:    Studio
Studio:       US - Providence, Rhode Island
   Entries:
Sothebys NY (Weissberg Coll.) 5/16/67: 160 (lot,
   R-1 et al);

**RIETH, O.** (German)
Photos dated: Nineteenth century
Processes:    Collotype
Formats:      Prints
Subjects:     Genre (nudes)
Locations:    Studio
Studio:       Germany
   Entries:
Swann NY 5/9/85: 415 (lot, R et al);

**RIFFAULT, Adolphe-Pierre** (French)
Photos dated: 1855
Processes:    Heliogravure
Formats:      Prints
Subjects:     Portraits
Locations:    Studio
Studio:       France
   Entries:
Sothebys NY 5/20/77: 50 (book, 1);

**RILE, H.F.** (American)
Photos dated: 1870s-c1890
Processes:    Albumen
Formats:      Prints, stereos
Subjects:     Topography
Locations:    US - Santa Monica, California
Studio:       US
   Entries:
Swann NY 4/20/78: 236 (4);

**RIMATHE**
Photos dated: 1890s
Processes:    Albumen
Formats:      Prints
Subjects:     Topography
Locations:    Argentina - Buenos Aires
Studio:
   Entries:
Swann NY 5/10/84: 303 ill(album, R-4 et al);

**RIMES**
Photos dated: 1880s
Processes:    Albumen
Formats:      Prints
Subjects:     Topography
Locations:    Ceylon - Kandy
Studio:
   Entries:
Phillips NY 11/4/78: 45 (lot, R-1 et al);

**RIMINGTON, J.W.** (British)
Photos dated: 1865
Processes:    Albumen
Formats:      Prints
Subjects:     Genre, topography
Locations:    England - Cowes
Studio:       England (Amateur Photographic
              Association)
   Entries:
Swann NY 2/14/52: 14 (lot, R et al);
Sothebys Lon 10/29/80: 310 (album, R et al);
Christies Lon 10/29/81: 359 (album, R-5 et al)
   (note);
Christies Lon 6/24/82: 96 (lot, R-1 et al);
Christies Lon 10/27/83: 218 (albums, R-14 et al);
Sothebys Lon 10/26/84: 108 (lot, R-9 et al);

**RINEHART, Frank A.** (American, 1862-1928)
Photos dated: 1881-1900
Processes:    Platinum, silver, photogravure
Formats:      Prints, stereos
Subjects:     Ethnography
Locations:    US - American west
Studio:       US - Omaha, Nebraska
   Entries:
Sothebys NY 9/23/75: 99;
Kingston Boston 1976: 186 ill(note), 187 ill, 188
   ill(3);
Wood Conn Cat 37, 1976: 319 ill(note);
Gordon NY 5/3/76: 323 ill, 324 ill;
Sothebys NY 5/4/76: 161, 162, 163 (6);
Gordon NY 11/13/76: 101 ill, 102 ill;
White LA 1977: 108;
Sothebys NY 5/20/77: 13;
Frontier AC, Texas 1978: 88 (lot, R-1 plus 2
   attributed, et al);
Sothebys LA 2/13/78: 70, 71 (2);
Witkin NY VIII 1979: 65 ill;
Witkin NY Stereos 1979: 16 ill (5);
Sothebys LA 2/7/79: 485 ill, 486, 487, 488, 489,
   490, 491, 492 ill, 493 ill, 494;
Swann NY 4/26/79: 422 (2);
Christies NY 5/4/79: 112B;
Phillips NY 5/5/79: 223;
Sothebys Lon 10/24/79: 52 (lot, R-11 et al);
Christies NY 10/31/79: 115, 116, 117 ill, 118;
Christies NY 5/16/80: 288 ill, 289, 290, 291, 292,
   293 ill, 294, 295 (2), 296 (2);
Sothebys NY 5/20/80: 418;
Phillips NY 5/21/80: 280 ill, 281 (2);
Phillips Can 10/9/80: 38 ill(2);
Swann NY 4/23/81: 366 (note);
Swann NY 11/5/81: 361 (book, 8)(note);
Christies NY 11/10/81: 73;
Christies Lon 3/11/82: 228;
Sothebys Lon 3/15/82: 237 ill;
Harris Baltimore 3/26/82: 220;
Swann NY 4/1/82: 348;
California Galleries 5/23/82: 375 (attributed);

RINEHART (continued)
Sothebys Lon 12/9/83: 17;
Harris Baltimore 12/16/83: 404;
Sothebys NY 5/8/84: 261 ill(5);
Sothebys Lon 6/29/84: 69 ill(2);
California Galleries 7/1/84: 619, 620 (album, 50)
   (attributed);
Christies NY 11/6/84: 58 ill;
Sothebys Lon 11/1/85: 3 (lot, R et al), 23 ill;
Swann NY 11/14/85: 12 (lot, R et al), 146 ill(8)
   (note);
California Galleries 3/29/86: 777, 778;
Phillips NY 7/2/86: 352 (2), 353 ill;
Christies NY 11/11/86: 334 ill(13);
Swann NY 11/13/86: 130 (lot, R et al), 288 (lot, R-1
   et al), 309;

RING, J.
Photos dated: Nineteenth century
Processes:      Albumen
Formats:        Prints
Subjects:       Topography
Locations:      New Zealand
Studio:
   Entries:
Phillips Lon 10/24/84: 171 (lot, R et al);

RIOKU, Insetsu (Japanese)
Photos dated: 1880s and/or 1890s
Processes:      Albumen
Formats:        Prints
Subjects:       Topography, architecture
Locations:      Japan
Studio:         Japan
   Entries:
Christies Lon 3/15/79: 163 (9);
Christies Lon 10/25/79: 242 (lot, R-1 et al);

RITCHIE, J.H. (British)
Photos dated: 1860s
Processes:      Albumen
Formats:        Prints
Subjects:
Locations:
Studio:         Great Britain (Amateur Photographic
                Association)
   Entries:
Christies Lon 10/27/83: 218 (albums, R-1 et al);

RITTER & MOSTENTELL
Photos dated: 1870s
Processes:      Albumen
Formats:        Prints
Subjects:       Topography
Locations:
Studio:
   Entries:
Christies Lon 3/28/85: 97 (album, R & M-1 et al);

RITTON, E.D. (American)
Photos dated: 1854
Processes:      Daguerreotype
Formats:        Plates
Subjects:       Portraits
Locations:      Studio
Studio:         US - Danbury, Connecticut
   Entries:
Rinhart NY Cat 2, 1971: 204;
Rinhart NY Cat 7, 1973: 571;

RIVAS (Spanish)
Photos dated: 1860s-1870s
Processes:      Albumen
Formats:        Cdvs
Subjects:       Documentary
Locations:      Studio
Studio:         Spain - Madrid
   Entries:
Swann NY 12/14/78: 376 (lot, R et al);

RIVE, Roberto
Photos dated: 1860s-1890s
Processes:      Albumen
Formats:        Prints, stereos
Subjects:       Topography, portraits
Locations:      Italy - Palermo, Naples, Rome,
                Florence, Pompeii
Studio:         Italy - Naples and Rome
   Entries:
Rinhart NY Cat 1, 1971: 427;
Vermont Cat 9, 1975: 578 ill(12);
Sothebys Lon 6/26/75: 124 (lot, R-9 et al);
California Galleries 9/27/75: 389 (lot, R et al);
California Galleries 4/2/76: 183 (lot, R-1 et al),
   263 (lot, R-2 et al);
California Galleries 4/3/76: 282 (lot, R-7 et al),
   384 (lot, R et al);
Christies Lon 10/28/76: 240 (lot, R-1 et al);
Sothebys NY 11/9/76: 51 (album, R-21 et al);
Swann NY 12/8/77: 413 (lot, R et al);
Swann NY 4/20/78: 349 (lot, R-3 et al);
California Galleries 3/30/80: 366 (5);
California Galleries 12/13/80: 329 (5);
Harris Baltimore 7/31/81: 100 (lot, R et al);
Phillips Lon 10/28/81: 157 (lot, R-2 et al);
Swann NY 11/5/81: 495 (lot, R-4 et al)(note), 497
   (lot, R-8 et al)(note);
Petzold Germany 11/7/81: 326 (lot, R et al);
Phillips Lon 10/27/82: 33 (lot, R et al);
Harris Baltimore 12/10/82: 399 (lot, R et al);
Christies Lon 10/27/83: 43 (lot, R-3 et al);
Harris Baltimore 6/1/84: 53 (lot, R et al);
Sothebys Lon 6/29/84: 48 (lot, R et al);
Christies Lon 3/28/85: 43 (lot, R et al);
Swann NY 5/15/86: 263 (albums, R-40 et al);
Christies Lon 10/30/86: 83 (lot, R et al);
Sothebys Lon 10/31/86: 2 (lot, R et al);

RIVES (see SCOWEN)

**RIVIÈRE, Georges** (French)
Photos dated: 1892
Processes:      Heliogravure
Formats:        Prints
Subjects:       Topography
Locations:      US
Studio:
   Entries:
Witkin NY I 1973: 184 (book, 1);
Swann NY 11/10/83: 138 (book);

**ROBBINS, Frank** (American)
Photos dated: c1866-c1873
Processes:      Albumen
Formats:        Stereos
Subjects:       Topography
Locations:      US - Oil City, Pennsylvania
Studio:         US
   Entries:
Rinhart NY Cat 7, 1973: 268 (3);
California Galleries 4/3/76: 449 (lot, R et al);
California Galleries 1/21/78: 189 (lot, R et al);
California Galleries 1/21/79: 309 (lot, R et al);
California Galleries 3/30/80: 408 (lot, R et al);

**ROBERT, Emile** (French)
Photos dated: 1871
Processes:      Albumen
Formats:        Cabinet cards
Subjects:       Documentary (Paris Commune)
Locations:      France - Paris
Studio:         France
   Entries:
Harris Baltimore 12/16/83: 400 (lot, R-1 et al);

**ROBERT, Louis-Rémy** (French, 1810-1882)
Photos dated: c1850-1861
Processes:      Salt (Blanquart-Evrard), albumen,
                carbon
Formats:        Prints
Subjects:       Topography, genre (still life),
                documentary (industrial)
Locations:      France - Saint Cloud, Sèvres,
                Versailles, Brittany
Studio:         France
   Entries:
Wood Conn Cat 41, 1978: 10 ill(note);
Octant Paris 3/1979: 21 ill;
Sothebys Lon 10/29/80: 119 ill, 120 ill(note);
Christies NY 11/11/80: 56 ill(note);
Sothebys Lon 3/27/81: 201 ill, 202 ill;
Sothebys NY 5/15/81: 94 ill;
Sothebys Lon 3/15/82: 193 ill;
Sothebys Lon 3/25/83: 81 ill(note), 82 ill;
Sothebys Lon 12/9/83: 51 ill, 52 ill;

**ROBERTS, H.L.** (American)
Photos dated: 1870s-1887
Processes:      Artotype, albumen, photogravure
Formats:        Prints, stereos
Subjects:       Topography
Locations:      US - St. Augustine, Florida
Studio:         US - Massachusetts
   Entries:
Swann NY 12/8/77: 67 (book, R et al);
California Galleries 3/30/80: 125 (book, R et al);
California Galleries 12/16/83: 86 (lot, R et al);

**ROBERTSON** (American)
Photos dated: 1850s
Processes:      Daguerreotype
Formats:        Plates
Subjects:       Portraits
Locations:      Studio
Studio:         US - New York City
   Entries:
Sothebys Lon 6/11/76: 138 (lot, R-1 et al);

**ROBERTSON, James** (British, born 1813?)
Photos dated: 1852-1865
Processes:      Salt, albumen
Formats:        Prints
Subjects:       Topography
Locations:      Malta; Greece - Athens; Turkey -
                Constantinople, Smyrna; Russia -
                Crimea; Egypt - Cairo; Palestine -
                Jerusalem; France - Marseilles; India
Studio:         Turkey - Constantinople
   Entries:
Goldschmidt Lon Cat 52, 1939: 173 ill(81)(note),
   192 (12)(note), 193 (6)(note);
Weil Lon Cat 1, 1943: 142 (lot, R et al)(note);
Weil Lon Cat 4, 1944(?): 245 (lot, R & Beato, 6)
   (note);
Weil Lon Cat 7, 1945: 85 ill(81)(note), 168 (11)
   (note), 169 (5)(note);
Weil Lon Cat 14, 1949(?): 313 (R & Beato, 6)(note);
Andrieux Paris 1951(?): 71 (7);
Swann NY 2/14/52: 287 (book, 53);
Rauch Geneva 6/13/61: 134 (R & Beato, 10)(note);
Vermont Cat 5, 1973: 492 ill(R & Beato)(note);
Sothebys Lon 12/4/73: 214 (R & Beato)(note), 215
   (R & Beato), 216 ill(R & Beato), 217 ill(R &
   Beato), 218 (2 ills)(album, R & Beato-17, et al)
   (note);
Ricketts Lon 1974: 8 ill(album, R-4 et al);
Sothebys Lon 6/21/74: 198 (R & Beato), 199 ill(R &
   Beato), 200 (R & Beato), 201 (R & Beato), 202
   (R & Beato), 203 ill(R & Beato), 204 (R &
   Beato), 205 (R & Beato), 206 (2 ills)(album,
   R & Beato, 58)(note);
Christies Lon 7/25/74: 387 ill, 388, 389, 390;
Sothebys Lon 10/18/74: 80 (book, R & Shepherd
   et al);
Edwards Lon 1975: 8 (album, R & Shepherd-1, et al)
   (note);
Sothebys NY 2/25/75: 33 ill(R & Beato)(note), 34
   (R & Beato), 35 ill(R & Beato), 36 (R &
   Beato)(2);
Sothebys Lon 3/21/75: 56 (album, R-1 et al)(note),
   70 (R & Beato)(note), 71 (R & Beato, 2), 72 ill
   (album, R & Beato-10, et al)(note);
Sothebys Lon 6/26/75: 126 (album, R & Shepherd-1,
   et al), 127 (album, R & Shepherd-3, et al), 131
   (album, R & Shepherd-1, et al), 132 (album, R
   & Beato-5, et al), 133 (album, R & Beato-3
   attributed, et al);
Sothebys Lon 10/24/75: 129 (albums, R & Shepherd et
   al), 132 (albums, R & Shepherd-2, et al), 201 ill
   (R & Beato), 201a (R & Beato), 202 ill(R &
   Beato), 203 ill(R & Beato, 25), 204 (R & Beato,
   4), 205 (2);
Colnaghi Lon 1976: 59 ill(R & Beato)(note), 60 ill
   (R & Beato)(note), 61 (R & Beato)(note), 62 (R &
   Beato)(note), 63 (R & Beato), 64 (R & Beato), 65
   (R & Beato), 66 (R & Beato), 67 (R & Beato), 68
   (R & Beato), 69 (R & Beato), 70 (R & Beato), 71
   (R & Beato), 72 (R & Beato)(note), 73 (R &

ROBERTSON (continued)

Beato), 74 ill(R & Beato), 75 ill(R & Beato), 76
ill(R & Beato), 77 ill(R & Beato), 78 (R &
Beato), 79 (R & Beato), 80 (R & Beato), 81 (R &
Beato)(note), 82 (R & Beato), 83 (R & Beato), 84
(R & Beato), 85 (R & Beato), 86 (R & Beato), 87
(R & Beato);
Lunn DC Cat 6, 1976: 3 (album, R & Beato, 58)
(note), 4.1 ill(note), 4.2 (note), 4.3 ill(note);
Witkin NY IV 1976: 217 ill;
Sothebys Lon 3/19/76: 246 ill(album, R & Beato,
12), 247 ill(album, R & Beato-17, et al), 248 (R
& Beato), 249 ill(R & Beato), 250 (R & Beato),
251 ill(R & Beato), 252 (R & Beato, 6), 253 (R &
Beato, 2), 254 (R & Beato, 5);
Sothebys NY 5/4/76: 55 ill(note), 56, 57;
Christies Lon 6/10/76: 75 ill;
Sothebys Lon 6/11/76: 232 (R & Beato, 8), 233 (R &
Beato), 234 ill, 235 (2);
Sothebys Lon 10/29/76: 53 (album, R & Shephed-6, et
al), 110 (albums, R & Shepherd-3, et al);
Sothebys NY 11/9/76: 38;
White LA 1977: 37 ill(R & Shepherd);
Sothebys Lon 3/9/77: 229 (R & Beato, 3), 230 (R &
Beato, 6);
Christies Lon 3/10/77: 133 ill(R & Beato,2 plus 1
attributed), 136 (album, R-2 et al);
Swann NY 4/14/77: 315 (attributed);
Gordon NY 5/10/77: 802 ill(R & Beato);
Christies Lon 6/30/77: 115 (album, R & Beato
attributed, et al);
Sothebys Lon 7/1/77: 56 (books, R & Shepherd et
al), 134 (album, R & Beato-1, et al);
Sothebys NY 10/4/77: 162 ill(album, R et al)(note),
176 (R-1, R & Beato-2);
Christies Lon 10/27/77: 126 (note);
Sothebys Lon 11/18/77: 101 (album, R & Shepherd-1,
et al), 118 ill(album, R & Beato, 20)(note), 119
(2 ills)(album, R & Beato, 58)(note), 120 ill
(album, R & Beato, 9);
Rose Boston Cat 3, 1978: 101 ill(R & Beato);
Sothebys LA 2/13/78: 87 ill(R & Beato)(note), 88
ill(R & Beato), 89 (R & Beato), 90 ill(R &
Beato), 91;
Christies Lon 3/16/78: 97 (album, R & Beato et al),
102 (album, R & Shepherd-3, et al), 347 ill(R &
Beato)(note), 348 (R & Beato)(note), 349 (R &
Beato, 3), 350 (R & Beato), 351 ill(R & Beato,
3), 352 (R & Beato, 8);
Sothebys Lon 3/22/78: 191 (album, R & Beato et al);
Christies Lon 6/27/78: 105 (R & Beato), 106 (R &
Beato)(note), 107 (R & Beato), 108 (R & Beato),
118 (album, R & Shepherd-3, et al);
Sothebys Lon 6/28/78: 70 ill(R & Beato, 12), 71 ill
(R & Beato), 72 ill(R & Beato), 73 ill(R &
Beato, 5), 74 ill, 75 ill, 76 ill;
Christies Lon 10/26/78: 288 (R & Beato, 3)(note),
289 (R & Beato), 290 (R & Beato, 4), 291 ill(R &
Beato, 2), 292 (R & Beato, 2), 293 (R & Beato,
3), 294 (R & Beato), 295 (R & Beato), 296 (R &
Beato);
Sothebys Lon 10/27/78: 162 (R & Beato, 15)
Phillips Lon 3/13/79: 73 ill;
Christies Lon 3/15/79: 170 (R & Beato)(note), 171
(R & Beato, 3), 172 (R & Beato);
Christies NY 5/4/79: 12 ill;
Sothebys NY 5/8/79: 60, 61 (R & Beato);
Christies Lon 6/28/79: 108 (R & Beato), 109 (lot,
R & Shepherd-2, et al);
Sothebys Lon 10/24/79: 101 (lot, R & Shepherd-1,
et al);

ROBERTSON (continued)

Christies Lon 10/25/79: 378 ill(album, R & Beato-3,
et al)(note);
Sothebys NY 12/19/79: 79 ill, 95 (lot, R & Beato
et al);
White LA 1980-81: 54 ill(R & Beato)(note), 55 ill
(R & Beato), 54 (R & Beato);
Sothebys LA 2/6/80: 169 ill(R & Beato, 11);
Sothebys Lon 3/21/80: 110 (R & Beato, 2);
California Galleries 3/30/80: 367;
Swann NY 4/17/80: 352 ill(album, 36)(note);
Christies NY 5/16/80: 95 ill(38), 96 (17);
Phillips NY 5/21/80: 236 (7);
Christies Lon 6/26/80: 216 (R & Beato), 217 (R &
Beato), 218 (R & Beato, 2), 225 (R & Shepherd);
Sothebys Lon 6/27/80: 55 (R & Shepherd), 255;
Sothebys Lon 10/29/80: 290 ill(R & Beato);
Christies Lon 10/30/80: 366, 367 ill, 368
(attributed)(note), 369 ill(lot, R & Beato-11,
et al)(note), 370 ill(R & Beato);
Sothebys NY 11/17/80: 90 ill(R & Beato)(attributed)
(note);
Christies Lon 3/26/81: 343 ill(album, R & Beato-25,
et al), 344 (lot, R & Beato-2, et al);
Sothebys Lon 3/27/81: 88 (lot, R & Shepherd et al),
97 (album, R & Shepherd et al), 413 ill(R &
Beato), 414 (2, attributed), 415 ill(R & Beato),
415a (R & Beato);
Phillips NY 5/9/81: 3 ill(5), 62 (attributed);
Sothebys Lon 6/17/81: 371 (R & Beato, 4), 372, 373
(3), 374 ill, 375 (R & Beato);
Christies Lon 6/18/81: 201 (R & Beato), 202 (R &
Beato), 203 (R & Beato), 204 (R & Beato)
(attributed), 205 (R & Beato)(attributed), 206
(R & Beato)(attributed);
Harris Baltimore 7/31/81: 281 ill(album, 42)(note);
Sothebys Lon 10/28/81: 151 (album, R & Shepherd-5,
et al), 329 (R & Beato), 330 (R & Beato), 332 ill
(R & Beato), 333 (R & Beato), 334 (R & Beato);
Christies Lon 10/29/81: 205 (R & Beato, 2), 206
(lot, R-1 attributed et al), 213 ill(R & Beato)
(attributed)(note), 235 (album, R-1, R &
Shepherd-2, et al);
Swann NY 11/5/81: 367 (R & Shepherd)(note), 539
(R-2, R & Beato-1, plus R & Beato attributed, 14)
(note);
Christies Lon 3/11/82: 152 (1 plus 1 attributed),
181 (album, R & Shepherd-7, et al), 252 (books,
R & Shepherd et al), 316 (album, R-21 et al);
Sothebys Lon 3/15/82: 87 (lot, R-1 et al), 123
(album, R & Shepherd-4, et al), 349 (R & Beato),
350 (8), 350a (R & Beato, 3);
Phillips Lon 3/17/82: 55 (attributed);
Harris Baltimore 3/26/82: 254 (2)(note);
Swann NY 4/1/82: 349;
California Galleries 5/23/82: 376;
Phillips Lon 6/23/82: 27 (attributed);
Christies Lon 6/24/82: 186 (R & Beato), 312 ill
(10)(note);
Sothebys Lon 6/25/82: 163 (R & Beato, 5), 164 ill
(album, R & Beato, 34);
Christies Lon 10/28/82: 57 (lot, R & Beato-3, et
al), 86 (R & Beato, 10), 88 (R & Shepherd), 93
(album, R & Shepherd-7, et al);
Sothebys Lon 10/29/82: 149;
Swann NY 11/18/82: 367 (lot, R-1, R & Beato-1, et
al), 422 (lot, R-1, R & Beato-1, et al);
Bievres France 2/6/83: 88 ill(2);
Phillips Lon 3/23/83: 57 ill(album, 31);
Christies Lon 3/24/83: 102 (albums, R & Beato-1, et
al), 106 (album, R & Shepherd-3, et al);

ROBERTSON (continued)
Swann NY 5/5/83: 340 (lot, R et al)(note), 423,
424, 425 (2), 426 (R & Beato, 3)(note);
Phillips Lon 6/15/83: 139 (album, 28);
Christies Lon 6/23/83: 127 ill(R & Beato, 6);
Christies Lon 10/27/83: 66 (album, R & Beato-3,
et al);
Phillips Lon 11/4/83: 47A (lot, R-1 et al);
Swann NY 11/10/83: 330 (album)(note);
Christies Lon 3/29/84: 189;
Swann NY 5/10/84: 327 (album, R & Beato-3, et al)
(note);
Christies Lon 6/28/84: 93 (lot, R & Shepherd et
al), 303 (lot, R-1 et al);
Sothebys Lon 6/29/84: 166 ill(lot, R & Beato-43, et
al), 167 (4);
California Galleries 7/1/84: 622 (6);
Phillips Lon 10/24/84: 106 (album, R, R & Beato,
et al);
Sothebys Lon 10/26/84: 55 ill(R & Beato), 56 ill(R &
Beato), 57 ill(R & Beato), 58 ill(R & Beato), 73
(2 ills)(album, R & Shepherd et al);
Christies NY 11/6/84: 4 ill(R & Beato, 3);
Swann NY 11/8/84: 246 (R & Beato, 5);
Christies Lon 3/28/85: 162 ill(R & Beato)(note), 308
(album, R-1 attributed et al), 329 (album, R-3
attributed et al);
Sothebys Lon 3/29/85: 80 ill(R & Beato), 81 ill(R &
Beato), 82 ill, 83 ill, 84 ill, 90 ill(R &
Shepherd)(4), 91 (R & Shepherd), 152 (albums, R
& Beato-1, et al);
Sothebys NY 5/7/85: 208A ill(album, R & Beato, 20);
California Galleries 6/8/85: 394 (6);
Sothebys Lon 6/28/85: 58 ill(R & Beato), 59 ill(R &
Beato), 60 ill(R & Beato), 61 ill(R & Beato), 62
ill(R & Beato);
Christies Lon 10/31/85: 120 ill(album, R-6 et al),
125 (albums, R & Shepherd-2, et al);
Sothebys Lon 11/1/85: 29 ill(R & Beato);
Swann NY 11/14/85: 74 (lot, R & Shepherd-1, et al);
Harris Baltimore 2/14/86: 338 (R & Beato)(note);
Phillips Lon 4/23/86: 264 (album, R & Shepherd
et al);
Christies Lon 4/24/86: 463 ill, 464 ill(21)(note);
Sothebys Lon 4/25/86: 28 ill(R & Beato), 29 (1 plus
1 R & Beato attributed), 30 (R & Beato, 2), 31
ill(R & Beato), 32 ill;
Phillips Lon 10/29/86: 389 (attributed);
Christies Lon 10/30/86: 84;
Sothebys Lon 10/31/86: 9 ill(album R-5, R &
Beato-6, et al), 26 ill(R & Beato), 27 ill(R &
Beato), 28 ill(R & Beato), 29 ill(R & Beato), 30
ill(R & Beato), 31 ill(R & Beato), 34 (album, R
& Shepherd et al), 35 (album, R & Shepherd-6, et
al), 106 ill(R & Beato);
Swann NY 11/3/86: 239 (album, R & Shepherd et al),
240 (album, R & Shepherd et al);

ROBERTSON, W.T. (American)
Photos dated: 1870s-1880s
Processes:    Albumen
Formats:      Stereos
Subjects:     Topography
Locations:    US
Studio:       US - Asheville, North Carolina
   Entries:
Rinhart NY Cat 6, 1973: 534;
California Galleries 4/3/76: 463 (lot, R et al);

ROBINS, Frank (American)
Photos dated: Nineteenth century
Processes:    Albumen
Formats:      Stereos
Subjects:     Topography
Locations:    US - Pennsylvania
Studio:       US
   Entries:
Harris Baltimore 4/8/83: 87 (lot, R et al);

ROBINS, R.S. (American)
Photos dated: 1859
Processes:    Ambrotype
Formats:      Plates
Subjects:     Portraits
Locations:    Studio
Studio:       US
   Entries:
Sothebys NY 11/21/70: 291 ill;

ROBINSON (British)
Photos dated: 1860s
Processes:    Albumen
Formats:      Stereos
Subjects:     Topography
Locations:    Ireland
Studio:       Ireland - Dublin
   Entries:
Sothebys Lon 6/29/84: 4 (lot, R et al);

ROBINSON, D.N.
Photos dated: Nineteenth century
Processes:    Albumen
Formats:      Prints
Subjects:     Topography
Locations:    Azores
Studio:
   Entries:
Rose Boston Cat 4, 1979: 75 (2 ills)(album, 43)
(attributed)(note);
Rose Florida Cat 7, 1982: 54 ill(album, 43);

ROBINSON, G.W. (American)
Photos dated: 1870s
Processes:    Albumen
Formats:      Stereos
Subjects:     Topography, documentary (railroads)
Locations:    US - Baltimore, Maryland
Studio:       US
   Entries:
Sothebys NY (Strober Coll.) 2/7/70: 513 (lot,
R et al);
Harris Baltimore 4/8/83: 8 (lot, R et al);
Harris Baltimore 12/16/83: 113 (lot, R-3 et al);

ROBINSON, H.N.
Photos dated: c1880
Processes:    Albumen
Formats:      Stereos
Subjects:     Topography
Locations:    Canada - Labrador
Studio:
   Entries:
Rinhart NY Cat 8, 1973: 36;

ROBINSON, Henry Peach (British, 1830-1901)
Photos dated: 1852-1889
Processes:      Albumen, phototype, photogravure,
                woodburytype, carbon, platinum
Formats:        Prints, cdvs, stereos, porcelain
Subjects:       Portraits, topography, genre
Locations:      Great Britain
Studio:         England - Leamington Spa, London,
                Tunbridge Wells
    Entries:
Lunn DC Cat 3, 1973: 108 ill, 109 ill;
Sothebys Lon 5/25/73: 14 (album, R et al);
Sothebys Lon 10/18/74: 303 ill(note), 304 ill(3),
    305 ill, 306 ill, 307 (2);
Vermont Cat 9, 1975: 604 ill(note), 605 ill(note),
    606 ill(note), 607 ill, 608 ill, 609 ill, 610
    ill, 611 ill, 612 ill, 613 ill, 614 ill, 615
    ill, 616 ill(note), 617 ill, 618 ill, 619 ill,
    620 ill, 621 ill;
Sothebys NY 2/25/75: 153 (3)(attributed);
Sothebys Lon 3/21/75: 348;
Sothebys Lon 6/26/75: 244 ill;
Sothebys NY 9/23/75: 58 ill(note), 59 ill;
California Galleries 9/27/75: 330 (attributed);
Colnaghi Lon 1976: 149 (2 ills)(album, 22)(note);
Sothebys Lon 3/19/76: 255 ill, 256 ill, 257;
California Galleries 4/3/76: 312 (attributed);
Gordon NY 5/3/76: 30 ill, 31 ill, 277 ill(note);
Christies Lon 10/28/76: 212, 213 ill, 214 ill
    (note), 244 (album, R-2 et al);
Sothebys Lon 10/29/76: 289 (lot, R-1 et al),
    299 ill;
California Galleries 1/22/77: 339 (attributed),
    340 ill(attributed), 341, 342, 343, 344;
Sothebys Lon 3/9/77: 218 (note);
Christies Lon 3/10/77: 280;
Swann NY 4/14/77: 143 (book, 1);
Sothebys Lon 7/1/77: 287 (2);
Sothebys NY 10/4/77: 192;
Christies Lon 10/27/77: 321 (lot, R-1 et al), 322
    ill(note);
Swann NY 12/8/77: 349 (lot, R et al);
Lehr NY Vol 1:2, 1978: 37 ill(note);
Rose Boston Cat 3, 1978: 28 ill(note);
California Galleries 1/21/78: 134 (lot, R et al),
    267 ill;
Christies Lon 6/27/78: 44 (lot, R-1 et al);
Sothebys Lon 10/27/78: 202;
Swann NY 12/14/78: 455 (note), 456 (R & Cherrill,
    1 plus 2 attributed);
Phillips Lon 3/13/79: 106 ill, 107 (2), 108 ill;
Sothebys Lon 3/14/79: 375 ill;
Christies Lon 3/15/79: 30 (lot, R-1 et al);
Swann NY 10/18/79: 392 ill(note);
Christies Lon 10/29/79: 76 (lot, R-2 et al);
Christies NY 10/31/79: 23 (R & Cherrill);
Sothebys NY 12/19/79: 78 ill(note);
Christies Lon 3/20/80: 106 (lot, R-1 et al), 377
    (note);
Sothebys Lon 3/21/80: 251 (lot, R et al);
California Galleries 3/30/80: 368, 369;
Swann NY 4/17/80: 353 (3);
Christies NY 5/14/80: 335 ill(book, R et al), 378
    (book, R et al);
Christies NY 5/16/80: 114 (R & Cherrill);
Christies Lon 6/26/80: 480 (albums, R-1 et al)
    (note);
Sothebys Lon 6/27/80: 333 ill;
Christies Lon 10/30/80: 416 (album, R-1 et al), 429
    (lot, R-4 et al);
Christies NY 11/11/80: 37 ill, 38, 39;

Christies Lon 3/26/81: 374 ill(album, 22)
    (attributed)(note), 375 ill(note), 386 (album,
    R-1 et al), 398 (album, R-1 et al);
Sothebys Lon 6/17/81: 347 ill;
Christies Lon 6/18/81: 90 (lot, R-4 et al);
California Galleries 6/28/81: 298, 299 (attributed);
Sothebys NY 10/21/81: 189 ill(note);
Christies Lon 10/29/81: 134 (lot, R-1 et al), 339
    ill(note), 340 ill;
Christies Lon 3/11/82: 327 (album, R et al);
Sothebys Lon 3/15/82: 364 ill;
California Galleries 5/23/82: 123A ill(book, 4);
Sothebys Lon 6/25/82: 202 ill;
Sothebys Lon 10/29/82: 53 (attributed);
Drouot Paris 11/27/82: 103 ill;
Christies Lon 3/24/83: 220 (note), 221 (note), 222
    (note);
Christies Lon 6/23/83: 241 (2 ills)(album, R-7
    et al);
Sothebys Lon 6/24/83: 96 ill;
Christies NY 11/8/83: 201 (book, R et al);
Swann NY 11/10/83: 281 (R & Cherrill)(note);
Christies NY 3/29/84: 112 (book, R et al);
Sothebys Lon 6/29/84: 208, 209;
Christies Lon 10/25/84: 121 ill(book, 3), 220 ill,
    318 (albums, R et al);
Sothebys Lon 10/26/84: 129 ill, 130 ill, 131 ill,
    132 ill, 133 ill, 134 ill, 135 ill(R & Cherrill);
Christies Lon 3/28/85: 209 ill, 321 (album, R
    et al);
Sothebys NY 5/8/85: 631 (lot, R et al);
Christies Lon 6/27/85: 180;
Sothebys Lon 11/1/85: 63 ill(2);
Sothebys NY 11/12/85: 264 ill, 265 ill;
Swann NY 11/14/85: 264 (books, R et al);
Wood Boston Cat 58, 1986: 136 (books, R-1, R &
    Cherrill-2, R et al);
Phillips Lon 4/23/86: 272 (lot, R-1 et al);
Sothebys Lon 4/25/86: 146 ill(note), 147;
Christies NY 5/13/86: 260 ill(note);
Swann NY 5/15/86: 133 (book, R & Cherrill et al);
Christies Lon 10/30/86: 99 (note), 236 (18)(note);
Swann NY 11/13/86: 219 (lot, R-1 et al);

ROBINSON, J.C. (British)(photographer or author?)
Photos dated: 1856
Processes:      Albumen
Formats:        Prints
Subjects:       Documentary (art)
Locations:      England - London
Studio:         Great Britain
    Entries:
Wood Conn Cat 49, 1982: 368 (book, 10)(note);
Wood Boston Cat 58, 1986: 341 (book, 10)(note), 342
    (book, 11)(note);

ROBINSON, John L. (British)
Photos dated: 1883
Processes:      Albumen
Formats:        Prints
Subjects:       Topography
Locations:      Great Britain
Studio:         Great Britain - Yeovil
    Entries:
Sothebys Lon 6/28/78: 127 (album, 105);

**ROBINSON, Ralph W.** (British)
Photos dated: 1891-1897
Processes:      Platinum
Formats:        Prints
Subjects:       Documentary
Locations:      Great Britain
Studio:         Great Britain
  Entries:
Christies Lon 10/31/85: 155 (2 ills)(book, 58);

**ROBINSON, W.A.** (American)
Photos dated: 1870
Processes:      Albumen
Formats:        Cdvs
Subjects:       Portraits
Locations:      Studio
Studio:         US - Chicago, Illinois
  Entries:
Swann NY 5/5/83: 385 (note);

**ROBUCHON, Jules** (French)
Photos dated: c1875-1892
Processes:      Albumen, heliogravures
Formats:        Prints
Subjects:       Topography
Locations:      France - Brittany
Studio:         France
  Entries:
Christies Lon 10/28/76: 106 ill(2)(note);
Phillips NY 11/4/78: 65 (book, 38);
Christies Lon 6/23/83: 104 (book, 50);
Christies Lon 3/29/84: 57 (book, 50);
Swann NY 11/14/85: 82 (lot, R et al);

**ROCCHINI**
Photos dated: Nineteenth century
Processes:      Albumen
Formats:
Subjects:       Portraits
Locations:
Studio:
  Entries:
California Galleries 5/23/82: 189 (album, R et al);

**ROCHE, Thomas C.** (American)
Photos dated: 1863-1870s
Processes:      Albumen
Formats:        Prints, stereos
Subjects:       Topography, documentary (Civil War)
Locations:      US - Utah; California; Civil War area
Studio:         US - New York City
  Entries:
Rinhart NY Cat 8, 1973: 63;
Sothebys LA 2/6/80: 46 (lot, R-1 et al);
Swann NY 11/5/81: 533 (2)(attributed)(note);
Harris Baltimore 5/28/82: 90 (attributed);
Harris Baltimore 9/16/83: 169 (3,
    attributed)(note), 197 (4)(note), 198 (note),
    199, 200, 201 (5, attributed);
Harris Baltimore 6/1/84: 333 (attributed);
Harris Baltimore 11/7/86: 296 (attributed)(note);

**ROCHER, Henry** (American)
Photos dated: early 1870s-c1890
Processes:      Albumen
Formats:        Prints, cabinet cards
Subjects:       Portraits
Locations:      Studio
Studio:         US - Chicago, Illinois
  Entries:
Sothebys NY 11/21/70: 357 (lot, R et al);
California Galleries 5/23/82: 234 (lot, R-1 et al);
Wood Boston Cat 58, 1986: 136 (books, R-1 et al);

**ROCKHILL, William Woodville** (American)
Photos dated: c1870-1910
Processes:      Albumen, platinum
Formats:        Prints
Subjects:       Topography, documentary (public
                events)
Locations:      China; Korea; Roumania; Serbia
Studio:
  Entries:
Swann NY 11/5/81: 540 ill(lot, R et al);

**ROCKWELL** (American)
Photos dated: between 1870s and 1890s
Processes:      Albumen
Formats:        Cdvs
Subjects:       Portraits
Locations:      Studio
Studio:         US - New York City
  Entries:
Swann NY 4/26/79: 284 (lot, R-1 et al);

**ROCKWELL, J.R.** (American)
Photos dated: 1862-1860s
Processes:      Albumen
Formats:        Prints, cdvs
Subjects:       Portraits
Locations:      Studio
Studio:         US - Petersburg, Virginia
  Entries:
Harris Baltimore 6/1/84: 276 (note);
Swann NY 11/8/84: 187 (album, R & Cowell et al);

**ROCKWOOD, George C.** (American)
Photos dated: 1863-1879
Processes:      Albumen, collotype
Formats:        Prints, cdvs
Subjects:       Portraits, documentary
Locations:      US - New York City
Studio:         US - New York City
  Entries:
Sothebys NY (Weissberg Coll.) 5/16/67: 172 (lot,
    R et al);
Sothebys NY (Strober Coll.) 2/7/70: 261 (lot,
    R et al), 266 (lot, R et al), 267 (lot, R-3
    et al), 269 (lot, R-1 et al), 318 (lot, R et
    al), 419 (lot, R-1 et al), 447 (lot, R-1 et
    al)(note);
Sothebys NY (Greenway Coll.) 11/20/70: 290 ill
    (books, 36);
Rinhart NY Cat 1, 1971: 380, 487 (book, 7);
Rinhart NY Cat 6, 1973: 338;
Rinhart NY Cat 7, 1973: 565;
Rinhart NY Cat 8, 1973: 101;
Sothebys Lon 6/21/74: 163 (lot, R et al);
Witkin NY III 1975: 481 (book, 13);

## ROCKWOOD, G.C. (continued)

Sothebys NY 2/25/75: 203 (lot, R-1 et al);
Sothebys Lon 3/21/75: 89 (album, R et al);
California Galleries 9/26/75: 178 (book, 6);
Witkin NY IV 1976: OP328 (book, 13)(note);
Wood Conn Cat 37, 1976: 321 ill;
Swann NY 4/1/76: 289 (book, 10);
Swann NY 11/11/76: 249 (book, 8), 277 (book, 10),
  280 (book, 5), 281 (book, 4), 282 (book, 7), 339
  (lot, R et al), 340 (lot, R et al), 346 (lot, R
  et al);
California Galleries 1/22/77: 211 (book, 6);
Swann NY 4/14/77: 51 (book, 10);
Lehr NY Vol 1:4, 1979: 47 (book, 6)(note);
Swann NY 4/26/79: 177 ill(4)(note);
Phillips NY 11/3/79: 127 (album, R et al);
Sothebys LA 2/6/80: 14 ill;
California Galleries 3/30/80: 257 (lot, R-2 et al);
Christies NY 5/14/80: 290 ill(books, 36);
Sothebys NY 5/20/80: 326 (books, R-18 et al);
California Galleries 6/28/81: 361, 363, 411;
Harris Baltimore 3/26/82: 395 (lot, R et al);
Swann NY 11/18/82: 476 (lot, R et al);
Harris Baltimore 4/8/83: 315 (lot, R et al), 322
  (lot, R et al), 390 (lot, R-1 et al);
Swann NY 5/5/83: 182 (book, 8)(note);
Harris Baltimore 9/16/83: 112 (lot, R-1 et al), 134
  (lot, R-3 et al);
Swann NY 11/10/83: 117 (book, 8)(note);
Swann NY 5/10/84: 93 (book, 7)(note);
Christies NY 2/13/85: 152 (lot, R-1 et al);
Harris Baltimore 3/15/85: 259;
Swann NY 11/14/85: 264 (books, R et al);
Swann NY 5/15/86: 271 (lot, R-2 et al);
Swann NY 11/13/86: 285 (attributed)(note);

## RODE (British)

Photos dated: 1850s
Processes:      Ambrotype
Formats:        Plates
Subjects:       Portraits
Locations:      Studio
Studio:         England - Wishaw
  Entries:
Christies Lon 10/4/73: 179 (lot, R-1 et al);

## RODER, C.G. (German)

Photos dated: 1892
Processes:      Collotype
Formats:        Prints
Subjects:       Topography
Locations:      Spain; Portugal
Studio:         Germany - Leipzig
  Entries:
Witkin NY V 1977: 114 ill(book, 100)(note);

## RODGER, Thomas (British)

Photos dated: c1845-1860s
Processes:      Salt, albumen
Formats:        Prints, cdvs
Subjects:       Portraits, topography
Locations:      Scotland
Studio:         Scotland - St. Andrews
  Entries:
Weil Lon Cat 1, 1943: 142 (lot, R-8 et al);
Weil Lon Cat 7, 1945: 170 (4)(note);
Rauch Geneva 6/13/61: 166 (8)(note);
Sothebys NY 11/21/70: 330 (lot, R et al);

## RODGER, T. (continued)

Sothebys Lon 10/29/76: 49 ill(album, R-16 et al);
Sothebys Lon 11/18/77: 242 ill(7)(note);
Lunn DC Cat QP, 1978: 7;
Sothebys Lon 10/24/79: 334 ill;
Sothebys Lon 3/21/80: 228;
Sothebys Lon 6/27/80: 235;
Christies Lon 6/24/82: 355 ill;
Christies Lon 10/27/83: 221;
Christies Lon 3/29/84: 321 (album, R attributed
  et al)(note);
Christies Lon 6/28/84: 314 (album, R et al);
Christies Lon 6/27/85: 119;
Phillips Lon 10/30/85: 33 (lot, R et al);
Christies Lon 10/31/85: 302 (album, R et al);
Sothebys NY 5/12/86: 402 (lot, R-2 et al)(note);
Sothebys Lon 11/1/85: 62 ill;
Christies Lon 10/30/86: 221 (album, R et al), 252
  (album, R et al), 256 (albums, R-1 attributed
  et al);

## RODRIGUEZ, A. (Spanish)

Photos dated: 1880s-1890s
Processes:      Albumen
Formats:        Prints
Subjects:       Topography
Locations:      Spain
Studio:         Spain
  Entries:
Christies Lon 6/30/77: 101 (album, R-10 et al);

## ROEMMLER & JONAS (German)

Photos dated: 1890-1891
Processes:      Bromide
Formats:        Prints
Subjects:       Topography
Locations:      Germany - Dresden
Studio:         Germany - Dresden
  Entries:
Christies Lon 10/28/76: 120 (10);

## ROESLER, A.

Photos dated: 1890s
Processes:      Albumen
Formats:        Prints
Subjects:       Topography
Locations:      Stockholm
Studio:         Europe
  Entries:
Christies Lon 6/28/84: 80;

## ROGERS (American)

Photos dated: c1880
Processes:      Albumen
Formats:        Prints
Subjects:       Topography
Locations:      US - California
Studio:         US - Los Angeles, California
  Entries:
Rinhart NY Cat 2, 1971: 429;

ROGERS, F.E. (American)
Photos dated: 1870s
Processes:    Albumen
Formats:      Stereos
Subjects:     Topography
Locations:    US - American west
Studio:       US - Los Angeles, California
    Entries:
California Galleries 1/23/77: 447 (lot, R et al);

ROGERS, Gertrude Elizabeth (British, 1837-1917)
Photos dated: c1860-1861
Processes:    Albumen
Formats:      Prints
Subjects:     Genre
Locations:    England - southern
Studio:       England - southern
    Entries:
Phillips Lon 6/27/84: 229 ill(attributed)(note), 230
    (attributed), 231 ill(attributed), 232 ill
    (attributed), 233 (attributed), 234 ill, 235
    ill, 236 ill, 237 ill, 238 ill, 239 ill, 240
    ill, 241, 242 ill, 243 ill, 244 ill, 245 ill,
    246 ill, 247 ill, 248 ill, 249 ill, 250 ill;

ROGERS, John S.E. (American)
Photos dated: c1875
Processes:    Albumen
Formats:      Stereos
Subjects:     Topography
Locations:    US - Massachusetts
Studio:       US - Gloucester, Massachusetts
    Entries:
Rinhart NY Cat 7, 1973: 225;

ROGERS, S. (American)
Photos dated: 1870s
Processes:    Albumen
Formats:      Stereos
Subjects:     Topography
Locations:    US - New York State
Studio:       US - Tarrytown, New York
    Entries:
Rinhart NY Cat 1, 1971: 195 (lot, R et al);

ROGERS, W.S. (American)
Photos dated: 1889-1890
Processes:    Albumen
Formats:      Boudoir cards
Subjects:     Documentary (public events)
Locations:    US - Oklahoma
Studio:       US - Wichita, Kansas
    Entries:
Swann NY 11/14/85: 140 (lot, R et al)(note);

ROGERS, William A.
Photos dated: 1896
Processes:    X-Rays
Formats:      Prints
Subjects:     Documentary (scientific)
Locations:
Studio:
    Entries:
Lehr NY Vol 1:4, 1979: 114 ill(book, 39)(note);

ROLF (see STOUTENBURG & ROLF)

ROLFE, A.F. (British)
Photos dated: Nineteenth century
Processes:    Albumen
Formats:      Prints
Subjects:     Topography
Locations:
Studio:       Great Britain
    Entries:
Christies Lon 10/25/84: 355 (lot, R-1 et al);

ROLLAN
Photos dated: c1890
Processes:    Albumen
Formats:      Prints
Subjects:     Topography
Locations:    Europe
Studio:
    Entries:
California Galleries 9/27/75: 306;

ROLLINS, William Herbert
Photos dated: 1872
Processes:    Albumen
Formats:      Prints
Subjects:     Topography
Locations:
Studio:
    Entries:
Christies NY 5/6/85: 306 ill(note);

ROLLS, J.A. (British)
Photos dated: 1860s
Processes:    Albumen
Formats:      Prints
Subjects:
Locations:
Studio:       Great Britain (Amateur Photographic
              Association)
    Entries:
Sothebys Lon 10/29/80: 310 (album, R et al);
Christies Lon 10/27/83: 218 (albums, R-28 et al);

ROMAIN (French)
Photos dated: 1850s
Processes:    Salt
Formats:      Prints
Subjects:     Topography, architecture
Locations:    France - Paris
Studio:       France
    Entries:
Christies Lon 10/30/80: 162 ill(note);
Christies Lon 6/18/81: 182 (note);

ROMANOWSKI
Photos dated: between 1850s and 1870s
Processes:    Collotype
Formats:      Prints
Subjects:     Documentary (engineering)
Locations:    France - Montpellier
Studio:       France - Montpellier
    Entries:
Sothebys LA 2/13/78: 121 (books, R et al)(note);

RONDEAU (see PARANT & RONDEAU)

RONKINI, F.
Photos dated: 1870s-1880s
Processes:      Albumen
Formats:        Prints incl. panoramas
Subjects:       Topography
Locations:      Portugal - Lisbon
Studio:
    Entries:
Christies Lon 3/28/85: 224;
Christies Lon 10/31/85: 89 (note);
Christies Lon 6/26/86: 26;

ROOT, Marcus Aurelius (American, 1808-1888)
Photos dated: 1843-1856
Processes:      Daguerreotype, ambrotype
Formats:        Plates
Subjects:       Portraits
Locations:      Studio
Studio:         US - Alabama; Louisiana; Missouri;
                Pennsylvania; New York; Washington,
                D.C.
    Entries:
Sothebys NY (Weissberg Coll.) 5/16/67: 92 (lot, R-2
    et al), 93 (lot, R-1 et al), 110 (lot, R-1 et
    al), 118 (lot, R-1 et al);
Vermont Cat 6, 1973: 521 ill;
Sothebys NY 11/9/76: 9 (2);
Vermont Cat 11/12, 1977: 561 ill(note);
Swann NY 12/14/78: 389 ill(attributed)(note);
Sothebys LA 2/7/79: 401;
Swann NY 4/23/81: 269 (lot, R-1 et al);
Petzold Germany 11/7/81: 158;
Harris Baltimore 12/16/83: 311;
Swann NY 11/14/85: 40 ill(note);

ROOT, Samuel (American, 1819-1889)
Photos dated: 1849-1850s
Processes:      Daguerreotype
Formats:        Plates
Subjects:       Portraits, documentary
Locations:      Studio
Studio:         US - Pennsylvania; New York; Iowa
    Entries:
Sothebys NY (Strober Coll.) 2/7/70: 116 (lot, R-1
    et al), 175 (note);
Vermont Cat 11/12, 1977: 562 ill(note);
Swann NY 4/23/81: 256 ill(lot, R-1 et al)(note);

ROPES, H. (American)
Photos dated: 1860s-1890s
Processes:      Albumen
Formats:        Stereos
Subjects:       Topography
Locations:      US - Boston, Massachusetts
Studio:         US - New York City
    Entries:
Rinhart NY Cat 2, 1971: 448 (lot, R et al);
Swann NY 4/20/78: 372 (lot, R et al);
Harris Baltimore 12/16/83: 86 (lot, R et al);

ROSE, John K. & HOPKINS, Benjamin S. (American)
Photos dated: 1896-1901
Processes:      Platinum, silver
Formats:        Prints
Subjects:       Ethnography
Locations:      US - Denver, Colorado
Studio:         US - Denver, Colorado
    Entries:
Sothebys Lon 3/9/77: 266 (lot, R & H-1 et al);
Sothebys LA 2/7/79: 495 ill, 496 ill;
Swann NY 5/9/85: 424;
California Galleries 6/8/85: 266;
Swann NY 11/13/86: 133 (lot, R & H et al);

ROSE, George
Photos dated: 1890s
Processes:      Albumen
Formats:        Stereos
Subjects:       Topography
Locations:      New Zealand; Australia; Japan
Studio:         Australia - Melbourne
    Entries:
Christies Lon 3/20/80: 110 (lot, R-1 et al), 111
    (lot, R-13 et al);
Old Japan, England Cat 5, 1982: 22 (2 ills)(6);

ROSE, P.H. (American)
Photos dated: 1885
Processes:      Albumen
Formats:        Prints, stereos
Subjects:       Topography
Locations:      US - Texas
Studio:         US
    Entries:
Sothebys NY (Strober Coll.) 2/7/70: 504 (lot,
    R et al);
Wood Boston Cat 58, 1986: 136 (books, R-1 et al);

ROSEBROOK
Photos dated: c1890s
Processes:      Albumen
Formats:        Cabinet cards
Subjects:       Portraits
Locations:
Studio:
    Entries:
California Galleries 9/27/75: 375 (lot, R et al);
California Galleries 1/22/77: 112 (lot, R et al);

ROSEBUD Agency (American)
Photos dated: 1888
Processes:      Albumen
Formats:        Prints
Subjects:       Documentary (public events)
Locations:      US - South Dakota
Studio:         US - South Dakota
    Entries:
Sothebys NY 11/21/70: 363 ill(8);

**ROSIER, M.**
Photos dated: 1858
Processes:     Albumen
Formats:      Stereos
Subjects:     Topography
Locations:    China
Studio:
   Entries:
Sothebys Lon 4/25/86: 12 ill(42)(note);

**ROSLING, Alfred** (British, 1802-1880s)
Photos dated: early 1840s-1860s
Processes:     Calotype, albumen
Formats:      Prints, stereos, microphotographs
Subjects:     Topography
Locations:    Great Britain
Studio:       Great Britain
   Entries:
Weil Lon Cat 4, 1944(?): 237 (album, R et al)(note);
Swann NY 2/14/52: 262 (album, R et al);
Sothebys Lon 3/21/75: 146 (book, R-6 et al), 286
   (album, R-1 et al);
Colnaghi Lon 1976: 142 ill(note);
Sothebys Lon 11/18/77: 66 (lot, R-1 et al);
Sothebys Lon 6/28/78: 80 (album, R-1 et al), 119
   (lot, R-2 et al), 236 (lot, R-3 et al);
Sothebys Lon 10/27/78: 116 (album, R-3 et al);
Sothebys Lon 3/14/79: 324 (album, R-1 et al);
Christies Lon 6/18/81: 158 (lot, R-2 et al);
Christies Lon 10/28/82: 38 (lot, R-2 et al);
Christies Lon 3/24/83: 51 (album, R-2 et al);
Christies Lon 6/23/83: 62 (lot, R-8 et al);
Christies Lon 6/28/84: 217 (lot, R-7 et al), 221
   (lot, R-2 et al);
Christies Lon 3/28/85: 151 (albums, R et al)(note);
Sothebys Lon 11/1/85: 59 (album, R-1 et al);

**ROSLING, Henry**
Photos dated: Nineteenth century
Processes:     Albumen
Formats:      Prints
Subjects:     Topography
Locations:    Norway
Studio:       Europe
   Entries:
Christies Lon 6/28/84: 217 (lot, R-6 et al);

**ROSNEY** (French)
Photos dated: c1850-1850s
Processes:     Daguerreotype
Formats:      Plates
Subjects:     Portraits
Locations:    Studio
Studio:       France - Paris
   Entries:
Christies Lon 6/18/81: 12;
Christies Lon 6/24/82: 7 (lot, R-1 et al);

**ROSS** (see PRINGLE, A.) [ROSS 1]

**ROSS & THOMSON** (British) [ROSS 2]
Photos dated: c1850-1860s
Processes:     Daguerreotype, ambrotype, salt,
             albumen
Formats:      Plates, cdvs
Subjects:     Portraits, topography
Locations:    Scotland
Studio:       Scotland - Edinburgh
   Entries:
Rauch Geneva 6/13/61: 47 (album, R & T et al);
Witkin NY III 1975: D50 ill;
Christies Lon 6/10/76: 13;
Sothebys Lon 6/11/76: 126;
Christies Lon 3/10/77: 40 (R & T-2 et al);
Christies Lon 10/26/78: 14;
Sothebys Lon 10/24/79: 328;
Christies Lon 3/20/80: 23 (lot, R & T-1 et al), 67
   (lot, R & T-1 et al);
Sothebys Lon 3/21/80: 22 ill;
Christies Lon 6/26/80: 18, 27, 486 (albums, R & T
   et al);
Christies Lon 10/30/80: 30, 433 (albums, R & T-7
   et al);
Phillips Lon 3/18/81: 102 (2);
Sothebys Lon 3/27/81: 354 (lot, R & T-1 et al);
Christies Lon 10/29/81: 23 ill(lot, R & T-2 et al),
   83 (lot, R & T-1 et al);
Sothebys Lon 3/15/82: 290 (lot, R & T et al);
Christies Lon 6/23/83: 259 (lot, R & T et al);
Christies Lon 10/27/83: 233 (album, R & T et al);
Christies Lon 10/25/84: 325 (albums, R & T et al);
Christies Lon 10/31/85: 302 (album, R & T et al);
Phillips Lon 10/29/86: 279;
Christies Lon 10/30/86: 252 (album, R & T et al);

**ROSS, Captain Horatio** (British, 1801-1886)
Photos dated: 1856-c1860
Processes:     Daguerreotype, salt, albumen
Formats:      Plates, prints
Subjects:     Genre (domestic), topography
Locations:    Scotland
Studio:       Scotland
   Entries:
Christies Lon 10/29/81: 335 (2 ills)(65)(note);
Kraus NY Cat 1, 1984: 33 ill(note), 34 ill, 35 ill
   (note), 36 ill, 37 ill;
Christies Lon 4/24/86: 479 ill, 480 ill;

**ROSS, L.**
Photos dated: 1860s-1870s
Processes:     Albumen
Formats:      Prints
Subjects:     Topography
Locations:    Europe - Alps
Studio:       Europe
   Entries:
Phillips NY 5/21/80: 212 (lot, R et al);

**ROSSE, L.**
Photos dated: Nineteenth century
Processes:     Albumen
Formats:      Prints
Subjects:     Topography
Locations:    France - Dinan
Studio:       Europe
   Entries:
Christies Lon 6/28/79: 137 (album, R-3 et al);

**ROSSETTI, Dante Gabriel** (British, 1828-1882)
Photos dated: 1865
Processes:      Albumen
Formats:        Prints
Subjects:       Portraits
Locations:      England - London
Studio:         England - London
   Entries:
Sothebys Lon 10/27/78: 189 ill(note);

**ROSSI, Giulio** (Italian, died 1884)
Photos dated: 1854-1881
Processes:      Daguerreotype, albumen, bromide
Formats:        Plates, cdvs
Subjects:       Portraits, topography
Locations:      Italy
Studio:         Italy - Milan
   Entries:
Sothebys NY 11/21/70: 346 (lot, R-1 et al);

**ROTH & Fils** (French)
Photos dated: 1860s
Processes:      Albumen
Formats:        Cdvs
Subjects:       Topography
Locations:      France
Studio:         France - Thionville
   Entries:
Petzold Germany 11/7/81: 327 (lot, R et al);

**ROTH, Bernard** (photographer or author?)
Photos dated: 1889
Processes:      Woodburytype
Formats:        Prints
Subjects:       Documentary (medical)
Locations:      England
Studio:         England
   Entries:
Wood Conn Cat 45, 1979: 207 (4 ills)(book, 8)(note);
Wood Conn Cat 49, 1982: 371 ill(book, 8)(note);

**ROTH, Herman** (German)
Photos dated: Nineteenth century
Processes:      Albumen
Formats:
Subjects:       Portraits
Locations:      Studio
Studio:         Germany - Stuttgart
   Entries:
Petzold Germany 5/22/81: 1980 (album, R et al);

**ROTHROCK** (American)
Photos dated: Nineteenth century
Processes:      Albumen
Formats:        Stereos
Subjects:       Topography
Locations:      US - American west
Studio:         US
   Entries:
Harris Baltimore 12/10/82: 109 (lot, R et al);

**ROTHWELL** (British)
Photos dated: 1860s
Processes:      Albumen
Formats:        Stereos
Subjects:       Topography
Locations:      Great Britain
Studio:         Great Britain
   Entries:
Sothebys Lon 6/25/82: 4 (lot, R et al);

**ROUSSEL** (French)
Photos dated: c1870
Processes:      Albumen
Formats:        Stereos, cdvs
Subjects:       Topography
Locations:      France
Studio:         France
   Entries:
California Galleries 4/2/76: 91 (lot, R et al);
California Galleries 3/30/80: 270 (lot, R et al);

**ROUSSET, Ildephonse** (French)
Photos dated: 1850s-1866
Processes:      Albumen
Formats:        Prints
Subjects:       Topography, genre
Locations:      France - Marne River and Bois de
Vincennes
Studio:         France
   Entries:
Andrieux Paris 1951(?): 723 (book, 10);
Swann NY 2/14/52: 207 (book, 26), 208 (book, 9)
   (note), 209 (book, 22);
Sothebys NY 11/21/70: 30 (book, 10)(note);
Sothebys Lon 7/1/77: 48 (book, 10);
Swann NY 4/20/78: 135 ill(book, 22);
Witkin NY X 1980: 64 ill(book, 25)(note);
Sothebys NY 5/20/80: 365 ill(book, 25);
Sothebys Lon 6/27/80: 164 ill(book, 31);
Sothebys Lon 3/27/81: 240 ill(book, 31);
Sothebys NY 5/24/82: 286;
Swann NY 11/10/83: 141 (book, 25)(note);

**ROUTZAHN, N.** (American)
Photos dated: 1860s
Processes:      Albumen
Formats:        Prints
Subjects:       Topography
Locations:      US - Winchester, Virginia
Studio:         US
   Entries:
Harris Baltimore 9/16/83: 187 (lot, R-1 et al);

**ROWE, J.**
Photos dated: Nineteenth century
Processes:      Albumen
Formats:        Stereos
Subjects:       Topography
Locations:      Australia
Studio:
   Entries:
Christies Lon 3/20/80: 111 (lot, R et al);

ROWE, J.F. (Canadian)
Photos dated: 1880-1890
Processes:     Albumen
Formats:       Prints
Subjects:      Topography
Locations:     Canada - Manitoba
Studio:        Canada - Portage la Prairie, Manitoba
    Entries:
Christies Lon 3/16/78: 132 (lot, R-11 et al);
Phillips Can 10/4/79: 81 (11);

ROWELL (see ALLEN & ROWELL)

ROWELL, Frank (American)
Photos dated: 1860s-1870s
Processes:     Albumen
Formats:       Stereos
Subjects:      Topography
Locations:     US - Niagara Falls, New york
Studio:        US - Boston, Massachusetts
    Entries:
Rinhart NY Cat 1, 1971: 143 (2), 291 (3);
Rinhart NY Cat 2, 1971: 542 (3);
Swann NY 4/23/81: 531 (lot, R et al);
Harris Baltimore 6/1/84: 109 (lot, R et al);

ROWMAN (English)
Photos dated: 1850s
Processes:     Ambrotype
Formats:       Plates
Subjects:      Portraits
Locations:     Studio
Studio:        England - London
    Entries:
Christies Lon 3/29/84: 7 (lot, R-1 et al);

ROWSELL (see COURRET)

ROY, C.L. (American)
Photos dated: 1895
Processes:     Albumen
Formats:       Prints
Subjects:      Topography
Locations:     US - Skowhegan, Maine
Studio:        US - Skowhegan, Maine
    Entries:
California Galleries 3/30/80: 210 ill(album, 49);

ROYAL PHOTGRAPHIC SCHOOL (British)
Photos dated: 1856
Processes:     Albumen
Formats:       Prints
Subjects:      Topography
Locations:     England
Studio:        England - Chatham
    Entries:
Sothebys NY 10/4/77: 162 ill(album, R et al);

ROYER & AUFIERE
Photos dated: between 1860s and 1890s
Processes:     Albumen
Formats:       Cdvs
Subjects:      Topography
Locations:     Egypt; Algeria
Studio:        Egypt - Cairo
    Entries:
Swann NY 5/15/86: 203 (lot, R & A et al);

ROYLE, Vernon (American)
Photos dated: early 1860s-1894
Processes:     Albumen, photogravure
Formats:       Stereos, prints
Subjects:      Documentary (industrial), genre
               (still life)
Locations:     US - Patterson, New Jersey
Studio:        US
    Entries:
Rinhart NY Cat 6, 1973: 511;
California Galleries 6/28/81: 301;
California Galleries 5/23/82: 377;

RUBELLIN & Son
Photos dated: 1880s
Processes:     Albumen
Formats:       Prints
Subjects:      Topography
Locations:     Middle East
Studio:        Middle East
    Entries:
Christies NY 2/22/84: 7 (album, R et al);
Christies Lon 3/29/84: 63 (album, R et al);
Swann NY 5/10/84: 276 (albums, R et al);

RUCKWARDT, Hermann (German)
Photos dated: 1884
Processes:     Albumen, photogravure
Formats:       Prints
Subjects:      Topography, documentary (art)
Locations:     Germany - Berlin
Studio:        Germany
    Entries:
Christies Lon 6/30/77: 100 ill(book, 53);
Sothebys Lon 11/18/77: 78 (14);
Christies Lon 3/16/78: 78 (35);
Christies Lon 10/26/78: 133 (album, 53);
California Galleries 3/30/80: 130 (book, 21);

RUDD (see SCHWING & RUDD)

RUDD, C. (see also PAYNTER)
Photos dated: 1870s-1890s
Processes:     Albumen
Formats:       Prints
Subjects:      Topography
Locations:     Australia - Sydney; Costa Rica; Europe
Studio:
    Entries:
Swann NY 11/6/80: 333 (lot, R & Paynter-1, et al);
Phillips NY 5/9/81: 69 (albums, R-10 et al);
Christies Lon 6/18/81: 238 (lot, R-2 et al);
Christies Lon 3/11/82: 237 (lot, R-2 et al);
Christies Lon 10/28/82: 121 (albums, R et al);
Christies Lon 3/24/83: 135 (album, R et al);
Harris Baltimore 6/1/84: 445 (lot, R et al);

**RUE, A.B.** (American)
Photos dated: 1881
Processes:      Albumen
Formats:        Prints
Subjects:       Portraits
Locations:      Studio
Studio:         US - Louisville, Kentucky
   Entries:
Rinhart NY Cat 8, 1973: 16 (book, R-1 et al);

**RUFF, George** (British)
Photos dated: 1860s
Processes:      Ambrotype
Formats:        Plates
Subjects:       Portraits
Locations:      Studio
Studio:         England - Brighton
   Entries:
Sothebys Lon 3/19/76: 70 (lot, R-2 et al);
Sothebys Lon 10/24/79: 224;
Christies Lon 10/29/81: 87 (lot, R-2 et al);
Phillips Lon 4/23/86: 209 (lot, R-3 et al);

**RUMINE, Gabriel de** (Russian)
Photos dated: 1859
Processes:      Albumen
Formats:        Prints
Subjects:       Topography
Locations:      Italy; Greece
Studio:         France - Paris
   Entries:
Sothebys NY 11/10/86: 288 ill(note);

**RUNNELS & STATELER** (American)
Photos dated: c1886
Processes:      Albumen
Formats:        Prints
Subjects:       Topography
Locations:      US - San Francisco, California
Studio:         US - San Francisco, California
   Entries:
Frontier AC, Texas 1978: 270 (note);

**RUPP, Phillip** (American)
Photos dated: 1850s
Processes:      Daguerreotype
Formats:        Plates
Subjects:       Portraits
Locations:      Studio
Studio:         US - New York City
   Entries:
Sothebys NY (Strober Coll.) 2/7/70: 157 (lot,
  R-1 et al);

**RUSFELDT, Emil**
Photos dated: 1870s-1880s
Processes:      Albumen
Formats:        Prints
Subjects:       Topography
Locations:      China
Studio:         China - Hong Kong
   Entries:
Rose Boston Cat 4, 1979: 93 ill(note);
Swann NY 11/18/82: 347 ill(lot, R et al)(note);

**RUSFELDT, E.** (continued)
Christies Lon 6/28/84: 102 (lot, R-2 et al)(note);
Christies Lon 10/30/86: 114 (album, R-1 et al)
  (note);

**RUSSELL** (American) [RUSSELL 1]
Photos dated: 1860s
Processes:      Tintype
Formats:        Plates
Subjects:       Portraits
Locations:      Studio
Studio:         US - New York City
   Entries:
Rinhart NY Cat 2, 1971: 266 (lot, R et al);

**RUSSELL** (American) [RUSSELL 2]
Photos dated: mid 1880s
Processes:      Albumen
Formats:        Cdvs
Subjects:       Portraits
Locations:      Studio
Studio:         US - Baltimore, Maryland
   Entries:
Rinhart NY Cat 8, 1973: 102;

**RUSSELL** (British) [RUSSELL 3]
Photos dated: 1890s
Processes:      Albumen, carbon
Formats:        Prints, cabinet cards
Subjects:       Portraits, genre (animal life)
Locations:      England
Studio:         England - London
   Entries:
Christies Lon 6/14/73: 155 (book, R et al);
Christies Lon 7/25/74: 328 (book, R et al);
Swann NY 2/6/75: 165 (book, R et al);
Sothebys Lon 3/9/77: 215 (lot, R-2 et al);
Christies Lon 6/30/77: 175 ill;
Christies Lon 10/27/77: 395 (lot, R-2 et al);
Christies Lon 10/26/78: 353 (lot, R-7 et al);
Sothebys Lon 3/21/80: 252 (lot, R et al)(note);
Christies Lon 10/30/80: 174 (lot, R-2 et al);
Christies Lon 3/24/83: 237 (lot, R et al);
Swann NY 11/10/83: 276 (album, R et al);
Harris Baltimore 3/15/85: 287 (lot, R et al), 302
  (lot, R et al);

**RUSSELL, Andrew Joseph** (American, 1830-1902)
Photos dated: 1863-1869
Processes:      Albumen
Formats:        Prints
Subjects:       Topography, documentary (Civil War,
             railroads)
Locations:      US - Civil War area, American west
Studio:         US
   Entries:
Swann NY 2/14/52: 356 (book, 50)(note), 358 (book,
  30)(note);
Sothebys NY (Strober Coll.) 2/7/70: 358 (13)(note),
  389 (lot, R-1 et al), 403 (5), 407 (lot, R-1 et
  al), 519 (lot, R-14 et al)(note);
Vermont Cat 1, 1971: 221 (note);
Vermont Cat 2, 1971: 238 ill(10);
Rinhart NY Cat 6, 1973: 136 (book, 30);
Vermont Cat 5, 1973: 550 ill;
Vermont Cat 7, 1974: 649 (lot, R-1 et al), 747
  (4 ills)(book, 30)(note);

RUSSELL, A.J. (continued)
Witkin NY II 1974: 584 ill(book, 30), 1099 ill
(attributed), 1129;
Swann NY 2/6/75: 87 (book, 30)(note);
Sothebys NY 2/25/75: 61 ill(book, 61);
Sothebys NY 9/23/75: 123 ill(4);
Kingston Boston 1976: 197 ill(note), 198 ill, 199
ill, 200 ill, 201 ill, 202 ill, 203 ill, 204
ill, 205 ill, 206 ill, 207 ill;
Wood Conn Cat 37, 1976: 361 (30)(note);
Swann NY 4/1/76: 305 (book, 13);
Sothebys NY 5/4/76: 150 (book, 30);
Vermont Cat 11/12, 1977: 528 (2 ills)(book, 30)
(note);
White LA 1977: 109 ill(note), 110 ill, 111 ill;
California Galleries 1/22/77: 212a (book, 30);
Wood Conn Cat 41, 1978: 179 ill(note), 180 ill, 181,
182, 183;
California Galleries 1/21/78: 192 ill(65,
attributed)(note), 392 ill(book, 30);
Swann NY 4/20/78: 283 (2 ills)(album, R et al)
(note);
Lehr NY Vol 1:4, 1979: 50 (book, 30);
Lehr NY Vol 2:2, 1979: 28 ill, 29 ill, 30 ill,
31 ill;
California Galleries 1/21/79: 266 (lot, R-1 et al),
451 (9);
Christies NY 5/4/79: 91 ill(book)(note);
Phillips NY 5/5/79: 203 ill(note), 204;
Phillips NY 11/3/79: 188 ill(note);
Rose Boston Cat 5, 1980: 16 ill(note), 17 ill, 18
ill, 19 ill;
California Galleries 3/30/80: 81 (book, 29);
Swann NY 4/17/80: 108 ill(book, 30)(note);
Phillips NY 5/21/80: 255 (2);
Sothebys NY 10/21/81: 192 ill(2);
Christies NY 11/10/81: 53 ill(note), 54 ill(note),
55 ill(note);
Sothebys LA 2/17/82: 324 ill(2), 325 ill(note), 326
ill(2), 327 ill(2);
Christies NY 5/26/82: 50 (6 ills)(book, 50)(note),
51 (note), 52, 53 ill(book, 30);
Swann NY 11/18/82: 219 ill(book, 30)(note), 438
(note), 439 (attributed)(note), 440 (attributed)
(note);
Harris Baltimore 12/10/82: 309 (note), 310 (note),
311 (attributed)(note), 312 (note);
Swann NY 5/5/83: 207 ill(book, 30)(note);
California Galleries 6/19/83: 63 ill(book, 30)
(note);
Harris Baltimore 9/16/83: 169 (3, attributed)
(note), 202 (note), 203 (2, attributed);
Harris Baltimore 12/16/83: 140 (lot, R-5 et al), 405
(note), 406 (note);
Harris Baltimore 6/1/84: 431 (note), 432 (note),
433, 434, 435 (note), 436, 437, 438, 439, 440,
441, 442 ill(attributed);
California Galleries 7/1/84: 623 ill;
Christies NY 9/11/84: 145 (note);
Christies NY 11/6/84: 35 (6 ills)(117)(note);
California Galleries 6/1/85: 399;
Christies NY 11/11/85: 366 ill(2)(note), 367 ill
(2), 368 (2)(note), 369 ill(2)(note), 370 ill(2)
(note), 371 ill(2), 372 (2)(note), 373 ill(2),
374 (2)(note);
Swann NY 11/14/85: 158 (lot, R et al);
Sothebys NY 5/12/86: 340 (2 ills)(book, 50)(note),
341 ill(2);
Swann NY 5/15/86: 141 ill(book, 30)(note);
Phillips NY 7/2/86: 354;
Sothebys NY 11/10/86: 329A ill(6);

RUSSELL, A.J. (continued)
Christies NY 11/11/86: 345 ill(11)(note);
Swann NY 11/13/86: 312 (16)(note);

RUSSELL, Charles (British)
Photos dated: 1860s
Processes: Albumen
Formats: Stereos
Subjects: Topography
Locations: England - London
Studio: Great Britain
Entries:
California Galleries 9/27/75: 448 (lot, R et al);

RUSSELL, Lieutenant Gerald Walter (British)
Photos dated: 1860s
Processes: Albumen
Formats: Prints
Subjects: Documentary (maritime)
Locations:
Studio:
Entries:
Christies Lon 10/30/80: 263 (2 ills)(album,
R et al), 271 (album, R et al);

RUSSELL, I.C. (American)
Photos dated: c1890s
Processes:
Formats: Prints
Subjects: Topography
Locations: US - Dismal Swamp, Virginia
Studio: US
Entries:
Swann NY 10/18/79: 357 (16);

RUSSELL, J. (British)
Photos dated: 1860s-1876
Processes: Albumen
Formats: Prints, cdvs
Subjects: Portraits, topography
Locations: England
Studio: England - Chichester
Entries:
Sothebys Lon 11/18/77: 252;
Sothebys Lon 3/22/78: 176;
Christies Lon 6/27/85: 281 (album, R et al);

RUST, Thomas
Photos dated: 1870s-1880s
Processes: Albumen
Formats: Prints
Subjects: Topography
Locations: India
Studio:
Entries:
Sothebys Lon 6/21/74: 72 (album, R-14 et al);
Edwards Lon 1975: 16 (album, R-16 et al);
Sothebys Lon 10/29/76: 159 (albums, R et al), 163
(album, R-10 et al);
Christies Lon 10/27/77: 144 (album, R-1 et al), 178
(albums, R-2 et al);
Sothebys Lon 11/18/77: 100 (lot, R et al);
Christies Lon 6/27/78: 149 (album, R-1 et al);
Sothebys Lon 6/28/78: 116 (albums, R et al);
Christies Lon 10/25/79: 195 (album, R-14 et al);
Christies Lon 6/26/80: 478 (lot, R et al);

RUST, T. (continued)
Christies Lon 3/26/81: 269 (album, R-2 et al)
  (note);
Sothebys Lon 10/28/81: 138 (album, R et al);
Christies Lon 10/29/81: 238 (album, R-2 et al);
Sothebys Lon 12/9/83: 37 (album, R et al);
Christies Lon 3/29/84: 66 (lot, R et al), 94 (lot,
  R et al);
California Galleries 7/1/84: 625 ill(3);
Phillips Lon 10/24/84: 108 (lot, R-4 et al);
Christies Lon 3/28/85: 329 (album, R-3 et al);
Christies Lon 4/24/86: 510 (lot, R-2 et al);

RUTHERFORD & Co. (American)
Photos dated: 1860s
Processes:    Albumen
Formats:      Stereos
Subjects:     Topography
Locations:    US - Atlantic City, New Jersey
Studio:       US - Atlantic City, New Jersey
  Entries:
Vermont Cat 11/12, 1977: 827 ill(12);

RUTHERFORD, Lewis Morris (American, 1816-1892)
Photos dated: 1865-1878
Processes:    Albumen, woodburytype
Formats:      Prints, stereos
Subjects:     Documentary (scientific)
Locations:    US
Studio:       US - New York City
  Entries:
Sothebys NY (Strober Coll.) 2/7/70: 525 (lot,
  R & Draper et al)(note);
Vermont Cat 4, 1972: 546 (lot, R-2 et al);
Rinhart NY Cat 7, 1973: 106 (book, R-1 et al), 351,
  399;
Vermont Cat 5, 1973: 546 (lot, R-2 et al);
Christies Lon 3/16/78: 227 (books, R-3 et al);
Swann NY 11/5/81: 289 (book, 2), 262;
Christies NY 11/8/82: 193 ill(lot, R-3 et al)(note);
Harris Baltimore 12/10/82: 59 (lot, R-3 et al);
Harris Baltimore 4/8/83: 60 (lot, R et al);

RUTTER (American)
Photos dated: c1890
Processes:    Albumen
Formats:      Prints
Subjects:     Topography
Locations:    US - Tacoma, Washington
Studio:       US - Tacoma, Washington
  Entries:
California Galleries 7/1/84: 700;

RYAN, D.J. (American)
Photos dated: 1870
Processes:    Albumen
Formats:      Prints, stereos
Subjects:     Portraits, topography
Locations:    US - Savannah, Georgia
Studio:       US - Savannah, Georgia
  Entries:
Sothebys NY (Strober Coll.) 2/7/70: 526 (lot,
  R et al);
Sothebys NY 2/25/75: 45 (lot, R et al);
Swann NY 11/14/85: 170 (lot, R et al);

RYDER & SOLOMON
Photos dated: late 1870s-early 1880s
Processes:    Albumen
Formats:      Prints
Subjects:
Locations:
Studio:
  Entries:
Gordon NY 5/3/76: 298 (books, R & S et al);

RYDER, James F. (American, died 1904)
Photos dated: 1864-1881
Processes:    Daguerreotype, albumen
Formats:      Plates, prints, stereos, cdvs,
              cabinet cards
Subjects:     Topography, portraits
Locations:    US - American west
Studio:       US - Cleveland, Ohio
  Entries:
Rinhart NY Cat 2, 1971: 387 (lot, R et al);
Ricketts Lon 1974: 11 (2 ills)(album, R et al);
Swann NY 10/18/79: 391 (lot, R-1 et al);
Harris Baltimore 7/31/81: 283;
Harris Baltimore 3/26/82: 395 (lot, R et al);
Harris Baltimore 12/16/83: 242 (lot, R-1 et al);
Wood Boston Cat 58, 1986: 136 (books, R-2 et al);

RYDER, P.S. (American)
Photos dated: c1865
Processes:    Albumen
Formats:      Cdvs
Subjects:     Portraits
Locations:    Studio
Studio:       US - Indianapolis, Indiana
  Entries:
Sothebys NY (Strober Coll.) 2/7/70: 324 (lot,
  R et al);
Swann NY 11/10/83: 259 (note);

RYLE, Mrs. J.C. (British)
Photos dated: 1860s
Processes:    Albumen
Formats:      Prints
Subjects:     Genre (rural life)
Locations:
Studio:       Great Britain (Amateur Photographic
              Association)
  Entries:
Christies Lon 10/27/83: 218 (albums, R-2 et al);
Christies Lon 6/28/84: 229 (lot, R-2 et al);

RYO-UN-DO (Japanese)
Photos dated: 1880s-1890s
Processes:    Albumen
Formats:      Prints
Subjects:     Topography
Locations:    Japan
Studio:       Japan - Kobe
  Entries:
Old Japan, England Cat 8, 1985: 46 (album, 50)
  (attributed);

**S., A.N.** [A.N.S.]
Photos dated: Nineteenth century
Processes:       Albumen
Formats:         Stereos
Subjects:
Locations:
Studio:
   Entries:
Christies Lon 6/26/86: 66 (lot, S et al);

**S., C.** [C.S.]
Photos dated: 1870s
Processes:       Albumen
Formats:         Prints
Subjects:        Topography
Locations:       Ceylon
Studio:
   Entries:
Sothebys Lon 10/28/81: 139 (album, S-1 et al);

**S., D.** [D.S.]
Photos dated: 1851-c1855
Processes:       Daguerreotype, albumen
Formats:         Plates incl. stereo, prints
Subjects:        Portraits, documentary
Locations:       England - London
Studio:          Europe
   Entries:
Christies Lon 3/28/85: 325 (album, S et al);
Sothebys Lon 11/1/85: 5 ill(2);

**S., F.** [F.S. & Co.]
Photos dated: c1870s
Processes:       Albumen
Formats:         Cabinet cards
Subjects:        Documentary (art)
Locations:
Studio:
   Entries:
Harris Baltimore 2/14/86: 339 (lot, S-5 et al);

**S., F.G.D.** [F.G.D.S.]
Photos dated: c1880s
Processes:       Albumen
Formats:         Prints
Subjects:        Topography
Locations:
Studio:
   Entries:
Swann NY 11/11/76: 449 (lot, S et al);

**S., F.G.O.** [F.G.O.S.]
Photos dated: 1860-1880
Processes:       Albumen
Formats:         Prints
Subjects:        Topography
Locations:       England
Studio:          Great Britain
   Entries:
California Galleries 9/26/75: 134 (album, S et al);
Wood Conn Cat 37, 1976: 236 (album, S-1 et al);
California Galleries 1/22/77: 168 (album, S et al);

**S., H.H.** [H.H.S.] (French)
Photos dated: Nineteenth century
Processes:       Albumen
Formats:         Stereos (tissue)
Subjects:        Genre
Locations:       France
Studio:          France
   Entries:
California Galleries 9/27/75: 544 (lot, S et al);

**S., J.** [J.S.]
Photos dated: c1858-c1861
Processes:       Albumen
Formats:         Prints, microphotographs
Subjects:
Locations:
Studio:
   Entries:
Christies Lon 3/20/80: 125 ill, 126 ill, 127 ill(2),
  128 ill(2);
Christies Lon 10/30/86: 249 (album, S-6 et al);

**S., T.W.** [T.W.S.] (British)
Photos dated: 1854
Processes:       Waxed-paper negative
Formats:         Prints
Subjects:        Topography
Locations:       England - Whitby
Studio:          Great Britain
   Entries:
Christies Lon 6/10/76: 37 (5);

**S., W.K.** [W.K.S.]
Photos dated: Nineteenth century
Processes:       Albumen
Formats:         Prints
Subjects:        Topography
Locations:
Studio:
   Entries:
Christies Lon 6/28/84: 221 (lot, S et al);

**SABATIER-BLOT, Jean Baptiste** (French, 1801-1881)
Photos dated: c1842-1844
Processes:       Daguerreotype
Formats:         Plates
Subjects:        Portraits
Locations:       Studio
Studio:          France - Paris
   Entries:
Lehr NY Vol 1:2, 1978: 38 ill;

**SABERTON, Tom S.** (British)
Photos dated: 1850s and/or 1860s
Processes:       Albumen
Formats:         Stereos
Subjects:        Topography
Locations:       England - Stratford-upon-Avon
Studio:          Great Britain
   Entries:
Sothebys Lon 3/27/81: 26 (lot, S et al);

**SABOUNGI, G.**
Photos dated: 1880s
Processes:      Albumen
Formats:        Prints
Subjects:       Topography
Locations:      Palestine
Studio:
  Entries:
Christies Lon 6/27/78: 123 (albums, S et al);

**SACCHI, Luigi** (Italian, 1805-1861)
Photos dated: 1840s-1850s
Processes:      Calotype, albumen
Formats:        Prints
Subjects:       Portraits, topography
Locations:      Italy - Rome, Genoa, Florence, Pisa
Studio:         Italy - Rome and Milan
  Entries:
Christies Lon 10/27/77: 88 (lot, S-2 et al);
Swann NY 4/20/78: 329 (album, S et al);
Sothebys Lon 10/27/78: 87;
Christies NY 5/16/80: 184 (lot, S et al);
Christies Lon 6/26/80: 191 (lot, S-1 et al);

**SACHE, John Edward** (see also MURRAY)
Photos dated: 1860-1880
Processes:      Albumen
Formats:        Prints, cdvs
Subjects:       Topography, genre
Locations:      India - Calcutta and Agra
Studio:         India
  Entries:
Sothebys Lon 10/14/74: 79 (album, S et al);
Edwards Lon 1975: 11 (album, S, S & Murray, 49), 17
  (album, S-3 et al);
California Galleries 9/26/75: 297;
Sothebys Lon 10/24/75: 129 (albums, S et al), 132
  (albums, S-5 et al);
Christies Lon 6/10/76: 79 (album, S et al);
Sothebys Lon 6/11/76: 36b (album, S-6 et al), 44
  (album, S-3 et al);
Christies Lon 10/28/76: 132 (album, S et al), 134
  (lot, S-16 et al);
Sothebys Lon 10/29/76: 160 ill(albums, 110), 163
  (album, S-1 et al);
Sothebys Lon 3/9/77: 42 (album, S-28 et al);
Christies Lon 3/10/77: 140 (album, S, S & Murray-4,
  et al);
Sothebys NY 5/20/77: 106 (4);
Christies Lon 6/30/77: 115 (album, S-1 et al);
Sothebys NY 10/4/77: 142 (album, 29), 145 (album,
  S et al);
Sothebys Lon 11/18/77: 101 (album, S-10 et al);
Lunn DC Cat QP, 1978: 25 ill(album, S, S & Murray,
  49);
Christies Lon 3/16/78: 97 (album, S-1 et al);
Christies Lon 10/26/78: 167 (album, S-2 et al);
Christies Lon 6/28/79: 110 (lot, S-5 et al);
Sothebys Lon 10/24/79: 104 (album, S et al);
Christies Lon 10/25/79: 231 (album, S-4 et al);
Christies Lon 10/30/80: 229 (lot, S-5 et al), 264
  (albums, S-13 et al);
Christies Lon 3/26/81: 270 (album, S-33, S &
  Murray-2, et al), 399 (albums, S & Hennah-1,
  et al);
Sothebys Lon 3/27/81: 84 (album, S attributed et
  al), 85 (album, S et al);
Christies NY 5/14/81: 40;

**SACHE** (continued)
Sothebys Lon 10/28/81: 138 (album, S et al), 148 ill
  (album, 77);
Christies Lon 10/29/81: 263 (albums, S-4 et al),
  276 (albums, S et al);
Christies Lon 3/11/82: 176 (album, S et al);
Christies Lon 6/24/82: 197 (lot, S et al), 199 ill
  (album, S et al), 225 (album, S et al);
Sothebys Lon 6/25/82: 69 ill(lot, S-12 et al), 70
  (album, S et al);
Sothebys Lon 10/29/82: 30 ill(30)(note);
Sothebys Lon 6/24/83: 25 (50)(note);
Christies NY 11/8/83: 168 (albums, 88);
Christies Lon 3/29/84: 68 (lot, S et al), 73
  (album, S, S & Murray, et al);
Christies NY 9/11/84: 127 (albums, 88), 152 (lot,
  S et al);
Christies Lon 10/25/84: 68 (lot, S-1 et al);
Sothebys Lon 10/26/84: 66 ill(album, S et al), 70
  (2 ills)(album, S et al);
Phillips Lon 3/27/85: 213 (lot, S, S & Westfield,
  et al);
Sothebys Lon 3/29/85: 102 (lot, S & Bourne et al);
Sothebys Lon 6/28/85: 82 ill(albums, S et al);
Christies Lon 10/31/85: 120 (album, S-29 et al);
Swann NY 11/14/85: 149 (album, S, S & Murray, et al)
  (note);
Phillips Lon 4/23/86: 257 (album, S et al);
Christies Lon 4/24/86: 406 (album, S-6 et al);
Christies Lon 6/26/86: 115 (albums, S et al);
Sothebys Lon 10/31/86: 34 (album, S et al), 38
  (lot, S-6 et al);

**SACRE, Edmond** (Belgian)
Photos dated: Nineteenth century
Processes:      Carbon
Formats:        Prints
Subjects:       Architecture
Locations:      Belgium
Studio:         Belgium - Ghent
  Entries:
Sothebys Lon 6/27/80: 94 (album, 6);

**SAFFORD, E.W.** (see THOMSON, William J. & SAFFORD)

**SAGE, G.**
Photos dated: 1890s
Processes:      Albumen
Formats:        Prints
Subjects:       Topography
Locations:      Egypt
Studio:
  Entries:
Christies Lon 10/30/80: 220 (lot, S et al);

**SAGLIO** (see PETER, F.)

**ST. CLAIR, Lady Hariette** (British)
Photos dated: 1850s-1860s
Processes:      Albumen
Formats:        Prints
Subjects:       Genre
Locations:      Great Britain
Studio:         Great Britain
  Entries:
Christies Lon 6/27/78: 229 (album, S et al)(note);

**ST. CROIX, M. de** (French)
Photos dated: 1839
Processes: Daguerreotype
Formats: Plate
Subjects: Topography
Locations: France - Rouen
Studio: France
    Entries:
Ricketts Lon 1974: 1 ill;

**ST. JOHN, Mrs. Jane-Marthe, née Hicks-Beach**
              (British, born 1801)
Photos dated: 1850s
Processes: Salt
Formats: Prints
Subjects: Portraits, genre
Locations: Great Britain
Studio: Great Britain
    Entries:
Sothebys Lon 7/1/77: 184 (album, S et al)(note);
Kraus NY Cat 2, 1986: 2.21 ill;

**SALMON, H.W.**
Photos dated: 1880s
Processes: Albumen
Formats: Prints
Subjects: Topography
Locations:
Studio:
    Entries:
Swann NY 5/5/83: 284 (album, S et al);

**SALOMON**
Photos dated: 1870s
Processes: Albumen
Formats: Prints
Subjects:
Locations:
Studio:
    Entries:
Swann NY 11/14/85: 263 (books, S et al);

**SALVIATI, Paolo** (Italian)
Photos dated: 1860s-1880s
Processes: Albumen
Formats: Prints
Subjects: Topography, architecture
Locations: Italy - Venice; Milan
Studio: Italy - Venice
    Entries:
Christies Lon 6/10/76: 59 ill(album, 25);
Swann NY 11/11/76: 388 (albums, S et al), 389
    (albums, S et al), 395 (albums, S et al);
Swann NY 12/8/77: 384 (lot, S et al), 433 (23);
Rose Boston Cat 3, 1978: 57 ill(note);
California Galleries 1/21/79: 342 (album, S-18
    et al);
Christies Lon 3/15/79: 119 (album, 18);
Christies NY 5/16/80: 181 (4);
Christies Lon 10/30/80: 189 (albums, S et al);
Christies Lon 3/26/81: 268 (lot, S et al);
Swann NY 4/23/81: 546 (album, S et al);
Swann NY 11/5/81: 498 (lot, S-1 et al);
Petzold Germany 11/7/81: 185 (lot, S et al);
Christies Lon 3/11/82: 139 (lot, S et al);
Christies Lon 6/24/82: 138 (lot, S et al);
Harris Baltimore 12/10/82: 391 (albums, S et al);

**SALVIATI, P.** (continued)
Harris Baltimore 6/1/84: 357 (albums, S et al);
California Galleries 7/1/84: 492 (lot, S-1 et al);
Swann NY 11/8/84: 199 (lot, S et al);
Harris Baltimore 2/14/86: 210 (albums, S et al);
Swann NY 11/13/86: 245 (lot, S et al);

**SALVIN, Osbert**
Photos dated: 1862-1863
Processes: Albumen
Formats: Stereos
Subjects: Topography
Locations: Honduras - Copan
Studio:
    Entries:
Christies Lon 10/25/79: 75 (24);
Sothebys Lon 3/15/82: 23 (3);

**SALZBORN** (see LIENHARD & SALZBORN)

**SALZMANN, Auguste** (French, 1824-1872)
Photos dated: c1852-1865
Processes: Salt (Blanquart-Evrard)
Formats: Prints, stereos
Subjects: Architecture, documentary
Locations: Palestine - Jerusalem
Studio: France
    Entries:
Maggs Paris 1939: 491 (note);
Rauch Geneva 6/13/61: 101 (album, 40)(note), 102
    (book, 14);
Vermont Cat 5, 1973: 485 ill(note), 486 ill, 487
    ill, 488 ill, 489 ill, 490 ill, 491 ill;
Witkin NY III 1975: 205 ill;
Sothebys Lon 6/26/75: 137 (3);
Gordon NY 11/13/76: 36 ill(note), 37 ill, 38 ill,
    39 ill;
Gordon NY 5/10/77: 779 ill;
Christies Lon 6/30/77: 276 ill(note);
Lennert Munich Cat 5, 1979: 8 ill, 9;
Phillips NY 5/5/79: 166 ill;
Octant Paris 11/1979: 1 ill(note), 2 ill, 3 ill, 4
    ill, 5 ill, 6 ill, 7 ill, 8 ill, 9 ill, 10 ill,
    11 ill, 12 ill, 13 ill, 14 ill, 15 ill, 16 ill,
    17 ill, 18 ill, 19 ill, 20 ill, 21 ill, 22 ill;
Sothebys NY 11/2/79: 234 ill;
Sothebys NY 12/19/79: 80 ill, 81 ill, 82 ill;
Christies NY 5/16/80: 131 ill(note), 132 (note);
Sothebys NY 5/20/80: 389 ill, 390 ill;
Auer Paris 5/31/80: 46 ill(note), 47 (note), 48
    (note), 49, 50;
Christies Lon 6/26/80: 394 ill(note), 395 ill(note);
Christies NY 11/11/80: 52 ill;
Lennert Munich Cat 6, 1981: 3 ill;
Christies Lon 3/26/81: 327 (note), 328;
Phillips NY 5/9/81: 53 ill;
Christies NY 5/14/81: 31 ill(note);
Christies Lon 6/18/81: 198 ill(note);
Christies Lon 10/29/81: 176;
Christies Lon 6/24/82: 309 ill(note), 310, 311;
Christies Lon 10/28/82: 83;
Drouot Paris 11/27/82: 25 ill;
Christies NY 5/9/83: 112 ill;
Christies Lon 6/23/83: 125;
Sothebys Lon 6/24/83: 75 ill;
Christies Lon 10/27/83: 90 (note), 91 (note), 92
    (note);
Phillips Lon 11/4/83: 99;

**SALZMANN, A.** (continued)
Christies NY 11/8/83: 169 ill, 170 ill, 171 ill;
Sothebys Lon 12/9/83: 57 ill, 58 ill, 59 ill;
Christies Lon 3/29/84: 169 (2)(note), 170 ill(note);
Sothebys NY 5/8/84: 269 ill;
Sothebys Lon 6/29/84: 110, 111, 112 ill, 113 ill,
   114 ill, 115 ill;
Sothebys Lon 10/26/84: 98 ill;
Sothebys NY 5/7/85: 209 ill;
Christies Lon 6/27/85: 138 ill;
Sothebys NY 5/12/86: 345 ill, 345A ill(books, 40)
   (note);
Sothebys Lon 10/31/86: 167 ill, 168 ill, 169 ill,
   170 ill;

**SAMPSON, Henry** (British)
Photos dated: 1858-1870
Processes:    Albumen, carbon
Formats:      Prints, stereos
Subjects:     Topography
Locations:    England - Old Southport
Studio:       England
   Entries:
Sothebys Lon 10/24/75: 92 (lot, S et al);
Sothebys Lon 3/29/85: 149 ill(album, 15);
Sothebys Lon 6/28/85: 225 ill(album, 12);

**SANBORN, VAIL & Co.** (American)
Photos dated: c1880
Processes:    Albumen
Formats:      Prints
Subjects:     Topography
Locations:    US - Oregon
Studio:       US - Portland, Oregon
   Entries:
California Galleries 3/30/80: 348 (lot, S-1 et al);
California Galleries 12/13/80: 316;
California Galleries 6/28/81: 285 (2);

**SANBORN, N.C.** (American)
Photos dated: 1870s-1880
Processes:    Albumen
Formats:      Prints, stereos
Subjects:     Architecture
Locations:    US - Lowell, Massachusetts
Studio:       US - Lowell, Massachusetts
   Entries:
Wood Conn Cat 42, 1978: 326 (book, 2);

**SANDERSON** (American)
Photos dated: Nineteenth century
Processes:    Albumen
Formats:      Cdvs
Subjects:     Portraits
Locations:    Studio
Studio:       US - New Orleans, Louisiana
   Entries:
Sothebys NY (Strober Coll.) 2/7/70: 295 (lot,
   S et al);

**SANDS & McDOUGALL** (Australian)
Photos dated: 1896
Processes:    Albumen
Formats:      Prints
Subjects:     Documentary (industrial)
Locations:    Australia
Studio:       Australia - Melbourne
   Entries:
Christies Lon 6/27/78: 128 ill (album, 25);

**SANDS, C.**
Photos dated: Nineteenth century
Processes:
Formats:      Prints
Subjects:     Topography
Locations:
Studio:
   Entries:
Christies Lon 3/28/85: 151 (albums, S et al)(note);

**SANDY, W.** (British)
Photos dated: 1860s
Processes:    Albumen
Formats:      Prints
Subjects:
Locations:
Studio:       Great Britain (Amateur Photographic
              Association)
   Entries:
Christies Lon 10/27/83: 218 (albums, S-1 et al);
Sothebys Lon 3/29/85: 159 (lot, S et al);

**SANFORD** (see DAVIS & SANFORD)

**SANFORD, W.H.** (American)
Photos dated: 1891
Processes:    Photogravure
Formats:      Prints
Subjects:     Topography
Locations:    US - Pike's Peak, Colorado
Studio:       US
   Entries:
Wood Conn Cat 42, 1978: 452 (book, 12)(note);
California Galleries 1/21/78: 137 (lot, S et al);

**SANGLAU, Achille**
Photos dated: 1863
Processes:    Albumen
Formats:      Prints
Subjects:     Topography
Locations:    Italy - Rome
Studio:
   Entries:
Christies Lon 6/24/82: 129 (11);
Christies Lon 10/27/83: 70 (11)(note);
Christies Lon 6/28/84: 208 (11);

**SANGLEBOEUF, E.**
Photos dated: 1887
Processes:      Albumen
Formats:        Prints
Subjects:       Documentary (art)
Locations:
Studio:
    Entries:
Christies Lon 6/28/79: 244 (albums, S-16 et al);

**SARGEANT, J.D.** (American)
Photos dated: 1864-1865
Processes:      Albumen
Formats:        Prints
Subjects:       Topography
Locations:      US
Studio:         US
    Entries:
Swann NY 11/14/85: 261 (book, S et al);
Wood Boston Cat 58, 1986: 136 (books, S-1 et al);
Swann NY 5/16/86: 130 (book, S et al)(note);

**SAROCK**
Photos dated: c1880
Processes:      Albumen
Formats:        Cabinet cards
Subjects:       Portraits
Locations:
Studio:
    Entries:
California Galleries 9/27/75: 374 (lot, S et al);

**SAROLIDES, G.** (Greek)
Photos dated: c1870-1880s
Processes:      Albumen
Formats:        Prints
Subjects:       Topography
Locations:      Egypt - Cairo
Studio:
    Entries:
Wood Conn Cat 37, 1976: 240 (album, S et al);
Rose Boston Cat 3, 1978: 102 ill(note);
Christies Lon 6/24/82: 171 (album, S-2 et al);
California Galleries 6/19/83: 330 (lot, S et al);
Christies Lon 6/27/85: 82 (album, S & Comianos-7, et al);
Christies Lon 6/26/86: 118 (albums, S et al);

**SARONY, Olivier Francois Xavier** (British, 1820-1879)
Photos dated: 1850s-c1879
Processes:      Daguerreotype, albumen
Formats:        Plates, cdvs
Subjects:       Portraits
Locations:      Studio
Studio:         England - Scarborough
    Entries:
Sothebys Lon 10/26/84: 25 (2);

**SARONY, Napoleon** (American, 1821-1896)
Photos dated: 1864-1896
Processes:      Albumen, carbon, woodburytype
Formats:        Prints, cabinet cards, cdvs, stereos
Subjects:       Portraits, documentary (medical)
Locations:      Studio
Studio:         England - Birmingham; US - New York City
    Entries:
Anderson NY (Gilsey Coll.) 1/20/03: 759 (lot, S-1 et al);
Anderson NY (Gilsey Coll.) 2/24/03: 2068 (lot, S et al), 2069 (lot, S et al);
Anderson NY (Gilsey Coll.) 3/18/03: 2281;
Sothebys NY (Weissberg Coll.) 5/16/67: 172 (lot, S et al), 173 (lot, S et al);
Sothebys NY (Strober Coll.) 2/7/70: 260 (lot, S-4 et al), 261 (lot, S et al), 263 (lot, S-2 et al), 268 (lot, S et al), 269 (lot, S et al), 273 (lot, S et al), 324 (lot, S et al), 366 (lot, S et al), 370 (8), 371 (5), 531 (lot, S et al);
Sothebys NY (Greenway Coll.) 11/20/70: 49 (lot, S-1 et al), 72 ill(lot, S-1 et al), 133 (lot, S-1 et al);
Sothebys NY 11/21/70: 321 (lot, S-1 et al), 326 (lot, S et al), 347 ill(lot, S et al), 350 (lot, S et al), 353 ill(3), 354 (lot, S-1 et al), 355 (lot, S et al), 356 ill(lot, S et al), 357 ill (lot, S et al), 359 ill;
Rinhart NY Cat 2, 1971: 31 (book, 4), 283 (lot, S et al);
Vermont Cat 2, 1971: 248 (lot, S-1 et al), 256 ill(4);
Rinhart NY Cat 6, 1973: 265, 469, 470;
Rinhart NY Cat 8, 1973: 14 (book, S-1 et al);
Witkin NY I 1973: 600 (book, 4);
Christies Lon 6/14/73: 219 (10);
Sothebys Lon 6/21/74: 163 (lot, S et al);
Sothebys Lon 10/18/74: 139 (lot, S et al);
Edwards Lon 1975: 12 (album, S et al);
Sothebys Lon 3/21/75: 171 (lot, S-1 et al);
Sothebys Lon 6/26/75: 269 (lot, S-2 et al);
Swann NY 9/18/75: 187 (2), 313 (lot, S-12 et al);
California Galleries 9/27/75: 377 (lot, S et al), 392;
Kingston Boston 1976: 577 (book, 4);
Wood Conn Cat 37, 1976: 167 (book, 4)(note);
California Galleries 4/2/76: 75 (lot, S et al);
Gordon NY 5/3/76: 304 (lot, S-2 et al);
Sothebys NY 5/4/76: 99 (album, S et al);
Sothebys Lon 6/11/76: 170 (album, S et al);
Swann NY 11/11/76: 259 (book, 1), 339 (lot, S et al), 341 (900)(note), 345 (lot, S et al), 346 (lot, S et al), 351 (lot, S et al), 352 (lot, S et al), 362 (lot, S et al);
Gordon NY 11/13/76: 106 ill;
California Galleries 1/22/77: 348 ill;
California Galleries 1/23/77: 498z (book, S-1 et al);
Swann NY 4/14/77: 168 (book, S-2 et al);
Gordon NY 5/10/77: 907 (album, S et al);
Christies Lon 6/30/77: 174;
Sothebys NY 10/4/77: 110 ill, 111, 112 (book, 4) (note);
Christies Lon 10/27/77: 394;
Swann NY 12/8/77: 118 ill(book, S et al), 418 (album, 65), 159 (book, 5);
Wood Conn Cat 42, 1978: 453 (book, 4)(note);
California Galleries 1/21/78: 139 (lot, S et al), 405 (4);
Sothebys LA 2/13/78: 45 (book, 4)(note);

## SARONY (continued)

Swann NY 4/20/78: 260 ill(lot, S et al);
Swann NY 12/14/78: 470 (lot, S et al);
Lehr NY Vol 1:3, 1979: 11, 31 ill;
Witkin NY IX 1979: 2/70 (book, 3);
Wood Conn Cat 45, 1979: 210 ill(book, 4)(note);
California Galleries 1/21/79: 235 (lot, S et al);
Swann NY 4/26/79: 424 (note);
Phillips NY 5/5/79: 216;
Sothebys NY 5/8/79: 5 (books, 8)(note);
Sothebys Lon 6/29/79: 263b ill(7);
Swann NY 10/18/79: 380, 383 (lot, S-13 et al), 442
    (lot, S et al);
Sothebys Lon 10/24/79: 321 (lot, S et al);
Christies Lon 10/25/79: 426 (lot, S-1 et al), 438
    (album, S et al);
Phillips NY 11/3/79: 197;
Phillips NY 11/29/79: 296 (lot, S-1 et al);
White LA 1980-81: 63 (2 ills)(lot, S-6 et al)(note);
Christies Lon 3/20/80: 347 (albums, S et al), 357
    (album, S et al), 366 (lot, S et al), 372 (lot,
    S et al), 373 (albums, S-1 et al);
Swann NY 4/17/80: 70 (lot, S-1 et al);
Christies NY 5/14/80: 335 (book, S et al);
Christies Lon 10/30/80: 407 (album, S et al), 416
    (album, S-1 et al), 431 (album, S-1 et al), 444
    (lot, S-3 et al);
Swann NY 11/6/80: 279 (4), 373 (lot, S et al);
Phillips NY 1/29/81: 140 (book, 4);
Swann NY 4/23/81: 551 (lot, S et al);
California Galleries 6/28/81: 372 (lot, S-1 et al),
    374 (lot, S et al), 382, 405;
Harris Baltimore 7/31/81: 155, 244 (lot, S-1 et
    al), 289 (6), 297 (lot, S et al);
Swann NY 11/5/81: 428 (4);
Wood Conn Cat 49, 1982: 379 (book, 4)(note);
Sothebys Lon 3/15/82: 235 (lot, S et al);
Harris Baltimore 3/26/82: 395 (lot, S et al);
Swann NY 4/1/82: 263 (lot, S et al);
Harris Baltimore 5/28/82: 141 (lot, S-1 et al);
Swann NY 11/18/82: 224 (book, 5)(note), 226 (book,
    1), 335, 476 (lot, S et al);
Christies NY 2/8/83: 42;
Harris Baltimore 4/8/83: 300 (lot, S et al), 322
    (lot, S et al);
Swann NY 5/5/83: 451 (22)(note);
California Galleries 6/19/83: 313;
Christies Lon 6/23/83: 242 (album, S et al);
Harris Baltimore 9/16/83: 112 (lot, S-1 attributed
    et al), 134 (lot, S-1 et al), 142 (lot, S-1 et
    al), 148 (lot, S et al), 152 (lot, S et al), 154
    (lot, S-1 et al);
Swann NY 11/10/83: 335 ill(note), 361 (album, S et
    al)(note);
Harris Baltimore 12/16/83: 110 (lot, S-2 et al);
Swann NY 5/10/84: 176 (lot, S et al);
Harris Baltimore 6/1/84: 248 (lot, S-1 et al), 254,
    289, 297, 298;
Swann NY 11/8/84: 275 (lot, S et al);
Harris Baltimore 11/9/84: 121, 132 (lot, S-1 et al);
Harris Baltimore 3/15/85: 21 (lot, S et al), 254
    ill, 306 (100);
Christies Lon 3/28/85: 319 (album, S et al);
Swann NY 5/9/85: 324 ill(lot, S et al)(note);
Swann NY 11/14/85: 20 (lot, S-7 et al), 264 (books,
    S et al), 291 ill(note);
Wood Boston Cat 58, 1986: 346 (book, 4)(note);
California Galleries 3/29/86: 748;
Christies Lon 4/24/86: 597 (albums, S-2 attributed
    et al);
Sothebys Lon 4/25/86: 224 ill;

## SARONY (continued)

Swann NY 5/16/86: 132 (book, S et al);
Christies Lon 6/26/86: 146 (lot, S et al);
Phillips Lon 10/29/86: 305;
Harris Baltimore 11/7/86: 211 (lot, S et al);

## SARONY, Otto (American)
Photos dated: 1890s
Processes: Albumen
Formats: Prints
Subjects: Portraits
Locations: Studio
Studio: US
    Entries:
Rose Boston Cat 1, 1976: 7 ill(note);

## SARRAULT (French)
Photos dated: between 1850s and 1870s
Processes: Albumen
Formats: Prints
Subjects: Documentary (engineering)
Locations: France - Asnières
Studio: France - Asnières
    Entries:
Sothebys LA 2/13/78: 121 (books, S et al);

## SAUNDERS (see HILLS & SAUNDERS)

## SAUNDERS, J.K.
Photos dated: 1860s-1870s
Processes: Albumen
Formats: Stereos
Subjects: Topography, portraits
Locations: Great Britain
Studio: Great Britain
    Entries:
Edwards Lon 1975: 12 (album, S et al);
Christies Lon 3/26/81: 128 (lot, S-1 et al);
Christies Lon 10/29/81: 138 (lot, S-2 et al);
Christies Lon 6/27/85: 33 (lot, S-6 et al);

## SAUNDERS, W.
Photos dated: 1862-1888
Processes: Albumen
Formats: Prints
Subjects: Topography
Locations: China - Shanghai and Hong Kong; Japan
Studio: China - Shanghai
    Entries:
Sothebys LA 2/16/80: 179 (lot, S-1 et al);
Sothebys Lon 3/21/80: 106 ill(26, attributed);
Christies NY 5/16/80: 213 (lot, S et al)(note);
Sothebys NY 5/20/80: 405 ill(album, S et al)(note);
Christies Lon 3/26/81: 235 ill(lot, S-12 et al)
    (note);
Christies Lon 6/18/81: 209 (album, S-14 attributed,
    et al), 216 ill(album, 50)(note);
Sothebys Lon 3/15/82: 111 (lot, S-11 et al);
Christies Lon 6/28/84: 136 (lot, S-1 et al)(note);
Christies Lon 10/25/84: 219 ill(album, 48)(note);
Swann NY 11/8/84: 184 (lot, S et al)(note);
Christies Lon 6/27/85: 79 (albums, S-1 et al)(note),
    80 (album, S attributed et al);
Swann NY 11/14/85: 59 ill(lot, S et al)(note);
Swann NY 5/16/86: 94 (books, S et al)(note),
    292 (6);

**SAUNDERS, W.** (continued)
Christies Lon 10/30/86: 114 (album, S et al)(note);
Harris Baltimore 11/7/86: 241 (album, S et al);
Swann NY 11/13/86: 49 (books, S & Stoss et al);

**SAUTO, Dr. Ambrosio C.** (Cuban)
Photos dated: 1860s
Processes:     Albumen
Formats:       Stereos
Subjects:      Topography
Locations:     Cuba
Studio:        Cuba - Matanzas
   Entries:
Swann NY 11/6/80: 380 (lot, S-2 et al);

**SAUVAIRE, Henri**
Photos dated: 1860s
Processes:     Albumen
Formats:       Prints
Subjects:      Topography
Locations:     Palestine - Jerusalem
Studio:
   Entries:
Christies NY 11/6/84: 23 ill(note);

**SAUZAY, A.**
Photos dated: 1870
Processes:     Albumen, autotype
Formats:       Prints
Subjects:      Documentary (industrial)
Locations:     England - London
Studio:        Great Britain
   Entries:
Swann NY 2/14/52: 159 (book, 8);
Edwards Lon 1975: 158 (book, 8);
Stern Chicago 1975(?): 49 (book, 8);

**SAVAGE, Charles Roscoe** (American, 1832-1909)
Photos dated: 1858-1906
Processes:     Albumen
Formats:       Prints, stereos, cdvs, boudoir cards
Subjects:      Topography, ethnography
Locations:     US - American west; Mexico
Studio:        US - Florence, Nebraska; Salt Lake
           City, Utah
   Entries:
Sothebys NY (Strober Coll.) 2/7/70: 314 (lot, S-3
   et al), 505 (lot, S et al), 507 (lot, S et al),
   511 (lot, S et al), 520 ill(lot, S-16 et al)
   (note), 531 (lot, S & Ottinger et al);
Sothebys NY (Greenway Coll.) 11/20/70: 147 ill;
Rinhart NY Cat 1, 1971: 263 (2), 264 (2), 265 (2),
   266 (2), 267 (2), 268 (2), 269 (2), 307 (lot,
   S-1 et al);
Rinhart NY Cat 2, 1971: 434 (album, S et al);
Rinhart Cat 6, 1973: 578, 579, 580, 597 (2);
Rinhart NY Cat 7, 1973: 143 (book, S et al), 303 (S
   & Ottinger);
Rinhart NY Cat 8, 1973: 80, 81;
Sothebys Lon 12/4/73: 213 (album, S et al);
Christies Lon 4/25/74: 254 (lot, S-5 et al);
Witkin NY III 1975: 208 (4 ills)(16);
Sothebys NY 2/25/75: 202 (book, 16)(note);
Sothebys Lon 3/21/75: 87 (album, S et al);
Sothebys NY 9/23/75: 128 ill(note);
California Galleries 9/27/75: 569 (10);
Kingston Boston 1976: 675 (note), 675A ill;

**SAVAGE, C.R.** (continued)
Christies Lon 10/28/76: 196 (lot, S-11 et al);
Sothebys Lon 10/29/76: 30 (lot, S et al);
Swann NY 11/11/76: 495 (lot, S-3 et al);
Vermont Cat 11/12, 1977: 828 ill(2);
Christies Lon 3/10/77: 183 (album, S-4 et al);
Swann NY 4/14/77: 318 (3);
Christies Lon 6/30/77: 132 (lot, S-1 et al), 133
   (lot, S et al);
Sothebys NY 10/4/77: 63 ill(note);
Frontier AC, Texas 1978: 273 (note), 274 (6), 275;
California Galleries 1/21/78: 198 (lot, S et al),
   278 (album, S-6 et al), 417 (lot, S et al);
Christies Lon 3/16/78: 133 (album, S-7 et al),
   135 (3);
Witkin NY Stereos 1979: 17 (2 ills)(S & Ottinger,
   16)(note);
Phillips NY 5/5/79: 205, 206 ill, 207, 208;
Sothebys NY 5/8/79: 10;
Swann NY 10/18/79: 393 (8), 431 (lot, S &
   Ottinger-8, et al);
Christies Lon 10/25/79: 251 (album, S-5 et al);
Christies NY 10/31/79: 80 (3);
Sothebys NY 11/2/79: 293 ill(lot, S-3 et al);
California Galleries 3/30/80: 375, 382 (lot,
   S-4 et al);
Christies NY 5/16/80: 266 (3);
Christies Lon 6/26/80: 223 (lot, S-1 et al);
Sothebys Lon 10/29/80: 106 (lot, S et al);
California Galleries 12/13/80: 209 (lot, S-1 et
   al), 338 (2), 339 (6), 351 (lot, S-2 et al);
Swann NY 4/23/81: 368;
Swann NY 11/5/81: 365 (1 plus 1 attributed)(note);
Rose Florida Cat 7, 1982: 92 ill(5);
Swann NY 4/1/82: 357 (lot, S et al);
California Galleries 6/28/81: 302 (lot, S-1 et al),
   305, 307 (lot, S-2 et al);
California Galleries 5/23/82: 382, 383;
Christies Lon 6/24/82: 221 ill(3);
Christies Lon 10/28/82: 113A;
Sothebys NY 11/10/82: 338 ill;
Harris Baltimore 12/10/82: 109 (lot, S et al);
Christies NY 2/8/83: 36 (lot, S et al);
California Galleries 6/19/83: 380 (2), 381 ill, 382
   (3), 383 (3), 384 ill(attributed);
Christies Lon 6/23/83: 44 (lot, S et al), 165
   ill(3);
Sothebys Lon 6/24/83: 1 (lot, S & Ottinger et al);
Christies Lon 10/27/83: 145 (lot, S et al);
Harris Baltimore 12/16/83: 140 (lot, S-10 et al),
   305 (lot, S-1 et al), 407 (4);
Swann NY 5/10/84: 13 (album, S et al)(note), 314
   (lot, S et al);
Harris Baltimore 6/1/84: 123 (lot, S-1 et al), 155
   (lot, S-24 et al), 446 (lot, S-1 et al);
California Galleries 7/1/84: 642, 643;
Christies Lon 10/25/84: 96 (lot, S-2 attributed,
   et al);
Swann NY 11/8/84: 143 (lot, S et al), 253 (lot,
   S et al);
Christies NY 2/13/85: 157 (2 plus 4 attributed);
Harris Baltimore 3/15/85: 108 (lot, S-1 et al);
Swann NY 5/9/85: 322 (lot, S et al), 433 (lot,
   S-2 et al);
California Galleries 6/8/85: 411, 441 (5);
Christies Lon 10/31/85: 127 (album, S-4 et al);
Sothebys NY 11/1/85: 3 (lot, S et al);
Harris Baltimore 2/14/86: 100;
Christies Lon 4/24/86: 395 (album, S-8 et al);
Swann NY 5/16/86: 162 (lot, S et al), 168 (album,
   S et al);

## SAVAGE, C.R. (continued)
Christies Lon 10/30/86: 150 (album, S-1 et al);
Swann NY 11/13/86: 132 (lot, S-2 attributed et al),
   133 (lot, S et al), 135 (album, S et al)(note),
   170 (albums, S et al), 288 (lot, S-2 et al);

## SAVAGE, R.G. (American)
Photos dated: 1891
Processes:      Photogravure
Formats:        Prints
Subjects:       Topography
Locations:      US - Utah
Studio:         US
   Entries:
California Galleries 1/22/77: 349 (note);

## SAVAGE, William (British)
Photos dated: 1866-1868
Processes:      Albumen
Formats:        Prints, cdvs
Subjects:       Topography, architecture
Locations:      England - Winchester et al
Studio:         England - Winchester
   Entries:
Vermont Cat 4, 1974: 754 ill(book, 32), 755 ill
   (book, 13), 756 (book, 32);
Sothebys Lon 6/21/74: 146 (book, 32);
Edwards Lon 1975: 138 (book, 32);
Swann NY 2/6/75: 155 (books, S-32 et al);
Sothebys Lon 3/21/75: 144 (book, 13);
Christies Lon 10/28/76: 282 (book, 32);
Christies Lon 6/30/77: 197 (book, 32);
Christies Lon 6/27/78: 164 (book, 32);
Christies Lon 10/26/78: 216 (book, 14);
Christies Lon 6/26/80: 310 (book, 32);
Christies Lon 10/30/80: 433 (albums, S-1 et al);
Swann NY 4/23/81: 175 (book, 13);
Wood Conn Cat 49, 1982: 381 (book, 32)(note);
Christies Lon 3/11/82: 339 (lot, S-1 et al);
Christies Lon 6/28/84: 150 (book, 32);

## SAVIOZ
Photos dated: 1870s
Processes:      Albumen
Formats:        Stereos
Subjects:       Topography
Locations:      Switzerland
Studio:         Switzerland
   Entries:
Harris Baltimore 4/8/83: 100 (lot, S et al);
Harris Baltimore 12/16/83: 132 (lot, S et al);

## SAWYER (see FRENCH, J.A.) [SAWYER 1]

## SAWYER (see OLDEN, SAWYER & Co.) [SAWYER 2]

## SAWYER & BIRD [SAWYER 3]
Photos dated: Nineteenth century
Processes:      Albumen
Formats:        Cdvs
Subjects:
Locations:
Studio:
   Entries:
California Galleries 1/21/78: 124 (lot,
   S & B et al);

## SAWYER [SAWYER 4]
Photos dated: 1874
Processes:      Autotype
Formats:        Prints
Subjects:       Topography
Locations:      Mexico
Studio:
   Entries:
Swann NY 7/9/81: 216 (book, S et al);

## SAWYER (British) [SAWYER 5]
Photos dated: 1860s-1880s
Processes:      Albumen
Formats:        Stereos, cdvs
Subjects:       Genre, topography, portraits
Locations:      England
Studio:         England - Norwich
   Entries:
California Galleries 9/27/75: 479 (lot, S et al);
California Galleries 1/23/77: 384 (lot, S et al);
Christies Lon 3/20/80: 363 (album, S et al);
Christies Lon 10/30/80: 440 (album, S et al);
Swann NY 4/23/81: 540 (lot, S et al);
Sothebys Lon 3/15/82: 206 (S, S & Bird, 22);
Christies Lon 6/24/82: 71 (lot, S et al), 364
   (album, S & Bird et al);
Christies Lon 3/24/83: 33 (S et al);

## SAWYER, Lydell (British, born 1856)
Photos dated: c1870-1891
Processes:      Albumen, photogravure
Formats:        Prints
Subjects:       Genre (street life)
Locations:      England
Studio:         England - Newcastle, Sunderland
   Entries:
Sothebys Lon 11/18/77: 260 (lot, S-4 et al)(note);
Sothebys Lon 3/22/78: 204 (lot, S-1 et al);
Sothebys Lon 10/27/78: 170 (lot, S-2 et al);
Sothebys Lon 3/15/82: 334;
Sothebys Lon 6/25/82: 54 (books, S-1 et al);
Christies NY 11/8/83: 201 (book, S et al);
Sothebys Lon 3/29/85: 173 ill;

## SAYRE, Lewis A. (American, 1820-1900)
                (photographer or author?)
Photos dated: 1877
Processes:
Subjects:       Documentary (medical)
Locations:      US - New York City
Studio:         US - New York city
   Entries:
Weil Lon Cat 31, 1963: 357 (book);

SCHAARWACHTER, J.C. (Dutch)
Photos dated: c1872-1896
Processes:      Albumen
Formats:        Stereos, cabinet cards
Subjects:       Portraits, topography
Locations:      Netherlands - Nijmengin
Studio:         Netherlands
    Entries:
Sothebys NY 11/20/84: 39 ill;

SCHAEBERLE, J.M. (American)
Photos dated: 1889
Processes:      Albumen
Formats:        Prints
Subjects:       Documentary (scientific)
Locations:      US - California
Studio:         US
    Entries:
Sothebys LA 2/7/79: 421 (book, S-2 et al)(note);

SCHAEFFER, C.
Photos dated: 1880
Processes:      Albumen
Formats:        Prints
Subjects:       Topography
Locations:      Hungary - Herculesbad
Studio:         Hungary - Herculesbad
    Entries:
Swann NY 4/17/80: 235 (album, 20)(note);

SCHAFER (German)
Photos dated: c1860
Processes:      Albumen
Formats:        Cdvs
Subjects:       Portraits
Locations:      Studio
Studio:         Germany - Frankfurt
    Entries:
Petzold Germany 11/7/81: 300 (album, S et al);

SCHALL, Johann Carl Conrad (German, 1805-1885)
Photos dated: 1842
Processes:      Daguerreotype
Formats:        Plates
Subjects:       Portraits
Locations:      Studio
Studio:         Germany - Berlin
    Entries:
Christies Lon 6/18/81: 5 ill(lot, S-1 et al)(note);

SCHALLER, L. (German)
Photos dated: 1892-1893
Processes:
Formats:        Prints
Subjects:       Topography
Locations:      Germany
Studio:         Germany
    Entries:
Petzold Germany 5/22/81: 1855 (4);

SCHARNZ (see YARDLEY & SCHARNZ)

SCHAUER, Gustav (German)
Photos dated: c1860s
Processes:      Albumen
Formats:        Cdvs
Subjects:       Documentary (art)
Locations:      Germany
Studio:         Germany
    Entries:
California Galleries 1/22/77: 127 (lot, S et al);

SCHEMBOCHE
Photos dated: 1885
Processes:      Albumen
Formats:        Prints
Subjects:       Documentary
Locations:      Italy - Rome
Studio:
    Entries:
California Galleries 9/26/75: 176 (album, 20);

SCHENKLER, M. (German)
Photos dated: 1885
Processes:
Formats:        Microphotographs
Subjects:       Documentary (scientific)
Locations:      Europe
Studio:         Europe
    Entries:
Weil Lon Cat 14, 1949(?): 420 (book, 60);
Weil Lon 1946: 120 (book, 60)(note);

SCHERER (Russian)
Photos dated: c1870-c1897
Processes:      Albumen
Formats:        Prints incl. panoramas, cabinet cards
Subjects:       Topography, portraits
Locations:      Russia - Moscow
Studio:         Russia - Moscow
    Entries:
Maggs Paris 1939: 554 (S & Nabholz);
Sothebys NY (Greenway Coll.) 11/20/70: 13 (lot,
    S-1 et al);
Swann NY 4/20/78: 341 (S & Nabholz);
Christies Lon 6/27/85: 251 (albums, S & Nabholz-7,
    et al);

SCHIER, Franz
Photos dated: 1864-1869
Processes:      Albumen
Formats:        Cdvs
Subjects:       Topography
Locations:      Germany
Studio:         Austria - Vienna
    Entries:
Petzold Germany 11/7/81: 325 (lot, S et al);

SCHLEGEL, Louis (American)
Photos dated: c1888
Processes:      Albumen
Formats:        Cabinet cards
Subjects:       Portraits
Locations:      Studio
Studio:         US - Richmond, Kentucky
    Entries:
Harris Baltimore 6/1/84: 252;
Harris Baltimore 2/14/86: 70;

SCHLEIER, T.M. (American)
Photos dated: 1870s-1880s
Processes: Albumen
Formats: Stereos, cdvs
Subjects: Topography, portraits
Locations: US
Studio: US - Knoxville, Tennessee
    Entries:
Sothebys NY (Strober Coll.) 2/7/70: 282 (lot,
    S et al), 298 (lot, S et al);

SCHLOSS
Photos dated: c1880
Processes: Albumen
Formats: Cabinet cards
Subjects: Portraits
Locations: Studio
Studio: US - New York
    Entries:
Harris Baltimore 11/9/84: 135 (lot, S et al);

SCHLUM (see MARC & SCHLUM)

SCHMEDLING
Photos dated: Nineteenth century
Processes:
Formats: Prints
Subjects: Topography
Locations: US - Tennessee
Studio:
    Entries:
Harris Baltimore 2/14/86: 329 (lot, S-1 et al);

SCHMIDT, A.
Photos dated: 1860s
Processes: Albumen
Formats: Prints
Subjects: Topography
Locations: Europe
Studio: Europe
    Entries:
Christies Lon 6/26/80: 193 (albums, S-3 et al);

SCHMIDT, C.
Photos dated: Nineteenth century
Processes: Albumen
Formats: Stereos
Subjects: Topography
Locations: Europe
Studio: Europe
    Entries:
Christies Lon 10/30/80: 120 (lot, S-6 et al);

SCHMIDT, Georg (German)
Photos dated: Nineteenth century
Processes: Albumen
Formats: Prints
Subjects: Topography
Locations: Germany - Nuremberg
Studio: Germany
    Entries:
Lennert Munich Cat 5, 1979: 21;

SCHMIDT, Gerst
Photos dated: 1860s
Processes: Albumen
Formats: Cdvs
Subjects: Topography
Locations: France
Studio: France - Colmar
    Entries:
Petzold Germany 11/7/81: 327 (lot, S et al);

SCHMIDT, Otto (German)
Photos dated: 1860s-1894
Processes: Albumen, heliogravure
Formats: Prints, stereos
Subjects: Architecture
Locations: Germany - Dresden
Studio: Germany
    Entries:
Wood Conn Cat 42, 1978: 456 (book, 60)(note);
Christies Lon 10/25/84: 126 (books, S et al);

SCHMITZ, A. (German)
Photos dated: 1860s-1880s
Processes: Albumen
Formats: Stereos, cabinet cards
Subjects: Topography
Locations: Germany
Studio: Germany
    Entries:
Christies Lon 6/26/80: 497 (album, S-3 et al);

SCHNAEBELI, H. (German)
Photos dated: 1863
Processes: Albumen
Formats: Prints
Subjects: Genre (animal life)
Locations: Germany
Studio: Germany - Hamburg
    Entries:
California Galleries 1/21/78: 268 (album, 30), 269
    (album, 13);

SCHNEIDER, T. & Son and/or W.T. (German)
Photos dated: 1850s
Processes: Daguerreotype
Formats: Plates incl. stereo
Subjects: Portraits, topography
Locations: Germany - Karlsruhe
Studio: Germany - Berlin
    Entries:
Petzold Germany 11/7/81: 171 ill(note);
Sothebys Lon 6/29/84: 23 ill(note);
Sothebys Lon 10/24/75: 51 ill;

SCHOEFFT, O. (see also NAYA)
Photos dated: 1870s
Processes: Albumen
Formats: Prints
Subjects: Ethnography
Locations: Egypt
Studio: Europe
    Entries:
Sothebys Lon 7/1/77: 246 (22);

SCHOENE, H.S. (American)
Photos dated: 1870s-1880
Processes:     Albumen
Formats:       Stereos
Subjects:      Topography
Locations:     US - Santa Cruz, California
Studio:        US - Santa Clara, California
    Entries:
California Galleries 5/23/82: 423 (lot, S et al);

SCHOENKE, F.
Photos dated: 1862-1888
Processes:     Albumen
Formats:       Prints, cdvs
Subjects:      Topography, portraits, ethnography
Locations:     China
Studio:        China - Foochow
    Entries:
Swann NY 12/14/78: 374 ill(albums, S-4 et al);
Phillips NY 11/3/79: 182a (album, S et al);
Christies Lon 6/24/82: 210 (album, S et al);
Christies Lon 10/28/82: 99 (lot, S-2 et al);

SCHOENSCHEIDT, J.H. and/or T.H. (German)
Photos dated: 1860s-c1880
Processes:     Albumen
Formats:       Prints, stereos
Subjects:      Topography
Locations:     Germany - Cologne
Studio:        Germany
    Entries:
California Galleries 9/26/75: 289 (2);
White LA 1977: 269 (12);
Christies Lon 3/20/80: 101 (lot, S et al);
Christies Lon 3/11/82: 66 (lot, S et al), 94 (lot,
    S et al);
Swann NY 5/16/86: 203 (lot, S et al);

SCHOFIELD, E.A.
Photos dated: 1880
Processes:     Albumen
Formats:       Prints
Subjects:
Locations:
Studio:
    Entries:
Wood Boston Cat 58, 1986: 136 (books, S-1 et al);

SCHOLFIELD, E.A. (American)
Photos dated: 1870s
Processes:     Albumen
Formats:       Stereos, cdvs
Subjects:      Topography
Locations:     US
Studio:        US
    Entries:
California Galleries 1/21/78: 124 (lot, S et al);
Harris Baltimore 11/9/84: 87 (lot, S-1 et al);

SCHOLL (American)
Photos dated: Nineteenth century
Processes:     Albumen
Formats:       Cabinet cards
Subjects:      Portraits
Locations:     Studio
Studio:        US
    Entries:
Sothebys NY 11/21/70: 356 (lot, S et al);

SCHOLTEN, John A. (American)
Photos dated: 1860s-1871
Processes:     Albumen
Formats:       Prints, stereos, cdvs
Subjects:      Portraits, topography
Locations:     US - St. Louis, Missouri
Studio:        US - St. Louis, Missouri
    Entries:
Swann NY 11/11/76: 164 (book, S et al);
Phillips NY 5/21/80: 266;
Wood Boston Cat 58, 1986: 136 (books, S-1 et al);

SCHOONMAKER, C.C. (American)
Photos dated: 1860s
Processes:     Ambrotype
Formats:       Plates
Subjects:      Portraits
Locations:     Studio
Studio:        US - Troy, New York
    Entries:
Vermont Cat 4, 1972: 400 ill;
Vermont Cat 10, 1975: 599 ill, 600 ill;

SCHRAG
Photos dated: Nineteenth century
Processes:     Albumen
Formats:       Prints
Subjects:      Architecture
Locations:     Italy
Studio:        Europe
    Entries:
Christies NY 5/16/80: 189 (lot, S et al);

SCHROAB, J.G. (German)
Photos dated: 1860s
Processes:     Albumen
Formats:       Prints
Subjects:      Architecture
Locations:     Germany
Studio:        Germany
    Entries:
Christies Lon 6/24/82: 130 (lot, S-1 et al);

SCHROEDER (American)
Photos dated: 1860s and/or 1870s
Processes:     Albumen
Formats:       Cdvs
Subjects:      Portraits
Locations:     Studio
Studio:        US - Brooklyn, New York
    Entries:
Rinhart NY Cat 2, 1971: 366 (lot, S et al);

**SCHROEDER & Co.** (Swiss)
Photos dated: 1870s-1890s
Processes:       Albumen
Formats:         Prints, cdvs, stereos
Subjects:        Topography
Locations:       Switzerland; Austria; Egypt
Studio:          Switzerland - Zurich
    Entries:
California Galleries 9/26/75: 128 (albums, S et al);
Swann NY 4/14/77: 293 (lot, S et al);
Swann NY 4/20/78: 373 (lot, S-1 et al);
Christies Lon 10/26/78: 161 (albums, S-6 et al);
Phillips Lon 3/13/79: 63 (album, S et al);
Christies Lon 6/26/80: 212 (lot, S et al);
Christies Lon 10/30/80: 197 (lot, S-3 et al), 276
    (album, S et al);
Swann NY 4/23/81: 455 (album, S et al);
Phillips NY 5/9/81: 50 ill(albums, S et al);
Christies Lon 6/18/81: 240 (album, S et al);
California Galleries 6/28/81: 326 (lot, S et al);
Bievres France 2/6/83: 122 (albums, S et al);
Christies Lon 3/24/83: 143 (albums, S et al);
Christies Lon 10/27/83: 159 (album, S et al);
Christies Lon 6/28/84: 142 (album, S et al);
Harris Baltimore 2/14/86: 345 (lot, S-1 et al);

**SCHRUPP, R.W.**
Photos dated: 1867
Processes:       Albumen
Formats:         Prints
Subjects:        Documentary (public events)
Locations:       England - Wolverhampton
Studio:          England
    Entries:
Sothebys Lon 6/28/85: 217 (lot, S et al);

**SCHTKY, J.C.**
Photos dated: 1867
Processes:       Albumen
Formats:         Prints
Subjects:        Topography
Locations:
Studio:
    Entries:
Christies Lon 6/10/76: 183 (book, 18);

**SCHULZ & SUCK** (German)
Photos dated: 1872
Processes:       Albumen
Formats:         Prints
Subjects:        Genre
Locations:       Germany
Studio:          Germany - Karlsruhe
    Entries:
White LA 1977: 57 ill;

**SCHULZE, Ludwig**
Photos dated: Nineteenth century
Processes:       Albumen
Formats:         Stereos
Subjects:        Topography
Locations:       Great Britain
Studio:          Europe
    Entries:
Christies Lon 3/29/84: 22 (lot, S et al);

**SCHUMACHER Brothers**
Photos dated: c1870-c1880
Processes:       Albumen
Formats:         Stereos
Subjects:        Topography
Locations:       Scotland; Ireland
Studio:          Europe
    Entries:
Rinhart NY Cat 1, 1971: 271 (9);
California Galleries 1/23/77: 395 (lot, S et al);

**SCHUMANN & Sohn** (German)
Photos dated: c1885-c1890
Processes:       Albumen
Formats:         Cabinet cards
Subjects:        Portraits
Locations:       Studio
Studio:          Germany
    Entries:
Swann NY 10/18/79: 337 (album, S et al);

**SCHURCH, William H.** (American)
Photos dated: 1860s-1873
Processes:       Albumen
Formats:         Prints, stereos, cdvs
Subjects:        Topography, portraits
Locations:       US - Pennsylvania
Studio:          US - Scranton, Pennsylvania
    Entries:
Swann NY 4/20/78: 177 (book, 25)(note);
Swann NY 4/23/81: 215 (book, 25)(note);
Harris Baltimore 6/1/84: 243 (book, 25)(note);
Swann NY 5/9/85: 281 (book, 25);

**SCHUT, J. Willem**
Photos dated: 1895
Processes:       Bromide
Formats:         Prints
Subjects:        Topography
Locations:       India - Delhi
Studio:
    Entries:
Christies Lon 3/20/80: 177 (album, 24);

**SCHUTZ, Th.** (German)
Photos dated: 1850s
Processes:       Daguerreotype
Formats:         Plates
Subjects:        Portraits
Locations:       Studio
Studio:          Germany - Bremen
    Entries:
Petzold Germany 11/7/81: 160 ill;

**SCHUTZMANN, A.** (German)
Photos dated: Nineteenth century
Processes:       Albumen
Formats:         Cabinet cards
Subjects:        Portraits
Locations:       Studio
Studio:          Germany
    Entries:
Petzold Germany 11/7/81: 324 (album, S et al);

SCHWARTZ & COLBY (American)
Photos dated: c1890s
Processes:
Formats:          Prints
Subjects:         Topography, architecture
Locations:        US - New York City; Brooklyn, New York
Studio:           US
    Entries:
Swann NY 12/8/77: 405 (lot, S & C et al);

SCHWARTZCHILD & Co.
Photos dated: 1860s
Processes:        Albumen
Formats:          Cdvs
Subjects:         Portraits
Locations:        Studio
Studio:           India - Calcutta
    Entries:
Christies Lon 10/27/77: 130 (album, S et al);
Phillips Lon 6/26/85: 124 (lot, S et al);
Phillips Lon 10/30/85: 57 (lot, S et al);
Phillips Lon 4/23/86: 239 (lot, S-4 et al);
Christies Lon 6/26/86: 32 (album, S-2 et al);

SCHWEIG, L.
Photos dated: 1853
Processes:        Calotype
Formats:          Prints
Subjects:         Topography
Locations:        Belgium - Antwerp
Studio:           Europe
    Entries:
Maggs Paris 1939: 492 (note);

SCHWENDLER, F.A. (German)
Photos dated: 1850s
Processes:        Daguerreotype
Formats:          Plates
Subjects:         Portraits
Locations:        Studio
Studio:           Germany - Dresden
    Entries:
Sothebys Lon 11/18/77: 171;

SCHWING & RUDD (American)
Photos dated: 1860s
Processes:        Albumen
Formats:          Cdvs
Locations:        US
Studio:           US
    Entries:
Harris Baltimore 11/9/84: 103 (lot, S & R-1 et al);

SCOTT & WILKINSON (British)
Photos dated: 1890s
Processes:        Albumen
Formats:          Cabinet cards
Subjects:         Portraits
Locations:        Studio
Studio:           England - Cambridge
    Entries:
Sothebys NY 5/2/78: 161 (3 ills)(albums,
    S & W et al)(note);

SCOTT, Allan (British)
Photos dated: 1862
Processes:        Albumen
Formats:          Stereos
Subjects:
Locations:
Studio:           Great Britain
    Entries:
Sothebys NY 5/20/80: 341 (books, S et al);

SCOTT, Arthur (American)
Photos dated: 1899
Processes:        Photogravure
Formats:          Prints
Subjects:         Topography
Locations:        US - Berkshires, Massachusetts
Studio:           US
    Entries:
Wood Conn Cat 37, 1976: 170 (book, 16)(note), 171
    (book, 16);
Halsted Michigan 1977: 255 (book, 16);
Wood Conn Cat 42, 1978: 458 (book, 16)(note);

SCOTT, B. (British)
Photos dated: Nineteenth century
Processes:
Formats:
Subjects:         Portraits
Locations:        Studio
Studio:           England - Carlisle
    Entries:
Edwards Lon 1975: 12 (album, S et al), 125 (book,
    S et al);

SCOTT, George W. (American)
Photos dated: 1881-1880s
Processes:        Albumen
Formats:          Prints
Subjects:         Ethnography
Locations:        US - Yankton, South Dakota
Studio:           US - Fort Yates, South Dakota
    Entries:
Frontier AC, Texas 1978: 321 (book, S-1 et al)
    (note);

SCOTT, J.C. (American)
Photos dated: 1860s
Processes:        Albumen
Formats:          Stereos
Subjects:         Topography
Locations:        US - New Jersey
Studio:           US - New Brunswick, New Jersey
    Entries:
Swann NY 11/8/84: 363 (lot, S et al);

SCOTT, R.D. (British)
Photos dated: c1865
Processes:        Albumen
Formats:          Cdvs
Subjects:         Portraits
Locations:        Studio
Studio:           England - Stricklandgate
    Entries:
California Galleries 7/1/84: 170;

**SCOTT, S.** (British)
Photos dated: 1863
Processes:      Ambrotype
Formats:        Plates
Subjects:       Portraits
Locations:      Studio
Studio:         England - Bath
   Entries:
Sothebys Lon 3/21/75: 180 (4);

**SCOTT, Thomas** (British)
Photos dated: 1863
Processes:      Albumen
Formats:        Prints
Subjects:       Architecture
Locations:      England - London
Studio:         Great Britain
   Entries:
Christies Lon 6/26/80: 308 (books, S-25 et al);
Christies Lon 10/30/86: 43 (book, S et al);

**SCOWEN & Co.** (British)
Photos dated: 1860s-c1870
Processes:      Albumen
Formats:        Prints incl. panoramas
Subjects:       Topography, documentary (scientific)
Locations:      Ceylon
Studio:         Ceylon
   Entries:
Sothebys Lon 3/21/75: 84 (albums, S et al);
Wood Conn Cat 37, 1976: 251 (album, S et al);
Swann NY 11/11/76: 372 (albums, S et al);
Christies Lon 3/16/78: 109 (album, S-1 et al);
Swann NY 4/20/78: 277 (2);
Sothebys NY 5/2/78: 135 (albums, S-4 et al);
Christies Lon 10/26/78: 162 (13);
Phillips NY 11/4/78: 45 (lot, S-1 et al);
Sothebys Lon 6/29/79: 93 (albums, S et al);
Christies Lon 10/25/79: 191 (lot, S-4 et al), 196
   (album, S-10, S & Rives-3, et al);
Sothebys NY 11/2/79: 248 (albums, S et al);
Sothebys Lon 3/21/80: 185 (album, S et al);
California Galleries 3/30/80: 274 (10);
Sothebys Lon 10/29/80: 111 (album, S et al);
Christies Lon 10/30/80: 268 (album, S-9 et al);
Christies Lon 3/26/81: 224 (albums, S-8 et al), 228
   (lot, S et al), 244 (album, S-1 et al), 267
   (album, S-2 et al);
Sothebys Lon 3/27/81: 59 (album, S attributed et
   al), 96 (lot, S et al), 99 (album, S et al);
Swann NY 4/23/81: 428 (lot, S et al)(note);
Phillips NY 5/9/81: 63 ill(lot, S-1 et al);
Sothebys Lon 6/17/81: 112 (album, S et al), 177
   (lot, S et al);
Sothebys NY 10/21/81: 211 (albums, S et al);
Sothebys Lon 10/28/81: 55 (album, S et al);
Christies Lon 10/29/81: 232 ill(lot, S-8 et al), 235
   (album, S-15 et al), 237 (lot, S et al), 267
   (albums, S-6 et al);
Swann NY 11/5/81: 442 (2);
Rose Florida Cat 7, 1982: 57 ill(note), 59 ill, 65
   (2 ills)(20)(note);
Sothebys LA 2/17/82: 330 ill(album, S et al);
Christies Lon 3/11/82: 178 ill(album, S et al), 184
   ill(18), 230 (album, S et al);
Sothebys Lon 3/15/82: 55 (album, S attributed et
   al), 64 (album, S et al), 106 (album, S et al),
   125 (album, S et al), 126 (album, S et al);
Christies Lon 6/24/82: 203 (album, S et al);

**SCOWEN** (continued)
Sothebys Lon 6/25/82: 76 (albums, S et al);
Phillips NY 9/30/82: 1040 (3)(S & Skeen,
   attributed);
Christies Lon 10/28/82: 116 (album, S et al);
Harris Baltimore 12/10/82: 397 (album, S et al);
California Galleries 6/19/83: 217 ill(17);
Christies Lon 6/23/83: 147 (15)(attributed), 175
   (albums, S et al);
Christies Lon 10/27/83: 105 (lot, S-12 et al), 158
   (album, S & Skeen et al);
Sothebys Lon 12/9/83: 12 ill (lot, S-14 et al);
Christies Lon 3/29/84: 94 (lot, S et al), 100
   (albums, S et al), 105 (albums, S & Skeen et al);
Christies Lon 6/28/84: 93 (lot, S et al), 96 (lot,
   S-1 et al), 135 (album, S et al);
Sothebys Lon 6/29/84: 91 (album, S et al);
Christies NY 9/11/84: 136 (album, S et al);
Christies Lon 10/25/84: 98 (album, S et al), 105
   (album, S et al), 110 (albums, S et al);
Swann NY 11/8/84: 183 ill(lot, S et al)(note), 217
   (album, S et al)(note);
Christies Lon 3/28/85: 97 (album, S-1 et al), 106
   (albums, S-61 et al);
Christies NY 5/6/85: 314 ill(album, S et al)(note);
Christies Lon 6/27/85: 72 (albums, S et al), 98
   (album, S et al);
Sothebys Lon 6/28/85: 73 ill(album, S et al), 81 ill
   (album, S et al);
Christies Lon 10/31/85: 103 (album, S-22 et al), 131
   (albums, S et al), 133 (albums, S-3 et al);
Sothebys Lon 11/1/85: 43 ill(albums, S-60 et al);
Christies Lon 4/24/86: 402 (lot, S-1 et al);
Swann NY 5/16/86: 219 (lot, S et al), 261 (lot,
   S et al);
Christies Lon 6/26/86: 46 (albums, S et al);
Christies Lon 10/30/86: 153 (albums, S et al);
Sothebys Lon 10/31/86: 40 (album, S et al);
Swann NY 11/13/86: 191 (albums, S et al), 192
   (album, S et al), 219 (lot, S et al), 242 (lot,
   S et al);

**SCRIPTURE, George R.** (American)
Photos dated: c1870-1870s
Processes:      Albumen
Formats:        Stereos
Subjects:       Topography
Locations:      US - Monadnock Mountains, New
                Hampshire
Studio:         US - Peterborough, New Hampshire
   Entries:
Rinhart NY Cat 2, 1971: 517 (17);
California Galleries 9/27/75: 512 (lot, S et al);
California Galleries 1/23/77: 410 (lot, S et al);
Harris Baltimore 12/16/83: 88 (lot, S et al);
Harris Baltimore 6/1/84: 15 (lot, s et al);

**SCRIPTURE, J.C.** (American)
Photos dated: 1870s
Processes:      Albumen
Formats:        Stereos
Subjects:       Topography
Locations:      US - California
Studio:         US - Big Trees, California
   Entries:
Harris Baltimore 12/10/82: 19 (lot, S et al), 60
   (lot, S et al);
Christies Lon 6/23/83: 47 (lot, S et al);

**SEAMAN, A.** (British)
Photos dated: 1880s-1900
Processes:      Albumen
Formats:        Prints, stereos
Subjects:       Topography
Locations:      England
Studio:         England - Chesterfield
    Entries:
Christies Lon 10/27/83: 62 (album, S et al);

**SEAVE** (see TAYLOR & SEAVE)

**SEAVER, C., Jr.** (American)
Photos dated: c1857-1870s
Processes:      Daguerreotype, albumen
Formats:        Plates, cdvs, stereos
Subjects:       Portraits, topography
Locations:      US - Massachusetts; Florida
Studio:         US - Boston, Massachusetts
    Entries:
Rinhart NY Cat 1, 1971: 145 (2);
Rinhart NY Cat 2, 1971: 448 (lot, S et al);
California Galleries 9/27/75: 450 (lot, S-2 et al),
    480 (lot, S et al);
California Galleries 1/23/77: 359 (lot, S-2 et al),
    385 (lot, S et al);
Harris Baltimore 12/10/82: 96 (lot, S-1 et al);
Swann NY 5/5/83: 332 (lot, S et al);
Harris Baltimore 12/16/83: 16 (lot, S et al), 109
    (lot, S et al), 143 (lot, S et al);
Harris Baltimore 6/1/84: 31 (lot, S et al), 60
    (lot, S et al), 107 (lot, S et al);
Harris Baltimore 3/15/85: 11 (lot, S et al), 86
    (lot, S-14 et al), 104 (lot, S et al), 113 (lot,
    S et al);

**SEBAH, J. Pascal** (see also BECHARD, H.)
Photos dated: 1868-1870s
Processes:      Albumen, phototype
Formats:        Prints incl. panoramas, cdvs, stereos
Subjects:       Topography, portraits, ethnography
Locations:      Turkey - Constantinople; Egypt; Greece
Studio:         Turkey - Constantinople; Egypt - Cairo
    Entries:
Rinhart NY Cat 1, 1971: 513 (book, S et al);
Rinhart NY Cat 7, 1973: 91 (book, S et al), 472 (S &
    Joaillier);
Witkin NY I 1973: 549 (album, S et al);
Witkin NY II 1974: 888 ill(lot, S-63 et al), 921
    (3 ills)(lot, S, S & Joaillier, et al), 1223 ill
    (album, S et al);
Sothebys Lon 3/8/74: 42 (lot, S et al);
Sothebys Lon 6/21/74: 81 (albums, S et al);
Sothebys Lon 10/18/74: 114 (albums, S-89 et al);
Sothebys NY 2/25/75: 156 ill(lot, S et al), 157
    (lot, S et al);
Sothebys Lon 6/26/75: 111 (albums, S et al);
California Galleries 9/26/75: 127 (album, S et al),
    258 (lot, S-2 et al);
Sothebys Lon 10/24/75: 102 (album, S et al);
Colnaghi Lon 1976: 233 (note), 234, 235 ill,
    236 ill;
Rose Boston Cat 1, 1976: 38 ill(note), 39 ill,
    40 ill;
Wood Conn Cat 37, 1976: 247 (album, S et al), 322
    (S & Joaillier, 23);
Sothebys Lon 3/19/76: 28 (albums, S et al);

**SEBAH** (continued)
California Galleries 4/2/76: 144 (album, S et al),
    179 (5);
Sothebys NY 5/4/76: 90 (2), 91 (S & Joaillier);
Christies Lon 6/10/76: 81 (album, S et al), 96
    (album, S et al), 97 (album, S et al);
Sothebys Lon 6/11/76: 53;
Christies Lon 10/28/76: 91 (albums, S et al), 133
    (album, S et al), 136 (album, S et al);
Sothebys Lon 10/29/76: 145 ill(album, S-5 et al),
    147;
Swann NY 11/11/76: 376 (album, 38), 409 (album,
    S & Joaillier et al);
Gordon NY 11/13/76: 44 (lot, S-4 et al);
Rose Boston Cat 2, 1977: 91 ill(note), 92 ill,
    93 ill;
California Galleries 1/22/77: 350;
Sothebys NY 2/9/77: 40 ill(album, S et al), 41 ill
    (albums, S et al);
Christies Lon 3/10/77: 148 (albums, S et al);
Swann NY 4/14/77: 242 (album, S et al);
Gordon NY 5/10/77: 803 (album, S et al);
Christies Lon 6/30/77: 122 (album, S-14 et al), 123
    (album, S-20 et al);
Sothebys Lon 7/1/77: 149 (albums, S et al);
Christies Lon 10/27/77: 102 (albums, S & Joaillier
    et al), 138 (67), 145 (album, S-16 et al);
Sothebys Lon 11/18/77: 106 (album, S et al);
Swann NY 12/8/77: 347 (lot, S et al), 365 ill(lot,
    S-3 et al), 399 (lot, S et al), 409 (lot, S &
    Joaillier et al);
Wood Conn Cat 42, 1978: 561 (album, S & Joaillier
    et al);
Sothebys LA 2/13/78: 137 (lot, S-2 et al), 139
    (album, S & Joaillier-19, et al);
Christies Lon 3/16/78: 105 (album, S-14 et al);
Sothebys Lon 3/22/78: 83 (album, S et al), 87 (lot,
    S et al);
Swann NY 4/20/78: 366;
Sothebys NY 5/2/78: 132 (album, S et al);
Christies Lon 6/27/78: 121 (lot, S et al), 122 (lot,
    S et al);
Christies Lon 10/26/78: 196 (albums, S, S &
    Joaillier, et al), 199 (albums, S et al), 335
    (lot, S-30 et al);
Mancini Phila 1979: 26 ill;
California Galleries 2/21/79: 340 (album, S et al),
    495 ill(S & Joaillier), 496 (lot, S & Joaillier
    et al);
Christies Lon 6/28/79: 114 (albums, S et al), 120
    (albums, S-5 et al);
Swann NY 10/18/79: 333 (album, S et al);
Sothebys Lon 10/24/79: 164 (album, S et al);
Christies Lon 10/25/79: 197 (lot, S-10 et al), 231
    (album, S-1 et al);
Sothebys NY 11/2/79: 242 (S & Joaillier)(note), 243
    ill(album, 38);
Phillips NY 11/3/79: 186 ill(2)(attributed);
Phillips NY 11/29/79: 275 (album, S et al);
Rose Boston Cat 5, 1980: 82 ill(note), 83 ill;
White LA 1980-81: 49 ill(note), 50 ill, 51 ill,
    52 ill;
Sothebys LA 2/6/80: 167 (lot, S-1 et al), 168 (22),
    170 ill(lot, S & Joaillier-9, et al);
Christies Lon 3/20/80: 199 (albums, S et al);
Sothebys Lon 3/21/80: 122 (album, 48);
California Galleries 3/30/80: 55 (album, S et al);
Christies NY 5/16/80: 204 (6);
Sothebys NY 5/20/80: 396 (note);
Phillips NY 5/29/80: 141 ill(albums, S et al);
Auer Paris 5/31/80: 67 ill(lot, S-1 et al), 98 (8);

## SEBAH (continued)

Christies Lon 6/26/80: 228 (lot, S & Joaillier-2, et al), 270 (albums, S, S & Joaillier-6, et al);
Sothebys Lon 10/29/80: 55 (album, S et al);
Christies Lon 10/30/80: 402 ill, 441 (album, S-3 et al);
Swann NY 11/6/80: 278 (album, S & Joaillier et al), 369 (6);
Christies NY 11/11/80: 79, 80 ill(album, S et al);
California Galleries 12/13/80: 342 (S & Joaillier);
Phillips Lon 3/18/81: 111 (album, S-128 et al), 118 (album, S et al);
Christies Lon 3/26/81: 223 (album, S-1 et al), 259 (album, S-36 et al), 264 (album, S-17 et al);
Sothebys Lon 3/27/81: 53 (lot, S et al), 63 (lot, S & Joaillier et al);
Swann NY 4/23/81: 454 (lot, S et al)(note);
Phillips NY 5/9/81: 58 ill(lot, S-1 et al), 60 ill (attributed), 61 (albums, S et al);
Petzold Germany 5/22/81: 1784 (lot, S-4 et al);
Sothebys Lon 6/17/81: 158 (lot, S-1 et al), 159 (lot, S et al);
Christies Lon 6/18/81: 235 (lot, S et al);
Phillips Lon 6/24/81: 85 (album, 128);
Phillips Lon 10/28/81: 156 (lot, S-6 et al);
Sothebys Lon 10/28/81: 105 (lot, S et al);
Christies Lon 10/29/81: 214 (album, S-1 et al), 220 (lot, S et al), 222 (album, S-9 et al), 276 (albums, S & Joaillier-10, et al);
Swann NY 11/5/81: 366 (S-2, S & Joaillier-2), 464 (album, S et al)(note);
Christies Lon 3/11/82: 159 (lot, S et al), 164 (album, S, S & Joaillier, et al), 238 (album, S et al);
Sothebys Lon 3/15/82: 67 (albums, S et al), 69 (album, S et al);
Phillips Lon 3/17/82: 57 (album, 128);
Swann NY 4/1/82: 330 (lot, S et al)(note), 351 ill (4)(note), 352 (4)(note), 353 (5)(note), 354 (10) (note);
California Galleries 5/23/82: 283 (lot, S-2 et al), 284 (lot, S-1 et al), 385 ill, 386 (lot, S & Joaillier-5, et al);
Sothebys NY 5/25/82: 321 ill(album, S et al);
Phillips Lon 6/23/82: 36 (albums, S et al);
Christies Lon 6/24/82: 170 (album, S-11 et al), 174 (lot, S-1 et al), 175 (lot, S & Joaillier et al), 178 (album, S-8 et al), 227 (albums, S-12 et al), 231 (lot, S & Joaillier-40, et al);
Phillips NY 9/30/82: 1037;
Christies Lon 10/28/82: 107 (lot, S-4 et al), 218 (album, S et al);
Sothebys NY 11/10/82: 339 (S & Joaillier);
Swann NY 11/18/82: 336 (album, S & Joaillier), 368 (lot, S-5 et al)(note), 443 (album, S et al) (note);
Harris Baltimore 12/10/82: 351 (lot, S et al);
Bievres France 2/6/83: 89 (8), 158 (5, attributed), 181 (4, attributed);
Christies NY 3/8/83: 33 (lot, S et al);
Christies Lon 3/24/83: 92 (album, S et al), 93 (lot, S et al), 94 (albums, S et al), 138 (album, S et al), 139 (albums, S, S & Joaillier, et al), 140 (album, S et al), 143 (lot, S, S & Joaillier, et al), 163 (book, S et al);
Swann NY 5/5/83: 339 (lot, S-4 et al)(note), 340 (lot, S et al), 405 (lot, S-8 et al), 406 (lot, S-7 et al);
California Galleries 6/19/83: 330 (lot, S et al);

## SEBAH (continued)

Christies Lon 6/23/83: 102 (album, S et al), 166 (albums, S et al), 167 (lot, S-70 et al), 173 (lot, S et al);
Christies Lon 10/27/83: 88 (albums, S et al), 101 (lot, S & Joaillier et al);
Swann NY 11/10/83: 142 (book, 74)(note), 184 (lot, S-1 et al)(note), 255 (albums, S et al);
Christies NY 2/22/84: 7 (album, S et al), 10 (albums, S et al), 11 (lot, S et al);
Christies Lon 3/29/84: 63 (album, S & Joaillier et al), 64 (album, S & Joaillier-7, et al);
Swann NY 5/10/84: 187 (lot, S et al), 277 (lot, S et al);
Christies Lon 6/28/84: 84 (album, S et al), 89 (lot, S et al), 140 (album, S & Joaillier et al);
Sothebys Lon 6/29/84: 49 (5 ills)(album, S et al), 53 (lot, S-3 et al), 77 (album, S & Joaillier-50, et al);
California Galleries 7/1/84: 644 ill(7), 645;
Phillips Lon 10/24/84: 125 (lot, S et al);
Christies Lon 10/25/84: 103 (album, S & Joaillier et al);
Swann NY 11/8/84: 194 (album, S et al)(note), 195 (album, S et al)(note), 214 (album, S et al) (note);
Harris Baltimore 3/15/85: 204 (albums, S & Joaillier-1, et al);
Christies Lon 3/28/85: 99 (album, S-7 et al), 101 (album, S-5 et al), 234 (S & Joaillier);
Swann NY 5/9/85: 384 (lot, S et al);
California Galleries 6/8/85: 415 (S & Joaillier);
Christies Lon 6/27/85: 69 (29);
Christies Lon 10/31/85: 69 (lot, S-1 et al), 96 (album, S-12 et al), 97 (album, S-5 et al), 126 (albums, S et al), 128 (lot, S-9 et al), 134 (albums, S et al);
Swann NY 11/14/85: 71 (albums, S-3 et al), 131 (lot, S et al), 148 (albums, S & Joaillier et al);
Phillips Lon 4/23/86: 268 (albums, S et al);
Christies Lon 4/24/86: 385 (lot, S-1 et al), 409 (albums, S-16 et al);
Swann NY 5/16/86: 231 (lot, S-10 et al);
Christies Lon 6/26/86: 34 (albums, S et al), 72 (lot, S et al), 92 (albums, S-34 et al), 105 (albums, S et al), 154 (album, S et al);
Christies Lon 10/30/86: 142 (albums, 52), 153 (albums, S & Joaillier et al), 217 (albums, S et al);
Sothebys Lon 10/31/86: 23 (lot, S-9, S & Joaillier-1, et al);
Harris Baltimore 11/7/86: 279 (lot, S-1 et al);
Swann NY 11/13/86: 212 (lot, S et al), 274 (lot, S-1, S & Joaillier, et al), 343 (lot, S & Joaillier et al);
Drouot Paris 11/22/86: 74 (album, Sebah & Joaillier);

## SEDDON, J.P. (British)

Photos dated: 1868
Processes:    Albumen
Formats:     Prints
Subjects:    Topography
Locations:    Germany
Studio:      Great Britain
  Entries:
Edwards Lon 1975: 166 (book, 14)(note);

SEDGFIELD, William Russell (British, died 1902)
Photos dated: 1842-1872
Processes:      Calotype, albumen
Formats:        Prints, stereos, cdvs
Subjects:       Topography, architecture, genre
Locations:      Great Britain - Warwickshire and Isle
                of Wight; Ireland
Studio:         Great Britain
     Entries:
Goldschmidt Lon Cat 52, 1939: 230 (book, S et al),
     235 (book, 12);
Weil Lon Cat 4, 1944(?): 198 (book, S et al)(note),
     247 (book, 12);
Weil Lon Cat 7, 1945: 97 (book, S et al);
Weil Lon 1946: 121 (book, 12), 122 (book, S et al);
Weil Lon Cat 10, 1947(?): 299 (book, S et al);
Andrieux Paris 1952(?): 719 (book, S et al);
Swann NY 2/14/52: 301 (book, S et al), 349 (book,
     S et al);
Sothebys NY 11/21/70: 26 (book, S et al);
Christies Lon 6/14/73: 199 (album, S et al);
Christies Lon 10/4/73: 99 (books, S et al);
Sothebys Lon 12/4/73: 13 (lot, S et al), 175 (books,
     S et al);
Vermont Cat 7, 1974: 752 (book, S et al), 753 (book,
     S et al);
Witkin NY II 1974: 206 (book, S et al);
Sothebys Lon 3/8/74: 163 (book, S et al), 165 (book,
     S et al);
Sothebys Lon 6/21/74: 150 (books, S et al), 151
     (book, S et al);
Sothebys Lon 10/18/74: 254 (book, S et al);
Edwards Lon 1975: 110 (book, S et al), 111 (book,
     S-2 et al), 164 (book, S et al), 197 (book, S-16
     et al);
Sothebys Lon 3/21/75: 315 (book, S et al), 316
     (books, S et al);
California Galleries 9/27/75: 559 (10);
Colnaghi Lon 1976: 143 (5 ills)(5)(note);
Kingston Boston 1976: 579 ill(book, 12), 580
     (book, 12);
Sothebys Lon 6/11/76: 157 (book, S et al), 158
     (book, S et al);
California Galleries 9/26/75: 179 (book, S et al),
     180 (book, S et al);
Christies Lon 10/28/76: 275 (books, S et al), 276
     (book, S et al);
Sothebys Lon 10/29/76: 170 (book, 12), 171 (book,
     S et al);
Swann NY 11/11/76: 269 (book, S et al)(note), 290
     (book, 6), 295 (book, S-16 et al);
Halsted Michigan 1977: 194 (book, S et al), 195
     (book, S et al);
Vermont Cat 11/12, 1977: 523 (book, S et al), 524
     (book, S et al);
California Galleries 1/22/77: 212 (book, S et al);
California Galleries 1/23/77: 439 (10);
Christies Lon 6/30/77: 193 (book, S et al);
Sothebys Lon 7/1/77: 21 (book, S et al), 22 (book,
     S et al), 33 (book, 6);
Christies Lon 10/27/77: 208 (book, S et al), 218
     (books, S et al);
Sothebys Lon 11/18/77: 6 (lot, S et al), 7 (lot,
     S et al), 175 (book, S et al), 176 (book, S et
     al), 188 (book, 13), 195 (books, S et al);
Christies Lon 3/16/78: 206 (books, S et al);
Sothebys Lon 3/22/78: 27 (book, 12), 28 (book, S et
     al), 29 (book, S et al);
Sothebys Lon 6/28/78: 19 (book, S et al), 20 (book,
     S et al), 21 (book, S et al);
Christies Lon 10/26/78: 208 (book, S et al);

SEDGEFIELD (continued)
Sothebys Lon 10/27/78: 211 (book, S et al);
Lehr NY Vol 1:4, 1979: 38 (book, S et al);
Rose Boston Cat 4, 1979: 19 ill(note);
Witkin NY IX 1979: 40 (book, S-9 et al), 41 (book,
     S-7 et al);
Wood Conn Cat 45, 1979: 141 (book, S et al), 250
     (book, S et al);
California Galleries 1/21/79: 114A (book, S et al);
Christies Lon 3/15/79: 83 (lot, S et al);
Christies Lon 6/28/79: 69 (lot, S et al), 156 (book,
     S et al), 157 (book, S et al);
Sothebys Lon 10/24/79: 37 (book, S et al), 254 (lot,
     S et al);
Christies NY 10/31/79: 25 (book, S et al);
Phillips NY 11/3/79: 147 (note);
White LA 1980-81: 3 ill(note);
Christies Lon 3/20/80: 88 (35), 218 (book, S et
     al), 223 (book, S et al);
California Galleries 3/30/80: 85 (book, S et al);
Christies Lon 6/26/80: 302 (book, S et al);
Sothebys Lon 6/27/80: 246;
Christies Lon 10/30/80: 98 (lot, S et al), 117
     (lot, S-23 et al), 121 (lot, S et al), 284
     (book, S et al);
Phillips NY 1/29/81: 85 (book, S et al);
Phillips Lon 3/18/81: 88 (book, S et al);
Christies Lon 3/26/81: 128 (lot, S et al);
Sothebys Lon 3/27/81: 15 (lot, S et al);
Swann NY 4/23/81: 177 (book, 8)(note);
Christies Lon 6/17/81: 2 (lot, S et al), 5 (lot,
     S et al), 444 (book, S et al), 445 (book, S et
     al), 450 (book, S et al);
Christies Lon 6/18/81: 75 (lot, S-1 et al);
Christies Lon 10/29/81: 138 (lot, S et al), 147
     (lot, S et al), 169 (album, S et al)(note), 192
     (lot, S-2 et al);
Petzold Germany 11/7/81: 82 (book, S et al);
Christies Lon 3/11/82: 73 (46), 85 (lot, S et al),
     114 (lot, S et al);
Sothebys Lon 3/15/82: 436 (books, S et al), 437
     (book, S et al);
Christies Lon 6/24/82: 87;
Sothebys Lon 6/25/82: 8 (lot, S et al);
Christies Lon 10/28/82: 17 (lot, S et al), 21 (lot,
     S et al), 25 (lot, S et al), 26 (lot, S et al);
Christies Lon 3/24/83: 32 (lot, S et al), 44 (lot,
     S et al), 146 (books);
Harris Baltimore 4/8/83: 195 (book, S et al);
Christies Lon 6/23/83: 43 (lot, S et al), 215 (6)
     (attributed);
Christies Lon 10/27/83: 29 (lot, S-2 et al), 36
     (lot, S-1 et al), 163 (book, S et al);
Phillips Lon 11/4/83: 29 (books, S et al);
Swann NY 11/10/83: 88 (book, S et al);
Harris Baltimore 12/16/83: 42 (lot, S-5 et al), 188
     (book, S et al);
Christies Lon 3/29/84: 29 (lot, S-1 et al), 43 (11)
     (note);
Harris Baltimore 6/1/84: 64 (lot, S et al);
Christies Lon 6/28/84: 46 (lot, S-6 et al), 56 (lot,
     S et al);
Phillips Lon 10/24/84: 85 (lot, S-9 et al);
Christies Lon 10/25/84: 36 (lot, S-6 et al), 41
     (lot, S et al), 44 (lot, S et al), 172 (5);
Sothebys Lon 10/26/84: 3 (lot, S et al);
Phillips Lon 3/27/85: 144 (lot, S-9 et al);
Christies Lon 3/28/85: 43 (lot, S et al);
Christies Lon 6/27/85: 33 (lot, S-15 et al), 120;
Harris Baltimore 2/14/86: 18 (lot, S attributed
     et al);

**SEDGEFIELD** (continued)
Christies Lon 4/24/86: 329 (lot, S et al), 334
    (22), 369 (lot, S-5 et al);
Christies Lon 6/26/86: 41, 66 (lot, S et al), 126
    (52), 136A (lot, S-22 et al), 150A (lot, S-5 et
    al), 175 (books, S et al);
Christies Lon 10/30/86: 31 (lot, S-22 et al), 32
    (lot, S et al);

**SEDGWICK, Professor**
Photos dated: Nineteenth century
Processes:      Albumen
Formats:        Stereos
Subjects:       Topography
Locations:      US - American west
Studio:         US
    Entries:
Sothebys NY (Strober Coll.) 2/7/70: 521 (lot,
    S et al);

**SEE & EPLER** (American)
Photos dated: c1890
Processes:      Albumen
Formats:        Prints, cabinet cards
Subjects:       Topography, portraits
Locations:      US
Studio:         US - New York City
    Entries:
California Galleries 6/28/81: 425;
Swann NY 11/13/86: 277 (lot, S & E et al);

**SEE TAY** (see TAY, See)

**SEELEY, A. & E.** (British)
Photos dated: 1864-1870s
Processes:      Albumen
Formats:        Prints, stereos, cdvs
Subjects:       Architecture, topography, documentary
                (art)
Locations:      England
Studio:         England - London
    Entries:
Swann NY 2/6/75: 65 (book, 14);
Christies Lon 10/25/79: 247 (album, S-1 et al);
Christies Lon 6/26/80: 269 (lot, S-1 et al);
Sothebys Lon 10/28/81: 77 (lot, S-3 et al);
Christies Lon 6/24/82: 71 (lot, S et al);
Swann NY 11/10/83: 277 (albums, S et al)(note);

**SEIBERT, S.R.** (American)
Photos dated: 1865
Processes:      Albumen
Formats:        Stereos
Subjects:       Documentary (Civil War)
Locations:      US - South Carolina
Studio:         US
    Entries:
Harris Baltimore 5/28/82: 184 (5, attributed);

**SELBY & DELANEY** (American)
Photos dated: Nineteenth century
Processes:      Albumen
Formats:        Cdvs
Subjects:       Portraits
Locations:      Studio
Studio:         US - Baltimore, Maryland
    Entries:
Sothebys NY (Greenway Coll.) 11/20/70: 159 ill;

**SELDEN & Co.** (American)(photographer or
                publisher?)
Photos dated: 1860s
Processes:      Albumen
Formats:        Stereos
Subjects:       Topography
Locations:      US - Richmond, Virginia
Studio:         US
    Entries:
Sothebys NY (Strober Coll.) 2/7/70: 485 (lot,
    S et al);
Christies Lon 6/18/81: 89 ill(lot, S-4 et al);
Harris Baltimore 5/28/82: 159 (lot, S-1 et al);
Harris Baltimore 6/1/84: 31 (lot, S et al);

**SELLA, Vittorio** (Italian, 1859-1943)
Photos dated: 1886-1908
Processes:      Albumen, photogravure, silver
Formats:        Prints incl. panoramas
Subjects:       Topography
Locations:      Europe - Alps; Asia - Caucasus,
                Himalayas; US - Alaska; Africa
Studio:         Italy - Biella
    Entries:
Rinhart NY Cat 7, 1973: 85 (book, S et al);
Wood Conn Cat 37, 1976: 176 (book, 25)(note);
California Galleries 4/2/76: 243 (lot, S-1 et al);
Sothebys NY 10/4/77: 219 ill(album, 33);
Sothebys LA 2/6/80: 120 ill;
Sothebys NY 5/20/80: 384 ill;
Harris Baltimore 3/15/85: 413 ill(books, 76);
Harris Baltimore 11/7/86: 299 (2 ills)(album, 60)
    (note), 300 (album, 51)(note), 301 ill(album, 79)
    (note);

**SELLECK, Silas** (American)
Photos dated: c1865-1880s
Processes:      Albumen
Formats:        Cdvs
Subjects:       Portraits
Locations:      Studio
Studio:         US - San Francisco, California
    Entries:
Swann NY 11/11/76: 358 (lot, S & Fisher et al);
California Galleries 1/21/79: 332 (album, S et al);
California Galleries 5/23/82: 248 (lot, s et al),
    257 (lot, S et al);

SELBY & DELANEY (American)
Photos dated: Nineteenth century
Processes:    Albumen
Formats:      Cdvs
Subjects:     Portraits
Locations:    Studio
Studio:       US - Baltimore, Maryland
  Entries:
Sothebys NY (Greenway Coll.) 11/20/70: 159 ill;

SELDEN & Co. (American)(photographer or
                   publisher?)
Photos dated: 1860s
Processes:    Albumen
Formats:      Stereos
Subjects:     Topography
Locations:    US - Richmond, Virginia
Studio:       US
  Entries:
Sothebys NY (Strober Coll.) 2/7/70: 485 (lot,
  S et al);
Christies Lon 6/18/81: 89 ill(lot, S-4 et al);
Harris Baltimore 5/28/82: 159 (lot, S-1 et al);
Harris Baltimore 6/1/84: 31 (lot, S et al);

SELLA, Vittorio (Italian, 1859-1943)
Photos dated: 1886-1908
Processes:    Albumen, photogravure, silver
Formats:      Prints incl. panoramas
Subjects:     Topography
Locations:    Europe - Alps; Asia - Caucasus,
              Himalayas; US - Alaska; Africa
Studio:       Italy - Biella
  Entries:
Rinhart NY Cat 7, 1973: 85 (book, S et al);
Wood Conn Cat 37, 1976: 176 (book, 25)(note);
California Galleries 4/2/76: 243 (lot, S-1 et al);
Sothebys NY 10/4/77: 219 ill(album, 33);
Sothebys LA 2/6/80: 120 ill;
Sothebys NY 5/20/80: 384 ill;
Harris Baltimore 3/15/85: 413 ill(books, 76);
Harris Baltimore 11/7/86: 299 ill(album, 60)(note),
  300 (album, 51)(note), 301 ill(album, 79)(note);

SELLECK, Silas (American)
Photos dated: c1865-1880s
Processes:    Albumen
Formats:      Cdvs
Subjects:     Portraits
Locations:    Studio
Studio:       US - San Francisco, California
  Entries:
Swann NY 11/11/76: 358 (lot, S & Fisher et al);
California Galleries 1/21/79: 332 (album, S et al);
California Galleries 5/23/82: 248 (lot, s et al),
  257 (lot, S et al);

SELMER, H. (Norwegian)
Photos dated: c1870
Processes:    Albumen
Formats:      Prints, cdvs
Subjects:     Ethnography
Locations:    Norway - Bergen
Studio:       Norway - Bergen
  Entries:
Sothebys Lon 10/24/75: 248 (15);
Christies Lon 6/24/82: 374 (album, S-13 et al);

SEMPLICINI, Pietro (Italian)
Photos dated: c1860s
Processes:    Albumen
Formats:      Prints
Subjects:     Topography
Locations:    Italy - Florence
Studio:       Italy - Florence
  Entries:
Rinhart NY Cat 7, 1973: 476 (2);

SENIOR, Lieutenant H.W. (British)
Photos dated: 1860s
Processes:    Albumen
Formats:      Prints
Subjects:
Locations:
Studio:       Great Britain (Amateur Photographic
              Association)
  Entries:
Christies Lon 10/27/83: 218 (albums, S-5 et al);

SERAN & GONZALES (Spanish)
Photos dated: 1880
Processes:    Albumen
Formats:      Prints
Subjects:     Topography
Locations:    Spain - Grenada
Studio:       Spain
  Entries:
Christies Lon 6/27/78: 92 (album, S & G et al);
Christies Lon 3/15/79: 120 (album, S & G-19 et al);

SEVAISTRE, Eugenio (French)
Photos dated: 1850s-1860s
Processes:    Albumen
Formats:      Stereos
Subjects:     Topography, documentary (military)
Locations:    Italy; France; Spain; Switzerland
Studio:       Italy - Palermo, Sicily
  Entries
Sothebys Lon 6/28/78: 4 ill(albums, 291);
Sothebys Lon 3/14/79: 9 ill(album, 222), 10 ill
  (album, 294), 11 ill(album, 216);

SEVERIN
Photos dated: 1880s
Processes:    Albumen
Formats:      Prints
Subjects:     Topography, portraits, genre
Locations:    US - Hawaii
Studio:
  Entries:
Swann NY 11/10/83: 282 (lot, S et al)(note);
Christies NY 2/22/84: 33 (album, S-56 et al);

SEWELL, D. (American)
Photos dated: c1890
Processes:    Albumen
Formats:      Prints, cdvs
Subjects:     Topography, portraits
Locations:    US - San Francisco, California
Studio:       US - San Francisco, California
  Entries:
California Galleries 5/23/82: 252;
California Galleries 6/8/85: 407;

**SHADBOLT, Cecil Victor** (British, 1859-1892)
Photos dated: 1888
Processes:      Photogravure
Formats:        Prints
Subjects:       Topography
Locations:      Palestine
Studio:
    Entries:
Sothebys Lon 7/1/77: 32 (book, 24);
Swann NY 4/20/78: 142 (book, 24);
Christies Lon 10/25/84: 120 (books, S-24 et al);

**SHADBOLT, George** (British, 1819-1901)
Photos dated: mid 1850s-late 1850s
Processes:      Salt, albumen
Formats:        Prints
Subjects:       Topography
Locations:      England - Hornsey
Studio:         England - Hornsey (Amateur
                Photographic Association,
                Photographic Club)
    Entries:
Swann NY 2/14/52: 262 (album, S et al);
Sothebys Lon 3/21/75: 286 (albums, S-1 et al);
Christies Lon 10/27/77: 241 (book, 24);
Sothebys Lon 3/14/79: 324 (album, S-1 et al);
Christies Lon 10/27/83: 218 (albums, S-1 et al);
Sothebys Lon 11/1/85: 59 (album, S-1 et al);

**SHAKESPEARE, Lieutenant Colonel J.** (British)
Photos dated: 1860s
Processes:      Albumen
Formats:        Prints
Subjects:
Locations:
Studio:         Great Britain (Amateur Photographic
                Association)
    Entries:
Christies Lon 10/27/83: 218 (albums, S-1 et al);

**SHAPLEIGH**
Photos dated: Nineteenth century
Processes:      Albumen
Formats:        Cdvs
Subjects:       Portraits
Locations:
Studio:
    Entries:
California Galleries 1/21/78: 125 (lot, S et al);

**SHARP, C.** (British)
Photos dated: c1855
Processes:      Daguerreotypes
Formats:        Plates
Subjects:       Portraits
Locations:      Studio
Studio:         England - London
    Entries:
Sothebys Lon 3/8/74: 138;

**SHARP, W.L.** (British)
Photos dated: 1850s
Processes:      Daguerreotype, ambrotype
Formats:        Plates
Subjects:       Portraits
Locations:      Studio
Studio:         England - Chester
    Entries:
Christies Lon 10/29/81: 76;
Christies Lon 6/24/82: 21 (lot, S-1 et al);

**SHATTUCK**
Photos dated: 1840s-1850s
Processes:      Daguerreotype
Formats:        Plates
Subjects:       Portraits
Locations:
Studio:
    Entries:
Swann NY 11/8/84: 180 (lot, S et al);

**SHAW** (American)
Photos dated: 1860s
Processes:      Tintype
Formats:        Plates
Subjects:       Portraits
Locations:      Studio
Studio:         US - Atlantic City, New Jersey
    Entries:
Rinhart NY Cat 2, 1971: 280 ill;

**SHAW, A.**
Photos dated: 1850s
Processes:
Formats:        Prints
Subjects:
Locations:      Ireland
Studio:         Ireland
    Entries:
Sothebys Lon 3/27/81: 175 (album, S et al)(note);

**SHAW, G.**
Photos dated: 1886
Processes:      Platinum
Formats:        Prints
Subjects:       Genre
Locations:
Studio:
    Entries:
Sothebys LA 2/7/79: 423 ill;

**SHAW, George** (British, 1818-1904)
Photos dated: 1841-1853
Processes:      Daguerreotype, salt
Formats:        Plates, prints
Subjects:       Genre (nature)
Locations:      Great Britain
Studio:         England - Birmingham
    Entries:
Sothebys Lon 3/19/76: 139 (book, 4);
Sothebys Lon 6/27/80: 41 ill(note);
Christies Lon 10/29/81: 160 ill(20)(note);

**SHAW, J.W.** (American)
Photos dated: 1870s
Processes:     Albumen
Formats:      Stereos
Subjects:     Documentary (disasters)
Locations:    US - Chicago, Illinois
Studio:       US - Chicago, Illinois
    Entries:
Sothebys NY 11/21/70: 368 ill(lot, S et al);
Vermont Cat 11/12, 1977: 829 ill;

**SHAW, L.**
Photos dated: 1860s
Processes:     Ambrotype
Formats:      Plates
Subjects:     Portraits
Locations:    Studio
Studio:       Great Britain - Buntingford
    Entries:
Christies Lon 6/26/80: 87 (lot, S-1 et al);

**SHAW, T.P.** (American)
Photos dated: 1866
Processes:     Albumen
Formats:      Prints
Subjects:     Documentary (educational institutions)
Locations:    US - New York City
Studio:       US
    Entries:
Rinhart NY Cat 1, 1971: 383;

**SHEETZ** (see CHANDLER & SHEETZ)

**SHELDON, F.N.** (American)
Photos dated: c1880
Processes:     Albumen
Formats:      Prints
Subjects:     Topography
Locations:    US - Santa Barbara, California
Studio:       US
    Entries:
Frontier AC, Texas 1978: 276;

**SHELDON, G.** (British)
Photos dated: 1850s and/or 1860s
Processes:     Albumen
Formats:      Stereos
Subjects:     Topography
Locations:    England - Chichester
Studio:       Great Britain
    Entries:
Sothebys Lon 10/29/76: 31 (lot, S-2 et al);

**SHEPHERD, Charles** (British)(see also BOURNE;
                ROBERTSON)
Photos dated: 1867-1873
Processes:     Albumen, autotype, heliogravure
Formats:      Prints, cdvs, stereos
Subjects:     Topography, ethnography, portraits
Locations:    India; Afghanistan
Studio:       India
    Entries:
Edwards Lon 1975: 6 (album, S et al), 8 (album,
    S-2, S & Robertson-1, et al)(note);
Sothebys Lon 6/26/75: 126 (album, S & Robertson-1,
    et al), 127 (album, S-1, S & Robertson-3, et al);
Sothebys Lon 10/24/75: 102 (album, S & Bourne et
    al), 125 (album, S & Bourne et al), 127 (lot,
    S & Bourne-4, et al), 128 (albums, S-1 et al),
    129 (album, S & Robertson et al), 132 (albums,
    S & Bourne-18, S & Robertson-2, et al);
Sothebys Lon 6/11/76: 44 (album, S-1, S & Bourne-2,
    et al);
Christies Lon 3/16/78: 102 ill(album, S-1, S &
    Robertson-3, et al);
Koch Cal 1981-82: 22 ill(note), 23 ill;
Wood Conn Cat 49, 1982: 52 (book, S & Bourne, 26)
    (note), 499 (book, S-1 et al)(note);
Sothebys Lon 3/15/82: 126 (album, S-1, S &
    Robertson-4, S & Bourne-5, et al);
Harris Baltimore 12/10/82: 396 (4)(note);
Sothebys Lon 3/25/83: 37 ill;
Christies Lon 6/23/83: 143 (album, S-1 et al), 259
    (lot, S & Bourne et al);
Christies Lon 10/27/83: 103 (albums, S & Bourne et
    al), 106 (album, S-1 et al);
Swann NY 11/10/83: 284 (albums, S, S & Bourne, et
    al)note);
Christies Lon 6/27/85: 82 (album, S & Bourne et
    al), 95 (album, S & Bourne-5, et al), 168
    (album, S, S & Bourne, et al)(note);
Christies Lon 10/31/85: 125 (albums, S-1, S &
    Robertson-2, et al);
Phillips Lon 4/23/86: 264 (album, S, S & Robertson,
    et al);
Christies Lon 4/24/86: 406 (album, S-1 et al), 417
    ill(book, 25), 447 ill, 509 (lot, S & Bourne-1,
    et al), 510 (lot, S & Bourne-3, et al);
Christies Lon 10/30/86: 48 (book, 25), 146 (albums,
    S & Bourne et al), 153 (albums, S & Bourne
    et al);

**SHEPHERD, G.** (British)
Photos dated: 1851-1854
Processes:     Salt, albumen
Formats:      Prints
Subjects:     Topography
Locations:    England - Dover, Canterbury, Hastings
Studio:       England - Dover
    Entries:
Sothebys Lon 3/27/81: 358, 359 ill;
Christies Lon 10/29/81: 159 ill(53);
Christies Lon 10/28/82: 50 ill(53);
Christies Lon 3/28/85: 136 ill;
Christies Lon 6/27/85: 131 ill(53);
Christies Lon 10/31/85: 177 ill;

**SHERLOCK, W.** (British)
Photos dated: 1843-1854
Processes:      Calotype, albumen
Formats:        Prints
Subjects:       Topography, genre (rural life)
Locations:      Great Britain; Greece - Athens
Studio:         Great Britain
   Entries:
Swann NY 2/14/52: 304 (12)(note);
Sothebys NY 11/21/70:  220 (2 ills)(2)(note);
Christies Lon 10/25/84: 52 (lot, S et al);

**SHERMAN**
Photos dated: 1890s
Processes:      Collodion on glass
Formats:        Lantern slides
Subjects:       Topography
Locations:      Canada
Studio:
   Entries:
California Galleries 3/30/80: 337 (lot, S et al);

**SHERMAN, W.H.** (American)
Photos dated: 1870s-1880s
Processes:      Albumen
Formats:        Stereos, cdvs
Subjects:       Topography, portraits
Locations:      US - Milwaukee, Wisconsin
Studio:         US - Milwaukee, Wisconsin
   Entries:
Sothebys NY (Strober Coll.) 2/7/70: 494 (lot,
   S-5 et al);
Harris Baltimore 4/8/83: 57 (lot, S et al);

**SHERRING, R.V.**
Photos dated: 1876-1886
Processes:      Albumen
Formats:        Prints
Subjects:       Topography
Locations:      Trinidad
Studio:
   Entries:
Sothebys Lon 12/4/73: 9 (album, 40);

**SHERRINGTON, W.** (British)
Photos dated: between 1840s and 1860s
Processes:
Formats:        Prints
Subjects:
Locations:      Great Britain
Studio:         Great Britain
   Entries:
Swann NY 2/14/52: 4, (album, S et al), 113 (lot,
   S et al);

**SHERWOOD, W.B.**
Photos dated: Nineteenth century
Processes:      Albumen
Formats:        Cdvs
Subjects:       Documentary (maritime), ethnography
Locations:      South Africa - Natal
Studio:         South Africa - Natal
   Entries:
Christies Lon 3/10/77: 68 (lot, S-1 et al);

**SHEW, Jacob and/or Myron** (American)
Photos dated: Albumen
Formats:        Prints, cdvs
Subjects:       Portraits
Locations:      Studio
Studio:         US - San Francisco, California
   Enties:
California Galleries 3/30/80: 376;
California Galleries 12/13/80: 344;
California Galleries 5/23/82: 255 (lot, S-3 et al);

**SHEW, William** (American, born 1820)
Photos dated: 1840-1903
Processes:      Daguerreotype, albumen
Formats:        Plates, prints, cdvs
Subjects:       Portraits, topography
Locations:      US - San Francisco, California
Studio:         US - San Francisco and Sacramento,
                California
   Entries:
Sothebys NY (Strober Coll.) 2/7/70: 169 (note);
Sothebys NY (Greenway Coll.) 11/20/70: 1 (lot, S-1
   et al);
Frontier AC, Texas 1978: 38 (book, S et al)(note);
California Galleries 1/21/78: 131 (album, S et al);
Drouot Paris 5/29/78: 41;
California Galleries 1/21/79: 332 (album, S et al);
California Galleries 5/23/82: 191 (album, S et al),
   255 (lot, S-10 et al);
Christies NY 2/28/83: 75 (lot, S-1 et al);
Phillips Lon 10/29/86: 260 (lot, S & Marks-1,
   et al);

**SHIPLEY, W.N.** (American)
Photos dated: c1885
Processes:      Albumen
Formats:        Prints
Subjects:       Portraits
Locations:      US
Studio:         US - Nashua, New Hampshire
   Entries:
California Galleries 1/21/79: 393;

**SHIPP, E.** (British)
Photos dated: 1860s
Processes:      Ambrotype
Formats:        Plates
Subjects:       Portraits
Locations:      Studio
Studio:         England - London
   Entries:
Christies Lon 10/28/76: 47 (lot, S-1 et al);

**SHIRAS, George, III**
Photos dated: 1898
Processes:
Formats:        Prints
Subjects:       Genre (animal life)
Locations:      North America
Studio:         North America
   Entries:
Swann NY 4/26/79: 427 (3)(note);

**SHOLTUS, J.** (American)
Photos dated: c1890s
Processes:      Albumen
Formats:        Prints
Subjects:       Documentary (public events)
Locations:      US - New York
Studio:         US - Gloversville, New York
   Entries:
Swann NY 4/20/78: 265;

**SHORT, John Golden** (British, born c1830)
Photos dated: c1875-1876
Processes:      Albumen
Formats:        Prints
Subjects:       Topography
Locations:      England - New Forest
Studio:         England
   Entries:
Wood Conn Cat 42, 1978: 469 (book, 10)(note);
Sothebys Lon 3/14/79: 242 (book, 10);
Christies Lon 10/25/79: 280 (book, 10);
Christies Lon 6/26/80: 326 (book, 10);
Wood Conn Cat 49, 1982: 395 (book, 10)(note);
Christies Lon 3/11/82: 307 ill(2)(note), 308 ill
   (4), 309 (6), 310(4), 311(4);
Phillips Lon 3/17/82: 54 (lot, S-11 et al);
Christies Lon 10/28/82: 53 (2);
Christies Lon 3/24/83: 64 (20);
Christies Lon 3/29/84: 222 (album, 90);
Christies Lon 10/25/84: 223 (lot, S-2 et al);
Christies Lon 3/28/85: 221;
Christies Lon 6/27/85: 182 (6);
Christies Lon 10/31/85: 223 (11), 224 (albums,
   S et al), 291 (lot, S et al);

**SHRIMPTON** (British)
Photos dated: c1870
Processes:      Albumen
Formats:        Cdvs
Subjects:       Topography
Locations:      England
Studio:         England
   Entries:
California Galleries 9/27/75: 386 (lot, S et al);

**SHULER, E.** (German)
Photos dated: c1870
Processes:      Albumen
Formats:        Stereos
Subjects:       Topography
Locations:      Germany
Studio:         Germany
   Entries:
Rinhart NY Cat 7, 1973: 175;

**SHUTE, C.H.** (American)
Photos dated: 1860s-1870s
Processes:      Albumen
Formats:        Stereos
Subjects:       Topography
Locations:      US - Edgartown, Massachusetts
Studio:         US - Edgartown, Massachusetts
   Entries:
Sothebys NY (Strober Coll.) 2/7/70: 467 (lot,
   S et al);
Swann NY 4/23/81: 530 (lot, S et al);
Harris Baltimore 3/15/85: 58 (lot, S et al);

**SIEBERT, Christ**
Photos dated: 1860s
Process:        Albumen
Formats:        Stereos, cdvs
Subjects:       Topography
Locations:      US
Studio:         US - Thomaston, Connecticut
   Entries:
Sothebys Lon 11/1/85: 3 (lot, S et al);

**SIEMMSEN, Hans** (German)
Photos dated: 1893-1900
Processes:      Albumen
Formats:
Subjects:       Portraits
Locations:      Studio
Studio:         Germany - Augsburg
   Entries:
Petzold Germany 5/22/81: 1977 (album, S et al), 1982
   (album, S et al);

**SIER**
Photos dated: Nineteenth century
Processes:      Albumen
Formats:        Cdvs
Subjects:       Portraits
Locations:
Studio:
   Entries:
Sothebys NY (Greenway Coll.) 11/20/70: 160 ill;

**SILKWORTH** (American)
Photos dated: 1880s
Processes:      Albumen
Formats:        Cabinet cards
Subjects:       Portraits
Locations:      Studio
Studio:         US - Brooklyn, New York
   Entries:
Phillips Can 10/4/79: 69 (album, S-1 et al);

**SILSBEE, George M.** (American)(see also MASURY &
               SILSBEE)
Photos dated: 1852-1857
Processes:      Daguerreotype, salt, albumen
Formats:        Plates, prints, cdvs
Subjects:       Documentary (scientific), portraits
Locations:      US - New England
Studio:         US - Boston, Massachusetts
   Entries:
Vermont Cat 4, 1972: 471 ill(S, Case);
Witkin IV 1976: OP320 (book, 1)(note);
Wood Conn Cat 37, 1976: 203 (book, 1)(note);
Swann NY 12/14/78: 247 (book, 1);
Lehr NY Vol 1:4, 1979: 55 (book, 1)(note);
Witkin NY IX 1979: 2/93 (book, 1)(note);
Phillips NY 5/21/80: 112 (book, 1);
Wood Conn Cat 49, 1982: 478 (book, 1)(note);
Swann NY 11/18/82: 261 (book, 1)(note);
Swann NY 5/5/83: 242 (book, 1)(note);
Swann NY 11/10/83: 162 (book, 1)(note);
Swann NY 11/6/84: 210 (book, 1)(note);
Swann NY 5/16/86: 163 (lot, S, Case-2, et al);
Harris Baltimore 11/7/86: 215 ill(S, Case), 219
   (lot, S, Case-1, et al);
Swann NY 11/13/86: 200 (lot, S, Case et al);

**SILVEIRA, J.** (Portuguese)
Photos dated: 1866
Processes:      Albumen
Formats:        Cdvs
Subjects:       Portraits
Locations:      Studio
Studio:         Portugal - Lisbon
    Entries:
Swann NY 5/9/85: 430;

**SILVER, T.** (British)
Photos dated: 1860s
Processes:      Albumen
Formats:        Stereos
Subjects:       Topography
Locations:      Ireland
Studio:
    Entries:
Sothebys Lon 6/29/84: 4 (lot, S et al);

**SILVER, W.W.** (American)
Photos dated: c1870
Processes:      Albumen
Formats:        Stereos
Subjects:       Topography
Locations:      US
Studio:         US - New York City
    Entries:
Rinhart NY Cat 7, 1973: 400;

**SILVESTER, Alfred** (British)
Photos dated: 1850s-1862
Processes:      Albumen
Formats:        Stereos
Subjects:       Genre, documentary (industrial)
Locations:      England - London
Studio:         England - London
    Entries:
Christies Lon 10/25/79: 83 (lot, S-5 et al);
Christies Lon 3/20/80: 102 (lot, S et al);
Christies Lon 6/26/80: 104 (lot, S-2 et al);
Sothebys Lon 6/27/80: 4 (lot, S et al), 6 (2);
Christies Lon 10/30/80: 90 (lot, S-2 et al), 103 (lot, S-1 et al);
Christies Lon 3/26/81: 113 (lot, S-1 et al);
Christies Lon 6/18/81: 93 (lot, S-3 et al), 95 (lot, S-2 et al), 97 (lot, S-1 et al);
Christies Lon 10/29/81: 120 (lot, S-1 et al), 125 (lot, S-1 et al), 147 (lot, S et al);
Christies Lon 3/11/82: 75 (lot, S-1 et al);
Christies Lon 6/24/82: 52 (lot, S et al), 53 (lot, S-2 et al), 67 (lot, S-3 et al), 70 (lot, S-1 et al);
Sothebys Lon 6/25/82: 6 (lot, S et al);
Christies Lon 3/24/83: 28 (lot, S et al), 32 (lot, S et al), 37 (lot, S-2 et al);
Christies Lon 6/23/83: 25 (lot, S-3 et al), 32 (lot, S et al), 33 (lot, S-1 et al), 42 (lot, S et al), 56 (lot, S-1 et al);
Christies Lon 10/27/83: 34 (lot, S-2 et al), 36 (lot, S-8 et al);
Christies Lon 3/29/84: 16 (lot, S-1 et al), 28 (lot, S-4 et al), 35 (lot, S et al), 36 (lot, S-2 et al), 40 (lot, S et al);
Christies Lon 6/28/84: 34 (lot, S et al), 40 (lot, S et al), 48 (lot, S et al);
Sothebys Lon 6/29/84: 18;

**SILVSTER, A.** (continued)
Phillips Lon 10/24/84: 92 (lot, S-3 plus 5 attributed, et al);
Christies Lon 10/25/84: 37 (lot, S et al), 38 (lot, S-1 et al), 43 (lot, S-1 et al);
Christies Lon 3/28/85: 36 (lot, S et al), 37 (lot, S et al), 38 (lot, S et al), 39 (lot, S et al), 53 (lot, S-1 et al);
Christies Lon 6/27/85: 34 (lot, S-1 et al);
Sothebys Lon 6/28/85: 7 (lot, S-1 et al);
Christies Lon 10/31/85: 60 (lot, S-1 et al);
Phillips Lon 4/23/86: 186 (lot, S-1 et al);
Christies Lon 4/24/86: 326 (lot, S-16 et al), 327 (3), 347 (lot, S-3 et al), 351 (lot, S-5 et al);
Christies Lon 10/30/86: 19A (lot, S et al), 27 (lot, S-10 et al), 29 (lot, S et al);

**SILVIS, J.B.** (American)
Photos dated: 1873-1876
Processes:      Albumen
Formats:        Prints
Subjects:       Topography
Locations:      US - American west
Studio:         US
    Entries:
Harris Baltimore 12/16/83: 409 ill(note);

**SILVY, Camille de** (French)
Photos dated: 1857-1869
Processes:      Albumen
Formats:        Prints incl. panoramas, cdvs
Subjects:       Portraits, topography, documentary
Locations:      England; France
Studio:         France - Paris; England - London
    Entries:
Swann NY 2/14/52: 302 (book, 16)(note);
Sothebys Lon 12/21/71: 179 (lot, S et al);
Sothebys Lon 10/18/74: 146 (album, S et al);
Sothebys Lon 3/21/75: 161 (album, S et al), 162 (album S-12 et al)(note), 163 ill (album, S-24 et al), 164 (album, S-36 et al), 165 (albums, S-4 et al), 166 (albums, S-8 et al), 278 (lot, S-4 et al), 284 (lot, S et al), 288 (album, S et al);
Sothebys Lon 6/26/75: 198 (album, S et al), 259 (album, S et al), 265 (album, S et al);
Sothebys Lon 10/24/75: 262 (album, S et al);
Colnaghi Lon 1976: 200 (album, S et al)(note);
Sothebys Lon 3/19/76: 167 ill(note);
Sothebys NY 5/4/76: 99 (album, S et al);
Christies Lon 6/10/76: 143 (4), 149 (album, S et al), 150 (album, S et al);
Sothebys Lon 6/11/76: 96 (album, S et al), 170 (album, S et al), 174 (album, S et al);
Christies Lon 10/28/76: 226 (albums, S et al), 234 (album, S et al);
Sothebys Lon 10/29/76: 84 (2), 93 (album, S-2 et al);
California Galleries 1/22/77: 169 (album, S-1 et al);
Sothebys Lon 3/9/77: 122 (album, S et al), 123 (album, S et al), 124 (albums, S et al);
Christies Lon 3/10/77: 248 (album, S-4 et al), 273 (lot, S-1 et al);
Swann NY 4/14/77: 109 (book, S-1 et al);
Christies Lon 6/30/77: 64 (lot, S-6 et al), 160 (album, S-1 et al), 161 (album, S et al);
Sothebys Lon 7/1/77: 234 (album, S et al);

## SILVY (continued)

Christies Lon 10/27/77: 367 (album, S-1 et al), 369
(album, S et al), 370 (albums, S-16 et al), 377
(album, S-1 et al);
Sothebys Lon 11/18/77: 29 (album, S et al), 39
(lot, S-1 et al);
Christies Lon 3/16/78: 296 (album, S et al), 299
(album, S-12 et al), 301 (albums, S et al), 302
(albums, S-10 et al);
Sothebys Lon 3/2/78: 195 (album, S et al), 298 ill
(album, 12)(note);
Christies Lon 6/27/78: 237 (album, S et al), 243
(album, S-2 et al);
Sothebys Lon 6/28/78: 132 (5);
Christies Lon 10/26/78: 325 (album, S et al), 331
(album, S et al), 337 (album, S et al);
Sothebys NY 11/9/78: 438 (6 ills)(18);
Sothebys Lon 3/14/79: 285 (7), 298 (album, S et al);
Christies Lon 3/15/79: 308 (albums, S-2 et al), 317
(albums, S-1 et al);
Christies Lon 6/28/79: 218 (album, S-2 et al), 225
(albums, S-6 et al);
Sothebys Lon 6/29/79: 172 (album, S et al), 174
(album, S et al), 178 (album, S et al);
Sothebys Lon 10/24/79: 2 (book, 1), 319 (lot,
S et al);
Christies Lon 10/25/79: 394 (album, S-2 et al), 395
(album, S-2 et al), 401 (album, S-2 et al);
Sothebys Lon 10/26/79: 633 (9 ills)(18);
Phillips NY 11/3/79: 127 (lot, S et al);
Christies Lon 3/20/80: 356 (albums, S et al), 357
(album, S et al), 372 (lot, S et al), 379
(album, S-1 et al);
Sothebys Lon 3/21/80: 231 (lot, S-1 et al), 237
(album, S et al), 250 (album, S et al);
California Galleries 3/30/80: 214 (album, S-1
et al);
Christies Lon 6/26/80: 472 (album, S-3 et al), 486
(albums, S et al);
Sothebys Lon 6/27/80: 214 (album, S et al), 215
(album, S et al), 219 ill(album, S et al);
Sothebys Lon 10/29/80: 215 (album, S et al)(note),
258 (album, S et al), 261 (album, S et al), 262
(album, S et al), 264 (8);
Christies Lon 10/30/80: 416 (album, S-6 et al), 425
(album, S et al), 429 (lot, S-6 et al), 433
(albums, S-1 et al), 438 (album, S et al);
Christies Lon 3/26/81: 385 (11), 386 (album, S-2 et
al), 395 (album, S-3 et al), 397 (album, S-10 et
al), 405 (album, S et al);
Sothebys Lon 3/27/81: 213 (8), 223 (album, S et
al), 403 (album, S et al);
Petzold Germany 5/22/81: 1856 (lot, S-3 et al);
Sothebys Lon 6/17/81: 224 (album, S et al), 260
(album, S et al);
Christies Lon 6/18/81: 421 (albums, S-10 et al), 431
(album, S et al);
Sothebys Lon 10/28/81: 307 (album, S-3 et al),
307a (6);
Christies Lon 10/29/81: 357 ill(album, S et al), 365
(albums, S-2 et al), 366 (album, S-10 et al),
368 (lot, S-2 et al);
Christies Lon 3/11/82: 305 ill, 316 (album, S et
al), 347 (albums, S-1 et al);
Sothebys Lon 3/15/82: 211 (lot, S-3 et al), 216
(7), 217 (albums, 75), 219 (album, S et al), 226
(album, S-36 et al), 227 (album, S et al), 229
(album, S et al), 235 (lot, S et al);
Christies Lon 6/24/82: 363 (album, S et al), 363A
(album, S et al);
Sothebys Lon 6/25/82: 50 (lot, S et al);

## SILVY (continued)

Phillips Lon 10/27/82: 28 (albums, S et al);
Christies Lon 10/28/82: 201 (album, S et al);
Sothebys Lon 3/25/83: 116a (10), 133 (album,
S et al);
Christies Lon 6/23/83: 241 (album, S-1 et al), 242
(album, S et al), 243 (album, S et al), 245
(album, S et al), 252 (album, S et al), 262
(album, S et al);
Christies Lon 10/27/83: 224A (album, S et al), 231
(album, S et al), 234A (album, S et al), 240
(album, S et al);
Christies Lon 3/29/84: 335 (album, S et al), 337
(album, S et al), 338 (albums, S et al), 349
(album, S et al), 350 (lot, S et al);
Swann NY 5/10/84: 291 (lot, S et al), 322 (albums,
S et al)(note);
Christies Lon 6/28/84: 302 (album, S et al);
Sothebys Lon 6/29/84: 228 (album, S et al), 235
(album, S et al);
Phillips Lon 10/24/84: 121 (lot, S-3 et al);
Christies Lon 10/25/84: 318 (albums, S et al), 320
(album, S et al), 325 (album, S et al);
Sothebys Lon 10/26/84: 171 (album, S et al), 173
(lot, S et al), 176 (album, S et al), 178
(albums, S et al);
Christies Lon 3/28/85: 151 (albums, S et al)(note),
308 (album, S et al), 309 (album, S et al), 319
(album, S et al);
Phillips Lon 6/26/85: 147 (album, S-2 et al), 204
(lot, S et al);
Christies Lon 6/27/85: 246 (albums, S et al), 270
(lot, S-29 et al), 271 (albums, S et al), 272
(album, S et al);
Phillips Lon 10/30/85: 32 (lot, S-15 et al), 35
(lot, S-3 et al);
Christies Lon 10/31/85: 282 (albums, S et al), 289
(lot, S et al), 302 (album, S et al);
Sothebys Lon 11/1/85: 123 (album, S et al), 126
(album, S et al);
Phillips Lon 4/23/86: 224 (lot, S-1 et al), 226
(album, S et al), 242 (album, S et al), 272
(lot, S-7 et al), 274 (album, S et al);
Sothebys Lon 4/25/86: 205 (album, S et al), 207
(album, S et al);
Christies Lon 6/26/86: 103 (albums, S et al), 146
(lot, S et al), 149 (album, S et al);
Phillips Lon 10/29/86: 296 (album, S-1 et al), 301
(lot, S-1 et al), 308 (lot, S-2 et al), 310
(lot, S-1 et al);
Christies Lon 10/30/86: 217 (albums, S et al), 222
(album, S et al), 226 (album, S et al), 227
(album, S et al), 237 (lot, S et al), 252
(album, S et al);
Sothebys Lon 10/31/86: 148 (album, S et al);

**SIMELLI, Carlo Baldessari** (Italian)
Photos dated: 1860s
Processes:      Albumen
Formats:        Prints
Subjects:       Topography
Locations:      Italy - Rome
Studio:         Italy - Rome
  Entries:
Christies Lon 10/27/77: 93;
Christies Lon 4/24/86: 378 (lot, S-2 et al)(note);

SIMMONS & Co. (British)
Photos dated: Nineteenth century
Processes:      Albumen
Formats:        Prints
Subjects:       Documentary (maritime)
Locations:      Great Britain
Studio:         England - Portsmouth
   Entries:
Christies Lon 3/20/80: 206 (album, S-2 et al);

SIMON, D.A. (American)
Photos dated: 1850s
Processes:      Daguerreotype
Formats:        Plates
Subjects:       Portraits
Locations:      Studio
Studio:         US - Manchester, New Hampshire
   Entries:
Vermont Cat 4, 1972: 495 (lot, S-3 et al);

SIMONS, Montgomery P. (American)
Photos dated: c1848-1860s
Processes:      Daguerreotype, albumenized salt,
                albumen
Formats:        Plates, prints, stereos
Subjects:       Portraits, topography
Locations:      Studio
Studio:         US - Philadelphia, Pennsylvania;
                Richmond, Virginia
   Entries:
Vermont Cat 9, 1975: 579 ill(7);
Sothebys Lon 3/21/75: 176;
Phillips NY 11/3/79: 194 (note);
Swann NY 5/16/86: 212 (lot, S-1 et al);

SIMONTON & MILLARD
Photos dated: 1850s-1860s
Processes:      Daguerreotype, ambrotype
Formats:        Plates
Subjects:       Portraits
Locations:      Studio
Studio:         Ireland - Dublin
   Entries:
Sothebys Lon 3/9/77: 119;
Christies Lon 10/25/79: 44 (lot, S & M-1 et al);
Sothebys Lon 3/15/82: 308;

SIMPSON, Miss (British)
Photos dated: c1845
Processes:      Salt
Formats:        Prints
Subjects:       Photogenic drawings, architecture
Locations:      Great Britain
Studio:         Great Britain
   Entries:
Sothebys Lon 10/31/86: 70 (4);

SIMPSON Brothers (British)
Photos dated: 1860s
Processes:      Albumen
Formats:        Prints
Subjects:       Documentary
Locations:      England - Essex and Cambridgeshire
Studio:         England
   Entries:
Sothebys Lon 6/29/84: 63 ill(110);

SIMPSON, Dr. B.
Photos dated: 1860s-c1870
Processes:      Albumen
Formats:        Prints
Subjects:       Topography
Locations:      India - Kandahar
Studio:
   Entries:
Sothebys Lon 10/14/74: 80 (book, S et al);
Christies Lon 10/27/77: 131 (lot, S-1 et al);
Sothebys Lon 11/18/77: 98 (lot, S-2 et al);
Christies Lon 6/27/78: 118 (album, S-4 et al);
Christies Lon 10/30/80: 227 (lot, S-1 et al);
Christies Lon 3/11/82: 252 (books, S et al);

SIMPSON, Joseph (American)
Photos dated: c1849-1850s
Processes:      Daguerreotype, ambrotype
Formats:        Plates
Subjects:       Portraits
Locations:      Studio
Studio:         US - Lowell, Massachusetts
   Entries:
Rinhart NY Cat 1, 1971: 52;
Vermont Cat 6, 1973: 522 ill;
Gordon NY 5/3/76: 268 (lot, S et al);
Rose Boston Cat 5, 1980: 161 ill;
Christies Lon 6/24/82: 24;

SIMS, J.D. (photographer or owner?)
Photos dated: 1870s
Processes:      Albumen
Formats:        Prints
Subjects:       Topography
Locations:      England
Studio:         England - Ipswich
   Entries:
Sothebys Lon 6/28/78: 262 (12);

SIMS, Thomas
Photos dated: Nineteenth century
Processes:      Albumen
Formats:        Cdvs
Subjects:       Portraits
Locations:      US; Europe
Studio:
   Entries:
Christies Lon 6/14/73: 217 (23), 218 (lot, S et al);

SINCLAIR (British)
Photos dated: 1869
Processes:      Albumen
Formats:        Prints
Subjects:
Locations:      Great Britain
Studio:         Great Britain (Amateur Photographic
                Association)
   Entries:
Sothebys Lon 10/18/74: 158 (album, S et al);

**SINCLAIR, E.W.** (American)
Photos dated: c1862-1860s
Processes:      Albumen
Formats:        Stereos
Subjects:       Documentary (Civil War)
Locations:      US - Beaufort, South Carolina; Florida
Studio:         US
    Entries:
Sothebys NY (Strober Coll.) 2/7/70: 547 (lot,
    S-2 et al);
Rinhart NY Cat 2, 1971: 453;
Harris Baltimore 5/28/82: 153 (lot, S-2 et al);

**SINCLAIR, James** (American)
Photos dated: c1870
Processes:      Albumen
Formats:        Stereos
Subjects:       Topography
Locations:      US - Stillwater, Minnesota
Studio:         US - Stillwater, Minnesota
    Entries:
Rinhart NY Cat 6, 1973: 494;
Harris Baltimore 6/1/84: 93 (lot, S et al);

**SIN-E-DO** (Japanese)
Photos dated: 1880s-1890s
Processes:      Albumen
Formats:        Prints
Subjects:       Topography
Locations:      Japan
Studio:         Japan - Kobe
    Entries:
Swann NY 11/8/84: 215 (lot, S et al);

**SINGLETON** (British)
Photos dated: Nineteenth century
Processes:      Albumen
Formats:        Prints
Subjects:       Topography
Locations:      Great Britain
Studio:         Great Britain
    Entries:
Christies Lon 10/26/78: 135 (albums, S et al);

**SINGLEY, B.L.** (American)
Photos dated: 1890s-1900
Processes:      Albumen
Formats:        Stereos
Subjects:       Topography, genre
Locations:      US; Europe
Studio:         US - Meadville, Pennsylvania
    Entries:
Vermont Cat 1, 1971: 228 (lot, S et al);
Vermont Cat 7, 1974: 613 ill(20), 657 ill(14);
Frontier AC, Texas 1978: 279 (42)(note);
Swann NY 11/8/84: 266 (lot, S-30 et al);

**SINNER**
Photos dated: Nineteenth century
Processes:      Albumen
Formats:        Cdvs
Subjects:       Topography
Locations:      Europe
Studio:         Europe
    Entries:
Swann NY 5/16/86: 203 (lot, S et al);

**SIPPERLY, William H.** (American)
Photos dated: c1870-1870s
Processes:      Albumen
Formats:        Stereos
Subjects:       Ethnography
Locations:      US - Saratoga Springs, New York
Studio:         US - Saratoga, New York
    Entries:
Rinhart NY Cat 7, 1973: 260;
Harris Baltimore 4/8/83: 67 (lot, S et al), 385
    (lot, S et al);
Harris Baltimore 12/16/83: 117 (lot, S et al);
Harris Baltimore 3/15/85: 88 (lot, S-2 et al);

**SISSONS, L.J.** (British)
Photos dated: 1862
Processes:      Albumen
Formats:        Stereos
Subjects:       Topography
Locations:      Switzerland - Lausanne
Studio:         Europe
    Entries:
Sothebys Lon 3/9/77: 11 (lot, S-2 et al);
Sothebys NY 5/20/80: 341 (books, S et al);

**SITKA Co.**
Photos dated: 1880s
Processes:      Albumen
Formats:        Boudoir cards
Subjects:       Topography
Locations:      US - Alaska
Studio:         US - Sitka, Alaska
    Entries:
Swann NY 11/8/84: 136 (lot, S-1 et al);

**SJOBERG, Axel** (Swedish, born 1866)
Photos dated: 1880s
Processes:      Albumen
Formats:        Prints
Subjects:       Topography
Locations:      Sweden
Studio:         Sweden
    Entries:
California Galleries 12/13/80: 341 (lot, S et al);
Christies Lon 10/27/83: 84 (albums, S et al);

**SJOMAN, R.S.** (Swedish)
Photos dated: 1860s-1870s
Processes:      Albumen
Formats:        Cdvs
Subjects:       Topography, ethnography
Locations:      Sweden
Studio:         Sweden - Stockholm
    Entries:
Christies Lon 10/27/83: 233 (album, S-22 et al);

**SKAIFE, Thomas**
Photos dated: 1857-1858
Processes:      Albumen
Formats:        Stereos
Subjects:       Genre
Locations:      Great Britain
Studio:         Great Britain
    Entries:
Sothebys Lon 6/28/78: 236 (lot, S-1 et al)(note);
Christies Lon 4/24/86: 371 ill(2)(note);

**SKEEN, W.H.L. & Co.**
Photos dated: 1870s-1890s
Processes:      Albumen
Formats:        Prints, cdvs
Subjects:       Topography, portraits
Locations:      Ceylon
Studio:         Ceylon - Colombo
   Entries:
Rinhart NY Cat 7, 1973: 113 (album, 18);
Sothebys Lon 10/18/74: 77 (album, S et al);
Swann NY 2/6/75: 45 (book, 18);
California Galleries 9/27/75: 341 (2);
Wood Conn Cat 37, 1976: 251 (album, S et al),
   256A (35);
Christies Lon 10/28/76: 144 (albums, S attributed
   et al), 176 (albums, S-8 et al);
Gordon NY 11/13/76: 34 ill(52);
Rose Boston Cat 2, 1977: 48 ill(note), 49 ill;
Sothebys Lon 7/1/77: 152 (album, S et al);
Rose Boston Cat 3, 1978: 34 ill(note);
Wood Conn Cat 41, 1978: 69 ill(note), 70, 71, 72,
   73, 74, 75 ill, 76 ill, 77, 78, 79, 80, 81, 82;
Christies Lon 3/16/78: 106 (album, S et al), 109
   (album, S-10 et al);
Swann NY 4/20/78: 278 (album, S et al);
Christies Lon 6/27/78: 150 (album, S-1 et al);
Christies Lon 10/26/78: 195 (album, S et al);
Sothebys Lon 10/27/78: 70 (album, S et al);
Phillips NY 11/4/78: 44 (10)(note), 45 (lot,
   S-4 et al);
Phillips Lon 3/13/79: 145 ill(9);
Sothebys Lon 3/14/79: 111 (album, S et al), 122
   (album, 36);
Sothebys NY 5/8/79: 108 ill(2), 109 ill;
Christies Lon 6/28/79: 145 (album, S-2 et al), 147
   (albums, S-4 et al);
Sothebys Lon 6/29/79: 91 ill(album, S et al);
Christies Lon 10/25/79: 191 (lot, S-1 et al);
Sothebys NY 12/19/79: 96 (2 ills)(lot, S et al);
Rose Boston Cat 5, 1980: 89 ill, 90 ill, 91 ill, 92
   ill, 93 ill;
Christies Lon 3/20/80: 173 ill(album, 30);
Swann NY 4/17/80: 375 (album, S-1 et al)(note);
Christies NY 5/16/80: 208 (album, 42);
Sothebys NY 5/20/80: 402;
Christies Lon 6/26/80: 227 (lot, S-1 et al);
Sothebys Lon 10/29/80: 111 (album, S et al);
Christies Lon 10/30/80: 269 (albums, S-3 et al),
   274 (album, S-2 et al);
Christies NY 11/11/80: 80 ill(album, S et al),
   82 (28);
Christies Lon 3/26/81: 224 (albums, S-7 et al), 242
   ill (albums, S-11 et al);
Swann NY 4/23/81: 426 (lot, S-1 et al), 427 (lot,
   S et al);
Phillips NY 5/9/81: 61 (albums, S et al), 63 ill
   (lot, S-1 et al);
Christies Lon 6/18/81: 211 (album, S-2 et al), 236
   (album, S-1 et al);
Christies Lon 10/29/81: 236 (album, S-5 et al), 237
   (lot, S et al), 241 ill(album, 53), 276 ill
   (albums, S-16 et al);
Swann NY 11/5/81: 485 (1 plus 4 attributed)(note);
Phillips Lon 6/23/82: 68 (album, S et al);
Christies Lon 6/24/82: 203 (album, S et al), 229
   (lot, S-1 et al);
Christies Lon 3/11/82: 178 ill(albums, S et al), 230
   (album, S et al);
Phillips NY 9/30/82: 1040 (3)(attributed);
Christies Lon 10/28/82: 91 (lot, S-16 et al), 116
   (album, S et al);

**SKEEN** (continued)
Harris Baltimore 12/10/82: 397 (album, S et al);
Christies Lon 3/24/83: 130 (album, S et al);
Harris Baltimore 4/8/83: 401, 402 (2);
Christies Lon 6/23/83: 147 ill(attributed);
Christies Lon 10/27/83: 158 (album, S & Scowen
   et al);
Swann NY 11/10/83: 284 (albums, S et al)(note);
Christies Lon 3/29/84: 105 (albums, S & Scowen
   et al);
Swann NY 5/10/84: 299;
Harris Baltimore 6/1/84: 445 (lot, S-7 plus 1
   attributed, et al);
Christies Lon 6/28/84: 93 (lot, S et al), 96 (lot,
   S-1 et al), 139 (album, S-2 et al);
California Galleries 7/1/84: 648;
Christies Lon 10/25/84: 75 ill(album, 68), 76
   (album, S et al);
Swann NY 11/8/84: 283 ill(lot, S et al);
Phillips Lon 3/27/85: 205 (album, S-1 et al);
Christies Lon 3/28/85: 95 (album, S-7 et al), 97
   (album, S-9 et al), 101 (album, S-2 et al), 207
   (lot, S et al);
Sothebys Lon 3/29/85: 105 (album, 63);
Christies Lon 6/27/85: 82 (album, S et al), 98
   (album, S et al);
Christies Lon 10/31/85: 103 (albums, S-11 et al);
Sothebys Lon 11/1/85: 43 (albums, S-12 et al);
Swann NY 11/14/85: 53 (lot, S et al);
Harris Baltimore 2/14/86: 200 (album, S et al);
Christies Lon 4/24/86: 407 (album, S-3 et al), 511
   (album, 39);
Swann NY 5/16/86: 219 (lot, S et al);
Christies Lon 10/30/86: 143 (albums, S-2 et al);
Sothebys Lon 10/31/86: 22 (album, S-26 et al);
Swann NY 11/13/86: 191 (albums, S et al), 192
   (album, S et al), 242 (lot, S et al);

**SKEOLAN** (British)
Photos dated: 1850s
Processes:      Daguerreotype
Formats:        Plates
Subjects:       Portraits
Locations:      Studio
Studio:         England - Manchester
   Entries:
Christies Lon 6/18/81: 37 (lot, S-1 et al);

**SKOIEN**
Photos dated: 1870s-1880s
Processes:      Albumen
Formats:        Prints
Subjects:       Topography
Locations:      Norway
Studio:         Europe
   Entries:
Sothebys NY 5/2/78: 85 (lot, S-2 et al)(note);
Christies Lon 10/27/83: 84 (albums, S et al);

**SKOLIK, Charles**
Photos dated: 1894
Processes:      Silver
Formats:        Prints
Subjects:       Topography
Locations:      Greece; Syria; Palestine; Egypt
Studio:         Austria - Vienna
   Entries:
Sotthebys Lon 10/31/86: 25 ill(album, 119);

SKRIVSETH (see TAYLOR & SKRIVSETH)

SLADE Brothers (British)(photographer or
                    publisher?)
Photos dated: late 1860s
Processes:      Albumen
Formats:        Cdvs
Subjects:       Portraits
Locations:      Studio
Studio:         England - London
    Entries:
Phillips Lon 3/27/85: 166A (book, 120);

SLATER (British)
Photos dated: 1890s
Processes:      Platinum
Formats:        Prints
Subjects:       Topography
Locations:      Wales
Studio:         Great Britain
    Entries:
Swann NY 11/5/81: 565 (lot, S-1 et al);

SLATER, W.H.
Photos dated: 1860s-1870s
Processes:      Albumen
Formats:        Stereos
Subjects:       Topography
Locations:      Great Britain
Studio:         Great Britain
    Entries:
Christies Lon 3/26/81: 128 (lot, S-2 et al);
Christies Lon 10/29/81: 138 (lot, S-2 et al);
Christies Lon 10/25/84: 41 (lot, S et al);

SLEE Brothers (American)
Photos dated: 1860s
Processes:      Albumen
Formats:        Cdvs, stereos
Subjects:       Portraits, topography, documentary
                (educational institutions)
Locations:      US - Poughkeepsie, New York
Studio:         US - Poughkeepsie, New York
    Entries:
Rinhart NY Cat 2, 1971: 366 (lot, S et al);
Harris Baltimore 6/1/84: 104 (lot, S-3 et al);

SLINGSBY, Robert (British)
Photos dated: 1889
Processes:      Albumen
Formats:        Stereos
Subjects:       Topography
Locations:      Great Britain
Studio:         England - Lincoln
    Entries:
Christies Lon 10/27/83: 21 (lot, S-1 et al);

SLOCUM, J.E. (American)
Photos dated: c1880s
Processes:      Albumen
Formats:        Prints
Subjects:       Topography, ethnography
Locations:      US - Los Angeles, California
Studio:         US - San Diego, California
    Entries:
Swann NY 4/17/80: 247 (lot, S et al);
California Galleries 6/19/83: 389 (lot, S-5 et al);

SMALL (see BARING & SMALL)

SMALLCOMBE (British)
Photos dated: Nineteenth century
Processes:      Albumen
Formats:        Cdvs
Subjects:       Topography
Locations:      Great Britain
Studio:         Great Britain
    Entries:
Sothebys Lon 3/21/75: 137 (lot, S et al);

SMART, C.W. (British)
Photos dated: 1883
Processes:      Albumen
Formats:        Prints
Subjects:       Portraits
Locations:      Studio
Studio:         England - Leamington
    Entries:
Edwards Lon 1975: 60 (book, 1);

SMEATON, Charles
Photos dated: between 1865 and 1877
Processes:      Albumen
Formats:        Prints
Subjects:       Topography
Locations:      Italy - Rome
Studio:
    Entries:
Christies Lon 4/24/86: 378 (lot, S-8 et al)(note);

SMEATONS (Canadian)
Photos dated: 1860s
Processes:      Albumen
Formats:        Cdvs
Subjects:       Portraits
Locations:      Studio
Studio:         Canada - Quebec
    Entries:
Swann NY 5/5/83: 291 (album, S et al);

SMILLIE, T.W. (American)
Photos dated: 1869-1870s
Processes:      Albumen, heliogravure
Formats:        Prints, stereos
Subjects:       Topography
Locations:      US - Washington, D.C.
Studio:         US
    Entries:
Rinhart NY Cat 7, 1973: 87 (book, S-1 et al);
Vermont Cat 9, 1975: 580 ill(6);
Harris Baltimore 7/31/81: 128 (lot, S et al);

SMILLIE, T.W. (continued)
Harris Baltimore 6/1/84: 156 (lot, S-26 et al);
Harris Baltimore 3/15/85: 111 (lot, S et al);

SMITH (see HURD & SMITH) [SMITH 1]

SMITH (British) [SMITH 2]
Photos dated: 1853
Processes:      Salt
Formats:        Prints
Subjects:       Topography
Locations:      England - Wales
Studio:         Great Britain
   Entries:
Christies Lon 6/23/83: 206 (lot, S-1 et al)(note);

SMITH (American) [SMITH 3]
Photos dated: 1860
Processes:      Albumen
Formats:        Cdvs
Subjects:       Portraits
Locations:      Studio
Studio:         US - Utica, New York
   Entries:
Rinhart NY Cat 2, 1971: 366 (lot, S et al);
Swann NY 12/8/77: 407 (album, S & Gardner);

SMITH (American) [SMITH 4]
Photos dated: 1860s
Processes:      Albumen
Formats:        Stereos
Subjects:       Topography
Locations:      US - Washington, D.C.
Studio:         US
   Entries:
Sothebys NY (Strober Coll.) 2/7/70: 480 (lot,
   S et al);

SMITH (American) [SMITH 5]
Photos dated: Nineteenth century
Processes:      Albumen
Formats:        Stereos
Subjects:       Topography
Locations:      US - Oberlin, Ohio
Studio:         US - Oberlin, Ohio
   Entries:
Harris Baltimore 4/8/83: 81 (lot, S et al);

SMITH, A.A. (American)
Photos dated: c1888
Processes:      Albumen
Formats:        Prints
Subjects:       Topography
Locations:      US - Dedham, Massachusetts
Studio:         US - Dedham, Massachusetts
   Entries:
Rinhart NY Cat 7, 1973: 473;
Wood Conn Cat 37, 1976: 222 ill(album, 32)(note);
Wood Conn Cat 42, 1978: 555 (album, 32)(note);

SMITH, Albert (British)(photographer or author?)
Photos dated: 1860
Processes:      Albumen
Formats:        Prints
Subjects:       Topography
Locations:      France
Studio:         Great Britain
   Entries:
Wood Boston Cat 58, 1986: 350 (book, 6)(note);

SMITH, B.F. (American)
Photos dated: c1880
Processes:      Albumen
Formats:        Prints
Subjects:       Architecture
Locations:      US
Studio:         US - New York City
   Entries:
Swann NY 11/18/82: 475 (lot, 23)(note);

SMITH, C.E. (American)
Photos dated: 1860s
Processes:      Albumen
Formats:        Stereos
Subjects:       Topography
Locations:      US - New England
Studio:         US - Bristol, Vermont
   Entries:
California Galleries 4/3/76: 406 (lot, S et al);
California Galleries 1/21/78: 175 (lot, S et al);

SMITH, C.P. (see SMYTH, C. Piazzi)

SMITH, Colvin (British)
Photos dated: early 1850s
Processes:      Salt
Formats:        Prints
Subjects:       Topography, genre (domestic)
Locations:      Scotland - Aberdeen
Studio:         Scotland - Aberdeen
   Entries:
Christies Lon 3/11/82: 315 (2 ills)(album, 82)
   (note);

SMITH, E.D. (British)
Photos dated: 1860s
Processes:      Albumen
Formats:        Stereos
Subjects:       Topography
Locations:      England - London
Studio:         England - London
   Entries:
Sothebys Lon 6/26/75: 5 (lot, S-12 et al);

SMITH, E.F. (American)
Photos dated: 1860s-1872
Processes:      Albumen
Formats:        Stereos
Subjects:       Documentary (disasters)
Locations:      US - Boston, Massachusetts
Studio:         US
   Entries:
California Galleries 4/3/76: 395 (lot, S et al);
Harris Baltimore 12/16/83: 36 (lot, S et al);

SMITH, Franklin W. (American)
Photos dated: 1892-1899
Processes:      Albumen
Formats:        Prints
Subjects:       Architecture
Locations:      US - Saratoga, New York
Studio:         US
   Entries:
Swann NY 4/1/76: 219 (lot, S-3 et al);

SMITH, G.S. (American)
Photos dated: 1840s-1850s
Processes:      Daguerreotype
Formats:        Plates
Subjects:       Portraits
Locations:      Studio
Studio:         US - Auburn, New York
   Entries:
Swann NY 4/23/81: 248 (lot, S-1 et al);

SMITH, George (American) [SMITH, George 1]
Photos dated: 1871
Processes:      Albumen
Formats:        Stereos
Subjects:       Documentary (disasters)
Locations:      US - Chicago, Illinois
Studio:         US
   Entries:
Rinhart NY Cat 2, 1971: 452 (lot, S-1 et al);

SMITH, George [SMITH, George 2]
Photos dated: 1875
Processes:      Autotype
Formats:        Prints
Subjects:       Topography
Locations:      "South Seas"
Studio:
   Entries:
Swann NY 4/14/77: 186 (book, 6)(note);
Swann NY 4/20/78: 175 (book, 6)(note);
Swann NY 4/17/80: 210 (book, 6)(note);

SMITH, H.G & TUPPER, H.W. (American)
Photos dated: 1874
Processes:      Albumen
Formats:        Prints, stereos
Subjects:       Documentary (art, scientific)
Locations:      US
Studio:         US - Boston, Massachusetts
   Entries:
Wood Conn Cat 37, 1976: 24 (book, 13)(note);
Wood Conn Cat 42, 1978: 80 (book, 13)(note);
Wood Conn Cat 45, 1979: 273 (book, 13)(note);
Harris Baltimore 7/31/81: 107 (lot, S et al);
Wood Conn Cat 49, 1982: 68 (book, 13)(note);

SMITH, H.P. (American)
Photos dated: Nineteenth century
Processes:      Albumen
Formats:        Stereos
Subjects:       Topography
Locations:      US - Syracuse, New York
Studio:         US
   Entries:
Stern Chicago 1975(?): 50 (book, 103);

SMITH, Henry (British)
Photos dated: 1850s
Processes:      Ambrotype
Formats:        Plates
Subjects:       Portraits
Locations:      Studio
Studio:         Scotland - Edinburgh
   Entries:
Sothebys Lon 6/26/75: 160 (lot, S-2 et al);

SMITH, J. (British) [SMITH, J. 1]
Photos dated: 1860s
Processes:      Ambrotype
Formats:        Plates
Subjects:       Portraits
Locations:      Studio
Studio:         England - London
   Entries:
Vermont Cat 10, 1975: 601 ill(note);

SMITH, J. (British) [SMITH, J. 2]
Photos dated: c1880
Processes:      Albumen, photogravure
Formats:        Prints
Subjects:       Topography, portraits
Locations:      Great Britain
Studio:         England - Warminster
   Entries:
Christies Lon 6/26/80: 157 (lot, S-6 et al);
Harris Baltimore 7/31/81: 292 (S & Caswall, 3);

SMITH, J.E. (American)
Photos dated: Nineteenth century
Processes:      Tintype
Formats:        Plates
Subjects:       Portraits
Locations:      Studio
Studio:         US - Philadelphia, Pennsylvania
   Entries:
Rinhart NY Cat 6, 1973: 235;

SMITH, J. Rennie (American)
Photos dated: 1891
Processes:      Albumen
Formats:        Prints
Subjects:       Topography
Locations:      US - New York City
Studio:         US - Newark, New Jersey
   Entries:
Rinhart NY Cat 1, 1971: 381;

SMITH, Jackson (American)
Photos dated: c1890s
Processes:
Formats:        Prints
Subjects:       Architecture
Locations:      US - New Mexico
Studio:         US - Denver, Colorado
   Entries:
Swann NY 11/6/80: 237 (lot, S-1 et al)(note);

**SMITH, Joseph Walden** (American)
Photos dated: 1887-1889
Processes:      Albumen, albertype
Formats:        Cabinet cards
Subjects:       Portraits, documentary (maritime)
Locations:      US - Massachusetts
Studio:         US - Boston, Massachusetts
    Entries:
Wood Conn Cat 45, 1979: 216 (book, 31)(note);
Swann NY 11/5/81: 450 (album, 31);
Wood Conn Cat 49, 1982: 399 (book, 31)(note);

**SMITH, Joshua** (American)
Photos dated: 1871
Processes:      Albumen
Formats:        Prints incl. panoramas
Subjects:       Documentary (disasters)
Locations:      US - Chicago, Illinois
Studio:         US - Chicago, Illinois
    Entries:
Swann NY 11/11/76: 430 (lot, S-1 et al);
California Galleries 1/21/78: 299;
Sothebys NY 5/2/78: 24 (lot, S-1 et al);
Rose Boston Cat 5, 1980: 98 ill;
Christies NY 2/8/83: 41 (S & McGreer, 2);

**SMITH, T.M.**
Photos dated: 1853
Processes:      Salt
Formats:        Prints
Subjects:       Portraits
Locations:
Studio:
    Entries:
Rinhart NY Cat 7, 1973: 474;

**SMITH, Reverend Theophilus** (British)
Photos dated: 1858-1865
Processes:      Albumen
Formats:        Prints, stereos
Subjects:       Topography
Locations:      England - Sheffield
Studio:         England - Sheffield
    Entries:
Weil Lon 1946: 123 (book, 15);
Rinhart NY Cat 7, 1973: 114 ill(book, 16);
Witkin NY III 1975: 745 (book, 16);
Sothebys NY 2/25/75: 69 (books, S et al);
Sothebys Lon 3/21/75: 310 (book, 16), 310a
    (book, 16);
Witkin NY IV 1976: OP336 (book, 16);
Sothebys Lon 10/29/76: 172 (book, 16), 173
    (book, 16), 174 (book, 16);
Sothebys Lon 7/1/77: 32 (book, 16);
Sothebys Lon 6/28/78: 23 (book, 16);
Christies Lon 10/26/78: 211 (book, 16);
Christies NY 10/31/79: 27 (book);
Christies Lon 10/25/84: 118 (book, 16);

**SMITH, W.H.** (American)
Photos dated: 1890s
Processes:      Albumen
Formats:        Prints
Subjects:       Topography
Locations:      US - Cape Cod, Massachusetts
Studio:         US
    Entries:
Swann NY 11/5/81: 436 (lot, S et al);

**SMITH, W.H.H.** (American)
Photos dated: Nineteenth century
Processes:      Albumen
Formats:        Cdvs
Subjects:       Portraits
Locations:      Studio
Studio:         US - Lafayette, Indiana
    Entries:
Sothebys NY (Strober Coll.) 2/7/70: 263 (lot,
    S-1 et al);

**SMITH, W. Morris** (American)
Photos dated: 1865
Processes:      Albumen
Formats:        Prints
Subjects:       Documentary (Civil War)
Locations:      US - Civil War area
Studio:         US
    Entries:
Wood Conn Cat 41, 1978: 129 (book, S-1 et al)(note);
Wood Conn Cat 45, 1979: 113 (book, S-1 et al)(note);
Christies NY 5/16/80: 240 (note);
Sothebys NY 5/20/80: 278 (lot, S-1 et al);
Harris Baltimore 9/16/83: 87;

**SMITH, Sir William** (British)
Photos dated: 1870s and/or 1880s
Processes:      Albumen
Formats:        Prints
Subects:        Topography
Locations:      England
Studio:         England
    Entries:
California Galleries 4/2/76: 218 (lot, S et al),
    220 (lot, S-1 et al);

**SMYTH, Charles Piazzi** (British, 1812-1900)
Photos dated: early 1840s-1858
Processes:      Calotype, albumen
Formats:        Prints incl. panoramas, stereos
Subjects:       Topography, documentary (scientific)
Locations:      South Africa - Capetown; Egypt; Spain
                - Canary Islands
Studio:
    Entries:
Weil Lon Cat 4, 1944(?): 249 (book, 20)(note);
Weil Lon Cat 7, 1945: 174 (book, 20)(note);
Weil Lon Cat 14, 1949(?): 424 (book, 20)(note);
Swann NY 2/14/52: 307 (book, 20)(note);
Sothebys NY (Strober Coll.) 2/7/70: 35 (book, 20)
    (note);
Rinhart NY Cat 7, 1973: 115 (book, 19);
Vermont Cat 7, 1974: 761 (4 ills)(book, 20)(note);
Witkin NY II 1974: 232 (book, 20);
Sothebys Lon 3/8/74: 168 (book, 20)(note);
Edwards Lon 1975: 181 (book, 20);
Stern Chicago 1975(?): 51 ill(book, 20);

## SMYTH (continued)

Sothebys Lon 6/26/75: 220 (book, 20);
Wood Conn Cat 37, 1976: 179 (book, 20)(note);
Swann NY 4/1/76: 345 (book, 20)(note);
Christies Lon 6/10/76: 178 (book, 20);
Sothebys Lon 6/11/76: 5 (book, 20);
Vermont Cat 11/12, 1977: 529 ill(book, 20)(note);
Christies Lon 6/30/77: 144 (book, 20);
Sothebys Lon 7/1/77: 5 (book, 20);
Christies Lon 10/27/77: 204 (book, 20);
Sothebys Lon 11/18/77: 19 (book, 20);
Wood Conn Cat 42, 1978: 472 (book, 20)(note);
Christies Lon 3/16/78: 196 (book, 20);
Sothebys Lon 3/22/78: 6 (book, 20);
Lehr NY Vol 1:4, 1979: 51 (book, 20)(note);
Swann NY 4/26/79: 178 ill(book, 20)(note);
Phillips Can 10/4/79: 8 (book, 20);
Swann NY 10/18/79: 201 ill(book, 20)(note);
Sothebys Lon 3/21/80: 69 (book, 20);
Sothebys NY 5/20/80: 346 (book, 20)(note);
Christies Lon 6/26/80: 297 (book, 20);
Christies Lon 10/30/80: 94 (book, 20);
Sothebys Lon 6/17/81: 448 (book, 20);
Christies Lon 6/18/81: 404 ill, 405 ill;
Christies Lon 10/29/81: 285 (book, 19);
Wood Conn Cat 49, 1982: 401 (book, 20)(note);
Christies Lon 3/11/82: 245 ill(book, 5)(note);
Swann NY 4/1/82: 202 ill(book, 20)(note);
Phillips Lon 6/23/82: 55 (books, S-20 et al);
Christies Lon 6/24/82: 237 (19);
Phillips Lon 10/27/82: 22 (books, S-20 et al);
Christies Lon 6/23/83: 21 (book, 20);
Christies Lon 10/27/83: 15 (book, 20);
Christies Lon 3/29/84: 47 (book, 20);
Harris Baltimore 6/1/84: 232 ill(book, 20);
Christies Lon 6/28/84: 42 (book, 20);
Sothebys Lon 6/28/85: 220 (book, 20);

## SNELL, William (American)

Photos dated: 1850s
Processes:      Daguerreotype
Formats:        Plates
Subjects:       Portraits
Locations:      Studio
Studio:         US - Salem, Massachusetts
    Entries:
Rinhart NY Cat 1, 1971: 46;

## SNELLING, Henry Hunt (American, 1817-1917)

Photos dated: c1858
Processes:      Daguerreotype, crystallotype
Formats:        Plates, prints
Subjects:       Portraits, genre
Locations:      US
Studio:         US - New York City
    Entries:
Christies NY 11/11/85: 390 ill(attributed)(note);

## SNOAD, George R. (American)

Photos dated: c1895
Processes:      Albumen
Formats:        Prints
Subjects:       Documentary (public events)
Locations:      US - St. Paul, Minnesota
Studio:         US - St. Paul, Minnesota
    Entries:
Rinhart NY Cat 7, 1973: 475 (3);

## SOAME, James (British)

Photos dated: 1858
Processes:      Albumen
Formats:        Prints
Subjects:       Portraits
Locations:      Studio
Studio:         England - London
    Entries:
Christies Lon 3/16/78: 294 ill(note);
Sothebys Lon 6/28/78: 134 ill;
Sothebys Lon 3/14/79: 321 ill(note), 322 ill;

## SODBELL, S.A. (American)

Photos dated: early 1850s
Processes:      Daguerreotype
Formats:        Plates
Subjects:       Portraits
Locations:      Studio
Studio:         US - Lebanon, Oregon
    Entries:
Sothebys NY 11/21/70: 247 ill;

## SOHUTAMARKO (Japanese)

Photos dated: 1870s
Processes:      Albumen
Formats:        Prints
Subjects:       Portraits, ethnography
Locations:      Studio
Studio:         Japan
    Entries:
Sothebys Lon 6/17/81: 192 (35);
Sothebys Lon 10/28/81: 318 (29);
Sothebys Lon 3/15/82: 104 ill(24);
Sothebys Lon 6/25/82: 81 ill;
Sothebys Lon 10/29/82: 34 ill(15);
Sothebys Lon 6/24/83: 32 ill(6);
Christies Lon 6/28/84: 241 (8);

## SOLER

Photos dated: 1880s
Processes:      Albumen
Formats:        Prints
Subjects:       Topography
Locations:      Africa - north
Studio:
    Entries:
Christies Lon 4/24/86: 385 (lot, S-5 et al);

## SOLOMON (see PHILP & SOLOMON)

## SOLON, L.

Photos dated: 1881
Processes:      Albumen
Formats:        Prints
Subjects:
Locations:
Studio:
    Entries:
Wood Boston Cat 58, 1986: 136 (books, S-1 et al);

**SOMERS, W.H.** (American)
Photos dated: 1885
Processes: Albumen
Formats: Cabinet cards
Subjects: Portraits
Locations: Studio
Studio: US
   Entries:
Harris Baltimore 2/14/86: 77;

**SOMERS-COCKS, Lord Charles** (Viscount Eastnor)
             (British)
Photos dated: c1860-c1868
Processes: Albumen
Formats: Prints
Subjects: Portraits
Locations: England
Studio: England
   Entries:
Sothebys Lon 6/21/74: 27 (album, S et al)(note);
Colnaghi Lon 1976: 150 ill(note);
Sothebys Lon 3/19/76: 224 ill(note);
Sothebys Lon 11/18/77: 286 ill;
Sothebys Lon 6/28/78: 135 (2)(attributed);
Christies Lon 10/25/79: 367 ill(note;

**SOMMER, Giorgio** (Italian, 1834-1914)
Photos dated: 1860-c1890
Processes: Albumen
Formats: Prints, cdvs, stereos, cabinet cards
Subjects: Topography, documentary (art)
Locations: Italy; Switzerland; Greece
Studio: Italy - Naples
   Entries:
Goldschmidt Lon Cat 52, 1939: 179 (album, 48)(note);
Rinhart NY Cat 2, 1971: 370 (10);
Sothebys Lon 12/21/71: 177 (10);
Rinhart NY Cat 6, 1973: 2 (album, S et al);
Witkin NY I 1973: 554 (album, 24);
Sothebys Lon 12/4/73: 165 (lot, S et al);
Vermont Cat 7, 1974: 742 ill(album, S-40 et al);
Witkin NY II 1974: 905 (3);
Edwards Lon 1975: 43 (album, 51);
Vermont Cat 9, 1975: 581 ill(8);
Sothebys NY 2/25/75: 138 (lot, S-11 et al), 141 (lot, S et al);
Sothebys Lon 6/26/75: 118 (albums, S et al);
Swann NY 9/18/75: 297 (22);
Sothebys NY 9/23/75: 74 (album, S et al);
California Galleries 9/27/75: 389 (lot, S, S & Behles, et al), 560 (14);
Kingston Boston 1976: 225 ill(6);
Witkin NY IV 1976: 243 ill, AL3 ill(album, S et al);
Wood Conn Cat 37, 1976: 219 (album, S-80 et al) (note), 220 (album, S-19 et al), 221 ill(album, 61), 250 (album, S et al);
California Galleries 4/2/76: 156 (album, S et al), 257 (lot, S, S & Behles, et al);
California Galleries 4/3/76: 282 (lot, S-3 et al);
Sothebys NY 5/4/76: 76 (4);
Christies Lon 6/10/76: 62 (lot, S et al), 89 (albums, S et al);
Christies Lon 10/28/76: 112 (album, 46);
Sothebys NY 11/9/76: 51 ill(album, S-22 et al) (note);
Swann NY 11/11/76: 380 (album, S et al), 392 (album, S-5 et al)(note), 407 (album, S et al), 450 (lot, S et al);

**SOMMER** (continued)
Rose Boston Cat 2, 1977: 72 ill(2)(note), 73 ill, 74 ill, 75 ill, 76 ill;
California Galleries 1/22/77: 170 (album, S et al), 180 (album, S et al), 321 (lot, S-1 et al);
Swann NY 4/14/77: 191 (lot, S et al), 245 (album, S et al);
Christies Lon 6/30/77: 95 (albums, S et al);
Swann NY 12/8/77: 383 (album, S et al);
Rose Boston Cat 3, 1978: 58 ill(note), 59 ill, 60 ill;
Witkin NY VI 1978: 113 ill(attributed)(note);
Wood Conn Cat 42, 1978: 553 (album, S et al)(note);
California Galleries 1/21/78: 112 (lot, S et al), 258 (lot, S-1 et al);
Christies Lon 3/16/78: 51 (lot, S-2 et al), 77 (albums, S et al);
Swann NY 4/20/78: 291 (album, S et al), 328 (lot, S et al);
Christies Lon 10/26/78: 147 (lot, S et al);
Sothebys Lon 10/27/78: 84 (album, 12);
Mancini Phila 1979: 27;
Phillips Lon 3/13/79: 62 (album, S et al);
Christies Lon 3/15/79: 84 (lot, S & Behles et al), 187 (albums, S-4 et al);
Christies Lon 6/28/79: 138 (albums, S et al);
Sothebys Lon 6/29/79: 121 (lot, S-11 et al);
Christies Lon 10/25/79: 166 (album, S et al), 238 (albums, S et al), 242 (lot, S-3 et al), 245 (album, S et al);
Phillips NY 11/29/79: 275 (album, S et al);
Christies Lon 3/20/80: 209 (album, S et al);
California Galleries 3/30/80: 327 (lot, S-1 et al), 377 (5);
Christies NY 5/16/80: 185 (lot, S et al), 186 (30), 187 (lot, S et al), 189 (lot, S et al);
Phillips NY 5/21/80: 134 (album, 20), 142 (album, S et al), 230 (lot, S et al);
Auer Paris 5/31/80: 95 (albums, S-6 et al);
Christies Lon 6/26/80: 201 (lot, S et al), 270 (albums, S et al), 278 (albums, S et al);
Christies Lon 10/30/80: 137 (lot, S et al), 188 (album, 40), 189 (albums, S et al), 197 (lot, S-3 et al), 203 (lot, S-9 et al), 272 (album, S et al);
Swann NY 11/6/80: 283 (lot, S et al);
Christies NY 11/11/80: 71 (albums, S et al), 200 (lot, S et al);
California Galleries 12/13/80: 345 (7);
Christies Lon 3/26/81: 130 (lot, S & Behles-12, et al), 182 (lot, S et al);
Swann NY 4/23/81: 461 (lot, S et al);
Phillips NY 5/9/81: 50 (albums, S et al), 65 (album, S attributed et al);
California Galleries 6/28/81: 136 (album, S-2 et al), 261 (lot, S-3 et al);
Harris Baltimore 7/31/81: 100 (lot, S et al), 123 (113);
Phillips Lon 10/28/81: 157 (lot, S-1 et al);
Christies Lon 10/29/81: 139 (lot, S & Behles-12, et al), 147 (lot, S et al);
Swann NY 11/5/81: 464 (album, S et al)(note), 495 (lot, S-1 et al), 500 (albums, S et al);
Petzold Germany 11/7/81: 185 (lot, S et al), 243 (lot, S-25 et al), 315 (album, 9), 326 (lot, S et al);
Rose Florida Cat 7, 1982: 36 ill(note);
Christies Lon 3/11/82: 83 (lot, S & Behles et al), 138 (lot, S et al);
Sothebys Lon 3/15/82: 82 ill(album, 35)(attributed);

## SOMMER (continued)

Harris Baltimore 3/26/82: 263, 264 (lot, S-11 et al);
Swann NY 4/1/82: 288 (albums, S et al)(note);
California Galleries 5/23/82: 184 (album, S-2 et al), 194 (album, S et al), 331 (lot, S-1 et al);
Phillips Lon 6/23/82: 40 (lot, S et al), 41 (album, 12);
Christies Lon 6/24/82: 131 (5), 175 (lot, S et al);
Phillips NY 9/30/82: 993 ill(album, S-30 et al), 1042 (lot, S et al);
Phillips Lon 10/27/82: 29 (lot, S et al), 33 (lot, S et al);
Christies Lon 10/28/82: 30 (lot, S & Behles et al), 63 (albums, S et al);
Swann NY 11/18/82: 403 (lot, S et al), 454 (lot, S, S & Behles, et al);
Harris Baltimore 12/10/82: 391 (albums, S et al), 399 (lot, S et al), 400 (albums, S-1 et al);
Bievres France 2/6/83: 122 (albums, S et al), 140 (31);
Christies NY 2/8/83: 34 (lot, S et al);
Christies Lon 3/24/83: 136 (albums, S et al), 143 (albums, S et al);
Harris Baltimore 4/8/83: 44 (lot, S et al), 289 (album, S et al);
Swann NY 5/5/83: 291 (album, S & Behles et al), 344 (albums, S et al), 380 (albums, S et al)(note), 402 (albums, S et al)(note), 444 (260)(note);
Christies Lon 6/23/83: 13 (lot, S-1 et al), 61 (lot, S-5 et al), 91 (lot, S-1 et al), 100 (album, S et al), 178 (album, S et al);
Christies NY 10/4/83: 101 (albums, S et al);
Christies Lon 10/27/83: 43 (lot, S & Behles-31, et al);
Swann NY 11/10/83: 304 (albums, S et al)(note), 348 (lot, S & Behles et al);
Harris Baltimore 12/16/83: 67 (lot, S & Behles et al), 128 (lot, S & Behles et al);
Christies Lon 3/29/84: 55 (lot, S et al), 322 (album, S-1 et al);
Swann NY 5/10/84: 187 (lot, S et al);
Harris Baltimore 6/1/84: 53 (lot, s et al), 357 (albums, S et al);
Christies Lon 6/28/84: 74 (lot, S et al), 140 (album, S et al);
Sothebys Lon 6/29/84: 8 (lot, S et al);
California Galleries 7/1/84: 649 (2), 650 (5);
Christies Lon 10/25/84: 103 (album, S et al), 110 (albums, S et al);
Swann NY 11/8/84: 200 (albums, S et al), 201 (albums, S et al), 284 (lot, S et al);
Christies NY 2/13/85: 142 (lot, S-1 et al);
Harris Baltimore 3/15/85: 51 (lot, S-6 et al);
Phillips Lon 3/27/85: 143 (lot, S-15 et al);
Christies Lon 3/28/85: 43 (lot, S & Behles et al), 62 (album, S et al), 101 (album, S-17 et al);
Swann NY 5/9/85: 386 (albums, S et al)(note);
California Galleries 6/8/85: 268 (lot, S et al);
Christies Lon 6/27/85: 93 (lot, S et al);
Sothebys Lon 6/28/85: 3 (lot, S et al);
Christies Lon 10/31/85: 87 (albums, S et al);
Christies NY 11/11/85: 295 (lot, S-1 et al);
Swann NY 11/14/85: 148 (albums, S et al), 162 (lot, S et al);
Harris Baltimore 2/14/86: 19 (lot, S et al), 210 (albums, S et al), 213 (album, S et al);
Phillips Lon 4/23/86: 185 (lot, S & Behles-4, et al);
Christies Lon 4/24/86: 344 (lot, S et al), 380 (album, S-1 et al);

## SOMMER (continued)

Swann NY 5/16/86: 202 (album, S & Behles et al), 263 (albums, S-23 et al), 264 (lot, S et al), 265 (lot, S et al), 293 ill(albums, 115)(note);
Christies Lon 6/26/86: 66 (lot, S & Behles et al);
Christies Lon 10/30/86: 224 (album, S et al);
Harris Baltimore 11/7/86: 260 (lot, S et al);
Swann NY 11/13/86: 216 (albums, S et al), 218 (lot, S et al), 244 (album, S et al), 245 (lot, S et al), 317 ill(albums, 147), 357 (lot, S et al);

## SONNTAG

Photos dated: 1880s
Processes: Albumen
Formats: Prints
Subjects: Topography
Locations: Europe
Studio: Europe
Entries:
Swann NY 11/13/86: 216 (albums, S et al);

## SONREL, A. (American)

Photos dated: 1860s-1870s
Processes: Albumen
Formats: Prints, cdvs
Subjects: Portraits
Locations: Studio
Studio: US - Boston, Massachusetts
Entries:
Rose Boston Cat 3, 1978: 15 ill(note);

## SOUANCE, Charles de (see MIEUSEMENT)

## SOUDER, S.T. (American)

Photos dated: 1872-1870s
Processes: Albumen
Formats: Stereos
Subjects: Topography
Locations: US - Fort Sumter, South Carolina
Studio: US - Charleston, South Carolina
Entries:
Swann NY 4/14/77: 119 (lot, S-1 et al);

## SOULE, G.

Photos dated: 1870s-c1890
Processes: Albumen
Formats: Prints
Subjects: Topography
Locations: France - Luchon
Studio: France
Entries:
Rinhart NY Cat 7, 1973: 477 (2);
California Galleries 9/27/75: 342;

**SOULE, John P.** (American)
Photos dated: 1861-1871
Processes: Albumen
Formats: Prints, stereos, cdvs
Subjects: Topography, documentary (disasters)
Locations: US - California; New Hampshire; Maine; Massachusetts
Studio: US - Boston, Massachusetts
Entries:
Swann NY 2/14/52: 60 (book, 10)(note);
Sothebys NY (Weissberg Coll.) 5/16/67: 184 (lot, S-5 et al);
Sothebys NY (Strober Coll.) 2/7/70: 452 (lot, S-4 et al), 466 (lot, S-19 et al), 467 (lot, S et al), 471 (lot, S-3 et al), 472 (lot, S-22 et al) (note), 473 (13), 480 (lot, S et al), 481 (lot, S et al), 501 (lot, S et al), 512 (lot, S-2 et al), 521 (lot, S et al), 525 (lot, S et al), 549 (lot, S-1 et al), 552 (11)(note);
Rinhart NY Cat 1, 1971: 174, 241 (lot, S et al), 273 (3), 274 (2), 275 (2), 276 (2), 292 (lot, S et al), 527 (book, 10);
Rinhart NY Cat 2, 1971: 543 (lot, S-2 et al);
Vermont Cat 1, 1971: 235 (lot, S et al);
Vermont Cat 2, 1971: 227 (lot, S et al), 236 ill (11), 237 (2);
Rinhart NY Cat 6, 1973: 386, 508 (3), 599, 612;
Rinhart NY Cat 7, 1973: 226, 227, 228, 261, 304, 305, 306, 339;
Witkin NY I 1973: 193 (book, 10);
Witkin NY II 1974: 216 (book, 10);
Witkin NY III 1975: 748 (book, 10);
California Galleries 9/27/75: 457 (lot, S et al), 470 (lot, S et al), 513 (lot, S-6 et al), 580 (lot, S et al);
Witkin NY IV 1976: S11 ill, OP338 (book, 10);
Wood Conn Cat 37, 1976: 120 (book, 10)(note);
Swann NY 4/1/76: 372 (book, 10)(note);
California Galleries 4/3/76: 412 (lot, S-5 et al), 435 (lot, S-9 et al);
Sothebys NY 5/4/76: 125 ill(3)(attributed)(note), 126 (2)(attributed), 127 (2)(attributed), 128 (3) (attributed);
Sothebys NY 11/9/76: 107 (book, 10);
Swann NY 11/11/76: 272 (book, 10)(note);
California Galleries 1/23/77: 364 (lot, S et al), 411 (lot, S-6 et al), 454 (lot, S et al);
Swann NY 4/14/77: 113 (book, 10)(note);
Sothebys NY 5/20/77: 8 (book, 10)(note);
Sothebys Lon 7/1/77: 65 ill (book, 10);
Sothebys NY 10/4/77: 48 (book, 10);
Swann NY 12/8/77: 102 (book, 9)(note);
Frontier AC, Texas 1978: 282 (note);
Wood Conn Cat 42, 1978: 291 (book, 10)(note);
Swann NY 12/14/78: 322 ill(32)(note), 323 (32) (note), 324 (34)(note), 325 (2)(note), 326 ill (36), 327 (35), 328 (40), 329 (53), 330 (54);
Lehr NY Vol 1:4, 1979: 39 (book, 10);
Witkin NY IX 1979: 2/72 (book, 10);
California Galleries 1/21/79: 292 (lot, S et al);
Sothebys LA 2/7/79: 418 (book, 10);
Swann NY 4/26/79: 450 (20)(note);
Swann NY 10/18/79: 427 ill(5)(note), 435 (lot, S et al)(note);
Phillips NY 11/3/79: 86 (book, 10)(note);
Witkin NY X 1980: 65 (book, 10);
California Galleries 12/13/80: 346 ill;
Swann NY 4/23/81: 536 (161)(note);
Christies Lon 6/18/81: 78 (lot, S-5 et al);
California Galleries 6/28/81: 104 ill(book, 10) (note);

**SOULE, J.P.** (continued)
Harris Baltimore 7/31/81: 85 (lot, S et al), 111 (lot, S-2 et al), 128 (lot, S et al);
Rose Florida Cat 7, 1982: 96 ill(4);
Wood Conn Cat 49, 1982: 248 (book, 10)(note);
Harris Baltimore 3/26/82: 15 (25), 356 (attributed);
Swann NY 4/1/82: 357 (lot, S et al);
California Galleries 5/23/82: 126 ill(book, 10), 388, 389, 402 (lot, S et al), 409 (lot, S-1 et al);
Swann NY 11/18/82: 447 (lot, S-8 et al);
Harris Baltimore 12/10/82: 19 (lot, S et al), 60 (lot, S et al), 69 (lot, S et al), 79 (lot, S-7 et al), 116 (lot, S et al);
Harris Baltimore 4/8/83: 12 (12), 62 (lot, S et al), 67 (lot, S et al);
California Galleries 6/19/83: 73 (book, 10)(note), 430 (lot, S-1 et al);
Swann NY 11/10/83: 144 (book, 9), 346 (lot, S et al), 353 (lot, S et al);
Harris Baltimore 12/16/83: 20 (lot, S et al), 36 (lot, S et al), 124 (48), 141 (lot, S et al), 194 (book, 10)(note);
Swann NY 5/10/84: 133 (book, 10), 134 (book, 10);
Harris Baltimore 6/1/84: 15 (lot, S et al), 31 (lot, S et al), 99 (lot, S et al), 109 (lot, S et al), 119 (lot, S et al), 148 (lot, S et al), 156 (lot, S et al);
California Galleries 7/1/84: 651;
Swann NY 11/8/84: 115 (book, 10), 252 (lot, S et al);
Harris Baltimore 3/15/85: 12 (lot, S et al), 13 (lot, S-1 et al), 67 (lot, S et al), 68 (lot, S et al), 75 (lot, S-12 et al), 86 (lot, S-6 et al), 108 (lot, S-1 et al);
Swann NY 5/16/86: 304 (lot, S et al);
Phillips NY 7/2/86: 355 (book, 10);
Phillips Lon 10/29/86: 247 (lot, S-18 et al);

**SOULE, William Stinson** (American, 1836-1908)
Photos dated: 1861-1902
Processes: Albumen
Formats: Prints, stereos
Subjects: Topography, ethnography
Locations: US - American west
Studio: US - Fort Dodge, Kansas; Fort Sill, Oklahoma
Entries:
Sothebys NY 11/21/70: 221 ill(note), 222 ill(note), 223 ill(note), 224 ill(note), 225 ill(note);
Lehr NY Vol 2:2, 1979: 32 ill(note);
Sothebys LA 2/7/79: 458 ill(note), 459 (note), 460 (note), 461 ill(note), 462 ill(note), 463 (note), 464 (note), 465 (note), 466 (note), 467 ill(note), 468 ill(note), 469 ill(note), 470 (note), 471 ill(note), 472 (note), 473 (note);
Christies NY 5/4/79: 105, 106;
Sothebys LA 2/6/80: 68 ill, 69 ill;
Christies NY 11/8/82: 208 ill(note), 209 ill(note);
Sothebys NY 11/10/82: 356 ill(4)(note);
Drouot Paris 11/27/82: 113 ill;
Christies NY 5/7/84: 225 ill(12)(note);
Swann NY 11/13/86: 299 (lot, S-1 attributed, et al);

**SOULIER, Charles** (French, c1840-c1875)(see also
FERRIER & SOULIER; CLOUZARD)
Photos dated: 1852-c1880
Processes:      Albumen, collodion on glass,
                photoglyph
Formats:        Prints, glass stereo plates
Subjects:       Topography, documentary (Paris
                Commune, military)
Locations:      France; Italy; Austria
Studio:         France - Paris
   Entries:
Rauch Geneva 12/24/58: 206 (lot, S-12 et al);
Sothebys NY 2/25/75: 18 (lot, S & Clouzard-1,
   attributed, et al), 138 (lot, S-1 et al);
Kingston Boston 1976: 183 (album, S attributed et
   al), 226 ill(note);
Sothebys NY 5/20/77: 97 (lot, S-3 et al);
Christies Lon 6/30/77: 302;
Sothebys NY 10/4/77: 200 ill(note);
Wood Conn Cat 41, 1978: 26 ill(note), 27 ill;
Christies Lon 6/27/78: 77;
Christies Lon 10/26/78: 119;
California Galleries 3/30/80: 378 ill;
Phillips NY 5/21/80: 230 (lot, S et al);
Sothebys Lon 6/17/81: 333;
Christies Lon 10/25/84: 181 (note), 182 ill(note),
   183 ill(note);
Christies Lon 3/28/85: 160 ill;
Christies Lon 10/31/85: 71 (lot, S-1 et al);
Sothebys Lon 4/25/86: 82 (lot, s-1 et al)(note);
Christies Lon 10/30/86: 105 ill;

**SOUTHWELL** (British) [SOUTHWELL 1]
Photos dated: c1860
Processes:      Ambrotype
Formats:        Plates
Subjects:       Portraits
Locations:      Studio
Studio:         England - London
   Entries:
Christies Lon 10/26/78: 54;

**SOUTHWELL Brothers** (British) [SOUTHWELL 2]
Photos dated: early 1860s
Processes:      Albumen
Formats:        Cdvs
Subjects:       Portraits
Locations:      Studio
Studio:         England - London
   Entries:
Sothebys NY (Strober Coll.) 2/7/70: 261 (lot,
   S-1 et al);
Sothebys Lon 10/24/75: 262 (album, S et al);
Witkin NY IV 1976: AL21 (album, S et al);
Sothebys Lon 6/11/76: 96 (album, S et al), 170
   (album, S et al);
Sothebys Lon 3/9/77: 123 (album, S et al);
Sothebys Lon 7/1/77: 243 (album, S et al);
Christies Lon 6/28/79: 218 (album, S-1 et al)(note);
Sothebys Lon 6/29/79: 257 (lot, S et al);
Sothebys Lon 10/24/79: 319 (lot, S et al);
Sothebys Lon 10/29/80: 261 (album, S et al);
Christies Lon 10/30/80: 407 (album, S et al), 425
   (album, S et al);
Christies Lon 3/11/82: 316 (album, S et al);
Christies Lon 3/29/84: 334 (album, S et al);
Sothebys Lon 10/26/84: 178 (albums, S et al);
Christies Lon 6/27/85: 272 (album, S et al);
Phillips Lon 10/30/85: 32 (lot, S-5 et al);

**SOUTHWELL Brothers** (continued)
Swann NY 11/14/85: 137 (album, S et al);
Phillips Lon 4/23/86: 224 (album, S-1 et al);
Phillips Lon 10/29/86: 296 (album, S-1 et al);

**SOUTHWORTH, Albert Sands** (American, 1811-1894)
   & **HAWES, Josiah Johnson** (American,
   1808-1901)
Photos dated: c1842-c1857
Processes:      Daguerreotype, salt, albumen
Formats:        Plates, Prints, cdvs
Subjects:       Portraits, topography
Locations:      US - Boston, Massacusetts; Niagara
                Falls, New York
Studio:         US - Boston, Massachusetts
   Entries:
Sothebys NY 10/4/77: 105 ill(2)(note);
IMP/GEH 10/20/77: 338 ill, 339 ill;
Christies NY 5/4/79: 76 ill(note);
Sothebys NY 12/19/79: 86 ill(note);
Christies NY 5/16/80: 224 ill(note), 225 ill(note),
   226 ill(note), 227 ill(note), 228 ill(note);
Christies NY 5/14/81: 42 ill(note), 43 ill(note);
Sothebys NY 10/21/81: 197 ill(note), 294 ill(note);
Christies NY 11/10/81: 34 ill, 35 ill(note), 36 ill,
   37 ill(note), 38 ill(note), 39, 40;
Harris Baltimore 3/26/82: 221 (note);
Harris Baltimore 12/16/83: 314 (attributed)(note);
Sothebys Lon 6/29/84: 44;
Sothebys Lon 3/29/85: 39 ill;
Christies NY 11/11/86: 362 ill;

**SOUTHEY, Reginald**
Photos dated: c1860
Processes:      Albumen
Formats:        Prints
Subjects:       Portraits
Locations:      Great Britain
Studio:         Great Britain
   Entries:
Sothebys Lon 11/18/77: 273 ill(album, S-1
   attributed, et al);

**SPACKMAN, Sargeant B.L.** (British)
Photos dated: 1850s-1856
Processes:      Albumen
Formats:        Prints
Subjects:       Documentary (art)
Locations:      England - London
Studio:         England - London
   Entries:
Christies Lon 10/27/83: 219 ill(album)(note);

**SPALDING, J.** (British)
Photos dated: 1860s
Processes:      Albumen
Formats:        Prints
Subjects:       Topography
Locations:      Great Bitain - Glen Ken
Studio:         Great Britain
   Entries:
Sothebys NY 5/20/77: 62 (albums, S et al);

SPALKE & KLUGE (German)
Photos dated: Nineteenth century
Processes:      Albumen
Formats:
Subjects:       Portraits
Locations:      Studio
Studio:         Germany - Augsburg
    Entries:
Petzold Gemany 5/22/81: 1977 (album, S & K et al);

SPANTON, W. (British)
Photos dated: 1860s
Processes:      Albumen
Formats:        Stereos
Subjects:       Topography
Locations:      Great Britain
Studio:         Great Britain
    Entries:
Christies Lon 6/24/82: 71 (lot, S et al);
Christies Lon 6/23/83: 57 (lot, S-2 et al);
Sothebys Lon 10/26/84: 3 (lot, S et al);

SPARHAWK, L.T. (American)
Photos dated: 1870s
Processes:      Albumen
Formats:        Stereos
Subjects:       Topography
Locations:      US - White Mountains, New Hampshire
Studio:         US - West Randolph, Vermont
    Entries:
Swann NY 5/5/83: 446 (lot, S et al);

SPENCER (see BISCHOFF & SPENCER)

SPENCER, C.
Photos dated: Nineteenth century
Processes:      Albumen
Formats:        Prints
Subjects:       Topography
Locations:      New Zealand (?)
Studio:
    Entries:
Christies Lon 10/29/81: 280 (album, S et al);

SPENCER, D.H. (American)
Photos dated: 1860s
Processes:      Ambrotype
Formats:        Plates
Subjects:       Portraits
Locations:      Studio
Studio:         US - Hudson, New york
    Entries:
California Galleries 1/21/78: 16 (lot, S-1 et al);
California Galleries 1/2/79: 225 (lot, S-1 et al);

SPENCER, J.A. (British)
Photos dated: 1856
Processes:      Albumen
Formats:        Prints
Subjects:       Documentary (art)
Locations:      England - London
Studio:         Great Britain
    Entries:
Weil Lon Cat 7, 1945: 194 (book, 9)(note);
Weil Lon Cat 14, 1949(?): 439 (book, 9)(note);

SPENCER, J.A. (continued)
Swann NY 2/14/52: 201 (book, 9);
Sothebys Lon 10/18/74: 257 (books, S-9 et al);
Edwards Lon 1975: 209 (book, 9);
Swann NY 9/18/75: 427 (book, 9);
Sothebys Lon 10/29/76: 60 (books, S-9 et al);
Christies Lon 3/16/78: 195 (book, 9);
Wood Conn Cat 45, 1979: 261 (book, 9)(note);
Christies Lon 6/18/81: 247 (book, 9);
Wood Conn Cat 49, 1982: 505 (book, 9)(note);
Sothebys Lon 3/15/82: 442 (book, 9);
Christies Lon 4/24/86: 415 (book, 9);

SPIELER, William F. (American)
Photos dated: 1844-1860
Processes:      Daguerreotype, albumen
Formats:        Plates, stereos, cdvs
Subjects:       Portraits
Locations:      Studio
Studio:         US - Philadelphia, Pennsylvania
    Entries:
Swann NY 11/10/83: 242 (lot, S et al)(note);

SPIERS, R.P. (British)
Photos dated: c1850-1860s
Processes:      Albumen
Formats:        Prints, stereos
Subjects:       Genre (nature), documentary
                (engineering)
Locations:      England - Oxford
Studio:         Great Britain
    Entries:
Christies Lon 6/18/81: 406;
Sothebys Lon 6/29/84: 10 (lot, S et al);

SPITHOVER, Joe. (German)
Photos dated: 1850s-late 1860s
Processes:      Albumen
Formats:        Prints, stereos
Subjects:       Topography
Locations:      Italy - Rome
Studio:         Italy - Rome
    Entries:
Sothebys Lon 12/4/73: 28 (album, S et al);
California Galleries 9/27/75: 564 (14);
Christies Lon 10/26/78: 117 (11);
Phillips Lon 3/13/79: 58 ill(album, 18);
Sothebys Lon 10/24/79: 348 (7);
Sothebys Lon 3/21/80: 369 (12, attributed);
Christies Lon 3/26/81: 133 (lot, S-1 et al);
Swann NY 4/23/81: 526 (lot, S et al);
Christies Lon 6/18/81: 103 (lot, S-3 et al);
Christies Lon 3/11/82: 90 (lot, S-3 et al), 94 (lot,
    S et al);
Christies Lon 10/28/82: 54 (lot, S-4 et al);
Christies Lon 3/24/83: 82 (lot, S et al);
Harris Baltimore 4/8/83: 44 (lot, S et al);
Christies Lon 6/23/83: 90, 93 (lot, S-13 et al),
    107 (lot, S-14 et al);
Sothebys Lon 6/24/83: 18 (lot, S et al), 40 ill,
    41 ill;
Christies Lon 10/27/83: 67 (lot, S-3 et al);
Swann NY 11/10/83: 348 (lot, S et al);
Christies Lon 3/29/84: 148 (lot, S-14 et al);
Christies Lon 10/25/84: 50 (lot, S et al);
Sothebys Lon 3/29/85: 106 ill(9);
Christies NY 2/13/85: 142 (lot, S-1 et al);
Phillips Lon 3/27/85: 146 (lot, S-3 et al);

**SPITHOVER** (continued)
Phillips Lon 6/26/85: 124 (lot, S-3 et al);
Christies Lon 6/27/85: 35 (92), 63 (lot, S-1 et
al), 149 (lot, S-1 et al);
Christies Lon 10/31/85: 193 (lot, S-7 et al);
Sothebys Lon 4/25/86: 57 (lot, S et al), 65 (lot,
S et al), 73 (lot, S et al);
Sothebys Lon 10/31/86: 60 (lot, S et al);

**SPITZ**
Photos dated: c1875
Processes:      Albumen
Formats:        Prints
Subjects:       Genre
Locations:
Studio:
    Entries:
Rinhart NY Cat 1, 1971: 429;

**SPITZ, Charles**
Photos dated: c1883-1890s
Processes:      Albumen
Formats:        Prints
Subjects:       Topography, ethnography
Locations:      Tahiti
Studio:
    Entries:
California Galleries 9/27/75: 344;
Christies NY 5/4/79: 56 (note), 57 ill, 58, 59;
California Galleries 5/23/82: 438 (attributed);
California Galleries 6/19/83: 397 ill(3)(note), 398
    (3), 399 (4), 400 (2), 401 (4), 402 ill, 403
    (4), 404 (2), 405 (2), 406 (3), 407 (4), 408
    ill(4), 409 ill, 410 (3), 411 ill(2), 412 ill
    (4), 413 (3), 414 ill(2), 415 (4), 416 (3);
California Galleries 7/1/84: 661 (2), 662 (3), 663
    (3), 664 (4), 665 (2), 666 (3), 667 (2), 668
    (4), 669 ill(3), 670 (4), 671 (4), 672 (4), 673
    (5), 674 (6), 675 (6), 676 (4), 677 (2);
California Galleries 6/8/85: 419 (3);

**SPODE, J.** (British)
Photos dated: Nineteenth century
Processes:      Albumen
Formats:        Prints
Subjects:       Topography
Locations:      Great Britain
Studio:         Great Britain
    Entries:
Christies Lon 3/28/85: 140 (2);

**SPOONER** (see REILLY, J.J.)

**SPOONER, D.B. & Co.** (American)
Photos dated: 1858
Processes:      Salt
Formats:        Prints
Subjects:       Portraits
Locations:      US - Amherst, Massachusetts
Studio:         US - Springfield, Massachusetts
    Entries:
Sothebys Lon 4/25/86: 220 ill(album, 65);

**SPOONER, John Pilcher** (American)
Photos dated: 1860s-1870s
Processes:      Albumen
Formats:        Prints, stereos
Subjects:       Topography
Locations:      US - California
Studio:         US - Stockton, California
    Entries:
Sothebys NY (Strober Coll.) 2/7/70: 356 (lot,
    S et al);
Harris Baltimore 12/10/82: 17 (lot, S-2 et al);

**SPOONER, W.M. & Co.** (British)
Photos dated: 1870s-1880s
Processes:      Albumen
Formats:        Prints
Subjects:       Documentary (scientific), topography
Locations:      England - London; Brazil - Rio de
                Janeiro; US - Niagara Falls, New York
Studio:         England - London
    Entries:
Swann NY 10/18/79: 262 (11)(note);
Christies Lon 10/25/79: 224 (lot, S-2 et al);
Christies Lon 6/18/81: 146 (lot, S-3 attributed
    et al);
Christies Lon 10/29/81: 174 (album, 26), 262
    (album, S-3 et al);
Christies Lon 3/28/85: 75 (album, S-1 et al);

**SPOONER, Zilpha H.** (American)(photographer or
                author?)
Photos dated: 1882
Processes:      Albumen
Formats:        Prints
Subjects:       Topography
Locations:      US - Plymouth, Massachusetts
Studio:         US
    Entries:
Wood Conn Cat 37, 1976: 182 (book, 6);
Wood Conn Cat 42, 1978: 479 (book, 6);

**SPREAFICIO, José** (Spanish)
Photos dated: mid 1860s-mid 1870s
Processes:      Albumen
Formats:        Prints, cdvs
Subjects:       Portraits, documentary (railroads)
Locations:      Spain - Malaga
Studio:         Spain - Malaga
    Entries:
Fraenkel Cal 1984: 64 ill(note), 65, 66;

**SPREAT, William** (British)
Photos dated: 1860s
Processes:      Albumen
Formats:        Stereos
Subjects:       Topography
Locations:      England - North Devon
Studio:         England - Exeter
    Entries:
Christies Lon 10/25/79: 91 (lot, S et al);
Christies Lon 3/26/81: 129 (lot, S-1 et al);
Christies Lon 6/18/81: 105 (lot, S-2 et al);
Christies Lon 10/29/81: 137 (lot, S et al);
Christies Lon 3/11/82: 65 (lot, S et al), 80
    (lot, S et al);
Christies Lon 6/24/82: 71 (lot, S et al);
Christies Lon 10/28/82: 17 (lot, S et al);

**SPREAT, W.** (continued)
Sothebys Lon 3/25/83: 4 (lot, S et al);
Sothebys Lon 6/29/84: 5 (lot, S et al);
Christies Lon 10/25/84: 52 (lot, S et al), 56
    (lot, S-12 et al);
Christies Lon 3/28/85: 43 (lot, S et al);
Sothebys Lon 3/29/85: 64 (lot, S et al);
Christies Lon 6/27/85: 36 (lot, S-12 et al);
Sothebys Lon 6/28/85: 1 (lot, S et al);
Christies Lon 4/24/86: 363 (lot, S-10 et al);

**SPROAT, R.J.** (British)(see also GARNETT, J.)
Photos dated: 1868
Processes:      Albumen
Formats:        Prints
Subjects:       Topography
Locations:      England - Lake District
Studio:         England
    Entries:
Swann NY 4/20/78: 120 (book, S et al);
Harris Baltimore 12/16/83: 42 (lot, S-5 et al);
Harris Baltimore 6/1/84: 64 (lot, S-2 et al);

**SPURGE** (British)
Photos dated: 1870s
Processes:      Albumen
Formats:        Prints
Subjects:       Topography
Locations:      England
Studio:         England
    Entries:
California Galleries 4/2/76: 217 (lot, S et al);
California Galleries 3/30/80: 299 (lot, S et al);

**SPURLING, S.** (British)
Photos dated: 1870s-1890s
Processes:      Albumen
Formats:        Prints
Subjects:       Topography
Locations:      Tasmania, Australia, and/or New
                Zealand
Studio:
    Entries:
Christies Lon 3/24/83: 134 (9);
Christies Lon 6/23/83: 180 (albums, S et al);
Christies Lon 3/29/84: 100 (albums, S et al);
Christies Lon 4/24/86: 407 (lot, S-3 et al);

**STABLER, Paul**
Photos dated: 1890s
Processes:
Formats:        Prints
Subjects:       Documentary (maritime)
Locations:
Studio:
    Entries:
Christies Lon 3/26/81: 337 (lot, S-11 et al);
Christies Lon 6/24/82: 160 (lot, S-11 et al);

**STACY George** (American)
Photos dated: 1850s-1860s
Processes:      Albumen
Formats:        Stereos, cdvs
Subjects:       Topography, documentary (Civil War)
Locations:      US - Niagara Falls, New York; Fort
                Monroe, Virginia
Studio:         US - New York City
    Entries:
Sothebys NY (Strober Coll.) 2/7/70: 551 (lot,
    S attributed et al);
Vermont Cat 11/12, 1977: 830 ill(2);
Swann NY 11/6/80: 388 (lot, S et al);
Christies Lon 3/26/81: 117 (lot, S et al), 125
    (lot, S-3 et al);
Harris Baltimore 12/10/82: 27 (lot, S et al);
Harris Baltimore 12/16/83: 11 (lot, S-2 et al);
Harris Baltimore 3/15/85: 76 (lot, S-2 attributed
    et al)(note);

**STADTFIELD, Maurice** (American)
Photos dated: 1864-1870s
Processes:      Albumen
Formats:        Prints, cdvs
Subjects:       Documentary (public events), genre
Locations:      US - New York City
Studio:         US
    Entries:
Witkin NY IV 1976: OP193 (book, S-2 et al);
Swann NY 11/11/76: 250 (book, S-2 et al);
Lehr NY Vol 1:4, 1978: 34 (book, S-2 et al);
Sothebys NY 5/8/79: 92 (lot, S-1 et al);
Swann NY 5/5/83: 122 (book, S-2 et al);

**STAFHELL & KLEINGROTHE**
Photos dated: Nineteenth century
Processes:      Gelatine silver
Formats:        Prints
Subjects:       Topography
Locations:      Sumatra
Studio:
    Entries:
Christies Lon 6/28/84: 249 (14);

**STAHL, Augusto**
Photos dated: 1853-1860s
Processes:      Calotype, albumen
Formats:        Prints
Subjects:       Topography, portraits
Locations:      Brazil - Pernambuco
Studio:         Brazil
    Entries:
Christies NY 10/31/79: 51 ill (lot, S et al);
Swann NY 4/17/80: 238 ill(note);
Christies NY 5/16/80: 192;
Swann NY 11/6/80: 252 ill(note);
Christies Lon 10/30/86: 151 (lot, S & Wahneschaffe
    et al);

STALLARD (American)
Photos dated: 1860s and/or 1870s
Processes:     Albumen
Formats:       Cdvs
Subjects:      Portraits
Locations:     Studio
Studio:        US - Lagoda, Indiana
   Entries:
Phillips Lon 10/29/86: 307 (lot, S-1 et al);

STANESBY, J.S.A. (British)
Photos dated: 1850s
Processes:     Daguerreotype
Formats:       Plates
Subjects:      Portraits
Locations:     Studio
Studio:        England - London
   Entries:
Christies Lon 10/31/85: 22 (lot, S-1 et al)(note);

STANLEY, Captain John Constantine (British,
              1837-1878)
Photos dated: 1857-1869
Processes:     Albumen
Formats:       Prints
Subjects:      Topography, portraits, genre
Locations:     India
Studio:        India
   Entries:
Christies Lon 4/24/86: 600 (2 ills)(album, 206)
   (note);
Sothebys Lon 10/31/86: 9 (album, S-2 et al);

STANLEY, Arthur Penrhyn
Photos dated: 1890
Processes:     Platinum
Formats:       Prints
Subjects:      Architecture
Locations:     England - Canterbury
Studio:        Great Britain
   Entries:
Christies NY 5/14/80: 310 ill(book, 15);

STANTON & BUTLER [STANTON 1]
Photos dated: Nineteenth century
Processes:     Albumen
Formats:       Cdvs
Subjects:      Portraits
Locations:
Studio:
   Entries:
Sothebys NY (Greenway Coll.) 11/20/70: 153 (lot,
   S & B-1 et al);

STANTON (British) [STANTON 2]
Photos dated: c1860
Processes:     Albumen
Formats:       Stereos
Subjects:      Genre
Locations:     Studio
Studio:        Great Britain
   Entries:
Christies Lon 3/28/85: 42 (lot, S et al);

STANTON (American) [STANTON 3]
Photos dated: Nineteenth century
Processes:     Albumen
Formats:       Stereos
Subjects:      Topography
Locations:     US - California
Studio:        US
   Entries:
Harris Baltimore 12/10/82: 17 (lot, S-2 et al);

STANTON, Henry (American)
Photos dated: c1895
Processes:
Formats:       Prints
Subjects:      Topography
Locations:     US - Florida
Studio:        US - Sea Breeze, Florida
   Entries:
California Galleries 7/1/84: 400 (lot, S-7 et al);

STARK, A.D. (American)
Photos dated: 1860s-1870s
Processes:     Albumen
Formats:       Stereos, cdvs
Subjects:      Topography
Locations:     US - New Hampshire
Studio:        US - Manchester, New Hampshire
   Entries:
Sothebys NY (Strober Coll.) 2/7/70: 281 (lot,
   S et al);
California Galleries 9/27/75: 512 (lot, S et al);
California Galleries 1/23/77: 410 (lot, S et al);
Swann NY 11/6/80: 390 (lot, S-1 et al)(note);
Harris Baltimore 6/1/84: 99 (lot, S et al);

STATELER (see RUNNELS & STATELER)

STAUFFER (American)
Photos dated: 1870s-1880s
Processes:     Albumen
Formats:       Stereos, cabinet cards
Subjects:      Topography, portraits
Locations:     US - New Jersey
Studio:        US - New Jersey
   Entries:
Harris Baltimroe 9/16/83: 149 (lot, S et al);
Swann NY 11/8/84: 263 (lot, S et al);

STEARN, Messrs. (British)
Photos dated: 1860s-1887
Processes:     Albumen, woodburytype
Formats:       Prints, stereos
Subjects:      Topography, genre, documentary
              (medical)
Locations:     England - Cambridge
Studio:        England - Cambridge
   Entries:
Swann NY 12/8/77: 325 (albums, S et al);
Phillips Can 10/4/79: 22 (books, 12);
Christies Lon 6/24/82: 377 (lot, S et al);
Swann NY 5/5/83: 283 (album, S et al);
Christies Lon 10/30/86: 138;

STEBBINS, Nathaniel L. (American, 1874-1922)
Photos dated: 1890s
Processes:    Albumen, photogravure, collotype
Formats:     Prints
Subjects:    Topography, documentary (maritime)
Locations:   US - New England
Studio:      US - Boston, Massachusetts
    Entries:
Rinhart NY Cat 1, 1971: 371, 372;
California Galleries 9/26/75: 203 (book, 46);
California Galleries 1/23/77: 499 (book, 46);
California Galleries 1/21/79: 214 (book, 46);
Phillips NY 11/29/79: 288 (10);

STECHER, August (German)
Photos dated: 1863-1864
Processes:    Albumen
Formats:     Prints
Subjects:    Topography
Locations:   Germany
Studio:      Germany
    Entries:
Wood Conn Cat 37, 1976: 183 (book);
Wood Conn Cat 42, 1978: 480 (book);

STEEL, Fairs
Photos dated: 1860s
Processes:    Albumen
Formats:     Cdvs
Subjects:    Portraits, ethnography
Locations:   Studio
Studio:      New Zealand - Aukland
    Entries:
Sothebys Lon 6/17/81: 235 (album, S-1 et al);

STEIGENBERGER, Jacob (German)
Photos dated: 1870s
Processes:    Albumen
Formats:     Cdvs
Subjects:    Documentary (public events)
Locations:   Germany - Oberammergau
Studio:      Germany - Wilheim
    Entries:
Christies Lon 10/26/78: 128 (album, S et al);
Swann NY 11/14/85: 138 (lot, S et al);

STELLWAGIN, Charles E. (American)
Photos dated: c1860
Processes:    Albumen
Formats:     Prints
Subjects:    Topography
Locations:   US - Washington, D.C.
Studio:      US
    Entries:
Harris Baltimore 5/28/82: 105;

STELZNER, Carl Ferdinand (German, 1805-1894)
Photos dated: 1842-1855
Processes:    Daguerreotype
Formats:     Plates
Subjects:    Portraits, genre, documentary
Locations:   Studio
Studio:      Germany - Hamburg
    Entries:
Petzold Germany 11/7/81: 163 ill(attributed)(note);
Sothebys Lon 6/29/84: 45 ill;

STENGEL & Co.
Photos dated: 1890s
Processes:    Albumen
Formats:     Prints
Subjects:    Topography
Locations:
Studio:
    Entries:
Phillips Can 10/4/79: 18 (albums, S et al);

STEPHENS, C. (British)
Photos dated: 1850s and/or 1860s
Processes:    Albumen
Subjects:
Locations:
Studio:      Great Britain
    Entries:
Christies Lon 10/28/76: 219 (albums, S-2 et al);

STEPHENS, Frederic G. (British)(photographer or
                author?)
Photos dated: 1865
Processes:    Albumen
Formats:     Prints
Subjects:    Architecture
Locations:   France - Rouen, Caen, Nantes, Bayeaux,
             Falaise
Studio:
    Entries:
Gordon NY 5/3/76: 296 ill(books, S-25 et al);
Christies Lon 6/26/80: 308 (books, S-25 et al);

STERNBERG, George M., M.D. (American)
Photos dated: 1883
Processes:    Heliotype
Formats:     Prints
Subjects:    Documentary (scientific)
Locations:   US
Studio:      US
    Entries:
Swann NY 2/14/52: 156 (book, 20);
Wood Conn Cat 37, 1976: 188 (book, 20);
Wood Conn Cat 42, 1978: 487 (book, 20);

STERRY (see McDONALD & STERRY)

STERRY, Charles (British)
Photos dated: 1840s
Processes:
Formats:     Prints
Subjects:
Locations:
Studio:      Great Britain
    Entries:
Swann NY 2/14/52: 4 (album, S et al);

STEVENS, Joseph Earle
Photos dated: 1890s
Processes:
Formats:     Prints
Subjects:    Topography
Locations:   Philippines
Studio:
    Entries:
Sothebys NY 10/4/77: 148 (albums, S-1,000 et al);

STEVENSON (see HOPKINS & STEVENSON)

STEVENSON, George, D. (British)
Photos dated: c1860
Processes:    Albumen
Formats:      Prints
Subjects:     Topography
Locations:    Spain; Italy
Studio:
    Entries:
Sothebys Lon 10/27/78: 157 (17);

STEVENSON, W. (British)
Photos dated: 1866
Processes:    Albumen
Formats:      Prints
Subjects:     Topography
Locations:    England - Lancashire
Studio:       Great Britain
    Entries:
Christies Lon 6/10/76: 40;

STEWARD, W.W. (American)
Photos dated: 1875
Processes:    Albumen
Formats:      Prints
Subjects:     Topography
Locations:    US - San Diego, California
Studio:       US
    Entries:
Rinhart NY Cat 7, 1973: 86 (book, S et al);

STEWART (British)
Photos dated: Nineteenth century
Processes:    Albumen
Formats:      Stereos
Subjects:     Topography
Locations:    England - Brighton
Studio:       Great Britain
    Entries:
Phillips Lon 10/24/84: 89 (lot, S-3 et al);

STEWART, John (British)
Photos dated: early 1850s-1855
Processes:    Salt (Blanquart-Evrard)
Formats:      Prints
Subjects:     Topography, portraits
Locations:    France - Pyrenees; Great Britain
Studio:       France - Pau
    Entries:
Rauch Geneva 6/13/61: 42m (2);
Sothebys Lon 3/21/75: 286 (album, S-1 et al);
White LA 1980-81: 27 ill(note);
Sothebys Lon 11/1/85: 59 (album, S-1 et al), 67 ill;
Christies Lon 10/30/86: 88 (album, S-2 et al);

STEWART, R. (British)
Photos dated: 1850s
Processes:    Ambrotype
Formats:      Plates
Subjects:     Portraits
Locations:    Studio
Studio:       Great Britain
    Entries:
Christies Lon 3/20/80: 55 (lot, S-1 et al);

STICKNEY, F.W. (American)
Photos dated: 1860s-1880s
Processes:    Tintype, albumen
Formats:      Plates, prints
Subjects:     Portraits, topography
Locations:    US; France
Studio:       US - New York City
    Entries:
Rinhart NY Cat 2, 1971: 266 (lot, S et al);
Sothebys NY 5/8/79: 95 ill(albums, 180)(attributed);

STIEHM, J.F. (German)
Photos dated: 1880
Processes:    Albumen
Formats:      Prints, stereos
Subjects:     Topography
Locations:    Germany - Rhine area
Studio:       Germany - Berlin
    Entries:
California Galleries 4/3/76: 375 (lot, S et al);
Christies Lon 10/30/80: 125 (lot, S-4 et al);
Swann NY 11/6/80: 92 (albums, S-11 et al);
Swann NY 11/14/85: 86 (lot, S et al);

STIELISKY
Photos dated: 1894
Processes:
Formats:      Cabinet cards
Subjects:     Portraits
Locations:
Studio:
    Entries:
Sothebys NY (Greenway Coll.) 11/20/70: 106 (lot,
    S-1 et al);

STIFF, C.W. (American)
Photos dated: c1870s
Processes:    Albumen
Formats:      Stereos
Subjects:     Topography
Locations:    US - Minnesota
Studio:       US - St. Paul, Minnesota
    Entries:
Swann NY 10/18/79: 428 (8)

STILES, I.B. (American)
Photos dated: Nineteenth century
Processes:    Albumen
Formats:      Stereos
Subjects:     Topography
Locations:    US - New York
Studio:       US
    Entries:
Swann NY 11/8/84: 264 (lot, S et al);

**STILLFRIED, Baron von** (Austrian)
Photos dated: 1870s-1885
Processes:      Albumen
Formats:        Prints
Subjects:       Topography, genre, portraits
Locations:      Austria - Vienna; Japan; Greece -
                Athens
Studio:         Austria - Vienna; Japan
    Entries:
Sothebys Lon 6/21/74: 76 ill(album, S & Andersen,
    200);
Colnaghi Lon 1976: 305 (S & Anderson)(note), 306
    (S & Anderson), 307 ill(S & Anderson), 308 (S &
    Anderson), 309 (S & Anderson), 310 (S &
    Anderson), 311 (S & Anderson), 312 ill(S &
    Anderson), 313 (S & Anderson), 314 (S &
    Anderson), 315 (S & Anderson), 316 (S &
    Anderson);
Christies Lon 6/10/76: 85 (album, S & Anderson, 61);
Christies Lon 10/28/76: 135 (S & Anderson, 76);
Sothebys Lon 10/29/76: 162 (album, S & Anderson,
    100);
Sothebys Lon 7/1/77: 153 (S & Anderson, 60);
Wood Conn Cat 45, 1979: 225 ill(albums, S &
    Anderson, 203)(note);
Sothebys Lon 6/29/79: 98 ill(album, S & Anderson,
    124);
Christies Lon 3/20/80: 172 (album, S-1 et al), 179
    (lot, S-1 et al);
Sothebys Lon 3/21/80: 98, 99 (lot, S & Anderson
    attributed, et al);
Sothebys NY 5/20/80: 410 ill(attributed)(note), 424
    ill (album, S et al)(note);
Phillips NY 5/21/80: 145 (album, S & Anderson et
    al), 240 ill(2)(note)
Christies Lon 10/30/80: 244 (albums, S et al), 246
    ill (album, S-6 attributed et al);
Christies NY 11/11/80: 93 ill(album, S et al), 94
    ill (album, S et al);
Christies NY 11/10/81: 79 (album, S et al)(note);
Old Japan, England Cat 5, 1982: 9 (lot, S et al),
    25 ill;
Christies Lon 3/11/82: 200 ill(album, S & Anderson
    et al), 201 (album, S & Anderson et al);
Sothebys Lon 3/15/82: 114 ill(album, S & Anderson,
    29);
Christies Lon 3/24/83: 107 (album, S et al)(note),
    111 (album, S et al), 112 (album, S et al);
Christies Lon 6/23/83: 150 (3)(attributed), 151 ill
    (album, S-1 et al);
Christies Lon 10/27/83: 116 ill(album, S et al);
Christies Lon 3/29/84: 88 ill(album)(attributed);
Christies Lon 10/25/84: 78A (album, S et al)(note);
Phillips Lon 3/27/85: 208 (albums, S & Anderson-27,
    et al);
Christies Lon 3/28/85: 90 (lot, S et al);
Christies Lon 6/27/85: 80 ill(album, S et al), 88
    (lot, S attributed et al);
Sothebys Lon 6/28/85: 70 ill(album, S & Anderson,
    52)(attributed);
Swann NY 11/14/85: 111 (album, S attributed et al);
Old Japan, England Cat 8, 1986: 18 (13), 19 (album,
    50), 20 (2 ills)(album, S-37 et al);
Christies Lon 6/26/86: 191 (lot, S et al);
Christies Lon 10/30/86: 111 (album, S et al), 115
    ill(album, S attributed et al);

**STILLMAN, William James** (American, 1828-1901)
Photos dated: 1858-1880s
Processes:      Salt, albumen, autotype, heliotype
Formats:        Prints
Subjects:       Topography
Locations:      Greece - Athens and Crete; US - New
                York, New Hampshire, Massachusetts;
                France; Italy
Studio:         US; England; Italy
    Entries:
Frumkin Chicago 1973: 113, 114;
Kingston Boston 1976: 604 (book, 12)(note);
Lunn DC Cat 6, 1976: 57.1 ill (note), 57.2 ill;
Wood Conn Cat 37, 1976: 363 (book 12)(note);
Gordon NY 5/10/77: 750 (book, 12)(note);
Sothebys Lon 11/18/77: 200 (book, 13);
Swann NY 12/8/77: 171 (book, 12)(note);
White LA 1977: 112 ill(note), 113 ill, 114 ill;
Swann NY 4/20/78: 151 (book, 12)(note);
Phillips NY 11/4/78: 78 (note);
Swann NY 12/14/78: 466 (note);
Wood Conn Cat 42, 1978: 493 (book, 12)(note);
Sothebys Lon 3/14/79: 372 (note);
Swann NY 4/26/79: 185 (book, 12)(note);
Phillips NY 5/5/79: 178 (4);
Swann NY 10/18/79: 209 (book, 12)(note);
Witkin NY IX, 1979: 2/81 (book, 12)(note);
Christies NY 5/4/80: 324 (book, 12), 334 (book,
    S et al);
Christies NY 5/16/80: 115 (4), 188 (lot, S et al)
    (note);
Phillips NY 5/21/80: 64 (books, S-12 et al);
Swann NY 11/6/80: 192 ill(book, 12)(note);
Witkin NY X 1980: 71 (book, 12);
Sothebys Lon 6/17/81: 126 ill(book, 25)(note);
Phillips NY 2/9/82: 251 (book, 12);
Wood Conn Cat 49, 1982: 419 ill(book, 12)(note);
Swann NY 5/5/83: 359 (lot, S-2 attributed et al);
California Galleries 6/19/83: 127A (book, 12);
Swann NY 11/10/83: 151 (book, 12);
Christies NY 11/6/84: 7 ill(3)(note);
Swann NY 11/8/84: 121 (book, 12);
Christies Lon 3/28/85: 155 ill;
Sothebys Lon 3/29/85: 148 (lot, S et al);
Phillips NY 11/12/86: 187 ill(2);
Swann NY 11/13/86: 102 (book, 12)(note), 336 (note);

**STIMSON, John** (American)
Photos dated: 1850s
Processes:      Daguerreotype, ambrotype
Formats:        Plates
Subjects:       Portraits
Locations:      Studio
Studio:         US - Boston, Massachusetts
    Entries:
Swann NY 11/14/85: 36 (4)(note);

**STIRLING, H.B.** (Canadian)
Photos dated: c1890
Processes:      Albumen
Formats:        Prints
Subjects:       Topography
Locations:      Canada - Prince Edward Island
Studio:         Canada
    Entries:
California Galleries 3/30/80: 364;

**STIRLING-MAXWELL,** Sir William (British, 1818-1878)
Photos dated: 1847-1848
Processes:      Talbotype (Reading Establishment)
Formats:        Prints
Subjects:       Documentary (art)
Locations:      Spain
Studio:         Scotland
    Entries:
Andrieux Paris 1951(?): 73 (book, 66)(note);
Swann NY 2/14/52: 315 (book, 66);
Witkin NY Cat X 1980: 100 (book, 66)

**STODDARD,** Senecca Ray (American)
Photos dated: 1870-1915
Processes:      Albumen, silver
Formats:        Prints, stereos, cdvs, boudoir cards
Subjects:       Topography
Locations:      US - New York, Maine, Alaska; Canada
Studio:         US - Glens Falls, New York
    Entries:
Sothebys NY (Strober Coll.) 2/7/70: 462 (lot,
    S et al);
Rinhart NY Cat 1, 1971: 215 (8);
Rinhart NY Cat 2, 1971: 557;
Rinhart NY Cat 6, 1973: 446, 527, 571;
Rinhart NY Cat 7, 1973: 262;
Vermont Cat 5, 1973: 553 ill(18);
Sothebys NY 9/23/75: 171 (7), 172 (lot, S-5 et al),
    173 ill(lot, S-12 et al), 174 ill(11);
California Galleries 9/27/75: 521 (lot, S et al);
Kingston Boston 1976: 676 ill, 676A ill, 676B ill;
Witkin NY IV 1976: 372 ill;
California Galleries 4/3/76: 470 (13);
Christies Lon 6/10/76: 101 (album, S et al);
Sothebys NY 11/9/76: 106;
Vermont Cat 11/12, 1977: 831 ill(9);
Swann NY 4/14/77: 297 (lot, S et al);       .
Sothebys NY 10/4/77: 93 (3);
Swann NY 12/8/77: 404 (lot, S et al), 427, 428 (7);
Frontier AC, Texas 1978: 290 (book, 12)(note);
Christies Lon 3/16/78: 149 (albums, S-2 et al);
Lehr NY Vol 2:2, 1979: 33 ill(note);
Witkin NY Stereo 1979: 18 (2 ills)(14)(note);
Phillips Can 10/4/79: 55 (album, S et al);
Swann NY 10/18/79: 346 (11)(note), 347 (5)(note),
    350 (books, S & Merrill et al);
Christies NY 5/14/80: 334 (book, S et al);
Swann NY 11/6/80: 396 (7)(note);
California Galleries 6/28/81: 156 (album,
    S-13 et al);
Christies Lon 10/29/81: 262 (album, S et al);
Rose Florida Cat 7, 1982: 94 ill(5);
Christies Lon 3/11/82: 84 (lot, S et al);
Swann NY 4/1/82: 333 (lot, S et al);
Christies Lon 10/28/82: 28 (lot, S et al);
Harris Baltimore 4/8/83: 98 (16), 99 (18);
Harris Baltimore 12/16/83: 129 (7);
Harris Baltimore 6/1/84: 138 (9);
California Galleries 7/1/84: 679 (3);
Phillips Lon 10/24/84: 157 (2);
Harris Baltimore 3/15/85: 93 (11);
Christies Lon 3/28/85: 44 (lot, S et al);
Wood Boston Cat 58, 1986: 136 (books, S-1 et al);
Harris Baltimore 2/14/86: 45 (4);
Christies Lon 4/24/86: 398 (album, S-2 et al);
Swann NY 5/15/86: 133 (book, S et al), 165 (lot,
    S et al);
Christies Lon 10/30/86: 153 (albums, S et al);
Harris Baltimore 11/7/86: 306 (lot, S-4 et al);
Swann NY 11/13/86: 337 (17);

**STOKES,** George B. (British)
Photos dated: 1853-1857
Processes:      Albumen
Formats:        Prints
Subjects:       Topography
Locations:      Wales - Tenby
Studio:         England - Bayswater (Photographic
                Club)
    Entries:
Sothebys Lon 3/21/75: 286 album, S-1 et al);
Sothebys Lon 3/14/79: 324 (albums, S-1 et al);
Sothebys Lon 6/29/84: 155 ill(note);
Sothebys Lon 11/1/85: 59 (album, S-1 et al);

**STOKES,** J. (British)
Photos dated: 1850s
Processes:      Ambrotype
Formats:        Plates
Subjects:       Portraits
Locations:      Studio
Studio:         England - Ipswich
    Entries:
Sothebys Lon 6/11/76: 119 (lot, S-22 et al);

**STOLZE,** Dr. (German)
Photos dated: 1860s-c1875
Processes:      Albumen
Formats:        Stereos
Subjects:       Genre
Locations:      Studio
Studio:         Germany - Berlin
    Entries:
Rinhart NY Cat 2, 1971: 496 (12);

**STONE,** J. (American)
Photos dated: 1850s
Processes:      Daguerreotype
Formats:        Plates
Subjects:       Portraits
Locations:      Studio
Studio:         US
    Entries:
Sothebys NY (Weissberg Coll.) 6/17/67: 114 (lot,
    S-1 et al);

**STONE,** Sir John Benjamin (British, 1838-1914)
Photos dated: 1870-1906
Processes:      Albumen, platinum
Formats:        Prints
Subjects:       Architecture, portraits, documentary
                (public events)
Locations:      England - Lichfield
Studio:         Great Britain
    Entries:
Christies Lon 6/14/73: 212 (27);
Christies Lon 10/4/73: 181 (17);
Edwards Lon 1975: 180 (book, 5);
Sothebys Lon 3/19/76: 145;
Christies Lon 3/16/78: 218 (book, 5);
Sothebys Lon 6/29/79: 262 (lot, S-39 et al);
Sothebys Lon 10/24/79: 359;
Sothebys Lon 6/27/80: 264 ill(63);
Sothebys Lon 10/29/80: 300;
Sothebys Lon 6/17/81: 345;
Christies Lon 10/29/81: 408;
Christies Lon 3/11/82: 369 ill(album, 25);

**STONEHOUSE, W.** (British)
Photos dated: c1857-1860s
Processes:      Albumen
Formats:        Stereos, cdvs
Subjects:       Topography
Locations:      England
Studio:         England
   Entries:
Rinhart NY Cat 6, 1973: 432;
Sothebys Lon 6/21/74: 65 (lot, S et al);
California Galleries 9/27/75: 479 (lot, S et al);
Sothebys Lon 1/23/77: 384 (lot, S et al);

**STORTZL**
Photos dated: 1860s
Processes:      Ambrotype
Formats:        Plates
Subjects:       Portraits
Locations:      Studio
Studio:         England - Liverpool
   Entries:
Sothebys Lon 10/24/79: 208 (lot, S-1 et al);

**STORY-MASKELYNE, Nevil** (see MASKELYNE, N.S.)

**STOSS** (see SAUNDERS, W.)

**STOUTENBURGH & ROLF** (American)
Photos dated: Nineteenth century
Processes:      Albumen
Formats:        Cdvs
Subjects:       Portraits
Locations:      Studio
Studio:         US
   Entries:
Sothebys NY (Greenway Coll.) 11/20/70: 198 (lot,
   S & R-1 et al);

**STREETER, E.W.** (photographer or author?)
Photos dated: 1877
Processes:      Albumen
Formats:        Prints
Subjects:       Documentary
Locations:      South Africa
Studio:
   Entries:
Edwards Lon 1975: 183 (book, S-2 et al);

**STRETTON, Captain W.G.** (British)
Photos dated: 1875-1877
Processes:      Albumen
Formats:        Prints
Subjects:       Topography
Locations:      India
Studio:         India - Calcutta
   Entries:
Sothebys NY 11/2/79: 259 ill(album, S et al)(note);
Christies Lon 6/26/86: 116 (albums, S et al);

**STREZEK**
Photos dated: 1850s
Processes:      Daguerreotype
Formats:        Stereo plates
Subjects:       Portraits
Locations:      Studio
Studio:         Austria - Vienna
   Entries:
Petzold Germany 5/22/81: 1746 ill(note);
Sothebys Lon 10/28/81: 38;

**STROHMEYER & WYMAN** (American)
Photos dated: 1887-1899
Processes:      Albumen
Formats:        Stereos
Subjects:       Topography, genre
Locations:      US - Pennsylvania; New York
Studio:         US
   Entries:
Rinhart NY Cat 7, 1973: 401;
Phillips Can 10/4/79: 48 (lot, S & W-3 et al);
Phillips NY 11/3/79: 136 (lot, S & W et al);

**STROUD, William** (American)
Photos dated: c1850-1850s
Processes:      Daguerreotype, ambrotype
Formats:        Plates
Subjects:       Portraits
Locations:      Studio
Studio:         US - Norristown, New Jersey
   Entries:
Vermont Cat 11/12, 1977: 690 ill;
California Galleries 1/22/77: 72 (lot, S-1 et al);

**STRUMPER & Co.**
Photos dated: 1880s
Processes:      Albumen
Formats:        Prints
Subjects:       Topography
Locations:      Europe
Studio:         Europe
   Entries:
Swann NY 11/13/86: 216 (albums, S et al);

**STUART, Charles** (British)
Photos dated: 1852-1857
Processes:      Calotype
Formats:        Prints
Subjects:       Portraits
Locations:      Great Britain
Studio:         Great Britain
   Entries:
Swann NY 2/14/52: 317 (13)(note);

**STUART, F.G.O.** (British)
Photos dated: 1860s and/or 1870s
Processes:      Albumen
Formats:        Stereos
Subjects:       Topography
Locations:      Great Britain
Studio:         Great Britain
   Entries:
Christies Lon 3/11/82: 65 (lot, S et al);

**STUART, John** (British)
Photos dated: 1860s-1904
Processes: Albumen
Formats: Prints, stereos, cdvs
Subjects: Topography, portraits, documentary
(railroads)
Locations: Scotland - Glasgow
Studio: Scotland - Inverness
Entries:
California Galleries 1/22/77: 124 (32);
Christies Lon 3/11/82: 329 ill(album, 129), 332 ill
(album, 69)(note);
Christies Lon 6/23/83: 52 (lot, S-3 et al);
Christies Lon 4/24/86: 583 (lot, S-1 et al);

**STUART, Provost**
Photos dated: 1883
Processes: Albumen
Formats: Prints
Subjects: Topography
Locations:
Studio:
Entries:
Swann NY 11/11/76: 275 (book, 10);

**STUBBS, R.**
Photos dated: 1880s
Processes: Albumen
Formats: Cdvs, cabinet cards
Subjects: Portraits
Locations: Studio
Studio: Great Britain
Entries:
Christies Lon 10/29/81: 385 (album, S et al);

**STUMP**
Photos dated: c1880
Processes: Albumen, photochrome
Formats: Prints
Subjects: Topography
Locations: Switzerland
Studio:
Entries:
Christies NY 11/11/80: 77 (lot, S et al);

**STURROCK, John**
Photos dated: 1857
Processes: Salt
Formats: Prints
Subjects: Topography
Locations: Great Britain - Forfarshire
Studio: Great Britain (Photographic Club)
Entries:
Rauch Geneva 6/13/61: 47 (album, S et al)(note);
Sothebys Lon 3/14/79: 324 (album, S-1 et al);

**STURTEVANT**
Photos dated: between 1870s and 1890s
Processes: Albumen
Formats: Stereos
Subjects: Topography
Locations: US - American west
Studio:
Entries:
Swann NY 11/13/86: 133 (lot, S et al);

**STYLES, A.F.** (American)
Photos dated: 1860s-1870s
Processes: Albumen
Formats: Stereos, cdvs
Subjects: Topography
Locations: US - Vermont; Florida
Studio: US - Burlington, Vermont
Entries:
Rinhart NY Cat 2, 1971: 571;
Harris Baltimore 4/8/83: 109 (lot, S et al);

**SUAREZ** (see VARELA & SUAREZ)

**SUBERCAZE** (French)
Photos dated: 1860s
Processes: Albumen
Formats: Cdvs
Subjects: Portraits
Locations: Studio
Studio: France - Pau
Entries:
Swann NY 11/13/86: 168 (album, S et al);

**SUSCIPI, Lorenzo** (Italian)
Photos dated: early 1840s-c1860
Processes: Daguerreotype, albumen
Formats: Plates, prints, stereos
Subjects: Portraits, topography
Locations Italy - Rome
Studio: Italy - Rome
Entries:
Christies Lon 10/26/78: 114 (note);
Christies Lon 3/11/82: 20;
Sothebys Lon 3/15/82: 80 (lot, S-4 et al);

**SUTCLIFFE, Frank Meadow** (British, 1853-1941)
Photos dated: c1875-1922
Processes: Albumen, carbon, platinum, bromide
Formats: Prints, cabinet cards, cdvs
Subjects: Topography, genre
Locations: England
Studio: England - Whitby
Entries:
Christies Lon 7/13/72: 71 ill(note), 72 ill, 73
(2), 74 (9), 75 (2), 76 (3), 77 (3), 78 (5), 79
ill, 80 (4), 81 ill, 82 (3), 83 (4), 84 (2), 85
(2), 86 (4), 87, 88 ill, 89 ill, 90 ill, 91 ill,
92 ill, 93 ill, 94 ill, 95 ill, 96 ill, 97 (7),
98 (5), 99 (2), 100 (7), 101 (6), 102 (5), 103,
104 (8);
Witkin NY I 1973: 404 ill;
Sothebys NY 5/24/73: 129 (6), 130 (3), 131 (19);
Christies Lon 6/14/73: 172 (album, S-1 et al), 180
(album, S-4 et al), 200, 201 (2), 202 (2), 203
(2), 204 (2), 205 ill, 206 ill, 207;
Sothebys Lon 12/4/73: 15 (album, S-2 et al)(note);
Witkin NY II 1974: 871 ill, 872 ill;
Sothebys Lon 3/8/74: 173 ill(2), 174 (2);
Christies Lon 4/25/74: 256 (2);
Sothebys Lon 6/21/74: 166, 170 (lot, S-2 et al);
Sothebys Lon 10/18/74: 100 (6), 314 ill;
Sothebys Lon 6/26/75: 228, 229 (3), 230;
Sothebys Lon 10/24/75: 268 ill(album, S-14 et al);
Alexander Lon 1976: 47 ill, 48 ill, 49 ill, 50 ill;
Anderson & Hershkowitz Lon 1976: 42 ill, 43 ill, 44
ill, 45 ill;
Kingston Boston 1976: 250 ill(note);

## SUTCLIFFE (continued)

Rose Boston Cat 1, 1976: 23 ill(note);
Sothebys Lon 3/19/76: 43 (album, S et al), 258, 259 ill(album, S-79 et al);
Christies Lon 6/10/76: 201 (album, 27), 202 ill(3), 203 (note), 204 ill(note), 205 ill(note), 206 (note), 207 ill, 208 ill, 209 (note), 210 (2 ills)(2), 211, 212, 213 ill, 214;
Sothebys Lon 6/11/76: 66 (album, S-2 et al);
Christies Lon 10/28/76: 326 ill(note), 327, 328, 329 ill(note), 330 (note), 331 (10), 332 (11), 333, 334, 335 (4);
Sothebys Lon 10/29/76: 300 (note);
Rose Boston Cat 2, 1977: 20 ill(note);
Sothebys Lon 3/9/77: 254 ill, 255 (2)(note), 256 ill, 257 (3), 258;
Christies Lon 3/10/77: 202 (lot, S-4 et al), 368 (note), 369 (3), 370 ill, 371 ill, 373, 374 ill, 375 ill, 376 (4), 377 (5), 378 (lot, S-3 et al);
Gordon NY 5/10/77: 878 ill, 879 ill, 880 ill;
Sothebys NY 5/20/77: 78, 79 (2), 80;
Christies Lon 6/30/77: 333 ill(3), 334 ill, 335 ill, 336, 337 (4);
Sothebys Lon 7/1/77: 47 (lot, S-2 et al), 288;
Sothebys NY 10/4/77: 186 (3);
Christies Lon 10/27/77: 402 ill, 403 ill, 404, 405 (5);
Sothebys 11/18/77: 67 (lot, S-1 et al), 87 (lot, S et al), 262 (4), 263 ill, 264, 265, 266;
Weston Cal 1978: 152 ill, 153 ill, 154 ill, 155 ill, 156 ill, 157 ill, 158 ill;
Christies Lon 3/16/78: 87 (albums, S-1 et al), 150 (albums, S-1 et al), 375, 376 ill, 377;
Sothebys Lon 3/22/78: 239, 240 ill, 241 (2);
Sothebys NY 5/2/78: 84 (2);
Christies Lon 6/27/78: 65 (lot, S-2 et al), 318 ill (note), 319, 320 ill, 321 ill, 322, 323, 324, 325 ill, 326, 327;
Sothebys Lon 6/28/78: 357 ill(note), 358, 359 ill (note), 360 ill, 361 ill, 362 ill, 363 ill;
Christies Lon 10/26/78: 365 ill, 366 ill, 367 ill, 368 ill, 369 ill, 370 ill, 371 ill, 372 ill, 373 ill, 374 (2);
Sothebys Lon 10/27/78: 170 (lot, S-7 et al), 241, 242;
Phillips NY 11/4/78: 118;
Swann NY 12/14/78: 469;
Phillips Lon 3/13/79: 154 (lot, S-2 et al), 156 (2), 157 (2), 158;
Sothebys Lon 3/14/79: 145 (album, S-5 et al), 149 (album, S-2 et al), 332 (album, S et al), 395, 396 (2), 397, 398, 399;
Christies Lon 3/15/79: 329 (2);
Christies NY 5/4/79: 127, 128, 129;
Christies Lon 6/28/79: 208 (note), 267, 268;
Sothebys Lon 6/29/79: 284, 285;
Phillips Can 10/4/79: 107;
Sothebys Lon 10/24/79: 319 (lot, S et al), 371 ill, 372 (2), 373 (2), 374 (2), 375, 376;
Christies Lon 10/25/79: 464 (2), 465, 466, 467, 468 (note), 469 ill, 470;
Phillips NY 11/3/79: 157 ill, 158 (note);
Phillips NY 11/29/79: 274;
Rose Boston Cat 5, 1980: 33 ill(note), 34 ill;
Sothebys LA 2/6/80: 155 ill(note), 156 (2);
Phillips Lon 3/12/80: 159 (11);
Christies Lon 3/20/80: 406;
Sothebys Lon 3/21/80: 342, 343, 344, 345 (4);
Phillips NY 5/21/80: 178, 179 ill, 180, 181 ill, 182, 183 ill, 184 ill, 185 ill, 186, 187, 188, 189, 190, 191, 192 ill;

## SUTCLIFFE (continued)

Phillips Lon 6/25/80: 126 (11);
Christies Lon 6/26/80: 539 ill(3), 540 (3), 541 (4), 542 (3), 543 (4), 544 ill(2), 545 (5), 546 (2);
Sothebys Lon 6/27/80: 329 ill, 330 (2), 331, 332;
Sothebys Lon 10/29/80: 295, 296 (lot, S-1 attributed et al);
Christies NY 11/11/80: 196 ill, 197;
Christies Lon 3/26/81: 275 (album, S attributed et al), 439 (9), 440 (3), 441 (album, 11);
Sothebys Lon 3/27/81: 494, 495 (3), 496 ill(album, S-19 et al), 497, 498, 499, 500 (2), 501;
Swann NY 4/23/81: 373 (2), 374 (2);
Phillips NY 5/9/81: 17 ill(note);
Christies Lon 6/18/81: 455 (4), 456, 457, 458 (lot, S-6 et al), 459 ill, 460;
Christies Lon 10/29/81: 354 (albums, S et al), 403 (2 plus 1 attributed), 404 (album, 26), 405 (album, 11), 406 ill, 407;
Swann NY 11/5/81: 375;
Christies Lon 3/11/82: 362, 363, 364 ill(album, S-35 et al), 365 (lot, S et al), 366 ill(lot, S-34 et al), 367, 368;
Sothebys Lon 3/15/82: 368 ill;
Phillips Lon 3/17/82: 99 ill(note);
Sothebys NY 5/24/82: 289 ill(note), 290 ill(note);
Christies NY 5/26/82: 25;
Phillips Lon 6/23/82: 84, 85 ill, 86 (2);
Christies Lon 6/24/82: 100 (album, S et al), 407, 408 ill(lot, S-1 et al), 409, 410, 411 (lot, S-5 et al), 412 ill;
Phillips Lon 10/27/82: 47, 48, 49;
Christies Lon 10/28/82: 242 (2), 243 (2);
Sothebys Lon 10/29/82: 160, 161 (2), 163 ill;
Swann NY 11/18/82: 259 ill;
Christies NY 2/13/83: 121 (3)(note);
Phillips Lon 3/23/83: 41, 42;
Christies Lon 3/24/83: 53 (album, S et al), 262 (2);
Sothebys Lon 3/25/83: 138 (2 ills)(album, 30)(note);
Swann NY 5/5/83: 449;
Christies Lon 6/23/83: 276 (3 ills)(album, 46);
Sothebys Lon 6/24/83: 113 ill, 114 ill, 115 ill;
Christies Lon 10/27/83: 258, 259 (lot, S-1 et al);
Phillips Lon 11/4/83: 60 (album, S-1 et al), 93 (6), 95;
Christies NY 11/8/83: 201 (book, S et al);
Sothebys NY 11/9/83: 271 ill(note);
Sothebys Lon 12/9/83: 110 ill, 111 ill, 112 ill, 113;
Christies Lon 3/29/84: 218 (note), 219;
Sothebys NY 5/8/84: 313 ill(album, 100)(note);
Christies Lon 6/28/84: 247, 248 (3);
Sothebys NY 6/29/84: 212, 213 ill, 214, 215 ill, 216 ill, 217 ill, 218 ill, 219 ill, 220 ill, 221 ill, 222 ill;
Phillips Lon 10/24/84: 105 (album, S-4 et al);
Christies Lon 10/25/84: 226 (2), 227 (note), 228 ill, 229 (2)(attributed), 230 ill(album, 21) (note);
Sothebys Lon 10/26/84: 158 ill, 159 ill, 160 (2 ills)(album, 26), 161 (attributed);
Sothebys NY 11/5/84: 274 ill, 317A ill;
Phillips Lon 3/27/85: 175 (albums, S-1 et al), 235 (3);
Christies Lon 3/28/85: 229 (1 plus 9 attributed), 230 (note), 231 (note);
Sothebys Lon 3/29/85: 188 ill, 189 ill, 190 ill, 191 (8), 192 ill, 193 ill;
Swann NY 5/9/85: 449 (album, 50);

## SUTCLIFFE (continued)

Christies Lon 6/27/85: 85 (albums, S-5 et al), 193 (2)(note), 194;

Sothebys Lon 6/28/85: 34 (albums, S-1 et al), 158 ill, 159 ill, 160 ill(2), 161 ill, 162 (5), 163 ill, 164 ill, 165 ill, 166 ill, 167 ill, 168 ill, 169 ill, 170 ill(6), 171 ill(2), 172 ill, 173 ill, 174 ill, 175, 176 ill;

Phillips Lon 10/30/85: 124 (album, S-1 et al), 135 (8), 136 (5), 137, 138 ill, 139 (5), 140 ill, 141, 142 ill, 143 (8), 144 ill;

Christies Lon 10/31/85: 77 (albums, S et al), 80 (albums, S-1 et al);

Sothebys Lon 11/1/85: 81 ill, 82 ill(4), 83 ill, 84 ill (12), 85 ill, 86 (2), 87 ill(3), 88 ill(2), 89 ill(2), 90 ill(2), 91 ill, 92 ill, 93 ill, 94 ill, 95 ill, 96 ill(album, S, S attributed, et al), 97 (lot, S-1 et al), 98 ill(5), 99 ill(3), 100 ill(2), 101 ill(album, S, S attributed, et al);

Phillips Lon 4/23/86: 296 (album, S-1 et al), 301 (11), 302 (2), 303 (7), 304, 305 (lot, S-6 et al);

Christies Lon 4/24/86: 519 (lot, S-2 et al), 520, 521 ill(albums, S-23 et al), 522 ill(album, 29) (note);

Sothebys Lon 4/25/86: 154 (album, S-2 et al), 155 ill, 156 ill, 157 ill, 158 ill, 159 ill, 160 ill, 161 ill, 162 ill(album, S-10 plus 6 attributed, et al), 163 ill(12), 164 ill(3), 165 ill;

Swann NY 5/16/86: 234 (album, S et al), 315 (lot, S-4 et al);

Christies Lon 6/26/86: 36 (lot, S-5 et al), 42 (2), 100 (albums, S et al), 141, 194 (3);

Phillips Lon 10/29/86: 371 (lot, S-16 et al);

Christies Lon 10/30/86: 161 ill(album, 20), 162 (4);

Sothebys Lon 10/31/86: 133 ill(4), 134 ill, 135 ill, 136 (5), 137 ill, 138 ill(note), 139 ill (6), 140 ill(5), 141 (8), 142 (8);

Phillips Lon 11/12/86: 191A (2);

Swann NY 11/13/86: 214 (album, S-4 et al), 219 (lot, S-5 et al);

## SUTTON (British)

Photos dated: 1850s-1860s
Processes:    Albumen, overpainted prints
Formats:     Prints, "photographic miniatures"
Subjects:    Topography, portraits
Locations:   Great Britain
Studio:      England - London
   Entries:
Sothebys Lon 10/24/75: 162;
Christies Lon 10/27/77: 37 (lot, S-1 et al);
Christies Lon 3/24/83: 51 (album, S-2 et al);
Christies Lon 6/23/83: 62 (lot, S-1 et al);

## SUTTON, Norman

Photos dated: Nineteenth century
Processes:    Calotype
Formats:     Prints
Subjects:    Topography
Locations:   Italy - Rome
Studio:
   Entries:
Sothebys Lon 12/4/73: 24 ill(lot, S-1 attributed et al);

## SUTTON, Thomas (British, 1819-1875)

Photos dated: 1852-1857
Processes:    Salt (Blanquart-Evrard)
Formats:     Prints
Subjects:    Topography
Locations:   Italy - Rome; France - Blois; England - Jersey
Studio:
   Entries:
Sothebys Lon 3/19/76: 21 (note);
Sothebys Lon 10/29/76: 294 ill(note);
Lehr NY Vol 1:2, 1978: 39 ill;
Christies Lon 6/18/81: 158 (lot, S-1 et al);
Christies Lon 10/29/81: 161 ill;
Christies Lon 6/28/84: 217 (lot, S-1 et al);
Sothebys Lon 3/29/85: 121 ill;

## SUZANNE, A.

Photos dated: 1860s
Processes:
Formats:     Prints
Subjects:
Locations:
Studio:      Great Britain (Amateur Photographic Association)
   Entries:
Sothebys Lon 10/29/80: 310 (album, S et al);

## SUZUKI, Shin'ichi (Japanese)

Photos dated: 1865-1901
Processes:    Albumen
Formats:     Prints, cdvs
Subjects:    Topography
Locations:   Japan
Studio:      Japan - Tokyo and Yokohama
   Entries:
Sothebys NY 10/21/81: 204 ill(album, 24);

## SVOBODA, A.

Photos dated: c1870s
Processes:    Albumen
Formats:     Prints
Subjects:    Topography
Locations:   Turkey; India
Studio:
   Entries:
Christies Lon 6/28/84: 221 (lot, S-1 et al);
Christies Lon 10/25/84: 102 (lot, S et al);
Sothebys Lon 10/26/84: 54 (lot, S et al);

## SWAIN (see MOTE & SWAIN)

## SWAN (see ANNAN, T.)

## SWANTON (American)

Photos dated: c1858
Processes:    Albumen
Formats:     Stereos
Subjects:    Topography
Locations:   US - Brooklyn, New York
Studio:      US
   Entries:
Rinhart NY Cat 6, 1973: 384;

SWASEY (American)
Photos dated: c1895
Processes:      Albumen
Formats:        Cabinet cards
Subjects:       Portraits
Locations:      Studio
Studio:         US - San Francisco, California
    Entries:
California Galleries 12/13/80: 202 ill, 210 (lot,
    S et al);

SWEBY, J. (British)
Photos dated: c1860
Processes:      Ambrotype
Formats:        Plates
Subjects:       Portraits
Locations:      Studio
Studio:         England - Hemel Hempstead
    Entries:
Christies Lon 6/28/79: 39 ill;

SWEENEY, Thomas T. (American)
Photos dated: 1865-1870s
Processes:      Albumen
Formats:        Prints, stereos
Subjects:       Documentary (disasters)
Locations:      US - Cleveland, Ohio; Chicago,
                Illinois
Studio:         US - Cleveland, Ohio
    Entries:
Sothebys NY (Strober Coll.) 2/7/70: 493 (lot,
    S-6 et al);
Rinhart NY Cat 6, 1973: 415, 477;
Christies NY 11/11/80: 131 (note);

SWEET
Photos dated: c1870-1880s
Processes:      Albumen
Formats:        Prints
Subjects:       Topography
Locations:      Australia - Adelaide
Studio:         Australia - Adelaide
    Entries:
Sothebys Lon 6/21/74: 94 (album, S et al);
Sothebys Lon 10/27/78: 100 ill(album, S et al);
Christies Lon 6/28/79: 140 (album, S et al);
Christies Lon 3/20/80: 207 (album, S-30 et al);
Sothebys Lon 10/28/81: 62 (album, S et al);
Sothebys Lon 3/15/82: 66 (album, S-2 et al);
Christies Lon 10/30/86: 169 ill(album, S et al);

SWEET, H.N. (American)(see also COOLIDGE, G.)
Photos dated: 1870-1887
Processes:      Albumen, photogravure
Formats:        Prints
Subjects:       Topography
Locations:      US - White Mountains, New Hampshire
Studio:         US - Boston, Massachusetts
    Entries:
Wood Conn Cat 37, 1976: 118 (book, S et al)(note);
Swann NY 4/14/77: 111 (book, S & Coolidge et al);
Swann NY 12/14/78: 140 (book, S & Coolidge, 11)
    (note);
Sothebys NY 5/8/79: 19 (books, S et al);

SWEETSER, M.F. (American)
Photos dated: 1879-1880
Processes:      Heliotype
Formats:        Prints
Subjects:       Topography
Locations:      US - New Hampshire; Maine
Studio:         US
    Entries:
White LA 1977: 379 (book, 17);
Wood Conn Cat 42, 1978: 500 (book, 10)(note);
Swann NY 12/14/78: 232 ill(book, 22), 333 (book,
    10), 334 (book, 10), 335 (book, 13);
California Galleries 1/2/79: 181 (book, 12);
Sothebys NY 5/8/79: 19 (books, S-10 et al);
California Galleries 3/30/80: 160 (book, 10), 161
    (book, 12);
Christies NY 5/14/80: 338 ill(book, 10);
Swann NY 11/6/80: 215 (book, 12);
Swann NY 11/18/82: 252 (book, 16);
Swann NY 10/10/83: 156 (book, 10);

SWIFT (British)
Photos dated: Nineteenth century
Processes:
Formats:        Microphotographs
Subjects:       Genre
Locations:      China
Studio:         Great Britain
    Entries:
Phillips Lon 10/30/85: 92A (2), 93 (lot, S-3 et al),
    94 (lot, S-1 et al), 95 (lot, S-2 et al);

SWITZER, Dr. B.W. (British)
Photos dated: c1870
Processes:      Albumen
Formats:        Prints
Subjects:       Ethnography
Locations:      India
Studio:
    Entries:
Sothebys Lon 10/18/74: 80 (book, S et al);
Christies Lon 3/11/82: 252 (books, S et al);

SWORDS Brothers (American)
Photos dated: c1890
Processes:      Albumen
Formats:        Cabinet cards
Subjects:       Portraits
Locations:      Studio
Studio:         US - York, Pennsylvania
    Entries:
Harris Baltimore 4/8/83: 386 (lot, S et al);
California Galleries 7/1/84: 550;

SYE SAUNG TUCK TAI (see TUCK TAI)

SYLAR, J.L. (American)
Photos dated: 1890s
Processes:      Silver bromide
Formats:        Prints
Subjects:       Documentary
Locations:      US - California
Studio:         US - Kelseyville, California
    Entries:
Swann NY 11/14/85: 175 (7)(note);

**SYMONDS & Co.**
Photos dated: 1880s-1890s
Processes:  Albumen
Formats:    Prints
Subjects:   Topography
Locations:
Studio:
   Entries:
Swann NY 4/23/81: 546 (album, S et al);

**SYMONDS, C.P.**
Photos dated: c1856
Processes:  Salt, albumen
Formats:    Prints
Subjects:   Topography
Locations:  Portugal - Lisbon
Studio:
   Entries:
Christies Lon 10/27/77: 85;
Christies NY 9/11/84: 113;

**SYMONDS, J.** (British)
Photos dated: 1860s
Processes:  Albumen
Formats:    Stereos
Subjects:   Topography
Locations:  England - Portsmouth
Studio:     England - Ryde
   Entries:
Christies Lon 6/18/81: 105 (lot, S-2 et al);
Christies Lon 3/11/82: 65 (lot, S et al);
Christies Lon 10/27/83: 21 (lot, S-1 et al);
Harris Baltimore 6/1/84: 64 (lot, S et al);

**SZABO, Samuel G.**
Photos dated: c1860-1870
Processes:  Albumen
Formats:    Prints
Subjects:   Documentary
Locations:
Studio:
   Entries:
Christies Lon 4/25/74: 226 (2 ills)(albums, 214)
   (note);

**SZATHMARI, Carol Popp de** (Roumanian)
Photos dated: 1843-1870s
Processes:  Daguerreotype, salt, albumen
Formats:    Plates, prints, cdvs
Subjects:   Topography, portraits
Locations:  Roumania - Bucharest; Russia - Crimea
Studio:     Roumania - Bucharest
   Entries:
Sothebys Lon 12/9/83: 35 ill (album, 25)(attributed)
   (note);
Swann NY 5/9/85: 425 (album, S et al)(note);

**SZUBERT, Awit**
Photos dated: 1870s-1875
Processes:  Albumen
Formats:    Prints, cabinet cards
Subjects:   Topography, portraits
Locations:  Poland - Tatra Mountains
Studio:     Poland - Krakow
   Entries:
Christies Lon 6/26/80: 202 ill(32)(note);
Christies Lon 3/26/81: 190 (album, 23)(note);
Harris Baltimore 3/15/85: 246 (lot, S-1 et al);

**T., C.** [C.T.]
Photos dated: 1860s
Processes:      Albumen
Formats:        Stereos
Subjects:       Topography
Locations:      France - Paris
Studio:         France
    Entries:
Christies Lon 10/28/82: 32 (lot, T et al);

**T., D.** [D.T.]
Photos dated: c1870
Processes:      Collodion on glass
Formats:        Stereo plates
Subjects:       Topography
Locations:      France - Paris
Studio:
    Entries:
Sothebys Lon 3/19/76: 3 (6);

**T., H.C.** [H.C.T.] (possibly Major Tytler, q.v.)
Photos dated: late 1850s
Processes:      Albumenized salt
Formats:        Prints
Subjects:       Topography
Locations:      India - Delhi, Lucknow, Agra
Studio:
    Entries:
Sothebys Lon 6/25/82: 72 ill(note), 73 ill, 74 ill,
    75 ill;
Sothebys Lon 6/24/83: 27, 28 ill, 29 ill, 30 ill,
    31 ill;
Sothebys Lon 6/29/84: 99 ill(4);
Sothebys Lon 10/26/84: 71 ill(4)(note);
Sothebys Lon 3/29/85: 94 ill(5)(note);
Sothebys Lon 6/28/85: 41 ill(3)(note), 78 ill(4)
    (note);

**T., J.R.** [J.R.T.] (British)
Photos dated: 1857
Processes:      Salt
Formats:        Prints
Subjects:       Photogenic drawings
Locations:      Great Britain
Studio:         Great Britain
    Entries:
Rauch Geneva 6/13/61: 42-1 (2);

**T., T.** [T.T.]
Photos dated: c1885
Processes:      Albumen
Formats:        Cabinet cards
Subjects:       Portraits
Locations:
Studio:
    Entries:
Maggs Paris 1939: 548;

**TABER, Charles** (American)
Photos dated: 1860s-1872
Processes:      Albumen
Formats:        Cdvs, stereos
Subjects:       Portraits, documentary (disasters)
Locations:      US - Boston, Massachusetts
Studio:         US - New Bedford, Massachusetts
    Entries:
Vermont Cat 4, 1972: 474 ill;
Harris Baltimore 12/16/83: 36 (lot, T et al);

**TABER, D.G.** (American)
Photos dated: 1850s-1860s
Processes:      Daguerreotype, ambrotype
Formats:        Plates
Subjects:       Portraits
Locations:      Studio
Studio:         US - Boston, Massachusetts
    Entries:
Rinhart NY Cat 6, 1973: 163 ill;
Sothebys Lon 10/29/76: 212 (lot, T-1 et al);
Swann NY 4/23/81: 270 (lot, T & Howland-1, et al);
California Galleries 6/19/83: 146;

**TABER, Isaiah West** (American, 1830-1912)
Photos dated: 1859-1905
Processes:      Ambroype, albumen, platinum
Formats:        Plates, prints, cdvs, cabinet cards
Subjects:       Portraits, topography
Locations:      US - California; Alaska; Alaska
Studio:         US - Syracuse, New York; San
                Francisco, California
    Entries:
Swann NY 2/14/52: 64 (album, T-4 et al);
Sothebys NY (Strober Coll.) 2/7/70: 356 (lot,
    T et al), 501 (lot, T et al);
Sothebys NY (Greenway Coll.) 11/20/70: 100 ill(lot,
    T-1 et al);
Sothebys NY 11/21/70: 10 ill(album, T et al);
Rinhart NY Cat 1, 1971: 283 (3), 284 (3), 315 (2),
    398, 399, 400, 401, 402, 403;
Rinhart NY Cat 2, 1971: 434 (album, T et al);
Rinhart NY Cat 6, 1973: 280, 302 (2), 303 (4), 304
    (4), 340, 354 (lot, T-1 et al), 356 (4), 358
    (2), 467 (attributed);
Rinhart NY Cat 7, 1973: 143 (album, T et al), 307,
    308, 309, 479;
Vermont Cat 5, 1973: 533 ill;
Witkin NY I 1973: 380;
Sothebys Lon 5/24/73: 81 (albums, T et al), 94
    (album, T et al);
Christies Lon 10/4/73: 253 (25);
Sothebys Lon 3/8/74: 26 (lot, T et al);
Sothebys Lon 10/18/74: 135 ill(album, T-15 et al);
Sothebys NY 2/25/75: 179 (album, T et al);
Sothebys Lon 3/21/75: 76 (album, T et al), 86
    (album, T et al), 87 (album, T et al);
Sothebys Lon 6/26/75: 260 (albums, T-3 et al);
Swann NY 9/18/75: 312 (2);
Sothebys NY 9/23/75: 64 ill, 95 (lot, T-4 et al);
California Galleries 9/27/75: 351, 352, 353 (lot,
    T-10 et al);
Sothebys Lon 10/24/75: 102 (album, T et al), 138
    (album, T-25 et al);
Kingston Boston 1976: 252 (8 ills)(40)(note), 253,
    254 ill, 255 ill, 256 ill, 257, 258 ill;
Wood Conn Cat 37, 1976: 332 ill, 333 ill, 334 ill;
California Galleries 4/3/76: 324 (2), 325
    (attributed);

## TABER (continued)

Sothebys Lon 6/11/76: 36a (album, T et al);
Christies Lon 10/28/76: 178 (album, T et al);
Swann NY 11/11/76: 352 (lot, T et al), 418 (2);
Halsted Michigan 1977: 738 (note), 739, 740;
Rose Boston Cat 2, 1977: 8 ill(note), 9 ill, 10 ill;
White LA 1977: 115 ill(note), 116 ill;
California Galleries 1/22/77: 133 (lot, T-1 et al),
    196 (album, 50), 251 (13), 352 (4);
California Galleries 1/23/77: 498z (book, T-1
    et al);
Sothebys NY 2/9/77: 81 (lot, T-1 et al);
Christies Lon 3/10/77: 169 (albums, T-40 et al),
    170, 171, 172 (3), 183 (album, T-2 et al);
Swann NY 4/14/77: 338 (lot, T et al);
Christies Lon 6/30/77: 133 (lot, T et al), 134
    (lot, T et al);
Christies Lon 10/27/77: 167;
Frontier AC, Texas 1978: 38 (book, T et al), 293 ill
    (album, 29)(note), 294, 295 (note), 296 ill,
    297, 298 ill(album, 40), 299 ill;
Rose Boston Cat 3, 1978: 16 ill(note), 17 ill;
California Galleries 1/21/78: 134 (lot, T et al),
    278 (album, T-2 et al), 279 (album, T-5 et al);
Sothebys LA 2/13/78: 49 (album, T et al);
Christies Lon 3/16/78: 136 (lot, T-4 et al);
Swann NY 4/20/78: 274 (2), 275 (2);
Sothebys Lon 6/28/78: 116 (albums, T-35 et al);
Sothebys Lon 10/27/78: 75 (album, T et al);
Swann NY 12/14/78: 343 (album, T-34 et al);
California Galleries 1/21/79: 501, 502 ill(9), 503,
    504;
Sothebys LA 2/7/79: 417 ill(album, T-37 et al);
Sothebys Lon 3/14/79: 104 (albums, T et al);
Christies Lon 3/15/79: 190 (album, T-12 et al);
Swann NY 10/18/79: 440 ill(album, 67);
Christies Lon 10/25/79: 251 (album, T-33 et al);
Sothebys NY 11/2/79: 293 ill(lot, T-1 et al);
Phillips NY 11/29/79: 282;
Rose Boston Cat 5, 1980: 8 ill(note), 9 ill;
Sothebys LA 2/6/80: 33 (lot, T et al), 34, 35 (lot,
    T-2 et al);
Sothebys Lon 3/21/80: 185 (album, T et al);
California Galleries 3/30/80: 231 (T & Howland)
    (note), 256 (lot, T et al), 425 (3), 426 (2),
    427 ill;
Swann NY 4/17/80: 276 (lot, T et al), 390 (13);
Christies NY 4/23/80: 271 (lot, T et al), 273, 274;
Christies NY 5/14/80: 378 (book, T et al);
Christies NY 5/16/80: 271 (lot, T et al), 273, 274;
Sothebys Lon 10/29/80: 106 (lot, T-2 et al);
Christies Lon 10/30/80: 269 (albums, T-5 et al), 270
    (albums, T et al);
Swann NY 11/5/80: 524 (album, T-8 et al)(note);
California Galleries 12/13/80: 159 (album, T et
    al), 208 (lot, T-1 et al), 269, 336 (lot, T-1 et
    al), 351 (lot, T-2 et al), 386, 387 (2), 388
    (2), 389 (2), 390 ill(3);
Sothebys Lon 3/27/81: 101 (album, T-36 et al);
Swann NY 4/23/81: 557 (2)(note);
Sothebys Lon 6/17/81: 108 (album, T et al);
California Galleries 6/28/81: 138 (album, T et al),
    156 (album, T et al), 193 (lot, T-1 et al), 246
    ill, 307 (lot, T-2 et al), 327 (2), 328 (3), 329
    (2), 330 (2), 331 (2), 428;
Christies Lon 10/29/81: 259 ill(lot, T-19 et al);
Swann NY 11/5/81: 524 (album, T et al)(note);
Wood Conn Cat 49, 1982: 444 (album, 28)(note);
Christies Lon 3/11/82: 222 (2), 218 ill(album,
    T et al);
Sothebys Lon 3/15/82: 63 (lot, T et al);

## TABER (continued)

Harris Baltimore 3/26/82: 395 (lot, T et al);
Swann NY 4/1/82: 249 (lot, T et al)(note);
California Galleries 5/23/82: 436 (2), 437 (2);
Swann NY 11/18/82: 461 (albums, 51)(note), 478
    (album, T et al)(note);
Christies Lon 3/24/83: 135 (album, T et al), 136
    (album, T et al);
Harris Baltimore 4/8/83: 385 (lot, T et al);
California Galleries 6/19/83: 99 (book, T-1 et al),
    101 (book, T-1 et al), 462, 463 ill, 464 ill,
    465, 466, 467, 468 ill, 469, 470 (3), 471, 472
    (2), 473 ill, 474, 475, 476 (2), 477, 478 (4),
    479, 480, 481 (3), 482, 483, 484 (2), 485 (2),
    486 (3), 487 (2), 488, 489 (2), 490 (2), 491
    (2), 492, 493 ill, 494 (4), 495, 496 ill, 497,
    498, 499 ill, 500 (2), 501 (2), 551 (lot, T-1
    et al);
Christies Lon 6/23/83: 160 (album, T et al), 180
    (albums, T et al);
Harris Baltimore 9/16/83: 148 (lot, T et al);
Christies Lon 10/27/83: 145 (lot, T-1 et al), 146
    (album, T-35 et al), 152 (lot, T et al), 158
    (album, T et al);
Swann NY 11/10/83: 360 ill;
Sothebys Lon 12/9/83: 184 (album, T-20 et al), 193
    (album, T et al);
Harris Baltimore 12/16/83: 293 (lot, T et al),
    416 (4);
Christies NY 2/22/84: 24 ill;
Swann NY 5/10/84: 314 (lot, T-32 et al);
Harris Baltimore 6/1/84: 141 (17)(note);
Christies Lon 6/28/84: 141 (album, T-1 et al);
Sothebys Lon 6/29/84: 66 ill(album, T et al);
California Galleries 7/1/84: 681 (album, 50), 682,
    683 (3), 684, 685 (3), 686 (2), 687, 688 (3),
    689, 690 (3), 691, 692 (2), 693 (2), 694, 695,
    696, 697 (2), 698 (3), 699 (3), 745 (lot, T-1 et al);
Christies NY 9/11/84: 124 (albums, T-13 et al);
Christies Lon 10/25/84: 105 (album, T et al);
Swann NY 11/8/84: 143 (lot, T et al);
Christies NY 2/13/85: 155 (lot, T et al);
Harris Baltimore 3/15/85: 153 (lot, T-4 et al);
Swann NY 5/9/85: 322 (lot, T et al);
California Galleries 6/8/85: 406 (2), 438 (lot,
    T et al), 454, 455, 456 (3), 457 (3), 458, 459,
    460 (2);
Swann NY 11/14/85: 136 (album, T et al), 158 (lot,
    T et al), 176 (5), 264 (books, T et al);
Wood Boston Cat 58, 1986: 136 (books, T-1 et al);
California Galleries 3/29/86: 784 (3);
Christies Lon 4/24/86: 395 (album, T et al);
Swann NY 5/16/86: 166 (lot, T-9 et al), 168 (album,
    T et al)(note), 192 (album, T-11 et al), 192A
    (lot, T-21 et al);
Christies Lon 10/30/86: 150 (album, T-28 et al);
Swann NY 11/13/86: 126 (lot, T et al), 132 (lot, T-2
    et al), 288 (lot, T-6 et al), 341 ill(13);

## TACKABERRY

Photos dated: 1863-1864
Processes:      Albumen
Formats:        Cdvs
Subjects:       Documentary
Locations:
Studio:
    Entries:
Swann NY 11/10/83: 236 (lot, T-1 et al);

**TAFT, Frank M.**
Photos dated: late 1870s
Processes:      Albumen
Formats:        Stereos
Subjects:       Genre
Locations:      US
Studio:         US - Chester, Vermont
    Entries:
Rinhart NY Cat 6, 1973: 461;

**TAFT, J.W.** (American)
Photos dated: c1863
Processes:      Albumen
Formats:        Cdvs
Subjects:       Documentary (maritime)
Locations:      US
Studio:         US
    Entries:
Rinhart NY Cat 7, 1973: 538 ill(2);

**TAFT, P.W.** (American)
Photos dated: 1869
Processes:      Albumen
Formats:        Stereos
Subjects:       Topography
Locations:      US - Vermont
Studio:         US - Bellows Falls, Vermont
    Entries:
Rinhart NY Cat 6, 1973: 551;

**TAGLIANO & RICORDI** (Italian)
Photos dated: 1898
Processes:
Formats:        Cabinet cards
Subjects:       Portraits
Locations:      Studio
Studio:         Italy - Milan
    Entries:
Sothebys NY 11/20/70: 51 ill(lot, T & R et al);

**TAGLIARINI, A.** (Italian)
Photos dated: 1870s-1880s
Processes:      Albumen
Formats:        Prints
Subjects:       Topography
Locations:      Italy
Studio:         Italy
    Entries:
Swann NY 5/15/86: 265 (lot, T et al);
Swann NY 11/13/86: 356 (lot, T et al);

**TAI, Tuck** (Chinese)(aka SYE SAUNG TUCK TAI)
Photos dated: 1870s-c1880
Processes:      Albumen
Formats:        Prints incl. panoramas
Subjects:       Topography
Locations:      China - Shanghai
Studio:         China - Shanghai
    Entries:
Sothebys Lon 10/27/78: 132 (note);
Wood Conn Cat 45, 1979: 317 (note);
Wood Conn Cat 49, 1982: 445 (note);
Christies Lon 6/26/86: 184 (album, 17);

**TAIRRAZ**
Photos dated: 1890s
Processes:      Albumen
Formats:        Prints, stereos, cdvs
Subjects:       Topography
Locations:      Europe - Alps
Studio:         France - Chamonix
    Entries:
Christies Lon 3/16/78: 169 (24);
Christies Lon 3/15/79: 81 (lot, T et al);
Phillips NY 11/29/79: 265 (lot, T-1 et al);
Christies Lon 3/20/80: 100 (lot, T-14 et al);
Christies Lon 10/29/81: 142 (lot, T et al);
Harris Baltimre 4/8/83: 100 (lot, T et al);
Harris Baltimore 12/16/83: 132 (lot, T et al);
Christies Lon 10/25/84: 110 (album, T et al);
Christies Lon 3/28/85: 51 (lot, T et al);
Christies Lon 4/24/86: 314 (lot, T et al);

**TAKESITA, Y.** (Japanese)
Photos dated: c1880
Processes:      Albumen
Formats:        Cabinet cards
Subjects:       Topography
Locations:      Japan - Nagasaki
Studio:         Japan - Nagasaki
    Entries:
California Galleries 6/8/85: 308;

**TALBOT, C.W.** (American)
Photos dated: 1890s
Processes:      Albumen
Formats:        Prints, stereos
Subjects:       Topography
Locations:      US - American west
Studio:         US
    Entries:
Vermont Cat 4, 1972: 601 ill(4);
Swann NY 5/10/84: 314 (lot, T et al);

**TALBOT, William Henry Fox** (British, 1800-1877)
Photos dated: 1836-1866
Processes:      Talbotype, photoglyph
Formats:        Prints
Subjects:       Photogenic drawings, topography,
                genre
Locations:      England; France; Austria; Switzerland
Studio:         England
    Entries:
Goldschmidt Lon Cat 52, 1939: 141 (4)(attributed)
    (note), 142 (attributed), 143 ill(10)
    (attributed), 144 (3)(attributed), 145 (11)
    (attributed), 147 (lot, T-1 et al);
Weil Lon Cat 1, 1943: 142 (lot, T-3 et al);
Weil Lon Cat 2, 1943(?): 236 (note);
Weil Lon Cat 4, 1944(?): 257 (book, 18)(note), 258
    (book, 23)(note);
Weil Lon Cat 7, 1945: 71 ill(lot, T-1 et al)(note),
    72 (note), 73, 73A (note);
Weil Lon 1946: 1 ill(note), 2 (note), 3 (note);
Weil Lon Cat 14, 1949(?): 305 (book, 21)(note), 306
    (book, 23)(note);
Andrieux Paris 1951(?): 74 (book, 1)(note);
Swann NY 2/14/52: 323 (6)(note), 325 (note), 326
    (book, 18)(note), 327 (book, 23)(note), 328 (2)
    (note);

Rauch Geneva 6/13/61: 42a (note), 42b ill(note),
    42c (2)(note), 42d (note), 42f (12)(note), 42g
    (2)(note), 42h ill(note), 43 (4);
Sothebys NY 11/21/70: 227 ill(note), 228 ill(note),
    229 ill(note), 230 ill(note), 231 ill(note), 236
    ill (attributed), 237 ill(attributed), 238 ill
    (attributed);
Sothebys Lon 12/21/71: 306, 307 ill(note), 308,
    309, 310 ill, 311 ill, 314 ill, 315 ill(book, 21)
    (note);
Lunn DC Cat 2, 1972: 126 ill;
Frumkin Chicago 1973: 115, 116, 117, 118, 119 ill,
    120, 121 ill, 122;
Rinhart NY Cat 6, 1973: 135 (book, 23)(note);
Vermont Cat 5, 1973: 493 ill(note);
Sothebys Lon 5/24/73: 114 ill(note), 115 ill, 178
    ill(note), 179 ill, 180 ill, 181 ill, 182 ill,
    183 ill, 184 ill, 185 ill;
Sothebys Lon 12/4/73: 219 ill, 220 ill;
Ricketts Lon 1974: 18 ill, 19 ill, 20 ill, 21 ill,
    22 ill, 23 ill, 24 ill, 25 ill, 26 ill;
Sothebys Lon 3/8/74: 46 ill(note), 47 ill, 48 ill,
    49 ill, 50 ill, 51 ill, 52 ill, 53 ill, 54 ill,
    55 ill;
Sothebys Lon 10/18/74: 267 ill(note), 268 ill, 269
    ill, 270 ill, 271 ill, 272 ill, 273 ill, 274
    ill, 275 ill(note), 276 ill;
Edwards Lon 1975: 1 ill, 55 (book, 1)(note), 56
    (book, 1);
Witkin NY III 1975: 224 ill(note);
Sothebys NY 2/25/75: 17 (note), 18 ill(lot, T-1 et
    al)(note), 19 ill(note), 20 ill(lot, T-1 et al),
    21 ill(3);
Sothebys Lon 3/21/75: 27 ill, 28 ill, 29 ill, 30
    ill, 31 ill, 32 ill, 33 ill, 34 ill, 35 ill, 36
    ill, 37 ill, 38 ill, 39 ill;
Sothebys Lon 6/26/75: 184 (48 ills)(album, 48)
    (note);
Sothebys NY 9/23/75: 14, 15, 16 ill;
Alexander Lon 1976: 76 ill;
Anderson & Hershkowitz Lon 1976: 3 ill, 4 ill, 5
    ill, 6 ill, 7 ill, 8 ill;
Colnaghi Lon 1976: 19 ill(note), 20, 21 ill, 22
    ill, 23 ill, 24, 25 (3 ills)(book, 24)(note);
Witkin NY IV 1976: 263 ill;
Sothebys Lon 3/19/76: 36 (album, T-1 et al), 192
    ill(2), 193 (3), 194;
California Galleries 4/3/76: 326 ill(attributed);
Gordon NY 5/3/76: 273 ill;
Sothebys NY 5/4/76: 20, 21 ill, 22, 23, 24 ill
    (note);
Christies Lon 6/10/76: 31 ill;
Sothebys Lon 6/11/76: 202 ill, 203 ill;
Christies Lon 10/28/76: 63 ill, 64 ill;
Sothebys Lon 10/29/76: 236 (2);
Halsted Michigan 1977: 741 (note);
White LA 1977: 58 ill(note);
California Galleries 1/22/77: 302 ill;
Sothebys Lon 3/9/77: 66 ill, 67 ill, 68 ill, 69
    ill, 70 ill, 214 (note);
Christies Lon 3/10/77: 56 ill(note), 57 ill(note),
    58, 59 (2 ills)(book, 23)(note);
Sothebys NY 5/20/77: 67 ill(note);
Christies Lon 6/30/77: 258, 258a (2 ills)(book, 7)
    (note), 259 ill(note), 260 ill;
Sothebys Lon 7/1/77: 92 ill, 93 ill, 94 ill, 95
    ill, 96 ill, 97 ill, 98 ill, 99 ill, 100 ill,
    101 ill, 102 ill, 103 ill, 104 ill, 105 ill;
Sothebys NY 10/4/77: 149 (attributed, 3)(note);
Christies Lon 10/27/77: 281 (note), 282;

Sothebys Lon 11/18/77: 51 ill(note), 53 ill(book,
    18)(note), 54 ill, 55 ill, 56 ill, 57 ill;
Swann NY 12/9/77: 307 (note), 308 ill(note), 309;
Rose Boston Cat 3, 1978: 29 ill(note);
Weston Cal 1978: 121 ill, 122 ill, 123 ill;
California Galleries 1/21/78: 271 ill(attributed);
Christies Lon 3/16/78: 275 ill(note), 276 ill, 277
    ill, 278 (2)(note);
Sothebys Lon 3/22/78: 37 ill, 38 ill, 39 ill, 40
    ill, 41 ill, 42, 43 (book, 1)(note);
Swann NY 4/20/78: 245A (note);
Christies Lon 6/27/78: 188, 189;
Sothebys Lon 6/28/78: 50 ill, 51, 52 ill, 53 ill,
    54 ill, 55 ill, 56 ill, 57 ill, 58 ill, 59 ill;
Sothebys Lon 10/27/78: 55 ill, 56 ill, 57 ill, 58
    ill, 59 ill, 60 ill (book, 18)(note), 61 ill, 62
    ill, 63 ill, 64 ill, 65 ill, 66 ill;
Phillips NY 11/4/78: 1 ill, 2 ill, 3, 4 ill, 5, 6,
    7 ill, 8, 9 (note), 10 ill, 11 ill(note);
Swann NY 12/14/78: 11 (book, 1)(note);
Lennert Munich Cat 5, 1979: 4 ill;
Lehr NY Vol 1:3, 1979: 9 ill, 21 ill;
Rose Boston Cat 4, 1979: 20 ill(note);
Witkin NY VIII 1979: 73 ill;
Phillips Lon 3/13/79: 9 ill, 10 ill, 11 ill, 12 ill,
    13 ill, 14 ill, 15 ill, 16, 17 ill, 18, 19 ill,
    20 ill(note);
Sothebys Lon 3/14/79: 67 ill, 68 ill, 69 ill, 70
    ill, 72, 73 ill, 74 ill, 75 ill;
Christies Lon 3/15/79: 197 (book, T-1 et al), 198
    (book, T-1 et al);
Swann NY 4/26/79: 460 (note), 461 ill;
Phillips NY 5/5/79: 110 ill, 111 ill, 112, 113 ill
    (10), 114, 115, 116 ill, 117 ill, 118, 119
    (note);
Sothebys NY 5/8/79: 56 ill, 57 ill(attributed);
Christies Lon 6/28/79: 179;
Sothebys Lon 6/29/79: 64 ill, 65 ill, 66 ill, 67
    ill, 68 ill, 69 ill, 70 ill, 71 ill, 72 ill,
    73 ill;
Sothebys Lon 10/24/79: 68, 69, 70 ill, 71 ill;
Christies NY 10/31/79: 1, 2, 3 ill;
Swann NY 12/31/79: 307 (note), 308 ill(note), 309;
Sothebys Lon 3/21/80: 194 ill, 195 ill;
Christies NY 5/16/80: 1 (note), 2;
Phillips NY 5/21/80: 152 ill;
Phillips Lon 6/25/80: 128 ill, 129 ill;
Sothebys Lon 6/27/80: 144 ill(note), 171 (book, 1);
Christies Lon 10/30/80: 282 (book, 1), 342, 343
    ill, 344 ill, 345 ill;
Christies NY 11/11/80: 3 ill(attributed)(note),
    4 ill;
Sothebys NY 11/17/80: 79 ill;
California Galleries 12/13/80: 391 (2), 392 (3)
    (note);
Sothebys Lon 3/27/81: 146 ill, 147 ill, 148
    (2 ills) (book, 5), 149 ill(book, 7), 150
    ill(book, 3), 151 ill(book, 3), 152 ill, 153
    (book, 1), 154 ill;
Swann NY 4/23/81: 307 (attributed)(note);
Christies NY 5/14/81: 1 ill;
Sothebys NY 5/15/81: 80;
Sothebys Lon 6/17/81: 84 ill, 85 ill, 86 ill, 87,
    88, 89, 90 ill, 91 ill, 92 ill;
Christies Lon 6/18/81: 121 ill(book, 5)(note), 122
    ill(book, 7)(note), 123 ill(book), 124 ill, 125
    ill, 126 ill, 127 ill, 128 ill, 129 ill, 130
    ill, 131 ill(note), 132 ill, 133 ill(note), 134
    (note), 135 ill(2), 393 (album, T-1 et al)
    (note), 396 (album, T-1 et al)(note), 397

TALBOT (continued)
(attributed)(note), 398 (attributed), 399 ill
(attributed), 400 (2)(attributed), 401
(attributed), 402 (attributed), 403 (attributed);
Sothebys NY 10/21/81: 207 ill;
Sothebys Lon 10/28/81: 155 ill, 156 ill, 157 ill
(book, 23), 158 ill, 159 ill, 160 ill;
Petzold Germany 11/7/81: 197, 198;
Christies NY 11/10/81: 1 ill(note), 2 (note), 3 ill
(note), 4 ill(note);
Rose Florida Cat 7, 1982: 19 ill(note);
Weston Cal 1982: 1 ill;
Christies Lon 3/11/82: 106 ill;
Sothebys Lon 3/15/82: 162 ill, 163 (note), 164 ill,
165 (book, 1), 166 ill, 167 ill, 168 ill(note),
169 ill, 170 ill, 171 ill, 173 ill, 174 ill
(note), 175 ill(note), 176 ill, 177 ill;
Phillips NY 5/22/82: 933 ill;
Christies NY 5/26/82: 1 ill(note);
Sothebys Lon 6/25/82: 136 ill, 137 ill, 138 ill,
139 ill(note), 140 ill, 141 ill(note), 142 ill,
143 ill, 144 ill, 145 ill, 146 ill;
Christies Lon 10/28/82: 45 ill, 45A;
Sothebys Lon 10/29/82: 51 (lot, T-1 attributed, et
al)(note), 62 ill, 63 ill, 64 ill, 65 ill, 66
ill, 67 ill, 68 ill;
Christies NY 11/8/82: 239 (2 ills)(books, 24)
(note), 240 ill(note);
Drouot Paris 11/27/82: 118 ill;
Christies Lon 3/24/83: 58 ill, 59 ill(17)(note);
Sothebys Lon 3/25/83: 104 ill, 105 ill, 106 ill,
107 ill;
Christies NY 5/9/83: 147 ill(note), 148 ill;
Christies Lon 6/23/83: 201 ill, 202, 203 ill;
Christies Lon 10/27/83: 184 ill(2)(note), 185 ill
(note);
Phillips Lon 11/4/83: 106 ill;
Christies NY 11/8/83: 202 ill(note), 203 ill(note),
204 ill;
Kraus NY Cat 1, 1984: 1 ill(note), 2 ill(note), 3
ill(note), 4 ill, 5 ill(note), 6 ill(note), 7 ill
(note), 8 ill(note), 9 ill(note), 11 ill, 12 ill
(note), 13 (24 ills)(book, 24)(note), 14 ill
(note), 15 ill, 16 ill, 17 ill, 18 (2 ills)(2)
(note), 19 ill;
Christies NY 5/7/84: 1 ill(note);
Sothebys NY 5/11/84: 228 ill;
Christies Lon 6/28/84: 169 ill;
Sothebys NY 6/29/84: 142 ill;
Christies Lon 10/25/84: 148 ill(note), 149 (2)
(note), 150 ill(note), 151 ill(note), 152
(5 ills)(book, 24)(note);
Sothebys Lon 10/26/84: 100 ill, 101 ill;
Christies NY 11/6/84: 1 ill(note);
Christies Lon 3/28/85: 129 ill(note), 130, 131 ill;
Sothebys Lon 3/29/85: 125a ill, 126 ill, 127 ill,
128 ill, 129 ill;
Christies NY 5/6/85: 353 ill(note);
Sothebys NY 5/7/85: 410 ill;
Sothebys Lon 6/28/85: 85 ill(note), 86 ill, 87 ill,
88 ill, 89 ill, 90 ill, 91 ill, 92 ill, 93 ill,
94 ill, 95 ill, 96 ill, 97 ill;
Sothebys Lon 11/1/85: 46 ill, 47, 48 ill, 49 ill,
50, 51 ill, 52 ill, 53 ill, 54 ill;
Sothebys NY 11/12/85: 348 ill, 349 ill(2)(note);
Swann NY 11/14/85: 177 ill(note);
Kraus NY Cat 2, 1986: 2.68 B ill(attributed), 4 ill,
5 ill(note), 6 ill, 7 ill, 8 ill(note), 9 ill
(note), 10 ill(note), 11 ill(note);
Christies Lon 4/24/86: 439 ill;

TALBOT (continued)
Sothebys Lon 4/25/86: 77 ill, 78 ill, 79 ill, 80 ill
(note), 81 (book, 1);
Swann NY 5/15/86: 310 (3);
Christies Lon 10/30/86: 58 ill, 59 ill, 59A ill,
60 ill;
Sothebys Lon 10/31/86: 71 ill, 72 ill (note),
73 ill;
Christies NY 11/11/86: 413 ill;

**TALFOR**
Photos dated:  c1880s
Processes:      Albumen
Formats:        Prints
Subjects:       Documentary (engineering)
Locations:      US - south
Studio:
    Entries:
Harris Baltimore 3/15/85: 183 (22)(note);

**TALLMAN** (see LANGDON & TALLMAN)

**TAMAMURA, Kihei** (Japanese)
Photos dated:  1880s-1912
Processes:      Albumen, collotype
Formats:        Prints, cdvs
Subjects:       Genre, topography
Locations:      Japan
Studio:         Japan - Yokohama; Kobe
    Entries:
Christies Lon 4/25/74: 240 (album);
Swann NY 4/23/81: 111 ill(book, T et al)(note);
Old Japan, England Cat 5, 1982: 11 ill(100), 12 ill
(album, 50), 13 ill(album, T-27 et al), 14
(album, 50);
Swann NY 11/18/82: 186 (book, T et al);
Christies Lon 3/24/83: 121 (book, T-22 et al);
Swann NY 5/5/83: 391 (album, T-1 attributed, et al)
(note);
Christies Lon 10/27/83: 143 ill(album, 46);
Christies NY 5/7/84: 21 ill(attributed)(album, 46)
(note);
Swann NY 5/10/84: 104 (book, T et al);
Old Japan, England Cat 8, 1985: 24 (album, 50), 25
(album, T et al), 39 (lot, T et al), 86, 89
(18), 90;
Christies Lon 4/24/86: 392 (album, 100);
Phillips Lon 10/29/86: 346 (album, 50)(note);
Swann NY 11/13/86: 35 (books, T-24 et al), 251
(lot, T-24 et al);

**TAMEMASA** (Japanese)
Photos dated:  1880s-c1915
Processes:      Albumen
Formats:        Prints
Subjects:       Topography
Locations:      Japan
Studio:         Japan - Nagasaki
    Entries:
Old Japan, England Cat 5, 1982: 23 ill(album, 48);
Old Japan, England Cat 8, 1985: 39 (lot, T et al);

**TANNER, Captain H.C.B.** (British)
Photos dated: c1870
Processes: Albumen
Formats: Prints
Subjects: Ethnography
Locations: India
Studio:
    Entries:
Sothebys Lon 10/18/74: 80 (book, T et al);
Christies Lon 3/11/82: 252 (books, T et al);

**TARBELL, John R.** (American)
Photos dated: 1896
Processes:
Formats: Prints
Subjects: Architecture
Locations: US - Arden, North Carolina
Studio: US
    Entries:
Swann NY 4/23/81: 509 (lot, T-5 et al);

**TARSA** (see CALERONI & TARSA)

**TARTARIAN, Bedros**
Photos dated: 1899
Processes: Photogravure
Formats: Prints
Subjects: Topography, ethnography
Locations: Mexico
Studio:
    Entries:
Witkin NY I 1973: 195 (book, T et al);
Witkin NY II 1974: 217 (book, T et al);
Witkin NY III 1975: 750 (book, T et al);
Swann NY 11/5/81: 200 ill(book, T et al)(note);
Swann NY 4/1/82: 205 ill(book, T et al)(note);
Swann NY 11/18/82: 232 (book, T et al)(note);
Swann NY 11/13/86: 97 (book, T et al)(note);

**TAUNT, Henry William** (British, 1842-1922)
Photos dated: 1868-1887
Processes: Albumen, woodburytype, glass
                diapositives
Formats: Prints, glass plates
Subjects: Topography
Locations: England - Oxford; Thames area
Studio: England - Oxford
    Entries:
Goldschmidt Lon Cat 52, 1939: 240 (book, 100);
Swann NY 2/14/52: 330 (book, 100);
Sothebys Lon 12/21/71: 247 (40);
Swann NY 2/6/75: 119 (book, 100);
Sothebys Lon 3/21/75: 314 (book, 102);
California Galleries 9/26/75: 190 (book, 80), 191
    (book, 100);
California Galleries 4/2/76: 167 (book, 100), 168
    (book, 102)(note);
Sothebys Lon 10/29/76: 178 (book, 100), 179 (book,
    100);
Swann NY 11/11/76: 293 (book, 100);
White LA 1977: 59 ill(note);
California Galleries 1/22/77: 214 (book, 80);
Sothebys Lon 7/1/77: 25 (book, 100), 26 (book,
    100), 27 (book, 80), 168 (album, T et al);
Sothebys Lon 11/18/77: 173 (book, 100), 186 (book,
    80), 187 (book, 100);

**TAUNT** (continued)
Wood Conn Cat 42, 1978: 504 (book, 29)(note), 505
    (book, 100)(note);
Christies Lon 6/27/78: 20 (2);
Christies Lon 10/26/78: 219 (book, 80);
Rose Boston Cat 5, 1980: 35 ill(note), 36 ill;
Witkin NY X 1980: 74 (book, 100), 75 (book, 100);
Christies Lon 3/20/80: 135 (lot, T-1 et al);
Christies Lon 6/26/80: 169 (albums, T-1 et al);
Sothebys Lon 6/27/80: 165 (book, 80);
Christies Lon 3/11/82: 248 (lot, T-2 et al);
Christies Lon 10/28/82: 127 (books, T-100 et al);
Sothebys Lon 10/26/84: 186 (books, T-100 et al);
Sothebys Lon 6/28/85: 233 ill(book);
Phillips Lon 10/29/86: 327 (lot, T et al);

**TAUPIN et Cie.** (French)
Photos dated: 1865-1880s
Processes: Albumen
Formats: Prints
Subjects: Genre (rural life)
Locations: France
Studio: France - Paris
    Entries:
Sothebys Lon 3/21/75: 279 (lot, T et al);
Lehr NY Vol 1:2, 1978: 40 ill;
Sothebys NY 5/2/78: 110 ill, 111, 112, 113, 114;
Sothebys Lon 3/25/83: 87 ill(2);
Sothebys Lon 10/26/84: 84 ill(2);
Sothebys NY 11/12/85: 350 (2);

**TAY, See**
Photos dated: c1875
Processes: Albumen
Formats: Cdvs
Subjects: Portraits
Locations: Studio
Studio:
    Entries:
Sothebys Lon 7/1/77: 156 (album, S-1 et al);
California Galleries 1/21/79: 235 (lot, T et al);
Cristies Lon 3/26/81: 267 ill(lot, S-1 et al)(note);
Sothebys Lon 3/15/82: 107 (lot, S-1 et al);

**TAYLOR** (see WENDROTH & TAYLOR) [TAYLOR 1]

**TAYLOR** (American) [TAYLOR 2]
Photos dated: 1860s
Processes: Ambrotype
Formats: Plates
Subjects: Portraits
Locations: Studio
Studio: US - San Francisco, California
    Entries:
California Galleries 6/28/81: 166 (lot, T-1 et al);

**TAYLOR** (American) [TAYLOR 3]
Photos dated: c1860s-c1870
Processes: Tintype, albumen
Formats: Plates, cdvs
Subjects: Portraits
Locations: Studio
Studio: US - Brooklyn, New York
    Entries:
Rinhart NY Cat 2, 1971: 245 (lot, T et al);
California Galleries 12/13/80: 221 (lot, T et al);

TAYLOR (American) [TAYLOR 4]
Photos dated: Nineteenth century
Processes:      Albumen
Formats:        Stereos
Subjects:       Topography
Locations:      US - Minnesota
Studio:         US
    Entries:
Harris Baltimore 6/1/84: 93 (lot, T et al);

TAYLOR & SEAVE (American) [TAYLOR 5]
Photos dated: early 1860s
Processes:      Albumen
Formats:        Prints
Subjects:       Documentary (Civil War)
Locations:      US - Civil War area
Studio:         US - Tennessee
    Entries:
Sothebys NY (Strober Coll.) 2/7/70: 418 (lot,
    T & S et al);

TAYLOR, A. & G. (British)
Photos dated: Nineteenth century
Processes:      Albumen
Formats:        Cabinet cards
Subjects:       Portraits
Locations:      Studio
Studio:         England - London
    Entries:
Petzold Germany 5/22/81: 1980 (album, T et al);
Sothebys Lon 3/15/82: 208 (lot, T-42 et al);
Harris Baltimore 3/15/85: 298 (lot, T et al);

TAYLOR, A. Silvester, Jr.
Photos dated: 1880s-1895
Processes:      Albumen, bromide
Formats:        Prints
Subjects:       Topography
Locations:      US; Barbados
Studio:         US; Barbados - Bridgetown
    Entries:
Christies Lon 10/30/80: 277 (album, T-11 et al);
Swann NY 11/14/85: 18 ill(albums, T et al);

TAYLOR, Dr. Alfred (British)
Photos dated: 1848
Processes:      Calotype
Formats:        Prints
Subjects:       Photogenic drawings
Locations:      Studio
Studio:         Great Britain
    Entries:
Christies Lon 6/30/77: 73 ill(lot, T-19 attributed,
    et al)(note);

TAYLOR, Captain C.C. (British)
Photos dated: c1870-1870s
Processes:      Albumen
Formats:        Prints
Subjects:       Ethnography
Locations:      India
Studio:
    Entries:
Sothebys Lon 10/18/74: 80 (book, T et al);
Sothebys Lon 7/1/77: 56 (books, T et al);
Christies Lon 3/11/82: 252 (books, T et al);

TAYLOR, Henry (British)
Photos dated: 1855-1862
Processes:      Salt, albumen
Formats:        Prints, stereos
Subjects:       Topography
Locations:      Great Britain - Busbridge
Studio:         Great Britain
    Entries:
Sothebys Lon 12/4/73: 173 (book, T et al);
Sothebys Lon 3/21/75: 286 (album, T-1 et al);
Sothebys NY 5/20/80: 341 (books, T et al);
Christies Lon 6/27/85: 117 ill;

TAYLOR, J.K.
Photos dated: c1870s
Processes:      Albumen
Formats:        Prints
Subjects:       Topography
Locations:
Studio:
    Entries:
Swann NY 4/14/77: 188 (album, T et al);

TAYLOR, John (British)(photographer or author?)
Photos dated: 1872
Processes:      Albumen
Formats:        Prints
Subjects:       Topography
Locations:      England - Bristol
Studio:         Great Britain
    Entries:
Christies Lon 3/10/77: 330 (book, 24);
Christies Lon 3/16/78: 225 (book);
Sothebys Lon 3/15/82: 429 (book, 24);

TAYLOR, John C. & HUNTINGTON (American)
Photos dated: 1870s-1890
Processes:      Albumen
Formats:        Prints
Subjects:       Documentary
Locations:      US
Studio:         US - Hartford, Connecticut
    Entries:
Sothebys NY (Strober Coll.) 2/7/70: 558 (21)(note),
    559(24)(note), 560 (lot, T-2 et al), 561 (lot,
    T-2 et al);
Rinhart NY Cat 6, 1973: 410;
Harris Baltimore 7/31/81: 88 (lot, H & T-1 et al);
Harris Baltimore 5/28/82: 91 (lot, T & H-1 et al),
    160 (26)(note);
Harris Baltimore 12/10/82: 26 (19);
Christies NY 2/8/83: 23 (44);
Harris Baltimore 6/1/84: 33 (40);
California Galleries 7/1/84: 347;
Harris Baltimore 11/9/84: 86 (lot, H & T-2 et al),
    92;
Swann NY 5/9/85: 370 (lot, T et al);
Harris Baltimore 2/14/86: 69 (lot, T & H-1 et al);
Harris Baltimore 11/7/86: 110 (lot, H & T-1 et al),
    112, 113;

**TAYLOR, John Wilson** (American, died 1918)
Photos dated: c1870s-c1880s
Processes:      Albumen
Formats:        Prints
Subjects:       Topography, documentary (engineering)
Locations:      US - Chicago, Illinois
Studio:         US - Chicago, Illinois
   Entries:
Sothebys Lon 3/9/77: 28 (album, T-1 et al);
Christies Lon 3/15/79: 180 (album, T-4 et al);
Swann NY 4/17/80: 382 (lot, T-1 et al);
Christies Lon 10/30/80: 270 (albums, T et al);
Swann NY 11/5/81: 524 (album, T-4 et al)(note);
Christies Lon 10/31/85: 129 (album, T et al);

**TAYLOR, Nat W.** (American)
Photos dated: 1870s-c1880
Processes:      Albumen
Formats:        Stereos
Subjects:       Topography
Locations:      US - North Carolina; Georgia;
                Tennessee
Studio:         US - Asheville, North Carolina
   Entries:
Rinhart NY Cat 6, 1973: 533 (7);
California Galleries 4/3/76: 463 (lot, T et al);

**TEAPE, J.S.** (British)
Photos dated: 1880s
Processes:      Photoceramics
Formats:        Plates
Subjects:       Portraits
Locations:      Studio
Studio:         Great Britain
   Entries:
Christies Lon 6/26/80: 130 ill(19);

**TEBBETTS, G.H.** (American)
Photos dated: Nineteenth century
Processes:      Albumen
Formats:        Stereos
Subjects:       Topography
Locations:      US - New Hampshire
Studio:         US - New Hampshire
   Entries:
California Galleries 9/27/75: 512 (lot, T et al);
California Galleries 1/23/77: 410 (lot, T et al);

**TEMPLEMORE, A.** (British)
Photos dated: 1850s
Processes:      Albumen
Formats:        Prints
Subjects:
Locations:      Great Britain
Studio:         Great Britain
   Entries:
Christies Lon 6/27/85: 249 (album, T-1 et al);

**TENNEY** (see HOARD & TENNEY)

**TENNEY, Charles A.** (American)
Photos dated: 1883-1880s
Processes:      Albumen
Formats:        Prints, stereos
Subjects:       Documentary (railroads, disasters)
Locations:      US - Wisconsin; Minnesota
Studio:         US - Winona, Wisconsin
   Entries:
Sothebys NY (Strober Coll.) 2/7/70: 521 (lot,
   T et al);
Harris Baltimore 3/26/82: 359 (5);
Harris Baltimore 4/8/83: 57;

**TERPEREAU, Alphonse** (French)
Photos dated: 1863-1870s
Processes:      Albumen, collotype
Formats:        Prints
Subjects:       Documentary (engineering)
Locations:      France - Bordeaux
Studio:         France - Bordeaux
   Entries:
Sothebys LA 2/13/78: 121 (books, T et al)(note);
Sothebys Lon 10/27/78: 161 ill;

**TERRACE, P.C.** (British)
Photos dated: 1860s
Processes:      Albumen
Formats:        Prints
Subjects:       Genre (public events)
Locations:      England - Cambridge
Studio:         England - Cambridge
   Entries:
Christies Lon 3/16/78: 52;

**TERRIS** (French)
Photos dated: Nineteenth century
Processes:      Collotype
Formats:        Prints
Subjects:       Documentary (engineering)
Locations:      France - Marseille
Studio:         France - Marseille
   Entries:
Sothebys LA 2/13/78: 121 (books, T et al)(note);

**TERRY**
Photos dated: 1860s
Processes:      Ambrotype
Formats:        Plates
Subjects:       Portraits
Locations:      Studio
Studio:         Chile
   Entries:
Christies Lon 10/4/73: 88;

**TERRY, T.** (British)
Photos dated: between 1851 and 1856
Processes:      Calotype
Formats:        Prints
Subjects:       Topography
Locations:      Great Britain
Studio:         Great Britain
   Entries:
Sothebys Lon 12/21/71: 138 (album, T attributed
   et al);

TERUEL (French)
Photos dated: 1870
Processes:    Albumen
Formats:      Cdvs
Subjects:     Topography
Locations:    France
Studio:       France
  Entries:
California Galleries 4/2/76: 91 (lot, T et al);
California Galleries 3/30/80: 270 (lot, T et al);

TESCH, Emil (German)
Photos dated: Nineteenth century
Processes:    Albumen
Formats:      Cabinet cards
Subjects:     Portraits
Locations:    Studio
Studio:       Germany
  Entries:
Petzold Germany 11/7/81: 324 (album, T et al);

TESLELIER, C. Rudolf
Photos dated: c1897
Processes:    Albumen
Formats:      Prints
Subjects:     Topography, ethnography
Locations:    "South Sea Islands"
Studio:
  Entries:
Sothebys LA 2/17/82: 365 ill(album, 160)(attributed)
  (note);

TESSARO
Photos dated: c1870
Processes:    Albumen
Formats:      Prints
Subjects:     Architecture
Locations:    Europe
Studio:       Europe
  Entries:
California Galleries 1/22/77: 300 (lot, T-1 et al);

TEYNARD, Félix (French, 1817-1892)
Photos dated: 1851-1858
Processes:    Salt, photolithograph (Poitevin
              process)
Formats:      Prints
Subjects:     Topography
Locations:    France - south; Egypt
Studio:
  Entries:
Christies Lon 10/27/77: 298 ill(note), 299 ill,
  300 ill, 301 ill, 302 ill, 303 ill, 304 ill,
  305 ill(3);
Christies Lon 6/27/78: 199 ill;
Octant Paris 3/1979: 14 ill;
Christies NY 5/16/80: 129;
Christies NY 5/14/81: 30 ill(note);
Sothebys NY 10/21/81: 208 ill;
Christies Lon 3/11/82: 308 ill;
Phillips NY 11/9/82: 281 ill(note);
Sothebys Lon 6/29/84: 116 ill, 117 ill, 118 ill;
Christies NY 11/6/84: 16 ill(note);
Christies NY 11/11/85: 422 ill, 423 ill;
Sothebys NY 11/12/85: 351 ill;
Swann NY 11/14/85: 178;
Sothebys NY 11/10/86: 233 ill, 291 ill(note);

THALAMAS (French)
Photos dated: 1850s-1865
Processes:    Daguerreotype
Formats:      Plates
Subjects:     Portraits
Locations:    Studio
Studio:       France - Paris
  Entries:
Sothebys Lon 5/24/73: 122 (3);
Drouot Paris 11/22/86: 92;

THAYER
Photos dated: 1850s
Processes:    Daguerreotype
Formats:      Plates
Subjects:     Portraits
Locations:
Studio:
  Entries:
Vermont Cat 5, 1973: 383 ill;

THIEBAULT (French)
Photos dated: 1860s-1870s
Processes:    Albumen, woodburytype
Formats:      Cdvs, prints, stereos
Subjects:     Portraits
Locations:    Studio
Studio:       France - Paris
  Entries:
Sothebys NY 11/21/70: 345 (lot, T-1 et al);
Sothebys Lon 6/11/76: 180 (lot, T et al);
Sothebys LA 2/13/78: 116 (lot, T-1 et al);
Swann NY 5/15/86: 201 (album, T et al);

THIERY, R.I. (French)
Photos dated: 1840s
Processes:    Daguerreotype
Formats:      Plates
Subjects:     Genre
Locations:    Studio
Studio:       France - Lyon and Paris
  Entries:
Christies NY 5/26/82: 28 ill;

THIRWALL, J. (British)
Photos dated: Nineteenth century
Processes:
Formats:
Subjects:     Portraits
Locations:    Studio
Studio:       England - Hereford
  Entries:
Edwards Lon 1975: 12 (album, T et al);

THOM (Canadian)
Photos dated: 1880s
Processes:    Albumen
Formats:      Prints
Subjects:     Topography
Locations:    Canada
Studio:       Canada - Winnepeg
  Entries:
Phillips Can 10/9/80: 49 (album, T-7 et al)(note);
Christies Lon 10/30/86: 150 (album, T-12 et al);

**THOMAS**
Photos dated: 1885
Processes:      Photograpvure
Formats:        Prints
Subjects:       Topography
Locations:      Spain
Studio:
    Entries:
White LA 1977: 370 (book, T et al);

**THOMAS, J.** (British)
Photos dated: early 1850s
Processes:      Ambrotype, calotype
Formats:        Plates, prints
Subjects:       Portraits, topography
Locations:      England
Studio:         England - Hastings
    Entries:
Sothebys Lon 12/21/71: 138 (album, T attributed
    et al);
Christies Lon 10/31/85: 30 (lot, T-1 et al);
Christies Lon 6/26/86: 59 (lot, T-1 et al);

**THOMAS, M.** (French)
Photos dated: early 1850s
Processes:      Daguerreotype
Formats:        Plates
Subjects:       Portraits
Locations:      Studio
Studio:         France - Paris
    Entries:
Christies Lon 6/30/77: 23 ill;
Christies Lon 6/27/78: 23 ill;

**THOMAS, R.** (British)
Photos dated: 1870s
Processes:      Albumen
Formats:        Prints
Subjects:       Architecture
Locations:      Great Britain
Studio:         Great Britain
    Entries:
Christies Lon 3/26/81: 413 (album, T et al);

**THOMAS, W.**
Photos dated: 1890s
Processes:      Albumen
Formats:        Prints
Subjects:       Topography
Locations:
Studio:
    Entries:
Christies Lon 3/28/85: 103 (albums, T et al);

**THOMPSON** (see McALLISTER)

**THOMPSON, Charles Thurston** (British, died 1867)
Photos dated: 1856-1867
Processes:      Albumen
Formats:        Prints
Subjects:       Topography, architecture, genre,
                documentary (art)
Locations:      England - London; Spain; Portugal;
                France
Studio:         Great Britain
    Entries:
Edwards Lon 1975: 154 (book, 50)(note);
Sothebys Lon 6/11/76: 160 (book, 31);
Christies Lon 3/16/78: 298 (26);
Sothebys Lon 3/22/78: 193 ill(8);
Sothebys Lon 10/27/78: 106 (7);
Christies NY 5/4/79: 19 (note);
California Galleries 3/30/80: 85 (book, T et al);
Christies Lon 6/26/80: 304 (book, T et al);
Christies Lon 3/26/81: 286 (book, T et al);
Sothebys Lon 3/27/81: 388 (8), 389 (2);
Sothebys Lon 6/17/81: 442 (book, 12);
Swann NY 11/5/81: 181 ill(books, T et al)(note), 182
    (book, T et al);
Sothebys Lon 3/15/82: 318 (2);
Christies Lon 10/28/82: 56 (lot, T-7 et al)(note);
Christies Lon 6/23/83: 98;
Christies Lon 10/27/83: 72A (lot, T-7 et al), 75
    (book, 20);
Christies Lon 6/28/84: 209 (20);
Sothebys Lon 6/29/84: 152 ill, 153 ill, 154
    (attributed);
Christies Lon 10/30/86: 43 (book, T et al);

**THOMPSON, E.O.**
Photos dated: 1850s
Processes:      Daguerreotype
Formats:        Plates
Subjects:       Portraits
Locations:      Studio
Studio:         US - Washington, D.C.
    Entries:
Christies Lon 10/30/80: 22;
Christies Lon 6/18/81: 25;

**THOMPSON, F.F.** (American)
Photos dated: Nineteenth century
Processes:      Albumen
Formats:        Stereos
Subjects:       Topography
Locations:      US - Pennsylvania
Studio:         US
    Entries:
California Galleries 9/27/75: 547 (lot, T et al);
California Galleries 1/23/77: 430 (lot, T et al);

**THOMPSON, Josiah W.** (American)
Photos dated: c1851-c1860
Processes:      Daguerreotype
Formats:        Plates
Subjects:       Portraits
Locations:      Studio
Studio:         US - New York City
    Entries:
Sothebys NY (Weissberg Coll.) 5/16/67: 94 (lot,
    T-1 et al);
Gordon NY 5/3/76: 267 (lot, T & Davis et al);
Gordon NY 11/13/76: 2 (lot, T & Davis et al);
Swann NY 4/14/77: 232 (2);

**THOMPSON, J.W.** (continued)
Sothebys Lon 10/29/80: 50 (lot, T & Davis-1, et al);
Christies Lon 3/26/81: 84;
Swann NY 4/23/81: 242 ill(lot, T-1 et al);
Sothebys Lon 10/28/81: 281;
Swann NY 11/18/82: 283 (2);
Swann NY 5/5/83: 315 (lot, T et al);
Christies Lon 4/24/86: 305 (lot, T-1 et al)(note);

**THOMPSON, S.J.** (Canadian)
Photos dated: late 1880s
Processes:     Albumen
Formats:       Prints
Subjects:      Topography
Locations:     Canada - British Columbia
Studio:        Canada
  Entries:
Christies Lon 6/27/85: 187 (3);
Sothebys Lon 10/31/86: 14 (albums, T et al);

**THOMPSON, Stephen** (British)
Photos dated: 1850s-1880
Processes:     Albumen, woodburytype
Formats:       Prints, stereos, cdvs
Subjects:      Topography, architecture, documentary
               (art)
Locations:     Great Britain; Ireland; Italy;
               Switzerland; Nineveh
Studio:        Great Britain
  Entries:
Swann NY 2/14/52: 301 (books, T et al), 322 (book,
  31), 335 (book, 25);
Sothebys NY 11/21/70: 26 (book, T et al);
Sothebys Lon 5/24/73: 150 (books, T et al);
Sothebys Lon 12/4/73: 13 (lot, T et al), 175 (books,
  T et al);
Vermont Cat 7, 1974: 753 (book, T et al);
Witkin NY II 1974: 206 (book, T et al);
Christies Lon 4/25/74: 201 (books);
Sothebys Lon 10/18/74: 254 (book, T et al), 260
  (book, T et al);
Edwards Lon 1975: 110 (book, T et al), 161 (book,
  T et al), 164 (book, T et al);
Sothebys Lon 3/21/75: 103 (book, 28), 316 (books,
  T et al);
California Galleries 9/27/75: 180 (book, T et al),
  265 (lot, T-1 et al);
Colnaghi Lon 1976: 145 ill(note);
California Galleries 4/2/76: 133 (book, 4);
Christies Lon 6/10/76: 44 (3);
Christies Lon 10/28/76: 275 (books, T et al), 276
  (book, T et al);
Vermont Cat 11/12, 1977: 524 (book, T et al);
Witkin NY V 1977: 130 (book, 4)(attributed)(note);
Christies Lon 6/30/77: 198 (book, 31);
Sothebys Lon 7/1/77: 22 (book, T et al), 141 (book,
  31);
Sothebys Lon 11/18/77: 176 (book, T et al), 195
  (books, T et al);
Wood Conn Cat 42, 1978: 514 (book, 4)(note);
Sothebys Lon 6/28/78: 19 (book, T et al), 20
  (book, T et al);
Christies Lon 10/26/78: 208 (book, T et al);
Swann NY 12/14/78: 242 (book, 10)(attributed);
Witkin NY IX 1979: 2/41 (book, T-12 et al);
Sothebys Lon 10/24/79: 38 (book, 24);
Christies Lon 10/25/79: 115 ill;
Swann NY 4/17/80: 201 (book, 2);
Christies Lon 10/30/80: 146, 147 (lot, T-1 et al);

**THOMPSON, S.** (continued)
Phillips NY 1/29/81: 85 (book, T et al);
Christies Lon 3/26/81: 146 (3), 182 (lot, T-1
  et al), 394 (lot, T-1 et al);
Sothebys Lon 6/17/81: 459 (book, 24);
Christies Lon 6/18/81: 258 ill(book, 37), 259 ill
  (book, 21);
Swann NY 11/5/81: 226 (book, 10)(note);
Wood Conn Cat 49, 1982: 499 (book, T-4 et al)(note);
Sothebys Lon 3/15/82: 436 (books, T et al);
Christies Lon 3/24/83: 146 (books);
Harris Baltimore 4/8/83: 195 (book, T et al);
Christies Lon 6/23/83: 173 (lot, T-10 et al);
Sothebys Lon 6/24/83: 17 (lot, T et al);
Phillips Lon 11/4/83: 29 (books, T et al);
Harris Baltimore 12/16/83: 67 (lot, T attributed
  et al);
Christies Lon 3/29/84: 24 (lot, T-1 et al);
Swann NY 5/10/84: 306 (lot, T et al);
Christies Lon 10/25/84: 120 (books, T-10 et al);
Christies Lon 3/28/85: 51 (lot, T et al);
Sothebys Lon 6/28/85: 231 (books, T-23 et al);
Christies Lon 4/24/86: 345 (lot, T et al);
Christies Lon 6/28/86: 175 (books, T et al);
Christies Lon 10/30/86: 227 (album, T et al);

**THOMPSON, T.A.** (American)
Photos dated: c1880s
Processes:     Albumen
Formats:       Prints
Subjecxts:     Topography
Locations:     US - Colorado
Studio:        US
  Entries:
California Galleries 5/23/82: 264 (lot, T-1 et al);
California Galleries 6/19/83: 227 (lot, T-1 et al);

**THOMPSON, W.C.**
Photos dated: c1890s
Processes:     Albumen
Formats:       Cabinet cards
Subjects:      Portraits
Locations:
Studio:
  Entries:
California Galleries 9/27/75: 375 (lot, T et al);
California Galleries 1/22/77: 112 (lot, T et al);

**THOMPSON, Warren** (American)
Photos dated: 1840-1859
Processes:     Daguerreotype
Formats:       Plates incl. stereo
Subjects:      Portraits
Locations:     Studio
Studio:        US - Philadelphia, Pennsylvania;
               France - Paris
  Entries:
Colnaghi Lon 1976: 12;
Sothebys Lon 3/19/76: 62 ill(note), 63 ill;
Christies Lon 10/25/79: 63;
Auer Paris 5/31/80: 11 ill;
Christies Lon 10/30/80: 88 ill(note), 89 ill, 90
  ill, 91 ill;
Christies Lon 3/11/82: 55;
Harris Baltimore 6/1/84: 42;
Christies Lon 6/28/84: 22 ill(note);
Christies Lon 10/25/84: 24 (note), 25 (note), 26
  (note), 27 (note);

**THOMPSON, Warren** (continued)
Sothebys Lon 6/28/85: 12 ill(2);
Christies Lon 4/24/86: 319;
Christies Lon 6/26/86: 9 (3);

**THOMS, William John** (British, 1803-1885)
Photos dated: 1855-1858
Processes:      Salt, albumenized salt
Formats:        Prints
Subjects:       Topography
Locations:      England - Sussex and Windsor
Studio:         England (Photographic Club,
                Photographic Exchange Club)
   Entries:
Weil Lon Cat 4, 1944(?): 237 (album, T et al)(note);
Sothebys Lon 3/21/75: 286 (album, T-1 et al);
Sothebys Lon 11/1/85: 59 (album, T-1 et al);

**THOMSON** (see ROSS & THOMSON) [THOMSON 1]

**THOMSON** (American) [THOMSON 2]
Photos dated: 1860s
Processes:      Tintype
Formats:        Plates
Subjects:       Portraits
Locations:      Studio
Studio:         US - New York City
   Entries:
Rinhart NY Cat 2, 1971: 266 (lot, T et al);

**THOMSON** (British) [THOMSON 3]
Photos dated: c1865
Processes:      Albumen
Formats:        Cdvs
Subjects:       Portraits
Locations:      Studio
Studio:         Great Britain
   Entries:
California Galleries 1/21/78: 131 (album, T et al);

**THOMSON, James** (American)
Photos dated: 1850s-1870s
Processes:      Albumen, glass transparencies
Formats:        Stereo plates, stereos cards
Subjects:       Topography
Locations:      US - New York; Louisiana
Studio:         US - Niagara Falls, New York
   Entries:
Christies Lon 3/10/77: 207 (lot, T-1 et al);
Sothebys Lon 7/1/77: 10 (lot, T et al);
Swann NY 5/5/83: 436 (lot, T-1 et al);
Sothebys Lon 6/29/84: 2 (lot, T et al);
Phillips Lon 6/26/85: 136 ill(lot, T-3 et al);

**THOMSON, John** (British, 1837-1921)
Photos dated: 1862-1897
Processes:      Albumen, woodburytype, platinum
Formats:        Prints
Subjects:       Topography, ethnography, genre,
                documentary (art), portraits
Locations:      England - London; China; Cyprus;
                Japan; Siam
Studio:         England - London
   Entries:
Swann NY 2/14/52: 336 (book, 96)(note), 337
    (book, 36);
Sothebys NY (Weissberg Coll.) 5/16/67: 78 (2)(note);
Frumkin Chicago 1973: 123 ill, 124, 125;
Lunn DC Cat 3, 1973: 133 ill, 134 ill;
Sothebys Lon 5/24/73: 15 ill(book, 36), 16 (book,
    21)(note), 160 ill(book, 36), 161 ill(26);
Sothebys Lon 12/4/73: 174 (2 ills)(book, 21);
Ricketts Lon 1974: 48 ill(book, 36);
Sothebys Lon 3/8/74: 171 (2 ills)(book, 36);
Sothebys Lon 10/18/74: 125 ill(album, T-5 et al),
    251 ill(book, 36);
Stern Chicago 1975(?): 54 ill(book, 200);
Witkin NY III 1975: 227 (note), 228, 229, 230, 231,
    232, 233, 234, 235, 236, 237, 238, 239, 240,
    241, 242, 243, 244, 245, 246, 247, 248, 249,
    250, 251, 252, 253, 254, 255 ill, 256 ill, 257
    ill, 258 ill, 259 ill, 260 ill, 261 ill, 262
    ill, 263 ill, 770 (book, 21), 1185;
Sothebys NY 2/25/75: 148 ill(note), 149 ill, 150
    ill, 160 (note);
Sothebys Lon 3/21/75: 120 ill(album, 38)(attributed)
    (note), 309 ill(book, 36);
Sothebys NY 9/23/75: 27 (book, 16)(note), 28 ill
    (note), 29 ill, 30 ill;
Sothebys Lon 10/24/75: 119 ill(album, 54)
    (attributed);
Alexander Lon 1976: 72, 73, 74 ill, 75 ill;
Colnaghi Lon 1976: 325 (4 ills)(book, 200)(note),
    326 ill, 327, 328 ill, 329, 330 ill, 331, 332
    ill, 333;
Lunn DC Cat 6, 1976: 5 ill(album, 16)(note);
Sothebys Lon 3/19/76: 30 (books, 60);
Gordon NY 5/3/76: 289 ill, 290 ill, 291 ill;
Sothebys NY 5/4/76: 65 ill, 66 ill, 67, 68;
Christies Lon 6/10/76: 93 (album, T attributed et
    al), 94 (album, T et al), 188 (5 ills)(book, 21);
Sothebys Lon 6/11/76: 39 ill(album, 52);
Sothebys Lon 10/29/76: 185 ill(book, 21);
Sothebys NY 11/9/76: 43 ill(note), 44, 45, 46, 47;
Gordon NY 11/13/76: 24 ill, 25 ill;
White LA 1977: 4 (2 ills)(book, 200)(note), 60 ill
    (note), 61 ill, 62 ill;
Sothebys Lon 3/9/77: 177, 178, 179 ill(book, 37);
Gordon NY 5/10/77: 829 ill, 830 ill, 831 ill,
    832 ill;
Sothebys NY 5/20/77: 71 ill, 72, 73, 74 ill(18), 75
    (2 ills)(album, 42);
Christies Lon 6/30/77: 209 (book, 36);
Sothebys Lon 7/1/77: 55 (2 ills)(book, 37), 58
    (book, T et al), 154 ill(book, 200);
Sothebys NY 10/4/77: 167 (books, T et al), 180 ill
    (4), 181 (lot, T-2 et al);
Christies Lon 10/27/77: 130 (album, T attributed et
    al), 134 (lot, T attributed et al), 226 ill
    (book, 35), 230 ill(book, 21);
Sothebys Lon 11/18/77: 201 ill(book, 37);
Lunn DC Cat QP, 1978: 39 (book, 21);
Wood Conn Cat 41, 1978: 96 ill(book, 200)(note), 97
    ill(note), 98, 99, 100, 101, 102, 103 ill, 104
    ill, 105, 106, 107, 108, 109 (book, 37);

**THOMSON, John** (continued)
Wood Conn Cat 42, 1978: 510 (book, 7)(note);
California Galleries 1/21/78: 272 (2)(note);
Sothebys LA 2/13/78: 127 ill(note), 128, 129;
Christies Lon 3/16/78: 103 ill(albumn, T attributed
et al)(note), 229 ill(book, 37);
Sothebys Lon 3/22/78: 186 ill;
Swann NY 4/20/78: 158 ill(book, 200)(note), 281 ill
(album, T attributed et al);
Sothebys NY 5/2/78: 81 (note), 82, 83, 135 (lot,
T et al);
Christies Lon 6/27/78: 115 ill(album, T-5 et al),
170 ill(book, 37)(note), 242;
Sothebys Lon 6/28/78: 22 ill(book, 37);
Christies Lon 10/26/78: 221 (book, 63);
Phillips NY 11/4/78: 43;
Swann NY 12/14/78: 374 (albums, T et al);
Lehr NY Vol 1:4, 1979: 53 (book, 14)(note), 54
(book, 12)(note);
Lennert Munich Cat 5, 1979: 38 (attributed);
Rose Boston Cat 4, 1979: 152 ill;
Wood Conn Cat 45, 1979: 224 (book, 7)(note);
Phillips Lon 3/13/79: 150 ill(book, 21);
Sothebys Lon 3/14/79: 236 (book, T et al);
Christies Lon 3/15/79: 184 (albums, T-1 et al);
Swann NY 4/26/79: 50 (book, T-2 et al)(note);
Christies NY 5/4/79: 35 (2 ills)(book), 36 (note),
37;
Phillips NY 5/5/79: 145;
Sothebys NY 5/8/79: 124 (album, T et al);
Christies Lon 6/28/79: 165 (2 ills)(book, 37), 168
(2 ills)(book, 21);
Sothebys Lon 6/29/79: 247, 248, 249, 250, 251 ill,
252 ill, 275 (book, T-1 et al);
Sothebys Lon 10/24/79: 35 ill(book, 21);
Christies Lon 10/25/79: 409;
Christies NY 10/31/79: 31, 32 ill;
Sothebys NY 11/2/79: 228A (2 ills)(book, 96), 229
(2 ills)(book, 37), 275 ill(album, T et al);
Phillips NY 11/3/79: 150, 151, 152 (2);
Phillips NY 11/29/79: 267 ill(4), 268 ill(3);
Sothebys LA 2/6/80: 153 ill(note), 154 ill;
Sothebys Lon 3/21/80: 176 ill(book, 37), 240, 242
(book, T et al);
Christies NY 5/16/80: 116 ill(book, 31), 117, 118,
119, 120;
Sothebys NY 5/20/80: 352 (5), 405 ill(album, T et
al)(note), 406 (album, T et al), 407 ill(album,
T et al), 408 ill(book, 96), 411 (2 ills)(album,
T et al)(note);
Phillips NY 5/21/80: 163 ill(5), 164, 237 ill
(attributed)(note);
Christies Lon 6/26/80: 146 ill, 147, 148, 149, 261
(lot, T-2 et al)(note);
Sothebys Lon 6/27/80: 128 (3 ills)(album, 111), 162
ill(book, 22);
Christies Lon 10/30/80: 459;
Christies NY 11/11/80: 40 (2 ills)(36), 41, 42, 43,
44, 45;
Koch Cal 1981-82: 17 ill(album)(note);
Sothebys LA 2/4/81: 51 ill(album, T et al)(note);
Christies Lon 3/26/81: 237 ill(album, 12);
Sothebys Lon 3/27/81: 247 (2 ills)(book, 200);
Swann NY 4/23/81: 197 ill(book, 21)(note);
Phillips NY 5/9/81: 14 (note), 64 ill(album,
T attributed et al), 65 (album, T attributed
et al);
Christies NY 5/14/81: 19 (2 ills)(book, 21);
Sothebys NY 5/15/81: 88 (2 ills)(book, 37), 108 ill
(lot, T attributed et al);
Sothebys Lon 6/17/81: 194 ill, 195 ill(113);

**THOMSON, J.** (continued)
Sothebys Lon 10/28/81: 389, 390, 391, 392, 393, 394;
Christies Lon 10/29/81: 376 (lot, T-5 et al);
Christies NY 11/10/81: 25 ill(5);
Rose Florida Cat 7, 1982: 25 ill(note), 26 ill;
Wood Conn Cat 49, 1982: 450 ill(book, 21)(note), 499
(book, T-2 et al);
Sothebys Lon 3/15/82: 446 ill(book, 37);
Swann NY 4/1/82: 363 (3)(note);
Phillips Lon 6/23/82: 51A (books, 171);
Sothebys Lon 6/25/82: 84 ill(book, 96), 85 ill
(album, T plus T attributed, 12);
Harris Baltimore 12/10/82: 320, 321 (60), 322
(attributed);
Sothebys Lon 3/25/83: 51 ill(9)(note), 52 ill(12),
53 (book, 7);
Swann NY 5/5/83: 235 (book, 200)(note);
Christies NY 5/9/83: 150 ill(book, 37);
Sothebys Lon 6/24/83: 34 ill, 35 ill(book, T-17
et al);
Swann NY 11/10/83: 157 (book, 200)(note), 158 ill
(book, 21)(note), 362 (3);
Sothebys Lon 12/9/83: 29 ill(book, 96), 30 (2 ills)
(book, 28), 31 ill(book, 37);
Christies Lon 3/29/84: 71 (album, T-3 et al);
Sothebys NY 5/8/84: 316 ill(book, 96);
Harris Baltimore 6/1/84: 444 (attributed);
Sothebys Lon 6/29/84: 95 (note), 210 ill(4), 211 ill
(book, 37);
Christies NY 9/11/84: 136 (album, T et al);
Christies Lon 10/25/84: 125 ill(book, 276);
Sothebys Lon 10/26/84: 68 ill, 69 (3 ills)(album, T
attributed et al), 164;
Sothebys Lon 3/29/85: 85 ill(album, T et al),
180 (3);
Phillips Lon 6/26/85: 143 (books);
Sothebys Lon 6/28/85: 71 ill(album, T-2 et al);
Christies Lon 4/24/86: 387 ill(album, T-4 et al)
(note), 418 ill(book, 19)(note);
Sothebys Lon 4/25/86: 154 (album, T-2 et al);
Sothebys NY 5/12/86: 397 ill(book, 21)(note);
Christies Lon 10/30/86: 51 (books, 19)(note), 114
(album, T et al)(note), 246 (lot, T-2 et al);
Sothebys Lon 10/31/86: 128 ill(8), 129 ill(6);
Harris Baltimore 11/7/86: 241 (album, T et al);
Sothebys NY 11/10/86: 248 ill(36);

**THOMSON, L.**
Photos dated: 1890s
Processes:      Bromide
Formats:        Prints
Subjects:       Documentay (military)
Locations:      Ireland
Studio:         Europe
Entries:
Christies Lon 10/25/79: 466 (albums, T-4 et al)
(note);

**THOMSON, Mary** (British)
Photos dated: 1884
Processes:      Bromide
Formats:        Prints
Subjects:       Genre (domestic)
Locations:      Scotland
Studio:         Scotland
Entries:
Christies Lon 10/27/77: 387 (14);

**THOMSON, William J. and/or SAFFORD, William Edwin**
                (American)
Photos dated: 1886
Processes:      Albumen
Formats:        Prints
Subjects:       Topography, ethnography
Locations:      Easter Island
Studio:
    Entries:
Swann NY 5/10/84: 209 ill(15)(note);

**THORN, G.** (American)
Photos dated: 1870s
Processes:      Albumen
Formats:        Stereos
Subjects:       Topography
Locations:      US - New Jersey
Studio:         US - Plainfield, New Jersey
    Entries:
Swann NY 11/8/84: 263 (lot, T et al);

**THORN, H.**
Photos dated: 1870s
Processes:      Albumen
Formats:        Prints, stereos
Subjects:       Topography
Locations:      England - Cornwall
Studio:         Great Britain
    Entries:
Sothebys Lon 6/17/81: 118 (lot, T-2 et al);
Christies Lon 10/31/85: 69 (lot, T et al);

**THORNE, George W.** (American)
Photos dated: 1874-1875
Processes:      Albumen
Formats:        Prints, stereos, cabinet cards
Subjects:       Topography, ethnography, portraits
Locations:      US - New York
Studio:         US - New York City
    Entries:
Sothebys NY (Strober Coll.) 2/7/70: 449 (lot,
    T et al);
Rinhart NY Cat 7, 1973: 481;
Christies Lon 10/30/80: 403 (lot, T-2 et al);
Swann NY 4/1/82: 333 (lot, T et al);
Harris Baltimore 12/10/82: 68 (lot, T et al), 109
    (lot, T et al);
Harris Baltimore 12/16/83: 95 (lot, T et al);

**THORNEWAITE** (see HORNE & THORNEWAITE)

**THRONEYCROFT, T.** (British)
Photos dated: 1869
Processes:      Albumen
Formats:        Prints
Subjects:       Topography
Locations:      US - New York
Studio:         Great Britain
    Entries:
Frontier AC, Texas 1978: 310 (book, 22)(note);

**THORNSON, James Jr.**
Photos dated: 1850s and/or 1860s
Processes:      Collodion on glass
Formats:        Stereo plates
Subjects:       Topography
Locations:      US - Niagara Falls, New York
Studio:
    Entries:
Phillips Lon 6/26/85: 135 (lot, T et al);

**THORPE** (American)
Photos dated: 1860s-1870s
Processes:      Albumen
Formats:        Cdvs
Subjects:       Portraits
Locations:      Studio
Studio:         US
    Entries:
Swann NY 4/14/77: 198 (lot, T et al);

**THORPE, J.M.**
Photos dated: 1880s-1890s
Processes:      Albumen
Formats:        Prints
Subjects:       Topography
Locations:      Africa
Studio:
    Entries:
Swann NY 5/10/84: 164 (lot, T-2 et al);

**THORPE, William E.** (British)
Photos dated: c1876
Processes:      Albumen
Formats:        Prints, stereos
Subjects:       Topography
Locations:      England - Hastings
Studio:         Great Britain
    Entries:
Swann NY 4/26/79: 195 (book, 12);
Christies Lon 6/18/81: 105 (lot, T-1 et al);

**THURBER, Dexter**
Photos dated: 1896
Processes:      Photogravure
Formats:        Prints
Subjects:       Genre
Locations:
Studio:
    Entries:
California Galleries 1/21/79: 505;

**THURLOW, J.** (American)
Photos dated: c1870-1870s
Processes:      Albumen
Formats:        Stereos, cdvs
Subjects:       Topography
Locations:      US - Colorado
Studio:         US - Manitou, Colorado
    Entries:
Rinhart NY Cat 1, 1971: 311 (lot, T-1 et al);
Vermont Cat 11/12, 1977: 832 ill;
Frontier AC, Texas 1978: 311 (19)(note);
Harris Baltimore 12/10/82: 29 (lot, T et al);
Harris Baltimore 3/15/85: 24 (lot, T et al);

**THURSTON, F.** (British)
Photos dated: Nineteenth century
Processes:      Albumen
Formats:        Prints
Subjects:       Topography
Locations:
Studio:         Great Britain
    Entries:
Sothebys Lon 12/4/73: 235 (lot);

**TIATOR**
Photos dated: 1860s
Processes:      Albumen
Formats:        Cdvs
Subjects:       Topography
Locations:      France
Studio:         France - Colmar
    Entries:
Petzold Germany 11/7/81: 327 (lot, T et al);

**TIBBS, N.J.** (American)
Photos dated: 1880s
Processes:      Albumen
Formats:        Stereos
Subjects:       Topography
Locations:      US - Eureka Springs, Arkansas
Studio:         US - Eureka Springs, Arkansas
    Entries:
Harris Baltimore 6/1/84: 7 (lot, T et al);

**TIERS, M.C.** (American)(photographer or author?)
Photos dated: 1864
Processes:      Albumen
Formats:        Prints
Subjects:       Portraits
Locations:      US - Cincinnati, Ohio
Studio:         US
    Entries:
Frontier AC, Texas 1978: 312 (book, 10)(note);

**TILTON, J.E.** (American)
Photos dated: 1865-1869
Processes:      Albumen
Formats:        Prints, cdvs
Subjects:       Portraits, documentary (art)
Locations:      Studio
Studio:         US - Boston, Massachusetts
    Entries:
Swann NY 4/20/78: 88;
California Galleries 3/30/80: 212 (album, 12);
California Galleries 12/13/80: 175 (album, 12);

**TIMBS, John** (British)
Photos dated: 1872
Processes:
Formats:
Subjects:       Topography
Locations:      England; Wales
Studio:         Great Britain
    Entries:
Wood Conn Cat 45, 1979: 238 (book, 12);

**TIMMS, J.F.** (British)
Photos dated: 1855-1860s
Processes:      Ambrotype, tintype
Formats:        Plates
Subjects:       Portraits
Locations:      Studio
Studio:         England - London
    Entries:
California Galleries 4/2/76: 55;
Christies Lon 10/28/76: 42;
Christies Lon 3/10/77: 31;
Christies Lon 6/30/77: 65 (lot, T-1 et al);
Christies Lon 3/16/78: 36 (lot, T-2 et al);
Christies Lon 10/30/80: 70 (lot, T-1 et al);
Phillips Lon 3/17/82: 22 (lot, T et al);
Sothebys Lon 6/25/82: 44 (lot, T-1 et al);
Christies Lon 6/23/83: 9 (lot, T-1 et al);

**TIMPE, A.**
Photos dated: c1870
Processes:      Tintype
Formats:        Plates
Subjects:       Portraits
Locations:
Studio:
    Entries:
California Galleries 3/29/86: 786;

**TIPTON, W.H.** (American)
Photos dated: 1860s-1890
Processes:      Albumen
Formats:        Cdvs, prints
Subjects:       Portraits, documentary (educational
                institutions), topography
Locations:      US - Pennsylvania
Studio:         US - Gettysburg, Pennsylvania
    Entries:
Rinhart NY Cat 7, 1973: 340;
California Galleries 9/26/75: 172 (book, 17);
California Galleries 4/3/76: 449 (lot, T et al);
California Galleries 1/21/78: 189 (lot, T et al);
California Galleries 1/21/79: 309 (lot, T et al);
Swann NY 10/18/79: 304 (lot, T et al);
California Galleries 3/30/80: 408 (lot, T et al);
Harris Baltimore 5/28/82: 157 (lot, T & Meyers-2,
    et al);
Harris Baltimore 12/10/82: 27 (lot, T et al);
Harris Baltimore 4/8/83: 20 (lot, T-4 et al);
Harris Baltimore 6/1/84: 31 (lot, T et al);
Swann NY 11/8/84: 129 (book, 17);
Harris Baltimore 11/9/84: 54 (lot, T-65 et al), 88
    (lot, T et al);
Harris Baltimore 2/14/86: 26 (10);

**TIRRELL, G.W. II** (American)
Photos dated: 1870s
Processes:      Albumen
Formats:        Stereos
Subjects:       Architecture
Locations:      US - Nantasket, Massachusetts
Studio:         US - Nantasket, Massachusetts
    Entries:
Rinhart NY Cat 2, 1971: 488 (note);

TISSOT, Victor
Photos dated: 1870s-c1890
Processes:      Albumen
Formats:        Prints
Subjects:       Topography
Locations:      Switzerland
Studio:
    Entries:
Sothebys NY 5/8/79: 19 (books, T-19 et al);
Christies NY 5/14/80: 344 (book, 17);

TOBY (British)
Photos dated: 1850s and/or 1860s
Processes:      Albumen
Formats:        Stereos
Subjects:       Documentary (art)
Locations:      Great Britain
Studio:         Great Britain
    Entries:
Christies Lon 6/23/83: 42 (lot, T-2 et al);
Sothebys Lon 6/29/84: 11 (lot, T et al);
Christies Lon 6/27/85: 34 (lot, T-1 et al);
Christies Lon 10/30/86: 29 (lot, T et al);

TODD
Photos dated: 1860s
Processes:      Albumen
Formats:        Cdvs
Subjects:       Portraits
Locations:      Studio
Studio:         China - Hankow
    Entries:
Sothebys Lon 3/15/82: 222 (album, T et al);

TODD, John A. (American)
Photos dated: 1870s-c1885
Processes:      Albumen
Formats:        Prints, stereos
Subjects:       Topography
Locations:      US - California
Studio:         US - Sacramento, California
    Entries:
Gordon NY 5/3/76: 298 (books, T et al);
Swann NY 11/11/76: 358 (lot, T et al);
California Galleries 6/8/85: 465;
Wood Boston Cat 58, 1986: 136 (books, T et al);

TODD, William (American)
Photos dated: 1891
Processes:      Photogravure
Formats:        Prints
Subjects:       Topography
Locations:      US
Studio:         US - St. Louis, Missouri
    Entries:
California Galleries 1/21/79: 506;

TOKURA, T. (Japanese)
Photos dated: c1890s
Processes:      Albumen
Formats:        Prints
Subjects:       Topography, ethnography
Locations:      Japan - Nagasaki, Kobe, Tokyo
Studio:         Japan - Miyanoshita
    Entries:
Old Japan, England Cat 8, 1985: 29 (album, 63)
    (attributed), 30 (album, 36)(attributed), 31
    (50, attributed), 34 (50, attributed);

TOKUYAMA, R. (Japanese)
Photos dated: c1890
Processes:      Albumen
Formats:        Cdvs
Subjects:       Topography
Locations:      Japan
Studio:         Japan
    Entries:
Christies Lon 10/27/83: 110 (lot, T-1 et al);
Old Japan, England Cat 8, 1985: 26 (22);

TOLLERTON, W.N. (British)
Photos dated: c1860
Processes:      Ambrotype
Formats:        Plates
Subjects:       Portraits
Locations:      Studio
Studio:         England - Lincoln
Entries:
Sothebys Lon 3/21/80: 279 (lot, T-1 et al);

TOMLINSON (see LUMPKIN)

TOMLINSON, William Agur (American, 1819-c1862)
Photos dated: 1846-1862
Processes:      Ambrotype
Formats:        Plates
Subjects:       Portraits
Locations:      Studio
Studio:         US - New Haven, Connecticut; New York
City
    Entries:
Christies Lon 6/28/79: 37 ill(note);
Swann NY 4/23/81: 260 ill;

TONG WO (Chinese)
Photos dated: 1860s and/or 1870s
Processes:      Albumen
Formats:        Cdvs
Subjects:       Documentary (art)
Locations:      China
Studio:         China
    Entries:
Swann NY 11/13/86: 195 (lot, T-1 et al);

**TOOQUERAY, Edouard** (French)
Photos dated: 1860s and/or 1870s
Processes:      Albumen
Formats:        Prints
Subjects:       Topography
Locations:      France
Studio:         France
    Entries:
Christies Lon 10/30/80: 173 (lot, T-2 et al);

**TOPLEY, William James** (Canadian, 1845-1930)
Photos dated: 1869-1880s
Processes:      Albumen
Formats:        Prints, cdvs, cabinet cards
Subjects:       Topography, portraits
Locations:      Canada - Ottawa
Studio:         Canada - Ottawa
    Entries:
Sothebys Lon 6/11/76: 38a (album, T et al);
Phillips Can 10/4/79: 43 (lot, T et al), 69 (album,
    T-1 et al);
Christies Lon 10/27/83: 154 (album, T-2 et al);

**TOURNACHON, Adrien** (French, 1825-1903)(see also de
                        BOULOGNE)
Photos dated: 1853-1861
Processes:      Salt, albumen
Formats:        Prints
Subjects:       Portraits, genre (animal life)
Locations:      France - Paris
Studio:         France - Paris
    Entries:
Rauch Geneva 12/24/58: 256 ill;
Rauch Geneva 6/13/61: 129 (note);
Sothebys Lon 3/14/79: 270 ill(note), 271 ill, 272;
Sothebys NY 5/8/79: 84 ill(note), 85 ill(note);
Sothebys Lon 10/24/79: 343 ill(note);
Sothebys Lon 3/27/81: 384 ill(note);

**TOURNACHON, Gaspard-Félix** (see NADAR)

**TOURNIER, Henri** (French)
Photos dated: 1863
Processes:      Albumen
Formats:        Prints, stereos
Subjects:       Topography, genre (animal life)
Locations:      France
Studio:         France - Paris
    Entries:
Rauch Geneva 12/24/58: 233 (book, 8);
Sothebys Lon 3/25/83: 88 (lot, T-2 et al);
Phillips Lon 10/30/85: 64 (lot, T et al);
Christies Lon 10/31/85: 64 (lot, T & Furne-5,
    et al);
Christies Lon 6/26/86: 28 (lot, F & Furne-5, et al);

**TOURTIN, Emile** (French)
Photos dated: Nineteenth century
Processes:      Albumen, woodburytype
Formats:        Prints, cdvs
Subjects:       Portraits incl. Galerie Contemporaine
Locations:      Studio
Studio:         France
    Entries:
Gordon NY 11/13/76: 48 (albums, T et al), 54 ill
    (lot, T-1 et al);
Gordon NY 5/10/77: 798 ill(lot, T et al);
Christies NY 5/14/81: 41 (books, T-3 et al);
Christies NY 5/26/82: 36 (books, T-2 et al);
Christies NY 5/7/84: 19 (book, T-2 et al);
Christies Lon 6/26/86: 86 (lot, T et al);

**TOUSLEY, H.S.** (American)
Photos dated: 1870s
Processes:      Albumen
Formats:        Stereos
Subjects:       Topography
Locations:      US - New York State
Studio:         US - Keeseville, New York
    Entries:
Rinhart NY Cat 2, 1971: 535 (lot, T-2 et al);
California Galleries 4/3/76: 414 (lot, T et al);

**TOWLE, Reverend S.** (American)
Photos dated: 1860s-1870s
Processes:      Albumen
Formats:        Stereos
Subjects:       Topography
Locations:      US - New England
Studio:         US - Lowell, Massachusetts
    Entries:
Rinhart NY Cat 1, 1971: 251 (4);
Rinhart NY Cat 7, 1973: 230 ill, 231;
Swann NY 10/5/81: 522 (lot, T et al);
Harris Baltimore 12/16/83: 105 (lot, T, T & Smith,
    et al);

**TOWLER, Professor John** (American)
Photos dated: 1861-1862
Processes:      Albumen
Formats:        Stereos
Subjects:       Topography
Locations:      US - New York State
Studio:         US - Geneva, New York
    Entries:
California Galleries 3/30/80: 38 (3)(note);
Harris Baltimore 12/16/83: 2 (lot, T et al)(note);

**TOWNSEND** (American)
Photos dated: c1865
Processes:      Albumen
Formats:        Cdvs
Subjects:       Portraits
Locations:      Studio
Studio:         US
    Entries:
California Galleries 1/21/78: 130 (album, T et al);

**TRASK, W.S.** (American)
Photos dated: 1860s-1870
Processes:      Tintype, albumen
Formats:        Plates, stereos, cdvs
Subjects:       Portraits, topography
Locations:      US - Michigan
Studio:         US
    Entries:
California Galleries 4/3/76: 400 (lot, T et al);
California Galleries 7/1/84: 157;
Swann NY 5/15/86: 222 (lot, T et al);

**TREMAUX, Pierre** (French, 1818-1895)
Photos dated: 1852-1855
Processes:      Calotype, albumen
Formats:        Prints
Subjects:       Topography, ethnography
Locations:      Egypt; Libya; Sudan; Tunisia; Turkey
Studio:
    Entries:
Maggs Paris 1939: 494 (note);
Rauch Geneva 6/13/61: 99 (book, 134)(note);
Christies Lon 3/10/77: 245;
Christies Lon 6/30/77: 277 ill;
Christies Lon 6/27/78: 111;

**TREMLETT** (British)
Photos dated: Nineteenth century
Processes:      Albumen
Formats:        Cdvs
Subjects:       Portraits
Locations:      Studio
Studio:         Great Britain
    Entries:
Phillips Lon 10/30/85: 57 (lot, T et al);
Phillips Lon 4/23/86: 293 (lot, T et al);

**TRIMM, J.**
Photos dated: 1880s
Processes:      Albumen
Formats:        Prints
Subjects:       Topography
Locations:      South Africa
Studio:
    Entries:
Sothebys NY 5/20/80: 398 ill(album, T et al);

**TRIMMELL, W.H.** (British)
Photos dated: 1850s and/or 1860s
Processes:      Albumen
Formats:        Stereos
Subjects:       Topography
Locations:      Great Britain
Studio:         Great Britain
    Entries:
Christies Lon 10/28/82: 17 (lot, T et al);

**TRINQUART** (French)(see also PETIT)
Photos dated: 1858-1860s
Processes:      Albumen
Formats:        Cdvs
Subjects:       Portraits, ethnography
Locations:      Studio
Studio:         France - Paris
    Entries:
Christies Lon 6/27/78: 239 (album, T et al);
Christies Lon 3/26/81: 412 (album, T-6 et al);
Petzold Germany 11/7/81: 302 (album, T et al);

**TRIPE, Captain Linnaeus** (British, 1822-1902)
Photos dated: 1855-1860
Processes:      Salt, albumenized salt
Formats:        Prints, stereos
Subjects:       Topography
Locations:      Burma; India
Studio:         Burma; India - Madras
    Entries:
Anderson & Hershkowitz Lon 1976: 33 ill, 34 ill;
Rose Boston Cat 2, 1977: 50 (note);
Christies Lon 6/30/77: 116 ill;
Christies Lon 10/27/77: 128 ill;
Sothebys Lon 11/18/77: 16 ill(book, 70);
Wood Conn Cat 41, 1978: 50 ill(note), 51 ill, 52
    ill, 53, 54, 55, 56, 57 ill, 58, 59, 60, 61,
    62, 63;
Sothebys Lon 3/22/78: 185 ill;
Sothebys Lon 6/28/78: 312 ill;
Sothebys Lon 10/27/78: 125 ill;
Phillips NY 11/4/78: 22 ill(note);
Phillips Lon 3/13/79: 34 ill(note);
Phillips NY 5/5/79: 134 ill;
Phillips NY 11/3/79: 175 ill(note);
Koch Cal 1981-82: 15 ill(note);
Christies NY 5/14/81: 10, 11 ill;
Sothebys Lon 10/28/81: 153 ill;
Phillips NY 5/22/82: 938 ill, 939 ill;
Christies NY 11/8/83: 208 ill, 209 ill;
Kraus NY Cat 1, 1984: 41 ill(note), 42 (2 ills)(2)
    (note), 43 ill(note), 44 ill;
Christies Lon 6/28/84: 200 ill(note);
Sothebys Lon 3/29/85: 132 ill(note), 133 ill(note),
    134 ill(note), 135 ill(note);
Christies Lon 5/6/85: 356 ill;
Sothebys NY 5/7/85: 319 ill;
Sothebys Lon 4/25/86: 92 ill(note), 93 ill(note);
Sothebys Lon 6/28/85: 107 ill(note), 108 ill, 109
    ill, 110 ill, 111 ill, 112 ill(note);

**TRISTAM, H.B.** (British)
Photos dated: 1882-1880s
Processes:      Albumen, woodburytype
Formats:        Prints
Subjects:       Topography
Locations:      Palestine
Studio:
    Entries:
Christies Lon 10/27/77: 229 (book, 22);
Wood Conn Cat 42, 1978: 519 (book, 22)(note);
Wood Conn Cat 45, 1979: 243 (book, 22)(note);
Wood Conn Cat 49, 1982: 455 ill(book, 22)(note);
Sothebys Lon 10/29/82: 47 ill(book, 4);
Christies NY 2/13/85: 168 (books, T et al), 169
    (books, T-24 et al);

TRONEL, A.
Photos dated: Nineteenth century
Processes:      Albumen
Formats:        Stereos
Subjects:       Topography
Locations:      Europe
Studio:         Europe
  Entries:
Christies Lon 3/11/82: 83 (lot, T et al);

TROTTER, Captain H.
Photos dated: 1873
Processes:      Albumen
Formats:        Prints
Subjects:       Topography
Locations:      China - Yarkund
Studio:
  Entries:
Sothebys Lon 7/1/77: 59 ill(book, T et al);

TROXELL
Photos dated: 1860s
Processes:      Albumen
Formats:        Cdvs
Subjects:       Portraits
Locations:
Studio:
  Entries:
Harris Baltimore 4/8/83: 318 (lot, T et al);

TRUCHELUT (French)
Photos dated: 1873-1874
Processes:      Woodburytype
Formats:        Prints
Subjects:       Portraits
Locations:      Studio
Studio:         France
  Entries:
Swann NY 4/20/78: 119 (book, T et al);
Wood Conn Cat 49, 1982: 332 (book, T et al)(note);

TRUEMAN, Robert H. & CAPLE (Canadian)
Photos dated: c1880-1900
Processes:      Albumen
Formats:        Prints
Subjects:       Topography, ethnography
Locations:      Canada - Vancouver, British Columbia
Studio:         Canada
  Entries:
Christies Lon 6/10/76: 73 (lot, T & C et al);
Swann NY 12/14/78: 343 (album, T & C et al);
Christies Lon 10/25/79: 225 (lot, T & C-6 et al);
Christies Lon 3/11/82: 197 (album, T & C et al);

TRUSCOTT, Charles (American)
Photos dated: Nineteenth century
Processes:      Albumen
Formats:        Prints
Subjects:       Documentary (public events)
Locations:      US - Philadelphia, Pennsylvania
Studio:         US - Philadelphia, Pennsylvania
  Entries:
Swann NY 11/5/81: 455;

TUCKER (see GORHAM & TUCKER)

TUCKER, H. (British)
Photos dated: 1865-1870
Processes:      Albumen
Formats:        Cdvs
Subjects:       Portraits
Locations:      India
Studio:         India - Allalabad
  Entries:
Sothebys Lon 10/26/84: 172 (album, T et al);

TUCKER, H.H. (American)
Photos dated: c1880
Processes:      Albumen
Formats:        Cabinet cards
Subjects:       Topography
Locations:      US - Texas; Mexico
Studio:         US - Sherburne, New York
  Entries:
Frontier AC, Texas 1978: 317 (3)(note);

TUCKER, Mrs. Harriet A. (British)
Photos dated: c1843-1845
Processes:      Calotype
Formats:        Prints
Subjects:       Genre (domestic), portraits
Locations:      England
Studio:         England
  Entries:
Sothebys NY (Weissberg Coll.) 5/16/67: 58 (3)(note);
Sothebys NY 2/9/77: 3 ill(note), 4 ill(note);
California Galleries 1/21/78: 273 ill(note);

TUGBY (see BABBIT)

TULL, B.H. (American)
Photos dated: c1875
Processes:      Tintype, albumen
Formats:        Plates, cdvs
Subjects:       Portraits
Locations:      Studio
Studio:         US - Lena, Illinois
  Entries:
California Galleries 1/22/77: 128 (lot, T et al),
  144 (lot, T-1 et al);

TULLE & Co.
Photos dated: c1865
Processes:      Albumen
Formats:        Prints
Subjects:       Topography
Locations:
Studio:
  Entries:
California Galleries 1/21/79: 508;

**TUMINIELLO, Ludovico** (Italian, 1824-1907)
Photos dated: 1842-c1880
Processes:    Calotype, albumen, woodburytype
Formats:     Prints
Subjects:    Topography, portraits incl. Galerie
             Contemporaine
Locations:   Italy - Rome; Africa
Studio:      Italy - Rome and Turin
   Entries:
Christies Lon 6/10/76: 62 (lot, T et al);
Christies NY 5/26/82: 36 (book, T et al);
Christies NY 5/7/84: 19 (book, T et al);

**TUNE, C.**
Photos dated: early 1870s
Processes:    Albumen
Formats:     Prints
Subjects:    Documentary (Franco-Prussian War)
Locations:   France - Paris et al
Studio:      France - Boulogne
   Entries:
Swann NY 5/15/86: 312 ill(album, 116);

**TUNNY, James G.** (British)(aka TUNNEY)
Photos dated: 1850s-1870s
Processes:    Albumenized salt, albumen
Formats:     Prints, cdvs
Subjects:    Portraits
Locations:   Scotland
Studio:      Scotland - Edinburgh
   Entries:
Sothebys NY 11/21/70: 337 (lot, T et al);
Sothebys Lon 10/18/74: 139 (lot, T et al);
Sothebys NY 5/2/78: 67 (note);
Christies Lon 10/29/81: 351 ill(2);
California Galleries 7/1/84: 702 (4, attributed);
Phillips Lon 6/26/85: 205 (lot, T-1 et al);
Christies Lon 10/31/85: 302 (album, T et al);
Sothebys Lon 4/25/86: 90 ill(album, T & Annan, 49,
   attributed);
Christies Lon 10/30/86: 252 (album, T et al);

**TUOHY, George** (British)
Photos dated: 1882
Processes:    Albumen
Formats:     Cabinet cards
Subjects:    Documentary (public events)
Locations:   Studio
Studio:      England - Richmond
   Entries:
Christies Lon 6/27/85: 283;

**TUPPER** (American)
Photos dated: Nineteenth century
Processes:    Albumen
Formats:     Cabinet cards
Subjects:    Portraits
Locations:   Studio
Studio:      US - Binghampton, New York
   Entries:
Vermont Cat 1, 1971: 250 (lot, T-1 et al);

**TURNBULL, W.C.**
Photos dated: c1890s
Processes:    Collodion on glass
Formats:     Lantern slides
Subjects:    Topography
Locations:   Canada
Studio:
   Entries:
California Galleries 3/30/80: 337 (lot, T et al);

**TURNER** (British)
Photos dated: c1865-1870s
Processes:    Albumen
Formats:     Cdvs, cabinet cards
Subjects:    Portraits
Locations:   Studio
Studio:      Great Britain
   Entries:
California Galleries 9/27/75: 374 (lot, T et al);
California Galleries 1/21/78: 130 (album, T et al);

**TURNER, Austin A.** (American)
Photos dated: 1850s-1860s
Processes:    Daguerreotype, ambrotype,
             photolithography
Formats:     Plates, prints, cdvs
Subjects:    Portraits, architecture
Locations:   US - New York State
Studio:      US - Boston, Massachusetts; New York
             City
   Entries:
Edwards Lon 1975: 189 (book, 31)(note);
Wood Conn Cat 41, 1978: 128 (book, 31)(note);
California Galleries 1/21/78: 129 (lot, T et al);
Phillips NY 11/29/79: 278 (book, T-2);
California Galleries 3/30/80: 268 (lot, T-1 et al);
California Galleries 6/28/81: 174 (lot, T-1 et al);
Wood Conn Cat 49, 1982: 456 (book, 31)(note);

**TURNER, Benjamin Brecknell** (British, 1815-1894)
Photos dated: 1849-1862
Processes:    Salt, albumen
Formats:     Prints
Subjects:    Topography
Locations:   England - Canterbury et al;
             Netherlands - Amsterdam
Studio:      England
   Entries:
Swann NY 2/14/52: 342 (book, 36);
Rauch Geneva 6/13/61: 48 ill(6)(note);
Sothebys Lon 3/21/75: 286 (album, T-1 et al);
Sothebys Lon 3/14/79: 324 (album, B-1 et al);
Christies Lon 6/26/80: 435 ill(note), 436 ill, 437
   ill, 438 ill, 439 ill, 440 ill;
Christies Lon 10/30/80: 385 ill(note), 386 ill, 387
   ill, 388 ill, 389 ill, 390 ill, 391 ill, 392
   ill, 393 ill, 394 ill, 395 ill;
Christies NY 11/11/80: 13, 14;
Christies Lon 3/26/81: 358 ill(note), 359 ill, 360
   ill, 361 ill, 362 ill, 363 ill, 364 ill, 365
   ill, 366 ill, 367 ill;
Christies Lon 6/18/81: 136 ill(note), 137 ill, 138
   ill, 139 ill, 140 ill, 141 ill, 142 ill, 143
   ill, 144 ill, 145 ill;
Sothebys Lon 10/28/81: 346 ill, 347 ill, 348 ill,
   349 ill;
Christies Lon 10/29/81: 313 ill(note), 314 ill, 315
   ill, 316 ill, 317 ill, 318 ill, 319;

**TURNER, B.B.** (continued)
Christies Lon 3/11/82: 333;
Sothebys Lon 10/29/82: 144, 145;
Christies Lon 10/25/84: 157 ill(note), 158 ill
    (note), 159 ill(note), 160 ill(note);
Christies NY 2/13/85: 113 (note);
Christies Lon 6/27/85: 122, 123 ill;
Sothebys Lon 11/1/85: 59 (album, T-1 et al);

**TURNER, E.R.** (Canadian)
Photos dated: late 1860s-1890s
Processes:     Albumen
Formats:       Stereos, cdvs
Subjects:      Topography, portraits
Locations:     Canada - Montreal
Studio:        Canada - Montreal; Toronto
    Entries:
Sothebys NY (Strober Coll.) 2/7/70: 509 (lot,
    T et al);
Rinhart NY Cat 6, 1973: 394;
Phillips Can 10/9/80: 44 (album, T et al);

**TURNER, R.** (British)
Photos dated: 1840s-1865
Processes:     Talbotype, albumen
Formats:       Prints
Subjects:      Architecture, topography
Locations:     Great Britain
Studio:        Great Britain
    Entries:
Christies Lon 10/27/77: 59 (lot, T-2 et al);
Christies Lon 6/28/79: 84 (lot, T-1 et al);

**TURRILL & WITTICK**
Photos dated: 1870s
Processes:     Albumen
Formats:       Prints
Subjects:      Topography
Locations:
Studio:
    Entries:
Christies Lon 10/25/84: 96 (album, T & W-2 et al);

**TURTON & HOWE** (American)
Photos dated: 1880s
Processes:     Albumen
Formats:       Prints
Subjects:      Topography
Locations:     US - Pensacola, Florida
Studio:        US
    Entries:
Swann NY 11/18/82: 378 (lot, T & H et al)(note);

**TUTTLE, C.B.** (American)
Photos dated: 1876
Processes:     Albumen
Formats:       Stereos
Subjects:      Topography
Locations:     US - Lynn, Massachusetts
Studio:        US - Massachusetts
    Entries:
Rinhart NY Cat 7, 1973: 232;

**TUTTLE, Charles K.** (American)
Photos dated: c1885-1890
Processes:     Albumen
Formats:       Prints, stereos
Subjects:      Topography
Locations:     US - Monterey, California
Studio:        US - Pacific Grove, California
    Entries:
Harris Baltimore 12/10/82: 17 (lot, T-1 et al);
California Galleries 7/1/84: 553;
California Galleries 6/8/85: 190 (lot, T et al);

**TWISS & Sons** (British)
Photos dated: 1860s and/or 1870s
Processes:     Albumen
Formats:       Stereos
Subjects:      Topography
Locations:     Great Britain
Studio:        Great Britain
    Entries:
Christies Lon 10/28/82: 17 (lot, T et al);

**TWYMAN & Son** (British)
Photos dated: 1860s-1870s
Processes:     Albumen
Formats:       Stereos
Subjects:      Topography
Locations:     England
Studio:        England - Ramsgate
    Entries:
Christies Lon 10/28/82: 17 (lot, T et al);
Christies Lon 6/23/83: 50 (lot, T-4 et al);
Christies Lon 3/29/84: 22 (lot, T et al);
Sothebys Lon 6/29/84: 9 (lot, T et al);
Sothebys Lon 3/29/85: 64 (lot, T et al);
Phillips Lon 10/29/86: 235 (lot, T-11 et al);

**TYLER & Co.** (see also Boston Daguerreotype Co.)
Photos dated: c1855-1856
Processes:     Daguerreotype
Formats:       Plates
Subjects:      Portraits
Locations:     Studio
Studio:        US - Boston, Massachusetts
    Entries:
Christies Lon 7/13/72: 44 (lot, T-1 et al);
Vermont Cat 5, 1973: 384 ill;
Swann NY 11/18/82: 285 (lot, T-1 et al);
Phillips Lon 6/26/85: 108 (lot, T-1 et al);
Phillips Lon 10/30/85: 2 (lot, T-1 et al);
Swann NY 11/14/85: 46 (lot, T et al), 47 (lot,
    T et al);

**TYRRELL, J.B.**
Photos dated: Nineteenth century
Processes:
Formats:       Prints
Subjects:      Topography
Locations:     Canada
Studio:
    Entries:
Swann NY 10/18/79: 348 (album, T et al);

**TYRWHITT, Reverend R. St. John** (British)
Photos dated: 1868
Processes:      Albumen
Formats:        Prints
Subjects:       Documentary (art)
Locations:      Europe
Studio:         Europe
    Entries:
Christies NY 5/14/80: 348 (book, 4);

**TYSON, C.J. & I.** (American)
Photos dated: 1863-1860s
Processes:      Albumen
Formats:        Cdvs, stereos
Subjects:       Portraits, topography
Locations:      Studio
Studio:         US - Gettysburg, Pennsylvania
    Entries:
Sothebys NY (Strober Coll.) 2/7/70: 541 (lot,
    T-2 et al);
Rinhart NY Cat 2, 1971: 290;
Rinhart NY Cat 6, 1973: 409;
Harris Baltimore 5/28/82: 157 (lot, T-2 et al);
Harris Baltimore 4/8/83: 315 (lot, T et al);
Harris Baltimore 12/16/83: 26 (lot, T-4 et al);
Harris Baltimore 6/1/84: 31 (lot, T et al);

**TYTLER, Major H.C.** (British)(see also T., H.C.)
Photos dated: 1858-1860s
Processes:      Albumen
Formats:        Prints
Subjects:       Topography
Locations:      India - Agra
Studio:
    Entries:
Christies NY 11/10/81: 18 ill(note);

**TYTLER, Stanley**
Photos dated: 1858
Processes:      Albumen
Formats:        Prints
Subjects:       Documentary (military)
Locations:      India - Benares
Studio:
    Entries:
Christies Lon 4/24/86: 454 (2 ills)

UCHIDA, Kyuichi (Japanese)
Photos dated: 1859-1875
Processes:      Albumen
Formats:        Prints
Subjects:       Portraits, ethnography
Locations:      Japan - Osaka and Yokohama
Studio:         Japan
    Entries:
Phillips NY 5/21/80: 145 (album, U et al);

UENO HIKOMA (Japanese)
Photos dated: 1860s-1890s
Processes:      Albumen
Formats:        Prints
Subjects:       Topography
Locations:      Japan - Nagasaki
Studio:         Japan - Nagasaki
    Entries:
Old Japan, England Cat 5, 1982: 2 (lot, U-1 et al),
    3 (lot, U-2 attributed, et al), 5 (lot, U-1 et
    al), 6 (lot, U-1 plus 2 attributed, et al), 24;
Old Japan, England Cat 8, 1985: 1 (5), 2 ill
    (album, 48), 3 (album, 46), 4 ill(album, 31), 5
    (album, 26), 6 (album, 50), 7 (album, 30), 21
    (album, U et al), 74 (2 ills)(2)(attributed);

UFER, Oswald (German)
Photos dated: 1860s-1871
Processes:      Albumen
Formats:        Stereos
Subjects:       Topography
Locations:      Italy
Studio:         Italy - Rome
    Entries:
Harris Baltimore 315/85: 51 (lot, U-4 et al);

ULKE, Henry (1821-1910) and/or
              Julius (1833-1910)(American)
Photos dated: c1860-1882
Processes:      Albumen
Formats:        Cdvs
Subjects:       Portraits
Locations:      Studio
Studio:         US - Washington, D.C.
    Entries:
Sothebys NY (Greenway Coll.) 11/20/70: 70 ill
    (lot, U-1 et al), 175 (lot, U-1 et al), 180
    (lot, U-1 et al), 217 (lot, U-1 et al), 258
    (lot, U-1 et al);

ULRICK, Frederick (American)
Photos dated: Nineteenth century
Processes:      Albumen
Formats:        Cdvs
Subjects:       Portraits
Locations:      Studio
Studio:         US - New York City
    Entries:
Sothebys NY (Strober Coll.) 2/7/70: 320 (lot,
    U-1 et al)(note);

UNNEVER, J.G.
Photos dated: 1870
Processes:      Albumen
Formats:        Prints
Subjects:       Documentary (art)
Locations:
Studio:
    Entries:
Christies Lon 3/20/80: 360 (lot, U-24 et al);

UPTON, Benjamin Franklin (American, born 1818)
Photos dated: 1857-1870s
Processes:      Albumen
Formats:        Prints, cdvs, stereos
Subjects:       Topography, ethnography
Locations:      US - Minnesota
Studio:         US - Minneapolis, Minnesota
    Entries:
Sothebys NY (Strober Coll.) 2/7/70: 506 (lot,
    U et al);
Rinhart NY Cat 1, 1971: 78;
Rinhart NY Cat 6, 1973: 493;
Rinhart NY Cat 7, 1973: 208 (3), 345;
California Galleries 9/27/75: 503 (lot, U et al);
California Galleries 1/23/77: 403 (lot, U et al);
Frontier AC, Texas 1978: 221;
Lehr NY Vol 1:4, 1979: 60 (album, U et al);
Swann NY 11/6/80: 343 ill(album, 24)(note);
Swann NY 11/5/81: 516 (album, U et al)(note);
Harris Baltimore 4/8/83: 57 (lot, U et al);
Harris Baltimore 6/1/84: 152 (lot, U-11 et al);

UPTON, H.B.
Photos dated: 1860s
Processes:      Daguerreotype, ambrotype
Formats:        Plates
Subjects:       Portraits, topography
Locations:
Studio:
    Entries:
Vermont Cat 7, 1974: 502 ill;
Vermont Cat 10, 1975: 541 ill;
Christies Lon 3/11/82: 43;

URBAN, E. d'
Photos dated: 1855
Processes:      Salt
Subjects:       Architecture
Locations:      France - Amiens
Studio:
    Entries:
Rauch Geneva 6/13/61: 98 (note);

URIE (see CLARY & URIE)

URIE, J. (British)
Photos dated: c1854-1865
Processes:      Daguerreotype, ambrotype
Formats:        Plates
Subjects:       Portraits
Locations:      Studio
Studio:         Scotland - Glasgow
    Entries:
Sothebys Lon 10/24/75: 32;
Christies Lon 10/28/76: 28 (note);
Sothebys Lon 11/18/77: 143 (lot, U-3 et al);

**URIE, J.** (continued)
Sothebys Lon 6/28/78: 16 (lot, U-1 et al);
Christies Lon 3/20/80: 53 (note);
Sothebys Lon 10/28/81: 290 (lot, U-1 et al);

**USHER**
Photos dated: c1850
Processes:      Collodion on glass
Formats:        Plates
Subjects:       Genre
Locations:
Studio:
   Entries:
Weil Lon Cat 14, 1949(?): 412 (2);

**USSING, Johan Ludvig** (German)
Photos dated: c1850
Processes:      Daguerreotype
Formats:        Plates
Subjects:       Portraits
Locations:      Studio
Studio:         Germany
   Entries:
Christies Lon 3/10/77: 18 ill;

**V., A.** [A.V.]
Photos dated: 1871
Processes:      Albumen
Formats:        Stereos
Subjects:       Documentary (Paris Commune)
Locations:      France - Paris
Studio:
     Entries:
Swann NY 11/14/85: 161 (lot, V et al);

**V., H.F.** [H.F.V.] (French)
Photos dated: 1840s
Processes:      Daguerreotype
Formats:        Plates
Subjects:       Portraits
Locations:      Studio
Studio:         France - Paris
     Entries:
Christies Lon 6/23/83: 2 (lot, V-1 et al)(note);

**V., J.** [J.V.]
Photos dated: 1860s
Processes:      Albumen
Formats:        Prints
Subjects:       Genre (animals)
Locations:
Studio:
     Entries:
Christies Lon 10/28/82: 207 (lot, V et al);

**V., Q.** [Q.V.] (French)
Photos dated: 1871
Processes:      Albumen
Formats:        Stereos
Subjects:       Documentary (Paris Commune)
Locations:      France - Paris
Studio:         France
     Entries:
Swann NY 5/10/84: 311 (lot, V et al);
Christies Lon 10/31/85: 69 (lot, V et al);

**VACQUERIE, Auguste** (see HUGO, Charles)

**VAERING, D.**
Photos dated: 1880s
Processes:      Albumen
Formats:        Prints
Subjects:       Topography
Locations:      Europe - north
Studio:         Europe
     Entries:
Christies Lon 10/27/83: 84 (albums, V et al);
Swann NY 11/13/86: 216 (albums, V et al);

**VAIL** (see PRENTICE & VAIL) [VAIL 1]

**VAIL** (see SANBORN, VAIL & Co.) [VAIL 2]

**VAIL, J.B.** (American)
Photos dated: 1860s
Processes:      Albumen
Formats:        Cdvs
Subjects:       Portraits
Locations:      Studio
Studio:         US
     Entries:
Swann NY 5/5/83: 329 (lot, V et al);

**VAILLAT, E.** (French)
Photos dated: 1843-1854
Processes:      Daguerreotype
Formats:        Plates
Subjects:       Portraits
Locations:      Studio
Studio:         France - Paris and Lyon
     Entries:
Rauch Geneva 6/13/61: 36 (lot, V-1 et al), 40 ill
     (lot, V-1 et al);
Sothebys Lon 12/21/71: 188 (lot, V-1 et al);
Vermont Cat 8, 1974: 473 ill;
Christies Lon 3/10/77: 21, 22 (2);
Lennert Munich Cat 5II, 1979: 3a;
Sothebys Lon 6/29/79: 29;
Christies Lon 10/30/80: 20;
Christies Lon 6/18/81: 7;
Sothebys Lon 6/25/82: 25 ill(note);
Sothebys NY 3/29/85: 37 (2);

**VALECKE, Jules** (French)
Photos dated: 1860s-1870s
Processes:      Albumen
Formats:        Stereos
Subjects:       Topography
Locations:      France; Belgium
Studio:         France - Paris
     Entries:
California Galleries 9/27/75: 570 (15);
Christies Lon 10/30/80: 120 (lot, V-3 et al);
Petzold Germany 11/7/81: 290 (lot, V et al);

**VALENTIN** (French)
Photos dated: c1880
Processes:
Formats:
Subjects:       Topography
Locations:      France - Chateau d'Ay
Studio:         France
     Entries:
Christies Lon 3/15/79: 112 (lot, V-1 et al);

**VALENTINE, J.** (British)
Photos dated: c1860
Processes:      Ambrotype
Formats:        Plates
Subjects:       Portraits
Locations:      Studio
Studio:         Scotland - Dundee
     Entries:
Sothebys Lon 3/21/78: 246 (lot, V-1 et al);
Christies Lon 10/26/78: 52;

VALENTINE, James (British, 1815-1880)
Photos dated: c1870s-c1885
Processes:   Albumen, platinum
Formats:     Prints, stereos
Subjects:    Topography, ethnography, portraits
Locations:   Scotland; England; Wales; New
             Zealand; Morocco - Tangier; Jamaica
Studio:      Scotland - Dundee
  Entries:
Sothebys NY 11/21/70: 338 (lot, V et al);
Rinhart NY Cat 1, 1971: 443 (4);
Rinhart NY Cat 2, 1971: 404 (album, V et al);
Vermont Cat 4, 1972: 577 ill(note), 578 ill, 579
  ill, 580 ill, 581 ill, 582 ill, 583 ill, 584 ill;
Rinhart NY Cat 7, 1973: 146 (album, V et al), 484,
  485, 486;
Witkin NY I 1973: 355 (album, V et al);
Christies Lon 6/14/73: 172 (album, V et al);
Christies Lon 10/4/73: 122 (albums, V et al), 132
  (album, V attributed et al);
Sothebys Lon 12/4/73: 2 (lot, V et al);
Vermont Cat 4, 1974: 747 (album, V et al);
Witkin NY II 1974: 575 (album, V et al);
Sothebys Lon 3/8/74: 37 (albums, V et al), 38
  (album, V et al), 40 (albums, V et al);
Christies Lon 4/25/74: 237 (albums, V et al);
Sothebys Lon 6/21/74: 82 (albums, V et al), 84
  (albums, V et al), 175 (albums, V et al);
Christies Lon 7/25/74: 351 (lot), 355 (albums,
  V et al);
Sothebys Lon 10/18/74: 97 (album, V et al), 101
  (album, 20), 102 (album, V et al);
Edwards Lon 1975: 24 (album, V et al), 36 (album,
  V-3 et al), 40 (album, V et al), 44 (album,
  V et al);
Sothebys NY 2/25/75: 146 (20);
Sothebys Lon 3/21/75: 75 (album, V et al), 76
  (album, V et al), 91 (albums, V et al), 121
  (albums, V-80 et al), 126 (album, V et al);
Sothebys Lon 6/26/75: 96 (album, V et al), 99
  (album, V et al), 103 (album, V et al), 107
  (albums, V et al);
California Galleries 9/26/75: 118 (album, V et al),
  131 (album, V et al), 134 (album, V et al), 167
  (album, V-1 et al)(note), 183 (album, V et al),
  199 (album, 14), 265 (lot, V-1 et al);
California Galleries 9/27/75: 356;
Sothebys Lon 10/24/75: 83 (lot, V et al), 92 (lot,
  V et al), 102 (album, V et al), 141 (album,
  V et al);
Colnaghi Lon 1976: 281, 282, 283 ill, 284, 285 ill,
  286 ill, 287, 288 ill, 289, 290 ill, 291 ill,
  292, 293, 294, 295, 296, 297, 298, 299, 300,
  301, 302 ill, 303, 304;
Kingston Boston 1976: 271 ill(note), 272 ill, 273
  ill(19), 274 ill(3), 275 ill(19), 276 (16);
Rose Boston Cat 1, 1976: 24 ill(note), 25 ill,
  26 ill;
Witkin NY IV 1976: AL8 (album, V et al);
Wood Conn Cat 37, 1976: 223 (album, 13), 231
  (album, V et al), 233 (album, V et al), 236
  (album, V et al), 249 album, V et al);
Sothebys Lon 3/19/76: 1 (lot, V et al), 31 ill
  (album, 200), 33 (lot, V et al), 42 (album,
  V et al), 43 (album, V et al);
California Galleries 4/2/76: 145 (album, V et al),
  148 (album, V et al), 222 (lot, V-1 et al);
California Galleries 4/3/76: 331 (lot, V-2 et al),
  342 (lot, V et al);
Sothebys NY 5/4/76: 79 (album, V et al), 81 (album,
  V et al);

VALENTINE (continued)

Christies Lon 6/10/76: 47 (albums, V et al), 94
  (album, V et al), 101 (album, V et al), 102
  (album, V et al);
Sothebys Lon 6/11/76: 2 (lot, V et al), 65 (album,
  V-9 et al);
Christies Lon 10/28/76: 85 (album, 200), 87 (album,
  V attributed et al), 89 (albums, V et al), 91
  (albums, V et al), 113 (albums, V et al), 219
  (album, V et al), 229 (albums, V et al), 250
  (albums, V et al);
Sothebys Lon 10/29/76: 30 (lot, V et al), 112
  (album, V et al), 125 (lot, V et al), 127
  (album, 144), 130 (albums, V et al), 131 (album,
  V et al);
California Galleries 1/22/77: 167 (album, V et al),
  168 (album, V et al), 187 (album, V et al), 197
  (album, 14);
Sothebys Lon 3/9/77: 25 (album, V et al), 48
  (album, V et al), 53 (album, V et al), 53a
  (albums, V et al);
Christies Lon 3/10/77: 83 (album, V et al), 86
  (albums, V et al), 119 (albums, V et al), 181
  (albums, V et al), 188 (album, V et al), 192
  (albums, V et al), 271 (albums, V et al);
Christies Lon 6/30/77: 79 (album, V et al), 80
  (album, V et al);
Sothebys Lon 7/1/77: 137 (album, V et al), 158
  (album, 76), 159 (album, V et al), 168 (album,
  V et al);
Sothebys NY 10/4/77: 125 (album, V et al);
Christies Lon 10/27/77: 65 (albums, V et al), 151
  (albums, V et al);
Sothebys Lon 11/18/77: 67 (lot, V et al), 75 (lot,
  V et al), 87 (lot, V et al), 88 (albums, V et
  al), 89 (lot, V et al);
Swann NY 12/8/77: 321 (album, V et al), 325
  (albums, V et al), 367 (lot, V et al), 411 (lot,
  V-10 et al), 431 (album, V et al);
Wood Conn Cat 42, 1978: 558 (album, 84)(note);
California Galleries 1/21/78: 209 (album, V et al),
  210 (album, V et al), 213 (album, V et al), 216
  (album, V-1 et al), 217 (album, V et al);
Christies Lon 3/16/78: 82 (album, 40);
Swann NY 4/20/78: 269 (album, V et al), 314 (lot,
  V et al);
Sothebys NY 5/2/78: 85 (lot, V-2 et al);
Christies Lon 6/27/78: 65 (lot, V et al), 68
  (album, V et al), 89 (albums, V et al), 97
  (album, V et al);
Sothebys Lon 6/28/78: 89 (album, V et al), 112
  (albums, V et al);
Christies Lon 10/26/78: 108 (album, V et al), 127
  (lot, V et al), 134 (album, 40), 192 (album,
  V et al), 194 (albums, V et al);
Sothebys Lon 10/27/78: 90 (30);
Witkin NY IX 1979: 2/91 (book, V-22 et al);
California Galleries 1/21/79: 511 (2), 512;
Phillips Lon 3/13/79: 138 (albums, V et al), 178
  (lot, V et al);
Sothebys Lon 3/14/79: 139 (album, 81), 140 (albums,
  V et al), 155 (album, 20), 332 ill(album, V
  et al);
Christies Lon 3/15/79: 80 (lot, V et al), 187
  (albums, V et al), 194 (albums, V et al), 317
  (albums, V-15 et al);
Phillips NY 5/5/79: 179 (lot, V-5 et al);
Sothebys NY 5/8/79: 80 ill(album, 40), 81 (albums,
  V et al);
Christies Lon 6/28/79: 90 (albums, V et al), 139
  (albums, V et al), 141 ( album, V et al), 143

## VALENTINE (continued)

(albums, V et al), 144 (lot, V et al), 146
(album, V et al);
Sothebys Lon 6/29/79: 93 (albums, V et al), 102
(album, 100), 104 (albums, 80);
Phillips Can 10/4/79: 18 (albums, V et al);
Swann NY 10/18/79: 386 (album, V et al);
Sothebys Lon 10/24/79: 113 (album, V et al);
Phillips NY 11/3/79: 159 (album, V et al);
Rose Boston Cat 5, 1980: 37 ill(note), 38 ill, 39,
40 ill;
Sothebys LA 2/6/80: 111 (lot, V et al);
Christies Lon 3/20/80: 135 (lot, V et al), 136
(lot, V-50), 137 (album, V et al), 148 (album, V
et al), 155 (album, V-5 et al), 158 (albums, V
et al), 204 (lot, V et al), 210 (album, V et
al), 364 (lot, V et al);
Sothebys Lon 3/21/80: 163 (album, V et al), 179
(album, V-20 et al), 187 ill(album, V et al);
California Galleries 3/30/80: 207 (album, V et al),
219 (album, 14), 432 (18), 433, 434;
Christies NY 5/16/80: 124 (lot, V et al), 202
(albums, V et al), 222 (album, V et al);
Phillips NY 5/21/80: 139 (albums, V et al), 172
(17), 173 (lot, V-5 et al);
Christies Lon 6/26/80: 154 (lot, V et al), 158
(lot, V et al), 162 (lot, V et al), 165 (albums,
V et al), 167 (book, V et al), 200 (album, V et
al), 205 (album, V et al), 209 (album, 40), 211
(albums, V et al), 272 (albums, V et al), 274
(album, V et al), 463 (albums, V et al), 491
(lot, V-4 et al);
Sothebys Lon 10/29/80: 306 (album, V et al);
Christies Lon 10/30/80: 149 (album, V-12 et al), 153
(albums, V et al), 157 (albums, V-76 et al), 189
(albums, V et al), 191 (albums, V et al), 222
(albums, V et al), 264 (album, V et al), 268
(album, V et al), 446 (lot, V et al);
Swann NY 11/6/80: 281 (lot, V et al);
California Galleries 12/13/80: 176 (album, V et
al), 400 (lot, V-18 et al);
Christies Lon 3/26/81: 129 (lot, V et al), 160
(albums, V et al), 161 (lot, V et al), 162
(albums, V et al), 163, (albums, V et al), 265
(album, V et al), 273 (album, V et al), 280
(albums, V et al);
Phillips NY 5/9/81: 12 ill(albums, V-322 et al), 24
(albums, V et al), 50 (album, V et al), 51
(albums, V et al);
Sothebys Lon 6/17/81: 111 (albums, V et al), 114
(lot, V et al), 121 (album, V et al);
Christies Lon 6/18/81: 161 (lot, V-12 et al), 166
(lot, V et al), 193 (albums, V et al), 234
(album, V-5 et al), 236 (album, V et al), 241
(albums, V et al), 437 (lot, V et al);
California Galleries 6/28/81: 136 ill(album, V et
al), 188 (lot, V et al), 339 (lot, V et al);
Harris Baltimore 7/31/81: 304 (12);
Sothebys Lon 10/28/81: 84 (album, 20);
Christies Lon 10/29/81: 354 (albums, V et al);
Christies Lon 3/11/82: 366 (lot, V et al);
Phillips Lon 3/17/82: 41 (albums, V-2 et al), 42
(albums, V-7 et al), 53 (albums, V-9 et al), 54
(lot, V-8 et al), 58 (lot, V-7 et al);
California Galleries 5/23/82: 144 (book, 10), 184
(album, V et al), 193 (album, V et al), 228
(lot, V et al), 446 (lot, V et al);
Phillips Lon 6/23/82: 23 (lot, V-1 et al), 26 (lot,
V-7 et al), 28 (lot, V et al), 29 (album, 36),
30 (lot, V et al), 34 (albums, V et al), 44
(albums, V et al);

## VALENTINE (continued)

Christies Lon 6/24/82: 101 (albums, V et al), 140
(album, V et al), 220 (album, V et al), 224
(albums, V et al), 232 (albums, V et al), 234
(album, V et al);
Phillips NY 9/30/82: 933 (album, V-2 et al), 1052
ill(album, 20);
Phillips Lon 10/27/82: 34 (lot, V et al), 35 (lot,
V et al), 36 (lot, V et al);
Christies Lon 10/28/82: 44 (album, V et al), 121
(albums, V et al), 127 (books, V et al), 217
(books, V et al);
Swann NY 11/18/82: 341 (lot, V et al), 373 (albums,
V et al)(note);
Harris Baltimore 12/10/82: 387 (albums, V et al),
389 (album, V et al), 391 (albums, V et al);
Christies NY 2/8/83: 34 (lot, V et al);
Phillips Lon 3/23/83: 45 (albums, V et al);
Christies Lon 3/24/83: 53 (albums, V et al), 55
(lot, V-1 et al);
Sothebys Lon 3/25/83: 34 (album, V et al);
Harris Baltimore 4/8/83: 37 (lot, V-1 et al), 287
(album, V et al), 288 (album, V et al), 370
(album, V et al), 413 (album, 20);
Swann NY 5/5/83: 281 (album, V et al), 282 (album,
V et al), 283 (albums, V et al), 284 (albums, V
et al);
Phillips Lon 6/15/83: 121 (album, V et al), 126A
(albums, V et al), 127 (albums, V et al), 128
(lot, V et al);
Christies Lon 6/23/83: 68 (albums, V et al), 70
(lot, V et al), 166 (albums, V et al), 177
(albums, V et al), 180 (albums, V et al);
Sothebys Lon 6/24/83: 20 (7);
Christies NY 10/4/83: 110 (lot, V et al);
Christies Lon 10/27/83: 60 (albums, V et al), 84
(albums, V et al), 159 (album, V et al);
Phillips Lon 11/4/83: 49 (album, V et al), 52
(album, V et al), 53A (albums, V et al), 54
(album, V et al), 56 (albums, V et al), 60
(album, V et al), 65 (albums, V et al), 71
(lot, V et al);
Swann NY 11/10/83: 277 (album, V et al)(note), 278
(album, V et al)(note);
Sothebys Lon 12/9/83: 9 (albums, V et al);
Harris Baltimore 12/16/83: 42 (lot, V-1 et al);
Christies NY 2/22/84: 6 (album, V et al);
Christies Lon 3/29/84: 52 (albums, V et al), 62
(albums, V et al), 76 (albums, V et al), 97
(album, V et al), 104 (albums, V et al), 208
(lot, V-1 et al);
Harris Baltimore 6/1/84: 445 (lot, V et al);
Phillips Lon 6/27/84: 183 (albums, V et al), 186
(albums, V et al);
Christies Lon 6/28/84: 134 (albums, V et al), 328
(lot, V et al);
California Galleries 7/1/84: 322 (lot, V-16 et al);
Christies NY 9/11/84: 121 (album, V et al), 125
(album, V et al), 128 (album, V et al);
Phillips Lon 10/24/84: 125 (lot, V et al), 128
(albums, V et al), 131 (lot, V et al);
Christies Lon 10/25/84: 58 (lot, V et al), 94 (lot,
V et al), 104 (album, V et al), 106 (album, V
et al);
Sothebys Lon 10/26/84: 38 (lot, V et al);
Swann NY 11/8/84: 154 (albums, V et al), 155
(albums, V et al), 200 (albums, V et al), 201
(albums, V et al), 202 (albums, V et al), 284
(lot, V et al);
Christies NY 2/13/85: 144 (albums, V et al);
Harris Baltimore 3/15/85: 184 (album, V-9 et al);

## VALENTINE (continued)

Phillips Lon 3/27/85: 147 (lot, V et al), 168 (album, V et al), 173 (album, V et al), 184 (album, V et al), 193 (albums, V et al), 204 (albums, V et al);

Christies Lon 3/28/85: 60 (lot, V-11 et al), 62 (album, V et al), 64 (album, 20), 76 (album, V et al), 95 (album, V et al), 103 (albums, V et al), 151 (albums, V et al)(note);

Swann NY 5/9/85: 386 (albums, V et al)(note);

California Galleries 6/8/85: 141 (album, V et al), 470 (12);

Phillips Lon 6/26/85: 179 (album, V et al), 188 (albums, V et al), 218 (album, V et al);

Christies Lon 6/27/85: 54 (lot, V et al), 57 (lot, V et al), 91 (lot, V et al), 96 (album, V et al);

Phillips Lon 10/30/85: 41 (albums, V et al), 73 (album, V et al), 130A (album, V et al);

Christies Lon 10/31/85: 77 (lot, V et al), 78 (lot, V-2 et al), 92 (20), 137 (album, V et al), 140 (album, V et al);

Swann NY 11/14/85: 28 (albums, V et al), 154 (lot, V-4 et al), 190 (lot, V et al);

Wood Boston Cat 58, 1986: 136 (books, V-1 et al);

Harris Baltimore 2/14/86: 204 (album, V et al), 209 (album, V-33 et al), 210 (albums, V et al), 214A (album, V et al), 220 (album, V et al), 227 (albums, 98), 299 (lot, V et al), 307 (lot, V et al), 308 (lot, V et al), 347 (lot, V et al);

Phillips Lon 4/23/86: 231 (album, V et al), 269 (albums, V et al);

Christies Lon 4/24/86: 369 (lot, V-8 et al), 373 (album, 57), 380 (album, V-6 et al), 401 (albums, V et al);

Swann NY 5/15/86: 133 (book, V et al), 203 (lot, V et al), 233 (lot, V et al), 234 (album, V et al), 235 (albums, V et al);

Christies Lon 6/26/86: 2 (lot, V et al), 23 (album, 20), 62 (albums, V et al), 66 (album, V et al), 96 (lot, V et al), 119 (album, 83), 127 (lot, V-22 et al), 137 (albums, V et al), 138 (album, V et al), 150A (lot, V-8 et al), 157 (albums, V et al);

Phillips Lon 10/29/86: 326 (lot, V et al), 327 (lot, V et al);

Christies Lon 10/30/86: 30 (lot, V et al), 33 (lot, V et al), 125 (album, V et al), 256 (albums, V et al);

Sothebys Lon 10/31/86: 7 (lot, V et al), 79 (lot, V-3 et al);

Harris Baltimroe 11/7/86: 274 (album, V et al);

Phillips NY 11/12/86: 201;

Swann NY 11/13/86: 214 (album, V et al), 215 (albums, V-20 et al), 216 (albums, V et al), 218 (lot, V et al), 344 (lot, V et al), 356 (lot, V et al), 357 (lot, V et al);

## VALENTINE, John
Photos dated: 1895
Processes: Bromide
Formats: Prints
Subjects: Topography
Locations: West Indies
Studio:
Entries:
Christies Lon 10/30/80: 277 (album, V-3 et al);

## VALERY (French)
Photos dated: c1868
Processes: Woodburytype
Formats: Prints
Subjects: Portraits incl. Galerie Contemporaine
Locations: Studio
Studio: France
Entries:
Sothebys NY 2/25/75: 121;
Witkin NY IV 1976: 140 ill;
Gordon NY 5/3/76: 303 ill(lot, V-1 et al);
Swann NY 4/20/78: 324 (lot, V-1 et al);
Christies NY 5/26/82: 36 (book, V et al);
Christies NY 5/7/84: 19 (book, V et al);

## VALLEE, Lois Parent (Canadian)
Photos dated: 1865-1880
Processes: Albumen
Formats: Stereos
Subjects: Topography
Locations: Canada - Quebec
Studio: Canada - Quebec
Entries:
Sothebys NY (Strober Coll.) 2/7/70: 509 (lot, V et al);
Rinhart NY Cat 6, 1973: 398, 399;
Rinhart NY Cat 7, 1973: 156 (lot, V-1 et al), 162;
Rinhart NY Cat 8, 1973: 28;
Vermont Cat 7, 1974: 611 ill(4), 612 ill(4);
Vermont Cat 9, 1975: 584 ill(3);
California Galleries 1/21/78: 145 (lot, V et al);
Swann NY 4/26/79: 436 (10)(note);
Christies Lon 6/26/80: 116 (lot, V-11 et al);
Swann NY 11/6/80: 379 (11)(attributed);
Swann NY 4/23/81: 540 (lot, V et al);
Harris Baltimore 4/8/83: 15 (lot, V et al);
Christies Lon 10/27/83: 44 (lot, V et al);
Harris Baltimore 12/16/83: 21 (lot, V-7 et al);
Harris Baltimore 6/1/84: 18 (lot, V-12 et al);
California Galleries 7/1/84: 198 (lot, V et al);
Harris Baltimore 3/15/85: 18 (lot, V-5 et al);
Harris Baltimore 2/14/86: 5 (lot, V-6 et al), 329 (lot, V-2 et al);
Christies Lon 10/30/86: 256 (albums, V-2 et al);

## VALLETO & Co. (Mexican)
Photos dated: c1890
Processes: Albumen
Formats: Cabinet cards
Subjects: Portraits
Locations: Studio
Studio: Mexico - Mexico City
Entries:
California Galleries 3/29/86: 780;

## VALLOU DE VILLENEUVE, Julien (French, 1795-1866)
Photos dated: 1840s-c1855
Processes: Salt
Formats: Prints
Subjects: Portraits, genre (nudes)
Locations: Studio
Studio: France - Paris
Entries:
Rauch Geneva 12/24/58: 253 ill(note);
Rauch Geneva 6/13/61: 95 (note);
Colnaghi Lon 1976: 92 ill(note);
Lunn DC Cat QP, 1978: 1 ill;

**VALLOU DE VILLENEUVE** (continued)
Christies Lon 3/26/81: 377 (2)(attributed);
Christies NY 5/13/86: 406 ill(note);

**VALOIS** (French)
Photos dated: 1870s
Processes:      Woodburytype
Formats:        Prints
Subjects:       Portraits incl. Galerie Contemporaine
Locations:      Studio
Studio:         France
   Entries:
Christies NY 5/14/81: 41 (books, V-1 et al);

**VAN AKEN, E.M.** (American)
Photos dated: 1870s
Processes:      Albumen
Formats:        Stereos
Subjects:       Topography
Locations:      US - Elmira, New York
Studio:         US - Elmira, New York
   Entries:
California Galleries 4/3/76: 417 (lot, V-10 et al);

**VAN BOSCH**
Photos dated: c1880c1895
Processes:      Albumen
Formats:        Cabinet cards, stereos
Subjects:       Portraits, topography
Locations:
Studio:
   Entries:
Rauch Geneva 6/13/61: 159 (lot, V et al);
Swann NY 4/26/79: 362 (lot, V et al);
California Galleries 12/13/80: 159 (album, V et al),
   416 (album, V-1 et al);
California Galleries 6/28/81: 138 (album, V et al);
Christies Lon 3/11/82: 66 (lot, V et al);

**VAN CAMP, Francisco**
Photos dated: early 1880s
Processes:      Albumen
Formats:        Prints
Subjects:       Topography
Locations:      Philippines - Manila
Studio:
   Entries:
Rinhart NY Cat 8, 1973: 24 ill(album, 55);
Swann NY 4/14/77: 304 (album, V et al);

**VANCE, Robert H.** (American, died 1876)
Photos dated: c1851-1865
Processes:      Daguerreotype, ambrotype
Formats:        Plates
Subjects:       Portraits, topography
Locations:      US - San Francisco, California
Studio:         US - San Francisco, California
   Entries:
Sothebys NY (Weissberg Coll.) 5/16/67: 92 (lot,
   V-1 et al), 162 (lot, V-1 et al);
Sothebys NY (Strober Coll.) 2/7/70: 165 ill(note);
Vermont Cat 6, 1973: 523 ill;
Vermont Cat 8, 1974: 474 ill;
Gordon NY 5/3/76: 267 (lot, V-1 et al);
Sothebys NY 5/4/76: 11 (note);
Vermont Cat 11/12, 1977: 563 ill;

**VANCE, R.H.** (continued)
Sothebys Lon 3/14/79: 23;
Swann NY 4/1/82: 248;

**VANDEN BOSSCHE**
Photos dated: 1890s
Processes:      Bromide
Formats:        Prints
Subjects:       Ethnography
Locations:      North America
Studio:
   Entries:
Christies Lon 3/20/80: 194 (lot, V-3 et al);

**VAN DER WEYDE, Henry**
Photos dated: 1889-1897
Processes:      Albumen, photogravures
Formats:        Prints, cabinet cards
Subjects:       Portraits
Locations:      Studio
Studio:         England - London; US - New York City
   Entries:
Witkin NY III 1975: 749 (book, V-4 et al);
Witkin NY IV 1976: OP 362 (book, 6);
Swann NY 4/17/80: 75 (book, V et al);
Swann NY 4/23/81: 509 (lot, V-1 et al);
Swann NY 5/5/83: 78 (book, V et al);
Harris Baltimore 3/15/85: 314 (lot, V et al);

**VANDYKE** (British)
Photos dated: Nineteenth century
Processes:
Formats:
Subjects:       Portraits
Locations:      Studio
Studio:         England - Liverpool
   Entries:
Edwards Lon 1975: 12 (album, V et al);

**VAN GRUISEN, N.L.** (photographer or author?)
Photos dated: 1879
Processes:      Albumen
Formats:        Prints
Subjects:       Topography
Locations:      Iceland
Studio:
   Entries:
Swann NY 12/14/78: 128 (book, 5);

**VAN HAEFTEN, Baron**
Photos dated: c1899-1902
Processes:
Formats:        Prints
Subjects:       Topography, ethnography
Locations:      Japan
Studio:
   Entries:
Christies Lon 7/13/72: 30 (album, 204);

**VAN LAUN** (See CREWES & VAN LAUN)

**VAN LINT, Enrico** (Italian)
Photos dated: 1861-1870s
Processes:       Albumen
Formats:         Prints, cdvs, stereos
Subjects:        Topography
Locations:       Italy
Studio:          Italy - Pisa
    Entries:
California Galleries 4/3/76: 384 (lot, V et al);
Swann NY 11/11/76: 391 (album, V-8 et al);
Christies Lon 6/26/80: 270 (albums, V et al);
Christies NY 11/11/80: 200 (lot, V et al);
Christies Lon 3/26/81: 218 (album, L-1 et al);
Swann NY 4/23/81: 461 (lot, V et al), 526 (lot,
   V et al);
Christies Lon 3/11/82: 139 (lot, V et al);
Christies Lon 6/24/82: 127 ill(album, V-1 et al),
   138 (lot, V et al);
Swann NY 5/5/83: 380 (albums, V et al)(note);
Christies NY 10/4/83: 101 (albums, V et al);
Christies Lon 10/27/83: 158 (albums, V et al);
Christies Lon 6/28/84: 140 (album, V et al);
Harris Baltimore 3/15/85: 51 (lot, V-4 et al);
Sothebys Lon 3/29/85: 120 (lot, V-1 et al);
Swann NY 5/15/86: 264 (lot, V et al), 265 (lot,
   V et al);
Swann NY 11/13/86: 244 (album, V et al);

**VAN LOAN, Samuel** (American)
Photos dated: 1844-1854
Processes:       Daguerreotype
Formats:         Plates
Subjects:        Portraits
Locations:       Studio
Studio:          US - Philadelphia, Pennsylvania
    Entries:
Sothebys NY (Weissberg Coll.) 5/16/67: 118 (lot,
   V-1 et al), 143 (lot, V & Ennis-1, et al);
Sothebys NY (Strober Coll.) 2/7/70: 148 (lot, V &
   Ennis-1, et al);
Rinhart NY Cat 1, 1971: 73;
Vermont Cat 10, 1975: 542 ill(note);
Sothebys Lon 3/21/75: 178 (V & Ennis);
California Galleries 9/26/75: 31 (lot, V-1 et al);
Vermont Cat 11/12, 1977: 564 ill(V & Ennis);
California Galleries 1/22/77: 80 (lot, V-1 et al);
Witkin NY IX 1979: 15 ill;
Swann NY 4/23/81: 241 ill(lot, V-1 et al)(note);

**VAN LOO, Leon** (American)
Photos dated: 1860s-early 1880s
Processes:       Albumen
Formats:         Prints, stereos, cdvs
Subjects:        Topography
Locations:       US
Studio:          US - Cincinnati, Ohio
    Entries:
Gordon NY 5/3/76: 298 (books, V et al);
Wood Boston Cat 58, 1986: 136 (books, V-1 et al);

**VAN MOL Soeurs**
Photos dated: 1880-1890
Processes:       Albumen
Formats:         Prints
Subjects:        Ethnography
Locations:
Studio:
    Entries:
Swann NY 11/14/85: 65 (lot, V et al);

**VANNERSON, Julian** (American, born 1827)
Photos dated: c1852-1864
Processes:       Daguerreotype, salt, albumen
Formats:         Plates, prints, cdvs
Subjects:        Ethnography, portraits
Locations:       US - American west
Studio:          US - Richmond, Virginia; Washington,
                D.C.
    Entries:
Sothebys NY (Strober Coll.) 2/7/70: 324 (lot,
   V et al);
Sothebys NY (Greenway Coll.) 11/20/70: 164 ill;
Sothebys NY 2/25/75: 45 (5 ills)(lot, V et al), 173
   (albums, V & J et al);
Sothebys LA 2/13/78: 59 ill (album, 43);
Christies NY 5/16/80: 272 ill(note);
Christies NY 11/11/80: 152, 153, 154;
Swann NY 4/1/82: 272 ill(album, V & J et al)(note);
Harris Baltimore 5/28/82: 133 ill(note);
Sothebys NY 11/10/82: 376 ill;
Harris Baltimore 12/10/82: 363 (lot, V & Jones-1,
   V & Levy-1, et al);
Harris Baltimore 9/16/83: 126 (note), 127 ill(note);
Sothebys NY 11/9/83: 282 (3)(note);
Swann NY 11/10/83: 238 (9)(note);
Harris Baltimore 12/16/83: 251;

**VAN OGDEN** (American)
Photos dated: c1870s-1880s
Processes:       Tintype
Formats:         Plates
Subjects:        Portraits
Locations:       Studio
Studio:          US - Chicago, Illinois
    Entries:
California Galleries 1/22/77: 144 (lot, V-1 et al);

**VAN ORSDELL, C.M.** (American)
Photos dated: 1870s
Processes:       Albumen
Formats:         Stereos, cdvs
Subjects:        Topography, portraits
Locations:       US
Studio:          US - Wilmington, North Carolina
    Entries:
Sothebys NY (Strober Coll.) 2/7/70: 318 (lot,
   V et al);

**VAN POOTEN**
Photos dated: Nineteenth century
Processes:       Albumen
Formats:         Cdvs, cabinet cards
Subjects:        Portraits
Locations:
Studio:
    Entries:
Christies Lon 6/26/80: 503 (album, V et al);

**VAN STAVOREN, J.H.** (American)
Photos dated: c1870
Processes:      Albumen
Formats:        Cdvs
Subjects:       Portraits
Locations:      Studio
Studio:         US - Nashville, Tennessee
    Entries:
Vermont Cat 1, 1971: 251 (lot, V-1 et al);

**VAN WAGNER** (American)
Photos dated: c1880
Processes:
Formats:        Prints
Subjects:       Portraits
Locations:      Studio
Studio:         US
    Entries:
Swann NY 5/10/84: 231 (lot, V et al);

**VARELA & SUAREZ** (Cuban)
Photos dated: 1872
Processes:      Albumen
Formats:        Prints
Subjects:       Topography, portraits
Locations:      Cuba - Havana
Studio:         Cuba - Havana
    Entries:
Swann NY 12/8/77: 356 ill(book)(note);

**VARELA, A.C.** (American)
Photos dated: 1870s-c1880
Processes:      Albumen
Formats:        Stereos
Subjects:       Topography
Locations:      US - Los Angeles, California
Studio:         US - Los Angeles, California
    Entries:
California Galleries 1/23/77: 447 (lot, V et al);

**VARIN Frères** (French)
Photos dated: 1853
Processes:      Albumen
Formats:        Prints
Subjects:       Topography
Locations:      France - Paris
Studio:         France
    Entries:
Sothebys Lon 4/25/86: 182 ill(note);

**VARLEY, T.P.** (American)
Photos dated: Nineteenth century
Processes:      Albumen
Formats:        Stereos
Subjects:       Topography
Locations:      US
Studio:         US
    Entries:
Christies Lon 6/26/80: 115 (lot, V et al);

**VARROQUIER, A.** (French)
Photos dated: 1865-1869
Processes:      Albumen
Formats:        Prints, stereos
Subjects:       Topography, genre (animal life),
                ethnography
Locations:      France - Paris; Egypt; Syria; Lebanon
Studio:         France - Paris
    Entries:
Sothebys Lon 10/24/75: 137 (lot, V-3 et al);
Sothebys Lon 3/25/83: 88 (lot, V-1 et al);

**VASSE, Jérome** (French)
Photos dated: 1852
Processes:      Daguerreotype
Formats:        Plates
Subjects:       Architecture
Locations:      France - Amiens
Studio:         France
    Entries:
Drouot Paris 11/22/86: 108 ill(note);

**VAUGHN** (American)
Photos dated: c1870s-1880
Processes:      Albumen
Formats:        Cdvs
Subjects:       Portraits
Locations:      Studio
Studio:         US - San Francisco, California
    Entries:
California Galleries 5/23/82: 257 (lot, V et al);

**VAUGHN, John** (British)
Photos dated: 1860s-1870s
Processes:      Albumen
Formats:        Prints
Subjects:       Genre (rural life)
Locations:      England
Studio:         England - Oxford
    Entries:
Sothebys Lon 3/25/83: 114 ill(album, V et al);

**VAUGHN, Deswell** (British)
Photos dated: c1879
Processes:      Albumen
Formats:        Prints
Subjects:       Genre
Locations:      Great Britain
Studio:         Great Britain
    Entries:
Christies Lon 6/30/77: 212 ill(book, 11);

**VAUGHN, W.E.** (American)
Photos dated: Nineteenth century
Processes:      Albumen
Formats:        Stereos
Subjects:       Topography
Locations:      US - New England
Studio:         US
    Entries:
California Galleries 4/3/76: 407 (lot, V-2 et al);
California Galleries 1/21/78: 174 (lot, V-2 et al);

**VAURY et Cie.** (French)
Photos dated: c1860
Processes:      Albumen
Formats:        Stereos, cdvs
Subjects:       Genre (nudes), ethnography
Locations:      Studio
Studio:         France
    Entries:
Christies Lon 3/26/81: 412 (album, V-1 et al);
Sothebys Lon 6/29/84: 13 ill(lot, V et al);

**VAVARY & Co.**
Photos dated: c1890
Processes:      Albumen
Formats:        Prints
Subjects:       Topography
Locations:      Switzerland
Studio:         Europe
    Entries:
California Galleries 4/3/76: 322 (lot, V-1 et al);

**VEDDER, F.P.** (American)
Photos dated: c1898
Processes:      Silver
Formats:        Prints
Subjects:       Topography
Locations:      US - Colorado; California
Studio:         US
    Entries:
California Galleries 7/1/84: 253 ill(album, 137)
    (attributed);

**VEEDER, Adam** (American)
Photos dated: 1870s-1880s
Processes:      Albumen
Formats:        Stereos
Subjects:       Topography
Locations:      US - Albany, New York
Studio:         US - Albany, New York
    Entries:
Rinhart NY Cat 1, 1971: 127 (2);
Rinhart Cat 8, 1973: 66 (2);
California Galleries 4/3/76: 478 (11);

**VEREY Brothers** (British)
Photos dated: c1870
Processes:      Gelatin silver
Formats:        Prints
Subjects:       Topography
Locations:      Great Britain - Castelmaine
Studio:         Great Britain
    Entries:
Christies lon 10/30/86: 168 ill(album, 12);

**VERMAY**
Photos dated: 1860s
Processes:      Albumen
Formats:        Cdvs
Subjects:       Ethnography
Locations:
Studio:
    Entries:
Christies Lon 3/26/81: 412 (album, V-1 et al);

**VERNEY, George H.** (British)
Photos dated: 1860s-1870s
Processes:      Albumen
Formats:        Prints
Subjects:       Topography
Locations:      England
Studio:         Great Britain
    Entries:
Sothebys Lon 7/1/77: 172 ill(albums, V-32 et al);
Sothebys Lon 6/29/79: 176 (album, 63);

**VERNON, the Honorable Warren W.** (British)
Photos dated: 1860s
Processes:      Albumen
Formats:        Prints
Subjects:       Topography
Locations:      Italy - Pisa
Studio:         Great Britain (Amateur Photographic
                Association)
    Entries:
Sothebys Lon 3/21/80: 156 (lot, V-6 et al);
Christies Lon 10/27/83: 218 (albums, V-2 et al);

**VERSCHOYLE, Lieutenant Colonel** (British)
Photos dated: 1860s
Processes:      Albumen
Formats:        Prints
Subjects:
Locations:
Studio:         Great Britain (Amateur Photographic
                Association)
    Entries:
Christies Lon 10/27/83: 218 (albums, V-1 et al);
Sothebys Lon 6/28/85: 134 (album, V et al);

**VERVEER**
Photos dated: c1880
Processes:      Albumen
Formats:        Cabinet cards
Subjects:       Portraits
Locations:      Europe
Studio:         Europe
    Entries:
Harris Baltimore 3/15/85: 279 (lot, V et al);

**VERZASCHI, Enrico** (Italian)
Photos dated: 1860s-1872
Processes:      Albumen
Formats:        Prints, stereos
Subjects:       Topography
Locations:      Italy - Rome
Studio:         Italy - Rome
    Entries:
Rose Boston Cat 5, 1980: 69 ill(note), 70 ill,
    71 ill;
Swann NY 11/5/81: 493 (3)(note);
Rose Florida Cat 7, 1982: 35 ill(3)(note);
Harris Baltimore 12/10/82: 399 (lot, V et al);

**VESEY** (Irish)
Photos dated: 1875
Processes:    Albumen
Formats:      Prints
Subjects:     Topography
Locations:    Ireland - Restrevor
Studio:       Ireland
    Entries:
Christies Lon 3/10/77: 78 (album, 35);
Christies Lon 3/16/78: 54 (albums, 54);

**VIALARDI, A.L.** (Italian)
Photos dated: 1866-1868
Processes:    Albumen
Formats:      Prints
Subjects:     Documentary (engineering, public
              events)
Locations:    Italy - Turin
Studio:       Italy
    Entries:
Vermont Cat 11/12, 1977: 530 ill(book, 8);
Petzold Germany 11/7/81: 179 (album, V et al);
Swann NY 11/10/83: 161 (book, 9)(note);

**VIANELLI** (Italian)
Photos dated: 1865-1880
Processes:    Albumen
Formats:      Cdvs, cabinet cards
Subjects:     Portraits
Locations:    Studio
Studio:       Italy
    Entries:
Maggs Paris 1939: 558;
Harris Baltimore 3/15/85: 277 (lot, V et al), 286
    (lot, V et al);
Swann NY 11/14/85: 147 (album, V et al);

**VICK, W.** (British)
Photos dated: c1856-1890s
Processes:    Albumen, bromide, silver (reprints),
              platinotype
Formats:      Prints, prints on cloth
Subjects:     Topography, portraits
Locations:    England - Ipswich
Studio:       England - Ipswich
    Entries:
Sothebys Lon 6/28/78: 259 (33), 260 (lot,
    V-2 et al);
Sothebys Lon 3/14/79: 381 (4)(note), 382 (4),
    383 (4);
Christies Lon 3/20/80: 138 (books, 63), 175
    (albums, V et al);
Sothebys Lon 10/29/80: 301 (2)(attributed);
Harris Baltimore 7/31/81: 263 (lot, V-2 et al);

**VICKERY, W.K.** (American)
Photos dated: 1883
Processes:    Salt
Formats:      Prints
Subjects:     Topography
Locations:    US - California
Studio:       US - California
    Entries:
Lehr NY Vol 1:2, 1978: 41 ill, 42 ill, 43 ill;
Lehr NY Vol 2:2, 1979: 34 ill, 35 ill;

**VICTOR** (French)
Photos dated: 1850s
Processes:    Daguerreotype
Formats:      Plates
Subjects:     Portraits
Locations:    Studio
Studio:       France
    Entries:
Rauch Geneva 6/13/61: 40 (lot, V et al);

**VIDAL, Léon** (French, 1833-1906)
Photos dated: 1870s
Processes:    Three-color pigment
Formats:      Prints
Subjects:     Documentary (art)
Locations:    France - Paris
Studio:       France
    Entries:
Lunn DC Cat QP, 1978: 26 ill(book, 39)(note);
Phillips Lon 3/13/79: 142 (4)(note);
Swann NY 11/10/83: 373, 374;
Sothebys Lon 4/25/86: 213 ill(13);

**VIGIER, Vicomte J. de** (French, died 1862)
Photos dated: 1853
Processes:    Salt
Subjects:     Topography
Locations:    France; Spain - Pyrenees
Studio:       France
    Entries:
Andrieux Paris 1951(?): 78 (album, 38)(note);
Andrieux Paris 1952(?): 754 (album, 38)(note);
Rauch Geneva 6/13/61: 94 (9)(attributed)(note);
Sothebys Lon 3/25/83: 90 ill(attributed), 91 ill
    (note);

**VIGNES, Lieutenant Louis** (French, 1831-1896)
Photos dated: 1864-1875
Processes:    Photogravure
Formats:      Prints
Subjects:     Topography
Locations:    Jordan; Palestine
Studio:
    Entries:
Wood Conn Cat 45, 1979: 188 (2 ills)(book, 64)
    (note);
Octant Paris 3/1980: 1 ill(note), 2 ill, 3 ill, 4
    ill, 5 ill, 6 ill, 7 ill, 8 ill, 9 ill, 10 ill,
    11 ill, 12 ill, 13 ill, 14 ill, 15 ill, 16 ill,
    17 ill, 18 ill, 19 ill, 20 ill, 21 ill, 22 ill;

**VILLARD** (French)
Photos dated: Nineteenth century
Processes:    Albumen
Formats:      Cdvs
Subjects:
Locations:
Studio:       France
    Entries:
Christies Lon 2/26/80: 261 (lot, V et al);

**VILLENEUVE** (see VALLOU de VILLENEUVE)

**VINKENBOS, W.F.**
Photos dated: 1860s
Processes:    Albumen
Formats:      Cdvs
Subjects:     Ethnography
Locations:    Europe
Studio:       Europe
    Entries:
Swann NY 5/15/86: 202 (album, V et al);

**VIVIAN, W. Graham** (British)
Photos dated: 1850s-1871
Processes:    Albumen
Formats:      Prints
Subjects:     Topography, portraits
Locations:    England; Wales; Scotland
Studio:       Great Britain (Photographic Club)
    Entries:
Sothebys Lon 3/21/75: 286 (album, V-1 et al);
Sothebys Lon 6/11/76: 174 (album, V et al)(note);
Sothebys Lon 7/1/77: 173 (album, 105)(note);
Lunn DC Cat QP, 1978: 23;
Sothebys Lon 6/28/78: 283 ill(album, V et al)(note);
Christies NY 5/4/79: 20 ill(note), 21;
Sothebys Lon 3/21/80: 250 (album, V et al);
Sothebys Lon 10/29/80: 297 ill;
Christies NY 11/10/81: 12 ill(note);
Phillips Lon 3/27/85: 275 (album, V-2 et al);
Sothebys Lon 11/1/85: 59 (lot, V-1 et al);

**VOGEL** (see ZEDLER & VOGEL)

**VOGEL, F. & J.**
Photos dated: 1850-1856
Processes:    Salt, albumen
Formats:      Prints
Subjects:     Portraits, genre
Locations:    Italy - Venice
Studio:
    Entries:
Maggs Paris 1939: 495 ill(V & Reinhardt)(note);
Rauch Geneva 6/13/61: 128 (3)(note);
Christies Lon 10/25/84: 66 (lot, V-2 et al);

**VOGNOS & HURFORD** (American)
Photos dated: 1880s
Processes:    Albumen
Formats:      Cabinet cards
Subjects:     Portraits
Locations:    Studio
Studio:       US - Canton, Ohio
    Entries:
Swann NY 10/18/79: 391 (lot, V & H-1 et al)

**VOLKERING, G.**
Photos dated: 1870s
Processes:    Albumen
Formats:      Prints
Subjects:     Topography
Locations:
Studio:       Germany - Dessau
    Entries:
Sothebys NY 5/2/78: 117;

**VON DIX**
Photos dated: Nineteenth century
Processes:    Albumen
Formats:      Cdvs
Subjects:
Locations:
Studio:
    Entries:
Christies Lon 6/26/80: 504 (album, V et al);

**VON MARTENS, Friedrich** (German, 1809-1875)
Photos dated: 1846-1861
Processes:    Daguerreotype, salt
Formats:      Plates, prints
Subjects:     Topography
Locations:    Switzerland
Studio:       France - Paris
    Entries:
Christies Lon 10/29/81: 61;
Sothebys Lon 6/25/82: 214 ill(note), 215 ill, 216
    ill(lot, V-1 attributed, et al);
Christies Lon 10/28/82: 61;
Sothebys Lon 10/29/82: 113 ill(3)(note), 114 (3);
Sothebys Lon 3/25/83: 98 (3), 99 (3), 100, 101;
Christies Lon 3/29/84: 72;

**VORADYEV** (Russian)(photographer or author?)
Photos dated: 1871
Processes:    Albumen
Formats:      Prints
Subjects:     Topography
Locations:    Mongolia
Studio:       Russia
    Entries:
Kingston Boston 1976: 208 (4 ills)(album, 20)(note);

**VOSE, S.S.** (American)
Photos dated: 1870s
Processes:    Albumen
Formats:      Stereos
Subjects:     Topography
Locations:    US - Maine; Vermont
Studio:       US - Skowhegan and Waterville, Maine
    Entries:
Rinhart NY Cat 1, 1971: 136 (5);
Harris Baltimre 4/8/83: 109 (lot, V et al);

**VRESTED, A.P.** (British)
Photos dated: 1860s
Processes:    Albumen
Formats:      Prints
Subjects:     Topography
Locations:    England; Egypt; Albania
Studio:
    Entries:
White LA 1980-81: 10 ill(note), 11 ill, 12 ill
    (note), 13 ill, 14 ill;

VROMAN, Adam Clark (American, 1856-1916)
Photos dated: 1892-1904
Processes:      Platinum
Formats:        Prints
Subjects:       Ethnography
Locations:      US - American west
Studio:         US - Pasadena, California
    Entries:
Swann NY 11/11/76: 410 (album, 55)(note), 411
    (album, 56)(note), 412 (album, 56)(note);
Swann NY 4/14/77: 339 (3 ills)(album, 70);
Witkin NY VI 1978: 126 ill(note), 127 ill;
California Galleries 1/21/78: 407 (2), 408 (3);
Phillips NY 5/5/79: 220 ill, 221, 222 ill;
Christies NY 9/28/79: 17 ill, 18, 19;
Christies NY 10/31/79: 111 ill, 112, 113, 114;
Sothebys NY 11/2/79: 383 ill;
Phillips NY 11/3/79: 209 ill;
Christies NY 5/16/80: 298A ill;
Sothebys NY 5/20/80: 419 ill, 420 ill;
Phillips NY 5/21/80: 279 (2);
Sothebys NY 11/17/80: 137;
Sothebys NY 5/8/84: 332 ill(note), 333 ill, 334 ill
    (note);
Christies NY 11/11/85: 436 ill, 437 ill;
Christies NY 5/13/86: 296 ill;
Sothebys NY 11/10/86: 389 (lot, V-1 et al);
Swann NY 11/13/86: 345 (2), 346 ill(2)(note), 347
    (lot, V-56 et al)(note);

**W. & B.** [same]
Photos dated: 1880s and/or 1890s
Processes:      Albumen
Formats:        Prints
Subjects:       Topography
Locations:      Tasmania and/or New Zealand
Studio:
    Entries:
Christies Lon 6/26/86: 108 (album, W & B et al);

**W. & K.** [same]
Photos dated: 1880s
Processes:      Albumen
Formats:        Prints
Subjects:       Topography, ethnography
Locations:      India
Studio:         India - Madras
    Entries:
Swann NY 11/10/83: 284 (albums, W & K et al)(note);

**W. & P.** [same]
Photos dated: 1880s-1890s
Processes:      Albumen
Formats:        Prints
Subjects:       Topography, ethnography
Locations:      Dutch East Indies
Studio:         Dutch East Indies - Batavia
    Entries:
Swann NY 11/18/82: 364 ill(lot, W & P-10 et al)
    (note);

**W. & S. Ltd.** [W&S Ltd.] (British)
Photos dated: c1890
Processes:      Carbon
Formats:        Prints
Subjects:       Portraits
Locations:      Studio
Studio:         Great Britain
    Entries:
California Galleries 6/8/85: 371;

**W., C.S.P.** [C.S.P.W.]
Photos dated: 1868
Processes:      Albumen
Formats:        Prints
Subjects:       Genre (animal life)
Locations:
Studio:
    Entries:
Christies Lon 10/30/80: 229 (lot, W-1 et al);

**W., E.A.** [E.A.W.] (British)
Photos dated: Nineteenth century
Processes:      Albumen
Formats:        Stereos
Subjects:       Topography
Locations:      England
Studio:         Great Britain
    Entries:
Christies Lon 10/27/83: 52 (lot, W-1 et al);

**W., EH/N** [EHW/N] (British)
Photos dated: 1867-1870
Processes:      Albumen
Formats:        Prints
Subjects:       Documentary (military)
Locations:      England
Studio:         Great Britain
    Entries:
Christies Lon 3/28/85: 323 (lot, W et al);

**W., E.J.** [E.J.W.] (American)(photographer or
                author?)
Photos dated: 1869
Processes:      Albumen
Formats:        Prints
Subjects:       Genre
Locations:      US
Studio:         US
    Entries:
Sothebys NY (Weissberg Coll.) 5/16/67: 69 (book, 30)
    (note);

**W., F.E.** [F. E. W.]
Photos dated: 1869
Processes:      Albumen
Formats:        Prints
Subjects:       Topography, ethnography
Locations:      India
Studio:
    Entries:
Sothebys Lon 7/1/77: 28 (book, 20);

**W., G.W.** [G.W.W.] (see WILSON, G.W.) [W., G.W. 1]

**W., G.W.** [G.W.W.] [W., G.W. 2]
Photos dated: 1860s
Processes:      Albumen
Formats:        Prints
Subjects:       Topography
Locations:      US; Canada
Studio:
    Entries:
Sothebys Lon 12/4/73: 212 (album, 50);

**W., L.** [L.W.]
Photos dated: 1850s
Processes:      Albumen
Formats:        Prints
Subjects:       Portraits
Locations:      Europe
Studio:         Europe
    Entries:
Phillips Lon 10/24/84: 165 (album, W-2 et al)(note);

**W., P.F.** [F.P.W.] (American)
Photos dated: c1870
Processes:      Albumen
Formats:        Stereos
Subjects:       Genre
Locations:      Studio
Studio:         US - New York City
    Entries:
Rinhart NY Cat 7, 1973: 362;

**W., R.** [R.W.](possibly Roland Winn)
Photos dated: 1850s and/or 1860s
Processes:     Albumen
Formats:       Prints
Subjects:      Topography
Locations:     Great Britain
Studio:        Great Britain
   Entries:
Swann NY 5/5/83: 284 (albums, W et al);
Christies Lon 6/27/85: 136 (lot, W-1 attributed
   et al);
Christies Lon 6/26/86: 97 (lot, W-1 et al)(note);

**W., T.** [T. W.]
Photos dated: early 1850s
Processes:     Salt
Formats:       Prints
Subjects:      Topography
Locations:     Jerusalem
Studio:
   Entries:
Sothebys Lon 3/29/85: 78 ill(4);

**W., T.R.** [T.R.W.] (see WILLIAMS, T.R.)

**WACQUEZ, A.**
Photos dated: Nineteenth century
Processes:     Albumen
Formats:       Stereos
Subjects:      Topography
Locations:     Europe
Studio:        Europe
   Entries:
Christies Lon 3/11/82: 94 (lot, W et al);

**WADDELL** (see DELTOR & WADDELL)

**WAGNER**
Photos dated: 1860s
Processes:     Albumen
Formats:       Cdvs
Subjects:      Documentary
Locations:
Studio
   Entries:
Christies Lon 6/27/85: 275 (lot, W-1 et al);

**WAHNSCHAFFE** (see also STAHL)
Photos dated: 1859
Processes:     Albumen
Formats:       Prints
Subjects:      Topography
Locations:     Brazil
Studio:
   Entries:
Christies NY 10/31/79: 51 ill (lot, W et al);

**WAITE, C.B.** (American)
Photos dated: c1890
Processes:     Albumen
Formats:       Prints
Subjects:      Topography
Locations:     US - Catalina Island, California
Studio:        US
   Entries:
California Galleries 6/19/83: 191, 192;

**WAITE, E.O.** (American)
Photos dated: 1870s
Processes:     Albumen
Formats:       Stereos
Subjects;      Topography
Locations:     US
Studio:        US - Bolton and Worcester,
Massachusetts
   Entries:
California Galleries 3/30/80: 436 (4);

**WAITE, J.H.** (American)
Photos dated: 1876-1893
Processes:     Albumen
Formats:       Prints
Subjects:      Topography, portraits
Locations:     US - Connecticut and California;
               Mexico
Studio:        US - Hartford, Connecticut
   Entries:
Wood Conn Cat 37, 1976: 224 (album, 8);
Swann NY 4/14/77: 217 (album, 32);
Christies NY 2/13/85: 155 (lot, W et al);

**WAKELY, G.D.** (American)
Photos dated: early 1860s-c1879
Processes:     Albumen
Formats:       Prints, stereos
Subjects:      Topography, documentary (disasters)
Locations:     US - Leadville, Colorado; Washington,
               D.C.
Studio:
   Entries:
Sothebys NY (Strober Coll.) 2/7/70: 310 (lot,
   W-3 et al), 351 (lot, W-2 et al), 480 (lot,
   W-5 et al), 482 (lot, W-4 et al);
Rinhart NY Cat 2, 1971: 388 (8)(note);
Rinhart NY Cat 7, 1973: 281, 282;
Sothebys NY 5/4/76: 123 (note);
Swann NY 4/14/77: 215 ill(note), 323 (lot, W et al);
Christies Lon 6/30/77: 164 (2);
Swann NY 12/8/77: 311 ill(note);
Swann NY 4/20/78: 371 (lot, W-1 et al);
Swann NY 12/14/78: 478 (3)(note), 479 ill(3);
California Galleries 1/21/79: 509 (lot, W-1 et al);
Harris Baltimore 7/31/81: 128 (lot, W et al);
Harris Baltimore 3/26/82: 23 (lot, W-2 et al);
Sothebys Lon 6/24/83: 1 (lot, W et al);
Harris Baltimore 12/16/83: 143 (lot, W et al);
Harris Baltimore 6/1/84: 157 (lot, W et al), 447;
Christies Lon 3/28/85: 42 (lot, W et al);
Swann NY 11/14/85: 181 (6);
Swann NY 11/13/86: 110 (book, 2)(note), 348 (2);

**WAKEMAN, J.H.** (American)
Photos dated: 1871
Processes:      Albumen
Formats:        Stereos
Subjects:       Documentary (disasters)
Locations:      US - Chicago, Illinois
Studio:         US
   Entries:
Rinhart NY Cat 7, 1973: 209;

**WALCOTT, C.D.** (American)
Photos dated: c1890s
Processes:
Formats:        Prints
Subjects:       Topography
Locations:      US - Tennessee; Idaho; Montana; Utah
Studio:         US
   Entries:
Swann NY 10/18/79: 349 (album, W et al)(note), 350
  (W & Kemp et al), 360 (albums, W et al);

**WALDACK, Charles** (American)
Photos dated: 1866
Processes:      Albumen
Formats:        Stereos, cdvs
Subjects:       Topography
Locations:      US - Mammouth Cave, Kentucky
Studio:         US - Cincinnati, Ohio
   Entries:
Sothebys NY (Strober Coll.) 2/7/70: 493 (lot,
  W-1 et al);
Rinhart NY Cat 1, 1971: 224 (lot, W-6 et al);
Rinhart NY Cat 6, 1973: 403 (6);
Rinhart NY Cat 7, 1973: 405;
Vermont Cat 7, 1974: 656 ill;
Christies Lon 6/18/81: 78 (lot, W-6 et al);
Harris Baltimore 12/10/82: 21 (3);
Harris Baltimore 3/15/85: 20 (lot, W-1 et al);
Christies Lon 3/28/85: 50 (18);

**WALERY** (see ELLIS)

**WALERY, Stanislv Ostrorog** (Polish)
Photos dated: 1875-1915
Processes:      Photogravures, enamel
Formats:        Prints, plates
Subjects:       Documentary (maritime), genre (nudes),
               portraits
Locations:      England; France
Studio:         England - London; France - Paris
   Entries:
Swann NY 2/6/75: 192 (book, W-1 et al);
Sothebys Lon 10/24/75: 171 (books, 181);
Sothebys Lon 10/29/76: 68 (book, 49);
Swann NY 11/11/76: 278 (book, 49);
Witkin NY IX 1979: 2/17 (book, W et al);
Sothebys Lon 6/26/79: 267 (3);
Sothebys NY 11/2/79: 214 ill(book, 49);
Sothebys Lon 10/28/81: 233 ill(book, 16);
Sothebys NY 5/24/82: 298 ill(note);
Swann NY 5/5/83: 455 (lot, W et al)(note);
Christies Lon 3/28/85: 345 ill(lot, W-6 et al);
Christies Lon 6/26/86: 86 (lot, W et al);

**WALKER & FAGERSTEEN** (American) [WALKER 1]
Photos dated: 1870s-1880
Processes:      Albumen
Formats:        Cabinet cards
Subjects:       Topography
Locations:      US - Yosemite, California
Studio:         US
   Entries:
Swann NY 11/6/80: 427 (4)(note);
California Galleries 6/19/83: 544 (lot, W & F-4
  et al);
Harris Baltimore 6/1/84: 15 (lot, W & F et al);

**WALKER** [WALKER 2]
Photos dated: Nineteenth century
Processes:      Albumen
Formats:        Stereos
Subjects:       Topography
Locations:      US - New York State
Studio:
   Entries:
Sothebys NY (Strober Coll.) 2/7/70: 463 (lot,
  W et al);
Harris Baltimore 2/16/86: 38 (lot, W et al);

**WALKER, C.B.** (British) [WALKER, C.B. 1]
Photos dated: Nineteenth century
Processes:
Formats:        Prints
Subjects:
Locations:      Great Britain
Studio:         Great Britain
   Entries:
Swann NY 2/14/52: 113 (lot, W et al);

**WALKER, C.B.** (American) [WALKER, C.B. 2]
Photos dated: 1860s
Processes:      Albumen
Formats:        Cdvs
Subjects:       Portraits
Locations:      Studio
Studio:         US - Bayswater, Florida
   Entries:
California Galleries 3/30/80: 269 (lot, W-1 et al);

**WALKER, E.R.** (American)
Photos dated: 1893
Processes:      Gelatin
Formats:        Prints
Subjects:       Documentary (public events)
Locations:      US - Chicago, Illinois
Studio:         US - Chicago, Illinois
   Entries:
Harris Baltimore 2/14/86: 201;

**WALKER, Lewis Emery** (American, 1825-1880)
Photos dated: 1857-1875
Processes:      Salt
Formats:        Prints, stereos, cdvs
Subjects:       Documentary (engineering), topography
Locations:      US - Washington, D.C.; New York City
Studio:         US - Washington, D.C.; New York
   Entries:
Sothebys NY (Strober Coll.) 2/7/70: 348 (28);
Rinhart NY Cat 6, 1973: 334;
California Galleries 4/3/76: 421 (lot, W et al);

**WALKER, L.E.** (continued)
Phillips NY 5/5/79: 185 ill(note);
Sothebys NY 11/19/79: 98 (4 ills)(note);
Sothebys NY 5/20/80: 282 ill;
Sothebys NY 5/15/81: 113 (2);
Harris Baltimore 7/31/81: 116 (lot, W et al), 308
    (note), 309, 310, 311, 312, 313;
Swann NY 11/10/83: 375 ill(note), 376, 377 (3)
    (note), 378 (3)(note), 379 (4)(note), 380 (6)
    (note);

**WALKER, Robert** (British)
Photos dated: Nineteenth century
Processes:      Albumen
Formats:        Stereos
Subjects:       Topography
Locations:      Great Britain
Studio:         Great Britain
    Entries:
Christies Lon 3/11/82: 85 (lot, W et al);

**WALKER, S.L.** (American)
Photos dated: 1850s
Processes:      Daguerreotype
Formats:        Plates
Subjects:       Portraits
Locations:      Studio
Studio:         US - Poughkeepsie, New York
    Entries:
Vermont Cat 4, 1972: 328 ill;
Christies Lon 7/13/72: 40, 41, 42 (4);

**WALKER, Samuel** (British)
Photos dated: 1880s-1890s
Processes:      Woodburytype, carbon
Formats:        Prints, cabinet cards
Subjects:       Portraits
Locations:      Studio
Studio          Great Britain
    Entries:
Sothebys Lon 3/9/77: 190 (lot, W et al);
Christies Lon 3/10/77: 344 (book, 33);
Harris Baltimore 3/15/85: 255 (lot, W et al), 270
    (lot, W-1 et al);
Christies Lon 6/27/85: 280 (album, W et al);

**WALKER, William** (British)
Photos dated: 1865-1867
Processes:      Albumen
Formats:        Prints, cdvs
Subjects:       Portraits
Locations:      Studio
Studio:         England - London
    Entries:
Sothebys NY 11/21/70: 330 (lot, W et al);
Sothebys Lon 12/4/73: 241 (album, 14);
Sothebys Lon 3/227/81: 225 (album, 15);
Harris Baltimore 4/8/83: 322 (lot, W et al);
Sothebys Lon 10/26/84: 120 (album, 15);

**WALKINGTON, William Marmaduke** (British)
Photos dated: 1860s-1870s
Processes:      Albumen
Formats:        Prints, stereos
Subjects:       Topography
Locations:      Great Britain
Studio:         Great Britain - Tenby
Sothebys Lon 10/27/78: 108 (album, 10);
Sothebys Lon 10/29/80: 6 (lot, W et al);

**WALL** (see COTTON) [WALL 1]

**WALL & Co.** [WALL 2] (American)
Photos dated: c1860
Processes:      Ambrotype
Formats:        Plates
Subjects:       Portraits
Locations:      Studio
Studio:         US - New York City
    Entries:
Sothebys Lon 10/29/80: 173;

**WALLER** (British)
Photos dated: 1860s and/or 1870s
Processes:      Albumen
Formats:        Stereos
Subjects:       Topography
Locations:      Great Britain
Studio:         Great Britain
    Entries:
Christies Lon 6/18/81: 102 (lot, W-1 et al);

**WALLICH, G.C.** (British)
Photos dated: 1870-1890
Processes:      Albumen
Formats:        Prints, cdvs
Subjects:       Portraits
Locations:      Studio
Studio:         England - London (Photographic
                Exchange Club)
    Entries:
Weil Lon Cat 4, 1944(?): 267 (book, 20)(note);
Weil Lon Cat 14, 1949(?): 435 (book, 20)(note);
Swann NY 11/14/85: 137 (album, W et al);

**WALLICH, Dr.**
Photos dated: 1873
Processes:      Heliotype
Formats:        Prints
Subjects:       Documentary (medical)
Locations:
Studio:
    Entries:
Swann NY 7/9/81: 103 (book, W et al), 104 (book,
    W et al);
Wood Conn Cat 49, 1982: 123 (Book, W et al);

**WALLIHAN, A.G.** (American)
Photos dated: 1894-c1897
Processes:      Albumen
Formats:        Prints
Subjects:       Genre (animal life)
Locations:      US - Colorado
Studio:         US
     Entries:
California Galleries 3/30/80: 175 (lot, W-2 et al);
California Galleries 12/13/80: 401;
California Galleries 6/28/81: 340;

**WALLIN, Charles E.** (American)
Photos dated: 1860s
Processes:      Albumen
Formats:        Cdvs
Subjects:       Topography
Locations:      US - York, Pennsylvania
Studio:         US
     Entries:
Harris Baltimore 11/9/84: 59 ill(4);

**WALLIS Brothers** (American)
Photos dated: 1864
Processes:      Albumen
Formats:        Prints
Subjects:
Locations:
Studio:         US - Chicago, Illinois
     Entries:
Wood Boston Cat 58, 1986: 136 (books, W-1 et al);

**WALLIS, George D.** (British)
Photos dated: 1860s
Processes:      Albumen
Formats:        Stereos, cdvs
Subjects:       Topography
Locations:      Great Britain
Studio:         England - Whitby and Scarborough
     Entries:
Sothebys Lon 6/21/74: 65 (lot, W et al);
California Galleries 9/27/75: 479 (lot, W et al);
California Galleries 1/23/77: 384 (lot, W et al);
Christies Lon 6/23/83: 43 (lot, W et al);
Swann NY 5/15/86: 130 (book, W et al)(note);

**WALMSLEY Brothers** (British)
Photos dated: 1890s
Processes:      Silver
Formats:        Prints
Subjects:       Genre
Locations:      Great Britain
Studio:         Great Britain
Sothebys Lon 6/27/80: 262 (2);

**WALSH, Thomas** (American)
Photos dated: c1851
Processes:      Daguerreotype
Formats:        Plates
Subjects:       Portraits
Locations:      Studio
Studio:         US - New York City
     Entries:
Sothebys NY (Weissberg Coll.) 5/16/67: 147 (lot, W-1
     et al);

**WALTER, H. and J.**
Photos dated: Nineteenth century
Processes:      Albumen
Formats:        Stereos
Subjects:       Topography
Locations:      Great Britain
Studio:         Great Britain
     Entries:
Christies Lon 3/11/82: 65 (lot, W et al);

**WALTER, James** (British)
Photos dated: 1874
Processes:      Heliotype
Formats:        Prints
Subjects:       Topography
Locations:      England - Stratford-upon-Avon
Studio:         Great Britain
     Entries:
Vermont Cat 1, 1971: 254 (album, W-1 et al);
Christies Lon 10/27/83: 59 (lot, W et al);
Swann NY 5/10/84: 298 (book);

**WALTER, M.V.** (American)
Photos dated: 1890s
Processes:      Cyanotype
Formats:        Prints
Subjects:       Genre
Locations:      US
Studio:         US - Bath, Pennsylvania
     Entries:
Swann NY 4/1/82: 279 (2), 280 (2);

**WALTHER, Jean** (Swiss)
Photos dated: 1853
Processes:      Salt (Blanquart-Evrard)
Formats:        Prints
Subjects:       Topography
Locations:      Switzerland - Vevey; Greece - Athens
Studio:         Switzerland - Vevey
     Entries:
Sothebys Lon 10/27/78: 153 (album, W et al);

**WALZ, W.G.** (American)
Photos dated: c1880
Processes:      Albumen
Formats:        Prints
Subjects:       Documentary (public events)
Locations:      US - El Paso, Texas
Studio:         US - Texas
     Entries:
California Galleries 7/1/84: 325;

**WALZL, Richard** (American)
Photos dated: 1850s-1870s
Processes:      Daguerreotype, albumen
Formats:        Plates, cdvs, cabinet cards, stereos
Subjects:       Portraits
Locations:      Studio
Studio:         US - Baltimore, Maryland
     Entries:
Sothebys NY (Stober Coll.) 2/7/70: 321 (lot,
     W et al), 483 (lot, W et al);
Vermont Cat 1, 1971: 233 (lot, W-1 et al);
Vermont Cat 5, 1973: 538 (lot, W et al);
Harris Baltimore 7/31/81: 84 (lot, W-3 et al);

**WANE, Marshall** (British)
Photos dated: 1880s-c1895
Processes:    Silver
Formats:      Cabinet cards
Subjects:     Portraits, documentary (public events)
Locations:    Great Britain
Studio:       Scotland - Edinburgh
   Entries:
California Galleries 1/21/78: 140 (album, W et al);
Christies Lon 6/26/86: 192 (32);

**WARD** (British)
Photos dated: 1860s
Processes:    Albumen
Formats:      Cdvs
Subjects:     Portraits
Locations:    Studio
Studio:       Great Britain
   Entries:
Phillips Lon 10/30/85: 32 (lot, W-2 et al)(note);

**WARD, E.J.** (American)
Photos dated: 1870-1888
Processes:    Heliotype, woodburytype
Formats:      Prints
Subjects:     Documentary (medical)
Locations:
Studio:
   Entries:
Swann NY 10/18/79: 148 (book, W et al);
Swann NY 4/17/80: 136 (book, W et al);
Swann NY 4/23/81: 128 (book, W et al);
Wood Boston Cat 58, 1986: 375 (book, W et al);

**WARD, H.D.** (American)
Photos dated: 1860s-1870s
Processes:    Albumen
Formats:      Stereos
Subjects:     Topography, documentary (engineering)
Locations:    US - North Adams, Massachusetts
Studio:       US
   Entries:
Sothebys NY (Strober Coll.) 2/7/70: 514 (lot,
   W et al);

**WARD, J.**
Photos dated: 1860s
Processes:    Albumen
Formats:      Stereos
Subjects:     Topography
Locations:    Egypt
Studio:
   Entries:
Christies Lon 3/29/84: 21 (lot, W-3 et al);

**WARD, Joseph A.** (American)
Photos dated: 1860s-1870s
Processes:    Albumen
Formats:      Cdvs, stereos
Subjects:     Portraits, documentary (scientific),
              genre
Locations:    US
Studio:       US - Boston, Massachusetts
   Entries:
Sothebys NY (Strober Coll.) 2/7/70: 525 (lot,
   W et al);
Rinhart NY Cat 7, 1973: 270;
Vermont Cat 11/12, 1977: 834 ill;
Harris Baltimore 4/8/83: 385 (lot, W et al);
Christies Lon 6/27/85: 276 (album W et al);

**WARLICK, D.A.** (American)
Photos dated: c1880s-c1890
Processes:    Albumen
Formats:      Prints
Subjects:     Documentary (industrial)
Locations:    US - Marietta, Georgia
Studio:       US - Marietta, Georgia
   Entries:
Rinhart NY Cat 6, 1973: 300 ill;
California Galleries 4/2/76: 241 (3);

**WARNER** (American)
Photos dated: 1860s and/or 1870s
Processes:    Albumen
Formats:      Cdvs
Subjects:     Portraits
Locations:    Studio
Studio:       US - Boston, Massachusetts
   Entries:
Christies Lon 10/26/78: 335 (lot, W et al);

**WARNER, J.** (British)
Photos dated: 1850s-1860s
Processes:    Albumen
Formats:      Stereos
Subjects:     Topography
Locations:    Great Britain
Studio:       Great Britain
   Entries:
Christies Lon 6/18/81: 102 (lot, W-1 et al);

**WARNER, M.P.** (American)
Photos dated: 1870s-c1890
Processes:    Autoglyph
Formats:      Stereos, prints
Subjects:     Topography
Locations:    US - Holyoke, Massachusetts
Studio:       US - Holyoke, Massachusetts
   Entries:
Wood Conn Cat 37, 1976: 202 (book, 20)(note);

**WARNER, W. Harding** (British)
Photos dated: 1860s
Processes:      Albumen
Formats:        Prints, stereos
Subjects:       Topography
Locations:      England - Hereford
Studio:         England - Bristol
    Entries:
Sothebys Lon 3/21/75: 147 (lot, W et al);
Christies Lon 6/26/80: 157 (lot, W-2 et al);
Sothebys Lon 3/27/81: 43 (lot, W et al);
Sothebys Lon 3/25/83: 4 (lot, W et al);

**WARNKY, F.C.**
Photos dated: 1878-1879
Processes:      Albumen
Formats:        Stereos
Subjects:       Topography, ethnography
Locations:      US - Colorado
Studio:         US - Alamosa, Colorado
    Entries:
Sothebys NY (Strober Coll.) 2/7/70: 507 (lot,
    W et al);

**WARRE, John** (British)
Photos dated: 1860
Processes:      Albumen
Formats:        Prints
Subjects:       Portraits
Locations:      Studio
Studio:         Great Britain
    Entries:
Sothebys Lon 6/11/76: 177 (album, W-1 et al);

**WARREN** (see LINDLEY & WARREN) [WARREN 1]

**WARREN & HEALD** [WARREN 2]
Photos dated: 1865
Processes:      Albumen
Formats:        Prints
Subjects:       Portraits
Locations:
Studio:
    Entries:
Lehr NY Vol 1:3, 1979: 17 ill;

**WARREN, C.W.** (British)
Photos dated: 1856-1858
Processes:      Salt, albumen
Formats:        Prints
Subjects:       Topography
Locations:      England; Ireland
Studio:         Great Britain
    Entries:
Sothebys Lon 10/28/81: 71 ill(album, 27)(note);
Christies Lon 6/24/82: 114 (9);
Christies Lon 3/24/83: 62 (8);
Christies Lon 6/23/83: 80 (3);
Christies Lon 6/27/85: 276 ill(album, W et al);

**WARREN, George K.** (American)
Photos dated: c1853-1870
Processes:      Daguerreotype, salt, albumen
Formats:        Plates, prints, cdvs, stereos
Subjects:       Portraits, topography, architecture
Locations:      US - New York; Massachusetts;
                Connecticut
Studio:         US - Lowell, Massachusetts
    Entries:
Anderson NY (Gilsey Coll.) 3/18/03: 2785;
Sothebys NY (Strober Coll.) 2/7/70: 265 (lot,
    W et al), 271 (lot, W et al);
Sothebys NY (Greenway Coll.) 11/20/70: 1 ill(lot,
    W-3 et al), 127 ill, 235 ill(lot, W-1 et al);
Sothebys NY 11/21/70: 347 (lot, W et al);
Rinhart NY Cat 1, 1971: 391, 529 (album, 123);
Rinhart NY Cat 2, 1971: 76 (album, W-12 et al), 387
    (lot, W et al);
Rinhart NY Cat 6, 1973: 272 (lot, W-1 et al);
Rinhart NY Cat 7, 1973: 36 (book, W-1 et al);
Rinhart NY Cat 8, 1973: 107, 108;
Sothebys NY 2/25/75: 111 (lot, W-8 et al);
California Galleries 9/26/75: 200 (album, 122);
California Galleries 9/27/75: 377 (lot, W et al);
Sothebys NY 9/11/76: 71 (albums, W et al);
White LA 1977: 271 (2 ills)(album, 81)(note), 272
    (album, 75);
Christies Lon 3/10/77: 246;
Swann NY 4/14/77: 336 (70);
Swann NY 4/20/78: 287 ill(album, 96);
Swann NY 12/14/78: 380 (album, 141)(note);
Lehr NY Vol 1:3, 1979: 42 ill;
Swann NY 4/26/79: 284 (lot, W-1 et al), 325 (album,
    90)(note);
Christies NY 10/31/79: 57;
Swann NY 4/17/80: 253 (album, 50)(note);
Christies NY 11/11/80: 95a (note);
Swann NY 11/18/82: 353 (album, 78)(note);
Christies NY 2/8/83: 77 (lot, W-2 et al);
Swann NY 5/5/83: 327;
Harris Baltimore 9/16/83: 151 (lot, W et al);
Swann NY 11/10/83: 242 (lot, W et al)(note);
Harris Baltimore 6/1/84: 247 (lot, W-1 et al);
Harris Baltimore 11/9/84: 133 (lot, W-1 et al);
Swann NY 5/9/85: 376 ill(album, W et al)(note);
Swann NY 11/14/85: 11 (album, W et al)(note), 60
    (album, W et al), 63 (lot, W et al);

**WARREN, Henry F.** (American)
Photos dated: 1865
Processes:      Albumen
Formats:        Prints, stereos
Subjects:       Portraits, topography
Locations:      US - Washington, D.C.
Studio:         US - Waltham, Massachusetts
    Entries:
Rose Boston Cat 1, 1976: 8 ill;
Sothebys NY 5/4/76: 107 (note);
Swann NY 5/5/83: 392 (note);
Christies NY 5/9/83: 154 ill(note);
Harris Baltimore 6/1/84: 274, 301;
Harris Baltimore 9/27/85: 43, 72;
Harris Baltimore 11/7/86: 94;

**WARREN, J.E.** (American)
Photos dated: Nineteenth century
Processes:      Albumen
Formats:        Stereos
Subjects:       Topography
Locations:      US - Massachusetts
Studio:         US
    Entries:
Harris Baltimore 3/15/85: 58 (lot, W et al);

**WARRENNE, Louise H.**
Photos dated: 1890-1896
Processes:      Platinum
Formats:        Prints
Subjects:       Genre
Locations:      Ireland - County Cork
Studio:
    Entries:
Christies Lon 10/26/78: 110 (2 ills)(album, 198);

**WARWICK, J.A.** (British)
Photos dated: 1857
Processes:      Albumen
Formats:        Prints
Subjects:       Topography
Locations:      England - River Dove Valley
Studio:         Great Britain
    Entries:
Sothebys Lon 3/21/80: 170 (book, 6);
Wood Conn Cat 49, 1982: 477 (book, 6)(note);

**WASHBOURNE, T.** (British)
Photos dated: 1850s
Processes:      Ambrotype
Formats:        Plates
Subjects:       Portraits
Locations:      Studio
Studio:         England - London
    Entries:
Sothebys Lon 6/11/76: 114 (lot, W-1 et al);

**WASHBURN** (American)
Photos dated: c1880
Processes:      Albumen
Formats:        Cabinet cards
Subjects:       Portraits
Locations:      Studio
Studio:         US - New Orleans, Louisiana;
                St. Louis, Missouri
    Entries:
Harris Baltimore 5/28/82: 129;
Harris Baltimore 9/27/85: 62;

**WASHBURNE, T.J.**
Photos dated: Nineteenth century
Processes:      Albumen
Formats:        Stereos
Subjects:       Topography
Locations:      Australia - Victoria
Studio:         Australia
    Entries:
Phillips Lon 10/29/86: 228 (lot, W-1 et al);

**WASHINGTON, A.** (American)
Photos dated: 1850s
Processes:      Daguerreotype
Formats:        Plates
Subjects:       Portraits
Locations:      Studio
Studio:         US - Hartford, Connecticut
    Entries:
Vermont Cat 4, 1972: 329 ill;

**WASSON** (American)
Photos dated: 1860s
Processes:      Tintypes
Formats:        Plates
Subjects:       Portraits
Locations:      Studio
Studio:         US - Brooklyn, New York
    Entries:
Rinhart NY Cat 2, 1971: 245 (lot, W et al);

**WATERHOUSE, Colonel James** (British)
Photos dated: 1868-1875
Processes:      Autotype, albumen
Formats:        Prints
Subjects:       Topography, documentary (scientific,
                art), ethnography
Locations:      India
Studio:         India - Calcutta
    Entries:
Sothebys Lon 10/14/74: 80 (book, W et al);
Sothebys Lon 10/29/76: 600 (books, W-7 et al);
Christies Lon 3/10/77: 332 ill (book, W & Greggs,
    53);
Christies Lon 10/30/80: 232 ill(album, W et al)
    (note);
Christies Lon 3/11/82: 252 (books, W et al);
Christies Lon 6/23/83: 135 (lot, W et al);
Wood Boston Cat 58, 1986: 263 (book, W et al);

**WATERMAN, E.** (American)
Photos dated:
Processes:
Formats:        Prints
Subjects:       Topography
Locations:      US - New York
Studio:         US
    Entries:
Phillips NY 5/21/80: 294 (lot, W-1 et al);

**WATKINS** (see HILL & WATKINS) [WATKINS 1]

**WATKINS** (British) [WATKINS 2]
Photos dated: c1855
Processes:      Daguerreotype
Formats:        Stereo plates
Subjects:       Genre (still life)
Locations:      Studio
Studio:         England - London
    Entries:
Sothebys Lon 3/8/74: 141, 143 ill;

**WATKINS, Carleton Eugene** (American, 1829-1916)
Photos dated: 1854-1906
Processes: Albumen
Formats: Prints, cabinet cards, stereos, cdvs
Subjects: Topography, documentary
Locations: US - California; Oregon; Utah
Studio: US - San Francisco, California
Entries:
Sothebys NY (Strober Coll.) 2/7/70: 352 (lot, W-1 et al), 356 (lot, W et al), 498 (31)(note), 499 ill(22), 502 (lot, W et al), 512 (lot, W et al), 517 (33), 522 (lot, W-1 et al), 524 (lot, W-5 et al), 536 (lot, W-1 et al);
Sothebys NY 11/21/70: 369 (lot, W-1 et al);
Rinhart NY Cat 1, 1971: 296 (3), 297 (2), 298 (2), 299 (3), 300 (3), 301 (3), 302 (3), 303 (2), 304 (2), 392;
Rinhart NY Cat 2, 1971: 430, 431, 432, 554, 573 (11)(note), 574 (2);
Rinhart NY Cat 6, 1973: 353, 355, 385, 565, 566 (attributed), 608, 609, 610, 615, 616, 617;
Rinhart NY Cat 7, 1973: 310, 639;
Vermont Cat 5, 1973: 558 ill(5);
Witkin NY I 1973: 384;
Sothebys Lon 12/4/73: 213 ill(album, W attributed, et al)(note);
Vermont Cat 8, 1974: 589 ill(note), 590 ill, 591 ill, 592 ill, 593 ill, 594 ill, 595 ill, 596 ill, 597 ill, 598 ill, 599 ill, 600 ill, 601 ill, 602 ill, 603 ill, 604 ill, 605 ill, 606 ill, 607 ill, 608 ill, 609 ill, 610 ill, 611 ill, 612 ill, 613 ill, 614 ill, 615 ill, 616 ill;
Vermont Cat 9, 1975: 585 ill(5), 586 ill;
Swann NY 9/18/75: 322 (lot, W-1 et al);
Sothebys NY 9/23/75: 118 (note), 119, 120 ill, 121 ill, 122 (3 ills)(album, W-10 attributed, et al);
California Galleries 9/27/75: 457 (lot, W et al), 459 (lot, W-2 et al), 460 (lot, W-1 attributed et al), 461 (lot, W-3 et al), 462 (lot, W et al), 582 (7)(note);
Colnaghi Lon 1976: 242 (note), 243, 244 ill, 245;
Kingston Boston 1976: 278 ill(note), 279 ill, 280 ill, 281 ill, 282 ill, 283 ill, 284 ill, 285 ill, 286 ill, 287 ill, 288 ill, 289 ill, 290 ill;
Lunn DC Cat 6, 1976: 56.1 ill(note), 56.2 ill, 56.3 ill;
Wood Conn Cat 37, 1976: 204 (book, 31)(note), 331 ill(attributed)(note), 354 ill(note);
Sothebys Lon 3/19/76: 34 ill(3);
Swann NY 4/1/76: 254 (5), 255 (10), 256 (5), 257 (40)(note);
California Galleries 4/3/76: 497 (16);
Gordon NY 5/3/76: 311 ill, 312 ill;
Sothebys NY 5/4/76: 129 ill (3)(attributed)(note), 130 (attributed)(note), 131 (3)(attributed), 132 (3)(attributed)(note), 133 (4)(attributed), 134 (attributed), 135 (attributed);
Swann NY 11/11/76: 464 (lot, W-1 et al);
Gordon NY 11/13/76: 86 ill, 87 ill, 88 ill (attributed), 89 ill(attributed), 100 (album, W attributed et al);
Halsted Michigan 1977: 751 (note), 752;
Vermont Cat 11/12, 1977: 919 ill, 920 ill;
White LA 1977: 84, 85, 117 ill(note), 118 ill, 119 ill, 120 ill, 121 ill;
California Galleries 1/22/77: 113 (lot, W-1 et al);
California Galleries 1/23/77: 364 (lot, W et al), 365 (lot, W-2 et al), 366 (lot, W-1 attributed et al), 367 (lot, W-3 et al);
Sothebys NY 2/9/77: 81 (lot, W-2 attributed, et al);

Christies Lon 3/10/77: 169 (albums, W-1 et al), 203 (lot, W-1 et al);
Swann NY 4/14/77: 340 ill(18), 341 (lot, W-1 et al);
Gordon NY 5/10/77: 838 ill(note), 839 ill, 840 ill, 841 ill, 842 ill, 843 ill;
Sothebys Lon 7/1/77: 8 (33);
Sothebys NY 10/4/77: 55 ill(note), 56, 57 (note), 58 ill(note), 59, 60, 61 ill, 62;
Frontier AC, Texas 1978: 328, 329 (2)(note);
Rose Boston Cat 3, 1978: 18 ill(note);
Witkin NY VI 1978: 129 (2 ills)(2)(note);
Wood Conn Cat 41, 1978: 147 ill(attributed)(note), 148 ill(note), 149 ill, 150 ill, 151 ill(book, W-24 et al)(note);
Wood Conn Cat 42, 1978: 534 (book, 31)(note);
California Galleries 1/21/78: 279 ill(album, W-1 et al), 411, 412 ill, 413, 414, 415, 416 (7), 417 (lot, W et al);
Sothebys LA 2/13/78: 47 ill(note), 48 (note), 49 ill(album, W attributed et al);
Christies Lon 3/16/78: 253;
Swann NY 4/20/78: 178 ill(book, W-24 et al)(note);
Christies Lon 6/27/78: 134 (lot, W-1 et al);
Christies Lon 10/26/78: 181;
Sothebys Lon 10/27/78: 79 ill (album, W attributed et al);
Swann NY 4/26/79: 452(8)(note), 453 (16)(note);
Phillips NY 11/4/78: 80 ill(note), 81 ill(note), 82 (note), 83;
Swann NY 12/14/78: 294 ill(5);
Lehr NY Vol 2:2, 1979: 36 ill, 37 ill, 38 ill, 39 ill;
Rose Boston Cat 4, 1979: 5 ill(note), 6 ill, 7 ill;
Witkin NY Stereo 1979: 19 (2 ills)(11)(note), 20 (2 ills)(16)(note), 21 (2 ills)(14)(note), 22 (2 ills)(10)(note), 23 ill(4)(note), 24 ill(4) (note);
California Galleries 1/21/79: 513 ill, 514, 515;
Sothebys LA 2/7/79: 414 ill(8)(attributed), 415 ill(8)(attributed), 416 (lot, W attributed et al);
Sothebys Lon 3/14/79: 171 (attributed), 172 ill (attributed);
Christies NY 5/4/79: 89 (3 ills)(album, W et al), 90 (2 ills)(album, W et al);
Phillips NY 5/5/79: 198 ill, 199 ill, 200 ill, 201 ill, 202;
Sothebys Lon 5/8/79: 7 ill(note), 8 ill(note), 9 ill (note);
Swann NY 10/18/79: 432 (6)(note);
Christies Lon 10/25/79: 97 (lot, W-24 et al), 228 ill;
Christies NY 10/31/79: 67 ill, 68, 69 ill, 70, 71 (18);
Sothebys NY 11/2/79: 294 ill, 295 ill, 296 ill, 297 ill, 298 ill(12)(note), 299 ill(12), 300 ill(12), 301 ill(12), 302 ill(12), 303 ill(13), 304 ill(12);
Phillips NY 11/3/79: 133 (10), 199 ill(attributed) (note), 200;
Sothebys NY 12/19/79: 99 (2 ills)(album, 40);
White LA 1980-81: 73 ill(note);
Sothebys LA 2/6/80: 26 (lot, W et al), 28 ill, 29 ill, 30 ill, 31 ill(note), 32 ill, 33 ill(lot, W-2 et al);
California Galleries 3/30/80: 382 (lot, W-4 et al), 416 ill(16), 417 ill(11), 437 (2, attributed), 438, 439 (2), 440 (3);
Swann NY 4/17/80: 371 (lot, W-6 et al), 372 (4), 377 ill(note);

## WATKINS, C. (continued)

Christies NY 5/16/80: 243 ill(note), 244 (note), 245 ill, 246, 247 ill, 248 ill, 249 ill, 250 (10), 251 (10), 252;

Sothebys NY 5/20/80: 290 ill(note), 291 ill, 292 ill, 293 ill, 294 ill, 295 ill;

Phillips NY 5/21/80: 267 (attributed, 9)(note), 268 (attributed)(note), 269 ill, 270 ill, 271 ill, 273, 274;

Sothebys Lon 6/27/80: 120 (attributed);

Sothebys Lon 10/29/80: 105 ill(3 plus 1 attributed);

Swann NY 11/6/80: 392 (7), 393 (8);

Christies NY 11/11/80: 138 ill, 139 ill, 140, 141, 142, 143 ill(book), 144 ill (albums, 60)(note), 145, 146, 147 ill;

Sothebys NY 11/17/80: 106 ill(note), 107 ill, 108 ill, 109 ill, 110 ill, 111;

California Galleries 12/13/80: 381 (lot, W-2 et al), 383 (lot, W-1 et al), 403, 404, 405 (attributed) (note), 406 (2, attributed), 407 (2, attributed), 408 ill(4, attributed), 409 (4, attributed), 410 ill(5, attributed);

Koch Cal 1981-82: 41 ill(album, W-67 et al)(note);

Sothebys LA 2/5/81: 464 ill(note), 465 ill, 466 ill, 467 ill, 468 ill, 469 ill, 470 ill;

Swann NY 4/23/81: 384 (album, 13)(note);

Christies NY 5/14/81: 45 ill, 46 ill(note), 47 ill, 48 ill;

Sothebys NY 5/15/81: 114 ill, 115 ill, 116 ill;

California Galleries 6/28/81: 156 ill(album, W-4 et al), 342 ill, 343 ill, 344 (attributed);

Harris Baltimore 7/31/81: 130 (lot, W-1 et al), 314 (note), 315;

Phillips NY 9/5/81: 72 ill, 73 ill(note), 74 ill (note), 75 (note);

Swann NY 11/5/81: 379 ill, 380, 381, 382;

Christies NY 11/10/81: 51 ill, 52 ill;

Rose Florida Cat 7, 1982: 7 ill(attributed);

Weston Cal 1982: 16 ill, 17 ill, 18 ill(note), 19 ill(note), 20 ill(note), 21 ill(note), 22 ill (note);

Sothebys LA 2/17/82: 380 ill(note), 381 ill, 382 ill;

Christies Lon 3/11/82: 96 (lot, W et al), 215 ill (3);

Sothebys Lon 3/15/82: 130 ill(album, 8)(note);

Harris Baltimore 3/26/82: 222;

Phillips NY 5/22/82: 953 ill(note), 954, 955 (2) (note);

California Galleries 5/23/82: 428 ill(6), 429 (11), 447 ill, 448 ill, 449, 450, 451, 452, 453, 454 (attributed), 455 (5, attributed);

Sothebys NY 5/25/82: 512 ill, 513 ill(note), 514 ill (note);

Christies NY 5/26/82: 41 ill, 42 ill, 43 ill, 44 ill, 45 ill, 46 ill, 47 ill, 48 ill, 49 ill (book, W-24 et al)(note);

Phillips NY 9/30/82: 1054, 1055, 1056 (4), 1057 (4);

Christies Lon 10/28/82: 114 (1 plus 1 attributed);

Christies NY 11/8/82: 243 ill(22);

Sothebys NY 11/10/82: 382 ill;

Swann NY 11/18/82: 453 ill(Lot, W-43 et al)(note), 478 (album, W attributed, et al)(note);

Harris Baltimore 12/10/82: 116 (lot, W et al), 326, 327 ill;

Christies Lon 3/24/83: 127 (4)(note);

Swann NY 5/5/83: 445 (7)(note);

Christies NY 5/9/83: 156 ill(2), 157 ill, 158 ill;

Sothebys NY 5/11/83: 519 ill(note), 520 ill (attributed)(note);

## WATKINS, C. (continued)

California Galleries 6/19/83: 423 (lot, W-2 et al), 452 (6), 453 (lot, W et al), 508, 509, 510 (note), 511 ill, 512, 513, 514, 515, 516, 517, 518, 519 ill, 520, 521 (6), 522, 523, 524, 525 (2 ills)(album, 30), 526 ills(album, 30), 527 ill, 528, 529 ill(attributed), 530;

Christies Lon 6/23/83: 44 (lot, W et al), 172 ill (album, W-12 et al);

Christies NY 10/4/83: 91 ill, 92 ill;

Christies Lon 10/27/83: 145 ill(lot, W-1 et al), 150 ill(lot, W-3 et al);

Phillips Lon 11/4/83: 79 ill(album, W-7 et al);

Christies NY 11/8/83: 211 ill, 212 ill(note);

Sothebys NY 11/9/83: 285 ill, 286 ill, 287 ill (note), 288 ill;

Swann NY 11/10/83: 381, 382 (note), 383, 384;

Sothebys Lon 12/9/83: 32 (2 ills)(album, 73)(note);

Harris Baltimore 12/16/83: 18 (lot, W-3 et al), 144 (13), 421;

Christies NY 2/22/84: 21, 22 ill, 23 (note);

Christies Lon 3/29/84: 79 (3);

Christies NY 5/7/84: 27 ill(note), 28 ill(note), 29 ill;

Sothebys NY 5/8/84: 327 ill(album, W attributed, et al), 335 ill, 336 ill, 337 ill, 338 ill(note), 339 ill(note), 340 ill(book, W-24 et al), 341 ill (attributed);

Harris Baltimore 6/1/84: 159 (lot, W-47 et al), 448 (note), 449 (note), 450 (note);

Christies Lon 6/28/84: 231 ill(note), 232, 233 (2), 234 ill, 235 ill, 236 (3), 237 ill(lot, W-4 et al)(note);

Sothebys Lon 6/29/84: 49 (album, W-1 et al), 66 (album, W-5 et al), 70 ill, 71 ill, 72 ill, 73 ill, 74 ill, 75 ill;

California Galleries 7/1/84: 197 (lot, W-1 et al), 221 (6), 711, 712 ill, 713, 714 ill, 715, 716 ill, 717 (2), 718 ill, 719 ill, 720 (album, 32), 721, 722, 723 ill, 724, 725 ill, 726, 727 ill, 728, 729, 730, 731 ill, 732, 733, 734 ill(note);

Christies NY 9/11/84: 149, 150 (attributed), 151 (2);

Christies Lon 10/25/84: 48 (lot, W-4 et al), 96 ill (album, W et al), 192 (5);

Sothebys Lon 10/26/84: 77a ill(note), 77b ill, 77c ill;

Christies NY 11/6/84: 38 ill, 39 ill, 40 ill, 41 ill, 42 ill, 43 ill(note), 44 ill, 45 ill(book, W-24 et al);

Swann NY 11/8/84: 136 (lot, W-1 et al), 253 (lot, W et al);

Christies NY 2/13/85: 156 (lot, W-1 et al);

Harris Baltimore 3/15/85: 108 (lot, W-1 et al), 241;

Christies Lon 3/28/85: 44 (lot, W-3 et al);

Sothebys Lon 3/29/85: 74 ill(lot, W-6 et al);

Christies NY 5/6/85: 366 ill(note), 367 ill, 368 ill (note), 369 ill;

Sothebys NY 5/7/85: 324 ill, 325 ill(2), 326 ill, 327 ill(2)(note), 413 (lot, W-1 et al), 416 ill (attributed);

Sothebys NY 5/8/85: 625 ill(lot, W et al)(note), 630 (lot, W-2 plus 1 attributed, et al);

Swann NY 5/9/85: 444 (13), 455 ill, 456 (3)(note);

California Galleries 6/8/85: 443 ill(4), 473, 474, 475, 476 ill, 477, 478, 479 ill, 480, 481, 482 ill, 483, 484, 485 ill, 486, 487, 488, 489, 490, 491;

Christies Lon 6/27/85: 185 ill, 186;

Sothebys Lon 6/28/85: 38 (3);

Phillips Lon 10/30/85: 64 (lot, W et al);

**WATKINS, C.** (continued)
Sothebys Lon 11/1/85: 21;
Christies NY 11/11/85: 438 (2 ills)(album, 51)
(note), 439 ill(note), 440 ill(note), 441 ill
(2), 442 ill(book, W-24 et al);
Sothebys NY 11/12/85: 361 (note), 362 ill(note),
363 ill(2);
Swann NY 11/14/85: 157 (lot, W et al), 182, 183
(2), 184 (3), 185 (lot, W-3 et al);
California Galleries 3/29/86: 793, 794, 795 (2),
796 ill, 797, 798, 799 (9), 800 ill(7), 801 ill,
802, 803, 804, 805 (attributed);
Christies Lon 4/24/86: 352 ill(lot, W-4 et al);
Sothebys NY 5/12/86: 408 ill(3), 409 ill(3);
Christies NY 5/13/86: 297 ill, 298 ill;
Swann NY 5/15/86: 166 (lot, W-1 et al), 167 (lot, W
et al), 168 ill(album, W et al), 192 (album, W
et al)(note), 192A (lot, W et al), 314;
Phillips NY 7/2/86: 356 ill, 357, 358, 359, 360,
361, 362, 363, 364 (book, W-24 et al);
Phillips Lon 10/29/86: 222 (lot, W et al);
Sothebys NY 11/10/86: 234 ill;
Christies NY 11/11/86: 426 ill;
Phillips NY 11/12/86: 204A, 205, 205A;
Swann NY 11/13/86: 349 ill(16)(note);

**WATKINS, Herbert** (British)
Photos dated: 1859-1860s
Processes:      Albumen
Formats:        Cdvs, stereos, microphotographs
Subjects:       Portraits
Locations:      Studio
Studio:         Great Britain
  Entries:
Anderson NY (Gilsey Coll.) 3/18/03: 3027;
Goldschmidt Lon Cat 52, 1939: 215;
Swann NY 2/14/52: 350 (book, 29)(note);
Sothebys NY (Strober Coll.) 2/7/70: 273 (lot,
W et al);
Sothebys NY (Greenway Coll.) 11/20/70: 22 ill, 44;
Sothebys NY 11/21/70: 337 (lot, W et al);
Witkin NY IV 1976: AL21 (album, W et al);
Swann NY 11/11/76: 485 (lot, W et al);
Christies Lon 6/28/79: 81 ill;
Christies Lon 10/25/79: 418 (6);
Christies Lon 6/18/81: 263 (book, W et al);
Christies Lon 3/11/82: 303 (2 ills)(album, 61)
(note), 327 (album, W et al);
Christies Lon 10/28/82: 201 (album, W et al);
Christies Lon 3/24/83: 237 (album, W et al);
Christies Lon 6/23/83: 34 (lot, W-1 et al), 68
(album, W et al), 252 (album, W et al);
Christies Lon 10/27/83: 224A (album, W et al), 231
(album, W et al), 232 (album, W et al), 309
(album, W et al);
Christies Lon 6/28/84: 302 (album, W et al);
Christies Lon 6/27/85: 169 (3 ills)(album, 242)
(note);
Phillips Lon 10/30/85: 63 (lot, W et al);
Christies Lon 10/31/85: 204A (9), 302 (album,
W et al);
Swann NY 11/14/85: 137 (album, W et al);
Christies Lon 4/24/86: 597 (album, W-4 et al);

**WATKINS, John and/or Charles** (British)
Photos dated: 1860s
Processes:      Albumen
Formats:        Prints, cdvs
Subjects:       Portraits, ethnography
Locations:      Great Britain
Studio:         England - London
  Entries:
Sothebys NY (Strober Coll.) 2/7/70: 273 (lot,
W et al);
Rinhart NY Cat 2, 1971: 363 (lot, J W-1 et al);
Sothebys Lon 12/21/71: 137 (lot, W et al);
Sothebys Lon 5/24/73: 11 (album, C W, 350);
Sothebys Lon 10/14/74: 139 (lot, C W et al);
Sothebys Lon 10/24/75: 175 (album, J W et al), 176
(lot, J & C W et al);
Christies Lon 3/20/80: 347 (albums, J & C W et al);
Christies Lon 6/26/80: 473 (album, J & C W-3,
et al);
Swann NY 11/5/81: 564 (album, J & C W et al)(note);
Christies Lon 3/24/83: 237 (album, J W et al);
California Galleries 7/1/84: 166;
Christies Lon 6/27/85: 271 (album, W et al);
Phillips Lon 4/23/86: 228 (album, C W et al), 244
(lot, C W et al);
Christies Lon 6/26/86: 149 (album, W et al);
Christies Lon 10/30/86: 252 (album, W et al);

**WATSON & WEDD**
Photos dated: c1880s
Processes:      Albumen
Formats:        Prints incl. panoramas
Subjects:       Topography
Locations:      "The Lakes, Mount Gambier"
Studio:
  Entries:
Christies Lon 3/28/85: 101 (album, W & W-1, et al);

**WATSON, Major**
Photos dated: 1870s
Processes:      Albumen
Formats:        Prints
Subjects:
Locations:      China
Studio:
  Entries:
Swann NY 5/15/86: 94 (books, W et al)(note);
Swann NY 11/13/86: 49 (books, W et al);

**WATSON, E.**
Photos dated: 1870s
Processes:      Albumen
Formats:        Prints
Subjects:       Topography
Locations:      Italy
Studio:         Italy - Rome
  Entries:
Sothebys Lon 3/14/79: 159 (12);
Swann NY 11/18/82: 403 (lot, W et al);

WATSON, H.G. (British)
Photos dated: 1856
Processes:
Formats:        Prints
Subjects:
Locations:      Great Britain
Studio:         Great Britain (Photographic Exchange
                Club)
    Entries:
Weil Lon Cat 4, 1944(?): 237 (album, W et al)(note);
Sothebys Lon 5/24/73: 14 (album, W et al);

WATSON, J.E.
Photos dated: 1880
Processes:      Albumen
Formats:        Prints
Subjects:
Locations:
Studio:
    Entries:
California Galleries 5/23/82: 456;
Wood Boston Cat 58, 1986: 136 (books, W-1 et al);

WATSON, J. Forbes (British)
Photos dated: 1867
Processes:      Albumen (hand colored)
Formats:        Prints
Subjects:       Documentary
Locations:      India
Studio:
    Entries:
Swann NY 2/14/52: 331 (book, 8);
Edwards Lon 1975: 199 (book, 9), 200 (book, 9);
Christies Lon 3/16/78: 211 (book, 9);
Sothebys Lon 6/28/78: 18 ill(book, 9);
Swann NY 4/26/79: 101 (book, 12);

WATSON, W.
Photos dated: 1875-1885
Processes:      Albumen
Formats:        Stereos
Subjects:       Topography, portraits
Locations:      Haiti
Studio:         Haiti - Port-au-Prince
    Entries:
Christies Lon 10/31/85: 57 (lot, W-2 et al);

WATTS, William Lord (photographer or author?)
Photos dated: 1875
Processes:      Albumen
Formats:        Prints
Subjects:       Topography
Locations:      Iceland
Studio:
    Entries:
Edwards Lon 1975: 201 (book, 12);

WAUD, Alfred R. (American)
Photos dated: 1860s
Processes:      Tintypes
Formats:        Plates
Subjects:       Genre (nudes)
Locations:      Studio
Studio:         US
    Entries:
Christies NY 10/4/83: 82 (2);

WAWRA (Austrian)(see also MIETHKE & WAWRA)
Photos dated: 1860s and/or 1870s
Processes:      Albumen
Formats:        Cdvs
Subjects:       Topography
Locations:      Austria
Studio:         Austria - Vienna
    Entries:
Petzold Germany 11/7/81: 328 (album, W et al);

WAY & Sons (British)
Photos dated: 1860s-1870s
Processes:      Albumen
Formats:        Stereos
Subjects:       Topography
Locations:      England - Devonshire
Studio:         England - Torquay
    Entries:
Sothebys Lon 3/27/81: 6 (lot, W-4 et al);
Harris Baltimore 7/31/81: 97 (lot, W et al);
Christies Lon 3/11/82: 85 (lot, W et al);

WAYLAND
Photos dated: 1899-1907
Processes:      Albumen
Formats:        Prints
Subjects:       Portraits, documentary
Locations:      England
Studio:         England
    Entries:
Christies NY 5/16/80: 323 (books, 49);

WEAVER Brothers (see WEAVER, Peter S.)

WEAVER, H.E. (American)
Photos dated: c1865
Processes:      Albumen
Formats:        Stereos
Subjects:       Topography
Locations:      US - Washington, D.C.
Studio:         US
    Entries:
Rinhart NY Cat 7, 1973: 286;

WEAVER, Peter S. (American)
Photos dated: 1863-1880
Processes:      Albumen
Formats:        Prints, stereos, cdvs
Subjects:       Documentary (Civil War), topography
Locations:      US - Gettysburg, Pennsylvania
Studio:         US - Hanover, Pennsylvania
    Entries:
Sothebys LA 2/17/82: 383 ill(note);
Sothebys NY 11/9/83: 24 ill(W Brothers, attributed)
    (note);
Sothebys NY 5/8/84: 342 (note);

**WEBB, A.P.**
Photos dated: 1891
Processes:       Photogravure
Formats:         Prints
Subjects:        Portraits
Locations:
Studio:
   Entries:
California Galleries 1/22/77: 353;

**WEBB, William Marshall**
Photos dated: c1855
Processes:
Formats:         Prints
Subjects:        Topography
Locations:       India - Dacca
Studio:
   Entries:
California Galleries: 1/21/78: 275 (3);

**WEBBER**
Photos dated: 1850
Processes:       Daguerreotype
Formats:         Plates
Subjects:        Portraits
Locations:
Studio:
   Entries:
Witkin NY IV 1976: D66 ill;

**WEBBER, J.** (British)
Photos dated: 1860s
Processes:       Albumen
Formats:         Stereos
Subjects:        Topography
Locations:       Great Britain
Studio:          Great Britain
   Entries:
Sothebys Lon 3/25/83: 4 (lot, W et al);

**WEBBER, Vivian** (British)
Photos dated: 1850s
Processes:       Salt
Formats:         Prints
Subjects:        Topography
Locations:       England; Wales
Studio:          Great Britain
   Entries:
Christies Lon 6/23/83: 206 (lot, W et al)(note);

**WEBER, F.J.** (American)
Photos dated: 1860s-1880s
Processes:       Albumen
Formats:         Cdvs
Subjects:        Portraits
Locations:       Studio
Studio:          US - Pennsylvania
   Entries:
Swann NY 4/14/77: 210 (lot, W et al);

**WEBSTER & ALBEE** (American) [WEBSTER 1]
Photos dated: 1880s-c1890
Processes:       Albumen
Formats:         Stereos
Subjects:        Topography
Locations:       US - New York; Illinois; Pennsylvania
Studio:          US - Rochester, New York
   Entries:
California Galleries 1/23/77: 431 (lot, W & A
   et al);
Swann NY 12/14/78: 272 (23);
California Galleries 3/30/80: 401 (lot, W & A-1
   et al);
Harris Baltimore 5/28/82: 157 (lot, W & A-1 et al);
Harris Baltimore 12/16/83: 47 (lot, W & A-13 et al);
Harris Baltimore 3/15/85: 53 (lot, W & A-6 et al);

**WEBSTER, E.Z.** (American) [WEBSTER 2]
Photos dated: 1860s-1870s
Processes:       Albumen
Formats:         Cdvs, stereos
Subjects:        Topography
Locations:       US - New England
Studio:          US - Norwich, Connecticut
   Entries:
Sothebys NY (Greenway Coll.) 11/20/70: 279 (lot, W-1
   et al);
California Galleries 4/3/76: 406 (lot, W et al);
California Galleries 1/21/78: 175 (lot, W et al);
Swann NY 11/5/81: 552 (lot, W et al);

**WEBSTER, Israel B.** (American, born 1826)
Photos dated: 1840s-1877
Processes:       Daguerreotype, albumen
Formats:         Plates, cdvs, stereos
Subjects:        Portraits, topography
Locations:       US - Louisville, Kentucky
Studio:          US - Louisville, Kentucky
   Entries:
Sothebys NY (Strober Coll.) 2/7/70: 298 (lot,
   W et al);
Vermont Cat 4, 1972: 330 ill;
Swann NY 4/23/81: 219;

**WEBSTER, William T.** (American)
Photos dated: 1870s
Processes:       Albumen
Formats:         Stereos
Subjects:        Topography
Locations:       US - Massachusetts
Studio:          US - Lynn, Massachusetts
   Entries:
California Galleries 4/3/76: 395 (lot, W et al);

**WEDD** (see WATKINS & WEDD)

**WEDDERBURN, J.** (British)
Photos dated: 1855
Processes:       Calotypes
Formats:         Prints
Subjects:        Documentary (art)
Locations:       Studio
Studio:          Scotland
   Entries:
Christies Lon 3/11/82: 313 (book, 20);

**WEED** (see MAYO & WEED)

**WEED, W.H.**
Photos dated: 1890s
Processes:
Formats:       Prints
Subjects:      Topography
Locations:     US - Montana
Studio:        US
    Entries:
Swann NY 10/18/79: 360 (albums, W et al);

**WEED, Charles L.** (American)
Photos dated: 1859-1875
Processes:     Albumen
Formats:       Prints
Subjects:      Portraits, topography
Locations:     US - Yosemite, California
Studio:        US - California
    Entries:
Wood Conn Cat 37, 1976: 104 (book, 44)(attributed)
    (note);
Gordon NY 5/10/77: 835 ill(attributed), 836 ill
    (attributed), 837 ill(attributed);
Texas AC, Texas 1978: 138 ill(book, W et al)(note);
Wood Conn Cat 41, 1978: 147 ill(attributed)(note);
Christies NY 10/31/79: 66 ill(attributed);
Phillips NY 11/3/79: 201 ill(attributed)(note);
Christies NY 5/16/80: 264 (attributed);
Sothebys NY 11/17/80: 105 ill(attributed);

**WEEKS** (see FREDERICKS and WEEKS) [WEEKS 1]

**WEEKS** (British) [WEEKS 2]
Photos dated: 1860s
Processes:     Ambrotype
Formats:       Plates
Subjects:      Portraits
Locations:     Studio
Studio:        England - Cheltenham
    Entries:
Vermont Cat 6, 1973: 600 ill;
Vermont Cat 7, 1973: 503 ill(note);

**WEGENSTEIN**
Photos dated: c1870
Processes:     Albumen
Formats:       Cdvs
Subjects:      Topograpraphy
Locations:     Europe
Studio:        Europe
    Entries:
California Galleries 4/2/76: 84 (lot, W et al);

**WEHNERT-BECKMAN, Bertha**
Photos dated: c1860
Processes:     Albumen
Formats:       Cdvs
Subjects:      Portraits
Locations:     Studio
Studio:        Germany - Leipzig; Austria - Vienna
    Entries:
Petzold Germany 11/7/81: 300 (album, W et al);

**WEHRLI**
Photos dated: c1880s
Processes:
Formats:       Prints
Subjects:      Topography
Locations:     Switzerland
Studio:        Europe
    Entries:
California Galleries 6/28/81: 326 (lot, W et al);

**WEIL** (American)
Photos dated: Nineteenth century
Processes:     Albumen
Formats:       Stereos
Subjects:      Topography
Locations:     US - New York City
Studio:        US
    Entries:
Harris Baltimore 6/1/84: 105 (lot, W et al);

**WEILBACH, Philip** (Danish)(photographer or author?)
Photos dated: 1866
Processes:     Albumen
Formats:       Prints
Subjects:
Locations:
Studio:        Denmark - Copenhagen
    Entries:
Swann NY 2/14/52: 106 (book, 24)(note);

**WEISS, William & Co.**
Photos dated: 1890s-1900
Processes:
Formats:       Prints
Subjects:      Genre
Locations:     Bermuda
Studio:        Bermuda - Hamilton
    Entries:
Sothebys NY 2/25/75: 207;
Rose Boston Cat 4, 1979: 73 ill;

**WEISSBROD** (German)
Photos dated: c1860
Processes:     Albumen
Formats:       Cdvs
Subjects:      Portraits
Locations:     Studio
Studio:        Germany - Frankfurt
    Entries:
Petzold Germany 11/7/81: 300 (album, W et al);

**WEISSMAN**
Photos dated: Nineteenth century
Processes:     Albumen
Formats:       Stereos
Subjects:      Topography
Locations:     Great Britain
Studio:        Great Britain
    Entries:
Christies Lon 4/24/86: 345 (lot, W et al);

**WEISTER, George M.** (American)
Photos dated: c1895
Processes:
Formats:        Prints
Subjects:       Documentary (expeditions)
Locations:      US - Mount Hood, Washington
Studio:         US - Portland, Oregon
  Entries:
White LA 1977: 99 ill (15);

**WEITFLE, Charles** (American)
Photos dated: 1870s-1882
Processes:      Albumen
Formats:        Stereos
Subjects:       Topography
Locations:      US - Colorado; Wyoming
Studio:         US
  Entries:
Sothebys NY (Strober Coll.) 2/7/70: 507 (lot,
  W et al);
Rinhart NY Cat 1, 1971: 307 (lot, W-1 et al);
California Galleries 4/3/76: 354 (lot, W et al);
Christies Lon 10/29/81: 147 (lot, W et al);
Harris Baltimore 12/10/82: 109 (lot, W et al);
Harris Baltimore 12/16/83: 140 (lot, W-1 et al);
Harris Baltimore 6/1/84: 153 (lot, W et al);
California Galleries 7/1/84: 350 (lot, W-1 et al);
Harris Baltimore 2/16/86: 55 (lot, W et al);

**WELL, P.F.**
Photos dated: Nineteenth century
Processes:      Albumen
Formats:        Stereos
Subjects:       Topography
Locations:      US - Washington, D.C.
Studio:
  Entries:
Vermont Cat 4, 1972: 603 (lot, W-1 et al);

**WELLER, F.G.** (American)
Photos dated: 1870-1880s
Processes:      Albumen
Formats:        Stereos
Subjects:       Topography, genre
Locations:      US - White Mountains, New Hampshire
Studio:         US - Littletown, New Hampshire
  Entries:
Rinhart NY Cat 6, 1973: 510;
Rinhart NY Cat 7, 1973: 367 ill, 368, 406;
Vermont Cat 5, 1973: 559 ill(5);
Sothebys Lon 6/21/74: 14a (lot, W et al);
Vermont Cat 9, 1975: 588 ill(6);
California Galleries 1/21/79: 316 (lot, W-1 et al);
Swann NY 4/26/79: 454 (140);
California Galleries 3/30/80: 413 (lot, W-1 et al);
Swann NY 4/23/81: 542 (lot, W et al);
California Galleries 6/28/81: 317 (lot, W-1 et al);
Harris Baltimore 7/31/81: 104 (lot, W-5 et al);
Harris Baltimore 3/26/82: 11 (lot, W-1 et al);
California Galleries 5/23/82: 409 (lot, W-8 et al);
Swann NY 11/18/82: 448 (lot, W et al);
Harris Baltimore 12/10/82: 53 (lot, W et al);
Harris Baltimore 12/16/83: 33 (lot, W et al);
Harris Baltimore 6/1/84: 160 (50);
California Galleries 7/1/84: 212 (lot, W et al);
Harris Baltimore 3/15/85: 29 (lot, W-10 et al),
  114 (42);
Harris Baltimore 2/14/86: 25 (lot, W-10 et al);

**WELLER, J.**
Photos dated: Nineteenth century
Processes:      Albumen
Formats:        Cdvs
Subjects:       Topography
Locations:      Australia - Victoria
Studio:         Australia
  Entries:
Phillips Lon 6/26/85: 203 (lot, W et al);
Phillips Lon 10/30/85: 57 (lot, W et al);
Phillips Lon 4/23/86: 239 (lot, W-1 et al);

**WELLING**
Photos dated: 1850s
Processes:      Daguerreotype
Formats:        Plates
Subjects:       Portraits
Locations:
Studio:
  Entries:
Sothebys Lon 3/14/79: 63;

**WELLINGTON, James Booker Blakemore** (British,
        1858-1939)
Photos dated: 1887-1899
Processes:      Photogravure, platinum
Formats:        Prints
Subjects:       Genre, topography
Locations:      England
Studio:         England
  Entries:
Sothebys Lon 11/18/77: 260 (lot, W-4 et al);
Sothebys Lon 10/25/82: 54 (books, W-1 et al);
Christies Lon 10/27/83: 62 (lot, W et al);
Christies NY 11/8/83: 201 (book, W et al);

**WELLS & HOPE** (American) [WELLS 1]
Photos dated: c1890
Processes:      Collotype
Formats:        Prints
Subjects:       Documentary (railroads)
Locations:      US
Studio:         US - Philadelphia, Pennsylvania
  Entries:
Harris Baltimore 12/10/82: 346 (2);

**WELLS, Dr.** [WELLS 2]
Photos dated: Nineteenth century
Processes:      Albumen, colldion on glass
Formats:        Glass stereo plates, card stereos
Subjects:       Documentary (medical)
Locations:
Studio:
  Entries:
Christies Lon 10/29/81: 147 (lot, W-33 et al)(note);

**WELLS, J.D.** (American)
Photos dated: 1850s
Processes:    Daguerreotype
Formats:      Plates
Subjects:     Portraits
Locations:    Studio
Studio:       US - Northampton, Massachusetts
  Entries:
Sothebys NY (Weissberg Coll.) 5/16/67: 146 (lot, W-1
  et al):
Rose Boston Cat 1, 1976: 76 ill;
Christies Lon 10/25/79: 23 (lot, W-1 et al);

**WELLS, W. Spencer**
Photos dated: 1849
Processes:    Calotype
Formats:
Subjects:     Topography
Locations:    Egypt
Studio:
  Entries:
Weil Lon Cat 14, 1949(?): 317 (album, W-2 et al);

**WENDELL, H.** (American)
Photos dated: c1860
Processes:    Ambrotype
Formats:      Plates
Subjects:     Portraits
Locations:    Studio
Studio:       US - Albany, New York
  Entries:
Christies Lon 10/26/78: 51;

**WENDEROTH, F.A. &/or TAYLOR** (American)
Photos dated: 1864-1867
Processes:    Albumen
Formats:      Cdvs, prints
Subjects:     Portraits, documentary (Civil War)
Locations:    US - Civil War area
Studio:       US - Philadelphia, Pennsylvania
  Entries:
Sothebys NY (Strober Coll.) 2/7/70: 331 (lot, W &
  T-2 et al), 423 (lot, W & T-1 et al), 425 (lot,
  W & T-1 et al);
Swann NY 4/20/78: 336 ill(note);
Swann NY 11/18/82: 349 ill(W & T & Brown)(note);
California Galleries 6/19/83: 92 (book, W & T &
  Brown-1, et al);
Swann NY 11/8/84: 189 (albums, W & T & Brown et al);
Harris Baltimore 9/27/85: 70 ill(note);
Swann NY 11/14/85: 11 (album, W & T & Brown et al)
  (note);
Wood Boston Cat 58, 1986: 136 (books, W-1 et al);
Harris Baltimore 2/14/86: 85;
Swann NY 5/15/86: 130 (book, W et al)(note), 131
  (book, W et al), 132 (book, W & T & Brown, et
  al), 223 (album, W & T & Brown et al);
Harris Baltimore 11/7/86: 74 (note);

**WENDROTH** (American)
Photos dated: c1855-60
Processes:    Calotype, albumen
Formats:      Prints
Subjects:     Topography
Locations:    US - Nashville, Tennessee
Studio:       US
  Entries:
Sothebys NY 2/25/75: 167a (W & Dodge, attributed);
Swann NY 11/14/85: 262 (book, W et al);

**WENDT** (American)
Photos dated: 1880s
Processes:    Albumen
Formats:      Cabinet cards
Subjects:     Portraits
Locations:    Studio
Studio:       US
  Entries:
California Galleries 1/22/77: 132 (lot, W-1 et al);
Harris Baltimore 4/8/83: 386 (lot, W et al);

**WERGE, John** (British)
Photos dated: c1850
Processes:    Daguerreotype, ambrotype
Formats:      Plates
Subjects:     Portraits
Locations:    Studio
Studio:       Scotland - Glasgow
  Entries:
Vermont Cat 6, 1973: 524 ill;
Sothebys Lon 10/18/74: 224 (lot, W-1 et al);
Sothebys Lon 3/19/76: 91 (lot, W-1 et al);
Sothebys Lon 6/11/76: 138 (lot, W-2 et al);
Christies Lon 10/25/79: 22;
Sothebys Lon 3/21/80: 55 ill;
Christies Lon 6/26/80: 34;
Christies Lon 3/26/81: 32 (2);
Swann NY 4/23/81: 268 (lot, W-1 et al);
Sothebys Lon 3/29/85: 41 (lot, W-1 et al);
Christies Lon 6/27/85: 12;

**WERNER, F.**
Photos dated: c1885
Processes:    Albumen
Formats:      Prints
Subjects:     Documentary (art)
Locations:    Europe
Studio:       Europe
  Entries:
California Galleries 1/21/79: 499 (lot, W-1 et al);

**WERNER, L.**
Photos dated: Nineteenth century
Processes:    Albumen
Formats:      Cdvs
Subjects:     Portraits
Locations:    Studio
Studio:       Ireland - Dublin
  Entries:
Christies Lon 6/24/82: 364 (album, W et al);

**WESFORD, T.G.** (British)
Photos dated: Nineteenth century
Processes:    Albumen
Formats:      Prints
Subjects:     Topography
Locations:    Great Britain - Johnstone Castle
Studio:       Great Britain
    Entries:
Christies Lon 10/25/79: 121 (lot, W-3 et al);

**WESSLER** (American)
Photos dated: c1885
Processes:    Albumen
Formats:      Prints
Subjects:     Topography
Locations:    US - California
Studio:       US - San Bernadino, California
    Entries:
California Galleries 6/28/81: 302 (lot, W-1 et al);

**WEST, G. & Son** (British)
Photos dated: c1880-c1890
Processes:    Woodburytype, chloro-bromide
Formats:      Prints incl. panoramas
Subjects:     Topography, documentary (maritime)
Locations:    England - Portsmouth
Studio:       England - Gosport and Southea
    Entries:
Vermont Cat 7, 1974: 745 ill(album, 172);
Sothebys NY 2/25/75: 151;
Phillips NY 5/2/80: 289 (2);
Christies Lon 4/24/86: 407 (album, W-2 et al);

**WEST, G.S.**
Photos dated: 1850s
Processes:    Daguerreotype
Formats:      Plates
Subjects:     Portraits
Locations:
Studio:
    Entries:
Vermont Cat 10, 1975: 543 ill;

**WEST, J.** (American)
Photos dated: 1870s-1880s
Processes:    Albumen
Formats:      Stereos
Subjects:     Topography
Locations:    US - Pennsylvania
Studio:       US - Pleasantville and Bradford,
Pennsylvania
    Entries:
Harris Baltimore 12/10/82: 81 (lot, W-4 et al);

**WEST, William** (British)
Photos dated: 1850s
Processes:    Salt
Formats:      Prints
Subjects:     Architecture
Locations:    England - Surrey
Studio:       Great Britain
    Entries:
Sothebys Lon 6/24/83: 92 ill, 93 ill;

**WESTFIELD** (see SACHE)

**WESTLY** (See CARPENTER & WESTLY)

**WESTON** (American) [WESTON 1]
Photos dated: 1840s-1850s
Processes:    Daguerreotype, ambrotype
Formats:      Plates
Subjects:     Portraits
Locations:    Studio
Studio:       US - Chatham, New York
    Entries:
Sothebys NY (Weissberg Coll.) 5/16/67: 90 (lot,
    W-1 et al);
Vermont Cat 7, 1974: 504 ill, 557 ill;
Witkin NY III 1975: D120 ill;
California Galleries 1/21/78: 86 (lot, W-1 et al);
Swann NY 4/23/81: 266 (lot, W-1 et al);
Sothebys Lon 6/17/81: 45 (lot, W-1 et al);
Swann NY 11/5/81: 460 (lot, W-1 et al)(note);
Swann NY 5/5/83: 305 ill;

**WESTON** (British) [WESTON 2]
Photos dated: 1850s
Processes:    Daguerreotype
Formats:      Plates
Subjects:     Portraits
Locations:    Studio
Studio:       England - Cheltenham
    Entries:
Sothebys Lon 3/21/75: 195 (lot, W-1 et al);
Sothebys Lon 10/26/84: 22 (lot, W-1 et al);
Christies Lon 10/30/86: 11 (lot, W-1 et al);

**WESTON, Arthur** (British)
Photos dated: 1890s
Processes:    Photogravure
Formats:      Prints
Subjects:     Portraits
Locations:    Studio
Studio:       England
    Entries:
Sothebys Lon 6/27/80: 261;

**WESTON, J.** (British)
Photos dated: Nineteenth century
Processes:
Formats:
Subjects:     Portraits
Locations:    Studio
Studio:       England - Folkstone
    Entries:
Edwards Lon 1975: 12 (album, W et al);

**WESTON, Lambert & Son** (British)
Photos dated: 1860s
Processes:    Albumen
Formats:      Stereos
Subjects:     Topography
Locations:    Great Britain
Studio:       Great Britain
    Entries:
Sothebys Lon 10/29/80: 14 (lot, W et al);

**WESTON, T.C.**
Photos dated: Nineteenth century
Processes:
Formats:      Prints
Subjects:     Topography
Locations:    Canada
Studio:
    Entries:
Swann NY 10/18/79: 348 (note);

**WEY, Francis** (photographer or author?)
Photos dated: 1897
Processes:
Formats:      Prints
Subjects:     Topography
Locations:    Italy - Rome
Studio:
    Entries:
Rinhart NY Cat 2, 1971: 73 (book, 20);

**WHARTON, T.**
Photos dated: 1841
Processes:    Daguerreotype
Formats:      Plates
Subjects:     Portraits, genre
Locations:    Studio
Studio:       Great Britain
    Entries:
Sothebys Lon 3/21/75: 190 (lot, W et al);
Sothebys Lon 10/29/76: 198;
Sothebys Lon 3/27/81: 186, 187, 188;
Sothebys Lon 6/28/85: 30 (lot, W-1 et al);
Phillips Lon 10/30/85: 8 ill;
Christies Lon 6/26/86: 90;
Phillips Lon 10/29/86: 255, 278;

**WHEELER** (see BARNHOUSE & WHEELER) [WHEELER 1]

**WHEELER** (see BROWN, J.M.) [WHEELER 2]

**WHEELER & Brothers** (American) [WHEELER 3]
Photos dated: 1850s
Processes:    Daguerreotype
Formats:      Plates
Subjects:     Portraits
Locations:    Studio
Studio:       US
    Entries:
Swann NY 4/23/81: 244 (lot, W-1 et al);

**WHEELER & Son** [WHEELER 4]
Photos dated: 1860s-1880s
Processes:    Albumen
Formats:      Prints
Subjects:     Topography, ethnography
Locations:    Australia; New Zealand; Tasmania
Studio:       New Zealand - Christchurch
    Entries:
Sothebys Lon 3/21/75: 78 (album, W et al), 85
    (albums, W et al);
Christies Lon 6/30/77: 147 (album, W et al), 180
    (album, W et al);
Christies Lon 3/15/79: 193 (album, W et al);
Swann NY 10/18/79: 386 (album, W et al);
Christies NY 11/11/80: 92 (album, W et al);

**WHEELER & Son** (continued)
Christies Lon 10/28/82: 121 (albums, W et al);
Christies Lon 10/27/83: 158 (album, W et al);
Christies Lon 3/29/84: 100 (albums, W et al);
Christies Lon 3/28/85: 95 (album, W et al);
Christies Lon 6/26/86: 108 (album, W et al);

**WHEELER, A.F.** (British)
Photos dated: c1874
Processes:    Albumen
Formats:      Prints
Subjects:     Topography
Locations:    England
Studio:       Great Britain
    Entries:
Sothebys Lon 12/21/71: 147 (album, 17)(note);
Sothebys Lon 6/21/74: 167 (17)(note);

**WHEELER, F.**
Photos dated: Nineteenth century
Processes:    Albumen
Formats:      Cdvs
Subjects:     Portraits
Locations:
Studio:
    Entries:
California Galleries 1/21/78: 122 (lot, W et al);
California Galleries 1/21/79: 233 (lot, W et al);

**WHEELER, W.H.** (American)
Photos dated: 1871
Processes:    Albumen
Formats:      Stereos
Subjects:     Documentary (disasters)
Locations:    US - Chicago, Illinois
Studio:       US
    Entries:
Swann NY 11/11/76: 431 (lot, W-2 et al)(note);

**WHEELER, W.H.** (British)(see also DAY & WHEELER)
Photos dated: 1888-1890s
Processes:    Collodion on glass, albumen,
              "Chromotype" on glass
Formats:      Stereos
Subjects:     Topography
Locations:    England - Oxford
Studio:       England - Oxford
    Entries:
Christies Lon 3/24/83: 56;
Christies Lon 6/28/84: 70;

**WHEELHOUSE, Dr. Claudius Galen** (British,
              1826-1909)
Photos dated: 1849-1850
Processes:    Calotypes
Formats:      Prints
Subjects:     Topography
Locations:    Greece; Egypt; Palestine; Spain -
              Seville
Studio:
    Entries:
Sothebys Lon 3/27/81: 357 ill;
Sothebys Lon 10/29/82: 115 ill;

**WHIPPLE, John Adams** (American, 1822-1891)
Photos dated: 1844-1874
Processes: Crystallotype (salt), ambrotype, albumen
Formats: Prints incl. panoramas, plates, cdvs
Subjects: Topography, portraits
Locations: US - Massachusetts, Illinois
Studio: US - Boston, Massachusetts
Entries:
Sothebys NY (Strober Coll.) 2/7/70: 25 (book, 1), 267 (lot, W-1 et al), 270 (lot, W et al), 282 (lot, W et al), 297 (lot, W et al), 302 (lot, W et al), 324 (lot, W et al), 327 (lot, W-1 attributed, et al);
Sothebys NY (Greenway Coll.) 11/20/70: 217 (lot, W-1 et al);
Rinhart NY Cat 1, 1971: 481 (book, 1);
Rinhart NY Cat 2, 1971: 288 (lot, W et al);
Vermont Cat 4, 1972: 483 ill;
Wood Conn Cat 37, 1973: 97 (book, 1)(note), 98 ill (book, 1)(note), 355 ill(attributed)(note);
Sothebys NY 9/23/75: 81 (book, 1), 89 ill;
Witkin NY IV 1976: 373 ill;
Swann NY 4/1/76: 309 (book, 1)(note);
Christies NY 5/4/76: 121;
Swann NY 11/11/76: 268 (book, 1)(note);
White LA 1977: 1 (3 ills)(book, 9)(note);
Swann NY 4/14/77: 198 (lot, W et al), 97 (book, 1);
Swann NY 12/8/77: 89 (book, 1)(note), 90 (book, 1);
Frontier AC, Texas 1978: 133 (book, 1)(note);
Wood Conn Cat 42, 1978: 247 (book, 1)(note), 248 (book, 1)(note);
Swann NY 4/20/78: 79 (book, 1)(note);
Sothebys NY 5/2/78: 4 ill;
Lehr NY Vol 1:3, 1979: 1 ill;
Lehr NY Vol 1:4, 1979: 56 (book, 1)(note);
Swann NY 4/26/79: 97 (book, W & Black, 1)(note), 98 (book, 1)(note);
Sothebys NY 5/8/79: 1
Swann NY 10/18/79: 108 (book, 1)(note);
Phillips NY 11/3/79: 196;
Swann NY 11/6/80: 107 (book, 1)(note);
Phillips NY 1/29/81: 80 (book, 1)(note);
Swann NY 4/23/81: 261 (book, 1)(note);
Harris Baltimore 7/31/81: 4 (book, 1);
Swann NY 11/5/81: 123 (book, 1)(note);
Wood Conn Cat 49, 1982: 219 (book, 1)(note), 220 (book, 1)(note);
Swann NY 11/18/82: 125 (book, 1)(note);
Harris Baltimore 4/8/83: 322 (lot, W et al);
Swann NY 5/5/83: 332 (lot, W et al);
Swann NY 11/10/83: 297 (note), 361 (album, W et al) (note);
Swann NY 5/10/84: 151 (book, 1)(note), 323, 324;
Swann NY 11/8/84: 133 (book, 1)(note), 188 (album, W et al), 280 (note);
Sothebys NY 5/7/85: 333 ill(attributed)(note);
Swann NY 11/14/85: 11 (album, W et al)(note);
Swann NY 5/15/86: 163 (lot, W-1 et al);
Christies Lon 6/26/86: 38 (book, 1);
Harris Baltimore 11/7/86: 212;
Swann NY 11/13/86: 201 ill(album, 140)(attributed) (note);

**WHISTLER, John** (British, 1830-1897)
Photos dated: late 1840s-1885
Processes: Salt, albumen
Formats: Prints
Subjects: Genre, architecture
Locations: England
Studio: England - Sherborne St. John, Hampshire
Entries:
Alexander Lon 1976: 53 ill, 54 ill;
Sothebys Lon 6/11/76: 89 ill(note), 173 ill (album, W-2 plus 2 attributed, et al);
Christies Lon 3/10/77: 101 ill(note);
Sothebys Lon 11/18/77: 225 ill, 226 ill, 227 ill (note), 228;
Sothebys Lon 3/22/78: 179;
Christies Lon 6/27/78: 227 (note);
Sothebys Lon 6/28/78: 318;
Christies Lon 3/15/79: 283 ill(note), 299 (lot, W attributed et al);
Sothebys Lon 6/29/79: 240 ill;
Sothebys Lon 6/27/80: 289 ill;
Christies Lon 10/30/80: 350, 351 ill, 352 ill, 353, 354, 355 ill;
Christies Lon 6/18/81: 150 ill;
Sothebys Lon 10/28/81: 326 ill, 327 ill, 328 ill;
Christies Lon 10/29/81: 311;
Christies NY 11/10/81: 7 ill;
Christies Lon 6/24/82: 334;
Christies Lon 6/23/83: 240 (lot, W-6 attributed, et al);
Sothebys Lon 6/29/84: 156 ill;
Christies Lon 10/25/84: 358 (lot, W-5 attributed, et al);
Sothebys NY 5/7/85: 210 ill(note);
Christies Lon 10/30/86: 72, 73 ill;

**WHITE** (see PRESCOTT) [WHITE 1]

**WHITE** (British) [WHITE 2]
Photos dated: 1850s
Processes: Daguerreotype
Formats: Plates
Subjects: Portraits
Locations: Studio
Studio: Scotland - Glasgow
Entries:
Christies Lon 3/26/81: 109 ill, 171 (lot, W-2 attributed, et al);

**WHITE** (British) [WHITE 3]
Photos dated: 1887
Processes: Albumen
Formats: Prints
Subjects:
Locations: Great Britain
Studio: Great Britain (Amateur Photographic Association)
Entries:
Sothebys Lon 3/21/80: 255 (album, W-1 et al);

**WHITE Brothers** (T.E.M. & G.F.) (American)
Photos dated: 1860s-1887
Processes: Albumen, photogravure
Formats: Prints, stereos
Subjects: Topography
Locations: US - New Hampshire; Massachusetts
Studio: US - New Hampshire; Massachusetts
   Entries:
Wood Conn Cat 37, 1973: 118 (book, W et al)(note);
Swann NY 4/14/77: 111 (book, W et al);
Swann NY 12/14/78: 308 (lot, W et al);
Sothebys NY 5/8/79: 19 (books, W et al);
Harris Baltimore 2/14/86: 348 (2)(note);

**WHITE, C.R.** (American)
Photos dated: 1890
Processes: Photogravure
Formats: Prints
Subjects: Topography
Locations: US - Maine
Studio: US - Portland, Maine
   Entries:
Wood Conn Cat 45, 1979: 253 (book, 25)(note);

**WHITE, Franklyn** (American)
Photos dated: 1859-1870s
Processes: Glass transparency, albumen
Formats: Stereos
Subjects: Topography
Locations: US - Washington D.C.; New Hampshire
Studio: US - Lancaster, New Hampshire
   Entries:
Sothebys NY (Strober Coll.) 2/7/70: 439 (lot,
   W-2 et al);
Vermont Cat 4, 1972: 604 ill(2);
Swann NY 12/14/78: 331 (3), 332 (3), 333 (50), 334
   (attributed);
Swann NY 10/18/79: 433 (14), 435 (lot, W et al)
   (note);
Swann NY 4/17/80: 373 (14);
Harris Baltimore 3/26/82: 24 (5);

**WHITE, George** (see MITCHELL & WHITE)

**WHITE, Henry** (British, 1819-1903)
Photos dated: 1854-c1864
Processes: Albumen
Formats: Prints
Subjects: Topography
Locations: England; Wales
Studio: England - London
   Entries:
Sothebys Lon 3/21/75: 286 (album, W-1 et al);
Sothebys Lon 3/9/77: 213 (2);
Christies Lon 6/30/77: 306 ill(note), 307 ill
   (note), 308 ill, 309 ill(note);
Phillips Lon 3/13/79: 74 (note);
Sothebys Lon 10/24/79: 138 ill;
Sothebys NY 5/20/80: 348 ill(note);
Sothebys Lon 10/29/80: 277 ill;
Christies NY 11/11/80: 10 ill(note), 11;
Sothebys Lon 3/27/81: 366 ill;
Phillips NY 5/9/81: 7 ill(note);
Sothebys NY 5/15/81: 85 ill(note);
Sothebys Lon 10/28/81: 350 ill, 351 ill;
Sothebys Lon 3/15/82: 351 ill;
Christies Lon 6/23/83: 209 ill;

**WHITE, H.** (continued)
Christies Lon 3/28/85: 142 ill;
Sothebys Lon 3/29/85: 154 ill;
Sothebys Lon 11/1/85: 59 ill(album, W-1 et al);
Christies Lon 6/27/85: 121 ill;
Christies Lon 4/24/86: 455 ill, 456 ill, 457 ill;

**WHITE, J. Claude**
Photos dated: 1890s
Processes: Carbon
Formats: Prints
Subjects: Topography
Locations: Asia - Himalayas
Studio:
   Entries:
Sothebys Lon 3/15/82: 335 (5);

**WHITE, J.H.** (American)
Photos dated: 1880s-early 1890s
Processes: Albumen, platinum, bromide
Formats: Prints
Subjects: Topography, ethnography
Locations: US - California; Wyoming
Studio: US
   Entries:
Sothebys LA 2/6/80: 36 (lot, W-4 et al);
California Galleries 3/30/80: 441 (4)(note);
Sothebys LA 2/5/81: 499 (11);
Christies NY 10/4/83: 113 (lot, W-24 et al);
California Galleries 3/29/86: 684;

**WHITE, Sydney Victor** (British)
Photos dated: 1884
Processes: Carbon
Formats: Prints
Subjects: Portraits
Locations: Studio
Studio: Great Britain
   Entries:
Swann NY 4/17/80: 14 (book, W et al);

**WHITEHURST, Jessie H.** (American, 1820-1875)
Photos dated: c1850-1865
Processes: Daguerreotype, salt, albumen
Formats: Plates, prints, cdvs
Subjects: Portraits
Locations: Studio
Studio: US - Washington, D.C.; Virginia;
   Maryland; New York City
   Entries:
Rauch Geneva 6/13/61: 35 (lot, W-1 et al)(note);
Sothebys NY (Strober Coll.) 2/7/70: 264 (lot,
   W et al), 281 (lot, W et al);
Rinhart NY Cat 7, 1973: 572;
Vermont Cat 5, 1973: 385 ill(note);
Vermont Cat 10, 1975: 544 ill;
Sothebys NY 2/25/75: 112 ill(note);
Vermont 11/12, 1977: 691 ill;
Swann NY 4/14/77: 235 (lot, W-1 et al);
Sothebys NY 10/4/77: 107 (lot, W-1 et al)(note);
Swann NY 4/20/78: 306 (lot, W-1 et al);
Swann NY 4/26/79: 348 (lot, W-1 et al);
Swann NY 10/18/79: 304 (lot, W et al);
Sothebys Lon 6/17/81: 45 (lot, W-1 et al);
Swann NY 11/5/81: 460 (lot, W-1 et al);
Harris Baltimore 3/26/82: 132, 137;

**WHITEHURST, J.H.** (continued)
Harris Baltimore 12/10/82: 362, 372 (20);
California Galleries 6/19/83: 156;
Harris Baltimre 9/16/83: 135;
Harris Baltimore 12/16/83: 247 ill;
Christies Lon 3/29/84: 6;
California Galleries 7/1/84: 346 (attributed);
Sothebys Lon 10/26/84: 22 (lot, W-1 et al);
Swann NY 11/13/86: 190;

**WHITEMAN**
Photos dated: c1840
Processes:      Daguerreotype
Formats:        Plates
Subjects:       Portraits
Locations:
Studio:
   Entries:
Witkin NY III 1975: D81 ill;

**WHITFIELD, G.C.** (British)(see also LOCK &
                WHITFIELD)
Photos dated: Nineteenth century
Processes:      Albumen
Formats:        Prints
Subjects:       Portraits
Locations:      Studio
Studio:         England - London
   Entries:
Christies Lon 10/27/77: 40 (lot, W-1 et al);

**WHITLOCK, H.J.** (British)
Photos dated: 1842-c1866
Processes:      Daguerreotype, albumen
Formats:        Plates, cdvs
Subjects:       Portraits
Locations:      Studio
Studio:         England - Birmingham
   Entries:
Sothebys NY (Greenway Coll.) 11/20/70: 11 ill
   (lot, W-1 et al);
Sothebys NY 11/21/70: 322 ill, 325 ill(lot, W et
   al), 333 (lot, W et al), 337 (lot, W et al);
Christies Lon 6/10/76: 16 (note);
Christies Lon 6/18/81: 18;
Christies Lon 10/29/81: 106 (lot, W-1 et al);
Swann NY 4/1/82: 367 (note);
Sothebys Lon 3/29/85: 50 (lot, W-1 et al), 51 (lot,
   W-1 et al);

**WHITNEY, Edward Tompkins** (American, born 1820)
Photos dated: 1844-1854
Processes:      Daguerreotype
Formats:        Plates
Subjects:       Portraits, topography
Locations:      US - New York; Connecticut
Studio:         US - Rochester, New York
   Entries:
Vermont Cat 5, 1973: 386 ill;
Vermont Cat 6, 1973: 525 ill;
California Galleries 9/27/75: 474 (lot, W-2 et al);
California Galleries 1/23/77: 375 (lot, W-2 et al);
Christies NY 2/8/83: 77 (lot, W-1 et al);
Sothebys Lon 6/29/84: 41 (5);

**WHITNEY, Joel Emmons** (American, 1822-1886)
Photos dated: 1852-1871
Processes:      Daguerreotype, albumen
Formats:        Plates, prints, stereos, cdvs
Subjects:       Topography, ethnography
Locations:      US - Minnesota
Studio:         US - St. Paul, Minnesota
   Entries:
Sothebys NY (Strober Coll.) 2/7/70: 506 (lot, W &
   Zimmerman-2, et al);
Rinhart NY Cat 6, 1973: 490, 492 (W & Zimmerman);
Rinhart NY Cat 7, 1973: 210, 536 (lot, W-1 et al);
Rinhart NY Cat 8, 1973: 52 (W & Zimmerman)
Vermont Cat 5, 1973: 535 (lot, W et al);
California Galleries 9/27/75: 503 (lot, W et al);
Sothebys NY 5/4/76: 149 (album, 50);
California Galleries 1/23/77: 403 (lot, W et al);
Swann NY 4/14/77: 322 (lot, W & Zimmerman et al);
Gordon NY 5/10/77: 862 ill(2);
Lehr NY Vol 1:4, 1979: 60 (2 ills)(album, W et al);
Sothebys NY 11/2/79: 291 (ill)(album, W et al)
   (note);
Swann NY 4/23/81: 497 (lot, W et al);
Swann NY 11/5/81: 516 (album, W et al)(note);
Rose Florida Cat 7, 1982: 6 ill(W & Combs);
Harris Baltimore 6/1/84: 93 (lot, W et al), 152
   (lot, W & Zimmerman-7, et al);

**WHITTLEY, L.** (American)
Photos dated: Nineteenth century
Processes:      Albumen
Formats:        Prints
Subjects:       Portraits
Locations:      Studio
Studio:         US
   Entries:
Sothebys NY (Greenway Coll.) 11/20/70: 193 (lot, W-1
   et al);

**WHITTMORE** (American)
Photos dated: 1850s
Processes:      Daguerreotype
Formats:        Plates
Subjects:       Portraits
Locations:      Studio
Studio:         US - New York City
   Entries:
Harris Baltimore 3/26/82: 338 (note);

**WHITVEL, R.V.**
Photos dated: 1888-1893
Processes:      Albumen
Formats:        Prints
Subjects:       Topography
Locations:      China - Shanghai
Studio:
   Entries:
Swann NY 11/13/86: 35 (books, W-12 et al);

**WICKES** (see HAINES, Eugene)

WIDGER, W. (British)
Photos dated: 1860s-1870s
Processes:      Albumen
Formats:        Prints, stereos
Subjects:       Topography
Locations:      England - Torquay
Studio:         England - Torquay
    Entries:
Sothebys Lon 3/29/85: 152 (albums, W et al);

WIDOKIM (Polish)
Photos dated: 1858
Processes:      Salt
Formats:        Prints
Subjects:       Architecture
Locations:      Poland - Warsaw
Studio:         Poland - Warsaw
    Entries:
Christies NY 11/11/80: 62 ill;

WIELE & KLEIN
Photos dated: 1870s and/or 1880s
Processes:      Albumen
Formats:        Prints
Subjects:       Topography
Locations:      India - Madras
Studio:
    Entries:
Swann NY 11/5/81: 487 (lot, W & K-1 et al);

WIGAND, C. (German)
Photos dated: 1850s-1860s
Processes:      Daguerreotype, albumen
Formats:        Plates, cabinet cards
Subjects:       Portraits
Locations:      Studio
Studio:         Germany - Berlin
    Entries:
Petzold Germany 11/7/81: 166, 324 (album, W et al);

WILCOX, Walter Dwight
Photos dated: 1896-1899
Processes:      Platinum, photogravure
Formats:        Prints
Subjects:       Topography
Locations:      Canada
Studio:
    Entries:
Witkin NY IV 1976: OP387 (book, 25);
White LA 1977: 390 (book, 25);
Witkin NY V 1977: 149 ill(book, 40);
Christies Lon 6/27/78: 142 (2);
Christies Lon 3/15/79: 179(2);
Christies Lon 10/25/79: 227 (2);
Sothebys LA 2/5/81: 515 (book, 5);

WILDER & WILLIAMSON (American)
Photos dated: c1880
Processes:      Albumen
Formats:        Stereos
Subjects:       Topography
Locations:      US - Dayton, Ohio
Studio:         US - Rochester, New York
    Entries:
Swann NY 4/17/80: 369 (12);

WILDEY (American)
Photos dated: Nineteenth century
Processes:      Albumen
Formats:        Stereos
Subjects:       Topography
Locations:      US - New York State
Studio:         US
    Entries:
Harris Baltimore 6/1/84: 103 (lot, W et al);
Harris Baltimore 3/15/85: 69 (lot, W et al);

WILHELMSCHOEHE (see CASSEL & WILHELMSCHOEHE)

WILKINSON, C.S. (Australian)
Photos dated: 1880s-1887
Processes:      Bromide
Formats:        Prints
Subjects:       Topography
Locations:      Australia - New South Wales
Studio:         Australia
    Entries:
Sothebys NY 10/4/77: 147 ill(4);
Christies NY 5/16/80: 198 (14);
Harris Baltimore 12/16/83: 295 (11);

WILKINSON, J. (British)
Photos dated: c1860
Processes:      Ambrotype
Formats:        Plates
Subjects:       Portraits
Locations:      Studio
Studio:         England
    Entries:
Christies Lon 6/30/77: 45 (lot, W-2 et al);

WILKINSON, O.R. (American)
Photos dated: 1860s-1874
Processes:      Albumen, collotype
Formats:        Stereos, prints
Subjects:       Topography
Locations:      US - New England
Studio:         US - Medford, Massachusetts
    Entries:
Rinhart NY Cat 7, 1973: 36 (book, W-1 et al);
Swann NY 11/5/81: 552 (lot, W et al);

WILKINSON, T. (British)
Photos dated: 1860s
Processes:      Albumen
Formats:        Prints
Subjects:       Topography
Locations:      England
Studio:         Great Brtain
    Entries:
Sothebys Lon 3/27/81: 12 (lot, W et al);

**WILLARD, O.T.** (American)
Photos dated: 1850s-1870
Processes:      Daguerreotype, ambrotype, albumen
Formats:        Plates, stereos, cdvs
Subjects:       Portraits, topography
Locations:      US - Philadelphia, Pennsylvania
Studio:         US - Philadelphia, Pennsylvania
  Entries:
Rauch Geneva 6/13/61: 32 (lot, W-1 et al);
Sothebys NY (Weissberg Coll.) 5/16/67: 159 (lot, W-1 et al);
Sothebys NY (Greenway Coll.) 11/20/70: 217 (lot, W-1 et al);
Sothebys Lon 12/21/71: 207 (lot, W-1 et al);
Rinhart NY Cat 6, 1973: 184;
Vermont Cat 6, 1973: 601 ill;
California Galleries 1/21/78: 40;
California Galleries 1/2/79: 247 (lot, W-1 et al);
Swann NY 4/23/81: 244 (lot, W-1 et al)(note), 256 (lot, W-1 et al);
Harris Baltimore 12/10/82: 102 (lot, W et al);
Swann NY 5/15/86: 212 (lot, W-2 et al);

**WILLAT** (British)
Photos dated: 1840
Processes:      Salt
Formats:        Prints
Subjects:       Photogenic drawings
Locations:      Studio
Studio:         Great Britain
  Entries:
Swann NY 2/14/52: 4 (album, W et al);

**WILLEME** (French)
Photos dated: 1870
Processes:      Albumen
Formats:        Prints, cdvs
Subjects:       Documentary (Franco-Prussian War)
Locations:      France
Studio:         France
  Entries:
Andrieux Paris 1952(?): 755 (2 plus 3 attributed);
Sothebys Lon 6/26/75: 202 (3);

**WILLIAMS** [WILLIAMS 1]
Photos dated: 1880s
Processes:      Albumen
Formats:        Prints
Subjects:       Topography
Locations:      Australia; New Zealand
Studio:         Australia - Ballarat
  Entries:
Christies Lon 10/27/77: 147 (album, W et al);

**WILLIAMS, Mrs.** (British) [WILLIAMS 2]
Photos dated: 1880s
Processes:      Albumen
Formats:
Subjects:       Portraits
Locations:      England
Studio:         England - Wolverhampton
  Entries:
Christies Lon 6/26/80: 512 (albums, W et al);

**WILLIAMS, E. Leader** (British)
Photos dated: 1860s
Processes:      Albumen
Formats:        Prints
Subjects:
Locations:
Studio:         Great Britain (Amateur Photographic Association)
  Entries:
Christies Lon 10/27/83: 218 (albums, W-2 et al);

**WILLIAMS, Frederick S.** (British)(photographer or author?)
Photos dated: c1875
Processes:      Albumen
Formats:        Prints
Subjects:       Topography
Locations:      England - Birmingham
Studio:         Great Britain
  Entries:
Christies Lon 10/28/76: 296 (book, 12);

**WILLIAMS, G.F.** (British)
Photos dated: Nineteenth century
Processes:
Formats:
Subjects:       Portraits
Locations:      England - Liverpool
Studio:         Great Britain
  Entries:
Christies Lon 10/30/86: 245 (album, W-1 et al);

**WILLIAMS, H.R.** (British)
Photos dated: 1860s
Processes:      Albumen
Formats:        Prints, cdvs
Subjects:       Portraits
Locations:      Studio
Studio:         England - Bath
  Entries:
Sothebys NY (Strober Coll.) 2/7/70: 280 (lot, W-1 et al);
Christies Lon 10/25/79: 403 (albums, W-1 et al) (note);

**WILLIAMS, J.A.** (American)
Photos dated: 1850s-1870s
Processes:      Albumen
Formats:        Cdvs, stereos
Subjects:       Topography
Locations:      US - Rhode Island
Studio:         US - Newport, Rhode Island
  Entries:
Rinhart NY Cat 6, 1973: 554, 555;
Harris Baltimore 12/10/82: 102 (lot, W et al);
Swann NY 5/5/83: 291 (album, W et al);
Harris Baltimore 3/15/85: 86 (lot, W-3 et al);

**WILLIAMS, J.J.**
Photos dated: 1880s
Processes:      Albumen
Formats:        Prints
Subjects:       Topography, ethnography
Locations:      Hawaii; Samoa
Studio:         Hawaii - Honolulu
　Entries:
Christies Lon 6/30/77: 180 (album, W et al);
Frontier AC, Texas 1978: 340 ill;
Christies NY 11/11/80: 172 ill(album, 24);

**WILLIAMS, James Leon** (American, born 1852)
Photos dated: 1887-1894
Processes:      Photogravure
Formats:        Prints
Subjects:       Genre
Locations:      England - Warwickshire; US - New York
State
Studio:
　Entries:
Rinhart NY Cat 1, 1971: 536 (book, 45);
Stern Chicago 1975(?): 56 (book, 45);
Sothebys NY 9/23/75: 86 (book);
California Galleries 9/27/75: 360;
Wood Conn Cat 37, 1976: 209 (book, 45)(note);
Sothebys NY 11/9/76: 148 (3 ills)(book, 45)(note);
Rose Boston Cat 2, 1977: 21 ill(note), 22 ill, 23
　ill;
White LA 1977: 280 (3 ills)(book, 45)(note),
　281 (30);
Sothebys NY 2/9/77: 33 ill(book, 45);
Sothebys Lon 3/9/77: 161 ill(book, 45), 221 (3);
Swann NY 4/14/77: 182 (book, 30);
Gordon NY 5/10/77: 895 (book, 30);
Sothebys NY 10/4/77: 191 (book, 45)(note);
Christies Lon 10/27/77: 249 (book, 45), 250
　(book, 38);
Sothebys Lon 11/18/77: 205 ill(book, 45);
Swann NY 12/8/77: 175 (book, W et al), 193
　(book, 30);
Rose Boston Cat 3, 1978: 30 ill(note), 31 ill;
Wood Conn Cat 41, 1978: 205 ill(book, 30)(note),
　206, 207, 208, 209, 210, 211;
California Galleries 1/21/78: 276A ill(book, 45)
　(note), 276B (2);
Christies Lon 3/16/78: 248 (book, 38);
Sothebys Lon 6/28/78: 25 (book, 45);
Wood Conn Cat 45, 1979: 254 (book, 30)(note), 255
　(book, 29)(note);
California Galleries 1/21/79: 187 ill(book, 45), 442
　ill(30);
Sothebys Lon 3/14/79: 249 (38);
Christies Lon 3/15/79: 228 (book, 45);
Phillips NY 5/5/79: 156 ill(book, 45);
Swann NY 10/18/79: 235 (book), 236 (book);
Christies NY 10/31/79: 132A (book);
Phillips NY 11/29/79: 291 (book, 45);
Rose Boston Cat 5, 1980: 41 ill(note), 42 ill,
　43 ill;
Sothebys LA 2/6/80: 149 ill(book, 30);
Sothebys Lon 3/21/80: 290 ill(book, 45);
California Galleries 3/30/80: 187 ill(book, 45), 442
　ill(30);
Christies NY 5/14/80: 334 ill(book, W et al), 335
　(book, W et al);
Phillips NY 5/21/80: 140 (books, 60);
Sothebys Lon 6/27/80: 158 ill(book, 45), 159
　(book, 45);
Swann NY 11/6/80: 216 (book)(note);

**WILLIAMS, J.L.** (continued)
Sothebys NY 11/17/80: 76 (book, 45);
Phillips NY 1/29/81: 179 (book, 45);
California Galleries 6/28/81: 350 (4);
Swann NY 7/9/81: 345 (book, 45);
Swann NY 11/5/81: 246 (book, 30)(note);
Wood Conn Cat 49, 1982: 493 (book, 45)(note), 494
　(book, 30), 495 (book, 29)(note);
Swann NY 4/1/82: 238 (book, 28)(note);
Swann NY 11/18/82: 275 (book, 30)(note), 276 (book)
　(note);
Harris Baltimore 12/10/82: 338 (27);
Swann NY 5/5/83: 254 (book, 30), 255 (book, 45);
Swann NY 11/10/83: 166 (book, 30);
Harris Baltimore 12/16/83: 218 (book, 39);
Swann NY 5/10/84: 154 (book)(note);
Christies Lon 6/28/84: 155 (book, 45);
Christies Lon 10/25/84: 114 (books, W-45 et al);
Sothebys Lon 3/29/85: 177 ill(book, 45);
Christies Lon 6/27/85: 105 (book, 30);
Christies Lon 10/31/85: 156 (book, 30);
Harris Baltimore 2/14/86: 198 (45);
Christies Lon 10/30/86: 165 (7);
Swann NY 11/13/86: 113 (books, 46);

**WILLIAMS, J.T.**
Photos dated: 1850s
Processes:      Daguerreotype
Formats:        Plates
Subjects:       Portraits
Locations:
Studio:
　Entries:
Rinhart NY Cat 8, 1973: 112;

**WILLIAMS, Sophus** (German)
Photos dated: 1860s-1880
Processes:      Albumen
Formats:        Stereos, prints, cdvs
Subjects:       Genre
Locations:      Studio
Studio:         Germany - Berlin
　Entries:
Rinhart NY Cat 2, 1971: 495 (6);
Christies Lon 6/18/81: 414 (album, W et al);
Harris Baltimore 12/16/83: 110 (lot, W-2 plus 3
　attributed, et al);
Harris Baltimore 3/15/85: 21 (lot, W et al);
Harris Baltimore 2/14/86: 43 (lot, W et al);

**WILLIAMS, Thomas R.** (British, 1825-1871)
Photos dated: 1849-1860s
Processes:      Daguerreotype, calotype, albumen
Formats:        Stereo plates, prints, stereos, cdvs
Subjects:       Genre, topography, ethnography,
                portraits
Locations:      Great Britain
Studio:         England - London
　Entries:
Sothebys Lon 6/21/74: 139 ill(note), 140 ill,
　141 ill;
Sothebys Lon 10/14/74: 192 ill(note), 194 ill, 196
　ill, 197 ill;
California Galleries 9/27/75: 478 (lot, W et al);
Sothebys Lon 10/24/75: 49;
Colnaghi Lon 1976: 8 (note);
Gordon NY 5/3/76: 272 ill;

## WILLIAMS, T.R. (continuing)

Sothebys Lon 6/11/76: 4 (lot, W-4 et al), 134 (lot, W-1 et al), 149 ill, 152 ill(note), 153, 154 ill (note), 155 ill;
Christies Lon 10/28/76: 26, 27 ill, 244 (album, W-1 et al);
Sothebys Lon 10/29/76: 26 (lot, W et al), 34 (lot, W-3 et al), 37 (100), 37a (lot, W et al);
Sothebys Lon 3/9/77: 24 ill(note);
Christies Lon 6/30/77: 146 (lot, W-2 et al), 179 (albums, W-8 et al), 370 (albums, W et al);
Christies Lon 10/27/77: 147 (album, W et al);
Sothebys Lon 11/18/77: 27 ill, 28 ill, 29 (album, W et al);
Christies Lon 3/16/78: 160, 161 ill;
Christies Lon 6/27/78: 45a ill(note);
Sothebys Lon 10/27/78: 12, 43 ill, 44 ill;
Phillips Lon 3/13/79: 4 ill(note);
Christies Lon 3/15/79: 57 ill, 58;
Christies Lon 3/20/80: 79 ill(note);
Christies Lon 6/26/80: 104 (lot, W-2 et al);
Sothebys Lon 10/29/80: 19 ill(attributed);
Christies Lon 10/30/80: 404, 407 (album, W et al), 416 (album, W-3 et al), 422 (album, W-1 et al), 429 (lot, W-2 et al), 438 (album, W et al);
Sothebys LA 2/5/81: 516 ill;
Sothebys Lon 3/21/80: 81a (lot, W et al), 89 ill (note), 90 ill, 91 ill;
Christies Lon 3/26/81: 109 ill, 171 (lot, W-2 attributed, et al);
Christies Lon 6/18/81: 68 ill, 69 ill, 70 ill, 71 ill, 72 (note), 107 (lot, W-1 et al);
Sothebys Lon 10/28/81: 36 ill, 37 ill, 39 ill, 43 ill;
Christies Lon 3/11/82: 53, 74 (lot, W-2 et al);
Sothebys Lon 3/15/82: 53 ill;
Phillips Lon 6/23/82: 14 (lot, W-1 et al);
Christies Lon 6/24/82: 35 ill, 36 ill, 78 (lot, W-1 et al);
Sothebys Lon 6/25/82: 13 ill, 14 ill;
Sothebys Lon 10/29/82: 1 ill, 2 ill;
Phillips Lon 3/23/83: 7 ill;
Christies Lon 3/24/83: 21 ill, 22, 38 (lot, W-2 et al);
Christies Lon 6/23/83: 35 (lot, W-2 et al);
Phillips Lon 11/4/83: 145 (album, W-3 et al);
Swann NY 11/10/83: 226 (attributed);
Christies Lon 6/27/85: 38 (lot, W-3 et al);
Christies Lon 10/31/85: 47 ill, 48 ill, 49 ill, 50 ill(lot, W-1 et al), 305 (album, W-1 et al);
Christies Lon 3/29/84: 21 ill(lot, W et al), 24 (lot, W-1 et al), 24 (lot, W-1 et al), 338 (albums, W et al);
Christies Lon 6/28/84: 21 ill;
Sothebys Lon 6/29/84: 12 (lot, W et al);
Sothebys Lon 10/26/84: 10 (lot, W et al);
Christies NY 2/13/85: 119 (lot, W et al)(note);
Phillips Lon 3/27/85: 136 (2, attributed);
Christies Lon 3/28/85: 28A ill, 29, 29A ill;
Sothebys Lon 11/1/85: 8 ill;
Christies Lon 4/24/86: 320 ill, 329 (lot, W et al), 351 (lot, W-1 et al);
Christies Lon 10/30/86: 19A (lot, W et al), 24;

## WILLIAMS, W.A. (American)

Photos dated: Nineteenth century
Processes:   Albumen
Formats:     Stereos
Subjects:    Topography
Locations:   US - Rhode Island
Studio:      US
  Entries:
Harris Baltimore 3/15/85: 86 (lot, W-3 et al);

## WILLIAMS, W.I. & Co. (American)

Photos dated: c1875
Processes:   Albumen
Formats:     Cabinet cards
Subjects:    Ethnography
Locations:   US - Arizona
Studio:      US - San Francisco, California
  Entries:
Swann NY 11/11/76: 464 (lot, W-2 et al);

## WILLIAMSON (see WILDER & WILLIAMSON)

## WILLIAMSON, Andrew (British)

Photos dated: 1880
Processes:   Albumen, platinum, photogravure
Formats:     Prints
Subjects:    Topography
Locations:   US - Colorado
Studio:
  Entries:
Sothebys NY 2/25/75: 65 (book, 18);
California Galleries 9/26/75: 201 (book, 18);
Frontier AC, Texas 1978: 342 (book, 18)(note);
Sothebys Lon 3/22/78: 24 ill(book, 18);
Swann NY 10/18/79: 238 (book, 18)(note);

## WILLIAMSON, Charles H. (American)

Photos dated: c1844-c1885
Processes:   Daguerreotype, salt, albumen
Formats:     Plates, prints, cdvs, stereos
Subjects:    Portraits, topography
Locations:   US
Studio:      US - Brooklyn, New York
  Entries:
Sothebys NY (Weissberg Coll.) 5/16/67: 117 (lot, W-1 et al), 155 (lot, W-1 et al);
Sothebys NY (Strober Coll.) 2/7/70: 135 (lot, W-1 et al)(note), 155;
Rinhart NY Cat 2, 1971: 366 (lot, W et al);
Vermont Cat 4, 1972: 331 ill;
Vermont Cat 9, 1975: 413 ill;
Witkin NY III 1975: D7 ill;
Sothebys Lon 3/21/75: 175 (lot, W-1 et al);
Swann NY 9/18/75: 186 (lot, W et al), 216 (lot, W et al);
California Galleries 9/26/75: 32;
California Galleries 1/22/77: 82;
California Galleries 6/28/81: 362 ill;
Swann NY 5/5/83: 454;
Harris Baltimore 6/1/84: 353 (note);

**WILLIAMSON, Fk.**
Photos dated: 1850s
Processes:      Ambrotype
Formats:        Plates
Subjects:       Portraits
Locations:
Studio:
   Entries:
Sothebys Lon 10/29/76: 219 (lot, W-1 et al);

**WILLIS & Son** (British)
Photos dated: 1850s
Processes:      Ambrotype
Formats:        Plates
Subjects:       Portraits
Locations:      Studio
Studio:         England - Gravesend
   Entries:
Vermont Cat 11/12, 1977: 692 ill;

**WILLIS, G.** (British)
Photos dated: 1860s and/or 1870s
Processes:      Albumen
Formats:        Stereos
Subjects:       Topography
Locations:      England
Studio:         England
   Entries:
Sothebys Lon 10/14/74: 7 (lot, W et al), 9 (lot,
   W et al);
Phillips Lon 10/29/86: 223 (lot, w et al);

**WILLIS, Reverend R.** (British)
Photos dated: 1867-1870s
Processes:      Albumen
Formats:        Prints
Subjects:       Architecture
Locations:      England - Canterbury
Studio:         Great Britain
   Entries:
Christies Lon 6/26/80: 314 (book, 26);
Christies Lon 3/26/81: 413 (album, W et al);
Christies Lon 4/24/86: 345 (lot, W et al);

**WILSON, Messrs.**
Photos dated: 1888
Processes:      Albumen
Formats:        Prints
Subjects:
Locations:
Studio:
   Entries:
Christies Lon 6/26/80: 337 (books, W-8 et al);

**WILSON, Alexander**
Photos dated: 1860s-1871
Processes:      Albumen
Formats:        Prints, stereos
Subjects:       Topography
Locations:      England - Kenilworth
Studio:         England - Leamington
   Entries:
Swann NY 11/11/76: 164 (book, W et al)(note);
Vermont Cat 11/12, 1977: 837 ill(5);
Christies Lon 10/30/80: 121 (lot, W et al);
Harris Baltimore 7/31/81: 120 (lot, W et al);

**WILSON, A.** (continued)
Christies Lon 3/11/82: 88 (lot, W et al);
California Galleries 5/23/82: 228 (lot, W et al);
California Galleries 7/1/84: 108 (book, 1);
Christies Lon 10/25/84: 44 (lot, W et al);
Harris Baltimore 3/15/85: 117 (lot, W et al)(note);
Christies Lon 10/31/85: 69 (lot, W et al);
Wood Boston Cat 58, 1986: 136 (books, W-1 et al);

**WILSON, Augustus** (British)
Photos dated: 1878
Processes:      Albumen
Formats:        Prints
Subjects:       Genre
Locations:
Studio:         England - Stoke Newington
   Entries:
Sothebys Lon 3/21/75: 274 (7)(note);

**WILSON, Charles** (British)
Photos dated: 1854-1856
Processes:      Salt, albumen
Formats:        Prints
Subjects:       Topography
Locations:      England
Studio:         Great Britain
   Entries:
Sothebys Lon 10/28/81: 70 (13);
Sothebys Lon 6/25/82: 107 (13);

**WILSON, Captain Charles W.** (British)
Photos dated: 1865-1869
Processes:      Albumen
Formats:        Prints
Subjects:       Documentary (expeditions)
Locations:      Egypt - Sinai; Palestine - Jerusalem
Studio:
   Entries:
Sothebys Lon 6/26/75: 135 ill(albums, 75)(note);
Sothebys Lon 6/17/81: 157 (album, W & Palmer, 47);

**WILSON, Edward L.**
Photos dated: late 1860s-1894
Processes:      Albumen, phototype
Formats:        Prints, stereos
Subjects:       Topography
Locations:      US; Egypt; Palestine
Studio:         US - Philadelphia, Pennsylvania
   Entries:
Rinhart NY Cat 6, 1973: 370;
Rinhart NY Cat 8, 1973: 73;
California Galleries 4/3/76: 451 (84);
Gordon NY 5/3/76: 298 ill(books, W et al), 300 ill
   (books, W-2 et al);
Christies NY 5/14/80: 336 (book, W et al), 387
   (book, W et al);
Harris Baltimore 12/10/82: 22 (lot, W-27 et al);
Harris Baltimore 4/8/83: 16 (lot, W-20 et al);
Harris Baltimore 12/16/83: 24 (lot, W et al)(note),
   146 ill(170), 147 (30);
Harris Baltimore 6/1/84: 48 (25), 161 ill(390);
Harris Baltimore 3/15/85: 32 (31), 33 (lot,
   W-19 et al);
California Galleries 6/8/85: 510 (lot, W et al);
Swann NY 11/14/85: 263 (books, W et al), 264
   (books, W et al);
Wood Boston Cat 58, 1986: 136 (books, W-4 et al);

**WILSON, E.L.** (continued)
Harris Baltimore 2/14/86: 6 (146), 57 (11);
Swann NY 5/15/86: 133 (book, W et al);
Harris Baltimore 11/7/86: 306 (lot, W-5 et al);

**WILSON, Francesca** (photographer or author?)
Photos dated: 1876
Processes:      Carbon
Formats:        Prints
Subjects:       Topography
Locations:      India
Studio:
   Entries:
Christies Lon 3/10/77: 335 (book, 12);

**WILSON, George Washington** (British, 1823-1893)
Photos dated: 1852-1888
Processes:      Albumen, collotype
Formats:        Prints, stereos, cdvs, cabinet cards
Subjects:       Topography, ethnography, portraits
Locations:      Great Britain; Ireland; South Africa;
                Spain; Gibraltar
Studio:         Scotland - Aberdeen
   Entries:
Goldschmidt Lon Cat 52, 1939: 230 (book, W et al),
   236 (book, 12);
Weil Lon Cat 4, 1944(?): 198 (book, W et al)(note);
Weil Lon Cat 7, 1945: 190 (book, 12)(note), 191
   (book, 12), 192 (book, 12), 193 (book, 12);
Andrieux Paris 1952(?): 719 (book, W et al);
Swann NY 2/14/52: 43 (book, 9), 369 (albums, 96)
   (note);
Sothebys NY 11/21/70: 349 ill(lot, W-1 et al);
Rinhart NY Cat 2, 1971: 404 (album, W et al);
Sothebys Lon 12/21/71: 140 (books, 22), 165 (lot,
   W-12 et al), 218 (lot, W-53 et al);
Vermont Cat 4, 1972: 616 (2 ills)(book, 10)(note);
Rinhart NY Cat 6, 1973: 2 (album, W et al), 3
   (album, W et al), 101 (book, 12), 124 (album,
   10), 430, 433 (2), 501;
Rinhart NY Cat 7, 1973: 189, 190, 191, 192, 193,
   544 (lot, W-1 et al);
Witkin NY I 1973: 230 (book, 12);
Sothebys Lon 5/24/73: 6 (lot, W et al), 126 (lot,
   W et al);
Christies Lon 6/14/73: 199 (album, W et al);
Christies Lon 10/4/73: 99 (books, W et al), 103
   (books, W-1 et al);
Sothebys Lon 12/4/73: 2 (lot, W et al), 173 (book,
   W et al), 175 (books, W et al);
Vermont Cat 7, 1974: 747 (album, W et al), 752
   (book, W et al), 764 (2 ills)(book, 13);
Witkin NY II 1974: 206 (book, W et al), 1245 (book,
   W-1 et al);
Sothebys Lon 3/8/74: 37 (albums, W et al), 38
   (album, W et al), 40 (albums, W et al), 163
   (book, W et al), 164 (book, W-1 et al), 164
   (book, W et al);
Sothebys Lon 6/21/74: 17 (lot, W et al), 82
   (albums, W et al), 84 (album, W et al), 91 (lot,
   W et al), 150 (books, W et al), 151 (book, W
   et al);
Christies Lon 7/25/74: 355 (albums, W et al);
Sothebys Lon 10/14/74: 7 (lot, W et al), 13 (lot, W
   et al), 68 (album, W et al), 96 (albums, W et
   al), 97 (album, W et al), 98 (album, 129), 99
   (album, 12), 102 (album, W et al);

**WILSON, G.W.** (continued)
Edwards Lon 1975: 24 (album, W et al), 63 (book, 9),
   110 (book, W et al), 162 (book, W et al), 163
   (book, W et al);
Vermont Cat 9, 1975: 589 ill(5);
Witkin NY III 1975: 613 (book, W-1 et al);
Swann NY 2/6/75: 156 (book, W-2 et al), 201 (10);
Sothebys NY 2/25/75: 147 (lot, W et al);
Sothebys Lon 3/21/75: 75 (album, W et al), 91
   (albums, W et al), 123 (24), 126 (album, W et
   al), 148 (album, W et al), 315 (book, W et al),
   316 (books, W et al);
Sothebys Lon 6/26/75: 3 (lot, W et al), 9 (lot, W
   et al), 99 (album, W et al), 103 (album, W et
   al), 110 (album, W et al);
Swann NY 9/18/75: 386 (book, W-1 et al);
Sothebys NY 9/23/75: 74 (albums, W et al), 80
   (books, W-10 et al);
California Galleries 9/26/75: 114 (album, W et al),
   118 (album, W et al), 131 (album, W et al), 134
   (album, W et al), 179 (book, W et al), 183
   (album, W et al), 202 (album, 12), 262 (lot, W-2
   et al), 266 (3);
California Galleries 9/27/75: 387 (lot, W et al),
   576 (18 plus 6 attributed);
Sothebys Lon 10/24/75: 72 (35), 83 (lot, W et al),
   84 (lot, W-20 et al), 86 (23), 88 (45), 141
   (album, W et al);
Colnaghi Lon 1976: 148 (2 ills)(4)(note), 200
   (album, W-1 et al);
Kingston Boston 1976: 315 ill(11)(note), 316 ill
   (17), 318 (album, 20);
Witkin NY IV 1976: AL8 (album, W et al);
Wood Conn Cat 37, 1976: 233 (album, W et al), 236
   (album, W-23 et al), 249 (album, W et al);
Sothebys Lon 3/19/76: 1 (lot, W et al), 42 (album,
   W et al);
California Galleries 4/2/76: 151 (album, W et al),
   161 (album, W-1 et al), 218 (lot, W et al);
California Galleries 4/3/76: 315 (lot, W-1 et al),
   388 (lot, W-1 attributed, et al);
Sothebys NY 5/4/76: 79 (album, W et al), 81 (album,
   W et al);
Christies Lon 6/10/76: 41 (lot, W et al), 47
   (albums, W et al), 94 (album, W et al), 146
   (album, W et al), 148 (album, W et al);
Sothebys Lon 6/11/76: 2 (lot, W et al), 4 (lot, W-3
   et al), 64 ill(album, W-2 et al), 66 (album,
   W-28 et al), 157 (book, W et al);
Christies Lon 10/28/76: 88 (albums, W et al), 89
   (albums, W et al), 91 (albums, W et al), 219
   (album, W et al), 229 (albums, W et al), 275
   (books, W et al), 277 (book, W-1 et al);
Sothebys Lon 10/29/76: 26 (lot, W et al), 32 (53),
   114 (albums, W et al), 125 (lot, W et al), 131
   (album, W et al), 133 (lot, W-12 et al), 171
   (book, W et al);
Sothebys NY 11/9/76: 56 (album, W et al);
Swann NY 11/11/76: 269 (book, W et al), 299 (book,
   11), 449 (lot, W et al);
Vermont Cat 11/12, 1977: 523 (book, W et al), 531
   ill(book, 10), 532 ill(book, 10), 533 ill(book,
   11)(attributed), 534 ill(book, 6)(attributed),
   535 ill(book, 12), 536 ill(book, 13), 537 ill
   (book, 10), 838 ill, 929 ill(note), 930 ill, 931
   ill, 932 ill, 933 ill, 934 ill, 935 ill, 936
   ill, 937 ill, 938 ill, 939 ill, 940 ill, 941 ill;
White LA 1977: 63 ill(note), 64 ill, 65, 66, 67;
California Galleries 1/22/77: 167 (album, W et al),
   168 (album, W et al), 212 (book, W et al), 213
   (book, W et al), 294 (lot, W-1 et al);

## WILSON, G.W. (continued)

Sothebys Lon 3/9/77: 7 (lot, W et al), 48 (album, W et al), 53a (albums, W et al), 54 (album, 32), 135 ill(album, 24);

Christies Lon 3/10/77: 83 (album, W et al), 188 (album, W et al), 192 (albums, W et al), 202 (lot, W et al), 252 (album, W et al), 321 (book, W et al);

Christies Lon 6/30/77: 76 (books, 24), 78 (albums, W-48 et al), 80 (album, W et al), 82 (albums, W-60 et al), 193 (book, W et al), 194 (books, 25);

Sothebys Lon 7/1/77: 21 (book, W et al), 34 (book, W et al), 137 (album, W et al), 165 (book, 12), 168 (album, W et al), 169 (albums, W et al);

Sothebys NY 10/4/77: 125 (album, W et al);

Christies Lon 10/27/77: 65 (albums, W et al), 208 (book, W et al);

Sothebys Lon 11/18/77: 12 (lot, W et al), 67 (lot, W et al), 68 (album, W et al), 75 (lot, W et al), 87 (lot, W et al), 88 (albums, W et al), 89 (lot, W et al), 175 (book, W et al), 177 (book, W-1 et al), 179 (book, W et al), 189 (book, 12), 191 (book, 40), 195 (book, W et al);

Swann NY 12/8/77: 321 (album, W et al), 325 (albums, W et al), 431 (album, W et al);

California Galleries 1/21/78: 209 (album, W et al), 215 (album, W et al), 216 (album, W-15 et al);

Christies Lon 3/16/78: 162 (lot, W et al), 183 ill (lot, W-12 et al), 208 (book, W et al), 225 (books, W-6 et al);

Sothebys Lon 3/22/78: 1 (lot, W et al), 63 (album, W et al);

Swann NY 4/20/78: 139 (book, W-1 et al), 269 (album, W et al), 314 (lot, W et al);

Christies Lon 6/27/78: 58 (album, W et al), 63 (lot, W et al), 68 (album, W et al), 97 (album, W et al), 159 (book, W et al);

Sothebys Lon 6/28/78: 2 (lot, W-21 et al), 21 (book, W et al);

Christies Lon 10/26/78: 88 (lot, W et al), 89 (lot, W et al), 106 (album, W et al), 127 (lot, W et al), 192 (album, W et al), 194 (album, W et al), 206 (book, W-1 et al);

Sothebys Lon 10/27/78: 112a (album, W et al);

Swann NY 12/14/78: 473 (album, W et al);

Lehr NY Vol 1:4, 1979: 38 (book, W-2 et al), 57 (book, 71)(note);

Witkin NY IX 1979: 2/40 (book, W-88 et al), 2/91 (book, W-2 et al);

California Galleries 1/21/79: 114A (book, W et al), 342 (album, W-27 et al);

Phillips Lon 3/13/79: 138 (albums, W et al);

Sothebys Lon 3/14/79: 103 (album, 20);

Christies Lon 3/15/79: 77 (lot, W-4 et al), 83 (lot, W et al), 102 (lot, W et al), 187 (albums, W et al), 189 (albums, W et al), 194 (albums, W et al), 317 (albums, W-1 et al);

Swann NY 4/26/79: 462 (album, W et al)(note), 465 (books, W-18 et al);

Phillips NY 5/5/79: 179 (lot, W-5 et al);

Sothebys NY 5/8/79: 81 (albums, W et al);

Christies Lon 6/28/79: 70 (lot, W-30 et al), 71 (lot, W et al), 90 (albums, W et al), 103 (albums, W et al), 139 (albums, W et al), 143 (albums, W et al), 145 (albums, W-9 et al), 146 (albums, W et al), 156 (book, W et al), 157 (book, W et al), 160 (book, W et al), 243 (album, W et al);

Sothebys Lon 6/29/79: 101 (album, 10), 103 (album, 90);

## WILSON, G.W. (continued)

Phillips Can 10/4/79: 19 (album, 20);

Sothebys Lon 10/24/79: 37 (book, W et al), 44 (book, 12), 58 (lot, W et al), 136 (6), 181 (album, 20), 354 (lot, W et al);

Christies Lon 10/25/79: 84 (lot, W-26 et al), 95 (lot, W et al), 121 (lot, W-5 et al), 122 (lot, W et al), 123 (album, W et al), 124 (albums, W et al), 129 (albums, W et al), 130 (album, W et al), 134 (lot, W-12 et al), 159 (albums, W et al), 231 (album, W et al), 244 (albums, W et al), 245 (album, W et al), 249 (albums, W et al), 250 (albums, W et al), 252 (album, W et al), 398 (lot, W et al), 420 (album, W et al);

Christies NY 10/31/79: 25 (book, W et al);

Phillips NY 11/3/79: 159 (album, W et al);

Phillips NY 11/29/79: 270 (2), 271 (album, W-7 et al);

Rose Boston Cat 5, 1980: 44 ill(note), 45 ill;

Witkin NY X 1980: 52 ill(book, W-1 et al);

Sothebys LA 2/6/80: 132 ill(albums, W-70 et al);

Christies Lon 3/20/80: 89 (lot, W et al), 106 (lot, W-1 et al), 131 (albums, W et al), 135 (lot, W et al), 148 (album, W et al), 158 (albums, W et al), 175 (albums, W et al), 204 (lot, W et al), 210 (album, W et al), 218 (book, W et al), 364 (album, W et al), 366 (lot, W et al);

Sothebys Lon 3/21/80: 76 (55), 81a (lot, W et al), 163 (album, W et al), 167 (albums, W et al), 173 (albums, W et al), 174 (album, 48), 175 (albums, W et al), 179 ill(album, W-41 et al);

California Galleries 3/30/80: 207 (album, W et al), 343 (lot, W-1 et al), 443 (6);

Christies NY 5/14/80: 269 (book, W et al);

Phillips NY 5/21/80: 139 (albums, W et al);

Christies Lon 6/26/80: 101 (lot, W-5 et al), 117 (lot, W et al), 119 (lot, W-4 et al), 160 (album, 50), 167 (book, W et al), 205 (album, W et al), 211 (albums, W et al), 261 (lot, W et al), 272 (albums, W et al), 274 (album, W et al), 278 (albums, W et al), 302 (book, W et al), 484 (album, W-2 et al);

Sothebys Lon 6/27/80: 110 (album, 30);

Sothebys Lon 10/29/80: 6 (lot, W et al);

Christies Lon 10/30/80: 121 (lot, W et al), 132 (lot, W-20 et al), 148 (albums, W et al), 149 (album, W et al), 151 (album, 48), 153 (albums, W et al), 189 (albums, W et al), 190 (album, W-16 et al), 198 (albums, W et al), 222 (albums, W et al), 264 (album, W et al), 268 (album, W et al), 284 (book, W et al), 446 (lot, W et al);

Swann NY 11/6/80: 281 (lot, W et al), 284 (lot, W et al);

Christies NY 11/11/80: 199 (72);

California Galleries 12/13/80: 147 (book, 12), 148 (book, 12), 176 (album, W et al), 400 (lot, W-2 et al), 412 (2);

Phillips Lon 3/18/81: 87 (book), 88 (book, W et al);

Christies Lon 3/26/81: 121 ill(215)(note), 128 (lot, W-1 et al), 129 (lot, W-6 et al), 139 (lot, W et al), 152 (album, 50), 161 (lot, W et al), 163 (albums, W et al), 194 (album, W et al), 196 (album, W et al), 259 (album, W et al), 265 (album, W et al), 273 (album, W et al);

Sothebys Lon 3/27/81: 7 (lot, W-11 et al), 15 (lot, W et al), 16 (lot, W-1 et al), 110 (album, W et al), 113 (5), 237 (book, 11), 496 (album, W-4 et al);

Swann NY 4/23/81: 516 (album, 117), 530 (lot, W et al);

## WILSON, G.W. (continued)

Phillips NY 5/9/81: 12 ill(albums, W-30 et al), 24
(albums, W et al);
Sothebys Lon 6/17/81: 111 (albums, W et al), 121
(album, W et al), 444 (book, W et al), 445
(book, W et al);
Christies Lon 6/18/81: 75 (lot, W-7 et al), 94
(32), 102 (lot, W-5 et al), 104 (lot, W et al),
105 (lot, W-2 et al), 106 (lot, W-1 et al), 161
(lot, W et al), 166 (lot, W et al), 192 (albums,
W et al), 193 (albums, W et al), 234 (album, W-7
et al), 241 (albums, W et al);
Phillips Lon 6/24/81: 63 (book);
California Galleries 6/28/81: 136 (album, W et al),
188 (lot, W et al), 339 (lot, W et al);
Harris Baltimore 7/31/81: 103 (lot, W-4 et al), 131
(lot, W-5 et al), 317 (19);
Phillips Lon 10/28/81: 133 (albums, W et al), 155
(albums, W et al);
Christies Lon 10/29/81: 136 (lot, W-4 et al)(note),
138 (lot, W-1 et al), 192 (lot, W-10 et al), 354
(albums, W et al);
Swann NY 11/5/81: 479 (albums, W et al);
Petzold Germany 11/7/81: 82 (book, W et al);
Christies Lon 3/11/82: 61 (lot, W et al), 80 (lot,
W et al), 82 (lot, W-1 et al), 85 (lot, W et
al), 89 (lot, W et al), 114 (lot, W et al), 344
(lot, W et al);
Sothebys Lon 3/15/82: 13 (76), 16 (110), 65 (lot,
W et al), 83 (albums, W et al), 436 (books, W
et al);
Phillips Lon 3/17/82: 8 (lot, W et al), 41 (albums,
W-11 et al), 42 (albums, W-69 et al), 53
(albums, W-10 et al), 54 (lot, W-1 et al), 58
(lot, W-8 et al);
Harris Baltimore 3/26/82: 26 (15), 255 (12), 384
(album, W et al);
California Galleries 5/23/82: 184 (album, W et al),
228 (lot, W et al), 289 (lot, W-5 et al), 459;
Phillips Lon 6/23/82: 23 (lot, W-2 et al), 26 (lot,
W-69 et al), 28 (lot, W et al), 30 (lot, W et
al), 36 (albums, W et al), 44 (albums, W et al);
Christies Lon 6/24/82: 60 (lot, W et al), 69 (lot,
W et al), 101 (albums, W et al), 140 (album, W
et al), 220 (album, W et al), 224 (albums, W
et al);
Christies Lon 10/28/82: 17 (lot, W et al), 21 (lot,
W et al), 25 (lot, W et al), 26 (lot, W et al),
27 (lot, W-29 et al), 116 (album, W et al);
Swann NY 11/18/82: 227 (book, 11)(attributed)
(note), 341 (lot, W et al), 373 (albums, W et al)
(note), 446 (lot, W et al);
Harris Baltimore 12/10/82: 111 (92), 387 (albums,
W et al), 389 (album, W et al), 391 (albums, W
et al);
Christies NY 2/8/83: 34 (lot, W et al);
Phillips Lon 3/23/83: 8 (lot, W et al);
Sothebys Lon 3/25/83: 3 ill(60);
Harris Baltimore 4/8/83: 116 (54), 370 (album, W et
al), 416 (album, 10);
Swann NY 5/5/83: 281 (album, W et al), 282 (album,
W et al), 284 (albums, W et al), 428 (lot, W-20
et al);
California Galleries 6/9/83: 382 (lot, W et al);
Phillips Lon 6/15/83: 121 (album, W et al), 127
(album, W et al), 128 (lot, W et al);
Christies Lon 6/23/83: 43 (lot, W et al), 45 (lot,
W et al), 52 (lot, W-10 et al), 57 (lot, W-8 et
al), 68 (albums, W et al), 70 (lot, W et al),
100 (album, W-100 et al), 166 (albums, W et al);

## WILSON, G.W. (continued)

Christies NY 10/4/83: 109 (lot, W et al), 110 (lot,
W et al);
Christies Lon 10/27/83: 28 (lot, W-10 et al), 29
(lot, W-12 et al), 60 (albums, W et al), 80
(album, W et al), 163 (book, W et al);
Phillips Lon 11/4/83: 29 (books, W et al), 65
(albums, W et al), 70 (album, W et al);
Swann NY 11/10/83: 88 (book, W et al), 167 (book,
9), 275 (album, W et al), 277 (album, W et al)
(note), 278 (album, W et al)(note), 348 (lot,
W et al);
Sothebys Lon 12/9/83: 9 (albums, W et al);
Harris Baltimore 12/16/83: 148 (40)(note), 188
(book, W et al);
Christies NY 2/22/84: 6 (album, W et al);
Christies Lon 3/29/84: 16 (lot, W-3 et al), 22
(lot, W et al), 23 (lot, W et al), 24 (lot, W-18
et al), 27 (lot, W-9 et al), 29 (lot, W-11 et
al), 52 (albums, W et al), 62 (albums, W et al),
76 (albums, W et al), 97 (album, W et al), 104
(albums, W et al), 207 (lot, W-3 et al), 208 ill
(lot, W et al);
Swann NY 5/10/84: 233 (lot, W et al), 301 (lot,
W-17 et al), 306 (lot, W et al);
Harris Baltimore 6/1/84: 162 (15);
Phillips Lon 6/27/84: 169 (lot, W et al), 176
(albums, W et al);
Christies Lon 6/28/84: 35 (lot, W-14 et al), 37a
(lot, W et al), 46 (lot, W-2 et al), 52 (lot,
W-10 et al), 56 (lot, W et al), 131 (album, W-10
et al), 146 (books, W-12 et al), 246 (book, 200)
(note), 314 (album, W et al), 315 (album, W
et al);
Sothebys Lon 6/29/84: 5 (lot, W et al), 9 (lot,
W et al), 15 ill (370), 61 (album, 50);
California Galleries 7/1/84: 152 (book, 10), 322
(lot, W-14 et al);
Christies NY 9/11/84: 122 (album, W et al), 125
(album, W et al), 128 (album, W et al);
Phillips Lon 10/24/84: 85 (lot, W-5 et al), 118
(albums, W et al);
Christies Lon 10/25/84: 36 (lot, W-2 et al), 41
(lot, W et al), 44 (lot, W-28 et al), 47 (lot,
W-9 et al), 55 (lot, W-14 et al), 56 ill(lot,
W et al), 60 (lot, W-2 et al), 94 (lot, W et
al), 104 (album, W et al), 106 (album, W et al),
119 (book, 12);
Sothebys Lon 10/26/84: 7 (lot, W-27 et al);
Swann NY 11/8/84: 154 (albums, W et al), 155
(albums, W et al), 201 (albums, W et al), 202
(albums, W et al), 284 (lot, W et al);
Christies NY 2/13/85: 144 (albums, W et al), 168
(books, W-18 et al);
Harris Baltimore 3/15/85: 34 (lot W-6 et al), 117
(lot, W-16 et al), 184 (album, W et al);
Phillips Lon 3/27/85: 144 (lot, W-5 et al), 153
(lot, W-3 et al), 180 (albums, W et al), 184
(album, W et al);
Christies Lon 3/28/85: 60 (lot, W-16 et al), 92
(albums, W et al), 40 (lot, W et al), 41 (lot,
W et al), 103 (album, W et al);
Sothebys Lon 3/29/85: 64 (lot, W et al), 66 ill
(370);
Sothebys NY 5/8/85: 631 (lot, W et al);
Swann NY 5/9/85: 386 (albums, W et al)(note);
California Galleries 6/8/85: 141 (album, W et al),
413 (lot, W-3 et al);
Phillips Lon 6/26/85: 126 (lot, W et al), 181
(albums, W et al), 202 (lot, W et al);

**WILSON, G.W.** (continued)

Christies Lon 6/27/85: 33 (lot, W-6 et al), 36 (lot, W et al), 42 (59), 443 (lot, W-24 et al), 56 (album, 50), 93 (lot, W et al), 96 (album, W et al);

Sothebys Lon 6/28/85: 1 (lot, W et al), 215 ill (album, 12)(attributed);

Phillips Lon 10/30/85: 15 (lot, W et al), 32 (lot, W-1 et al), 57 (lot, W et al), 71 (album, W et al), 73 (album, W et al);

Christies Lon 10/31/85: 58 (lot, W et al), 70 (lot, W-46 et al), 77 (lot, W et al), 90 (album, 410), 137 (album, W et al), 138 (album, W-24 et al), 147 (books, W-1 et al), 149 (books, W-12 et al);

Swann NY 11/14/85: 27 (lot, W et al), 28 (albums, W et al), 162 (lot, W et al), 170 (lot, W et al);

Wood Boston Cat 58, 1986: 136 (books, W-1 et al);

Harris Baltimore 2/14/86: 58 (5), 209 (album, W-36 et al), 210 (albums, W et al), 220 (album, W et al), 307 (lot, W et al), 308 (lot, W et al), 347 (lot, W et al);

Phillips Lon 4/23/86: 231 (album, W et al), 235 (album, W et al), 239 (lot, W et al), 269 (albums, W et al);

Christies Lon 4/24/86: 333 (lot, W-60 et al), 350 (lot, W-43 et al), 351 (lot, W et al), 352 (lot, W-36 et al), 368 (lot, W-41 et al), 369 (lot, W-117 et al), 380 (album, W-25 et al);

Swann NY 5/15/86: 154 (book, 9)(attributed)(note), 203 (lot, W et al), 226 (lot, W-1 et al), 233 (lot, W et al), 234 (album, W et al), 235 (albums, W et al), 286 (lot, W-2 et al), 315 (lot, W-340 et al);

Christies Lon 6/26/86: 3 (lot, W et al), 96 (lot, W et al), 127 (lot, W et al), 137 (albums, W et al), 138 (album, W et al), 150A (lot, W-117 et al), 175 (books, W et al), 188 (albums, W-22 et al);

Phillips Lon 10/29/86: 326 (lot, W et al);

Christies Lon 10/30/86: 19A (lot, W et al), 30 (lot, W et al), 32 (lot, W et al), 237 (lot, W et al), 256 (albums, W et al);

Sothebys Lon 10/31/86: 7 (lot, W et al);

Swann NY 11/13/86: 170 (albums, W et al), 214 (album, W et al), 216 (albums, W et al), 218 (lot, W et al), 319 (lot, W-1 et al), 324 (lot, W et al), 344 (lot, W et al), 356 (lot, W et al), 357 (lot, W et al);

**WILSON, J.N. & Co.** (American)
Photos dated: 1860s-1870s
Processes:      Albumen
Formats:        Stereos
Subjects:       Topography
Locations:      US - American south
Studio:         US - Savannah, Georgia
  Entries:
Sothebys NY (Strober Coll.) 2/7/70: 486 (lot, W et al);
Vermont Cat 1, 1971: 228 (lot, W et al), 242 (W & Havens, 2);
Harris Baltimore 4/8/83: 95 (lot, W-9 et al);
Harris Baltimore 3/26/82: 23 (lot, W-5 et al);
Harris Baltimore 12/10/82: 92 (lot, W & Havens et al);
Harris Baltimore 6/1/84: 150 (lot, W et al);
Christies Lon 3/28/85: 46 (lot, W et al);
Harris Baltimore 2/14/86: 13 (lot, W et al);

**WILSON, Thomas** (British)
Photos dated: 1859
Processes:
Formats:        Prints
Subjects:
Locations:
Studio:         Great Britain
  Entries:
Sothebys Lon 12/4/73: 173 (book, W et al);

**WILSON, William** (American)
Photos dated: 1898
Processes:      Albumen
Formats:        Prints
Subjects:       Documentary (military)
Locations:
Studio:         US - Savannah, Georgia
  Entries:
Swann NY 4/23/81: 521 (7);

**WILZ** (see KOCH & WILZ) [WILZ 1]

**WILZ** (French) [WILZ 2]
Photos dated: Nineteenth century
Processes:      Albumen
Formats:        Prints, stereos
Subjects:       Topography
Locations:      France
Studio:         France - Rouen
  Entries:
Bievres France 2/6/83: 87 (lot, W-15 et al);

**WIMMER, A.**
Photos dated: c1885-c1895
Processes:      Albumen
Formats:        Prints
Subjects:       Topography, architecture
Locations:      Germany; Austria; Czecholslovakia; Hungary
Studio:         Austria - Vienna
  Entries:
California Galleries 5/23/82: 194 (album, W et al);
Christies Lon 3/24/83: 143 (albums, W et al);
Christies NY 9/11/84: 120 (album, W et al);
Christies NY 2/13/85: 145 (lot, W et al);

**WINDER, J.W.** (American)
Photos dated: 1860s-1870s
Processes:      Albumen
Formats:        Steros
Subjects:       Topography
Locations:      US
Studio:         US - Cincinnati, Ohio
  Entries:
Christies Lon 3/28/85: 46 (lot, W et al);

**WINDOW & GROVE** (British)
Photos dated: 1870s-c1890
Processes:    Albumen
Formats:      Cdvs, cabinet cards
Subjects:     Portraits
Locations:    Studio
Studio:       England - London
  Entries:
California Galleries 12/13/80: 206 ill;
Harris Baltimore 3/26/82: 397 (lot, W & G et al);
Swann NY 5/5/83: 455 (albums, W & G et al);

**WINGFIELD, Lewis Strange** (1842-1891)
Photos dated: 1863
Processes:    Albumen
Formats:      Prints
Subjects:     Topography
Locations:    Great Britain
Studio:       Great Britain
  Entries:
Christies Lon 6/27/85: 52 (album, 12)(note)

**WINGRAVE, J.** (British)
Photos dated: 1860s
Processes:    Albumen
Formats:      Stereos
Subjects:     Topography
Locations:    England - Coventry
Studio:       England - Coventry
  Entries:
Christies Lon 3/11/82:  85 (lot, W et al);
Christies Lon 10/28/82: 25 (lot, W et al);

**WINKLER, Christian** (American)
Photos dated: Nineteenth century
Processes:    Albumen
Formats:      Cdvs
Subjects:     Ethnography
Locations:    US - Fort Sill, Oklahoma
Studio:       US
  Entries:
Vermont Cat 1, 1971: 242 ill(3), 243 (4);

**WINSOR** (see HURD)

**WINTER, A.**
Photos dated: 1880s
Processes:    Albumen
Formats:      Prints
Subjects:     Topography
Locations:    Tasmania - Hobart
Studio:       Tasmania - Hobart
  Entries:
Christies Lon 3/26/81: 272 ill(album, W-12 et al);
Sothebys Lon 3/15/82: 66 (album, W-10 et al);
Christies Lon 10/30/86: 172 (album, W et al);
Swann NY 11/13/86: 342 ill(34);

**WINTER, Charles H.** (French)
Photos dated: 1850s-1880s
Processes:    Daguerreotype, albumen
Formats:      Plates, prints, cdvs
Subjects:     Topography, portraits
Locations:    France - Strasbourg
Studio:       France - Strasbourg
  Entries:
Christies Lon 10/25/79: 153 (album, W et al);

**WINTER, Lloyd** (see also LANDERKIN & WINTER)
Photos dated: 1870s-1890s
Processes:    Albumen
Formats:      Cabinet cards, boudoir cards
Subjects:     Topography, ethnography
Locations:    US - Alaska
Studio:       US - Juneau and Eugene City, Alaska
  Entries:
Swann NY 11/8/84: 136 (lot, W & Brown-3, W & Pond-2,
  et al);
Swann NY 11/14/85: 12 (lot, W et al);

**WINTER, Thomas L.M. and/or John S.** (British)
Photos dated: 1853-1855
Processes:    Calotype, albumen
Formats:      Prints
Subjects:     Topography, portraits
Locations:    England - Tottenham
Studio:       Great Britain
  Entries:
Christies Lon 6/10/76: 38 (3 ills)(album, 48)(note);

**WISEMAN**
Photos dated: 1860s
Processes:    Albumen
Formats:      Stereos
Subjects:     Topography
Locations:    England - Southampton
Studio:       England - Southampton
  Entries:
Christies Lon 3/26/81: 129 (lot, W-1 et al);
Christies Lon 6/18/81: 102 (lot, W-5 et al);
Christies Lon 6/24/82: 69 (lot, W et al), 71
  (lot, W et al);
Christies Lon 6/23/83: 43 (lot, W et al);
Christies Lon 3/29/84: 22 (lot, W et al);
Harris Baltimore 6/1/84: 64 (lot, W et al);
Christies Lon 10/25/84: 44 (lot, W et al);

**WITHA, Josef**
Photos dated: 1860s and/or 1870s
Processes:    Albumen
Formats:      Prints
Subjects:     Topography
Locations:    Europe
Studio:       Europe
  Entries:
Wood Conn Cat 37, 1976: 249 (album, W et al);

**WITHERS, W.B.** (photographer or author?)
Photos dated: 1870
Processes:  Albumen
Formats:    Prints
Subjects:   Topography
Locations:  Australia - Ballarat
Studio:
    Entries:
Edwards Lon 1975: 203 (book, 4);

**WITTE** (see LUTZE & WITTE)

**WITTE, W.F.** (American)
Photos dated: 1880
Processes:  Albumen
Formats:    Stereos
Subjects:   Topography, documentary (industrial)
Locations:  US - Hazleton, Pennsylvania
Studio:     US - Camden, New Jersey
    Entries:
Rinhart NY Cat 7, 1973: 271 (4), 272 (2);
California Galleries 4/3/76: 490 (31);

**WITTICK** (see TURRILL & WITTICK)

**WO** (see TONG WO)

**WOELMONT, Baron A. de**
Photos dated: 1870
Processes:  Carbon
Formats:    Prints
Subjects:   Topography
Locations:  Great Britain
Studio:     Great Britain
    Entries:
Sothebys Lon 7/1/77: 52 (books, W-27 et al);

**WOLCOTT, A.** (American)
Photos dated: c1840
Proceses:   Daguerreotype
Formats:    Plates
Subjects:   Portraits
Locations:  Studio
Studio:     US
    Entries:
Weil Lon Cat 2, 1944(?): 238 (note);

**WOLFE** (American)
Photos dated: 1865
Processes:  Albumen
Formats:    Cdvs
Subjects:   Portraits
Locations:  Studio
Studio:     US
    Entries:
California Galleries 1/21/78: 130 (album, W-1
    et al);

**WOLFRAM** (German)
Photos dated: c1860
Processes:  Albumen
Formats:    Cdvs
Subjects:   Portraits
Locations:  Studio
Studio:     Germany - Dresden
    Entries:
Petzold Germany 11/7/81: 298 (album, W et al);

**WONDERLY, M.A.** (American)
Photos dated: 1855-c1866
Processes:  Salt, albumen
Formats:    Prints
Subjects:   Portraits
Locations:  Studio
Studio:     US - Baltimore, Marlyand
    Entries:
Sothebys NY 9/23/75: 62 ill(album, 30);
Christies NY 2/8/83: 6 (2);

**WOOD** [WOOD 1]
Photos dated: 1857-1858
Processes:  Ambrotype
Formats:    Plates
Subjects:   Portraits
Locations:
Studio:
    Entries:
Christies Lon 10/25/79: 36 (4 ills)(4);
Christies Lon 10/29/81: 73 (4);

**WOOD & Brother** (American)(see also WOODBURY,
                D.B.) [WOOD 2]
Photos dated: 1862-1870s
Processes:  Albumen, tintype
Formats:    Prints, cdvs, plates
Subjects:   Documentary (Civil War), portraits
Locations:  US - Civil War area
Studio:     US - Albany, New York
    Entries:
Sothebys NY (Strober Coll.) 2/7/70: 409 (lot,
    W-5 et al);
Rinhart NY Cat 2, 1971: 267 (lot, W et al);
Vermont Cat 4, 1972: 463 ill;
Sothebys Lon 6/21/74: 162 (album, W & Gibson et al);
Sothebys Lon 10/14/74: 137 (book, W & Gibson et al);
Lunn DC Cat 6, 1976: 49.7 (W & Gibson), 49.8 (W &
    Gibson);
Swann NY 11/11/76: 352 (lot, W et al);
Sothebys NY 2/9/77: 66 (W & Gibson)(note);
Swann NY 4/14/77: 250A (book, W et al);
Wood Conn Cat 41, 1978: 129 (book, W & Gibson-5,
    et al)(note);
Lehr NY Vol 2:2, 1979: 40 ill, 41 ill;
Wood Conn Cat 45, 1979: 113 (book, W & Gibson-5,
    et al)(note);
Swann NY 11/6/80: 87 (book, W et al);
Harris Baltimore 5/28/82: 32 (W & Gibson), 33 (W &
    Gibson), 34 (W & Gibson);
Harris Baltimore 12/10/82: 247 (W & Gibson);
Harris Baltimore 4/8/83: 363, 364, 365, 366, 381
    (lot, W et al), 385 (lot, W et al);
Swann NY 5/5/83: 107 (book, W & Gibson et al)(note);
Harris Baltimore 9/16/83: 12 (W & Gibson), 13 (W &
    Gibson), 14 (W & Gibson), 15 (W & Gibson), 16
    (W & Gibson);

**WOOD & Brother** (continued)
Sothebys NY 5/8/84: 155 ill(book, W & Woodbury
et al)(note);
Swann NY 5/10/84: 52 (book, W & Gibson et al)(note);
California Galleries 7/1/84: 420, 421;
Harris Baltimore 11/9/84: 4 (W & Gibson), 5 (W &
Gibson), 6 (W & Gibson);
Harris Baltimore 3/15/85: 193 (lot, W & Gibson-1,
et al);
California Galleries 3/29/86: 688 (W & Gibson);

**WOOD, E.G.** (British)
Photos dated: 1850s-1860s
Processes:      Albumen
Formats:        Stereos
Subjects:       Topography, genre
Locations:      Great Britain
Studio:         Great Britain
   Entries:
Christies Lon 3/11/82: 61 (lot, W et al);
Christies Lon 10/28/82: 27 (lot, W et al);

**WOOD, H.**
Photos dated: 1860s and/or 1870s
Processes:      Albumen
Formats:        Stereos
Subjects:       Documentary (art)
Locations:
Studio:
   Entries:
Harris Baltimore 12/16/83: 128;

**WOOD, H.T.** (British)
Photos dated: 1857
Processes:      Albumen
Formats:        Prints
Subjects:       Topography
Locations:      England - Kent
Studio:         Great Britain (Photographic Club)
   Entries:
Sothebys Lon 3/14/79: 324 (album, W-1 et al);

**WOOD, J.** (American)
Photos dated: c1880
Processes:      Albumen
Formats:        Prints
Subjects:       Portraits
Locations:      Studio
Studio:         US - New York City
   Entries:
Harris Baltimore 6/1/84: 299 (lot, W-1 et al);

**WOOD, S.A.** (American)
Photos dated: c1859-c1880
Processes:      Salt, albumen
Formats:        Prints
Subjects:       Portraits, architecture
Locations:      US - New York City
Studio:         US - New York City
   Entries:
Rinhart NY Cat 1, 1971: 365 ill;
Swann NY 11/13/86: 298;

**WOODBERRY** (see HOLMES & WOODBERRY)

**WOODBRIDGE, Louise Deshong** (American, 1848-1925)
Photos dated: 1884-1915
Processes:      Albumen, platinum
Formats:        Prints
Subjects:       Topography
Locations:      US - New York State; New Hampshire;
                New Jersey; Rhode Island
Studio:         US - Philadelphia, Pennsylvania
   Entries:
Lehr NY Vol 1:2, 1978: 45 ill, 46 ill;
Lehr NY Vol 2:2, 1979: 42 ill, 43 ill, 44 ill;
Lehr NY Vol 6:4, 1984: 1 ill(note), 2 ill, 3 ill,
   4 ill, 5 ill, 6 ill, 7 ill, 8 ill, 9 ill, 10
   ill, 11 ill;

**WOODBURY, David B.** (American)(see also WOOD)
Photos dated: 1863
Processes:      Albumen
Formats:        Prints
Subjects:       Documentary (Civil War)
Locations:      US - Chikohominy, Virginia
Studio:         US
   Entries:
Sothebys Lon 6/21/74: 162 (album, W et al);
Sothebys Lon 10/14/74: 137 (book, W et al);
Swann NY 4/14/77: 250A (book, W et al);
Sothebys NY 10/4/77: 7 (lot, W-1 et al);
Wood Conn Cat 41, 1978: 129 (book, W-1 et al);
Christies Lon 3/16/78: 258 ill;
Wood Conn Cat 45, 1979: 113;
Swann NY 11/6/80: 87 (book, W et al);
Harris Baltimore 5/28/82: 106 ill(note);
Swann NY 5/5/83: 107 (book, W et al)(note);
Harris Baltimore 9/16/83: 17;
Sothebys NY 5/8/84: 155 ill(book, W & Wood et al)
   (note);

**WOODBURY, Walter Bentley** (British, 1834-1885)
Photos dated: c1858-1870s
Processes:      Albumen, woodburytype
Formats:        Prints, cdvs
Subjects:       Topography, portraits, ethnography
Locations:      Australia; Java; Summatra; Borneo
Studio:
   Entries:
Sothebys Lon 6/29/79: 275 (book, W et al);
Sothebys Lon 10/24/79: 170 (album, W & Page, 17);
Christies NY 5/16/80: 108 ill(book, 109)(note);
Christies Lon 10/30/80: 256 (W & Page, 2)
   (attributed);
Christies Lon 3/26/81: 241 (album, W & Page-12,
   et al);
Swann NY 4/23/81: 159 (book, W et al);
Christies Lon 6/18/81: 113 (5)(attributed);
Wood Conn Cat 49, 1982: 499 (book, W-2 et al)(note);
Christies Lon 6/23/83: 141 ill(album, W & Page-74
   attributed, et al);
Christies Lon 10/27/83: 154 (album, W & Page-7,
   et al);
Christies Lon 3/29/84: 73 (album, W & Page et al),
   93 (lot, W & Page-7, et al);
Swann NY 5/10/84: 52 (book, W et al)(note);
Christies Lon 6/28/84: 95 ill(lot, W & Page et al);
Sothebys Lon 6/29/84: 49 (5 ills)(album, W &
   Page-26 attributed, et al);
Sothebys Lon 10/26/84: 29 ill(album, W & Page-12
   attributed, et al);
Swann NY 11/8/84: 240 (lot, W & Page-1, et al);

**WOODBURY, W.B.** (continued)
Christies Lon 6/27/85: 97 ill (album, W & Page-34
    et al);
Swann NY 11/14/85: 114 ill(album, W & Page
    attributed, et al)(note);
Christies Lon 4/24/86: 411 (album, W & Page-34,
    et al)(note);
Swann NY 11/13/86: 357 (lot, W et al);

**WOODCROFT** (British)
Photos dated: c1860-1880s
Processes:      Albumen
Formats:        Prints
Subjects:       Topography
Locations:      Great Britain
Studio:         Great Britain
    Entries:
Sothebys Lon 3/21/75: 173 ill(album, W-1 et al)
    (note);
Sothebys Lon 7/1/77: 245 ill(album, W-1 et al);
Christies Lon 3/28/85: 100 (album, W-1 et al);

**WOODS, Edward L.** (American)
Photos dated: 1880s
Processes:      Salt, albumen
Formats:        Prints
Subjects:       Topography
Locations:      US
Studio:         US - California
    Entries:
Sothebys Lon 10/24/75: 140 (12);

**WOODWARD, C.W.** (American)
Photos dated: 1870s-1880s
Processes:      Albumen
Formats:        Stereos
Subjects:       Topography
Locations:      US - Pennsylvania; New York;
                California
Studio:         US - Rochester, New York
    Entries:
Sothebys NY (Strober Coll.) 2/7/70: 502 (lot,
    W et al);
California Galleries 9/27/75: 546 (lot, W et al);
California Galleries 4/3/76: 421 (lot, W et al),
    449 (lot, W et al), 494 (lot, W et al), 498 (8);
California Galleries 1/2/78: 179 (lot, W et al),
    189 (lot, W et al);
California Galleries 1/21/79: 299 (lot, W et al),
    309 (lot, W et al);
California Galleries 3/30/80: 380 (lot, W et al),
    408 (lot, W-1 et al);
Harris Baltimore 7/31/81: 128 (lot, W et al);
Harris Baltimore 3/26/82: 12 (lot, W et al);
Harris Baltimore 12/10/82: 115 (lot, W et al);
Harris Baltimore 4/8/83: 72 (lot, W et al), 81
    (lot, W et al);
Harris Baltimore 12/16/83: 92 (lot, W-1 et al), 95
    (lot, W et al);
Harris Baltimore 6/1/84: 119 (lot, W et al);
Swann NY 11/8/84: 253 (lot, W et al);
Harris Baltimore 3/15/85: 58 (lot, W et al), 88
    (lot, W-2 et al);
Harris Baltimore 2/14/86: 38 (lot, W et al);

**WOODWARD, Bernard Bolingbroke** (British)
Photos dated: 1871
Processes:      Woodburytype, carbon
Formats:        Prints
Subjects:       Topography
Locations:      England - Windsor
Studio:         Great Britain
    Entries:
Sothebys Lon 10/18/74: 252 (book, 22);
Sothebys Lon 6/11/76: 162 (book, 22);
Christies Lon 6/30/77: 203 (book, 23);
Swann NY 11/10/83: 168 (book, 23);

**WOODWARD, Lieutenant Colonel Joseph Janvier**
                (American)
Photos dated: 1871-1872
Processes:      Albumen
Formats:        Microphotographs, prints
Subjects:       Documentary (medical, scientific)
Locations:      Studio
Studio:         US
    Entries:
Swann NY 12/14/78: 165 (book, 20)(note);
Christies NY 5/16/80: 241 (book, 19);
Wood Conn Cat 49, 1982: 500 ill(book, 34)(note), 501
    (book, 22)(note);
Swann NY 5/15/86: 316 ill(8)(note), 317 ill(17);
Swann NY 11/13/86: 355 ill(8)(note);

**WOOLSEY, Edward J.** (American)
Photos dated: 1869
Processes:      Albumen
Formats:        Prints
Subjects:       Genre
Locations:      US
Studio:         US
    Entries:
Wood Conn Cat 42, 1978: 550 (book, 30)(note);

**WORINALD, C.** (British)
Photos dated: 1875
Processes:      Albumen
Formats:        Prints
Subjects:       Documentary (railroads)
Locations:      England
Studio:         England - Leeds
    Entries:
Christies Lon 10/30/86: 240 (album, W-1 et al);

**WORK, D.P.**
Photos dated: c1870s
Processes:      Albumen
Formats:        Stereos
Subjects:       Topography
Locations:      US - Detroit, Michigan
Studio:
    Entries:
Rinhart NY Cat 1, 1971: 179 (3);

WORMELL (American)
Photos dated: Nineteenth century
Processes:      Albumen
Formats:        Cdvs
Subjects:       Portraits
Locations:      Studio
Studio:         US - Portland, Maine
    Entries:
California Galleries 6/28/81: 144 (album,
    W-1 et al);

WORMWALD, E. (British)
Photos dated: 1860s-1882
Processes:      Albumen
Formats:        Prints, stereos
Subjects:       Architecture, topography, documentary
                (art)
Locations:      England - Leeds
Studio:         Great Britain
    Entries:
Sothebys Lon 10/29/76: 114 (albums, W et al);
Christies Lon 6/24/82: 71 (lot, W et al);
Sothebys Lon 6/28/85: 9 (lot, W-2 et al);

WORTH, J. (British)
Photos dated: 1850s
Processes:      Ambrotype
Formats:        Plates
Subjects:       Portraits
Locations:      Studio
Studio:         Great Britain
    Entries:
Christies Lon 3/20/80: 55 (lot, W-1 et al);

WORTH, T.B. (British)(photographer or author?)
Photos dated: 1878
Processes:      Albumen
Formats:        Prints
Subjects:       Architecture
Locations:      England - Exeter
Studio:         Great Britain
    Entries:
Edwards Lon 1975: 206 (book, 2);

WORTHLEY, W.E.G. (American)
Photos dated: 1850s-1870
Processes:      Daguerreotype, albumen
Formats:        Plates, stereos
Subjects:       Portraits, topography
Locations:      US
Studio:         US - Lewiston, Maine
    Entries:
Rose Boston Cat 4, 1979: 147 ill;

WORTLEY, Colonel H. Stuart (British, 1832-1890)
Photos dated: c1860-1882
Processes:      Albumen, autotype
Formats:        Prints
Subjects:       Topography, genre, portraits
Locations:      Tahiti et al
Studio:
    Entries:
Goldschmidt Lon Cat 52, 1939: 198;
Lehr NY Vol 1:2, 1978: 44 ill;
Christies Lon 6/27/78: 56;
Sothebys Lon 6/28/78: 327 ill;

WORTLEY, H.S. (continued)
Christies Lon 3/15/79: 95;
Christies Lon 6/28/79: 86;
Sothebys NY 5/20/80: 353 ill;
Phillips NY 5/21/80: 158;
Christies Lon 6/26/80: 172, 173 (attributed)(note);
Sothebys Lon 6/27/80: 161 (book);
Sothebys NY 11/17/80: 77 (book);
Christies Lon 3/26/81: 373 ill;
Sothebys Lon 10/28/81: 342, 343 ill;
Christies NY 11/10/81: 24 ill;
Wood Conn Cat 49, 1982: 433 (book, 31)(note), 499
    (book, W-4 et al)(note);
Sothebys NY 5/24/82: 300 ill;
Sothebys Lon 6/24/83: 95 ill;
Christies Lon 10/27/83: 200 ill;
Swann NY 11/10/83: 153 (book, 31);
Christies NY 2/13/85: 117 ill;
Harris Baltimore 3/15/85: 418 (book, 31);
Sothebys Lon 3/29/85: 162 ill, 163 ill;
Sothebys Lon 6/28/85: 152 ill, 153 ill(2);
Christies Lon 10/31/85: 207 ill;
Christies Lon 4/24/86: 586 ill(album, S-3 et al);
Swann NY 5/15/86: 145 (book, 31);
Christies Lon 10/30/86: 245 (album, W-1 et al);

WOTHLY, J. (German, 1823-1873)
Photos dated: c1865
Processes:      Albumen
Formats:        Prints
Subjects:       Topography
Locations:      Italy - Rome
Studio:         Germany
    Entries:
Petzold Germany 5/22/81: 1863 ill(lot, W-1 et al),
    1864 (6), 1865 ill(3), 1866 ill(3);
Petzold Germany 11/7/81: 251 ill(3), 252 ill(3),
    253 (3), 254 ill(3);

WRIGHT (see HARDESTY)

WRIGHT, Reverend A.E.
Photos dated: 1880s
Processes:      Albumen
Formats:        Prints
Subjects:       Genre
Locations:
Studio:
    Entries:
Christies Lon 3/20/80: 385 (lot, W-8 et al);

WRIGHT, Frank Lloyd (American, 1869-1959)
Photos dated: c1895
Processes:      Photogravure
Formats:        Prints
Subjects:       Genre
Locations:      Studio
Studio:         US - Wisconsin
    Entries:
Sothebys NY 12/19/79: 106 ill(note);
Sothebys NY 5/19/80: 41 ill(note), 42 ill;
Sothebys NY 11/17/80: 147 ill(note), 148 ill;
Sothebys NY 5/15/81: 136 ill(note);
Sothebys NY 11/10/86: 294 (2 ills)(2)(note);

WRIGHT, H.P. (British)
Photos dated: 1885
Processes: Albumen
Formats: Prints
Subjects: Documentary (medical)
Locations:
Studio:
    Entries:
Lehr NY Vol 1:4, 1979: 42 (book, 8);

WRIGHT, Hendrick B. (American)(photographer or
                author?)
Photos dated: 1873
Processes: Albumen
Formats: Prints
Subjects: Topography, genre
Locations: US - Luzerne County, Pennsylvania
Studio: US
    Entries:
Swann NY 2/14/52: 370 (book, 25);

WRIGHT, Henry (American)
Photos dated: 1850s
Processes: Daguerreotype
Formats: Plates
Subjects: Portraits
Locations: Studio
Studio: US - West Rock Hill, Pennsylvania
    Entries:
Witkin NY IV 1976: D1 ill;

WRIGHT, M.E.
Photos dated: Nineteenth century
Processes: Albumen
Formats: Stereos
Subjects: Topography
Locations: Great Britain
Studio: Great Britain
    Entries:
Christies Lon 3/11/82: 82 (lot, W-1 et al), 96 (lot,
    W et al);

WRIGHT, T. (British)
Photos dated: Nineteenth century
Processes: Albumen
Formats: Cabinet cards
Subjects: Portraits
Locations: Studio
Studio: England - London
    Entries:
Harris Baltimore 4/8/83: 311 (lot, W-2 et al);

WRIGHT, U.E. (British)
Photos dated: c1860
Processes: Albumen
Formats: Prints
Subjects: Topography
Locations: Great Britain
Studio: England - Oxford
    Entries:
Sothebys NY 9/23/75: 67 (lot, W-1 et al);

WRIGHT, William A. & RICHARDSON, Edward A.
                (American)
Photos dated: c1895
Processes: Albumen
Formats: Prints
Subjects: Topography
Locations: US - New England
Studio: US
    Entries:
Swann NY 10/18/79: 261 (album)(note);

WRIGHT, William Samuel (British)
Photos dated: 1867
Processes: Albumen
Formats: Prints
Subjects: Portraits, topography
Locations: England
Studio: England
    Entries:
Edwards Lon 1975: 208 (book, 17);
Christies Lon 3/16/78: 210 (book);
Sothebys Lon 10/24/79: 49 (book, 18);
Sothebys LA 2/6/80: 150 (book, 12);
Sothebys Lon 6/17/81: 210 (book, 18);

WRIGLEY, M. (British)
Photos dated: 1889
Processes: Photogravure
Formats: Prints
Subjects: Topography, ethnography
Locations: Algeria - Algiers
Studio:
    Entries:
Christies Lon 6/26/80: 336 (book, 100);

WULFF Jeune (French)
Photos dated: 1871
Processes: Albumen
Formats: Prints
Subjects: Documentary (Paris Commune)
Locations: France - Paris
Studio: France
    Entries:
Vermont Cat 8, 1974: 580 ill, 581 ill, 582 ill, 583
    ill, 584 ill, 585 ill;
Phillips Lon 3/13/79: 144 (book, 19);
Swann NY 11/10/83: 169 (book, 20);

WURTHLE, F. (See BALDI and WURTHLE)

WYATT, M. Digby (see SPENCER, J.A.)

WYBRANT (American)
Photos dated: c1880
Processes: Albumen
Formats: Prints
Subjects: Portraits
Locations: Studio
Studio: US - Louisville, Kentucky
    Entries:
Swann NY 5/10/84: 273 (lot, W et al)(note);

**WYER, H.S.** (American)
Photos dated: 1870s
Processes:     Albumen
Formats:       Stereos
Subjects:      Topography
Locations:     US - Nantucket, Massachusetts; New
               York
Studio:        US - Yonkers, New York
    Entries:
Swann NY 5/15/86: 165 (lot, W et al);

**WYKES**
Photos dated: c1860
Processes:     Ambrotype
Formats:       Plates
Subjects:      Portraits
Locations:
Studio:
    Entries:
Sothebys Lon 10/29/80: 171 (lot, W-1 et al);

**WYKES, W.** (American)
Photos dated: 1871-1885
Processes:     Albumen
Formats:       Prints
Subjects:      Documentary (industrial)
Locations:     US
Studio:        US
    Entries:
California Galleries 7/1/84: 107 (book, 1);
Wood Boston Cat 58, 1986: 136 (book, W-1 et al);

**WYLES, Benjamin** (British)
Photos dated: 1879
Processes:     Heliotype, collodion on glass
Formats:       Prints, glass stereo plates
Subjects:      Topography
Locations:     Great Britain
Studio:        England - Southport
    Entries:
Christies Lon 10/29/81: 288 (book);
Christies Lon 6/24/82: 79 (lot, W-5 et al);

**WYMAN** (see STROHMEYER & WYMAN)

**WYMAN, E. & H.** (American)
Photos dated: late 1850s
Processes:     Calotype, ambrotype
Formats:       Plates, prints
Subjects:      Portraits
Locations:     Studio
Studio:        US - Boston, Massachusetts
    Entries:
Rinhart NY Cat 2, 1971: 421 (note);
Christies Lon 7/13/72: 44 (lot, W-1 et al);
Vermont Cat 8, 1974: 531 ill;

**WYNFIELD, David Wilkie** (British, 1837-1887)
Photos dated: 1850s-1860s
Processes:     Albumen
Formats:       Prints
Subjects:      Portraits
Locations:     England
Studio:        England
    Entries:
Sothebys Lon 10/18/74: 293 (5), 294 ill;
Sothebys Lon 3/21/75: 288 ill(album, W-3 et al)
    (note);
Sothebys Lon 6/26/75: 249 (3);
Sothebys NY 9/23/75: 34 ill(note);
Colnaghi Lon 1976: 160 ill(note), 161 ill, 162;
Sothebys Lon 3/19/76: 119;
White LA 1977: 70 ill(note), 71 ill;
Sothebys Lon 3/9/77: 184;
Christies Lon 3/10/77: 211 ill, 212;
Sothebys Lon 11/18/77: 270 (5)(attributed);
Sothebys Lon 10/27/78: 177 ill(4), 178 ill, 179 ill
    (4), 180 (4), 181 (4), 182 (5);
Sothebys Lon 3/14/79: 370;
Christies NY 5/4/79: 33;
Phillips NY 5/5/79: 135;
Sothebys NY 5/8/79: 64 ill(note), 65;
Christies Lon 6/28/79: 215 ill(note);
Sothebys Lon 10/24/79: 303 (4);
Christies Lon 10/25/79: 368 ill, 369 ill;
Christies NY 11/31/79: 21, 22 (attributed);
Christies Lon 3/20/80: 330 ill(note), 331, 332,
    333, 334, 335, 336 ill, 337, 338, 339;
Christies NY 5/16/80: 113;
Christies Lon 6/26/80: 459, 460;
Christies Lon 10/30/80: 399;
Sothebys Lon 6/17/81: 221;
Sothebys Lon 10/28/81: 302, 303;
Sothebys Lon 3/15/82: 214;
Swann NY 5/15/86: 318 (4)(note);
Christies Lon 10/30/86: 116 (2);

**X.** (French) [X]
Photos dated: 1870s-1889
Processes:      Albumen
Formats:        Prints
Subjects:       Topography, documentary (public
                events)
Locations:      France - Paris et al
Studio:         France - Paris
   Entries:
Rinhart NY Cat 7, 1973: 138 (book, 23);
Swann NY 2/6/75: 133 (book, 23);
California Galleries 9/26/75: 94 (lot, X et al), 95
   (lot, X et al), 97 (lot, X et al);
Wood Conn Cat 37, 1976: 249 (album, X et al), 250
   (album, X et al);
California Galleries 4/2/76: 228 (lot, X-3 et al);
Christies Lon 6/10/76: 101 (album, X et al);
Swann NY 11/11/76: 388 (albums, X et al), 389
   (albums, X et al), 395 (albums, X et al);
Rose Boston Cat 2, 1977: 126 ill(album, X et al);
Swann NY 4/14/77: 188 (album, X et al);
Swann NY 12/8/77: 367 (lot, X et al), 372 ill(lot,
   X et al), 413 (lot, X et al);
California Galleries 1/21/79: 343 (album, X-1
   et al);
Swann NY 4/26/79: 282 (albums, X et al);
Christies Lon 10/25/79: 132 (lot, X et al);
Rose Boston Cat 5, 1980: 57 ill;

Christies Lon 3/20/80: 150 (album, X et al);
California Galleries 3/30/80: 307 (lot, X-3 et al);
Phillips NY 5/21/80: 131 (album, 36);
Christies Lon 6/26/80: 204 (lot, X et al);
Christies Lon 10/30/80: 276 (album, X et al);
California Galleries 12/13/80: 253 (lot, X-3 et al);
Christies Lon 3/26/81: 26 (lot, X et al);
Phillips NY 5/9/81: 28 (albums, X et al);
Christies Lon 6/18/81: 240 (album, X et al);
California Galleries 6/28/81: 155 (album, X et al),
   293 (lot, X et al);
California Galleries 5/23/82: 195 (album, X et al);
Swann NY 11/18/82: 373 (albums, X et al);
Harris Baltimore 4/8/83: 394 (album, X et al);
Christies Lon 3/29/84: 62 (albums, X et al);
California Galleries 7/1/84: 402 (lot, X et al);
Swann NY 11/8/84: 201 (albums, X et al), 284 (lot,
   X et al);
California Galleries 6/8/85: 141 (album, X et al);
Swann NY 11/14/85: 82 (lot, X et al), 104 (albums,
   X et al), 190 (lot, X et al);
Harris Baltimore 2/14/86: 211 (album, X et al), 225
   (album, X et al), 347 (lot, X et al);
Swann NY 5/15/86: 233 (lot, X et al), 234 (album,
   X et al), 235 (albums, X et al);
Christies Lon 6/26/86: 137 (albums, X et al);
Swann NY 11/13/86: 214 (album, X et al), 216
   (albums, X et al), 218 (lot, X et al);

**YA, On** (Chinese)
Photos dated: c1870
Processes:      Albumen
Formats:        Cdvs
Subjects:       Ethnography
Locations:      China
Studio:         China
    Entries:
Sothebys Lon 10/31/86: 18 ill(album, Y et al);

**YAERING, P.**
Photos dated: 1890s
Processes:      Albumen
Subjects:       Topography
Locations:      Norway
Studio:         Europe
    Entries:
California Galleries 4/3/76: 294 (lot, Y et al);

**YAMAMOTO, W.** (Japanese)
Photos dated: Nineteenth century
Processes:      Albumen
Formats:        Prints
Subjects:       Portraits
Locations:      Studio
Studio:         Japan - Yokohama
    Entries:
Christies Lon 6/26/86: 136 (album, 50);

**YARDLEY, A.C. & SCHARNZ, A.**
Photos dated: 1854
Processes:      Salt, albumen
Formats:        Prints
Subjects:       Topography
Locations:      Egypt - Cairo
Studio:
    Entries:
Sothebys Lon 4/25/86: 40 ill(album, 14)(note);

**YATMAN, H.**
Photos dated: c1855
Processes:      Salt, albumen
Formats:        Prints
Subjects:       Portraits
Locations:
Studio:
    Entries:
Christies Lon 10/26/78: 322 ill(note);
Christies Lon 10/30/80: 400 (lot, Y-1 et al);

**YAWATAROO** (Japanese)
Photos dated: 1880s-1890s
Processes:      Albumen
Formats:        Prints
Subjects:       Topography
Locations:      Japan
Studio:         Japan
    Entries:
Swann NY 5/5/83: 391 (album, Y-2 et al)(note);

**YEAGER, F.M.** (American)
Photos dated: 1870s
Processes:      Albumen
Formats:        Stereos
Subjects:       Topography
Locations:      US; Switzerland; Ecuador
Studio:         US - Reading, Pennsylvania
    Entries:
California Galleries 9/27/75: 561 (lot, Y et al);
California Galleries 4/3/76: 471 (lot, Y et al);
California Galleries 1/21/78: 195 (lot, Y et al);
California Galleries 1/21/79: 317 (lot, Y et al);

**YEATES, Horatio** (Irish)
Photos dated: 1860s
Processes:      Albumen
Formats:        Stereos
Subjects:       Topography
Locations:      Ireland - Dublin et al
Studio:         Ireland - Dublin
    Entries:
Christies Lon 6/26/80: 99 (lot, Y et al), 105 (lot,
    Y et al);

**YENNI, Charles T.** (American)
Photos dated: 1865
Processes:      Albumen
Formats:        Prints
Subjects:       Documentary (Civil War)
Locations:      US - New Orleans, Louisiana
Studio:         US - New Orleans, Louisiana
    Entries:
Harris Baltimore 9/16/83: 206 ill;

**YOKOYAMA, Matsusaburo** (Japanese)
Photos dated: 1865-1878
Processes:      Albumen
Formats:        Prints
Subjects:       Topography
Locations:      Japan - Tokyo
Studio:         Japan - Yokohama
    Entries:
Old Japan, England Cat 8, 1985: 23 ill(book, 73);

**YONG, Lai**
Photos dated: c1875-1885
Processes:      Albumen
Formats:        Cdvs
Subjects:       Portraits
Locations:      Studio
Studio:         US - San Francisco, California
    Entries:
Sothebys NY (Strober Coll.) 2/7/70: 279 (lot,
    L-1 et al);
California Galleries 12/13/80: 223 (5);

**YORK** (see also KIRKMAN, GREEN & YORK)
Photos dated: 1860
Processes:     Albumen
Formats:       Prints
Subjects:      Topography
Locations:     South Africa
Studio:
    Entries:
Edwards Lon 1975: 148 (book, 17);
Sothebys NY 5/2/78: 131 ill(book, Y et al);
Sothebys NY 11/2/79: 230 (book, Y et al);

**YORK, Frederick** (British)
Photos dated: 1866-1870s
Processes:     Albumen
Formats:       Stereos, cdvs
Subjects:      Topography
Locations:     England - London et al
Studio:        England - London
    Entries:
Rinhart NY Cat 6, 1973: 426;
Rinhart NY Cat 7, 1973: 194;
California Galleries 9/27/75: 448 (lot, Y et al);
Sothebys Lon 7/1/77: 4 (lot, Y et al);
Swann NY 11/6/80: 284 (lot, Y et al);
Christies Lon 3/11/82: 82 (lot, Y-8 et al);
Christies Lon 10/28/82: 27 (lot, Y et al);
Harris Baltimore 4/8/83: 52 (lot, Y-15 et al);
Christies Lon 10/27/83: 28 (lot, Y-3 et al);
Harris Baltimore 12/16/83: 57 (lot, Y-7 et al);
Christies Lon 6/28/84: 52 (lot, Y-3 et al);
Christies Lon 10/25/84: 44 (lot, Y-4 et al);

**YOUNG** (see BARR & YOUNG) [YOUNG 1]

**YOUNG** (British) [YOUNG 2]
Photos dated: Nineteenth century
Processes:     Albumen
Formats:       Prints
Subjects:      Topography
Locations:     Wales - north
Studio:        Great Britain - Dolgellau
    Entries:
Edwards Lon 1975: 24 (album, Y et al);

**YOUNG, Andrew** (British)
Photos dated: 1879
Processes:     Woodburytype
Formats:       Prints
Subjects:      Genre (nature)
Locations:     Scotland
Studio:        Scotland - Burnt Island
    Entries:
Christies Lon 10/27/77: 227 ill(book, 29);
Rose Boston Cat 4, 1979: 153 ill(note), 154 ill;

**YOUNG, J.C.**
Photos dated: 1869
Processes:     Albumen
Formats:       Prints
Subjects:      Genre (public events)
Locations:     Australia
Studio:        Australia - Perth
    Entries:
Christies Lon 10/31/85: 294 (album, Y-2 et al);

**YOUNG, J.H.** (American)
Photos dated: 1850s-1860s
Processes:     Daguerreotype, ambrotype
Formats:       Plates
Subjects:      Portraits
Locations:     Studio
Studio:        US - New York City
    Entries:
Swann NY 12/8/77: 332 (lot, Y et al);

**YOUNG, R.Y.**
Photos dated: 1890s-1900
Processes:     Albumen
Formats:       Stereos
Subjects:      Topography
Locations:     US; Cuba
Studio:        US - New York City
    Entries:
California Galleries 4/3/76: 495 (lot, Y-2 et al);
Harris Baltimore 6/1/84: 144 (lot, Y-4 et al);
Harris Baltimore 3/15/85: 99 (lot, Y-1 et al);

**YOUNG, William D.** (British)
Photos dated: 1890s
Processes:     Silver
Formats:       Prints
Subjects:      Topography
Locations:     Kenya - Mombassa
Studio:        Kenya - Mombassa
    Entries:
Sothebys Lon 3/21/80: 126 (album, 48);

**YOURLSON, Mrs. G.** (British)
Photos dated: 1860s
Processes:     Albumen
Formats:       Prints
Subjects:      Topography
Locations:     Great Britain - Glaenken
Studio:        Great Britain
    Entries:
Sothebys NY 5/20/77: 62 (albums, Y et al);

**Z., N. [N.Z.]**
Photos dated: 1860s
Processes:  Albumen
Formats:    Stereos
Subjects:   Topography
Locations:  China - Canton
Studio:
  Entries:
Christies Lon 6/18/81: 88 (lot, Z-6 et al);

**Z., P. [P.Z.]**
Photos dated: 1880s-1898
Processes:  Albumen, bromide (colored)
Formats:    Prints
Subjects:   Topography
Locations:  Europe
Studio:     Europe
  Entries:
Christies Lon 10/30/80: 202 (album, Z et al);
Swann NY 11/8/84: 200 (albums, Z et al);

**ZABRISKIE, F.N.** (photographer or author?)
Photos dated: 1867
Processes:  Albumen
Formats:    Prints
Subjects:   Topography
Locations:  US - Claverack, New York
Studio:
  Entries:
Wood Conn Cat 37, 1976: 214 (book);
Wood Conn Cat 42, 1978: 552 (book);

**ZAHNER, M.H.** (American)
Photos dated: 1890s-1900
Processes:  Albumen
Formats:    Prints, stereos
Subjects:   Topography, documentary (disasters)
Locations:  US - New York; Texas
Studio:     US - Niagara Falls, New York
  Entries:
Witkin NY IV 1976: 374 ill;
Frontier AC, Texas 1978: 345 (5);
Harris Baltimore 2/14/86: 38 (lot, Z et al);

**ZAHRA & SCHEMBRI**
Photos dated: Nineteenth century
Processes:  Albumen
Formats:    Prints
Subjects:   Topography
Locations:  Malta
Studio:     Europe
  Entries:
Christies Lon 6/27/85: 64 (lot, Z & S-1 et al);

**ZAMBONI**
Photos dated: 1880s-1890s
Processes:
Formats:
Subjects:   Topography
Locations:  Austria - Vienna
Studio:
  Entries:
Swann NY 12/8/77: 411 (lot, Z et al);

**ZAMBRA** (see NEGRETTI & ZAMBRA)

**ZANGAKI, P.**
Photos dated: 1860s-1880s
Processes:  Albumen
Formats:    Prints
Subjects:   Topography
Locations:  Egypt
Studio:     Egypt
  Entries:
Rinhart NY Cat 7, 1973: 431, 432, 433;
Witkin NY II 1974: 1223 ill(album, Z et al);
Sothebys Lon 3/8/74: 29 (lot, Z et al);
Sothebys Lon 6/21/74: 60 (lot, Z et al), 61 (albums, Z et al);
Sothebys Lon 10/18/74: 108 (album, Z et al), 109 (lot, Z et al), 111 (album, Z et al), 114 (albums, Z-84 et al);
Edwards Lon 1975: 37 (album, Z et al);
California Galleries 9/26/75: 127 (album, Z et al), 128 (albums, Z et al), 252 (lot, Z-7 et al);
Wood Conn Cat 37, 1976: 240 (album, Z-43 et al), 247 (album, Z et al);
California Galleries 4/2/76: 144 (album, Z et al), 210 (lot, Z et al);
Sothebys NY 5/4/76: 92 (album, Z et al);
Christies Lon 6/10/76: 84 (album, Z et al), 89 (albums, Z et al), 103 (album, Z et al);
Sothebys Lon 6/11/76: 38 (album, Z et al);
Christies Lon 10/28/76: 136 (album, Z et al), 137 (album, Z et al), 227 (lot, Z-4 et al);
Sothebys NY 2/9/77: 41 (albums, Z et al), 42 (lot, Z-9 et al);
Christies Lon 3/10/77: 142 (album, Z et al);
Swann NY 4/14/77: 240 (album, Z et al), 242 (album, Z et al);
Sothebys Lon 11/18/77: 105 (albums, Z et al);
Swann NY 12/8/77: 366 (album, Z et al), 380 (album, Z et al), 398 (lot, Z et al)(note), 399 (lot, Z et al);
Rose Boston Cat 3, 1978: 103 ill(note), 104 ill, 105 ill, 106 ill, 107 ill, 108 ill;
Sothebys LA 2/13/78: 135 (15), 137 (lot, Z-1 et al), 139 (album, Z-8 et al);
Christies Lon 3/16/78: 148 (albums, Z et al);
Sothebys Lon 3/22/78: 83 (album, Z et al);
Sothebys NY 5/2/78: 132 (album, Z et al);
Christies Lon 6/27/78: 124 (album, Z et al);
Sothebys Lon 6/28/78: 120 (albums, Z et al);
Christies Lon 10/26/78: 199 (albums, Z et al);
California Galleries 1/21/79: 340 (album, Z et al), 341 (album, Z-2 et al), 354 (album, Z-7 et al), 422 (11);
Phillips Lon 3/13/79: 63 (album, Z et al);
Christies Lon 3/15/79: 187 (albums, Z et al);
Swann NY 4/29/79: 276 (albums, Z et al), 277 (lot, Z et al);
Phillips NY 5/5/79: 170 (lot, Z-1 et al);
Sothebys NY 5/8/79: 106 (lot, Z et al);
Christies Lon 6/28/79: 114 (albums, Z-66 et al), 140 (album, Z et al), 148 (albums, Z et al);
Sothebys Lon 6/29/79: 124 (albums, Z et al);
Christies Lon 10/25/79: 197 (lot, Z-2 et al), 234 (album, Z et al), 236 (lot, Z-1 et al), 240 (lot, Z-2 et al), 244 (album, Z et al), 246 (albums, Z et al), 254 (lot, Z-1 et al);
Phillips NY 11/29/79: 261 (album, Z-6 et al);
Sothebys NY 12/19/79: 46 ill(lot, Z et al);
Christies Lon 3/20/80: 205 (album, Z-2 et al), 206 (album, Z-6 et al), 207 (album, Z et al);
Sothebys Lon 3/21/80: 123 (album, 57);
Christies NY 5/16/80: 204A (lot, Z et al);
Phillips NY 5/21/80: 142 (album, Z et al);

## ZANGAKI (continued)

Auer Paris 5/31/80: 70 (lot, Z et al), 71 (album, Z-39 et al);
Christies Lon 6/26/80: 272 (albums, Z et al);
Sothebys Lon 6/27/80: 74 (album, Z et al);
Christies Lon 10/30/80: 219 (album, Z et al), 220 (lot, Z et al), 221 (album, Z-19 et al), 248 (albums, Z et al), 275 (album, Z-6 et al);
Swann NY 11/6/80: 314 (lot, Z et al), 316 (album, Z et al);
Swann NY 4/23/81: 418 (album, Z et al), 455 (album, Z et al), 507 (lot, Z-1 et al);
Phillips NY 5/9/81: 59 ill(album, Z-2 et al), 61 (albums, Z et al);
Christies Lon 6/18/81: 235 (lot, Z et al), 437 (lot, Z et al);
California Galleries 6/28/81: 216 (lot, Z et al), 280 ill(lot, Z et al), 281 (lot, Z et al);
Christies Lon 10/29/81: 219 (albums, Z et al), 221 (lot, Z et al), 238 (album, Z-1 et al), 276 (albums, Z-20 et al), 277 (album, Z et al);
Swann NY 11/5/81: 463 (album, Z et al), 481 (lot, Z et al), 515 (lot, Z-3 et al);
Christies Lon 3/11/82: 159 (lot, Z et al), 161 (lot, Z et al), 164 (album, Z et al), 230 (album, Z et al);
Sothebys Lon 3/15/82: 68 (lot, Z et al), 69 (album, Z et al), 79 (album, Z et al);
Phillips Lon 3/17/82: 43 (albums, Z-8 et al);
Swann NY 4/1/82: 285 (album, Z et al)(note), 327 (album, Z et al);
California Galleries 5/23/82: 284 ill(lot, Z-5 et al), 351 (lot, Z-5 et al);
Christies Lon 6/24/82: 171 (album, Z-15 et al), 173 (album, Z et al), 175 (lot, Z et al), 197 (lot, Z et al), 226 (album, Z-3 et al), 229 (lot, Z-19 et al), 232 (albums, Z et al);
Phillips NY 9/30/82: 968 (album, Z-10 et al);
Phillips Lon 10/27/82: 39 (lot, Z-30 et al);
Christies Lon 10/28/82: 121 (albums, Z et al);
Swann NY 11/18/82: 336 (album, Z et al);
Harris Baltimore 12/10/82: 385 (album, Z-8 et al), 391 (albums, Z et al);
Bievres France 2/6/83: 126 (lot, Z et al);
Christies Lon 3/24/83: 93 (lot, Z et al), 94 (albums, Z et al), 130 (lot, Z et al), 136 (albums, Z et al), 138 (album, Z et al), 139 (albums, Z et al), 140 (album, Z et al), 143 (albums, Z et al), 163 (book, Z et al);
Swann NY 5/5/83: 340 (lot, Z et al), 404 (10)(note);
California Galleries 6/19/83: 327 (lot, Z-7 et al), 328 (lot, Z-5 et al), 331 (12), 358 (lot, Z-1 et al);
Christies Lon 6/23/83: 166 (albums, Z et al);
Christies Lon 10/27/83: 87 (albums, Z et al), 88 (albums, Z et al);
Swann NY 11/10/83: 304 (lot, Z et al);
Christies NY 2/22/84: 7 (album, Z et al);
Christies Lon 3/29/84: 61 (album, Z-66 et al), 63 (album, Z et al), 64 (album, Z-3 et al), 65 (album, Z et al), 94 (lot, Z et al), 98 (album, Z et al), 100 (albums, Z et al);
Sothebys NY 5/8/84: 326 ill(album, Z et al);
Harris Baltimore 6/1/84: 445 (lot, Z-5 et al);
Christies Lon 6/28/84: 133 (lot, Z-4 et al), 139 (album, Z-2 et al), 140 (album, Z et al), 142 (album, Z et al);
Christies Lon 10/25/84: 103 (album, Z et al), 104 (album, Z et al), 106 (album, Z et al), 110 (albums, Z et al);

## ZANGAKI (continued)

Swann NY 11/8/84: 193 (album, Z et al)(note), 199 (lot, Z-3 et al);
Christies Lon 3/28/85: 68 (albums, Z-9 et al), 70 (album, Z et al), 213 (album, Z-3 et al);
California Galleries 6/8/85: 208 (2);
Christies Lon 6/27/85: 70 (lot, Z et al), 71 (album, Z et al), 83 (lot, Z et al), 91 (lot, Z et al), 92 (lot, Z et al), 93 (lot, Z et al), 95 (album, Z-3 et al);
Phillips Lon 10/30/85: 75 (album, Z et al), 124 (album, Z et al);
Christies Lon 10/31/85: 96 (album, Z-25 et al), 98 (albums, Z-16 et al), 108 (albums, Z et al), 126 (albums, Z et al), 129 (album, Z et al), 131 (albums, Z et al), 134 (albums, Z et al), 139 (album, Z et al);
Swann NY 11/14/85: 131 (lot, Z et al);
Harris Baltimore 2/14/86: 202 (album, Z et al), 210 (albums, Z et al), 250, 296;
Phillips Lon 4/23/86: 296 (album, Z et al);
Christies Lon 4/24/86: 386 (album, Z-29 et al), 407 (album, Z-3 et al), 409 (albums, Z-15 et al);
Christies Lon 6/26/86: 34 (albums, Z et al), 72 (lot, Z et al), 118 (albums, Z et al), 154 (album, Z et al);
Christies Lon 10/30/86: 127 (album, Z et al), 143 (albums, Z-1 et al), 146 (albums, Z et al), 153 (albums, Z et al), 176 (album, Z et al);
Swann NY 11/13/86: 212 (lot, Z et al), 274 (lot, Z-2 et al);

## ZARUANINS, J.

Photos dated: 1870s
Processes: Albumen
Formats: Prints
Subjects: Topography
Locations: Egypt - Suez
Studio:
  Entries:
Christies Lon 6/26/86: 133 (5)(note);

## ZEDLER & VOGEL (German)

Photos dated: 1897
Processes:
Formats: Prints
Subjects: Topography
Locations: Germany
Studio: Germany - Bremen
  Entries:
Swann NY 4/26/79: 365 (books, Z & V et al);

## ZEDLER, Carl (see BRUCKMANN, F.)

## ZELLNER (see PENNELL & ZELLNER)

## ZELNER, James (American)

Photos dated: Nineteenth century
Processes: Albumen
Formats: Stereos
Subjects: Topography
Locations: US - Pennsylvania
Studio: US
  Entries:
Harris Baltimore 4/8/83: 86 (lot, Z et al);

ZIEGLER (see BOSTON & ZIEGLER)

ZIEGLER, E. (French)
Photos dated: c1875
Processes:      Albumen
Formats:        Prints, stereos (tissue)
Subjects:       Topography
Locations:      France - Paris
Studio:         France
    Entries:
California Galleries 1/23/77: 428 ill(lot,
    Z et al), 429 (lot, Z et al);
Swann NY 11/13/86: 274 (lot, Z-3 et al);

ZIESLER, M. (German)
Photos dated: 1888-1895
Processes:      Albumen
Formats:        Prints
Subjects:       Topography
Locations:      Germany - Kiel
Studio:         Germany - Berlin
    Entries:
Petzold Germany 5/22/81: 1867 ill(7), 1868;

ZIMMERMAN, Charles A. (American, c1844-1900)
              (see also WHITNEY, J.E.)
Photos dated: 1855-1894
Processes:      Albumen
Formats:        Prints, stereos
Subjects:       Topography, ethnography, documentary
                (disasters)
Locations:      US - American west
Studio:         US - St. Paul, Minnesota
    Entries:
California Galleries 9/25/75: 503 (lot, Z et al);
Rose Boston Cat 1, 1976: 9 ill(note);
Witkin NY IV 1976: S14 ill, S15 ill;
Rose Boston Cat 2, 1977: 11 ill(note);
California Galleries 1/23/77: 403 (lot, Z et al);
Wood Conn Cat 41, 1978: 126 ill(note);
Swann NY 11/6/80: 383 (lot, Z-1 et al);
Rose Florida Cat 7, 1982: 90 (lot, Z et al);
Harris Baltimore 4/8/83: 57 (lot, Z et al);
Swann NY 5/5/83: 431 (lot, Z et al)(note);
California Galleries 6/19/83: 97 (book, Z-1 et al);
Harris Baltimore 6/1/84: 93 (lot, Z et al);
Swann NY 11/8/84: 253 (lot, Z et al);
Harris Baltimore 3/15/85: 102 (lot, Z et al);
Wood Boston Cat 58, 1986: 136 (books, Z-1 et al);
Harris Baltimore 2/14/86: 51 (lot, Z-10 et al);

ZYBACH, J.
Photos dated: 1860s and/or 1870s
Processes:      Albumen
Formats:        Prints
Subjects:       Topography
Locations:      Canada
Studio:
    Entries:
Christies Lon 3/28/85: 324 (album, Z et al);

# The Author

Gary Edwards has been in the Foreign Service of the United States for the past twenty years with assignments in press attaché or cultural affairs officer positions in U.S. embassies in Morocco, Athens, London, and Paris, where he is now serving. He has also worked for the United Nations and for the Massachusetts Council on the Arts and Humanities. He combined his longtime interest in collecting nineteenth-century photographs with his diplomatic assignment in Athens, where he researched, cocurated, and wrote an introductory catalogue essay for the exhibition "Athens 1839-1900, a Photographic Record," which took place at the Benaki Museum in Athens in 1985. He also published in the Greek cultural review Dialogos an article on the American photographer W. J. Stillman, who served as American consul in Crete in the nineteenth century. International Guide to Nineteenth-Century Photographers and Their Works is an outgrowth of his interest in collecting and researching nineteenth-century photographs.